# AMERICAN
## ART, HISTORY, AND CULTURAL IDENTITY
# ENCOUNTERS

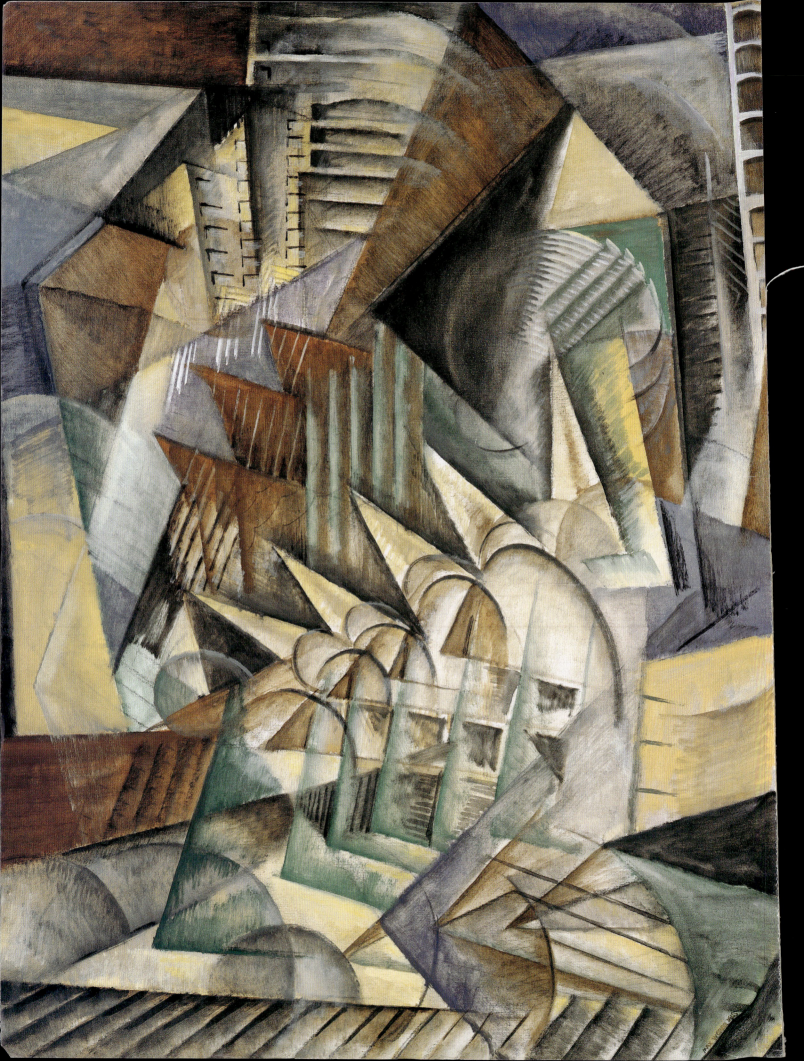

# AMERICAN
## ART, HISTORY, AND CULTURAL IDENTITY
# ENCOUNTERS

ANGELA L. MILLER

JANET C. BERLO

BRYAN J. WOLF

JENNIFER L. ROBERTS

Contributors: Margaretta M. Lovell   David Lubin

PEARSON

Prentice
Hall

Upper Saddle River, NJ 07458

Library of Congress Cataloging-in-Publication Data is available upon request.

Editor-in-Chief: Sarah Touborg
Senior Sponsoring Editor: Helen Ronan
Editorial Assistant: Christina DeCesare
Editor-in-Chief, Development: Rochelle Diogenes
Development Editor: Margaret Manos
Senior Managing Editor: Mary Rottino
Operations Specialist: Brian Mackey
Director of Marketing: Brandy Dawson
Executive Marketing Manager: Marissa Feliberty

Credits and acknowledgments borrowed from other sources and reproduced, with permission, in this textbook appear on page 671-672.

This book was produced by Laurence King Publishing Ltd., London.
Copyright © 2008 Prentice Hall.

Published by Pearson Education, Inc., Upper Saddle River, New Jersey, 07458. Pearson Prentice Hall.

Pearson Education LTD.
Pearson Education Australia PTY, Limited
Pearson Education Singapore, Pte. Ltd
Pearson Education North Asia Ltd
Pearson Education, Canada, Ltd
Pearson Educación de Mexico, S.A. de C.V.
Pearson Education–Japan
Pearson Education Malaysia, Pte. Ltd

This book was designed and produced by
Laurence King Publishing Ltd, London.
www.laurenceking.com

*Frontcover* (detail) *and backcover:* ERASTUS SALISBURY FIELD, *The Historical Monument of the American Republic,* 1867–88. Oil on canvas, 9 ft 3 in × 13 ft 1 in (2.81 × 3.98 m). Museum of Fine Arts, Springfield, Massachusetts.

*Frontispiece:* MAX WEBER, *Rush Hour, New York,* 1915. Oil on canvas, 36¼ × 30¼ in (92 × 76.8 cm). National Gallery of Art, Washington, D.C. Gift of the Avalon Foundation.

1 0 9 8 7 6 5 4 3 2
ISBN: 978-0-13-030004-1

# Contents

# Preface

SINCE ITS INCEPTION the United States has been a nation of diverse peoples. Its demographic profile has changed dramatically over time, and it continues to do so into the present. Three hundred years ago "America" was a country comprised of hundreds of Native groups speaking a wide range of languages, of European colonizers mostly from England and Spain, and of Africans forcibly enslaved and exiled from their homes. Two hundred years ago the country had become a nation that defined its heritage as northern European, Protestant, and English, despite the continuing presence of Indians and Blacks, as well as Hispanic Catholics in the Southwest. One hundred years ago, this nation absorbed millions of immigrants—from northern and southeastern Europe and Russia through Ellis Island—who transformed American life. Since then, America has attracted people from all over the globe and has become the forefront of cultural encounter among the peoples of the world. Our arts embody this.

In recent decades historians have come to recognize the contributions to American art made by diverse peoples alongside of the more fully studied "mainstream" fine arts. While these peoples, situated on the margins of American society, may not have had access to the networks of influence and power that conventionally sustain the practice of fine art, nevertheless their influence has been penetrating and profound, as we shall show. However, rather than presenting a multicultural history of discrete traditions, this book emphasizes the innovation and adaptation that has resulted from creative encounters *among* various groups. Throughout our history, cross-cultural exchange among Europeans, Native Americans, Africans, and later immigrants has been an essential part of American creativity and lived experience. In materials, workmanship, and stylistic forms, American art repeatedly offers instances of the mixing and merging of traditions.

The visual arts articulate meeting points between cultures. New England silver and porcelain drew on Chinese decorative traditions; the crazy quilt was inspired by the crazed glazes on imported Japanese ceramics; the adobe buildings of northern New Mexico fused Native traditions of mud building with those brought to Spain by Muslims in the eighth century. Such processes were at work among European forms as well: mansions on plantations in Tidewater, Virginia, represent a migration of an architectural form from Italy to England to its overseas colonies,

changing at each point in its global journey to accommodate local tastes and conditions. By observing cultures in relation to one another, we can form a fuller understanding of the ways in which traditions develop: through interaction and appropriation, change and adaptation. These processes are "the yeast of history."

## Why Encounters?

The theme of encounter is at the heart of our book—encounter not only among traditions, but between fine arts and commercial mass media, as well as among alternative versions of American identity. But this book examines well-known works as well. Set in a new context, the "canon" of American fine arts—those familiar landmarks of our cultural education—acquires new meaning and complexity. We see that those who created these well-known and well-loved works did so often in moments of cross-cultural awakening. For example, the arts were catalyzed by their encounter with Japanese aesthetics following Japan's opening to international trade in the 1850s. Or again, Abstract Expressionists, emulating the works of Native artists they collected and studied, pushed their art beyond the representation of magic and ritual to its enactment in paint. Through such examples, we discover just how international our "American" traditions of fine art and design really are. Our theme of encounter not only expands *what* we look at but *how* we look at it.

From the time of European colonization, North America has been crisscrossed by population currents: west from Europe and Africa, north from Mexico, east from the Pacific Asian world, northwest from the Caribbean. West and Central Africans, forcibly uprooted from their homeland, encountered Spanish colonizers and Indians in Florida, French Creole culture in New Orleans, or English settlers in the Northeast. American Indians from the Northeast, forced progressively westward, encountered other Indian societies from the South and the Plains. Hispanic settlers in the Southwest encountered Pueblo and Navajo. The products of these various encounters are all American artworks. As we shall show, heterogeneous mixture is not a new American story at all.

Indeed such encounters predate the contact between Europe and the "New World." Even before the first contact with Europe, Native societies were engaged in networks of

cultural exchange through trade, migration, and warfare. The facts contradict the conventional image of Indians as a timeless people living in a static world impervious to change.

The European colonization of North America vastly accelerated the rate of cultural encounter that characterized the centuries before contact. The historical period from the sixteenth through the twentieth centuries is distinguished by a global system of commodity exchange, in which raw materials, goods, and human beings circulated among the Americas, Africa, Europe, and Asia. While these economic engines of exchange proved highly destructive of traditional societies, they also introduced a range of new materials, new motifs, and creative interactions between and among people.

Encounters between the colonizers and New World cultures, however, were frequently lopsided. Europeans held disproportionate power over the peoples already here. Impelled by a powerful sense of mission, Europeans settling in America reproduced many aspects of the societies from which they came. Their arts and material culture (those humanly made objects of everyday life that shape and transmit culture) are all around us, holding a place of honor in our national memory, in our museums, and in our built environment. Their history has crucially shaped the nation's identity, although it has undergone radical revision in recent decades. It remains a central thread in any account of the meeting of societies and peoples in the New World.

Modernization brought another form of encounter, introducing massive changes in people's everyday lives, and drawing them with greater intensity toward historical anchors in the past. Virtually every ethnic group we examine in this book revived earlier traditions—"reinventing tradition"—in some manner. Around the time of the 1876 Centennial celebration Americans of northern European ancestry looked back to the seventeenth and eighteenth centuries, a time they associated with rural simplicity and civic virtue. In the early twentieth century, Pueblo potters in the Southwest revived earlier techniques of black earthenware and incorporated the geometric patterns of ancient Mimbres and Anasazi pottery. In the decades between World War I and World War II European-American critics, designers, and artists looked back to the nineteenth century for historical precedents for a "machine" aesthetic in the twentieth. In many cases, the traditions from which later generations borrowed were themselves hybrid and retrospective. This process of recovery and reinvention was directed at preserving cultural memory and continuity during periods of accelerating historical change.

The older art historical concept of influence might seem at first glance a perfectly good way of explaining these transitions between cultures and generations.

Influence, however, primarily concerns the elements of style, and it assumes a linear history across time, a one-way flow from artist to artist. Encounter expands the notion of influence beyond individual artists and makers to take in broader visual traditions. Unlike influence, it flows in multiple directions, between, across, and among cultures, as when nineteenth-century European-American artists documenting Plains Indian cultures became the source for twentieth-century efforts among American Indians to reproduce lost traditions of dress and ritual. Above all, encounter reminds us of the enormous malleability, resilience, and capacity for productive change that characterize human expression. Encounter is dynamic in nature; both parties get something different out of the exchange.

Encounters between different traditions may be friendly (trade and alliance), filled with suspicion, dread, or physical aggression (colonialism, conquest, and war), or full of comic, or sometimes tragic, cultural misunderstandings. The sixteenth-century Spanish writer Antonio de Ciudad Real recounts an act of naming by which the Spanish took symbolic possession of new lands. Asking the Indian inhabitants what they called their country, the Indians replied "uic athan," meaning "'what do you say or what do you speak, that we do not understand you?' And then, the Spaniard ordered it set down that [the new country] be called *Yucatán*."[1] As this story reveals, cultural encounter frequently involves misunderstandings that nonetheless serve the needs of the interpreting party. In the process, a new reality emerges, a Yucatán of the imagination that affects both parties.

While exchanges between and among different ethnic groups continued to vitalize the arts, the emergence of mass culture introduced another axis of encounter. Beginning in the late nineteenth century, mass media—the chromolithograph, the illustrated newspaper, comics, animation, film, and photography—introduced technologically mediated forms of visual culture which challenged concepts of artistry and originality. Many artists reacted to mass media by appropriating and borrowing from them, but the encounter also produced a form of "boundary policing" in which the two realms were strictly separated. As our text suggests, the conversation between the fine arts and mass media produced both fruitful exchange and defining opposition.

## Our Relationship to the Past

Framing the entire book is our own relationship to history. Scholars, as well as artists and designers, reinterpret the past in light of their concerns. We study the art of the past because it is a reservoir of visual quotation from which

each generation of artists, designers, architects, filmmakers, and advertisers draw. Our study promotes an understanding of how objects affect us, what messages they carry—explicit and otherwise—and what stories they can tell us about ourselves as a people. Our text opens its own conversation with the next generation of students and scholars in the field of American art. We recognize that you—our readers—differ from the readers of a similar text twenty, thirty, or sixty years ago, when the field of American art history had its origins in the cultural nationalism of the post-war years. Furthermore, we believe that our text is more "true" to the past than this older version. Since there is certainly room for debate on that question, we must as authors acknowledge how much our present moment has shaped our text.

As scholars susceptible to events occurring around the world, we are profoundly uneasy with narrow concepts of nationalism, especially those rooted in rigid definitions of ethnic identity and cultural difference sustained by prolonged histories of suffering and inequality. The present text embodies a cosmopolitan vision of American culture, defined not around differences from others but around the conversation between traditions, the energizing exchanges, borrowings, and appropriations from other cultures that have contributed so much to our art. Turning away from arguments grounded in difference—and exclusivity—*American Encounters* looks toward points of contact and overlap.

## What Shapes this Version of the Past?

1. *A 'post'-national perspective that moves beyond the notion of defining a national identity through the arts*: Earlier histories of American art established their account of the visual arts around the concept of national identity. But as scholar Michael Leja has written, "How viable is the national art of the United States as a field of study when that art is thoroughly permeated by significant ties to the arts of other nations, in Europe, the Americas, and throughout the world?" How do we define the boundaries of "American" arts? While our account is still centered on the United States and its historical antecedents (excluding Canada and Mexico), we are no longer concerned with the need to define a national identity through the arts.

A related idea shaping earlier histories is that a "national art" expresses a unitary identity shared—to one degree or another—by everyone. The role of the arts, in this model, is consensual: part of a broad network of common beliefs, shared political and social objectives, in which regional, ethnic, and class differences were subsumed within a common culture. Indeed much American art itself—since the advent of the nation-state in 1776—purported to speak on behalf of a unitary public. In recent decades, such claims to a common culture of more or less like-minded citizens have been reassessed: we no longer approach any particular artistic expression as one voice representing the many, but in terms of one among multiple speakers, revealing its specific conditions, time, and place.

2. *A view **beyond exceptionalism** to a multiplicity of traditions and their dialogues with one another*: Part and parcel of nation-centered accounts of the arts is the idea of American exceptionalism: the guiding assumption that America is different from the rest of the world. In this view, the United States has developed according to historically unique laws that distinguish its history from that of any other nation-state. Belief in American exceptionalism has had a dramatic effect on how we have understood the arts as expressions of American national identity. Exceptionalism isolates national life from the historical influences and processes of cultural formation that have shaped other creative traditions. In moving beyond exceptionalist histories, we also go beyond singularity to the multiplicity of local, regional, international, and cross-cultural influences. We consider how the arts articulate identities across space and national borders, and the ways in which ethnic and local loyalties cut across allegiances to an often abstract and distant concept of nation. Furthermore, we consider the enormous debt that the arts owe to European mother cultures and "ancestral homelands" such as Africa and Mexico, as well as to an increasingly international marketplace of motifs, ideas, materials, working methods, and sites of exhibition. The result is not one American tradition but multiple traditions, each in dialogue with a range of other expressive forms.

3. ***Feminist and gender studies scholarship** offers a means to an inclusive history*: Beginning in the 1970s a generation of scholarship by and about women expanded our sense of the past and of the critical role played by women artists at every level of cultural production. Inserting these women into the prevailing history of male artists, this generation also revalued traditional "women's arts" of the needle, from quilts to samplers. Long relegated to a low status as "domestic" products, these works contain a rich history shaped by the same processes of exchange and adaptation that characterize other forms of art. The new, more inclusive history of the arts that emerged from this scholarship offered an important critique of many of the inherited assumptions underlying art history as a discipline. Since that first generation of feminist historians, scholars in "gender studies" have broadened our understanding of the many

ways in which gender identity has shaped the arts, from the manner in which artistic training has excluded women, to the objectification of women as the subjects of artists, to the ways in which artistic genius has always carried a masculine gender. Such scholarship also understands male artistic experience as equally shaped by historically specific and changing gender ideals and roles. All of these are informed by the emergence of gender as an integral dimension of any historically balanced account.

4. *"Post-colonial studies" provide a framework:* From the mid-twentieth century onward, movements for national independence have given a voice to cultures previously marginalized by a historical account of the past centered on Europe and its evolving societies—including America. In this post-colonial framework, the rise to dominance on the part of European colonizers is no longer taken for granted, but is opened up to historical scrutiny. How was such dominance established? How do material and visual forms create hierarchies of value? And through what avenues are such values promoted and circulated throughout a culture?

5. *A visual studies approach* informs the selection of objects: *American Encounters* recognizes the role of visual forms that have been, until the past decade or two, considered outside the boundaries of Art History as a discipline, such as maps, festivals, cartoons, quilts and needlework, animation, and "outsider" art. These vernacular visual forms, too long considered non-artistic, play a role in the process by which individuals acquire a sense of selfhood and participation in a broader public. More than broadening the boundaries that define our objects of study, visual studies also shift our sights from the aesthetic object as a self-contained product of a singular creative effort, to the object as it exists at the juncture of multiple histories. This, in the largest sense, is how we understand our defining theme of encounter. The object becomes a site of encounter between creator and culture, individual and community; between past and present; between functional requirements and the need for beauty and symbolic meaning. It symbolizes the preservation of communal memory, the survival and persistence of cultural traditions, the conferral of status and identity by which individuals come to feel themselves part of larger groups and nations. This attention to cultural process over static artifact is a defining feature of contemporary scholarship.

## Our Methods

Any understanding of the past based on surviving artifacts is necessarily limited: it is shaped by those objects that have been preserved into the present. Such objects give us an unequalled insight into how earlier generations saw and experienced their world. They do so with a tactile immediacy, often with a strangeness that provokes our curiosity and leads us to ask questions. Individuals create and transmit culture. This process occurs through languages of style, form, and symbolism that frame the individual expression.

Our ultimate purpose is to form a compassionate understanding of history and human cultures, in their creative, expressive, ritualistic, and memorializing functions, but our method of access is through the aesthetic and material world. We draw different stories out of objects and works of art depending on what questions we ask as we look and study. One of the greatest challenges, and rewards, of Art History is to explore how material and aesthetic *forms* and media are linked to *content*—not just to narratives, subject matter, and internal structures of meaning, but to the cultural and historical experience that shaped them. As you use this book, please keep this in mind. Asking questions actively transforms how we see the "reality" around us. Seeing and knowing are intimately related in the discipline of Art History. Neither one should take priority; description blooms into knowledge when avid observation and historical curiosity go hand in hand.

## How to Use This Book

Ours is an integrative approach in which diverse topics interrelate; our goal is to broaden understanding of cultural and historical connections among various objects, media, and subject matter in order to increase our understanding of culture as a whole. This book repeatedly demonstrates the multitudinous nature of the past—not one, but many. Accordingly any picture of the past depends on one's point of entry. If some stories appear to be neglected (the story, for instance, of the individual career from start to finish), others come more strongly to the surface. We hope that the overall patterns that emerge will offer opportunities for students to approach American arts in new, productive ways.

We also hope that this book will be an active presence in the classroom, a text to argue with and to assist in framing issues. It furnishes a set of core works, as well as a survey and analysis of media and themes central to American visual culture, around which students can construct their own narratives. Our selection of works tries to balance issues of aesthetic quality with choices that embody our general themes. This book is a roadmap; you are the navigator. As in geography, so in history: there are many ways to arrive at one's destination.

## CHRONOLOGICAL RANGE AND THEMES

Our text is arranged chronologically around themes, rather than around individual careers. You will find in reading this book that artists and objects reappear in different chapters. Objects, like the people who owned them, often have several lives, and the historian can tell more than one story about them. The Palace of the Governors in Santa Fe, for instance, appears in chapters 2, 3, and 15. Built and rebuilt over three centuries since its original construction in the early 1600s, the Palace of the Governors embodies the complex history of New Mexico as colony and later as state. For the historian, it furnishes evidence of Hispanic town planning and architecture in the seventeenth century, as well as of the reinvention of Hispanic forms in the early twentieth century. It also served as a stage for the annual Santa Fe Fiesta.

This book begins in the centuries before the arrival of Europeans. Some will choose to skip over this part of the story. But it *is* a part of the story, since American identities have always been shaped in relation not only to European heritage but also to the North American continent itself, with its long history of habitation. The braided stories of European and Native artistic expression tell us a great deal about the distinctive values, attitudes toward nature, and concepts of history and identity, at work within different societies occupying the same environment.

Our book concludes with two chapters offering extensive coverage of art since 1960, and we have taken special care to ensure that this section bears an organic relationship to the preceding chapters. This strategy represents a departure from many other survey texts on American art. Traditionally, the scope of the American art field has been delimited by a twentieth-century cutoff date separating "American Art" as such from contemporary art (for many years this date was set at 1945; now it tends to fall around 1960). Works of art created on opposite sides of this imaginary watershed have come to occupy the segregated territories of two entirely different pedagogical fields. A painting by Joseph Stella done in New York in 1920 lies within the purview of "Americanists" and tends to be taught near the tail end of American art surveys, while a painting by Frank Stella done in New York in 1960 falls to "modernists" and tends to be taught in courses on global modernism or contemporary art. To be sure, this artificial division has emerged in response to legitimate pressures (practical as well as political and theoretical). But we believe that its reification is becoming increasingly problematic— even potentially crippling—for the study of American art.

This textbook demonstrates that international and cross-cultural currents have defined American art from the outset. Hybridity, adaptation, and appropriation have always been linked to the arts in America. While today they have become increasingly self-conscious strategies, they have also been embedded in the historical realities of societies in transition. Americanists have much to contribute to discussions about global contemporary art, and contemporary art specialists can bring new perspectives to the study of the global context of earlier American culture. But this is only possible once we break down the artificial division between American and contemporary. The final two chapters of this text accordingly suggest connections between late twentieth-century and earlier American art. Our aim in proposing such links is not to collapse historical distinctions, but rather to draw attention to the persistent problem of modernity in America.

By attending carefully to contemporary art we also hope to encourage an awareness of the complexities of art-historical methods among our student readers. Over the past fifty years, many artists have developed extremely nuanced and self-conscious interrogations of history itself. Thus, their work offers us a special opportunity to bring the end of this textbook in line with the beginning. Contemporary artists have played a crucial part in developing the critical understandings of encounter, hybridity, and media that have made this textbook possible in the first place.

Running beneath our chronological narrative are broad historical processes that tie together very different times and places: the role of architecture and the visual arts in expressing power and cultural self-assertion throughout the often tense and uneven encounters between different ethnic and social groups; the creative resilience manifested by marginal groups as they respond to challenging conditions; the growing force of international trade and a market-based economy in stimulating exchange, recombination, and new expressive forms; and the fluid and adaptive nature of identity itself, on the ever-shifting ground of historical encounter and cultural mobility. As you use this book, it is important to keep in sight both change over time, and continuity. The history of American arts encapsulates the dynamism of modernity itself.

## THE BOX PROGRAM

Several times in the course of a chapter readers will find a separate narrative inserted into the text. These boxes add information and context that enrich the main narrative. There are five different categories of boxes:

FAST FORWARD links historical material to topics closer to the reader in time, or explores the historical trajectory of a particular cultural or artistic form, its life through time. (e.g. "Disney's *Fantasia*: Middlebrow Modernism" p. 403)

FRAMING THE DISCOURSE steps out of the historical

narrative to explore the terms with which we understand or study a subject. (e.g. "Diaspora and Creolization " p. 98)
**METHODS AND TECHNIQUES** focuses on the means of art: its formal components, its materials, and its technical procedures. (e.g. "Reading Architectural Plans" p. 82)
**CULTURAL CONTEXTS** goes beyond the themes of the chapter to consider broader intellectual, historical, social, or cultural factors that have shaped visual culture. (e.g. "The China Trade" p. 159)
**MYTHS AND LEGENDS** looks at a subject through the lens of stories that are both reflected in and shaped by visual artifacts. (e.g. "The Puritan Ideal" p. 64)
The materials included in the boxes offer opportunities for research, class discussion, and the consideration of other dimensions of our subject than those covered in the main narrative.

## ACKNOWLEDGMENTS

We extend our most profound thanks to our editors, Helen Ronan and Margaret Manos, at Prentice-Hall. Margaret's meticulous line-editing and her gift for economy of language improved our diverse prose styles immensely. Helen, our project editor, calmly guided us to think about the shape of the book as a whole. At Laurence King Publishing, in London, the editorial production team headed by Richard Mason demonstrated infinite patience, courtesy, and tact during months of editing, layout, and illustration procurement. We are grateful to Eve Sinaiko, formerly of Harry N. Abrams, Inc., who first conceived of this project with Angela Miller, more than a decade ago, and to Julia Moore, senior editor at Abrams, for coaxing us through the early stages of the project. We would also like to thank the Andrew W. Mellon Foundation, and Max Marmor in particular, for their grant for travel and research in the early stages of the textbook.

Thanks are due as well to the many readers who gave crucial critical feedback on the manuscript and helped shape it: Anna Vemer Andrzejewski, University of Wisconsin-Madison; Karen Bearor, Florida State University; Rebecca Bedell, Wellesley College; M. Elizabeth Boone, Humboldt State University; Donna Cassidy, University of Southern Maine; Melissa Dabakis, Kenyon College; Anne Dawson, Eastern Connecticut State University; Ursula Ehrhardt, Salisbury University; Roberta Smith Favis, Stetson University; Donald Harington, University of Arkansas; Carmenita Higginbotham, University of Virginia; Victor Katz, Holyoke Community College; Barbara Platten Lash, Northern Virginia Community College; Michael Leja, University of Delaware and University of Pennsylvania; Diana Linden, Pitzer College; Maurie McInnis, University of Virginia;

Alexander Nemerov, Yale University; Matthew Rohn, St. Olaf College; Kathleen Spies, Birmingham-Southern College; Elizabeth West Hutchinson, Barnard College / Columbia University; Mark White, Oklahoma State University; and Cecile Whiting, University of California Irvine.

One reader in particular—Mary Coffey of Dartmouth College—engaged our deepest themes with vigor, pushing us to clarify our commitments and to refine and nuance our use of the encounter model. Her sustained involvement with our text deserves special thanks.

We are very grateful as well for the editorial advice and suggestions of Paul Staiti at a very busy time; and to Margaretta Lovell and David Lubin for their invaluable contributions and generous participation in this project.

Angela Miller would like to thank the following individuals who have given material help, encouragement, and crucial support as this book was completed: Matthew Bailey, Elizabeth Childs, Andrew Hemingway, Theresa Huntsman, John Klein, Diana Linden, Paula Lupkin, David Miller, Dwight Miller, Julia Moore, Eric Mumford, Mike Murphy, Susan Rather, Eve Sinaiko, Paul Staiti, Maren Stange, Alan Wallach, Sherry Wellman, and Betha Whitlow. The biggest thanks go to her co-authors, in particular to Janet Berlo. Janet's keen eye for cliché and insistence on the highest standards of scholarship and writing throughout endless revisions, and despite her own pressing commitments, has made this a better book. Her friendship, and her sense of satire, have lightened the burden and heightened the pleasures of collaboration.

Janet Berlo would like to thank Aldona Jonaitis and Ruth Phillips for reading selected sections on Native American art, and her former graduate students Norman Vorano, Lucy Curzon, and Elizabeth Kalbfleisch for their research assistance when this book was in its formative stages.

Jennifer L. Roberts would like to thank Carrie Lambert-Beatty and Robin Kelsey for their critical feedback at the manuscript stage, Jacob Proctor and Megan Luke for their invaluable research assistance, and the entire authorial team for giving her the opportunity to participate in the project.

Bryan Wolf would like to thank the Stanford Humanities Center and the Stanford School of Arts and Sciences for a sabbatical fellowship to complete work on the textbook; Susan Jane Williams, formerly of the Yale Visual Resources Collection, for her expertise and support in image acquisition; and former graduate students Robert Savoie and Susee Witt, for their skilled research assistance. He would like to thank Marissa, Micah, and Gabriel.

*Angela L. Miller, Janet C. Berlo,*
*Jennifer L. Roberts, Bryan J. Wolf* JUNE 2007

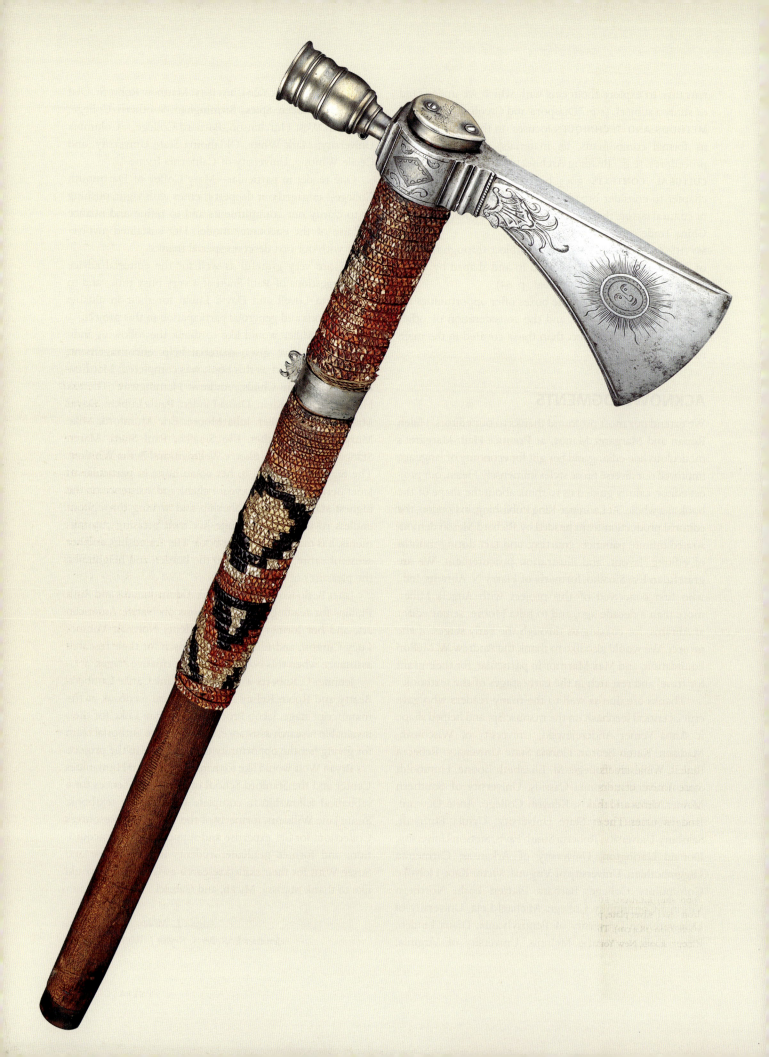

# From Ancient Times to the Late Colonial Era

THE PIPE TOMAHAWK on the facing page embodies several ideas that drive Part I. A product of diverse hands and ideological realms, it conjoins contradictory meanings: a pipe for peace, and a hatchet for war. Intended neither for smoking nor fighting, it was a cross-cultural gift, an ambivalent symbol of alliance between divergent worlds. A Native woman fashioned the quillwork. A white man forged the metal. The silver likely came from Mexico. The finished object made its way to England—perhaps the souvenir of an ancestor's foray to the New World.

In ancient times, aboriginal Americans transported both art and ideas across long distances. This set the pattern for an accelerated mobility of people and goods in the two centuries after 1492. Imperial ambitions propelled Europeans throughout the Americas. Their mobility—the Dutch in New York and Surinam, the Spanish ranging from Argentina to California, the French in Florida, Canada and the Great Lakes region—surpassed that of the indigenous peoples. But after contact, many Native peoples were dislocated from their homelands due to white settlement, epidemic, forced relocation, inter-tribal raiding, and warfare. By necessity, they became increasingly mobile, too.

The story of cultural and artistic encounter in ancient and colonial North America is not a simple one. Starting several thousand years ago, in the eastern part of the continent, tribal chiefs marshaled people to build towns and ceremonial centers of impressive size. Later, European governments and their agents competed for control of land and resources. The ever-expanding European populations of North America expressed their differing cultural heritages in the ways they laid out settlements, painted portraits, and how they depicted and characterized Native and African peoples. And of course, West and Central Africans from many ethnic groups, transported against their wills across the Atlantic, brought traditions that would form part of the fabric of American culture.

Sometimes it is tempting to reduce complex cultural categories to simple ones: Indians, Blacks, Europeans. Yet, like Europeans, Indian peoples had age-old alliances and enmities, and a plethora of arts and customs, as did the Africans brought to this continent. And, of course, not all the inhabitants of the lands under English sovereignty were English. By the end of the seventeenth century, the Atlantic seaboard colonies included the Dutch, as well as religious refugees from across Europe: French Protestants, Sephardic Jews, and Protestant Germans. In the East, Indians remained visible in Native communities; as craftsmen and servants among the European population; and even—for some captives in wars and uprisings—as slaves. By the beginning of the seventeenth century, slaves were arriving directly from Africa, and indirectly from the Caribbean. The early artistic contributions of Indians and Blacks are now difficult to document, for much of what they made was perishable, and not carefully preserved.

In upcoming chapters we use terms such as "encounter" to discuss a variety of productive ways that diverse peoples met, interacted, and made art objects that were both meaningful and beautiful. This is not meant to understate the staggering inequalities of the different sides of these encounters. Yet simply to ascribe victimhood to Native Americans or African-Americans is to ignore the demonstrable fact that their arts and cultures have both endured and flourished, despite dire adversities. Indeed, like this pipe tomahawk, we shall see the multitude of ways in which art asserted cultural values in the face of conquest, and bridged vast cultural divides.

(opposite) RICHARD BUTLER et al, Pipe tomahawk, c. 1770. Iron, steel, silver plate, pewter, quillwork, wood, shaft 21⅛ in (53.4 cm), blade 7¼ in (18.4 cm). Thaw Collection, Fenimore Art Museum, Cooperstown, New York.

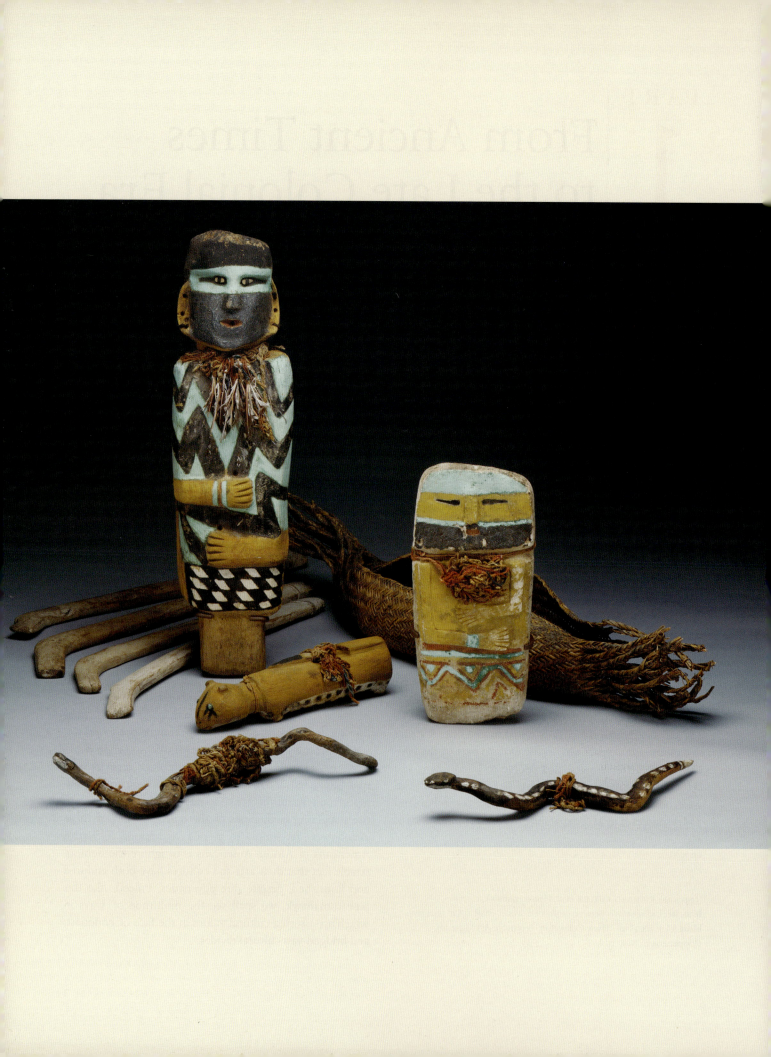

# 1 The Art of Indigenous Americans

## BEFORE 1500 C.E.

A PERFORMER DRESSED in feathered wings, tail plumes, and a hooked beak mask enters the crowded plaza and dances by torchlight to a rhythmic beat of drum and song. Gradually, in the eyes of the beholders, he transforms into a falcon (**fig. 1.1**). Seven hundred years ago, in Spiro, Oklahoma, this "Birdman," as archaeologists call him, was responsible for bringing the power of the sky realm into the human community, and his ritual performance combined human-to-animal transformation, sacred warfare, and blood sacrifice, the prerogatives of chiefs. His performance would have stirred not only the citizens of Spiro, but people throughout the eastern half of the continent, where similar performances took place. Objects commemorating such ritual spectacles—like the engraved shell cup illustrated here—were exchanged over long distances and are found interred in the graves of high-ranking individuals. Clearly, a thriving society had been established here. But this was by no means the beginning of civilization in North America.

(opposite) MIMBRES ARTIST, Ritual figures, Salado Region, New Mexico, c. 1350. Stone, wood, cotton, feathers, pigment and plant fiber, largest figure 25⅛ in (64 cm) tall. Art Institute of Chicago, Illinois.

1.1 (right) Ceremonial shell cup engraved with falcon impersonator ("Birdman"), Spiro Mounds, Oklahoma, c. 1300 C.E. Whelk shell, 5⅛ × 11¼ × 7⅛ in (13.2 × 28.6 × 17.8 cm). National Museum of the American Indian, Smithsonian Institution, Washington, D.C.

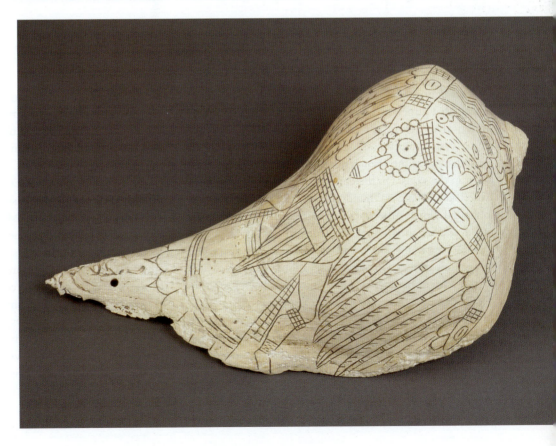

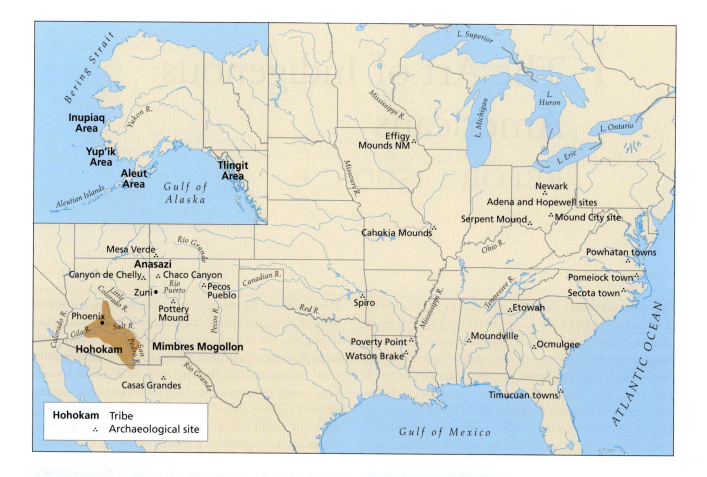

1.2 Map of Ancient America (focusing on three regions: East, Southwest, Alaska), 1500–1000 B.C.E.

American arts had already been developing for about three thousand years by the time the Birdman's dance conjoined the powers of earth and sky.

This engraved whelk shell is only one of countless art objects that dispel the commonly held—and self-serving—notion that before the arrival of Europeans America was a vast, "empty continent, a desert land awaiting its inhabitants," as the French observer Alexis de Tocqueville put it in the 1830s. On the contrary, millions of indigenous Americans, living in hundreds of Amerindian nations, inhabited North America when Europeans claimed, colonized, and began settling in the sixteenth century. Not only was the land in use, but it had been occupied by successive indigenous civilizations for several thousand years. Much of this ancient heritage of our country has been lost, principally because the construction of modern cities eradicated the ancient ones. Nevertheless, evidence of North Americans living in complex cultures, starting around 1500 B.C.E., does survive and is widespread in the archaeological record. Many Americans have heard of Cahokia Mounds, Illinois (see fig 1.11), or visited Chaco Canyon, New Mexico (see fig. 1.17 and 1.18), but few know that over two thousand years before either of those communities flourished, peo-

ple elsewhere in ancient America moved earth into huge embankments and formed mounds and enclosures (see fig. 1.3)—the beginning of an unbroken line of artistic expression among indigenous Americans that continues to the present.

This chapter presents the art of three cultural regions in ancient America: the Eastern Woodlands (the forested land extending from the Midwest to the Atlantic), the Alaskan Arctic, and the desert Southwest (Map, **fig. 1.2**). In each region, during the three thousand years of the "pre-contact period" (before Europeans began arriving in the sixteenth century), concepts developed that have continued to shape Native American artistic expression even down to the present. These systems of belief were entirely different from those motivating Europeans, and their persistence in indigenous visual forms, despite centuries of conquest and domination, is remarkable. The ancient arts of North America illustrate how physical and spiritual transformation was at the heart of religious experience and public ceremony. Imagery often combines human and

animal aspects, sometimes referring to powerful ancestors or supernatural beings. Many Native cultures share a belief in an animating spirit that pervades all things—lightning, plants, animals, mountains, as well as people. These ideas inform the objects and ritual environments explored in what follows.

From the beginnings of human culture, trade has been one of the primary forms of encounter; accordingly it plays an important role in our story. Long before the arrival of Europeans, Native American societies incorporated new ideas and materials through a network of long-distance trade. Their trade routes—across deserts, over mountains, and along rivers—carried not only goods and raw materials but political, religious, and artistic ideas as well; and this cultural interchange continued after the European invasion. At the hubs of these networks, settlements such as Poverty Point and Cahokia, in the east, and Chaco Canyon, in the Southwest, developed arts that included pottery, complex representational systems, and large-scale multipurpose architecture. In contrast to the earthworks of the East and stone architecture of the Southwest that we shall consider in this chapter, what are left of the ancient arts of Alaska are principally small-scale sculptures in materials such as walrus ivory. These, too, reveal fine artistic achievement at

an early date. In the harsh northern climate, ceremonies were conducted inside village dance houses, rather than outside in public plazas. Nevertheless, like the art of indigenous Americans farther south, they evince a concern with the relationship of humans to the world of animals and supernatural beings.

## The Art of the Eastern Woodlands

Thirty-five hundred years ago, people all over the world were constructing cities and making art. In the Middle East, the Tigris and Euphrates River Valleys, north of the Persian Gulf, were the home of numerous Sumerian city-states. On the Huang-he River, in China, the rulers of the Shang dynasty lived in earth-walled precincts, and made burials in which slaves, chariots, and animals shared the afterlife with their owners. By 1500 B.C.E. the city of Mohenjo-daro, built above the floodplains of the Indus River, in Pakistan, had reached its cultural peak and was already in decline. Likewise, along the Egyptian Nile River,

## New World Origins

ONE OF THE MOST PERPLEXING topics in archaeology is the date of the peopling of the Americas. For generations, archaeologists theorized that the first Americans were Asians who crossed a land bridge from Siberia to Alaska (now the water-filled Bering Strait) in pursuit of large game animals at the end of the last Ice Age—about twelve thousand to fifteen thousand years ago. A large body of archaeological evidence from several regions of North and South America points to this idea and suggests a rapid peopling of the entire hemisphere sometime before 10,000 B.C.E. Other evidence, from Monte Verde, Chile, suggests that humans may have been making rudimentary tools there some thirty thousand years ago, but that dating remains controversial. The dating of other recent finds also challenges the traditional theory. In some circles, the ethnicity of early Americans is hotly debated, with some people arguing that Asians may not have been the only racial stock to arrive in prehistoric times. Furthermore, the question of whether humans arrived in a single migration or in a series of discrete

migrations has remained difficult to answer conclusively. These questions can become "hot-button" political issues when they challenge common assumptions. Today, new techniques such as DNA analysis are being added to existing methods of archaeology, anthropology, and linguistics to help render a more complete picture of the prehistoric peopling of the Americas.

In any event, it is clear that many successive generations of humans lived in diverse parts of North America between the peopling of the Western Hemisphere, at least twelve thousand years ago, and the emergence of art making in nonperishable materials, about five thousand years ago. Lost to us, except in the most fragmentary evidence, are intervening stages of cultural development: the invention of basket-making technologies, for example, or the earliest stages of the making of masks and other ceremonial regalia. New finds and research will continue to improve our understanding of the earliest Americans, their movements, and their efforts at establishing culture.

# Table 1.1: Time Periods in Ancient America

| REGION | DATES | SITES DISCUSSED |
| --- | --- | --- |
| **EAST** | Archaic Period c. 6000 B.C.E.–500 B.C.E. | Poverty Point, LA |
| | Woodland 500 B.C.E.–400 C.E. | Hopewell, OH |
| | Mississippian 800 C.E.–1400 C.E. | Cahokia, IL |
| | | Moundville, AL |
| | | Spiro, OK |
| **ALASKA** | Old Bering Sea Culture 500 B.C.E.–500 C.E. | |
| | Ipiutak Stage 100–800 C.E. | |
| **SOUTHWEST** | Basketmaker Culture 100 B.C.E.–700 C.E. | |
| | Anasazi Culture 700–1300 C.E. | Chaco Canyon, NM |
| | (Great Pueblo Period 1050–1300 C.E.) | |
| | Classic Mimbres-Mogollon Culture 1000–1150 C.E. | |
| | Proto-historic Era 1400–1600 C.E. | Hopi |
| | | Zuni |
| | | Acoma |

A note on dating: In this book, we follow the custom in archaeology of using the letters "B.C.E." (Before the Common Era") and "C.E." (Common Era"), rather than B.C. (Before Christ) and A.D. (*Anno Domini*, Latin for "Year of Our Lord"), which reference a Christian tradition.

the pharaohs of the New Kingdom, such as Rameses II and Tutankhamun, controlled vast cities and claimed a place for themselves in the afterlife by building rock-cut tombs in the Valley of the Kings.

In eastern North America, almost all ancient cities were founded along the riverine network that crisscrosses this part of the continent. In the rivers, fish and turtles were caught for food. The floodplains along their banks provided fertile soil. Village life relied on farming, as well as on hunting and the gathering of abundant natural resources. Great flocks of birds, and mammals such as deer and rabbits, which were hunted for their flesh and their pelts, were plentiful. These rivers also served as highways, on which long-distance travel and economic exchange were conducted.

People had been living in small communities for several thousand years, when, around 1500 B.C.E., a new mode of living arose. Some communities became gradually less egalitarian and more hierarchical. In these societies, people used items obtained through long-distance trade to create works of art. Judging from the rich burials found in ancient American cities, these art objects held status for their owners, both in this life and in the afterlife. These hierarchical societies also built large-scale earthworks. Found throughout

the Americas, these mounds manifest widely shared religious ideas; they served as focal points for the ceremonial expression of spiritual beliefs, as well as validations of status and power. They were not an architecture of shelter and enclosure; perishable structures would do for that. Unlike the builders of ancient Europe, who focused on spanning large spaces with roofs, arches, and domes, Native builders, especially in the Eastern Woodlands, strove to create solid structures that resembled mountains or animal forms. In some cases, the intended viewers must have been the denizens of the sky world, for some of the grandest earthworks of ancient America became apparent only with the advent of aerial photography in the twentieth century.

## The Art of Archaic and Woodland Cultures

By about 1500 B.C.E., people in the Eastern Woodlands had been gathering for some time in settled communities and engaging in long-distance trade. Much of what we know about these people is derived from objects found in their graves—evidence of a custom of honoring the dead by burying them with valued gifts. Part of a correct

# Names and Native Americans

In the last few decades new attention has focused on the names used to refer to Native American peoples. The power to name is a formidable one, and Native peoples are increasingly rejecting the names imposed on them by others. In the absence of a perfect consensus about names, in this book we follow the practices currently accepted among most scholars.

We interchangeably use the terms *American Indian, Native American, Native,* and *Indigenous people* to refer to the original inhabitants of North America—as do most Native people themselves (except in Canada, where the term *First Nations* is widely used). Regarding the names of particular ethnic groups, we use those terms that are currently recognized by anthropologists and that cause the least amount of confusion. For example, we use *Cheyenne* rather than *Tsistsistas*, a designation that some Cheyenne people prefer. In another example, we use **Anasazi** and **Ancestral Pueblo** interchangeably to refer to the ancient town-dwellers of Arizona and New Mexico, though *Ancestral Pueblo* is becoming more common. In the Arctic, the indigenous peoples of Alaska today routinely use the word *Eskimo* as a general term, in addition to regionally and ethnically specific terms such as *Yupik* and *Inupiat*. The term *Inuit* refers to the Eskimoan peoples of Canada and is almost never used in Alaska.

relationship with other people in many societies is the presentation of gifts, especially finely crafted objects. In Native belief systems, to conduct oneself in a ritually correct way, toward the forces of nature and toward the community, has always been important. In the colonial era, Native peoples bestowed gifts upon the newcomers, just as they do upon valued individuals today, and it is evident from the archaeological record that the custom of honoring the dead by the bestowal of gifts goes back to ancient times. The characteristics of the objects interred with the deceased have helped us to piece together a picture of the living societies that created them.

**POVERTY POINT.** Numerous towns, from western Tennessee down to the Gulf of Mexico, were part of the Poverty Point culture, which arose around 1700 B.C.E., in what is now northeast Louisiana, a region where people had lived for several thousand years. This era is called the Archaic Period (see Table 1.1), for it is the oldest time period during which Native people were beginning to develop complex art and architecture. Perhaps the earliest hierarchical society of the Archaic Period, Poverty Point was the locus of a complex chiefdom where people created large-scale earthworks and used the products of long-distance trade to create high-status goods.

Poverty Point is the largest site in North America dating from the period before 600 B.C.E. Most of the large-scale construction there was done between 1500 and 1000 B.C.E., and it is a remarkable example of engineering and artistry (**fig. 1.3**). Six concentric embankments of earth form a large C-shape oriented toward a bluff overlooking the Mississippi River floodplain. The diameter of the outermost ridge is nearly 4000 feet across—more than three-quarters of a mile. Atop these ridges, small houses faced a vast plaza, measuring some 37 acres. Several avenues led out of this plaza like spokes of a wheel. In addition to the ridges, nearby there are several large mounds, the most significant of which is shaped like a flying bird, with a wingspan of over 600 feet.

The existence of this huge plaza suggests that 3500 years ago indigenous Americans conducted public festivals and ceremonies, as the people at Spiro did in 1300 C.E. (see fig. 1.1), and as Native Americans have done ever since. All of the types of earth architecture seen in eastern North America over the next 3000 years are in evidence at Poverty Point: giant geometric embankments, temple mounds, and **effigy mounds** (earthworks in the shape of animals).

Such architectural complexity indicates a culture capable of marshaling a large workforce and housing and feeding them while they labored. It also assumes the existence

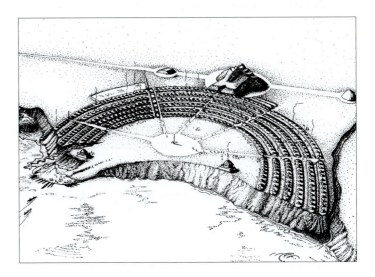

1.3 Reconstruction of ceremonial enclosure (by Jon Gibson), Poverty Point, Louisiana, c. 1500 B.C.E. University of Southwestern Louisiana.

of a surplus of labor—that some individuals within a village could be spared from food gathering and production in order to devote themselves to such an ambitious project. In addition to specialists in building, there was a **lapidary industry** (working precious stones) at Poverty Point. This was a direct result of long-distance trade, which had brought to this region materials from a variety of sources, both distant and close at hand: copper from the Great Lakes; chert, flint, and other stones from the upper Missouri River area; mica and jasper from Alabama. Red jasper, feldspar, hematite, and magnetite were made into practical items that showed an appreciation of the beauty of finely polished stone. Spears and spear throwers (among many finely wrought tools), stone weights for fishing nets, beads in the shape of owls and locusts—all of these demonstrate high technical proficiency, as well as a well-developed aesthetic sensibility.

The people at Poverty Point set the pattern that would continue in North America for the next few thousand years: interdependent cultures that drew upon vast trade networks for raw materials and for ideas. Within these cultures arose towns and cities, thanks to various factors such as location, high levels of artistic skill, and a genius for urban planning, or compelling ritual and symbolic systems. Because we know of Poverty Point only through archaeological excavation, much of what existed at this city has been lost. We have their earthworks, and over a hundred thousand small items: beads, clay figurines, finely crafted stone weights, and spear points. Yet, when we look at historic American Indian art and see how much artistic ingenuity is displayed in the way that fur, hide, feather, wood, plant fiber, shell, and other perishable materials were crafted, we must remember that this prehistoric culture, too, must have produced much fine work in such materials, which has now been lost.

**HOPEWELL CULTURE.** The Hopewell culture took shape in the eastern United States from 200 B.C.E. to 400 C.E. The greatest elaboration of this culture was in Ohio, where large earthworks, like those of the Archaic culture at Poverty Point, were also constructed. These included effigy mounds as well as complex burial mounds in which high-ranking individuals were interred with finely worked grave goods. Hundreds of thousands of basket-loads of earth were then heaped over the burial to form an imposing mound. Like those at Poverty Point, the Hopewell mounds contained goods and materials that had been traded from afar, including copper from Lake Superior, mica and quartz from the Appalachian Mountains, shells from Florida, and obsidian from the Rocky Mountains.

Here, too, fine craftsmanship is evident. Copper was pounded into thin sheets and fashioned into elaborate bird and animal shapes (**fig. 1.4**). The example shown represents the ever-important falcon seen in so much ancient art of eastern North America (see figs. 1.1 and 1.8). The graves of the highest ranking dead were remarkable for the splendor of their contents. For example, a pair of burials in one mound contained nearly one hundred worked copper plates similar to that in figure 1.4. Other graves contained hundreds of copper ear spools, or thousands of shell beads. Such gifts honored the dead, who would intercede for the living in the spirit world.

Stone pipes, used to smoke ritual tobacco, were also carved into bird and animal forms. (Although they might not look like pipes to a modern viewer, the platform served as both the mouthpiece and the handle.) Such pipes were often broken before being grouped in large offerings, which

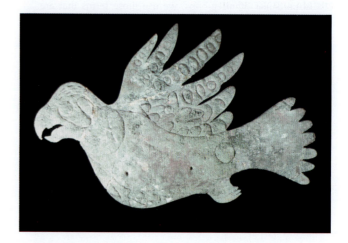

1.4 Falcon-shaped cut-out, Hopewell culture, Mound City, Ohio, 200 B.C.E.–1 C.E. Copper. Mound City National Monument, National Park Service, Chillicothe, Ohio.

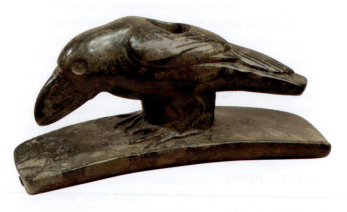

1.5 Raven-effigy platform pipe, Crab Orchard culture, Rutherford Mound, Illinois, 200 B.C.E.–200 C.E. Stone, 2⅜ × 4¾ in (6.2 × 12.2 cm). Illinois State Museum, Springfield, Illinois.

were ritually burned and covered with earth. Although rendered useless for smoking in this world, they remained a valuable offering taken out of human circulation and placed with the honored dead. Some pipes were made, used, and buried locally, while others traveled hundreds of miles; for example, the Raven pipe (**fig. 1.5**) was buried in a site in Illinois. Again, long-distance relationships were forged through the exchange of art and ideas, a practice that would become elaborated more fully during the subsequent Mississippian era.

The animals in Hopewell **iconography** have continued to be important to Native people throughout North America. The falcon and other raptors represent powers of the sky realm; the raven represents the wise and cunning trickster who teaches by bad example; the snake and other reptiles represent earthly and subterranean powers. Both falcon and reptile imagery are signs of power throughout ancient and recent times in the Eastern Woodlands.

## Mississippian Culture

While there are numerous regional variants of ancient Woodland cultures in the eastern United States, some of the most famous sites and artifacts are part of what is known as the Mississippian culture (c. 800–1500 C.E.). This has been described by one archaeologist as "a complex patchwork of chiefdoms large and small [which] flourished for about six centuries up to European contact and beyond." In Mississippian art, we see the expansion of Hopewell ideas into a more complex iconographic system, which emphasized human/animal supernatural figures, rites of agriculture, and warfare as a sacred pursuit of chiefs. Moundville, near Tuscaloosa, Alabama; Spiro, in eastern Oklahoma; and Cahokia, near St. Louis, were all substantial communities and trade centers ruled by chiefs who held religious as well as political power. A shared religious ideology expressed in the arts linked these centers, though each metropolis had its own distinct variant.

# Nineteenth-Century Myths of the Moundbuilders

IN THE LATE EIGHTEENTH and early nineteenth centuries, many theories were proposed to explain the origins of the mysterious mounds in the Ohio and Mississippi River Valleys. Were they built by the lost tribes of Israel or some other unknown precursor to the American Indian? People found it hard to reconcile the impression of these monumental undertakings with their view of Indians as "savages."

Before the advent of archaeology as a scientific discipline, many interested amateurs (writers, politicians, military men) dug in the mounds of the eastern and midwestern United States. George Washington (who himself owned land upon which ancient burial mounds were located), like most of his contemporaries, believed that the country had been "once inhabited by a race of people more ingenious, at least, if not more civilized than those who at present dwell there."

The scene of Marietta, Ohio, in John Egan's *Panorama of the Monumental Grandeur of the Mississippi Valley* (**fig. 1.6**), encapsulates mid-nineteenth century attitudes. The buckskin-clad Indians, on the left, are mere passive onlookers to the orderly layout of the ancient mounds. Many nineteenth-century people believed that the Indians they knew had forcibly overrun the land inhabited by a distinct, peaceful people who had built

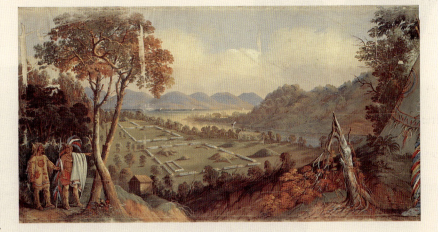

1.6 JOHN EGAN, *Marietta, Ohio* from *Panorama of the Monumental Grandeur of the Mississippi Valley*, c. 1850. Tempera on muslin. Saint Louis Art Museum, Missouri.

the mounds (when, of course, it was they themselves who had engaged in that enterprise). Thus, white Americans created a mythic history that justified their own displacement of Native peoples. Many cities of the Midwest and South—Cincinnati, St. Louis, Pittsburgh, Nashville, and Natchez among them—were built upon the ruins of these ancient cities. By the mid-twentieth century, more than 90 percent of the ancient aboriginal architecture that had been visible a century earlier was obliterated by the expansion of American cities.

**MOUNDVILLE.** As we have noted, ancient Native Americans hunted animals, told elaborate stories about supernatural animals, and, above all, used animal imagery in their art. The stone objects in figures 1.7 and 1.8 are remarkable examples of the interplay between **abstraction** and **naturalism** that is the hallmark of much of this art, particularly its animal imagery. The bowl (**fig. 1.7**) is made of diorite, a hard stone, painstaking to carve using only stone tools. The body of the crested wood duck forms the bowl, nearly 12 inches in diameter, with walls that are only ¼ inch thick. The body is plain, but the arching neck and head are incised with curving and straight lines. The pipe (**fig. 1.8**) depicts a falcon lying on its back, its talons curving between the two holes of the pipe. The bird's head, with its open beak, wraps around the stone in low relief. While stylizing the image to fit within the shape of the pipe, the artist also managed to convey realistic details, such

as the distinctive feather shape, and the hump on the eagle's tongue. Smoked in solemn ceremony, this pipe connected the smoker to the sky realm through the intermediary of the eagle—the great raptorial warrior of the sky.

Both of these objects were discovered in excavations at Moundville, an important Mississippian site on the Black Warrior River, in Alabama. Around 1250 C.E., the ruling elite at Moundville apparently consolidated both power and population, for there is evidence that many people from the surrounding region moved into the city, where they were protected by a great wooden palisade. Within, a large plaza was marked by numerous burial mounds and flat-topped residential mounds for the elite. But by the time the Spanish explorer Hernando de Soto arrived, in December of 1540, Moundville was much diminished, only a shadowy remnant of the former vigorous metropolis.

1.7 Wood-duck effigy bowl, Moundville, Alabama, 1250–1500 C.E. Diorite, 11⅜ × 15¾ in (29 × 40 cm). National Museum of the American Indian, Smithsonian Institution, Washington, D.C.

1.8 (above) Falcon pipe, Moundville, Alabama, 1250–1500 C.E. Limestone, 4⅝ in (11.9 cm).

1.9 (right) Mask with antlers, Spiro Mounds, Oklahoma, 1200–1350 C.E. Wood, 11½ in (29.2 cm). National Museum of the American Indian, Smithsonian Institution, Washington, D.C.

**SPIRO.** Spiro, the westernmost Mississippian city, was founded near the Arkansas River, in eastern Oklahoma, in a region where woodland gives way to plains. Although Spiro was inhabited before the ninth century, the height of its importance in the Mississippian trade network was between 1200 and 1350 C.E. One great earthen mound at Spiro, Craig Mound, was used as a burial site for more than 600 years. Perhaps the single richest grave mound in all of North America, it was looted in the 1930s; thousands of pots, effigy pipes, beads, and copper plaques were sold

by the plunderers. The impressive number of high-status goods in Craig Mound and elsewhere at Spiro attests to the wealth and prominence of the chiefs buried there.

Elite families from the region around Spiro may have been brought to this great city of the dead for burial. Lavish graves contained litters covered with fine textiles, used to carry the bodies, fine basketry, vast quantities of shells, and transformational masks (**fig. 1.9**). This nearly life-size wooden mask was one of thousands of rich offerings in Craig Mound. The mouth and eyes are inlaid

marine shell, and the deer antlers are carved of wood. Perhaps it is a three-dimensional rendition of one of the transformational figures engraved on shell cups. Particularly distinctive and plentiful in the art of Spiro are incised whelk shells from the Gulf of Mexico, shaped into cups and interred with the dead (see fig. 1.1). Here,

the Mississippian artist has engraved a figure of a dancing Birdman. He wears a breechcloth and a necklace, from which hangs one of these whelk shells. Part human and part falcon, he is one of many mythic heroes and animal ancestors combining attributes of more than one species (**fig. 1.10**). Their presence in Native art signifies

a relationship to a complex world in continual and fluid transformation, within which humans—rather than dominating—are merely a part.

The imagery on these engraved shells suggests that public performances involved high-ranking men impersonating falcons, panthers, and rattlesnakes. By claiming ancestral relationship to these powerful animals, they legitimized their rule. They also legitimized acts of aggression against other communities, linking such acts with supernatural stories and rituals. Intense rivalries among neighboring polities were common in Mississippian times, as their chiefs vied for control of natural resources and power.

The line drawings depict some of the most common emblems of Mississippian cosmology, warfare, and rulership. In the upper right, a successful warrior brandishing a club holds the severed head of a sacrificial victim—a trophy of war. In the drawing at the bottom, a hawk—among the most skillful birds of prey—metaphorically represents a warrior preparing for a war expedition. The rattlesnake capes worn by performers (large central drawing) and the other rattlesnake emblems refer to the swift death inflicted by a venomous serpent—or a powerful ruler. The earthly powers of the serpent balance those of the falcon's sky domain. Sometimes the serpents themselves are feathered, uniting both realms (lower left). Powerful supernatural beings and their earthly representatives at Spiro, Cahokia, and elsewhere were represented in the act of crossing temporal and spatial boundaries, and conjoining seemingly opposite powers (sky/earth, bird/snake).

**CAHOKIA.** The widespread Mississippian iconographic system can be found from the Atlantic to Oklahoma and from the Gulf of Mexico to the Great Lakes. One of the earliest and by far the largest Mississippian city was Cahokia, east of modern St. Louis (**fig. 1.11**). People had lived in the fertile land around Cahokia for many generations, but after about 1000 C.E. the site became increasingly urbanized, even though it was based on an agricultural economy. The city's network of trade spanned much of the continent. By 1150, Cahokia had a population of about 20,000 people—larger than London at that time and probably larger than any other North American community. Shortly thereafter, palisades of huge wooden logs were erected around central Cahokia (emblematic of the regional raids and warfare that were so common). The fence was nearly two miles in circumference, and within it rose a number of small temple mounds and one enormous one.

Monk's Mound may be the largest earthwork in the world. Archaeologists estimate that it contains some 22 million cubic feet of earth (deposited by the basket-load by a giant workforce). It is 100 feet high—as tall as a ten-story building, and covers more than 16 acres at its base. It presided over a vast plaza, used for ceremonial gatherings. Outside the central plaza, scores of other mounds dot the landscape.

1.11 Plan of Cahokia Mounds, East St. Louis, Illinois, c. 1200 C.E. Courtesy William Morgan Architects, Jacksonville, Florida.

As at other Mississippian sites, Cahokia's rulers were interred in lavish burials, sometimes accompanied by human sacrifices. The extravagant attention paid to the high-ranking dead at places such as Spiro and Cahokia can be understood in part through comparisons with the beliefs among the historic southeastern tribes, including the Cherokee, Creek, and Natchez. In Cherokee belief, a powerful supernatural being called Uktena has the body of a rattlesnake, the head of a deer, and wings. In its forehead a crystal emits a blinding light—a means of divining the future. Similar composite beings are found throughout Mississippian iconography. Several carved figures unearthed at Cahokia reveal an iconography derived from birds of prey and the transformative powers of male rulers.

In their encounters with the chiefdoms of the Southeast, early Spanish and French explorers reported that the paramount ruler was thought to be the brother of the sun, or was sometimes himself called "The Great Sun." Temples contained the bones of the honored relatives of this ruler, as well as all previous rulers. The temples housing these bones, and the lavish mortuary offerings deposited with them, were considered the spiritual heart of the community. No doubt this was true at many late Mississippian sites, too. Interest in the sun was of astronomical as well as

religious significance. Sites dating as early as the Archaic period evince some interest in orienting buildings to the cardinal directions (north, south, east, west), or to the places on the horizon where the sun reaches its most distant point from our northern hemisphere (the winter solstice) or its closest point (the summer solstice).

The best evidence of the astronomical orientation of structures comes from Cahokia, where archaeologists have determined that several circles of cedar posts once stood—one circle as large as 410 feet across. Particular posts marked the solstices. In the winter, such observations would have ceremonial use, for they indicated when human intervention was needed to "persuade" the sun to return from its most distant point in the heavens. Such observations would also be useful in determining times for planting and for agricultural rituals.

Although the observations needed to determine astronomical alignments may seem mysterious to us today, since we are accustomed to telescopes and accurate clocks and calendars, many societies in the Americas, lacking

1.12A,B Female figurine tilling the jaguar-serpent earth ("Birger Figurine"), Cahokia Mounds, Illinois, c. 1100 C.E. Bauxite. University of Illinois, Illinois Transportation Archaeological Research Program.

these conveniences, were expert at "naked-eye" astronomy. Many ancient cities and ceremonial centers were oriented to astronomical positions, especially to the movements of the sun. (As we shall see, this was of interest in the ancient Southwest, as well.)

The central role of the sun, linked to the power of the ruler, forms a part of a broader cosmology found throughout the ancient Mississippian world. As in much of Native America, this worldview pictured a multilayered universe, with certain powers belonging to the underworld, others to the land upon which humans live, and yet others to the beings of the sky. The cardinal directions are also important to this schema; the center—the place of human community—occurs at the juncture of the vertical dimensions (underworld, land, and sky) and the horizontal (points of the compass). Spiritual transformation entailed movement between such realms, and between the realms of the living and the dead.

While much Mississippian art expresses the identification of male powers with birds of prey (the sky world) and powerful snakes (the earth world), the Birger figurine (**fig. 1.12**) suggests that female powers also relate to the earth and its powerful inhabitants, such as the serpent—but in the realm of agriculture, rather than warfare and human sacrifice. Carved of local hard flint clay (a reddish brown substance that looks like bauxite), the figurine depicts a woman who kneels on the ground. Her right hand tills the soil with a hoe. Her left hand seems to caress the surface of the earth, but as one turns the figure to look at it from another angle, it becomes evident that she is caressing the head of a coiled snake on which she kneels. The tail of this earth serpent bifurcates into a gourd vine that coils around the body of the woman. Does this object commemorate the female ancestor who first domesticated plants? Is she the Earth Mother who interceded with the serpent to obtain plants for human use? This remarkable image recalls many Native American stories about women's powers over plants. The talents of female horticulturalists were crucial to the rise of complex society in North America, and perhaps such works of art signified that their success depended upon supernatural powers.

Many Indian groups of eastern and midwestern North America are the descendants of ancient Moundbuilder cultures. Although the elaborate Mississippian system of rank and rulership was deteriorating even before the coming of Europeans, the system fractured completely in the seventeenth century, as a consequence of its own internal problems, as well as the diseases, forced migration, and decimation of Native cultures wrought by invaders from Europe.

# Arctic Alaska

In ancient times, highly refined art forms also flourished in coastal Alaska, along the northern Bering Sea. Here, most of the works that have survived are small objects of bone and walrus ivory, made by hunters who lived in villages at the edge of the sea. The sea provided almost everything these people used in life as well as art: fish and marine mammals for food, clothing, and carving materials. Whereas the first archaeological goods in Alaska date from around 4000 years ago, it was only late in the first millennium B.C.E. that a culture distinguished principally by fine artistry—the Old Bering Sea Culture (circa 500 B.C.E. to 500 C.E.)—came into being.

## Old Bering Sea Culture

Evidence from archaeology and from anthropological research among historic Eskimoan peoples illuminates the lives of these ancient ivory carvers. They were primarily hunters of sea mammals, especially walruses. The thick, sturdy hides they brought home provided materials for boats, shelter, and clothing. The durable and handsome tusks were carved for artistic value and for practical and spiritual use. While more perishable materials disintegrated long ago, the strong dentine material of walrus tusks has survived through the centuries, testifying to the rich artistic inventory of ancient peoples of northern Alaska. In these artifacts, hunting technology, religion, and artistic skill are inseparable. Tools such as harpoons were beautifully carved and incised, probably to attract game animals, as some historic Native groups believed. Elegantly formed hunting implements and amulets were thought to increase the success of the hunt; in recent decades, indigenous Arctic hunters have declared that animals are pleased to be hunted with beautiful weapons!

The key role played by the hunt in an Arctic environment, where there was no agriculture, explains the centrality of shamanism in both ancient and more recent times. Religious intermediaries called *shamans* were thought to have the unique power to contact potent animal spirits who helped control the hunt. They thus performed a function similar to that of the political spiritual leaders in Mississippian cultures, though in a less hierarchical context (see fig. 1.1). In the far north, religion was a much more individualistic pursuit than it was in the hierarchical Mississippian society.

The tiny female amulet shown here (**fig. 1.13**) is less than 7 inches tall. Though it has feet, it does not stand on its own, but was meant to be held in the hand or strung

on a line as an ornament. As with all ancient ivory, its creamy white color has weathered to a rich mottled amber hue. The body's surface is incised with circles and lines that resemble the body tattooing practiced by Eskimo women until a century ago (indeed, one frozen, desiccated woman's body, dating from approximately 400 C.E., discovered on St. Lawrence Island, has such tattoos on her hands and arms). On the figurine, these designs call attention to her breasts, abdomen, and pubic area, suggesting women's powers of procreation. Could it have been a charm used by a female shaman in ceremonies for pregnancy or childbirth?

## Ipiutak Stage

From a slightly later period (fifth–ninth centuries C.E.), named after the Bering Sea culture that flourished in this period, comes the so-called rake (**fig. 1.14**), surely a ceremonial tool rather than a practical one. Its daggerlike handle has a small seal-head knob. The top of the implement appears at first glance to be a face with a long horizontal mouth, whose teeth (the prongs of the rake) clamp into a hinged jaw. All of these movable parts were painstakingly carved from a single ivory tusk. Close examination of the elaborately carved head above the horizontal mouth of the tool reveals that it is a bear with two eyes and a snout. Around the bear's head are clusters of smaller seal heads. If the implement is turned upside down, the bear's eyes become those of a human, with a small nose between them, on what would be the bear's cranial ridge. One archaeologist has described this characteristic of Old Bering Sea art as "polyiconic," meaning that it conjoins multiple images in one form, thus expressing the Native principle of the fluid interconnectedness of human, animal, and spiritual realms.

Ancient Eskimoan peoples emigrated from Siberia only four thousand years ago (the last Amerindian peoples to cross over from Asia), and they share many linguistic traits, religious beliefs, materials, and artistic styles with ancient peoples of Asia. In the sinuous, curvilinear style of art combining fantastic animals with humanlike faces, some scholars see links with the art of the Shang and Chou dynasties of China (1766–256 B.C.E.), and with the Scythian art style of the nomadic hunters who roamed from the Black Sea across Siberia from the ninth century B.C.E. to the second century C.E. In both of these cultures, shamanism and a reverence for the spiritual power of animals were prevalent. Ancient Eskimos even made occasional use of iron from Japan in their art- and tool making, but this probably came either from North Siberian middlemen or from Japanese shipwrecks. Thus, at the northernmost extremity of North America, we find evidence of encounter and exchange between seemingly remote cultures.

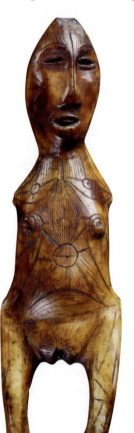

1.13 (left) Okvik Eskimo figure, Okvik, Alaska, 200 B.C.E.–100 C.E. Ivory, 6¾ in (17 cm). University of Alaska Museum, Fairbanks, Alaska.

1.14 (below) Zoomorphic rake, Ipiutak, Point Spencer, Seward Peninsula, Alaska, 450–850 C.E. Walrus ivory, 10¼ in (26 cm). University of Alaska Museum, Fairbanks, Alaska.

# Ancient Art of the Southwest

The desert Southwest is home to several cultures whose ancient legacies of architecture, pottery, and religious practice have been well preserved. Ancient peoples of this region were farmers, who coaxed corn, beans, and squash from an arid land. In their worldview, this cultivation depended on careful plant selection as well as an elaborate ceremonial system focused on seasonal changes and petitions to the spirit world for rain. Although agriculturalists, they lived in remarkable multistory apartment compounds, built of stone and wood. Their trade network extended to California, Mexico, and the Great Plains. Although there were several regional traditions in ancient Southwestern art, we shall focus on the ancient Anasazi, with a brief look at the painted pottery of their southern neighbors, the Mimbres.

## From Basketmakers to Potters and Architects

Early southwestern culture is dubbed "Basketmaker" culture (c. 100 B.C.E.–700 C.E.) because its most distinctive art was the weaving and twining of fibers into baskets, clothing, footwear, and other practical items. Woven baskets—as well as pairs of new yucca-fiber sandals for use in the afterlife—are found in many burials. Ancient basketry forms include trays, carrying containers, bags, aprons, and watertight baskets lined with pitch. Out of Basketmaker culture arose the Anasazi or Ancestral Pueblo culture (700–1300 C.E.).

## Anasazi or Ancestral Pueblo

*Anasazi* is a Navajo word meaning "enemy ancestors." The later Navajo (on whose land many Anasazi archaeological sites are found) coined this term for the makers of the remarkable architecture existing in their lands, which they recognized had not been made by their own forebears, who arrived in the region after 1300 C.E. The Anasazi were the ancestors of modern Hopi, Zuni, and other Pueblo peoples; for this reason, this culture is sometimes called "Ancestral Pueblo." These ancient people are best known for their architecture and painted pottery, especially from the Great Pueblo period (1050–1300 C.E.). The superbly crafted baskets and pottery made in this era stand at the beginning of an unbroken tradition that persists today. In recent centuries—and probably in ancient times, too—these have generally been the work of Pueblo women. Over generations, women determined which roots and grasses would endure processing without excessive fading and cracking, and they ingeniously combined materials of different properties to serve particular functions: strength for a carrying basket, beauty for a gift basket, watertightness for a food basket. The bilobed basket shown here (**fig. 1.16**) is technically complex, the patterns of its dyed and coiled fibers relating to painted pottery and walls. It survives in excellent condition because it was preserved in a dry cave.

Potters' skills, too, developed over generations of experimentation. The era from 1050 to 1300 C.E. when Anasazi women and their Mimbres neighbors were making finely crafted vessels (see figs. 1.15, 1.19, 1.20), and the era from 1400 to 1600—when the direct ancestors of modern Hopi people developed their painted **polychrome** vessels (see fig. 1.21)—were high points of artistic achievement. In Anasazi pottery, black-on-white painting was the most widespread and enduring style. Ancient wares were characterized by regional as well as individual diversity. The potter's repertoire included mugs, bowls, seed jars, and animal effigies. The most widely admired form was the wide-shouldered storage jar (called by its Spanish name, *olla*), painted with semi-abstract designs (**fig. 1.15**). On this vessel, a triangular maze-like design encircles the small neck. The painting on the rest of the vessel alternates between larger circles divided into quadrants (perhaps a directional referent) and complicated asymmetrical stepped elements. The design field alternates between bold, thick lines and tiny parallel or crosshatched ones. This bold sense of graphic design distinguishes the finest Anasazi pots.

Ancient potters used processes and tools similar to ones still in use by their descendants today. They dug the clay from particular sites where the mineralogical properties were right for fine pottery. Then they refined the clay and

1.15 ANASAZI ARTIST, Olla (jar), northern Arizona, c. 1150 C.E. Clay and pigment, 14⅙ in (36 cm) diameter. Private Collection.

1.16 **ANASAZI ARTIST**, Bi-lobed basket, Anasazi, Mogui Canyon, Utah, c. 1200 C.E. Plant fibers. University of Pennsylvania.

coiled the pots by hand, using sections of gourd to smooth and shape the walls. Polishing stones were used to rub the surface to a high gloss. Ribs of yucca plants were collected, dried, and chewed to make paintbrushes to paint the fine parallel lines seen so often on these vessels.

The other enduring achievement of the Ancestral Pueblo people was in architecture. The original architectural form used in the Southwest was a **pit house**, built partly underground. Its key features included a round room, supporting wooden posts, an entrance hole in the roof, and walls and ceilings of sticks and dried mud plaster. The *sipapu*, a hole in the floor, symbolized the hole through which—according to a Pueblo origin story still told today—human beings emerged onto the surface of the earth from their previous dark home in the underworld. After 900 C.E., this humble circular room was combined with small rectangular rooms to become the components of the most ambitious houses ever conceived in aboriginal North America: the great apartment compounds and cliff dwellings that, by 1050 C.E., dotted the landscape of the Four Corners region: where Arizona, New Mexico, Utah, and Colorado meet. In the multiroom, many-storied apartment complexes of the eleventh and twelfth centuries, the ancestral architectural form—the semi-subterranean pit house with an entrance hole in the roof—survived as a ceremonial enclosure known as a *kiva*. Some kivas are small and were used primarily for family ritual. Others accommodated scores of people.

**CHACO CANYON.** The archaeological site of Chaco Canyon, New Mexico, contains nearly three hundred separate apartment compounds within a range of just a few miles: some on the valley floor, others on top of the mesa. Pueblo Bonito, the grandest of these compounds, was built in semicircular form (**fig. 1.17**). By 1100 C.E., it may have had as many as eight hundred rooms, built five deep and four to five stories in height. Yet Pueblo Bonito was probably not fully given over to living spaces; instead, its three-dozen kivas and its suites of large rooms were used for ceremony and the storage of trade goods. Some of the walls of this building were laid more than a yard thick at ground level, to bear the load of multiple stories. The walls narrowed as they rose.

Characteristic of architecture throughout Chaco Canyon, and especially evident at Pueblo Bonito (**fig. 1.18**), is its construction from precisely fitted horizontal courses of sandstone blocks. In some cases they are aligned in intricate patterns of different sizes, widths, and colors. The sandstone was cut from nearby cliffs, while the wooden beams in the floors and roofs required cutting more than

1.17 Pueblo Bonito, Chaco Canyon, New Mexico, 850–1150 C.E.

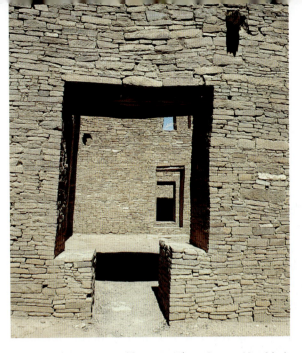

1.18 Door alignments, Pueblo Bonito, Chaco Canyon, New Mexico, c. 1100 C.E.

200,000 trees, some from forests as far as 50 miles away.[1]

One noteworthy architectural feature found at Pueblo Bonito and elsewhere at Chaco is the "Great Kiva," a type of building that has been called a "ritual theater" because its size and grandeur suggest this function. Some Great Kivas were as much as 60 feet in diameter. Spectators would flank the walls, while ritual performers danced in the center. Great Kivas were oriented to the cardinal directions; for this reason they have been called architectural versions of cosmic maps and metaphors of an ideal universe. At one Great Kiva, Casa Rinconada, the sun shone into a window precisely at the summer solstice, serving to mark the date when particular ceremonies were to be conducted.

In fact, the whole apartment compound of Pueblo Bonito is itself aligned to the skies: on the equinoxes, the sun rises and sets in perfect alignment with its southern wall. Ancient Pueblo astronomers also used the walls of cliffs to record astronomical data. High on Fajada Butte, in Chaco Canyon, daggers of sunlight project through thin cracks between slabs of sandstone onto a spiral figure incised on the opposite rock wall. The light illuminates different points in the spiral at the solstices and equinoxes.

The inhabitants of Chaco also made good use of the practical aspects of the sun, harnessing solar power to heat their apartment complexes. Because these dwellings had no windows, apart from the roof opening, they resisted extremes of temperature. In winter, when the sun is low in the sky, the sandstone walls absorb heat during the day and release it at night, keeping the rooms much warmer than the cold desert air outside.

Encompassing dozens of separate apartment compounds, Chaco Canyon probably served as a ceremonial center as well as the hub of a great interregional economy. Over the roads radiating out from Chaco (some extending in straight lines for more than 50 miles) came trade goods, including marine shells from the Gulf of California, copper bells and tropical birds from Mexico. These found their way into the ceremonial finery worn by living people, as well as burials of the honored dead.

Anasazi architecture gives visual form to a communal organization that survives among Pueblo peoples even today. Clusters of small rooms are punctuated by larger spaces, both private and public. Enclosed subterranean spaces would have been used for family or clan-based rituals, while open plazas suggest that a thousand years ago, as today, to gather publicly and dance for the gods was a fundamental part of being Puebloan. Ancient astronomers at Chaco, like those at Cahokia and elsewhere in the east, also used their observational powers to predict the seasons and to time the ceremonies that were crucial to maintaining the proper relationships between humans and supernatural beings.

## Mimbres Painted Pottery

During the same decades that Ancestral Pueblo potters were perfecting their fine-line geometric painting, their Mimbres neighbors to the south were painting both geometric and figural designs in the interiors of hemispheric bowls. Although Mimbres pottery was made for over 500 years (600 to 1150 C.E.), its artistic high point occurred in the eleventh and early twelfth centuries. Mimbres bowls were hand coiled, smoothed, and shaped, and then painted on the interior before firing. More than ten thousand of these bowls

have been found; some feature geometric designs and fine-line painting reminiscent of Anasazi work, while others use a figurative vocabulary expressing a relationship to the natural and supernatural worlds, while reducing animal shapes to their sparest recognizable forms. Animals such as mountain sheep (**fig. 1.19**), bats, and rabbits appear on Mimbres pots, as do composite mythological beings. The black-and-white-striped masked figure (**fig. 1.20**) suggests that aspects of Mimbres culture were absorbed into Pueblo culture, for this striped figure appears in modern ritual and art as a Pueblo clown (see fig. 2.30, *Koshares of Taos*). The Mimbres people almost certainly had contact with more distant cultures: images on their pots also suggest links with ancient Mexico.

These pots also reveal something of the Mimbres' beliefs about the afterlife. Most of them have been found in burials beneath the floors of simple one-story apartments. Usually inverted over the head of the corpse and stacked in groups, most are punctured at the very bottom where the first tiny coil was shaped to begin forming the vessel (see fig. 1.20). Called by archaeologists the "**kill hole**," this renders the vessel unusable in this world, but implies a spiritual use. Modern Pueblo people describe the sky as a dome that rests upon the earth like an inverted bowl that can be pierced to allow passage between different worlds. The Pueblo belief about human emergence from a hole in the ground onto the surface of the earth

1.20 MIMBRES ARTIST, Bowl with Koshare figure, Pruitt Site, New Mexico, c. 1200 C.E. Clay and pigment, 4¼ in high × 9¼ in (10.8 × 23.5 cm). Taylor Museum, Colorado Springs Fine Art Center.

also reflects this idea of permeable boundaries between worlds. By placing their painted and pierced "domes" over the heads of the dead, the Mimbres people may have been expressing in tangible form their beliefs about the travel of the deceased into the spirit world, just as modern Pueblo people describe the transformation of the dead into spirit beings and clouds in the dome of the sky.[2]

## Art and Cultural Change in the Proto-historic Period: Hopi, Zuni, and Acoma

A severe drought in the twelfth century may have triggered the collapse of the complex economy centered at Chaco Canyon. Many sites were abandoned, and new, smaller, regional sites appeared, particularly along the Rio Grande, where water was more plentiful. Soon thereafter, the communities of Hopi, Acoma, and Zuni began to develop in what is today northeastern Arizona and northwestern New Mexico, gradually becoming the centers of Pueblo life and art. Pueblo oral histories that recount ancient migrations in search of a new homeland are almost certainly recalling the migrations of this late precontact period.

Like Mimbres pottery, fourteenth-century shrine figures discovered in a cave in the Mimbres region (**p. 2**) demonstrate the persistence and prevalence of ritual beliefs in the Southwest. Two painted figures (one made of stone and

1.19 MIMBRES ARTIST, Bowl with mountain sheep, Mattocks Site, New Mexico, c. 1200 C.E. Clay and pigment. Maxwell Museum of Anthropology, New Mexico.

one of wood), smaller wooden snake or lightning figures, and other emblems suggest rituals like those still performed today in the Native villages of northern Arizona and New Mexico. These figures seem to be prototypes for Hopi and Zuni spirit figures in painted wood (see fig. 9.29, kachina figure). The placement of these stone figures in a cave reflects an abiding interest in cosmological order, in mapping the world, and in venerating sacred places in the landscape. Pueblo people today continue to use sacred shrines at caves, mountains, and lakes.

While many of the earlier vessels in both the Mimbres and Anasazi traditions were painted simply black and white, late prehistoric Hopi pottery is polychrome (multi-colored). Sikyatki polychrome pottery (named for a Hopi site) was meticulously hand polished using smooth stones, and painted in rich earth pigments, ranging from yellow and orange to umber and black (**fig. 1.21**). The women who painted these pots used designs that ranged from simple geometric motifs (dots, dashes, triangles, and stepped forms) to semi-representational designs that reference earth, clouds, sky, rain, spirit beings, and animal forms. Such iconographic elements persist in Pueblo pottery and painting in the modern era (see fig. 15.16, *Koshare on Rainbow*).

The elegant widemouthed jar is painted on its shoulder, while the base of the jar is the simple biscuit-color of the clay. The line encircling the mouth of the jar (and another, unseen in this photograph, which divides the shoulder from the base) has a break, a feature of some modern Pueblo pottery, where it is said to represent the *sipapu*, or place of emergence from the underworld, also found in ancient Pueblo architecture. Perhaps even in ancient times these vessels, made from the clay body of "mother earth," were conceptualized as miniature painted worlds. Used in ceremony, they were also used in daily life, to contain nour-

1.21 ANCIENT HOPI ARTIST, Sikyatki polychrome jar, Northeastern Arizona, c. 1450–1500 C.E. Clay and pigment, 8⅝ in high × 14⅞ in diameter (22 × 37.8 cm). Fenimore Art Museum, Cooperstown, New York. Thaw Collection.

ishment for the body—like the earth itself. The painted designs on the shoulder of the vessel repeat four times with subtle differences as they rotate around the jar. Painted free-hand with great skill, they seem to represent semi-abstract birds with curled wing feathers and straight tail feathers.

By the sixteenth century, Pueblo life was flourishing at Hopi, Zuni, Acoma, and numerous small villages along the Rio Grande. Pueblo people had, in the last four hundred years, weathered drought, warfare, and migrations. But their biggest challenge was soon to come—in the form of an armed band of Spaniards who had set forth from Mexico City looking for fabled "cities of gold" in the desert Southwest.

## Conclusion

Encounter, trade, and exchange—among distant groups as well as neighboring ones—were fundamental to the development of art and culture in ancient America. After Columbus's historic voyage of 1492, successive waves of intrusion brought new kinds of foreigners onto the American landscape—ones whose weapons discharged thunder, and who possessed different trade goods and artistic styles, as well as rigid ideas about religion and social hierarchy. In the Southwest they came overland, on foot and on horseback from what is today Mexico; in Alaska, they arrived first from Russia in boats; and in the east they arrived in multiple migrations, some from Mexico, and some directly from Europe. One and a half million newcomers arrived against their will, from Africa. The rate and level of cultural encounter would accelerate in a way previously unimagined in the Americas. All of the land's inhabitants—aboriginal and newcomer—and their visual cultures would be changed irrevocably by the next five centuries of encounter.

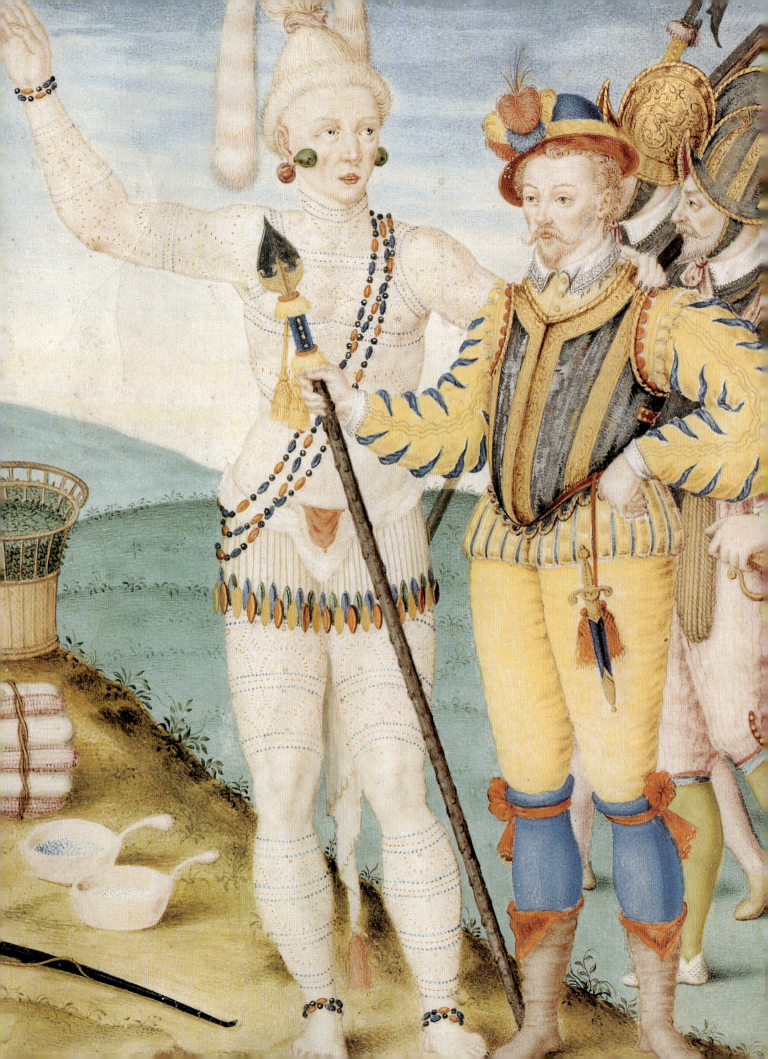

# 2 | The Old World and the New: First Phases of Encounter, 1492–1750

When Columbus "discovered" America, the urbanized Native societies of the Southeast and Southwest had already been in decline for more than a century, as a consequence of migrations caused by drought, warfare, and other upheavals. Even so, after 1492 the rate and level of decline among Native cultures throughout the Americas intensified exponentially in ways difficult for us to imagine. The Taino of the Caribbean, for example—the first Natives encountered by Columbus—were virtually extinct by 1550, as a result of epidemic and suicide following enslavement by the Spanish. The Conquest also toppled the great civilizations of the Aztecs, in Mexico, and the Incas, in Peru. Scholars hotly dispute estimates of the indigenous American population before and after Columbus, but some assert that as many as nine out of ten Native people died as a result of the invasion. "We are crushed to the ground; we lie in ruins," wrote a Nahuatl (Aztec) poet.

This chapter will consider the "New World" that took shape between the arrival of Columbus and the establishment of permanent English, Spanish, and French settlements. This phase of first encounter produced a range of transformations and adaptations of built forms, materials, and symbols as a result of cultural exchange between European and Native. On the eastern seaboard, the English encountered the Algonkian peoples of Virginia and North Carolina; in Florida, the French made contact with the Timucua Indians; and in New Mexico, the Spanish attempted to convert the **Pueblo** peoples, after subduing

them by force. These Native cultures shared some common characteristics: they were settled societies that subsisted by agriculture, trade, hunting, and fishing. But in each case the encounters differed, depending on the specific conditions and parties involved. We shall retrieve the varied histories of these encounters from early visual representations of the "New World" made by Europeans, and from objects, dress, architecture, and ritual performances made by the Native peoples and European colonizers in these various regions.

This chapter also examines the distinctive motives and methods of the English, the French, and the Spanish, along with differences among the societies whose labor they used, and with whom they traded, made war, and eventually settled into a tense and unstable relationship. Interweaving these separate stories of conquest and colonization highlights both differences and similarities in their parallel histories, and in the arts that resulted from what were often cataclysmic encounters. We will see how religious attitudes, colonizing methods, material culture, and imbalances of power affected the outcomes. By presenting these histories—and art histories—together, we hope to portray the varieties of first-encounter experience through the lens of the arts that resulted.

## European Images of the New World: The First Century

Since there are no surviving Native images from North America depicting their first encounter with Europeans, our selection is necessarily limited to images made by

(opposite) JACQUES LE MOYNE, *René de Laudonnière and Chief Athore of the Timucua Indians at Ribaut's Column* (detail), 1564. Watercolor on vellum. Wallach Division of Arts, Prints and Photographs, New York Public Library. (See also fig. 2.11)

Europeans. (Significant exceptions to this come from Mexico and Peru, but these are outside our scope.) The sixteenth-century European images of the New World and its people reveal a range of attitudes, with roots deep in classical antiquity and Judeo-Christian belief. During the first century of European exploration, conquest, and settlement, the wondrous news from the New World intermixed with the preconceptions of Old World myth and religion, producing a fanciful, at times distorted, image of its Native occupants, which has cast a long shadow across American culture and literature.

## The Earliest Images

The earliest images of first encounter disclose more about European wishes and desires than about ethnographic realities. Some time needed to elapse before those who voyaged to America were able to see its Native peoples—so radically different from themselves—with any degree of objectivity.

**COLUMBUS LANDING IN THE INDIES.** The first images of New World encounter were woodcuts produced in Italy to accompany Columbus's letter to his Spanish patrons (**fig. 2.1**). These images of Natives fleeing from the

2.1 *The Landing of Christopher Columbus*, title page of Giuliano Dati's *La lettera dell isole che ha trovato nuovamente il Re di Spagna*, 1493. Woodcut, 4⅛ × 4⁷⁄₁₆ in (12.1 × 11.9 cm). British Library, London.

approaching Europeans are the only visual remnants of that first encounter. Broadly circulated, they represented the first "news" from the front, showing Europeans in terms of superior technology (ships), political power (in this print, a king, scepter in hand, establishes authority over the New World), and military might. But above all, it was the nakedness of the Natives depicted that lodged in European minds. Their Judeo-Christian legacy associated nakedness with the innocence of Adam and Eve before their expulsion from the Garden of Eden. Nakedness (as opposed to nudity) also conveyed vulnerability and the lack of defining traditions, rites, and religion—a cultural void upon which Europeans could project their desire for dominion.

**PARADISE AND HELL.** Europeans imagined the New World as both paradise and hell. The Old World's ambivalent image of the New is strikingly apparent in a woodcut published in 1505 in Augsburg, Germany (**fig. 2.2**) accompanied by lines from Amerigo Vespucci: "The people are ... naked, handsome, brown, well-formed in body [and] covered with feathers. ... No one owns anything but all things are in common. The men have as wives those that please them, be they mothers, sisters or friends. ... They also fight with each other. They also eat each other even those who are slain, and hang the flesh of them in smoke. They live one hundred and fifty years. And have no government." In the distant background are two Portuguese galleons, while the gruesome remains of two unfortunate sailors hang suspended from a tree. In the foreground cannibals gnaw upon severed body parts. Yet in the same print are blissful scenes of love beneath a wooden bower, nursing mothers and children, and stately men in feathered skirts and headdresses. The ideal of a paradise to the west, beyond the pillars of Hercules (Gibraltar), lived on from antiquity, shaping attitudes toward the New World. But coexisting with this was a fascination with what Europeans perceived as monstrous and savage behavior—nakedness, free love, cannibalism, and other practices threatening European notions of civilized life. This duality would persist through the next four centuries of European–Native encounters.

**THE "NOBLE SAVAGE."** The sixteenth-century encounter also inspired new ideas within European society. The exotic strangeness of the New World as a "bower'd" arcadia, where presumably no labor was required to pluck the fruits of the earth, and where "mine" and "yours" were unfamiliar concepts, delighted a Europe racked by prolonged wars and political and religious turmoil. Europeans marveled at a new people apparently without guile,

2.2 *The People of the Islands Recently Discovered…*, c. 1505. Woodcut with color wash. Bayerische Staatsbibliothek, Munich.

selfishness, or inhumanity who appeared to be free of legal disputes, weights and measures, money, and books, as well as lying, deceit, joyless labor, greed, envy, jealousy, and dishonesty. Early descriptions associate the Indians of North America with a life of liberty and unfettered pleasure,

living in a moral innocence unknown to jaded Europeans. Out of these first encounters was born the image of the "noble savage," the personification of ancient longings and new possibilities.

**A BECKONING PRINCESS.** The nakedness of Native peoples fostered a quasi-sexual perception of them as vulnerable and receptive to European advances. *Vespucci*

FAST FORWARD

## The Long History of the Feathered Headdress

THE EUROPEAN INVENTION of the Indian as a symbol of the New World began with the first sightings of the Tupinamba Indians of Brazil in the early sixteenth century; shortly thereafter, some actual Natives were exhibited to a European audience in Rouen, France. Very quickly, the most familiar attribute of New World people would become the feathered headdress and skirt, sometimes coupled in artistic imagery with severed body parts to indicate cannibalism. Feathered decoration made its appearance in countless allegorical representations of America—from English theatrical costumes to European tapestries, to wallpaper. Later, the feathered

headdress became a symbol of the rebellious colonies. Such stereotypes of New World identity migrated freely between cultures for the next three centuries, serving many symbolic purposes. A range of indigenous cultures were collapsed into a single generic "new world" symbolized by the feathered headdress as an image of exotic difference. In the twentieth century, the eagle-feather headdress of Plains cultures would become an all-purpose sign of Indian identity, popularized by Hollywood and simultaneously adopted by Native Americans themselves to express pan-Indian identity.

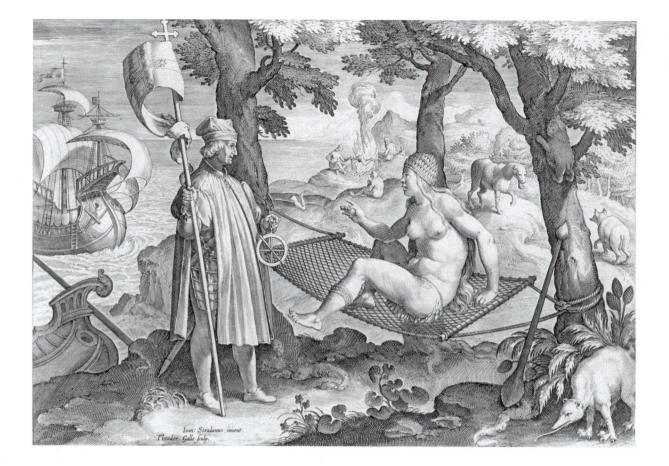

2.3 THEODOR GALLE, after Stradanus (Jan van der Straet), *Vespucci Discovering America*, 1600. Engraving. British Museum, London.

*Discovering America* (**fig. 2.3**) depicts a Renaissance explorer—an embodiment of masculine European knowledge and power—confronting a reclining nude Indian princess. Jan van der Straet (Stradanus), a Flemish artist working in Italy, furnished the 1589 drawing for a print honoring the Italian explorer Amerigo Vespucci. He holds an astrolabe—a measure of his navigational expertise—and a banner bearing a cross, suggesting respectively the twin sources of his authority: science and religion. Beneath his scholar's cloak he wears armor and sword. Lying on a hammock, wearing only a feathered skirt and cap, the Indian maiden gestures toward Vespucci as if awakened by his presence. In the background, human limbs are roasting over a fire. Anteater, tapir, and sloth, as well as a pineapple, all make their appearance, meticulously labeled on the original drawing as new species. Exploiting a range of visual sources, Stradanus has amalgamated details from Brazilian, Caribbean, and Mexican cultures into a single image. Alongside a new empirical precision is the vision of an exotic and feminized new world receptive to colo-

nization. This idea of a new world brought to life by its encounter with a superior European culture would persist in later allegories.

## The Empirical Eye of Commerce

All sorts of misunderstandings attended the early encounters between Europeans and Natives. The newcomers misinterpreted indigenous people's relationships to the land, their gender relations, their artistic expressions, and their social organization. Some commentators marveled at what they saw; others disparaged it. The English settler and self-trained artist John White chronicled it carefully. His drawings depict an exotic land at the last moment before cultural encounter will change it forever. Subsequently, Theodor de Bry published editions of engravings based on the renderings of White and others, furnishing a visual chronicle of New World voyages.

**JOHN WHITE.** Beginning in the late 1500s, the English encountered the Algonkian peoples of Virginia and North Carolina—settled societies that subsisted by agriculture, hunting, and fishing. English would-be settlers—and the

investors who financed their voyages—required practical information about the conditions awaiting them on the other side of the Atlantic. In 1585 John White accompanied the first English expedition to establish a colony on the eastern seaboard, on Roanoke Island, in present-day North Carolina. This venture, backed by Sir Walter Raleigh, was unsuccessful; but two years later, a second (also temporary) colony was founded there, and for this one White served briefly as governor. During the time of the first colony, he furnished his English sponsors with an extensive, detailed visual record of the land they claimed. In White's extraordinary watercolors, myth and preconception give way to studied observation.

White painted the Algonkian town of Secota, or Secotan (**fig. 2.4**), depicting it as an orderly place, with well laid-out fields of corn, tobacco, squash, and sunflowers. He indicated both a dancing ground (lower right) and a holy ground (lower left). Although White may have made the village look too neat and manicured, his outlines are probably essentially correct. Barrel-shaped dwellings were constructed of thin saplings bent over, lashed together, and covered with bark or reed mats. Often Algonkian women built such houses nestled under the protective shade of trees, as White depicts them.

White's representations of Indian priests, conjurers, elders, women, and children provide details of the tattoos, dress, physiognomy, and customs of these Eastern Woodland societies—details highly useful to modern anthropologists and art historians. His figures turn in space and gesture as they spear fish in the shallow waters off the Carolina coast (**fig. 2.5**). Portraying the reed fences that the Algonkians used in trapping fish, he tilted the ground plane up, opening a space in which to include the varied marine life of the coastal waters. This rendering also employs a gridlike series of horizontals and verticals, which lock the variety of the natural world into order. He painted a meticulously observed flying fish (**fig. 2.6**), which combines deft draftsmanship with information about coloration, gills and fins, and skin pattern. In like manner, he also drew land crab, scorpions, triggerfish, translucent Portuguese man-of-war fish, flamingoes, and reptiles: the most extensive body of natural history illustration yet inspired by the New World.

White's gridded vision of nature along the coast of the Carolinas, together with his precise rendering of native flora and fauna, reflect his European, post-Renaissance manner of organizing knowledge. Empiricism, with its focus on verisimilitude and inventory, served the emerging natural sciences and enabled Europeans to assert their dominance over indigenous cultures epistemologically—that is, through their manner of knowing the world.

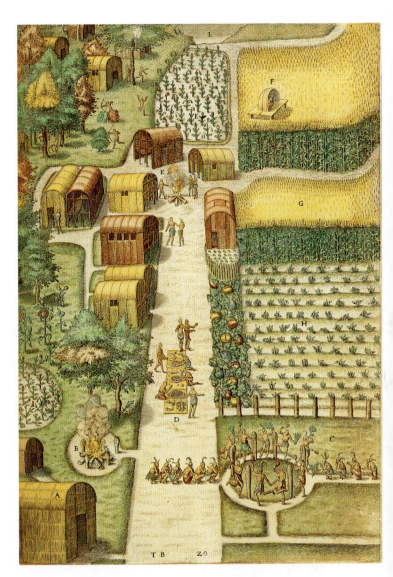

2.4 JOHN WHITE, *Village of Secoton*, 1585. Colored engraving. Gilcrease Museum, Tulsa, Oklahoma.

Whatever may have motivated White to depict his new surroundings, his watercolors supplant an imaginary picture founded in myth and religion with an objective one based on observation and forethought, apprehending nature as an object of scrutiny, analysis, and economic exploitation.

Native depictions of animals also demonstrated keen observation. For example, the falcon pipe in the previous chapter (see fig. 1.8) combines accurate details of a falcon (feather shape, humped tongue, crooked beak) in an elegantly stylized abstraction, which allows the bird form to be wrapped and compressed around the bowl of a stone pipe. So although Native artists, too, observed nature closely, the result was stylized rather than strictly mimetic, in conformity with ritual and ceremonial norms.

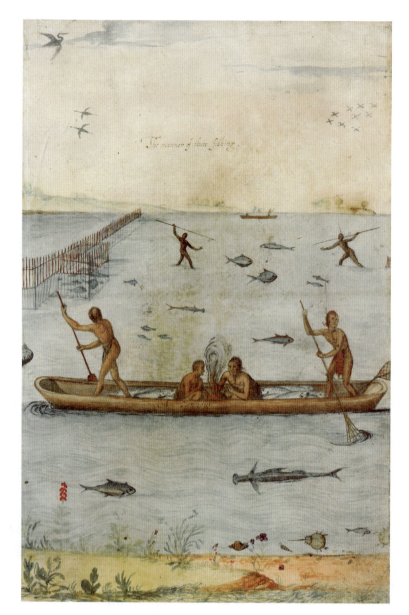

2.5 JOHN WHITE, *Indians Fishing*, c. 1585. Watercolor touched with white and gold, 13⅞ × 9 in (35.3 × 22.8 cm). British Museum, London.

2.6 JOHN WHITE, *Flying Fish*, c. 1585. Watercolor, 10⅞ × 9⅛ in (27.6 × 23.5 cm). British Museum, London.

**DE BRY'S *GREAT VOYAGES*.** The period between Columbus's arrival in 1492 and the English colonizing efforts of the later sixteenth century produced many written accounts of New World exploration, but few illustrations. However, in 1590 a family of engravers based in Germany undertook a major publishing venture that offered Europeans a richly imagined chronicle of New World conquests during the preceding century. The *Great Voyages* of the De Bry family was a compendium of fourteen volumes, written by various travelers, missionaries, colonizers, and adventurers, for which the De Bry family furnished the illustrations. The first book in the series was based on White's watercolors of the Virginia Algonkians, which Theodor De Bry had been quick to acquire. To his source materials, De Bry frequently added landscaped backgrounds, carefully observed anatomy, and perspective. Together, text and image gratified European curiosity, offering a reassuring picture of peaceful Indians in an exotic land of abundance. Later volumes in the series, however, featured horrific accounts of Spanish brutalities toward the Indians in Mexico, Peru, and Brazil. Such images played out Old World hostilities and rivalries; De Bry had himself suffered at the hands of Spanish oppressors in the late-sixteenth-century wars of religion between Protestant and Catholic. The composite picture the *Great Voyages* offered of the New World was complex and contradictory—both an Eden-like refuge from the worst excesses of European society and a land where European greed and plunder were acted out with ruthlessness and brutality.

## New World Maps

Direct witness—such as that provided by White—played a major role in the British colonization of new lands. Hoping to encourage investment in Virginia (as the English then called all the lands they claimed on the eastern seaboard), early travelers emphasized marketable commodities, including fruits, fish, and building materials, as well as the supposedly receptive people. They also minimized the difficulties of planting a new colony. "The country about this place is so fruitful and good that England is not to be compared to it," observed Thomas Hariot in 1588 (*A Briefe & True Report of the New Found Land of Virginia*).

Knowledge was power, and maps offered another form of knowledge, which proved indispensable for the Spanish, Dutch, English, and French powers vying for control of the new continent. Maps were at times the object of espionage, as these rival powers attempted to monopolize geographical knowledge for private commercial interests. Although valued largely for their accuracy, maps also reveal their creator's motives, emphasizing some features while neglecting others, altering scale, and in some cases inventing geography.

Since the Middle Ages, a type of map known as a "portolan chart," used mainly by sailors, had emphasized coastlines, harbors, and points of entry into a continent over the interior features of new lands, thus promoting the expansion of international trade and overseas markets. By 1543, well after Magellan's circumnavigation of the globe (1519–22), the World Map of the Genoese cartographer Battista Agnese (**fig. 2.7**) traced the Spanish route across the Atlantic to the fabled gold riches of the New World in a manner that clarifies the imperial stakes that motivated exploration.

Emblazoned with the coats of arms of their imperial patrons, and devoid of references to the Native presence, maps also signaled possession of the new lands, in claim if not in deed. Over time, English and Spanish place names appeared in lieu of Indian names. In a map of Virginia based on one produced by John White and Thomas Hariot during the Raleigh expedition (**fig. 2.8**), Indian settlements are indicated by tiny circular stockades, and Indian names are retained. But larger block letters—"Virginia"—claim the new lands for the "Virgin Queen" Elizabeth; most of the map's information is contained between two stylized cartouches, further asserting the queen's proprietary stake in these lands. Overscaled galleons patrol the coastal seas, while tiny Indian figures appear stationed to greet the newcomers. Bisecting the land mass shown in the map is a wide coastal river that penetrates into the heart of the new land, leading directly to a mountain range shown at the top of the map. The scholar David Quinn has suggested that mountains not only served as geographical

2.7 BATTISTA AGNESE, World map, c. 1543–45. Watercolor, 8 × 11⅛ in (20.3 × 28 cm). The John Carter Brown Library, Brown University, Rhode Island.

2.8 THEODOR DE BRY, after JOHN WHITE & THOMAS HARIOT, Map of Virginia, c. 1590. Engraving. Library of Congress, Washington, D.C.

markers but also signified the possibility of gold in the interior. While providing useful geographical information about Native towns and passage into the continent, the sixteenth-century map of Virginia prepared adventurers and investors alike to see the region as a stage on which to enact dreams of wealth and possession.

## Ceremonies of Possession

In the three centuries following 1492, rival European powers each established their own claims upon the land, wealth, and peoples of North America: England and France in Canada, France and Spain in Florida, England and Holland on the Atlantic seaboard in between, and—in the late eighteenth century—Russia in the Pacific Northwest. Although the dynasties and burgeoning commercial republics of Europe had different motives for colonizing, each sought to legitimize its presence in the New World, often by establishing alliances with Native societies. They did so by enacting what scholar Patricia Seed has called "ceremonies of possession," performed for the benefit of those already living on the land, as well as of those watching from Europe.[1] Declaring that the land was theirs, such ceremonies effaced all prior indigenous claims, at least in the minds of the colonizers. Ceremonies of possession varied from one colonizing nation to another, and each found expression in

the visual arts. They tell us as much about the cultures of the colonizers as they do about the peculiar circumstances they faced in the New World. They also reveal a range of ways in which the first encounter was understood by Europeans, from the willed and arbitrary assertion of royal authority over conquered people to the middle ground in which European and Native maintained alliances on the basis of complementary needs and desires.

**THE SPANISH *REQUIRIMIENTO*.** Spanish ventures into the New World were accompanied by a ceremony known as the *Requirimiento*, or Requirement, by which the Spanish announced to uncomprehending Natives their intention of claiming the land for the Spanish Crown. With this proclamation went a demand that the Natives accept their new status as subjects of the Crown—the representative of the pope and his Christian empire. The Requirement did not demand instant conversion to Christianity, but merely consent to becoming peaceful subjects of the Spanish. This demand was followed by a threat to wage war upon any and all who refused these terms. "If you do not do it … with the help of God, I will enter forcefully against you, and I will make war everywhere and however I can … and I will take your wives and children, and I will make them slaves. …" Instituted in 1512, the *Requirimiento* illustrates the autocratic character of the Spanish government, which

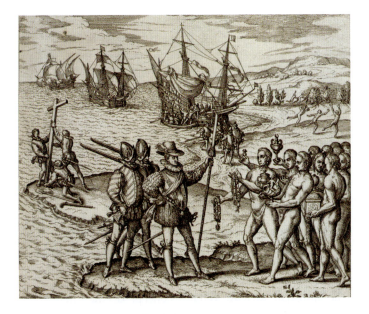

2.9 THEODOR DE BRY, *The Landing on Española*, 1594. Engraving. British Library, London.

during that time ruled by decree rather than by consent. The *Requirimiento* in turn reflected the experience of the Spanish themselves under Moorish occupation, when Muslim rulers exacted tribute from their Christian subjects. Now the Spanish turned the same methods on their New World subjects.

Rival colonizing powers were quick to seize on this feature of Spanish behavior in the New World, by circulating prints of Spanish brutalities toward the Natives. Over time, such events gave rise to the "legend of the Black Spanish," disseminated by critics within Spain, and then propagated by rival nations in their efforts to discredit Spanish claims in the New World. In such scenes as Theodor de Bry's *The Landing on Española* (**fig. 2.9**), the Spanish encounter with New World Indians is backed up by the threat of military force—halberds, swords, and cannons on nearby ships.

**THE FRENCH AND THE TIMUCUA.** Along with John White, the cartographer/artist Jacques Le Moyne—a member of an early French Huguenot (Protestant) expedition to Florida in 1564—executed some of the earliest objective impressions of the New World. For example, Le Moyne's engraving of a palisaded village in Florida, showing several dozen low structures, some round and some rectangular, encircling a larger rectangular chief's house in a central plaza, suggests what Cahokia might have looked like some three hundred years earlier (**fig. 2.10**; see fig. 1.11).

In another, possibly more fanciful work, Le Moyne illustrates a ceremony that he witnessed (**fig. 2.11** and

**p. 22**)—placing a faceted obelisk, adorned with the fleurs-de-lys—the royal French coat of arms—at the center of his image. Its placement on the land marked French claims in Florida. On either side stand tattooed and elaborately coiffed Timucua Indians, who resemble performers in a French royal fête. The leader of the French expedition, René de Laudonnière, stands to the right, attended by helmeted guards. Such military protection appears unnecessary, however, as the central figure of Chief Athore gestures toward the obelisk and presses the shoulder of his European counterpart in a sign of acceptance. The local Indians have festooned the column with garlands of fruit and flowers, bringing gourds, squash, corn, bows and arrows, and other offerings in a show of respect to the French.

The Timucua probably interpreted this imperial marker as a sacred pole. Among many indigenous peoples, sacred poles were (and still are; see fig. 2.30) erected to signify a site where a ritual of cosmological significance takes place. In the Southeast, such poles were related to rituals of diplomacy. In the seventeenth century, the French explorer La Salle and his expedition took part in such rituals with Quapaw and Caddo Indians, in what is now Arkansas. Wooden poles were erected and festooned with gifts for the foreign visitors. Brave men, French and Native alike, were expected to strike the pole with tomahawks and recount their deeds of valor. Such ceremonies were meant to cement diplomatic ties, transforming strangers into trading partners and allies.

In his history of his own expedition, Laudonnière relates how the friendly Indians of Florida compelled him

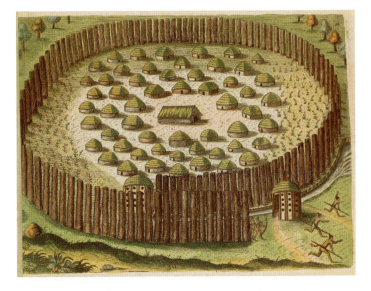

2.10 JACQUES LE MOYNE (artist) & THEODOR DE BRY (engraver), *An Enclosed Village in Florida*, 1564 (published 1591). Engraving on paper, 6¼ × 8⅜ in (15.8 × 22 cm). British Museum, London.

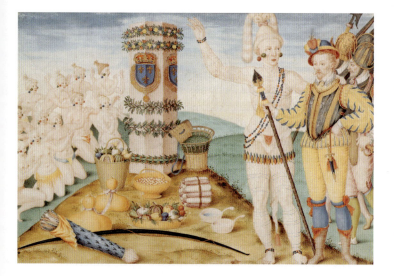

2.11 JACQUES LE MOYNE, *René de Laudonnière and Chief Athore of the Timucua Indians at Ribaut's Column*, 1564. Watercolor on vellum, 7 × 10¼ in (17.78 × 26 cm). Wallach Division of Arts, Prints and Photographs, New York Public Library. (See also p. 22)

to share their idolatrous worship of an object actually intended to establish French sovereignty over their lands. Laudonnière and his men apparently mistook a ceremony of high diplomacy for one of "idolatry"—the only category the French had for interpreting such actions. The French believed that the obelisk established their claim on the land; the Timucua took it to be a symbol of diplomatic exchange, assimilating foreign visitors into their own system of ritual. The scene is an example of what historian Richard White calls "expedient misunderstanding" between cultures, in which each side interprets symbolic events in a manner that reinforces its own belief systems while contributing to cultural alliances.

**THE ENGLISH: TAKING POSSESSION OF THE LAND.**
Right of ownership, according to English law and history, went to those who not only inherited land but who invested labor and time in it. As concepts of private property matured, the delineation of ownership through fencing, agricultural fields, houses, and other markings connoted the establishment of a civilized order. From the first permanent English settlements in North America—in Jamestown, Virginia, in 1607 and in Plymouth, Massachusetts in 1620—through the centuries of westward expansion, Anglo-Americans took possession of the land through acts of surveying, laying out grids, and drawing boundaries. In the process they created, in the words of environmental historian William Cronon, "a world of fields and fences."

The image of the new land as a garden, marrying natural abundance to the improving hand of the gardener,

was deeply rooted. It also resonated with the biblical call to God's "chosen," the Jews, to go forth into the wilderness and, in the words of the Book of Isaiah, make the desert "rejoice and blossom like the rose." This faith took many forms over the next three centuries, and found its grandest expression in the late nineteenth century, when the American West became the focus of scientific investigation, resource extraction, and settlement.

## Indigenous Eastern North America: Forging a Middle Ground

The historian Richard White's concept of the "middle ground" helps one to understand moments when diverse peoples come into contact and create new systems of meaning and exchange. The middle ground is a place where worlds overlap, yet leave a space in which cultures can adapt to new conditions.[2] Despite the unequal power between themselves and the colonists, indigenous North American societies were able, over time, to adapt to the new presence in their land, finding some convergences between their artistic practices and those of the Europeans. The term used to define this form of cultural encounter is *syncretism*—the melding of two or more different belief systems, artistic styles, or cultural practices to form a third, distinctly different one.

Although many indigenous societies had been dislocated from their ancestral homelands as a result of white settlement, epidemic, forced relocation, intertribal raiding, warfare, and shifting ethnic alliances, they were nevertheless often able to devise a culture of the middle ground. The crucial factor permitting this was that Natives and Europeans met in partnerships from which each benefited, based on trade. Natives retained aspects of their cultural autonomy as they hunted and trapped America's abundant wildlife to supply an international market. The pelts and hides were sent to Europe; in exchange, cloth, iron and silver, and glass beads made their way across the ocean to North America. The indigenous artistic repertoire expanded to incorporate these trade goods. Although their cultures were changing so rapidly as to be threatened with virtual extinction, Native people acquired and assimilated new materials and motifs, while trying to exploit new opportunities for economic and artistic enrichment. The visual culture of the middle ground was hybrid and inventive, resilient in the face of foreign occupation.

Early twentieth-century anthropological schemes sought to classify American Indian art objects in terms of individual tribal styles with recognizable differences. But in the eastern half of the continent, in the centuries from 1600 to 1900, this sort of classification is not useful. In the middle ground of the Great Lakes, for example, tribal affiliation was less important than village or clan affiliation. Villages often included members of several different tribes, drawn together because of the pressures caused by colonization. Cross-cultural bonds were established through gift giving, adoption, intermarriage, and ceremonies that transcended tribal affiliation, like the ritual smoking of tobacco and the exchange of **wampum**; see "The Repatriation of Wampum," page 39. All of this had ramifications for the visual arts, in which both cultural conflict and accommodation were played out.

## New Materials and New Markets

Only a few artistic objects made by Native Americans have survived from before the mid-eighteenth century. Most were made of perishable materials such as wood, feather, skins, porcupine quills, and moose hair—items that deteriorate unless held under optimal conditions.

**"POWHATAN'S MANTLE."** One of the earliest items collected and preserved in a European museum is an object nicknamed "Powhatan's Mantle" (**fig. 2.12**). It is unclear whether this did, in fact, belong to Powhatan (1547–1618), the paramount chief of the Virginia Algonkians. Moreover, it is far too big to be a mantle or cloak (over 7 by 5 feet). Consisting of four deerskins sewn together, it is decorated with marginella shells. These are sewn to depict a frontal human figure flanked by two animals in a field of many

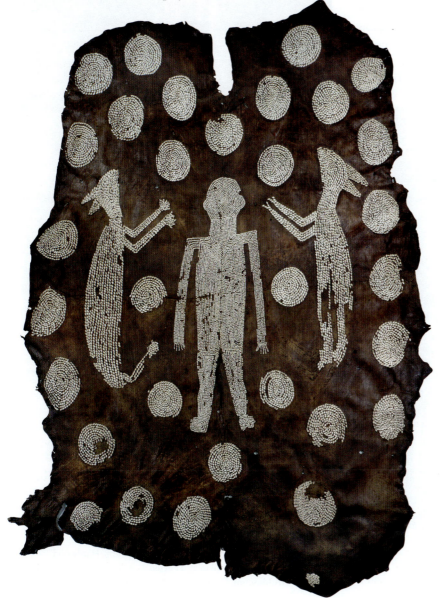

2.12 Powhatan's mantle, Algonkian culture, Virginia, before 1638. Deer hide, marginella shells, 87⅞ in (223 cm). Ashmolean Museum, Oxford.

circles. This may have been a valued object kept in a temple and used in ceremonies for hunting magic or other spiritual pursuits. It is a good example of an indigenous pictorial tradition that would soon be transformed by contact with European artistic conventions.

**HORSE EFFIGY COMB.** Native peoples often showed a readiness to treat new subject matter in familiar materials. As we have seen, they had a long tradition of representing animals in their art, and this continued after their contact with Europeans. In some cases they depicted the clan animals of particular families; for example, among the Iroquois, during the sixteenth and seventeenth centuries, it was the custom to add handles carved as wolves or bears—Iroquois clan animals—to the combs they carved from bone, wood, and moose antler. When the horse made its first appearance in western New York (then a colony) in 1677, it must have caused a sensation among the Iroquois, whose belief system included great respect for the power of animals and who naturally wished to incorporate this majestic animal into their imagery. This comb (**fig. 2.13**)

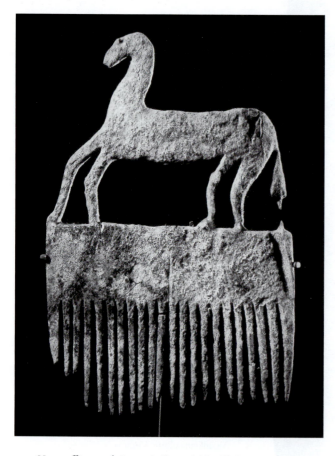

2.13 Horse effigy comb, Iroquois (Seneca), New York, c. 1670–87. Moose or elk antler, 4½ × 2⅞ in (11.4 × 7.3 cm). Thaw Collection, Fenimore Art Museum, Cooperstown, New York.

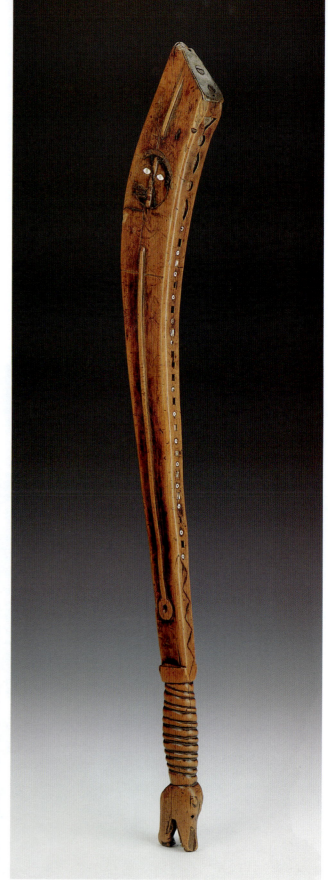

2.14 War club, Eastern Woodlands (Iroquois?), c. 1675. Hardwood, brass, iron, copper, and shell inlay, 24 in (60.9 cm) long. Thaw Collection, Fenimore Art Museum, Cooperstown, New York.

depicting a horse was excavated from an Iroquois site near Victor, New York, and can be dated to 1670–87. It records the appearance of a new subject in a traditional format.

**WAR CLUB.** The war club shown here (**fig. 2.14**) is a modification of an indigenous weapon—the wooden club—with some aspects of new weaponry included. The artist has examined European sabers with some care: the raised line that extends down the club mimics the raised strengthening rib of a European saber, while the handle mimics its wire-wrapped hilt. The club ends in a carving of

a wolf's head. The edge of this wooden "saber" is inlaid with both local shell and European beads—this combination of materials and form suggesting that the maker sought to copy a new weapon in materials that he understood. By doing so, perhaps he hoped to draw spiritual and military power from sources both local and distant.

The small head with inset shell eyes incised on the club (**fig. 2.15**) may portray the object's owner. The head is abstract in its moonlike roundness, but the diagonal line bisecting the face and the three-pronged tattoo on the mouth surely denote an individual who would be recognizable to his peers, thus making it a portrait. Although a Native artist made this club for his own use, a white man acquired it in combat. A family tradition claims that Lieutenant John King of Northampton, Massachusetts got it in a 1676 battle; the club passed down through his family until the mid-twentieth century.

**PIPE TOMAHAWK.** In addition to serving as the spoils of warfare, objects moved across cultures through gift giving. Both the tomahawk and the pipe were indigenous items, used for warfare and ceremony. But in the world of the middle ground, these two items could merge into a curious hybrid: the pipe tomahawk was a decorative presentation piece, often made for cross-cultural gift giving. The one shown here (**fig. 2.16**) dating from just before the American Revolution, combines Native wrapped **quillwork** with European metalsmithing. The hatchet/pipe bowl, made of pewter, is engraved with the names of the Euro-American gunsmith who forged it and the military man who owned it. A uniquely American form, the pipe tomahawk

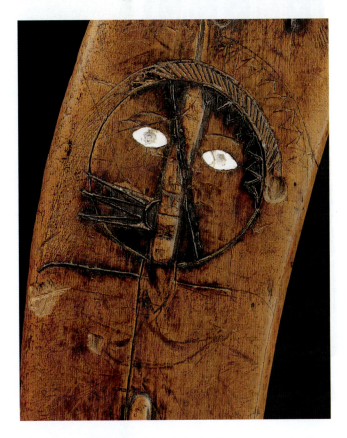

2.15  Incised and inlaid portrait head, detail of fig. 2.14.

2.16  RICHARD BUTLER et al, Pipe tomahawk (see also p. xviii), c. 1770. Iron, steel, silver plate, pewter, quillwork, wood, shaft 21⅛ in (53.4 cm), blade 7¼ in (18.4 cm). Thaw Collection, Fenimore Art Museum, Cooperstown, New York.

2.17 Tabbed skin bag, Anishnabe, Great Lakes Region, c. 1790. Black-dyed deerskin, porcupine quills, silk binding, deer hair tassels, tin cones, 20½ × 6½ in (52 × 16.5 cm). Thaw Collection, Fenimore Art Museum, Cooperstown, New York.

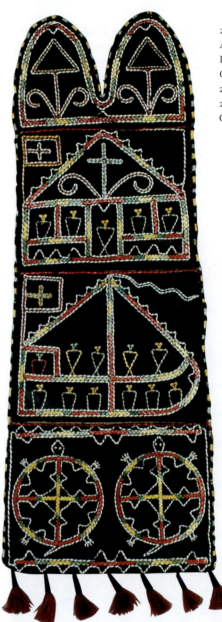

2.18 Wall pocket, Anishnabe, Great Lakes Region, c. 1800. Quillwork on hide, 20⅞ × 8½ in (53 × 21.5 cm). Field Museum, Chicago, Illinois.

was intended to bridge the gap between cultures. It is an odd hybrid, for the pipe generally signifies peace, while the hatchet signifies warfare—is it an object that extends the possibility of both conflict and accommodation? Pipe tomahawks were sometimes used as diplomatic gifts, presented at the signing of peace treaties. The wooden shaft is covered with plaited quillwork, the artistry of a Native woman, so its manufacture crosses not only cultural boundaries but gender roles, too. Many such items still exist in British family homes, souvenirs brought home by ancestors who fought in wars in North America.

**A PAIR OF CEREMONIAL POUCHES.** Native women in different parts of North America used bird and porcupine

quills (like those on the shaft of the pipe tomahawk) for artistic purposes, softening and dyeing them, and then using them to wrap or embroider items to decorative effect. A transformation of indigenous form and subject is illustrated in two ceremonial pouches from the Great Lakes region, which use quillwork to represent religious iconography. On one side, the eighteenth-century Anishnabek tabbed bag (**fig. 2.17**) carries the image of a thunderbird (a powerful mythical denizen of the sky world), while on the other side two turtles (symbolic of the earthly world) float beneath the horizon. With its two-legged shape, the bag itself looks like an otter, and was used to hold ritual paraphernalia. The wall pocket in figure **2.18** (a European form used as a holder for papers) employs

the same pictographic strategy as the tabbed bag, yet the symbols extend across two cultures, Native and Christian, encompassing, in Ruth Phillips's words, "a spectrum of representational possibilities that were exploited simultaneously." Turtles, again, ornament the bottom. Above, semi-abstract human figures—some arriving in a boat, some inside a church—occupy the middle ground. Crosses adorn the church and the flags. Here, Christian iconography seems to be subsumed into an indigenous worldview, represented by the two floating forms of "turtle island" (as some Native groups conceptualize the earth). Such items were made for use both by Native practitioners of traditional religion and by Native converts to Christianity; some were sold to whites.

**A PAINTED HIDE.** When indigenous artistic traditions came into contact with European ones, changes also ensued in style. Native representations of people and animals were pictographic as well as semi-abstract, with animals often depicted in a geometric, simplified style, as in the turtles mentioned above. Yet sometimes vivid detail was rendered with great economy. Often, Native artists chose to adopt aspects of Euro-American painting—for example, by demarcating a **ground line**, or through some limited use of perspective or naturalistic detail. This meeting of indigenous

2.19 "Three Villages" Robe, Algonkian, Great Lakes Region, 18th century. Hide, pigments, 74½ × 57⅝ in (189.4 × 146.5 cm). Musée du Quai Branly, Paris.

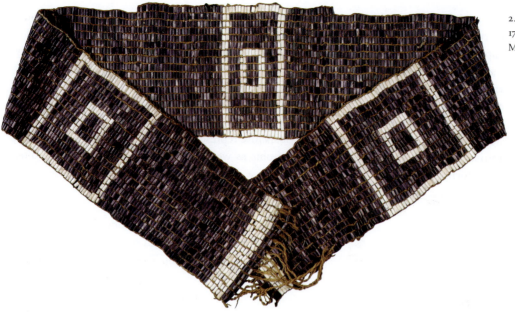

2.20 Iroquois wampum belt, 17th century. Shell beads. British Museum, London.

and European modes of representation took place in different regions at different times. A hide painted by a Great Lakes man shows some of these changes (**fig. 2.19**).

Both in the Great Lakes region and on the Great Plains, hides were tanned and painted in a manner that reflected the animal form from which they came. Here, the frame for the picture is five sided and has a tail. Like the pipe tomahawk and the wall pocket described above, the scene seems to represent both conflict and accommodation. On one side of the hide, figures aim weapons at each other; on the other side, they join hands. At the bottom of the hide, the conical houses of indigenous Illinois people are contrasted with the French mission and trading post on the left. The writing on the hide (perhaps done by Jesuits at the mission) identifies particular villages and tribes. No historical records survive concerning the acquisition of this hide painting, which has long been in France. Its subject matter suggests that it is an intercultural record of an important alliance among the French, and the Algonkian and Quapaw Indians.

The middle ground of the sixteenth and seventeenth (and in some regions, the eighteenth) centuries was a space that emerged within a context of ongoing conflict and resistance, a space in which each party to the encounter gained something from the exchange or adaptation of forms and symbols. For Native people, this could occur by accommodating foreign elements within indigenous belief systems, ensuring continuity in the midst of enforced change. In other cases, the middle ground emerged during periods when Native people enjoyed relative sovereignty—for example, when the Iroquois traded items as political equals with Europeans. (See also "The Repatriation of Wampum," p. 39.) As competition for land and resources raised the level of conflict, however, the middle ground proved all too fragile.

## Wampum: A Contract in Shells

Wampum beads (from the Algonkian word *wampomeag*) were made from the dark purple shell of the quahog clam and the white shell of the whelk—and were worn and exchanged by indigenous peoples of the Northeast. During the seventeenth century they were also used as money by Dutch and British colonists when European coins were scarce. The Iroquois strung wampum beads onto belts, often in pictorial designs (**fig. 2.20**). An inland people, they did not manufacture the beads themselves, but obtained them through trade with coastal peoples and later through trade with the Dutch at Fort Orange (Albany, New York).

Originating in the seventeenth century, wampum belts were made to commemorate important events within the Iroquois community, as well as treaties and legal transactions between the Iroquois and other ethnic groups. As part of the protocol of treaty-making, the Dutch and English quickly learned to use them as the Iroquois did: as both gifts and evidence of contractual arrangements. The images worked in beads were mnemonic devices, linked to a tradition of oratory by which history was handed down through the generations. The belt shown here is formed almost completely of purple quahog-shell beads, whose rich, dark texture is interrupted only by three double rectangles of white beads. Although the oral history that goes with this piece has been lost, it may commemorate an alliance among three groups, each represented by a set

of white beads. Another belt, the Two-Row Wampum, uses two parallel rows of purple beads set on a field of white to symbolize the separate and equally sovereign paths of two great nations: the Iroquois Confederacy and the United States.

From the perspective of U. S. history, one of the most famous pictorial belts is the George Washington Covenant Belt, made c. 1776, which is over 6 feet long and contains some ten thousand beads. Thirteen large human figures join hands with two smaller figures standing on either side of a house. The large figures have been interpreted as emblems of the founding colonies of the United States joined in an alliance of peace and friendship with the Mohawks and Senecas who, among the Iroquois Confederacy, are known as the Keepers of the Eastern and Western Doors (the territory of the Confederacy being visualized metaphorically as a house, with the Mohawks on the east side of what is now New York State and the Senecas on the west).

## The Repatriation of Wampum

"**Repatriation**," a term increasingly used in relation to Native American materials, means the return of objects of cultural significance to their original owners or makers. The repatriation of important Indian objects housed in museums has accelerated recently, due to the passing of the Native American Graves Protection and Repatriation Act of 1990. Somewhat earlier, the Iroquois were the first to urge that important objects of their **cultural patrimony**—wampum belts—be returned to their nation, where an individual entitled "Keeper of the Wampum" is invested with the authority to guard and narrate the histories of these objects. Following laws passed in the 1970s and 1980s, many Iroquois wampum belts previously considered the property of museums, including the George Washington Covenant Belt, were returned to reservation authorities, both in New York State and in Ontario. George Abrams, an Iroquois scholar, has remarked that, to the Iroquois, "wampum was and is the manifestation of their sovereignty as distinct nations and as political equals among other nations."[3] Though these wampum belts were made as objects of intercultural encounter, they reside today in the hands of their original makers, and are sometimes brought out in public to help narrate the history of the Iroquois Confederacy.

The Iroquois were not the only people to commemorate transactions in wampum. Some Huron and Abenaki belts with Latin inscriptions were sent in the seventeenth century as gifts from Catholic Indians and French Jesuit priests to Chartres Cathedral, in France, where they still remain. In the 1710 portrait of his visit to London (see fig. 2.22), a Mohawk man holds a wampum belt aloft. Wampum belts circulated among cultures, constituting a new form of communication across the gulf of divergent languages, histories, and representational forms.

## "Fond of Finery": Portraiture and Self-Display

The Frenchman Pierre Pouchot, writing about his sojourn in eastern North America in the 1750s, recalled that Indians he encountered were "fond of finery." From ancient times, Native people had presented their bodies as canvases for self-decoration. Ochre clays were used to paint temporary designs on the skin, and carbonized materials were used for permanent tattoos. Indian people were pleased to trade for Chinese vermilion and European inks, which worked well for these purposes. The Indian figure in the foreground of Benjamin West's painting *The Death of General Wolfe* (see fig. 4.34) represents such tattoos in detail. That warrior has abstract tattoos on his limbs and face and a naturalistic serpent on his shoulder blade. The small pipe shown here (**fig. 2.21**) may have served as the model for his head: it sports the same triangular pendant earring and face painting design, and was originally in Benjamin West's own art collection.

2.21 Effigy pipe bowl (owned by Benjamin West), Great Lakes Region, 18th century. Soapstone, metal, 3¾ in (9.5 cm). British Museum, London.

Both this small soapstone pipe bowl and the delicate face on the seventeenth-century Iroquois club discussed above (see detail in fig. 2.15) bring up the issue of portraiture in Native American art. Since tattoo and face paint designs were particular to the person, both images may depict actual individuals. Seldom in Native art before the twentieth century do we see portraiture that relies solely on physiognomy to identify an individual, as in European and Euro-American painting. Instead, distinctive tattoos (such as the lines, dots, and mouth tattoo on the face on the club), hairdos, and items of ceremonial regalia identify the individual. In eastern North America during the colonial period, an idiosyncratic and stylish wardrobe was a mark of distinction for warriors, prosperous Native women, and diplomats.

Indigenous dress drew upon materials from the plant and animal world: hides of deer, moose, caribou, and other animals; bird pelts and feathers; deer hooves and dew claws; porcupine and bird quills; whole shells and beads painstakingly worked from shells. Daily dress was relatively simple. Weather permitting, men often went naked, or nearly so. (Again, *The Death of General Wolfe* provides a realistic depiction.) Women may have worn simple deerskin dresses. Yet dress for important occasions was quite elaborate, as European travelers throughout eastern North America attest. For example, Bernard Romans, who traveled in Florida in the eighteenth century, described Native women dressed for dancing:

> I observed the women dressed their legs in a kind of leather stockings, hung full of hoofs of the roe deer in form of bells, in so much as to make a sound exactly like that of castagnettes; I was very desirous of examining these stockings and had an opportunity of satisfying my curiosity on those of my land lady on her return home. I counted in one of her stockings four hundred and ninety three of these claws; there were nine of the women at the dance with this kind of ornament, so that allowing each of them to have had the same number of hoofs, and eight hoofs to a deer, there must have been killed eleven hundred and ten deer to furnish this small assembly of ladies with their ornaments, besides which, earrings, bracelets, &c. are by no means forgot; an instance of luxury in dress scarcely to be paralleled by our European ladies.[4]

Such profligate use of deer hooves in indigenous dress was a secondary result of the extensive fur trade. Deer and other fur-bearing animals were being hunted by men, and the skins tanned by women as fodder for the European trade. In 1726, for example, an estimated fifty thousand

deerskins a year were exported by the French from the region around New Orleans alone![5] Europeans coveted these hides for use in clothing, having depleted their own local sources of game over many centuries of hunting and settlement.

Most eighteenth-century travelers noticed that Native finery made from the materials of the local, natural world (or items gained from long-distance trade with other Native groups) was rapidly being replaced by trade goods. Native people quickly adopted—and adapted—men's shirts, cloth by the yard, trade blankets, ribbons, thread, hats, silver ornaments, and glass beads to fashion new styles of clothing valued both by Indians and by some whites who lived and worked closely with them, such as fur traders and soldiers. As Native and whites alike grew more prosperous due to the fur trade, and as military men sought to demonstrate their familiarity with the new and diverse world of North America, practices of dress and self-adornment in the middle ground grew more hybrid and more inventive, as the following analysis of two sophisticated travelers reveals.

**HENDRICK AND JOHN: TWO EIGHTEENTH-CENTURY GENTLEMEN AT THE BOUNDARIES OF CULTURES.** Two portraits of high-ranking men, a Mohawk in European clothing and an Irishman in Native dress, illustrate what we mean by arts made at the boundaries of cultures. One, painted at the beginning of the eighteenth century, was among the first influential and widely distributed portraits of an Indian. The other, painted at the end of the century, was a private portrait for the home of an Irish lord who had served in the wars in America. Both paintings imply the existence, at the time, of patrons comfortable with the idea of cross-cultural movement. The work of trained European artists, both portraits suggest the possibility that in America—unlike Europe, with its rigid class system—a man could remake himself according to his ambition and talent.

In 1710, four headmen of the Mohawk nation (one of the member nations of the Iroquois Confederacy) traveled from their home near Albany, New York, to England to petition Queen Anne to send them a British clergyman (whom they would prefer to the French Catholic Jesuits who had worked among the Iroquois). Their journey was well publicized, both in America and in England. As was customary in Indian diplomacy, many gifts were exchanged. The Mohawks gave the British monarch gifts of wampum and other finely crafted items made by Iroquois artists. Queen Anne, in turn, gave them a Bible, cash, fine textiles, and a set of silver religious items engraved with her coat of arms (a gift still preserved today by the Iroquois as an

heirloom). She outfitted them in fine clothing at her expense, and commissioned portraits of the four to be painted by the Dutch artist John Verelst. The "Four Indian Kings," as they came to be called, were the toast of British society. Other portraits were painted, too, and small, inexpensive engravings based upon these were widely circulated in the streets of London. Their speeches were printed in broadsides, and ballads were even composed about them.

The highest ranking among the four was Tee Yee Neen Ho Ga Row (c. 1680–1755), also known as Hendrick, the name under which he was baptized as a young man. Born a Mahican, but adopted by the Mohawks as a child, he lived in Canajoharie village, in what is today central New York State. He rose to become one of the headmen,

or "sachems," of his community (a rank that the British wildly exaggerated, calling him "Emperour [*sic*] of the Six Nations"). Set in an illusionistic landscape (**fig. 2.22**), he appears as a sophisticated statesman, dressed in gentlemen's shoes with silver buckles, dark hose, and a long black waistcoat over a white linen shirt. Atop this he wears a scarlet blanket, an item of trade that Indians rapidly adopted as their own. In his right hand he holds a wampum belt. Its pattern of repeated crosses is perhaps symbolic of the delegation's quest to ask the queen for a missionary from the Church of England. Behind Hendrick lurks a wolf, symbolizing Hendrick's membership in the Mohawk wolf clan. Cast down on the ground before him is a tomahawk. Hendrick does not hold a weapon, for he is a

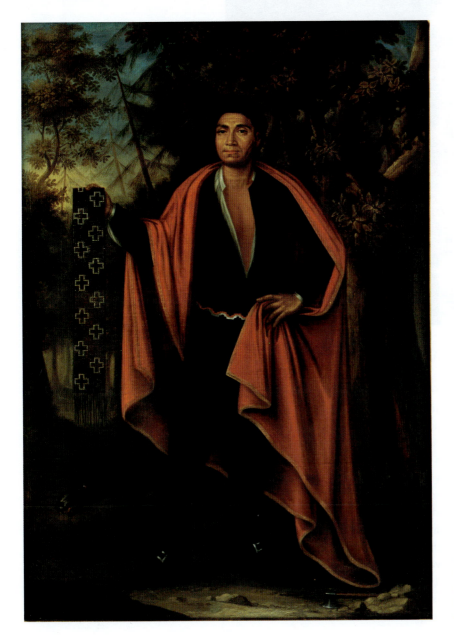

2.22 JOHN VERELST, *Hendrick of the Wolf Clan, "One of Four Indian Kings"*, 1710. Oil on canvas, 36 × 25⅜ in (91.5 × 64.5 cm). Public Archives of Canada, Ottawa.

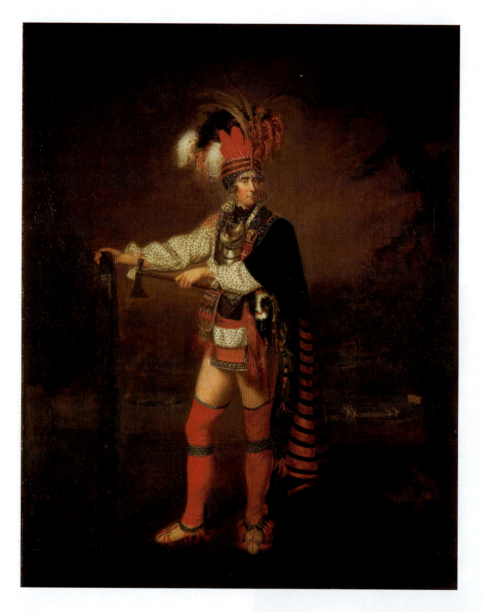

2.23 UNKNOWN ARTIST, *Portrait of Sir John Caldwell*, c. 1785(?). Oil on canvas, 50 × 40 in (127 × 101.6 cm). Collection of the King's Regiment, Merseyside County Museums, Liverpool, England.

2.24 (opposite) Map of Spanish America.

diplomat, as the wampum belt indicates. Adopted by the Mohawks, first converted by Catholics, preparing for conversion to the Anglican faith, and dressed in British finery accented with Native and European trade items, Hendrick is the very picture of the cosmopolitan, moving between disparate worlds.

Some seventy years after Hendrick's portrait was painted, an Irish nobleman returning from America commissioned a portrait in which he, too, is dressed in the finery of another culture (**fig. 2.23**). Sir John Caldwell served as an officer in the British Army and was stationed at Fort Niagara and Fort Detroit. While in North America, he established good relations with the Ojibwa Indians, and was named a headman among them. Like Hendrick, John Caldwell holds a wampum belt in his outstretched right hand. The design worked in white on the purple belt is of

a hatchet, like the one he holds in his left hand. At his waist is a brass-handled saber.

Caldwell wears deerskin moccasins, red cloth leggings held up with beaded garters, a short breechcloth, a printed calico shirt, and a dark blue and red cloak. Adorning his body are many items made and used by both Indians and whites throughout the Northeast in this era: a quilled leather pouch, a medicine bag made of a skunk skin, a quilled knife sheath, and much silver and brass jewelry. Just as his whole costume is a statement about intercultural commerce, so too is his headdress. It is composed of a quilled band, metal ornaments, and both local and exotic plumes, including ostrich feathers.

The cosmopolitan Hendrick and John remind us that negotiating multiple realms has been an integral part of Native-white interaction since the first European contact.

# Northern New Spain: Crossroads of Cultures

From Columbus's first landfall up to 1700, Spain was the foremost colonial power in Europe. At its fullest extent, the Spanish empire in the New World spread from the tip of South America to its farthest point north in what is now St. Louis (**fig. 2.24**). Spain's North American empire, stretching from California to Florida and the Caribbean, was administered from Mexico City, which in turn reported to Seville, the imperial center across the Atlantic.

During the years when it established its New World empire, Spain was a cosmopolitan society combining classical, Islamic, and Christian influences. These influences are apparent in the architecture and arts of its New World colonies. Ancient Roman domination of the Spanish penin-sula had left a substratum of classical influences on language, politics, urbanization, and architecture, including the arch and its related form the barrel vault. In the centuries following the collapse of the Roman Empire, the Visigoths invaded from northern Europe, followed in the eighth century by the Moors from North Africa. In 1492 the Spanish Crown embarked on a phase of aggressive Christian proselytizing. This precontact history would shape the attitudes of Spanish colonizers toward the Indian cultures they encountered in the Americas.

Brutally "pacified" in 1598 by Juan de Oñate, New Mexico was a colony of a colony (Mexico City), twice removed from the imperial center in Spain. This remoteness meant that colonists developed local building traditions, invented new solutions to old problems, and created forms of religious devotionalism unique to New Mexico. As in other isolated places, expressive forms—whether in architecture,

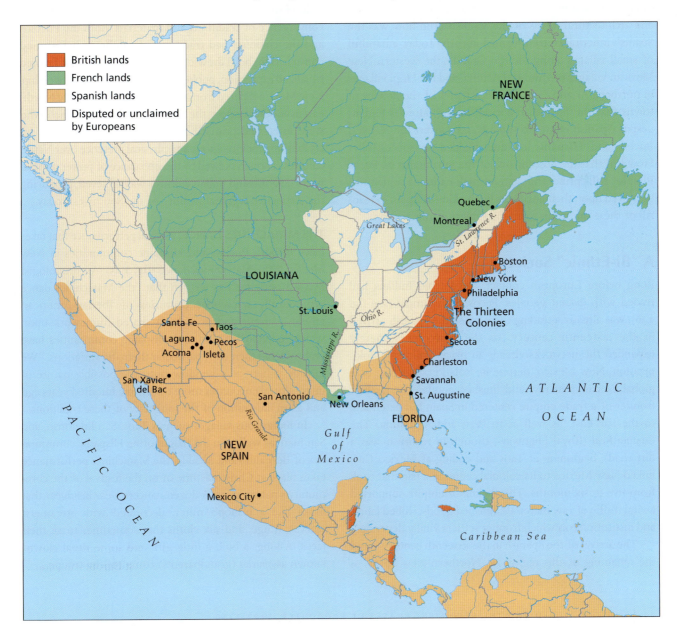

language, or music—have persisted, with great vibrancy, into the present.

When the Spaniard Francisco Vásquez de Coronado and his men set forth from Mexico in 1540 in search of the rumored golden cities of the north, they encountered a vast Pueblo world of some one hundred fifty flourishing towns, inhabited by the descendants of the Ancestral Pueblo peoples who had lived there since the late thirteenth century (see Chapter 1). The explorers, impressed by the apartment-like compounds of these diverse villages, gave their inhabitants the collective name Pueblo Indians, from the Spanish word for "town" or "people." Over the next centuries, some aspects of Pueblo art and culture were retained, while others fused with the traditions of their Spanish conquerors.

What produced this fusion of cultures, despite a resistant and periodically militant population of Indians that far outnumbered the newcomers? How did the Native inhabitants assimilate, subvert, or adapt the new artistic and architectural forms of the Spanish? And how was the Spanish inheritance transformed in turn? Today, a handful of small villages along the Rio Grande, the western New Mexican villages of Zuni and Acoma, and the Hopi villages in northern Arizona, are all that remains of the dozens of towns that the Spanish reported finding. How is it that, despite Spanish efforts to subdue and convert the Natives, Pueblo and **Hispanic** cultures melded so successfully? How is it that the descendants of the inhabitants of Pecos Pueblo still prize the ceremonial cane of authority bestowed upon their ancestors by the king of Spain in 1620? All of these questions form the subject of this section.

## A "Bi-Ethnic" Society

Long before European contact, the Pueblo Indians had traded with distant peoples. Pecos, for example (see fig. 2.36), was already a trading town when the Spanish arrived in the sixteenth century, so the newcomers merely expanded the networks already in place. Following colonization, New Mexico, despite its isolation, was part of a global exchange in raw and finished goods—the farthest frontier of a trade empire centered in Spain but extending to the Far East, as well as to Peru and Argentina. The *Camino Real* (Royal Highway—though in reality it was a dirt road), beginning at Taos and ending at Mexico City, linked New Mexico to its colonial center in a trip that took from five to six months. This lifeline of empire supported a vital traffic of raw materials, finished goods, skilled labor, and institutions on which frontier settlers vitally depended.

The arrival of the Spanish in the sixteenth century—and the renaming of this region as "Northern New Spain"—

began a four-centuries-long process of intercultural influence. While striving to suppress indigenous traditions, often through violent means, the Spanish presence in fact dramatically expanded the creative and material resources of Pueblo societies, introducing new materials, design traditions, and building forms. And it did the same for Spanish forms brought from the Old World. The blending of Hispanic and Indian cultures in the Southwest changed the texture of each in profound ways, resulting in a bi-ethnic "Indo-Hispanic" society. Intermarriage, cultural exchange and adaptation, and a shared physical environment promoted productive coexistence. Images of the Christian saints found places of honor in the pueblos of the Rio Grande Valley, alongside Native practices. Native and Christian ceremonial days came to overlap in the yearly round of ritual and celebration.

Compared to the middle ground of the eastern colonies, Indo-Hispanic culture was marked by a much stronger convergence of traditions and materials. Both the Pueblos and the colonists had traditions of **adobe** or baked mud construction; both drew upon religious forms that favored ritualized expression, public festival, and communal worship. New Mexico differed from the middle ground of the Northeast in another respect: the Spanish—unlike the French, who were interested primarily in trade—had come intent on establishing their religious and physical presence over Native cultures. Though skewed by the imbalance of power, a melding of Spanish and Indian cultures was achieved, producing the distinctive regional identity of the Southwest today.

**THE MATACHINES DANCE.** A ritual performance that takes place in both Pueblo and Hispanic communities in New Mexico is the Matachines dance (**fig. 2.25**). Anthropologist Sylvia Rodriguez has written that "the Matachines dance symbolically telescopes centuries of Iberian-American ethnic relations and provides a shared framework upon which individual Indian and Hispanic communities have embroidered their own particular thematic variations." We include it here as a window onto the possible nature of intercultural encounter more than three hundred years ago and as an illustration of the longevity of these traditions.

In indigenous villages such as Taos, San Ildefonso, and San Juan, as well as in the neighboring Hispanic communities of Bernalillo and Alcalde, the Matachines performance takes place at Christmastime or on the festival of the community's patron saint. A dozen dancers wear headgear that looks like a bishop's miter, decorated with streamers, scarves, fringe, and silk cloths that sometimes mask their faces. A king, a bull, a little girl, and some ritual clowns known as *abuelos* (grandparents) complete the troupe.

2.25 Matachines Dance, Taos Pueblo, 1991.

The name of the dance comes from Renaissance Europe, where a "matachin" was a costumed sword dancer or a harlequin. In Conquest dances throughout Latin America and the American Southwest, Native and Hispanic performers reenact the conquest of the Moors (North Africans) by the Spanish Catholics in the fifteenth century, an event that prefigured the later conquest of New World peoples. Centuries ago, this ritual drama—first performed by the Spanish to celebrate the Conquest—may have been imposed on indigenous performers, but today it has been incorporated into Pueblo culture and modified to tell their own version of events. Native and Hispanic communities attribute different histories to the dance. Pueblo traditions relate that the sixteenth-century Aztec ruler Montezuma himself brought the dance from Mexico (though, in fact, there is no evidence that any Aztec king ever traveled that far north). In their dance, the figure named *El Monarca* (the king) stands for Montezuma. In Hispanic communities, the standard interpretation is that the Matachines dance was first performed by the Spanish, who reenacted the Christian conquest of the Moors when they conquered New Mexico in the late sixteenth century.

Although not a feature of all Matachines dances, a maypole is commonly seen at Taos, where the dance is performed repeatedly on December 24, 25, and 26. The dancers, holding streamers made of long wool belts attached to the top of the pole, wind around it in time to the music, some moving clockwise, others counterclockwise. Although the maypole is European in origin, it may have had particular

resonance at Taos, where an indigenous festival involves the use of a pole climbed by clowns (see fig. 2.30). The linkage of poles and clowns is yet another example of the convergence of cultures that takes place in a situation of colonial encounter, allowing new traditions to be formed.

The *abuelos,* a combination of buffoons and stage managers, police the event and provide acerbic commentary on gender or ethnic relations, or on simple human foibles with which all viewers can identify. Today, they wear ski masks, chimpanzee masks, and even masks depicting the American president. Though the maskers are male, one may take the role of grandmother, so cross-dressing and the burlesque of female behavior by male players is part of the entertainment as well.

The *abuelos* seem also to be a latter-day variant of the ancient ritual clowns of the Southwest, whose important role is to guide the ceremony and provide irreverent commentary, humor, and ridicule. In the Hispanic communities, the Matachines dance not only commemorates the coming of their ancestors from the Iberian Peninsula to northern New Spain but also expresses a twenty-first-century Hispanic determination to persist in the face of the dominant English-speaking culture of the United States. As Sylvia Rodriguez comments, like the maypole itself, around which the Matachines weave, "the dance is a living composite of diverse received and improvised multi-colored elements, braided together through the collective act of performance."

In centuries past, the Matachines dance acted out the contest of cultures on the frontier of colonization, while fusing elements of Spanish and Indian ritual life. Embodying both encounter and resistance, the Matachines is a vivid example of the inventive new forms that evolve at the meeting of divergent cultures.

## Pueblo and Mission in New Mexico

Of the southwestern states that trace their beginnings to Spanish colonization, New Mexico was converted first and most successfully. Within twenty-five years of the conquest in 1598, there were ninety Christianized pueblos, twenty-five mission churches, and numerous smaller churches. From 1581 to 1680, Spanish officials and Franciscan friars organized the conquest of what came to be called "The Kingdom of New Mexico." Pueblo people were forced to repudiate their traditional religion. Ceremonial masks and other regalia were seized and burned. Crosses and churches were erected, kivas destroyed. Catholic priests tried to stamp out indigenous ritual dramas, substituting theatrical liturgies concerning Jesus, Mary, and the saints, as well as public performances commemorating the battles of the Moors

# Santa Fe Fiesta—Reenacting the Conquest

ANOTHER FESTIVAL PERFORMED YEARLY in New Mexico marks the imposition of a European colonial order onto the new land. Around Labor Day, the city of Santa Fe stages an elaborate fiesta, which lasts several days and includes mass spectacle, dramatic reenactments of history, pageants, costume parades, a candlelight mass, an Indian market, and staged plays, along with those three essential elements of a festival—music, dancing, and feasting. Unlike the Matachines dances, which also mark the arrival of the Spanish, Santa Fe Fiesta from its beginnings has given pride of place to the Hispanic history of conquest and settlement. In recent years, however, historical tensions have surfaced around Fiesta in a revealing manner.

The Santa Fe Fiesta traces its history to 1712 and lays claim to being the oldest communal festival in North America (a claim that overlooks the far more ancient indigenous festivals). Its modern form, however, dates to 1919. At the core of Fiesta is the commemoration of the 1692–93 reconquest of New Mexico after a revolt in 1680 by Pueblo people. During the central pageant, costumed players reenact the planting of the Cross by Diego de Vargas and his Spanish soldiers in front of the Palace of the Governors in 1692 (**fig. 2.26**), commemorating the peaceful return of the Spanish to New Mexico. De Vargas then reads a proclamation to the assembled Indians, similar to the *Requirimiento*. The procession of an effigy of New Mexico's patron saint, *Nuestra Señora de la Conquista*, or "La Conquistadora," through Santa Fe occupies a place of symbolic importance in Fiesta, which also commemorates the restoration of Catholicism after the revolt. The pageant, however, neatly sidesteps the bloody siege of Santa Fe in 1693 which followed the initial reentry of the Spanish. Instead, Fiesta reenacts the colonial history of New Mexico as a process of peaceful coexistence, a "commemoration of the *reunion* of two peoples," as a 1933 description carefully emphasized. Santa Fe Fiesta—directed at ethnic reconciliation—depends on the willing participation of all groups, including those very Pueblo Indians who, for historical reasons, may feel they have little to celebrate. Although they have in fact been central players in the cultural history of New Mexico, Pueblo participants in Fiesta have felt marginalized, as they are made to play the role of secondary actors in the larger story of Spanish dominance. In 1977 the All Indian Pueblo Council staged a boycott of Fiesta, and the event has continued to trouble ethnic sensitivities lying just below the surface. At their best, festivals offer opportunities to experiment with new forms of social, gender, and ethnic relations. However, as the organizers of Fiesta have come to understand in recent years, it also opens up old wounds.

2.26  The reenactment of the Planting of the Cross by Diego de Vargas and his Spanish soldiers in front of the Palace of the Governors in 1692, Sante Fe, New Mexico, 1920. Photograph.

and the Christians. Due to warfare and smallpox epidemics (as well as periodic droughts), the Pueblo population was reduced from approximately sixty thousand at the beginning of the seventeenth century to fewer than ten thousand at the beginning of the nineteenth. In addition, Spanish colonists exacted tribute and forced labor from the mission Indians, despite Franciscan efforts to protect them from exploitation.

Pueblo society freed itself from this stranglehold for a few years when, in 1680, many villages banded together to overthrow the Spanish, successfully driving them out of New Mexico for twelve years. In this short period after the Pueblo Revolt, as it is called, Native people turned the tables on their conquerors, burning churches and crosses, and reconsecrating their kivas. Because of this destruction, very little of the Spanish missions of the seventeenth century remains intact. Following the reestablishment of Spanish rule in 1692, aspects of traditional Pueblo religion were once again driven underground—the only way they

managed to survive. Yet the conquerors succeeded only in creating a multilayered religious, artistic, and performance tradition, one encompassing both Christianity and ancient Native worldviews.

Only after the Spanish reformed the oppressive colonial system that had sparked the rebellion were they able to resume their conversion of the Pueblos. Many more mission churches were built, some of which are still in use in Pueblo villages today. Alongside the indigenous kivas and dance plazas, these churches are at the heart of community life. Even today, European-derived dances may be performed in front of a church one day, and an indigenous animal masquerade performed the next.

**ACOMA.** Long continuities of Pueblo architectural tradition coexist with changes brought by the Spanish. The multistory apartment compounds of Acoma Pueblo (**fig. 2.27**) have been rebuilt and altered over many centuries. Built atop an easily defensible mesa and known as the "Sky City," Acoma, some 60 miles west of Albuquerque, dates back at least to the thirteenth century. On the south side of these compounds, each succeeding story is set back from the one beneath it, creating rooftop outdoor working space. Similar stepped terraces were found in Ancestral Puebloan architecture (see fig. 1.17), at Pecos in the proto-historic era (see fig. 2.36), and are still in use at Taos, where they serve as viewing stands for ceremonies in the plaza below (see figs. 2.25, 2.29, 2.30). These south-facing setbacks maximize exposure to the sun, to aid in drying fruit or corn for winter, or drying laundry. They also serve as a passive solar heating system, keeping the interiors warm in the winter. The north face of the apartment compound, in contrast, is a three-story adobe wall, punctuated only by small windows, with no entrance (**fig. 2.28**).

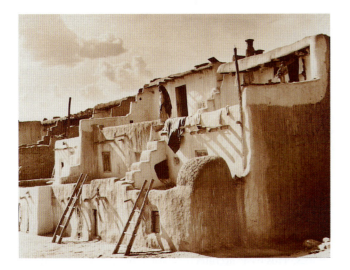

2.27  Acoma house cluster, Acoma Pueblo, New Mexico, 1933. Arizona State Museum, University of Arizona, Tucson.

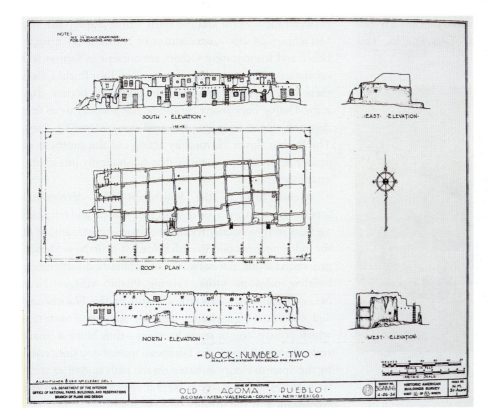

2.28  Elevation drawing of Old Acoma Pueblo, New Mexico, 1934. Drawing. US Department of the Interior.

The elevation drawing shown here comes from a rich record of photos and architectural drawings of Acoma Pueblo that was made in 1934 by the Historic American Buildings Survey, one of the New Deal projects organized during the Great Depression. In 1960, Acoma was designated a National Historic Landmark, in recognition of its status as the oldest continuously occupied town in North America, its roots stretching back nearly a millennium. While such antiquity may be commonplace in European and Asian cities, this is an impressive duration of time in a nation whose historical founding dates only to 1776.

**ADOBE: CONVERGING TRADITIONS.** While ancient construction techniques favored the use of locally quarried stone, most historic Pueblo architecture uses adobe bricks. Handmade in wooden molds by members of the community, adobe blocks were an innovation introduced by the Spanish. The Pueblo themselves organized the work along traditional gender lines—the men doing the construction and the women plastering the walls with wet mud to provide a durable coat over the mud bricks.

The Spanish had adapted adobe construction from the Arab cultures of North Africa and the Near East ("adobe" descends from the Arab word *atob*, or "brick"). It had been introduced into Spain with the Moorish invasion from North Africa in the eighth century. In those places, as in the American Southwest, it was well suited to the dry climate. The Native tradition of puddling predated the Spanish conquest and continued to be used at Taos Pueblo. This

involves hand-packing mud into walls, sometimes over stones, or an armature of thatch and wood. This puddling and hand-plastering influenced the sculptural quality of Hispanic adobe buildings such as the apse of the church of Saint Francis of Assisi, in Ranchos de Taos, painted and photographed numerous times over the past century. Another example of cultural migration and adaptation is the *horno*, a beehive-shaped outdoor oven (**fig. 2.29**, foreground). The form—like adobe itself—originated in the Near East, coming to Spain in the eighth century, then migrating to New Spain and spreading up to New Mexico with the first frontier settlements. The Pueblo Indians then adopted the *horno*, and today it can be seen throughout the Pueblo villages of northern New Mexico, where visitors often assume it is an indigenous form.

Most of the Rio Grande pueblos, including Taos and Pecos (see fig. 2.36), were built on the valley floor, rather than rising up out of a rock outcropping. At Taos, two apartment complexes, a north and a south house block, rise on either side of the vast dance plaza, which is bisected by a stream. Behind them rises Taos Mountain, the pyramidal shapes of the apartment complexes echoing its shape. Taos's north house block rises to five stories in some places. This basic architectural form has persisted for more than a millennium. The dance plaza is the focus of the architectural and ritual environment, for it is in ceremonies held there that people demonstrate the reciprocity between their world and the spirit world. Some—like the Matachines dances—are mixtures of Native and Christian belief and iconography. Others are ancient in format and substance—like the **koshares** (clowns) of Taos Pueblo, with their characteristic gray-and-white striped bodies (**fig. 2.30**). Dating back many centuries, the *koshares* were first depicted on pottery painted around 1100 C.E. (see fig. 1.20). The Pueblo clown instructs by acting out the antithesis of proper behavior in a manner that symbolically inverts the established order.

Architecture in the Southwest—like ceremonial forms—is a mixture, arising from the political and religious agendas of the conquerors and the preexisting traditions of the indigenous people. Spanish colonization in New Mexico proceeded along the networks of established settlement, building missions within existing Pueblo villages. New Mexico's missions were typically run by the Franciscans, and consisted of a church with an adjacent "convent," which housed one or more brothers—thus being a small-scale, frontier version of a European monastery. Conceived by the Spanish clergy as a step on the path to civil or secular parishes, these missions were a critical element in the colonization of the frontier of New Spain.

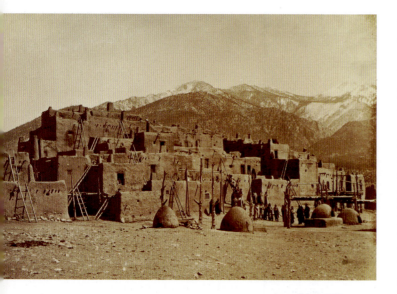

2.29 BENJAMIN H. GURNSEY, *Taos Pueblo, New Mexico*, 1878. Albumen print. Collections of Western Americana, Princeton University, Princeton, New Jersey.

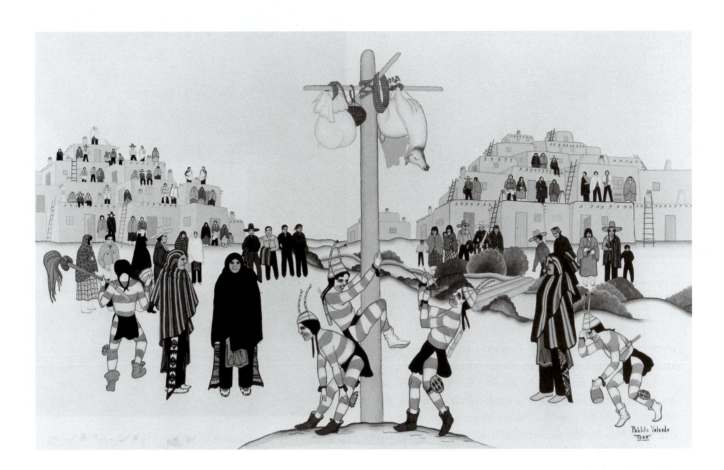

## THE MISSION AND CONVENT OF SAN ESTEBAN AT ACOMA PUEBLO.

The oldest example of New Mexico's missions is San Esteban, at Acoma Pueblo. Named after Saint Stephen, the Church of San Esteban (**fig. 2.31**) is located on a slight rise, apart from the Native dwellings that extend across the mesa. To the right of the church is the convent's cloister (a courtyard with a surrounding covered walkway), the private quarters of the friars, and other monastic buildings. Franciscan missionary efforts at Acoma had begun in 1623, and an ambitious building program soon followed. Although its original fabric dates from sometime between 1629 and 1664, the complex was restored and rebuilt many times; a series of twentieth-century restorations has further modified the original structure. Larger than later mission churches (the nave height soars to 50 feet), San Esteban recalls the fortress mosques of the Arab world, which left their imprint on Spain. Its size and mass—as well as its location, atop an inaccessible mesa—made it virtually invulnerable to attack and announced to the surrounding Indian pueblos that New Spain had successfully subdued the Acoma Indians, who had most fiercely resisted colonization. Aspiring to the proportions of the great sixteenth-century cathedrals of Mexico, San Esteban asserted the power of the church

2.30 (above) PABLITA VELARDE, *Koshares of Taos, New Mexico*, 1940s. Watercolor, 13¼ × 22½ in (33.6 × 57.1 cm). Philbrook Museum, Tulsa, Oklahoma.

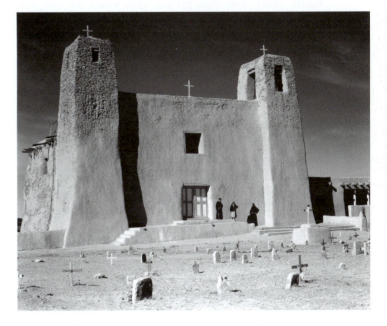

2.31 *Church of San Esteban, Acoma Pueblo*, 17th century.

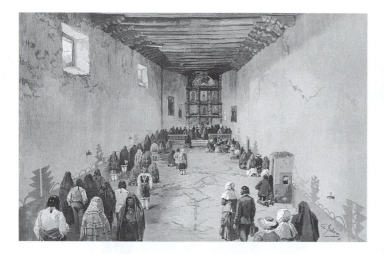

2.32 CHARLES GRAHAM, *Interior of San Esteban Church, Acoma, New Mexico*, 1890. Engraving. Private Collection.

2.33 Transverse clerestory window, Church of San Agustin, Isleta Pueblo, New Mexico, 1612.

over newly Christianized Natives—in part by being constructed right in the heart of the village.

San Esteban was built by Pueblo laborers supervised by a Franciscan from Mexico named Juan Ramírez. The Indians of Acoma worked with Ramírez to realize an extraordinary building campaign, manually dragging huge timbers for the roof, harvested 40 miles away, and field stone (used in tandem with adobe), up the 400-foot cliff from the plains below. Like most colonial religious structures in New Mexico, San Esteban consists of a single nave without transepts (**fig. 2.32**). The width of the nave (33 feet) is established by the length of the spanning timbers (or ***vigas***). Their hewn ends project from where the roof and sides meet. The use of *vigas* to span roofs was a feature of Pueblo architecture easily adapted to Spanish mission buildings. Using Native mud-and-rubble construction methods, the Acoma builders widened the base of the walls to support their weight, and built massive buttresses at the nave ends. These structural modifications produced the battered profile characteristic of New Mexico churches. The flat plane of the façade is broken only by two massive towers. In front is the burial ground, also used for outdoor preaching. This atrium-like space, surrounded by a retaining wall 45 feet high in places, was a feature of many mission churches throughout New Spain. Such outdoor spaces, animated by ritual and performance, were already familiar to the Pueblos, with their traditions of communal ceremony.

**THE CHURCH OF SAN AGUSTÍN AT ISLETA PUEBLO.** In a related example, there is evidence that the Spanish Franciscans of New Mexico oriented their churches so that

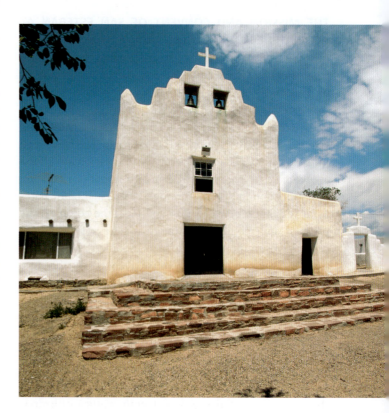

2.34 Church of San José, Laguna Pueblo, New Mexico, 1699.

the light of the winter solstice on December 22—a day of key importance in the ritual life of the Pueblos—would illuminate the sanctuary, holding the image of Christ, at the end of the nave. The invention of the **transverse clerestory** window, seen at the Church of San Agustín, at Isleta Pueblo, near Albuquerque (**fig. 2.33**), brought lighting into the altar and choir area through a window running across the nave at the point where the higher roof meets the lower sanctuary. By illuminating the sanctuary on the winter solstice with effects resembling Baroque lighting, the transverse clerestory window effectively translated Native practice into Christian form, creating architecture and symbolism that resonated with Pueblo and Hispanic Catholics alike.

### THE MISSION CHURCH AND CONVENT OF SAN JOSÉ AT LAGUNA PUEBLO.

The mission of San José at Laguna Pueblo (north of Acoma) also fuses Pueblo and Hispanic Catholic cultures. The stepped outline of the adobe exterior, painted white (**fig. 2.34**), frames two bells, which regulated the lives of the Pueblo converts. The step motif asserts Pueblo symbolism in the very midst of Catholic authority (see fig. 9.28). The interior contains another example of mixed traditions. On the ceiling above the altar is a buffalo-skin canopy (**fig. 2.35**) painted by Indian artists and depicting a sun embellished with stepped cloud motifs and zigzagging arrows, moon, rainbow, and stars, all elements deriving from Pueblo culture. Such symbols can also be found in Christian iconography as attributes of the Virgin and other religious figures. Did the Franciscans of New Mexico simply tolerate the intrusion of Native belief systems into their church? Or did they, like the friars proselytizing among the Aztecs and other indigenous peoples in Latin America, make deliberate use of parallels between Native and Christian practices in an effort to encourage the Indians' conversion to their own faith? The point remains debated, yet the wisdom of such a strategy—adapting to local conditions—became more evident after 1692: the mission at Laguna was founded soon after the Pueblo Revolt.

Today, Pueblo Indians who practice Catholicism continue to use and maintain the mission churches of the Rio Grande Valley. Yet despite missionary efforts to replace the ancient Pueblo spirit helpers with the Christian Savior, powerful ties to ancient history have helped preserve Pueblo identity over more than four centuries.

### PECOS PUEBLO AND MISSION: AN INTERCULTURAL ZONE.

Mostly abandoned by the early nineteenth century, Pecos Pueblo and Mission is among the most thoroughly

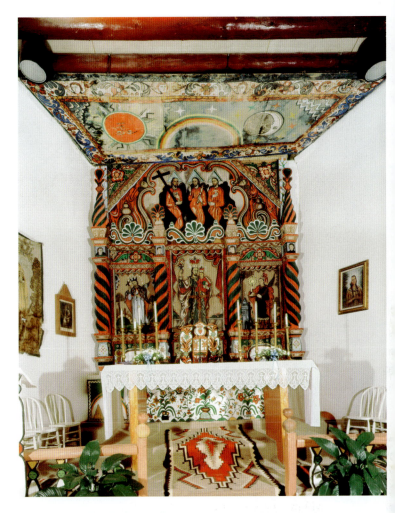

2.35 Retablo (altar screen) with saints and synchronous trinity, buffalo-skin canopy above altar, Church of San José, Laguna Pueblo, New Mexico, 1699–1710.

documented archaeological sites in the Southwest (**fig. 2.36**). For over a millennium, it has been at the center of the historic changes that have made New Mexico a region of cultural encounter, playing a key role in trade, and serving as a gateway to the Great Plains to the north and east. Architecture and material remains, along with historic documents, shed light on the dramatic events centered in Pecos: trade, warfare, domination, rebellion, reconquest, and the eventual abandonment of the town.

Pecos was founded around 800 C.E. at a site in north-central New Mexico that was advantageous for trade. It had access eastward to the river systems that extended into the southern Plains, as well as south along the Pecos River and west to the pueblos along the Rio Grande. Ancient trade goods found at Pecos included shells from the Pacific

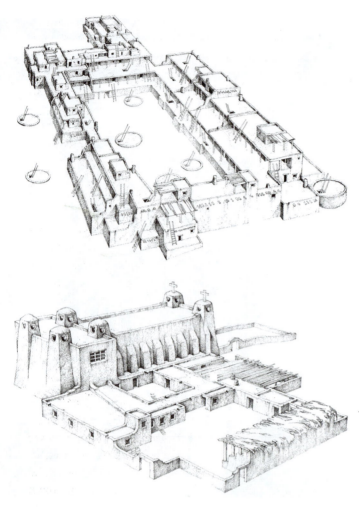

2.36 Pecos Pueblo, 16th century, and church, 17th century.
Reconstruction drawings. Southwest Parks and Monuments Association,
Tucson, Arizona.

drawing (see fig. 2.36, upper drawing) demonstrates what a substantial building the north pueblo was. The ground floor of the sixteenth-century pueblo consisted mainly of storage rooms, while the second, third, and fourth floors contained apartments. The need for protection against enemies and the conservation of heat is evident in the small number of windows and external doors. In times of defense against marauding Apaches and Comanches (or later, Spaniards), the ladders—here as at other Pueblo communities—could be pulled up.

The conquest of New Mexico proceeded in fits and starts, and from the beginning, Pecos was at the forefront of these efforts. Following their initial resistance to the first armed entry of Spanish soldiers in 1591, the Pecos Indians allowed Franciscans to dedicate a small mission there in 1617/18. This was followed shortly by the construction of the largest church in all of Northern New Spain to accommodate the large population of Indians, under the direction of Father Juárez, a Franciscan (see fig. 2.36). Its massive appearance—with walls up to 10 feet thick at the sides, six towers, and a series of buttresses along the nave—recalled the Muslim fortress, later reclaimed by Christians, in Father Juárez's hometown near Córdoba, in Spain. An adjacent one-story building contained the priests' quarters, stables, and workshops. All of this was built by Pueblo workmen under the direction of Juárez. This impressive frontier building was destroyed during the Pueblo Revolt of 1680, but replaced in 1717 with another, smaller structure. Following the revolt, the Pueblo people built subterranean kivas in the quarters of the Catholic priests to reassert their own religious and architectural traditions, using adobe bricks salvaged from the burned church.

Following colonization, Pecos retained its importance as a trading center. During the seventeenth and eighteenth centuries, the town was the site of vast trade fairs, which drew Indians from all over the Southwest and the southern Plains—traders from Mexico and all the way from St. Louis. Pecos pottery has been found as far away as central Kansas. Fragments of export Chinese porcelain were excavated from the ruins of Pecos itself (perhaps brought up from Mexico City as personal belongings of some Spanish settlers). This is just one more reminder of the global reach of culture as early as the seventeenth century.

The last few indigenous inhabitants left Pecos around 1840, their numbers having been reduced from a high of two thousand in the early seventeenth century, to fewer than twenty individuals. They moved nearby, to Jemez Pueblo. In 1999, their descendants reburied the bones of their ancient ancestors, which had been removed during twentieth-century archaeological excavations. In a public

and the Gulf of Mexico, flint artifacts, pottery, and shell beads. By 1400 C.E., multiple-room and multistory apartment complexes—like those at Acoma and Taos, but made principally of cut stone—were well established. From Coronado's first exploratory foray into New Mexico in the 1540s, the Spanish colonizers found a prosperous community—more than two thousand people living in four-story apartment complexes, which had more than a thousand rooms and twenty-six kivas. They were impressed, remarking that its buildings were "the greatest and best of these provinces." Pecos was a vibrant trade center: substantial amounts of corn, chili peppers, and beans were stored there, and buffalo hides from the southern Plains were traded for cotton textiles, pottery, and turquoise from the Pueblos.

At Pecos today, one can see the "footprint" of the ancient multistory pueblo, and the thick walls of the early-eighteenth-century mission church. The reconstruction

procession remarkable for what it conveyed of the fusion, conflict, and overlay of cultures in the American Southwest, the descendants carried two important items deeply emblematic of their historic relationship to their conquerors: the ceremonial cane of authority bestowed upon the native governor of the Pueblo by King Philip III of Spain in 1620, and another staff, which was a gift from President Lincoln in the 1860s. These symbols of power and authority were perhaps given in recognition of the recipients' loyalty to a larger system of government. But their Pueblo owners see them as emblems of their long history as a sovereign people and as signifying their coequal relationships with the Spanish and, later, the American newcomers in their land.

## The Segesser Hides: A Pictorial Record of Spanish and Pueblo Bravery on the Great Plains in 1720

The history of the Southwest is full of narratives of animosity between the Pueblos and the Spanish. Less often told, but eloquently recorded in one visual narrative, is the story of Spanish and Pueblo alliances. An extraordinary hide painting in the Palace of the Governors, in Santa Fe, sheds light on conflicts and alliances in the eighteenth-century West. One of two paintings called the Segesser Hides (after the Swiss family that owned them for more than two centuries), this 17-foot-long panorama is pieced together from buffalo hides (**fig. 2.37**). Canvas for painting was scarce in Northern New Spain. Native material such as buffalo hide was adapted to make large painted wall coverings like this one, a rough, New World version of the woven pictorial tapestries that adorned the walls of European palaces and great houses. (In Spain, animal skins were sometimes used for wall coverings and altarpieces, another legacy of the Muslim influence there.)

This painting tells the story of an historic event that transpired in 1720, when government officials in the Province of New Mexico became concerned about possible French encroachments into Spanish territory. French explorers and traders had traveled down the Missouri River from Canada onto the Great Plains, and La Salle had explored the Gulf of Mexico. A number of Spanish scouting expeditions traveled onto the Great Plains to look for evidence of French settlement. The expedition recorded in this hide painting was the ill-fated one of Pedro de Villesur. Accompanied by some four-dozen Spanish troops and five-dozen Pueblo Indian auxiliaries, Villesur headed northeast from Santa Fe, through present-day Kansas, as far as eastern Nebraska.

On August 14, 1720, while the troops from New Mexico were sleeping in their tents and tipis near the confluence of the Loup and Platte Rivers (shown realistically in another portion of this long pictorial scene), Pawnee and Oto Indian warriors (the native inhabitants of that region, allies of the French) attacked. Some three-dozen Spaniards, including Villesur himself and Father Juan Minguez, the Franciscan priest who accompanied the expedition, were killed. So was Joseph Naranjo, the Santa Clara Pueblo Indian who led the Native troops, and ten of his men. The rest returned to New Mexico in defeat, having lost all of their trade goods and supplies.

The detail shown here from the center of the 17-foot-long scene depicts the Spaniards and their Pueblo allies being overwhelmed by their attackers. On the right is the defensive position of the Spanish camp. A blue painted tipi is shown at center right. Other, unpainted canvas tents, more difficult to discern in this faded painting, encircle the Spanish men, huddled together as they try to defend themselves with muskets and spears. Their Pueblo allies must have been the first line of defense, for a number of them lie dying.

Spanish and Pueblo men all wear sleeveless jackets made of several layers of hide to repel arrows. (The effectiveness of such garments is demonstrated in the lower right of the scene, where two Pueblo soldiers continue to fight, though their garments are riddled with arrows.) The Spanish are distinguished by their wide-brimmed brown hats. The Pueblo men are hatless, their long hair tied in buns at the nape of the neck.

The Frenchmen and their Native allies differ dramatically from each other, as well as from their New Mexican opponents. The French wear blue or brown knee-length coats, tricorne hats, and leggings, while the tall Pawnee and Oto are naked. These vividly painted warriors must have presented a startling sight to their Pueblo opponents, because the artist has taken great pains to convey the individuality of each: one is blue with white legs, another brown with blue legs and forearms; yet another is gray with white spots, and others have red stripes. Many Pawnee and Oto men have horizontal bands of paint on their faces, as well. The Native men fight with bows and arrows, hatchets, swords, and spears; only the white men have firearms.

On the right, some three-dozen figures are spread out over otherwise blank canvas, making this portion of the conflict easier to read than the battle to the left, where in the center of the composition stands the Franciscan, Juan Minguez, holding a cross. He seems intent on blessing the dead and comforting the dying, paying no heed to his own

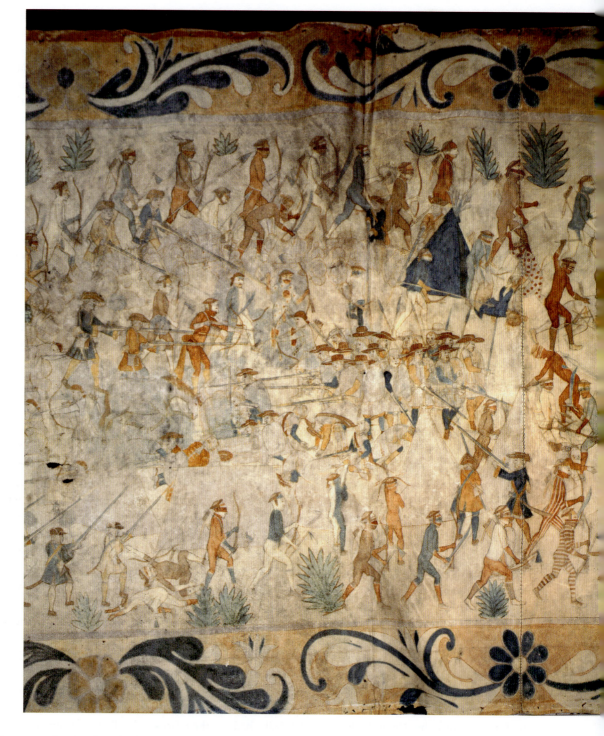

2.37 The battle scene at the right of the Spanish camp (Segesser II), c. 1720. Pigment on hide, 17 × 4½ ft (4.31 × 1.14 m). Museum of New Mexico, Santa Fe, New Mexico.

danger. Although he covers his head with the hem of his robe, he has already been struck by an arrow. The artist has made it clear that the Pawnee in pursuit will finish him off presently. Directly in front of him, a Pueblo soldier leads the way into the camp.

Who painted this epic scene? In eighteenth-century Santa Fe, the Spanish employed Pueblo people to manufacture goods such as clothing, wagons, and painted hides

for export south to more prosperous markets in New Spain, and there is archival evidence that painted hides like this one were produced by Pueblo artists in workshops there. Following a practice that we know existed in central Mexico, one or two Spanish artists, trained in European techniques, may have overseen scores of Native apprentices. The artist or artists who worked on this painting (completed sometime between the events of 1720 and

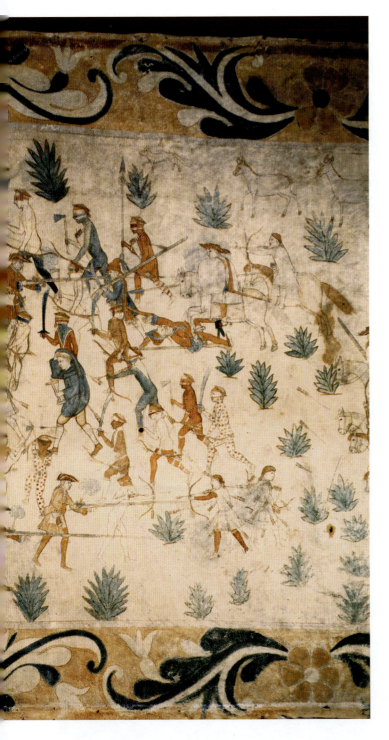

fusion, tumult, and gory detail of hand-to-hand combat. Many of the details are so vivid that it might have been painted by a survivor of the battle, or at least a Pueblo painter who had heard firsthand accounts of the bravery of the Pueblo and Spanish forces when faced with overwhelming odds. Of the sixty Pueblo militia who traveled on this expedition, forty-nine made it home alive; one of them certainly could have worked on this scene. One thing remains a mystery: surviving narrative accounts of this battle do not mention the presence of the French (easily identified in the hide painting by their blue and red coats, hats, and muskets). Was this painted as a kind of propaganda piece, exaggerating to Spanish government officials the threat of the French to their empire? Or does the image—so accurate in all other respects—shed new light on the details of an early eighteenth-century cultural clash on the Spanish frontier? Indians fought on both sides of the battle depicted here. This reflects not only ancient enmities but shifting modern alliances, as competing European powers jockeyed for control of the North American continent.

## Conclusion

Of the three colonizing powers examined in this chapter—England, France, and Spain—France did not maintain a foothold outside Canada. French interest in the lower part of the continent (or what is now the United States) was focused on the fur trade; French incursions into the Southwest would inspire the Spanish to extend their missionary efforts into Texas, as later the Russian presence in northern California would inspire a chain of Spanish missions (see Chapter 4) to counter Russian influence.

Both England and Spain, however, did establish colonies in the land that eventually became the United States beyond the initial phase of encounter. This occurred through forms of settler colonialism—the emergence of settled communities that established new patterns of social organization, land use, and material culture. In New Mexico and throughout the Spanish colonies, land use was controlled by distant authorities in Spain. English settlers enjoyed relative autonomy vis-à-vis the central government, but naturally tended to replicate forms they knew from England. In the later phase of colonization, the space of the middle ground gave way to "fragment societies," shaped by the memory of forms from the Old World, as well as by an emerging international market of trade goods, which would dramatically shape Native and European cultures in the next century.

1758, when it was sent to Europe) adapted European conventions of naturalistic detail, foreshortening, overlapping of figures, and a limited use of perspective. The plants are very schematized, but the figures are convincingly rendered. Many are shown in profile, while others turn in space, their bodies depicted with skillful naturalism.

Witnesses' accounts surely contributed to the realism of this battle scene, rendered in a way that evokes the con-

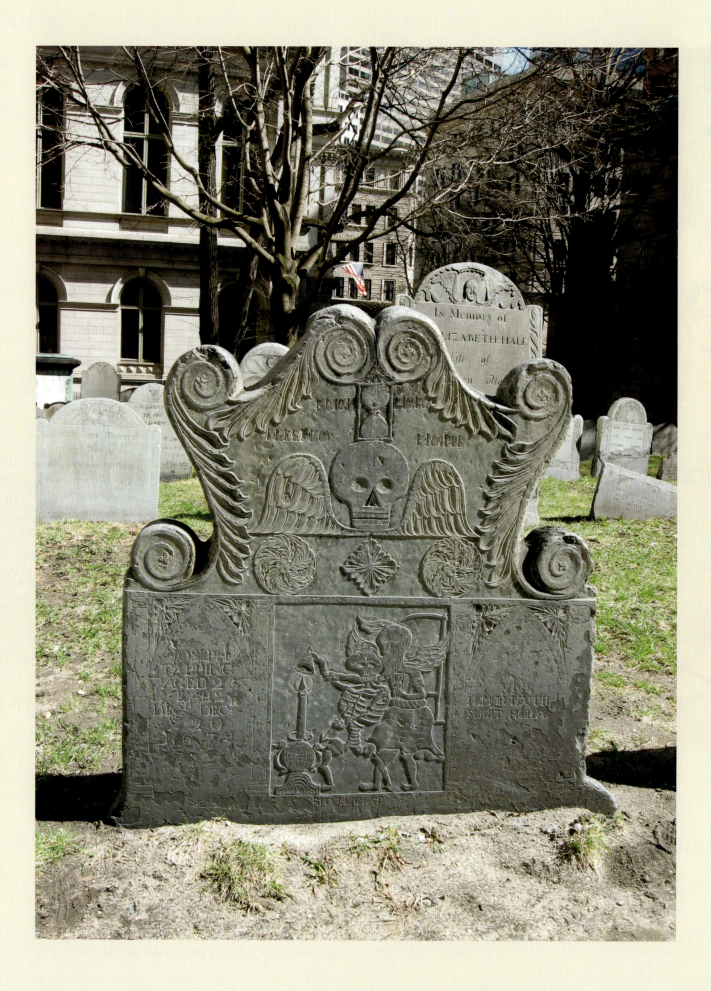

# 3 | Early Colonial Arts, 1632–1734

THE HENRY WHITFIELD HOUSE, built in 1639, is the oldest stone house in New England. Surprisingly, its second-story façade is furnished with a cannon port, an opening in the wall for firing a cannon, which faces Long Island Sound and the harbor (**fig. 3.1**). Built to defend against attacks from sea, rather than raids from the forest, where Native Americans might appear, the cannon port reminds us that relations between European nations in the New World were anything but friendly. When Frenchmen, Spaniards, and Englishmen encountered each other, rivalries erupted.

This preoccupation with defensive fortifications can also be seen in documents from the period. French maps detail British New England's batteries and defenses as well as its coastline and cities. Such maps remind us that the conquest of North America was driven partly by the competition for empire, and war between European nations—not to mention Indian surprise attacks—was always an uneasy possibility.

From a seventeenth-century perspective, English predominance in North America was by no means inevitable. On the contrary, persecution and civil war racked England

(opposite) **THE CHARLESTOWN STONE CUTTER**, Gravestone of Joseph Tapping, King's Chapel, Boston, Massachusetts, 1678. Slate.

3.1 (right) Henry Whitfield house, Guilford, Connecticut, 1639–40. Courtesy Henry Whitfield State Museum, Guilford, Connecticut.

through much of the seventeenth century as a result of quarrels among Anglicans and Puritans. These religions coexisted more peaceably in the colonies, where they were separated spatially, with the Church of England in Virginia and the Puritans in Massachusetts. But only later did these places become pluralistic and diverse; in these early times, only Rhode Island—a refuge for religious exiles of every stripe—embraced religious tolerance.

As the Spanish consolidated their hold in the South and Southwest, the other European "superpowers" of the sixteenth and seventeenth century—England, France, and Holland—competed with each other on the eastern seaboard. The French dominated the fur trade along the Saint Lawrence River in what is now Canada, extending their influence inland into the regions around the Great Lakes. The English claimed territories from present-day southern Maine to the mid-Atlantic states. The Dutch, who vied with England for control of the seas, had a smaller presence in the Hudson River Valley.

In greedily competing for colonies, each of these European powers was eager to create and control markets for its own goods. Each hoped to increase its wealth by regulating trade, encouraging exports, and limiting imports, a policy that economist Adam Smith later termed "mercan-

3.2 Map of colonial North America.

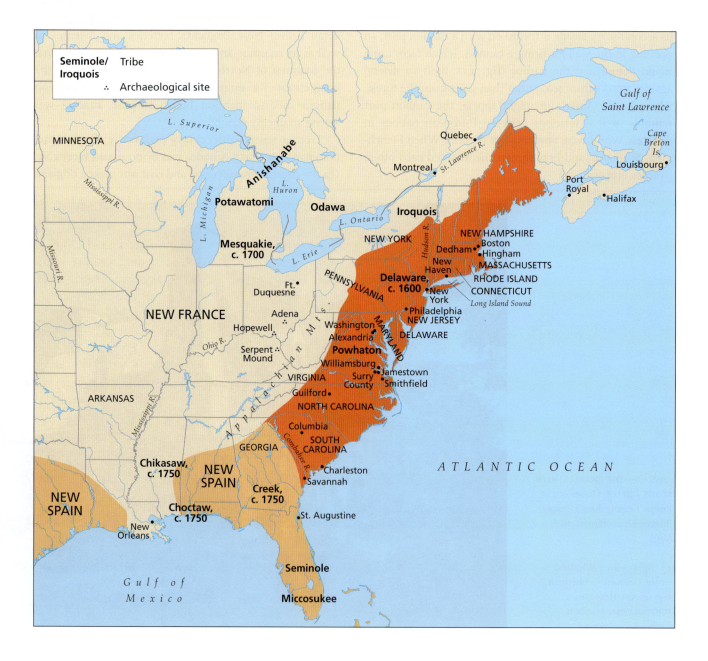

tilism." All coveted colonies as exploitable sources of raw materials and as captive markets for finished products to be manufactured in Europe from those raw materials.

Patterns of colonial exploitation differed. The Spanish Crown exercised direct control over its colonies in the New World, doing its utmost to funnel gold and silver back to court. The British Crown, on the other hand, rather than ruling its North American possessions through an imperial bureaucracy, granted large tracts of land directly to individuals and trading companies, resulting in an empire of heterogeneous, locally managed colonies. The Dutch West India Company established successful trading alliances with the Iroquois, but had difficulty persuading Dutch citizens to emigrate to the New World. In 1664, during one of the sporadic Dutch-English wars, English warships entered the main Dutch port, New Amsterdam. The governor, Peter Stuyvesant, surrendered without a shot. The English promptly renamed Stuyvesant's city New York (after the king's brother, the Duke of York), marking the beginning of its predominance along the Atlantic coast. The French, however, would engage the British in battles and territorial disputes throughout the eighteenth century. The British victory in the French and Indian War (1755–63) left Britain with Canada and all French territory east of the Mississippi. The French continued to hold lands west of the Mississippi until 1803, when Thomas Jefferson, the American president, obtained French lands extending to the Rocky Mountains in the Louisiana Purchase.

In this chapter, we shall see how the early colonists maintained their memories of the Old World while settling the new one. We begin with the large view, looking at town maps and general land usage in Spanish and British North America. We then examine Puritan painting in the Massachusetts colony and the local arts of the Spanish Southwest. Next, we turn to a range of architectural styles that distinguished British and Spanish North American building types, as well as objects associated with everyday life (decorative arts, needlework, gravestones), noting the role each played in maintaining family and community. We conclude the chapter by addressing race and slavery. In adapting to North America, the colonists also adopted new labor practices. By cultivating labor-intensive tobacco—a New World plant that ignited a lucrative European trade—colonists required ever-greater numbers of field hands. The abundance of land and scarcity of labor led to the importation of African slaves; and the combination of Africans and Europeans, together with indigenous peoples, transformed the New World into a remarkable meeting ground of different cultures, a place of brutal military encounter, extensive commercial exchange, and innovative cultural experiment.

# Designing Cities, Partitioning Land, Imaging Utopia

Land planning can be an art form; a city can be a work of art. A people can express who they are by how they use the land and shape the landscape. To European eyes, the New World appeared vacant and untended. Of course, the continent had been inhabited for centuries, but Native American land use practices along the eastern seaboard—seasonal migration, communal property, the delegation of farming to women—lacked the elements of improvement and private property that Europeans associated with land occupancy. In the Southwest, by contrast, the Spanish encountered Native Americans living in settlements of adobe construction, and readily recognized practices that were similar to their own. But the English, French, and Dutch on the Atlantic coast were not similarly impressed by the Eastern Woodland peoples. Although they adopted some Indian place-names for rivers and mountains and used Indian pathways (indeed, many roads in use today are paved over Indian trails), these newcomers saw the Atlantic coast as land to be "settled" and transformed into useful property.

## Hispanic Patterns of Land Settlement in North America

In the American Southwest, the Spanish laid claim to whatever lands they found. They ignored Native customs of settlement, land management, and cosmological belief, imposing instead their own sense of order based on Old World patterns. As a consequence, the Spanish felt beset by hostile Indians and the threat of insurgency from colonized Natives. Along with the Catholic mission, the earliest form of Spanish settlement was the military garrison, or *presidio*. Likewise, the frontier agricultural village and the private plantation (or *estancia*) were shaped by the embattled mentality of frontier life.

Spanish colonization was fully controlled by the Crown. Authoritarian, and bureaucratically centralized, Spanish administration was driven by the need to maintain control over distant colonies, whose purpose was the acquisition of wealth and Indian conversion. In 1573, Spain's settlement policies in the New World empire were codified into 148 official ordinances, "The Laws of the Indies." (The name reflects the original error of Columbus in thinking that he had discovered a sea route to Asia rather than a new continent.) All towns in New Spain were—in theory—uniform. The Laws of the Indies dictated their size and arrangement—specifying, for example, a central,

3.3 Plaza, Santa Fe, New Mexico.

3.4 Plaza, El Cerro de Chimayo, Chimayo, New Mexico, mid-1960s.

packed-earth plaza for religious processions, markets, and military exercises. Many features of Spanish colonial planning derived from the architectural theories of Renaissance Italy, and ultimately from the first-century B.C.E. Roman writer Vitruvius. These plans were intended as an ideal pattern for New World settlement. In Mexico and South America, they were imposed upon the imperial capitals of the Aztecs and the Inca.

Although the Laws of the Indies were never followed to the letter, their main features characterize most Spanish colonial towns: a grid-pattern layout of streets with a plaza at the center, flanked by government and religious buildings. The plaza functioned as an open space for social, religious, and military gatherings. In smaller towns such as Santa Fe, New Mexico, and Saint Augustine, Florida, it also served as a market (**fig. 3.3**). The key building was the palace of the governor appointed by the king (see fig. 2.26), a physical reminder of the Crown's authority. Social status was indicated by the proximity of one's residence to the central plaza. Accordingly, royal appointees born in Spain and the wealthier merchants lived nearest the plaza, while people of lesser status, born in the New World, were more removed. People of mixed race, including mulattos (European and African) and mestizos (European and Indian), lived on the margins of town. In Spanish colonial society, social caste was premised on purity of Spanish descent, and mapped onto the physical spaces of settlement.

**EL CERRO DE CHIMAYO.** In New Mexico the best-preserved example of the fortified colonial plaza on a small scale (420 by 330 feet) is El Cerro de Chimayo, northeast of Santa Fe (**fig. 3.4**). A thriving farming village well into

the mid-twentieth century, Chimayo originated in the early eighteenth century as a walled settlement that could be defended against the attacks of Apache and Pueblo Indians. The villagers' one- and two-story adobe homes were arranged around all four sides of the plaza in solid formation. Access into the plaza was at the corners, so that the village exterior presented an almost unbroken wall. Although families used the plaza itself for small garden plots, major farming was done in the outlying areas. Running through the village and connecting the inner and outer areas was an irrigation ditch, or *acequia*. On one side of the plaza we find a rare example of a private family chapel dating from the eighteenth century. Inward-turning in its attitude, the village of Chimayo typifies the agricultural, religious, defensive, and domestic aspects of a Hispanic frontier settlement.

## British Patterns of Land Settlement in North America

Reflecting traditional concepts of community, custom, and nature, English settlements invoked the familiar patterns of the Old World while also sometimes expressing utopian aspirations for life in the New World. They were shaped by three principles: customs regarding property, farming, and patriarchy; English law regarding private land ownership; and a hopeful vision of a new civil society.

Seventeenth- and eighteenth-century settlers thought of civic space in terms of roads, houses, gristmills, sawmills, churches, and harbors; but they also thought of it as something abstract and ideal, as if seen through the eye of God. Surviving town plans show both concepts: concrete patterns of land use and abstract concepts of spatial organization.

## AN ENGRAVED MAP OF SAVANNAH.

For example, *A View of Savannah, Georgia* (**fig. 3.5**) illustrates the colonists' defensive concerns about unfriendly natives, rival Europeans, wild beasts, and the deep forest surrounding them. The community is depicted as cleared land, extracted from the wilderness and transformed into a new civic space with roads and buildings. *Savannah* records a polarity between civilization—ordered, safe, and upstanding—and nature—disorganized, dangerous, and morally deficient.

With cultivation, building, and husbandry, however, nature could be made good. One of the prime instruments of this transformation was geometry. Regularity and right angles indicated the presence of civilization: straightness was not just about lines, it was a theological position. Cleared land, milled lumber, geometric rooms, upright posture, and straight roads marked space as civilized and Christian.

## NEW HAVEN.

The town of New Haven, Connecticut, founded in 1638 by Puritans, was laid out with an idealized geometry that equated civic space with theological and moral space. Its founders located their city where there was a good harbor and river access to inland markets. They also designed it so as to induce its inhabitants to live a godly life—to live as though they inhabited an earthly version of the New Jerusalem. Taking as their inspiration the Book of Revelation and woodcut illustrations of the New Jerusalem, the founders gave New Haven a perfectly square plan, consisting of nine squares demarcated by straight streets. The outer squares were designated as private property, to accommodate houses, shops, and orchards, while the central square served the community as a whole. On this grassy space stood the meeting house (or church). Here, too, other public functions were held; there was a burial ground, stocks for malefactors, and later, in the eighteenth century, a grammar school and a jail. The city was planned as a model for other peoples and other cities.

The Wadsworth plan of New Haven (**fig. 3.6**) was drawn by a Yale undergraduate in 1748 (as what we would call a senior thesis project). Wadsworth included on his map a list of the heads of households by name and occupation, leaving us a rich sociological document of this little city just over a century after its founding. More than a century

3.5 PETER GORDON, *A View of Savannah, Georgia, as it Stood the 29th of March, 1734,* 1734. Engraving. Library of Congress, Washington, D.C.

3.6 JAMES WADSWORTH, *Plan of New Haven, Connecticut* (plan attributed to Theophilus Eaton, 1638), 1748. Watercolor. Beinecke Library, Yale University, New Haven, Connecticut.

3.7 (opposite above) **CHRISTOPHER WREN**, *A Plan for Rebuilding the City of London after the Great Fire in 1666*, 1666, from John Knox, *A New Collection of Voyages, Discoveries, and Travels* (London: 1767). Engraving. Library of Congress, Washington, D.C.

3.8 (opposite below) **FRANCIS DEWING** (engraver) after **CAPT. JOHN BONNER**, *The Town of Boston in New England, Boston*, 1722. Engraving. Stokes Collection, New York Public Library.

after New Haven was platted (that is, surveyed) and settled, its patriarchs still arrayed themselves in a hierarchy, the most important situating themselves closest to the meeting house. By this time, however, commercial pressures had distorted the plan, causing clustered and irregular development near the harbor—the busiest segment of town—and altering its original abstract and theological unity. Such changes would continue as the city grew, but the original nine-square plan with a central green still defines the core of the city today.

**ORGANIC, GRID, RADIAL.** Urban studies identify three essential types of city plan—organic, grid, and radial—all of which can be seen in English America. In an organic plan, streets and property lines are aligned with major topographical features. Streets follow the crests of hills and

trace declivities and stream plains. They are also aligned with major human-made features such as defensive walls and wharves. Organic plans often appear to have meandering, illogical layouts. Developing from many small decisions about the use of space and access to resources over long periods of time, they are the result of accumulation, accretion, accident, and accommodation.

The second important plan type is the grid. In the West, the grid was originally used by the always-practical imperial legions of ancient Rome, who arrayed their camps in a regimental rank and file, placing the general's headquarters at the center. The Renaissance fascination with optical perspective revived the grid as a model of rationality, whereby intentionality and order could be applied to the gritty task of making a city. From the first English colonies in Virginia and Massachusetts, in the early 1600s, through the centuries of westward expansion, Anglo-American settlers took possession of the land through acts of surveying, gridding, and boundary drawing, creating in the process "a world of fields and fences," according to environmental historian William Cronon.

The third major plan type, the radial plan (**fig. 3.7**), derives from the Baroque period. It expresses the arrangements of power relations and social authority more directly than the other two forms. If the organic plan speaks, in general, to local and decentralized decision making, and the grid speaks to practicality and order, the radial plan speaks of the show of power, using dramatic vistas and the theatrical compression and relaxation of space to aggrandize institutions of power. The radial plan emphasizes symbols of authority and expresses a very different attitude toward space, people, and power than does the organic plan. Where the organic plan reflects a city's haphazard evolution over time, and the grid imposes a culture's sense of rationality onto the landscape, the radial plan reveals the desire of a ruling elite to display power.

**BOSTON.** In English America, the most common seventeenth-century plan, as seen in Boston (**fig. 3.8**), is organic. The principal roadways of early Boston align with or move perpendicular to major topographical features.

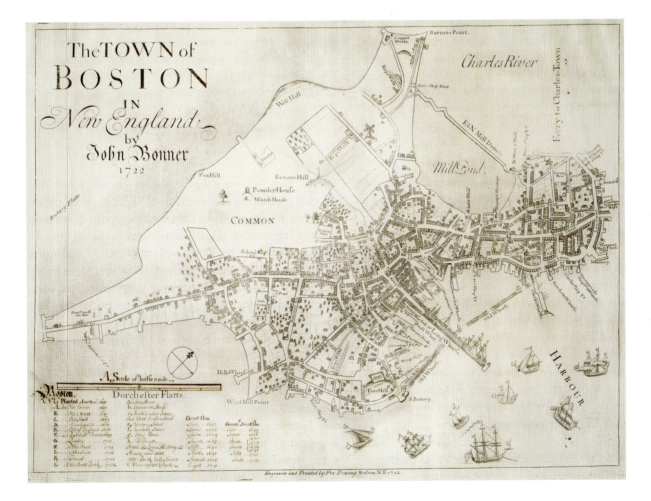

# The Puritan Ideal

THE EARLIEST ENGLISH SETTLERS of New England were called "Puritans," a label coined and hurled at them derisively by their enemies. The label stuck; and even today, nearly four hundred years later, we tend to think of the first settlers of Massachusetts as dour killjoys. This view of Puritan society derives from the prejudices of later generations, who disparaged their Puritan progenitors as the kind of repressive folk they most loved to hate.

The "Puritan" epithet both clarifies and obscures these early English settlers for us. Members of the Church of England, they did not wish to leave the church but to purify it. Their "purifying" mission sought to rid the church of its elaborate customs and showy ritual. They wanted a simple style of worship, appropriate to what they viewed as God's truth. As their model, they took the "primitive church," Christianity in its earliest years before its institutionalization—and to Puritan eyes, corruption—in Rome.

In rejecting pomp and ostentation, the Puritans were also condemning the church as an elitist institution allied with the aristocracy. They sought to make religion appropriate to the values of their own emerging middle class. The Puritans believed that salvation did not lie in a set of rituals performed by the church on behalf of the sinner but in a drama within the soul of the believer, and they called those whom God had saved "saints." They believed in a "revolution of the saints" and viewed themselves as the culmination of a biblical narrative that extended without interruption from ancient Jerusalem to their own time.

The Puritans were not democrats: like most people of their day, they subscribed to a hierarchical view of the world organized in a "Great Chain of Being," a scale that ranked all creation from the lowest orders to the highest in graduated steps, mirroring the mind of God. Though they despised the "corruption" of aristocratic culture, they nonetheless maintained the deferential customs of a class society in which the "lower orders" deferred to the authority of their "betters." They had only a limited notion of what we call today scientific causality. They viewed all events as direct signs from God, rather than as the results of natural causes.

And yet, even as they dragged a large portion of the late-medieval world across the ocean with them, the Puritans also produced the first outlines of modern social life. They enjoyed the highest literacy rate in seventeenth-century Western society, insisting that salvation was tied to a person's ability to read the Bible. Within six years of founding the Massachusetts Bay Colony, in Boston, the Puritans established Harvard College (1636); and within ten years, they were publishing the first books in English in the New World.

---

Settlement bunches in merchant-dominated communities at points where one form of transportation links up with another: roads with markets, wharves with ships. Seventeenth-century Boston consisted almost entirely of private property, with the exception of the streets and a large open space known as the Common, which was public and, in contrast to the Spanish plaza, was seeded in grass for the pasturage of milk cows. Unlike horses, sheep, and steers, which could be pastured at a distance, cows needed to be kept handy for twice-daily milking. This large space was understood to be an essential public resource among the English, who were habituated to a bread-and-dairy diet. Yet while privately owned cows could fatten on the Common, the gristmills and bakeries that supplied the bread remained private businesses.

**NEW YORK CITY.** The Dutch in New York also developed an organic plan. A 1660 map of New Amsterdam—as it was known then—shows irregular house lots on roads that roughly parallel the two riverfronts (**fig. 3.9**). The houses, orchards, and gardens have long since disappeared, but New Yorkers "remember" Dutch settlement in names such as the Battery (where the Dutch built their fort), Canal Street (where the Dutch excavated a canal), Wall Street (just inside the defensive rampart), Broadway (the widest street in their city), and the Bowery (where Peter Stuyvesant had his farm). Still today retaining its organic street plan, the lower tip of Manhattan is distinctly different from the rest of the island. By the mid-eighteenth century, the northern reaches of the island were increasingly laid out in a grid pattern (**fig. 3.10**). Elsewhere in America, too, the grid supplanted the organic plan. But the organic plan did not disappear; after the Civil War it went elsewhere. It migrated to the suburbs, where meandering roads and paths, intentionally contrived, have become associated with pleasurable, healthful habitation and class privilege.

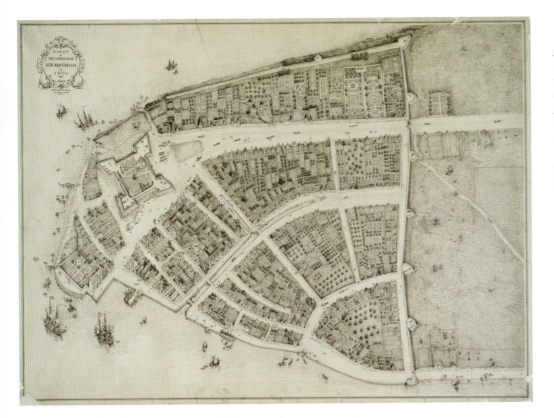

3.9 JOHN WOLCOTT ADAMS & I.N. PHELPS STOKES (based on unknown artist's map), *Redraft of the Castello Plan, New Amsterdam in 1660*, from a manuscript Plan of New Amsterdam, 1660. Engraving, 1916 (after a manuscript original in the Medici Library, Florence). Stokes Collection, New York Public Library.

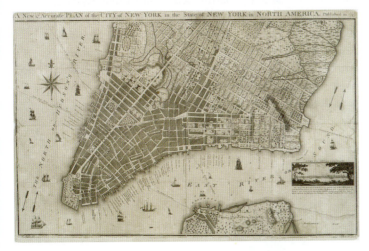

3.10 B. TAYLOR, *A New & Accurate Plan of the City of New York in the state of New York in North America*, 1797. Print. Stokes Collection, New York Public Library.

**PHILADELPHIA.** To the basic question, "What tales do we tell about ourselves in the way we lay out cities?" the grid offers a story different from the organic plan. First, it tells a tale of separation from nature, an attitude reflected in the image of Savannah (see fig. 3.5). Second, as New Haven demonstrates, the grid embodied the ideal of a heavenly Jerusalem, perfect and planted on earth (see fig. 3.6). An important exemplar of the grid for national development is the city of Philadelphia, designed in 1682 by its proprietor,

William Penn. Chastened by the Great Fire of London scarcely sixteen years earlier, Penn was intent that Philadelphia be "a green and pleasant town that never will burn." To this end, he specified the use of brick in construction, and arranged roads and utilities with a fire plan foremost in mind. He also incorporated geometric principles that he believed revealed the rationality of "Nature" (**fig. 3.11**).

Laid out between the Schuylkill River (connecting Philadelphia with its hinterlands) and the Delaware River (connecting the city with the Atlantic marketplace), Philadelphia's gridded brick cityscape became an important model for the nation. Philadelphia's plan (which reflects its origins as a Quaker settlement) is rational, clear, and humane, punctuated by five public squares (four of them planted with shade trees according to the 1682 plan). The grid was, and continues to be, associated with an ideology of equal access and fair dealing. Its allowances for rapid response to fire also permit easy orientation for visitors unfamiliar with the city. Philadelphia prospered, as a port exporting the agricultural goods of America's richest farmland and as an entry point of European immigration, especially during the eighteenth and early nineteenth centuries. Immigrants stopped in Philadelphia before heading west and took with them the memory of a large-scale, highly functional urban grid. In the mid-nineteenth century, the railroads adopted the grid plan for the many towns in the Midwest and West that they established along their rights-

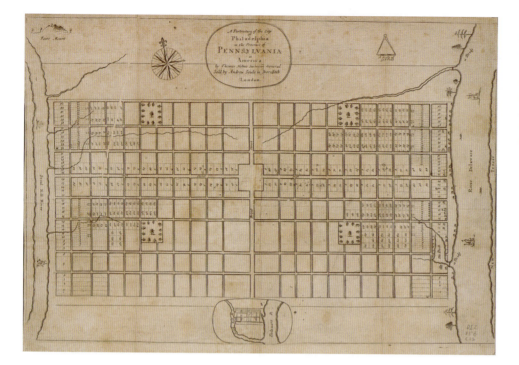

of-way. The grid became a hallmark of European-American settlement, a stamp of regularity, efficiency, and rationality on the landscape.

**THE ORDINANCE OF 1785.** The Ordinance of 1785 was the second of several acts passed by Congress dealing with the settlement of the Northwest Territory: the land between the Appalachian Mountains and the Mississippi River. It surveyed the land and partitioned it into 1-mile squares, each containing 640 acres and called a section. Thirty-six sections constituted a township, the political unit of middle America. A quarter section (160 acres) made up a standard family farm—the economic and social unit that has since been mythologized in so much American art and literature. Roads and fences followed these property lines, as one can still see from an airplane, establishing a grid in

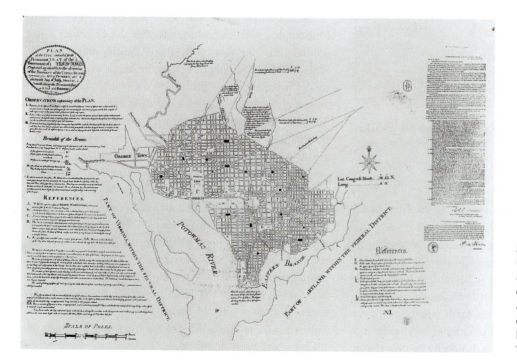

which the natural is made geometric, and the political expressed in design.

In the late eighteenth century, Napoleon Bonaparte lost whole armies on islands in the Caribbean trying to quell slave uprisings and restore sugar production. Quitting the Caribbean, he had no more use for the central portion of the North American continent which had been designated the breadbasket for these plantations. In 1803, Thomas Jefferson, then president, purchased these immense lands for the United States. The Louisiana Purchase consisted of 828,000 square miles stretching up the Mississippi River from New Orleans to the Rocky Mountains and Canada. This land, too, was divided into a patchwork of 1-mile sections.

**THE DISTRICT OF COLUMBIA.** The radial plan is less common than the grid or the organic plan. Used in the early 1700s in the colonial capitals of Maryland and Virginia—Annapolis and Williamsburg—the radial plan is most grandly realized in Washington, D.C. Unlike Boston, New Haven, New York, and Philadelphia, Washington was not a colonial settlement. It was designed specifically as the capital of the new nation by a French immigrant, Pierre Charles L'Enfant. The model L'Enfant chose was the most dramatic and imperial plan available. Artist, military engineer, and the son of a court painter, L'Enfant had been born in Paris and was familiar with Versailles—the splendid Baroque palace built for Louis XIV. L'Enfant came to the colonies, as did many other French sympathizers with the patriot cause, arriving in 1777. Fourteen years later, in 1791, George Washington hired him to design the new capital city and its public buildings. Although embroiled in land speculation and dismissed the following year, L'Enfant nevertheless shaped the city of Washington as it was built—a grid overlaid with a dramatic radial plan (**fig. 3.12**). In his own words:

> Having determined some principal points to which I wished to make the others subordinate, I made the distribution regular with every street at right angles … and afterwards opened some … as avenues to and from every principal place, wishing thereby not merely to [contrast] with the general regularity but also to offer pleasant prospects and to connect principal buildings giving to them reciprocity of sight and making them thus seemingly connected.

Fifteen squares with "statues, columns, obelisks" and grand fountains were to punctuate the cityscape, according to L'Enfant's plan. Washington was conceived on such a grand scale that the city would experience a century of development before it caught up with L'Enfant's imperial plan.

# Seventeenth-Century Painting: Puritans in Kid Gloves

During the colonial period in English America, two kinds of images flourished—natural history drawings and oil paintings of magistrates, ministers, merchants, and members of their families. Both were intended to document. Natural history drawings recorded the look of New World plants and the customs and dress of its native inhabitants. They were often engraved and circulated among Europeans hungry for images of New World flora, fauna, and native life (see Chapter 2). Portraiture recorded faces and identities that were understood to be useful, binding families together by reminding all concerned of their mutual obligations and duties. While various other kinds of oil painting flourished in seventeenth-century England and Holland—still-life, landscape, genre, and religious or history painting—they were virtually unknown in America until after the Revolution. Portraits were important to the colonists; other kinds of oil painting were not.

## Portraits

The market for portraits proved especially vigorous among the Puritans of Boston. They produced more images of themselves than the wealthy Church of England Virginians or the *patroon* (land-owning) Dutch New Yorkers. Although popularly associated with austerity and plainness, Puritans, in fact, saw no conflict between piety and worldly success. They viewed themselves as stewards of God's world and sought to increase its bounty in the name of God's glory. They demonstrated an enthusiasm for intricate patterns, bright colors, and richly elaborated surfaces in their furniture, textiles, silver, and portraits.

The surviving portraits from seventeenth-century Massachusetts often record on the canvas front the sitter's name, age, and the date of the work. Physiognomy, name, age—these are primary ingredients of identity now as then, noted, for instance, on our passports and driver's licenses. They define each of us as individuals. For an observer, the face is the most powerful ingredient in identity; for the sitter, it is consciousness itself. These two—facial uniqueness and consciousness—establish a human actor with individual will and responsibility. Other ingredients of portraits—posture, clothing, accoutrements, address to the viewer—establish a human actor with social roles, inhabiting a material universe.

Paintings in colonial British America were commissioned—that is, the patron requested the artist to make a

portrait, usually of himself, his wife, and/or his children. The patron would negotiate price and size at the outset (portraits were priced by size and number of figures). Half the cost was paid in advance to seal the deal, and the subjects would then sit (or stand) for hours over the course of several days or sometimes weeks, while the artist rendered what he observed and what he knew to be the key ingredients of social identity in his culture. The painting was not finished nor the second half of the price paid until the patron was satisfied. Changes were frequently made—technical analysis, using such tools as X-rays, can reveal these alterations—before the work was declared complete. Mrs. Freake, for instance (see p. 69), was originally painted as a single figure, but the composition was substantially altered to add her child, who was born three years after the portrait was initially completed. The portrait medium—pigments suspended in oil on canvas—readily permits such changes, which are usually invisible to the naked eye. If the patron refused the work, the painting did not survive, as the artist would scrape down the image and reuse the canvas. The survival of these portraits indicates that the patrons approved the artists' efforts.

Unlike Spanish America, with its virtually all-male cohorts of priests and soldiers, English America was settled by families. Bachelors were viewed with suspicion and remained under the governance of their fathers, masters, or court-appointed guardians until marriage, when they acquired the rights and responsibilities of an adult male. Widowers seldom remained unmarried, and widows,

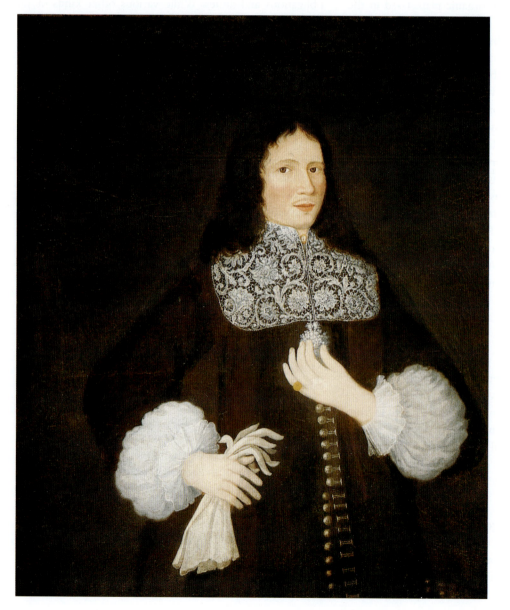

3.13 (left) THE FREAKE-GIBBS PAINTER, *John Freake*, Boston, c. 1671–4. Oil on canvas, 42½ in (107.9 cm) × 36¾ in (93.4 cm). Worcester Art Museum, Worcester, Massachusetts. Sarah C. Garver Fund.

3.14 (opposite) THE FREAKE-GIBBS PAINTER, *Mrs. Freake and Baby Mary*, Boston, c. 1671–4. Oil on canvas, 42½ in (108 cm) × 36¾ in (93.4 cm). Worcester Art Museum, Worcester, Massachusetts. Gift of Mr. and Mrs. Albert W. Rice.

especially those with young sons and property, also promptly remarried. The household was the primary economic as well as social unit, incorporating not only parents and children but also live-in apprentices, indentured servants, and miscellaneous unmarried relatives, all ruled by the male head of household. The household was arranged in a hierarchy of who sat where, who spoke first, and who wore what—a system of dominance and deference incorporated into gestures, postures, clothing, utterances, and material culture. The inheritance of the family name, prerogatives, and goods by the rightful heirs was a paramount concern to the whole community. Portraits illustrate the importance of these concepts of family and heritage among those prosperous few who expected to pass wealth on to successive generations.

**THE FREAKE PORTRAITS.** We have more surviving portraits of men than of women from the colonial period because portraits were often commissioned to record male achievements, such as a military victory or an appointment as minister of a church. Many portraits, however, were commissioned in pairs—images of husband and wife at the time of marriage or arrival of first born child—to commemorate the formation of couples and the joining of families that would, through their offspring, continue a lineage. While many of these paired portraits have been separated over the intervening centuries, two portraits executed in Boston by an unknown painter in 1671 (with additions in 1674) of John Freake and his wife, Elizabeth Clarke Freake, and their baby Mary, have remained together (**figs. 3.13** and **3.14**). Painted on canvases of equal

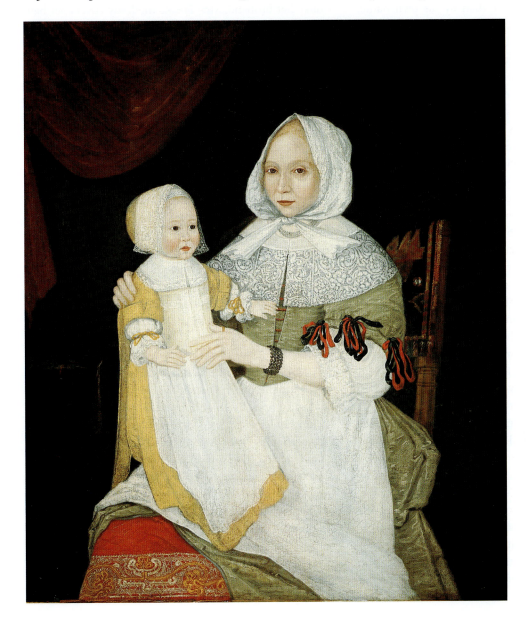

size, the two figures turn toward each other while directing their gazes to the viewer. To a seventeenth-century observer, the outward gaze accomplished two things: it established a bond of intimacy with the viewer (assumed to be a family member or friend), and it reminded the viewer of the Freakes' high social station, their right to command authority with their eyes. For viewers today, their eye contact creates a sense of psychological immediacy, which erases the centuries between our time and theirs.

These canvases, like almost all colonial portraits, are unsigned. When a name is affixed to the surface or the back of the canvas, it is usually that of the sitter. Such images are about the patron, his spouse, and his progeny—not about the artist. The portraitist who executed these two images is known as the Freake-Gibbs painter, identified by his patrons rather than by his own name, which has been lost to history. From the similarity of these works to paintings executed in England a century earlier, we can conclude that the painter was probably trained in an English country town where older styles of painting—we call them Tudor or late medieval—persisted into the seventeenth century. First, we observe an evenness in focus—the buttons and laces are as precisely depicted as the facial features. Secondly, the painter is more interested in surface pattern than in giving us an illusion of rounded forms occupying three-dimensional space. We can conclude from these two characteristics—overall precise focus and emphatic surface pattern—that the patrons, the painter, and the culture they inhabited valued surface design over the illusion of pictorial space. That more "Renaissance" way of understanding painting as a window onto a three-dimensional world would come later, when new ideas about the picture plane as a field of illusion—its dramatic light and shadow simulating a reality continuous with our own—took hold. The Puritan emphasis on decorative surfaces would give way over the next half century to a new interest in the body as a three-dimensional object placed within the empirical world.

Later, as we shall see in the portraits by, for instance, John Singer Sargent and Thomas Eakins, dress will be subordinated visually to face and hands. Costume will appear less sharply focused than the sitter's flesh. As viewers, we are drawn to scrutinize faces: we give them visual priority. Our eyes see only a small area in sharp focus in any given moment, leaving the rest of our visual field more impressionistic, and causing us to "scan" any scene of reasonable size. Puritan portraiture cuts against this tendency of vision by highlighting all parts of the surface equally. The result is that Puritan portraiture can seem old-fashioned to us today.

John Freake, as suggested by his silky locks, wide lace collar, pliant kid gloves, pendant jewel, and multiplicity of silver buttons, was a successful man: a merchant, brewer, and ship owner. When he died, shortly after these two paintings were completed, an inventory of his belongings described a household rich in imported luxury goods. The portrait of his wife and infant daughter (the artist has written in paint on the surface of the canvas "Aetatis Suae 6 mo$^{th}$," Latin for "at the age of 6 months" to the left of the child) adds bright primary and vibrating complementary colors to the exuberant material world of these affluent Puritans. Intricate lace on Mrs. Freake's collar and skirt, and delicate needlework on the baby's bonnet, suggest a lively aesthetic sense as well as wealth. But Mrs. Freake and her daughter are also described as good Puritans. Unlike her husband, Mrs. Freake modestly covers her hair, a symbol of faithfulness among married women and chastity among unmarried ones in Puritan culture. Both she and her child wear the petticoats (meaning "small coats" or skirts) that are emblems of their subordination to males. John Freake stands and Mrs. Freake sits stiffly, and little Mary, swaddled straight under her skirts, is held as erect as possible, suggesting her potential for a morally upright life. For the Puritans, the body in its natural state was tied to nature in its fallen mode: unredeemed and dangerous. The curled-up body of an infant, which we today understand as natural, signified for the Puritans a failure of discipline. Salvation required that the body be subdued and transformed into the geometry of an orderly, civilized life. Attached to the back shoulders of Mary's dress are straps by which her mother will help hold her upright as soon as she is strong enough to try to stand and walk. By her posture and her clothing, Mary's body and mind are being formed to be good, and to exhibit her progress for others to see.

**THE MASON CHILDREN.** While obedience and deference were omnipresent in Puritan life—both within the household and among heads of household, in carefully calibrated pecking orders—so, too, were reminders from the pulpit that patriarchs must love their wives and children. The unknown artist, possibly the Freake-Gibbs painter, who depicted the children of Boston baker Arthur Mason and his wife, Joanna Parker Mason, in 1670, has portrayed three siblings whose father extended himself to equip his children according to his social station and to record their well-acculturated forms (**fig. 3.15**). The leather gloves and silver-headed walking stick mark David, age eight, as dominant, a young male recently "breeched"—that is, taken out of petticoats, which were commonly worn by children

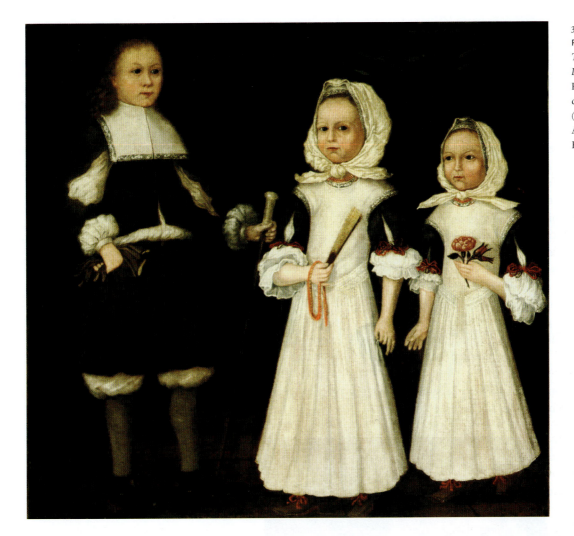

3.15 **THE FREAKE-GIBBS PAINTER** (attrib.), *The Mason Children: David, Joanna, and Abigail*, Boston, 1670. Oil on canvas, 39 × 42½ in (99 × 107.9 cm). Fine Arts Museums of San Francisco, California.

of both sexes, and put into breeches. His sisters, demurely coifed, sport coral beads, vermilion ribbons, snowy aprons, and other accoutrements appropriate to girls. Costume was not just a matter of personal preference and purse in seventeenth-century English America; it was regulated by highly specific sumptuary laws. These laws, enacted in southern as well as northern colonies in the seventeenth century, restricted the use of certain expensive materials and items (silk, certain kinds of lace, certain cuts of coat, boots, and gloves). They had two objectives: to curtail excessive, showy spending at funerals (where the number of gold rings, expensive gloves, and other tokens bestowed by the deceased on the mourning community was proportionate to his or her eminence), and to restrict the uses of the finest wares to those (especially males) at the top of the social hierarchy. Sumptuary laws were designed to make the status of different social classes explicitly visible, so that deference or dominance, especially among males, could be quickly "read." Social gestures were also coded. In this image, Joanna and Abigail, with their closed body posture and overlapping forms, defer to their swaggering brother. Nevertheless, it is Joanna, nervously fingering her apron, who eyes the spectator and convinces us of her distinct personality.

As in other surviving seventeenth-century paintings, the artist of *The Mason Children* elaborates the details of dress and the individual facial features of his sitters. His attention is more on surface than on volume. If we had no other evidence, the gilt lettering hovering on the surface of the canvas beside each child's head ("Anno Dom 1670…8…6…4," indicating age at the pictured moment) would make clear that the artist, his patron, and his culture cared less about illusion and more about document, detail, and surface.

**CAPTAIN THOMAS SMITH'S *SELF-PORTRAIT*.** The writing in Captain Thomas Smith's *Self-Portrait*, instead of hovering decoratively on the surface, as in *The Mason Children* and *Mrs. Freake and Baby Mary*, lies on a sheet of painted paper, illusionistically folded over the edge of the

table in the lower left (**fig. 3.16**). We read Smith's letter as ink on paper—that is, as tangibly there with the man in his pictorial space, along with the table. There are other ways in which Smith has introduced three-dimensionality into this image. The subject's face exhibits decisive contrasts between light and shadowed features; his lace neck cloth has such deep folds that its floral pattern is obscured. When we describe the painting, we might use such terms as "the letter lies on a table under a skull behind which the man's hand emerges"; "in the background a fierce naval engagement takes place." These terms, "on a table," "under a skull," "behind," "in the background," suggest spatial terms and locations that were not applicable in our discussions of the earlier three paintings. What is being introduced here is a conception of pictorial space as continuous with our own inhabited space, a heightened interest in realism, which displaced the late-medieval concern with surface that governed the Freake painter's world. Yet Smith has not fully mastered spatial recession; three ships appear to float above the horizon line established by the fortress.

Captain Thomas Smith painted this image—a harbinger of the pictorial system that would become dominant in

eighteenth-century Britain and British America—some time between 1680, when he first appeared in Boston records, and 1691 when he died there. Given the acceptance of death expressed in the poem under the skull, we can hazard that it was painted about the time he wrote his will in 1688, when he speaks of himself as "sick in body but … of sound disposing mind." The poem in the painting reads:

> Why why should I the world be minding
> Therein a World of Evils Finding.
> Then Farwell World: Farwell thy Jarres
> thy Joies thy Toies thy wiles thy Warrs
> Truth Sounds Retreat: I am not sorye.
> The Eternall Drawes to him my heart
> By Faith (which can thy Force Subvert)
> To Crowne me (after Grace) with Glory.
> T. S

Smith, who appears in records as a ship's captain, died a wealthy man. It is clear that he was an adept painter, aware of London trends. The painting is unusual in other respects. Self-portraits were rare in the colonies, where, generally speaking, no canvas was painted without money changing hands. The brooding introspection we see here is

3.16 **CAPTAIN THOMAS SMITH**, *Self-Portrait*, Boston, c. 1680. Oil on canvas, 24¾ in (62.9 cm) × 23¾ in (60.4 cm). Worcester Art Museum, Worcester, Massachusetts.

also very unusual. It is more likely to appear in a Puritan diary than in a portrait. Puritan grave markers often used the image of the skull to remind villagers as they passed through the churchyard of the transitory nature of life, the ever-present nature of death, and the final reckoning of one's acts in the afterlife. But this image is different. It portrays Smith as a recognizable individual who lived, observed, and ruminated. He is rendered alongside the skull that he would soon become.

However, other elements of the painting work against the emblematic skull and the poem about the fragility of life. The background ships, flying English and Dutch flags, appear to wage war against an Islamic foe, identified by the three crescents on the flag in the lower left. This battle probably took place on the north coast of Africa, where the Muslims who ruled the Barbary States were warring with Protestant navies. Smith's travels throughout the Atlantic world and his participation in this conflict testify to his worldliness, as do his elaborate lace neck cloth and his mastery, as a painter, of three-dimensionality and bodily presence. The poem, on the other hand, pleads for spiritual retreat from the seductions of earthly glory. Smith's self-portrait seems poised between medieval and modern worlds, between self-renunciation and pride in the achievements of the individual man.

# Hispanic Village Arts

New Mexico has produced a rich tradition of carved and painted religious art, which has embodied the communal and ethnic identities of Hispanic New Mexicans from the eighteenth century to the present. While preserving this tradition, however, the village arts of New Mexico have never been static. They have undergone continual revival, transformation, and adaptation in the face of changing historical circumstances. To understand this remarkable flowering of local art, we need to look at the forces shaping regional life in New Mexico, which from the sixteenth to the early nineteenth century was a colonial outpost of New Spain.

The two major colonizing powers in the New World—Spain and England—were both located on the periphery of Europe. Each assimilated the Renaissance revival of classical learning and the construction of perspectival spaces somewhat later than its neighbors. In colonial New Mexico, traditional habits of thought persisted alongside a pre-modern material culture. Anonymous carvers on this colonial frontier shared with the artists of seventeenth-century New England an emphasis on two-dimensional forms characteristic of

pre-Renaissance art. All this had changed in New England by the end of the seventeenth century, when trade with the Atlantic world introduced the English colonies to the latest European tastes. New Mexico's isolation, however—along with local preferences—preserved these older visual forms well into the early nineteenth century.

## The Santero Tradition

Beginning in the late eighteenth century, anonymous artisans known as *santeros* produced images of the saints (*santos*) for domestic and communal use. Placed in private family chapels, in village or mission churches, or in *moradas*—buildings dedicated to religious male confraternities—images of the saints were believed to act as intercessors on behalf of a household or village in times of need or crisis. They were (and still are) the object of daily household devotion and prayer.

**SAINT JOSEPH BY RAFAEL ARAGÓN.** At the same time, carved statues of the saints, or **bultos**, covered with gesso and painted, gave great spiritual immediacy to everyday worship in the villages of northern New Mexico. Rafael Aragón's *Saint Joseph* (**fig. 3.17**) bears the Christ child on his extended arm. In European painting, Saint Joseph is

3.17 RAFAEL ARAGÓN, *Saint Joseph*, c. 1860–62. Wood, 35¼ in (89.5 cm). Taylor Museum, Colorado Springs Fine Arts Center, Colorado.

traditionally depicted as an aged and frail figure. In this example, however, Saint Joseph appears as a youthful Spanish patriarch. He wields his flowering staff—emblem of his role as the Christ child's surrogate father—with the benevolent authority of a spiritual guide.

## Retablo Painting and the Santero Tradition

Paintings of the saints initially appeared as part of an elaborate architectural frame, placed behind or above an altar, known as a *retablo*. The major surviving example of the retablo in New Mexico dates from the early nineteenth century. It is located in the Church of San José, in Laguna Pueblo, which we have already examined as a fusion of Native and European forms (see Chapter 2). We now return to this church to consider the contribution of Hispanic, rather than Native, artisans.

**RETABLO AT SAN JOSÉ, LAGUNA PUEBLO.** Dating from between 1800 and 1809, the retablo at the end of the nave is the work of an anonymous itinerant artist known simply as the Laguna Santero, who was active in New Mexico from the 1780s until around 1810. Like many altarpieces, this one has been retouched. At the center of the San José

retablo is Saint Joseph, holding the Christ child. The tier above contains a representation of the Trinity (**fig. 3.18**): three identical figures carrying different attributes (scepter, dove, and lamb). This way of representing the Trinity may be traced to the medieval period, but had mostly fallen out of use by the Renaissance, as European Catholicism came to favor three distinct representations for the Father, Son, and Holy Spirit. The older image of the "Triune" Trinity (three in one) persisted, however, on the New Mexico frontier, a striking instance of a vernacular tradition with roots in the pre-modern past.

**SANTERO PAINTING.** Throughout the nineteenth century, the work of the Laguna Santero and other masters was extended and then modified by followers. Santero design became simplified and flattened, moving away from the illusionism of the eighteenth century to produce a quasi-abstract appearance. Working on pine panels with water-based paints similar to those employed by the Pueblo Indians, New Mexican santeros reconceived three-dimensional volume in linear terms. Forms were outlined in black, and colors were rarely shaded; draperies were rendered as a series of flattened patterns with minimal descriptive function (**fig. 3.21**). The key to this stylistic transformation lies in the international circulation of

3.18 Synchronous trinity, Church of San José, Laguna Pueblo, New Mexico.

# The Virgin of Guadalupe: Transnational Icon

KNOWN AS THE "MOTHER OF THE AMERICAS," Our Lady of Guadalupe (**fig. 3.19**) is the patron saint of Hispanic Catholics throughout Mexico and the United States. Reaching across national borders, she has evolved into a symbol of Mexican identity and an image connecting Mexican Americans throughout the Southwest. According to legend, a vision of the Virgin appeared before Juan Diego, an Indian peasant, outside Mexico City in 1531. Crowned with stars, surrounded by dagger-shaped points of light, her feet resting on a crescent-shaped moon, the dark-skinned Virgin of Guadalupe is a New World version of the much older European Virgin Immaculate, while also drawing upon objects of pre-Hispanic worship such as the Aztec earth goddess.

The meaning of Our Lady of Guadalupe has changed over time and according to context. Her popularity was initially a useful means of spreading Christianity among indigenous Mexicans (she spoke to Juan Diego in his native Nahuatl language). In the early nineteenth century, in the years surrounding the Mexican Revolution, she became a source for a distinct New World identity that focused on aspirations for independence from Spain. In the twentieth century, she developed into a symbol of ethnic pride that promoted solidarity during times of political and social struggle, guiding striking farm workers in California as well as offering protection to Hispanic communities across the Southwest. Mexican-American grocers have her image painted on storefronts; she adorns calendars, cars, earrings, and T-shirts, transcending religious affiliation. For feminist artists, she has come to embody the spirit of liberation. Yolanda López's *Portrait of the Artist as the Virgin of Guadalupe*, 1978, transforms the Virgin into a figure of independence and self-assertion (**fig. 3.20**). With her running shoes, frontal pose, and tight grasp of the snake in her hand (the snake is both a Nahuatl god and a Freudian symbol), López's Virgin leaps out of the picture frame and into the future. Rather than rejecting the past, she appears to carry it along with her. Each generation of Mexican Americans appropriates the Virgin of Guadalupe anew, adapting her image to meet the needs of particular communities and affirming their ties to the mother culture of Mexico.

3.20 YOLANDA LÓPEZ, *Portrait of the Artist as the Virgin of Guadalupe*, 1978. Oil pastel on paper, 32 × 34 in (76 × 61 cm). Collection of the artist.

3.19 THE TRUCHAS MASTER, *Our Lady of Guadalupe*, 1780–1840. Wood (pine) panel and water-based natural pigments, 25⅞ × 15½ in (65.8 × 39.4 cm). Taylor Museum, Colorado Springs Fine Arts Center, Colorado.

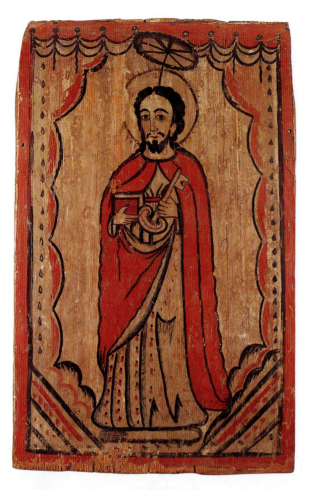

3.21 ARROYO HONDO ARTIST, *Saint Peter*, 19th century. Pine. Taylor Museum, Colorado Springs Fine Arts Center, Colorado.

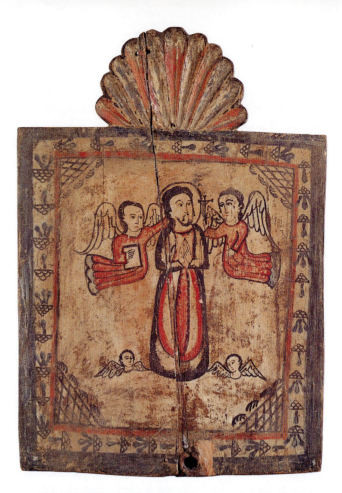

3.22 QUILL PEN SANTERO, *Saint Peter Nolasco*, c. 1830–50. Wood panel. 17⅜ × 12⅜ in (44.1 × 31.4 cm). Taylor Museum, Colorado Springs Fine Arts Center, Colorado.

printed matter. Santero painters relied on religious engravings of Mexican Baroque and Rococo art, which translated rich painterly effects into line. Tonal variation in prints was translated by both santeros and later provincial New England artists into flat blocks of color. New Mexican artisans transformed the swirling draperies, dramatic light effects, and immediacy of expression that characterized Baroque art in Europe and Mexico City into increasingly abstract, simplified, and immobile images of saints floating in non-perspective space. Their simplified forms reflect the linear shapes of illustrated books and prints.

**NATIVE ELEMENTS IN SANTERO PAINTING.** Some of these religious images are believed to be the work of Native American artisans. A painting from the early nineteenth century by an artist known only as the Quill Pen Santero, *Saint Peter Nolasco* (**fig. 3.22**), shows the Spanish saint ascending into heaven. The borders of the image are filled with clouds, but they are not the usual clouds of European art. Instead they are the Pueblo Indian symbol for clouds. Framing the saint's skyward ascent, these repeated Pueblo

symbols suggest how profoundly Catholic and Native traditions intermingled in the region's art.

# Architecture and Memory

Newcomers to the New World tended to be confident about their ideas concerning property, religion, land use, and settlement patterns. They were equally confident about architectural design, building materials, and construction methods. They knew how a church, a house, or a barn should look, and they knew how to build it. We all carry ideas about form and use in our heads: both how a structure looks and how it should be experienced. The room in which you are reading this text probably has straight walls that meet each other and the floor and ceiling at right angles; the doorways are rectangles. Although this geometry appears "natural," it is, in fact, cultural—that is, it is taught. Geometry does cultural work for us, reassuring us about rationality and giving our world predictability. It also connects us to the European building traditions imported to the New World in the seventeenth century.

## The Spanish in the Southeast: Saint Augustine

The Florida town of Saint Augustine is the oldest continuously occupied European settlement in the United States. It also has the distinction of being the first Catholic mission in North America. In 1565, "La Florida," as Saint Augustine was known, was settled by some eight hundred Spanish soldiers and colonists on the site of a Timucua Indian village. (It would be another forty years before English settlers would successfully colonize the mainland at Jamestown, Virginia.) Through a system of involuntary servitude, local natives provided much of the food, animal hides, and labor that the Spanish needed. Like the other towns of New Spain, Saint Augustine was a gridded, planned community.

For two centuries, Saint Augustine may have been the most multiracial colony in the history of New World settlement. It brought together Spaniards born in Europe and in the New World, farmers from Germany and the Canary Islands, imported to increase agricultural production, local Native people, Africans imported as slaves, and *mestizo*, or mixed-blood, peoples. The material remains of this rich fusion of cultures were largely destroyed, first by an Indian uprising in 1577, then by the sacking and burning of this Spanish outpost by the English adventurer Sir Francis Drake a decade later. However, recent archaeological work has revealed that Saint Augustine households used rough clay olive jars and finely painted Majolica pottery, both imported from Spain, as well as Indian pottery made by local people and by Indians farther up the coast.

The need for a strong military defense remained paramount throughout Spain's empire. In both North and South America, the Spanish built steep-sided stone fortresses in coastal cities that were vulnerable to pirate raids. From Havana, Cuba, to Veracruz, Mexico, and from Cartagena, Colombia, to Saint Augustine, Florida, fortress architecture was a key feature of Spanish settlement. These impressive structures, based on European military design, were built largely by African and Native American labor. Thomas Smith's *Self-Portrait* (see fig. 3.16) includes a four-sided fortress in the background similar to the ones that played a prominent role in the colonial wars of the seventeenth century (see fig. 3.9).

**CASTILLO DE SAN MARCOS, IN SAINT AUGUSTINE.** The northernmost point of the Spanish chain of fortifications is the Castillo de San Marcos, built during the last quarter of the seventeenth century in Saint Augustine (**fig. 3.23**). It replaced an earlier wooden fortress, which, after being beset by Indian attacks, marauding pirates, and pillaging Englishmen, finally proved inadequate. The castillo was based on Renaissance designs—a square with four bastions, one at each corner, surrounded by a moat—and built in a local stone called *coquina*. A porous mixture of shells and sand compressed by ancient glaciation, coquina was easy to quarry and shape. A Spanish military engineer oversaw the construction, employing slaves, convicts, skilled masons and artisans, and a large paid labor force of local Indians. The Indian laborers added significantly to the population of the colony, and spurred the development of new neighborhoods in Saint Augustine. With battered walls (sloping from the ground) 12 feet thick at the base to deflect cannon fire, the castillo represented a dramatic extension of the Spanish garrison plan and was among the most ambitious New World building projects of the seventeenth century.

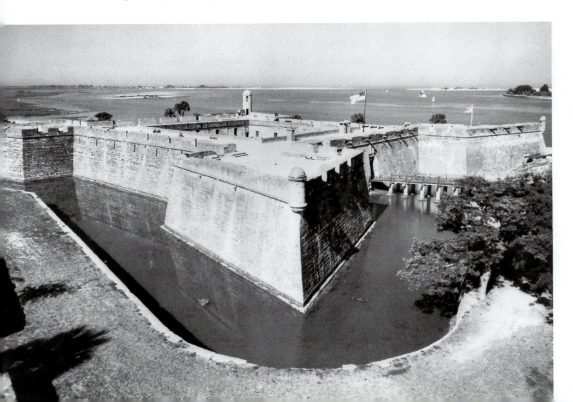

3.23 Castillo de San Marcos, Saint Augustine, Florida, 1672–87. Library of Congress, Washington, D.C.

## Building in New England and Virginia

The English Americans who settled the eastern seaboard colonies and moved inland along major rivers in the seventeenth century also carried their culture with them. They did so in two ways: physically, in the things they owned—lace and cattle, chests of drawers and sacks of grass seeds, Bibles and steel weapons—and mentally in the concepts they retained—field patterns, barn designs, artisanal secrets, and house plans. These objects and cognitive models were informed by ideas about design; they incorporated abstract principles and artistic practices that the colonists understood to be good, right, and practical.

Most seventeenth-century English Americans did not own paintings, nor could they find them in public places. Art museums were yet to be invented, and portraits were private family matters. But other forms of art—the grave markers that clustered in the churchyard, the straight rows in which crops were grown, and the built fabric of the settlement itself, with its town plan, fences, and architecture—these were art forms visible to and appreciated by all. We can know what these early immigrants thought by studying surviving buildings and contemporary descriptions, but also by examining old contracts, probate inventories, and town ordinances, and by conducting archaeological excavations. For the most part, colonists from the British Isles sought to replicate what they remembered from "home"—Protestantism (except in Maryland), comfortable family-based economic units, private ownership of productive resources such as land, and so forth. They also had occasion, in a few instances, to redesign familiar architectural forms afresh. The encounter between ideas of design imported as memory and new social and physical conditions resulted in structures that would have been recognizable to their countrymen back home, but that were also somewhat different. In the New World, wood and land were plentiful whereas labor was scarce, making wood roof shingles more practical than English thatch—a cheap material but very labor intensive to install. There were also environmental differences—the temperature range from about 0 to about 100 degrees Fahrenheit in New England, for instance, was greater than in northern Europe, increasing the potential for damage when construction materials expanded and contracted differentially, so lapped horizontal wood sheathing called clapboarding was routinely applied to building surfaces. This technology, which accommodates wide variations in temperature and humidity, was rare in the British Isles, where wood was scarce.

**HINGHAM MEETING HOUSE, MASSACHUSETTS.** The Puritans, who, in early-seventeenth-century England, had maintained a low profile as an embattled minority, were a majority in Massachusetts and ready to express themselves architecturally with an innovative building type, the meeting house. Meeting houses, unlike traditional churches, were designed as social and civic spaces as well as houses of worship. The Puritans felt that God could be experienced in any setting and that religion was best expressed without the ornate symbolism of traditional churches, with their steeples, crosses, and processional spaces. The meeting house dominated the settlement. New Haven's Meeting House, as we have seen, was placed at the center of the town, and was the largest structure in view (see fig. 3.6).

The one seventeenth-century meeting house that has survived is the Hingham Meeting House, just south of Boston (**fig. 3.24**). This Puritan place of worship was built of wood with clapboard siding. As originally built, it eschewed a steeple (added in the eighteenth century) and other signs of special usage, and did its best to look ordinary,

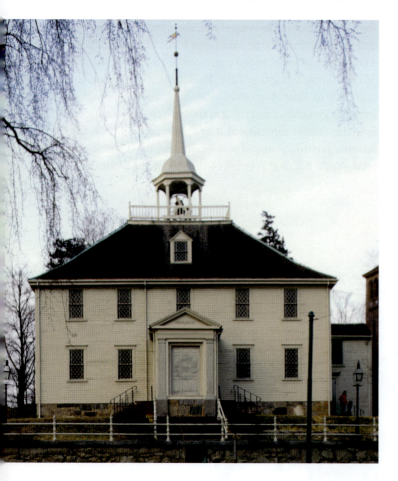

3.24 Meetinghouse, Hingham, Massachusetts, 1681; enlarged, steeple added, windows modernized, 1731, 1755.

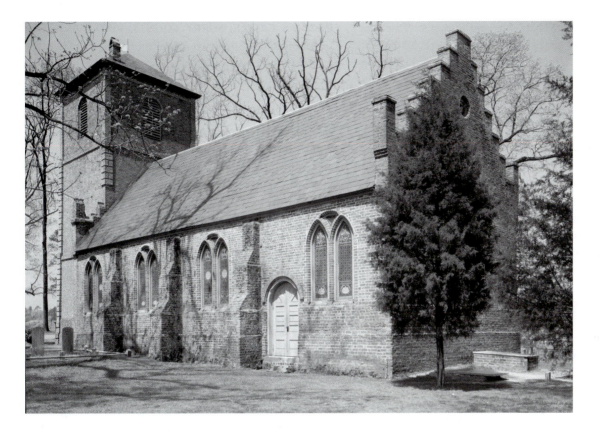

like a rather large square house. This plain look was echoed in the choice of vessels from which Puritans and their descendants, New England's Congregationalists, took Communion: the same cups and tankards that they used every day at home (see fig. 4.23). While choosing an "ordinary" look for the shape of their meeting houses, they nevertheless expressed their exuberance for color in the painting of both the interior and the exterior. Recent scholarship suggests that the color scheme for the Hingham Meeting House included yellow, blue, green, red, orange, gray, white, and pink.[1]

**SAINT LUKE'S CHURCH, SMITHFIELD, VIRGINIA.** By contrast, in Virginia the Church of England was the established church, and its buildings (and Communion vessels) followed age-old patterns. In fact, the seventeenth-century Saint Luke's Church, in Smithfield, Isle of Wight County, with its buttressed brick walls, square bell tower, and processional west entrance leading toward a great Gothic-style east window and altar table, could be mistaken for one of the small medieval churches seen throughout England (**figs. 3.25** and **3.26**). In terms of plan and overall form, the religious architecture of Virginia was not only more "European," it was also more similar to contemporary Spanish churches beginning to rise on the other side of the continent, than to those of their countrymen in New

3.25  St. Luke's Church (Newport Parish), Isle of Wight County, Virginia, 1632/1685(?).

3.26  St. Luke's Church interior, looking toward the east window, 1632/1685(?).

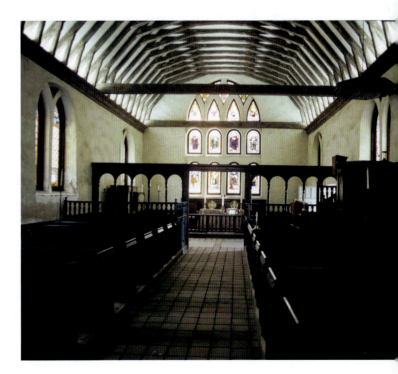

England to the north. New England Puritans refused the ritualized sense of space of both the Church of England and the Roman Catholic Church. Their meeting houses lacked the processional spaces of most European churches.

**HOUSES.** Most European-Americans spent their days and nights in modest one- or two-room houses, which served simultaneously as home for possibly four to ten people, workshop, and storehouse for artisan, merchant, and farm family alike. But unlike the tiny cottages with shared party walls clustered in tightly knit villages, which the colonists remembered from England, even the humblest home in the New World sat on its own plot of land—a new way of defining home and community that still affects the way Americans think about land and resources today.

**BACON'S CASTLE, SURRY COUNTY, VIRGINIA.** Few of the common one- or two-room houses survive from the seventeenth century (except where they have been later incorporated within larger structures), but dozens of the grander four- or even six-room homes that were built for ministers, merchants, and owners of large landholdings can still be found. One relatively grand colonial home still visible today is a four-room brick house with cross gables and dramatic "Flemish" end gables known as Bacon's Castle, in Surry County, Virginia (**figs. 3.27** and **3.28**), which was built c. 1655. Its windows have been altered, but it retains both its exterior footprint and interior plan—two rooms to a floor, flanking a cross passage linking an imposing entry porch and an equally prominent stair tower. Although the idioms of Bacon's Castle are specific to Virginia, the emphatic chimneys, steep gables, and two-rooms-to-a-floor plan are common to surviving homes of this size throughout the English colonies.

**WARD HOUSE, SALEM, MASSACHUSETTS.** The largest number of surviving seventeenth-century houses is to be found in Massachusetts. Characteristic is the John Ward House of Salem, Massachusetts, begun in 1684 (**fig. 3.29**). Like Bacon's Castle, it has steep gables and a decorative chimney, echoing the basic late-medieval English architectural vocabulary. Dramatic cross gables (triangular wall sections placed at 90-degree angles to the roof), the deep shadow of a second-story overhang, or "jutt," small diamond-paned casement windows, and an envelope of overlapping clapboards are characteristic of New England houses. As in Virginia, the house has its two principal rooms on the ground floor (here divided by a behemoth chimney stack rather than a cross passage) with two chambers above, and dormer-lit garrets tucked under the roof. The ground-floor rooms in seventeenth-century houses were identified as a "hall" and a "parlor." In the former, inventories locate cooking equipment, drinking vessels, dairying equipment, and sometimes bedding; in the parlor, inventories list the highest-value bed, the most expensive furniture, and the finest eating equipment. The hall served as a combination eat-in kitchen, multipurpose workroom, and, in smaller homes, also a bedroom, while the parlor was what we would call the master bedroom, but also an entertaining space. Chambers (rooms above the hall and parlor) usually contained bedding, but they also frequently contained textile processing equipment, such as a spinning wheel, along with wool and yarn. Inventories indicate that the unheated garrets contained more bedding, but these spaces were also used for the storage of grain and other foodstuffs. In other words, almost every room was used for both sleeping and working.

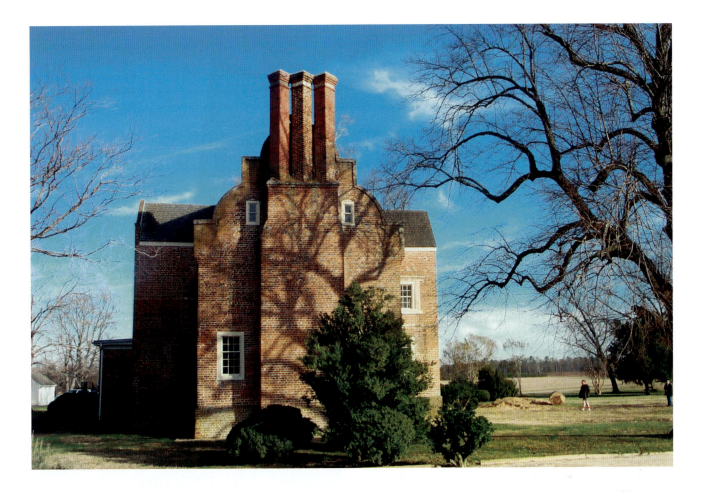

3.27 (above) Bacon's Castle from the west, Surry County, Virginia, c. 1655. Association for the Preservation of Virginia Antiquities, Richmond, Virginia.

3.28 (below) Plan of first floor of Bacon's Castle (redrawn by Cynthia Cobb), Surry County, Virginia, c. 1655. Library of Congress, Washington, D.C.

A house the size of the Ward House, while unexceptional today, indicated wealth and social position in seventeenth-century North America, even though it might house seven or eight people, including a multi-generational family, apprentices, and indentured servants. Average houses consisted of one room (18 by 18 feet) with a chamber or half-story dormer room above. Large homes, such as the Ward House, built by New England communities for their ministers or by wealthy merchants to house themselves and their businesses, were often 38 by 20 feet and consisted of two full stories totaling four rooms, plus a garret. The lack of privacy, in which all sleeping chambers and most beds were shared and work was done in equally tight quarters, apparently did not cause major problems among the disparate class, age, and gender cohorts, governed by well-understood systems of authority and deference. When more money became available, homeowners invested in land, livestock, and luxury goods rather than in additional living space.

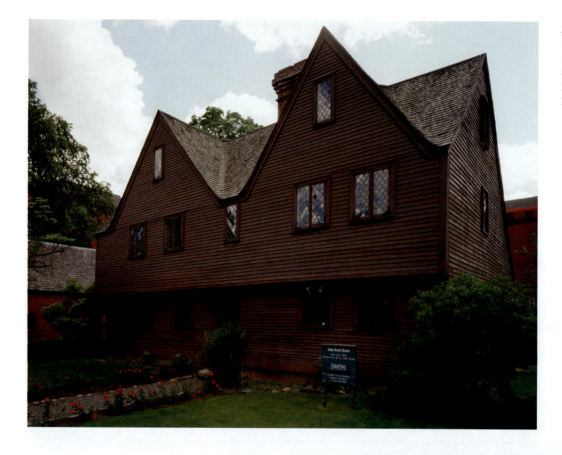

## FAIRBANKS HOUSE, DEDHAM, MASSACHUSETTS.

Perhaps the most remarkable architectural survivor from seventeenth-century Massachusetts is the Fairbanks House, in Dedham (a town originally named Contentment). Built in the early seventeenth century by Jonathan Fayerbanke, a wool merchant from Yorkshire, it still remains in the Fairbanks family today (**fig. 3.30**). Fayerbanke emigrated to America at the age of forty in 1633 with his wife, Grace, and six children. He hired a master builder to construct the central four-room-plus-garret house in 1636–37. Soon after, he added an unheated lean-to (a fireplaceless back room with a shed roof reaching almost to the ground), and by 1654 the house was extended on both ends by a pair of houselets (each one room plus dormer room above) for two grown married sons. The Fairbanks family was near the top of the social scale. The house was assessed at £28 in 1648, when it was the eighth-highest in Dedham; but three years later, Jonathan's son Jonas was prosecuted under local sumptuary laws and fined for "wearing great boots" before he was worth £200. Puritan New England patriarchs kept a close eye on their families, and the town elders kept a close eye on the patriarchs. Studying town plans such as that of New Haven and house plans such as the Fairbanks house helps us understand how this was done.

## Reading Architectural Plans

ARCHITECTURAL PLANS and elevations are line drawings used to describe architectural form. They provide accurate to-scale visualizations of certain aspects of buildings, such as the thickness of walls and the relationship of elements within a structure. They communicate information that the architect wants the builder to know, and that the architectural historian wants his or her readers to understand. Architectural plans and elevations follow conventions that are very useful to learn. A "plan" is a horizontal slice (or section) as seen from above. It describes the "footprint" of a structure—that is, the pattern its external walls make on the ground and the arrangement of interior walls. An "elevation" is an exterior side view of a structure. Sectional elevations can reveal interior relationships that may be invisible in ordinary elevations. They describe materials and measure the relationships of walls, windows, and doorways. Occasionally they also describe surface details, even furnishings. Partial drawings are called "details."

With its lean-to behind and its gambrel-roofed additions to either side, the Fairbanks House grew, as most such late-medieval houses grew, by expanding outwardly in three directions in response to social needs. The house passed through six generations of Fairbanks owners with few changes except for the replacement of casement windows by sash windows (allowing more light into the interior). In 1832 it passed to a widow with three unmarried daughters, and later to a niece, who lived there until 1903. This unusual chain of unmarried female custodianship resulted in a delicate balance: there was apparently just enough means available to keep the house intact but not enough to spur renovations and modernizations. By 1903 the house was regarded as a rare relic of the colonial past, and it became the focus of family, regional, and national antiquarian curiosity. Indeed, in the late nineteenth century the long sloping "cat slide" roof of this and similar early colonial structures inspired the development of one of America's most original and successful architectural movements: the Shingle Style (see Chapter 9).

**STYLE AND SUBSTANCE.** Seventeenth-century architecture in English North America was a product of stylistic memory (Gothic east windows, steep roofs, decorative chimneys), accommodations to local conditions (severe weather, ample wood, and the shortage of labor), and socially eloquent patterns of use (who slept or worked or ate where, in proximity to what kinds of goods and people). It was also a product of important ideas concerning the role of the master builder (trained as a craftsman, on the job, by a master builder of the previous generation), the skills of the joiner (fabricator of the individual mortise-and-tenon joints of which the building's frame was composed), and the strength of the massive wooden beams fastened into cooperative service by wooden pegs called trunnels. The engineering that gave the structure stability and shape is visible from the interiors of these structures—as we can see in the roof truss of Saint Luke's, for instance (see fig. 3.26), giving all parts of the structure, but especially ceilings, an aesthetic of muscular, functional candor.

3.30 Fairbanks House, Dedham, Massachusetts, 1636, 1654, lean-to added before 1668.

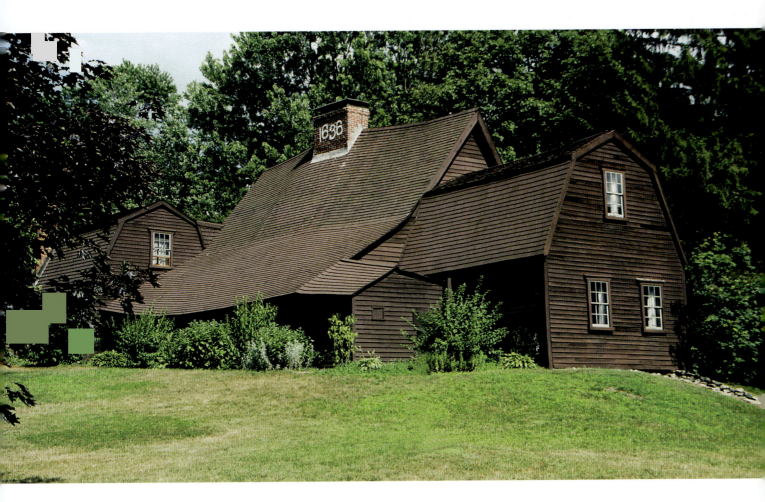

# Design, Material Culture, and the Decorative Arts

Seventeenth-century settlers from the British Isles brought with them chests and needlework patterns, tools, and velvet cloth. They also brought ideas about how to live. They equipped their houses with furnishings that appealed to the eye. The objects that have survived—furniture, textiles, and silver—suggest a preference for intricate patterns, rich textures, and bold contrasts.

## The Seventeenth-Century Interior

**Figure 3.31** shows a group of surviving seventeenth-century objects assembled in a seventeenth-century room installed in a twentieth-century museum. The low ceiling (with heavy beams and joists), the bare, wide floorboards, and the combination of furnishings for eating, sleeping,

3.31 Seventeenth-century room, Winterthur Museum, Winterthur, Delaware.

working, and storage are typical of the period. The cavernous fireplace surmounted by a massive girt (or structural beam) is characteristic of the hall, the room where most cooking was done and where the household gathered for meals, work, and prayer. Two centuries later the idea of the kitchen/hall with its dramatic hearth was seized upon by historically minded architects looking for symbols of American authenticity. Family rooms today are frequently equipped with fireplaces—not as shrines to outmoded cooking and heating technology, but to suggest the aura of wholesome virtue and community that the wood-burning fireplace has come to symbolize in our culture.

**THE CHAIR.** In furnishing their seventeenth-century hall, the curators of the Winterthur Museum have included one armchair, two side chairs, and a long bench, suggesting what we know from other sources, such as probate inventories: that the armchair was available only to the head of the household. Side chairs (called back stools) were sometimes available to other senior members of the household, but most ate and worked on benches and stools. Young children stood to eat, a signal of their deference and

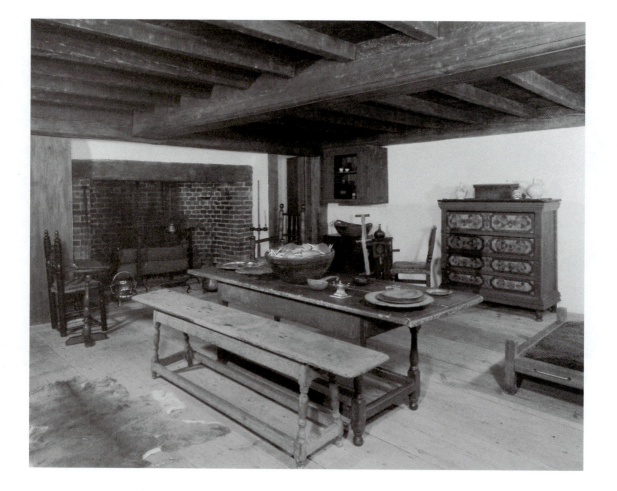

# Theories of architectural preservation

TWO SCHOOLS OF THOUGHT exist about the way historical buildings—whether private homes or house museums open to the public—should be treated. The first, dominant in the early and mid-twentieth century, privileges the original structure, removes all subsequent additions and modifications, and recreates "accurate" (but brand new) parts in order to simulate the original. The second, more recent school of thought believes that every era in the life of an historic structure plays a significant role in its story. Thus architectural adaptations tell critical stories about evolving attitudes, shifting technology, and economic vicissitudes. They are left intact as much as is reasonable.

dependence. The term "chairman" derives from this seating arrangement. Some of these magisterial seventeenth-century armchairs have survived, including the Pierson chair at Yale, official seat of the college's president (**fig. 3.32**). Even softened by feathered pillows, which would have made it more comfortable, the Pierson chair is uncompromisingly upright.

**THE COURT CUPBOARD.** Similarly foursquare and crafted of sturdy oak, the furniture form known as the court cupboard speaks a language of geometric solidity, but with surface elaboration (**fig. 3.33**). Like the John Ward House (see fig. 3.29) (the sort of prosperous home in which such an object would be found), this court cupboard sports giddy overhangs, emphasized by pendant drops. The flat top, the shelf lying on stretchers at ankle height, and the canted corners on the middle section provided places to display pewter, ceramic, and silver objects. More important, the volume enclosed in the middle section served as lockable storage for these and other valuables. Locks are

3.32 Wainscot Chair, 1640–60. White oak, 41¼ × 20¹⁵⁄₁₆ × 13⅞ in (104.8 × 53.2 × 35.2 cm). Yale University Art Gallery, New Haven, Connecticut. Gift of John E. Bray.

3.33 Court cupboard, Massachusetts, 1667(?). Winterthur Museum, Winterthur, Delaware. Bequest of Henry Francis du Pont.

one of the most telling design features of case furniture—chests, boxes, desks, and chests of drawers—made in the seventeenth- and eighteenth-century colonies. The introduction of locks in case furniture goes hand in hand with the new importance attached to privacy and personal property during this period. Whether imported or made locally, crafted objects were prized (and coveted) for their workmanship, their design, and, in the case of silver, gold, and textiles, their materials.

**A SILVER SUGARBOX.** Of all the New World crops that variously contributed to the seventeenth-century global economy (tobacco), increased human longevity (potatoes), and spurred radically new agricultural practices on every continent (corn), the only one that was memorialized with an important art form is sugar. Using silver mined by Native peoples of the western parts of Mexico, minted into doubloons in Mexico City, and often commandeered off

treasure ships bound for Madrid by enterprising colonial privateers, the silversmiths of Boston, New York, and other colonial towns crafted objects of use and visual pleasure (**fig. 3.34**). As large as a football, the sugar box made of Mexican doubloons by Boston silversmith Edward Winslow, to keep and transport precious table sugar grown (as sugar cane) and refined in the Caribbean, uses the vocabulary of European aristocratic forms to lend dignity to his New England patron's table. The natural world is represented on the surface of this intricately wrought object by dense patterns and highly stylized foliage, in this case acanthus leaves around the top and rising from the feet. On the hasp, Saint George, the patron saint of England, gallops, sword-aloft, in quest of dragons. This sugar box is a cross-cultural object representing the travel

3.34 **EDWARD WINSLOW**, Sugar box, Boston, 1702. Silver, 5½ in (13.9 cm) high. Winterthur Museum, Winterthur, Delaware.

of materials, people, and design ideas all over the Atlantic. Like the shimmering silver buttons on John Freake's coat (see fig. 3.13), such objects glittered and made resplendent the dark interiors in which they played the part of money-made-useful-and-beautiful. Because silver was a currency as well as a craft material, silversmiths functioned as both bankers and artisans for their clients. Their crafted objects are among the most important works of art surviving from the seventeenth century. Today we tend to esteem easel painting over other art forms, but in the seventeenth century—as itemized inventories make clear—this sugar box (like the court cupboard discussed above) would have been much more highly valued than John Freake's portrait.

We know that this sugar box—one of a half dozen surviving examples from the decade around 1700 in New England—was made by Edward Winslow because American silver was customarily stamped with the mark of its maker. The maker's stamp served as guarantee of quality in a product in which adulteration with lesser metals was not easily detectable. By contrast, no warranty was necessary for paintings, so they are unsigned. This is not because the silversmith was proud of his work while the painter was not; it is because silver objects were valued by weight. The maker's stamp guaranteed that the alloy was as reliable as the craftsman's name.

## Textiles

Textiles, including objects of clothing and bedding, were among the most valued household possessions; but most, due to their fragility, have disappeared. Before the Industrial Revolution reduced the cost of cloth and clothing, a person's dress indicated his or her social position. One's clothes were part of one's social identity and expressed one's authority and station in life. Seventeenth-century clothing transformed the body into a carefully crafted social document; a person's status was rendered legible through art and costume.

**EMBROIDERY.** Women in England had produced fine needlework since the Middle Ages. Beginning in the sixteenth century, they were aided in this art by the publication of many pattern books of stitches. The women who settled eastern North America in the seventeenth century brought these needlecraft skills with them, as well as the steel needles that made such work possible. One rare American example of a popular English object is an embroidered cabinet (**fig. 3.35**). This small chest, with embroidered panels inset on every exterior surface, is said to have been made by one or more of the daughters of

3.35 THE DAUGHTERS OF GOV. JOHN LEVERETT, Embroidered cabinet with original wooden case, c. 1670. Silk, linen, metallic threads and braid, wood, gilding, gesso, and brass, 12 × 10⅞ × 7½ in (30.4 × 27.6 × 19 cm). The Peabody Essex Museum, Salem, Massachusetts.

Governor John Leverett of the Massachusetts Bay Colony, probably in the 1670s. The wooden box itself may have been sold in kit form, leaving the embroiderers to choose the imagery to stitch on the fabric panels. The workmanship exemplifies the artistic accomplishments of cosmopolitan young women who, born in Massachusetts, traveled to England while their father represented the colony at court. They brought back to the New World the latest in artistic fashions, and may even have started to embroider their cabinet on the long sea voyage home. The large panels on the doors depict the Old Testament theme of the presentation of Esther to Xerxes, the Persian king whom Esther persuaded to spare the lives of the Jews in his kingdom. The scene of a sailing vessel and a rowboat on the sloping front panel probably alludes to the Leveretts' transatlantic travel.

More common in this era is the sampler, a literal "sampling" of stitches that shows off the technical virtuosity of a young embroiderer. The first American samplers closely followed their English prototypes: long, narrow strips of linen in which many different stitches and patterns

3.36 MARY HOLINGWORTH, Sampler, Salem, Massachusetts, c. 1665. Linen with silk floss, height 25 in (63.5 cm), width 7½ in (19.5 cm). The Peabody Essex Museum, Salem, Massachusetts.

were worked in bands across the cloth, usually including the name of the maker, the date, and a Bible verse or moral admonitions. Designs on seventeenth-century textiles, furniture, and silver exhibit a tendency toward serial patterns, abundant decorative motifs, and abstracted floral forms. Mary Holingworth's sampler (**fig. 3.36**), with its geometric designs and linear outlines, exhibits this preference for nature transformed by civilization. The sampler suggests one reason why the Puritans did not commission landscape paintings. For them, nature was good only in proportion to its regularization by art, craft, and ingenuity.

**A NATIVE BASKET.** Very few examples remain of seventeenth-century Native American arts from the eastern seaboard. This is partly because many of the materials used in Native art were ephemeral, and partly because Native—and later, African—labor was largely subsumed within European goods and economies. Their work became invisible. Examples of seventeenth-century objects made outside the English community but preserved within it are rare. A small basket made in 1676 in Rhode Island by an Algonkian woman uses traditional upright form and weaving techniques (**fig. 3.37**). But woven in with the tree bark and grasses are threads of red and blue wool, unraveled from a trade blanket and introduced here to produce a work of startling chromatic and ethnic interweaving. Baskets are fragile, even when their design and execution exhibit considerable expertise. The survival and documentation of this small object evidence the high value placed on it by the Englishwoman to whom it was given, and a sense of historical obligation toward it on the part of her descendants. The integration of Native with English materials, as well as the basket's movement from one people to another and its deliberate preservation, testify to its hybrid quality and its unusual status as art within an English community.

## The Carver's Art: Colonial New England Gravestones

Puritan gravestones represent colonial America's earliest tradition of surviving figural sculpture. The first grave markers may have been simple wooden posts, followed by upright slate stones incised with simple names and dates. By the end of the seventeenth century, however, a distinctive style begins to appear in the carvings on New

3.37 UNKNOWN ALGONKIAN WOMAN, Basket, Providence, Rhode Island, 1676. Bark. Rhode Island Historical Society.

England gravestones: allegorical and emblematic figures exhort the beholder—and perhaps the deceased—to focus on the hereafter. Over time, this style spread south into other colonies.

## "THE CHARLESTOWN STONECUTTER."

"THE CHARLESTOWN STONECUTTER." Foremost among the carvings of the late seventeenth century is the gravestone of Joseph Tapping. The creator of the Tapping gravestone did not leave a mark or signature. He is known today simply as "the Charlestown Stonecutter," and is believed to be the first master gravestone carver in the Boston area (p. 56).

Tapping's 1678 monument, with its profusion of English iconography, is an allegory of Puritan beliefs about death. The design comes directly from a popular English emblem book published in 1638 by Francis Quarles. The skeleton at the bottom seeks to snuff out the candle of life, while Father Time, holding an hourglass in his left hand, restrains him. These personifications of death and time derive from earlier medieval sources. Emblems such as the skull, arrow, portals, hourglass, and winged head occur repeatedly on later eighteenth-century gravestones. Most common were stones with a winged skull or cherub's head at the top, and various ornamental scenes framing the epitaph.

Like the Puritan sermons and literature of the day, such imagery admonished the pious and sinners alike to consider their souls. On the Day of Judgment, the righteous would join God in heaven; all others would burn in eternal damnation. The common Latin phrase *memento mori* (be mindful of death) cautioned against wasting time with vanities, for only the righteous would face the Last Judgment with God's grace.

**THE LAMSON FAMILY CARVERS.** In the first quarter of the eighteenth century, at least thirteen stonecutters were producing gravestones in greater Boston, some learning their craft in family workshops. Carvers earned high wages, and many became prosperous, filling commissions outside their local territories. In Charlestown, Massachusetts, Joseph Lamson, one of the most skillful early carvers, had two sons, Nathaniel and Caleb, who apprenticed in his workshop. Nathaniel Lamson carved fine gravestones while still in his teens (**fig. 3.38**). In Jonathan Pierpont's grave marker, 1709, Nathaniel expertly uses the iconographic formula set down by his father. A winged skull fills the curved section at the top. Below this, on either side of an hourglass representing the sands of time as they run out, small figures (sometimes called "death imps") carry shrouds. Small plaques—like miniature gravestones themselves—are inscribed with Latin phrases familiar to the pious: *memento mori* and *fugit hora* (the hours are fleeting).

On the side panels, the carver demonstrates his virtuosity. Here, the rounded tops, or finials, contain frontal portraits of males with prayer books—probably stylized representations of Pierpont, who was a minister. The Lamson carvers were innovative in this use of portraiture on gravestones. Beneath are flowers, rosettes, scrolls, and leaves—an ornamental vocabulary shared with seventeenth century furniture and needlework, as we have seen. Such ornaments became popular in sixteenth-century England, when German and Flemish woodworkers emigrated from the Continent and subsequently influenced furniture design.

The central panel of the headstone was reserved for information about the person being memorialized. On the Pierpont stone, it focuses on the life and work of minister Jonathan Pierpont. Other stones often contained cautionary phrases: *Dear Friends, for me pray do Not Weep/ I Am Not Dead but here do Sleep/ And here In Deed I Must Remain/ til Christ Shall Rais* [sic] *Me Up Again.*

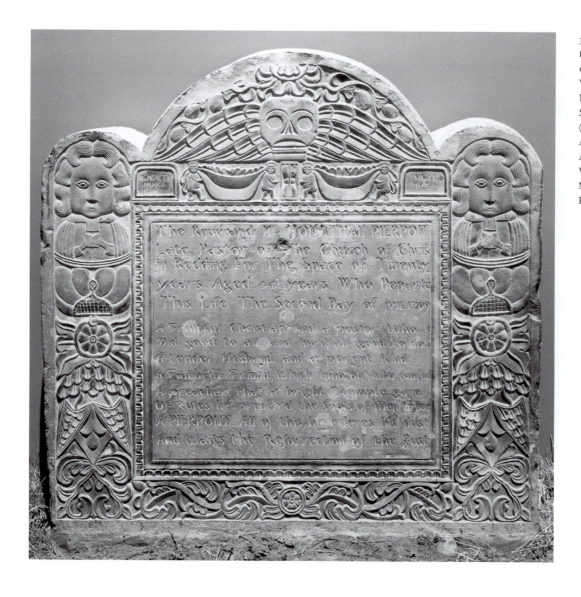

3.38 NATHANIEL
LAMSON, Gravestone
of Jonathan Pierpont,
Wakefield,
Massachusetts, 1709.
Slate, 30 × 27¼ in
(76.2 × 69.2 cm).
American
Antiquarian Society,
Worcester,
Massachusetts.
Farber Collection.

# Representing Race: Black in Colonial America

Visitors today to the British Museum, in London, may discover an odd fact. A seventeenth-century drum housed in the museum's collections is not what it appears to be (**fig. 3.39**). The drum displays all the signs of West African craftsmanship. The indented base, cylindrical body, pegged membrane, and decorative carving resemble drums made by the Asante peoples of Ghana. A glance at the museum label, however, reveals that the drum does not come from Africa but from colonial Virginia. It was collected by British agents in the New World and then acquired by the London physician Sir Hans Sloane in 1645. Sloane's acquisitions form the nucleus of what would subsequently become the British Museum.

Labeled simply "Slave Drum," this object tells a remarkable story. It suggests how African cultures survived far beyond the boundaries of that continent. Made from West African wood, it must have been brought to North America, perhaps by its maker, a woodcarver captured in Africa, who was shipped across the Atlantic and enslaved in Virginia. A woodcarver enjoyed elevated social status in many West African cultures, and probably possessed such status among fellow slaves. The drum was used for dance, rituals, and musical talking: with its deerskin head, it reproduces the rhythms and tones of Asante speech. Many European colonists feared African drumming, interpreting the music as a call to rebellion, and sought to ban it.

To a black audience, however, drumming signified the continuity of African identity. It bound the Old World to the New, bringing familiar cultural forms into unknown situations. Objects like the Slave Drum allowed peoples

3.39 UNKNOWN ASANTE CARVER, Drum, Ghana, late 17th century. Height 18 in (45.7 cm). British Museum, London.

abducted from their homelands to sustain practices and memories that without such artifacts they might otherwise forget. The survival of particular West and Central African customs depended on artisans who could remember the past and refashion it in America. Over time, these artisans adapted new materials—different woods and fibers—to altered ends, transforming objects of the African diaspora into African *American* art.

## The First Africans in America

The first enslaved Africans imported to North America came by way of the West Indies and the Caribbean. In 1619, John Rolfe, a Virginia tobacco planter, noted the arrival of "20 and odd Negroes, which the Governor ... bought [in exchange] for victualles." Slavery was not unique to the New World. Arabs and Europeans had owned slaves centuries before the discovery of the Americas, and Africans enslaved other Africans from different ethnic groups. No group, however, desired to enslave members of its own religion. Arabs turned to sub-Saharan Africa for slaves who were neither Christian nor Muslim. They purchased these slaves from African tribal lords, who

provided European slave traders with an abundant supply of fellow Africans, often captured in raids upon rival tribes. In Arabic, the word for slave, *abd*, became synonymous with "black man."

British North America slowly adopted the slave practices of the Spanish and Portuguese. In the colonies, the English first tried to use the Indian population as a source of cheap labor. In early Carolina, settlers encouraged Indians to "make War amongst themselves," so that white planters could purchase captives enslaved by other Natives as trophies of war. The Natives, however, made poor laborers. Indian men refused to engage in agricultural labor, which they considered women's work. Because they knew the countryside better than their white captors, they readily escaped. Furthermore, the intertribal warfare that the English encouraged too often developed into Indian attacks upon white settlements.

**COLONOWARE.** Throughout the South, contact between African slaves and Indians was frequent and one result of this was a form of pottery called colonoware, which combined ceramic traditions of both cultures. Colonoware (named after the colonial period, when it was manufactured) is a type of handmade ceramics fired over low heat (hearths rather than kilns). This pot from the eighteenth century was found buried in the mud of the Combahee River at Bluff Plantation, South Carolina (**fig. 3.40**).

3.40 Colonoware jug, Combahee River, Bluff Plantation, South Carolina, 18th century. Low-fired, hand-built earthenware, 10¼ × 10 in (26 × 25.5 cm). South Carolina Institute of Archeology and Anthropology, University of South Carolina, Columbia.

The decorations resemble African patterns, but they are incised onto a pot shaped in an Indian style. Colonoware was used by masters and slaves alike. Its hybrid form suggests one way that traditional artifacts acquire new meanings through cross-cultural contact.

## The Descent into Race-Based Slavery in America

When African and African Caribbean slaves first arrived in English North America, they were treated by the same rules that governed indentured servants. They worked for a contractual period of four to seven years, and upon the completion of their indentures, they were granted their freedom and the right to own property. Like workers from the British Isles and continental Europe, these African laborers were viewed as members of a vast multiracial labor force.

Within a scant forty years, however, the status of African slaves changed. Labor-intensive crops like tobacco and, later, rice, together with a shortage of workers, led European planters to declare Africans "chattel." While indentured servants from Europe were free to start afresh after completing their contracts, Africans lost whatever legal rights they had possessed. They were considered, instead, to be hereditary property held in perpetuity by their owners. In 1661, the Maryland legislature declared slavery to be a lifelong status. Virginia followed suit in 1670. Over the next several decades, English North America developed the legal scaffolding necessary to support a racialized and increasingly repressive system of slavery. That system would stand for the next two hundred years.

**TWO AFRICAN AMERICAN SLAVE SCULPTURES.** Two artifacts surviving from colonial times demonstrate the persistence of West and Central African forms and memories in the everyday life of American slaves. A wrought-iron figure from the late eighteenth century of a standing man with outstretched hands, flattened chest, and elongated torso was discovered in a blacksmith shop in the slave quarters on the site of a plantation in Alexandria, Virginia (**fig. 3.41**). The figure had been buried in the dirt floor, which suggests that it might have been hidden from sight and used for ritual purposes. It duplicates almost exactly figures produced by the Mande peoples of Mali, who were known for their blacksmithing skills.

In a parallel vein, a runaway slave in the eighteenth century carved a pine figure holding a rounded vessel (**fig. 3.42**). The forward thrust of the seated man's arms and thighs is balanced by the verticality of his torso and lower

legs. His stability and bodily repose, when combined with his abstracted features, form a sculpture of remarkable dignity. Seated figures like this one derive from Congo (Central Africa) carving traditions.

As enslaved Africans were denied legal rights, they were also denied their heritages. Early slave traders had distinguished groups of Africans by terms like "Angolan," "Calabar," "Nago," and "Koromanti" (a term to describe first- and second-generation African-born slaves). Though imprecise, these terms acknowledged differences among the peoples of West and Central Africa. However, with the

3.41 Standing figure, late 18th century. Wrought iron, 11 in (27.9 cm) high. Adele Ernest Collection, Stony Point, New York. Smithsonian Institution, Washington, D.C.

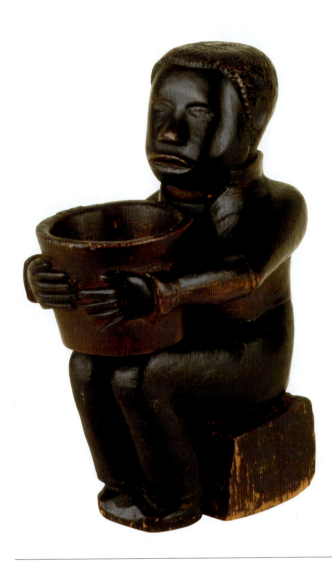

passage of time and the consolidation of slavery, most traders reverted to simpler and more racially charged terms, "Negroes" (from the Spanish word for "black") or "blacks." This shift in terminology imposed a fiction of sameness on all slaves at the same time as it rendered the division between black and white absolute.

As recognition of the multiplicity of African cultures disappeared, so did respect for the African American's humanity, to be replaced by a pejorative notion of blackness adapted from medieval characterizations of the devil (as a black man). This attitude ignored the diversity of African peoples, languages, and customs, and lumped Africans together as a childlike, inferior, even depraved race. Thus the series of social, legal, and political steps taken to obtain and exploit cheap labor developed into a system of race-based enslavement and segregation that seemed preordained and universal. In the course of little more than a century, racism became institutionalized.

3.42 Seated figure vessel, 18th century. Pine. Abby Aldrich Rockefeller Folk Art Museum, Colonial Williamsburg Foundation, Williamsburg, Virginia.

# Conclusion

During the seventeenth century, European powers endeavored to maintain their empires in North America. They did so both defensively (to prevent other nations from acquiring too much power) and offensively (to extend their wealth through trade and colonization). In vying for territory, however, they accomplished more than they had intended. English settlers along the eastern seaboard brought their memories as well as their weapons. They designed towns and buildings that reminded them of home. They crafted objects that expressed their penchant for geometric forms and rational order.

So, too, among the Spanish priests and soldiers in the Southwest, who shaped their missions and fortresses according to memories of what they had left behind. They expressed their nostalgia for European Catholic culture in outcroppings of medieval forms, holdovers from an earlier time.

For Africans, involuntarily brought to the New World, the story was far more fraught. Over the course of the seventeenth century, enslaved Mande, Fulani, Wolof, and other West African peoples were stripped of their local and tribal identities and recast simply as "Africans" or "blacks," terms that were generalizing and anonymous. Slavery grew as the demand for cheap labor increased, fueled by the rise of labor-intensive crops like tobacco. For them, the past stayed alive through objects, images, and customs that embodied shared values and helped maintain a sense of the local and tribal identity stripped from them by their masters.

What brought all these peoples into collision was a newly emergent world economy tied to European imperial ambitions. That global economy would continue to grow in the coming century, producing unparalleled demands for new goods and products. As we shall see in the next chapter, the seeds of empire planted in the seventeenth century would bear fruit in the new consumer economy of the eighteenth.

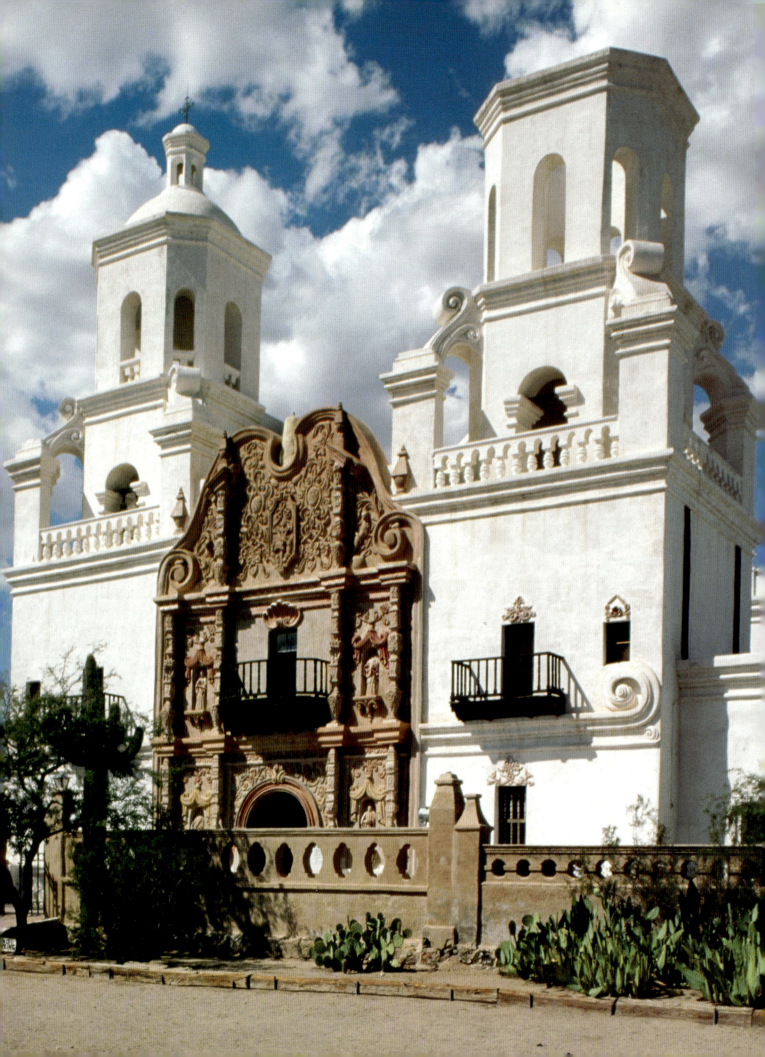

# 4 | Late Colonial Encounters: The New World, Africa, Asia, and Europe,

## 1735–1797

THIS CHAPTER IS ABOUT colonial culture at its zenith, before the American colonies became a nation. It is also about early consumerism. During the second half of the eighteenth century, patterns of consumption in the colonies changed dramatically. European Americans—especially of the upper classes—developed increasingly sophisticated tastes. They supplemented locally made products with more expensive imported items. Rather than drink cider made from local apples in wooden cups or pewter tankards they preferred to sip imported tea from a delicate cup of Chinese origin, poured from a teapot made of Mexican silver. This preference for "high end" items suggests the ways colonists shifted gears over the course of the eighteenth century: they developed a new taste for luxury objects, dependent on international commerce.

Life in colonial America was increasingly saturated with objects from elsewhere. Imported items were adapted for domestic needs, and foreign goods were imitated in local materials. These combinations yielded objects that were sometimes new, sometimes traditional, and always expressive of cultural change and adaptation.

We examine this pattern of contact and exchange—and the new types of art that it produced—through a variety of lenses. We look first at the world of Africans and those of African descent in North America. Despite enslavement, Africans carried memories of their homeland with them. They blended African forms, objects, and architecture with New World materials. At the same time that African

Americans were adapting to their changed circumstances, European Americans were planting their feet ever more firmly on North American soil. As they did so, they kept a steady gaze over their shoulders at developments across the ocean. In the Southwest, Spanish-speaking populations looked south to Mexico as they adapted past forms to present conditions. What they found—or remembered—drew on even older traditions of Muslim–European contact in late-medieval Spain. This, then, is our story: the memory of African customs and artifacts among enslaved and free blacks; the remarkable marriage of Catholic, Muslim, and Native American traditions across the Spanish Southwest; and the centrality of global trade and European fashion among colonists up and down the eastern seaboard. It is a tale first about slavery (how a global export market depended upon a labor-intensive economy); then about taste (how trade allowed for ever greater levels of "refinement" among colonial elites); and finally about class (how new social divisions fueled higher levels of consumption).

## The African Diaspora

A watercolor from the end of the eighteenth century suggests how African traditions survived in the New World (**fig. 4.1**). The image shows two groups of figures clustered in front of slave cabins. Joining the figures in the center is a barefoot dancer who holds a wooden stick or cane in his two hands. Dancing barefoot with sticks and scarves was a custom among the Yoruba of southwestern Nigeria. It is

(opposite) San Xavier del Bac, near Tucson, Arizona, 1783–97.

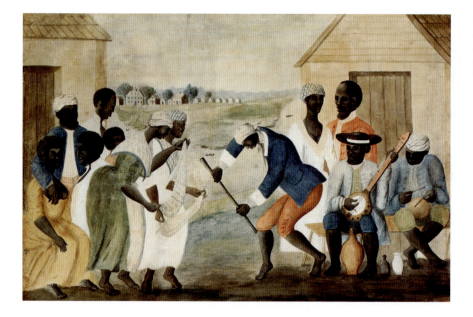

4.1 UNKNOWN ARTIST, *Plantation Scene*, 18th century. Abbey Aldrich Rockefeller Folk Art Museum, Colonial Williamsburg, Virginia.

possible that the central figure is "jumping the broom," a dance of Yoruba origin associated with wedding festivities. It is also possible that the activities are secular in nature—a demonstration of West African martial arts, for example. The two seated figures to the right play instruments probably modeled on African antecedents: a drum that resembles a Yoruba "gudugudu" of wood and animal skin, and a hollowed gourd with strings, the prototype for today's banjo. The women, in turn, appear to play the "shekere," a gourd rattle used widely in West Africa. Though the men and women wear Western clothing, their patterned headdresses recall African fabrics and style. Enslaved Africans were normally clothed in coarse linen or a cheap burlap-like material called hemp. The clothing of the figures in *Plantation Scene* suggests that they sometimes managed to resist plantation conditions by retaining clothing styles from Africa.

The unknown artist who recorded this scene used European painting techniques to capture a moment in the life of the slave community. The artist combines the linear and flattened forms of provincial art with the recessional spaces of more academic painting. By contrasting animated figures in the foreground with a line of houses in the distance, he or she emphasizes a difference between two realms. The artist removes African culture from the surveillance of the master, highlighting instead its preservation in a new world. The image celebrates community, family, and generational continuity. In doing so, however, it tends to idealize its subject. Slave fathers often lived separately from their families. They and their wives frequently belonged to different masters, and the men were sometimes encouraged to take more than one wife (a practice that produced more slave children for their owners). Masters often refused to recognize slave marriages as legal. They could sell any member of a slave family at any time.

Against these threats to the slave family, the painter of the *Plantation Scene* depicts the slave quarters as a space of safety at one remove from the master's control. Families are reunited, and rituals from Yoruba and Mende (West African) life bind the community together. The *Plantation Scene* confirms what we know today of the "secret" life of the slave quarters—for example, the way slave parents would often bestow African names on their children without the knowledge of their masters. Dancing was considered a sacred activity, associated with reverence for ancestors. Spirituals—the slaves' religious songs—were sung to the beat of the "ring shout," a dance in which the participants stamped their feet while moving counterclockwise. These observances not only helped the slaves endure oppression but united them in a new, evolving African American culture that blended Christian and African customs.

**THOMAS CORAM'S *VIEW OF MULBERRY HOUSE AND STREET.*** Depictions of slave quarters tell yet another story of African survival in the New World. Slaves built their houses from a combination of materials supplied by the master and those foraged from nature. In the seventeenth century, these houses resembled those in West and Central Africa. They had dirt floors, reed or palmetto roofs, and walls made of clay, **wattle-and-daub**, or "tabby" (lime and shells). The *View of Mulberry House and Street* of c. 1800 by Thomas Coram (c. 1758–1811) shows two rows of slave huts leading to the main house at Mulberry Plantation, South

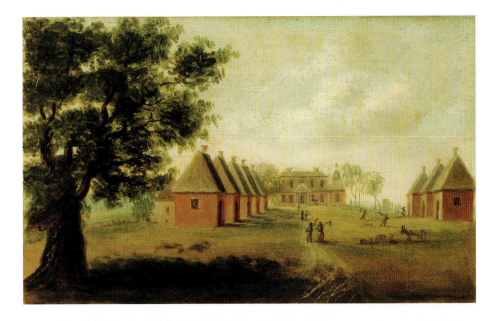

4.2 THOMAS CORAM, *View of Mulberry House and Street*, 1805. Oil on paper, 4¹⁄₁₆ × 6¹¹⁄₁₆ in (10.4 × 17 cm). Gibbes Museum of Art/Carolina Art Association, Charleston, South Carolina.

Carolina (**fig. 4.2**). The slave quarters are distinguished by their small windows, arched doors, and steeply pitched roofs. Unlike the slave dwellings in *Plantation Scene*, which stand apart from the distant manor house, the slave quarters in Coram's painting form diagonal rows leading directly to the main house. Coram intended his painting as a preparatory sketch for a book of engraved views of plantations that he could sell, at a handsome profit, to the plantation owners. His image reinforces the plantation owner's sense of hierarchical authority: all roads lead, in effect, to the manor house.

Over time, the construction styles of slave houses became increasingly Europeanized. Timber frames and hewn logs replaced earlier materials, and a breezeway (called a "dogtrot") was sometimes added between the original rectangular huts to create cooler and better ventilated spaces. To the master, the single-room slave huts, 10 to 12 feet square, somewhat resembled the peasant cottages found in the British Isles. They contrasted with the elaborate forms of the manor house, and reflected, in their simplicity, the subservience that masters expected from their slaves.

The same architectural forms that confirmed the master's dominance, however, could also affirm the slaves' collective memory. The small, square rooms echoed African forms. The steep-roofed houses that we see in *Plantation Scene* and *View of Mulberry* repeated the shape, and probably the feeling, of dwellings in West Africa. The clustering of homes in the slave quarters, in either circular or linear arrangements, recalls the communal style of African compounds.

**THE SHOTGUN HOUSE.** A second form of African-influenced architecture, the shotgun house, represents a major contribution made by African American building forms to American **vernacular** architecture (**fig. 4.3**). The name "shotgun" derives in all probability from the Yoruba word *to-gun*, a term signifying a "place of assembly." Combining Yoruba (Africa) and Arawak Indian (Caribbean) plans, the shotgun house probably originated in colonial Haiti and Cuba, and made its way from there to New Orleans and South Carolina in the early nineteenth century. It is still found today in both urban and rural settings throughout the South. Shotgun houses are characterized by a rectangular floor plan, a hipped roof, and an entrance on the narrow, and sometimes gabled end that faces the street. Their modest cost, efficient use of space, and adaptability to climate have contributed to their enduring popularity.

4.3 The Shotgun House, New Orleans, mid-19th century.

## Diaspora and Creolization

THE AFRICAN "DIASPORA" involved the largest forced migration in human history: four million Africans forcibly transported to North America, the Caribbean Islands, and South America over the course of four centuries. Scholars of the African diaspora have attempted to account for the many complicated ways that African customs and beliefs survived in the New World. They use the term "creolization" to describe the process of give-and-take that occurs when different cultures exchange practices and in the process produce a new and hybrid culture. Creolization differs in this way from an older notion of "acculturation." Acculturation assumes the gradual but complete absorption of a minority culture into the dominant one. In creolization, on the other hand, different cultures do not "merge" or "assimilate," but instead form a mixed society in which elements of each culture still remain visible.

**THE AFRICAN HOUSE.** An alternative African building tradition survives today on the former Yucca Plantation in Isle Breville, Louisiana. The African House, constructed c. 1798, echoes the form of West African (savannah region) granaries (**fig. 4.4**). The African House was built for Marie Thérèse (1742–1816), a former slave whose lover, Claude Thomas Pierre Metoyer, a Frenchman, granted her 70

4.4 The African House, Melrose plantation, Isle Breville, Louisiana, c. 1798–1800.

acres of land in 1778. Marie Thérèse cultivated tobacco and indigo. Through additional purchases and an astute use of Spanish land grants, Marie Thérèse built the plantation into a 10,000-acre operation. By the early nineteenth century, the creole Metoyer family possessed the largest number of slaves owned by free blacks in the United States.

The African House possibly reflects the influence of Marie Thérèse's African-born parents. The African House consists at ground level of whitewashed soft bricks, which support, in turn, a loft of timbers filled in with deer hair, moss and mud. Large cypress beams at the loft level support the over-sized, hipped roof. The slaves of the Metoyer family who built the African House also constructed buildings for white planters throughout the area.

## Virginia: Eighteenth-Century Land Art

By the early eighteenth century, the lands along the seacoast and riverways in British America had been largely settled and put to use. This was a handmade landscape of fields cleared of forest and rocks, marked by fences, pathways, and service buildings. A typical farm was worked by its owner, his family, hired help, and, in some cases, servants. Europeans, Indians, and, increasingly, Africans, provided wage labor, sometimes working off an indenture, sometimes (especially in the southern colonies) toiling as slaves. The property owner made fundamental decisions about the use of land and labor. He was judged by others on how well he used these resources, whether prudently or wastefully, whether resulting in a "fine farm" or a poor one. The closer to the house, the more orderly the land was expected to be: trees in neat rows in orchards, for instance, often abutted the house, whereas woodlots (bits of residual forest regularly culled for firewood) were kept at a distance.

**OAK ALLEY PLANTATION (VACHERIE, LOUISIANA).** In the early eighteenth century, large landowners favored axial vistas lined by trees planted in straight rows up to a mile long. At Oak Alley Plantation, Louisiana, flanking rows of live oak trees, planted in the 1730s, survive and ennoble the approach to a house built a century later (**fig. 4.5**). Such symmetry had precedents in Italian villas such as Palladio's Villa Emo. Suggesting control, orderliness, and good government, the axial vista concentrates emphasis at the center. It implies self-assurance—a system with no

4.5 Oak Alley Plantation, Vacherie, Louisiana. Allée of trees 1730s; house 1830s.

4.6 (below) SAMUEL VAUGHAN, Plan and elevation of Mt. Vernon, site plan of gardens and outbuildings, 1787–99. Mount Vernon Ladies' Association.

surprises and no doubts—and asserts the occupant's claim of power and possession. Although persisting in America and France until the end of the eighteenth century, in England this geometric style of landscaping gave way to a new and different attitude in the middle decades of that century. One of the first practitioners in the New World of this new way of seeing and organizing the landscape in "natural," rather than formal, terms was George Washington.

**MOUNT VERNON.** The idea behind the organization of space at Washington's home, Mount Vernon, in Fairfax County, Virginia, began during the early 1700s in England, where the architect (and painter) William Kent began designing estates that replaced straight lines, symmetry, and geometric planting beds with pastoral landscapes of greenswards, meandering pathways, and indirect approaches. Kent emphasized variety and visual adventure, rather than controlled vistas. Viewers beheld prospects of animals grazing on meadows interrupted and bordered by irregular groves of trees. Kent's circuitous routes to the manor house produced the delight of surprise rather than the satisfaction of predictable axial patterns. The gentry and planter classes viewed themselves as stewards of nature's order, and they took pleasure in the beauty that such order produced. They modeled themselves, and their estates, on the pastoral ideals of the Roman Republic.

George Washington was a surveyor and farmer as well as a military strategist and president. He knew a great deal about land, crops, topography, and trees. Mount Vernon, his home farm with four contiguous satellite farms, produced wheat, alfalfa, rye grass, hops, hogs, sheep, turkeys, and dairy and beef cattle; but, in accordance with the new aesthetic, only the pastoral landscape of trees, lawn, and grazing animals was visible in the approach to the house or in the vistas from it (**fig. 4.6**). Washington expressed his

4.7 GEORGE WASHINGTON, Landscape approaching Mt. Vernon from the ha-ha, 1754–97.

interest in the visual experience of those approaching or leaving Mount Vernon in a directive to his manager in 1797: "In leaving the clumps [of trees], if it can be done consistent with the thick growth of the Trees, pay attention to the look of them, in going to or returning from the house."[1] This concern for the pictures formed by irregular topography and for natural planting underlies the approach to Washington's home. Emerging from a little dell and small forest, the visitor crossed an open meadow and then once more viewed the house on axis across the lawn before passing through a gate at the ha-ha (a retaining wall and ditch designed to contain animals but invisible from the house; see the bottom of the site plan; fig. 4.6). Deflected once again, the traveler could follow one of two serpentine pathways along bosky woods, which Washington called "wildernesses," to the forecourt and the house.

The approach was one of indirection, deflection, and visual variety. Looking outward from one façade of the house one could see trees, meadows, and—kept at a distance from the house by the ha-ha (**fig. 4.7**)—grazing cattle, horses, and sheep. This was the picture of pastoralism—a combination of "fenceless" open meadows and irregular clumps of trees—that Washington and his peers admired in English practice. They associated the pastoral landscape with the recovery of agricultural and political virtues linked to classical antiquity and republicanism.

The route to Mount Vernon described above was for the owner and his guests. Others, including enslaved Africans who provided most of the work force on Washington's farms, used a service road. The slave quarters (not shown in fig. 4.6) flanked the square greenhouse in the walled garden on the left in the site plan. The various outbuildings— carpentry shop, spinning house, salt house, smokehouse, wash-house, stables—formed a businesslike "street" at right angles to the forecourt axis. These outbuildings processed the crops and provided the services necessary to keep the plantation running. The landscapes of labor, business, and money were thus axial, while the landscapes of leisure, respite, sociability, sport, and aesthetic pleasure are marked by serpentine lines and greenswards, relieved by the variety and shade of deciduous trees.

Mount Vernon provides an early glimpse of an aesthetic preference still informing our concept of the comfortable life today—one still reflected on house lots throughout suburbia. Separated spatially from sites of labor and production, suburban zones, associated with health, privacy, shade trees, lawns, curving roadways, and serpentine walkways (that is, with beauty and repose), are a central feature of the American dream.

# The Classical Orders

RENAISSANCE DESIGN REVIVED what we term today the "classical orders," an architectural hierarchy codified by the ancient Greeks, which includes unornamented columns (Doric), columns with scrolls at the top (Ionic), and columns with elaborate carvings of acanthus leaves at the crown (Corinthian). Two other column types, Tuscan and Composite, later brought the list of orders to five. Tuscan columns combine a simple capital and base with a plain shaft. The Composite order mixes Ionic with Corinthian. Design books from the sixteenth to the eighteenth century opened with a plate of the five orders, which constituted the basic syntax of architectural form. The classical orders determined a building's proportions, moldings, decorative detail, and expressive character (**fig. 4.8**).

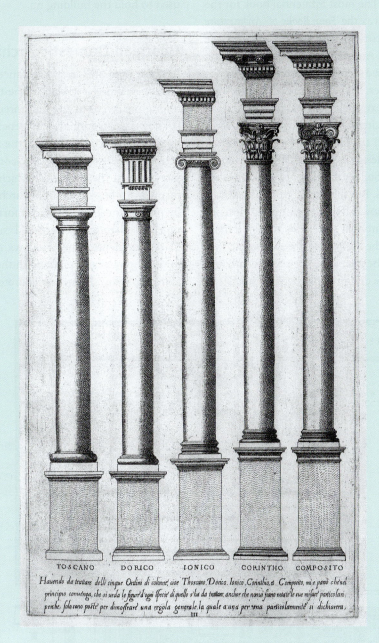

4.8 The Five Orders of Architecture. Engraving from *Regola delli Cinque Ordini d'Architectura* (Rome: 1607) by Vignola. Private Collection.

# Palladio and "Georgian" Building

**PALLADIO'S *FOUR BOOKS*.** In the second half of the eighteenth century, artists and designers measured and drew newly excavated architectural fragments of Roman antiquity. They extrapolated rules of design and proportion from the classical fragments they studied, inventing along the way accommodations to early modern living (fireplaces, chimneys, glazed windows, etc.). The medium through which this new architectural language traveled was the illustrated book. The most influential book for the English-speaking world was the *Four Books of Architecture* (*I Quattro Libri dell'Architettura*) published in 1570 by the northern Italian architect Andrea Palladio. Palladio's book recorded and disseminated his plans and **elevations** for dozens of villas, churches, and civic structures, making them available for study, extrapolation, and mimicry everywhere (**fig. 4.9**). But the circulation of the expensive work was necessarily limited to the gentry. Before the development of the illustrated design book the craft of building was passed from master builder to apprentice in a face-to-face transmission of skills. But the arrival of the book as a source of architectural knowledge and communication put the power to design squarely in the hands of gentlemen, and created the figure of the heroic architect with which we are familiar today. Over the course of the seventeenth and eighteenth centuries some design books became smaller in size; with titles like *The Builder's Benchmate* they clearly addressed the artisan as well as the gentleman architect.

Another key aspect of the architectural revolution occurring in the early years of the eighteenth century was the suppression of visible engineering—such as the dramatic roof truss in St. Luke's Church (see figs. 3.24 and 3.25)—in favor of what we can call pseudo-engineering. Instead of revealing the beams and joints that supported a building, Renaissance interiors were plastered over with smooth surfaces, often ornamented with columns, pilasters (attached columns), and **entablatures**, which only rhetorically reference the post-and-beam structural system used to hold the building up.

## Georgian Domestic Architecture

Because this Italian Renaissance style was popular in Britain (whence it spread to the thirteen British colonies) during the reigns of the first three Hanoverian Georges, it is known as "Georgian." Its general principles dominated building practice throughout the region in the eighteenth century. The popularity of Georgian architecture stems in part from the ease with which builders could copy its forms from books. Georgian architecture is characterized by proportional and balanced forms: regularity of design; repeated shapes; proportional sizes; and symmetrically placed elements. The windows of a Georgian building, for example, align exactly with the windows on the floors above or below. In more elaborate buildings, the windows

4.9 ANDREA PALLADIO, Villa Saraceno, Vicenza, 1545, from *I Quattro Libri dell'Architettura* (Venice, II Book, p. 56: 1570). Private Collection.

are flanked by pilasters and centered in symmetrically arrayed bays.

**MOUNT AIRY, IN VIRGINIA.** Mount Airy, in Richmond County, Virginia, exemplifies Georgian architecture at its most expansive (**fig. 4.10**). Compared with seventeenth-century practice, its roof is flatter, its façades more symmetrical, with apertures directly over apertures, and doorways centered and emphasized. Changes in planes are marked and highlighted (at corners and where wall planes meet eaves), and the whole structure is raised above ground level. Mount Airy is arranged in three horizontal tiers: a basement story, forming a raised platform for the elevated main story, above which is a subordinate upper story. Following Palladian practice, Mount Airy is flanked by dependencies (small symmetrical lateral buildings, designed to house kitchens, offices, extra family bedrooms, schoolrooms, and such), which are linked to the main rectangular block by subordinate one-story connectors. In sum, it is a composition expressing physical and social hierarchy, as well as "Roman" associations. The unknown architect of Mount Airy would not have seen Palladio's Villa Saraceno (see fig. 4.9), near Vicenza, but he certainly saw an English design derived from it: James Gibbs's drawings "for a gentleman in Dorsetshire" in his *Book of Architecture*, published in London in 1728. Because of the rise of the illustrated design book, therefore, an eighteenth-century colonial Virginian could receive instruction from a sixteenth-century Italian architect.

4.10 **UNKNOWN ARCHITECT**, Mount Airy, Richmond County, Virginia, built for John Tayloe, 1754–64.

Mount Airy was a manor farm and country "seat." The relationship of the main house to the various other structures was one of head to subordinate parts. The manor was a microcosm of the larger society, and all its residents recognized the patriarchal authority that governed it as natural and absolute. These social relations were embedded symbolically in its buildings and landscape. The house stood above its surroundings on a little rise and was visible on axis as a harmonic, proportionate assemblage of parts, signifying for family members, servants, hangers-on, and slaves alike the authority at the center of their lives.

Mount Airy—like other plantations of the period—functioned like a small village. The manor house served as the equivalent of a town hall or county seat. Its owners oversaw the social, political, and economic arrangements of the community: producing crops and exporting them to Europe, overseeing the everyday lives of hundreds of people, managing ties with religious and political leaders, and educating its non-African children. All male heads of households (poor, middling, and rich) owned the labor of their wives and children as well as servants and slaves, and owned all the means of production. What tended to distinguish an eighteenth-century plantation from a traditional village was profit: most work of the plantation was designed to enrich a single individual or family, rather than the larger community.

As the scholar Dell Upton has noted, plantations such as Mount Airy employed architecture and the built environment to create two different landscapes: one as experienced by the owner and wealthy whites, and one as experienced by enslaved workers, artisans, tradesmen, professionals, and poor whites. The buildings and surrounding lands of the plantation established, for the world of the white planters, a series of social barriers. Beginning with the estate itself (trees, lawns, and gardens), and continuing with the outbuildings (kitchen, shops, and slave quarters), the plantation was designed as a sequence of spatial boundaries that needed to be crossed, one by one, in approaching the manor house. The plantation house in turn—prominent, as Mount Airy was, for all to see but few to enter—divided its spaces into degrees of ever greater proximity to the master and his family, from the terrace, steps, and doorway, to the large reception hall and waiting chambers, to the dining room and spaces for more intimate conversation. The higher one's social status, the more of these architectural barriers one could pass through. The landscape formed a processional movement from the outskirts of the estate to the manor house and its semi-private rooms, a journey that was mental as well as spatial.

For blacks and poor whites, these same spaces produced a different meaning. Their landscape tended to revolve around familiar, and usually marginalized, locations: the one- or two-room slave huts, the adjacent fields and work areas, and the woods, marshes, and swamps at a distance from the manor house. To some degree, the laborers of the plantation, both enslaved blacks and poor whites, conducted their lives in work and residential spaces that—despite the master's agent's surveillance—they might claim as their own. Moreover, black occupants of the plantation stood partially outside the deferential barriers erected for white visitors. Through their duties as domestic servants, they had real, if covert, access to the main house that allowed them to enter into its intimate spaces as if invisible. Their landscape was less hierarchical than it was defensive, and, on occasion, subversive. This landscape within a landscape converted the distance from the main house into an alternative realm of residences and woods where African American practices could survive.

**MOUNT PLEASANT, IN PENNSYLVANIA.** In the Middle Colonies, Georgian domestic architecture was, in part, similar. In its grandest versions, such as Mount Pleasant (1761), a two-and-a-half-story hipped-roof rectangular structure dominates its flanking dependencies (**figs. 4.11** and **4.12**). Mount Pleasant is defined by a symmetrical five-bay façade and an emphasized doorway. The land on which this house is built, a knoll overlooking the Schuylkill River, just outside Philadelphia, was bought in 1761 by John MacPhearson, a Scot with two marriageable daughters (as well as two sons). In September 1775 John Adams, later the second president of the United States, visited the house and recorded in his diary: "Rode out of town, and dined with Mr. McPherson. He has the most elegant seat [establishment] in Pennsylvania, a clever Scotch wife, and two pretty daughters.

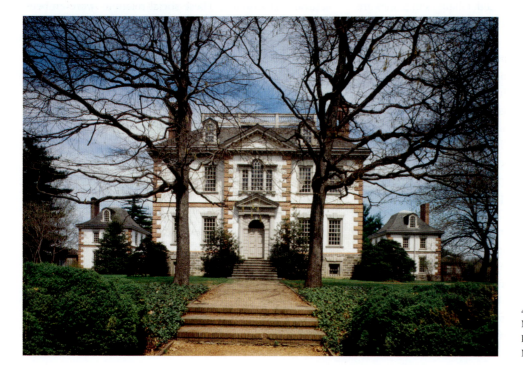

4.11 UNKNOWN ARCHITECT, Mount Pleasant, Philadelphia, Pennsylvania, built for John MacPhearson, 1761.

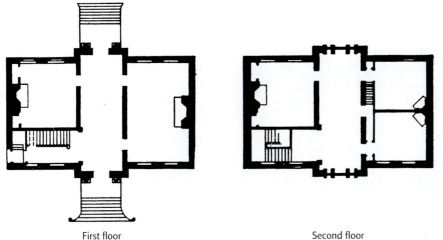

First floor                    Second floor

His seat is on the banks of the Schuylkill. He has been nine times in battle; an old sea commander; made a fortune by privateering; an arm twice shot off, shot through the leg, etc. He renews his proposals of taking or burning ships."[2] MacPhearson was robust, assertive, *nouveau riche*, a retired privateer—that is, a legalized pirate licensed to prey on enemy shipping—and the elegance of his house was probably intended to promote the marriage of his daughters into older, more established families. Being rich in the eighteenth century was important, but belonging to a web of mutually recognizing families was even more important. Key to the family's prominence was its "seat," or family estate, and its alliances within the social structure.

Like most high-style Georgian houses, Mount Pleasant has two nearly identical principal façades, what we today call front and back, both dominated at the center by distinctive features. At the roofline a **pediment** crowns a "**jut**," advancing the central bay slightly but emphatically— the change in planes marked by **quoins** (large, contrasting corner blocks) at the edges. Lighting the upper hallway, a "**Palladian**" **window** lends the dignity of a mini-triumphal arch to the composition. In general, the sash windows— composed of twenty-four "lights," or panes of transparent glass—were expensive indicators of wealth in this period. The door surrounds, with their flanking Doric columns "supporting" correct (that is, patternbook) entablatures and mini-pediments, invoke the classical orders at this privileged position.

The building vocabulary used at Mount Airy and Mount Pleasant is so familiar to us that it is hard to see it as novel. It has been much imitated and adapted in the many phases of the colonial revival because its orderly symmetry, its hierarchical masses, and its **rhyming forms** express a set of ideals that our culture continues to esteem. It has come to represent—in nineteenth-century and later suburbs, up to the present—an idealized Golden Age of civic virtue and social clarity. It should also remind us of MacPhearson and those other eighteenth-century gentry who literally shot their way to the top.

**WHITEHALL, IN RHODE ISLAND.** Mount Pleasant and Mount Airy are exceptional. Most Georgian building in the colonies was less lavish in scale, materials, design, and in the adoption of the Georgian vocabulary, with less expensive materials and, of course, smaller houses to suit the pockets of the less affluent. Whitehall, for instance (**fig. 4.13**), built near Newport, Rhode Island, in 1729 to house the philosopher George Berkeley, probably by a builder without access to design books but with an inkling of Georgian design, has the five-bay façade, hipped roof, sash windows aligned precisely above one another, and an entry marked by Ionic pilasters capped by a tidy proportionate pediment—that give it a family resemblance to Mount Pleasant and Mount Airy. But Whitehall is built of wood and is clapboarded. It is not raised on a basement story, and its façade—with its off-center chimney and larger left half—is casually asymmetrical. Most dramatically, its rear elevation abandons all effort at Georgian systems of design and presents a long "**catslide**" lean-to roof. All of these irregularities are familiar from seventeenth-century construction practice, which persisted side-by-side with the new Italianate forms and combined with them to produce new (and regionally varying) vernaculars. Although Berkeley—a churchman of the urban elite who had traveled to Italy—undoubtedly thought of the front as the "right" façade, regarding the rear as odd, it was the rear vernacular elevation that, one hundred fifty years later, New York City architects and painters drew and copied, inserting this design "embarrassment" into the Shingle Style homes they designed for their elite clients (see Shingle Style, Chapter 9, fig. 9.17). The tendency of old types to persist in hybridized form, and the tendency on

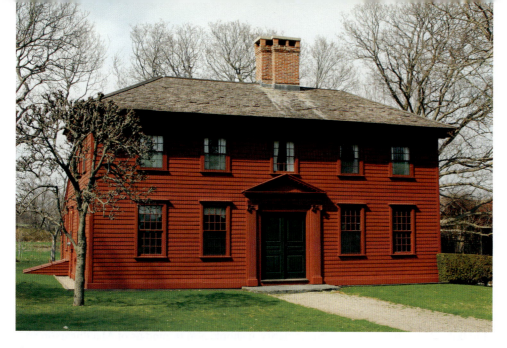

4.13 Whitehall, Newport, Rhode Island, 1729.

the part of artists, architects, and their patrons to mine the past for visual quotations, remind us that terms such as "vernacular" and "colonial" are chameleon. It is important to understand the past as a fluid place—one where meanings are constantly being remade. The present, in turn, never speaks with one voice; it always drags some portion of the past with it.

## Georgian Religious Architecture

The size, materials, location, and architectural vocabulary of a house could tell a passerby a good deal about the prosperity of its inhabitants, but it would tell her little about one of the most important ingredients of identity for the British colonists: their religion. Unlike the French colonies to the north and New Spain in the West (which were almost entirely Roman Catholic), the eastern seaboard settlements were, by 1750, religiously diverse. The arrival of royal governors in the 1680s also brought the Church of England, to the discomfort of Puritans in Massachusetts and also Quakers in Pennsylvania. Scots-Irish immigration had brought Presbyterianism, and Germans had brought Lutheranism. Rhode Island by 1750 was a refuge for religious dissenters; there were Quakers, Congregationalists, Baptists, Anabaptists, Jews, and Anglicans in the capital city, Newport, each congregation with a distinctive building type representing in material form the practices, core beliefs, and history of its group.

**THE QUAKER MEETING HOUSE.** In 1699 the Quakers in Newport built a large, unadorned meeting house (the central portion in **fig. 4.14**). They subsequently added onto it on both sides in an ad hoc fashion; but despite their considerable wealth and central position in the local politics, their Meeting House remained unornamented. This architectural straightforwardness served to express the Quaker belief in the inner light of individual souls.

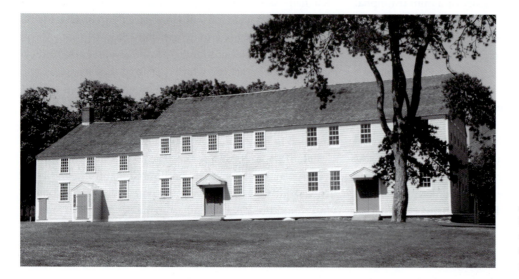

4.14 Quaker (Friends) Meeting House, Newport, Rhode Island, 1699–1807 (center 1699; left addition 1729; right addition 1807).

**THE TOURO SYNAGOGUE.** Newport's Touro Synagogue, by contrast, combines elaborate Georgian architectural forms with traditional Jewish elements (**fig. 4.15**). Designed by the architect Peter Harrison (1716–65) in 1759, the synagogue derives from the large collection of English architectural design books that Harrison owned. The building, set at a slight angle to the street, allows the congregants to face east toward Jerusalem when praying. A screen of twelve Ionic columns represents the twelve tribes of ancient Israel. Each column was made from a single tree; together they mark off the perimeter around the elevated Bimah (a raised altar and lectern) and support the Women's Gallery above. This use of classical columns that actually bear weight is rare in the colonial context. It is found most commonly in large-scale public buildings such as synagogues, churches, and statehouses.

**TRINITY CHURCH.** Nearby Trinity Church (1725) supports a similar gallery above family box pews (**fig. 4.16**). Trinity is Anglican and is arranged, like St. Luke's a century earlier (see figs. 3.24 and 3.25), as a long rectangle. Where the focus in the square synagogue is on the Ark and the lectern, in Trinity the nave leads to a lectern, a raised pulpit (the sounding board above amplifying the minister's sermon), the altar, and a large east window. In both cases—synagogue and church—the orders add dignity to the space and to the religious services within that space. They permit each building to span great widths, and they establish proportion among all the parts.

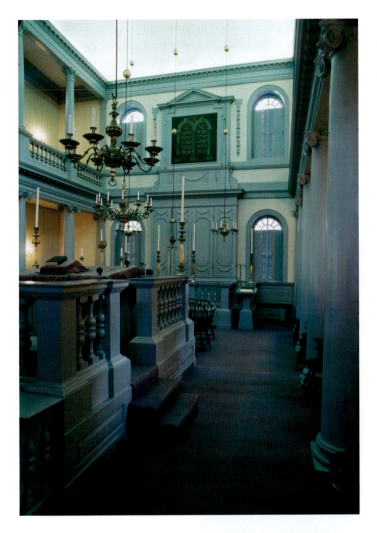

4.15 (above) PETER HARRISON, Touro Synagogue, Newport, Rhode Island, 1759–63.

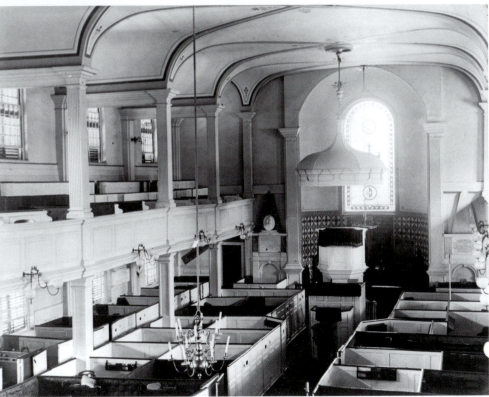

4.16 RICHARD MUNDAY, Trinity Church, Newport, Rhode Island, 1725–26, nave lengthened 1762.

**THE "COLONIAL CHURCH."** Given the wide variety of religious structures that were built in the English colonies, it is perhaps surprising that one single type has come to dominate our idea of the "colonial church." Derived originally from the designs of Sir Christopher Wren, whose parish churches combined the new Italian Renaissance vocabulary with the old Gothic idea of a steeple, and were built all over London after the fire of 1666, this building type was popularized and disseminated by James Gibbs in the eighteenth century. His *Book of Architecture* provided models, including St. Martin's-in-the-Fields, London, that inspired variants throughout the colonies. In its full-blown form, with a giant portico in front and pilasters marking the bays down the sides, an elaborated steeple, two rows of round-headed windows, and masonry construction, it can be seen in St. Michael's Church, Charleston, South Carolina, of 1752–61 (**fig. 4.17**). More modest variants were built of wood, omitted the portico, or even truncated the steeple, but this rectangular white structure with round-headed windows and aspiring steeple became the archetypal church for Protestants of all denominations as they carried their religion and their ideas about architecture throughout the continent.

4.17 St. Michael's Church, Charleston, South Carolina, 1752–61.

# The Mission System in Texas, Arizona, and California

Across the Spanish Southwest, mission life and architecture varied from region to region. At the heart of the mission institution was the process of *reducción*, by which the Native population was brought under Spanish religious and secular control. Throughout the Southwest, *reducción* was accomplished by working with already settled communities of Natives. In New Mexico, as we saw in Chapter 2, Spanish missionaries built their churches on the sites of existing Pueblo villages throughout the Rio Grande Valley. Some twelve-dozen Pueblo villages were reduced to fewer than four dozen by the end of the seventeenth century.

The case was very different in Texas, Arizona, and California, where Franciscan missionaries encountered smaller, more dispersed Native populations. In contrast to the modest scale of the church-convent in New Mexico, integrated within local communities, these later missions were larger and multifunctional. The church was only one building among many, in what was effectively a vast plantation that produced virtually everything needed by the mission. The Indians of Texas, Arizona, and California—unlike their counterparts in New Mexico—lacked an indigenous tradition of large-scale building. A small number of itinerant skilled artisans from Spain and Mexico taught Native laborers European building techniques and decoration, taking them beyond the limits of frontier technology. This diminished the influence of Native traditions, and resulted in a more European look among these later missions.

## Texas Missions

Throughout the eighteenth century, the Spanish struggled to establish a foothold in Texas, suffering repeated setbacks. Spanish colonists were unable to subdue the Apaches and Comanches who raided the frontier. The threat of Indian attack intensified after Plains Indians acquired horses—originally brought from Spain. "Mission Indians," decimated by disease and unused to the heavy agricultural labor imposed on them, deserted or died in droves. Although three dozen missions were established in Texas between the 1680s and 1794, colonization took root only in what is now San Antonio, where five missions have survived into the present. Built of porous local limestone known as tufa, these missions withstood a century of neglect and disuse until the 1930s, when they were restored by the federal government.

## New England Meets Hawai'i

At its westernmost destination, a variant of the colonial church was built in Hawai'i: Kawaiahao Church in Honolulu, completed in 1842 (**fig. 4.18**). Designed by the Rev. Hiram Bingham—who had arrived from New England with his wife in 1820 to Christianize the Hawai'ians (inspired by a Hawai'ian who had found his way to Connecticut)—the church was built of coral quarried into blocks of building stone and served as the church of the Hawai'ian royal family. Just as the materials suggest a local re-invention of imported forms, the language of the services is not English but Hawai'ian. The missionaries also introduced milled lumber and the tradition of New England quilting to the Hawai'ian Islands, resulting in hybrid—and novel—achievements in both building and in needlework. The migration of English and colonial architectural forms to locations as distant as Hawai'i suggests the ways that art and religion have historically accompanied—and sometimes paved the way for—colonial expansion.

4.18 REV. HIRAM BINGHAM, Kawaiahao Church, Honolulu, Oahu, Hawai'i, 1842.

**SAN JOSÉ Y SAN MIGUEL DE AGUAYO.** The missions of Texas—even more than those in New Mexico—resembled medieval monasteries, housing all the functions required to sustain the religious community and its converted Indians. In San Antonio, San José y Miguel de Aguayo (1768–82), the best-preserved mission complex in Texas, was called in 1777 "Queen of the Missions" of New Spain. The mission church is the capstone of an extensive working compound arranged as a vast quadrangle around a central courtyard eight acres in area (**fig. 4.19**). The courtyard was surrounded by defensive stone walls three feet thick in some places. Towers armed with cannons and swivel guns stood at the corners. The complex protected a garrison of soldiers, cells for Native families, storehouses and workshops for weaving and tanning, and an arsenal, smithy, and kitchen. Arcaded cloisters and a living area for the friars stood at one side of the church.

Mission San José is defined by a Spanish Baroque style of architecture and decoration found from South America to Texas. Here, the itinerant Spanish artisan Pedro Huizar created an extraordinary façade portal carved of limestone with a rose window to the side. The façade and all exterior walls were colorfully painted in earth tones and blue, in designs recalling the geometric patterns of Moorish tiles, though today only dim traces are visible. The two-tiered portal and window break the flat planes of the façade (**fig. 4.20**). Columns with scalloped niches (later filled with statues) stand on either side of the central doorway. Decoration throughout consists of floral and shell motifs,

reverse curves, and volutes. This animated surface is set within a sober classical frame of pilasters and entablatures, playing the sculptural, three-dimensional qualities of the architecture against its **planar** surfaces. Similar applied decoration appears frequently in Mexican colonial buildings, and Huizar may have brought these metropolitan styles from Mexico City to San Antonio.

Texas mission churches, unlike those in New Mexico, were generally **cruciform** in shape, with **transepts** and domes. The domes at Mission San José and elsewhere were constructed from a concrete mixture of pulverized stone and sand, poured into wood forms. Workers shaped earth into mountain-like "berms" or platforms, which could then be used instead of scaffolding to support construction of the dome.

## Arizona Missions

During the late seventeenth century, the Jesuits established a chain of missions extending from Sonora, Mexico, into Arizona. These missions were the life's work of Father Eusebio Francisco Kino (1645–1711).

**SAN XAVIER DEL BAC.** Called the "white dove of the desert," the church of San Xavier del Bac rises like a mirage out of the heat-shimmering desert near Tucson, Arizona (**p. 94**). Originating as a pilgrimage church under Father Eusebio, the present structure is the third built on the site. The Franciscans, who assumed control of San Xavier after the Jesuits, incorporated the fired brick of the older building into an ambitious new structure, begun in 1783 and completed in 1797. (In 1767, the Spanish king, leery of the Jesuits' growing alliances with the pope, had ordered them to leave their missions in the Americas.)

The name combines a Spanish saint (San Xavier) with an Indian word (Bac) meaning a watering place, anticipating the fusion of Native and European elements in the structure itself. The architectural balance, however, tilts in the direction of European influences. San Xavier was built nearly a century and a half after San Esteban in Acoma, New Mexico (see fig. 2.31), and the differences are striking. San Xavier is constructed of fired brick with a foundation of river stone, and is covered with lime plaster. Its forms are sharper and less malleable than the massive earthen profile of San Esteban, which was constructed by Indian builders who modified and reshaped Spanish forms.

San Xavier probably employed artisans from Mexico directing Native labor. Twenty-nine Spanish families lived at San Xavier in 1795; ten years later all were gone—an indication that they had come for the express purpose of

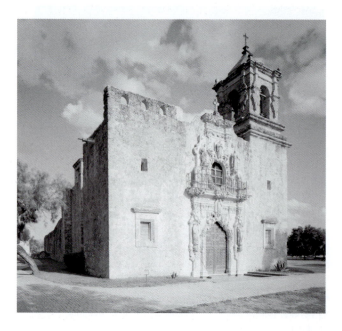

4.19 San José y San Miguel de Aguayo Mission Church, San Antonio, Texas, 1768–82.

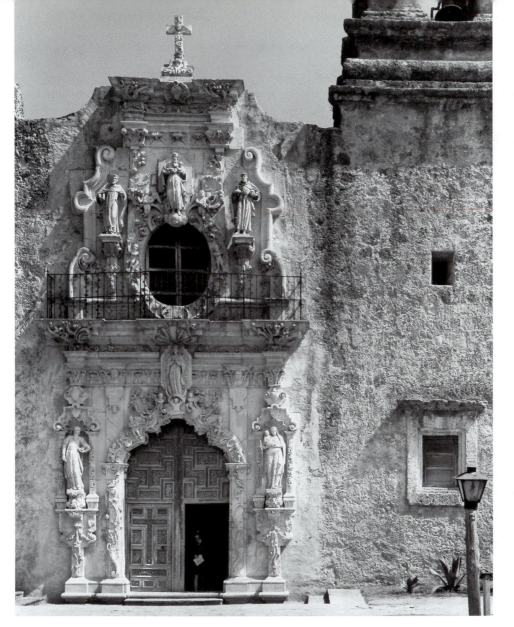

building the church. The presence of Spanish builders at San Xavier helps explain the mission's most characteristic quality—its mixture of forms imported from Mexico City with indigenous versions of the same forms by local Indian workmen. San Xavier represents the northernmost extension of New World Spanish Baroque forms. It is recognizably linked to the more elaborate—and far wealthier—seventeenth- and eighteenth-century churches of urban New Spain.

San Xavier, like San Esteban, today serves a largely Indian parish, having preserved a continuous link with the original Indian converts, ancestors of the modern Pima and Papago Indians. The church is a mixture of Baroque, Moorish, Byzantine, and Renaissance elements—the influences central to the architecture of Spain itself. The façade presents two pierced, octagonal towers rising from square bases. For reasons that are unclear, only one of these towers is domed. Throughout the exterior, unembellished wall surfaces—plastered in lime made at a local kiln—highlight the geometries of cube, octagon, and sphere, suggesting architectural links with both Arab North Africa and the Spanish Renaissance. At the center of the façade is a reddish ochre, two-story gabled panel of brick and stucco—materials widely used by the Moors in Spain. The gable breaks into interweaving designs of leaves, grapes, and tendrils, which in their **flat relief** carving and symmetry resemble the Moorish-influenced design that first appeared in Mexican churches in the sixteenth century. Along with the Franciscan coat of arms, medallions, and scallop shells associated with St. James, patron saint of pilgrims (a motif repeated throughout the interior), there are niches in the walls holding statues of the saints. The combination of Moorish-influenced **arabesque** designs with human figures is unique to the religious architecture of Spain and its New World colonies.

This jewel-like façade anticipates the grand *retablo*, or altar screen, inside at the end of the nave (**fig. 4.21**). Both

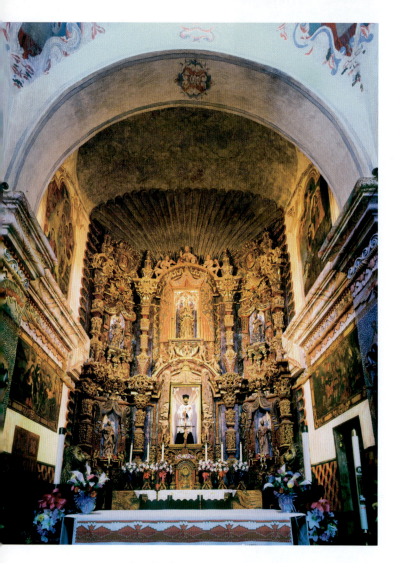

4.21 Nave and *retablo* (altar screen), San Xavier del Bac (see also p. 94), near Tucson, Arizona, 1784(?)–97.

mission churches; and here a shallow, spherical dome caps the crossing, where transepts and nave intersect, its windows bringing light into this area. In addition, five shallow oval domes, located along the nave, transepts, and **apse**, simulate a series of cloth canopies floating above the viewer; they are painted to simulate pleated folds.

Like the façade, the *retablo* (see fig. 4.21) is constructed from fired brick covered with plaster, then gilded and painted. Canopied niches hold statues and scallop shells. Carved and painted images of the saints appear throughout the church. They represent the most impressive on-site collection of religious art in the Southwest—fifty-five sculptures, as well as many paintings. Most were imported, like the skilled labor pool itself, from Europe or New Spain.

## The California Mission Chain

Twenty-one missions dot the coastline and immediate inland area of California in a chain from San Diego to north of San Francisco. They represent the final phase of Spanish colonial expansion into what is now the United States, and were large, multifunctional, self-sustaining complexes similar to those in Texas. Ordered by Spain, this late phase of mission construction began in 1769 to counter the threat of Russia's expansion down the coast of California from its foothold in Alaska. The effort was led by the Franciscan Father Junipero Serra (1713–84), whose name appears on streets and schools in modern California and whose idea it was to place the missions at intervals positioned "so that every third day one might sleep in a village," as he wrote to his superior in 1774.

Unlike the village-dwelling Pueblo Indians of New Mexico, coastal California's more nomadic and geographically dispersed Natives, who had lived in relatively small and flexible village groups, harvesting the bounty of the sea and the land, were herded onto missions and forced into strenuous labor. As one scholar has characterized it, the Franciscan friars endeavored to "transform the coastal hunter-gatherer peoples into a peasant class of neophyte Catholics."[3]

After baptism and all the promises that conversion entailed, their lives became brutally harsh. They were forced, first, to build the missions, and then to live within their compounds, where every aspect of life was regulated by bells dictating times for prayer, for meals, and especially for long days of arduous work. Because the number of Spanish overseers was small, Native labor provided everything—from raising crops to making tallow, soap, and roof tiles. Even visitors of the era remarked on the Natives' harsh lives—the incarceration of these workers in squalid, airless barracks, and the use of whips and stocks for control.

façade and *retablo* are examples of late-phase Mexican Baroque, which prevailed between about 1730 and 1780. Late-phase Baroque architecture is distinguished by an unusual type of column. Departing from classical usage, the column is visually broken up and reassembled as a series of elongated cubes and inverted pyramids, forms deriving from northern European **mannerism** as transmitted through Flemish design treatises. Flanders was governed by the king of Spain; its cultural products circulated among Spanish builders.

The interior of San Xavier is more elaborate than the single-naved mission churches of New Mexico, combining the massive weight of Romanesque architecture with Renaissance detailing. It features the bleached white surfaces typical of Moorish buildings with wall painting done by Spanish and Native workers (only traces of this remain today). Entablature and piers, painted to resemble marble, travel the length of the nave in stately Renaissance rhythms. In the eighteenth century, domes became a feature of

By the age of seven, girls were separated from their parents, to live in locked compounds from which escape was impossible—the only door gave onto the guarded interior walled court. The harsh mission social structure had much in common with southern plantations, only here the masters were Spanish friars and the enslaved workers were Indians.

**MISSION SANTA BARBARA.** The Mission of Santa Barbara (**fig. 4.22**) was founded in 1786; however, the present church was completed in 1820, following an earthquake in 1812, which destroyed an earlier building. Located on the coast and dramatically framed by the San Gabriel Mountains, the mission was built principally by the Chumash Indians, and is one of the few California missions that have not been significantly altered. The façade is framed by two stepped bell towers capped by domes and is punctuated by six neoclassical columns. The façade differs strikingly from that of other California missions, a fact explained by its late date. When Junipero Serra died in 1795, Mexican builders, eager to purge the excesses of the Baroque style, incorporated the neoclassical influences that were then appearing in European architecture. Though built by local labor, the Santa Barbara mission employs the same international styles found among the

English colonies on the eastern seaboard. Like its eastern counterparts, Mission Santa Barbara derived its form from the language of the classical orders, as widely disseminated in illustrated architecture books.

Just as the economies of the eighteenth- and nineteenth-century eastern colonies depended upon the labor of enslaved African Americans, so too did the mission system of California exploit indigenous Californians. Native workers were soon demoralized by the harsh discipline and back-breaking labor enforced by mission life. The combination of disease and malnutrition produced a dramatic decline in the Indian population, undermining the missions' reason for being. There were numerous small rebellions against the California mission system, but they never had any measure of success. The Chumash Indian uprising of 1824 lasted only three weeks, after which some four hundred Indians fled Mission Santa Barbara, never to return. By the early nineteenth century, most missions were abandoned: their nomadic Indian congregants dispersed, and their buildings slipped into steep decline. Following Mexico's independence from Spain in 1821, the California missions were secularized, although Santa Barbara remained under Franciscan control. Decades of abandonment left the missions in ruins. Despite all, Christianized Natives had created a legacy of tilled fields and orchards, extensive stock herds, and other forms of material wealth that prepared the way for later settlers.

4.22 Mission Santa Barbara, California.

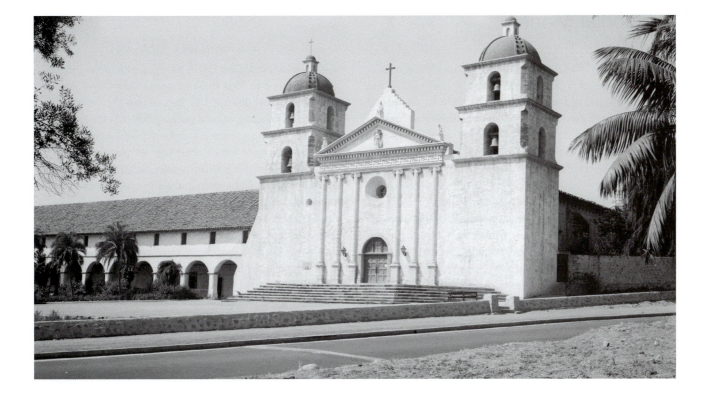

## The Crafted Object

The arts of the Southwest developed, as we have seen, from the complex interactions of Spanish, Moorish, and indigenous traditions. A parallel situation existed among the colonies of the eastern seaboard, where British and Italian styles were joined by a third, more distant influence: Asia. Surviving objects from the eighteenth century reveal a strong Chinese influence, for China's superior abilities in the manufacture of ceramics and silk attracted traders from around the world. Equally important, colonial drinking habits supplemented fermented alcoholic drinks made from locally grown crops (ale, beer, cider) with imported boiled water drinks, tea, chocolate, and coffee, made from plants grown in the tropics and Asia. New tastes created new global markets and substantial trading ports for Western trade in China and India. The adventuring Westerners in these exchanges looked at Asian culture and Asian art from a decidedly "outsider" perspective: they saw Asian aesthetic forms not on their own terms but as exotic and different from European ones. By the same token, their Asian trading partners, anxious to guard trade secrets and protect their societies from foreign influence, restricted Western access to specified ports only.

## Ben Franklin's Porringer

In his autobiography (written in the 1770s), Benjamin Franklin recounts his rise from penniless runaway printer's apprentice to successful author, scientist, and diplomat. He includes this vignette of his domestic life in the 1740s:

> My Breakfast was a long time Bread and Milk, (no Tea) and I ate it out of a twopenny earthen Porringer with a Pewter Spoon. But mark how Luxury will enter Families, and make a Progress, in Spite of Principle. Being call'd one Morning to Breakfast, I found it in a China bowl with a Spoon of Silver. They had been bought for me without my Knowledge by my Wife, and had cost her the enormous Sum of three and twenty Shillings, for which she had no other Excuse or Apology to make, but that she thought her Husband deserv'd a Silver Spoon and China Bowl as well as any of his Neighbours. This was the first Appearance of Plate [silver] and China [porcelain] in our House, which afterwards in a Course of Years as our Wealth encreas'd augmented gradually to several Hundred Pounds in Value.[4]

The account is both factual—about an upgrade in his material possessions—and a parable about aesthetic acquisition and a global economy. It coyly casts his wife, like a "daughter

## Colonial Money

COSTS, DEBTS, WAGES, AND VALUES in British colonial records were expressed in pounds (abbreviated £), shillings (s), and pence (d), and written, for instance, as 1/3/0 for one pound three shillings. Twelve pence equaled one shilling and twenty shillings equaled one pound. Deborah Franklin's outlay of 23 shillings, then, was 1/3/0. Transactions between gentlemen were usually calculated in guineas (a guinea being the equivalent of one pound plus one shilling, a sort of super pound). Although this was the monetary system in which transactions were computed, British currency was scarce in the colonies. Silver (and sometimes gold) coinage from other countries such as Holland, France, and Portugal circulated as cash. Equivalency tables were printed for the benefit of traders, but more often small pocket scales facilitated the use of such foreign coins by weight rather than face value. The most widely circulated coin in the British colonies was the Spanish dollar, as the world's source of precious metals in the eighteenth century was New Spain. More than 20 million Spanish dollars were minted annually in Mexico City in the eighteenth century, most of them shipped to Madrid. Some treasure ships were intercepted by colonial privateers as they crossed the Caribbean, their cargoes enriching colonial purses rather than the Spanish Crown. In Spanish currency a dollar equaled eight *reales*. Spanish dollars were known, therefore, as "pieces of eight." Because they were not official currency issued by the British sovereign, they could be melted down to make objects such as Franklin's silver spoon or clipped and cut to create subcategories of currency. Dollars were routinely cut into four equal pie-shaped sections called "quarters," and these halved to make eight "bits." This unofficial currency was so important that in 1792 the dollar (rather than the pound) became the basis of official U.S. currency. Silver objects created in the colonies contain the same proportions of trace metals as Spanish dollars, confirming the flow of precious metals northward and their fabrication into art.

of Eve," as the agent of Franklin's "fall" into consumerism and material competition with his "Neighbours." Yet he concludes with a self-congratulatory assessment of his current position in the world *as measured by* the possession of china and silverware worth "several Hundred Pounds." By this last comment Franklin tells us two things: his taste has improved, and he has become a gentleman. For eighteenth-century self-starters like Franklin, silver and porcelain provided a measure of social identity among successful peers.

Silver and porcelain imported from China were not just luxury goods but, as Franklin implied, a sort of savings account. They retained their value and could be sold or traded readily. (Indeed, silver items were often marked on the bottom with their weight to facilitate such transactions.) Even a near-indigent man might die in possession of a silver spoon or a few silver buttons. This was a way spare cash could serve a useful function, remain "liquid," and even suggest—as in Franklin's case—the possibility of upward mobility.

Franklin's original implement, the pewter spoon, was made of tin and antimony—probably from Britain. Pewter was the common material for spoons, plates, bowls, and other tableware in the eighteenth century because it was plentiful, easy to cast at low temperatures, and easy to recycle when damaged. Silver was not just more valuable as a material; it also required a higher level of artisanal skill and labor. The move from an earthenware bowl to a china bowl was a shift of a different sort: from an object made by a lone local potter, using local clays fired at low heat, to an object made by a factory of workers halfway around the globe, using special clays and very high temperatures. The Chinese product was light, white, translucent, and strong (see fig. 5.25), whereas the discarded earthenware bowl was heavy, reddish brown, opaque, and easily damaged. With her purchases, Deborah Franklin had changed the look of her husband's modest breakfast table as well as the family's "portfolio." To eighteenth-century eyes, few materials matched the reflective qualities of silver or the magical thin whiteness of Chinese porcelain.

## Paul Revere the Silversmith

Silver was used in ceremonial, religious, and public places, as well as in the home. Churches in particular served as major patrons of colonial silversmiths. Characteristic of such patronage is a set of six tankards made by Paul Revere (1735–1818) in 1772 for the Third (Congregational) Church of Brookfield, Massachusetts, with funds provided in a parishioner's will (**fig. 4.23**). Such gifts had been common practice since the earliest years of settlement. Consistent with their avoidance of special clerical vestments, Puritans, Congregationalists, and many other Protestants took communion from beakers, two-handled cups, and mugs

4.23 PAUL REVERE, Set of six tankards bought by the Third Church of Brookfield, Massachusetts, with a legacy of Mary Bartlett, 1772. Silver, 89¼ in (226.6 cm) high. Winterthur Museum, Winterthur, Delaware.

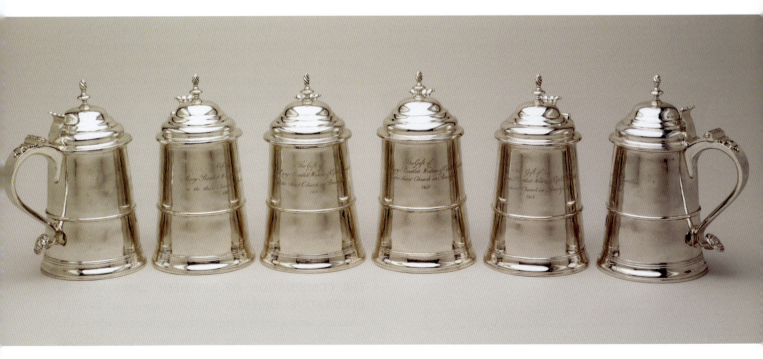

as well as tankards. These were the same vessels used in the home, and, just as in the home, they were passed around among those assembled. Over the course of the eighteenth century, the sharing of vessels decreased at most socioeconomic levels, except in ceremonial contexts. As the sense of privacy increased, the tradition of communal sharing decreased.

Paul Revere was a talented silversmith as well as a celebrated patriot (see fig. 4.32). We know his business well—what he made for whom, and when—because some of his account books and many objects with his touchmark (stamp) have survived. Beyond fashioning a wide range of silver objects—tankards and teapots, spoons, and frames for miniature portraits—he was an engraver, produced prints and illustrations, made gold jewelry, practiced dentistry, cast bronze bells and cannon, and assisted in the Revolutionary cause with his knowledge of metallurgy.

**SONS OF LIBERTY BOWL.** Revere's most famous commission is known as the *Sons of Liberty Bowl* of 1768 (**fig. 4.24**). Silver vessels are not cast but "raised," that is, a flat disk of silver (in this case one weighing three pounds) is hammered over a small anvil to gradually "raise" the desired shape. Once completed, the object is frequently engraved. The *Sons of Liberty Bowl* bears an inscription commemorating the solidarity of the ninety-two members of the Massachusetts House of Representatives who voted in 1768 "not to Rescind" their letter of defiance decrying the Townshend Acts (onerous taxes, especially taxes on tea)—that is, not to buckle under pressure from the British Crown. This cohort of elite men commissioned this substantial bowl to commemorate their daring, "undaunted by the insolent Menaces of Villains in Power" (as the

inscription puts it), and drank toasts from it when they gathered. By publicly criticizing their government, they risked everything; that they did so as one body helped to ensure the success of their revolutionary undertaking. Silver objects for public use often express collective memories—a congregation's memory of the deceased (in the case of church silver) and in this case the merchants' memory of their courageous stand in the face of what they understood to be an attack on Magna Carta and English liberties. In the private sphere, too, silver often was designed to evoke memory. It passed from generation to generation, often with new names engraved beside those of their predecessors, a physical link to the family's ancestral past.

## The Line of Beauty

Revere's bowl is frequently reproduced—replicas are given as trophies and wedding presents every day—not because there is a clear public understanding of its history but because its shape is considered beautiful, a "classic." Its contour is generous, curving upward until, nearing the lip, the curve flares outward, creating a gentle S profile. This S-shaped contour, also seen in the handles of Revere's tankards, is one of the key elements in eighteenth-century design. We saw it in the serpentine paths of Washington's approach to Mount Vernon (see figs. 4.6, 4.7), and we will see it below in portraits. Where did it come from and what meanings became attached to it?

The English artist William Hogarth (1697–1764) called the S-curve the "Line of Beauty." In 1753 he published a treatise entitled *The Analysis of Beauty*, in which he discussed (and diagrammed in a series of engraved plates) the presence of this line in sculptures from antiquity, ladies' corsets, chair legs, and human anatomy. Contrasting ideal curves with others that appear too stiff or too loose, he makes a case for a universal principle of design. This is not, he believes, human invention, but rather a principle inherent in nature, like the harmonic relationships of the octave in music. Conversely, angularity and abrupt contrasts without variety display, for Hogarth, an absence of beauty. While Hogarth's book did not introduce the serpentine line—indeed, it had been used in English gardens and decorative arts for some decades—it did codify and popularize its appeal.

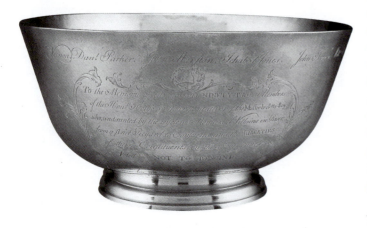

4.24 PAUL REVERE, *Sons of Liberty Bowl*, 1768. Silver, height 5½ in (13.9 cm); depth of base 5¹³/₁₆ in (14.7 cm); depth of lip 11 in (27.9 cm). Museum of Fine Arts, Boston, Massachusetts.

**THE COMBINATION OF AESTHETIC LANGUAGES IN DECORATIVE OBJECTS.** Looking again at Revere's tankards, we see them merging two aesthetic systems—the Hogarthian serpentine line and the architectural language

of the orders. The S-curve is associated with nature (flowers, faces, bodies) and with surprise and happy accident. The orders, on the other hand, are linked to antiquity (both architectural and human history) and with rationality and universal proportion. Structured like a miniature building, with moldings derived from column bases, the tankard's body is divided into proportionate parts and marked by a band reminiscent of the **stringcourses** that define stories on buildings. The tankard is surmounted by a lid (also derived from classical moldings) and a finial (as is, for instance, Palladio's Villa Saraceno; see fig. 4.9). These two aesthetic languages, the classical orders and the S-curve, are combined most frequently in decorative art objects. Look again at the foot of Revere's Liberty Bowl; it replicates, in miniature and upside down, the capital of a Tuscan column. Revere, like other artisans of his day, designed in both of these aesthetic languages.

In architecture of the period, the rule of the orders and of geometry is absolute. In furnishings, the serpentine line intrudes; here flora and fauna (shells, **cabriole** legs with paws or claws) disport themselves. The S-curve cabriole leg provides a very different metaphor than do the classical orders for the weight-bearing function of these supports; it seems to flex, like an animal's leg, rather than standing erect like a post. In the case of this high chest we see the cabinetmaker's reconciliation of these two disparate vocabularies (**fig. 4.25**). Like Revere's tankard and Mount Pleasant, the high chest is divided into three hierarchical sections—a "basement" set off from the "main story" by an architectural molding, and, on top, a pedimented "attic." This pediment is basically an architectural feature (like the pediment over the door at Mount Pleasant), and is embellished with architectural moldings, but it is carved into a double serpentine to echo the legs.

Although a novelty in the West in the seventeenth and eighteenth centuries, the serpentine leg had been used in China since at least the fifteenth century, and this form may recall Chinese antecedents. Certainly the surface of the Boston-made high chest is based on Chinese sources. Gilt imaginary creatures, flowers, and figures cavort in unperspectival space across the drawer fronts. Called "**japanning**," this surface treatment mimics in paint, gilding, and gesso (a plaster material that gives the figures relief) Chinese lacquer chests imported to the West.

Unlike colonial oak chests from the seventeenth century (large, undifferentiated containers like trunks), the high chest displays an important eighteenth-century development: drawers. For a burgeoning consumer culture, in which more individuals had more things (especially textiles), drawers allowed greater organization and easier retrieval.

Because these belongings were valuable and the households in which they were installed included many individuals—including apprentices, servants, and sometimes slaves, as well as family—the decorative program of the drawers includes ornamental brass keyholes for locks as well as brass pulls for access.

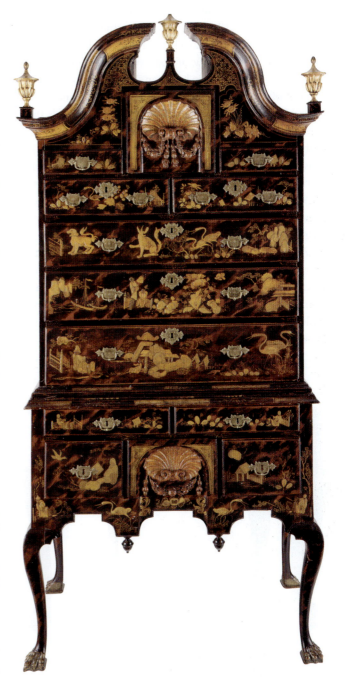

4.25 JOHN PIMM (cabinetmaker) & THOMAS JOHNSON (japanner) (attribs.), High chest of drawers, Boston, 1740–50. Japanning on maple and white pine, 95¾ (243.2 cm) high, 42 in (106.6 cm) wide, 24½ in (62.2 cm) deep. Winterthur Museum, Winterthur, Delaware.

## The Colonial Artisan

Less wealthy householders could not afford japanned high chests, but these people were part of the same culture, and participated in the same economy, through employment as mariners, sawyers, porters, clerks, or artisans. How did artisan businesses work? How did craftsmen learn the theory and practice of design, the management of tools and materials? Many men in the British colonies were artisans—pewterers, silversmiths, cabinetmakers, cobblers, tailors, housewrights, barrelmakers, and others. Neither working-class nor gentry, artisans occupied a broad spectrum of social positions in between. Master craftsmen were owners of property; businessmen who commanded the labor of others; merchants who marketed the goods they produced; masters of tools, materials, and techniques; and lastly, educators of the next generation of craftsmen. Lesser artisans included propertyless journeymen: laborers who worked for wages and, with the accumulation of capital, might aspire to master status. A shop also included apprentices, young men bound by contract to work without wages in exchange for learning a marketable skill.

Artisans learned their trades not in school but on the job. Most began as apprentices at age thirteen or fourteen, when their fathers contracted for them to leave home and live for seven years with a master craftsman. In exchange for learning a trade, apprentices received knowledge in lieu of wages; they promised to be obedient and diligent.

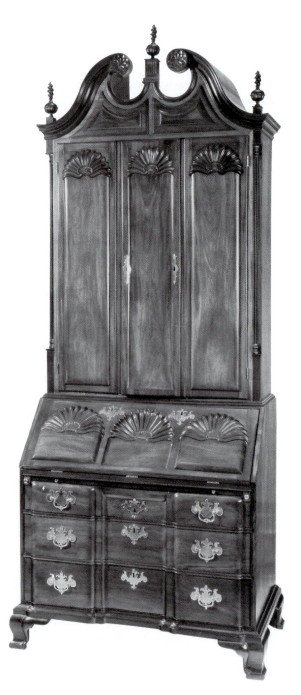

4.27 JOHN GODDARD, Desk-and-bookcase, Newport, Rhode Island, 1760–90. Mahogany, black cherry, chestnut, white pine, 106¾ in (271 cm) high, 44¼ in (113.6 cm) wide, 25¼ in (64.1 cm) deep. Yale University Art Gallery, New Haven, Connecticut.

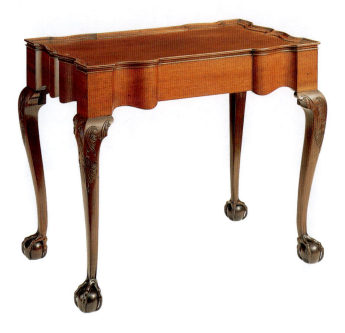

4.26 JOHN GODDARD, Tea table, Newport, Rhode Island, 1763. Mahogany with tulip poplar, 26⅞ in (68.3 cm) high, 32¾ in (83.1 cm) wide, 20⅜ in (51.8 cm) deep. Winterthur Museum, Winterthur, Delaware.

**JOHN GODDARD, MASTER CABINETMAKER.** A master craftsman ran his home and business as a single economic and social unit. John Goddard (1723–85) oversaw a successful cabinetmaking shop in the rear of his two-and-a-half-story house. With the assistance of apprentices, journeymen wage workers, servants, and perhaps his children (three of his sixteen children are known to have become cabinetmakers), he produced such objects as the tea table in **fig. 4.26**. The edge has been raised slightly to safeguard the

Chinese porcelain the table was intended to support and display. Goddard's shop—like others nearby—also produced larger, more complex mahogany objects, such as the desk-and-bookcase (**fig. 4.27**), which were made for local sale as well as for export to the West Indies. Like chests of drawers, desks were an eighteenth-century innovation—in this case tied to the increasing importance, in a newly international economy, of record keeping, correspondence, and bookkeeping. A New England design, the blockfront desk, with its pattern of convex-concave surfaces, marks one of the high points of colonial art. The desk combines rhyming forms, an architectural vocabulary (note the quarter columns framing the corners), and the sinuous S-curves of the shells to form an extraordinarily inventive, well-proportioned, and well-crafted object.

## The Cosmopolitan Wigwam

Probate records make it clear that by the end of the eighteenth century even householders of only moderate means had many more possessions than their counterparts a century earlier. Ezra Stiles—minister, Yale College president, and early ethnographer—was interested in the welfare of Native Americans of the Connecticut coast. Stiles noted, for instance, the number of wigwams (domed houses made of bent saplings covered by bark, used by many Indian peoples in the East) and "English houses" (Native American homes built of milled lumber) in Native settlements on his route. On October 26, 1761, he visited the wigwam of Phebe and Elizabeth Moheegan at Niantic, Connecticut, and measured and sketched the interior (**fig. 4.28**). Their wigwam was 17 feet 4 inches long and 12 feet wide. It had a raised U-shaped platform with mats, which served as seating and beds (K); a fire was located on the floor between the mats (L). Its furnishings included a chair (I), a table (G), two chests (C and D), and a dresser, that is, a chest of drawers (H), and, most conspicuously, at A—on an axis with the entrance and the fire—a tea table. This tea table and chest of drawers illustrate the role of material objects in the process of culture change. They also provide evidence that Native Americans developed a taste not only for tea, but for the ceremonies and conveniences of ambient English culture. Like Ben Franklin's Chinese bowl fifteen years earlier, the arrival of tea and a tea table in the Moheegan wigwam forms a vignette of international horizons and changing cultures.

4.28  EZRA STILES, *Phebe and Elizabeth Moheegan's Wigwam, Niantic, Connecticut*, Oct. 26, 1761. Ink on paper. Bienecke Library, Yale University, New Haven, Connecticut.

# Artists Painting

While our culture tends to regard easel painting as the highest form of art, this preference for painting did not pertain in colonial America. By every measure (value in probate inventories, anecdotal commentary, relative cost, number of surviving objects), colonials preferred objects that were useful as well as aesthetically pleasing. A painting and a silver teapot cost about the same, and most who had the choice opted for the teapot.

How did painting evolve over the course of the eighteenth century? How did artists learn their craft, and how did they find customers for their wares? The story is principally one of portraits and portraitists. As we have seen (see Chapter 3), some extraordinary paintings survive from the seventeenth century in the Boston area (very few appear to have been painted south of New England until the eighteenth). Portraits are an exceptional kind of painting, for, unlike other genres, they were intended for the private family and usually descended through a family line; once purchased, they had no commodity value. They performed important work within that context, memorializing the likeness of individuals, couples, and sometimes family groups. Few individuals who bought other luxury goods purchased portraits in the seventeenth century. But by the early eighteenth, an increasing number of patrons in all the colonies were willing to commission portraits, and more artists were available to satisfy this market.

Some already accomplished painters immigrated to the colonies. The most important of these, John Smibert (1688–1751), settled in Boston in 1729. He arrived in the entourage of the philosopher George Berkeley as professor

4.29 JOHN SMIBERT, *Dean Berkeley and His Entourage (The Bermuda Group)*, 1729. Oil on canvas, 5 ft 9½ in (1.77 m) × 7 ft 9 in (2.3 m). Yale University Art Gallery, New Haven, Connecticut.

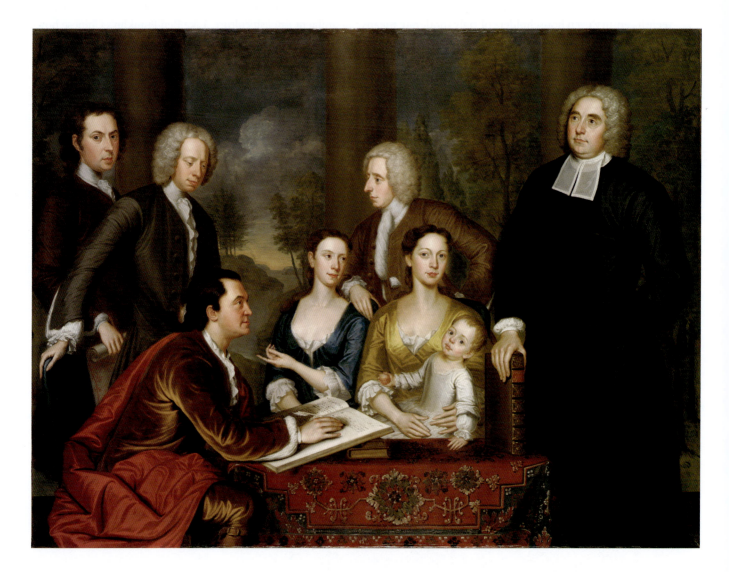

of fine art in a university Berkeley planned—he is the figure on the far left of his large painting commemorating the venture (**fig. 4.29**). Berkeley stands at the opposite end of the painting. Berkeley's upward gaze suggests his concern with heaven (he was a clergyman, eventually a bishop in the Church of England). His right hand, however, points downward, highlighting the expensive gilt binding of the book in his hand and the equally luxurious Turkish carpet that covers the table. The madonna-like mother and son remind the viewer of the importance of family and patrimony, while the grouping of men around the background columns suggests that they are figures of uprightness and character. The seated women—one gesturing delicately toward the distant landscape—hint at the group's larger mission: to bring civilization to the wilderness. Smibert's role in all this is to record the enterprise for posterity. His painting combines likenesses of all involved with a visual statement of their values: family, education, and property.

How did colonial artists find customers? Since there were no exhibitions and it was ungentlemanly to hang out a shop sign or advertise in the newspapers (although some did both), artists depended on reputation. An artist's reputation was created and circulated in the same milieu as the portraits: the family. Eighty percent of John Singleton Copley's several hundred colonial sitters, for instance, fit on just twenty-eight family trees. Since his identity was well known in this context, most of his colonial works are unsigned. When Copley began exhibiting in London at the Royal Academy exhibitions—open to the public and a primary place for finding new customers—he routinely signed his works, putting his name conspicuously on his achievements with an eye to bringing potential patrons to his studio.

Although Smibert and Copley are high achievers, for whom we have relatively good records and many surviving works, there are dozens of other artists about whom we know very little. Almost all of them—in both the colonial and early national (post-independence) period—were portraitists, and they worked in both the principal towns and in the countryside. Color shops provided imported pigments, canvas, and other supplies. Smibert ran such a shop in Boston, which not only gave him steady income but served to introduce his work (*Dean Berkeley and His Entourage* hung on the wall of the adjoining studio) to amateur artists among the gentry who were also potential patrons.

By the close of the colonial era, painters were available throughout the colonies, and even middle-class families were commissioning portraits. Education in art was random and informal, but sufficient numbers of artists acquired sufficient skill to satisfy this burgeoning demand.

History paintings, with their overtones of elite education, aristocratic patronage, and theatrical didacticism, never caught on in America, but by the opening of the nineteenth century there was a blossoming of genre and landscape painting. Done on speculation and sold through middleman dealers, many of these paintings were produced by artists who had trained in newly established art academies in Philadelphia and New York or in Europe.

## Copley and West: Beacon Hill and the Academy

Two important artists to emerge from colonial America—John Singleton Copley (1737–1815) and Benjamin West (1738–1820)—took disparate paths from obscurity to the center of British art production in London. West and Copley not only mastered the techniques and practices emanating from London, they also revolutionized those practices.

Copley and West followed different routes to acquire training in depicting the human form. Copley's stepfather, Peter Pelham, had been a printmaker with some painting skills. When Pelham died, the thirteen-year-old Copley took over Pelham's tools and began to paint professionally. He set himself a program of study that included copying an anatomy book and Italian prints of mythological subjects, minutely observing the Bostonians around him, and drawing plaster casts of antique sculpture. The resources in Pelham's studio, together with those from Smibert's after the latter's death in 1751, were sufficient to give Copley a working knowledge of Grecian and Roman statues. Smibert's well-stocked studio, only blocks away from Copley's home, was a treasure trove of prints, drawings, and copies of Old Masters. Keen observation—Copley is known to have spent ninety hours on a single portrait—gave him knowledge and the means to render bodies, faces, furniture, and fabric convincingly.

In 1765, when he was twenty-seven, Copley sent a portrait of his half-brother, Henry Pelham, to London for comment. Benjamin West, who had emigrated to London six years earlier, responded warmly and encouraged him to come abroad, to learn the European tradition and contribute to that tradition, but Copley lingered in the colonies for another decade. In Boston he produced ever more polished works, married well, and purchased five acres of property, with three houses, on Beacon Hill next to John Hancock, one of the wealthiest men in the city. His skill had brought him prosperity, but it had also clearly brought him (as well as his customers) pleasure in the sheer power of its illusionism.

**COPLEY'S COLONIAL PORTRAITS.** Characteristic of Copley's achievement in America in the years leading up to the Revolution are his portraits of Nicholas Boylston (**fig. 4.30**) and Mrs. Thomas Gage (Margaret Kemble Gage) (**fig. 4.31**). Both appear in informal, indoor garb, appropriate for domestic pictures, but both also incorporate references to the much broader world. Boylston is pictured in a standard half-length canvas (that is, half the size of a canvas on which a full standing figure would be depicted), the size favored by Copley's patrons. Opulent textiles drape Boylston's table and the "window" behind his form.

Ledgers and a distant ship bespeak his merchant identity; a velvet cap and silk clothing underline his prosperity. The robe that covers his clothes (it will be replaced by a fitted coat when he goes out) is called a *banyan*, a form derived from India, lending an exotic touch to the portrait.

A more complicated case of exotic costume is offered by the contemplative Margaret Kemble Gage, who is dressed in what was known as *turquerie*; that is, she wears a belted caftan over her uncorseted torso, and her loose hair is ornamented with pearls and a rich turban. This costume, so unlike the clothing Western women generally wore,

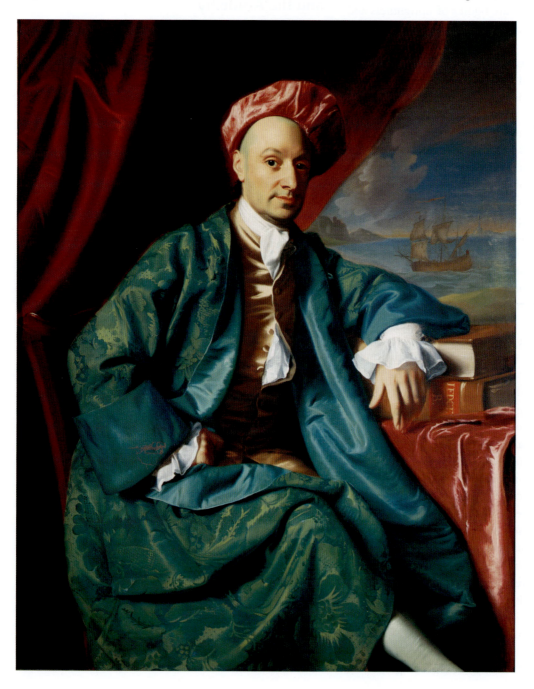

4.30 JOHN SINGLETON COPLEY, *Nicholas Boylston*, 1767. Oil on canvas, 49¼ × 39¼ in (125 × 99.5 cm). Harvard University Portrait Collection, Harvard, Massachusetts.

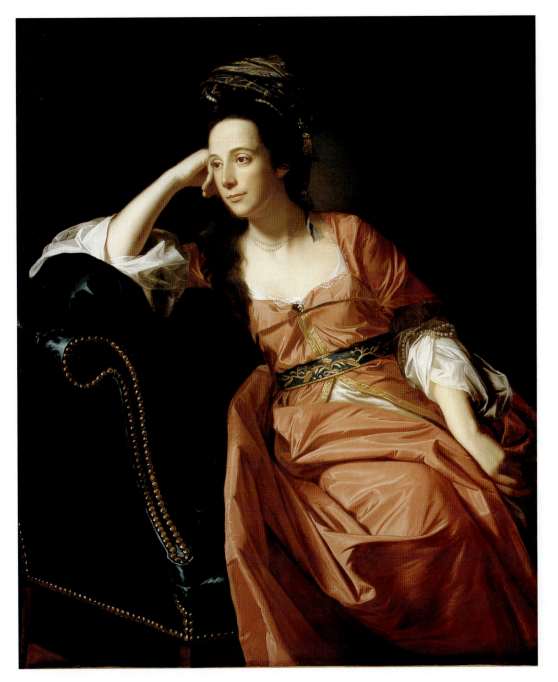

4.31 JOHN SINGLETON COPLEY, *Mrs. Thomas Gage (Margaret Kemble Gage)*, 1771. Oil on canvas, 50 × 40 in (127 × 101.6 cm). Timken Museum of Art, San Diego.

derives from descriptions of Turkish culture and fashion included in the letters of an Englishwoman, Lady Mary Wortley Montagu. These detailed observations, widely circulated in her lifetime and published in London in 1763 after her death, were promptly republished in the colonies—an indication of the curiosity among colonial women concerning the material culture and social experience of their distant counterparts. Not just manifestations of a fad, such costuming (on Mrs. Gage and the other eight women similarly attired in Copley portraits) alerts us to an empathetic interest among Copley's sitters in different cultures and alternative ways of being in the world. Margaret Gage was an American woman of Greek extraction who was deeply sympathetic to the Revolutionary cause but married to a British general. Her pose suggests a complex, but not easily decodable, discourse about dependence and independence, resistance and submission. Certainly her *turquerie* represents a kind of fictionalizing disguise, one that reads—together with her pensive posture—as eloquent of a thoughtful inner life. On both Boylston and

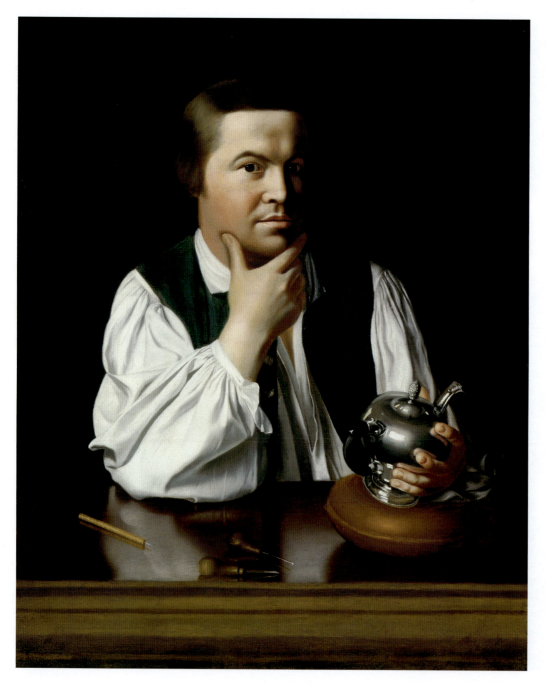

4.32 JOHN SINGLETON COPLEY, *Portrait of Paul Revere*, 1768. Oil on canvas, 35 × 28½ in (88.9 × 72.3 cm). Museum of Fine Arts, Boston, Massachusetts.

Gage the cloaks of exoticism could simply (and superficially) be read as markers of wealth and an orientalizing turn of mind. But the portraits also suggest a more complex relationship between identity and costume, between here and elsewhere.

In John Singleton Copley's *Portrait of Paul Revere*, 1768, the issue of clothing again comes to the fore (**fig. 4.32**). Revere cradles a teapot, which he is about to engrave with the tools on the table before him. Lacking the usual signs of gentlemanly status (wig, waistcoat, heraldic or family

markers), Revere wears instead the blouse (or shirt) of an artisan. The fingernails of his left hand are dirty. He appears to pause in his labors, as if considering the next step in his work, or reflecting more generally on his craft. By picturing Revere as a thinker, as much as a maker, Copley suggests that Revere engages the world with his mind as well as his hands. His work requires thought and vision. Despite his work clothes, Revere behaves as an artist-gentleman, someone whose contemplative pose suggests the intellectual habits of the upper classes. Copley's *Portrait*

of *Paul Revere* is thus more than a portrait. The painting reveals Copley's own aspirations to high social status. It is a portrait of the artisan as artist.

The teapot that Revere grasps forms an essential part of the portrait. That teapot is not just an inverted pear-shaped object with a highly reflective serpentine surface. It is part of a burgeoning international economy of objects and cultural practices. It was made of silver from Mexico and fashioned in Boston to prepare tea—a drink brewed from leaves grown in Asia and sweetened with sugar cut in the Caribbean by African slaves. Thus one small teapot encompasses a global economy of ideas, foods, and people, as well as design.

**WEST'S HISTORY PAINTINGS.** For Benjamin West, as for Copley, the dilemma was how to achieve a purpose beyond the visual delight of mimicry and recording family history. Because the claims for painting as a gentlemanly occupation rested on intellectual and moral content, as well as on public exposure, the solution—for West—lay in London.

Benjamin West emigrated to Europe from his native Pennsylvania in 1759, at the age of twenty-one. He spent three years studying in Italy, and then established himself in London as a history painter and a portraitist. His first triumph was a history painting commissioned by the archbishop of York in 1768, *Agrippina Landing at Brundisium with the Ashes of Germanicus* (**fig. 4.33**). The subject, drawn from ancient history, pictures Agrippina, the widow of Germanicus, bringing her husband's ashes back to Rome in defiance of the emperor Tiberius. Germanicus had been a general with republican leanings; he stood next in line to become ruler of the empire. Instead, he was murdered. Cradling the funerary urn, Agrippina, together with her mourning children and attendants, disembarks at the port of Rome at Brundisium, modern Brindisi. She is a figure of popular sympathy. The image is simultaneously "chaste,"

4.33 BENJAMIN WEST, *Agrippina Landing at Brundisium with the Ashes of Germanicus*, 1768. Oil on canvas, 5 ft 4 in × 7 ft 10 in (1.63 × 2.39 m). Yale University Art Gallery, New Haven, Connecticut.

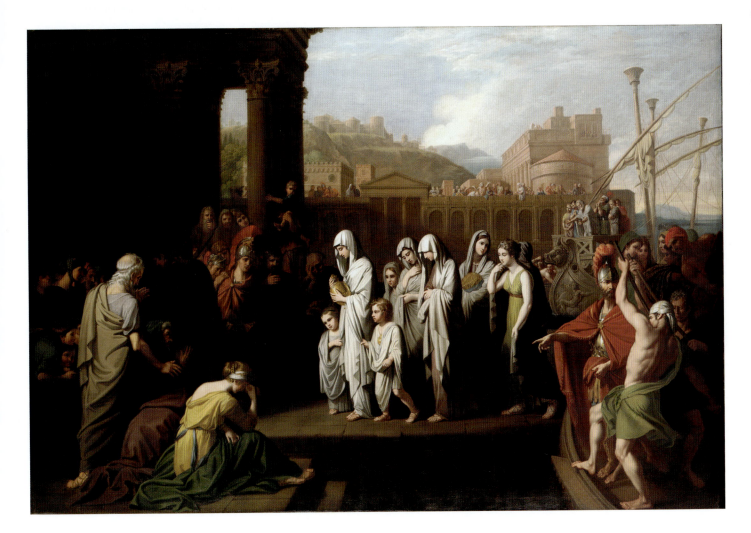

in the frieze of central figures (copied from a classical relief carving on the Ara Pacis in Rome), and robust, in the nearly nude mariner exerting himself in the right foreground. The urn that Agrippina holds represents, in miniature, the values that the artist most desired in painting: it contains not only the ashes of Germanicus but also the memory of classical virtue that he embodied and that she enacted. It bears witness to civilization's most cherished ideals. West's painting made the past immediate for mid-eighteenth-century Londoners and prompted contemplation of honor, resilience, and public virtue. We see in this work the essential ingredients of history painting: high seriousness, large-scale narratives of death and sacrifice drawn from well-known texts and histories, the incorporation of visual quotations, and meditations on the struggle between wickedness and virtue.

West's most important work, *The Death of General Wolfe*, 1770, exhibited at the newly founded Royal Academy in 1771, introduced Londoners to the idea of modern costume and modern events in history painting; it also rendered explicit the ideal of self-sacrifice for one's country

(**fig. 4.34**). The painting resulted in West being appointed history painter to the king. *The Death of General Wolfe* pictures an event in the French and Indian War when, in 1759, British forces achieved a victory that resulted in the near elimination of the French empire in North America. During the Battle of Quebec the leading British general, James Wolfe, died from his wounds. Arranged in a tableau echoing a traditional "Descent from the Cross" or "Lamentation," the Christ-like Wolfe lies limp in the arms of his comrades. One officer swoons (evoking the Virgin) into the arms of his companions. Central to this group is the Native American in the foreground. His heroic semi-nudity associates him with antique sculpture while his anthropologically correct accoutrements signal his status as an indigenous American. More than any other figure in the painting, this contemplative Indian conveys an understanding of the enormity of the event. For West's educated

4.34 BENJAMIN WEST, *The Death of General Wolfe*, 1770. Oil on canvas, 59½ × 84 in (151.1 × 231.4 cm). National Gallery of Canada, Ottawa.

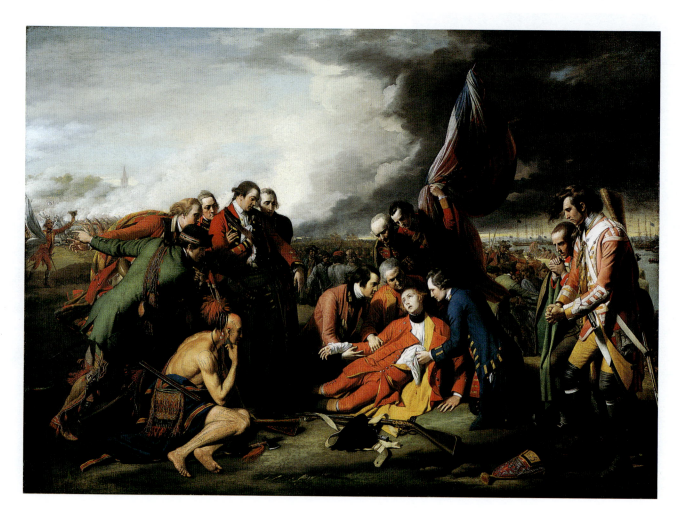

contemporaries, the painting's "moral" echoed the words of the Roman poet Horace, *Dulce et decorum est pro patria mori* ("It is sweet and honorable to die for one's country"). West's Mohawk warrior also reminded his British viewers that American colonials and their Indian allies had supported the British during the French and Indian War. Seated next to the figure of William Johnson, an American known for his work with Indians but not actually present at the battle for Quebec (Johnson wears Indian leggings), this warrior demonstrates West's deep sympathy for colonial causes. Painted at a moment of high tension between Britain and the American colonies, West's image brings together Johnson and the Mohawk as embodiments of New World sympathy, naturalness, and virtue. West presented the colonists, and their Indian allies, as valued partners that the British could not afford to lose.

The following year, West again turned to history in order to comment on the present. In *William Penn's Treaty with the Indians in 1683*, 1771–72, West commemorated an encounter in 1673 when William Penn, founder of the Pennsylvania colony, negotiated one of several land exchanges with the Leni-Lenape (Delaware) Indians (**fig. 4.35**). The French philosopher Voltaire would later describe Penn's treaty as the "only treaty" between Europeans and Indians that was "never infring'd." The painting divides into two halves: the lush and slightly darker world of the Native Americans on the right, and the ordered world of Penn and his circle of Quaker merchants on the left. At the center of the canvas, an unrolled bolt of cloth links the two parties. The viewer can barely see the text of Penn's treaty in the hands of the man to Penn's side. The painting focuses, instead, on the cream-colored cloth. Anthropologically, the cloth illustrates the process of diplomacy with Native tribes—the drawing up of a contract being followed by an exchange of goods, demonstrating the honorable intentions of both parties. At a political level, however, the cloth suggests something else. The fabric is linked visually to the trunk below it, to the second trunk in

4.35 BENJAMIN WEST, *William Penn's Treaty with the Indians in 1683*, 1771–2. Oil on canvas, 75½ in × 107¾ in (191.7 × 273 cm). Pennsylvania Academy of the Fine Arts, Philadelphia. Pennsylvania.

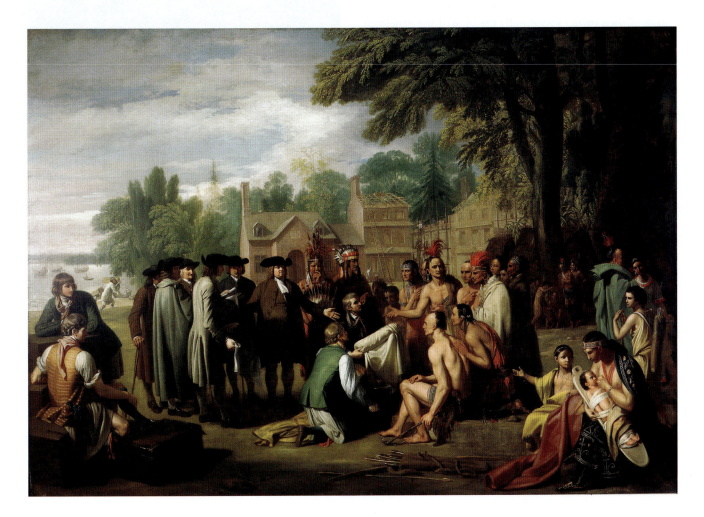

the lower left corner of the painting, and to the forces of commerce and trade associated with the harbor, ships, and sailors in the left background. The exchange between Penn and Natives becomes, in West's painting, a metaphor for fairness and mutual exchange between Old World and New: the portly and benign Penn and the colorful and animated Native Americans. The use of strong horizontal and vertical lines in the painting—in contrast with the dominant diagonals of *The Death of General Wolfe*—reinforces the painting's sense of equanimity and calm. Penn's fair dealings with his New World neighbors signal West's own hopes, in the years before the battles of Lexington and Concord, for just relations between the colonies and the Crown tied to commerce, consumption, and mutual respect. History, as we know, turned out differently.

## Painting, Portraiture, and Race

Long before Benjamin West featured a Mohawk warrior in *The Death of General Wolfe*, African Americans had begun to appear in colonial portraits and group paintings. They were portrayed most often as slaves and servants, signs of their owner's wealth. By the time of the American Revolution, however, some painters, including John Singleton Copley, had begun to view the figure of the African American in a more sympathetic light. In this section, we shall examine the way colonial painters portrayed their African American subjects, and the reasons why Copley altered that equation.

**JUSTUS KÜHN'S *HENRY DARNALL III AS A CHILD*.** The earliest known portrait of an African American in colonial painting is Justus Kühn's *Henry Darnall III as a Child*, c. 1710 (**fig. 4.36**). Kühn (d. 1717) was a German immigrant to the Annapolis area in the first decade of the eighteenth century. He offered his Maryland clients the fantasy of European-style grandeur. He portrayed Henry Darnall, son of one of Maryland's wealthiest families, as a young aristocrat of imperious mien. Darnall's world is defined by his possessions, from his richly embroidered jacket and flowing green tunic (an allusion to classical portraiture) to the idealized garden on the other side of the balustrade. No such garden existed in the colonies in 1710. The garden's tight geometry, instead, represents a fantasy of an ordered, stable, and hierarchical world linked to class privilege and property ownership.

Kühn thus takes a young provincial from the New World and portrays him as an assured member of a transatlantic aristocracy. Darnall's black slave, in turn, attends his master from behind and below, fenced by the

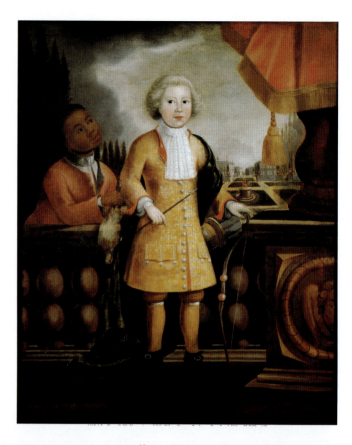

4.36 JUSTUS ENGELHARDT KUHN, *Henry Darnall III as a Child*, c. 1710. Oil on canvas, 54¼ × 44 in (137.8 × 112.4 cm). Maryland Historical Society, Baltimore, Maryland.

balustrade. The silver shackle around his neck indicates his status as property. The artist seems less interested in the slave as a person than in his fine attire, concerned that the domestic slave of an elite family must appear outfitted for the role. Accordingly, as young Darnall sports the weapons of the hunt, amusing himself, as a young gentleman should, with leisurely and aristocratic pursuits, his slave admires him.

**JOHN GREENWOOD'S *SEA CAPTAINS CAROUSING AT SURINAM*.** African slaves appear in scenes of everyday life as well as in portraiture (see fig. 4.1). The earliest is a large genre painting (also called a subject picture), *Sea Captains Carousing at Surinam*, 1757–8, by a Boston-born painter and printmaker, John Greenwood (1727–92), who spent five years in Surinam, a Dutch colony on the northern coast of South America (**fig. 4.37**). A busy international entrepôt, Surinam was frequented by traders from all round the Atlantic. Greenwood's painting, based loosely on a print by Hogarth, *A Midnight Modern Conversation*, 1733, that parodies excess drink, displays the bodies of the sea captains with an angularity that Hogarth, in his *Analysis of*

*Beauty*, associates with ugliness, and with a lack of dignity that he associates with comedy. The only three figures exempt from the viewer's comic disdain are the three blacks—one hands a full punchbowl from the tavern's bar, another lies asleep in the left foreground, and the third, a boy, carries a salver with two glasses toward a pair of dancing men. This last figure, his near-nude body turning adroitly in space, evidences the steady hand of sobriety, even grace, in the sea of drunkenness through which he moves.

**WATSON AND THE SHARK.** John Singleton Copley similarly punctuates a scene of disorder with the graceful figure of a black man. Copley achieved one of his first public successes after emigrating to London when he exhibited *Watson and the Shark* (1776) at the Royal Academy (**fig. 4.38**). The painting expands the conventions of history painting by focusing on a personal incident in the life of Copley's patron Brook Watson, rather than on a scene of public virtue and sacrifice. The large scale and serious tone of *Watson and the Shark* re-create the moment when Watson, then a young man, lost a leg to a shark while swimming in Havana harbor. If Greenwood composed *Sea Captains* in terms of an eighteenth-century theory of comedy, then Copley invoked a different aesthetic theory of the time—the sublime—when painting *Watson*. Most memorably outlined by Edmund Burke in *A Philosophical Enquiry into the Origin of Our Ideas of the Sublime and Beautiful* (1757),

this theory proposes that terror—from a safe aesthetic distance—can cause pleasure. Copley intends a visceral response to the shark—so huge and so close to both Watson and the viewer. The near-life-size rescuers in the boat display the emotions that the situation provokes in the viewer. The nude body of Watson is based on an antique sculpture known as the Borghese Warrior, here locked in deadly combat with a savage force of nature. For an educated audience, *Watson and the Shark* offered two pleasures: a feeling of sublime horror at Watson's situation, and the pleasure of recognition at Copley's classical allusion.

The art historian Albert Boime has interpreted *Watson and the Shark* as a political critique of the American Revolution. The painting draws attention to the hypocrisy of colonial claims to independence when such claims rest upon the continuance of slavery. The prominent position of the black man in the boat—one of only two figures standing—highlights the centrality of the slave trade to mercantile interests throughout the Atlantic.

In an earlier sketch for *Watson and the Shark*, Copley had drawn a white sailor in the position that he later gave to the standing black man. Why Copley substituted the figure of the black man in the finished version is unclear. Brook Watson himself might have suggested the change, or might have described the scene to Copley as including

4.37 JOHN GREENWOOD, *Sea Captains Carousing at Surinam*, 1757–8. Oil on canvas, 37¾ in × 75¼ in (95.7 × 191 cm). St Louis Art Museum.

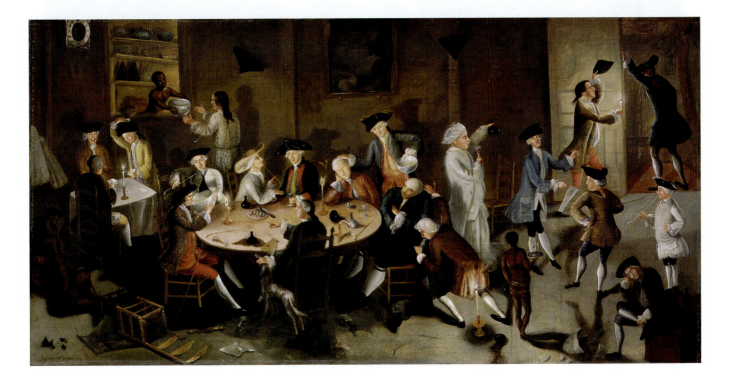

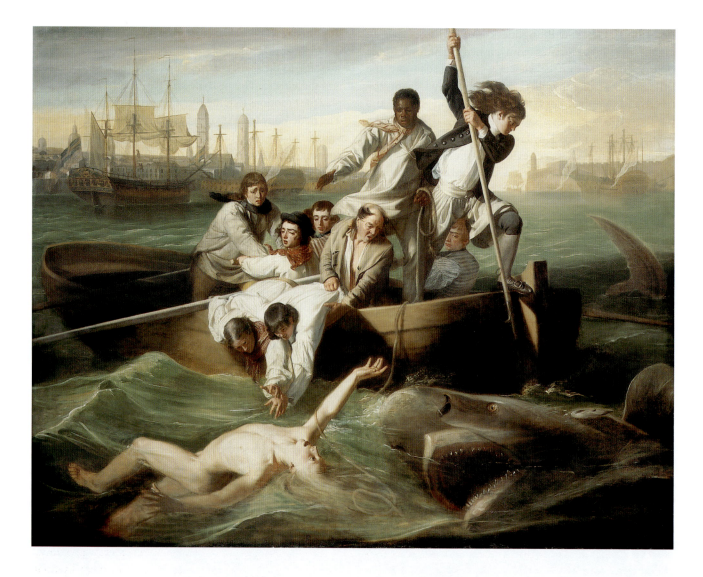

4.38 JOHN SINGLETON COPLEY, *Watson and the Shark*, 1776.
Oil on canvas, 71 × 90½ in (182.2 × 29.8 cm). National Gallery of Art,
Washington, D.C. Ferdinand Lammot Belin Fund.

a black man. What is important, however, is Copley's "editorial" control. He has placed the black man at the center of the triangle that visually organizes the figures in the boat. The man's outstretched right hand gestures to Watson in the waters below him. That gesture is repeated in reverse direction by Watson's own upward-reaching right hand. The painting thus binds together Watson and his black rescuer, a white body and a black man held together visually—and historically—by modes of interdependence that neither can avoid.

When Copley's painting was first exhibited in London in 1778, viewers expressed skepticism at the efforts of the black man to save Watson. They noted the lax quality of the rope dangling from his hands and the failure of Watson to grasp it. The painting appeared to reinforce, rather than challenge, contemporary racial assumptions. It placed the black man *behind* a white figure in a position appropriate to a dedicated servant, and it left the black man's role in the ultimate rescue of Watson ambiguous. Nevertheless, Copley has not only integrated a black man prominently into the painting's central drama, but endowed him with psychological depth and profound humanity. Highlights upon the man's forehead and beneath his right eye suggest inwardness and contemplation.

The painting's significance for us, then, lies in its combination of humanistic values and conservative politics. Copley opposes the secession of the British colonies. His criticism of demands for American independence hinges on a racial argument: that the people who proclaim their freedom are, hypocritically, the same people who maintain slavery. The more human Copley's black man appears to be, the more untenable the colonists' claims to freedom

become. Copley thus produces an opening salvo in what will become a dissenting tradition of blacks being portrayed sympathetically by white artists.

*Watson and the Shark* summarizes many of the social complications pervading colonial culture in the years leading up to the American Revolution. The scene is located in Havana harbor, an outpost of the Spanish empire that functioned as a key stop in the slave trade of the eighteenth century. Ships left New England and the colonies for Africa. They traded rum for slaves, and then headed to Cuba and the West Indies, where they sold their African cargo for sugar and molasses, ingredients essential to the colonial economy. The painting thus draws together the transatlantic worlds of Europe and America in their mutual dependence upon enslaved labor from Africa. The painting also imagines its little world as a microcosm of the larger world: individuals from different classes (where differences in clothes denote differences in social rank) all work together under the direction of a single, upper middle-class man (the figure with the boat hook) in a hierarchy that sets white upper class over white working class, and both over black. And yet the painting does more than mark off the social and racial divisions of colonial society. By heroicizing its figures, and transforming an incident of commerce into a drama of salvation, the painter articulates a utopian vision of cooperation and interdependence that will take on new life in the following decade with the onset of the American Revolution.

## Conclusion

The eighteenth century can look remarkably modern to contemporary eyes. It marks the beginning of consumerism in American culture, that penchant for measuring status and identity by the objects that surround us. Consumerism, then as now, was underwritten by an international—what we today call a "global"—economy. The tea consumed in delicate porcelain cups on elegantly crafted wooden tea tables by increasing numbers of eighteenth-century colonials came from Asia, and it required the machinery of empire to arrive in British North America, where it steeped in silver pots in Georgian houses up and down the eastern seaboard. Those teapots, like the buildings that housed them, employed elements of symmetry and order that were understood by their makers to express nature's larger harmonies.

The Southwest represented a different kind of empire. Life in missions across Texas, Arizona, and California drew on memories from the metropolitan centers of Spain and New Spain. These centers, in turn, wove together influences from medieval Europe, from Muslim Spain and Northern Africa, from Native American life in the Southwest, and, by the end of the century, from the neoclassical forms emanating from Europe. The international flow of goods and styles that we take as a hallmark of early-twenty-first-century life really began three centuries ago, despite all the differences in systems of transportation, exchange, and dissemination.

None of this would have been possible without the labor of slavery and the enforced servitude of Native workers in the Southwest. Colonial painting tends to make visible what otherwise would go unremarked: the way that cultures of consumption rely on economies of cheap labor. Sometimes the laborer is shown as a loyal servant; sometimes he appears, as in Copley's *Watson and the Shark*, as co-contributor to the larger social good. Only occasionally does the laborer's view of the world make its way into the historical record.

The unexpected part of this story is what happens next: revolution. As the economy prospered, American colonists came to chafe at the restrictions placed on them by their peers on the other side of the Atlantic. Britain needed to find a way to finance what had become a very expensive war: the French and Indian War, depicted in West's *Death of General Wolfe*. Parliament turned to the colonies for relief, and the colonies, in turn, grew resistant to what felt like restrictions on their pockets and their liberties.

As we shall see in the following chapter, artists plunged headlong into the debate: justifying rebellion, imagining a new nation, and, when the Revolution began to look a bit more radical than many had expected, trying to limit the social upheaval they themselves had helped foment.

# 2 Forging a New Nation, 1776–1865

IN PART II, we shift our attention from empire-building to nation-building. During the first three centuries of European settlement in the New World, the arts played a central role in the network of goods, services, and ultimately, *peoples*, exchanged between Europe, Africa, and the Americas. By the late eighteenth century, this global economy extended across the Pacific to China. But the British Empire was soon cursed by its own success. The British could not hold on to their increasingly prosperous colonies across the Atlantic. The consumer revolution of the eighteenth century created an assertive mercantile elite—and a supporting cast of artisans, farmers, plantation owners, bankers, merchants, shop keepers, and laborers—unhappy with their colonial status, enamored with Enlightenment discourses of freedom, and eager to assert their rights. The result was revolution.

The two young men staring at us across the page represent the face of revolution. Their enigmatic smiles are part of a "deceit," which is the term their father, painter Charles Willson Peale, gave to the life-sized canvas. Peale extended the painting into the viewer's space. He placed a wooden riser at the painting's base, and a doorframe around its sides. By fooling the viewer's eye, Peale playfully challenged his audience to enter the world depicted in the painting as if it were real.

Peale's painting was more than a visual joke. Known today as *The Staircase Group*, it represents an opening salvo in a war waged by the arts to find new audiences in the years after the American Revolution. Artists began to forge alliances between themselves and their fellow citizens by linking the arts to politics and everyday life. They attempted to elevate the tastes of those around them and educate their viewers in their duties as citizens.

The first half of the nineteenth century marked the beginnings of industrialization in the United States. Artists responded in their work to the many changes they saw occurring around them. They noted the rise in immigration, and the nation's shifting demography, by depicting scenes of everyday life filled with the many new faces and "types" associated with different regions of the country: the sly New England merchant, the rugged western pioneer, the gullible country "bumpkin." They dealt with race and slavery by providing white patrons with reassuring images of contented African American subjects. They responded to urbanization—and growing unrest among the working classes—by idealizing the countryside as a space of pre-industrial beauty and harmony. They invested the landscape with spiritual powers, equating the nation's newness with fresh beginnings and unlimited possibilities. They transmuted the nation's rapid, and often violent, expansion westward into a vision of "Manifest Destiny," the country's divinely ordained mission to bring civilization to the wilderness.

Artists focused their efforts, in other words, on the business of nation-building. They created a vision of the United States that—though occasionally critical—tended to idealize the nation's past and future, to bring people together across class and economic divides, and to forge consensus.

That dream of national unity blew apart in the spring of 1861, when southern artillery bombed federal troops in Fort Sumter, South Carolina. In the ensuing four years, artists produced images and objects, from portraits to quilts, that addressed the war raging around them. In the end, however, it was a newly invented technology—photography—that displayed the horrors of modern warfare in unprecedented fashion. The Civil War marks the triumph not only of an industrial economy over an agrarian one but the ascent of a powerful mechanical device, the camera, which introduced new ways of representing and interpreting the world.

(opposite) **CHARLES WILLSON PEALE**, *The Staircase Group* (detail), 1795. Oil on canvas, 89 × 39 in (227 × 100 cm). Philadelphia Museum of Art, Pennsylvania. (See also fig. 5.32)

# 5 | Art, Revolution, and The New Nation, 1776–1828

THIS CHAPTER EXAMINES the ways in which artists influenced the American Revolution and then helped shape life in the early republic. In the years leading up to the Revolution, artists on both sides of the Atlantic provided cartoons, prints, and images satirizing relations between Britain and the colonies and justifying rebellion. In the years after the Revolution, American artists proceeded to create myths to celebrate the new nation. For this, they turned to the art of Greece and Rome, finding a model of moderation, stability, and balance in classical forms.

During the early years of the republic, the taste for classicism swept through all facets of daily life, from the look of government buildings to the designs of women's needlework. Neoclassicism, as it was called, was not unique to America. It was part of a transatlantic culture in the throes of war and revolution, beginning with the American and French Revolutions of the late eighteenth century and continuing through the Napoleonic Wars of the early nineteenth century. Characterized by symmetry and order, Neoclassicism offered people threatened by social turmoil a countervailing vision of timeless values and universal truths, a vision linking America's present and future with the achievements of ancient history. Neoclassicism allowed rival geographical regions, as well as different social classes and competing commercial interests, to see themselves as part of a single nation unified by shared values dating back to antiquity.

By the close of the eighteenth century, however, American society was changing. In 1803, Thomas Jefferson, third president of the United States, virtually doubled the size of the United States by purchasing the lands between the Mississippi River and the Rocky Mountains from France (see Chapter 3). The Louisiana Purchase marked the end of the French Empire in North America and transformed the young nation's outlook, encouraging westward expansion and multiplying its resources, but also providing new territories for slavery and intensifying regional competition among the states. For $15 million (3½ cents per acre), Jefferson changed the destiny of America.

By 1828 (the year in which Andrew Jackson was elected president), Americans themselves had changed. The world of the American Revolution—with its language of civic virtue, its emphasis on universal values, and its faith in the classical past—looked increasingly quaint to new generations accustomed to political factionalism, rising immigration, growing cities, and the first stirrings of industrialization. Neoclassicism started to seem less like a shared set of values than a nostalgia for an idealized past.

## The American Revolution in Print, Paint, and Action

With the close of the French and Indian War in 1763, writers on both sides of the Atlantic had begun to imagine the American colonies as the future birthplace of a great civilization. A Connecticut minister, Ezra Stiles, exulted, "Not only science, but the elegant Arts are introducing apace, and in a few years we shall have ... Painting, Sculpture, Statuary ... in considerable Perfection among us." Colonial leaders increasingly viewed North America

(opposite) MARIA CROWNINSHIELD, *Allegory of Female Education*, 1804. Silk, watercolor, metallic thread and reverse painting on glass, 24¼ × 19¼ in (62.8 × 48.8 cm). The Peabody Essex Museum, Salem, Massachusetts.

as the home for a new art surpassing the achievements of the Old World.

There was a problem, though. The American colonies were not independent. They were part of someone else's empire, and the rules of empire were clear: colonies served their mother country's needs. British colonies were to provide raw materials for British manufacturing and a market for British goods—not to compete with the mother country commercially or develop their own manufactured goods. In this self-centered arrangement, Britain measured the health of the empire by taking her own pulse. What happened in the colonies was of little concern, so long as London prospered.

This indifference inflamed American grievances. The British laws that infuriated American colonists and eventually provoked rebellion—the Stamp Act (1765), the Townshend Act (1767), and the Tea Tax (1773)—were intended to subordinate the colonies to British imperial needs. By imposing taxes and customs duties on its American colonies, Parliament hoped to pay for its debts from the French and Indian War (1754–1763). In the game of empire, Parliament was playing by the rules; the American colonials were not. They resented what they perceived as the erosion of their rights as Englishmen, and they responded by banding together to boycott British goods.

By the middle of the eighteenth century, colonial America surpassed Great Britain in size, population growth, and standard of living. Ben Franklin wondered out loud why the American colonies—with their unlimited resources and vast commercial potential—had not yet overtaken England in the arts. "Why should that petty Island [England] which compar'd to America is but like a stepping Stone in a Brook, scarce enough of it above Water to keep one's shoes dry; why, I say, should that little Island, enjoy in almost every Neighbourhood, more sensible, elegant and virtuous Minds, than we can collect in ranging 100 Leagues of our vast Forests?" Franklin believed that America's time would soon come. He consoled himself with the belief that "the Arts delight to travel Westward."[1]

Americans imagined their independence through the metaphor of a child growing up. They saw themselves as Britain's loyal offspring and believed that they had outgrown their childhood. They began to think of Britain as an "unnatural" mother who stifled her offspring's need for independence. This vision of Britain as an unnatural parent animated the rhetoric of the colonies in the years before the Revolution. In newspapers, cartoons, prints, and **broadsides**, the colonists portrayed themselves as the innocent victims of British willfulness. They turned to print culture to help shape a nascent American identity.

## Print Wars

In an era before computers and television, the printed page rivaled word-of-mouth as the main medium of information. Prints were rapidly produced and quickly circulated. Most popular prints of the eighteenth century were created by incising lines on a metal plate, either by **etching**, in which the lines are cut by acid, or by **engraving**, in which the lines are cut by hand, using special engraving tools. Printers could pull many copies from one plate, which allowed them to sell the prints to large numbers of people. Hawked on the street, sold in bookshops, or offered through advanced subscriptions, prints ranged in price and quality. Like newspaper cartoons today, they frequently satirized political events, public controversies, and local fashions. Often witty and biting in tone, they sought to influence opinion and mobilize support. Frequently prints combined images with text, which appealed to an increasingly literate audience eager to discuss the issues of the day. Eighteenth-century print culture flourished on both sides of the Atlantic. Often fostering modern notions of individual rights, prints played a vital role in transforming politics from a pastime of the elite to a concern of all classes.

***THE DEPLORABLE STATE OF AMERICA.*** The Stamp Act of 1765, enacted by Parliament without the consent of the North American colonies, imposed a new tax on paper products to help pay for the French and Indian War. John Singleton Copley (see Chapter 4) responded to the Stamp Act by re-engraving a political cartoon that had appeared previously in England. In *The Deplorable State of America*, 1765, Copley personifies England as a winged woman who hovers over the Atlantic Ocean while offering Pandora's box to the inhabitants of America (**fig. 5.1**). England says to her "daughter," America, "Take it Daughter its only a S— A— [Stamp Act]." America is portrayed as an Indian with feathers in her cap. She raises both hands in protest and cries out to the helmeted figure behind her, "Minerva shield me I abhor it as Death." Minerva, the Roman goddess of wisdom, warns in turn, "Take it not for poor Liberty." Behind England float the fragments of the Magna Carta, the basis for British civil liberties, now torn up and discarded. A Liberty Tree stands at the center of the image (most American towns now had a tree designated as a meeting place for Patriots and called the tree by this name). At its foot a supine Indian, another representative of America, cries out, "And canst thou Mother! And have pity this horrid box"—a reference not only to Pandora but also to the larger perversion of mother-child relations, which defines the colonies' unhealthy ties to Britain.

5.1 JOHN SINGLETON COPLEY, *The Deplorable State of America*, 1765. Cartoon. The Library Company of Philadelphia, Pennsylvania.

The gallows in the background stands ready to hang offending stampmasters, while the dog in the left foreground urinates on a Scottish thistle. The dog belongs to the member of Parliament William Pitt (the Elder), a strong supporter of American independence. The thistle stands for Lord Bute, whom colonialists reviled as a staunch proponent of taxation. A rattlesnake, emblem of American freedom, glides out from under the thistle. During the French and Indian War of the previous decade, Benjamin Franklin had printed a widely distributed image of a snake divided into segments. The accompanying words, "JOIN, or DIE," urged the American colonies to defend themselves and their freedoms by uniting into a single body.

Copley's print links references to classical mythology and British history with symbols tied to particular people and causes (Lord Bute and the thistle; the rattlesnake and American freedom). The viewer is assumed to be sufficiently well informed to catch the references and synthesize them. In this way, the print is as much read as viewed.

**THE BLOODY MASSACRE.** Five years later, in 1770, Paul Revere published a print commemorating the killing of some Bostonians by British soldiers that year and portraying the event as a slaughter of the innocents. Revere's print, *The Bloody Massacre*, was plagiarized from a drawing by Copley's step-brother Henry Pelham. The print circulated widely in the weeks after British soldiers, quartered in Boston, had opened fire on a hostile crowd of local workers (**fig. 5.2**). Revere depicts the British redcoats as an organized war machine. They stand under a fictitious sign proclaiming "Butcher's Hall." The soldiers' left legs all face forward; their bodies form a sharp diagonal, slicing into space; their muskets almost touch the unarmed Bostonians facing them; and their coordinated gunfire produces clouds of smoke, converting the square into a smoldering inferno.

The Americans, by contrast, stand or slump in disarray. Two lie wounded on the ground, while a third falls into the arms of a companion in a pose recalling Christ's deposition from the Cross. The massacre occurs against the background of Boston landmarks (the Old State House—called the Towne House during the colonial period—and the steeple of the First Church), a visual emphasis designed to inflame locals already sensitive to the British occupation of Boston. Revere's print distorts the historical record—which suggests that the colonists deliberately provoked British troops—for the sake of propaganda. Initially, many Bostonians were wary of those who participated in the "Massacre" and assumed that the motley crowd of Irish Catholics, African Americans, and European Americans was a mob run amok. Revere's print helped galvanize anti-British sentiment by recasting the mob as victims of British aggression.

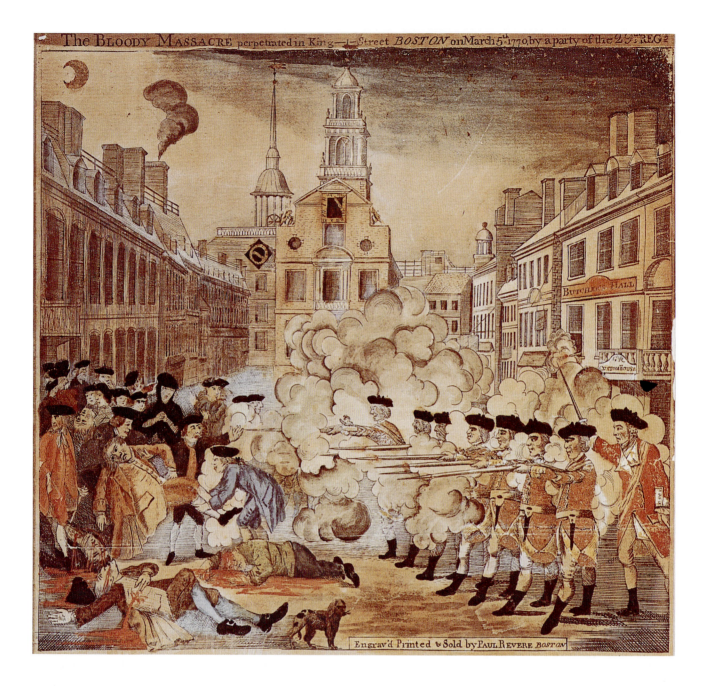

The BLOODY MASSACRE perpetrated in King—t—Street BOSTON on March 5th 1770, by a party of the 29th REG.

Engrav'd Printed & Sold by PAUL REVERE BOSTON

5.2 PAUL REVERE, *The Bloody Massacre*, 1770. Hand-colored engraving, 10 × 8 in (26 × 22 cm). Private Collection.

**"PLAYING INDIAN."** No one was better at inflaming local feelings than Samuel Adams, the silver-tongued Boston radical. When the Sons of Liberty—an alliance of colonists eager to contest British policies—failed to persuade the captains of ships in Boston harbor to return their cargo of tea unopened to England, as a protest against the tax levied on it, Adams told a concerned gathering at the Old South Meeting House that they "could do nothing more to preserve the liberties of America." His phrase was probably a signal. No sooner were the words said than "Indian"

war whoops issued from the street. A group of men disguised as Mohawk Indians dashed to the harbor and boarded the ship *Dartmouth*. They systematically dumped 342 chests of tea into the harbor, an event that we now call the Boston Tea Party.

By dressing as Indians, the colonists created a form of street theater that captured two different ways of imagining themselves. The first mode, illustrated in a print published in *London Magazine* in 1774, represents America as a vulnerable Indian princess (**fig. 5.3**). With her breasts bared, her skirt lifted, and her arms and legs pinioned by others, America lies vulnerable to British assault. Yet as Lord North (the prime minister) force-feeds the Indian

5.3  *The Able Doctor, or America Swallowing the Bitter Draught*, from *London Magazine* (May 1774). Massachusetts Historical Society, Boston.

princess tea, she fights back, spewing hot liquid into his face. This indelicate act highlights the second role that the colonists played by dressing as Indians. They asserted themselves as agents of resistance: "savage" in their innocence and independence.

The cultural historian Philip DeLoria has noted that American identity—from the Boston Tea Party to the present—has been inextricably bound to Native American identity. By "playing Indian," the colonists were doing more than transforming Native cultures into a handy symbol for New World life. To play Indian was to be a revolutionary. Indians represented many things to the colonists: innocence, savagery, nature, North America itself. For the colonists, playing Indian meant trying on a new self and embracing the revolutionary possibilities of the New World.

## Reinterpreting the Revolution: John Trumbull

John Trumbull (1756–1843)—the son of a former governor of Connecticut—served briefly as a mapmaker in the Continental Army. After the war, Trumbull sought to mythologize the Revolution in a series of celebratory paintings. Beginning in 1786, and continuing for the next thirty-five years, he created a cycle of revolutionary paintings that lifted the war out of history and into the realm of legend. His goal, as he explained in a letter to Thomas Jefferson, was to transform painting from a "frivolous" trade, "little useful to society," into a form of cultural memory. Trumbull wished to give the "future sons of oppression and misfortune, such glorious lessons of their rights, and of

the spirit with which they should assert and support them," that mankind would never forget one of its greatest moments. Trumbull also hoped to turn a profit by exhibiting the paintings to paying audiences and by selling prints engraved from the series to subscribers. In painting the events of the American Revolution, Trumbull brought together his feelings of patriotism, his ambitions as a painter, his desire to place art in the service of the new nation, and his need for income. He failed in this last ambition: neither Trumbull's paintings nor the prints based upon them captured the audience or the profit Trumbull hoped for.

At the time that Trumbull began the series, the nation was in turmoil. The system established by the Articles of

## Festivals and Parades

PRINTS PROVIDED ONE WAY for Americans to mobilize opposition and identify as a community. A second way lay in the older tradition of street theater: festivals and parades, which helped the colonists identify themselves as American citizens, rather than British subjects. By bringing together different classes, trades, and groups, these parades helped unite the new nation across traditional boundaries. After independence, the spectacle of the parade proclaimed that *all* had participated in the Revolution and that all were entitled to its fruits. Parades also kept the past alive. They allowed the Revolution to be remembered and reinterpreted year after year. Fourth of July parades, banners, bonfires, and other ceremonial activities permitted the new nation, as historian David Waldstreicher has phrased it, to celebrate its own origins in repeated "rites of assent."

During the struggle for independence, there were mock funeral marches for King George III, theatrical performances, and military reenactments. In 1779, the Boston militia staged a "mock engagement" before a "vast concourse of spectators," followed by a meal for one hundred patriots under a tent on the Boston Commons. The purpose of these events was not entertainment, but nation building. These "rites of assent" allowed people across a wide spectrum of classes to affirm their collective identity as Americans. People had been used to thinking of themselves in terms of their local affiliations. Now, in addition to their local or regional identities, the former colonists began to view themselves as citizens of a new nation.

Confederation (1781), which loosely bound the colonies together in the years after the Revolution, was in a state of collapse. To replace it, a new Constitution was drafted in 1787, proposing a strong central, or federal, government. This quickly divided Americans into two bitterly opposed camps, the Federalists and the Anti-Federalists. The Constitution was finally ratified by the required majority of states (nine) in 1788 and so came into effect that year; but the arguments continued.

Other issues, too, divided Americans. Social changes engendered by the Revolution—the enfranchisement of ever-greater numbers of white males, the breakdown of traditional forms of deference among social classes, and the general weakening of class authority—were proving to be more radical and egalitarian than some leaders had bargained for. Conservative figures such as Trumbull sought to slow the Revolution's tendencies toward social leveling. Where Revere's *Bloody Massacre* had earlier inflamed colonial passions by pitting Patriot against Loyalist, Trumbull's paintings two decades later sought to reconcile the former antagonists in a transatlantic alliance of shared civic values.

**THE DEATH OF GENERAL WARREN AT THE BATTLE OF BUNKER'S HILL, 17 JUNE, 1775.** Trumbull painted the first canvas of the series, *The Death of General Warren at the Battle of Bunker's Hill, 17 June, 1775*, while he was a student in the London studio of Benjamin West (**fig. 5.4**). The battle, which Trumbull had witnessed through field glasses from a distance, allowed both sides to claim victory. Although the British officially won the battle, they suffered severe losses: 1,150 men killed—almost three times the casualties suffered by the Americans. Trumbull's painting depicts the fatalities of both sides' commanding officers: American General Joseph Warren, shot in the head, dies in the arms of a comrade, while the British Major John Pitcairn, similarly wounded, collapses below a British flag into the arms of his son.

Trumbull drew on precedents such as Benjamin West's *The Death of General Wolfe* (see fig. 4.34) for this painting,

5.4 JOHN TRUMBULL, *The Death of General Warren at the Battle of Bunker's Hill, 17 June, 1775*, 1786. Oil on canvas, 25 × 34 in (63.5 × 86.3 cm). Trumbull Collection. Yale University Art Gallery, New Haven, Connecticut.

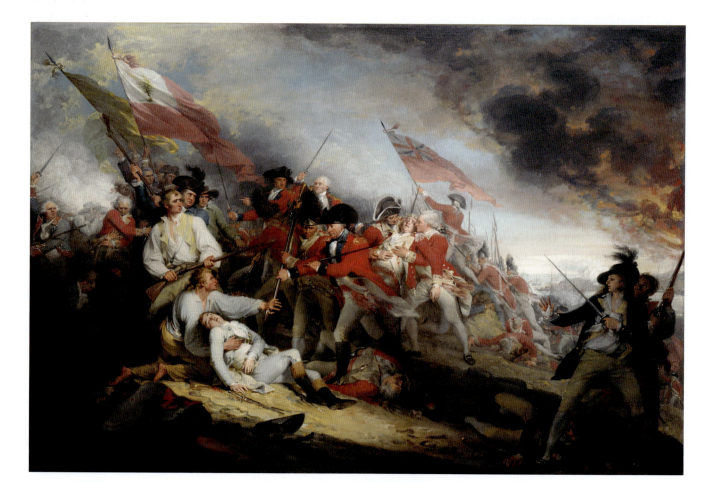

but he transforms West's relatively static and neoclassical composition with the introduction of emotionally charged diagonal wedges. Through dramatic contrasts of light and dark, Trumbull emphasizes the alarm of his subjects at a moment of great intensity. As General Warren, clad in white, lies dying, a British grenadier—above him and to the right—prepares to stab him, in effect killing him a second time. A British officer stays the grenadier's bayonet, while the kneeling American who cradles Warren likewise extends an arm to fend off his thrust. The two officers, one British and one American, are linked by a shared code of honor. The painting highlights the death of a gentleman in a patriotic cause, contrasting his sacrifice with the mean thoughtlessness of the grenadier. The officers' coolheaded restraint of the hasty grenadier symbolizes aristocratic mastery over impulse and irrationality. The lesson: even when encountered as enemies, true gentlemen value honor and duty above all else.

Such lessons were especially timely for Trumbull in 1786. This was the year of Shay's Rebellion, when a group of debt-ridden Massachusetts farmers took up arms against the state government. Although the rebellion was ultimately subdued, it left Federalist figures like Trumbull profoundly alarmed at the unworthy behavior of the commonality. Trumbull's painting reconstructs the Battle of Bunker Hill (as it is now called) as a moment of upper-class solidarity. To an elite audience in 1786, this portrayal of revolution in terms of social stability must have felt reassuring.

Two black figures appear in Trumbull's painting: a slave who stands loyally behind his master in the painting's lower right corner, and a black man whose face only is visible in the crowded group of figures at the left edge of the painting. A contemporary observer of the battle credited Peter Salem, a former slave, with the killing of the British Major Pitcairn: "Among the foremost of the leaders was the gallant Major Pitcairn, who exultantly cried 'the day is ours,' when Salem, a black soldier, and a number of others, shot him through and he died."[2] Although it is unclear whether the black man in Trumbull's painting is Salem, it is quite clear that he is disallowed any real role in the battle. His musket points up and away from the fighting, and his posture signals subservience rather than bravery. Over the course of the American Revolution, more than five thousand African Americans fought against the British. Several blacks fought at Bunker Hill, and one performed heroically enough for his commander to honor him as "an experienced officer as well as an excellent soldier." Many of the free and enslaved blacks who joined the American forces were put to work as agricultural or construction workers, because their commanders were reluctant to arm them.

Trumbull's attention to black-white relations in *The Death of General Warren* stands in marked contrast to West's earlier focus on Native Americans in *The Death of General Wolfe*. By 1786, white Americans felt increasingly confident that North America belonged to them as a birthright. Where West depicted the French and Indian War of the 1760s as an alliance between Native Americans and colonists (in fact, both sides included large numbers of Indian combatants), Trumbull shifts the focus two decades later to African Americans. This transfer of attention suggests how much American independence brought black-white relations to the fore. It also reveals the racial anxieties that Trumbull shared with many of his colleagues. Trumbull subordinates his African American figures to their white commanders.

Trumbull's decision to portray an armed black man as a faithful servant reflects the reluctance of white Americans to view Africans outside their traditional roles. In mythologizing the Revolution, Trumbull focuses on its promise of social *stability* rather than its more egalitarian possibilities. Though his interest lies in American independence, he seems unable to imagine a wholesale rethinking of class or racial relations. His goal instead is to preserve a vision of civic order congenial to the beliefs of the governing classes.

## Celebrating Franklin and Washington

Not all commemorative images of the Revolution focused on historic moments or scenes of battle. Portraits of revolutionary heroes—Washington, Franklin, Jefferson—proved immensely popular. In fact, the demand for such images was so great that an entire industry arose to satisfy it. Benjamin Franklin developed into an international celebrity.

**FRANKLIN AS EXPERIMENTALIST.** In 1789, only months before Franklin's death, the American Philosophical Society commissioned Charles Willson Peale (1741–1827) to record Franklin's likeness. Peale produced a portrait that focuses on Franklin's appeal to the "common man" (**fig. 5.5**). The seated Franklin is shown against a lightning bolt in the background, an allusion to his famous experiments with electricity. Franklin's appearance is down-to-earth. His character is conveyed by his abstracted gaze, his calm demeanor, and his bifocals (with whose invention he is generally credited). He is a thinker. The writing implements at his hand remind us that Franklin's work is conducted within the realm of learning, science, and letters. The manuscript page in front of him contains a quotation from his book *Experiments and Observations* (1751), about the success or failure of lightning rods. Franklin holds a lightning

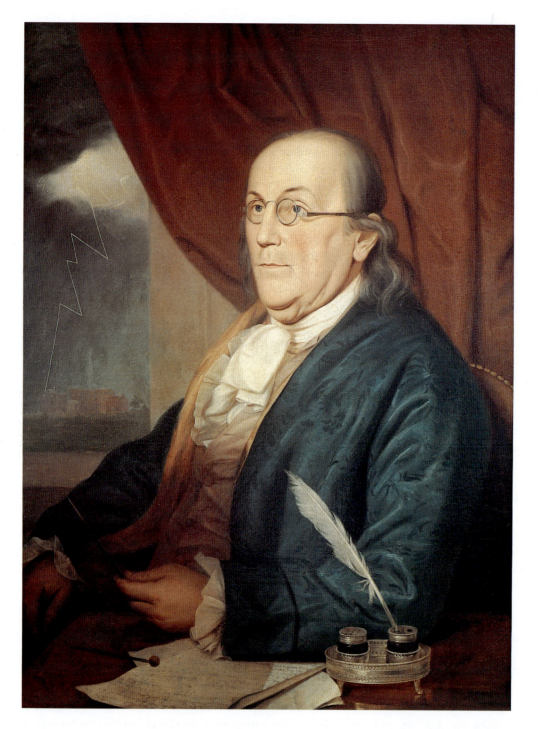

5.5 CHARLES WILLSON PEALE, *Benjamin Franklin*, 1789. Oil on canvas, 36 × 27 in (91.4 × 68.5 cm). Historical Society of Pennsylvania, Philadelphia, Pennsylvania.

rod with a pointed tip in his left hand, while a second lightning rod with a rounded tip lies unused on the table before him.

The lightning rods here allude to politics as much as to science. The Royal Society of London for Improving Natural Knowledge had once asked Franklin to serve on a committee to investigate the safest way to protect armories loaded with gunpowder from lighting hits. Franklin's fellow committeeman Benjamin Wilson recommended round-tipped lightning rods, on the grounds that they attract fewer lightning bolts. Franklin objected, advocating pointed rods as less dangerous, while noting that rounded "knobs" draw lightning at "greater distances."

The controversy soon escalated from lightning rods to politics. King George III sided with Wilson against Franklin. The king's decision not only infuriated Franklin but cast the debate as a contest between British and American ways of doing things. Peale's painting includes

both types of rods. By placing the diagonally elevated pointed rod in Franklin's hands and leaving the knobbed rod on the table, Peale draws attention to the nascent nationalism of Franklin's leadership. His science goes hand in hand with his patriotism.

So, too, for the blue banyan that Franklin wears. A casual item of dress originally imported from India and designed for private wear in the home, the banyan suggested the leisurely nature of scholarly pursuit and the capacity of calm men to remain undistracted by outside pressures in the quiet of their studies. Men like Franklin investigate the world—and ultimately govern it—with no interest in mind other than the public good.

**THE "ATHENAEUM PORTRAIT."** The portrait of George Washington painted by Gilbert Stuart (1755–1828) in 1796 is among the most celebrated of American images (**fig. 5.6**). Known as the "Athenaeum Portrait" because it was acquired by the Boston Athenaeum after Stuart's death, it has been reproduced more frequently and circulated more widely than any other American painting and has done a great deal to define the national memory of Washington.

5.7 ADOLPH WERTMÜLLER, *George Washington*, c. 1794. Oil on canvas, 25⅛ × 21⅛ in (64.4 × 53.7 cm). Philadelphia Museum of Art, Pennsylvania, Philadelphia. Gift of Mr. and Mrs. John Wagner, 1986.

From its customary position high on the classroom wall, the portrait has stared down reproachfully at generations of misbehaving children, reminding them of the formidable virtues of this Founding Father. But even as it has been used to perpetuate Washington's status as an icon, the painting has also attained a casual familiarity in everyday life. As you read this, in fact, you may well have a few reproductions of the painting in your wallet; Stuart's painting is the source of the image on the one-dollar bill.

The Athenaeum Portrait was only one of dozens for which George Washington posed in his lifetime. Yet today it has become so seemingly natural that we are likely to be shocked by the alien strangeness of other portraits like that by Adolph Wertmüller (1751–1811), painted about the same time, circa 1794 (**fig. 5.7**). Despite our sense that the rather dour Washington in Wertmuller's painting is somehow "wrong," it is interesting to note that Stuart's was not necessarily a faithful likeness. Many competing painters claimed that their portraits were more accurate. One early nineteenth-century writer playfully suggested that if Washington were suddenly to appear to his friends looking

5.6 GILBERT STUART, *George Washington (The "Athenaeum Portrait")*, 1796. Oil on canvas. National Portrait Gallery, Washington, D.C.

# Washington as Zeus

IN 1832, HORATIO GREENOUGH (1805–52), the first American sculptor to study in Italy, was awarded a prestigious commission to sculpt a public statue of George Washington (**fig. 5.8**). Congress allocated $20,000 for its purchase (a whopping sum at the time). Greenough's idea was to model Washington on the ancient Greek sculptor Phideas's fifth-century B.C.E. statue of Zeus. Greenough's statue bears the instantly recognizable visage from Gilbert Stuart's portrait now fitted onto the exposed torso of a muscled superhuman, seated and enthroned. While Washington's right hand points heavenward, his left hand offers his sword to the viewer: twin gestures that link Washington's authority with his renouncing of monarchial power. Greenough's statue alludes to the Roman leader Cincinnatus, who was linked to Washington in the public imagination because he refused dictatorial power and retired instead to the quiet life of a private citizen.

Placed in the Rotunda of the Capitol and unveiled to the public in 1841, Greenough's colossal sculpture was instantly controversial. Supporters admired the "loftiness" of Greenough's vision, but detractors—and there were many of them—found the statue inaccurate, offensive, even comical. Philip Hone, a New York politician, lambasted it for depicting Washington "undressed, with a napkin lying in his lap." Most Americans simply did not want to see their first president, however heroic, in a state of semi-nudity. The 12-ton statue proved too heavy for the Rotunda; it cracked the floor. Greenough's Washington was moved to the East Front of the Capitol in 1843 and eventually wound up in what is now the Smithsonian's National Museum of American History.

5.8 HORATIO GREENOUGH, *George Washington*, c. 1840. National Museum of American History, Smithsonian Institution, Washington, D.C.

as he did in Stuart's portrait, he would have to show his credentials in order to prove his identity.

Stuart had several sittings with Washington (who disliked posing for portraits but endured it nonetheless), before he "pinned" the image that has come down to us. It differed significantly from other portraits. Although Washington, by all accounts, had pale skin, Stuart endowed him with ruddy features, adding vivid touches of red to Washington's cheeks and nose. He darkened Washington's eyes, rendered his face more compact and less elongated than in other portraits, pursed his lips, and emphasized the aquiline shape of his nose. Stuart's interpretation turned out to be the perfect and necessary formula for expressing Washington's national image. The ruddy skin tones suggested a man of energy and passion, while the stern gaze and taut lips hinted at the discipline and self-control that rendered Washington the master of his own emotions. The slightly downward cast of Washington's stare confirmed the viewer's sense that he was in the presence of a moral giant, but the simplicity and directness of the portrait leavened Washington's godlike power, thus avoiding unsavory comparisons with European monarchs.

Deviating from common practices of depicting rulers (found in some of his own portraits as well), Stuart avoided placing Washington in a grand architectural setting, draping him in ermine, pinning him with sashes and military medals, or surrounding him with objects emblematic of his power and his office. Instead, he focused exclusively on Washington's face. This had several effects. First, it accorded with Washington's reputation for unpretentious candor. Second, by removing him from the realm of everyday life, the portrait achieved a timeless quality. Finally, and perhaps most importantly, the close focus on the head enabled the portrait to be readily copied, adapted, and appropriated in a way that a full-length portrait with complicated trappings could not. The face was thus well suited to fill the rapidly growing demand for images of Washington among the adoring American public.

Stuart left the portrait unfinished. Once he had painted the face, he realized that the image would be invaluable as a template from which he could produce multiple copies. Despite repeated pleas for the portrait by Washington's wife, Martha (who had commissioned it), Stuart decided not to finish the painting, so that he could retain possession rather than deliver it to her. He kept it in his studio long after Washington's death, eventually producing sixty oil copies. Unwittingly anticipating the portrait's later function as currency, Stuart took to calling the copies his "hundred dollar bills," since that was what he charged for them.

## The African American Enlightenment

At the same time that artists were shaping the American Revolution—visualizing it, justifying it, mythologizing it—African American artists and writers found themselves exploring a different notion of "independence." What might freedom mean to an artist who could rarely participate in popular debates about liberty and justice and had no legal right to his or her own body? During the years of the Revolution a quiet but extraordinary dialogue developed between two gifted African Americans, the poet Phillis Wheatley and the artist Scipio Moorhead.

### SCIPIO MOORHEAD'S PORTRAIT OF PHYLLIS WHEATLEY.

In what is perhaps the first portrait (1773) produced by an African American of a member of his own race, Moorhead (c. 1750–?) depicts Phyllis Wheatley, a fellow Bostonian and fellow slave, seated at a writing desk with a quill pen in one hand (**fig. 5.9**). (The image is unsigned, but scholars generally attribute it to Moorhead.) Wheatley gazes into the distance, as if pausing in the midst of inspiration.

Wheatley (c. 1753–84) was something of a prodigy. Brought to Boston from Gambia, West Africa, in 1761, while still a young child, she flourished under the tutelage of her

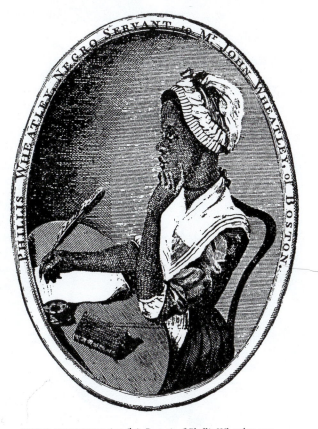

5.9 SCIPIO MOORHEAD (attrib.), *Portrait of Phyllis Wheatley*, 1773. Engraving. Library of Congress, Washington, D.C.

mistress, mastering English, Latin, and the Bible. At the age of twenty, Wheatley published the first documented book of poetry by an African American—and thus became a *cause célèbre* in Boston. Her poems and commemorative pieces, reproduced in newspapers throughout New England, served as a test case for European Americans on the question of whether Africans were capable of intellectual as well as manual labor.

The ironies surrounding Wheatley's case are daunting. The generation that justified their own political revolution in the name of reason had a difficult time ascertaining whether reason played any role at all in the lives of black people. In the same years that Thomas Jefferson and the other Founding Fathers were declaring that "liberty" was a universal principle applicable to all people, they also justified slavery as a system rooted in what they believed was the "inferior" moral and intellectual capacity of Africans.

Moorhead's portrait of Wheatley engages those debates. Engraved in 1773 as the frontispiece for her first volume of poetry—a book printed in London after colonial American printers refused to publish it—the image casts Wheatley as a thinker rather than a domestic worker. The image is less a "snapshot" of Wheatley herself than an argument for the intellectual aspirations of African Americans. Moorhead draws upon the same visual formula used by John Singleton Copley in his portrait of *Paul Revere* (see fig. 4.32), a pairing of head and hands with attributes of the sitter's labor. While Copley's portrait engages issues

5.10 SAMUEL JENNINGS, *Liberty Displaying the Arts and Sciences*, 1792. Oil on canvas, 60¼ × 73⅛ in (153 × 185.4 cm). The Library Company of Philadelphia, Pennsylvania.

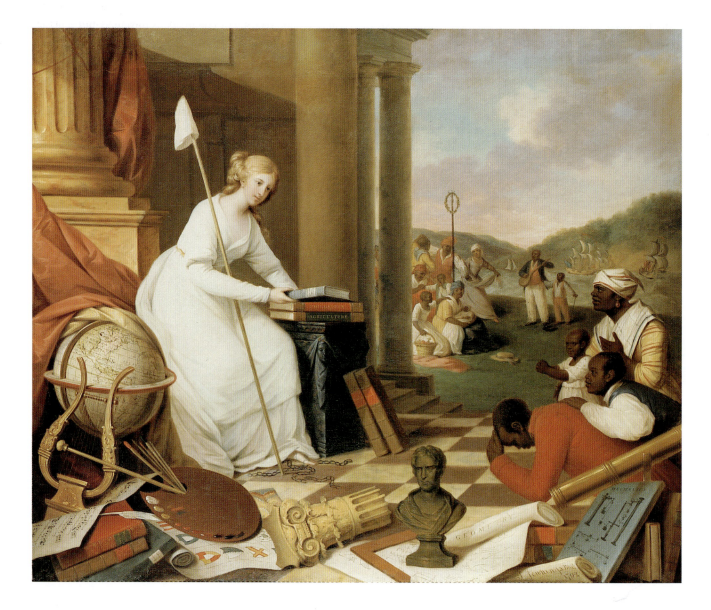

of class and the social status of the artist, Moorhead's portrait refocuses the debate to take in race and the social status of the slave. Moorhead's image includes no signs of domestic work. Instead, Wheatley's quill connects the page to the brightness of her eyes, hence the brightness of her mind. She is defined not by her employment as a slave but by her attainments as a poet. The image is a salvo in the battle for black rights. Wheatley's attainments as a poet—and a pious one at that (her simple cap suggests her modesty)—assert the capabilities of all African Americans: if black people can create culture, if they can master European poetic forms, then they must be accorded the "natural rights" common to all humanity.

Besides suggesting the sitter's propriety (in the modest cap), the engraving hints at an intellectual bond between painter and poet. He portrays her in a moment of inspiration. Moorhead's portrait echoes lines in Wheatley's poem dedicated to him, "To S. M., A Young African Painter, on Seeing His Works": "Still may the painter's and the poet's fire / To aid thy pencil, and thy verse conspire!" Wheatley's poem links the painter and the poet together in a common enterprise. The term "conspire" derives from the Latin root for "breathing together." It suggests not only that the painter and poet share the same experience as slaves and artists but that they "conspire" together in their labors, each affirming through the other the humanity they both share. Though slaves in their private lives, they "breathe together" in their art.

**LIBERTY DISPLAYING THE ARTS AND SCIENCES BY SAMUEL JENNINGS.** Two decades later, when the Free Library of Philadelphia decided to build new premises, it commissioned the Philadelphia painter Samuel Jennings (c. 1755–after 1834) to paint an image of the Goddess of Liberty assisting a group of free blacks "resting on the earth or in some attitude expressive of ease and joy."

*Liberty Displaying the Arts and Sciences* (1792) reflects not only the aspirations but also the limitations of progressive abolitionist thought at the close of the eighteenth century (**fig. 5.10**). The painting unfolds as a drama of racial uplift. A figure of Liberty, dressed in contemporary fashion, sits amid objects that represent science and the arts: music, painting, architecture, geography, sculpture, architecture, geometry, astronomy. She cradles a pole with a "liberty cap," an image of freedom dating back to Roman times. Her right hand holds a catalogue of the Free Library, which rests in turn upon volumes labeled "Agriculture" and "Philosophy." The broken shackles at her feet symbolize emancipation. The portrait bust in the foreground probably represents Henry Thornton, a prominent abolitionist leader.

Liberty bestows the gifts of Western civilization upon a grateful group of former slaves. The prostrate father and son in the foreground are dressed in Western fashion, while the mother, wearing an African headdress, places her left hand over her heart. In the mythic scene behind them, a group of black figures celebrate by dancing around a Liberty Pole. The masted ships in the background represent Philadelphia's mercantile activities. When seen against the forested and uncultivated background hills, however, they could also allude to the Middle Passage, the route that brought slaves from Africa to America.

Jennings's painting combines local pride with strong dissent against the practice of slavery. But the painting understands civilization as a one-way street: Europeans possess culture; Africans lack it. Their gestures of supplication in the foreground of the painting suggest their hunger for cultural and racial uplift. Even abolitionists sympathetic to the plight of slaves viewed Africa as a "heathen" land, and, blind to African customs, they viewed Africans and African Americans as in need of Western values.

**JOSHUA JOHNSTON.** Joshua Johnston (also spelled Johnson; c. 1765–1830), a free black artist active in the Baltimore area in the early nineteenth century, is the earliest known African American painter to succeed professionally as a full-time artist. Documents suggest that Johnston was born into slavery in Baltimore but gained his freedom in

FAST FORWARD

## Two Versions of Education

THE TWO VOLUMES in *Liberty Displaying the Arts and Sciences*, "Agriculture" and "Philosophy," anticipate debates about race that will take place in the following two centuries. Each side in the debate will stress the importance of education, though each side will mean something different by that term. Booker T. Washington, in *Up From Slavery* (1901), will emphasize the importance of agricultural labor and manual training for black advancement. W. E. B. Dubois, on the other hand, will insist that talented black men and women receive the same advanced intellectual schooling as their white peers (*Souls of Black Folk*, 1903). This argument over the best means to black empowerment goes back to the tension between "Agriculture" and "Philosophy" in Jennings's painting. The debate will continue well into the twentieth century.

1782. Baltimore had a large and prosperous population of free blacks. Little is known about Johnston's career until he began advertising in the *Baltimore Intelligencer* in 1798 as a "self-taught genius" who "experienced many insuperable obstacles in the pursuit of his studies."

Johnston painted the merchants, seafarers, military men and clergy who constituted Baltimore's thriving middle class. His portrait *The Westwood Children* (c. 1807), shows a flair for design and decorative detail (**fig. 5.11**). The rhythmic pattern of the boys' boots echoes the flow of their intertwined hands and ruffled collars. Johnston experiments with flatness and recession, playing the shallow space of the Westwood children on the left against the deep space of the window scene on the right. The painting teeters between abstraction and realism, balancing the oval faces and cylindrical bodies of the Westwood children against the details of birds, flowers, and buttons.

Johnston's appealing provincial style suited his mercantile patrons. His portraits confirmed their prosperous middle-class status, bestowing upon them a sense of dignity. To hang paintings like Johnston's in the parlor was to announce to all visitors a family's worldly success.

Two surviving portraits by Johnston portray black figures. One of them, *Portrait of a Gentleman* (1805–10), has been identified tentatively as a portrait of the Reverend Daniel Coker, a member of Baltimore's black elite and one of the founders of the African Methodist Episcopal Church (**fig. 5.12**). Coker published a pamphlet calling attention to the discrepancy between American principles of freedom and the continuance of slavery and urging universal emancipation and Christian egalitarianism.

It is possible that Johnston, like his patron, belonged to a group of black leaders engaged in an effort to create what the scholar Ira Berlin has termed a "united black caste." Rather than separate themselves from slaves or ingratiate themselves into white society, this African American intelligentsia fought to better the economic, social, and political conditions of all blacks. The African Methodist Episcopal Church, for example, brought together free and enslaved blacks in a loosely knit confederation of schools, benevolent societies, and fraternal organizations.

Johnston's portraits of black leaders, though rare, hint at the extensive circle of patronage that brought black artists and clients together. The artist appears to have shared with his African American patrons a taste for middle-class values, a pleasure in the material comforts of American domestic life, and a commitment to black economic and social advancement. Several of his white patrons with abolitionist sentiments probably shared his commitments.

5.11  JOSHUA JOHNSTON, *Westwood Children*, c. 1807. Oil on canvas, 41⅛ × 46 in (104.5 × 117 cm). National Gallery of Art, Washington, D.C.

5.12  JOSHUA JOHNSTON, *Portrait of a Gentleman*, 1805–10. Oil on canvas, 28 × 22 in (71.1 × 55.9 cm). American Museum in Britain, Bath, United Kingdom.

# Classical America

In 1795, George Washington was halfway through his second term as president. The long journey toward nationhood had begun, each step forward producing increased confidence at home and growing respect from abroad. Alexander Hamilton, the brilliant but arrogant secretary of the treasury, sought to diversify the economy of the new republic, rendering it less reliant on agriculture and more committed to commercial development. His economic policies dovetailed with a policy of American neutrality toward France and Britain, again at war as a consequence of the French Revolution. American ships transported goods from both nations, resulting in a decade of peace and prosperity.

But advances in the realms of diplomacy and foreign trade were offset by problems on the domestic front. The Federalist Party—the party of Washington and John Adams—favored manufacturing, growth, and a strong national government. Their policies provoked protest from southerners fearful of northern dominance, from mid-Atlantic states resentful of federal tax legislation, and from farmers hostile to manufacturing interests. These constituencies formed a new coalition behind Thomas Jefferson. Jefferson's election to the presidency in 1800 marked the end of Federalist policy. The new century brought with it more egalitarian social practices and a more diversified electorate.

Americans felt confident about embracing novel forms of government because they did not believe that such forms truly broke with the past or relied upon untested models of human nature. They viewed their republican experiment instead as a return to a lost golden age. They felt that the conditions for virtue that had existed in ancient Greece and republican Rome could be recaptured, encoded, and taught in the New World. Jefferson and his colleagues believed that freedom without virtue resulted in mayhem: unbridled personal appetite and will. Thus the form of architecture they favored, Neoclassicism, was not merely a style, but an embodiment, a way of being in the world, which involved emotional, ethical, and political engagement. It was also a form of mimicry. Bits of ancient building vocabulary—columns, capitals, entablatures, and **pediments**—were adapted imaginatively. The goal of such adaptation was political: to achieve, by suggestion, a republic of virtue.

The classical world was known to Americans and to early nineteenth-century Europeans in three ways. First, some people (including Jefferson and Copley) traveled in Italy and southern France to study antiquity firsthand. Second, images and descriptions of ancient buildings and structures by Renaissance architects such as Palladio were widely available to Americans in books (see Chapter 4).

5.13 PAUL REVERE, Coffee urn, 1793. Silver, 18 in (45.7 cm) high. Museum of Fine Arts, Boston, Massachusetts.

Book knowledge of antiquity stressed the orders and rules concerning proportions based on surviving temples and architectural fragments. A third new source of knowledge became available late in the eighteenth century, when systematic archaeological excavations were begun at Pompeii and Herculaneum, two Roman cities near Naples that had been overwhelmed by the cataclysmic eruption of Mount Vesuvius in 79 C.E. The discovery of the sites in the mid-1700s and the subsequent slow removal of a thick blanket of soil and ash exposed ancient Roman domestic structures, wall paintings, and vestiges of daily life, which had been preserved virtually intact. These sites endowed the classical world with an immediacy and intimacy formerly unknown.

For a post-Revolutionary generation, classical forms bestowed an aura of moderation, rationality, and balance on all they touched. They had the power to turn consumer objects into civic lessons. Paul Revere's coffee pot of 1793, shaped like a Greek urn, endowed a utilitarian object with the values of the classical past (**fig. 5.13**). Designed to keep

coffee hot and to dispense it through a spigot at the bottom, this vessel combines two motifs of antique design: the fluted column (its concave ribs evoke the graceful shafts of Corinthian columns) and the funerary urn. Revere's coffee urn served not only as an object of status for its owner but also as an emblem of the owner's patriotism, of values that linked America with the classical past. We call this style "neoclassicism."

Objects in the neoclassical style helped reassure commercial and intellectual elites that the times had not gotten out of hand. By highlighting symmetry and balance, they suggested that moderation would prevail in politics as it did in fashion. Neoclassicism, though also popular in Europe, was particularly well received in the young United States. The style invoked the virtue and uncorrupted "youth" of Western civilization, given here, on a "new" continent, a second chance.

## Thomas Jefferson's Western Prospect

For more than fifty years, from 1768 until 1822, Thomas Jefferson designed buildings and landscapes. While serving as a delegate to the Continental Congress, governor of Virginia, minister to France, and secretary of state (in Washington's presidency), vice president (under John Adams), and president, he also devoted thought to buildings and the organization of social space. Jefferson's three prin-

cipal architectural projects are his home, Monticello, near Charlottesville, Virginia (1769–84; 1796–1809), the Virginia State Capitol in Richmond (1785–96), and the University of Virginia, in Charlottesville (1817–26). These three structures bear the stamp of his own considerable genius, but they are also expressive of concepts he shared with his generation.

**MONTICELLO.** In its final form, Monticello is a symmetrical domed structure of one main story with a hidden second story, between an extensive ground-level series of service and storage rooms (invisible from Monticello's main, western entrance) that extend in bracketing arms, terminating in two small dependencies (**fig. 5.14**). One of these was the first structure on the site, and it served as Jefferson's home during years of the extensive building campaigns. The completed structure (familiar to us from its image on the back of the nickel coin) crowns its rural mountaintop and evokes the man himself. Not much bigger than a large suburban tract home built today, Monticello nevertheless marshals extraordinary dignity and presence.

The population at Monticello during Jefferson's lifetime was considerable, as this was not just a home but the management center of a 5000-acre farm. Tobacco was the cash crop until 1794, succeeded by wheat. The visual

5.14 THOMAS JEFFERSON, Monticello, near Charlottesville, Virginia, 1770–82, 1796–1809.

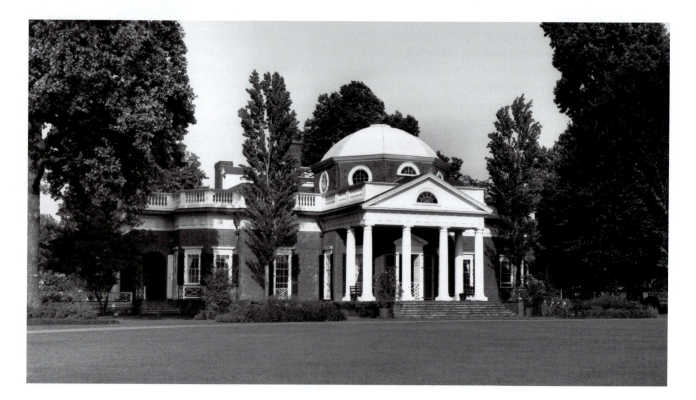

subordination of the service corridors (and those who served), by banking them into the hillside so that they are at convenient ground level on the "business" side and invisible on the view side—is an architectural device that our culture continues to use. The effect is to render all forms of servitude, free or enslaved, as invisible as possible. Jefferson also incorporated into Monticello a number of unique mechanical inventions that aided service and afforded him privacy, including a wine dumbwaiter and a rotating door with service shelf. A specially designed clock, bed, and clothing storage system exhibit Jefferson's fertile mind applying reason, engineering, and ingenuity to domestic life.

Between the windows in the tea room—a bay extending from the dining room, where he and his family took their evening meal—busts of worthy and exemplary men gazed upon the gathering. In the two-story entrance hallway a rather different discourse of objects greeted the family and their visitors. Here classical patinated plaster busts were supplemented by elk antlers, bison and big-horn sheep heads, and Native American paintings on buffalo hides brought back from Lewis and Clark's expedition through the Louisiana territory. In this display Jefferson was continuing a long European tradition in which the medieval hall—the primary gathering and eating space for the lord, his knights, retainers, and household—was hung with trophies of war (armaments and flags captured in battle) and trophies of the hunt (usually antlers) as objects of memory and instruction. Jefferson, with the aid of his friend Charles Willson Peale, was among the first to include taxidermically-treated mammal heads in this room—adding the "busts" of creatures to those of Cicero and Voltaire.

Monticello, like most freestanding American Georgian buildings, was not designed with a front and a back; rather, it has two façades, one facing east to Europe—toward Rome, Britain, and history—and the other facing west—toward what Jefferson understood to be nature and the future. The western façade was built facing the frontier, in western Virginia where the great spine of mountains dividing the Atlantic coastal plain from the Mississippi heartland begins. Jefferson was a western-looking man. He firmly believed that the American form of government depended on personal virtue and civic responsibility, and that those qualities were best nurtured in the farmer, who was rooted economically and emotionally in the landscape.

**THE VIRGINIA STATE CAPITOL.** Jefferson's faith in the West was matched by his lively appreciation of European culture and antiquity. Sent by Washington to France as an emissary, Jefferson found the time to travel to Nîmes, a city that the Romans had occupied two millennia earlier.

There, they had built a stately temple that had survived through the centuries almost intact. Jefferson reported in a letter to a close woman friend that he had gazed at this temple, called the Maison Carrée, "like a man at his mistress." The depth of his admiration—emotional and physical as well as intellectual—prompted him to adopt the structure for the design of the Virginia State Capitol. **Figure 5.15** shows the scale model that he and his French collaborator, Charles-Louis Clerisseau, sent to Virginia. His search for an appropriate model to contain and express the new politics of his native state had reached a dead end in Paris ("The style of architecture in this capital [is] far from chaste," he wrote in 1785, recoiling from the baroque and modern splendor of Louis XVI's capital). So the Maison Carrée, both "chaste" and his "mistress," was copied in Richmond, becoming the first clone in North America of a whole antique structure.

The Maison Carrée is a Roman temple, a rectangular marble sanctuary set up on a raised dais and fronted with a portico, which announces its importance and through which the building is entered. It is a unitary volume without windows or stories or staircases. Although Jefferson's copy strongly resembles the Maison Carrée, it is also an adaptation, made suitable to house a state government. For Jefferson, the temple form expressed dignity (in the raised dais), permanence (in the use of masonry), clarity (in its symmetrical, axial format), and sanctity (being originally a religious building). It is also alluded explicitly to a "Golden Age" (antiquity) and to the founders of Western political and scientific thought. Moreover, it was associated in

5.15 THOMAS JEFFERSON & CHARLES-LOUIS CLERISSEAU (design), & JEAN-PIERRE FOUQUET (model maker), Model for the Virginia State Capitol, Richmond, Virginia, 1785–6. Plaster, 13¾ × 29¼ × 17¼ in (34.9 × 74.2 × 43.8 cm). Virginia State Library and Archives, Richmond, Virginia.

Jefferson's mind with republican forms of governance. This temple and the classical revival it spawned represented the repudiation of monarchy and the beginning of a new "Golden Age."

## THE UNIVERSITY OF VIRGINIA.

Jefferson's last and most ambitious architectural project was the University of Virginia (**fig. 5.16a, b**). A departure from other colleges in the United States and Europe at the time, the design established the idea of the college "campus" as we know it. Unlike the single large multipurpose buildings at Harvard, Princeton, and William and Mary (which Jefferson attended), and equally unlike the cloistered colleges at Oxford and Cambridge dominated by their halls and chapels, Jefferson's university is arranged as a hierarchy of structures around an open-ended tree-lined "Lawn." Jefferson described the university as an "academical village."

Surrounding the Lawn in a U-shape is a series of two-story pavilions containing classrooms on the first floor and faculty housing on the second. A continuous colonnade fronts a range of one-story student rooms and connects these temple-like structures. Behind, gardens enclosed with serpentine brick walls terminate with more student rooms and larger pavilions, which served as dining halls. Dominating the whole is the Rotunda, based on the

5.16A, B **THOMAS JEFFERSON**, University of Virginia, plan and aerial view, 1817–26. University of Virginia Library, Virginia.

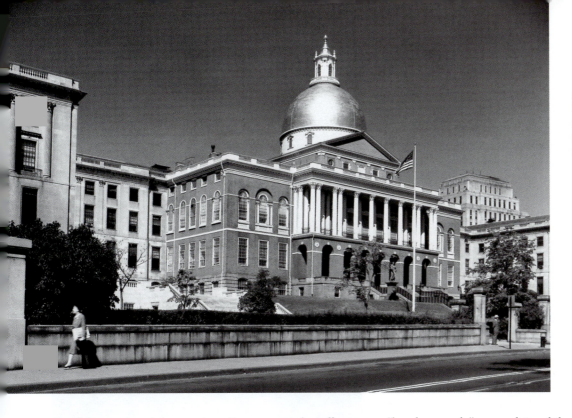

5.17 CHARLES BULFINCH, Massachusetts State House, 1793–6. Massachusetts Historical Society, Boston, Massachusetts.

Pantheon—a surviving ancient Roman temple Jefferson would have known from books—which houses the library and classrooms. Circular in plan, spherical in conception, and fronted with a grand portico, Jefferson's Rotunda expresses the perfection of geometry and the authority of the classical world. It also symbolically situates the written word and book learning—neither the church nor the hierarchy of academic fellowship—at the heart of the educational enterprise.

Jefferson's university is more than a context for learning—it is a lesson in its own right. Each of the pavilions arranged along the Lawn is designed to exhibit different facets of the classical architectural orders, although all conform to the scale, intervals, and materials of the colonnade. Jefferson considered the university to be one of his three greatest accomplishments. Disregarding his two terms as president of the United States, he directed that his epitaph should read simply: "Thomas Jefferson, Author of the Declaration of American Independence, of the Statute of Virginia for Religious Freedom, and Father of the University of Virginia."

## Capitols in Stones and Pigment

Jefferson's wish to create buildings embodying republican values was shared by many of his contemporaries; the years of the early republic saw the development of new building types to house the new institutions of government. The designs of these public structures included abstract and pictorial motifs that were intended to symbolize the new nation. Americans eager to establish government "by the people" wanted its philosophical underpinnings expressed in spatial and symbolic form, as well as in the language of the Constitution itself.

**CHARLES BULFINCH, ARCHITECT.** Charles Bulfinch (1763–1844), considered today one of the first professional architects in the United States, designed the Massachusetts State House (1793–6) (**fig. 5.17**). After graduating from Harvard and touring Europe, Bulfinch returned to Boston eager to employ the neoclassical styles he had seen on his Grand Tour. Drawing on his memories of Somerset House, in London, Bulfinch created the Massachusetts State House as a study in balance, texture, and color. The red bricks of the building's classical central block set off the elegant white gallery of Corinthian columns. The gallery sits above a simple arcade of brick arches and flanks rows of gracefully arched, white-trimmed windows on either side. At the center of the State House stands a high wooden dome that was clad in copper soon after the State House's completion. The dome was later gilded to catch the sun's glow. The Massachusetts State House crowns the top of Beacon Hill, overlooking Boston Common, then as now a greensward at the center of the city. It presides over "nature" in a language of symmetry, order, and—with its shining dome—light.

**THE UNITED STATES CAPITOL.** The United States Capitol was designed as the centerpiece of the newly created capital city of Washington, D. C., a building in which the representatives of the states (the Senate) and of the people (the House of Representatives) would meet to discuss,

debate, and persuade by rational argument (**fig. 5.18**). As conceived by its original architects, the design of the Capitol utilizes three vocabularies: the primary building blocks of geometry (such as the sphere, the semicircle, and the square); the forms of antiquity (such as the column, the dome, the pediment); and agricultural motifs associated with the prosperity of the new nation (corn, tobacco, and cotton). According to the initial plans, the building was to unite under one roof the Senate and House of Representatives, which would rest over a ground floor housing the Supreme Court. A meeting place for these three branches of government was envisioned under the majestic dome where sculptural images of the Founding Fathers would be installed, reminding successive leaders of the heroism and virtue of their predecessors.

Designed originally by an obscure physician from the West Indies, William Thornton, according to a plan favored by George Washington and Thomas Jefferson, the Capitol quickly developed into an architectural stew of different historical forms. By the early nineteenth century, it consisted of two separate wings without a center. After the Capitol was gutted by the British, during the War of 1812—a national humiliation—its rebuilding was entrusted to Benjamin Henry Latrobe (1764–1820). Latrobe, who had been professionally trained as an architect, transformed the Capitol's hodgepodge appearance and gave it an increasingly classical look. Latrobe equated rationality with geometric forms; he wished to demonstrate the rationality of nature. He also bestowed on the Capitol a more distinctively American look by inventing three new

5.19 **BENJAMIN HENRY LATROBE**, Tobacco capital (agricultural order), United States Capitol, Washington, D.C, c. 1810. Architect of the Capitol, Washington, D.C.

architectural "orders" or types of column. Latrobe's columns were crowned at the top not by traditional scrolls or acanthus leaves, but by images of corn, cotton, and tobacco, the principal cash crops in the United States. These quirky capitals quickly became the part of the building most admired by the senators and congressmen who inhabited it (**fig. 5.19**). The modern dome of the Capitol, not completed until after the Civil War, was designed by Thomas U. Walter.

The U. S. Capitol, like Jefferson's Virginia State Capitol, looks backward. It incorporates Roman prototypes as well as Renaissance and Baroque public building ideas, but it also includes iconography specific to the agricultural basis of wealth and trade in the new nation. It is not just a building, but a discourse in stone about the ideological beliefs and hopes of the founders.

**A PORTRAIT OF THE CAPITOL: MORSE'S *THE HOUSE OF REPRESENTATIVES.*** By the 1820s, the older generation of Revolutionary-era leaders believed that the nation was sorely at risk of losing its political vision and social cohesion and that it stood in strong need of political and cultural instruction. These views were shared by an aspiring painter named Samuel F. B. Morse (1791–1872), who would later invent the telegraph. Morse disapproved of the growing factionalism of American politics; he disagreed with the

5.18 **WILLIAM THORNTON, CHARLES BULFINCH, & BENJAMIN HENRY LATROBE**, *United States Capitol, Washington, D.C, East Front*, c. 1846. Daguerreotype. Library of Congress, Washington, D.C.

movement in the 1820s to abolish property ownership as a requirement to vote; and he was alarmed at the shift in power in Congress from an older eastern elite to an alliance of southern and western states, which, he believed, increasingly represented a "vicious threat to stable and correct government."

What better way to counter this lapse from the principles of the Founding Fathers than through the educative powers of art? Morse hoped to provide a model for proper republican government by aligning architecture with painting. His goal was to represent democratic culture as it ought to be, rather than as it was. The idea he hit upon for communicating his political beliefs was a huge portrait of *The House of Representatives* (1822–23) (**fig. 5.20**). Morse's ambition for the canvas was twofold: to endow an otherwise fractious and quarrelsome Congress with an air of what art historian Paul Staiti has termed "civic heroism," and to make enough money from the exhibition of his painting to help recoup his dwindling family fortunes. Though Morse was successful at the former, he was a dismal failure at the latter. Not many Americans agreed with Morse's vision of government.

Most people in the 1820s had no idea what their government in Washington actually looked like. Washington in the 1820s was still a swampy, malaria-ridden city. Only those who had business with the government were likely to travel there. Morse felt that a painting of the newly restored Capitol would show Americans not only how their government appeared but how it functioned. It would demonstrate a marriage of great architecture with good government. And it would illustrate, by its example, the decorum and values appropriate to a democratic society.

Morse's painting takes full advantage of Latrobe's neoclassical spaces. The painting highlights the enormous scale of the dome above the House of Representatives, with its illusionistically painted coffers and shadows, its supporting columns (made of stone from a Virginia quarry), and its great oil-fired Swiss chandelier. Critics of the painting found it static and airless. They noted the diminutive size of the figures and accused Morse of draining the subject of any human drama. What little drama there is in the painting lies in the efforts of the House doorkeeper—seen standing on a ladder at the lower center—to light the chandelier.

And yet that august stillness was Morse's point. He wished to present the House of Representatives as a harmonious national body, where congressmen subordinated their individual interests to the common good. Morse in fact painted Congress in a leisurely moment prior to the opening of the evening's session precisely because he wished to avoid depicting the partisan behavior that characterized Congress when in session. The congressmen's casual encounters in the aisles, and their easy familiarity, suggested a unity of purpose larger than any single member's partisan interests. Morse hoped to demonstrate in his painting the social cohesion that he felt resulted from enlightened leadership. The warm glow of the chandelier at the center of the painting suggests that "enlightenment" stems from rational governance.

5.20 SAMUEL F.B. MORSE, *The House of Representatives*, 1822–3. Oil on canvas, 86½ × 130¾ in (219.7 × 332.1 cm). Corcoran Gallery of Art, Washington, D.C.

# The White House

PIERRE CHARLES L'ENFANT (1754–1825), designer of the city of Washington, originally imagined the "President's House," as it was then called, as a huge European-style palace. L'Enfant's 1791 plan for Washington called for a building five times the size of the present White House. After George Washington dismissed L'Enfant for insubordination, he chose James Hoban (c. 1762–1831), an Irish-born architect, to design the President's House. Hoban envisaged a traditional Georgian-style structure, with a projecting bay on the south façade and a pediment on the north, or entrance front. Behind the bay he placed the building's most distinctive feature: an oval office.

Construction began in 1793, and in 1801, John Adams became the first president to occupy the still-unfinished residence. During the War of 1812, British troops invaded Washington. They delayed torching the White House until they had first eaten a dinner there that had been prepared earlier in the day for the president. Although the interior of the building was gutted, the façade was left standing. Hoban returned after the invasion to reconstruct the building in collaboration with Benjamin Henry Latrobe. James Monroe was the first president to return to the rebuilt White House, in 1817. The White House took on its current appearance when two porticoes, on the north and south façades, were added in the 1820s.

## Domestic Life

During the early republic, houses continued to be constructed along the same basic principles we saw in the late colonial period—symmetrical, hierarchically arranged façades and plans. The most expensive of these homes continued to be two-story, hipped-roof buildings, with five bays (vertical divisions) on the front and a double pile plan.

But there were two significant differences. First, surfaces grew flatter and thinner; the transition from plane to plane was less **articulated**. Gone were the "plastic" (sculptural), three-dimensional quoins, **dentil** courses and high-relief aperture surrounds of Georgian building. Secondly, plans and elevations exhibited more varied shapes, with the curving forms of ovals and circles enlivening the older rectilinear

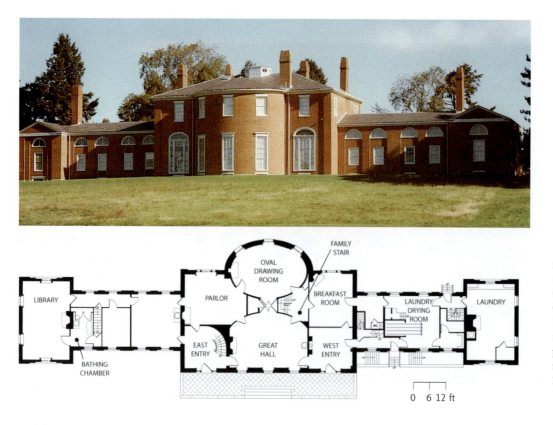

5.21A, B CHARLES LEGRAND & REBECCA (MRS. CHRISTOPHER) GORE, *Gore Place, Waltham, Massachusetts,* 1801–06. Plan and photograph of south façade. Courtesy Gore Place.

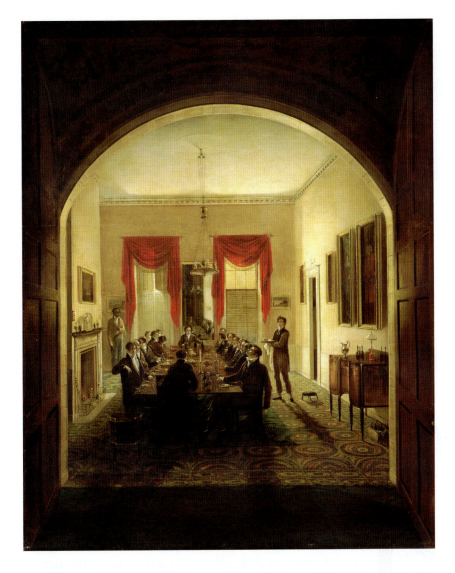

5.22 HENRY SARGENT, *Dinner Party*, c. 1820. Oil on canvas, 61⅛ × 49¾ in (156.4 × 126.2 cm). Museum of Fine Arts, Boston, Massachusetts.

world of colonial architecture. In the words of the English neoclassical architect and theorist Robert Adam:

> *Movement* … in different parts of a building … adds greatly to the picturesque[ness] of the composition. For the rising and falling, advancing and receding [and] the convexity and concavity [of forms] have the same effect in architecture, that hill and dale, fore-ground and distance, swelling and sinking have in landscape: that is, they serve to produce an agreeable and diversified contour, that groups and contrasts like a picture, and creates a variety of light and shade, which gives great spirit, beauty, and effect to the composition.[3]

**GORE PLACE, A NEOCLASSICAL HOME.** Christopher Gore, governor of Massachusetts, built a summer house in Waltham (west of Boston), which overlooks the Charles River (**fig. 5.21**). Gore Place (1801–06), was designed by Gore's wife, Rebecca, together with the French architect

Jacques-Guillaume Legrand (1743–1807?). It was constructed with many modern conveniences, including running water, a bathtub, and a wood-burning, cast-iron cookstove. Reception areas and a grand staircase flow in circular and oval patterns. Its twenty-two rooms include a music room, billiard room, library, family dining room, banqueting room, and butler's room. These specialized rooms—each designed for a single purpose—were novelties introduced in the neoclassical era. They necessitated the development of specialized furniture, such as the expanding dining table and the sideboard, as seen in Henry Sargent's painting (c. 1820) (**fig. 5.22**). The dinner party, as you can see from the painting, was usually an all-male affair—this would not change until the late nineteenth century. The New York-made sideboard in **figure 5.23** is a particularly elaborate one. Following the rules of design articulated by Robert Adam, it is a composition of "advancing and receding [planes], with convexity and concavity … to produce an agreeable and diversified

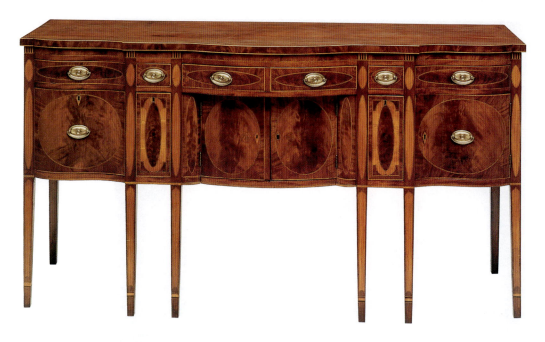

5.23 Sideboard, 1795–1805. Mahogany, satinwood veneers, white pine, tulip, ash, 41 × 79½ × 28 in (104.1 × 201.9 × 71 1 cm). Winterthur Museum, Winterthur, Delaware. Bequest of Henry Francis du Pont.

5.24 SAMUEL MCINTIRE (attrib. carver), Side chair, Salem, Massachusetts, c. 1795. Carved mahogany, ebony, ash, birch, and pine. Winterthur Museum, Winterthur, Delaware.

contour." The function of this large object is threefold: to provide lockable storage of silver and other valuable objects; to provide lead-lined (waterproof) drawers (the tall thin drawers flanking the midsection) at a convenient height, so that bottles of wine could be chilled and kept close at hand; and, most important, to provide a broad surface at standing height from which a waiter might serve the various courses of a meal. The sideboard also served as a work of art to be admired in its own right.

**A CARVED MAHOGANY CHAIR, ATTRIBUTED TO SAMUEL MCINTIRE.** One of the most important aspects of neoclassical design was its serious tone. The sort of chair Christopher Gore's peers commissioned for dining is illustrated in **figure 5.24**. Like architecture of the period (c. 1800), it is thinner, lighter, and less sculptural than late colonial chairs. But it is not just a chair. Beyond offering a comfortable place to sit, it composes a little sermon in citizenship and sacrifice. Probably carved by Salem's pre-eminent architect-designer-carver, Samuel McIntire, its back is shaped like an ancient Roman soldier's shield, and its central feature is an urn—specifically a funerary urn—from which sprigs of wheat sprout. The chair preaches in symbolic fashion that noble sacrifice for one's country yields peace and plenty for the nation. But a second lesson for us lies in its materials—mahogany from the Caribbean, white pine from Maine, ebony from Africa, and silk from China. Together they recite a litany of global trade. The shieldback chair embodies the cosmopolitanism of the early republic when raw materials, finished objects, traders, immigrants, and ideas increasingly came from distant lands.

# The China Trade

WITH INDEPENDENCE from Great Britain, the scope of American merchants grew broader, soon including direct trade with China. Americans were adept artisans, and their workshops and manufactures produced fine goods. But there were two things they desired, yet lacked the materials and skills to manufacture: silk and porcelain. For these they went to China. The large porcelain bowl in **figure 5.25** is Chinese in form and material, but its surface ornament is American. The Chinese painter probably copied a print to draw this gunboat, with its improbably giant flag. The subject, a frigate built in Philadelphia in 1815, reminds us that, in order to protect its burgeoning merchant marine fleet, the young nation had now built a navy as well as civic institutions and domestic infrastructures.

5.25 Punchbowl with depiction of USS Franklin, c. 1820. Porcelain, 10 ⅛ in (25.4 cm) diameter. Courtesy H. Richard Dietrich, Jr. Dietrich American Foundation.

**LADIES' FURNISHINGS.** The early republic was the first period in which household furniture was made specifically for women. The exquisite lady's writing table (**fig. 5.26**), with its graceful sliding **tambours** (bending doors), mahogany veneers, and fine proportions, was made by John and Thomas Seymour in Salem, Massachusetts, 1794–1804. Sewing tables and writing desks like this suggest the sorts of activities women participated in. Colonial laws had mandated that women be taught how to read (see below). The existence of such an object as the Seymour desk points to a culture in the early national period in which some gifted women wrote letters, poems, and in a few cases, such as Mary Otis Warren, author of

5.26 JOHN SEYMOUR & THOMAS SEYMOUR, *Tambour Lady's Writing Table*, Boston, 1794–1804. Mahogany inlaid with light wood, white pine, elm, enamel pulls, 41⅛ × 37¾ × 18½ in (105.9 × 95.8 × 46.9 cm). Winterthur Museum, Winterthur, Delaware.

# A Greek Revival Interior

A QUARTER OF A CENTURY after the completion of Gore Place, a new passion for Greek forms and styles succeeded the more eclectic borrowings of Neoclassicism. A watercolor by the architect Andrew Jackson Davis suggests how pronounced the vogue for Greek culture became (**fig. 5.27**). A screen of stately Ionic columns and pilasters forms a background and marks the space between double parlors. Both rooms are equipped with seating based on chairs and other furniture pictured in paintings on Greek vases (the *klismos* chair in the middle of the watercolor, for example, derives from a fifth-century B.C.E. Greek vase). Antique forms such as the couch in the corner of Davis's drawing were copied and manufactured by America's most ambitious designers and cabinetmakers. Benjamin Latrobe designed a suite of furniture in the Greek style for the White House in 1809. Sitting on Greek-style sofas allowed a posture of greater repose than furniture of the eighteenth century allowed. Looser, less structured garments, in turn, permitted a freer, more informal disposition of the body for both men and women.

5.27 ANDREW JACKSON DAVIS, *Study for a Greek Revival Double Parlor*, c. 1830. Watercolor, ink and wash, 13¼ × 18⅛ in (33.6 × 45.9 cm). New-York Historical Society.

a three-volume history of the American Revolution, serious works of scholarship.

**WOMEN'S ARTISTIC EDUCATION.** In 1803, twelve-year-old Anne Kimball of Newburyport, Massachusetts, embroidered the following verse on her sampler: *How blest the Maid whom circling years improve/ Her God the object of her warmest love/ Whose useful hour's successive as they glide/ The book,* *the needle, and the pen divide* (**fig. 5.28**). In colonial America, there was a great deal of controversy about how much training in "the book and the pen" young women needed, but it was generally agreed that the needle was the foremost tool in their education. Both girls and boys were taught to read, but in most communities only boys were taught to write. Girls learned to fashion their letters through the use of an embroidery needle.

By the end of the eighteenth century, girls from middle-class urban families were sent to private academies, where they learned the skills and accomplishments necessary to their social standing. The women who ran these schools were generally needlework experts, and so girls received first-rate training in this art form. Mrs. Rowson's Academy, in Boston, is a good example. In 1797 Mrs. Rowson placed a newspaper advertisement stating that she would be "instructing young Ladies in Reading, Writing, Arithmetic, Geography, and needle-work." The works of embroidery and painting done at the school were publicly shown at annual exhibitions. Medals were awarded for excellence, and the exhibitions reviewed in Boston magazines. So even before 1800, women had venues in which to exhibit their work outside of the domestic environment. These works were often far more innovative than the earlier samplers that followed English patterns (see fig. 3.35).

Anne Kimball embroidered floral vines on three sides of her sampler. Beneath the alphabet, worked in several types of stitch, and the verse quoted at the opening of this section, the artist stitched *Anne Kimball, born June 14, 1791, wrought this Sampler in The twelfth year of her age Newbury Port 1803.* With her needle, she populated an idealized landscape with animals, fruit trees, and flower-filled urns. In contrast to Kimball's idealized pastoral landscape, Hannah Otis's *View of Boston Common* (**fig. 5.29**), which measures nearly 30 by 58 inches, is based on a real landscape (the "common," or green park, at the heart of Boston) and a recognizable house (The Hancock house, built in 1737). On the right, she depicted animals frolicking

5.28 ANNE KIMBALL, Sampler, 1803. Silk and linen, 28 × 22 in (71.1 × 55 cm). The Peabody Essex Museum, Salem, Massachusetts.

5.29 HANNAH OTIS, *View of Boston Common*, c. 1750. Linen, embroidered with silk, wool, metallic thread beads, 29¼ × 57¾ in (74.2 × 146.6 cm). Museum of Fine Arts, Boston, Massachusetts.

on the Common under the watchful eyes of a gentleman on horseback and his black manservant. This naturalistic landscape, with its accurately rendered Georgian colonial house, rolling hills, flora and fauna, is a masterwork of eighteenth-century American art.

When people talked about "female accomplishments" in the eighteenth and early nineteenth centuries, they were referring especially to fine needlework, music, and watercolor painting, all taught by schoolmistresses such as Susanna Rowson. Such women, who provided guidance in style and subject matter and set the direction for more than a century of female accomplishment, have been called by the scholar Betty Ring "the most neglected of American artists." The regional variety identifiable in samplers is due to the influence of particular teachers, who trained generations of needlework artists in cities such as Boston, Newport, and Philadelphia.

Shortly after the American Revolution, a young Connecticut woman named Prudence Punderson designed and embroidered an allegorical self-portrait, which she titled *The First, Second, and Last Scene of Mortality* (**fig. 5.30**). Punderson's portrait not only reveals her Christian piety but also sheds light on the domestic mores of an upper-class New England household. On the right, the artist depicts herself as a baby in a cradle, being tended by an African American servant. Above the servant is a picture on the wall, perhaps another embroidered figural scene. The artist presents her adult self in the center of the composition,

sitting at a round Chippendale-style tea table, where her artistic materials are displayed. On the left, she has stitched her own coffin, the initials "PP" embroidered on top. This is a female version of the three stages of life, a familiar iconographic motif. Behind the coffin, a mirror is shrouded for mourning. We don't know why the young Prudence Punderson was pondering her own mortality; a few years later she married, and then died at the age of twenty-six. Her haunting image may be the earliest self-portrait by an American woman artist.

Although thousands of schoolgirls became accomplished needlewomen, not all liked this work and not all were good at it. One Maryland girl embroidered into her sampler the sentiment "Patty Polk did this and she hated every stitch she did in it. She loves to read much more." Other girls' embroideries celebrated their love of learning in a more elegant fashion. Fifteen-year-old Maria Crowninshield embroidered an allegorical image of female education (**p. 134**) while a student at the Ladies' Academy, in Dorchester, Massachusetts, which she enthusiastically described as a "delightful mansion of happiness." Following neoclassical style, the picture represents a classical temple, in which a young girl in flowing robes reads from a book held by her teacher, while a goddess crowns her with a wreath.

The propriety of education for women was hotly debated at the beginning of the nineteenth century. It is noteworthy that in this image, the book from which the pupil reads is the English writer Hannah More's *Strictures*

5.30 PRUDENCE PUNDERSON, *The First, Second, and Last Scene of Mortality*, c. 1778–83. Silk thread on silk, 12¾ × 17 in (32.3 × 43.1 cm). The Connecticut Historical Society, Hartford, Connecticut.

on the *Modern System of Female Education*, published in 1799. In her popular book, this moderate educational reformer urged that better education would make women better mothers and educators of the next generation of male citizens. Her more radical colleague, Mary Wollstonecraft, in *Thoughts on the Education of Daughters* (1787) and *A Vindication of the Rights of Woman* (1792), argued that women could be the intellectual equals of men if properly trained. Wollstonecraft was widely read (and often pilloried) in educated households in post-Revolutionary America. These British writers scorned "female accomplishments" as trivial; they believed that young women's minds should be sharpened by exposure to the same subjects studied by young men. Wollstonecraft argued that needlework constricted female minds "by confining their thoughts to their persons." Yet Maria Crowninshield deftly and mutely turned her talents in female accomplishments to a quietly subversive end: arguing through her stitching that female education is a lofty and worthy goal, fitting with the neoclassical aspirations of the new republic.

# Painting in the New Nation

The challenge facing artists in the early years of the republic was daunting. They needed to justify their art to a nation with little direct exposure to the fine arts. This meant thinking about art in a new way: trying to understand how the arts in a democracy differed from those produced under monarchy. It also meant finding new sources of patronage in a world where the traditional patrons of art—notably church and aristocracy—played much-diminished roles. Artists needed to understand who their audiences were: those educated classes knowledgeable about the arts, or the larger but untutored world of ordinary citizens? Four artists—Gilbert Stuart, Charles Willson Peale, John Vanderlyn, and Washington Allston—supply four answers to the question of patronage in a democracy and illustrate the transformation that occurred over the course of the early national period, as art shifted from the expression of civic ideals to a new emphasis on sentiment and feelings.

## Portraiture and Commercial Life: Gilbert Stuart

In the half century between winning independence (1783) and the election to the presidency of Andrew Jackson (1828), there was only one sure way for a painter to support himself by his art: portraiture. As before (see Chapters 3 and 4), Americans preferred portraits: images of themselves and their families that they valued both as keepsakes and as ways of recording family lineages. Gilbert Stuart, whose portrait of George Washington we have already examined (see fig. 5.6), was the preeminent American portraitist of the early national period. A former pupil of Benjamin West, he was also an accomplished conversationalist and an extravagant dresser, who spent large portions of his life eluding creditors.

***THE SKATER.*** In 1782, while working in London, Stuart persuaded William Grant, a Scottish gentleman who had commissioned a full-length portrait, to pose on ice skates. The result was *The Skater* (**fig. 5.31**). Although Stuart later

5.31 GILBERT STUART, *The Skater (Portrait of William Grant)*, 1782. Oil on canvas, 96 ⅛ × 58 ⅛ in (245.6 × 147.6 cm). National Gallery of Art, Washington, D.C.

spun many tales around the event—among them that Grant had to hold on to Stuart's coattails while Stuart skated gracefully across London's Serpentine pond in Hyde Park—he produced an image that won instant acclaim when shown at the Royal Academy's exhibition that year. The painting counterpoints its dominant grays and blacks against small areas of bright color: the flushed pink of Grant's face, the occasional reds of skaters in the background, and even a few spots of red on the background tree. Stuart's contemporaries described *The Skater* as simultaneously "reposed" and "animated," a union of character traits that indicated—according to the standards of the day—an inner strength independent of birth or class.

The cultural historian Jay Fliegelman has interpreted the painting politically. He notes that Grant's poise is possible only for a skater in motion. Were Grant actually standing still, he would topple over. For Fliegelman, this image of balance-in-motion suggests a new and nonaristocratic model of citizenship. Stuart seems to embrace motion as the condition of life. Unlike more aristocratic images, which tend to present a fixed and unchanging vision of the social order, Stuart's portrait of Grant depicts stability in the very midst of change. Stuart's painting represents the worldview of a mercantile society. His skater balances character with motion, self-assurance with worldliness, and independence with community (those figures behind him). He embodies virtues crucial to the success of a commercial republic.

## Painting and Citizenship: Charles Willson Peale

For Charles Willson Peale (1741–1827), a Philadelphia painter and naturalist, the future of the arts depended on the ability of artists to place their work in the service of the nation. Peale sought to *instruct* the viewer in values that increasingly came to be thought of as particularly American. This instruction in good citizenship, in turn, helped justify the arts as a vital part of a democratic society. Peale hoped to persuade—or badger—the government into supporting the arts by providing commissions for works that displayed the principles central to a democratic culture.

**THE STAIRCASE GROUP.** In 1795, at the first group exhibition ever held in the United States of works by American artists, Peale displayed a painting now called *The Staircase Group* (**fig. 5.32** and **p. 132**). Peale termed his life-size work a "deception." It featured his eldest son, Raphaelle, ascending a winding staircase with Titian Ramsay Peale, a younger

5.32 CHARLES WILLSON PEALE, *The Staircase Group*, 1795. Oil on canvas, 89 × 39 in (227 × 100 cm). Philadelphia Museum of Art. (See also p. 132)

brother, looking down from the bend above. To heighten the illusionism of the painting, Peale installed it within a door frame, complete with an actual stair step and riser at the base of the painting. The effect was electrifying. When George Washington visited Peale's Philadelphia Museum two years later (see fig. 5.33), he saw the reinstalled painting, and, according to a report by Peale's son Rembrandt, "bowed politely to the painted figures." So powerful was Peale's illusionism that Washington had mistaken Peale's figures for living persons.

Peale directs his painting toward two types of potential audiences: sophisticated viewers who already value art and untutored viewers who do not. *The Staircase Group* makes

no special demands on its viewer; it requires no prior knowledge of the history of art. Instead, it attempts to seduce the eye through playfulness and optical vitality, deceiving the eye so completely that the work of art can be mistaken for the world it represents. Peale's remarkable verisimilitude is thus an advertisement for the sheer pleasure of looking at paintings.

It is also part of what the art historian David Steinberg has called Peale's "project of cultivating a public for high art." Despite its illusionism, *The Staircase Group* possesses meanings that extend beyond its realistic style. Raphaelle's progress along the stairwell with his palette and **maulstick** suggests that not just he, but the arts themselves, are ascending. The painting links cultural endeavor with national progress in a theme of uplift and ascent.

This association between art and nationhood was reinforced by the very place in which Peale's deception was exhibited: the former Senate Chamber of Independence Hall, in Philadelphia. Peale was a tireless advocate for a system of federal support for the arts. *The Staircase Group* fosters support not only *of* the government, but *by* it. Both pleasurable and practical, art stands as a testament to the nation's cultural health. It creates good citizens.

**THE ARTIST IN HIS MUSEUM.** Several years earlier, in 1786, Peale had converted his collection of preserved animals—together with his portrait busts of illustrious Americans—into a museum, the first natural history museum in America. His goal was "to bring into one view a world in miniature." Situated on the second floor of Independence Hall in Philadelphia, Peale's Museum included more than ninety species of mammal, seven hundred bird specimens, and four thousand species of insects. Labels were printed in Latin, French, and English. The birds were displayed in glass-fronted cases with painted backdrops portraying their natural habitats. Most species were classified according to the recently established Linnaean system of taxonomy.

Unlike other museums opened in the eighteenth century—the British Museum opened in 1759, the Louvre in 1793—Peale's Museum was not directed primarily toward the elite. His goal was to provide access to as wide an audience as possible, to introduce what the scholar Edgar P. Richardson has termed "the ideal of rational pleasure," to instruct *and* entertain. In so doing, Peale sought two results: the creation of an enlightened citizenry and the demonstration that all social order derived from universal principles of nature. The "great book of nature," he wrote, "may be opened and studied, leaf by leaf, and a knowledge gained of the character which the great Creator has stamped on each being."[4] For Peale, the Museum was a logical extension of his lifelong commitment to republican forms of government founded on the principles of nature.

*The Artist in his Museum* (1822), painted when Peale was eighty-one, reflects his vision of a harmoniously ordered cosmos (**fig. 5.33**). The painting not only repeats the general layout of Peale's Museum (slightly changed for the sake of visual coherence); it also embodies Peale's own values and dramatizes his point of view. To move into the painting's visual world is, in effect, to step into the mind of Charles Willson Peale and to experience, with him, a particular vision of the American past and future.

The trick lies in how we enter the painting. To proceed, we first pass under the fictional red curtain held aloft by Peale himself. What we encounter is Peale's version of American history. Above us to the left sits a bald eagle, while below it in the foreground, a turkey lies draped over a box of taxidermy tools. These two birds, framing the painting's left side, had earlier been the center of a political debate over which to choose for the "national bird." Franklin had advocated the turkey, a native bird

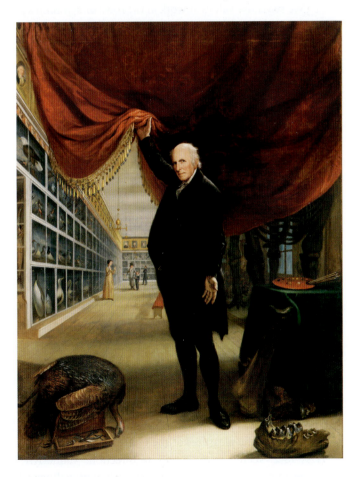

5.33 CHARLES WILLSON PEALE, *The Artist in His Museum*, 1822. Oil on canvas, 103¾ × 79⅞ in (263.5 × 202.9 cm). Pennsylvania Academy of the Fine Arts, Philadelphia, Pennsylvania.

associated with industriousness and humility. He disliked the eagle for its historical associations with imperial European power. Memories of the debate linger in Peale's juxtaposition of both birds at the entrance to the Long Room of his Museum.

The objects in front of Peale—turkey, taxidermy tools, mastodon bones—have not yet been assembled and mounted. They await the efforts of the artist, or, if we are to accept his beckoning left hand, the viewer, who is not only invited into the Museum but asked to join in its tasks. The foreground of *The Artist in his Museum* thus occupies the world of Peale in the present and anticipates work to be performed in the future. By contrast, the background of the painting—the area behind the red curtain—embodies the past. Unlike the foreground, its world is sealed: the creatures sit stuffed in their display cases, the portraits of prominent Americans hang fixed in their frames. What we encounter on the other side of the curtain is not just a museum, but Peale's visual shrine to Enlightenment values.

We see those values at work in the rows of symmetrical displays, and the perspectival system of the painting itself. Peale's long **orthogonals** unite the foreground and background of the canvas in a single visual sweep. *The Artist in His Museum* thus exhibits more than specimens and portraits. It teaches the viewer about nature's underlying rationality, and it transforms the American Revolution, present through the portrait busts that line the Museum's walls, into a triumph of Enlightenment principles.

Peale's clothing similarly reflects national concerns. His knee breeches identify the artist as a member of the Revolutionary generation and contrast with the trousers of the man and boy in the background. This contrast in fashion highlights Peale's unique role as a chronicler of the American Revolution—someone who not only participated in its events, but who now instructs the viewer in its lessons. The grandfatherly figure of Charles Willson Peale invites us to continue the Revolution that his generation began.

## Myth and Eroticism: John Vanderlyn

While Charles Willson Peale attempted to instruct the public in the virtues of good citizenship, turning the viewer's thoughts from "sensuality and luxury" to good citizenship and the pleasures of the intellect, John Vanderlyn (1755–1852) veered in the opposite direction. Vanderlyn's career mirrors the larger shift in the early national period from a culture of "republican virtue" to one increasingly occupied with private pleasures.

***ARIADNE ASLEEP ON THE ISLE OF NAXOS.*** In *Ariadne Asleep on the Isle of Naxos* (1809–1812), Vanderlyn drew on Venetian traditions of the nude to portray a woman from mythology abandoned by her lover (**fig. 5.34**). *Ariadne*, however, reaches beyond the grace and beauty of its Renaissance style to appeal to less refined sentiments. The painting offers an eroticized spectacle that flies in the face of the decorum and restraint expected of neoclassical art.

Vanderlyn's American viewers were scandalized. They were unprepared for a nude female figure dominating a lush landscape. Vanderlyn himself had anticipated this response. In a letter written in 1809, he observed that the "subject may not be chaste enough for the more chaste and modest Americans, at least to be displayed in the house of any private individual, to either the company of the parlor or drawing room, but on that account it may attract a greater crowd if exhibited publickly [sic]." Vanderlyn believed that he would draw large crowds to his painting precisely because of the controversy it was likely to cause.

At one level, *Ariadne* embodies European traditions of high art. Ariadne's creamy, voluptuous body derives from Italian precedents, linking Vanderlyn—and by association, American art itself—not only with the classical past, but with a cosmopolitan, transatlantic culture of refined taste. From this point of view, *Ariadne* was Vanderlyn's way of showing that American art was not provincial. On the contrary, American painters could match anything Europe had produced.

At another level, *Ariadne* represents nature itself: innocent, unguarded, and voluptuous. She can be understood as an allegory of the American landscape. In her recumbent posture, she is as exposed and inviting as the New World, and like it, she invites conquest. Painted in the years immediately following the Louisiana Purchase and the Lewis and Clark expedition (both achievements of the Jefferson administration), Vanderlyn's painting translates continental expansion into a discourse on female availability.

But *Ariadne* also offers veiled eroticism. Ariadne's lover, Theseus, disappears in the distant background, where he is about to join his ships and embark for Athens. With Theseus's disappearance, the viewer is free to attend to the painting outside its mythic narrative. Despite its classical framework, the canvas's emotional charge lies elsewhere: in the realm of the viewer's unacknowledged desires. Although *Ariadne's* style derives from high European art, the painting's affect—its emotional jolt—appeals to a world of private tastes and hidden pleasures.

*Ariadne* begins, then, where Peale leaves off. It offers a not-so-chaste vision of nature grounded less in rational

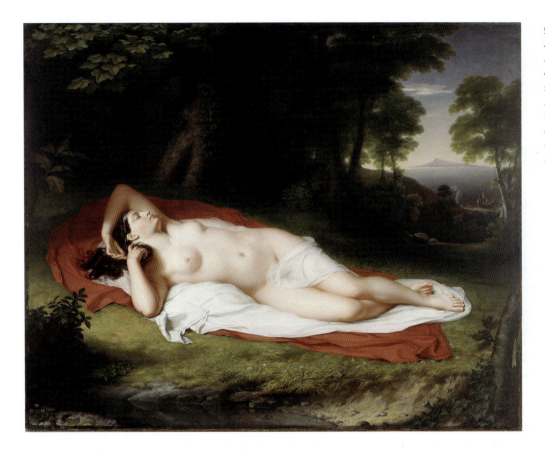

5.34 JOHN VANDERLYN, *Ariadne Asleep on the Isle of Naxos*, 1809–12. Oil on canvas, 68⅛ × 87 in (173.3 × 220 cm). Pennsylvania Academy of the Fine Arts, Philadelphia, Pennsylvania. Gift of Mrs. Sarah Harrison to the Joseph Harrison, Jr., Collection.

principles than in a more subterranean realm of feeling and desire. Vanderlyn shifts the inner logic of painting from moral and civic uplift—the idea that art instructs its viewer—to something we recognize more familiarly today from advertising and television: images charged with an erotic undercurrent. Where Peale takes the "high road," Vanderlyn swerves down the low, dressing up desire in the language of classical taste.

## Early Romanticism: Washington Allston

Washington Allston (1779–1843), Vanderlyn's friend and younger contemporary, carries the notion of the private one step further. A native of South Carolina, Allston graduated from Harvard College in 1800 and soon departed for Europe, where he settled in London and studied with Benjamin West at the Royal Academy. He returned permanently to Boston, after further travel, in 1818. An avid reader of gothic novels (he would later write one himself), Allston was shaped by the currents of romanticism swirling through Europe. While visiting Italy in 1804, he befriended the British poet and essayist Samuel Taylor Coleridge. Allston learned from Coleridge and his circle of friends the central tenets of romantic thought: a mistrust of rationality; a preference for intu-

ition; an emphasis on heightened states of emotion; a faith in the high calling of the poet and painter; and a deep skepticism about society as anything more than a corruption of individual innocence.

Romanticism viewed the world as a breathing organism. Matter was not *merely* matter, but was always animated by a larger, living force. This idea of a "universal intellect," lending vitality equally to people and inanimate objects, marked the end of an older, more rationalistic sensibility. Intuition, rather than reason, provided the most truthful access to the world. An older emphasis on proper conduct and good behavior gave way to new emphases on emotions and the inner life. Allston's deepening romanticism isolated him increasingly from his Boston patrons. His vision of art as an expression of an "ideal world" left little room for their commerce and profit.

***ELIJAH IN THE DESERT.*** In 1817–18, Allston painted *Elijah in the Desert*, a work that was greeted by Boston's cultural elite with equal amounts of indifference and hostility (**fig. 5.35**). Allston's monumentally sized canvas (4 by 6 feet) brings the ambitions of history painting to the newly emergent genre of landscape (see Chapter 8). Although it derives its story from the Bible, and thus qualifies as a suitable subject for history painting, its spaces are devoid of

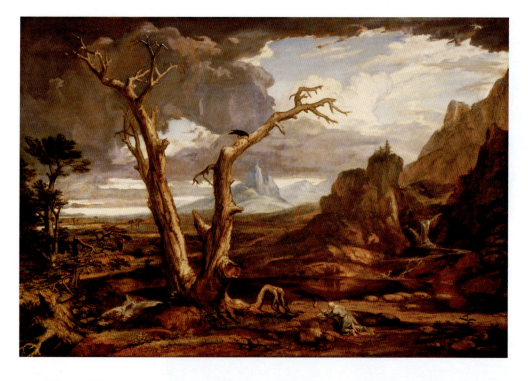

5.35 WASHINGTON ALLSTON, *Elijah in the Desert*, 1818. Oil on canvas, 49¼ × 72¾ in (125.09 × 184.7 cm). Museum of Fine Arts, Boston, Massachusetts.

social forms. There are no cities, no gatherings of people, no signs of classical order to link the frail prophet in the foreground with a larger realm of civic endeavor. On the contrary, the downcast posture of Elijah suggests that his voyage is an internal one, a private affair defined by introspection and imagination, rather than reason. The prophet becomes a type of the romantic genius: isolated from society, inspired by nature (Elijah is being fed by ravens), and reliant on his imagination to bridge the gap between the barrenness of the world he inhabits and the promises of the ideal realm he seeks.

Allston's painting technique reinforces his romantic concerns. In *Elijah in the Desert*, he abandons the classical tradition, with its emphasis on clearly outlined figures and

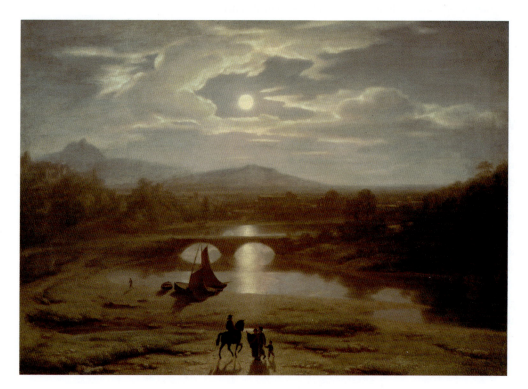

5.36 WASHINGTON ALLSTON, *Moonlit Landscape (Moonlight)*, 1819. Oil on canvas, 25⅛ × 35¼ in (64 × 90.6 cm). Museum of Fine Arts, Boston, Massachusetts.

color bounded by form, in order to work with **impastoed** surfaces and rich glazes. He lays his paint on with a loaded brush and then applies layers of translucent varnishes, each tinged with a slightly different color. The result is a surface that vibrates with light, each element in the composition joined seamlessly to the others. This emphasis on atmosphere and texture encourages the viewer to approach Allston's painting empathetically.

No wonder, then, that the painting's first Boston viewers expressed surprise. They sensed, correctly, that *Elijah in the Desert* represented a profound challenge to their world. Its apocalyptic undertones, its focus on what the art historian David Bjelajac has called "solitary meditation," its indifference to social custom all threatened their faith in reason and society.

**MOONLIT LANDSCAPE (MOONLIGHT).** In *Moonlit Landscape (Moonlight)* (1819), Allston offers a night scene more magical than real (**fig. 5.36**), choosing mood over reason, color over line, moon over sun. Painted soon after his return to Boston, the canvas is filled with imagery of travel, as if its figures were on a quest that we, as viewers, can only imagine. The foreground individuals appear to be at the beginning—or end—of a voyage. The boats and bridge and the curving river all suggest motion and change. The youth walking at the edge of the river carries a staff in his hand, the emblem of the traveler. Yet despite these hints of a story, the painting remains a mystery. The art historian Marcia Wallace has interpreted the *Moonlit Landscape* as a moment when Allston's past and present coalesce. The background hills and mountain recall his life in Italy, while the foreground figures, bathed in moonlight, echo Allston's description of the October night he arrived in Boston harbor, when the "moon looked down upon us like a living thing, as if to bid us welcome." The cropped shadows of the foreground figures, together with the ribbon of light running under the bridge, owe their visual power to the moon, which brings together sky and earth, background and foreground, past and present.

*Moonlit Landscape* announces a new type of painting in the United States. What matters to Allston is feeling and sentiment, as if the viewer were beholding an inner landscape, a space more psychological than real. By mixing memory with magic, and hinting at meanings it will not reveal, *Moonlit Landscape* transforms painting from an exercise in civic values (Stuart and Peale), or a retreat into erotic fantasy (Vanderlyn), to a form of private reverie. The painting carries the viewer away from social life and public issues to a realm defined by poetry, mood, and suggestion.

# Conclusion

We normally think of the American Revolution as a political event. For artists in the years surrounding the Revolution, however, political issues were dogged by another issue. What role should artists play in shaping the new nation? In this chapter, we have watched artists attempt to answer that question. Although individual artists would respond in different ways, they tended collectively to arrive at a similar conclusion. They cast themselves as bearers of the values of their emerging nation. Most of them viewed art as a form of civic uplift, educating the general public in good citizenship. Seizing on the enthusiasm for classical culture that gripped the transatlantic world at the close of the eighteenth century, they turned to styles borrowed from Ancient Greece and Rome in order to imagine the United States as a modern revival of the ancient world. Whether we are looking at a coffee urn by Paul Revere or at needlework by fifteen-year old Maria Crowninshield, we encounter, again and again, classical motifs employed in the noble service of civic idealism and patriotic forms of expression.

All that will change, however, as the nineteenth century progresses. The end of the early national era coincided with new forms of personal expression and increasing concern for the inner life. The slow industrialization of the countryside (where water power provided energy for mills and factories) and the rapid growth of cities led to profound shifts in everyday life. Men increasingly worked outside the home, where they were associated with the rough-and-tumble world of commerce. Women, in turn—especially middle-class women—found themselves identified by their domestic duties, presiding with growing authority over family and household. Still barred from most political life, women became instead custodians of culture, preserving and transmitting the nation's ideals. The result was a new emphasis on romantic values: feeling, intuition, and empathy. What begins with artists of Allston's generation as a rebellion against the forces of commercialization will develop into a full-fledged culture of "sentimentalism," a world where public action is measured by private emotion, and where who one is depends on what one feels.

# 6 | The Body Politic, 1828–1865

DURING THE DECADES from the election of Andrew Jackson to the presidency in 1828 until the outbreak of the Civil War (1861), a period known as the antebellum years, the visual arts played an active role in shaping national identity. By "arts," we mean something more than painting and sculpture. We also include the buildings people made; the homes they lived in; the goods they created; and the styles they enjoyed. Art helped people express their values, share their visions, and comment on the issues of the day. Prints and paintings represented scenes of everyday life— not necessarily as it was, but as it was imagined. Images in almanacs and newspapers showed readers what people from other regions of the country looked like. Artists created recognizable types and stereotypes; they engaged with politics and contemporary social issues. In an age of extraordinary social transformation—as increasing numbers of Americans were moving from farms to cities; as industrialization proceeded at alarming speeds; as new technologies such as the telegraph and the cotton gin and new transportation systems such as the train and steamboat transformed the pace of daily life; as the gap between workers and managers widened; as the numbers of immigrants, especially non-Protestant immigrants, increased dramatically; as the problem of slavery grew intractable; and as regional tensions between North, South, and West intensified—artists sought to bind society's many disparate parts together.

## The Language of Emotion

During the antebellum years, sentiment played a leading role in shaping American life. Sentimental culture extolled the virtues of honesty and simplicity. Its heroes were chaste women and selfless mothers, and it viewed childhood as an age of purity and innocence. Sentimental culture was also obsessed with death, partly because so many women died in childbirth and so many children failed to live to adulthood. Its highest virtue was self-sacrifice, the willingness to give one's life for others.

## Home and Family

Historically, sentimentalism is tied to the separation of the workplace from the home. In the seventeenth and eighteenth centuries, a household might include servants, apprentices, boarders, and a family network of children, cousins, grandparents, aunts, and uncles. Going to work rarely required leaving home. But by the beginning of the nineteenth century, this older artisanal economy was giving way to industrialization: the clustering of workers in work spaces outside the home; the organization of work into separate, repetitive tasks; the substitution of cheap labor for skilled labor; and the rise of a managerial class to oversee this less-skilled workforce.

The household changed, too. It ceased to be the central economic unit of society. Among the middle classes— especially in New England and the Mid-Atlantic states—the middle-class home became a "haven in a heartless world." Women's work was associated with childrearing and emotional nurture. Women provided men with emotional support to face the workplace anew each day, and they educated their children into their role as future citizens. To accomplish this, women were expected to be paragons of virtue and self-sacrifice. They were placed on a pedestal and honored for their purity and selflessness. Their labor seemed invisible, recognized for its emotional worth rather than its economic value. Home and family, in turn, came to be viewed in opposition to the world of work. The result was a new notion of domesticity.

(opposite) JAMES JOHN AUDUBON, *The Carolina Parakeet*, 1825. Watercolor. New-York Historical Society.

**LILLY MARTIN SPENCER.** In painting, sentimentalism is exemplified by the work of Lilly Martin Spencer (1822–1902), who specialized in images of middle-class domestic life. Spencer was one of the few successful female artists of the antebellum period and one of the only women invited to join the prestigious National Academy of Design, in New York, the dominant organization of professional artists throughout the nineteenth century. Spencer's membership, however, did not include voting rights. Her *Domestic Happiness* (1849) (**fig. 6.1**) shows a glowing couple watching their two children sleep. A light shines beatifically on the children, contented in each other's arms. The mother holds up one hand to her husband's chest in a gesture of intimacy that links husband and wife together physically (as the children also are linked). And yet her gesture also contains an element of restraint, as if she were warning against waking the children. In this way, the mother's gesture quietly asserts her control over the domestic sphere. *Domestic Happiness* is based on a drawing of Spencer's oldest sons, who were among her thirteen children. Taken as a whole, Spencer's images glorify the domestic piety of female-dominated sentimental culture. They cherish sincerity, empathy, and feeling above logic, efficiency, and rationality—catchwords of commercial culture. Although women of Spencer's era were not allowed to vote, own property independently of their husbands, or hold political

6.1 LILLY MARTIN SPENCER, *Domestic Happiness*, 1849. Oil on canvas, 55½ × 45¼ in (140.9 × 114.9 cm). Detroit Institute of Arts. Michigan.

office, they nonetheless exerted considerable power over public opinion and the social issues of the day. They did so through their influence at home—in the nursery, drawing room, and bedroom—as well as in public spaces, such as the church, schoolhouse, and assembly hall, and in women's magazines.

**"SENTIMENTALISM IN NATURE."** Sentimentalism was such a backbone of American mid-nineteenth-century culture that its trace is visible even in the natural-history illustrations of John James Audubon (1785–1851). Many of his 435 watercolors of American birds treat his subjects as if they were members of a household. For example, the *Carolina Parakeet*, first painted in 1825, places a young parakeet, which has not yet developed the colorful plumage characteristic of the adults, in the lower center of the image (**p. 170**). The immature bird is surrounded by an adult female, below, and two males, directly above it. This protective triangulation is reinforced by the branches of the cocklebur tree that surround and enclose the young bird. The adults gesture aggressively toward the viewer, as if warning us away from the guarded space of the family. The young parakeet, with its turned head, appears to meet our eyes; the female faces us directly. This eye contact establishes empathy between viewer and birds, which softens their warning to keep our distance.

## Sculpture

Sculpture proved to be an especially fertile ground for sentimental values. During the antebellum years, a wave of American artists, many of them women, sailed for Italy to seek their fortunes. They learned very quickly to adapt neoclassical conventions to the rising taste for sentimental images.

There were many reasons why America's first generation of sculptors would congregate in Rome. The purest white marble—the same marble used by Michelangelo and other Renaissance artists—was still available in quarries in Carrara and Lucca. Examples of Greek and Roman sculpture were visible everywhere in Italy. And unlike the United States, Italy had a long tradition of stone carvers and artisans, who could translate the artist's vision into a finished work.

Most American sculptors worked in clay or plaster. They created small models, which their Italian assistants would then translate into full-sized marble works. The rates for such skilled labor were fairly standard and relatively inexpensive, and American artists soon developed a reputation for paying better than their European peers.

This division of labor between the artist, who conceived and modeled the work, and the stonecutter, who actually executed it, gave women artists a special opportunity. Not only could they live lives less encumbered by gender roles; they could also create life-size and monumental sculptures without engaging in the arduous labor required to carve marble. The community of American woman artists in Rome grew so large that at one point the author Henry James, looking back to their heyday at mid-century, described them as "the white marmorean flock," a reference to the pure marble that they used and, perhaps less kindly, to their visibility as women sculptors in Rome.

Sentimentalized sculptures were often purchased by Americans visiting Europe on the Grand Tour. While in Rome, they would visit the studios of American artists, seeing finished products as well as works in progress. They could have a portrait bust of themselves modeled rapidly in clay or plaster, and then return at the end of their Italian journey to pick up the finished piece in marble. Because the carvings were replicated from an original plaster cast, additional copies could readily be made for other family members or other patrons. Sculpture in marble proved to be a medium oddly amenable to the world of early mass production.

Neoclassicism provided American sculptors with exactly the right style. The dominant mode in European sculpture, Neoclassicism emphasized idealized figures and decorously balanced form. Sentimental culture tended to idealize women as "angels of the household," associating them with purity, innocence, simplicity—values that neoclassical sculpture, with its chaste forms in white marble, could convey naturally.

**HARRIET HOSMER.** A marble sculpture entitled *Beatrice Cenci* (1856), by Harriet Hosmer (1830–1908) weds neoclassical sculpture with sentimental values (**fig. 6.2**). The story concerns a young sixteenth-century Roman woman who was sentenced to death for planning the murder of her father, who had been physically abusive to her brother and sexually abusive to her mother and herself. Hosmer shows the heroine lying quietly on a prisoner's bench, contemplating her fate and holding rosary beads in her languid left hand. Viewers cannot help but notice her youth, beauty, and piety. The pillow on which she rests her head, though carved from marble, appears soft and downy, an appropriate support for Cenci's sinuous body. The story of Beatrice Cenci was published throughout the nineteenth century as a sensational tale of extreme emotions, but Harriet Hosmer has cast it instead as a narrative of female piety and family justice, the triumph of a spiritually exalted

6.2 HARRIET HOSMER, *Beatrice Cenci*, 1856. Marble, 24 × 60 × 24 in (60.9 × 152.4 × 60.9 cm). Saint Louis Mercantile Library, Missouri.

woman over wrongs inflicted by a man. Beatrice Cenci's serenity and faith—seen in her calm devotion to her rosary—confirm all that sentimental culture wanted to believe: women's purity, selflessness, and devotion to family.

**EDMONIA LEWIS.** *The Old Indian Arrowmaker and His Daughter* (1872), by Edmonia Lewis (c. 1845–1905), treats a very different—though equally sentimentalized—father–daughter relationship (**fig. 6.3**). Lewis, the daughter of a Chippewa mother and an African American father, was educated at Oberlin College, the first college in the United States opened to blacks, Native Americans, and women, as well as to white men. Eventually making her way to Rome, Lewis created sculptures that explored racial concerns in a neo-classical idiom. She portrays this elderly Indian as a crafts-man. Although he may be old, he is not, as most whites believed, a doomed member of a vanquished race; instead, he gazes with his daughter into a promising future. By giv-ing father and daughter a craft, Lewis endows them with the values of hard work and independence that her middle-class patrons espoused, while also suggesting the existence of sentimental family values among people supposed, by these patrons, not to possess them.

**HIRAM POWERS.** Perhaps the most notorious moment associated with sentimental sculpture occurred in 1847, when the Vermont expatriate artist Hiram Powers (1805–73)

sent his *Greek Slave* (1843) on a tour of major cities in England and the United States (**fig. 6.4**). Powers was well aware of the potential for scandal that his unclothed figure might cause, but by a combination of clever craftsmanship (her left hand covers her genitals) and brilliant advertising he succeeded in convincing the public that his statue was entirely proper. A pamphlet accompanying the tour of the *Greek Slave* explained that Powers's figure was unclothed against her will.

Powers imagined the *Greek Slave* as a Christian woman recently captured by Turkish invaders eager to place her on the auction block. Her family, according to the narrative, had been murdered by the invaders, while she remained the sole survivor. Her modest demeanor and down-turned eyes revealed her resignation and Christian meekness. The chains binding her hands reinforced the viewer's sense of her vulnerability, eliciting feelings of sympathy and con-cern from both male and female viewers. Though entirely naked, Powers's *Greek Slave* stood as a model of sentimental propriety.

At the same time, the statue also enabled the viewer to regard a female nude without conscious feelings of voyeurism. The Unitarian minister Orville Dewey wrote, upon seeing the statue, that "the Greek Slave is clothed all over with sentiment; sheltered, protected by it from every profane eye. Brocade, cloth of gold, could not be a more complete protection than the vesture of holiness in which she stands."[1] As the art historian Joy Kasson notes, Dewey's comments, in effect, reclothed her nude body in the invisible robes of Christian virtue. The "civilized" viewer would

6.3 EDMONIA LEWIS, *The Old Indian Arrowmaker and His Daughter*, 1872. Marble, 21½ in (54.6 cm) high. Smithsonian American Art Museum, Washington, D.C.

now, according to Kasson, "see the *Greek Slave* without seeing her body at all." What the viewer beheld instead was a quintessential sentimental heroine: spiritual and chaste.

If women viewers beheld the *Greek Slave* as the embodiment of sentimental virtue, they might also have seen her as emblematic of their own social limitations—as captives in their roles as mothers and wives. If so, then Powers's heroine functioned in contrasting ways: as a reminder not only of what sentimentalism required of women, but also of how it worked to empower them. The statue's stoic demeanor suggested both resignation and, implicitly, resistance, a willingness to stand up to oppression and engage it—if not overtly, then by sheer force of character.

6.4 HIRAM POWERS, *The Greek Slave*, 1843. Marble, 65 in (165.1 cm) high. Yale University Art Gallery, New Haven, Connecticut.

## Gothic America

In 1840 Thomas Cole—who is better known for landscape paintings (see Chapter 8)—painted *The Architect's Dream* for one of his patrons, Ithiel Town, of New York and Connecticut (**fig. 6.5**). Town was an architect, and this large canvas positions him lounging among architectural design books against a panorama of the history of Western architecture. In the distance an Egyptian pyramid and **hypostyle** hall, and in the middle distance a Greek temple and Roman aqueduct, lead forward in chronological order to Renaissance forms just above the figure on his majestic pedestal. Set apart on the left and in shadow, a Gothic church glows from within, its silhouetted spire pointing heavenward, mimicking the forms of the trees in the midst of which it nestles. The architect holds in his hand a plan on which we see a classically derived portico similar to that behind him, but he gazes raptly at the Gothic building with its steep roofs, **cross gables**, agitated skyline, and **lancet windows** fitted with colored glass. The turn to the Gothic that this gaze represents entails a turn from the authority of classical design ideas—which had held sway virtually uncontested for more than a century—to those thought more native to countries in northern Europe (Britain, France, Germany), the culture of origin for most

American citizens in 1840. It also entails a turning away from designs associated with rationality, clarity, symmetry, straight lines, and right angles to designs more closely associated with emotion, irrationality, mystery, asymmetry, and irregular diagonals.

**LYNDHURST, BY ARCHITECT ALEXANDER JACKSON DAVIS.** What exactly did antebellum Americans like about the forms, plans, and aura associated with the Gothic? And what does this enthusiasm tell us about them? A close look at one of the most ambitious buildings in this taste, Lyndhurst, in Tarrytown, New York, is instructive (**fig. 6.6**). Lyndhurst was built in 1838 with substantial additions in 1865—both phases designed by the architect Alexander Jackson Davis (1803–92)—and was owned by a sequence of men prominent in politics and business in nearby New York City. Built of gray cut stone, Lyndhurst exhibits the earthy colors, busy skyline, pointed tracery windows, and steep gables characteristic of the Gothic style. Individual elements, including stained glass, bay windows, and wraparound verandas, exemplify antebellum

6.5 THOMAS COLE, *The Architect's Dream*, 1840. Oil on canvas, 4 ft 5 in × 7 ft ¹⁄₁₆ in (1.35 × 2.14 m). Toledo Museum of Art, Toledo, Ohio.

6.6 ALEXANDER JACKSON DAVIS, *"Lyndhurst" near Tarrytown, New York, Elevation and Plan, 1838*, 1865. Watercolor on paper, 18¾ × 26¾ in (47.6 × 67.9 cm). Metropolitan Museum of Art, New York.

attention to visual effects—the coloration of interior light, the breadth of view available from the interior, and the invitation to enjoy nature from extensive porches.

Unlike Georgian or Classical Revival forms, the structure is irregular and unpredictable. Its surface is punctuated by windows that vary in size, character, and treatment; masses jut forward or step back, rise into many stories or hug the ground. Lyndhurst is a house that exhibits an interest in surprise and in shadows. This latter characteristic also suggests curiosity about the darker regions of the human soul.

A Gothic Revival structure is marked not only by outward signs of medievalism but also by distinctive elements. Unlike the Georgian or Classical Revival building, in which the overall volume, proportion, and footprint is established first and the rooms accommodate themselves to this predetermined shell, the Gothic structure gives priority to interior space. Gothic buildings express, in their footprint, exterior façade, and massings, the character and uses of their individual rooms. These rooms frequently protrude into space and extend beyond traditional rectilinear patterns.

Four aspects of Lyndhurst represent novelties in American building that appeared with the Gothic Revival and have tended to persist to the present. First, the tall bay windows, which light the dining room at the left end of the building, take the form of a grand window in a medieval hall, which marked the place where the lord sat at table. Second, the library, which developed into a space set aside from other activities—becoming an area devoted to books, reading, and the imagination. Usually associated with privacy, privilege, and male retreat, the library is found in even rather modest homes in this and subsequent periods (becoming known in the mid-twentieth century as the "den"). Third, the great hall, a double-height room with elaborate truss overhead, marked on the exterior at Lyndhurst by a grand window evocative of a west window in a cathedral, recalls the gathering, eating, tale-telling, trophy-displaying place for the lord and his warriors in medieval buildings. At Lyndhurst the great hall is a picture gallery, hung with artistic "trophies." It provides an unusual prospect of the Hudson River through its grand window, which is inset with magnifying lenses, providing watchers with a binocular view of the passing events on the river outside. Fourth, Lyndhurst sports an exemplary tower. A characteristic of both churches and castles, towers spoke "medievalness," and therefore "feeling," more forcefully than any other feature of the building.

**MOSS COTTAGE, OAKLAND, CALIFORNIA.** Because of its presumed affinity with nature, the Gothic style was most popular in rural settings and in the new **horsecar suburbs** springing up around major cities. Like other revival styles (see below), it could be found throughout the country, including California, where Moss Cottage was erected in 1864 (**fig. 6.7**). Less than eight decades after the Spanish missionization of northern California and the conversion of the landscape to large-scale cattle ranching, and only fifteen years after the Gold Rush brought European immigrants and U. S. citizens flocking to the newly acquired territory, the banker Joseph Moss built his house on the edge of Oakland, near San Francisco. He hired the architect S. H. Williams (who, in turn, made use of design books) to realize his Gothic soul. Both the house and the thirty-page contract survive to clarify Moss's intent. Two features stand out. First, despite its "medieval" costuming, with steep gables trimmed with ornate **bargeboards**, the house is technologically avant-garde. Piped for hot and cold running water, it was equipped with flush toilets, a French tin-lined copper bathtub, and Italian marble countertops. It was lit by gaslight, generated by a gas plant on the property. Second, the contract specifies nine different kinds of wood, each selected with an eye to use, aesthetic effect, resistance to rot and insects, and smoothness (redwood, mahogany, cedar, eastern white pine, among other species). Such planning indicates the existence of a national market in lumber even before the completion of the transcontinental railroad in 1869. Moss Cottage thus represents a moment when northern European culture was self-consciously planting itself on the Pacific Rim, combining architectural forms from the eastern seaboard and Europe with the most recent technological advances. The house exhibits the sort of American know-how and ingenuity that was rapidly gaining an international reputation.

**GOTHIC REVIVAL FURNISHINGS.** Inside the home at mid-century, furnishings emphasized comfort (with the advent of innerspring upholstery) and alluded, in their design, to a variety of historical eras. Furniture began to be made and bought in "suites." Tables and chairs were left in the middle of the room in conversational ensembles (as they are today) rather than pushed against the wall, as in the eighteenth century, when not in use. Perhaps the most dramatic furniture from the mid-1800s, the dining-room sideboard evolved from the cabinet-and-serving surface we considered earlier in the neoclassical version of c. 1800 (see fig. 5.23) into a towering and expressive piece of sculpture. The sculptural program on the grandest of these sideboards combines a Renaissance Revival form with "Gothic" motifs and usages (**fig. 6.8**). Although derived from French precedent, this sideboard is Americanized by its crowning feature—a bald eagle atop a shield of the United States. With its aggressive posture, this eagle is explicitly in search of prey. A Native American bow across the shield recalls the hunting so central to Native and to medieval baronial life. An unquiet object, this magnificent sideboard evidences the capacity of power tools to simulate hand

6.7 S.H. WILLIAMS, *Moss Cottage* (built for Joseph Moss), Oakland, California, 1864.

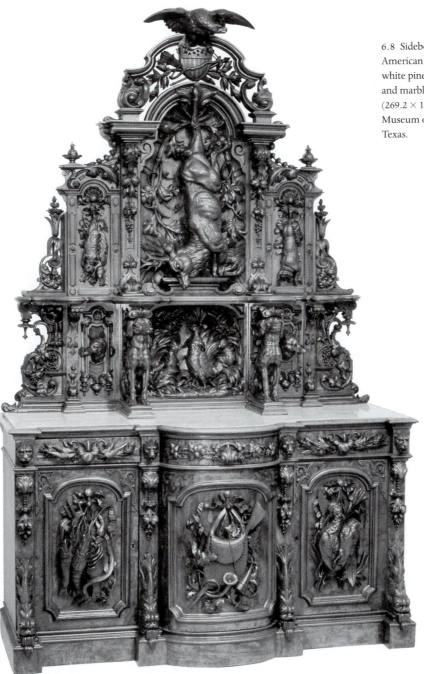

6.8 Sideboard, c. 1855.
American tulip wood, northeast
white pine, black walnut,
and marble, 106 × 69 × 28 in
(269.2 × 175 × 71.1 cm).
Museum of Fine Arts, Houston,
Texas.

carving in this period. At the center of the composition beneath the dramatic trophy stag, two caryatid hounds flank a pair of game birds, whose sheltering greenery forms a bull's-eye at the diners' eye level. Its vivid references to predators and hunting suggest a certain obsession with masculinity and an anxiety about gender roles among its industrial-era owners.

**THE AMERICAN WOMAN'S HOME.** One major source for the popularization of the Gothic style was a text about house management of the mid-nineteenth century, *The American Woman's Home*, by Catherine E. Beecher and her sister, Harriet Beecher Stowe, better known for her novel *Uncle Tom's Cabin*. The Beecher sisters explicitly identified the Gothic-style home with Christianity, with nature, and with women's responsibility to make the nurturing lessons of the home's architecture, furnishings, and natural setting explicit for children. Full of advice about **fern-pockets**, picture frames made out of twigs, and other natural materials brought indoors, the book also tackles women's responsibilities in ensuring healthy air in the home and establishing an efficiently run kitchen, so as to give themselves more time to nurture a love of nature and virtue in their young charges.

## Egyptian Revival

At the same time that Classical and Gothic Revival structures were redefining the way Americans thought about space, the idea of ancient Egypt also attracted followers. If Greek and Roman structures expressed an admiration for public virtue, then allusions to another ancient civilization, Egypt, signaled a darker concern with death and immortality. Egypt was linked in the popular imagination with mummified bodies and time-defying pyramids. Buildings constructed in a neo-Egyptian taste tended to be large and dramatic. When the city of New York needed to erect a new Hall of Justice and House of Detention (1835–8), John Haviland (1792–1852) designed it after an Egyptian temple. Popularly known as The Tombs, the structure reminded passersby of the fact of death, the prospect of eternity (or at least long sentences), and the "resurrection" awaiting penitent released felons.

**THE WASHINGTON MONUMENT.** The best known example of Egyptian Revival taste is the Washington Monument, in Washington, D.C., modeled on ancient obelisks found in Egypt (**fig. 6.9**). Such obelisks had been transported to Paris, with great difficulty, by Napoleon's armies, and marveled at by subsequent visitors to the French capital, where they enjoyed an international vogue. The Washington Monument, a 555½-foot white marble shaft, was conceived by Robert Mills (1781–1855), who would later create many other government buildings. Mills's original plan called for a huge Doric **peristyle**: 200 feet in diameter and 100 feet tall. Designed in 1833, the Monument took more than 50 years to build, including several interruptions, major design simplifications, and the elimination of Mills's grandiose base. As with other Egyptian Revival structures, the Washington Monument is a somber evocation of death and immortality.

**A SILVER SAUCEBOAT.** On a smaller scale, a silver sauceboat crafted by Anthony Rasch in Philadelphia (c. 1810) combines sphinx feet, a ram's-head spout, and an asp handle (**fig. 6.10**), an indication of how Egyptian taste extended to items of household use as well as to buildings. By turning Cleopatra's asp, whose bite brought about her death, into the handle of the sauceboat, Rasch has given the act of dining arresting immediacy. Structuring the sauceboat so that the diner grasps the asp to enjoy the sauce, Rasch is inducing a state of pleasurable discomfort that was an important dimension of antebellum aesthetics. Pain and terror, when experienced at a safe remove, can result in pleasure, or so Edmund Burke theorized and Rasch realized.

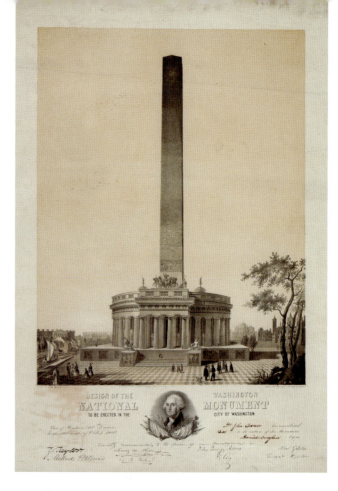

6.9 ROBERT MILLS & OTHERS, *Washington Monument, Washington, D.C,* 1848–88. Width of base 55 ft (16.7 m); height 555½ ft (169.3 m). Private Collection.

# Art of the People

When we speak of "sentimental culture," we are describing a society in which the values of the home—and the worlds of women and children within it—come to define public expectations and behavior. Both inside and outside the home, complex social webs link women and men to their families, to their communities, and to each other. Many forms of art and many kinds of objects were produced by people who did not necessarily think of themselves as artists but who cared deeply about the shape and look of things.

## Quilts and Women's Culture, 1800–60

In 1826, fourteen-year-old Sarah Johnson (1812–76), of eastern Pennsylvania, made her fourth quilt (**fig. 6.11**). Its central medallion was made of hundreds of bits of fabric composed into a complex design. Radiating out from this is a repeating geometric pattern of blocks of colored eight-pointed stars, alternating with plain white squares. The geometric shapes and colors appear to stand out against

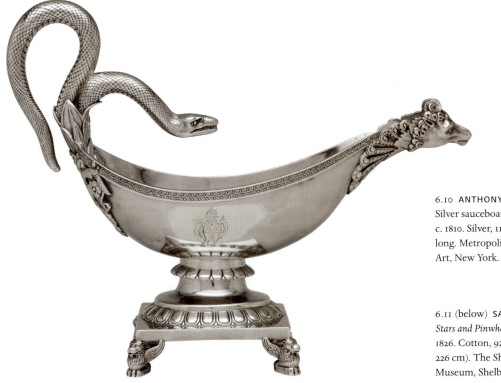

6.10 **ANTHONY RASCH & CO.**, Silver sauceboat, Philadelphia, c. 1810. Silver, 11⅞ in (30.2 cm) long. Metropolitan Museum of Art, New York.

6.11 (below) **SARAH JOHNSON**, *Stars and Pinwheel Medallion Quilt*, 1826. Cotton, 92 × 89 in (233.6 × 226 cm). The Shelburne Museum, Shelburne, Vermont.

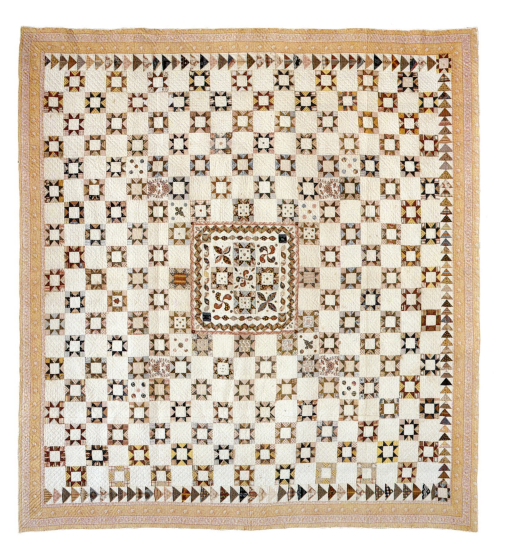

the white, which then functions as a background. Sarah Johnson has surrounded her quilt with a border of pieced triangles in a pattern known as "flying geese." The triangles, in turn, are bordered by bands of orange and pink, which enclose the whole design. This quilt demonstrates the way that nineteenth-century women transformed quilting into an endlessly fascinating—and often abstract—play of geometric shapes.

Johnson's quilt is composed of more than four thousand individual pieces of fabric. Some may have been scraps left over from dressmaking, though certainly the white, pink, and orange (as well as the fabric for the backing) would have been purchased specifically for this project.

It would not have been uncommon in the nineteenth century for a fourteen-year old girl to have completed as many as four quilts. Little girls mastered simple hand-sewing techniques by the age of four or five, and soon became proficient needlewomen, as numerous eighteenth- and nineteenth-century samplers demonstrate (see Chapter 5). In the colonial economy, such skills were a practical necessity, for all members, even the youngest, contributed to the household through hard work. By the 1820s, however, with a growing middle class, women's skills were directed more

to "fancy work," such as this quilt, than to the plain work of mending or sewing for necessity.

The patchwork quilt has served—throughout the twentieth century and today—as a metaphor for all that people value about the American character. As such, the quilt has accrued many myths regarding its history. Erroneously described as anonymous works made of scraps and leftovers, quilts seem to be symbols of a typically American ingenuity. They are associated with the triumph of artistic vision over adversity and celebrate women's thrift and industry—a collective sort of "making-do."

In fact, however, the large majority of American quilts were not made of scraps. They were deliberate artistic statements made from whole cloth, which was cut up and reassembled in a painstaking and purposeful way to produce elegant optical patterns. Most were not intended to be anonymous. In fact, many boldly incorporate the artist's name in the imagery. Few were collectively made or designed, though women may have helped each other with the finishing work after the quilt top had been pieced.

In many early-nineteenth-century homes (and persisting later in rural areas), quilts were among the most treasured objects owned by a family. We know how much women valued the work of their needles by the fact that quilts are prominently mentioned in nineteenth-century wills. Thousands of them have been preserved, sometimes unused and unwashed, from every decade from 1800 to the present—a demonstration of how they were prized as works of art.

The earliest American quilts seem to have been made of large pieces of whole cloth, then normally wool or linen, stitched together to form a "sandwich" (quilt top, inner layer, and backing). The surface of this wool or linen blanket would then be covered by a subtle layer of imagery laboriously formed by hand, using needle and thread to work patterns of vines, flowers, or geometric designs. In the late eighteenth and early nineteenth centuries, imported cloth was expensive, and except among the wealthiest people, was usually combined with local hand-spun cloth.

Early-nineteenth-century quilts look very much like their European counterparts, usually featuring some combination of **piecework** and **appliqué**. ("Piecework," also called "patchwork," is the sewing together of small pieces of cloth into geometric patterns, while "appliqué" is the stitching of one fabric shape or motif onto another.) Often such quilts incorporate pieces of British or (Asian) Indian chintz (a glazed cotton cloth printed with lush, multicolored floral patterns). Chintz was prized as a mark of wealth and status.

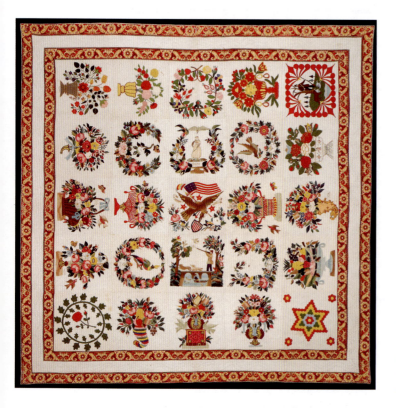

6.12 **MARY SIMON & OTHERS**, Baltimore Album quilt, 1847–50. Cotton, 104 × 103 in (264.1 × 261.6 cm). Museum of Fine Arts, Boston, Massachusetts.

The large-scale manufacture of printed fabrics began in New England and the Mid-Atlantic states during the first decades of the nineteenth century, advanced largely by immigrants who were expert in English roller-printing methods. By 1835, the mills of Lowell, Massachusetts, alone turned out more than 750,000 yards of cotton fabric per week—an output that would vastly increase after the Civil War. The growing profusion of printed cottons in American quilts is one measure of the advance of the Industrial Revolution in the United States.

**BALTIMORE ALBUM QUILTS.** In the middle of the nineteenth century, few professional avenues, other than sewing and teaching, were open to women who needed to support themselves and their families. While some women earned money piecing and quilting for others, there is evidence of at least one enterprising woman who parlayed her skills into a business, in which she prepared quilt blocks for other women to sew and to present as their own achievements.

Born in Bavaria in 1810, Mary Heidenroder Simon arrived in Baltimore in 1844, at the start of a new local fad in quilt making, which was characterized by remarkably ambitious appliqué patterns. The Baltimore Album quilt, as it came to be called, made use of the abundance of fine cottons available in that city (**fig. 6.12**). Baltimore was then the nation's largest seaport. Its prosperity was built on imported textiles, as well as the calico fabric milled there from cotton grown on southern plantations. As a mother at home with babies, Mary Simon bought fine fabrics, and cut and basted them onto white cotton in ambitious pictorial designs of her own devising, which she then sold as kits to more affluent women.

Many of Mary Simon's blocks were incorporated into quilts finished by others and exhibited as their own work. As a working-class immigrant, she did not socialize with prosperous ladies, who sewed at home as an avocation. But her ingenuity allowed their less innovative needlework skills to shine; their names were inked on each block when they gave the finished quilt to a friend on her wedding day. The quilt, then, became not only a pictorial album of lush garlands, flower baskets, and cornucopias, but an album of friendship, too—a large-scale, colorful version of the tiny autograph albums that were also popular in that era.

**FRIENDSHIP QUILTS.** During the antebellum period, many American women were joining hands to make more modest Friendship quilts. A group of women would make identical piecework blocks, often out of scrap fabrics, usually with a central block of plain white or cream-colored

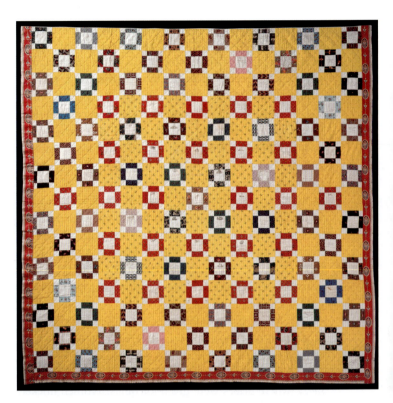

6.13 MARTHA KNOWLES & HENRIETTA THOMAS, *My Sweet Sister Emma*, 1843. Cotton, 107 × 109 in (272 × 277 cm). International Quilt Studies Center, University of Nebraska, Lincoln, Nebraska.

muslin. The use of scraps in nineteenth-century Friendship quilts probably gave rise to the erroneous assumption that all quilts were collective art works made of scraps. Mid-nineteenth-century advances in steel pen nibs and indelible writing inks (inks made without iron, which would disintegrate fabric) made it easier to write on cloth. Women inscribed their names, dates, and sentimental verses on the plain cloth in the center of the patchwork blocks, as in the nine-patch design illustrated here (**fig. 6.13**). Fine hand quilting is not a hallmark of Friendship quilts; they seldom have the exquisite stitchery seen on Baltimore Album quilts, for example. They were keepsakes of female friendship and, ironically, are sometimes the only place where a woman's name is preserved through the generations; in the mid-1800s, the government census listed only the name of the "head of the household," usually male.

Friendship quilts were often given as engagement presents or going-away presents. During the era when such quilts were most popular (1840–60), tens of thousands of women made the journey to a new life in the West. A huge exodus of people from towns and farms in New England, New York, Ohio, and Kentucky set out on the Oregon Trail, the main westward route. By 1860, some three-hundred thousand American "overlanders" had made the trek. When

embarking upon the westward journey, people rightly assumed that they might never see their loved ones again. Many were given Friendship quilts as an enduring sign of affection. Literally blanketed by her friends, a pioneer woman felt fortified for the perilous journey upon which she was embarking. Moreover, in the new communities formed on the trail, and in the West, women's arts were a means of bonding with other women. Quilt block patterns and fabrics could be exchanged, and pieced tops could be quilted together. The cheerful Friendship quilt illustrated in figure 6.13 was inscribed "From M. A. Knowles to her Sweet Sister Emma, 1843." Other friends and church members signed the quilt, too—one with the motto "A faithful friend is the medicine of life." Martha Ann Knowles (1814–98) made this quilt for her younger sister several years before Emma's marriage to a minister, perhaps as a gift for Emma's hope chest.

While few, if any, quilts hung on museum walls in the nineteenth century, many were offered for public viewing at fund-raising events in the 1830s–1860s and especially at the numerous county and state fairs (and later world's fairs), where prizes were given for quilts. Women flocked to these public events, just as painters and sculptors looked to exhibitions held at academies, salons, and museums. Many more people visited quilt exhibitions at county and state fairs in the nineteenth century than visited museums—hundreds of thousands would attend a large fair such as the Ohio State Fair. Quilt making was a democratic art, which crossed boundaries of class and ethnicity.

**RAISING FUNDS AND SOCIAL AWARENESS.** Nineteenth-century American women made quilts to raise money and to enlighten their peers on behalf of the social causes they supported. In many cities, they formed "ladies' benevolent sewing societies" to make quilts and other goods needed by missionaries. Some of these groups ardently supported social reform: some were antislavery, while the others set the stage for the temperance and the women's suffrage movements.

Quilts and other handmade goods were displayed and sold at antislavery fairs, held in Boston starting in 1834 and in other cities thereafter. Women raised thousands of dollars for the antislavery cause. Small cases for sewing needles were emblazoned with abolitionist Sarah Grimke's famous cry, "May the point of our needles prick the slave owner's conscience."[2]

During the Civil War, northern women organized U. S. Sanitary Commission fairs (an early version of today's Red Cross). Halls lavishly festooned with quilts and American flags were opened to the public. By selling their needle-work and other goods, women raised money and sent medical supplies (including handmade bandages, and quilts to cover the soldiers' infirmary beds) to the battlefields. Northern women raised more than $4,500,000 through such fairs. At one fair in Iowa in 1864, women raised $50,000 through the sale of their quilts in just eight days. Abraham Lincoln himself praised the industry of American women:

> Nothing has been more remarkable than these fairs, for the relief of suffering soldiers and their families. And the chief agents in these fairs are the women of America... I have never studied the art of paying compliments to women; but I must say that if all that has been said by orators and poets since the creation of the world in praise of women were applied to the women of America, it would not do them justice for their conduct during this war.[3]

The same principle expressed in Friendship quilts was often used in fund-raising quilts. Women would solicit donations of 5 cents or 10 cents to inscribe the name of the subscriber on a strip of cloth to be incorporated into a quilt. The quilt would then be sold, and both subscription money and sale price donated to the cause.

## Folk and Vernacular Traditions

For almost a century, scholars and collectors have sought to define folk art. The more everyone tries, the more slippery the notion becomes. In 1950, after more than three decades of intensive collecting of folk art, experts confidently listed the following as among the range of adjectives to describe folk art: *unselfconscious, naive, unsophisticated, provincial, rural, dynamic, romantic, isolated, untroubled by lack of skill.* One scholar proclaimed, "Folk art is child art on an adult level," while another observed that it was made by "simple people who live in a static society." Today we sense that these definitions tend to reveal more about society's preconceptions and blind spots than they do about the art or artists under examination.

Historically, folk art has been seen as a product of regional or ethnic traditions. Examples include Shaker furniture, Pennsylvania German (or "Dutch," a corruption of "Deutsch," or German) *fraktur*, or New Mexican *santero* carving. Sometimes folk artists work in rural communities, far from the urban centers where artistic standards are dictated. Sometimes folk art parallels academic art; in other instances it diverges from academic trends.

Many scholars now prefer the term *vernacular traditions*, a term that means "local" or "everyday" traditions.

"Vernacular" refers not only to the handmade but also to popular, mass-produced items such as commercial posters and billboards. Some prefer the term *self-taught*, but that is not accurate in relation to many folk traditions, in which standards and skills are carefully transmitted within families and communities, or through apprenticeship.

**RURAL PAINTERS.** Itinerant artists traveled from farm to farm throughout rural America, bringing with them the commercial revolution that had already transformed life in the nation's towns and cities. Attuned to the hunger of those around them for fashionable consumer items, they responded to what the scholar David Jaffe has termed the "commercialization" of the countryside by pioneering low-cost, high-volume portraiture. These "artisan-entrepreneurs" often began as painters of signs, carriages, sleighs, or houses and turned to portrait painting as the demand for the amenities of middle-class life expanded. They provided black and white silhouettes for those without much money; they added color for an extra fee; and, at the high end, they offered painted portraits distinguished by bold lines, bright colors, and decorative surfaces. With a far-flung clientele, country painters could standardize their portraits while still satisfying their customers. They made use of stencils and stylized forms—modes of painting that speeded the process along—while simultaneously individualizing their portraits by adding their sitters' distinctive possessions. They thus allowed their country sitters to show off their wealth and social status while minimizing the time required to complete each painting.

Rufus Porter (1792–1884), for example, began his career as a house and sign painter in Portland, Maine. He soon took to the road, using a camera obscura—a box with a lens and mirror—to cast the sitter's image onto a sheet of paper, trace the image, and then sell the "correct likeness" for 20 cents. He could produce as many as 20 profiles an evening (**fig. 6.14**). Itinerant artists such as Porter helped satisfy the demand for consumer goods—and especially for objects of "culture"—that swept rural America into the accelerating commercial revolution during the early and middle decades of the nineteenth century.

One of the most prolific—and distinctive—of these vernacular painters was Ammi Phillips (1788–1865), whose fifty-year career in New York and New England resulted in an extraordinary legacy of images of the rural middle class. Like other country painters, Phillips developed a set of conventions, props, and styles, which he could vary from sitter to sitter while still producing a recognizable likeness of each subject. Phillips's portrait of *Jane Ann Campbell* (c. 1820) includes red drapery at the edge of the

6.14 **RUFUS PORTER**, Handbill (Advertisement for profile portraits), c. 1818–20. American Antiquarian Society, Worcester, Massachusetts.

painting, which appears again and again in works of his early career (**fig. 6.15**). The three-quarters profile allowed him to paint only one ear, a trick repeated in the doll on Jane Campbell's lap. Although Jane Campbell was only three years old at the time Phillips painted her image, she appears, like her doll, to have the timeless features vernacular painters used to signify early childhood in general. Phillips has lavished attention on Jane's accessories: her patterned dress, embroidered hem and cuffs, lace ruff, and pearl necklace. The busy patterns of the carpet and footstool, by contrast, are painted broadly and lack the detailed attention that distinguishes Jane's clothing.

An irony of portraits such as *Jane Ann Campbell* is that they have been idealized as "folk art," naive reminders of a simpler, preindustrial world. In fact, they are one of the earliest forms of mass-produced imagery that we possess. Their stylization is a result of the painter's need to maximize productivity; their portrayal of objects and goods

6.15 AMMI PHILLIPS, *Jane Ann Campbell*, c. 1820. Oil on canvas, 33½ × 26 in (85 × 66 cm). Private Collection.

ically transferred the outline of the head onto an adjacent sheet of folded paper. Using scissors or a blade, the artist would then carefully cut along the outline; because the paper had been twice folded, this process automatically yielded four copies of the silhouette. Introduced to America around the turn of the nineteenth century, the physiogno-trace was a popular concession at Charles Willson Peale's Museum in Philadelphia (see Chapter 5), where Moses Williams, a former slave of the Peale family, made his living operating the machine and cutting the portraits. During the early years of the nineteenth century, Williams made as many as eight thousand portraits a year in the museum at a cost of 8 cents per sitter. The physiognotrace image of Williams shown here (**fig. 6.16**) may be a self-portrait.

While the production of silhouettes was, compared to oil portraiture, relatively simple, the cultural meanings of the resulting images were complex. Like the photographs that would eventually supersede them, silhouettes featured patterns of light and shade automatically produced by the sitter. They were thus seen as an unimpeachably direct and accurate form of representation. As the art historian Wendy Bellion has shown, this mantle of "true representation" gave silhouettes a special meaning in the early republic, when American society was consumed by broad-ranging debates about appearance and deception in politics and daily life.

Silhouettes were also associated with classical virtues. The profile format not only recalled images on ancient coins and medals but also figured in a well-known ancient

is a result of their sitters' desire to affirm their "arrival" as members of the middle class; and their "naiveté" is calculated, a result of economic efficiency.

**SILHOUETTES.** Silhouettes were the most common portraits in the first half of the nineteenth century. Popular in both urban and rural America, these intimate, delicate shadow portraits preserved the outlines of the sitter's profile in ink or cut paper. There were various techniques for producing them; some artists made freehand tracings of the shadows cast by subjects sitting in front of candles or lamps, while others, such as Rufus Porter, adapted optical devices such as the camera obscura.

The physiognotrace was invented specifically for the mechanical production of silhouettes. Using this device, the artist skimmed a dowel along the contours of the sitter's head. The dowel was connected to a stylus, which automat-

6.16 MOSES WILLIAMS or RAPHAELLE PEALE (attrib.), "Moses Williams, cutter of profiles," c. 1803. White laid paper on black stock, 4 × 5 in. Library Company of Philadelphia, Pennsylvania.

account of the origin of visual representation. In Pliny the Elder's *Natural History* (77 C.E.) a Corinthian maiden, whose lover is about to depart for war, traces the outline of his profile on the wall and thereby invents the art of painting. Pliny's tale added further nuance to the cultural meaning of the silhouette; along with its suggestions of the true and direct presence of the sitter, the silhouette thus also carried sentimental connotations of separation and mourning. This rich dual significance is echoed in the structure of all silhouettes. The detailed outline preserves the unique physical presence of the sitter, but the dark, blank shape simultaneously suggests absence and loss.

**"JUST FOR PRETTY."** Throughout the history of the United States, people who do not necessarily consider themselves artists have created a huge number of unique objects of great wit, aesthetic pleasure, and eloquence. The German-speaking people who settled Pennsylvania and other mid-Atlantic states in the nineteenth century have a special phrase for such art: *Yuscht fer schnee* (just for pretty). They mean by this phrase art that gives pleasure to its viewers purely through its decorative effect.

Mary Ann Willson, for example, who lived on the western frontier of New York State in the early decades of the nineteenth century, produced numerous watercolors distinguished by their love for decorative play. Willson's "Marimaid" (mermaid) is a wonderfully cheerful figure, with her bulging lower body of bright, overlapping scales,

each one elaborated with dots, dashes, circles, or hatch marks (**fig. 6.17**). Willson created religious scenes, portraits, birds, and flowers, adapting images she found in prints to her own vision. A nineteenth-century tourist book of the region notes that Willson sold her work "from Canada to Mobile." Her career suggests how folk art operates within a larger market culture. Even without academic training, numerous folk artists managed, through enterprise, to earn a living from their art.

**FRAKTUR.** Sometimes the decorative qualities of vernacular art go hand in hand with a more practical purpose, like keeping family records. Many Germans who immigrated to Pennsylvania practiced a calligraphy called *fraktur schriften*, a phrase for the stylized or "fractured" writing on medieval religious manuscripts. *Fraktur* was created by specialists and amateurs, both male and female. In the late eighteenth and the nineteenth century, many birth certificates and baptismal records (as well as prayers, Bible verses, and moral sayings) were inscribed in this decorative format, often accompanied by painted scenes of hearts, flowers, birds, and people. These works of art could serve as legal documents submitted to prove age and citizenship, but mostly they were made in loving celebration of important family events. Around 1810, Friedrich Bandel made a family record (**fig. 6.18**). Within the heart on the left is recorded in German the birth of George Manger to Henrich and Elizabeth Manger on June 6, 1809. Above are representations

6.17 Mary Ann Willson, *Marimaid*, 1810–25. Ink and watercolor on paper, 13 × 15½ in (33 × 39.3 cm). Fenimore Art Museum, Cooperstown, New York.

6.18 Friedrich Bandel, Birth and baptismal certificate for George Manger, c. 1810. Watercolor and ink on paper, 11⅞ × 15⅛ in (30.2 × 38.3 cm). Abbey Aldrich Rockefeller Folk Art Museum, Colonial Williamsburg Foundation, Williamsburg, Virginia.

of Adam and Eve in the Garden of Eden. In small blocks between the hearts are recorded the words "love," "faith," "hope," "humility," "patience," among other virtues. Later in the nineteenth century, professionally printed death certificates replaced the hand-drawn *fraktur* for recording family history.

## NATIVE IMAGERY IN VERNACULAR ART.

Images of Indians were common in the vernacular art of the nineteenth century. Dennis Cusick (1799–c. 1822) created watercolors that combined his love for detail and surface play with a vision of Native American identity. Cusick, a Tuscarora Indian (one of the member tribes of the Iroquois Confederacy), was active in the Congregationalist Mission School on the Seneca Reservation, near Buffalo, New York (**fig. 6.19**). Although Native, his family was Christian and acculturated, and his father had served as a lieutenant in the American army during the Revolutionary War.

In *Keep the Sabbath*, Cusick depicts more than five dozen students and the details of their classroom on a surface smaller than 5 inches by 8 inches The students stand in prayer, led by their teacher. By depicting them in the Native dress of the period, Cusick is intent on showing that despite religious conversion, they have not forsaken Iroquois identity. The boys wear the *gustoweh*, elaborate traditional plumed headgear. The artist depicts books on the shelves, writing charts on the walls, slates (for practicing letters) on the table, and the open Bible on the teacher's desk. James Young, the teacher pictured here, noted that Cusick was self-taught, probably from copying prints and engravings. In one of his works (painted on a box in which white Americans deposited contributions to the mission school)

he expressed his vision of Native acculturation: "My friend, You see I am not white like you; I am Red—but my heart is in the same place with your heart; my blood is the same colour as your blood; my limbs are like your limbs. I am an AMERICAN."[4]

Perhaps the most familiar image of Native Americans in the nineteenth century stemmed from the cigar-store Indian, a figure that often stood as a large three-dimensional advertisement outside of tobacconist shops. Indians were linked in the popular imagination to tobacco, a distinctly New World crop. Both male and female Indian figures served as cigar-store advertisements, often with rolls of cigars in their hands or sheaves of tobacco as part of their adornment.

*Chief Black Hawk* (**fig. 6.20**) is a regal figure, standing nearly 7 feet tall. The art historian Ralph Sessions has observed that this is not, in fact, a portrait of the famous Sauk chief named Black Hawk (1767–1838), who lived in the Great Lakes region and led his people in the so-called Black Hawk War of 1832. Instead, *Black Hawk* (c. 1848–55) is an idealized portrait of a stoic Indian. Merging neoclassical and Native stereotypes, his pose and toga-like costume recall ancient statues of Roman senators, while his animal pelt and scalp lock place him as a Native American of colonial times. Together these attributes form a third stereotype—that of the "Noble Savage" (see Chapter 2). Black Hawk stood in front of a cigar store in Louisville, Kentucky, during the second half of the nineteenth century.

"Saint Tammany" (**fig. 6.21**) is a semi-mythic figure deriving from a renowned Delaware chief named Tamanend, who, with William Penn, forged many treaties

6.19 DENNIS CUSICK (TUSCARORA), *Keep the Sabbath*, 1821. Watercolor on paper, 4⅜ × 7⅞ in (11.1 × 20 cm). Private Collection.

6.20 UNKNOWN ARTIST, *Chief Black Hawk*, c. 1850. Painted wood, 80½ × 26½ × 19 in (204.4 × 67.3 × 48.2 cm). Heritage Plantation of Sandwich, Massachusetts.

Indians. In Pennsylvania, the Saint Tammany Society was an anti-British organization dating from before the American Revolution. After the Revolution, Saint Tammany became the patron of men's patriotic fraternal societies, especially in Pennsylvania and New York. The Saint Tammany weathervane illustrated here stood atop the headquarters of one such club.

As the historian Philip Deloria has demonstrated, Tammany allowed for the creation of a new identity for American patriots—one that drew from both aboriginal and European traditions. Just as art changes radically over time, so do symbols. In American history, Tammany is best remembered as the name of a powerful and corrupt political organization that ruled New York City politics through much of the nineteenth century. Yet the political machine never totally lost its connection with Indian symbolism, however tenuous: its headquarters, an imposing building, was known as the Tammany Hall "Wigwam."

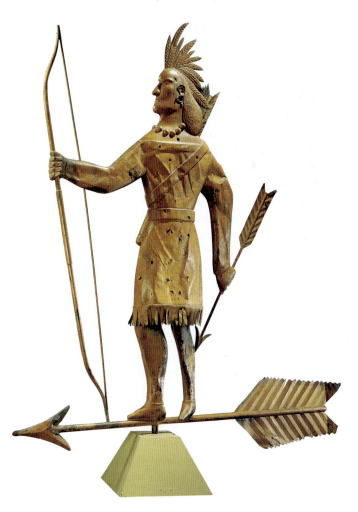

of the 1680s and 1690s. These treaties insured more than seventy years of peace between the relatively un-warlike Delaware and the pacifist Quakers and Mennonites who were populating eastern Pennsylvania. The legendary stature of this chief led people to begin to call him "King Tammany"; by the end of the eighteenth century he had become "Saint Tammany," a figure invoked in public spectacle, such as May Day celebrations, which often involve creative mischief by Anglo-American men garbed as

6.21 UNKNOWN ARTIST, Saint Tammany Weathervane, New York, mid-19th century. Copper, paint, 102½ × 103 × 12 in (260.3 × 261.8 × 30.4 cm). Museum of American Folk Art, New York.

## Shaker Art and Innovation

The Shakers were among the most innovative religious groups to flourish in the United States. Though never numerous—they had no more than six thousand adherents at their high point in the first half of the nineteenth century—their legacy in American design and technology endures. They called themselves "the United Society of Believers in Christ's Second Appearing," but were more popularly known as the Shakers (from "Shaking Quakers") because of their ecstatic dancing as a form of prayer. The founder of the sect, Ann Lee, came to America from England in 1774. Within several decades there were Shaker communities in a huge area spreading from New England to Kentucky. Shakers didn't believe in slavery, private property, or male dominance. They were celibate, increasing their numbers by conversion and by taking in orphans. Mother Ann Lee exhorted early believers to "put their hands to work and hearts to God." Out of this simple dictum came some of the finest and best-loved innovations in household design and technology of the nineteenth century.

Shakers earned money by selling their produce, furniture, and implements to outsiders. A Shaker product was known for its good quality—from the seeds they sold in packets (they were the first to do so) and the medicinal herbs and remedies they marketed, to the boxes and chairs they sold in quantity.

Unlike the Amish and other religious sects who spurn modern advances in technology, nineteenth-century Shakers welcomed technological advancement. For example, around 1800, Theodore Bates, a Shaker from Watervliet, New York, developed the flat broom of the type still used today—a significant improvement on the unwieldy round brooms then generally used. Ten years later, Tabitha Babbitt, a Shaker from Massachusetts, invented an early version of the circular saw. Shakers have also been credited with the clothespin, and with many refinements in farm tools, woodworking tools, baking ovens, and washing machines, but their innovations are hard to document because most Shakers did not believe in the concept of patents.

Shaker design was motivated by utility, not aesthetic consideration. Usefulness was paramount—both in one's life and in the fruits of one's labors; "superfluities" must be avoided. Shaker laws, set down in 1821, dictated, "Fancy articles of any kind, or articles which are superfluously finished, trimmed, or ornamented, are not suitable for Believers, and may not be used or purchased." Indeed, one nineteenth-century elder proclaimed, "The beautiful is absurd and abnormal. It has no business with us."

**SHAKER BOX.** The Shaker oval box is a good example of their ethic (**fig. 6.22**). The sides, or walls, of the boxes and their lids are sheets of maple split from a plank. These strips (some as thin as ½ inch) bend easily when soaked or steamed. They are wrapped around an oval mold and fastened shut with copper tacks through their **swallowtail joints**. Durable pine boards are used for the flat tops and bases.

Shakers did not invent this box form; but as with everything they made, they pared it down to the simplest shape and the finest craftsmanship. An industrious Shaker woodworker might make three or four dozen of his box walls in a day, in a system of mass production in which many walls were made at once, and then many lids. Shaker boxes were often sold in multiples of graduated sizes. They held dry foodstuffs, sewing implements, and other personal effects, and were marketed to non-Shakers as well as to each other. Although some people imagine Shakers as historical and unchanging "folk artists," in fact, their works were part of the "consumer revolution."

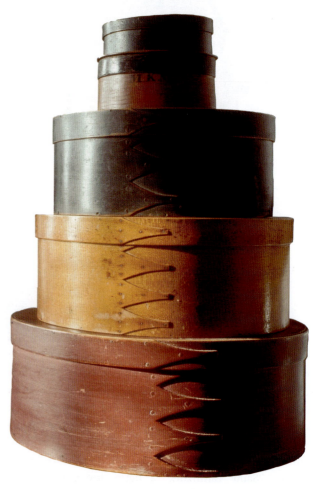

6.22 Shaker oval boxes, mid-19th century. Maple, pine, and copper tacks.

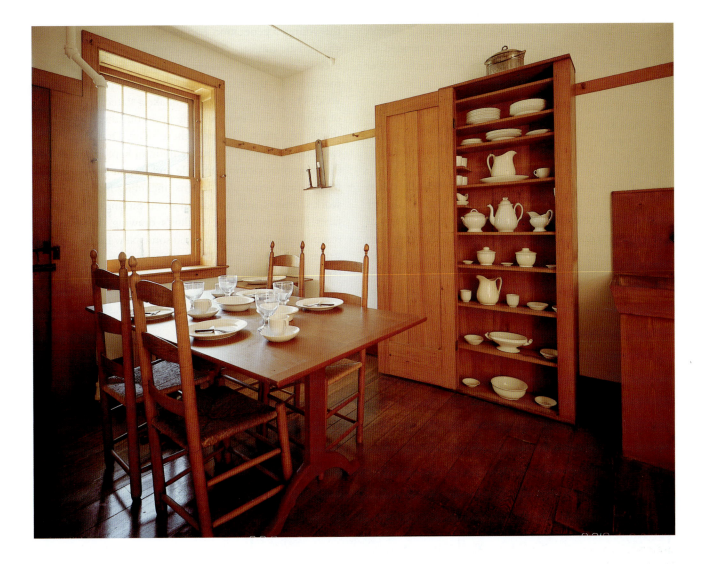

6.23 Ministry dining room (reconstructed), Hancock Shaker Village, Hancock, Massachusetts.

**SHAKER FURNITURE.** Shaker chairs, in production since about 1790, take the idea of the eighteenth-century New England ladder-back chair and refine it (**fig. 6.23**). The Shaker chair is more slender and lightweight than a traditional ladder-back chair. It lacks ornamentation on the lathe-turned posts, except for a simple, graceful finial at the top. Often the legs are tilted, so that the chair angles slightly backward, rather than being stiffly—and uncomfortably—upright. Some chairs incorporate wooden ball bearings on the bottom of the back legs, allowing the sitter to lean back without toppling over. Variants include armchairs, rocking chairs, and even wheelchairs. The seats were woven from cloth tape or natural cane. While today most Shaker reproductions (and most Shaker furniture in museum collections) are left the natural color of the wood, in the early nineteenth century Shakers often used yellow, red, or green pigments to paint their furniture (in a manner similar to the oval boxes). As with the manufacture of boxes, the Shaker chair industry was a robust business in the mid-nineteenth century.

**SHAKER SPIRITUAL VISIONS.** The Shakers also produced eloquent ink and watercolor drawings that recorded their spiritual visions. People who received heavenly visions were called "instruments," for they were seen as literally the tool by which a heavenly vision was transmitted to the community. Such human "instruments" often made drawings as gifts to other members of the community. Their visions were thought to be transmitted directly from Mother Ann Lee, their founder, who had died in 1784.

In *An Emblem of the Heavenly Sphere*, Polly Collins (1801–84), who lived in the Shaker community in Hancock, Massachusetts, depicted her vision of the layout of heaven

**(fig. 6.24).** Rows of saints and prophets (including Mother Ann Lee) fill the center of the drawing, surrounded by the flowering trees of paradise. The verse at the upper left begins:

> Here is an emblem of the world above
> Where saints in order, are combined in love;
> Where thousands, and ten thousand souls as one
> Can join the choir and sing around the Throne.

Many Shaker drawings were inscribed as if Mother Ann Lee herself had drawn them—evidence that Shaker graphic artists considered themselves mere transmitters of a divine message, a gift from heaven. These drawings were made principally by young women during the 1840s and 1850s, a time of religious crisis in Shaker communities. Mother Ann Lee had been dead for some sixty years, and the younger generation had no direct experience of her charismatic ministry. The drawings were meant to affirm a close connection between Mother Ann and the living members of the community, and to keep her memory vivid. The religious laws of the Shakers stated, "No pictures or paintings shall ever be hung up in our dwelling rooms, shops, or Office." Instead, these "Gift Drawings" were examined on the lap, or on the floor, or kept in a cupboard for occasional viewing. In style and format such drawings recall other vernacular designs, including *fraktur*, needlework samplers, and wood and stone carvings. The frontal faces lined up in Polly Collins's drawing, for example, resemble the portraits carved on some New England gravestones (see Chapter 3). The artist may have come from a family of Vermont stone carvers, whose work influenced her own.

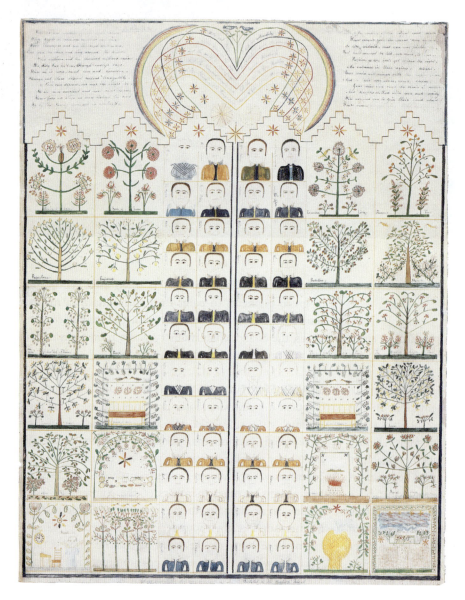

6.24 POLLY COLLINS, *An Emblem of the Heavenly Sphere*, 1854. Ink and watercolor on paper, 23¾ × 18⅝ in (60.3 × 47.2 cm). Andrews Collection, Hancock Shaker Village, Hancock, Massachusetts.

# The Cultural Work of Genre Painting

"Genre painting," a catchall term for anecdotal, often humorous or didactic scenes from everyday life, flourished in antebellum America. These paintings portrayed various character "types"—easterners, westerners, city dwellers, country folk, rich people, poor people, dandies, beggars, merchants, housewives, children, servants, and slaves—with varying degrees of admiration, sympathy, respect, and, on occasion, disrespect and disdain, reflecting the attitudes of the middle class for whom they were intended. The middle class, however, was not a single, cohesive entity, but was made up of multiple factions with competing interests. Genre paintings, too, reflect the diversity of their audience. Beyond their anecdotal humor, genre paintings sometimes rendered an idealized version of the United States as a nation without conflicts, class divisions, or industrial disruptions. Although genre painting appears to reproduce everyday life, in fact, it only renders a version of it shaped according to certain social, political, or class imperatives. Genre painting, in other words, employs a realistic style to create a fantasy of public and private life.

## Culture vs. Commerce: Allston, Morse, Mount

In the first decades of the nineteenth century, as regional economies expanded and business multiplied the ranks of the wealthy, some observers worried that the ideals of the republic were being trampled on by the stampede to make money. These commentators looked askance at the world of business, which they considered crude and vulgar, an enemy to culture, refinement, and virtue.

**THE POOR AUTHOR AND THE RICH BOOKSELLER.** Such is the viewpoint illustrated by one of America's earliest genre scenes, *The Poor Author and the Rich Bookseller* (**fig. 6.25**), produced in 1811 by the history painter and landscape artist Washington Allston (see Chapter 5). In this picture Allston shows his disdain for commercial enterprise by way of a thin, gangly writer, his pocket stuffed with a manuscript, standing awkwardly on one foot in front of a portly merchant, who sits enthroned while his office boy sweeps away the rubbish—and, in effect, the hapless writer, too. Poking fun at the world of commerce, the picture draws a sharp distinction between the underfed author and the overfed publisher.

6.25 WASHINGTON ALLSTON, *The Poor Author and the Rich Bookseller*, 1811. Oil on canvas, 31½ × 28¼ in (80.01 × 71.7 cm). Museum of Fine Arts, Boston, Massachusetts. Bequest of Charles Sprague Sargent, 1927.

**THE GALLERY OF THE LOUVRE.** Allston's pupil Samuel Morse, painter of *The House of Representatives* (see fig. 5.20), seconded his teacher's disdain for the preoccupation with material success. After a trip abroad in 1829, Morse painted a genre scene that served as both a lecture on European art history and a manifesto of American cultural independence. Called *The Gallery of the Louvre* (1833) (**fig. 6.26**), it provides a view of the Paris art museum's Salon Carrée, with some thirty-seven Old Master paintings hung on its walls. Seventeenth- and eighteenth-century paintings had similarly portrayed vast collections of art treasures, but in those works, the spectators who stroll amid the galleries are kings, dukes, bishops, popes, or, at the very least, wealthy merchants. Here, smartly dressed ordinary men and women mingle among the masterpieces. At home in this great repository, they are duly respectful, but not cowed; the former palace is now their domain. As with Allston's *Poor Author and Rich Bookseller*, but more didactically and less comically, *The Gallery of the Louvre* takes the production and distribution of culture as its subject. Its attitude toward Europe is: learn from it, admire it, but do not be in awe of it.

6.26 SAMUEL FINLEY BREESE MORSE, *The Gallery of the Louvre*, 1833. Oil on canvas, 78¾ × 108 in (20 × 274.3 cm). Terra Foundation for the Arts, Chicago, Illinois. Daniel J. Terra Collection, 1992.

Morse helped found the National Academy of Design, devoted to the advancement of the fine arts through education and exhibition, and he served as its first president from 1826 to 1845. An inventor as well as a painter, he also developed the electromagnetic telegraph and devised its international language, Morse code. Dismayed that the United States was becoming increasingly crude and vulgar, he urged reversing this trend by education and by restricting immigration. As a leading member of the Native American Party, an anti-immigrant organization dubbed the Know-Nothings, he blamed many of the nation's problems on unchecked immigration from Europe, especially Catholics from Ireland and Germany. It was one thing to revere masterpieces of European art, but Europeans themselves were another matter.

**THE PAINTER'S TRIUMPH: A REPLY TO MORSE.** Morse's veneration of Old World culture and fear of rampant commercialism struck some younger artists as misguided. One of these was William Sidney Mount (1807–68), whose genre scene *The Painter's Triumph* (**fig. 6.27**) scoffs at the high-mindedness of *The Gallery of the Louvre*. Mount received some training at the National Academy of Design under the leadership of Morse; but finding the academy's principles dry and stuffy, he set out on his own and soon achieved commercial success as a portrayer of daily life on rural Long Island. City dwellers nostalgic for their own country roots were drawn to his quaint and amusing depictions of festive barn dances, boys trapping rabbits, farm workers relaxing in the noonday sun, and rustic gentlemen gathering to make country music.

In *The Painter's Triumph* (1838), a cocky young artist points delightedly toward a canvas set on an easel in his studio. We cannot see what he has painted, because the canvas is turned away from us, but his visitor, identified as a farmer by his kerchief, hat, and whip, crouches to

get a good look and appears to be amused. Perhaps the painting-within-a-painting contains the farmer's portrait—Mount was a prolific portrait painter of his neighbors on then-rural Long Island—or maybe it shows a humorous genre scene, of the type Mount was already renowned for painting.

The painter's studio, with its unadorned walls and broad plank flooring, forms a striking contrast to the over-sized, crammed grandeur of Morse's *Gallery of the Louvre*. The long hallway in the earlier painting, receding steeply into space, suggests centuries of European history leading up to the present, whereas *The Painter's Triumph* is, in effect, free of the past. Mount's painter has turned his back on imported culture, as embodied by the classical Apollo pinned to the wall. Instead, he draws from the life around him. Hence the approving grin of his visitor.

In *The Gallery of the Louvre*, a young teacher (Morse in a self-portrait) leans instructively over the shoulder of a student, who draws not from life but from art, not from the New World but from the Old. Defying subservience, the artist in *The Painter's Triumph* (Mount in a self-portrait) strikes a victorious pose, like that of a fencer who cries, "*Touché*" at a well-executed point. He embodies the attitude expressed in the previous year, 1837, by the New England sage Ralph Waldo Emerson, who declared in his celebrated "American Scholar" address, "Our day of dependence, our long apprenticeship to the learning of other lands, draws to a close. I ask not for the great, the remote, the romantic;

6.27 WILLIAM SIDNEY MOUNT, *The Painter's Triumph*, 1838. Oil on wood, 19½ × 23⁵⁄₁₆ in (49.5 × 60.1 cm). Pennsylvania Academy of the Fine Arts, Philadelphia, Pennsylvania.

what is doing in Italy or Arabia; what is Greek art, or Provencal minstrelsy; I embrace the common, I explore and sit at the feet of the low. Give me insight into to-day, and you may have the antique and future worlds."[5]

Despite such declarations of cultural independence, neither Emerson nor Mount wished to abandon Old World culture. Mount repeatedly drew on classical prototypes for his inspiration, and one might see *The Painter's Triumph* less as a turning away from European tradition than as an expression of how the American artist mediates between high and popular cultures (the Apollo on the wall and the rustic before the easel) and between the past and the future (the Apollo and the unseen canvas). Whichever way the painting is interpreted, Mount seems more relaxed than Allston and Morse and considerably more good-natured about the business end of creativity.

## Woodville: the Pleasures and Perils of the Public Sphere

During the 1830s, Mount was the leading genre painter in America. His anecdotal scenes of country life enjoyed the patronage of wealthy collectors and the general public alike. Newspaper and magazine reviewers lavished praise on him for his talent and observant wit. The art historian Elizabeth Johns has argued that Mount's contemporaries also understood his works to be visual puns that alluded to the politics of the day. Thus two bartering men in *Bargaining for a Horse* (1835) played on the expression "horse trading," slang for political wheeling and dealing. A scene of farmers making cider alludes to a notorious campaign in which politicians doled out hard cider to prospective voters on Election Day to elicit their support.

**WAR NEWS FROM MEXICO.** Equally political was Mount's younger contemporary Richard Caton Woodville (1825–56). Exhibited at the American Art-Union in 1849 and distributed nationwide in an 1851 engraving, *War News from Mexico* (**fig. 6.28**) attracted notice because of its lively depiction of the home front at a time of national crisis. It portrays a sampling of the electorate gobbling up the latest news from a daily paper, which dominates the composition and serves as its focal point.

Radiating outward from the newspaper are eleven figures and the bottom half of an eagle, all gathered under or beside the portico of a combined tavern, inn, and post office identified, with heavy-handed significance, as the "American Hotel" (hence the eagle). With wide eyes, gaping mouth, and exaggerated body language, the man at center stage reads aloud from the newspaper clutched in his fists.

It reports on the latest happenings in the Mexican War (1846–8), which cost the lives of thousands of soldiers on both sides and resulted in the addition to the United States of 500,000 square miles of conquered territory in the West. The supporting players mug and gesticulate their reactions: one figure, in the shadowy background, throws up his hand; another grasps the frame of his eyeglasses; a third raps his knuckles against one of the portico's pilasters; a fourth, who relays the news to an old gentleman with hearing difficulties, points a thumb emphatically toward the newspaper.

Despite the obviousness of these gestures, it's not altogether evident whether the news is good or bad for the denizens of the American Hotel. Clearly, though, they're all personally involved in what they are hearing, and that includes the humble black man and his little girl in rags; the outcome of the war had a direct bearing on how far west Congress would permit slavery to extend. Those opposed to slavery also opposed the war. The black family is situated at the periphery: they are not part of the

6.28 RICHARD CATON WOODVILLE, *War News from Mexico*, 1848. Oil on canvas, 27 × 24¼ in (68.5 × 61.5 cm). Manoogian Collection, Grand Rapids, Michigan, on loan to the National Gallery of Art, Washington, D.C.

consensus, and although they have a personal stake in the war, they have no democratic say in it. A white woman, squeezed to the side of the canvas and visible in the window, is similarly characterized as marginal to the sphere of public discourse, which Woodville shows to be populated exclusively by adult white men. Yet she, unlike the two African Americans, occupies a place securely within, rather than outside, the national hotel.

In Woodville's day, the elderly gentleman in old-fashioned knee breeches would have been understood as a member of the Revolutionary-era generation. His presence in the scene lends legitimacy to the current military conflict, suggesting that the war that started in 1846 embodied the ideals behind the war declared in 1776. But to the extent that the old man wears a grim or confused expression, the painting implies that '46 is not indisputably the moral successor to '76, and that the values of the present do not necessarily accord with those of the past.

**POLITICS IN AN OYSTER HOUSE.** In *Politics in an Oyster House* (1848) (**fig. 6.29**), two men from different genera-tions sit across from each other in a tavern of the sort reserved for men during the antebellum period to consume shellfish, alcohol, and news of the day. A bearded youth arrogantly ticks off his point of view to his companion while waving the newspaper at his side. The older gentle-man turns toward the viewer, as if seeking commiseration for his having to endure the young man's harangue.

The theme of generational conflict was hardly unique to Woodville. In the 1840s, large numbers of his contem-poraries ruminated and editorialized at length about the widening chasm between themselves and their elders. In literature and politics, the so-called Young America move-ment, which recruited to its ranks writers such as Walt Whitman, Herman Melville, and Nathaniel Hawthorne, advocated breaking away from what they considered to be the tired, dried-up conventions of the previous generation. The Young Americans loudly insisted on the salutary value of fresh and daring new ideas. For many of them, this included wresting California and other western lands away from Mexico so that the United States could achieve its Manifest Destiny—a term coined by a newspaper editor who was also an avid Young American.

In Woodville's world, men of different generations, classes, or politics argue, frown, grin, grimace, disapprove, and deceive. Typically set in male-dominated public spaces and often containing newspapers—symbols of public discourse and debate—these satirical, socially observant genre scenes portray the land of *E Pluribus Unum* (out

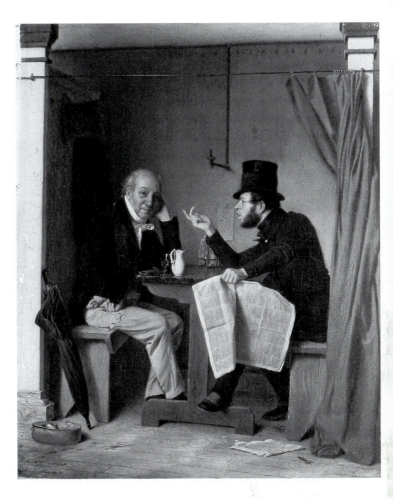

6.29 RICHARD CATON WOODVILLE, *Politics in an Oyster House*, 1848. Oil on canvas, 27 × 24¼ in (68.5 × 61.5 cm). Walters Art Museum, Baltimore, Maryland.

of many, one; the U.S. motto) as teeming with tricksters, blusterers, and warmongers. Despite their apparent good humor, they convey an underlying message that the world is a contentious place, full of sharks and charlatans, of which visitors and inhabitants alike must beware.

## Street Scenes

Relatively few antebellum genre painters attempted urban street scenes, which by their nature had so many unruly elements to control: multiple figures, faces, still-life objects, architectural structures, and varied light sources. Those exterior city scenes that survive were typically by lesser-known and less well-trained artists, and little has been written about them. Yet they deserve a closer look, for they boisterously, if crudely, depict the American "street" as a thoroughfare of hustlers and go-getters, whose actions are observed by members of the public.

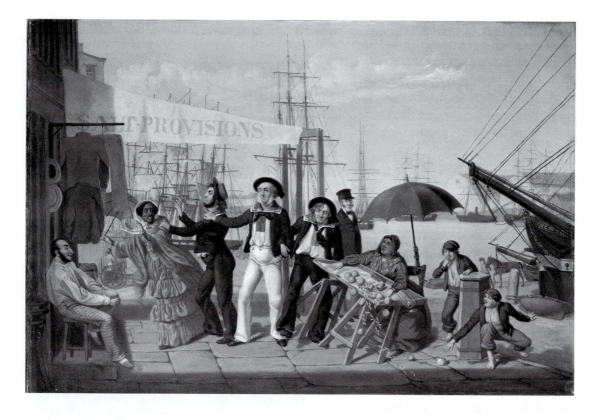

6.30 JOHN CARLIN, *After a Long Cruise (Salts Ashore)*, 1857. Oil on canvas, 20 × 30 in (50.8 × 76.2 cm). Metropolitan Museum of Art, New York.

**JOHN CARLIN.** Take, for example, *After a Long Cruise (Salts Ashore)* (**fig. 6.30**). Painted by the deaf miniaturist, poet, and novelist John Carlin (1813–91), who later became a leading activist on behalf of the hearing impaired, *After a Long Cruise* shows a pair of drunken sailors making mischief on the docks of New York. One of the young "salts" harasses an attractive and well-dressed African American woman, who, like a winged Nike figure from ancient Greece, flees his grasp, while a second companion upsets a fruit vendor's apple stand. A street youth exploits the windfall. An older sailor, a boatswain with white muttonchop whiskers, attempts to restrain his shipmates, while a bystander looks on with amusement. Although stiff and almost cartoonlike in style, *After a Long Cruise* pungently combines street-scene reporting and moral commentary, taking as its milieu the shady commercial waterfront, the border zone between sea and city, which also attracted the scrutiny of Carlin's contemporary Herman Melville, the author of *Moby-Dick*. Carlin transforms racial and class antagonism into a more benign form of humor.

**YOUNG HUSBAND: FIRST MARKETING, BY LILLY MARTIN SPENCER.** Another street scene is *Young Husband: First Marketing* (**fig. 6.31**) by Lilly Martin Spencer (see above). Its urban setting—a rain-slicked pavement on a stormy day—provides a mixture of comedy (the man who

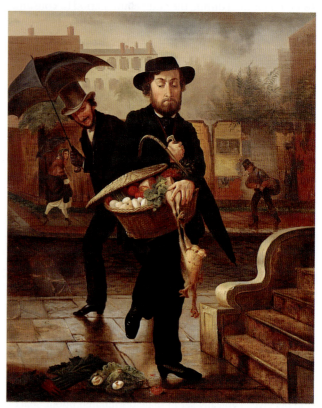

6.31 LILLY MARTIN SPENCER, *Young Husband: First Marketing*, 1854. Oil on canvas, 29½ × 24¼ in (74.9 × 62.9 cm). Hunter Museum of American Art, Chattanooga, Tennessee.

# Hannah Stiles and the "Trade and Commerce Quilt"

THE APPLIQUÉ QUILT could sometimes serve as "canvas" onto which an American woman could stitch a pictorial composition akin to a genre painting of the day. In a quilt made in the early 1830s, Hannah Stockton Stiles (1799–1879) took the central "Tree of Life" motif (often used in samplers and quilts) in a new direction, surrounding it on three sides with a riverscape containing eleven large boats and several smaller ones (**fig. 6.32**). This scene, in turn, is flanked by a border depicting the bustling life of her neighborhood (Northern Liberties) in Philadelphia. Hannah Stiles lived on the Delaware River waterfront at a time when Philadelphia was one of America's busiest ports, bustling with ships from China, India, the Caribbean, and Europe. Her accurate depictions of the paddle-wheel steamers, sloops, and small dories suggests a firsthand knowledge of maritime activity. The men off-loading boards from a sloop and meticulously stacking them between the grocery store and the tavern in the left border of the quilt may have been employees of her husband, a prosperous lumber merchant. From their home on the riverfront, Hannah Stiles chronicled in cloth the commercial transactions as well as activities at local taverns and bathhouses. At the bottom, the artist has stitched men and women in fashionable attire, the women wearing the mutton-sleeved dresses that were the height of style in the early 1830s. The Trade and Commerce quilt is unusual in showcasing the social and economic life of Stiles's day.

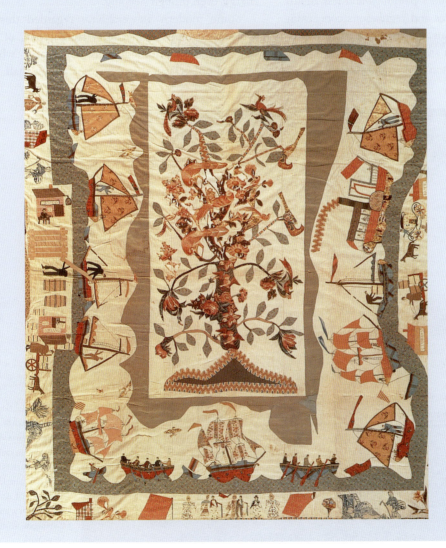

6.32 HANNAH STOCKTON STILES, *Trade and Commerce Quilt*, c. 1835. Cotton, chintz, sprig, and solid, 105 in (266.7 cm) high, 89 in (226 cm) wide. Fenimore Art Museum, Cooperstown, New York.

takes on the traditional woman's role as shopper can't manage the task), dandyism (the gloved and rakish bachelor who laughs at the young husband), and female sexuality (the raised skirts of the attractive young pedestrian across the street). It also implies a certain level of social disorder, for in Spencer's day the term "husband" referred not only to a male spouse, but also to the administrator or steward of a large household, farm, or estate. Thus, as seen here, the young husband's difficulties may have stood for those of the young nation, which, in the years leading up to the Civil War, struck increasing numbers of Americans as being mismanaged by its political and business leaders.

In this painting, as in the Carlin docks scene described above, the city street is an arena for brisk, impersonal, and sexually fraught encounters between strangers. Portraying pride, indifference, clumsiness, and humiliation, quirky paintings such as these characterize urban America as a comic spectacle meriting the viewer's laughter. They are more raucous than Woodville's paintings and less tightly controlled by academic rules and regulations concerning orderly composition and tone. Yet they, too, picture antebellum democracy not as a smooth unity but rather as a world of individuals in motion, ever about to clash.

## Mount: Abolitionism and Racial "Balance"

One of the most intriguing elements of William Sidney Mount's art (see above) is its recurrent attention to race. In his early genre scenes, broadly grinning blacks appear only a step removed from caricature. But in his later works, African American figures take on a central—yet ambiguous—position.

**FARMERS NOONING.** *Farmers Nooning* (**fig. 6.33**), from 1836, shows a group of field hands enjoying a break from their labors. Three young men rest in the shade of an apple tree, and a fourth, reclining on a haystack, sleeps in the sun while a mischievous boy tickles his ear with a piece of straw. The man on the haystack, an African American, commands attention with his beautiful figure, elegantly upturned arm, and noble face. Clad in creamy trousers, a blazing white shirt, and a red undergarment, which shows through with bright crimson highlights, he radiates visual energy, even though sleeping.

Some modern viewers have regarded this painting as a typical nineteenth-century stereotyping of blacks as lazy sensualists; although this field hand, whose pose is based on a classical sculpture of a faun (half man/half

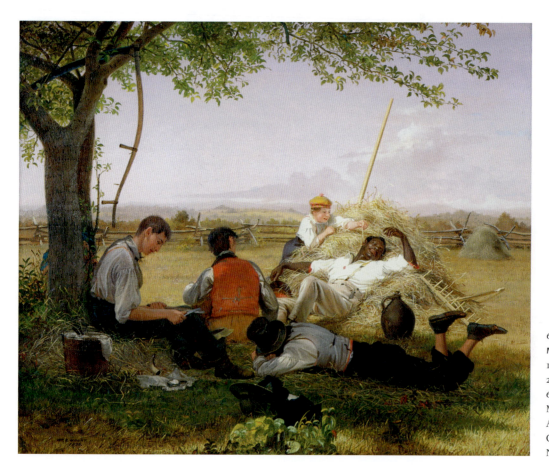

6.33 WILLIAM SIDNEY MOUNT, *Farmers Nooning*, 1836. Oil on canvas, 20¼ × 24¼ in (51.4 × 61.5 cm). The Long Island Museum of American Art, History, and Carriages, Stony Brook, New York.

goat), snoozes carelessly, one of his white counterparts industriously takes advantage of the lunch break to sharpen his tools. This argument, however, overlooks the white figure stretched out in the foreground with his face buried in his arms. Introducing a more complex response, the art historian Elizabeth Johns has interpreted the painting as an anti-abolitionist political allegory. She notes that the boy tickling the ear of the sleeping giant wears a Scottish cap (a "tam-o'-shanter"), an unusual article of clothing, which at the time was routinely associated with abolitionism, inasmuch as Scotland was then the hotbed of the international antislavery movement. This intrusive child may thus symbolize what Mount viewed as the troublemaking abolitionists of the 1830s, dangerously rousing black Americans from the long sleep of subservience.

**EEL SPEARING AT SETAUKET.** Mount was not progressive in his notions about African Americans, believing that their separate and inferior status was justifiable. He conveyed this view in one of the most intriguing works of his career, *Eel Spearing at Setauket* (1845) (**fig. 6.34**). Mount portrays a young white child and his dog seated in the stern of a small fishing craft on a hot summer's day. In the bow,

a black woman, most likely a worker on the boy's family farm, leans her weight forward as she thrusts a long fishing spear into the water. The yellowed hillside behind them looks as dry as parchment. Above it, the pale sky is lifeless and blank, save for a vapor that zigzags behind the spear, as if to suggest its motion. The glassy-smooth water mirrors the strip of land and the skiff and symmetrically reverses the directions of the paddle and the spear, forming a series of triangles and lozenges over the flat surface of the picture.

As a result, the painting has a hard, enameled, jewel-like quality and a sort of fairytale simplicity. All is in elemental harmony here: sky and water, dryness and moisture, child and adult, male and female, master and servant—and, in keeping with the artist's own views on the subject, white and black. The picture would seem to say that America is best served by a judicious separation of races, with each keeping its own appointed place on opposite ends of the boat, the two coexisting in peaceful and productive balance. *Eel Spearing* provided Mount's white clientele with a feeling of reassurance. It maintained child and adult in their separate spheres—she labors while he benefits from her labor—while also suggesting, through its sense of balance,

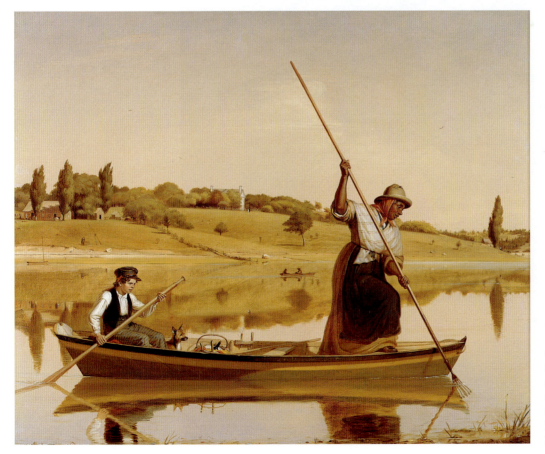

6.34 WILLIAM SIDNEY MOUNT, *Eel Spearing at Setauket*, 1845. Oil on canvas, 29 × 36 in (73.6 × 91.4 cm). Fenimore Art Museum, Cooperstown, New York.

harmony, and timelessness, that white dominance was an entirely natural and universal phenomenon.

## Antebellum Anti-Sentimentalist: Blythe

The Pittsburgh genre artist David Gilmour Blythe (1815–65) also painted children. But whereas Lilly Martin Spencer's children appear angelic and mildly demanding, Blythe removes the qualifier "mildly" altogether. In a series of pictures of Pittsburgh newsboys and street urchins that Blythe painted in the 1850s, the subjects are not impish, but demonic. Blythe displays the darkest outlook of any American antebellum genre painter; his children of the street represent base human impulse—unloved and unlov-

able. We cannot be certain that Blythe's young riffraff were meant to be understood as immigrant, rather than simply poor, Americans. Either way, they threaten the social order—or at least signify its corruption. In *Post Office* (**fig. 6.35**), Blythe's masterpiece of cynicism, he shows boys picking the pockets of men and women who gather around a general delivery window but are too preoccupied with their mail to notice. We've encountered the symbolic civic space of the post office in Woodville's *War News from Mexico*. In that instance, citizens interact in a relatively positive way, but here their only interaction is to push and shove for a place in line—so much for republican civility—and no one gives a damn about anything except his or her own individual news from elsewhere, as embodied by the small sheets of

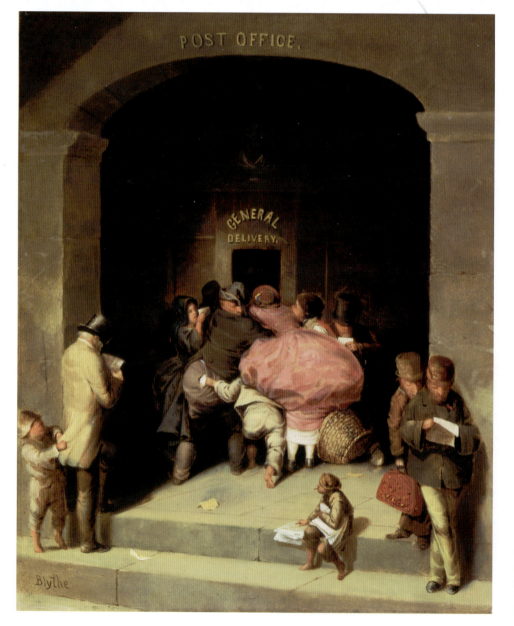

6.35 DAVID GILMOUR BLYTHE, *Post Office*, 1859–63. Oil on canvas, 24 × 20 in (60.9 × 50.8 cm). Carnegie Museum of Art, Pittsburgh, Pennsylvania.

paper they clutch in their hands (in contrast to the large broadsheet newspapers held aloft in Woodville's painting). In *War News*, the populace faces outward from the American Hotel. Here, civic experience is thoroughly privatized.

*Post Office* expresses satirical dismay with modern civilization. The heroic bust mounted high above the general delivery window is practically lost in the shadows, ignored by the crowd. *Post Office* even casts a nod to the famous Italian fresco *The School of Athens*, painted by Raphael three and a half centuries earlier. In Raphael's allegorical tribute to the glories of human knowledge, the great thinkers of antiquity, including Plato and Aristotle, come forward from on high to share their wisdom with the artists, poets, and intellects of Raphael's own era, the Renaissance. Blythe borrows two of the more conspicuous figures in the fresco—the philosopher and truth seeker Diogenes, who sits alone on the marble steps, and the brooding artist and poet Michelangelo, who hunches in the foreground over a sheet of paper—and combines them into a cigar-chomping, monkey-like newsboy on the post office steps.

Like the other genre painters we have examined, Blythe was a keen observer of democratic society. His attention, however, was devoted almost exclusively to flaws. With a jaundiced eye, Blythe sizes up antebellum America as a bleak and dingy place, where corruption trumps honesty, and art records—without correcting—the vices of the times.

## Slaves and Immigrants

As a whole, antebellum genre painting served as a looking glass in which the middle classes could flatter themselves and feel morally superior to other social groups. But individual genre artists, reflecting different regions, classes, political parties, and genders, differed from one another concerning the issues of the day. Among these issues were war, abolition, racial divisions, westward migration, family responsibilities, art versus commerce, and the faltering of republican values. Genre painting thrived because—in an era long before the invention of movies and television—it provided an endless succession of lively narrative images that enabled viewers, rightly or wrongly, to make sense of themselves, their neighbors, and their world.

Racial prejudice in the United States did not spring up overnight. Instead, attitudes toward race developed over time, reflecting changing social, economic, and class imperatives. In the 1830s and 1840s racial and ethnic stereotypes began to proliferate. We have already seen this in paintings by Mount, Woodville, and Carlin. Initially, such stereotypes applied as much to immigrant groups like the Irish as they did to African Americans. Writers of the period described the Irish with terms such as "childish," "irresponsible," "primitive," and even "simian." By mid-century, over half of New York's population was foreign born; immigrant workers dominated the industrial labor force in cities up and down the eastern seaboard. As the tide of Irish and then German immigration rose over the next two decades, native-born citizens, fearful for their jobs and their way of life, expressed their hostility in political action.

**JOHN QUIDOR.** Two paintings by John Quidor (1801–81), both from the 1830s, suggest the dynamics of antebellum racial sentiment. Name calling and race baiting could be aimed in a variety of directions. In *Antony van Corlear Brought into the Presence of Peter Stuyvesant* (1839), Quidor jumps on board the bandwagon of anti-Irish sentiment (**fig. 6.36**). Although the painting includes an unflattering image of a wildly dancing black man, it directs its social disdain at the Irish immigrants portrayed in the background. In an earlier painting, *The Money Diggers* (see fig. 6.37), Quidor lampoons the black man scrambling from a pit in the painting's foreground. The two paintings together demonstrate the ways that animosity against the Irish could spill over into an antagonism against blacks. No record survives of Quidor's political affiliations. Judging from his art, however, he probably would have felt quite comfortable at a local gathering of the Know-Nothing Party.

Quidor grew up in Tappan, New York, a stone's throw from Washington Irving's estate in Tarrytown, and his paintings often derive from incidents in Irving's stories. The lower Hudson River Valley, where Quidor spent his childhood, underwent rapid change in the first half of the nineteenth century, in part because of the Erie Canal, which opened New York to the West in 1825. What had once been a region of small farmers turned into a region of factories and growers producing for an export market. People who struggled to meet the needs of an industrializing economy soon grew to resent the unskilled immigrant laborers who competed for their jobs. Quidor was one such figure. He received little recognition during the antebellum years, instead supporting himself as a painter of signs, fire engines, banners, and coaches. He traveled from New York to Illinois at one point in his career, trying his hand at religious paintings in the style of Benjamin West. In the early 1850s he returned to New York, where he resumed painting images from Irving's stories. Quidor was absent from most histories of American art until his rediscovery in the mid-twentieth century.

6.36 JOHN QUIDOR, *Antony van Corlear Brought into the Presence of Peter Stuyvesant*, 1839. Oil on canvas, 27 × 34 in (68.5 × 86.3 cm). Munson-Williams-Proctor Arts Institute, Utica, New York.

*Antony van Corlear Brought into the Presence of Peter Stuyvesant* draws on an incident from Irving's *Knickerbocker's History of New York*. The painting reaches back two centuries to the Dutch settlement of New Amsterdam in order to explore issues vital to 1830s America. In Irving's comic tale, Antony van Corlear, the town crier of New Amsterdam, has been summoned by Peter Stuyvesant, director-general of the colony of New Netherland, to explain his unparalleled popularity among the women of the city. He responds to Stuyvesant's questions by "sounding my own trumpet," an act of self-assertion that turns Irving's laconic tale into a burlesque of the every-man-for-himself individualism associated with Jacksonian democracy.

The painting works visually as a staged battle between images of order and symbols of disorder. The older Dutch establishment, represented by the seated figure of Stuyvesant, has been challenged by van Corlear and his "delectable" trumpet. Both the sentry at the door and the older gentleman cradling a musket between his legs listen intently to van Corlear's musical "charge." Their postures are repeated and parodied in the figure of Stuyvesant himself, whose outstretched wooden leg, dangling sword, and erect cane all suggest the erotic appeal of van Corlear's

trumpet. Even van Corlear's belt, designed to hold in his rotund belly, sits high above his waist, as if it too had given up on any effort to contain the man.

Quidor's painting links Jacksonian individualism with unruly social behavior. It also delves into deeper ethnic and racial issues. The black man on the left, gesticulating in stereotyped fashion, is paired with the baying dog at the window on the right. The figures visible across the street from Stuyvesant's chambers respond to the trumpet blast by pressing against the balcony railings. They are associated visually with Irish immigrants, linked in Quidor's painting to drinking, taverns, and revelry. They stand poised to overrun Stuyvesant's chambers, which are guarded only by the glum sentry in the doorway. We can anticipate their success, their ability to overwhelm what little order still exists in Stuyvesant's office, by the signs of chaos already visible in the room: the proliferation of phallic forms, the burst breeches of the gentlemen, even the tricorner hat lying haphazardly on the floor. That hat would have suggested to a nineteenth-century audience the attire of the Founding Fathers. By dropping it randomly onto the orderly grid of the floor tiles, Quidor hints at the disarray that lurks everywhere in the painting, a disarray associated in particular with the threat of Catholic and Irish immigration.

The politics of the painting, like the later policies of the Know-Nothing Party, link the Democratic Party—the party of Andrew Jackson—with pandering to immigrants and a betrayal of the ideals of the Founding Fathers.

Although Quidor lumps blacks and Irish together in *Antony van Corlear Brought into the Presence of Peter Stuyvesant*, he seems most concerned about the latter, who threaten the painting's fragile order more seriously than the gyrating black man. Anxieties about black people figure more prominently in Quidor's *The Money Diggers* (1832) (**fig. 6.37**). Here, he captures two picaresque Irving characters, Wolfert Webber and the German immigrant "scholar" Dr. Knipperhausen, as they dig by moonlight for buried treasure. They are attended by the "Black Fisherman Sam," who scrambles out of the pit he has dug after spying the ghost of a drowned buccaneer on the ledge above him.

Irving's tale casts a jaundiced eye on human greed. It satirizes the changes to traditional ways of living wrought by a growing market economy. Quidor's painting repeats Irving's larger concerns while shifting the emphasis from greed to race. The burlesque form of the black man in the foreground bears the brunt of the painting's anxieties. He straddles two realms: the nether world of the pit, and the middle-ground space of the two frightened money diggers. Dr. Knipperhausen, the figure to the right of the fire, knocks his knees together at the sight of Sam. His posture resembles that of a man protecting his private parts, an anxiety highlighted in the painting by the string of keys dangling from his crotch. Wolfert Webber turns as if to flee from Sam while staring at the drowned buccaneer on the ledge. Like Knipperhausen, he sports a dangling appendage—a rope—at crotch level. For both men, the emergence of the black man from the pit signals a moment of crisis.

That crisis concerns more than treasure hunting. It centers visually upon Sam and the large pit from which he rises. Quidor's white characters confront a fantasy of blackness cast as their own worst fear. The spidery tree limbs behind Wolfert not only echo his gestures but suggest a

6.37 JOHN QUIDOR, *The Money Diggers*, 1832. Oil on canvas, 16¼ × 21½ in (41.2 × 54.6 cm). The Brooklyn Museum of Art, New York.

world where people and objects take their shape from the way others perceive them. Tied to the realms of nature and the body, Sam is both human and subhuman. He haunts Irving's two bumbling heroes as much as does the figure of the drowned buccaneer, with whom he is allied visually. Both appear unexpectedly out of darkness, and each represents an element of antebellum society (greed, slavery) that Wolfert and his companion would rather ignore. The painting hints at the way that white society has buried or held at bay its anxieties about slave-holding—anxieties that are destined to resurface over time.

The irony of Quidor's painting lies in what happened next. Four years after Quidor completed *The Money Diggers*, the U. S. House of Representatives, fearful about the divisive effects of slavery, sought to suppress all further Congressional debate on the issue. They passed legislation known as a "gag rule," a procedure that automatically tabled any antislavery petition brought before the House. Quidor's painting suggests the ultimate futility of such efforts.

**MINSTREL SHOWS.** In *The Money Diggers*, Quidor's two white figures confront the specter of race in American history through the figure of a frightened black man. Quidor's portrayal of African Americans derives from two sources: printed images, which circulated in ever-greater numbers throughout the antebellum period, and a new form of entertainment, the minstrel show, which began appearing in frontier towns up and down the Ohio and Missouri Rivers in the 1830s. *The Money Diggers* shares with the minstrel show a sense of burlesque humor bordering on the grotesque. The painting's stagelike space, together with its drama of white characters responding to the antics of a black man, repeat the relation of white audience to blackfaced performers familiar from minstrel shows of the period.

Minstrel shows—parodies of black slave life on southern plantations—featured white entertainers who "blacked up" by rubbing burnt cork on their faces. They painted their lips ruby red, donned tattered clothing, and maintained a toothy grin throughout their performance. Characters like Jim Crow, a gullible country fool, and Zip Coon, a city dandy and trickster, spoke in broken English punctuated by double-entendres and other sexual innuendo (**fig. 6.38**). They delighted their audience by behaving like naive and mischievous children, gesticulating in outlandish fashion, and dancing with abandon. Minstrel shows drew immense crowds throughout the nineteenth century. They traded on a notion of African American culture as primitive, lustful, and undisciplined. In this way, African Americans came

to embody a degree of sensuality that most audience members felt was lacking in their own, more "civilized," lives. White audiences viewed the minstrel show with mixed feelings of pleasure and contempt: pleasure at the world of childlike antics that they found on the stage and contempt for the exhibition of behaviors they could never condone in themselves.

Minstrel shows did more than satirize black life; they helped European American audiences overcome their own ethnic and social divisions. By identifying African American culture as the "other," as that which is both desired and repudiated, minstrel shows allowed native and immigrant workers to transcend their class and economic differences, to see themselves collectively as white, and to separate themselves from black working-class culture. They knit together a variety of competing ethnic groups (Irish, Scottish, German, and native-born laborers) and potentially antagonistic classes (wage workers and shop managers) and united them all under the banner of whiteness.

6.38 *Zip Coon*, c. 1830. Sheet music cover. Hewitt & Co. Lester S. Levy Collection of Sheet Music, Milton S. Eisenhower Library, Johns Hopkins University, Baltimore, Maryland.

6.39 FANNY PALMER, *Across the Continent: "Westward the Course of Empire Takes its Way,"* 1868. Lithograph. The Newberry Library, Chicago, Illinois.

## Conclusion: Domesticity and the West

Questions of race involved not only white-black relations, but the relation of both to Native Americans. As Americans moved westward across the continent in ever-increasing numbers during the 1850s, they brought their beliefs and values with them. They justified their continental expansion as the triumph of civilization over savagery, imagining the Native American occupants of the landscape as a doomed people—superceded by civilization itself. However romanticized the figure of the Native American might be in his "simplicity" and closeness to nature, he could not compete—according to the myth of Manifest Destiny—with the superior values that families migrating across the continent brought with them.

Manifest Destiny was an evangelical belief that America's expansion across the continent was guided by God. It is a powerful ideology exemplified by Fanny Palmer's lithograph *Across the Continent: Westward the Course of Empire Takes its Way* (1868) (**fig. 6.39**). In it, Palmer (1812–76) has imagined the West as a tame and empty landscape where exotically dressed Indians witness white settlement but put up no resistance to their own fate as a doomed race. The foreground displays the signs of transition from wilderness to civilization: trees being cleared in the left corner; a neat and orderly arrangement of homes, businesses, and school beyond the trees; Conestoga wagons and well-dressed families filling the village; and a train that puffs out tidy balls of smoke in its westward progress. By highlighting the "Public School" in the foreground, Palmer imagines Manifest Destiny as a civilizing mission. The settlers who arrive on the train, as well as those who will travel farther upon it, extend the values of middle-class domestic life from New York to San Francisco. The sharp diagonal of the tracks across the picture lends the image a charge of energy, as if the westward trek were an inevitable—and unstoppable—process. Viewers who purchased the print had probably never been west of the Great Lakes, but they could now imagine the Midwest, which had earlier been called "the Great American Desert," as an endless extension of prosperous farms.

In the next chapter, we shall pursue Palmer's cue, examining the ways in which the West changed from a space of alliance and intercultural exchange between white and Indian to a space defined by conquest and expansion. In the process, Indian cultures were exiled to the sidelines of American history.

# 7 Native and European Arts at the Boundaries of Culture: The Frontier West and Pacific Northwest, 1820s–1850s

THIS CHAPTER CONSIDERS the artistic products of the second great era of encounter between Native and white cultures—an encounter that occurred principally in the region known as the Great Plains, the vast plateau stretching from the Mississippi River west to the Rockies, and from Texas north into Canada (see map, **fig. 7.1**). Our time span in this chapter is more or less the same as in Chapters 6 and 8 (the decades before the Civil War), but our focus shifts to the trans-Mississippian West, where the dynamics of first encounter, long past in the East, were re-enacted. From the seventeenth to the nineteenth century, Native groups crisscrossed this region, and from the late eighteenth century on, contact with trappers, trading companies, and explorers vastly expanded their networks of exchange. At first, trappers and traders were searching for the beaver pelts that had fueled trade with Indians in previous centuries, supplies of which had been exhausted in the East. Later, plentiful deer, antelope, and buffalo hides attracted interest to the West. The explorers came in search of data about the landscape—geological features and natural resources that might serve colonization. Then, beginning in the 1840s, settlers from the East spread westward, fleeing exhausted farmlands in pursuit of the fabled new lands of the frontier.

What distinguished this post-1820 frontier encounter was an emerging expectation that the United States's political and social future lay in the West. This widely shared belief was driven by a sense of racial and national entitlement: the conviction that American democratic institutions—of northern European and Anglo-Saxon ancestry—were destined by providence to triumph over all other groups that claimed the land. "Manifest destiny"—the term coined in 1845 by the journalist John L. O'Sullivan—was both a rallying cry for westward expansion, and the start of a new era of white/Indian relations that pitted the ambitions of the young nation-state against its territory's indigenous occupants. The economic and social opportunism released by Andrew Jackson's election to the presidency in 1828 found reinforcement in a sense of Protestant mission to redeem the wilderness from Indians, Catholics, and the mixed races of the Mexican frontier. With the annexation of Texas in 1845, the Oregon Territory in 1846 following a boundary dispute with Great Britain, and the Mexican Cession that concluded the Mexican–American War (1846–8), the vast territories of California, the Southwest, and the Pacific Northwest joined the Union in quick succession, expanding the United States into a nation that stretched from coast to coast. Southern slaveholding

(opposite) **ALFRED JACOB MILLER**, *Interior of Fort Laramie* (detail), 1858–60. Watercolor and white body paint on paper, 11⅛ × 14⅛ in (29.7 × 35.8 cm). Walters Art Museum, Baltimore, Maryland. (See also fig. 7.2)

interests drove expansion as well, bringing a tense political antagonism to the process of national growth that would become a major precipitant of the Civil War.

The **antebellum** era encounter differed from earlier encounters not only in the assumption of racial supremacy that energized it, but also—paradoxically—in the impulse to document those very cultures whose way of life was threatened by this supremacy. These visual documents— "witnesses to a vanishing America"—were motivated by a desire to salvage a record of cultures believed to be on the edge of extinction.

Alternating between Native and white arts of the frontier, this chapter explores what the encounter with new environments and new people meant for each. We also include indigenous arts and arts of encounter from Alaska. Falling outside the continental boundaries of the United States, and becoming U.S. territory only in 1867, Alaska did not occupy a place in the nation's collective dream of continental empire; nevertheless, like other "remote" frontier areas, it was a crossroads of cultures in these same years.

7.1 Map of the West, mid-19th century, showing major tribes.

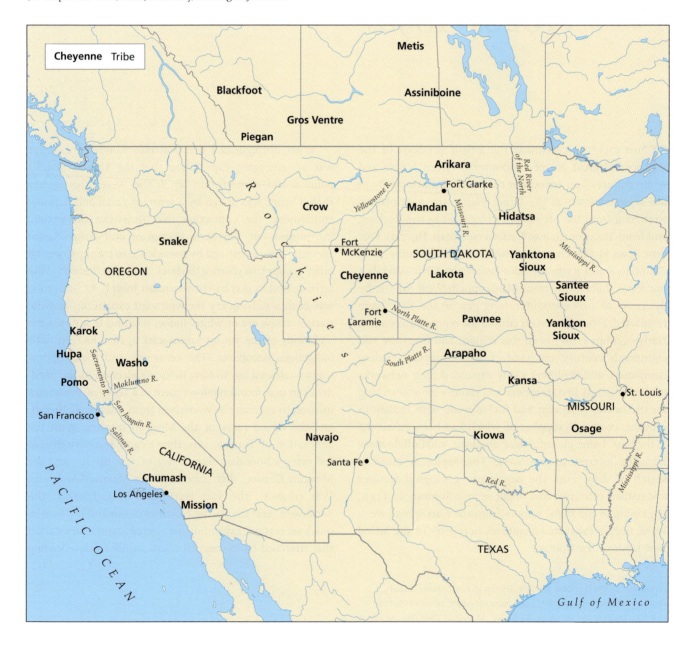

# Plains Cultures of the West: From Both Sides

Over three centuries European colonists had fought and negotiated with Indians as allies and adversaries in the East, sometimes creating cultural middle grounds, and sometimes drawing harsh boundaries between cultures. The Native inhabitants of the Plains had only limited contact with outsiders until waves of explorers, military men, and traders opened the way for successive generations of settlers. Though together they reached compromises during the first four decades of the nineteenth century, these proved to be fleeting, as epidemics, alcoholism, and rapacious demands by whites for land and its resources sapped the resilience of Plains people. Nonetheless, Plains cultures maintained their cultural autonomy until the Reservation Era that began in the 1860s, consolidating and extending their older traditions while adapting to the newcomers, their arts, and their trade goods.

## The Myth of the Frontier

Native peoples of the Plains knew the lands west of the Mississippi as their homelands, and were connected to the landscape by ancestral ties, and by sacred stories about their origins. The lands and wildlife of the West were interwoven with their daily lives and belief systems. For Eastern Americans, on the other hand, the West was a powerful abstraction remote from their everyday experience, a vast region where dreams of a better life of wealth and opportunity might find fulfillment. From the sixteenth to the nineteenth century, the European encounter with the West was shaped by such imaginings.

John Cawelti has identified four distinct versions of the frontier myth. For some, the new trans-Mississippi frontier West reinvigorated the dreams of gold and newfound wealth that had, since the beginning, drawn Europeans to what they perceived as the New World. For others, the West offered opportunities to renew and reform a corrupt society—motivations similar to those of the seventeenth-century Protestants who migrated to New England. The West also signified escape from the burdens of a restrictive social order: unstructured by family, church, law, and school, "the territories" represented a flight from civilization. A final concept of the West rose to prominence in the period 1840–1900: the "West as America," the idea that the process of western expansion, conquest, and settlement was the most powerful force shaping national character and identity. All four

versions of the West have had a long cultural afterlife in film and fiction.

None of these versions of the mythic West acknowledged the long presence of Native societies, nor that of earlier colonizers. In the mythic West, Anglo-Americans were the main actors. Yet the writer Arthur King Peters evoked a frontier society where a range of peoples met and mingled:

> In 1822, the muddy streets of St. Louis bustled with all the crowded activity of a grand-opera stage, peopled with a variety of races that defined the melting-pot character of the early frontier town. In summer the scene teemed with prowling Indians from various tribes, some with shaven heads, some roached and feathered, and decked out distinctively with jewelry, bone and quill ornaments, and colored blankets; with sauntering Spanish traders up from Chihuahua, Santa Fe, or Taos, in broad sombreros and adorned with silver accoutrements; with French Canadian voyageurs, Mexican mule drivers, and bullwackers. All mingled in the dust and mud with a flood of local teamsters, boatmen, soldiers, farmers, and traders, to the background strains of creaking wagons, cracking whips, bellowing animals, clanking sabers, and curses in several languages—the music of the frontier.[1]

Peters's colorful frontier types—Spanish traders, French voyageurs, and Mexican mule drivers—earn a place in his account by virtue of their exoticism, a prelude to the great pageant of westward expansion that would, according to this older view of western history, replace the unruly variety of the Old West with solid white settler families. This process of domesticating the West was the subject of much western genre painting from the 1840s on. The preceding generation, however, brought the first wave of white artists to the frontier to document the Native societies that stood in the path of expansion—the opening of a long history of nostalgia for the cultures most threatened by colonization.

## Setting Differences Aside on the New Frontier

The period from 1806, when Meriwether Lewis and William Clark returned East bearing specimens, maps, and voluminous records of the new lands, to the 1830s defines the first phase of sustained contact between European Americans and the Native societies of the trans-Mississippi West. In these years the power differential between European and Native was more evenly balanced

than it was to become after the Civil War, and this led to open-ended relations less shaped by predetermined goals. Trappers developed extensive contacts with Native peoples, ranging from marital alliances to business cooperation. Images of the fur trade reveal a region in which cultures mixed, whites freely adopted Native ways, and Indians forged ties with other Native groups from all over the West. In Alfred Jacob Miller's (1810–74) *Interior of Fort Laramie* (**fig. 7.2** and **p. 208**), Indians and whites both relax their vigilance. The fort—the very symbol of frontier hostilities between Indian and white—is transformed into a sheltering refuge, where, according to Miller, Indians from the far West, the Southwest, and the North gather to do business, often with their families in tow. Setting aside the markers of their cultural difference (notice the long rifle on the left opposite the lance and medicine bag on the right), they smoke, gather in conversational groups, and clamber to the lookout, or simply gaze at the spectacle. Over two decades after his trip to the West from his home in Baltimore, the image remained vivid for Miller. On the fur-trading frontier, people interacted with fewer assumptions about the superiority of European Americans. Yet with the decline of the fur trade in the late 1830s, and the growing pressures of settlement, this frontier of peaceful intercultural exchange came to an end. What was the Native Plains culture that French and American trappers and a few intrepid European and American artists and explorers encountered in the 1820s and 1830s?

## Native Plains Culture in the 1820s and 1830s

The roached and feathered Indians, decked out in bone and quill as they wandered the streets of St. Louis in Peters's description above, represented Plains cultures with rich traditions of bodily ornament, self-display, and storytelling. More than two dozen Native societies inhabited the Plains in the eighteenth and nineteenth centuries: the Lakota, Crow, Mandan, Pawnee, Kiowa, Cheyenne, and others. Some had arrived from further west and southwest; others, like the Lakota and related Siouan peoples, were pushed westward out of the Great Lakes area by population pressures from other Native and settler groups. Still others migrated north, remnants of the great Mississippian cultures (see Chapter I). The Mandan and Hidatsa had lived on the northern Plains for at least a thousand years, in semi-permanent villages of spacious earth lodges. The Lakota and Crow, in contrast, were true nomads, whose temporary camps followed the great migrating herds of buffalo across the prairies. Their architecture was portable: painted hide lodges or tipis draped over sturdy poles.

**THE VISION QUEST.** Plains Indian art shares with Native cultures of the East fundamental beliefs about the interdependence of the human, animal, and spiritual worlds. Men painted scenes on tipis and shields recording the spiritual encounters they had while on vision quests—solitary

7.2 ALFRED JACOB MILLER, *Interior of Fort Laramie*, 1858–60. Watercolor on paper, 11⅝ × 14⅛ in (29.7 × 35.8 cm). Walters Art Gallery, Baltimore, Maryland. (See also p. 208)

7.3 UNKNOWN ARTIST, Crow shield, Northern Plains, c. 1860. Rawhide, buckskin, wool, feather, pigment, 21 in (53.3 cm) diameter. Collection of Buffalo Bill Historical Center, Cody, Wyoming.

7.4 Warrior's shirt, Mandan, Northern Plains, 1800–1830. Animal skin, porcupine quills, beads, pigments, 35½ × 53½ in (90.1 × 135.9 cm). Berne Historical Museum, Berne, Switzerland.

meditations in the wilderness during which they asked the spirits of earth and sky for aid (**fig. 7.3**). Because shield designs were gifts from spirit helpers, bestowed in vision quests or dreams, the right to use a particular design belonged strictly to the man who received the vision. For example, a Crow warrior named Big Bear owned this unique design of a bear (for which the artist is named). The bear runs bravely toward a hail of bullets, leaving his distinctive paw tracks behind him. Big Bear painted several versions of the design. Such images were thought to have spiritual power, helping to protect their owners in battle. Yet in addition to this traditional concern with relationships to the spirit world, and the world of animals and ancestors, Plains art of this era introduced a new narrative form: the pictorial chronicle of personal and tribal history. In the following section we examine the interaction of two men, a white artist/explorer and a Native warrior/artist. Two intertwined objects created by each of them—a portrait and a painted buffalo robe—encapsulate the meeting points of Plains Indian and European American cultures and representational systems.

## Picturing Prowess

History painting of military valor had held a place in European art since the Renaissance; among the earliest efforts toward an independent American art were John Trumbull's dramatic series of Revolutionary War battles (see fig. 5.4). Such visual commemorations of historical events were unusual in most areas of indigenous North America, but Plains Indian men developed a **pictographic** language by which they memorialized their prowess in war and the hunt. Before contact with Europeans, this pictorial system was schematic, consisting of abstract-looking stick figures, usually engaged in battle scenes, with few individuating details. Men painted their exploits on deer- or antelope-hide shirts or buffalo-skin robes (**fig. 7.4**). These pictorial chronicles were intended to have a verbal accompaniment: their wearers amplified this visual record through storytelling. Without knowing or hearing the story, the pictorial details could not easily be deciphered.

**CHIEF MÁH-TO-TÓH-PA AS PORTRAYED BY GEORGE CATLIN.** In one striking instance from the early years of encounter, we do know the meaning of a buffalo-hide robe—as well as the rest of the ceremonial regalia of one chief—through a translation furnished by the American artist George Catlin (1796–1872). In 1832, he arrived at Fort Clark, on the upper Missouri River, where he painted a full-length portrait of the Mandan chief Máh-to-tóh-pa (c. 1800–37), "Four Bears" in English, and sometimes written as Mato-tope (**fig. 7.5**). Catlin was intent upon painting portraits, genre scenes, and landscapes as part of a systematic documentation of Plains cultures that were still completely unfamiliar to anyone but the traders and military men who had served at the forts in this region (see George Catlin's Indian Gallery, pages 218–221). He also recorded Máh-to-tóh-pa's oral history in his journals.

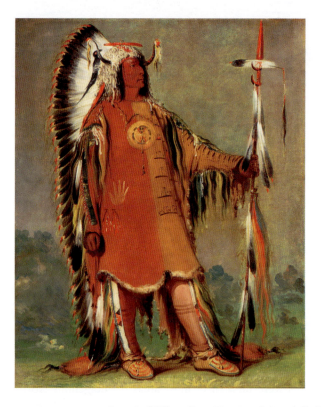

7.5 GEORGE CATLIN, *Portrait of Máh-to-tóh-pa, "Four Bears", Second Chief, in Full Dress*, 1832. Oil on canvas, 29 × 24 in (73.6 × 60.9 cm). American Art Museum, Smithsonian Institution, Washington, D.C.

Catlin recounted with some pride that when Indian people saw his naturalistic portraits, they were in awe of his artistry, commenting that he had made "living beings," for they could see their chiefs alive in two places. While this may be hyperbole on Catlin's part, it reveals the astonishment of a people who, before the days of photography, had never seen such realistic art. In their own art works, personal identity was expressed not through the realistic depiction of facial features, as in European and Euro-American art, but through identifiable emblems of clothing and regalia.

Catlin described Máh-to-tóh-pa as the second highest chief of the Mandan, but "the first and most popular man in the nation. Free, generous, elegant, and gentlemanly in his deportment—handsome, brave, and valiant; wearing a robe on his back with the history of his battles emblazoned on it which would fill a book themselves, if properly translated." He explained that even the name "Four Bears" was given by his Assiniboine enemies, who admired Máh-to-tóh-pa for rushing into battle "like four bears."

Catlin provided a full explanation of the meaning of the clothing Máh-to-tóh-pa wore for his formal portrait. His shirt, made of two soft mountain sheepskins, was ornamented with porcupine-quill embroidery medallions on the chest and bands down the seams on the arms and shoulders. Attached to the quilled seams are feathers and locks of hair. Catlin said that these locks were from enemies slain in battle (though on the Northern Plains, this could also be hair willingly given in tribute by a warrior's female relatives). While rather indistinct in Catlin's portrait, this shirt also bears drawings of scenes of bravery in warfare, much like those on the shirt in figure 7.4 above. These episodes are amplified on the buffalo-skin robe discussed below. His leggings and moccasins were adorned with quillwork done by his female relatives.

Catlin described the headdress of eagle feathers and ermine skins as "the most costly part of an Indian's dress in all of this country." While only high-ranking individuals could wear such a headdress, the real sign of Máh-to-tóh-pa's status were the split buffalo horns at the front of his headdress. Catlin remarked that only those "whose exceeding valour, worth, and power is admitted by all the nation" wore such emblems of power.

When Máh-to-tóh-pa came to Catlin's tipi to pose for his portrait, he was wearing many other accoutrements that Catlin omitted from the portrait for simplicity's sake, but which we know from his written description. These included a bear claw necklace, a painted shield, a bow and a quiver full of arrows, a long pipe and tobacco sack, a belt holding his tomahawk and scalping knife, a beaver-skin medicine bag, and a war club. This would be the Plains equivalent of a four-star general dressed in full military rig, with all his medals, epaulets, ribbons, and stars. Each item is an emblem of the chief's rank and status, and each reveals some aspect of his military history. But to Máh-to-tóh-pa's mind, the most important aspect of his ceremonial dress was the feathered, steel-tipped lance he holds in his left hand in the portrait. It had been the lance of an enemy who killed Máh-to-tóh-pa's brother with it, and left it stuck in his body. Máh-to-tóh-pa took it, swearing to avenge his brother's death. Four years later, he traveled some distance to the Arikara enemy village, entered the tipi of the sleeping chief, and drove the lance through its previous owner's body. The warrior then scalped him, and returned home with both lance and scalp. Since all such stories of military bravery were told and retold around campfires, all who saw Máh-to-tóh-pa in his ceremonial splendor would recall his exploits. In the early nineteenth century, such garments were considered to exemplify the finest artistry of Plains people; the clothing itself was important and admired, whereas in Catlin's culture it was the painted *representation* of a man wearing such finery that was valued.

**MÁH-TO-TÓH-PA'S DEPICTIONS OF HIS OWN HEROIC EXPLOITS.** In addition to the portrait, the written history,

7.6 MÁ-TO-TÓH-PA (MANDAN), Painted buffalo robe with autobiographical scenes, c. 1835. Native-tanned buffalo hide, red wool cloth, sinew, dyed porcupine quills, horsehair and human hair, pigments, 63 × 82¾ in (160 × 210.1 cm). Berne Historical Museum, Berne, Switzerland.

and Catlin's impressions of Máh-to-tóh-pa as an individual, we have the chief's hide robes—his own painted histories of his exploits (**fig. 7.6**). This hide painting is not the one that he gave to Catlin; it is a version he made as a gift for a European who visited the Mandan several years later. It provides a visual digest of his greatest exploits as a warrior. Arrayed around a central sunburst design are eight different pictorial **vignettes**, each representing a different historical moment. Such a work of art would not only be worn, but used as a pictorial aid when recounting the exciting events of past battles where Máh-to-tóh-pa had triumphed. On the lower right, he has drawn himself wearing his distinctive striped leggings, standing over the body of a Cheyenne enemy who wears a red British frock coat. Thirty marks above the fallen warrior's head commemorate the thirty Cheyenne adversaries whom Máh-to-tóh-pa fought in this battle. Below and to the left, Máh-to-tóh-pa and a Cheyenne engage in hand-to-hand combat. Moving clockwise, at the bottom of the hide, the hero carries a long feathered lance which he uses to "count coup on" another Cheyenne enemy. (Counting coup is an act of male bravery in warfare in which an enemy, alive or dead, is touched by his opponent with a coup stick. While shooting a man from afar requires skill, getting within touching range requires nerves of steel, and so was considered the ultimate act of bravery.) Moving further left along the hide, we see a depiction of a fallen Cheyenne chief in a huge

feather headdress, with his feathered shield and his horse. On the upper left, Máh-to-tóh-pa, his horse and shield behind him, points his lance at the bodies of two Ojibwe Indian women. The deaths of two women might not seem to be something worth boasting about, but the killing took place while he was hiding within an Ojibwe enemy village for six days, intent on avenging a death among his people.

At the very top of the skin, facing left, our hero again holds his lance and shield. In front of him are more than three-dozen small marks, each an indication of an Assiniboine enemy whom he faced down while his own forces retreated. Rather than drawing all three-dozen enemies in a small space, he presents them in this economical way. Similarly, on the upper right, Máh-to-tóh-pa on horseback charges toward a massed group of Assiniboine enemies, depicted as small dashes and horseshoe shapes. Below this, he fires a rifle at a single enemy warrior, whose own weapon has fallen on the ground.

In style, Máh-to-tóh-pa's hide robe is far more detailed than the painted shirt in figure 7.4. Through contact with white artists in the 1830s, 1840s, and 1850s, indigenous artists of the Great Plains adopted a more realistic style of depiction, elaborating the details of clothing and personal adornment that were so revealing of personal exploits and history. Clearly they were influenced by the works of such artists executed while in their midst. Yet not all Plains artists accepted these innovations. During his trip west,

Alfred Jacob Miller encountered Ma-wo-ma, the leader of the Snake Indians, and "a man of high principle." He recorded in his journals that Ma-wo-ma was unimpressed by Miller's paintings, which he found "vulgar and familiar," too closely resembling what he saw when he peered into his looking glass.[2] This suggests that the schematic nature of some pictographic images was a deliberate strategy, and that not all Plains artists sought to emulate the naturalism of Euro-American artists.

It is important to remember that hides like that in figure 7.6, and the one described by Catlin, were gifts freely exchanged between equals. Later in the nineteenth century, under very different historical circumstances, drawings and other personal items were often taken from battlefields as trophies of war by military men more interested in subduing Native people than documenting or learning from them.

**"AUTHENTIC" INDIANS.** When the German explorer Prince Maximilian of Wied (1782–1867) and the Swiss artist Karl Bodmer (1809–93) traveled up the Missouri River in 1833–4, they visited a region of the Northern Plains that few non-Indians had seen. Nonetheless, the results of nearly a century of trade with non-Natives (principally fur traders and the small numbers of militia who manned the forts) were already in evidence—much to their dismay, for Maximilian and Bodmer thought of themselves as adventurers into a pristine land. The sedentary Mandan and their neighbors already had many goods of British manufacture, including the red frock coat that Máh-to-tóh-pa depicted his enemy wearing in figure 7.6. In fact, at Fort McKenzie in August 1833, the prince was surely astonished that one of the gifts presented to him by a Blackfeet chief was a British officer's scarlet coat acquired in a previous encounter with traders who came down the rivers from Canada (or New France, as it was then called). In his diary, Maximilian recorded his distress at seeing such European overcoats and top hats worn as finery, and Bodmer omitted any such "tainted" influence in his portraits. After all, he and Maximilian were intrepid explorers, chronicling the uncharted, on behalf of the European scientific community! Bodmer did, however unwittingly, document evidence of long-distance trade: his sensitive portrait of a Piegan Indian man shows him wearing a Navajo trade blanket (**fig. 7.7**; compare fig. 9.29, Navajo chief's blanket), and a Pueblo silver neck pendant. Prized by Plains Indians, both items were worn hundreds of miles from their place of indigenous manufacture in the southwestern desert.

Indeed, the vectors of global mercantilism extended into western North America from all directions. French-Canadian traders and fur trappers crossed the prairies to

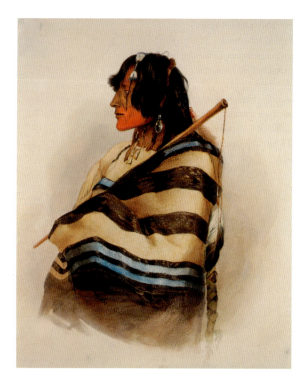

7.7 **KARL BODMER**, *Kiasax, Piegan Blackfeet Man*, 1833–4. Watercolor on paper. Joslyn Art Museum, Omaha.

reach the upper Missouri River region and the northwest by the end of the eighteenth century. Goods from the Pacific coast, and even from China, reached the interior through the trading center long established at The Dalles, on the Columbia River in Oregon, which one early-nineteenth-century fur trader characterized as "the great emporium or mart of the Columbia." Every trader's inventory book in the eighteenth and nineteenth centuries lists substantial stocks of beads from Venice and Czechoslovakia, as well as brass buttons, thimbles, needles, awls, and bolts of wool and cotton calico. On the northwest coast, Chinese coins with holes in them (see fig. 7.25, Tlingit mask) were a part of the system of trade that circulated from Boston to the ports of the Pacific Northwest, and on to Canton, China, from the 1780s to the 1840s. Some of these made their way inland through The Dalles as well.

The red pigment widely used across North America for painting both the human body and hide clothing was Chinese vermilion (derived from mercury and processed in southwest China). So an essential part of any trader's inventory was at least a few dozen packets of Chinese vermilion, an expensive trade item, costing as much as $2.50 a pound in the mid-nineteenth century. To achieve a look that the explorers admired as "authentic" and "pristine," Native peoples of the West drew upon trade routes that stretched from Czechoslovakia to China.

## Plains Women's Artistry in Quills and Beads

The warrior of the Plains has been the archetypal Indian in the American imagination. His female counterpart was neglected in these narratives of the West. This ignoring of women did not reflect the worldview of Plains peoples themselves. In the Native view, men and women had, and have, different spheres of activity that provide parallel paths to power, status, and prestige. Plains cultures believed that the world, which must stay in balance, is not whole without both of these contributions. Their roles and realms were different, but one was not more praiseworthy than the other.

As we have seen, men's arts in Plains cultures were traditionally pictographic and narrative, recording both individual and collective histories. Women's arts, by contrast, were principally geometric and abstract. Some arts, like men's painted and quilled war shirts (see fig. 7.4), reflect the complementarity of men's and women's skills: men hunted the buffalo; women used their specialized technical knowledge to process the raw materials, tan the hides, and fashion the geometric quillwork panels. The artistic elaboration of skins and hides did not change until the last quarter of the nineteenth century, when the buffalo herds were depleted by white expansion, forcing Plains peoples to rely more on trade cloth as the basis for arts and clothing.

**QUILLWORK.** The most widespread art practiced traditionally by women on the Great Plains was the art of quillwork. Porcupine quills may seem an unlikely artistic medium, but Native American women devised an ingenious technology for working with them.

According to the Lakota, quillwork had its origins in a sacred dream, in which a girl was visited by Double Woman, an important Lakota supernatural, who taught her how to use porcupine and bird quills as the raw material for art. Before that, no one knew that such items had a practical or aesthetic value. After her dream, this young woman gathered her materials and entered her tipi to work alone. She dyed the quills and separated them according to length. She wrapped and plaited them, and attached them to the hide with sinew. Eventually she shared these new techniques with a friend. Together they quilled an entire buffalo robe, prepared a feast, and invited many other women to learn this new art.

Several indigenous groups on the Great Plains had guilds in which women learned the arts of quillwork and beadwork; within these artistic guilds they earned status and prestige as their expertise developed. A young woman followed set procedures when embarking upon her first major quillwork project: she made a public vow in front of the assembled guild, describing her intentions. She held a feast, and requested that one of the senior guild members draw the preliminary pattern of design on the item to be quilled. These steps demonstrated the seriousness with which the women approached their art. Women's artistic pursuits were sacred, for, in the mythic past, they were taught by sacred beings such as Double Woman. Beautifying the world by undertaking an artistic project was an act of honor and devotion.

**A NORTHERN PLAINS DRESS.** In most tribes, quillwork decreased during the nineteenth-century, in direct proportion to the increasing popularity of beadwork. Yet quillwork continued to incorporate new designs and materials, as demonstrated in the early-nineteenth century Northern Plains dress (**fig. 7.8**). While this garment has usually been illustrated as an example of original, "precontact" Plains clothing, in fact it is a compendium of everything that

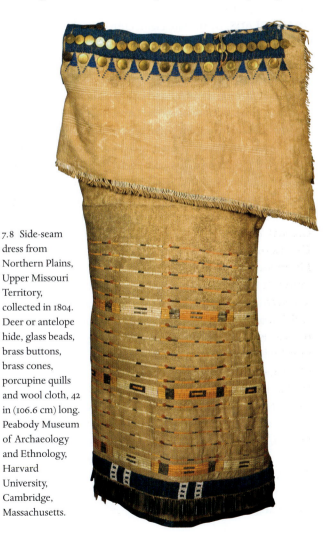

7.8 Side-seam dress from Northern Plains, Upper Missouri Territory, collected in 1804. Deer or antelope hide, glass beads, brass buttons, brass cones, porcupine quills and wool cloth, 42 in (106.6 cm) long. Peabody Museum of Archaeology and Ethnology, Harvard University, Cambridge, Massachusetts.

was new and international on the Plains circa 1800. The cut of the garment, in which two hides are sewn together, one of them flapping over the chest area, is a late-eighteenth-century Plains style. But the ornamentation on it combines the old with the new. Bands of porcupine and bird quills ornament the body of the dress. At the bottom hem, tin cones are affixed, making a pleasing noise as the wearer walks or dances. On the yoke are brass buttons from England, cowrie shells from the Pacific, and glass trade beads from Italy. Anthropologist Castle McLaughlin has eloquently described this dress as a material embodiment of many linked worlds, rather than an artifact of a single culture. Indeed, it is a harbinger of the reach of globalization deep into the interior of North America in the early years of the nineteenth century, a time when whites on the East coast thought of this region as uncharted wilderness. Little did they know that the most stylish women on the Northern Plains (often those who formed relationships with traders and other intercultural agents) already had access to the products of Europe and the Pacific.

**TRADE BEADS.** By the late eighteenth century, trade beads had become a valued commodity on the Plains; the Crow, for example, would trade one horse for a mere one hundred beads. Native women quickly recognized beads' artistic potential. Strong, durable, and colorful, beads were much easier to work with than quills. Levels of ease in technical matters is a relative thing—the tens of thousands of beads used in an ambitious project still had to be individually strung on thread or sinew, and then grouped. Like quills, beads could be used to form small, discrete color areas or large monochromatic ones. They were easily sewn to both hide and cloth, and were used alongside quillwork for extra richness of ornamentation. In many areas of the Plains, beads replaced quillwork by the mid-nineteenth century, just as they had in the eastern part of the continent.

The explorer and anthropologist George Bird Grinnell, who lived among the Cheyenne in the 1890s, said that quill- and beadwork were highly valued, and "quite as creditable as were bravery and success in war among men." In meetings of the quillwork society the assembled women recalled their previous fine works, "telling of the robes and other things that they had ornamented. This recital was formal in character, and among women closely paralleled the counting of coups by men." From this it is apparent that women's fine artistic designs required the same resolve and finesse as a warrior's act of getting close enough to touch his enemy. In the 1980s, the expert Crow beadworker Violet Bird of Montana reaffirmed that this idea lives on: "A good design is like counting coup."

## George Catlin's Indian Gallery

Catlin's portrait of Máh-to-tóh-pa was only one work in an extensive "Indian Gallery" that eventually encompassed some 422 paintings, the basis of his artistic reputation. Catlin's Indian Gallery embodies the ethical complexities involved in the project of representing cultures whose way of life was threatened. The process of producing an invaluable historical document of Native cultures unfamiliar to his Eastern audiences transformed the very subject of his study. His documentation of the Indian through his presence on the Indian–white frontier was itself part of the broader historical shift that overtook Plains cultures and forever altered them.

The Lewis and Clark expedition had returned to the East laden with Indian artifacts—robes, feathered pipes, and other collections of objects along with specimens of previously unknown flora and fauna. Collecting was the first phase of encounter; it was followed in the 1830s by a fuller portrait of Plains cultures, produced by Catlin and his European contemporary Karl Bodmer. Their images went far beyond the modest watercolors of diplomatic encounters in the 1820s. Catlin and Bodmer produced sustained records of the Native people of the upper Missouri River that continue to speak today with an extraordinary documentary power.

Catlin conceived his Indian Gallery in 1824, after seeing a delegation of Indians from the "Far West" passing through his native city of Philadelphia. Apart from a handful of sympathetic images from the eighteenth century, along with studio portraits of Indian delegations to Washington beginning in the early nineteenth, few works of art between the initial sixteenth-century encounter and the 1820s had been devoted to the delineation of Native features and dress for their own sake. Catlin's Indian Gallery was one of several assembled by American artists in the first half of the nineteenth century: Charles Bird King (1785–1862), Seth Eastman (1808–75), John Mix Stanley (1814–72), and Charles Deas (1818–67) all undertook to document the Native cultures of the West, some in their Plains homes, others as they journeyed to the capital city on treaty-making delegations. Of these galleries, Catlin's was the most complete, but all reveal an ethnographic impulse to catalogue the customs and ceremonial life of Native cultures. All shared the conviction that Native societies were doomed, and needed to be recorded in paint before fading into history.

By 1837, Catlin's Indian Gallery included portraits of individuals from over forty-eight tribes. These 422 oil paintings depicted everyday life on the plains and landscapes of the Missouri and Mississippi valleys. Modeling his

collection on Charles Willson Peale's museum (see fig. 5.33), Catlin also included Indian artifacts—tipis, painted robes, headdresses, medicine bags, war clubs, and pipes among them. Catlin painted quickly, brushing in his portraits with broad strokes often loosely detailed and inattentive to anatomical structure. Yet this technique proved so effective in conveying dress and body paint that today contemporary Plains Indians refer to his portraiture in reconstructing their own ceremonial dress for pow-wows. Consistent with older traditions of portraiture, the majority of Catlin's portraits are of important male figures—chiefs, warriors, and medicine men—although he also painted women, genre scenes of Native sports, methods of buffalo hunting, and sacred ceremonies. A number of these views were later published as lithographs in his *North American Indian Portfolio* in 1844.

**WILLIAM FISKE'S PORTRAIT OF CATLIN.** The painting (**fig. 7.9**) shows the artist dressed in fringed buckskin; behind him, in the shadowed interior of the tipi where he works, is a handsome Plains warrior with a female

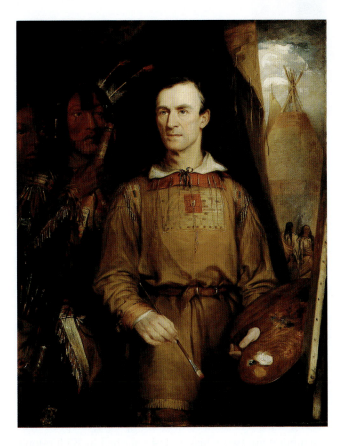

7.9 **WILLIAM FISKE**, *George Catlin*, 1849. Oil on canvas, 50 × 40 in (127 × 101.6 cm). National Portrait Gallery, Smithsonian Institution, Washington, D.C. Gift of May C. Kinney, Ernest C. Kinney, and Bradford Wickes.

companion. William Fiske's (active 1849–) portrait seems to suggest an identification between the artist Catlin and his Native subject. The red pigment on the brush Catlin holds alludes to his role as the painter of the "red man." Yet the Native man behind Catlin asserts his own claims on the viewer. Fiske's portrait reveals the tension between the living reality and the objectification of the Indian that took place in the act of painting him. Increasingly over the course of the nineteenth century, Native Americans lost an active voice in their representation, literally—as here—pushed into the shadows.

Catlin explicitly framed his project, as did other Indian galleries of these same decades, as a mission of cultural salvage. As he wrote in *Letters and Notes on Manners, Customs, and Conditions of the North American Indians* (1841), he wished "to fly to their rescue, not of their lives or their race (for they are doomed and must perish) but … of their looks and modes. …" Through his paintings, the American Indian would rise "phoenix-like" from the palette of the artist. Catlin, and other artists of his generation, were self-styled "witnesses to a vanishing America," in the words of historian Lee Clark Mitchell, including not only Native societies, but the many species of wildlife that faced obliteration by the end of the nineteenth century. The passenger pigeons that had once turned the skies dark with their numbers were close to extinction by the end of the nineteenth century; buffalo had disappeared from the lands east of the Mississippi by the late eighteenth. Likewise, in the 1830s, the artist-naturalist John James Audubon (see p. 170) had been spurred to action by a dawning recognition of the ecological devastation caused by expanding agricultural settlement, dedicating himself to documenting the birds of America. Contemporaries dubbed Catlin "the Audubon of the Indians."[3]

**DOCUMENTING "A DYING RACE."** The impulse to document is never pure; Catlin "desired to erect a monument to a dying race" but also, as he proclaimed in the opening pages of his two-volume study of North American Indians, "a monument to myself." Like other artists of the American West who would follow him, Catlin found in the subject of the Indian a vast new field for his professional ambitions. The West was an entrepreneurial frontier for artists hoping to tap a new market fueled by eastern curiosity. Having achieved little success as a portraitist in Philadelphia, Catlin turned to Indian subjects as the instrument of his fame and fortune.

But Catlin's project served his Plains subjects as well, furnishing them with an opportunity to present themselves in full ceremonial regalia to a non-Indian audience,

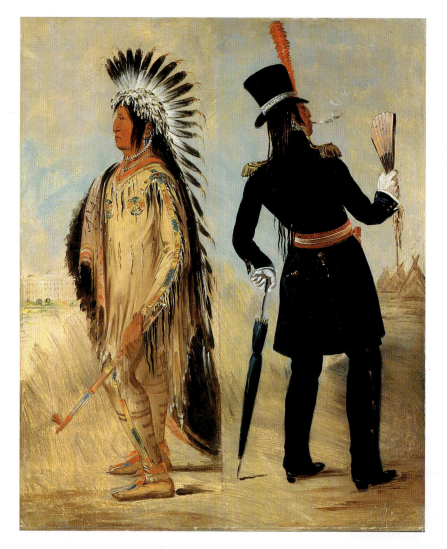

7.10 GEORGE CATLIN, *Wi-Jun-Jon (Pigeon's Egg Head) Going to and Returning from Washington*, 1837–9. Oil on canvas, 29 × 24 in (73.6 × 60.9 cm). Smithsonian American Art Museum, Washington, D.C. Gift of Mrs. Joseph Harrison, Jr.

with a sense of pride in their accomplishments. Yet their encounter with Catlin coincided with the beginnings of catastrophic changes in Native cultures. Catlin was in the West through the agency of the American Fur Company. The fur trade brought not only artists and trade goods but contagious disease. In terms of the Mandan, at least, Catlin unwittingly realized his intention of documenting "a dying race": only five years later, the Mandan that Catlin had painted with such dignity were ravaged by smallpox, unwittingly introduced on a visiting steamship. (Máh-to-tóh-pa, who was by then the paramount chief of the Mandan, succumbed, along with his entire family; his tribe was reduced from some 1600 to 125 souls in just a few weeks.) Increasingly for Catlin and his audiences, there was no middle ground of productive encounter between cultures. Instead there was only a stark polarity between the Indian in a noble state of nature, and the Indian irredeemably corrupted, or destroyed by contact with white society.

Nowhere is this polarity more starkly presented than in Catlin's *Wi-Jun-Jon (Pigeon's Egg Head) Going to and Returning from Washington* (**fig. 7.10**). Catlin's two-part composition compares the splendid dignity of the handsome Assiniboine man on a trip to the nation's capital city (seen in the background) with the strutting vanity of the dandified Wi-Jun-Jon following his return from Washington. The before-and-after format contrasts every detail: the ceremonial peace pipe versus the civilized vice of the cigarette; the dignified *contrapposto* as opposed to the exaggerated swagger; the stoic bearing contrasted with the self-satisfied attitude. Lastly, the buffalo hide painted with the exploits of the warrior stands in striking contrast to the effeminate adornments of the so-called "civilized" Indian: white gloves, umbrella, and fan. Wi-Jun-Jon affects military wear: an officer's coat with epaulets, sword, and sash adds a further irony to Catlin's portrait. These empty symbols of military status stand in sorry contrast to the pictorial histories valued by Plains warriors, chronicling the self-testing of hand-to-hand combat. Completing this portrait of corruption are two whiskey flasks stashed in Wi-Jun-Jon's pockets. Catlin composed a chart of paired terms contrasting the pure and the corrupt Indian which he appended to *Letters and Notes*: the "pure" Indian was "graceful,"

"cleanly," "independent," and "happy"; the Indian in a corrupt state (following contact with white cultures) was "graceless," "filthy," "dependent," and "miserable." As far as Catlin was concerned, the Indian on the frontier, at the boundary between civilized and savage, was already contaminated, so Catlin set his sights on the Far West, presumably beyond the taint of contact with whites.

The tale of Wi-Jun-Jon had a sad conclusion: on his return west, his stories of the great populated cities to the east were rejected as lies by his people. Those who had not seen for themselves these cities, with their towering stone buildings and grand boulevards, could not imagine that so many white people existed. They responded with resentment and suspicion, eventually killing and scalping Wi-Jun-Jon. For Catlin, who had himself come under suspicion of fabricating his paintings and lying about his experiences, Wi-Jun-Jon's misfortune had personal significance, revealing the dangers of standing between two cultures.

# The Indian as Spectacle

TODAY, MANY FROM around the world travel to pow-wows and inter-tribal fairs to watch Indian people dance and display their best clothing and beadwork. Yet few spectators realize that they are participating in the marketing of indigenous ethnicity that has a history more than 450 years old.

In 1551, in the first known instance of indigenous Americans being brought to Europe as an exotic spectacle, some four dozen Tupinamba Indians from Brazil were brought to Rouen, France, to take part in a festival to honor the visit of King Henri II. On the river's edge they reconstructed their village, with canoes, hammocks, and other accoutrements of daily life. Such visits continued through the centuries, sometimes involving individual notable personages, such as Pocahontas, who visited England in 1616, or the Iroquois who visited England in 1710 (see fig. 2.22, portrait of Hendrick).

Catlin's Indian Gallery, which opened in New York City in 1837, involved paintings rather than real Indians. Unlike earlier exhibitions of Indian subjects, Catlin's combined popular spectacle with education and advocacy. Lecturing to his audiences, he exposed the complicity of the fur trade and the federal government in undermining traditional Plains cultures. Yet advocacy ran headlong into the desire to profit from the spectacle of the American Indian; after touring his gallery in England, Catlin incorporated living Indians into a continental tour that included a performance before King Louis Philippe in Paris, thereby returning full-circle to the sixteenth century and the royal festival at Rouen, when live Indians were displayed to the courts of France. Susceptible to the diseases of their new European environment, some members of the touring troupe died. The boundary between ethnographic display and spectacle remained blurred over the next century. By far the most famous popular spectacle of the Indian was Buffalo Bill's "Wild West" show, which toured North America and Europe from 1883 to 1917 and was seen by millions (see fig. 9.42 and discussion below).

The great international world's fairs beginning in the later nineteenth century—most notably those at Chicago in 1893 and St. Louis in 1904—continued the tradition of Indians on display, underwriting public curiosity about America's exotic others with claims to scientific authority. The public display of Native Americans in Chicago was overseen by leading scientists from the Smithsonian Institution and Harvard's Peabody Museum of American Ethnology and Archaeology. Beyond the official ethnographic exhibits at the fairs was the Midway, dedicated to commerce and entertainment. Just three years after the 1890 massacre at Wounded Knee in South Dakota (considered to be the last major episode of the bloody subjugation of Plains people that began after the Civil War), the Midway exhibited newly pacified Plains Indians alongside specimens of other "primitive" cultures from around the world, including the aboriginal people of Japan (the Ainu) and the Philippines. American Indians were situated in a "living museum of humanity," and located within a racial and cultural hierarchy that served America's emerging identity as an empire.[4] Such displays were intended to justify colonial conquest and cultural containment.

The 1893 World's Fair premiered the first dioramas of Native life-size figures engaged in customary activities and shown against realistically painted landscape backdrops. The diorama was a form of display taken up by ethnographic museums through much of the twentieth century. Science, public education, museum formation, and commerce together shaped the spectacle of the Indian into the twenty-first century. (See fig. 19.17, James Luna, "Artifact Piece," for a contemporary artist's commentary on museum display practices and Native people.)

# Living Traditions and Icons of Defeat

The Indian Removal policies set in place by Andrew Jackson, president from 1828 to 1836—culminating in the notorious ethnic cleansing of settled agrarian Cherokee people from Georgia (the 1838 "Trail of Tears")—forced Native groups westward from their homelands in the southeast and the so-called "Old Northwest" (the upper Great Lakes). One result of these uprootings was that during the decades before the Civil War, formerly separate Native societies now shared with one another a limited territory and a loss of sovereignty. Having created new lives for themselves in the southeast, they adapted once again to restricted quarters, as they struggled to preserve cultural identity. In their new homes, they mingled traditions and integrated new trade materials into traditional arts. Migration brought displacement from ancestral grounds, and trade meant a shift from a self-sufficient subsistence economy to growing dependence on the market for hides and skins, furthered by reliance on guns and horses. To these challenges was added the growing volume of white settlement as the century wore on. Yet, as we have seen, Native artistic traditions throughout these decades paradoxically flourished, showing a technical and artistic inventiveness born of new threats to their cultural identity.

For many Easterners looking westward, coexistence with Indians was out of the question. Unable, or perhaps unwilling, to confront the historical dilemmas of westward expansion, many in the East, including artists and image-makers, consigned Native cultures—very much alive though struggling—to the historical margins. Central to the ideology of white expansion into the West was the idea of wilderness: an image of the West as a space void of culture, empty and ready to receive civilization. The idea of wilderness was actively promoted by those who invested in the future of the West as a region that would replicate the institutions and middle-class domesticity of the East. Wilderness had no human past; it nullified the possibility of a middle ground, premised on an encounter between cultures. In the context of these deeply rooted cultural ideas, Native people of the West were confronted as obstacle, or as threatening other. Images of westward expansion as an inevitable tide of civilizing institutions in this sense went hand-in-hand with the political program of Indian removal, and a more general dehumanization of Native cultures.

## The "Vanishing" American Indian

As the balance of power in the West shifted toward the claims of white settlers, Eastern Americans began to view Indian cultures as tragically doomed by history itself. Along with Catlin, many were able to imagine only one future for Native societies: to move progressively westward toward the setting sun, and inevitably toward extinction. These beliefs were shaped and encouraged by widely circulated images of Native people in postures of noble resignation and tragic defeat. Through constant repetition, the phrase "vanishing American Indian" acquired the aura of truth, in the face of the fierce persistence of real Indians.

THE "GOOD" INDIAN. Eastern audiences, themselves more than a century removed from conflict with Native cultures, dealt with their own moral misgivings about their

7.11 Bank note, n.d. Paper engraving. New York Public Library, Prints Division. Astor, Lenox, and Tilden Foundations.

7.12 **ASHER B. DURAND**, *Progress, or The Advance of Civilization*, 1853. Oil on canvas, 48 × 72 in (121.9 × 182.8 cm). Westervelt Warner Museum of American Art, North River, Tuscaloosa, Alabama.

7.13 (below) **THOMAS CRAWFORD**, *The Indian: Dying Chief Contemplating the Progress of Civilization*, 1856. Marble, 55 in (139.7 cm) high. New York Historical Society.

government's destructive Indian policy by sentimentalizing the whole idea of the Indian. The "sentimental" version—appearing in painting and sculpture, theater, poetry, and fiction—took its place beside the abused slave as an object of humane pity. Yet unlike the humane reaction to slavery, the figure of the idealized Indian did not produce any significant protest until nearly half a century later. According to the myth of the "vanishing" American Indian, to protest his fate was to protest the course of nature itself, and equally pointless. The figure of the vanishing Indian also offered a measure of American progress; in a standard juxtaposition, the Indian gazes out from his wilderness prospect at factories, farms, and tilled fields—a vision of rising empire repeated everywhere from bank note engravings (**fig. 7.11**) to ambitious exhibition works such as *Progress or The Advance of Civilization* (**fig. 7.12**) by Asher B. Durand (1796–1886). In the most extreme expression of the theme, an Indian family stands on the western edge of the continent, contemplating the sun as it sinks below the horizon, the emblem of their defeat. There is nowhere else to go.

The "vanishing" American Indian in art reveals a nation torn between alternative identities: symbolically allied to nature and yet committed to its agrarian and industrial transformation. An emblem of America's difference from Europe, and its virtuous attachment to nature, the Indian in the arts also came to symbolize the nation's past—the subject of nostalgic regret for what had been lost in the rise to continental empire. The arts expressed a cultural ambiva-

lence regarding change and the pace of progress, even as the national commitment to development drew generations of Americans toward an unstable future.

Thomas Crawford's (1813–57) *The Indian: Dying Chief Contemplating the Progress of Civilization* (**fig. 7.13**) embodied this ambivalence. The sculpture looks back to classical representations of the conquered barbarians of ancient Rome

(such as the *Dying Gaul*), whose nobility is evident in the language of the idealized male nude. A version of the *Dying Chief* was located within a series of emblematic figures on the east pediment of the U.S. Capitol (Senate) in Washington (**fig. 7.14**). A female allegory of the Republic anchors the sequence, which moves from soldier to merchant, schoolmaster, mechanic, and axe-wielding frontiersman, tracing a story of the nation's rise to power. The defeated Native cultures are wedged into the corners of the pediment, symbolically and literally pushed to the margins of history.

**THE "BAD" INDIAN.** The theme of the noble but doomed American Indian was, however, only one face of a dual image of Native cultures in the antebellum years. The heroic mission of establishing civilization required savage antagonists. From the Captivity narratives of the early colonial period, in which white women were abducted and held captive by Indians, the "bad" Indian was a fixture of American culture—a brutish enemy that furnished a convenient target for the regenerative violence of frontiersmen. Richard Slotkin has argued that violence against Indians was a ritualized act through which colonists gained control over their own most savage impulses. As white trappers and then settlers struggled to establish a foothold

in the West of these years, what they feared in Indian cultures was often what they most feared in themselves—a descent into barbarism.

In Charles Deas's *Death Struggle* of c. 1845 (**fig. 7.15**) the intertwined bodies of Indian foe and bearded white trapper suggest a confusion of identities. The painting is a study in cliff-hanging sensationalism—the stuff of popular literature, tall tales, and Western almanacs. The outcome is in little doubt. Astride their steeds, Indian and trapper plummet headlong into a gulf whose obscurity intensifies the horror. The Indian clutches onto the trapper in one final effort to plunge his knife into his foe, even as the embrace suggests as well a desperate desire to save himself. Neither white nor Indian will come out alive.

Physically linking their fates is the small body of the beaver—the animal at the center of the international fur trade, whose economic value shaped the early phases of expansion into the West. Its paws still caught in the steel trap, it is the reason for the death struggle between white and Indian. Painted after the passing of the "trapper's frontier," *Death Struggle* imagines the West as a place of elemental violence and conflict between cultures over diminishing resources. Despite the symbolism of white and dark, with its moral imputation of good and bad, the helix-like

7.14 THOMAS CRAWFORD, *Progress of Civilization*, US Capitol, Senate, East Pediment, Washington, D.C, 1855–63. Marble, 960 ft (292.6 m) long. Architect of the Capitol, Washington, D.C.

7.15 **CHARLES DEAS**, *Death Struggle*, c. 1845. Oil on canvas, 30 × 25 in (76.2 × 63.5 cm). Shelburne Museum, Vermont.

formation of Indian, trapper, and beaver suggests that the identity of the white trapper on the frontier could never remain separate from those who shared the environment with him. Both Indian and white participated in the same system of international trade in animal pelts that was drawing the West into a market economy. Though exploiting the popular appeal of Western frontier violence, Deas's work looks beyond the frame to a wider world of violent economic and social competition.

The presence of the Indian in American arts and literature of the antebellum period invariably carried within it a narrative about the rise of the republic that framed both the "good" Indian—pure but doomed—and the "bad" Indian—the embodiment of nature's darkest aspects, who needed to be mastered in order to establish a new culture in the West. This West of settlement was a place of moral absolutes, offering little in the way of a middle ground. Following the collapse of the trapper's frontier, which had seen the first artistic representations of Plains people,

the next phase of expansion into the West would be driven by settler colonialism.

## George Bingham and the Domestication of the West

In the decades following the passing of the explorer's and trapper's frontier, the literary and artistic figure of the pioneer emerged as one of the founding myths of the young nation-state in its transition to continental empire. Unlike the explorer's frontier, which looked to the West as a place of exotic difference and wondrous curiosities requiring documentation and preservation, the settler's frontier saw the West as an extension of the East. Here lay the nation's future, appointed by destiny to receive civilization through the heroic acts of its citizens.

***DANIEL BOONE ESCORTING SETTLERS THROUGH THE CUMBERLAND GAP.*** George Caleb Bingham's painting of 1851–2 (**fig. 7.16**) distilled these beliefs for later generations. Beginning in the 1840s, nation-builders looked to Boone's pioneering qualities at a period in the nation's history when many felt the country was falling away from the revolutionary values of independence, stalwart individuality, and sacrificial courage. In the terms of the Boone myth which Bingham helped to shape, the settlement of the West was nothing less than a religious mission. But this was a vision that obscured the contentious politics of expansion: slave versus free; settler versus Indian; rancher versus farmer.

Dressed in buckskin, Boone strides toward the viewer, illuminated from above, the very type of the independent Westerner as the advance guard of civilization settling the wilderness. He is framed by a pyramid of settlers; at the apex is Rebecca Boone riding a white horse. According to popular accounts, Rebecca was the first white woman west of the Allegheny Mountains. Her appearance here is fittingly sanctified, the prototype of the "pioneer Madonna," whose pacifying and uplifting influence promised a new domestic stability to a region known for its rowdy men. Her thematic importance here is underscored by Bingham's dedication of the painting "To the Mothers and Daughters of the West." The deep space of the painting carries us through the stages of frontier settlement, from hunting, herding, and clearing the land to farming and domestication. The pioneer myth embedded in Bingham's work emphasized the sacrifices and difficulties of settling a wilderness—dramatized in the storm-riven and foreboding landscape. The biblical concept of wilderness served expansionists well, for it conveniently dispensed with all prior claims to the land.

7.16 GEORGE CALEB BINGHAM, *Daniel Boone Escorting Settlers through the Cumberland Gap*, 1851–2. Oil on canvas, 36½ × 50½ in (91.7 × 127.6 cm). Mildred Lane Kemper Art Museum, Washington University, St. Louis, Missouri. Gift of Nathaniel Phillips, 1890.

**BINGHAM'S AESTHETIC.** Originally from Virginia, Bingham (1811–79) passed his boyhood on the Missouri frontier, largely self-taught from prints until a trip to Europe in 1856. He was politically involved and committed to bringing Missouri out of its frontier isolation and into the broader life of the nation. But Bingham also understood the role played by art and aesthetics; the form, as well as the content, of his art carried a powerful message of integration and reassurance.

Bingham incorporated frontier into nation aesthetically by endowing regional or local figures like Boone with broad symbolic attributes, couching the pioneer pilgrimage of Boone's company in the biblical language of the Israelites passing through the wilderness on their journey to the promised land, with Boone cast in the role of the new Moses. Such allusions were familiar to a viewership steeped

in the Bible. Bingham also framed his frontier themes, which lacked a history of representation, in the forms of past art. Anchored by the stable planar and pyramidal compositions of Renaissance painting, which he knew through print sources, he endowed riverboatmen, raftsmen (**fig. 7.17**: *The Jolly Flatboatmen*), frontiersmen, and low-life squatters with weight and dignity. Always with an eye to the market potential of images of the West, Bingham intended his boisterous western characters to take their place as national types alongside the Yankee figures who already occupied a secure place in national affections. His interest in creating national narratives and characters was shared by one of the leading art institutions of the mid-nineteenth century: the American Art-Union (see Institutional Contexts, page 228).

**FUR TRADERS DESCENDING THE MISSOURI.** Seeing a chance to shape the public's opinion of the West, Bingham sent works such as *Fur Traders Descending the Missouri* of 1845 (**fig. 7.18**) to the Art-Union to be engraved. Its patronage is evidence of the growing importance of the West in the public imagination.

7.17 GEORGE CALEB BINGHAM, *The Jolly Flatboatmen*, 1846. Oil on canvas, 38⅛ × 48½ in (96.7 × 123.1 cm). Private Collection. On loan to the National Gallery of Art, Washington, D.C.

7.18 (below) GEORGE CALEB BINGHAM, *Fur Traders Descending the Missouri*, 1845. Oil on canvas, 29 × 36½ in (73.6 × 92.7 cm). Metropolitan Museum of Art, New York. Morris K. Jesup Fund, 1933.

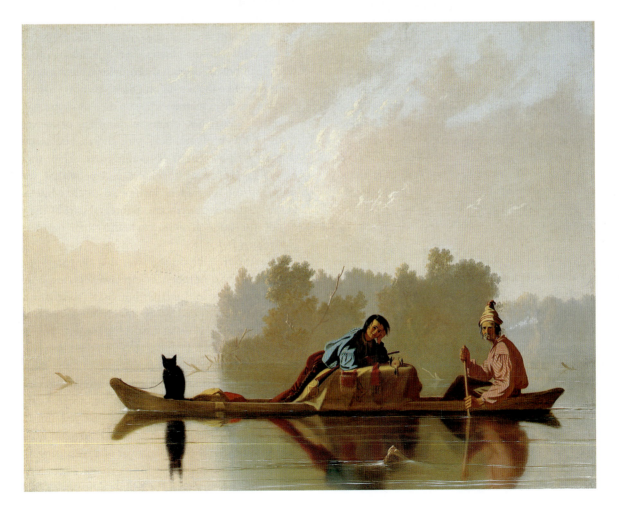

## Institutional Contexts: The American Art-Union

FOUNDED IN 1839 after a pattern established in Europe, the American Art-Union sought to foster the development of a national art and to democratize the practice of painting in America by extending the joys of art ownership to a middle-class audience. The Art-Union furnished a new source of patronage by providing young artists with national exposure and financial support through the purchase of original works of art. These were then engraved and entered into a national lottery. Subscribers to the Art-Union received one engraving a year, for the price of $5.00, while the lucky winners of the lottery received an original oil painting.

The Art-Union grew quickly into an immensely popular and influential institution. Paintings selected for engraving encouraged a sense of collective history and values based on historical figures and events, landscapes, and familiar character types. American frontier subjects seemed particularly suitable because they redirected attention away from the growing tension between North and South toward the region that represented the collective future of the nation, in theory at least. In 1853, the Supreme Court ruled the art lottery to be an illegal form of gambling, and the Art-Union soon came to an end. Its demise left artists once more dependent on individual patrons and the vagaries of the art market. However public-spirited, the Art-Union remained the work of private individuals; later efforts to foster national identity through the arts would be undertaken by the federal government in the 1930s.

The painting depicts a father and son gliding along a tranquil river in the wilderness. The trapper smokes a long-stemmed pipe that leaves a puff of smoke behind him, and he gazes off in the viewer's direction as he pulls his paddle. His raven-haired child, clad in a blue shirt and maroon trousers, leans over the covered cargo that they are taking downriver to a frontier settlement. The harmony between father and son mirrors their harmony with nature, embodied not only by the landscape but also by the leashed cub of undetermined species that occupies the bow as they ply the gentle river on this pristine morning.

*Fur Traders* invokes a series of primal encounters cast in a glowing light. The most immediately noticeable encounter is between men and wilderness. Another encounter is between child and adult; father and son. A third is racial: Bingham originally entitled the painting *French Trapper and His Half-Breed Son*, ensuring that the son would be understood as half-Indian. But since the reference to mixed parentage played on eastern fears about the mixing of races, he changed the title. A fourth encounter, more subtle, is between regions: the subjects of the painting are westerners, but the intended viewers were easterners (Bingham sent it to New York for exhibition), and the painting brings these disparate groups into implicit dialogue by having the figures in the boat make eye contact with the viewer.

This interaction served Bingham's intentions. Dedicated to improving the economy of his home state of Missouri, he wished to encourage investment and settlement from the East. Set a generation or so earlier than its execution, *Fur Traders* depicts a fundamental stage in the prospering of the West. It suggests that the region's present-day commercial activity originated in one of the most ancient and time-tested forms of Western enterprise, trapping and trading.

Unlike Bingham, the contemporary viewer is likely to think about the unacknowledged realities of race and gender that this painting glosses over. The nineteenth-century term "half-breed" disguised a complex reality: many French fur traders like the one in Bingham's painting took up with Native American women while on their long voyages. Some were true marriages, others relationships of convenience. Native women offered help with chores, and companionship, as well as crucial economic partnership: they were expert at processing the hides and pelts that were the source of the fur traders' income. As such, while invisible in this picture, women were an integral part of the success of the fur trade economy, whether their partners were Native or white.

The carefree life on the river that Bingham portrayed appealed to vast numbers of city-dwellers; low-cost prints of his paintings sold in the thousands. Bingham and his fellow artists provided viewers with images of a West of the imagination, a fantasy world of rugged and carefree individualism. Such images catered to the dream of a simpler life, flourishing on the frontier beyond the Mississippi: a life free of stress and class antagonism. While imagining the future nation as reaching from sea to sea, easterners struggled to assimilate the West—like an unsocialized child—into the family of the nation. Bingham minimized the unruliness of the West in favor of a reassuring image of a region tamed and civilized, its rough edges smoothed away, while preserving its appealing difference.

7.19 UNKNOWN ARTIST, *A Tongariferous Fight with an Alligator*, 1837, from *Davy Crockett's Almanack of Wild Sports in the West, Life in the Backwoods, & Sketches of Texas*, 1837. University of Tennessee Library, Nashville, Tennessee.

**THE BAWDY WEST.** Bingham's *Jolly Flatboatmen* treats a West of exuberant energies firmly locked into place by stable composition. His squatters, menacing Indians, and men without women take their place in an unfolding history of domesticating institutions that assured the region's eventual incorporation into the body of the nation. Popular media expressed a very different "West of the imagination." Western almanacs—cheaply printed pamphlets containing information on weather and farming conditions as well as tall tales—also published woodcuts of a bawdy West, where white men traded identities with Indians and grizzly bears, women straddled alligators, and

nature was disturbingly alive and threatening. Spiced with allusions to masturbation and fornication, and accounts of eye-gouging and scalping, the almanacs presented a highly colored new frontier vernacular—both visual and verbal. *A Tongariferous Fight with an Alligator*, from an 1837 almanac (**fig. 7.19**), overturns gender hierarchies—in which women stayed home while men battled the wilderness—and disturbs the boundary between wild and civilized by showing woman and beast locked in mortal combat.

Charles Christian Nahl's (1818–78) *Sunday Morning at the Mines* (**fig. 7.20**)—a motley gathering of men in the California Gold Rush country—humorously exposes the

7.20 CHARLES CHRISTIAN NAHL, *Sunday Morning at the Mines*, 1872. Oil on canvas, 72 × 108 in (182.8 × 274.3 cm) Crocker Art Museum, Sacramento, California.

worst fears of non-Westerners about the region. On the right, miners piously read the Bible, write letters home, and attend to domestic duties, while on the left, mayhem rules; other miners gallop horses through the gulch, and brawl in the background. One fellow, whose dark complexion and exotic looks suggest a racial mixture, is restrained by his companions as he drunkenly spills his precious gold dust from a scrotum-like bag. Here the wild freedom of the frontier appears as a place where libido is unrestrained by a disciplined work ethic. The productive economy of gold-mining and other extractive industries is literally blown to the wind in the whirl of unbridled energies. The bodily excess and extreme behavior of this bawdy West was avidly consumed by young urban mechanics, laborers, and immigrants in the East, part of a popular culture that fed fantasies of frontier license and daydreams of escape from work, women, and family.

## Native Arts of Alaska

The Native arts of Alaska, like those of other regions previously examined, reveal the global reach of culture, almost from the moment of first encounter. Native people came into contact with foreign explorers in the late eighteenth century. By the nineteenth, some grew wealthy from their exchanges with British and American fur traders. While coastal Alaska may seem remote from the cosmopolitan cities of Europe and eastern North America, in the eighteenth and nineteenth centuries it was a crossroads of cultures, a meeting place of Native, Russian, Spanish, British, and American economic interests from the previous century. In addition, traders, whalers, explorers, military men, and missionaries pursued diverse ambitions in the territory. Their impact on Native cultures was dramatic. Some Native individuals and communities prospered through participation in the international fur trade; others were almost wiped out by smallpox, influenza, and other diseases. Some groups became mutual trading partners, while in other cases coercion and bloodshed ruled. Alaskan arts embodied these cultural changes, as Native cultures seamlessly integrated such external influences into their social needs and ceremonial life, and as imported goods became fundamental to clothing, sculpture, and the ritual of gift exchange, for example. The non-Native arts that we compare to Native ones are small portable objects made by whalers rather than broadly appealing images directed at a national audience.

The indigenous inhabitants of what is now Alaska include Eskimos and related Aleut peoples of the northern and western coast and the Aleutian Islands, northern Athabaskan peoples of the interior, and Tlingit in the southeast Alaska panhandle (see map, **fig. 7.21**). Eskimo cultures share a great deal with Siberian and Canadian Eskimos.

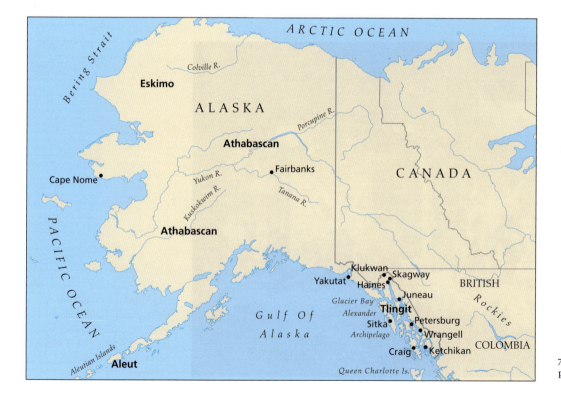

7.21 Map of the Alaskan Panhandle.

(In Canada, they are called Inuit, though in Alaska, Eskimoan people prefer the more specific cultural designations of Yupik or Inupiaq.) The Tlingit are the northernmost extension of Northwest Coast Native culture. Their art and social systems are most closely related to the Haida and other indigenous peoples of the coastal province of British Columbia in Canada.

From Vitus Bering's first voyage in 1741 to its purchase by the United States in 1867, Alaska was claimed by Russia. Seeking to make their fortunes, the Russians were principally interested in seal and sea otter pelts to sell in China. The Russian–American Company, a trading concern chartered by the tsar in 1799, was the most prominent organization. Russian nobility and government officials held shares in it, but its business went well beyond the world of commerce. It was authorized to explore and colonize, in the hopes that the northwest coast of North America would become an income-producing area of the Russian empire. By the end of the eighteenth century, Russian traders (followed by Russian Orthodox missionaries) had settled the Aleutian Islands and the panhandle of Alaska; they even maintained a fort in northern California. Following the Russians, Americans changed the face of Alaska through exploration, mining, settlement, and tourism. The historic arts of this region reflect its cultural hybridity. Indigenous technologies were put to foreign use. Foreign materials and tools irrevocably changed Native arts. New markets opened for Native artists as well.

## Tlingit Art: Wealth and Patronage on the Northwest Coast

The visual realm of the Tlingit people provides a remarkable example of how art can function as currency in a system of social status, self-display, and family prestige. The Tlingit have lived in the panhandle region of Alaska for several thousand years, and have used for well over a thousand the distinctive pictorial style they share with their Haida and Tsimshian neighbors in Canada.

Though Tlingit art is made principally from local materials such as cedar, it has long been involved in an international exchange of ideas and materials. Before the coming of Europeans in the eighteenth century, the Tlingit traded with Eskimos to the north for walrus ivory, with Athabaskan peoples in the interior for animal hides embellished with bird quill decoration, and with neighboring Northwest Coast groups.

In the late eighteenth century, Russian, Spanish, and British explorers sailed into the harbors near Tlingit villages. Russians established a fort in their territory in 1799 and settled there until the U.S. purchase of Alaska (though the

Tlingit claimed that the $7,200,000 should have been paid to them, rather than the Russian interlopers).

In the early to mid-nineteenth century, the Tlingit grew wealthy from their exchanges with British and American fur traders. The outpouring of art made during this period is a reflection of that prosperity. Traditional culture was highly stratified, from chiefs of important clans and their close relatives downwards. Art works commissioned for chiefly feasts and give-away ceremonies, known as "**potlatches**," displayed family crests and emblems. In Northwest Coast belief, Raven, Whale, Wolf, Bear, and other animal heroes interacted with ancestors in the distant past, and that relationship formed the basis for social status, embodied in artistic imagery.

**THE WHALE HOUSE OF THE RAVEN CLAN.** An 1895 photo of the interior of the Whale House depicts how family wealth was displayed, not only in the architecture itself, but in the other possessions belonging to the high-ranking members of this family (**fig. 7.22**). Ambitiously carved and painted screens covered with heraldic designs were often erected on the rear platforms of houses. The most famous of these, called the Rain Screen, was installed in the Whale House in the village of Klukwan, perhaps at the very beginning of the nineteenth century. The painted, low-relief carving probably depicts Raven, the Northwest Coast culture hero, who stole water from another bird in order to given humankind the fresh water (in the form of rain, rivers, and lakes) needed for communal survival. The huge eyes of Raven can be seen directly behind the figures wearing ceremonial garb and standing on the top step of the platform. Above, a series of smaller, seated figures represents the personified raindrops that splashed from Raven's beak as he flew over the world with his precious cargo of water.

Carved posts on either side of the screen stand adjacent to posts that support the beams of the house. They are embellished with human and animal figures, stacked in totem pole fashion. These figures depict characters in myth and clan history that relate to the founding of certain family lines. Unlike some of their Northwest Coast neighbors, the Tlingit did not carve tall, outdoor totem poles until late in the nineteenth century. Instead, they carved structural elements in the large communal houses, such as the screen and house posts here. They also carved masks, headdresses, and storage boxes, much like those displayed on the platform steps.

By the time this photograph was taken in 1895, the Tlingit had been trading with and living near European people for over a century. They wore tailored shirts and trousers, as is evident in the photograph, but they continued

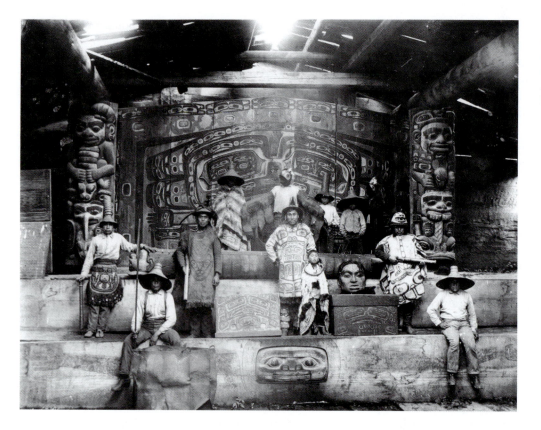

7.22 LLOYD WINTER & E. PERCY POND, Interior of the Whale House of the Raven Clan, Klukwan, Alaska, 1895. Alaska Historical Society, Juneau.

to make and use traditional carvings and regalia, and value the objects made by their forebears; much of the clan wealth displayed here was already several generations old.

**RAVEN AND THE SUN.** A house post from Taquan village shows the elegance of nineteenth-century Tlingit carving (**fig. 7.23**). The post depicts a downward-facing Raven clasping the sun in its beak. Its wings and tail feathers are ornamented with formlines and ovoids (see below),

the building blocks of Northwest Coast imagery. While it would originally have been painted in traditional colors of black, red, and blue-green, the many peeling layers of over-painting were eventually removed, the better to reveal the delicacy of the carving. The raven's head stands out from the surface of the post in high relief, while the body, wings, legs, and tail feathers are carved in much lower relief.

Both this house post and the headdress frontlet (**fig. 7.24**) have as their subject Raven and the Sun. A famous myth

---

METHODS AND TECHNIQUES

## Formlines and Ovoids: The Building Blocks of Northwest Coast Design

ART OF THE NORTHERN Northwest Coast is immediately recognizable because of its graphic design system, shared by the Tlingit, Haida, and Tsimshian peoples. Worked out by artists centuries ago, and still in use today, this system is built of form-lines, ovoids, and split U-forms. A formline is a connecting contoured line which structures the design and generally outlines human or animal anatomy. An ovoid is a slightly rectangular oval shape (usually with a hint of an upward bulge at its base) which delineates eyes, feathers, joints, and other points of

emphasis. Feather-like U-forms often fill both formlines and ovoids in a harmonious way. The carver would trace formlines on the wood, either freehand or using a stencil, before he began to use his adze.

An artist could use formlines and ovoids in a simple manner, to make a graphic image easily legible (see fig. 7.28, Grizzly Bear screen) or in a complex manner, to make the images almost disappear in an elegant welter of shapes decipherable only by another master artist.

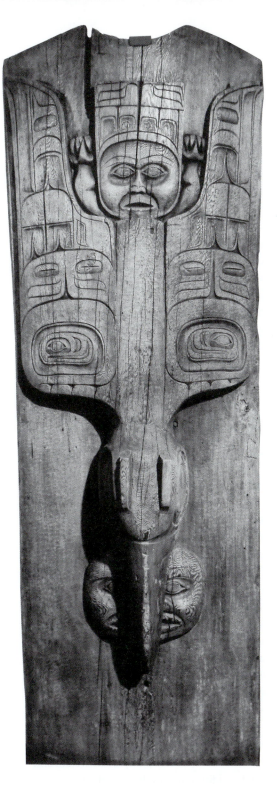

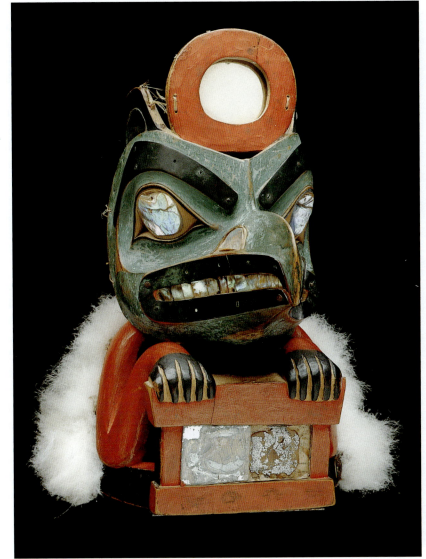

7.23 (left) UNKNOWN ARTIST, House post depicting Raven carrying the sun in his beak, Tlingit Culture, Taquan Village, Southeastern Alaska, c. 1820–40. Red cedar, paint, 105 × 38 × 12¾ in (266.7 × 96.5 × 32.3 cm). Fenimore Art Museum, Cooperstown, New York. Thaw Collection.

7.24 (above) UNKNOWN ARTIST, Box of Daylight Raven Hat, Tlingit Culture, Taku Village, Southeastern Alaska, c. 1850. Maple, mirror, abalone shell, flicker feathers, sea lion whiskers, eagle down, copper, 11⅞ × 7¼ × 12¾ in (30.2 × 19.6 × 32.3 cm). Seattle Art Museum, Washington. Gift of John H. Hauberg.

recalls that in ancient times a greedy chief kept daylight hidden in a box in his house, causing the creatures of the world to live in gloomy twilight. But the meddling hero, Raven, snatched the box in his strong claws, and flew out of the chief's house to give sunlight to the whole world. In figure 7.24, Raven holds the precious box. (In contrast, in the house post, Raven carries the fiery globe in his beak.) The outside of the box is inlaid with a sparkling mirror fragment. Another mirror sits in the orb above Raven's head, like a miniature sun. Oral history handed down with this object, which dates from around 1850, tells that the mirror, a treasured heirloom, was acquired from the first white man known to the people of this village.

Folded into the quintessential Northwest Coast story of Raven and daylight is a tale of intercultural encounter, as expressed in the materials that make up the object. Raven

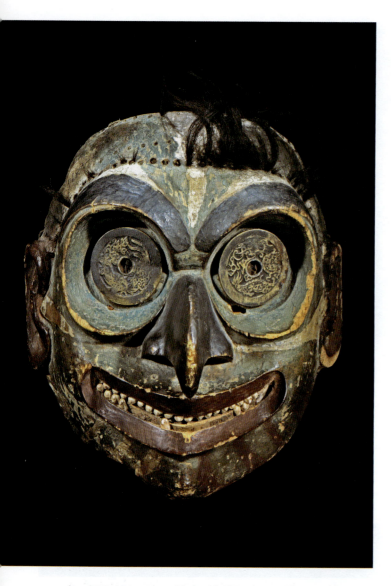

7.25 UNKNOWN ARTIST, Mask with Chinese coins, Tlingit Culture, Southeastern Alaska, mid 19th-century. Wood, hair, opercula, brass coins, paint, 9½ in (24.1 cm) high. National Museum of Natural History, Smithsonian Institution, Washington, D.C.

effortlessly incorporates materials from diverse parts of the world: in addition to the imported mirror, on the back of the headdress (not illustrated here) is a woven band of flicker tail feathers, probably made by Native people of California, and the shiny abalone shell in Raven's teeth, nostrils, eyes, and ears also came from that region.

**TRADE GOODS.** Here, as elsewhere in Native North America, imported goods were significant components of the visual vocabulary. For a period of about fifty years starting around 1780, Northwest Coast Indians traded sea otter pelts to British and American ship captains, who exchanged metal, guns, cloth, food, and exotic goods for

these valuable furs, much prized in China. Ships leaving Boston harbor would sail around South America, up to the Pacific Northwest, across to Hawaii, and then on to Canton in China where they would exchange the furs for tea, fine porcelains, and silks. They often realized a profit of between 200 and 600 percent for their efforts. This Pacific trade brought large quantities of manufactured goods into Native hands. At the beginning of the nineteenth century, one sea otter pelt could be exchanged for five muskets, or six yards of cloth, or sturdy wool blankets, or a collection of kettles, knives, combs, buttons, and beads. Much of this new material found its way into Northwest Coast art.

The importance of cosmopolitan materials, and the ingenious uses to which they could be put in order to reinforce traditional beliefs, are demonstrated in another mask (**fig. 7.25**). A hook-nosed eagle spirit with inlaid shell teeth has large round eye sockets containing Chinese coins as eyes. In ceremonial dances, conducted in the flickering firelight of a large clan house, the shiny metal eyes, pearly teeth, and real hair of such a mask would give a life-like aura to the spirit represented by the dancer, while the exotic eyes perhaps hinted at the spirit's connection with, or power in, distant worlds.

In some cases, imported materials and tools were refashioned into statements of local ethnic identity. The British blunderbuss, a relatively short gun with a wide muzzle (**fig. 7.26**), was surely obtained in exchange with a British trader. The Tlingit artist personalized it by carving low-relief formline and ovoid designs of a wolf into the walnut stock. Such imprinting of cultural symbols onto foreign objects recalls the hybrid images from the first centuries of encounter on the East coast (see figs. 2.14 and 2.16, war club and pipe tomahawk). Here, even the thunder-discharging guns of the white men have been taken into the universe of local objects.

The 1904 photograph of a potlatch in Sitka, Alaska (**fig. 7.27**), is an encyclopedia of the trade among European, Asian, and Native societies. Trade goods were creatively transformed to produce an impressive display of wealth and cosmopolitanism. In addition to locally carved headdresses and basketry caps, the high-ranking clan members in this photo wear tailored ermine jackets modeled after Russian sea captains' coats, locally woven robes, and cloaks constructed from imported wool blankets festooned with buttons. Beaded bags and bibs attest to trade with inland Athabaskan Indians.

For male artists on the Northwest Coast in the late eighteenth and early nineteenth centuries, trade with Euro-Americans made a profound difference in the way

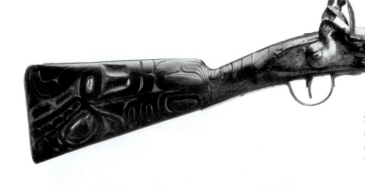

7.26 Blunderbuss, of British manufacture but modified by Tlingit artist, Southeastern Alaska, c. 1800. Brass, walnut, steel, 32 × 2¾ in (81.2 × 6.9 cm). Fenimore Art Museum, Cooperstown, New York. Thaw Collection.

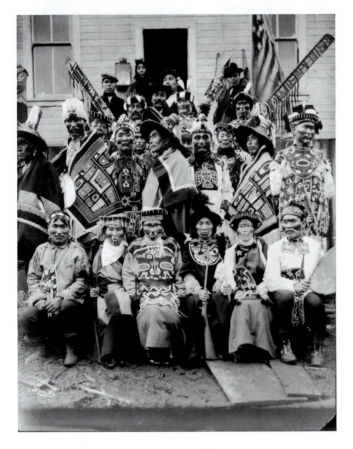

7.27 E.W. MERRILL, *Sitka Potlatch*, December 1904. American Museum of Natural History, New York.

they practiced their arts. New tools of iron were a marked improvement on indigenous carving tools of stone and bone, allowing them to carve on a grander scale and with greater ease and rapidity. For female artists, it was not innovative tools that revolutionized their arts; it was an entirely new vocabulary of materials. Considering the length of time it took to spin, dye, and weave an intricate blanket, it is not surprising that women adopted woven trade cloth, embellished it with beads and buttons, and made new ceremonial garments. The earliest European

and American visitors to the Northwest Coast all report that wool blankets, beads, and buttons were highly valued trade items, as the potlatch photograph indicates.

The great British maritime explorer Captain James Cook (in his 1778 voyage from Hawaii and up the west coast of North America), and the Russians who sailed across the Bering Strait and down the coast of Alaska, were among the first to bring beads and cloth to the Northwest Coast. These clothing items were so rapidly assimilated into Native life that only fourteen years after Cook's voyage another sea captain observed that one chief's family arrived at a banquet all dressed in English woolens. By the mid-nineteenth century, the Hudson's Bay Company wool blanket had become a unit of currency. Rich individuals accumulated hundreds of them, and at ceremonial potlatches scores of blankets were given away as gifts.

**THE CONCEPT OF *AT.ÓOW*.** All of the artworks illustrated here were used in status-conferring rituals, feasts, and theatrical displays. Central to understanding Tlingit art is the concept of *at.óow* (status, meaning, and power derived through ownership). Art objects, names, stories, and other things both tangible and intangible can accrue *at.óow* when they are displayed, sung, danced, or recounted in public ritual witnessed by other people. Objects, names, and songs can be handed down from generation to generation, accruing more meaning, value, history, and prestige with each generation. This system connects past generations with those to come, and links the human community to the spiritual one.

## Aleut, Yupik, and Inupiaq Arts: Hunters and Needleworkers

During the decades when frontiersmen and Indians encountered each other in the trans-Mississippian West, and the Tlingit were trading with the Russian Navy and

# Tlingit Art, Ownership, and Meaning Across the Generations

TLINGIT POET AND SCHOLAR Nora Dauenhauer has described her culture's art in Western museums as "like a movie without a soundtrack," for without the animating force of oratory and the public acknowledgment of rights, an art object is essentially meaningless, according to Tlingit worldview. Western museums may contain objects that are recognized by the Tlingit as still being the property of particular clans, or of individuals. For example, for more than fifty years the Denver Art Museum has "owned" a painted architectural screen from the Grizzly Bear Clan House at Wrangell, Alaska (**fig. 7.28**). The Grizzly Bear is the most important crest of the Shakes family, whose chiefs go back countless generations. Although the screen itself is in a museum, the crest image is owned by Chief Shakes, in a system akin to a Western system of copyright. The Denver screen, dating from the mid-nineteenth century, probably replicates an even earlier house screen. In the 1930s, the Denver screen served as the model for a new community house dedicated to the seventh Chief Shakes, Charley Jones, who assumed his hereditary title when this building was dedicated in 1940. (For further discussion, see fig. 16.18: CCC photo of restoration of Chief Shakes house.)

In Northwest Coast culture, replacements are routinely commissioned for worn-out heirlooms; what an individual holds inalienably is the right to own, display, and replicate certain enduring family emblems. Oral history relates that in ancient times the bear accompanied Shakes ancestors as they scaled a mountain to escape a flood; since that time they have owned the rights to the bear emblems. In an early-twentieth-century photograph of a modern Chief Shakes house (see fig. 9.44), European-style architecture (with wooden clapboards, glass windows, and hinged door) provides the setting for Chief Shakes VI's totem poles (George Shakes, who served as chief from c. 1876 to 1916). One pole depicts a human figure wearing a Killer Whale crest hat; the other depicts the Grizzly Bear of the clan's founding legend. On the pole are the footprints of the bear as it scaled the mountain with the Shakes family's ancestors. Tradition exists seamlessly with modern "improvements."

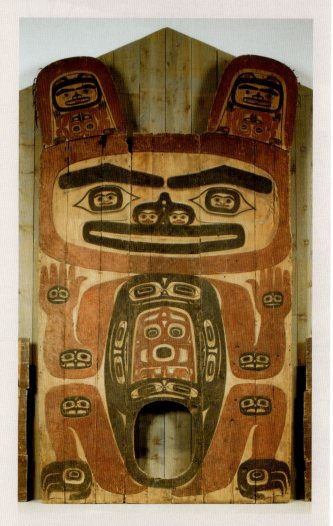

7.28 UNKNOWN ARTIST, Interior house screen from the Grizzly Bear Clan house, Tlingit Culture, Wrangell Village, Southeastern Alaska, c. 1840. Cedar, paint, 15 × 9 ft (4.57 × 2.74 M). Denver Art Museum, Colorado.

New England whalers, the Native peoples living further north in coastal Alaska had their own interactions with foreigners, some of whom came to depend on the skills of indigenous hunters and seamstresses in order to survive the bitter northern weather.

**A WATERPROOF GARMENT OF SEAL INTESTINE.** Skin and hide clothing is fundamental to survival in the Arctic. Without the warmth of several layers of animal skins to combat the prolonged sub-zero temperatures of an Arctic winter, there would have been no Eskimo civilization.

From the shores of the Bering Strait in Alaska, across northern Canada, and into Greenland, Eskimo bands have survived for thousands of years through the skill of male hunters and female clothing specialists. Above the treeline in the tundra, there were no other materials for garments. There was no weaving, except for isolated instances of grass-reed basket weaving. People relied on caribou, walrus, and seal for food, clothing, and shelter. In addition to the well-known fur parka, Eskimo and Aleut women made a distinctive waterproof parka that men wore over their fur garments while hunting in icy waters. These parkas were made of gutskin—the dense, inner layer of walrus, sea lion, or seal intestine. When butchering the sea mammal,

women would clean and scrape its many yards of intestine and cut them into long strips. Sewing the strips together with thread of animal sinew made the garments waterproof, for sinew expands when moistened, making watertight seams.

Whalers and explorers found that they could learn much from local people about survival in the Arctic winter, quickly recognizing the superiority of Native garments over their own. They commissioned women to make them parkas like those worn by indigenous people, but the newcomers also readily accepted a new garment that Aleut women designed, modeled on the eighteenth-century Russian Navy officer's greatcoat. A wool greatcoat was exceedingly heavy when wet, but a gutskin cape or greatcoat weighing just a few ounces would effectively protect a man on the deck of a ship from rain and salt spray.

This marvelous transcultural garment (**fig. 7.29**) represents the marriage of the finest indigenous technology with a recognized European clothing style to make an item of use and beauty that was widely traded. The Russian–American Company purchased them for their crews. Under the auspices of this business, thousands of sea mammals were slaughtered for their fur, which was shipped to Russia and China and made fortunes for these maritime entrepreneurs. Through the ingenious artistry of Aleut seamstresses, the intestines from these animals kept the traders dry while they plied northern waters. Virtually every greatcoat surviving in a museum collection demonstrates that these women were not simply making a utilitarian garment for a market. All the examples are embellished with tufts of fur or cloth, bands of bird quill designs, and other ornamental flourishes.

**A HUNTING VISOR.** In the sea-mammal hunting cultures of northern and western Alaska, much of ceremonial life was devoted to placating the spirits of these animals. The traditional belief (still maintained today) is that animals have souls, and the job of the human community is to honor the souls of animals captured in the hunt. Aleut and Yupik sea-mammal hunters wore bentwood visors to shade their eyes from the sun's glare (**fig. 7.31**). But the aesthetic and symbolic aspects of these visors were even more important than the practical ones. Hunters adorned themselves in elegant ways as a sign of respect for the animals that allowed themselves to be hunted. Such adornments narrated previous success in the hunt and pleased the animal spirits. Aleutian visors were elaborately painted, while Yupik carvers embellished their visors with ivory amulets decorated with abstract as well as figural designs. A group of three-dimensional walrus heads is fastened to the middle

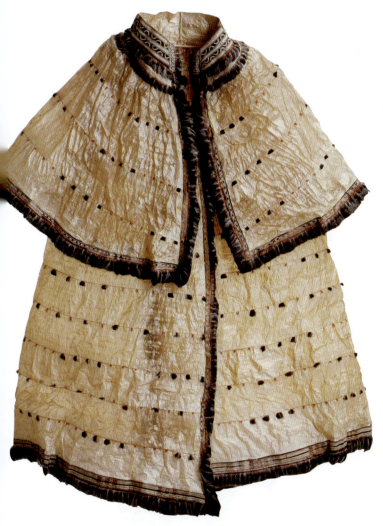

7.29 UNKNOWN ARTIST, Gut cape, Aleut Culture, Pribilof Islands, Alaska, mid-19th century (before 1865). Gut, sealskin, caribou hair, woolen yarn, esophagus membrane, feathers, 50⅓ (128 cm) long, 2½ (6.5 cm) collar, 110¼ (280 cm) hem length. National Museum of Finland, Helsinki, Finland.

of the visor illustrated here. These are flanked by abstract loon heads, for the loon is a great hunting bird, diving into the sea to snag its prey. The loon beaks are incised with scenes of hunting for bear and caribou.

**BENDING WOOD AND BONE.** Yupik and Aleut hunter/carvers used ingenious steaming technology to make these hats. We know from archaeological excavations that this method of steaming wood and bone into curved shapes dates from ancient times. In one of many acts of cross-cultural artistic exchange, Native artists learned about pictorial imagery from the printed materials and photographs the whalers carried (see Intercultural Arts, below), while New England whalers learned the skills of ivory carving and bentwood technology from Eskimo men hired to work on board their ships. The New Englander Horace Young, who made the box in **figure 7.32** around 1850, almost certainly learned the unusual craft of splitting and steaming whalebone from an Eskimo expert in the north Pacific on one of his four voyages on a whaling ship. He

## Intercultural Arts in Nome, Alaska, circa 1900

WHILE ESKIMO ARTISTS have been carving ivory for more than two thousand years, some of the best-known works date from the decades around 1900, when new markets opened for these craftsmen as a result of the Alaskan gold strikes of the 1890s. Gold was discovered on Cape Nome in 1899, and the next two years witnessed a stampede to the tiny hamlet of Nome; in 1900 alone twenty thousand hopeful prospectors left ports on the West Coast and headed there. It quickly became a boomtown of prospectors, speculators, and businessmen, and a trading center for local Eskimos. So the arts in early-twentieth-century Alaska underwent yet other changes, as their audience expanded to include greater numbers of white residents and tourists.

An Inupiaq man named Angokwazhuk (1870–1918) arrived in 1900. He had come from a distinguished hunting family, but an accident on the sea ice left him partially lame. At the age of twenty-two, he signed on with a whaling ship as a cabin boy, and there he observed the art of scrimshaw. In Angokwazhuk's capable hands, the whalers' technique of incising scenes on ivory and darkening the incisions with graphite or ink merged with his own native heritage of ivory carving. In Nome, he carved full-time, and successfully sold his incised cribbage boards and other ivory items. Widely recognized as the finest carver in Nome, Angokwazhuk could also incise pictures on a walrus tusk with near-photographic precision. He often copied photographs or advertising images, producing portraits of President Woodrow Wilson, local businessmen and tourists, and even a self-portrait. He occasionally signed his work "Happy Jack," the English nickname given to him by the white inhabitants of Nome because of his disposition.

In one engraved tusk (**fig. 7.30**), Angokwazhuk has drawn a life-like portrait of an orthodox Jewish couple. A Hebrew inscription reads "May you be inscribed for a good year 5671" (i.e. 1910). A commission for the Jewish New Year in 1910, the tusk contains a gold nugget in the shape of a Star of David, and the inscription "Nome, Alaska." This unusual tourist item (perhaps a gift from one of Nome's Jewish merchants for long-separated relatives elsewhere in the country) stands as a testimony to the intercultural commerce and art in the far north at the beginning of the twentieth century.

7.30 ANGOKWAZHUK ("HAPPY JACK"), Engraved walrus tusk with Jewish New Year's greeting, Inupiaq Eskimo, Nome, Alaska, 1910. Engraved walrus tusk with gold inset, 10 × 1 in (25.4 × 2.54 cm). The Jewish Museum, New York.

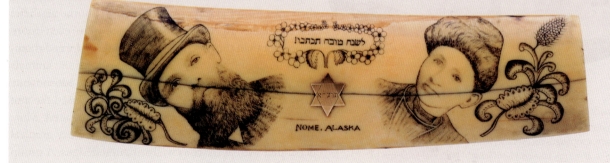

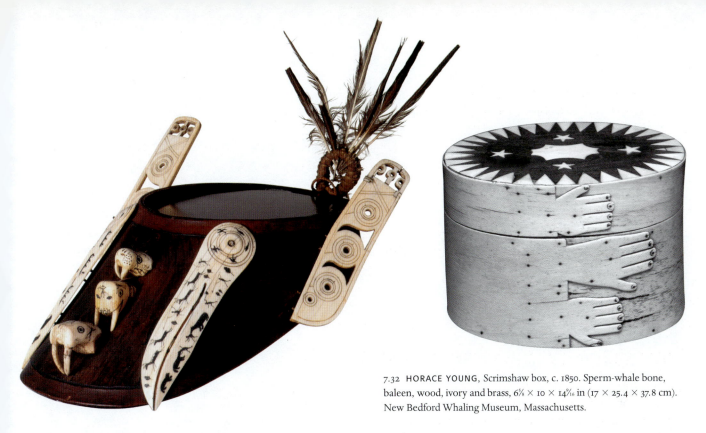

7.32 **HORACE YOUNG**, Scrimshaw box, c. 1850. Sperm-whale bone, baleen, wood, ivory and brass, 6⅝ × 10 × 14⁹⁄₁₆ in (17 × 25.4 × 37.8 cm). New Bedford Whaling Museum, Massachusetts.

7.31 **UNKNOWN ARTIST**, Visor, Yup'ik Culture, Alaska, 19th century. Wood, ivory, paint, feathers, plant and animal fiber, 7¼ × 13¼ × 9¾ in (18.4 × 33.6 × 24.7 cm). Joslyn Art Museum, Omaha.

made the box for his wife back home, who used it to store coffee (yet another product of a maritime cultural encounter). Ivory from whale teeth is inlaid in a sunburst and star pattern on the lid of the box. The piece of steamed whalebone from which the box is made is cleverly joined:

Young fashioned hands—a right hand for the lid and two left hands for the container itself—as if the box holds its precious contents tight.

While we do not know if Young made other such objects, he was one of many nineteenth-century whalers who, to pass the long days at sea, took up the art of **scrimshaw**. Some of these men, like Young, made unusual vernacular objects such as this one as a keepsake of their travels in distant waters.

# Conclusion

From the time of the Lewis and Clark expedition of 1803–6 the Western frontier became the advance line of the expanding American empire, an ever-changing contact zone between white and Native. At first, the trans-Mississippian West was a place of relatively free exchange, but within a generation the influx of whites tipped the balance, as people of the Plains suffered epidemic, alcoholism, and intertribal conflict, as well as the forced migrations of Indian Removal. Throughout the first half of the nineteenth century, Indians resisted white incursion in multiple small-scale wars.

In the face of all these stresses, Native men and women sought sustenance and continuity in the act of recording their feats of valor and incorporating new materials into their artistic repertoires, while trying to adapt to the new

circumstances with creativity and dignity. In these same decades, images of the frontier West made by white artists gave formal and thematic expression to the belief that the republic would span the land from ocean to ocean, through the movement of families, schools, commerce, and religion into the western "wilderness." These images supplanted the view of a multicultural West with a vision of the inevitable triumph of middle-class values, modes of ownership, and social organization in the new territories. Sentiment and the domestic analogy—nation as family—furnished one means of addressing the national contradictions exposed by slavery and expansion (see Chapter 6). The following chapter considers some of the ways the arts addressed and embodied internal social strains in the urban middle class of the eastern region during the antebellum decades.

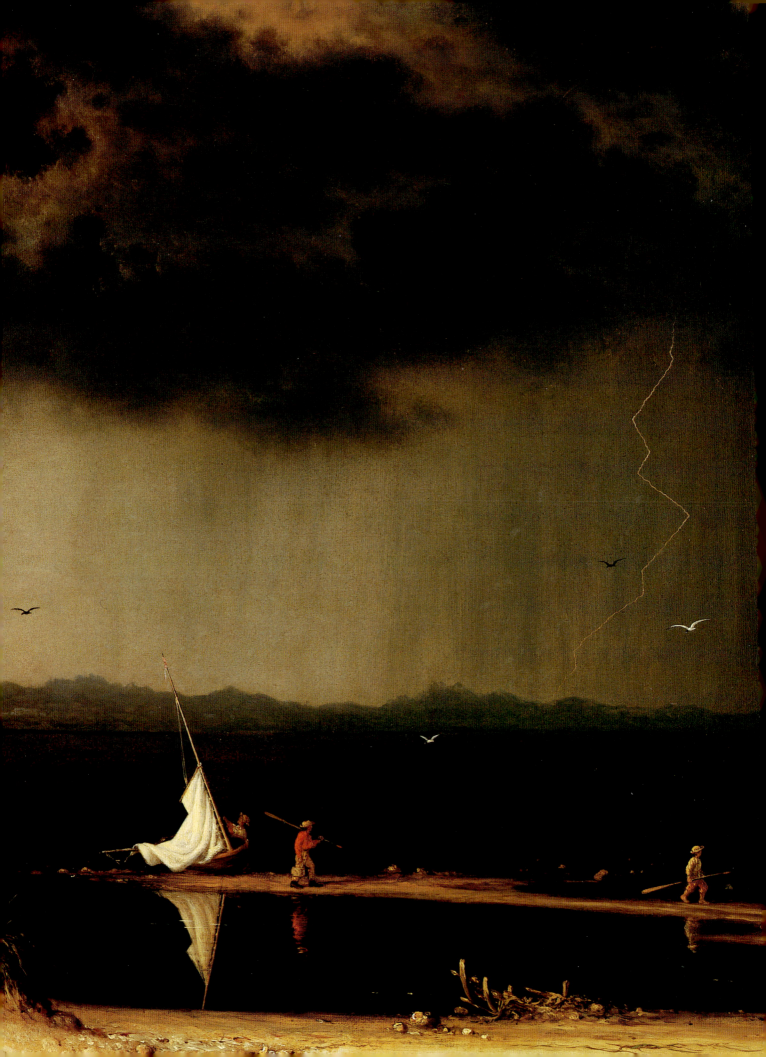

# 8 | Nature's Nation, 1820–1865

THE AMERICAN POET Robert Frost once proclaimed, "The land was ours before we were the land's." Frost believed that a long passage of time had been required before Americans learned how to live with their own landscape. They had to unlearn an older notion of nature as a "howling wilderness" and replace it with a more romanticized vision of the landscape as a realm of innocence and renewal. In the process, they came to identify themselves with the very nature they were hard at work conquering.

Most Americans were busy settling nature in the nineteenth century, too busy in fact to look up from their work of extending the nation from "sea to shining sea." When they did look up, they found themselves surrounded by a chorus of voices exhorting them to labor less and to seek meaning in the landscape instead. Writers like Emerson and Thoreau called upon mid-nineteenth-century audiences to treat nature as a treasure. The seemingly untouched quality of the nation's wildernesses distinguished the United States from Europe. The landscape came increasingly to embody what Americans most valued in themselves: an "unstoried" past, an "Adamic" freedom, an openness to the future, a fresh lease on life. In time, Americans came to think of themselves as "nature's nation." And yet one of the paradoxes of American history, as painters like Thomas Cole noted, lay in the unresolved tension between the subduing of the wilderness and the honoring of it. That tension is still alive with us today, in the competing voices of environmentalists and advocates of development.

Nature was understood in many ways during the antebellum period: as a preindustrial realm separated from the stresses of modern life; as a quasi-religious space filled with spiritual promise; and as an untapped resource ripe for commercial development. Nineteenth-century Americans sought natural forms in all aspects of their experience: in their art, their urban spaces, their mechanical designs, and their architecture. They extolled the landscape for what they too often did not find in their daily lives: a realm that transcended social divisions. Landscape appreciation began as an elite social pleasure. Its popularity expanded as rural cemeteries, urban parks, and tourist itineraries all began to emphasize the restorative powers of nature. In the two decades prior to the Civil War, the landscape was seen increasingly in national terms. A landscape painting, for example, was valued less for the view it offered than for the way it embodied commonly held values. Nature was understood to be larger than the economic, racial, or sectional differences that threatened the United States in the years before the Civil War. In this way, landscape helped unite an increasingly divided nation by providing it with an image—or at least a dream—of shared values.

At the same time that nature engaged people's attention, a new vernacular form, the photograph, changed the way individuals saw and remembered each other. Introduced in 1839, photography was quickly taken up by middle-class families as an inexpensive way to create "keepsakes." At mid-century photography provided a startling revelation when viewers witnessed for the first time images of dead soldiers strewn across the battlefields of the Civil War. That glimpse into the horrors of war altered the ways Americans perceived events around them, and marked an end to the world we term "antebellum America."

## Why Paint Landscapes?

If we were to ask an early-nineteenth-century audience why anyone would paint a landscape, we would receive a surprising answer. Landscape, for our nineteenth-century observer, had as much to do with matters of class as it did

(opposite) **MARTIN JOHNSON HEADE**. *Thunderstorm Over Narragansett Bay* (detail), 1868. Oil on canvas, 32⅛ × 54¾ in (81.5 × 39 cm). Amon Carter Museum, Fort Worth, Texas. (See also fig. 8.30)

with nature. Look, for example, at John Trumbull's (1746–1853) *Niagara Falls from an Upper Bank on the British Side*, one of the earliest landscape paintings of a famous American landmark (**fig. 8.1**). The irony of the painting, to modern eyes, is that it shows us everything *but* the falls. Rather than focus on the plunging waters, Trumbull features the landscape that frames them: the small hill and cluster of trees in the foreground, the sedate pathways that help us navigate the painting's spaces, and the human figures who promenade around Niagara in formal attire. Trumbull's upper-class tourists are safe, dry, and removed from the water's turbulence. Trumbull has, in effect, divided the landscape into two realms: a region of wildness, energy, and power (the falls themselves), and a space of rational organization and control (the pathway and promenaders). The issue here is not nature, but the ability of a certain class of society to harness and contain nature's forces.

Trumbull's painting approaches the landscape symbolically. He is interested less in providing information about a specific locale, more in encoding the landscape as a microcosm of society. The mist and clouds act as a visual cap to Niagara's energies; they bind the swirling, but invisible,

waters below, containing the water's force pictorially as surely as Trumbull's patrician culture attempted to control the social classes beneath them.

Trumbull viewed the fate of the early republic from an aristocratic vantage point. He believed that social order depended upon the wise judgments of a ruling caste, and expected the lower classes to defer to the leadership of this cultured—and propertied—elite. By the late 1790s, however, this viewpoint was on the wane. Thomas Jefferson (1743–1826), always skeptical of concentrated power, entered the White House in 1800. With Jefferson's presidency, the mantle of state power passed from an older elite to an increasingly popular and democratic—though still white and male—citizenry.

From this point of view, Trumbull's painting of Niagara represents an effort to reassert a patrician vision of society. He subordinates the power of Niagara Falls to the power of society, and imaginatively frames and binds

8.1 JOHN TRUMBULL, *Niagara Falls from an Upper Bank on the British Side*, c. 1807–08. Oil on canvas, 24⅜ × 36⅜ in (61.9 × 92.9 cm). Wadsworth Atheneum, Hartford, Connecticut.

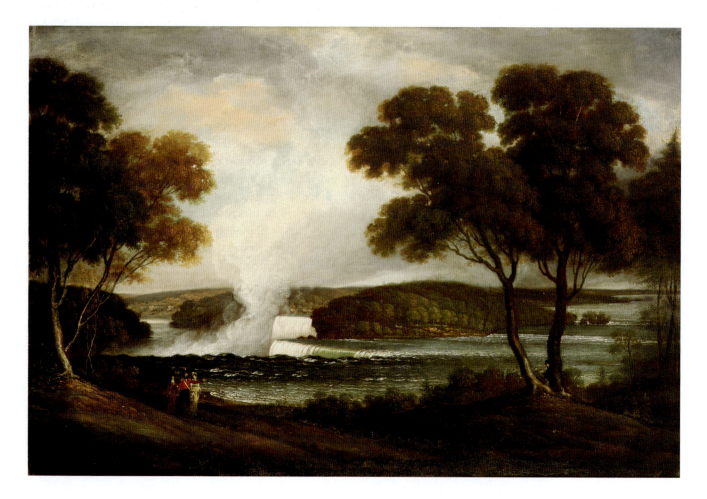

# A Brief History of the Word "Landscape"

THE TERM "LANDSCAPE" originated in seventeenth-century Holland as *landschap*. It suggested a rural agricultural community. It made its way into the English language as *landskip*, and referred, when first used, not to the countryside itself, but to paintings—or prints—of the countryside. To see a landscape was not to go out into nature but to view a representation of nature, usually in a style borrowed from the Dutch or Italian painters of the seventeenth century. Over time, the term migrated from art to nature, and came to refer to the countryside itself. By the eighteenth century, a landscape could be either a painting or a place. Its appreciation, however, remained the province of those instructed in the niceties of aesthetic conventions. Such instruction came from travel guides, treatises on aesthetics, paintings, and prints—forms of experience available primarily to genteel classes.

tempestuous forces to render them safe. Trumbull envisions a world where class privilege extends seamlessly into a naturally ordered landscape.

We learn from Trumbull that landscape painting in the early nineteenth century has much to tell us about society. By presenting the viewer with a "world apart," an alternative space imagined as "rural" or "natural," it can embody a wide range of other concerns as well. The artist transforms nature into a symbolic place where social, cultural, and political concerns can be worked through safely. The choices the painter makes in composing his or her landscape—the arrangement of forms, the interaction of colors and shapes, the accessibility of the spaces, the viewer's point of view—all tell us about the painter's social world.

## Picturesque Beginnings

Edmund Burke, the eighteenth-century English philosopher, historian, and political thinker, wrote of the beautiful and sublime as opposing but complementary categories. According to Burke, the beautiful draws upon a "feminine" sensibility, and is linked to soft colors, sensual—and often curving—forms, smallness, symmetry, and harmony, provoking feelings of pleasure and sociability. The sublime, by contrast, resembles a powerful, punishing father, and evokes

feelings of awe and terror. Sublime vistas are associated with masculine prowess, vague and obscure feelings, and brute force. As opposed to the self-contained and ordered nature of the beautiful, the sublime tends toward the rugged, the uncompleted, the infinite.

A third category, the picturesque, developed as a midway point between the beautiful and the sublime. This category derived from landscape compositions characterized by asymmetry, irregularity, surprise, and variety, a "middle ground" pastoral world neither wild nor over-cultivated, where farmers prosper and shepherds contemplate. Picturesque painting wrapped a mantle of nostalgia over the landscape, offering reassurance that country life was free from commercial contamination or modern technology. As seen in early-nineteenth-century American painting, the picturesque supplied a rapidly changing, modernizing society with a comforting, premodern image of itself.

***LOOKING EAST FROM DENNY HILL.*** In 1800 Ralph Earl (1751–1801), a New England portraitist who had lived for several years in England, painted *Looking East from Denny Hill*, a large canvas that depicts a productive, rural Massachusetts landscape (**fig. 8.2**). Earl's contemporaries judged the painting accurate and "delightful." Framed theatrically by trees on the right and left, the scene shows the stages of haying—cutting, drying, turning, stacking, and loading on a haywagon. Beyond these harvest scenes are cultivated fields of various crops, each ripening in the sun. Woodlots crown hilltops, follow creek beds, and mark property edges; stone and wooden fences define fields and protect crops from wandering livestock. This is a landscape in which labor, land, and know-how produce crops, beauty, order—and money. It helps us understand the way beauty was understood at the time, and the ways that the landscape was ordered for aesthetic effect. An orderly vista was thought to provoke pleasure; and beauty derived from a larger social harmony.

***VIEW NEAR FISHKILL.*** Almost two decades later, William Guy Wall (1792–after 1864), arriving in New York from England in 1812, painted scenes up and down the Hudson River, most of which were then engraved by another British immigrant, John Hill, for Wall's *Hudson River Portfolio* (1821–5). Wall's *View Near Fishkill*, like so much of his work for the *Portfolio*, tends to render the New York landscape as a timeless agrarian idyll peopled by self-sufficient farmers (**fig. 8.3**). There are no signs of commercial activity in the composition. Wall composes the canvas with a stand of leafy trees and a scattering of boulders on either side of the image. He then provides the viewer with a series of signs for navigating the landscape: the dirt path in the foreground,

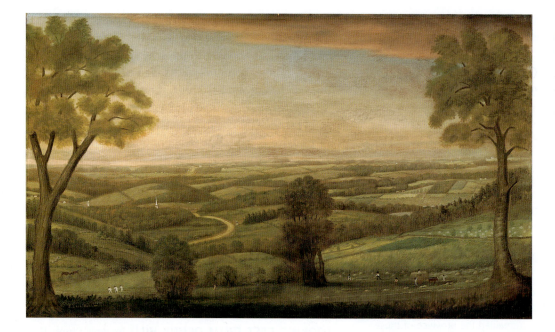

8.2 RALPH EARL, *Looking East From Denny Hill*, 1800. Oil on canvas, 45¾ × 79⅜ in (116.2 × 201.6 cm). Worcester Art Museum, Worcester, Massachusetts. Museum purchase.

the ribbon of light across the river, and the passage, at the river bend, into the distant vista. This vista is framed, like an opened door, by two mountains that rise on either side of the Hudson River. Wall's composition is both traditional and new. It relies on picturesque conventions derived from seventeenth-century Italian painting: rustic figures, winding waterways, receding spaces, and asymmetrically framed vistas. Were it not for the contemporary costume of the figures at the water's edge, and the architecturally

distinct shape of the two farmhouses, we might think we were viewing a scene in Italy.

And yet Wall hints at things to come. The visual flow of the painting—the route taken by the eye—differs from the physical pathways within it. Though viewers are invited to enter the painting via the foreground road, they are also asked to abandon the road and continue instead on an imaginative journey across the Hudson River. The two figures in the middle ground assist us on this journey,

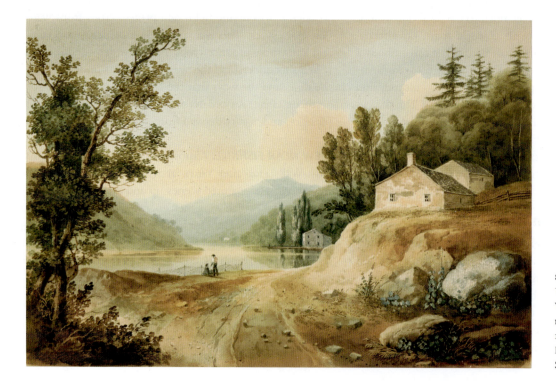

8.3 WILLIAM GUY WALL, *View Near Fishkill*, 1820. Watercolor on paper mounted on cardboard, 14 × 21⅛ in (35.5 × 53.5 cm). New York Historical Society.

directing us to the distant mountains along the line of light that runs from the foreground path, through the figures and river, and into the hazy distance.

Wall's composition anticipates the element of spiritual odyssey that distinguishes Hudson River painting in the following decades. But his formulaic approach tends to overshadow this innovation. For Wall, conforming to the visual conventions of the picturesque is more important than embodying spiritual values. Though his publisher boasted that his paintings were completed on the spot rather than synthesized in the studio, Wall's art demonstrates very little of this "faithful attention to nature."

## Picturesque Parks

The picturesque aesthetic proved to be so compelling a way of looking at the landscape that it came to dominate social life as well as fine art production. Middle-class Americans turned to parks, gardens, and, ironically, cemeteries, to provide a respite from the urban environments that came increasingly to dominate their lives. As more and more people moved into cities, they adapted to urban conditions by seeking out non-urban spaces. City dwellers sought natural settings where they could meditate quietly, away from the bustle of the city. They longed for renewed contact with their own agrarian roots, and they sought to instill a taste for nature among the immigrant populations residing in the city. This hunger for the countryside stemmed from a Jeffersonian ideology that linked the success of the republic to its small landholders. Jeffersonians believed that good citizenship required economic and social independence, precisely the sort of freedom exemplified by the **yeoman** farmer. The dilemma for the nation's new urbanites was how to preserve those agrarian values in an increasingly commercial society.

The solution they invented was twofold: either bring the city to nature or nature to the city. They achieved the first in a rather unexpected way: by designing suburban cemeteries at the edge of the city. The writer Washington Irving was influential in changing public opinion about death and burial. He urged people to convert the graveyard from a place of "disgust and dismay" into a site for meditation by transforming the cemetery into a picturesque rural park. (Even the use of the word "cemetery" was new. A more gentle word than the Puritan "burying ground," it derives from the Greek for "sleeping room," and presented death in softer terms.) New ideas about death focused on melancholy, and the comfort offered by nature. Weeping willows and burial urns began to replace winged skulls and cherub's heads on tombstones.

**MOUNT AUBURN.** One of the earliest of these picturesque cemeteries, Mount Auburn, opened outside Boston in 1831 (**fig. 8.4**). Mount Auburn cemetery was fashioned according to landscape principles imported from English country estates. Situated on a popular picnic site with beautiful views of Boston, it incorporated all the central elements of picturesque design: rolling hills, variegated vistas, ponds and lakes, and a series of paths winding among the trees

VIEW FROM CONSECRATION DELL.

8.4 UNKNOWN ARTIST, *Mount Auburn Cemetery: View from Consecration Dell*, n.d. Lithograph. Courtesy Mount Auburn Cemetery, Massachusetts.

# Memorializing Death

THERE WERE MANY WAYS to mourn in the nineteenth century. Women often cut locks of hair from the dead, for example, and fashioned them into elaborate flower-like brooches. They also sewed memorial embroideries. Hundreds have survived from New England and the Mid-Atlantic states. These typically depict one or more mourners, a memorial urn, and a weeping willow tree in a pastoral setting. They were sometimes supplemented by portrait faces painted by expert miniaturists, and epitaphs printed on cloth and stitched to the fabric. Memorial embroideries were usually elaborately framed to hang in the home as a memento of a dead family member. Interestingly, the idealized images on these embroideries pre-date the actual use of a pastoral landscape as a cemetery. It is as if people first visualized the ideal setting in art, and then set about creating it in life.

While many quilters made remembrance quilts out of fabric cut from the clothing of the dead, Elizabeth Roseberry Mitchell (1799–1857) of Kentucky devised a quilt that served ingeniously as both a family record and an object of mourning (**fig. 8.5**). She created a pieced quilt in a pattern known as the LeMoyne Star. Instead of the customary large star at the center, however, she sewed a graveyard. A larger fence on the quilt's border echoes this interior enclosure.

Though Mitchell sewed this quilt after the deaths of two of her sons in 1836 and 1842, she envisioned it as a family record—not only of herself, her husband, and their eleven children, but their future families. In addition to appliquéing some two-dozen coffins (most on the perimeter of her quilt), Elizabeth Mitchell hand-stitched the outlines for many more possible coffins along the fencing that borders the quilt. Most of the coffins have strips of paper or cloth attached to them, labeled with family names. She also embroidered trees and flowering vines around the fencing of the central graveyard, making it a more hospitable place for the coffins that were eventually moved there.

After the artist's death, her daughter Sarah Mitchell Stallcup assumed responsibility for the quilt. She sewed her mother's coffin in the central graveyard, joining those of her brothers John and Mathias. Sarah Stallcup also had the unhappy task of adding the coffins of her own husband and her baby. Neither these coffins, nor those of spouses or other babies of the next generation, were put in the graveyard at the center of the quilt. The graveyard was reserved instead for the thirteen immediate members of the artist's family; in addition to the four coffins resting there, hand-stitched outlines indicate where nine others might fit. After 1870, no more coffins were moved and no more cloth strips with penned notations were added. Though the quilt passed down through the Mitchell family for ninety more years, it ceased to serve as a family death register. It became instead a reminder of the woman who had devised such a remarkable quilt.

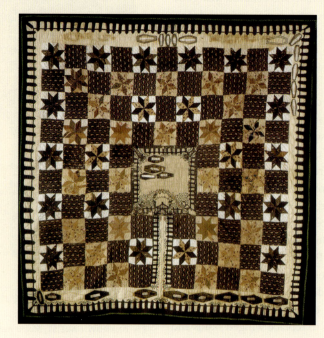

8.5 ELIZABETH ROSEBERRY MITCHELL, *Quilt*, 1843. Cotton, paper (walnut hull dyes), 85 × 81 in (215.9 × 205.7 cm). Kentucky Historical Society, Frankfort.

and shrubbery. The cemetery proved extremely popular, a site where the living, as well as the dead, could find peace. According to the architect Andrew Jackson Downing, Mount Auburn Cemetery attracted thirty thousand visitors in a single season in 1849.

What made cemeteries like this so attractive—Philadelphia, New York, and St. Louis soon opened up their own rural cemeteries—was the way they provided a counterbalance to the stresses of "modern" life. Visitors were encouraged to wander contemplatively through the landscape and to meditate on the lessons that nature taught. Those who strolled through the cemetery honored the dead by sharing with them the serenity of its picturesque surroundings. Joseph Story, a speaker at the opening dedication of the cemetery, noted the way that the vistas at Mount Auburn allowed "the rivalries of the world" to "drop from the heart." Story proclaimed that at Mount Auburn "the selfishness of avarice will be checked; the restlessness of ambition will be rebuked."

Individuals were buried in family plots there. Unlike the older, urban cemeteries, where graves and cenotaphs jostled unceremoniously against each other, Mount Auburn and other private cemeteries offered families the opportunity to remain together through eternity. The rural cemetery movement dovetailed with the growing emphasis on family life and sentimental values in Victorian society. With their picturesque surroundings and genteel atmosphere, such cemeteries converted death from a Puritan-like punishment for sin—a release from the mortal body—to a sentimentalized opportunity for family togetherness.

**CENTRAL PARK.** For those without the option of a rural burial, or a leisurely picnic among the dead, the next best thing was to bring nature to the city. Cities such as New York took their cue from the success of the rural cemetery movement to create new urban parks based on picturesque principles. The first of these urban parks was Central Park (1856–83), designed by Frederick Law Olmsted (1822–1903) and Calvert Vaux (1824–95) (**fig. 8.6**). Together with the Bois de Boulogne in Paris, Central Park was the first large urban park designed for public rather than private use. The park transposed picturesque vistas familiar from English country houses into a new type of shared urban space. Olmsted and Vaux created a variety of different landscape terrains: meadows, rolling hills, lakes, woodlands. They worked with the local topography, at the same time radically transforming what they found to give it a picturesque look. Their goal was to create an idealized nature in the middle of the city, offering New Yorkers a place of rejuvenation.

8.6 JOHN BACHMANN, *Central Park*, 1863. Lithograph. Private Collection.

For elite and middle-class urbanites, this meant a place to promenade, to see and to be seen, while enjoying the restorative power of the landscape. For immigrant and working-class New Yorkers, however, Central Park represented a break from the regimented world of factories and labor. Their desire to use it as a sometimes rowdy escape from the world of work contrasted with their employers' desires, not only to maintain an air of quiet dignity in the park, but to convert it into the equivalent of a giant, outdoor civic lesson. Middle-class Protestant New Yorkers hoped that Central Park would provide the growing number of Catholic working-class immigrants with a salutary dose of agrarian virtue. They viewed its meadows and woodlands as civilizing spaces, places where nature could exercise its healing influence upon workers otherwise doomed to the unnatural temptations of the city.

To the consternation of Central Park's working-class constituents, Olmsted and Vaux tried to ban sports and playing fields, which they felt were distractions from a more genteel and contemplative experience of nature. This debate over the proper use of Central Park continued well past its construction, as New York's working-class and immigrant populations battled the park's more well-to-do neighbors on Fifth Avenue and Central Park West over issues of proper land use well into the twentieth century. So keen was their desire to separate city from country, and in the process to preserve the nation's agrarian heritage, that Olmsted and Vaux sank the roadways that cross the park below the sightlines of those promenading through it.

8.7 FREDERICK LAW OLMSTED & CALVERT VAUX, *Central Park*, 1856–83. Print. Central Park Conservancy, New York.

They believed that any exposure to urban traffic would spoil the serenity of the park's spaces (**fig. 8.7**). After the success of Central Park, Olmsted continued to design picturesque landscapes, including the Boston and Chicago Park systems and the Stanford University campus.

## Picturesque Architecture: Andrew Jackson Downing

Olmsted's partner in the design of Central Park, Calvert Vaux, had previously worked with Andrew Jackson Downing (1815–52), the leading popularizer of picturesque aesthetics in the United States. In magazine articles and pattern books published in the 1840s and 1850s, Downing argued with the zeal of a born-again reformer for the power of picturesque settings to counter the debilitating effects of modern life. He focused on domestic life, seeing property ownership and the family as the bulwark of a democratic culture, and he believed that the physical style and layout of a house profoundly influenced the spiritual state of its inhabitants. Downing designed what he termed "villas" for the upper classes, "cottages" for the middle classes, and "farmhouses" for the working classes. Though each style derived from familiar types of European domestic architecture, they all drew upon the picturesque as an antidote to the excesses of commercial life. Downing did not actually oppose modern life. He sought instead to buttress the family against that unholy trinity of modern forces: urbanism, capitalism, and industrialism.

His picturesque architecture represents an early form of environmental reform. Downing sought to counteract the effects of city life by surrounding people with many restorative "natural" forms.

Downing designed homes that embodied what he felt was the moral power of the surrounding landscape. Because nature was picturesque and irregular, the ideal home should also be varied, "organic," and never merely "functional." A true home was more than a place of shelter; it had to express refined feelings and elevated truths. To that end, Downing advocated forms that harmonized rather than contrasted with the landscape. He urged that homes be painted in neutral colors. He favored large and simple porches so that nature's influence could be felt right up to the front door. And he doted on Italianate architecture and Gothic Revival homes. Taking his cue from the Tuscan countryside, Downing created Italianate houses with asymmetrical façades, a flat-roofed tower for surveying the landscape, a spacious veranda for relaxing with nature, and an overall rectangular "footprint" for fitting comfortably into suburban lots (**fig. 8.8**).

**ROTCH HOUSE.** One of Downing's most famous gothic cottages, the Rotch House, c. 1845–7, adapted an older tradition of British domestic architecture to the standard four-room Georgian house (**fig. 8.9**). With its steeply pitched roofs, sharply pointed dormers, gables, and ornaments, the Rotch House directed the attention of its

8.8 ANDREW JACKSON DOWNING, *A Villa in the Italianate Style*, 1850. Engraving. Private Collection.

8.9 ANDREW JACKSON DOWNING, *Rotch House* elevation, New Bedford, Massachusetts, 1845–7. Engraving. Private Collection.

inhabitants upward, drawing on a tradition of spiritualizing architectural forms. In an age of evangelical revivals, the house provided the Christian family—increasingly nuclear and isolated—with a space designed to be both nurturing and uplifting. The arrangement of the rooms, in turn, reinforced growing class divisions. As the architectural historian Clifford Clark, Jr., has noted, the working space of the kitchen was physically segregated from the social space of the family by closets, pantries, and servants' stairwells. This separation provided both groups—family and servants—with privacy and the liberty to converse amongst themselves. While the prosperous middle-class family enjoyed its picturesque surroundings, a coterie of servants labored invisibly "off-stage."[1]

Downing's homes reflected the gendered values of their Victorian inhabitants. The exterior of a Downing house, as the architectural historian Dell Upton has noted, projected an authoritative "masculine" look, while the landscape and gardens, with their more passive and softening influence, suggested the spiritualizing influence of the wife and mother.[2] Downing emphasized "honesty" and "truth" in his domestic architecture, by which he meant that the appearance of a house should reflect the social status of its occupants. Like so many other Victorians, Downing was deeply preoccupied with the anonymity of urban life. His houses countered the loss of identity on the street by reinforcing class distinctions in the home. Through its size, style, and embellishments, a Downing home announced what sort of people inhabited it. In a society "filled with an increasing number of aliens and immigrants," Downing's homes reasserted the importance of social distinctions, providing a clear vision of social place and hierarchy.

## The Anti-Picturesque: Functionalism and "Yankee Ingenuity"

While Downing turned to nature—and to European architectural forms—to counteract the effects of modernization, others, like the sculptor and art critic Horatio Greenough (1805–52), moved in the opposite direction. Greenough was a "functionalist." He wanted no Victorian fripperies, no decorative add-ons, and no aesthetic flourishes. In a series of essays collected in 1852 under the title *Travels, Observations, and Experiences of a Yankee Stonecutter*, Greenough inveighed against Greek temples, embraced vernacular design, and articulated a theory of art that presages twentieth-century modernist aesthetics.

Greenough held up America's nameless artisans and builders as the paramount designers. They, he argued, followed the surest pathway to efficiency and beauty: nature. "Observe a ship at sea!" he implored, "What academy of design, what research of connoisseurship, what imitation of the Greeks produced this marvel of construction?" (**fig. 8.10**). By listening to nature rather than imitating historical models, American shipbuilders, in Greenough's day, had designed the swiftest ships on the oceans. They had also designed extraordinarily beautiful objects: "Let us consult nature," Greenough said, if we wish to produce a "compact, effective, and beautiful engine."

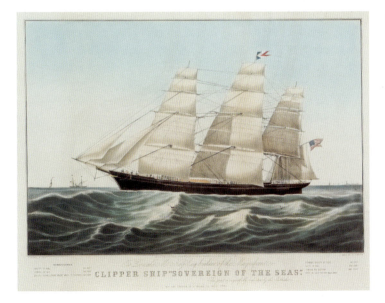

8.10 CURRIER & IVES, Clipper Ship "Sovereign of the Seas", 1852. Lithograph. Museum of Fine Arts, Springfield, Massachusetts.

For Greenough, the artisan's "consulting" nature was the right move. It allowed American artists and architects to employ Greek *principles* rather than imitate Greek structures. They could do this, he argued, by an "unflinching adaptation of forms to functions." The result would be both beautiful and useful: "I define Beauty as the promise of Function."[3]

**MECHANIZED MANUFACTURE.** Greenough relished the ease with which artisans dispensed with traditional forms and embraced their own ingenuity. Their goal was efficiency, and they sought to economize on materials, time, and labor, while maximizing speed. The result was profitable patents for some, and cheaper, more efficient manufactured goods for many. The mechanisms for steaming and bending wood, for instance, developed by Samuel Gragg of Boston and patented in 1808, allowed him to produce fashionably curvaceous sidechairs for a fraction of the cost of those produced by carving away wood from a solid block (**fig. 8.11**). Both European and American furniture-makers quickly took full advantage of this technology. In the realm of transportation, the invention of the lattice truss by Ithiel Town of New Haven, Connecticut,

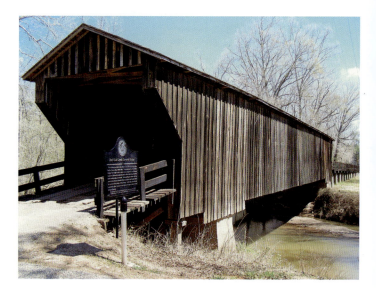

8.12 ITHIEL TOWN, Town lattice truss bridge, c. 1830. Meriwether County, Georgia.

capitalized on the rigidity of triangles to create a light, adaptable, easily assembled bridge with simplified abutment requirements which was therefore cheaper and faster to build. Pattern books then provided builders across the United States with information about the lattice truss. Of the hundreds, perhaps thousands, of wooden Town truss bridges built to span rivers and streams from Maine to Georgia in the nineteenth century, several survive and are still in service. The one illustrated here was built using a Town truss about 1830 by Horace King, slave of John Godwin, contractor, in Meriwether County, Georgia (**fig. 8.12**). Spanning Red Oak Creek, its roof and board-and-batten side sheathing protect the wooden structural members from the weather, and hence from decay.

**BALLOON FRAME CONSTRUCTION.** An even more important innovation of this period affecting all subsequent construction is the balloon frame (**fig. 8.13**). It was invented in Chicago in 1833 by Augustine D. Taylor, who built a small church for only $400 (an incredibly low sum even then). Taylor's church was crafted of light 2-inch by 4-inch timbers and nails, rather than heavy, individually cut structural members that were morticed and tenoned together joint by joint. Using fewer and less-skilled workmen, less wood, and much less time, this new technology depended on the development of mechanically made nails (purchased for less than the cost of the *tax* on nails in Europe) and standardized sizes of lumber. These structures went up so fast they appeared to "balloon" into the landscape. The technology was promptly adopted,

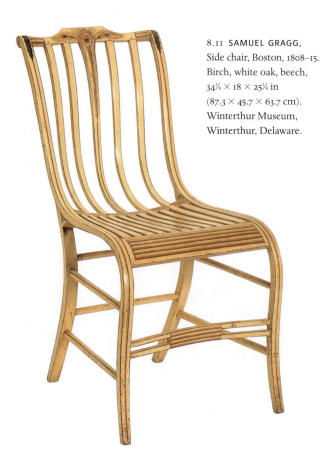

8.11 SAMUEL GRAGG, Side chair, Boston, 1808–15. Birch, white oak, beech, 34⅛ × 18 × 25⅛ in (87.3 × 45.7 × 63.7 cm). Winterthur Museum, Winterthur, Delaware.

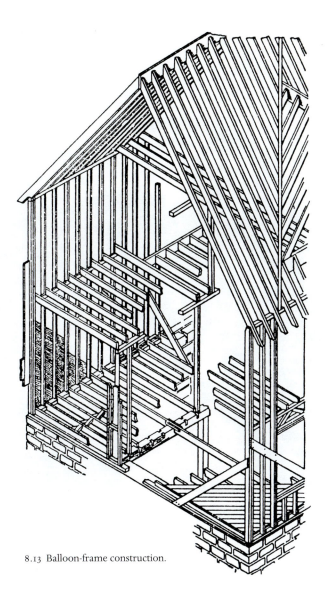

8.13 Balloon-frame construction.

8.14 WILLIAM MUNSON, Eli Whitney Gun Factory, c. 1826-8. Oil on canvas, 24¼ × 29½ in (61.6 × 74.9 cm). Yale University Art Gallery, New Haven, Connecticut.

especially in the fast-developing Midwest. It continues to be standard carpentry for houses, in this country and elsewhere, today.

**INTERCHANGEABLE PARTS.** This drive to build ships, houses, and bridges more cheaply, quickly, and efficiently also brought substantial changes to the daily life of artisans, mechanics, and workers. Because shops became larger in the early nineteenth century to take advantage of volume production and distribution of wares, the capital necessary to start a competitive business rose dramatically. Fewer and fewer artisans could rise above wage labor status. At the same time, the new concentration of labor meant increasing specialization on the part of each journeyman, and hence a greater distance from the finished product. As early as 1800 journeymen identified themselves as a class and engaged in oppositional politics with masters on a city-wide basis in New York, Hartford, and elsewhere.

New relations between master-entrepreneurs and journeymen, and new tools—the power drill, trip hammer, and power loom—were not the only changes in the workshop culture in antebellum America. Perhaps the most pivotal innovation was the principle of interchangeable parts. Just as standardized lumber contributed to the development of the balloon frame, standardized interchangeable parts in manufactured goods enabled businesses to make objects more quickly and inexpensively, required less training for workmen, and led to the development of what has been called "the American system of manufactures," with rationalized machine-assisted movement of goods through an assembly-line manufacturing process. Eli Whitney's gun factory in New Haven, Connecticut, pictured in William Munson's painting of 1826–8, made the first guns with interchangeable parts (**fig. 8.14**). They worked better, were easier to repair and cheaper to produce than guns made individually from start to finish by a single, highly trained craftsman. Whitney built worker housing—looking like interchangeable parts—suggesting that workers were also, now, more interchangeable, which, in fact, was the case. Manufacture now concentrated skill in the hands of a single designer, requiring less skill and ingenuity on the part of fabricators and assemblers. The passion for efficient forms of industrial production would culminate, a century later, in Henry Ford's invention of the moving assembly line.

# The Sublime: The Formation and Development of the Hudson River School of Painting

In the same years that Downing helped popularize the picturesque landscape, and Greenough converted nature into a lesson in practical design, artists and entrepreneurs were discovering the commercial possibilities of sublime prospects and mountain vistas. In 1824, a small tourist hotel opened in the Catskill Mountains near Kaaterskill Falls, New York. Situated high upon a rocky ledge with breathtaking views of the nearby ridges and valleys, the Catskill Mountain House provided its visitors with an opportunity to experience the wilderness from the comfort of a private room. Visitors to the Catskill Mountain House were awakened each morning by a hotel employee, who would arouse them just in time to catch the rising sun. They would spend the rest of the day exploring the nearby woods, visiting Kaaterskill Falls, or awaiting the late-afternoon thunderstorms that often raged in the valley below. Their experiences mark the beginning of a national love affair with the wilderness, an affair all the more popular for being consummated from the safety of a hotel balcony.

Edmund Burke had insisted that terror by itself was not sublime (see page 243). The sublime required an assurance of safety: powerful forces viewed from a distance. The Catskill Mountain House provided tourists with a way of testing Burke's statement.

8.15 JOHN RUBENS SMITH, *Catskill Mountain-House: A Celebrated Summer Hotel*, 1830. Colored aquatint. New York Public Library.

## The Practice of Landscape Appreciation

The first guests at the Catskill Mountain House tended to be elite or middle-class travelers from Boston, New York, and the urban centers of the northeast. They arrived at the mountain as one leg of a larger "pilgrimage" that frequently included Niagara Falls and the springs at Saratoga. Their goal included more than relief from the summer heat, or a quest for novel experiences. They sought a first-hand encounter with the spiritual possibilities of the landscape. The way had been paved for them, metaphorically speaking, by an outpouring of prints, travel books, and pamphlets in the 1820s and 1830s extolling the pleasures of landscape viewing. With the help of these guidebooks, visitors to the Catskill Mountain House saw themselves less as travelers than as "pilgrims," finding in the vistas before them a glimpse into "divine" truth. Upon reaching the summit, one traveler noted that he immediately "leaned upon my staff," gazed out at the "omnipotent picture" before him, and "looked abroad upon its God-written magnitude." The language reveals the traveler's reliance on contemporary travel literature, which frequently described the landscape as sacred space. The "staff," a necessary prop for any would-be pilgrim, appeared in countless images of mountain visitors.[4]

**CATSKILL MOUNTAIN-HOUSE.** This print from 1830 depicts a group of genteel travelers climbing South Mountain en route to the hotel (**fig. 8.15**). The vertical format of the print highlights the sense of ascent, suggesting that the hotel represents not only a physical but a spiritual endpoint to a morally edifying journey. As scholar Kenneth Myers points out, the focus in the image on the travelers themselves, rather than on the vista that they view, draws our attention to "the practice of landscape appreciation itself."[5] Three figures point off to the distance; their gesture underscores the act of instruction.

They teach their fellow travelers how to see, offering their companions—as well as the viewer of the print—an edifying lesson in landscape appreciation.

**NIAGARA FALLS.** Similar lessons were available to visitors at Niagara Falls. Niagara was depicted so frequently in gift books, travel literature, and popular prints that it was virtually impossible for anyone in the nineteenth century not to be familiar with its general appearance. Niagara became a required destination on every tourist's itinerary. Charles Dickens, visiting the United States in the early 1840s, brought back a "small piece of rock from the Niagara Falls" for his mother, and promised a friend a "phial [vial] of Niagara water."

Like the Catskill Mountain House, Niagara offered its viewers a glimpse into God's secret workings. Edward Hicks (1789–1849), for example, a Quaker preacher and painter, recast the falls as a natural wonderland, a place where beaver, deer, and tourists all enjoyed the spectacle of God's presence (**fig. 8.16**). Hicks's painting, of 1825, domesticates the "awful" terror of the falls, converting Niagara from a spectacle of raw power to an emblem of God's omnipotence. In so doing, he places the sublime in the service of an American national "religion." He also eliminates the many signs of commercial development that surrounded the falls in the early nineteenth century. By portraying Niagara as a pristine landscape, Hicks converts it from an overdeveloped tourist site—with hotels, factories, and shops—to an unspoiled place of spiritual renewal. The falls embodied for Hicks, as for the many tourists who visited Niagara, a reminder not only of God's presence in the world, but of that special covenant that nineteenth-century Americans felt linked them, and the nation as a whole, to nature and nature's God.

## Politics by Other Means: Thomas Cole

At the same time as Hicks was painting his view of Niagara Falls, Thomas Cole (1801–48), a twenty-four-year-old English immigrant, arrived in New York, pencils and sketch-book in hand. As a youth in Lancashire, in northern England, Cole had grown up in a family of artisans and skilled tradesmen in the early years of the Industrial Revolution. Emigrating as a teenager with his family to Philadelphia, Cole spent the next few years wandering through western Pennsylvania and Ohio as an itinerant artist. Eventually he studied drawing at the Pennsylvania Academy of the Arts and viewed with admiration the

8.16 EDWARD HICKS, *The Falls of Niagara*, 1825. Oil on canvas, 31½ × 38 in (80 × 96.5 cm). Metropolitan Museum of Art, New York. Gift of Edgar William and Bernice Chrysler Garbisch, 1962.

works of early landscapists on display in Philadelphia. He would come to revolutionize American landscape painting. Though never the leader of a formal school or academy, Cole spearheaded a movement among many New York artists to paint the mountainous regions north of New York City. Known loosely as the Hudson River School, these artists often traveled and sketched in the summer, when the weather was good, and then returned each winter to their studios in New York to compose oil paintings based upon their earlier sketches.

Steeped in European theories of art, Cole insisted on the "great and serious" calling of the artist. Unlike other early landscapists in America, he reacted strongly against any notion that his pictures should be literal transcriptions of what the eye sees. He believed instead in a "higher style of landscape," a way of imbuing the landscape with "moral and imaginative" power. He achieved that by sorting through and then combining sketches made outdoors into a built "composition" at his studio. Landscape composition for Cole was never a "dead imitation" of nature, but an imaginative leap into those "invisible" meanings that lie unseen on the other side of nature. He proclaimed that, "If the imagination is shackled, and nothing is described but what we see, seldom will anything truly great be produced in either Painting or Poetry."[6]

**EXPULSION FROM THE GARDEN OF EDEN.** In this painting of 1827–8, Cole places his sense of landscape painting's "higher style" in the service of social criticism (**fig. 8.17**). The painting is divided into two halves: Paradise on the right, and a turbulent and primeval landscape on the left. Eden has been painted according to the conventions of the beautiful—symmetry, balance, and harmony—while the fallen world leaps straight out of Burke's treatise on the sublime. Its volcanic peaks and writhing forms suggest dangers unimagined in Paradise, where a pair of swans glide

8.17 THOMAS COLE, *Expulsion from the Garden of Eden*, 1827–8. Oil on canvas, 39 × 54 in (99 × 137.1 cm). Museum of Fine Arts, Boston, Massachusetts. M. and M. Karolik Collection.

gracefully upon an undisturbed lake. Their innocence contrasts with the tiny but poignant forms of Adam and Eve, who stand on the far end of the rocky bridge that separates Eden from the savage world before them. Exiting Eden, Adam looks back wistfully to the massive archway that now bars his return. The gentle diffusion of light in Eden has turned suddenly into a series of dagger-like spikes. Eve gazes downward and forward. Ashamed at her disgrace, she looks to the earth as the source of her future toil and sustenance.

Cole depicts Adam and Eve as Janus-like figures. Their divided posture summarizes, in miniature, the larger dualisms that define the painting: Eden and exile, light and darkness, sun and volcano, safety and danger. The Expulsion occurs for Adam and Eve as a fall into historical time, the great enemy, along with change. The left foreground is dominated by a towering tree blasted by a storm: unlike the changeless foliage of Eden, this tree will never return to its earlier state. It has been altered permanently by history. At its base, a vulture and wolf compete for the remains of a fallen animal. Their existence is defined by struggle and death. The bent form of the palm trees above them echoes, in turn, the hand-in-hand pose of Adam and Eve: mankind's fall carries all nature in its wake. Change and instability dominate the left half of the canvas, from the cascading waters below Adam and Eve to the spewing volcano directly above them. A large crack runs through the granite bridge they cross, suggesting that even the most stable of terrestrial forms might crumble at any moment.

Cole's painting pictures Eden as a stable, preindustrial landscape. It views the fallen world of Adam and Eve, by contrast, as a realm of history, a landscape defined by change, time, and death. And it defines the human condition as forever divided between memories of an agrarian past and prospects of a clouded future. Without so much as a single reference to factories, mills, or industry (aside from the black smoke of the volcano itself), Cole provides a radical critique of the Industrial Revolution, which he defines not by its machinery but by its effects.

To understand Cole's critical response to industrialization, we need to direct our attention to an event that occurred in New York City in the summer of 1825. The *Seneca Chief* arrived in New York from Buffalo, the first steamboat to travel the newly opened Erie Canal. Completing her passage from Lake Erie to the Atlantic in nine days, the *Seneca Chief* inaugurated a new era in American life, ushering in a commercial revolution that would soon affect the lives of every inhabitant. The Erie Canal opened up Western wares to eastern markets at a

time when horse-drawn wagons were so expensive that it cost almost as much to transport goods thirty miles by land as it did to ship them three thousand miles across the Atlantic. Built by Irish immigrants, who worked for less than $10 a month and a daily ration of whiskey—but who were later excluded from the ceremonies that marked the canal's debut—the Erie Canal represented the greatest engineering triumph of its day.

How did a young man raised in the British industrial heartland come to distrust the new commercial world represented by the Erie Canal? The answer lies in Cole's background. His parents had fled Lancashire during the long economic depression that followed the Napoleonic Wars. His father had drifted from one profession to another, incapable of supporting his family while in England and doomed, once the family settled in the United States, to a series of business disasters. For the young Cole, the lesson was clear: the Industrial Revolution was more curse than blessing. What others termed "progress," Cole experienced only as a source of loss and displacement. He distrusted change, and he interpreted the spread of commerce and industry—what he termed the "groveling pursuits"— as disruptions to the stable rhythms of a preindustrial landscape.

***THE COURSE OF EMPIRE.*** Cole traveled to Europe in 1829, where he witnessed firsthand the political turmoil in Italy and the class hostilities leading up to the July Revolution of 1830 in France. Upon his return, he proposed a series of five paintings depicting the rise and fall of empire to Luman Reed, a self-made man of humble origins who had accumulated a fortune in the wholesale grocery business. By creating an art gallery in his New York home, Reed elevated his own social respectability. He opened the gallery once a week to the public. Cole's *Course of Empire* straddled the fireplace in Reed's art gallery: two paintings (one hung above the other) on both sides of the fireplace, and one painting, larger than the rest, over the mantle. Moving sequentially, the canvases are keyed to the times of day. The first painting in the series, *The Savage State*, shows a group of hunter-gatherers amidst a turbulent sunrise in early spring. The last picture, *Desolation*, features architectural ruins against an elegiac sunset. The three canvases in between (**figs. 8.18–8.20**) represent corresponding moments in the progress of a day, a year, and an empire.

They also represent a profoundly pessimistic vision of Jacksonian society. Completed in 1836 during Andrew Jackson's second presidential term, Cole's five canvases suggest the fate awaiting any nation wed excessively to profit and self-interest. Cole viewed Jackson and the

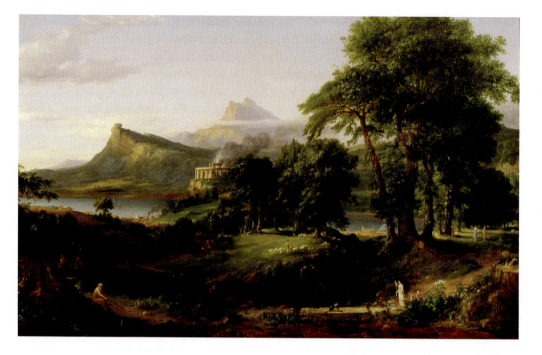

8.18 THOMAS COLE,
*The Course of Empire:
The Pastoral State*, 1834.
Oil on canvas, 39¼ × 63¼ in
(99.6 × 160.6 cm). New-
York Historical Society.

Democratic Party with unease. Comprised of a shifting alliance of Western farmers, Southern slaveholders, and small businessmen along the eastern seaboard, the Democratic Party embodied almost everything that Cole feared: commerce, partisanship, and materialism. Cole was especially critical of the myth of progress that underpinned Jacksonian optimism and justified westward expansion. Like many of his patrons he favored a politics of deference,

one in which an educated elite exercised a form of benevolent stewardship over others. He feared the vulgarity and ignorance of the mass of men, and he saw the popularity of Andrew Jackson, whom Cole regarded as nothing more than a demagogue, as proof of his fears.

*The Course of Empire* might be read as Cole's meditation on the past, present, and future of the American republic. The series expresses not only his ambivalence about the

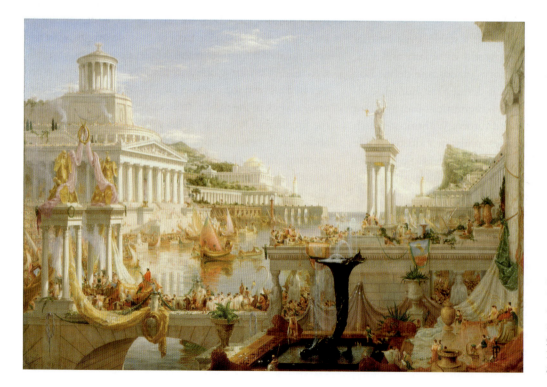

8.19 THOMAS COLE,
*The Course of Empire: The
Consummation of Empire*,
1835–6. Oil on canvas,
51¼ × 76 in (130.1 × 183 cm).
New-York Historical
Society.

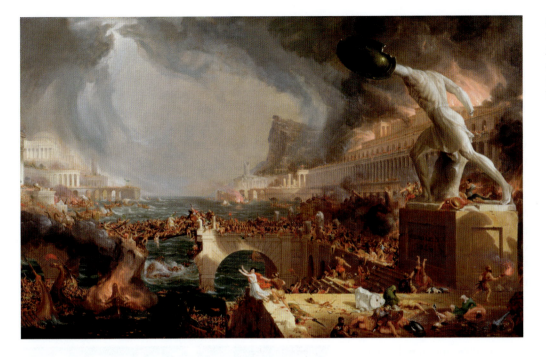

8.20 THOMAS COLE, *The Course of Empire: Destruction*, 1836. Oil on canvas, 33¼ × 63¼ in (84.4 × 160.6 cm). New-York Historical Society.

relation of civilization to nature, but his deeper anxiety about the fate of the republic presided over by figures like Jackson and in the grip of unfettered capitalism. Cole countered antebellum notions of progress with an older and more aristocratic understanding of history as cyclical in nature. He believed that no society, however powerful, could endure forever. Civilizations, like individuals, begin in youth and glory but conclude in disillusionment and death. For Cole's American viewers, the issue was not whether his vision was correct, but whether it applied to *them*. Was the doom foretold in *The Course of Empire*—the passage from greatness to destruction—a record of past civilizations or a prophecy about the future of the United States itself?

*The Course of Empire* unfolds as a drama of hubris, both individual and collective. Cole's version of a modern hero-turned-demagogue appears at the lower left of *Consummation*, the third and largest canvas, presiding over a triumphal procession across the painting's foreground (see fig. 8.19). In ornate splendor, the red-robed figure surrounds himself, as Cole wrote, with "captives on foot, and a numerous train of guards, senators &c." This figure is a reference to Andrew Jackson, who was to Cole an American Caesar, a democrat turned military hero, conqueror, and usurper. Cole's emperor embodies all that can go wrong in society when wealth and status replace the simpler virtues seen in the previous canvas, *The Pastoral State*. Democracy turns into demagoguery, as a reverence for nature—the central theme of the earlier canvas— degenerates into a worship of power and empire.

The implications are clear. The very principles that propel civilization to its greatest achievements—the ability to reason and abstract, linked in practice with the capacity to conquer and subdue—now spell its doom. What had once existed in *The Pastoral State* as a celebration of mankind's higher faculties turns at the moment of *Consummation* into ostentation and self-congratulation. In that central canvas, despotism replaces republican virtue, and civilization exceeds its rightful limits.

The mountain peak that reigns majestically in the background of the first two canvases is barely visible in *Consummation*; its sides have been built over with roads, battlements, and terraces. Only in *Destruction* does nature reassert itself in the form of furious storms, billowing smoke, and roiling waves, and only in *Desolation* does nature finally settle in for the long, slow task of reclaiming the landscape from the human ruins that litter it.

Cole's series is thus not about nature but politics. *The Course of Empire* describes the ways that democracy, when left in the hands of the masses, turns into what anti-Jacksonians like Cole termed "mobocracy." As cities in the United States felt the first sting of the Industrial Revolution, as wage labor transformed artisans into de-skilled workers, as neighborhoods began to swell with foreign immigrants, as the issue of slavery loomed increasingly across the boundaries between North and South, and as partisan party politics replaced earlier, more fluid political boundaries, Cole looked to the future with trepidation. *The Course of Empire* represents his effort to reinvent landscape art as a mode of moral critique.

## Democratizing the Landscape: Asher B. Durand

Cole's ambivalence about the future ended abruptly in 1848, when he died unexpectedly at his home in Catskill, New York. At the time of his death, Cole was universally acclaimed as the "father" of American landscape painting. The great irony of Cole's career, however, lies in how much his successors ignored it. Cole was more revered than followed. His successors borrowed his forms—his ways of constructing a landscape—without also adopting his political point of view. Where Cole criticized Jacksonian optimism and cautioned against American dreams of empire, his followers reversed direction: they converted American landscape painting from an exercise in social criticism to an endorsement of American expansionism and Manifest Destiny.

***KINDRED SPIRITS.*** We can see this move away from Cole's work in Asher B. Durand's (1796–1886) memorial portrait to Cole, *Kindred Spirits* of 1849 (**fig. 8.21**). The picture yokes the painter Cole with the poet William Cullen Bryant on a stone outcropping within a wilderness scene reminiscent of Cole's own paintings. The names of the two men appear on a tree in the left foreground, while below the promontory a broken tree trunk that echoes Cole's blasted trees provides an emblem for his truncated life. The right half of the tree plunges toward the earth, while its left portion points to the ribbon of water that conducts the eye into the distance. The tree thus provides a metaphor for death and salvation. It directs the viewer away from its own fallen history in the foreground to the distant promise of the background sky.

The composition of the painting formalizes the tension between foreground and background, surface and depth. The rounded sweep of trees in the left corner of the canvas arches across the top and then bends down to the right, where it meets the answering line of cliffs. The movement creates a circular, doughnut-like form that opens at its center into the light-filled depth of the background, a movement reinforced by the angle of the promontories and the pointing figure of Cole, each directing the viewer toward the sky. The viewer must break out of the luxuriant foreground world in order to ascend along a visual pathway defined by stream and birds to a more generalized world of light—and spirit. The "kindred spirits" of the title refer not simply to Cole, Bryant, and the "sister arts" (painting and poetry), but to the larger relation of the individual to nature, and beyond that, of nature to a spiritual realm visible through it.

Where Cole emphasized danger in his landscapes, and created a sense of vertigo in his rock outcroppings, Durand domesticates Cole's wilderness into a womb-like enclosure that protects rather than threatens. Where Cole required his viewer to make a perilous journey across the canvas, Durand opens up the center of the canvas for the viewer's visual delectation. Where Cole addressed his viewer in stern and didactic tones, Durand offers instead an optimistic vocabulary of spiritual uplift. Durand abandons Cole's allegorical imagery for a version of nature that feels comforting and familiar.

There are reasons for this change. Durand's painting addresses the fundamental challenge facing American landscape painting in the two decades before the Civil War. What role does landscape painting play in a nation committed to westward expansion and commercial growth? In what ways can it affirm the expansive optimism

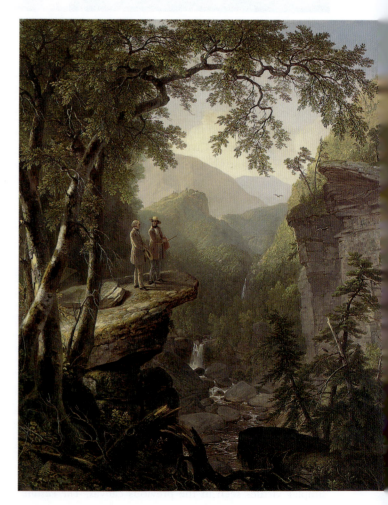

8.21 ASHER B. DURAND, *Kindred Spirits*, 1849. Oil on canvas, 46 × 36 in (116.8 × 91.4 cm). On loan to the National Gallery of Art, Washington, D.C. Courtesy the Walton Family Foundation.

of American society? Durand's answer to these questions is to democratize Cole's landscape. He removes the visual impediments. He promises a safe trip. And he offers two guides—a painter and poet—to assist us on our journey. Rather than admonish the viewer about the dangers facing the nation, Durand encourages the viewer to find personal and spiritual fulfillment in the landscape.

The trick lies in the eye. *Kindred Spirits* is first and foremost a painting about seeing. The viewer gains access to the landscape not by actually traversing it, but by taking imaginative possession of it. We see into the heart of nature, finding light, energy, and redemption in a Catskill landscape. For Durand, nature embodies those spiritual values most cherished by the middle classes: innocence, optimism, and progress. To voyage into nature is to voyage away from the social ills that might otherwise define daily life in the 1840s. What we do not find in Durand's Catskill scenery—what is pointedly missing—is a litany of social problems: no battles over slavery, no urban unrest, no economic anxiety, no class division.

## The New National Landscape: Frederic Edwin Church

In the years after Cole's death, no artist was more responsible for reimagining the landscape as an embodiment of collective as opposed to private values than Frederic Edwin Church (1826–1900), Thomas Cole's only student. Church took up the mantle of "heroic landscape" art in the United States. The son of a prominent Hartford businessman, he spent two years in the mid-1840s in Cole's studio, learning from him the "higher calling" of landscape composition. For Cole, the artist was always a solitary visionary. For Church, on the other hand, landscape painting was a way of taking the national pulse. Nature and nation were virtually identical concepts. In a manner that was more naturalistic and less stylized than Cole's, Church portrayed nature in tones that mirrored the national mood. In the 1840s and early 1850s, Church's imagery tended to be affirmative, expansive, and optimistic. As regional tensions increased and the country drew ever nearer to war, his work—like that of many of his contemporaries—became increasingly strident and melodramatic. With garish colors and turbulent skies, Church's New World landscapes grew apocalyptic in tone, visual reminders that the nation was edging ever closer toward conflict.

**THE INFLUENCE OF CLAUDE LORRAIN AND THE "MIDDLE LANDSCAPE."** The transformation of the landscape from a space of private feelings to an embodiment of national values depended historically upon two developments. The first was the creation of what scholars such as Leo Marx have termed the "middle landscape." Playing upon the notion of America as "Eden," viewers of nature sought neither wildness nor tameness, but a middle ground between the two. They turned to the paintings of the seventeenth-century French artist Claude Lorrain (1600–82) for their inspiration. Claude's canvases move from a foreground framed by trees, to a middle-ground space where Arcadian shepherds frolic, to a background of distant vistas and visionary prospects. For American artists, Claude's compositions provided a model for organizing space in terms of time. Each of the painting's planes represented a different stage in the history of the republic. When viewed in succession, they created a narrative of national progress. By moving visually from foreground to background, the viewer repeated the history of the nation as whole, a temporal progress from the clearing of the wilderness to the creation of an agrarian republic (see fig. 7.12).

Paintings of the middle landscape all told a single tale: the triumph of civilization over wilderness. The story was in the composition. In the foreground plane were to be found the remnants of wilderness, usually in the form of tree stumps and forest clearings. Such scenes stood as witnesses to an older frontier, an earlier moment in the history of the nation. The middle ground, by contrast, displayed farms, fences, and houses, reminders that what was once wilderness had subsequently been tamed. The middle-ground plane confirmed the success of American history: the larger transmutation of nature into an agrarian paradise. The background embodied the future, the space toward which society aimed, the place in the painting where land and sky, man's progress and God's promise, merged into one.

**MERGING THE LOCAL WITH THE NATIONAL: NEW ENGLAND.** The second ingredient crucial to the nationalization of the landscape is the conversion of local places and events into sites of collective importance. As sectional differences intensified in the decades before the Civil War, artists, writers, and intellectuals attempted to imagine a version of the landscape untouched by regional tensions. They sought to achieve in their art what they could not experience in their lives: a feeling of national unity. The more polarized the nation became—the more riven by divisions of city and country, black and white, wage earner and capitalist, North and South—the more pressure these artists experienced to heal or revivify the national mood. They did so by turning to local vistas and imbuing them with shared national values.

New England in particular came to embody the spirit of the nation as a whole. The demand for images of New England was fed by a theory known as "associationism," a belief that the landscape was important not for its intrinsic features, but for the historical associations that it conveyed. Thus, for instance, Church's *New England Scenery*, 1851, pictures what the viewer might think of as a "New England of the Mind," a composite landscape that combines pastoral conventions, historical allusions, and invented geography (**fig. 8.22**). The background mountain, for example, alludes to the central peak in Cole's *Course of Empire*. It helps Church stake his claim as a rightful heir to Cole's heroic style. It bears little resemblance to any actual peaks in New England. The small white church steeple nestled against the mountain alludes, in turn, to New England village life, recalling the original religious ideals of European emigration that associate the taming of the wilderness with freedom of worship.

The Conestoga wagon, in turn, suggested westward expansion to nineteenth-century viewers. By locating the wagon in New England—as opposed, for example, to St. Louis, the jumping-off point for settlers heading west in the 1850s—Church renders New England as the embodiment of a westering, national spirit. He also converts the notion of westward expansion from a social and economic phenomenon, a rather brutal process of land appropriation and anti-Indian policies, into a saga of collective spiritual journeying. What began in the seventeenth century as a religiously motivated quest continues right up to the present. Church's cozy, canvas-covered wagon carries the burden of civilization with it. It extends the values of a democratic republic to an untamed wilderness. In the process, it also affirms the centrality of New England to the national mission. The spirit of Plymouth Rock hovers over the pioneers at Pike's Peak.

New England was anything but a distillation of American values. Its leaders tended to be Whigs and dissenters from the national consensus. It staunchly opposed the Mexican War of 1846–8, seeing it as a barely disguised land grab by the South and West, an unwarranted opportunity to extend slavery westward. Its population tended to be better educated than the rest of the nation; its countryside was filled with factories and other harbingers of the industrial

8.22 FREDERIC EDWIN CHURCH, *New England Scenery*, 1851. Oil on canvas, 36 × 53 in (91.4 × 134.6 cm). George Walter Vincent Smith Art Museum, Springfield, Massachusetts. George Walter Vincent Smith Collection.

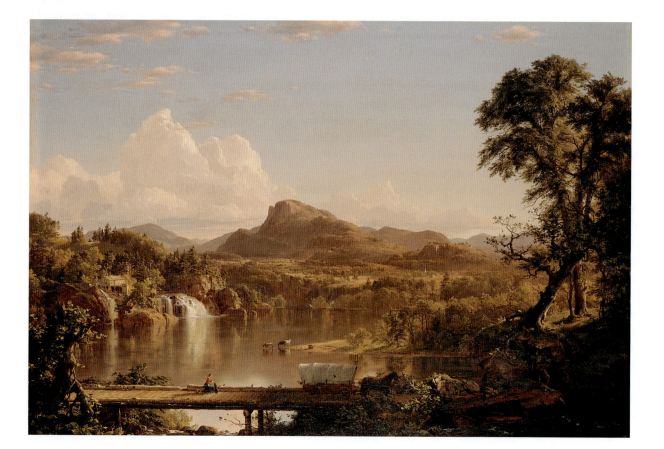

8.23 CURRIER & IVES, after G.H. DURRIE & J. SCHUTLER, *Home to Thanksgiving*, 1867. Lithograph. Museum of Fine Arts, Springfield, Massachusetts.

age to come; its woodlands were being cut down in order to provide fuel for the rapidly expanding railroads; and its farms were undergoing a precipitous decline as tillable land grew scarce and the soil became exhausted. Even its central ports, cities such as Boston, Providence, and New Haven, were all losing ground to New York, which by mid-century reigned supreme as the nation's commercial capital.

What New England possessed that the rest of the nation lacked was a rich civic mythology. Artists and writers increasingly came to associate New England's Puritan past with a history of civil and religious freedom. They defined the region's revolutionary tradition—the battles of Lexington and Concord, the Boston Tea Party, the saga of Paul Revere—as embodiments of a national spirit. They converted New England from a troubled industrial center to a spiritual standard-bearer for the nation. As its exports declined, its value as a center of culture increased. Paintings like *New England Scenery* combined with poems like Longfellow's "The Midnight Ride of Paul Revere" to celebrate a national history viewed through local New England eyes. Artists and writers converted the region from an increasingly marginalized commercial area to the embodiment of national—or at least Northern—values.

At the same time that Church was mythologizing the New England landscape, popular printmakers such as Currier and Ives were marketing images of American scenes for those who could not afford an original oil painting. In *Home to Thanksgiving*, for example, Currier and Ives translated a winter scene by the New England painter George Henry Durrie (1820–63) into a fond reminder of agrarian values and "the good old days" (**fig. 8.23**). The

print links the New England countryside not only to the Pilgrim past, but to the contemporary rituals of family togetherness. New Englanders had long campaigned to make Thanksgiving a national holiday. Led in part by the efforts of the novelist Harriet Beecher Stowe, they succeeded when Abraham Lincoln (1809–65), at the height of the Civil War, proclaimed a national day of "thanksgiving" to be held annually on the last Thursday of each November. *Home to Thanksgiving* unites families and friends of different generations in a shared moment of renewal. The cold of the snow and sky is overcome by the tidy order of the New England farmstead. The animals are well tended, the buildings in good repair, and the wood supply abundant. The rectilinear composition—the use of horizontals and verticals to organize space—reinforces the viewer's sense of order. The general air of serenity in Durrie's landscape represents a larger national dream of harmony embodied in the New England farm.

**GEOLOGY AND CHURCH'S "GREAT PICTURE": *HEART OF THE ANDES*.** Despite our tendency today to segregate art and science into separate spheres, painters and scientists in the nineteenth century still viewed each other as close allies. Artists and illustrators regularly accompanied scientific expeditions to the American West, and scientists often turned to artists to help visualize and popularize their findings. In the early part of the century, geology was the queen of the sciences. Geologists had recently come to understand the world as having developed over millions of years. Their long view of history challenged the more traditional account in Genesis of a universe created in only

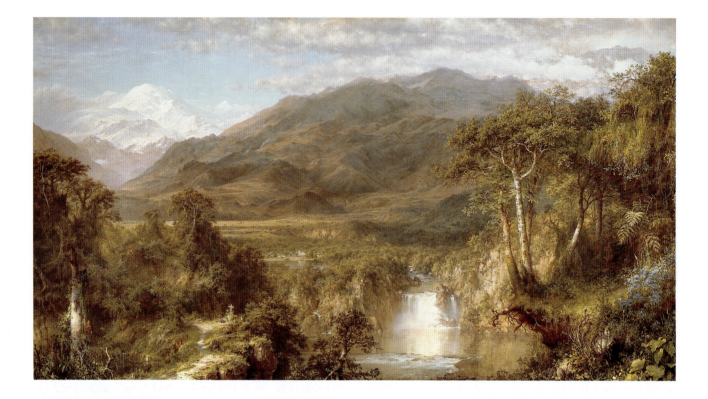

8.24 FREDERIC EDWIN CHURCH, *Heart of the Andes*, 1859. Oil on canvas, 5ft 6⅛ × 9ft 11¼ in (1.68 × 3.03 m). Metropolitan Museum of Art, New York. Bequest of Margaret E. Daws, 1909.

six days. Though geologists were divided over whether change happened in rapid and cataclysmic events (a theory known as "catastrophism") or occurred instead in slow and gradual shifts, they were united in their understanding of geologic time as part of the "big picture." What brought painters and geologists together, as the art historian Rebecca Bedell has noted, was their shared commitment to "a careful observation of the natural world." Both "were dedicated to illuminating the diversity and order of God's creation. Moreover, both geologists and landscape painters were self-conscious participants in the antebellum enterprise of nation-building."[7]

Church traveled twice to South America, in 1853 and 1857, following the footsteps of the German naturalist Alexander von Humboldt (1769–1859). Humboldt's five-volume *Cosmos* had portrayed the mountains of Ecuador and Colombia as ecosystems that were biologically diverse and geologically complex. He had also pointed to the larger unities of nature, which he understood as located in both science and religion. Church converted the lessons of *Cosmos* into an occasion to paint nature on a grand scale (5 feet 6 inches × 10 feet) in *Heart of the Andes* of 1859, which he termed the "Great Picture" (**fig. 8.24**). Humboldt had valued the Andes of South America for the way they embodied an unusually diverse range of New World ecosystems, from alpine valleys and meadows to majestic, snow-capped peaks, each flowing into the other within the

span of a few miles. Following Humboldt, Church divides his canvas into a series of visual bands, set one on top of the other, and each representing a different geological or ecological zone. The foreground overflows with the vegetation of an alpine valley. In the right corner the viewer spots a tree fern, a large-leaved anthurium, and a climbing vine, all plants of the humid mountain valleys. The exposed rock face of the middle-ground cliffs—set in the right center of the painting against the vertical forms of the towering tree ferns—reveals the patterns of erosion that, for Humboldt, characterized the earth's crust. Humboldt believed in geological instability rather than stability. Church's landscape similarly portrays a world of change and accommodation. As one of the pamphlets accompanying the exhibition of *The Heart of the Andes* notes, the mountains in the painting, climbing one above the other, provide "tokens of primeval convulsions; proofs everywhere of change, building, razing, upheaval, sinking, and deliberate crumbling away."

At the same time that *The Heart of the Andes* displays a Humboldtian vision of ecological diversity, it also hints at a more traditional Christian narrative of spiritual salvation. Drawing on John Bunyan's *Pilgrim's Progress*, a seventeenth-

century allegory popular throughout the nineteenth century, Church constructs his Andean landscape as a visual pilgrimage. The viewer commences his journey in the dense foliage of the lateral foreground, and soon encounters pilgrims praying before a cross on a sunlit ledge on the left. The voyage beyond is filled with earthly perils and tribulations, through the painting's middle ground, where the "war of light and shade" that defines the central mountain represents the "vigor and toil and perplexity" of the pilgrim's upward struggle. Only after ascending to the "region of final mysterious battle in clouds and darkness, on the verge of final triumph beyond the veil," can the viewer-pilgrim at last take refuge in the "Dome of snow," the "emblem of permanent and infinite peace." By converting the biological diversity of the foreground into the worldly adversity of Christian allegory, Church knits together nature and nature's God into one seamless spectacle.

The theatrical nature of Church's painting is deliberate. *The Heart of the Andes* was displayed in cities from Boston to St. Louis, in theaters and auditoriums that Church rented specifically for the purpose (**fig. 8.25**). Church flanked the painting on both sides with drapes, pulling them back so as to suggest the view from a South American hacienda window. The picture's enormous walnut frame was carved, in turn, to resemble a window frame. Above the painting, the viewer discovered portraits of the first three presidents of the United States: George Washington, John Adams, and Thomas Jefferson. By placing the Founding

8.25 UNKNOWN PHOTOGRAPHER, Frederic Church's *Heart of the Andes* in its original frame, exhibited with other works of art at the Metropolitan Fair in aid of the Sanitary Commission, New York, April 1864. Stereograph. New-York Historical Society.

Fathers above a South American landscape, Church revealed both the imperial ambitions of American policy (there was talk in the 1850s about American colonization of portions of South America and the Caribbean) and the linkage between "patriotism" and the landscape. Program guides were sold at the entrance to the exhibition, and the viewer was invited to view the painting through opera glasses, following the point-by-point references in the guidebooks as if moving visually through the Stations of the Cross. The dramatic effect was then completed by artificial lighting, a cordoned-off viewing space, and a general hush of reverence in the exhibition hall.

*The Heart of the Andes* marries science to religion, and then markets both to the new mass audiences that were developing in cities throughout the nation. Through diligent advertising, well-placed reviews, and splashy openings, Church helped transform painting from art to entertainment. His exhibition practices bypassed the usual procedures. Rather than displaying his art in group exhibitions mounted by the National Academy of Design or some other art institution, Church leapfrogged the traditional institutional arrangements and appealed directly to the public. He helped create a democracy of the curious and the paying. In the process, he paved the way for future artists who hoped to promote their own art in a profitable fashion. By weaving together art, science, religion, and nationalism, Church created an art of mass appeal. By the time of the Civil War, he had become America's first "superstar" artist. His paintings were the subject of public discussion; his exhibitions drew large crowds who often waited in line for hours to see a single work; and his canvases sold for enormous sums of money.

## Feminizing the Landscape: Luminism

The Hudson River School of painting rapidly declined in popularity in the years following the Civil War. After the carnage of battle, the cheerful optimism of antebellum art began to look hopelessly old-fashioned, a trend reinforced by the growing attraction of American painters to the new and more cosmopolitan styles emanating from Europe. But before losing the public's attention, Hudson River School painting went through one final, glorious phase, called today "Luminism," a term that describes a recurrent concern with light, an absence of visible brushstrokes, and a feeling of stillness in many mid-century landscape paintings. Though the luminist painters were not linked together in any conscious fashion—they were never a "school" and they were not always aware of each other's work—they nonetheless share certain characteristics.

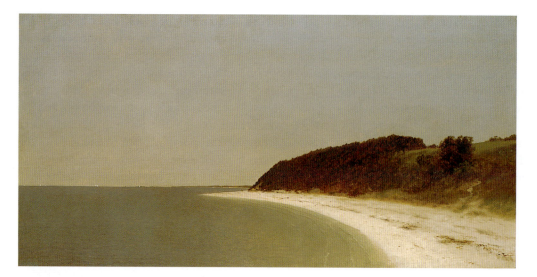

**JOHN KENSETT.** Those characteristics are most clear if we look at John Kensett's (1816–72) *Eaton's Neck, Long Island*, 1872 (**fig. 8.26**). Unlike Durand's *Kindred Spirits*, with its shifts in tone from foreground to background and busy display of details, *Eaton's Neck* is defined by compositional simplicity and the cessation of motion. The canvas is first and foremost planar in construction, composed of a series of flattened forms, each parallel to the picture plane, and each juxtaposed with the other. *Eaton's Neck* reduces its spaces to abstract, horizontal masses: a green and inanimate Long Island Sound; a beach and hillock whose lack of detail and general abstraction contradict the tendency of the land to recede diagonally into the painting's depths; and a flat, featureless sky occupying two-thirds of the painting's space. The work substitutes stasis for motion, and eliminates any visible brushstrokes, endowing the image with a

8.27 FITZ HENRY LANE, *Owl's Head, Penobscot Bay, Maine*, 1862. Oil on canvas, 16 × 26 in (40.6 × 66 cm). Museum of Fine Arts, Boston, Massachusetts.

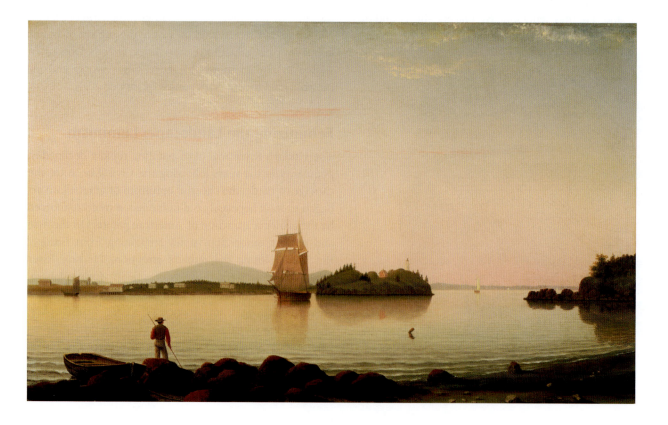

hard, crystaline quality. Luminist paintings turn on a paradox: that images of depth and recession should instead produce spaces that are flat, abstract, and planar. Composed in the summer of Kensett's death, *Eaton's Neck, Long Island* produces an almost proto-modern vision of abstraction in its fidelity to the surface of the canvas.

**FITZ HENRY LANE.** This printer and painter (1804–65) devoted his life to New England coastal scenes. In *Owl's Head, Penobscot Bay, Maine*, 1862, Lane pinions a solitary pilgrim-figure, staff in hand, twice: between water and land, and then again between boats and rocks (**fig. 8.27**). The empty boat to the left echoes the larger emptiness of the canvas, stilled and serene. It also mimics the tall ship at the painting's center. Though the ship's sails are unfurled, it appears to be motionless. There is no wake to disturb the glassy surface of Penobscot Bay. Instead, the abstract plane of the sky—occupying the upper two-thirds of the canvas—mirrors the flattened silver-blue of the bay, converting the painting's potential for motion into a smooth, mirror-like surface.

This emphasis on rectangles and planes in *Owl's Head* is set in counterpoint with an imagery of circles, from the rounded shape of the foreground rocks to the larger oval of the bay itself. More a protective cove, the bay is a place of safe mooring prior to the voyager's ocean-bound journey. That journey is imagined via the diagonal sightline that runs from the standing man across the bay to the outlet at the right and then on to the ocean. It stands in tension with the static, rectilinear composition of the painting. Lane plays surface against depth, planar flattening against three-dimensional recession. In the process, he opens the bay up into the larger world. The painting suggests that the cosmic is only a stone's throw from the local, that sacred vistas are available for those with an eye to see, that the voyage out into the world is, as Emerson suggests in his essay *Nature*, also a voyage into consciousness. And all the while the traveler need never have moved his feet.

**SANFORD R. GIFFORD.** At the same time that luminist paintings develop a flat, crisp, hard-edged quality, as if their spaces were sealed behind glass, they can also appear in a very different format. Art historians term this variant mode, with its misty atmospheres, its emphasis on haze, and its eagerness to dissolve objects into a larger visual unity, "atmospheric luminism." Sanford R. Gifford's (1823–80) *October in the Catskills* of 1880, a late work in the luminist style, scoops out the mass of land and mountains that tended to dominate earlier Hudson River School painting and fills the space instead with air (**fig. 8.28**).

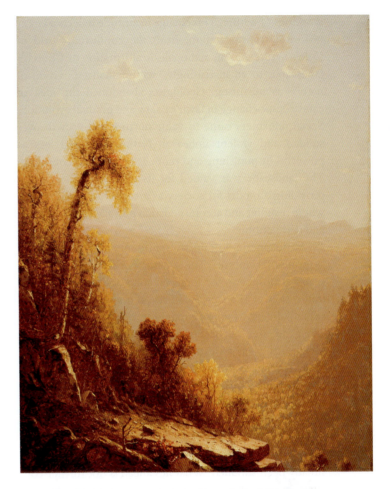

8.28 SANFORD ROBINSON GIFFORD, *October in the Catskills*, 1880. Oil on canvas, 36⅜ × 29⅜ in (92.4 × 74.6 cm). Los Angeles County Museum of Art, California.

Gifford's subject is not the landscape itself but the light and color that define it. His nature lacks individual details. The trees behave as heliotropic sunflowers, bending their golden heads toward the white sun at the painting's center. The trees are painted in hues of gold and green. They function visually as colorful accents within the larger monochromatic unity of the painting.

Gifford does not see nature as the space of traditional antebellum landscape. The tunnel-like recession into the valley highlights the emptiness of space rather than its fullness. The painting's monochromatic unity asks the viewer to identify with nature rather than conquer it, to take it in at a glance rather than traverse it, front to back, over time. This altered vision of the landscape can be viewed as a willingness to understand nature as a coherent space of nurture and ecological unity. The viewer, according to this understanding, is not the conquering master standing at the precipice of the landscape ahead, but a humble team-player who fulfills a role within the larger—and integrated—

workings of nature. This change in attitude reflects a larger historical transformation, from the conflicted world of Cole's nature and the nationalistic affirmation of Church's landscapes to an increasingly "sentimentalized" vision of nature as nurturing. Geologists abandoned the idea of catastrophic change in favor of slow and gradual evolution. Social reformers came to value nurture and growth over sudden and violent upheaval. Nature appeared less as powerful or punishing and more as benign and consoling. The landscape was valued for its unity and integration, providing a model for society as a cooperative enterprise, where restraint and accommodation prevailed over violence and competition.

Atmospheric luminism represents the triumph of "sentimental culture." The softening of forms, the emphasis on atmosphere, the focus on color and haze, the tonal unification of the canvas, all reveal a new effort by landscape painters to portray nature in more feminine terms. Their canvases, in effect, redefine nature—and by analogy, society itself—as an extension of the home: a warm and protective space. Instead of the majestic, operatic spaces of Church's pictures, the new canvases of luminism emphasize intimacy and immediacy. The viewer no longer navigates through a plot-filled narrative but is immersed in a welcoming world of light, air, and color. Atmospheric luminism signals to its audiences that the landscape has already been subdued. What lies ahead is not further conquest, but a deeper transformation of nature into culture.

# Representing War

The Civil War (1861–65) interrupted all this. It brought the fantasy of nurturance and social accommodation to a crashing halt. Frederic Church's *Cotopaxi*, 1862, was painted in the same year that Union and Confederate troops pulverized each other in the Battle of Antietam, the bloodiest twenty-four hours of the entire Civil War (**fig. 8.29**). Church abandons the environmental harmonies that unified *Heart of the Andes* and substitutes in their place a vision of nature torn and divided. An Ecuadorian volcano erupts at the left, its smoke almost blotting out the sun that competes with it for dominance of the heavens on the right. The division between volcano and sun is reinforced by the canyon in the foreground, ripping the composition along its central axis. Church's Humboldtian world has exploded into competing realms tinged with blood-like reds. If Church still intends his viewers to believe they are pilgrims, their destination is now the apocalypse.

A similar drama grips Martin Johnson Heade's (1819–1904) *Thunderstorm Over Narragansett Bay*, 1868, painted in the immediate aftermath of the War (**fig. 8.30** and **p. 240**). Heade fills the quiescent air of luminist painting with blackness and a dramatic bolt of lightning. The glass-like surface of the water has become as dark as the

8.29 FREDERIC EDWIN CHURCH, *Cotopaxi*, 1862. Oil on canvas, 48 × 85 in (121 × 215 cm). Detroit Institute of Arts. Michigan.

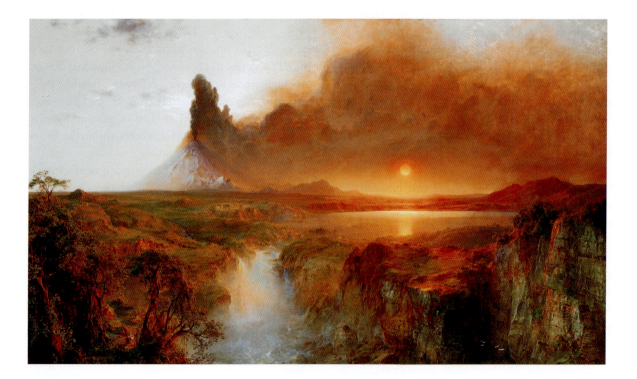

8.30 MARTIN JOHNSON HEADE. *Thunderstorm Over Narragansett Bay*, 1868. Oil on canvas, 32⅛ × 54¾ in (81.5 × 39 cm). Amon Carter Museum, Fort Worth, Texas. (See also p. 240)

foreboding sky; the sails of the small boats in the bay droop in the airless atmosphere; and the miniature men returning from their excursions look like puppets rather than Jacksonian adventurers. Only the hovering gulls, white in contrast with the surrounding darkness, offer any sign of escape. And their winged destination, above the men and between the two moored boats, is uncertain: are they harbingers of hope or signals of distress? Heade's electrically charged atmosphere, where dark surfaces bristle with

apocalyptic energies, marks one painter's farewell to the peace and serenity of former times.

Even Eastman Johnson's (1824–1906) *Negro Life at the South*, painted in 1859, two years before the bombing of Fort Sumter and the eruption of war, demonstrates how a scene of everyday black life, filtered through the prism of the minstrel show, carries disruptive possibilities directly beneath its calm surface (**fig. 8.31**). The frieze of figures across the lower portion of the canvas is a virtual catalogue of slave

8.31 EASTMAN JOHNSON, *Negro Life at the South*, 1859. Oil on canvas, 36 × 45½ in (91.4 × 115.5 cm). New-York Historical Society.

characters: the boy at the center of the composition, who pauses wistfully to listen to the banjo player (a familiar stereotype from minstrel shows); the exotic young mulatto who coyly cocks her head in response to the suitor who leans toward her; and the dark woman at right of center—probably a slave of West Indian descent—who watches a young boy dancing. Johnson's picturesque treatment has led many to read this painting as an apology for "the peculiar institution," as slavery has been called. Yet he subtly undercuts stereotypes: the banjo player leans back with a melancholy expression, resisting the role of minstrel entertainer. Each figure seems oddly static, as if lost in thought, or deliberately indifferent to the entrance of the white mistress on the right. Johnson's "behind-the-scenes" look at slavery seems staged, as if the main figures are biding their time until their need to perform before white observers is over. The decaying overhang at the rear of the house—along with the rundown condition of the yard—hints at the demise of slavery in the near future. Following disputes about the location of the scene, the scholar John Davis has established that the painting was done literally in the artist's backyard, in the notorious alleyways of Washington, D.C., Johnson's home. His behind-the-scenes glimpse thus reveals the hollowness of Northern claims about black freedom. At the very edge of the Mason-Dixon Line, black life is still staged as a minstrel show. Johnson's behind-the-scenes glimpse reveals the existence of slavery in the heart of the nation's capital, hidden from view. His act of exposing slavery provided yet another voice in the clamor that led to war.

As these three different paintings suggest, the challenge facing artists and photographers of the Civil War was twofold: how to capture the chaotic reality of war and the social issues behind it while still suggesting a larger order and purpose to the struggle. The Civil War has been characterized by historians as the first modern war. With over 600,000 casualties, it introduced mechanized weaponry, trench warfare, and corporate forms of organization. The historian Eric Foner has noted an unexpected irony to the Civil War. It ended the way of life that Lincoln had fought to preserve: the world of the independent artisan-entrepreneur. The victory of the North was a victory for modernization: the centralizing of state power; the rapid spread of industry; the mechanization of labor; the rise of large bureaucracies; the emergence of national corporations; and the uninhibited expansion of the North's capitalist economy.

Though artists could not tell this story directly—paintings, after all, are not inventories of battles—they could provide images that explored both the causes and the consequences of war. In the sections that follow, we focus primarily—but not exclusively—on photography. The invention of photography precedes the onset of the Civil War, and the photograph developed into the medium *par excellence* for telling the story of that war. The photograph's sobering combination of black and white tones, together with its blunt air of truthfulness, left the public hungry for, as well as horrified at, the vision of war that emerged from the photographer's lens.

But in order to understand Civil War photography, we need to backtrack briefly to the invention and early history of photography itself.

## Daguerreotypes and Early Photography

Photography was the "new kid on the block" in the antebellum era. Invented in France and England, and first launched in 1839, this technological form of image-making astonished its early audiences. Samuel F. B. Morse, a skilled painter and inventor of the telegraph, observed the work of Louis-Jacques Daguerre in Paris and wrote that the images were "Rembrandt perfected." Morse explained that the "minuteness" of detail in a **daguerreotype** resembled the use of a "telescope in nature" (**fig. 8.32**).

American responses to photography veered between a love of magic and a desire for mimesis. Nineteenth-century audiences viewed the daguerreotype as nature's own self-portrait: the way that "nature paints herself." The lack of handwork—the absence of brushstrokes or engraver's marks—was thought to guarantee the "objectivity" of the image. Photography represented the height of realism, the dream of artists from the Renaissance onward to produce the illusion of a real world on a flat surface. But photography was no illusion. As its name suggests, the photograph was "writing with light." Photographs were thought to reveal the truth of nature without the distortions of human intervention. A prominent merchant, explaining to others how his daguerreotype was made, said simply that you "sat and looked at the glass" lens until you "grinned yourself on the plate."[8]

Very soon after its introduction, photography led to a virtual industry of new patents and technologies. Some of these innovations were designed to improve the quality of the image, while others focused instead on photography's commercial applications. In the countryside, itinerant artists converted from painting portraits to making photographs, and were joined by other craftsmen who wished to take advantage of the new technology: blacksmiths, shoemakers, apothecaries, artisans, and enterprising inventors. These rural "image-mongers" tended to work individually, moving from door to door and town to town with daguerreotypes of varying quality. In the cities, to the contrary, daguerreotypists

8.32 SOUTHWORTH & HAWES, *Woman in Striped Bodice*, c. 1850s. Daguerreotype, 8⁹⁄₁₆ × 6⁹⁄₁₆ in (21.7 × 16.7 cm). Museum of Fine Arts, Boston, Massachusetts.

sought to appeal to a more cultured clientele. They advertised themselves as professionals, touted the aesthetic quality of their work, and set up shops that employed assistants and helpers. Daguerreotypes became so popular that by the early 1850s there were "daguerreotype factories" across the urban centers of the United States. Each offered low prices, standardized packages (poses, mats, cases), familiar props, and speedy delivery.

By the end of the 1850s, the daguerreotype had given way to a new photographic technology, the **wet-plate process**. Unlike daguerreotypes, which produced a single, non-reproducible image on a plate coated with reflective silver (there was no negative), the wet-plate photograph allowed unlimited paper prints to be made from a single exposure. By allowing for multiple prints, it helped answer the almost insatiable demand among all classes for photographs of family and friends.

If photography satisfied the need of the Victorian family for images of itself, it also answered a larger social anxiety. Photography provided a society undergoing rapid urbanization with a way to affirm the importance of "character." Photographers advertised their ability to bring out the truth of their sitters: to capture a person's essence in a single image. The photograph revealed not just an enduring likeness, but a true expression of the sitter's personality.

As cultural historians Alan Trachtenberg and Karen Halttunen have pointed out, antebellum urban America suffered from a "crisis of social confidence." As cities swelled in size, people feared their inability to "read" the true motives and designs of the strangers they encountered. Photographers seized on this anxiety by creating a visual product that allowed the viewer to "discern inner character from outer appearance." Daguerreotypists—and later wet-plate photographers—created a standardized set of poses and expressions designed to reveal the "inner character" of their sitters. This process helped reassure a middle class concerned about modernization that they were still able to discern truth from falsity, good from bad. In this regard, photography performed a cultural role similar to that of genre painting. Both media provided people with a vocabulary of familiar characters and types that allowed them to navigate their daily lives with confidence. What you saw was what you got.

**PHOTOGRAPHIC DOCUMENTS OF SLAVERY.** At the same time that daguerreotypes were marketed as family keepsakes, they were also enlisted in the service of such pseudo-sciences as phrenology and physiognomy. Practitioners of these and other popular movements claimed to be able to read human character from the shape of the head and the configuration of the body. With the aid of the camera, they sought to create an "objective" visual record that distinguished the normal from the abnormal. Photographs were used to document criminals, immigrants, and slaves. By the end of the century, photography had developed into an essential tool of the police and government in monitoring the population and tracking social "deviance."

In 1850, the Harvard professor Louis Agassiz, perhaps the most famous geologist and scientist in America, commissioned J. T. Zealy, a daguerreotypist in Columbia, South Carolina, to take a series of photographs of slaves from nearby plantations. The goal of the series was to provide evidence for the theory that Africans were not direct descendants of Adam and Eve but products of a separate, "second" creation. The doctrine of "separate creation" was intended to justify white racism and slavery. Zealy photographed African-born slaves whom he regarded as

8.33 J.T. ZEALY, *Jack* (driver), Guinea, 1850. Daguerreotypes. Peabody Museum of Archaeology & Ethnology, Cambridge, Massachusetts.

specimens or "types" (**fig. 8.33**). The portraits he sent to Agassiz stand today as perhaps the most haunting and painful images to emerge from the era of the daguerreotype. They show naked or partially clothed figures facing the camera head-on. They also reveal whip-marks, scars, and other disfigurations from slavery. What rage, pain, humiliation, or resistance the making of the daguerreotypes provoked among the sitters goes unrecorded. We are left instead with their stares, stoic and impassive, masking worlds of feeling that the viewer can only imagine.

**MATHEW BRADY AND HIS "GALLERY OF ILLUSTRIOUS AMERICANS."** Nowhere was this appeal to the "truth-telling" characteristics of the daguerreotype more evident than in the emergence of photographic galleries devoted to images of public figures. Mathew Brady (c. 1823–96), known today primarily for his daguerreotypes of the Civil War, was famous among his contemporaries for an exhibi-

tion space in New York filled with portraits in this medium of celebrated citizens, civic leaders, politicians, artists, and renowned visitors. Begun originally as a portrait studio in 1844, the gallery moved many times as it grew more popular, relocating always to a more fashionable address. Brady saw himself as a chronicler of public history. He viewed his work as part of his "obligation to my country to preserve the faces of its historic men and mothers."

Brady invited the notable figures of his day to pose for him. Their photographic portraits were then displayed in the gallery as both a public service and a keen method of self-promotion. Brady referred to his collection as his "Gallery of Illustrious Americans." He published engravings of his daguerreotypes in book form and in popular magazines of the day. Like P. T. Barnum, whose famous American Museum mingled high-minded exhibits with curiosities and oddities, Brady drew a steady flow of visitors to his gallery by highlighting its civic appeal. Visitors could study the likenesses of public figures and discover their inner "character," the sources of their greatness. Such discoveries would lead not only to appreciation but emulation. Viewers of Brady's gallery would be educated in their civic responsibilities and inspired to continue in the footsteps of those they beheld (**fig. 8.34**).

The irony of Brady's gallery is that it was organized more like a modern factory than an institution for civic advancement. Brady employed a vast array of workers who managed the gallery, greeted visitors, and produced photographs of those who desired to have their portraits taken. The work was divided into specialized tasks. Brady, whose eyesight was failing by the 1850s, rarely took his

8.34 Mathew Brady's new photographic gallery at Tenth Street and Broadway, New York, from *Frank Leslie's Illustrated Newspaper*, January 5, 1861. Wood engraving. Library of Congress, Washington, DC.

own pictures. His role instead resembled that of manager and foreman. He oversaw the whole, ensuring that any portrait that carried his brand name, "Brady of Broadway," measured up to the highest standards. As Alan Trachtenberg notes, a Brady portrait bestowed "instant recognition and prestige."[9]

## The Photographic Image and the Civil War

With the advent of the Civil War, Brady hired as many as twenty teams of photographers to record the unfolding tragedy. Though he spent most of the war years managing his various teams, he also traveled to several important battle sites. Unusually for him at this point, Brady personally photographed scenes from Bull Run, Antietam, Fredericksburg, and Gettysburg. He displayed his photographs from the war, as he had earlier displayed his portraits of notable people, in his New York gallery. Visitors viewed the images "with the aid of a magnifying glass," seeking to discover the individual features of the dead. Like visitors to the Vietnam Memorial in Washington, D.C., a century later, viewers at Brady's gallery approached his photographs as almost talismanic reminders, through the powers of art, of lives lost and now mourned.

The heroism of war, however, was gone. Or at least it was impossible to capture with photographic equipment that required hours of preparation, long exposure times, and vast amounts of labor. Because photographers could not record the travails of battle itself, they turned instead to the mundane details of the "before" and "after": life in the camps before battles, and scenes from the field after them. What they presented was not war, but the peripheries and vestiges of battle. The camera recorded disheveled, disenchanted, and bored men; it paused over scenes of daily life in army camps and hospitals; and it lingered in the fields in the hours and days after battle. There it captured the litter of dead bodies and devastated landscapes.

**IMAGES OF THE FALLEN.** A photograph by Thomas C. Roche (died 1895), *A Dead Confederate Soldier, Petersburg, Virginia*, of 1865, conveys the anonymity of war (**fig. 8.35**).

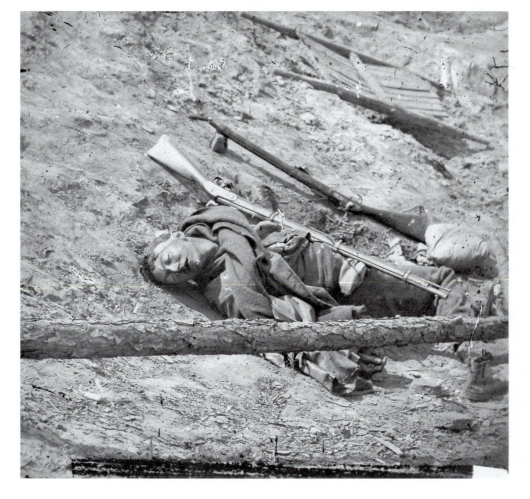

8.35 THOMAS C. ROCHE, *A Dead Confederate Soldier, Petersburg, Virginia*, April 3, 1865. Photograph. Library of Congress, Washington, D.C.

The pine trunk in the foreground serves as a visual barrier, separating the viewer from the dead soldier. The tree's cropped position adds a note of arbitrariness to the image, undermining the photograph's square format with its oddly angled placement. The emptiness of the space—the barrenness of the ground, the lack of vegetation—isolates the soldier visually and depersonalizes the scene surrounding him. The photograph shocks the viewer at the same time as it undermines any effort on the viewer's part to heroicize the soldier's death. The viewer encounters instead sheer *corporeality*: the body damaged and lifeless.

No wonder then that what is perhaps the most famous photograph of the Civil War, Timothy O'Sullivan's (c. 1840–82) *A Harvest of Death, Gettysburg, July, 1863*, counters its vision of decay and anonymity with a hint of mystery (**fig. 8.36**). The photograph's propensity for realism dissolves as the eye travels from foreground to background. The ghostly figures in the distant haze appear like versions of the Grim Reaper. The very title of O'Sullivan's photograph, *A Harvest of Death*, adds an almost biblical dimension to the scene. The photograph seems to implore its viewer to step imaginatively over the wall of bodies in the foreground. What follows is a

recession into deep space. The farther we travel toward the horizon, the more the battlefield and bodies seem to dematerialize. O'Sullivan's photograph leaves open the question of whether the light in the background represents hope or emptiness.

Another Gettysburg image, Alexander Gardner's (1821–82) *Home of a Rebel Sharpshooter, Gettysburg, 1863*, refuses any suggestion of hope (**fig. 8.37**). The dead Confederate soldier in the foreground blends in with the rocks that surround him. He seems already one with the inanimate world. His rifle leans against a pile of boulders that once formed a wall to hide and protect him. That wall serves no purpose now. In contrast to the sweep of open space that distinguishes *The Harvest of Death*, the perspective in *Home of a Rebel Sharpshooter* is entirely blocked. The viewer is hemmed into the shallow foreground and possesses no visual pathway to the background. The photograph's unforgiving realism—its allegiance to death and decay—leaves little room for transcendence. Years

8.36 TIMOTHY O'SULLIVAN (negative) & ALEXANDER GARDNER (positive), *A Harvest of Death, Gettysburg, July, 1863*, 1863. Photograph. Library of Congress, Washington, D.C.

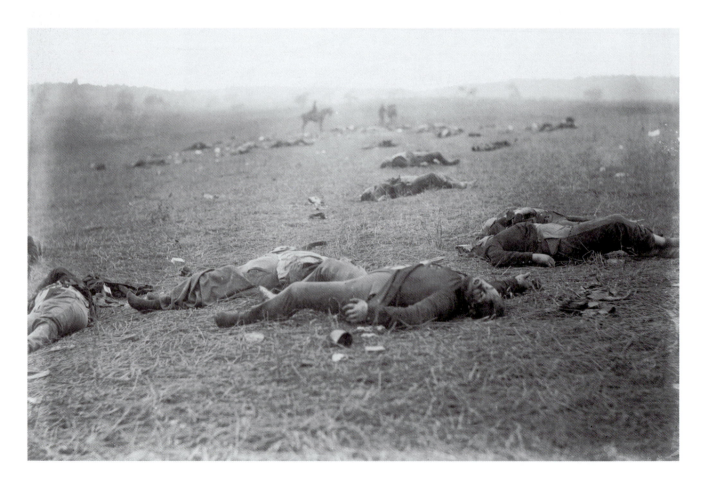

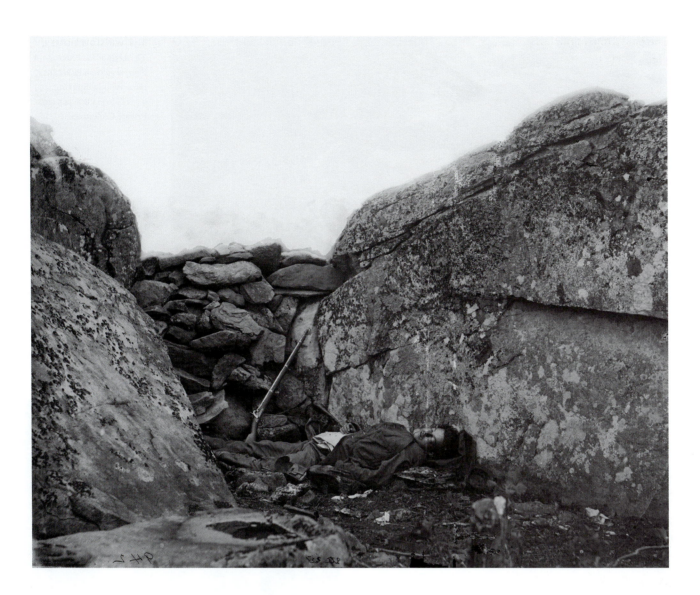

8.37 ALEXANDER GARDNER, *Home of a Rebel Sharpshooter, Gettysburg,* 1863. Photograph. Library of Congress, Washington, D.C.

after the photograph was taken, the image was discovered to have been posed. Gardner and his assistants carried the body to the spot where it was photographed, and added the rifle.

This staging of an image that seems so immediate and real testifies to the pressure that photographers felt to make meaning of otherwise senseless events. By placing the soldier in the ravine behind a barrier of rocks, Gardner created an implicit narrative of spying and danger. That narrative, in turn, lends dignity to the life of the fallen soldier.

Photographers like Gardner had three barriers to overcome during the Civil War: they needed to master the slowness and complexity of their own instruments; they needed to transform the randomness of what they saw into moments of significance; and they needed to counter-act the unflattering realism of the photographic image itself, which tended to highlight the physical and bodily aspects of war at the expense of its heroism. Gardner's *Home of a Rebel Sharpshooter* copes dramatically with all three concerns.

We might contrast Gardner's bleak image of a Confederate sharpshooter with an engraving produced the previous year by Winslow Homer (1836–1910), a young Boston-born artist who spent the war years illustrating soldiers' lives for *Harper's Weekly*. Magazines of this kind lacked the technology to reproduce photographs. They had to rely instead on artists and illustrators for a steady stream of images. In *The Army of the Potomac—A Sharpshooter on Picket Duty*, 1862, Homer captures the deli-cate balance of a Union sharpshooter perched in a tall pine

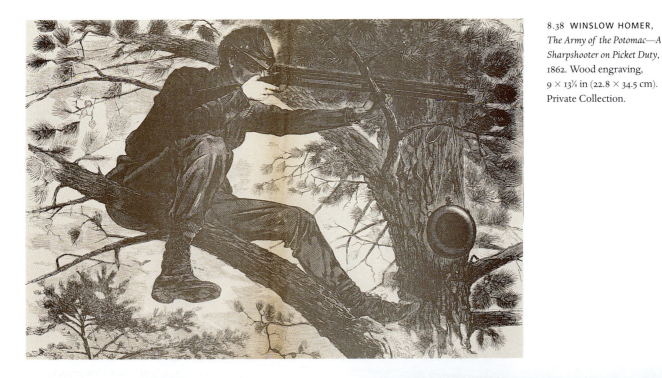

8.38 WINSLOW HOMER, *The Army of the Potomac—A Sharpshooter on Picket Duty*, 1862. Wood engraving, 9 × 13⅜ in (22.8 × 34.5 cm). Private Collection.

tree (**fig. 8.38**). The diagonals of the tree's limbs, the soldier's feet and the rifle lend the image an off-balanced perspective. The soldier counters the tilt of the tree with his left hand and foot, each braced against the tree as he steadies the rifle. The canteen hanging from the limb on the right hints at the long duration of his "picket duty." He has probably sat in one position for hours. The soldier's mastery of his situation—his ability to balance himself against the odds—contrasts sharply with the sprawled and defeated form of Gardner's sharpshooter.

## War and Peace

For all the efforts of artists to transmit images from the front as rapidly as possible, no photographer was present at Appomattox Court House at the conclusion of the Civil War. Instead, Mathew Brady took a portrait of General Lee shortly after his surrender (**fig. 8.39**). The image shows Lee standing in front of his Richmond home wearing his gray Confederate uniform one last time. Lee had to be persuaded by his wife to venture outside the house and pose for Brady, whom he had met before the war. Brady portrays Lee as a figure of dignity and honor. The large upholstered chair to the left, coupled with the visually prominent door and doorknob, transform Lee into a latter-day Cincinnatus, the Roman general who preferred privacy and retirement to war. By capturing Lee in a domestic context, Brady anticipates the homecoming awaiting soldiers of both sides at the end of the war.

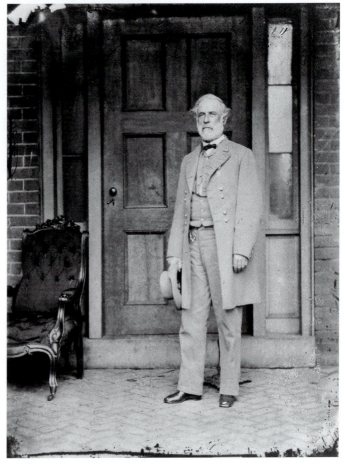

8.39 MATHEW BRADY, *General Robert E. Lee at his Home*, April 1865. Photograph. Library of Congress, Washington, D.C.

His photograph gestures in the direction of national reconciliation and a return to normalcy.

### *PRISONERS FROM THE FRONT* BY WINSLOW HOMER.

Brady's emphasis on reconciliation has echoes in the post-war painting of Winslow Homer. For Homer, the end of the war meant the beginning of a new era. In *Prisoners from the Front*, 1866, Homer pits a Union officer against three disarmed Confederate prisoners, their standard-issue rifles tossed upon the ground before them (**fig. 8.40**). Four years of fratricidal strife are reduced in Homer's painting to the spatial and psychological gulf that separates the victor from the vanquished.

The power of Homer's painting lies in the dignity displayed by each of its main characters. Homer's Union officer refuses to lord it over his prisoners; instead, he regards them respectfully. Their heads, like his, just puncture the horizon line. In this way, they share with him a capacity to rise above nature and transcend their recent histories. Though the painting's four protagonists still need

8.40 WINSLOW HOMER, *Prisoners from the Front*, 1866. Oil on canvas, 24 × 38 in (60.9 × 96.5 cm). Metropolitan Museum of Art, New York. Gift of Mrs. Frank B. Porter, 1922.

to resolve their fraught relations, they give promise, by their postures and calm demeanors, of a future defined by respect and reconciliation. For a painting completed only one year after the war's end, *Prisoners from the Front* demonstrates a sense of compassion very different from the post-war bitterness expressed by many of Homer's peers.

The painting also reveals the influence of photography on Homer's work. Early cameras tended to wash out the sky and background of outdoor scenes. Homer clusters the soldiers in the foreground, close to the picture plane, and empties the background of detail, repeating in his painting ways of seeing made popular by the camera. In the process he foregoes the middle-ground landscape of the Hudson River School, with its language of progress and optimism. Instead, Homer converts the two-dimensional and voided spaces of landscape photography into a new style of painting: psychologically acute, empirically driven, and reticent about any promise of transcendence.

### TWO VERSIONS OF THE HOME FRONT.

While Homer converted the image of captured soldiers into a meditation on the possibility of national reconciliation, other artists focused on the role of domestic life in the healing of the

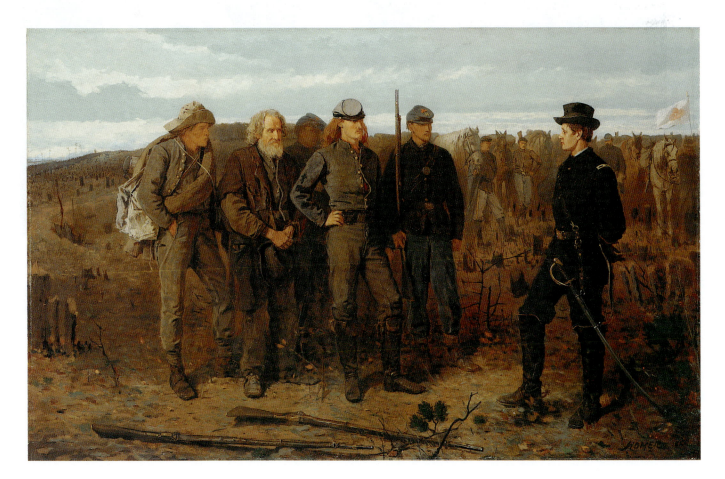

8.41 LILLY MARTIN SPENCER, *War Spirit at Home (Celebrating the Victory at Vicksburg)*, 1866. Oil on canvas, 30 × 32¾ in (76.2 × 83.1 cm). Ohio Newark Museum.

nation. Lilly Martin Spencer (1822–1902), whom we have already encountered as an antebellum sentimental artist (see fig. 6.1), engaged post-war history in her own way. In *War Spirit at Home* (**fig. 8.41**), Martin shows a Northern mother reading a freshly unfolded *New York Times* with news of the 1863 Union victory at Vicksburg. Three of her four children parade around the family table, merrily imitating the victorious troops. It is a humorous, anecdotal scene, and yet, for all that, the painting also argues for the role of women in shaping domestic life, transmitting, through their children, the values for which the war was fought. By allying the woman with the *New York Times*, Spencer links her heroine to the larger public sphere. She also suggests that women bear responsibility—like the popular media of the day—for maintaining and preserving knowledge of the past. Painted in 1866, one year after the conclusion of the war, *War Spirit at Home* fires its own preliminary shot in the post-war battle over the war's memory.

Edmonia Lewis (b. 1845), a sculptor we have already encountered (see fig. 6.3), creates a very different image of the work of the family in the rehabilitation of post-war society. Lewis, of mixed Native and African American heritage, turns to the family to safeguard the rights of newly freed African Americans. Her most famous work, *Forever Free*, 1867, depicts two former slaves, male and female, at the moment of their emancipation (**fig. 8.42**). Standing in a classical **contrapposto** pose, the man rests his weight on one straight leg while bending the other, as if about to vault forward into the promise of the future. His left hand raises his severed shackles skyward in a gesture at once thankful and exultant. The clasp of the manacle still binds his arm, though the chain has been broken. His right arm rests protectively on the shoulder of the woman, presumably his wife, who kneels beside him. His muscular torso calls attention to his strength and dignity, while his curly hair suggests his African ancestry as well as a resemblance to classical statuary.

The woman, on other hand, shows no signs of African heritage. Both her hair and her facial features are entirely classical. The scholar Kirsten Buick interprets the contrast between the two figures—one visually identified as African American, the other not—as part of Lewis's desire to universalize and idealize her women. By depicting the woman in neoclassical terms, Lewis was, in effect, indicating how she herself wanted to be viewed: as neither a "carrier of property," nor a "racist stereotype," but a free woman.[10]

How then do we explain the kneeling woman's subordinate position relative to the man? The answer lies in the politics of black advancement in the years following the Emancipation Proclamation of 1863. Abolitionists had long criticized slavery for the destructive effects of separating parents from children and husbands from wives. Lewis's sculpture converts that criticism into a post-Emancipation challenge. The task facing African Americans after slavery was to reestablish the family. According to the values that prevailed at the time, the husband acted paternally to

protect those in his care, while his wife professed sentimental values: "submission, piety, and virtue." *Forever Free* wishes to advance the cause of African American freedom by portraying a strong, if traditional, family as the first step toward independence. Lewis's goal was not parity between the sexes, but equality among the races.

8.42 **EDMONIA LEWIS**, *Forever Free*, 1867. Marble, 40 in (103 cm) high. Howard University Gallery of Art, Washington, D.C.

# Conclusion

Edmonia Lewis's statue hints at the problems facing the United States in the years after the Civil War. The war did not end racial strife in the United States. Instead, it opened the door to heated debate about how former slaves could become citizens. Nor did the war resolve the problems produced by industrialization. To the contrary, it confirmed the triumph of industrial capitalism over more agrarian and more traditional modes of life. With the end of the Civil War, the United States looked toward its western territories for new commercial opportunities. As industrialization spread, urbanization accelerated, and class differences grew larger, Americans looked back in history to a time before the nation emerged as a modern democracy.

# 3 | From Reconstruction to Turn-of-Century: 1865 to 1900

LOUIS SULLIVAN'S lushly organic bronze decoration for his Carson-Pirie-Scott Department Store in Chicago gathers a fecund nature into rhythmic curves that sweep outward with centrifugal force before funneling back toward the center. It is an apt image of the contrary energies of the nation in the post-war years. An international *expansion* of travel and trade was introducing a more cosmopolitan artistic and expressive language. Yet the fine arts were characterized by inward *contraction*: interior scenes, psychological portraiture, and paintings whose main subject was the orchestration of mood through color and form.

In 1860 the United States was a relatively minor player in the world economy. The United Kingdom, France, and Germany all boasted higher levels of industrial output. The Civil War changed all that. It opened the way for new national markets, mass modes of production, and large-scale forms of organization. It sped the construction of a national transportation infrastructure of rails and bridges, as well as the development of steel-cage construction enabling the tall office building; and it accelerated the rise of the "corporation," which transformed businesses from simple family partnerships into large-scale integrated enterprises. By 1890 the United States led the world in industrial production. Clocks and mechanization displaced natural rhythms. Identities defined by locality, by family, and by the intertwined worlds of home and work, gave way before the growing mobility of both people and information. This mobility was made possible by transcontinental railroads, transatlantic ocean liners, and the first transatlantic telegraph.

The Civil War had also undermined faith in American exceptionalism, the belief that the republic enjoyed a special relationship to providence, appointed to stand at the vanguard of the world's nations. The tragedy of the war had brought in its wake a sense of national mourning, and consequently a new awareness of moral complexity.

Still, amidst such transformations, the old ideal of a stable rural republic remained enshrined in both the popular and the fine arts. By taking refuge in ideals linked to an older vision of the republic, the arts tended to evade the social challenges that followed in the wake of Emancipation and large-scale immigration. Yet artists in these years also explored subjective sensations, they playfully embraced artifice, and they and their contemporaries crossed scientific, psychological, and cultural frontiers. All these factors pointed toward a modern sensibility.

Sullivan's department store—the perfect stage set for a world of mostly female shoppers engaged in new forms of personal consumption—also represents an emergent public realm shaped by economic consolidation. Large-scale industrialization required huge concentrations of capital for the rapid exploitation of vast resources and the employment of multitudes of workers. Efforts to control the marketplace through consolidation could not, however, stave off the boom-and-bust cycles that characterized the nation's economy. Along with the shock to traditional religion delivered by Darwin's *Origin of Species* (1859), with its explanatory principle of natural selection, economic instability created a climate of cultural, social, and epistemological indeterminacy. Like the shadowed recesses of Sullivan's ornament—blurring the boundaries between solid and void—knowledge itself was unsettled from its secure foundations in religion and "common-sense" philosophy. The scepticism of the late nineteenth century—a doubt about the foundations of all inherited forms of authority—introduced characteristically modern anxieties while also encouraging a spirit of experimentation and adaptability to the challenges posed by uncertainty.

(opposite) **LOUIS SULLIVAN**, Schlesinger and Mayer Department Store (Carson-Pirie-Scott; detail), 1899. (See also fig. 10.23)

# 9 Post-War Challenges: Reconstruction, the Centennial Years, and Beyond, 1865–1900

THE SELF-TAUGHT New England painter Erastus Salisbury Field (1805–1900) conceived in his old age a painting that would embody the history of America from the first British settlement in Jamestown in 1607 to the end of the Civil War (**fig. 9.1**). On a canvas nine feet tall and thirteen feet long, he created a metropolis of ten huge towers joined by a fanciful aerial railway. Scenes from American history drawn from famous American paintings such as Trumbull's *The Death of General Warren at the Battle of Bunker Hill* (see fig. 5.4) and West's *William Penn's Treaty with the Indians in 1683* (see fig. 4.35) appear on these buildings as sculptural **bas-reliefs**. On the central tower Field depicted Abraham Lincoln's assassination and transport to heaven in a chariot guided by an angel.

An ardent abolitionist, Field completed the major portion of his *The Historical Monument of the American Republic* in 1867 to commemorate Lincoln's antislavery efforts and the successful resolution of America's Civil War. He reworked his monumental canvas in 1876, in honor of the centennial celebration of the nation's founding, and added the two last towers in 1888, when he was eighty-three years old.

In 1876, many believed that the events of American history contained an internal coherence and logic, as a story of struggle against slavery and disunion resolving into unity and progress. The Centennial of the nation's founding celebrated the triumph of national unity and offered symbolic closure to the trauma of the Civil War. However, the triumphal vision of the Centennial Fair was

only possible by ignoring the challenges that faced the nation. Unity and closure were to be as fanciful as the towers of Fields's painted monument. Only a few months after the Centennial's grand opening in Philadelphia, Americans were stunned by the news of General George Armstrong Custer's disastrous defeat at Little Big Horn and the loss of all his troops on June 25, 1876.

The following year brought an end to Reconstruction, a period that commenced in hope but ended in the abandonment of the nation's commitment to racial equality. Born of the desire to reconcile a nation sundered by war, the objective of Reconstruction was the political, economic, and social reform of the South in order to institute equal access to the voting booth and to educational and social opportunities for all male citizens. Yet these reforms required the presence of armed federal troops when southerners resisted the enfranchisement of blacks, and eventually northern congressmen voted to discontinue Reconstruction policies in order to appease the South. The collapse of Reconstruction in 1877 resulted in the resegregation of the South and the denial of full citizenship to blacks, upheld in the Supreme Court decision *Plessy v. Ferguson* in 1896, which affirmed the constitutionality of the doctrine of "separate but equal" and the legality of "**Jim Crow**" laws that perpetuated a system of racial apartheid. After momentarily tasting the fruits of emancipation, black Americans were forced back to the margins; northerners and southerners were one nation once again, bound together by whiteness.

The range of American arts around the Centennial years reveals the opposing pulls of mutually defining

(opposite) JOHN QUINCY ADAMS WARD, *The Freedman*, modeled in plaster, 1863. Bronze, 19⅝ in (49.9 cm). Art Institute of Chicago.

9.1 ERASTUS SALISBURY FIELD, *The Historical Monument of the American Republic*, 1867–88. Oil on canvas, 9 ft 3 in × 13 ft 1 in (2.81 × 3.98 m). Museum of Fine Arts, Springfield, Massachusetts.

forces: between racial stereotype and new ways of seeing freed black Americans; between past and present, country and city; between different versions of the West; and between local identities and nationalizing forces.

## Representing "Race": From Emancipation to Jim Crow

Lincoln's Emancipation Proclamation in January of 1863—in the midst of the Civil War—finally freed black Americans to claim their constitutional civil rights. But their newfound autonomy provoked racist images in the press. Like the physical and social boundaries confining black Americans, these racist caricatures drew perceptual boundaries, intended to limit the possibilities of the newly freed race by distorting and dehumanizing its members' appearance. In

1870, the Fifteenth Amendment granted voting rights to black men. Black emancipation and political sovereignty, as the scholar Kirk Savage has analyzed, challenged older traditions of representation and dramatized the role of the arts in creating a new space for the freed black.

In art, an emergent language of realism countered the persistent stereotype of blacks as indolent, childlike, emotional, and lacking reason or will; both black and white artists reconceived the image of the new black citizen while tracing the ongoing impact of ethnic typing and caricature. In examining these artworks, we confront a broader dilemma: how to understand a historical experience defined by skin color without limiting and defining the black American by that alone.

### Thomas Nast: Racial Caricature and the Popular Press

Throughout the nineteenth century, ethnic typing was directed at drawing boundaries between "us" and "them," shifting categories that at various times included blacks and immigrants from Ireland, Asia, and eastern Europe. Viciously racist caricatures frequently appeared in the

widely circulated cartoons of the popular press. Produced since the eighteenth century, the cartoon, with its physical exaggeration, topicality of subject matter, humor, narrative condensation, and visual drama, was not considered art. Regardless, such images wielded considerable power and influence in society.

The consummately skilled political cartoonist Thomas Nast (1840–1902)—creator of the Democratic Donkey, the Republican Elephant, and the popular image of Santa Claus—won both admiration and loathing during his career. Ulysses S. Grant credited Nast's cartoons with helping him get elected to the presidency, while the corrupt Boss Tweed of New York held Nast responsible for his downfall: "… my constituents don't know how to read, but they can't help seeing them damned pictures."[1]

Between 1862 and 1885 Nast produced some three thousand cartoons, mostly for *Harper's Weekly*, and shaped political opinion by unmasking the lies and hollow rhetoric that beleaguered the nation's public life. Nast's political cartoons operated in the gap between the nation's ideals and its behavior; he directed images, for instance, against the persecution of Chinese laborers and other ethnic injustices. "Every Dog (No Distinction of Color) Has His Day" (**fig. 9.2**) targets the hypocrisy of the Nativist movement against Chinese immigration. Nast grasped the structural character of American racism: minorities occupied interchangeable positions in a society where power was linked to white ancestry, and sustained by skin color.

Yet Nast also stereotyped ethnic minorities when it served his own purposes. Irish Americans had long occupied the margins of the European social order, and like African Americans, they were also the subjects of caustic caricature following their mass immigration, leaving Ireland on the heels of the potato famine (1845–9). After the Civil War, Nash's cartoons pitted African Americans and Irish Americans against one another, portraying Irishmen as bestial and lazy in contrast to the hardworking and honest black farmer, whose civil rights he ardently defended. By the end of Reconstruction, however, Nast had discarded his earlier support for black emancipation, turning his visual talents against the African American citizen he had earlier embraced. In "The Ignorant Vote—Honors Are Easy" (**fig. 9.3**), caricatural representations of a black and an Irish voter are weighed as equally ill-equipped to assume citizenship.

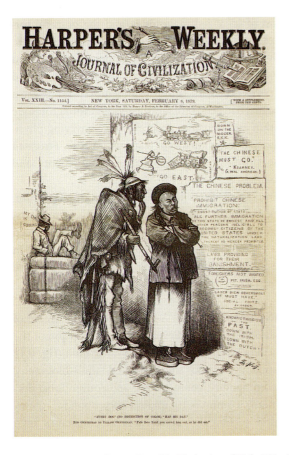

9.2 THOMAS NAST, "Every Dog (No Distinction of Color) Has His Day," *Harper's Weekly*, February 8, 1879. Private Collection.

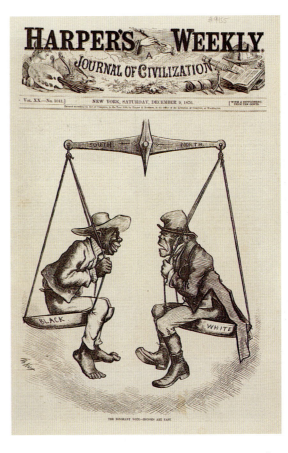

9.3 THOMAS NAST, "The Ignorant Vote—Honors Are Easy," *Harper's Weekly*, December 9, 1876. Private Collection.

## The Mixed Legacy of Emancipation: Monuments to Freedom

Thomas Ball (1819–1911), an American sculptor from Boston, was inspired by the assassination of Lincoln to create his *Emancipation Group* of 1876 (**fig. 9.4**). Living in Florence at the time, Ball departed from the neoclassical and allegorical mode in favor of greater naturalism. Wearing contemporary dress, Ball's figure of Lincoln rests his unfurled Emancipation Proclamation upon a shield bearing the national coat of arms. His left arm is outstretched, conferring freedom on a crouching slave. The act of emancipation travels in one direction, from Lincoln to slave.

Ball's sculpture expresses the hierarchy of master over slave, and white over black, in other ways as well. On the verge of standing, the kneeling slave is still bound to the earth, while Lincoln towers above him. The trappings defining the terms of cultural participation—books, proclamations, symbols of nation—are all on the side of Lincoln. Meanwhile, the black man remains naked, lacking attributes of power.

While aspiring to represent a new era, Ball's *Emancipation Group* uses the traditional language that blocks new ways of imagining black identity. His freed slave gazes up, as if hearkening to his new status. Yet his individuality is crushed by the weight of old assumptions.

**THE FREEDMAN.** Another sculptor—John Quincy Adams Ward (1830–1910)—offered a strikingly different conception of the freed slave. Though done two years before Ball's, Ward's *Freedman* imagines the agent of emancipation to be the man himself. *The Freedman* eliminates the figure of Lincoln, focusing instead on the powerfully modeled slave. Entirely nude except for drapery across his loins, he still wears one manacle on his left wrist. His torso twists to the right, where his arm anchors the torque of his body in a pose that conveys coiled strength. His seated posture implies a further ambiguity—is he resting his weight upon the tree trunk that props his body up, or is he preparing to stand? The tension of his pose suggests an open-ended future no longer dictated by external forces but by the internal poise and dynamic power of the man himself.

Like Ball's sculpture, *The Freedman* was originally intended as a monument (**p. 280**). But unlike the later work, *The Freedman* speaks a sculptural language that originates in antiquity. The classical canon of proportion, the athleticism of idealized male form, and the graceful torsion of head and body, are all apparent in Ward's freedman. Unusually for this period, Ward uses a heroic model from antiquity—the Hellenistic *Belvedere Torso*, which linked physical perfection with moral grandeur—to represent a racial type that had been ordinarily associated with grotesque exaggeration and ungainly proportions. Conveying physical power and individualized features, Ward's *Freedman* holds the promise of fuller human endowments and responsibilities.

*The Freedman* reflects the uncertainties of the future. This black American frees himself through his own efforts. Yet he cannot act alone. A decade of federally enforced efforts to establish a new order of equality collapsed in 1877, foreclosing for the time being the unrealized promise of racial justice.

**AN EMANCIPATION QUILT.** A striking social document of Emancipation done in needlework at the conclusion of the war is Lucinda Ward Honstain's (1820–1904) quilt (**fig. 9.5**). In forty appliquéd blocks, she combined family biography, political commentary, genre scenes, and conventional decorative motifs common to mid-century appliqué quilts. The central rectangular block depicts Honstain's own home in Williamsburg, an area of Brooklyn, New York. Below, an equestrian figure probably represents her daughter Emma, an accomplished horsewoman. To the right is a

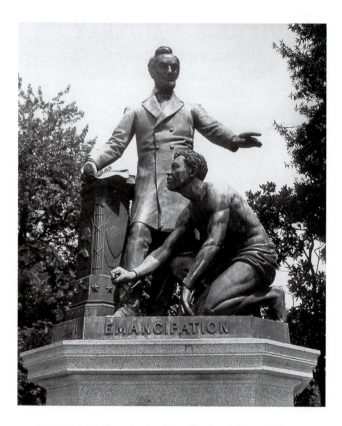

9.4 **THOMAS BALL**, *Emancipation Group* (*Freedmen's Memorial Monument to Abraham Lincoln*), Lincoln Park, Washington, D.C., 1876. Bronze, approx 9 ft high (2.75 m). National Park Service.

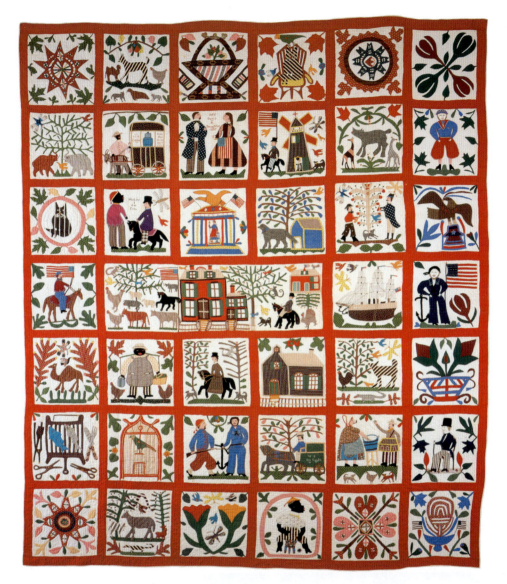

9.5 LUCINDA WARD HONSTAIN, Pictorial appliqué quilt, 1867. Cotton, 97 × 84 in (246 × 213 cm). International Quilt Study Center, University of Nebraska, Lincoln.

three-masted ship from the nearby Brooklyn Navy Yard where Emma's husband's ship had embarked for its Civil War tour of duty. In the second row from the bottom, one of the blocks depicts a man driving a horse-drawn wagon. Embroidered on the side of the wagon is "W. B. Dry Goods," a reference to the firm of Ward and Burroughs owned by the artist's brother.

Honstain was a professional dressmaker. Yet she was avidly interested in the events of the day, for in the sewing she did for herself she commemorated patriotic, military, and political themes, including Jefferson Davis (1808–89) (second row, middle). The famous Confederate president had been released from prison in 1867—the year she was working on the quilt—after two years' incarceration for treason. In the third row, left, an eloquent reminder of the Civil War is inscribed in the embroidered message "Master I am free," uttered by a black man facing a white man on

horseback. Honstain's family had owned slaves when she was a child; after the passage of the New York antislavery law of 1827, those freed blacks continued to live in the neighborhood. In several scenes, Honstain provides insight into the jobs available to freed blacks in New York City: boot black (bottom row) and ice cream vendor (second row, left). Though the assimilation of blacks into the trades was a major theme in social and literary discourse of the period, this was seldom depicted in genre painting, making this quilt an even more notable artifact of nineteenth-century American visual culture.

Honstain's opinion about African Americans is hard to discern. Like many images circulating in the popular press, her quilted and stitched image does not avoid stereotype, in the use of large everted lips and other exaggerations of physiognomy, suggesting that there were few other models on which to base a view of the black American.

## Saint-Gaudens's *Memorial to Robert Gould Shaw*: Common and Uncommon Soldiers

Perhaps no nineteenth-century image of black Americans so well captured the unfinished project of race equality, launched by the Civil War, as Augustus Saint-Gaudens's (1848–1907) *Memorial to Robert Gould Shaw* (**fig. 9.6**). Dedicated in 1897, it prompted the French sculptor Auguste Rodin to remove his hat in homage.[2] Yet this memorial, despite its power to imagine new possibilities, also embodied the limits of "equality." *The Shaw Memorial* has yielded a wide range of interpretation, from the celebratory to the critical.

Robert Gould Shaw was the only son of a prominent Boston family of abolitionists. Following Emancipation, the Northern army began accepting African American volunteers, many of them former slaves who faced skepticism about their courage under fire and ability to follow army discipline. Shaw was selected by the Governor of Massachusetts to lead the 54th Regiment, one of only two all-black regiments to fight in the war. Two months after parading through the streets of Boston, Shaw and most of his regiment were killed in a doomed effort to take Fort Wagner in South Carolina from the Confederate army, who outnumbered them two to one. Stripped of their uniforms, Shaw and his men received a Confederate burial in a mass grave; Shaw's family resisted offers to rebury his body, insisting that he remain with his troops.

Individual identities—with the exception of Shaw's—were lost until a rededication of the memorial in 1982, when names of the black regimental members were inscribed into the stone reverse of the monument. Yet from the start,

Shaw's family had wanted names to be attached to the anonymous black soldiers, "in order," in the words of Shaw's sister, "to leave no excuse for the feeling that it is only men with rich relations and friends who can have monuments."[3]

The rise of realism, while it might continue to express the old forms of racial hierarchy (as in Thomas Ball's memorial), also instigated a new, more individualized representation of African Americans, as evident in the Shaw Memorial. As with his other memorials to Civil War heroes, Saint-Gaudens combines specificity of observation—based on some forty preparatory studies done from life—with a figure in the allegorical mode who hovers above the mounted Shaw, carrying an olive branch, signifying peace, and poppies, alluding to death and remembrance. A sense of determination and movement is balanced by reverential stillness. The architectural frame for the memorial—designed by the architect Charles McKim of the firm of McKim, Mead, and White—resembles a shallow proscenium arch; the regiment, facing stoically forward, marches in unison to the beat of the young drummer at the head of their ranks. Just as they paraded through the streets of Boston prior to their departure for the war, they also proceed across the stage of history toward destiny. Here and throughout, Saint-Gaudens seamlessly integrates realism and allegory.

Saint-Gaudens accepted the commission for the monument in 1884, but it took him nearly fourteen years—until 1897—to complete. His initial sketches reveal conventionality: an equestrian monument to the lone hero. But, under pressure from Shaw's family, the sculptor eventually placed Shaw in the midst of his troops, recognizing that his

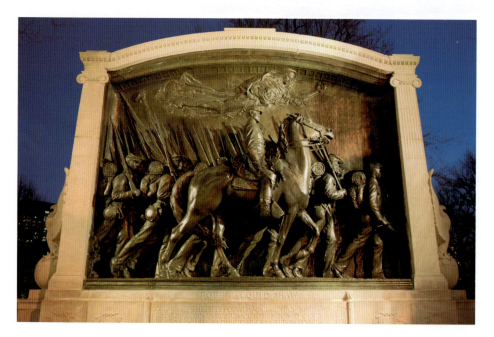

9.6 Augustus Saint Gaudens, *Memorial to Robert Gould Shaw*, 1897. Bronze relief, figures lifesize. Knoxville marble frame. Boston, Massachusetts.

heroism arose out of his bond to his men, bearing witness, in the words of the philosopher William James at the dedication of the memorial, "to the brotherhood of man."

In Saint-Gaudens's memorial, the tiers of black soldiers are ranged in orderly files around Shaw. They are the foot soldiers whose gallantry, while appearing less glorious than the exalted vision of Shaw, is no less worthy. Distinguishing between common and uncommon heroes, Saint-Gaudens nonetheless acknowledges the entwined fates of white and black. Yet his vision still centers on the white man who leads, miraculously borne above the chaos of war into a timeless realm.

## The Post-War South: Richard Brooke and Winslow Homer

In the decades after the Civil War, a number of white artists took up the subject of black life in the South, including Richard Brooke (1847–1920) and Winslow Homer (1836–1910). For Brooke, newly returned from study in the Parisian studio of Léon Bonnat in 1879, southern black life offered an American version of the peasant subject matter so appealing to European artists in the later nineteenth century.

*A PASTORAL VISIT.* This painting by Brooke of 1881 (**fig. 9.7**) is staged to furnish "characteristic" attitudes and types of black life. The slumped father gazes wearily toward the upright figure of the pastor, who returns his look with an implied rebuke, while the middle daughter gives a sidelong glance in the direction of the visitor. Beneath the polish of Brooke's academic style are longstanding stereotypes. The powerful matriarch ladles food onto the minister's plate, arms akimbo, while her husband seems disinclined to anything but playing the banjo. Yet the figure of the black father—despite his posture—is powerfully and realistically modeled, in keeping with the artist's French academic training.

*A Pastoral Visit* offered audiences a picturesque and humorous scene distanced from caricature by its mastery of academic realism. Yet Brooke's image also reveals the persistence of old stereotypes, making the drama of the newly reunited black family a spectacle that deftly avoids the difficult uncertainties faced by black communities following Reconstruction.

9.7 RICHARD BROOKE, *A Pastoral Visit*, 1881. Oil on canvas, 47¾ × 65¼ in (121.2 × 167 cm). Corcoran Gallery of Art, Washington, D.C.

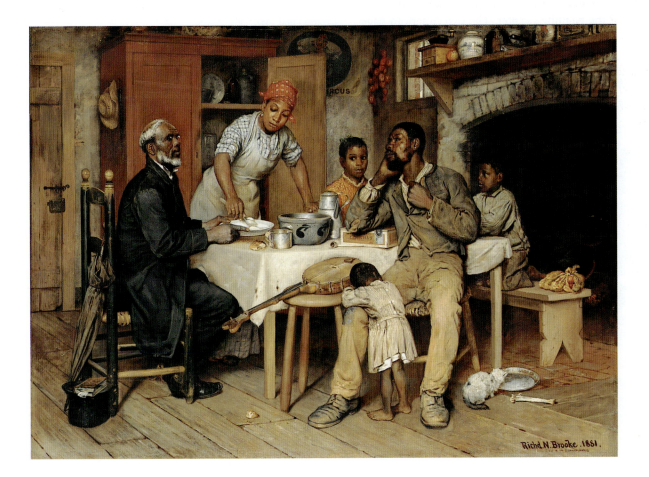

**DRESSING FOR THE CARNIVAL.** In 1877, Winslow Homer traveled from Boston to Petersburg, Virginia, a city familiar to him from his days as a Civil War illustrator for *Harper's Weekly*. Homer's decision to revisit the site coincided with the end of Reconstruction, as the federal government withdrew its troops from the South. Homer traveled south just as these troops were headed north, and his intention—to paint black life in Virginia—can be understood as a symbolic counterpoint to the federal withdrawal. Homer wished to paint what the art historian Nicolai Cikovsky has called "national subjects," images that spoke to the concerns of the day. The question of what would happen to the former slaves of the South—how they would survive economically, what their social and political future might entail—was especially timely after the collapse of Reconstruction, as the federal government abandoned its protection and the former Confederacy reverted to southern control.

In a painting now known as *Dressing for the Carnival* (**fig. 9.8**), Homer combined his own brand of realism—flattened spaces, loose and vigorous brushwork—with historical and symbolic references. *Dressing for the Carnival* (1877) depicts two women, both probably former slaves, sewing last-minute touches to the patchwork costume of the man at the painting's center. The two American flags

held by the children on the right remind the viewer that the man is about to join an Independence Day parade. The shape of his hat recalls a Phrygian cap, worn by freed slaves in the Roman Empire, and associated with liberty since the Revolutionary era of the late eighteenth century; its red, white, and blue colors meld the themes of American freedom from colonial rule with African American emancipation. For blacks during Reconstruction, Independence Day represented an opportunity to demonstrate their patriotism and their integration into the mainstream of American history.

Homer's painting extends, however, beyond the Fourth of July to allude also to Jonkonnu, a festival occurring around Christmas that fused West African and European performance traditions. Jonkonnu was celebrated on plantations from the Caribbean to Virginia. During the festival, slaves would don masquerade costumes, pass beyond the picket fence that usually separated the slave quarters from the master's residence, and perform on the front porch of the plantation house, often in comic fashion. They were rewarded with coins and gifts from the master. The shreds

9.8 WINSLOW HOMER, *Dressing for the Carnival*, 1877. Oil on canvas, 20 × 30 in (50.8 × 76.2 cm). Metropolitan Museum of Art, New York. Lazarus Fund, 1922.

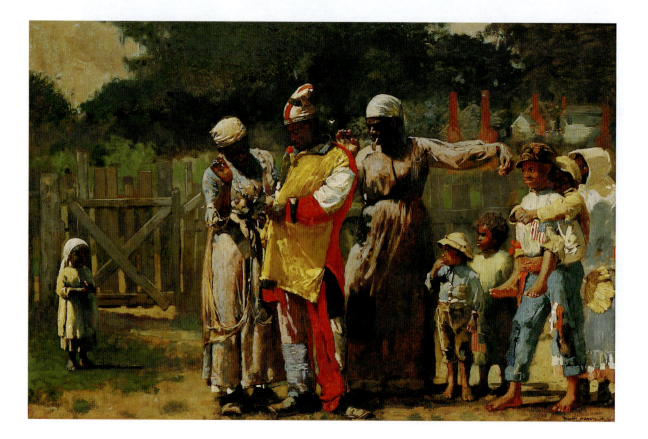

of cloth that adorn the central figure in *Dressing for the Carnival* resemble the strips of fabric that adorned the costume of the "Pitchy Patchy" or "Rag Man" from Jonkonnu.[4] They also allude to "Harlequin"—a clown-like character in European masquerade traditions known for his wit and guile.

*Dressing for the Carnival* is less a simple description of everyday life among former slaves in the South than a meditation on the fate of African Americans in post-Reconstruction America. The painting dramatizes both the dignity of Homer's subjects and the tenuousness of their lives. They shuttle between American celebrations of freedom and post-Reconstruction denials of it. They marry ancestral West African with European performance traditions. They costume themselves for succeeding in a white world. The sewing skills of the women—their ability to adjust the man's costume just *so*—contrast implicitly with their lack of control over the larger forces of the outside world, the one on the other side of the fence. Will the costumed man need to dance and sing in minstrel fashion in order to solicit the good will of his former masters, or will he soon join the Fourth of July parade as an enfranchised citizen?

Though Homer poses no answers to these questions, he also refuses to simplify the questions. The painting's sense that freedom is as much play-acting as reality reflects Homer's desire to capture black experience outside the prevailing stereotypes. He alludes instead to the precarious nature of black economic survival (the rags and the children's bare feet), to the prospect that the future will only repeat the past (the plantation world on the other side of the fence), and to the endless improvisations that former slaves must make. At the same time, the small white butterfly frozen in mid-air behind the man's head carries associations of flight, freedom, and transformation. The question that Homer poses for the viewer is: how are we to interpret that butterfly? Is it an affirmation of the aspirations of the figures surrounding it, or is it a suggestion of how much has been—and will be—lost?

**THE GULF STREAM.** More than twenty years later, Homer provided a tragic answer to the questions posed in the earlier picture. *The Gulf Stream*, 1899, sets an isolated black man, stranded on a rudderless boat, against a swarm of circling sharks (**fig. 9.9**). The turbulent water is flecked with red, signifying the violence that comes not only from the sea and sharks, but from the large waterspout—a kind of

9.9 WINSLOW HOMER, *The Gulf Stream*, 1899. Oil on canvas, 28 × 49 in (71.1 × 124.4 cm). Metropolitan Museum of Art, New York. Wolfe Fund.

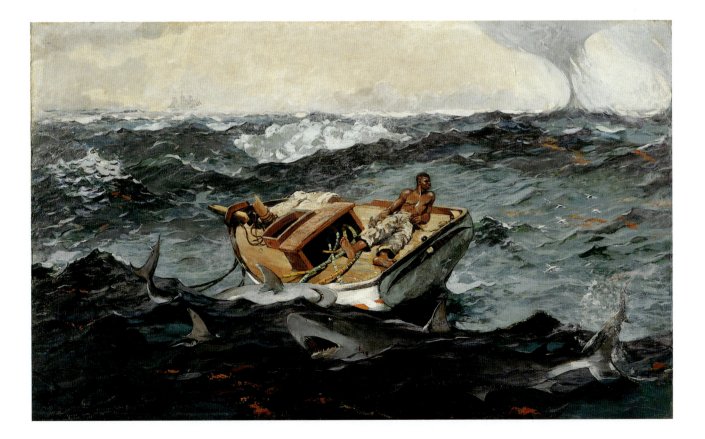

tornado at sea—in the far right background. Sharing the horizon with the waterspout, but at the opposite end of the canvas, a tall-masted ship heads serenely into the light, away from the stranded boat.

The background ship represents the community in a general sense, and, as a visual pun, the "ship of state." Its distance from the horrors of the foreground suggests the indifference of the nation to the plight of the stranded black man, who looks away from the ship, having long since abandoned any hopes of help from that quarter. Instead he directs his attention to the shark-infested waters, intent on survival. The odds that he will succeed look slim.

In the ocean to his right a school of flying fish breaches the red-capped surface. The fish embody freedom, and they contrast, in their flight, with the earthbound fate of the painting's protagonist. They provide the painting with a visual equivalent of the small white butterfly in *Dressing for the Carnival*. In the earlier painting, the butterfly represented simultaneously a vision of freedom and an ironic comment on the difficulty of attaining it. In *The Gulf Stream*, the flying fish are entirely ironic. They dart to the right as the boat wanders hopelessly to the left. Divided between the two, the black man looks toward the fish while his body drifts with the boat. Freedom exists as a vision that recedes even as he watches.

The chain-like forms at his feet are in fact stalks of sugar cane. They allude to his dependence on field work, bodily labor, and an international market that exports the raw products of the South and the Caribbean to manufacturing centers—and profits—elsewhere, large and overwhelming forces that radically curtail his freedom and render him helpless.

Though the imagery of Homer's paintings tends to be natural, the crises they reveal are invariably social. Homer's critics have tended to interpret him as a painter of timeless, universal human truths. We need to understand him, instead, as one of America's most astute social commentators.

**THE TURTLE POUND.** In contrast to the despair of *The Gulf Stream*, Homer created a series of remarkable watercolors during his visit to the Bahamas in 1898. These intimate scenes portray indigenous figures in their everyday work environments. In *The Turtle Pound* (**fig. 9.10**), for example, Homer shows two Bahamians, at home in the water, transferring a sea turtle to a holding pound where it can grow and

9.10 WINSLOW HOMER, *The Turtle Pound*, 1898. Watercolor, 16 × 21⅛ in (40.6 × 54.3 cm). The Brooklyn Museum, New York. A.T. White Memorial Fund and Others.

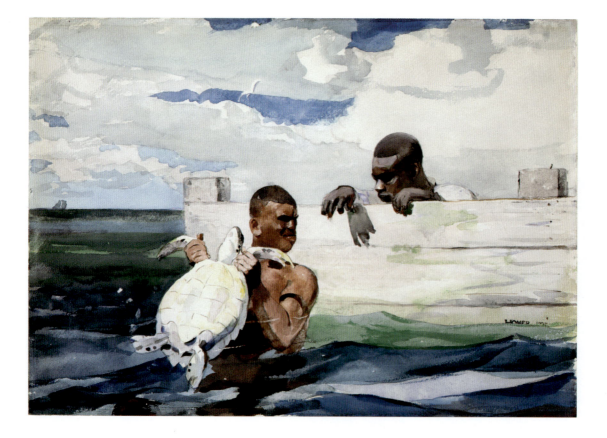

fatten. The men are defined by their mutual cooperation, their intent engagement in their work, and their indifference to the viewer, whom they do not acknowledge. They work beyond the industrialized rhythms of factories and time clocks, and their gracefulness mirrors the wholeness of their world. They embody for Homer what industrial America had lost: a unity of mind and body prior to the modern "division of labor." This organic unity of body and soul, man and nature, extends to the very substance of this watercolor. Homer allows the whiteness of his drawing paper to show through, weaving its texture into his arrangement of clouds and pound boards.

## Harriet Powers's Bible Quilts: Popular Religion and Black Emancipation

We have already seen one example of how women used needlework to explore the black presence in the public sphere. The African American quilter Harriet Powers's two Bible quilts, one in the Smithsonian (c. 1886), the other in the Museum of Fine Arts, Boston (c. 1895, **fig. 9.11**), are among the best known and most widely illustrated examples of the quilting arts. A seamstress who was born a slave in Georgia in 1837, Powers (d. 1911) completed these two works in her late middle age, using a range of typical fabrics

of the time. Most of the work was done on a sewing machine, in a free-spirited manner more concerned with her message than with delicacy of execution. Powers's quilts demonstrate that black women—the most marginalized voices in nineteenth-century culture—were engaged with the social and religious issues of their day. While they could neither vote nor wield direct political power, women articulated ideas in the medium they knew best—cloth.

Powers called her quilts "sermons in patchwork." She turned to needlework—a medium readily available to her as a black woman—as a way of participating in a tradition of biblical prophecy traditionally dominated by men. The quilt illustrated here is composed of fifteen scenes, many referring to biblical stories, including Adam and Eve, Jonah and the Whale, Job, Moses, John baptizing Christ, and the Crucifixion. Four other scenes depict mysterious weather occurrences, among them "Black Friday" in 1780—when pollution caused by forest fires darkened the sky—and the meteor storms of 1833 and 1846. A fifth tells the story of an "independent hog that ran five hundred miles from Georgia to Virginia," possibly a reference to runaway slaves during her youth.

9.11 HARRIET POWERS, Bible quilt, c. 1895. Cotton, 60 × 105 in (152.4 × 266.7 cm). Museum of Fine Arts, Boston, Massachusetts.

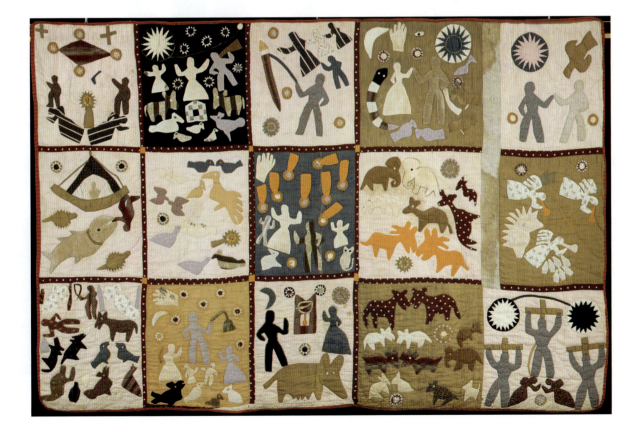

The square directly in the center of the quilt depicts the all-night Leonid meteor storm of November 13, 1833. Eight yellow stars stand out vividly against the blue background. A large white hand is appliquéd to the upper left corner of this central block. Powers said of this event, "the people were fright and thought that the end of time had come. God's hand staid the stars." Some scholars have linked Powers's quilts with West African traditions of pictorial appliquéd banners. But in fact, most slaves in Georgia had been brought from the Central African regions of Angola and the Congo, rather than West Africa. Powers's quilt does contain cosmological symbols—hand, eye, snake, sun, and cross—used in the various West and Central African cultures from which slaves were taken. So it is possible that such symbols fuse African and Christian prophetic traditions.

Powers was a devout Christian who exhibited and sold her quilts at international fairs to white buyers. Her Smithsonian quilt was displayed at the 1886 Cotton Fair in Athens, Georgia, and circumstantial evidence suggests that the quilt illustrated here was on view at the 1895 Cotton States and International Exposition in Atlanta, where the black educator Booker T. Washington first proposed his ideas about improving the condition of southern blacks through economic self-reliance and cooperation with their former masters. Powers's quilt, however, sounded a different message. In the popular tradition of interpreting natural events as providential warnings, and in the symbolism of runaway slaves, Powers gave African Americans a more active role in shaping their own destinies. Her unforgettable pictorial narrative is a potent symbol of African American creativity and tenacity in the aftermath of slavery.

## Henry Ossawa Tanner

In the post-war years, many Americans assumed that slavery had deprived blacks of both tradition and history, a devastating denial of identity and shared humanity. The black academically trained artist Henry Ossawa Tanner (1859–1937) had a stake in issues of cultural identity other than that of white artists painting black subjects. Tanner engaged racial stereotypes only to turn them around in a respectful exploration of black traditions.

Tanner's father was a pastor in the African Methodist Episcopal Church; he had grown up steeped in ideals of black cultural uplift, access to education, and belief in the place of the African American artist in the nation's future. Yet he had also experienced racial harassment from students at the Pennsylvania Academy, where he was

studying under Thomas Eakins. Like many artists of his generation, Tanner went to study in Paris, making his permanent home there from 1894 on, and winning respect and admiration from the French, who considered him, according to one critic, "the greatest artist that America has produced."[5] Much of his later career was devoted to biblical history paintings, which he did as an expatriate.

**THE BANJO LESSON.** In 1893 Tanner painted this work (**fig. 9.12**) while in Philadelphia, to which he had returned from Paris to recover from typhoid fever. *The Banjo Lesson* was one of two genre paintings Tanner produced at this time in which poor southern blacks, still scarred by slavery, are presented with unsentimental dignity. The reserve of Tanner's subjects departs from the traditional image of the gregarious black performer. *The Banjo Lesson* was painted three years before the Supreme Court decision *Plessy v. Ferguson* (1896), during a period when whites were

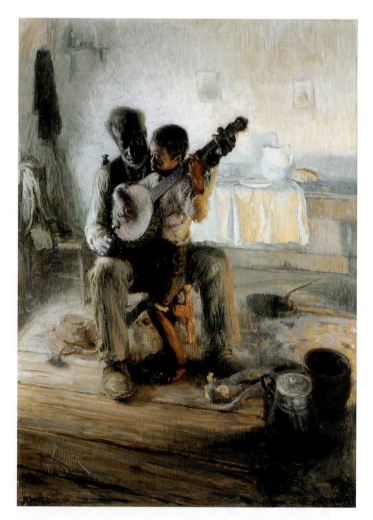

9.12 HENRY OSSAWA TANNER, *The Banjo Lesson*, 1893. Oil on canvas, 49 × 35 in (124 × 90 cm). Hampton University Museum, Virginia.

committing lynchings and other crimes of intimidation to reestablish racial separation in the South.

In this quiet scene a young boy is cradled in the arms of an older black man who holds up the neck of the banjo—an instrument too large for the boy to support. The boy tentatively strums the banjo with his awkwardly cocked right hand, while his left hand struggles with fingering. The two figures form a tight compositional and emotional unit, thoroughly absorbed in their world. They are situated in a simple, scrubbed domestic interior, the remains of a meal just eaten visible on the table in the background. An internal radiance sets off the massive dark brow and head of the man and illuminates the face of the young boy, a study in concentration. Knees spread wide, the man frames the boy in a metaphor of protection, tradition, and the bond furnished by music as it is passed from generation to generation. Tanner may have drawn this subject on travels to North Carolina before returning to Paris. As the art historian Judith Wilson has pointed out, Tanner transforms the conventional view of blacks as innately musical by emphasizing the role of teaching in the transmission of black cultural forms.[6] The young boy's face is illuminated from the left, in a traditional metaphor of enlightenment. In their embrace of vernacular subjects, these works by Tanner look forward to twentieth-century black artists who explored the place of tradition in black cultural identity.

Traditions have a double-edged significance in African American communities, asserting continuity but also recalling a history of oppression. Tanner remained sensitive to this. In his work the banjo—associated with the minstrel tradition of grinning, extroverted blacks—becomes an instrument of generational exchange. Furthermore, as a New World adaptation with roots in Africa, the banjo harkens back to a preslavery past, and reconnects with ancestral traditions. Even so, Tanner explores black tradition in a style of painting that is indistinguishable from that of white American artists who, like him, also studied in Paris in the later nineteenth century.

Tanner's position between the worlds of American and French art, and between a supportive black family and white patrons, may, as Al Boime has suggested, have freed him from confining perspectives and allowed him to confront the experience of African Americans with new directness. Held up throughout his life as a representative of his race, Tanner himself resisted being labeled a "Negro" artist, insisting that race was irrelevant to his ambitions. And yet Tanner's social experience endowed him with uncommon sensitivity to the problems of black representation.

## Facing Off: Divided Loyalties

In the years surrounding the Centennial, images of feathered Indians and shaggy buffalo appeared widely, on decorative items such as silver punch bowls and porcelain vases as well as in paintings and prints. Once symbols of America's difference from Europe, American Indians now served as decorative icons of the nation's growing imperial control over the continent. Karl Mueller's porcelain *Century Vase* (**fig. 9.13**), exhibited at the Centennial Fair, fuses the Indian chieftain, the buffalo head, and the spread eagle—complete with jagged thunderbolts recalling stylized Native American forms—into a composition centered on the portrait bust of the founding father, George Washington. Vignettes of telegraph poles and factories alternate with Western wildlife: grizzly bear, wolf, and buffalo, along with scenes commemorating the origins of the republic. The technological future and the heroic past fuse seamlessly.

The *Century Vase* encapsulates the cultural contradictions of the fair itself. Throughout the great halls of

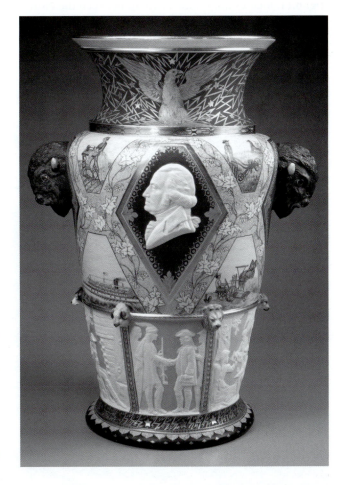

9.13 **KARL MUELLER**, *Century Vase*, c. 1876. Porcelain. Brooklyn Museum.

the Centennial exposition, the past—as colonial history and as savage frontier—was displayed alongside industrial machinery announcing the triumph of technology over nature. Looking backward and forward, the fair offered little contemplation of the present; its vast spectacle conveniently overlooked the Plains wars, the failures of Reconstruction, and the birth pains of a new industrial order.

## Compositional and Thematic Polarity

While the displays of the 1876 fair may have been refashioning the past to announce a triumphant technological future, the strains of modernization were becoming evident nonetheless. Compositional and thematic polarities observable in some thoughtful artworks of the period embody the characteristic divisions around which rural and industrial, elite and democratizing forces confronted each other in the years around 1876.

**THE MORNING BELL.** Painted prior to his trip south after the Civil War, Winslow Homer's *The Morning Bell* of 1866 (**fig. 9.14**) focuses not on the divisions between the North and the South but on those internal to an industrializing society. The painting plays on the contrast between the

bucolic world it depicts and a new industrial order, advancing upon it as steadily as the lone woman crossing the bridge. *The Morning Bell* is composed around two primary axes that intersect in the figure of the lone woman. The bridge and the three women on the right define a horizontal axis. What begins on the right as open space grows increasingly claustrophobic as we travel leftward toward the darker mill building with its bell tolling the new rhythms of industrial life. By contrast, the vertical axis—defined by the rickety side bridge—opens toward the forest and sky, culminating in a lone bird soaring above the treetops, a distant symbol of flight and freedom. The woman crossing the bridge stands midway in transition, from right to left, vertical to horizontal, and rural to industrial. The wildflowers, dappled sunlight, and distant cabin recall a rural world of homespun clothing, like that worn by the three bonneted girls who gossip about the arrival of the fashionably dressed young woman. Her clothes, by contrast, are a product of the textile mills and ready-to-

9.14 WINSLOW HOMER, *The Morning Bell*, 1866. Oil on canvas, 24 × 38¼ in (60.9 × 97.1 cm). Yale University Art Gallery, New Haven, Connecticut. Bequest of Stephen Carlton Clark.

wear clothing industry that changed the look of the nation in the years after the Civil War.

In its spatial and narrative organization, *The Morning Bell* opposes the rural basis of national life before the war, rooted in natural time, with an emergent order of regulated labor; the isolated figure of the female laborer contrasts with the communal world of the three farm girls, who also now work in a factory. The tree on the left, which literally anchors the bridge, has been symbolically sawn and planed to furnish the planks out of which the bridge is constructed. Homer's painting makes a piercing comment on the inadequacy of antebellum values within a post-Civil War society. The New England countryside in the painting mirrors the popular imagination of rural peace, but it harbors within itself a deeper change, a slow, step-by-step movement into a world of industry and mechanization that spells the end of that once idyllic dream.

## The Persistence of the Past: The Colonial Revival

Despite the tendency of Americans to invoke divine authority to sanctify their ambitions, the Civil War had exposed the all-too-human fallibility of the fragile social covenant. Adding to the strains were the political scandals and partisanship of the **Gilded Age**, as well as the greed unleashed as new territories were opened to commercial exploitation. As time and events distanced the nation from its founding, the generation of 1876 desired reassurance that core values had not changed, that America remained culturally homogeneous and connected to a past at once heroic and humble.

For visitors, the Centennial Fair offered a sentimental journey into history. Nostalgia—the longing for home, for the past—set the tone for much of the art made in these years, symptomatic of a generation searching for emotional ties to a past being increasingly pushed aside by change. This period occasioned a time of national introspection, of yearning for artisanal labor, rural childhood, and village scenes. Such subjects carried national memory past the carnage of the Civil War to a period before the birth-pangs of industrial democracy. Architects, designers, artists, and illustrators sought inspiration from the seventeenth and eighteenth centuries, times of chaste restraint, homely simplicity, and moral rectitude. Yet this so-called "Colonial Revival" went hand in hand with a vision of America as a nation at the forefront of progress. The Philadelphia Fair displayed the contradictions inherent in this combination.

At the symbolic center of the Philadelphia fairgrounds towered the giant Corliss engine, a turbine that powered

the 450 acres of exhibits. A Centennial print (**fig. 9.15**) shows President Ulysses S. Grant inaugurating the fair by firing up the Corliss, in the company of visiting dignitaries from Brazil. Locked into place by stairs leading to high platforms, the engine seems a Frankenstein monster of technology tamed for social purposes, and a proud symbol of the new nation whose birthday is being celebrated.

The presence of the Corliss engine at the fair points to a redirection of America's sense of nationhood from nature to technology. Mechanization created new unities of time and space; telegraphs, railroads, and standardized time zones spanned the enormous distances that had once separated Americans from one another, and these connections diminished the provincial and local character of

9.15 "President Grant and the Emperor of Brazil Starting the Great Corliss Engine in Machinery Hall", from the Philadelphia Centennial Exhibition, 1876. Private Collection.

American life. Yet at fair exhibits, visitors could return to the colonial and frontier eras of American history. While putting technology on display, the fair also celebrated preindustrial time.

The Colonial Revival focused national identity on New England origins. Seeing "New Englandly," in the poet Emily Dickinson's words, became a national habit, as Americans from different regions and ethnic backgrounds imagined a past of white clapboard houses and manicured greens, remote from immigration, cities, and industry. This image of the New England village was itself an invention of the Colonial Revival; historically, the greens had been muddy commons, and houses of the seventeenth and eighteenth centuries were not painted white.

The themes of Colonial Revival were taken up by a range of painters, sculptors, printmakers, photographers, designers, and architects in the decades following 1876. Increasingly, as the urban upper class consolidated its financial and commercial power, it turned to genealogical societies, American antiques, and crafts such as needle-work to ground its activities in a comfortingly stable and unified past.

**THE PURITAN.** Augustus Saint-Gaudens's *The Puritan* of 1887 (**fig. 9.16**) is both tribute and parody. It was commis-sioned at a time when America was besieged by moral backsliding at every turn: public graft, prostitution, and self-serving behavior. The Puritan strides toward us with a summons to self-examination, recalling viewers to the memory of Old New England as the symbolic heart of the republic. Yet Saint-Gaudens's grimfaced, Bible-toting Pilgrim Father possesses a rectitude that borders on rigidity and tramples on the delicate foliage underfoot. Dead set on the straight and narrow, the Puritan would come to be reviled as the zealous, provincial, and joyless type of American.

Of French and Irish ancestry, Saint-Gaudens did not share unequivocally in the myth of the nation's Puritan and Anglo-Saxon origins. Colonial themes in painting and book illustration, house design, and consumer culture, however, maintained a persistent place in the lives of affluent Americans. These themes offered what the architectural historian Dell Upton has called an "ancestral homeland" in the form of Windsor chairs and spinning wheels as well as suburban house types from the Tudor to the Cape Cod and Georgian. All offered instant "tradition."

**THE SHINGLE STYLE.** Seventeenth-century New England houses also helped inspire the so-called "Shingle Style," one of the first distinctly national design idioms, and

9.16 AUGUSTUS SAINT GAUDENS, *The Puritan (Deacon Samuel Chapin)*, 1887. Bronze, 30½ × 20½ × 12 in (77.5 × 52.1 × 30.5 cm). Virginia Museum of Fine Arts, Richmond. The Charles G. Thalhimer Family Fund.

an American version of an international movement that grounded domestic architecture in vernacular forms and materials. Designers such as Charles McKim (1847–1909) (**fig. 9.17**), H. H. Richardson (1838–86), and Stanford White (1853–1906) were all enthusiasts of the Shingle Style, finding inspiration in such colonial predecessors as the Fairbanks house (see fig. 3.30), with its irregular profile, multiple dormers and gables, and shingle sheathing. The additive qualities of seventeenth-century houses—in which rooms were built onto the main structure over generations—were an architectural symbol for generational continuity and the seamless presence of the past. Interior plans were open and relaxed, with large, non-axial room arrangements. An idiom particularly favored by older monied families in New England, but which eventually spread throughout the

9.17 MCKIM, MEAD, & BIGELOW, Mrs. A.C. Alden House, "Fort Hill," Lloyd's Neck, Long Island, New York, 1879. Print. Library of Congress, Washington, D.C.

United States, the Shingle Style avoided antiquarianism, splicing Japanese and medieval influences onto more local sources, and combining American origins with such up-to-date amenities as wrap-around porches, elaborate wall paneling, and built-in sideboards.

**QUAINT, ENDEARING, AND COMFORTING.** By 1876, needlework samplers were considered a quaint reminder of early America. They began to be collected and prized as museum specimens. The Leverett sisters' embroidered chest of the 1670s (see fig. 3.34) was displayed at the "Exhibition of Antique Relics" at the Centennial.

The Centennial's backward glance also fastened on images of rural childhood given currency in Mark Twain's *The Adventures of Tom Sawyer,* the eponymous hero of which is only the best known of a troupe of endearingly naughty ragamuffins who resisted the discipline of bath, school, and church. *The Berry Boy* (**fig. 9.18**) by J. G. Brown (1831–1918) reinforced a popular mythology about the wholesome rural origins of the urban entrepreneur, a training ground for the resourceful independence required to succeed in the business world of post-war America. With his direct, wide-eyed gaze and plucky appearance, the barefoot boy, like his urban counterpart, Ragged Dick—the rags-to-riches hero of Horatio Alger's popular series of novels—epitomized the belief in upward mobility that was essential to maintaining faith in democracy. Yet in an era of increasing corporate consolidation, the image of stalwart self-reliance had become increasingly out of step with the realities of the white-collar workplace. Straddling a stone wall, the barefoot boy also straddled another symbolic divide, between an agrarian and a commercial nation. Such images spoke to the middle-class preference for easily readable narratives that helped them navigate the challenges of adulthood by offering them a comforting refuge from these very demands. In much post-war genre painting, child's play anticipates and prepares the way for adult

roles and responsibilities. Scenes of childhood, by Eastman Johnson (1824–1906), Winslow Homer, and others, explored the nation's own moral and social coming-of-age.

9.18 J.G. BROWN, *The Berry Boy,* c. 1877. Oil on canvas, 23 × 15 in (58.4 × 38.1 cm). George Walter Vincent Smith Art Museum, Springfield, Massachusetts. George Walter Vincent Smith Collection.

## Popular Prints and the Emergence of Cultural Hierarchies

Among the many commercial firms to profit from the new rage for nostalgia and patriotic celebration were the New York City printmakers established in 1837 by Nathaniel Currier (1813–88) and James M. Ives (1824–95), who issued a series of prints illustrating the now mythic life of George Washington: commanding the Continental Army, crossing the Delaware, and virtuously renouncing claims to power after the war. Using the most modern of means—division of labor, assembly-line production, catalogue distribution, and an early form of "niche" marketing—Currier and Ives enjoyed a market that reached beyond the United States to Europe. Ranging between 15 cents and three dollars, their prints flattered public pride in the future of the republic with images of railroads, clipper ships, steamboats, and urban monuments, as well as reassuring scenes of rural homesteads, cozy farms, and frontier adventure.

From 1840, when Currier first began providing eye-witness images of news events, until the 1890s, when other forms of mass-circulation images such as **photogravure** and **half-tone** photography replaced them, hand- and machine-colored **lithographs** had far greater cultural influence than works of fine art. Currier and Ives catered indiscriminately to an image-hungry public, playing to all sides. While capitalizing on the passion for patriotic images of the Union war effort, they also marketed nostalgic images of the old South after the war (**fig. 9.19**). Their comic images of newly emancipated blacks contained a casual racism, yet their stock also included depictions of the evils of slavery. They sold portraits of Irish nationalists and souvenirs of

Irish landscape, history, and legend, along with caricatured images of Irish Americans. Neither politics, ideology, nor loyalty to their mostly native-born, middle-class buyers kept them from serving other groups, as long as a market existed.

**CHROMOLITHOGRAPHY.** If Currier and Ives's prints were often poorly drawn and crassly commercial, the related medium of **chromolithography** pursued a higher aim of inculcating "a taste for art" into a broad public. The "chromo"—a color print that often reproduced an original work of art—could be found in middle-class homes throughout the later nineteenth century. In Mark Twain's 1889 novel *A Connecticut Yankee in King Arthur's Court*, Hank Morgan, transported to medieval England, yearns for home—in particular, for the "chromo": "It made me homesick to look around over this proud and gaudy but heartless barrenness and remember that in our home in East Hartford, all unpretending as it was, you couldn't go into a room but you would find an insurance-chromo, or at least a three-color God-Bless-Our-Home over the door—and in the parlor we had nine." Though today we dismiss such sentimental images, for Hank they were deeply meaningful: "I saw now that without my suspecting it a passion for art had got worked into the fabric of my being, and was become a part of me." Hank expresses the tastes of an American middle-class public for whom art was a domestic affair. Twain's own fiction was itself an often searing look at the moral evasions of middle-class culture in the United States. And yet, despite the satirical tone of the above passage, Twain was onto something.

Chromolithography did indeed encourage "a passion for art," but its commercial origins and availability to a wide public put a huge marketplace of goods within the reach of those with more money than taste. As middle-class consumers purchased mechanically reproduced high-style goods to emulate the wealthy, those concerned with preserving class distinctions attacked the sham values and derivative products of what the cultural historian Miles Orvell has called a "culture of replication" based on Old World forms.

The condemnation was summed up in the term "chromocivilization" coined by the editor E. L. Godkin in 1874. For Godkin and others, the democratization of art threatened "mental and moral chaos."[7] But chromolithography also had many defenders among those who believed that art was not just for the privileged few but could have a refining influence on a democratic public. For Catharine Beecher, the influential co-author, with her sister Harriet Beecher Stowe, of *The American Woman's Home*

9.19 CURRIER & IVES, "A Home on the Mississippi", 1871. Lithograph. Museum of Fine Art, Springfield, Massachusetts.

(1869), chromolithographs provided an ideal, inexpensive, and morally uplifting wall decoration for middle-class families. Beecher was one of a growing number of newly professionalized female authors who both created and filled a need for guidance—moral and material—in the conduct of middle-class domestic life. Middle-class mothers and wives looked to authors of domestic help manuals for advice on everything from efficient use of kitchen space to the maintenance of a healthy home environment. Godkin had no reason to fear mental and moral chaos; with the help of women such as Beecher, the American middle class learned that the health of the republic depended on a virtuous and well-regulated household.

The gap between high art and popular culture widened toward the end of the nineteenth century. This contest between elitist and what would later be called "middle-brow" approaches to art persisted over the course of the twentieth century. High modernism—an art that defined itself as challenging and difficult—increasingly focused its identity around opposition to middlebrow taste, with particular reference to cultural products that demanded little from their audiences, such as the chromo.

# Print Techniques

INVENTED IN 1798 in Germany and quickly refined in France and England, lithography was an autographic process; rather than having the image transferred, the artist drew directly onto the lithographic stone. Lithography thus eliminated the necessity of translating the source drawing to the surface to be printed. It was quick and far less labor-intensive than earlier relief (in which only the raised portions are printed), or intaglio (in which the image is engraved or bitten into the printing plate). As the process became rapidly commercialized by the mid-nineteenth century, lithographic firms such as Currier and Ives served a business class needing advertisements, trade cards, sheet music, and portraits, as well as meeting a growing demand for affordable art to grace middle-class homes. Taking control away from the individual artist, popular lithography divided printmaking into delineators who drew on the stone (often anonymous), inkers, printers, colorers, and "grainers" (to smooth the stone face). Requiring minimal skills, the final phase of hand-coloring prints furnished employment for women untrained in traditional crafts. This division of labor became common in such mass-produced arts of the twentieth century as animation.

Unlike the hand-colored lithographic prints of Currier and Ives, colors in chromolithography were each printed separately with a different stone; the greatest technical challenge was making sure the **register**, or overlap of color areas, was precisely accurate. The result, in the hands of such firms as Louis Prang (**fig. 9.20**), was a stunning ability to reproduce the look and texture of oil paintings: landscapes, still lifes of fruit and game, Old Master paintings, and patriotic images to instruct, refine, and please.

9.20 UNKNOWN ARTIST, *"Lower Yellowstone Range"*, after a watercolor by Thomas Moran, 1874. Chromolithograph by Louis Prang, 14 × 9¹³⁄₁₆ in (35.5 × 24.8 cm). National Museum of History and Technology, Division of Graphic Arts, Smithsonian Institution, Washington, D.C.

# The Post-War West: Expansion, Incorporation, and the Persistence of the Local, 1860–1900

In 1876, the West offered an escape from the pressures of the moment. But it also occupied a new place of importance in the life of the nation. The driving of the Golden Spike at Promontory Point, Utah, in 1869, an event documented by the photographer Andrew J. Russell (**fig. 9.21**), is emblematic of the double-edged nature of post-war progress. Commemorating the completion of the transcontinental railroad with the meeting of its two halves—west to east and east to west—the event quite literally bound together with iron rails a nation once sundered by civil war. With the movement of commerce, industry, and large-scale settlement, as settlers, businessmen, and industrialists went west, they trespassed on Indian lands. Just beyond the margins of Russell's celebratory image were the Chinese laborers who played such a central role in the industrialization of the West.

The completion of the transcontinental railroad in 1869 was more than a triumph over the vast distances of the new continent. It was also a symbolic moment holding the promise that eventually all of this land would be incorporated and its raw materials transformed into resources of the nation-state. Yet, while being a symbol of renewed national hopes

9.21 ANDREW J. RUSSELL, *East and West Shaking Hands at Laying [of] Last Rail*, 1869. Albumen print. Union Pacific Historical Museum, Omaha, Nebraska.

and opportunities, the West was also the home of Plains, Navajo, Pueblo, and Hispanic peoples who were struggling to preserve their identities in the face of white expansion. The emergence of a national market for industrial goods inspired a backlash, as these cultures resisted consolidation, holding fast to their own traditions, values, and forms.

In the East, local cultures posed little resistance to nationalizing energies. The situation was different in the West, where these cultures had existed outside the nation-state much longer.

## Landscape Art, Photography, and Post-War National Identity

From the sixteenth century through the nineteenth, the way west had offered the promise of wealth and new opportunities for gain to European adventurers and later to white entrepreneurs. To settlers migrating from the east, it promised new beginnings. Yet the vast natural resources of the region opened to industry and settlement after the war also unleashed ruthless ambitions. The post-war colonization of the West opened up very different visions of the region's future, pitting the quest for private wealth against the public trust, and challenging older myths about the West as a place of personal and social redemption.

The West was colonized by the eye as much as by the rifle. From John White's watercolors of the first colony in Virginia to the United States Geological Surveys of the West in the late nineteenth century, artists assisted explorers and scientists in their efforts to map, publicize, and colonize lands unfamiliar to European travelers. These images of first encounter in the far West tend to fall into two categories: "booster artwork" and "disinterested" documentation.

**"BOOSTER ARTWORK": YOSEMITE AND THE SIERRA NEVADA.** "Booster artwork" rendered new lands in exotic terms and cast them as the answer to social ills back home. Often overtly propagandistic, such images encouraged colonization—and, gradually, tourism—by contrasting the richness of the new lands with the economic hardships of home.[8]

Following the trauma of war, the heroic wilderness landscape of the antebellum years—large-scale, exotic, and full of promise—had tremendous appeal. Yosemite Valley in California's Sierra Nevada range was one such landscape. At once pastoral and sublime, the valley itself is surrounded by towering rock walls, a natural paradise sealed off from history. This protected condition was further guaranteed by the popular movement to establish a system of national parks, beginning with Yosemite in 1864, as "public" space "inalienable for all time," wilderness, primeval and untouched.[9]

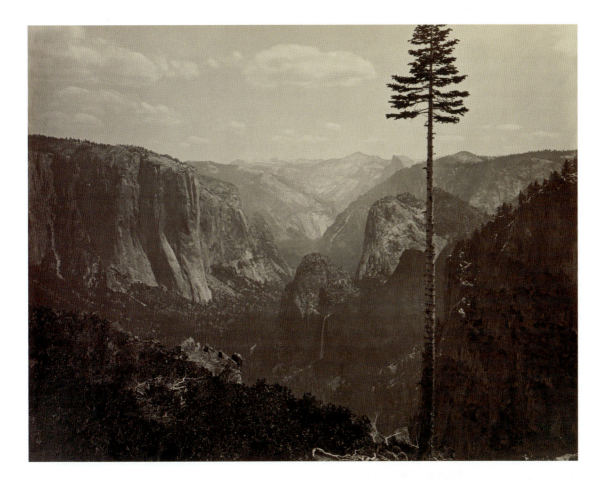

9.22 CARLETON WATKINS, *Yosemite Valley from the Best General View*, 1865. Albumen print. American Geographical Society Collection, University of Wisconsin Milwaukee Library.

In paintings and photographs—created for a public eager to consume images of the "golden West"—Yosemite was depicted as pristine and uncorrupted by human contact. Carleton Watkins (1829–1916), who had moved to California as a young man, found steady employment from the railroad and mining industries. But he was also a commercial photographer with a studio in San Francisco, who appealed to local and national pride by promoting Western scenery. Watkins presents the West as a sublime spectacle. His *Yosemite Valley from the Best General View* of 1865 (**fig. 9.22**) frames the valley as a series of receding planes, atmospherically muted. This method of composition derives from landscape painting, and presents the view aesthetically. The foreground tree not only provides scale and drama to the image, but acts as a surrogate for the viewer, as if the tree, too, were merely a traveler pausing to absorb the scene. Viewed from a height, and rendered in panoramic scale, the monumentality of Yosemite is cast in an easily readable form, a readymade memory for the tourist or occasional visitor.

CULTURAL CONTEXTS

# Circulating the West

UNLIKE EARLIER DAGUERREOTYPES, which produced only a single image at a time and did not allow for serial printing, the new process of wet-plate photography permitted many images to be printed from a single glass plate. These large-format cameras, though still cumbersome and labor-intensive, made possible the widespread distribution of photographs of the West. The photographs, in turn, were often reproduced through other media: lithographs, engravings, book illustrations, and, later, **rotogravures**. The photographic historian Martha A. Sandweiss estimates that the Pacific Railroad survey report—issued in large numbers as a multi-volume illustrated set—produced a combined number of approximately 6,660,000 total images, roughly one for every five Americans. The audiences for such images ranged from "congressional sub-committees to would-be immigrants, from wealthy private patrons to large crowds of entertainment seekers."[10] The cultural impact of such widely circulated images of the West was immense.

As documents, photographs sometimes obscure other forms of truth. In Yosemite, for example, Indians had regularly set fires to the underbrush and saplings of the valley for centuries, in order to maintain their hunting trails. The process had allowed an unusually large number of black oaks to mature over time, resulting in landscape that accorded with European American traditions of the picturesque. The Yosemite that photographers like Watkins captured was not the primeval landscape that viewers—and Congress—took it to be, but an ecosystem altered by centuries of input from humans. Yet Watkins's photographs banish all signs of an indigenous population and make the landscape an emblem of the nation: innocent, uncorrupted, eternal.

This vision of primeval nature also obscured another process transforming the West: the industrial extraction of natural resources. Albert Bierstadt (1830–1902), for example, adroitly reconciled an idealized image of the West with the realities of a land undergoing radical environmental change. Bierstadt's *Donner Lake from the Summit* (**fig. 9.23**) acknowledges the industrial infrastructure, framing it, however, within the broader myth of a land of beauty and natural plenty. Nestled in the shadows of the Sierra Nevada, and barely visible in Bierstadt's painting, the railroad brought intense economic competition to California,

cost many lives in its construction, and gave the state's "Big Four" industrialists—Crocker, Stanford, Huntington, and Hopkins—enormous power over its future. Bierstadt's sun-gilt landscape, its blue lake mirroring the heavens, glosses over the environmental toll, the lives lost, and the concentration of capital and power, capturing instead a powerful sense—still strong today—of the West as a place apart.

## "DISINTERESTED KNOWLEDGE": YELLOWSTONE AND OTHER SURVEYS OF THE WEST.

A second mode of "first encounter" images sought "disinterested" knowledge of the territories that opened up after the war. Though these images were always part of a larger effort to colonize the landscape and exploit its economic potential, they expressed these ends through the language of science. They illustrated the geological formations, the local fauna and flora, and, occasionally, the native populations that lent the lands of the West their strange aura. In the Centennial years, the preferred medium of scientific encounter was photography, which possessed the authority of objective truth.

Between 1867 and 1879, a series of geological surveys—first civilian, later military—used their photographic

9.23 ALBERT BIERSTADT, *Donner Lake from the Summit*, 1873. Oil on canvas, 72½ × 120 in (184 × 304 cm). New-York Historical Society.

documentation of the West to advance the political goals of publicizing and funding their research. The Ferdinand V. Hayden expedition of 1871, for example, was assigned the task of separating fact from fiction in reports describing the Yellowstone region. A silvery lake high in the Yellowstone Mountains, for instance, had been rumored to flow all the way to the Pacific ocean. Hayden, head of the U.S. Geological and Geographical Survey of the Territories, appointed the photographer William Henry Jackson to accompany the expedition. Though they failed to find the legendary river, they produced such spectacular images of the Yellowstone region that Congress enacted legislation the next year to establish Yellowstone National Park.

Thomas Moran's (1837–1926) *Grand Canyon of the Yellowstone* of 1872 (**fig. 9.24**) commemorated the Hayden expedition, which he joined at his own expense, in the process launching a lifelong career producing dramatic Western landscape art. Capitalizing on the growing interest for views of the West, Moran, like Bierstadt, recomposed his raw material for heightened effect. Lacking the documentary authority of the photograph, Moran's painting persuaded through a combination of scientific and aesthetic strategies. The painting is breathtaking not only in size—more than 6 by 12 feet—but in its complex mastery of geological detail, suavely integrated into a panoramic unity.

At the base of the great V-shaped composition formed by the shadowed foreground and the sunlit distance stand two tiny figures, a survey scientist and an Indian in ceremonial dress. The Indian faces us, while the scientist turns toward the landscape. Following his look, the viewer's eye is plunged into the deep space of nature, where it encounters a grand white column of spume exhaled by the Yellowstone Falls. In these two figures Moran conveys past and future: the moment when guardianship of the vast and wondrous beauty of the West is transferred from native dweller to survey scientist, who represents the interests of the newly powerful nation-state.

Moran's scene of peaceful transfer disguised a more contentious truth. By 1879, seven years after the Yellowstone region had been designated a national park, a system of military defense was in place to protect the newly created wilderness against the Indians who had previously made their home there. The park system—designated "uninhabited wilderness"—coincided with the removal of Native people from their traditional homelands, and the creation of the federal reservation system (begun in 1867–8)

9.24 THOMAS MORAN, *Grand Canyon of the Yellowstone*, 1872. Oil on canvas, 84 × 144 in (213 × 266 cm). National Museum of American Art, Smithsonian Institution, Washington, D.C.

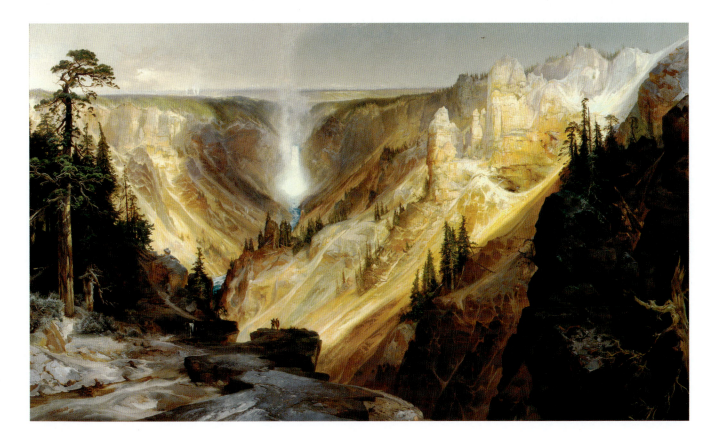

to manage and contain those who had been displaced. Though valued as symbols of America's western wilderness, the day-to-day presence of indigenous people in the national parks of Yosemite, Yellowstone, and elsewhere was an unwelcome reminder that the nation's self-appointed guardianship of the West was not cost-free.

The story of Yellowstone contains a second paradox. Moran's paintings and watercolors of the region focused attention on the natural wonders of the West. Yet this vision of majestic, untamed wilderness also drove a growing industry of tourism, promoted by the new railroads that first opened the region to mass travel—an industry that commodified the exotic West through easy access, mass-circulation photographs and posters, and the middle-class ritual of "nature worship."

Timothy O'Sullivan's (1840–82) survey photographs—done for Clarence King's Fortieth Parallel Survey in 1868 through Nevada—draw their power from the sublime contrast between the vast emptiness of nature and the more diminutive signs of human presence. They exist at a far remove from Watkins's commercial photography, which domesticate the West for aesthetic consumption. O'Sullivan's *Sand Dunes, Carson Desert, Nevada* (**fig. 9.25**) measures human endurance against nature's overwhelming indifference. The horses and wagon add a poignant note: they will soon be gone, their tracks covered up by the sands. In fact, both horses and wagon belonged to O'Sullivan, who needed them to haul his camera and over 400 lb. of photographic supplies. The footsteps visible in the sand record O'Sullivan's trek from the wagon to the point from which the picture was taken. The image thus takes

on a self-reflexive character. Nature's forces are defeated by the photographer's capacity to frame and order, and human impermanence is redeemed by the camera.

In *Ancient Ruins of the Cañon de Chelly* (**fig. 9.26**), the "ancient ruins" refuse to tell their history; they are as speechless as the desert that engulfs them, both part of a mysterious nature. At the same time, they radiate an almost metaphysical resistance: their very survival testifies to the ingenuity of their human makers. In these haunting images, we find an impulse quite different from the desire to colonize the unknown. O'Sullivan's photographs express instead the intractable strangeness of Western nature and history.

## New Mexico and Arizona Territories: Local Cultures and Expanding Markets

In communities throughout the United States and its territories, the post-Civil War decades were a time for taking stock of tradition, responding to the threats of encroachment, and struggling to preserve identity in a time of dynamic change. Among the Pueblo and Navajo people of New Mexico and Arizona, and the Hispanic villages of northern New Mexico, local resistance to national incorporation took form in diverse artistic and religious practices.

At the conclusion of the Mexican–American War in 1848, New Mexico and Arizona became territories of the United States. This region had carried on trade with its northern neighbor since Mexican independence from Spain in 1821, but the pace of exchange accelerated sharply with the arrival of the railroad in the 1880s. The emergence

9.25 TIMOTHY O'SULLIVAN, *Sand Dunes, Carson Desert, Nevada*, 1868. Albumen print, 7⅞ × 10¼ in (20 × 27.3 cm). Library of Congress, Washington, D.C.

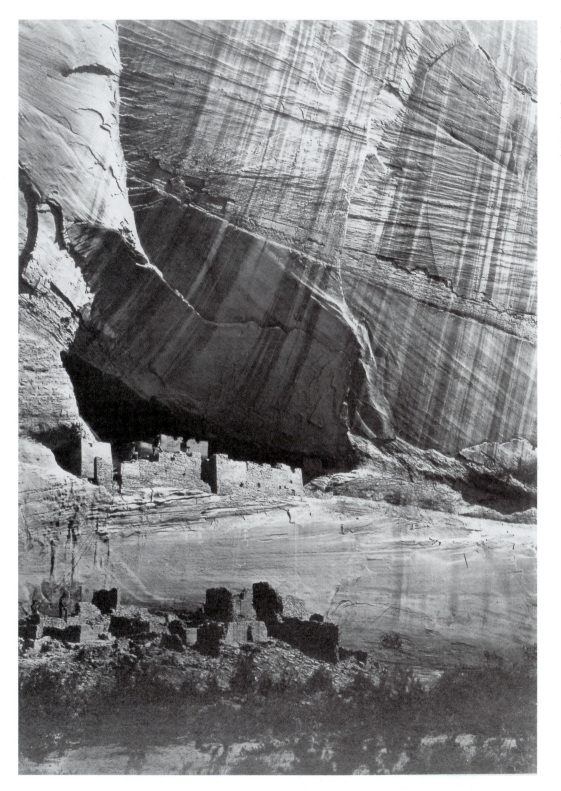

9.26 TIMOTHY O'SULLIVAN, *Ancient Ruins of the Cañón de Chelly, New Mexico, in a Niche 50 Feet above Present Canyon Bed*, 1876. Albumen print, 7⅞ × 10¾ in (20 × 27.3 cm). Library of Congress, Washington, D.C.

of a national market in these territories furnished new opportunities to extend and vary traditional forms. The railroad expanded the range of available raw materials and consumer goods. It also offered distant markets for goods produced by local craftspeople.

Despite the expansion of trade, these territories remained regionally distinct. This distinctiveness attracted tourists who could travel by rail, and the burgeoning tourist economy would shape the identity of the region in the twentieth century.

**PUEBLO POTTERY AND CARVING.** In the decades after the Centennial, middle-class Americans began collecting Navajo rugs, Pueblo pottery, and other Native arts as well as sepia-toned photographs of Native peoples by Edward Curtis (1868–1952), a photographer based in Seattle, Washington. By the turn of the century, the popular interest in Native cultures was at a peak, offering an expanding market for Indian goods.

The pueblos along the Rio Grande and Zuni Pueblo in western New Mexico, as well as the remote Hopi villages in Arizona, produced remarkable pottery and figural carving in the second half of the nineteenth century, much of which is preserved in museum collections today. The Spanish early on recognized the fine quality of the painted pottery made in the pueblos. One observer wrote in 1581, "These vessels are so excellent and delicate that the process of manufacture is worth watching, for they equal and even surpass the pottery made in Portugal." By the time of this observation, Pueblo women had been making fine pottery for nearly a thousand years, though almost no examples exist today from the colonial period.

The nineteenth century saw a great flowering of the Pueblo potter's art. When the first expeditions from the Smithsonian Institution traveled to the Territories in the 1880s, they purchased several thousand pottery vessels at Zuni, a village of just a few hundred inhabitants. These works had not been made for the market; they comprised the painted pottery of previous generations of women that was valued and kept within households. By this process, the artistic legacy of several generations of Zuni potters left the village in the course of just a few years.

Some of the adornment of this historic pottery involved fine-line geometric-style painting with yucca twig brushes, closely paralleling that done in the eleventh century C.E. (see Chapter 1). Other pots featured parrots, floral motifs, and other curvilinear embellishments adapted from the furniture, architectural paintings, or embroidered altar cloths of the churches of Northern New Spain. By the early nineteenth century, the distinct village styles of pottery that we recognize today had taken shape. It is possible to chart a system of aesthetic preferences consistent in Zuni pottery painting for two centuries. The pottery vessels, long considered among the finest in the Southwest, especially in terms of their surface design (**fig. 9.27**), were conceptualized as two distinct design fields: the "neck" and the "stomach." This analogy with the human body transformed the vessel from an inanimate object to something with presence, a personal existence. When the anthropologist Frank Hamilton Cushing (see fig. 11.16) studied at Zuni in the late nineteenth century, he reported that after a

9.27 UNKNOWN ARTIST (ZUNI), Polychrome jar, c. 1825–40. Clay, 11¾ in (29.8 cm) diameter. Taylor Museum, Colorado Springs.

woman built, polished, and painted a vessel, she referred to it as a "Made Being."

In Zuni pottery, the neck and the body or stomach are painted in different ways. The base is unpainted. The transition from neck to stomach is accentuated by a continuous line around the pot, deliberately left open at one small place. This line break holds symbolic significance, referring to the *sipapu*, or place of emergence from the underworld, and by analogy, the human birth canal. Potters still talk about this opening as a way to keep energy or spirit from being trapped. Zuni pottery painters have favored a balance of white ground and painted forms, and a dynamic asymmetry in which similar designs repeat or alternate, but without too much exactitude. Everyday arts such as pottery—made for daily use and for sale—also contain a spiritual dimension. The seemingly abstract design of the vessel above may refer to elements in Zuni cosmology: the step fret recalls the cloud motif evident in Pueblo-built churches such as that at Laguna Pueblo (see fig. 2.34), the spiral a streamlined Horned Serpent, and the design on the neck an abstract bird.

In the Pueblo world, the forces of nature—including plants, animals, and aspects of the weather—are embodied in supernatural beings known as **Kachinas** or **Katsinas**. Human beings, too, upon their deaths, join the world of the Kachinas. These ancestor and spirit beings are thought to influence the affairs of the living and to visit the village during performances by male members of various Kachina societies. Hundreds of different Kachinas appear within the Pueblos in sacred masquerades; only men make and

wear the masks that allow the gods to become manifest. Pueblo people believe that the masks worn in those ceremonial dances should not be displayed in museums or illustrated in books. Lifeless and devoid of ceremonial context, such displays are regarded as a profanation of religious knowledge intended only for the initiated.

Over the past hundred years, many depictions of Kachina dances have been painted by Pueblo artists, and wooden replicas of these spirit figures, known as Kachina dolls or *tihu*, are carved by men not only for Pueblo children, but also as a major category of art made for sale. This *tihu* (**fig. 9.28**) represents "corn grinding girl." Her face is painted in conventionalized geometric designs and her oversized wooden headdress features step-fret cloud motifs. She wears the traditional dark dress and one-shoulder cape of a nineteenth-century Hopi woman. Unlike the sacred masks, *tihu* are not spirit beings themselves, but rather gifts from the supernaturals to educate children. (In fact, Hopi do not customarily say that someone has carved a doll but rather "the Katsina gives it.")

Painted stone effigies from the prehistoric era suggest that the making of *tihu* has a long history (see p. 2, ritual figures). Their increasing realism and three-dimensionality may be a result of the influence of eighteenth- and nineteenth-century Spanish friars who employed Native artists to carve statues of saints for the mission churches. Since the late nineteenth century, Kachinas have worn clothing, and have been given movable arms. These modifications, along with their more naturalistic depictions, point to Hispanic influence, and recall the naturalism of clothed saints in the Catholic churches of New Mexico and Arizona.

Nineteenth-century observers describe dozens of *tihu* hanging from the rafters in Hopi houses. In the last quarter of the century, hundreds were bought by traders and anthropologists who gained greater access to the Hopi villages when, in 1882, the railroad came through Holbrook, Arizona, only seventy miles south of Hopi. *Tihu* were perhaps the first Hopi items to be commodified; since then they have enjoyed a big market among art collectors, museums, and tourists.

**NAVAJO WEAVING AND WORLDVIEW.** The ancestors of the Navajo migrated from the interior of Alaska and Northwest Canada, arriving in the Southwest some time after 1200 C.E. The distinctly Navajo culture that evolved there is an amalgam of artistic, religious, and intellectual traits adapted from their Pueblo and Hispanic neighbors from the fifteenth through the eighteenth century, and the materials and markets provided by eastern Americans in the nineteenth and twentieth. Having learned weaving from Pueblo people before the seventeenth century, Navajo women transformed this craft into their own distinctive art form.

The Navajo initially found a market for their blankets among Pueblo and Plains Indians, and Hispanics. At the beginning of the nineteenth century, the New Mexican representative to the Spanish parliament, Don Pedro Bautista Pino, described Navajo weaving as the most important product of the province of New Mexico. While early sources characterize Navajo weavings as technically superior to those of Hispanic New Mexican weavers, Navajo artists did adopt certain principles from the Hispanic style. When the U.S. government forcibly relocated the Navajo from their vast desert home to Bosque Redondo (Fort Sumner, in eastern New Mexico) during 1864–8, it issued them with thousands of Rio Grande blankets made by Hispanic weavers. The serrated diamond

9.28 UNKNOWN ARTIST (HOPI), Palhikwmana-Kachina *tihu* figure, Arizona, 1901. Wood, textile, 16½ in (41.9 cm) high. Berlin Ethnological Museum.

motifs with enframing borders (which the New Mexican Hispanic weaver, in turn, had learned from the finely woven Saltillo serapes of Northern Mexico) became part of the Navajo design vocabulary.

When the Navajo were allowed in 1868 to return to their homelands in northeast Arizona and northwest New Mexico, they endeavored to reestablish their traditional ways. But life was in flux. Shortly thereafter, the transcontinental railroad came through the Southwest, bringing new goods and visitors, and taking Navajo weavings to an even larger market. The government issued annuity goods that included commercial wool yarns and chemical dyes. All of this helped change the face of Navajo weaving. Historically, "wearing blankets" were traded throughout a region that reached from Northern Mexico to the Great Plains. In the late nineteenth century, rugs began to be collected by anthropologists and tourists, and circulated nationwide by traders and other middlemen.

Weaving is not only an important source of income; it is a sacred activity and a paradigm for womanhood. To every Navajo who follows traditional ways, it is imperative to live one's life by creating *hozho* (beauty or harmony). One might do this by living in a ritually correct manner, or by creating beautiful works of art on a loom. Such objects may conform to a set pattern (see fig. 9.29), or they may be completely original and idiosyncratic (see fig. 9.30). What is most important is the act of their creation.

The two textiles pictured here demonstrate the range of styles in Navajo weaving. The "Chief's Blanket" (**fig. 9.29**) demonstrates the weaver's bold, graphic experiments in color and geometry. As valued items of trade throughout the West, chiefs' blankets were high-status attire for nineteenth-century Plains Indians. (Indeed, Karl Bodmer's watercolor of the Piegan man Kiasax, see fig. 7.7, depicts the Plains warrior wrapped in a Navajo chief's blanket like that in figure 9.29.) In the first two-thirds of the nineteenth century, Navajo weavers favored broad bands of stripes sometimes augmented with large-scale diamonds or crosses. In this late example the bold dark stripes and vivid red crosses are balanced by the delicacy of the small serrated designs within each cross.

By the end of the century, numerous trading posts were established on the reservation. White traders became the main link between isolated Navajo households and the larger market economy. Traders such as Lorenzo Hubbell, near Ganado, Arizona, and J. B. Moore at Crystal, New Mexico, were influential middlemen; they knew what was wanted by their customers in places like St. Louis, Boston, and Philadelphia: small to medium-sized rugs that looked like the Middle Eastern carpets already familiar to them.

9.29 UNKNOWN ARTIST (NAVAJO), "Chief's Blanket," c. 1880. Handspun wool and four-ply commercial Germantown yarn, 63 × 54½ in (160 × 137.7 cm). Millicent Rogers Museum, Taos, New Mexico.

Some traders used photographs or paintings of Persian rugs to suggest new design directions to the weavers. The ever-resourceful Navajo artists complied, making rugs with design fields of complex geometric motifs and enframing borders.

While the chief's blanket uses a changing vocabulary of forms and colors within a rigorously geometric format, other textiles simply show off the weaver's fluency with her materials and imagination. At the end of the century, brightly dyed, finely spun yarn was imported to the reservation. This high quality material, commercially manufactured in the Germantown neighborhood of Philadelphia, began in many instances to replace the yarn Navajo women spun from their own sheep's wool. In making a Navajo rug, more than two-thirds of the time expended was devoted to the preliminary stages of shearing the sheep, and washing, carding, dyeing, and spinning the wool. So it stood to reason that if a weaver did not have to devote hundreds of hours to these preliminaries, but had the opportunity to work with fine commercially produced yarns, she could devote more time to complicated labor-intensive design patterns.

During the two decades after large freight and passenger trains first made their way across the reservation landscape in the 1880s, many weavers incorporated images

of trains into their work. In this example (**fig. 9.30**), the weaver has combined trains, a store, and information signs in English ("Santa Fe Route") with the finely serrated diamond-shaped designs that work so effectively in fine Germantown yarns. At a time when the railroad brought this yarn and tourists to the reservation, and carried local, Native-made goods to urban markets in the east, the Navajo weaver saw fit to comment upon this process in her art.

**THE ART OF THE PENITENTE BROTHERHOOD.** The growing volume of trade with the United States brought an end to the classic period of domestic and village *retablo* production in the territory of New Mexico. The need for images of the saints was now served by naturalistic religious "chromos" by European and American firms, including Currier and Ives, produced for the Catholic population of the new territory (**fig. 9.31**). Both the choice of saint (the *Santo Niño* or Christ child was a favorite of New Mexico Catholics) and the hammered tin frame surrounding the image—the product of local craftsmen using salvaged tin cans from the north—framed these mass-produced commercial prints with local associations and meanings. But if local *retablo* production shrank, the *santero* tradition found new life in the production of **bultos** (carved images of the saints) for public festivals associated with Holy Week, as well as for the all-male religious organization known as the **Penitente** Brotherhood.

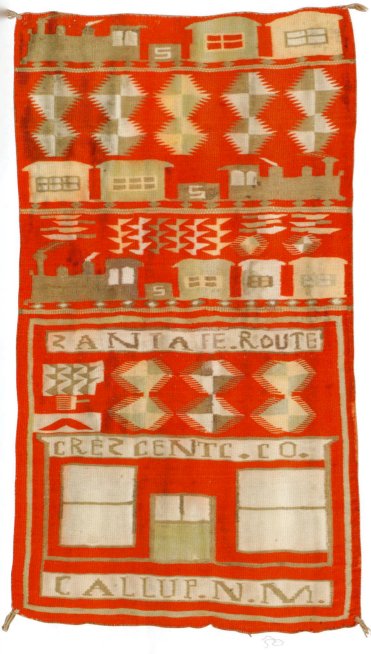

9.30 UNKNOWN ARTIST (NAVAJO), Navajo pictorial rug, c. late 1880s. Germantown yarn and aniline dye, 46 × 25½ in (117 × 65 cm). Denver Art Museum, Colorado.

9.31 CURRIER & IVES, *Santo Niño de Atocha (Holy Child of Atocha)*, mid- to late-19th century. Chromolithograph print, 18 × 11½ in (45.7 × 29.2 cm). Taylor Museum, Colorado Springs.

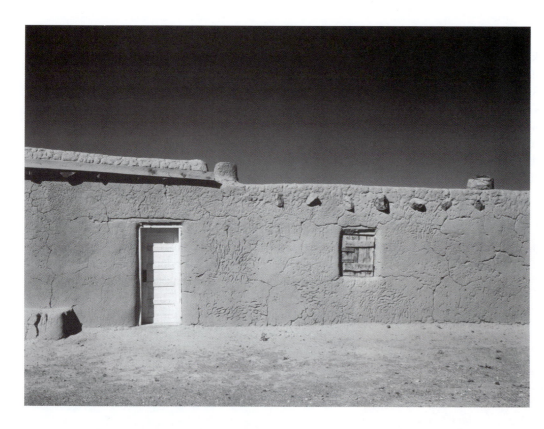

9.32 ANSEL ADAMS, *Penitente Morada at Coyote, New Mexico*, c. 1950. Gelatin silver print. Center for Creative Photography, University of Arizona.

9.33 JOSÉ BENITO ORTEGA, *Jesus, Nazarene*, c. 1875–1907. Wood, water-based paints, gesso, cotton cloth, 36 in (91.4 cm) high. Taylor Museum, Colorado Springs.

Since the late eighteenth century, New Mexico had suffered a shortage of Franciscan priests. Taking matters into their own hands, villagers initiated self-governing religious confraternities. The most important of these was the all-male *Penitente*, associated with the Holy Week reenactment of the Passion of Christ, which included flagellation (the ritualized scourging of the body with a whip) and other forms of self-mortification. Such practices came to Mexico from medieval Spain; but by the late eighteenth century they had been outlawed. Remote from the Catholic hierarchy in Mexico City, however, these extreme penitential practices persisted in New Mexico, going underground in the face of official opposition in the 1850s. (In 1947 the Catholic Church finally granted them legitimacy.) Their practices were centered around a building type known as the **morada** (from the Spanish *morar*, meaning "to dwell"), a long, narrow adobe building consisting of two to three rooms with few windows. In form the *morada* lies somewhere between domestic dwelling and church building, and it served as the meetinghouse of the brotherhood (**fig. 9.32**), combining social and devotional practices.

Life-size images of Christ, supported by boards extending from the base of the carved statue through its middle, were lifted aloft by villagers (**fig. 9.33**) during Holy Week processions. The type recalls the "Man of Sorrows" traceable to medieval Christianity. José Benito Ortega (1858–1941) was perhaps the best known of the late-nineteenth-century *santeros*; his focus on the gut-wrenching sufferings of

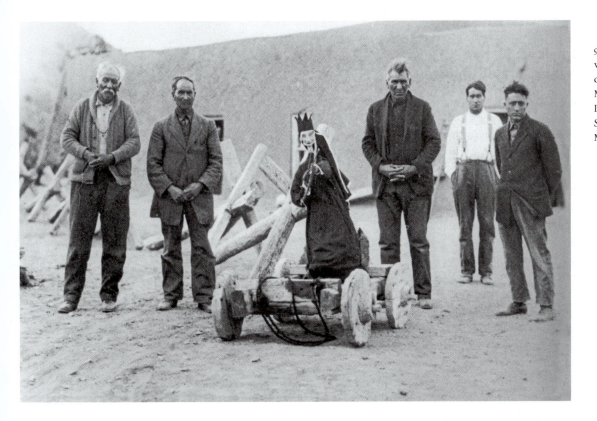

9.34 Doña Sebastiana
with Los Hermanos,
c. 1930. Photograph.
Museum of
International Folk Art,
Santa Fe, New
Mexico.

Christ is characteristic of this later generation of New Mexico village artists. Glass eyes, a leather crown of thorns, blue-tinted flesh tones and globules of red paint flowing from wounds on the head, side, and knees of Christ all animated the spectacle of his suffering. Also related to penitential practices is the carved figure of Death dragging her cart to the cemetery (**fig. 9.34**). Known as *La Doña Sebastiana*, such figures were housed in the village *morada*. The chalk white face of Death, with its gaping black mouth, beady blank stare, and bow and arrow or bloody scythe trained upon the worshiper reminded him of his inevitable fate, and induced ardent acts of penance to win salvation. These New Mexico figures of Death should not be confused with the carved figures associated with the Mexican "Days of the Dead" celebrations, which Hispanic migrants brought to the United States (see fig. 15.20).

The period of greatest *Penitente* activity (after 1848) occurred during the decades that witnessed increasing cultural, political, and religious influences from the north. (New Mexico remained a territory until statehood in 1912.) The *Penitente* Brotherhood fostered and preserved traditions of Hispanic spirituality and village devotion in the midst of pressures to adapt to U.S. culture. Villagers remote from urban culture retained traditional forms of worship that were obsolete elsewhere. Shrouded in secrecy, and resisting external control, the *Penitente* presence is still marked throughout the landscape of northern New Mexico by the large wooden crosses and *moradas* that dot the landscape.

# The Clash of Cultures, From Both Sides

Plains Indian people presented their own views of their culture and history in art during the same decades that they were so widely represented by white artists. Theirs is a story of displacement by post-war white expansion. Chronicle, commemoration, loss, witness, and removal from history, all play a role in their story, as told by both sides.

The year 1876—that of the Philadelphia Centennial—marked both celebration (the republic was one hundred years old) and setback (the defeat of George Armstrong Custer by Plains warriors just a few months into the great national birthday celebration). "Custer's Last Stand" became a symbol of the nation beset by hostile Indians, immigrant anarchists, and striking workingmen, common enemies of the republic's westward progress and industrial expansion. The Plains Indian wars—of which the Battle of Little Big Horn was but one episode—concluded in 1890 when federal troops massacred 146 Lakota men, women, and children at Wounded Knee, South Dakota. Methodically deprived of their way of life and confined to the reservations, Plains Indians would no longer threaten western settlement. For older Native Plains cultures, this was a time to commemorate the losses that accompanied forced assimilation and displacement.

## Plains Ledger Drawings: Native Commemoration in an Era of Change

In the years around the Centennial, white Americans were not alone in looking to the past. For Plains cultures at war with the U.S. army this era was shrouded by an atmosphere of crisis and loss. Their treaty rights ignored, their ancestral lands invaded and exploited, their hunting grounds diminished, their dignity in question, Plains artists seized a new medium—drawing on paper—to commemorate a disappearing way of life, recording traditional scenes of armed combat and horse capture. They also chronicled their painfully changing circumstances, situated between worlds. Although white and Indian shared an impulse toward recollection and commemoration, they did so under radically different conditions. Confronting modernization, white Americans indulged in wistful fantasies of a simpler time; for Plains peoples, facing a loss of their way of life through forced removal and confinement, the ability to recollect and express spiritual meaning and personal accomplishment was a matter of survival.

Plains artists eagerly adopted the paper and pens provided by traders and explorers early in the century and by military men and Indian agents later on. Often the paper they drew on was discarded from lined account books, or ledgers, hence the name "ledger drawings." In other instances, they were given artists' notebooks or small writing tablets. Ledger drawings miniaturized the imagery painted on the much larger hide robes. In some instances, men carried their small books of autobiographical pictures into battle; such books were among the plunder taken by army soldiers from dead braves on the battlefield. In other instances, drawings were readily sold or exchanged as gifts with whites. From 1865 to 1890, Plains artists made thousands of these drawings, many of which still exist in museums and historical societies, though a few remain in Native hands.

**SITTING BULL'S EXPLOITS AS DEPICTED BY FOUR HORNS.** While men most often depicted their own exploits, occasionally they might also record the brave deeds of a relative. In 1870, Four Horns, by then one of the most respected chiefs of the Hunkpapa band of the Lakota, drew fifty-five images of his nephew Sitting Bull's war record (**fig. 9.35**). In order to make clear that he was not claiming these deeds as his own, but simply recording his illustrious nephew's accomplishments, Four Horns drew an extra-large name glyph—a sitting bull—behind the horseman on the right, and connected it to his face by a line. (A knowledgeable Lakota examining the drawing would also recognize the raptorial bird on the shield as Sitting

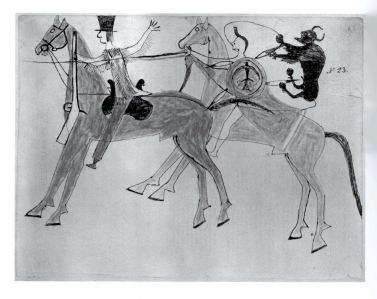

9.35 FOUR HORNS (LAKOTA), *Sitting Bull Shoots a Frontiersman*, 1870. Ink and watercolor on paper, 7¾ × 10½ in (19.6 × 26.6 cm). National Anthropological Archives, National Museum of Natural History, Smithsonian Institution, Washington, D.C.

Bull's distinctive emblem.) Sitting Bull's victim is a frontiersman in a buckskin jacket. While facial features were unimportant to the artist, Four Horns carefully rendered the flintlock rifle, saddle, war shield, and name glyph with great accuracy. While it was not uncommon for a fine draftsman to be commissioned to draw the exploits of a comrade, it may be that Four Horns was documenting Sitting Bull's bravery and generosity to promote his nephew for the new role of paramount chief, who would speak for all the Sioux.

These drawings not only provide a record of one man's career, but also reveal the pride an elderly uncle took in the successes of his beloved nephew. Sitting Bull earned his first war honor at the age of fourteen. By 1870 he and his uncle had traveled on many war parties together, captured many horses, and fought many Crow enemies. An army doctor, James Kimball, bought fifty-five drawings of Sitting Bull's life from Four Horns in 1870 at Fort Buford in Dakota Territory. Eleven years later, the illustrious chief Sitting Bull, who had taken his followers to Canada rather than submit to reservation life, surrendered to the U.S. army at the same fort.

**PRISON DRAWINGS FROM FORT MARION.** In 1875, several dozen Kiowa and Cheyenne men, accused of crimes against white settlers in "Indian Territory" (present-day Oklahoma), were incarcerated for three years at Fort Marion, formerly the Spanish Castillo San Marcos, in St. Augustine, Florida (see fig. 3.22). In an unusual experi-

ment, their jailer, Lieutenant Richard Pratt (who later became the head of the first Indian boarding school), gave these prisoners drawing supplies and encouraged them to make drawings to sell to the tourists who frequented this seaside resort, as well as to influential reformers such as the novelist Harriet Beecher Stowe, and Episcopal Bishop Henry Whipple, who visited the men at what was considered to be a model prison.

The artists at Fort Marion recorded scenes of warfare and the hunt, common in the Plains pictorial tradition, but they also added scenes from their new experiences as warriors who had been transported by train and paddle-wheel steamer far from their prairie homes. The Kiowa artist Zotom (1853–1913), for example, drew a scene of the prisoners standing on the parapet of the massive stone fort, the day after they arrived in humid St. Augustine (**fig. 9.36**). They stare out at the harbor lighthouse and ocean beyond— a vista far from home. Though each figure is tiny, and all face away from us, Zotom makes the viewer confront the grim realities of displacement, and the poignant despair of those who have been torn from the fabric of their culture.

With access in prison to chromolithographs, newspapers, and photographs, Zotom and some of the other warrior-artists mastered the rudiments of perspective, depth, and foreshortening. Their works stand somewhere between the flat pictorial depictions of their forebears on the Great Plains, and the complex perspectival spaces of nineteenth-century painters. In this drawing, Zotom depicts a heart-rending moment: the prisoners have not yet been stripped of their traditional blankets and leggings and forced to wear army garb; yet their fate as captives in hostile territory is painfully clear.

Zotom's life story exemplifies the complexity of Native experience between cultures at the end of the nineteenth century. Raised as a traditional warrior, he converted to Christianity during his imprisonment in Florida. After his release in 1878, he trained as a deacon in the Episcopal Church in New York. Finally, after some years of preaching Christianity in Indian Territory, he renounced his ministry and returned to traditional Kiowa spirituality.

**WOHAW IN TWO WORLDS.** Another artist-prisoner at Fort Marion stands alone among Plains graphic artists of his generation in his remarkable fusion of reality and metaphor in *Wohaw Between Two Worlds* (**fig. 9.37**). In a poignant expression of Native ambivalence at being trapped between two incompatible ways of life, Wohaw (1855–1924) depicts himself extending a peace pipe to symbols of both realms: the wild buffalo and tipi of traditional Kiowa life, and the domesticated steer, plank house, and plowed field

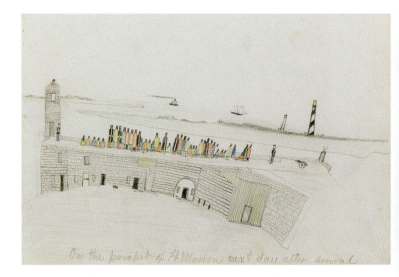

9.36 ZOTOM (KIOWA), *On the Parapet of Fort Marion Next Day After Arrival*, 1876–7. Graphite and colored pencil, 8½ × 11 in (21.5 × 27.9 cm). The National Cowboy and Western Heritage Museum, Oklahoma City. Arthur and Shifra Silberman Collection.

of the western settler. The sun, crescent moon, and falling star look on in mute witness to this moment of historical transition. Wohaw uses one figure—himself—to depict the plight of all Indian people in the last third of the nineteenth century. Indeed, the metaphor of "standing with a foot in two worlds" is still invoked by Native artists (see fig. 18.24: T. C. Cannon, "the Collector"). Wohaw's drawing—while presenting loss—locates the artist at the center of the encounter and the conflict between cultures, trying to make peace with both.

Wohaw juxtaposes the expressive modes of two different cultures in another unusual composition in which a warrior on horseback looks up at three portrait images of Kiowa people (**fig. 9.38**). The framed portraits, with their stiff frontal and three-quarter views, derive from the conventions of portrait photography, a genre familiar on the Great Plains by the 1870s. The formal photographic portrait was also familiar to the prisoners at Fort Marion, for they posed for such portraits, and the photographic process was an occasional subject of their drawings. The double image of the Indian, in both indigenous and western garb, was a standard trope of late-nineteenth-century photographic portraiture, suggesting to the white viewer of the time the uplifting effect of "civilization." To the Native artist and audience, however, such imagery may have held a different meaning.

The men at the upper left wear plumed U.S. cavalry dress hats and officers' fancy-dress frock coats, complete with shoulder insignia and gilt buttons. One prominently displays his peace medal, suggesting he is a man of social

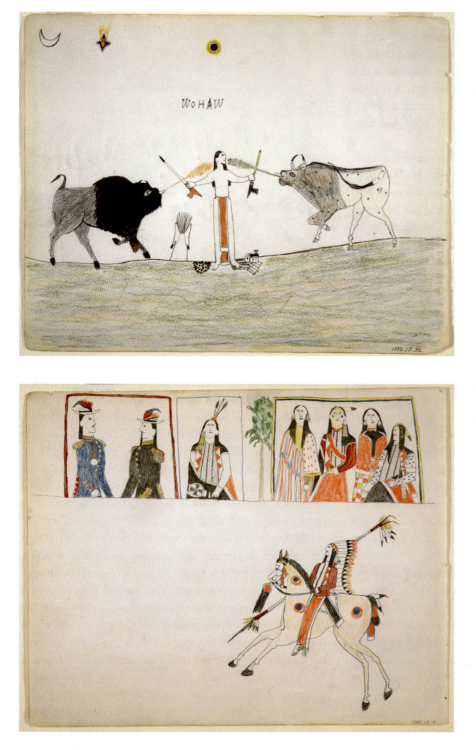

9.37 WOHAW (KIOWA), *Wohaw Between Two Worlds*, 1876–7. Pencil and crayon on paper, 8¾ × 11¼ in (22.2 × 28.5 cm). Missouri Historical Society, St. Louis.

9.38 WOHAW (KIOWA), *Warrior on Horseback with Three Portraits*, 1876–7. Pencil and crayon on paper, 8¾ × 11¼ in (22.2 × 28.5 cm). Missouri Historical Society, St. Louis.

stature. The figures in the other portraits, both male and female, wear equivalent Kiowa finery: breastplates made of bone pipes, fine cloth blankets with beaded rosettes, and dresses of patterned trade cloth. Negotiating between two worlds, the artist may be playing with the idea of cultural equivalence, equating U.S. military and Kiowa formal dress. Below, the Kiowa equestrian also wears his sartorial best: the eagle-feather war bonnet is among the most impressive items of Plains ceremonial regalia.

**BLACK HAWK'S VISION OF A THUNDER BEING.** While captive Kiowa and Cheyenne artists at Fort Marion were chronicling new themes, graphic artists on the reservation also depicted both traditional and innovative imagery.

In 1880, a Lakota holy man and artist named Black Hawk (c. 1831–c. 1890), who lived on the Cheyenne River Sioux Reservation in South Dakota, made seventy-six drawings encompassing a wide view of the Lakota world. Unlike some of his contemporaries, he seems deliberately to have avoided drawing scenes of white men, though some of his drawings depict their imported goods, such as trade cloth and guns. Black Hawk's spiritual power came from his potent visionary experiences.

In a picture captioned "Dream or vision of himself changed to a destroyer and riding a buffalo eagle" (**fig. 9.39**), Black Hawk sought to convey what was surely one of the most sacred moments of his life. His composition is based on the image of a horse and rider—a ubiquitous theme in Plains iconography. Yet the steed and rider are anything but ordinary. Their extremities have been transformed into eagle talons, and buffalo horns curve from their heads. The intensity of the rider's clenched teeth in his round head is enhanced by his mesmerizing yellow eyes. Both figures are covered with small dots, representing hail, and are connected by lines of energy radiating between the rider's talons and the animal's mouth. Horse and rider fly though the sky, encircled by a rainbow formed from the beast's multicolored tail.

While Black Hawk called this a "destroyer," it clearly represents a Thunder Being—a powerful supernatural creature said to appear to supplicants in vision quests. Depictions and descriptions of Thunder Beings often combine attributes of eagle, horse, and buffalo, all sacred animals. The rainbow, too, is not only an entrance to the spirit world, but a symbol of Thunder Beings. Various descriptions of Thunder Beings emphasize their powerful eyes. Another Lakota holy man, Black Elk, who saw these creatures in his own visions, commented that every time the beast snorted, "there was a flash of lightning and his eyes were bright as stars." When men performed public dances impersonating such figures, their black-horned head coverings had mirrors where the eyes should be, in order to flash and glitter in the same manner as these lightning-eyed spirit beings. The bringers of summer's powerful electrical storms, Thunder Beings are the sacred embodiment of thunder, lightning, wind, and hail.

## The Noble Indian and the "Vanishing Race," Once Again

If Wohaw placed himself at the center of historical change in the decades surrounding the Centennial, eastern artists in these same years consigned Indians to noble defeat at the margins of history, reinforcing the widely held idea that they no longer possessed any cultural existence. White artists memorialized a "dying" culture whose tragic fate was sealed by the inevitability of continental empire. In photography, painting, and popular imagery the idealized figure of the Native American consistently appeared in a posture of defeat. Measured against the standards of "civilization," Native cultures appeared maladapted, backward, disadvantaged by history itself.

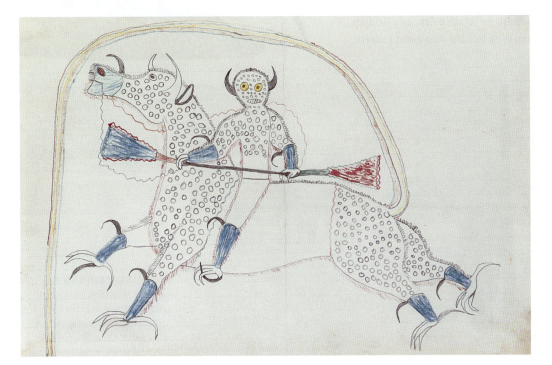

9.39 BLACK HAWK (LAKOTA), "Dream or vision of himself changed to a Destroyer and riding a Buffalo Eagle," 1880. Ink and pencil on paper, 9½ in (24.1 cm) high, 15½ in (39.3 cm) wide. Fenimore Art Museum, Cooperstown, New York.

**THE END OF THE TRAIL.** This sculpture by James Earl Fraser (1876–1953) (**fig. 9.40**) was first modeled in 1894 and exhibited in a monumental version at the San Francisco Panama Pacific Exposition of 1915. Fraser's statue took its inspiration from the poet Marion Manville Pope: "The trail is lost, the path is hid and winds that blow from out the ages sweep me on to that chill borderland where Time's spent sands engulf lost peoples and lost trails." A mounted Plains Indian slumps over, the lines of his body mimicking those of his steed, whose bowed neck, closed eyes, tail between legs, and hooves meeting on a contracted point of land, all signify defeat. The downward-pointed spear suggests a cessation of hostilities, defeated manhood, and a draining of virile energies. Fraser's treatment of the conquered recalls the defeated barbarians subdued by the Roman empire. Raised in South Dakota, and having seen at firsthand the demoralizing effects of the reservation, Fraser sympathized with the Indians' plight.

**THE DAWES ACT.** In 1887, the federal government passed the Dawes Act, which subdivided communal reservation lands into individual allotments, enforcing an agricultural order on western Indians. Federal policy toward American Indians was directed at the systematic eradication of Native languages, dress, and ritual life—all those things that tied Native Americans to their own past, obstructing the process of willed assimilation that was the official intention of the government. "We must kill the Indian in order to save the man," as Richard Pratt, the jailor of the Fort Marion prisoner-artists, put it. Pratt went on to found the Carlisle School, the first in a network of "Indian schools" that endeavored to turn Indians into good citizens and workers.

**THE SONG OF THE TALKING WIRE.** Contemporary audiences understood the defeat of the Indian as the inevitable triumph of a technologically and culturally superior nation over a backward race. The evidence was there in the establishment of a nationwide industrial system connecting space by railroad and telegraph. Henry Farny's (1847–1916) *The Song of the Talking Wire* of 1904 (**fig. 9.41**) examines the clash of cultures as an aging Indian brave, wrapped in

9.40 (above) JAMES EARL FRASER, *The End of the Trail*, c. 1894. Bronze, 44 in (111.7 cm) high. Thomas Gilcrease Institute of American History and Art, Tulsa, Oklahoma.

9.41 HENRY FARNY, *The Song of the Talking Wire*, 1904. Oil on canvas, 22 1/16 × 40 in (56.1 × 101.6 cm). Taft Museum of Art, Cincinnati, Ohio. Bequest of Mr. and Mrs. Charles Phelps Taft.

# The Past as Spectacle: Buffalo Bill Cody's "Wild West"

FROM 1883 TO 1916, William F. Cody ("Buffalo Bill") thrilled audiences throughout the United States and Europe with his "Wild West," a heart-pounding spectacle combining live animals and human performers who restaged the life and times of the Old West (**fig. 9.42**). Scholars such as Joy Kasson see in Buffalo Bill's "Wild West" the birth of mass entertainment and of a media culture that blurred the differences between history and spectacle, truth and fiction. Despite its claims to present the real history of the conquest and settlement of the frontier, the "Wild West" offered a fictional version of the past as it lived on in the popular imagination, conflating history with public myths about the progressive unfolding of American civilization across the continent. Later generations recoiled at the underlying violence that lay at the heart of the spectacle of Buffalo Bill. Yet this exhibition of manly prowess, adventure, and death-defying courage left its imprint on twentieth-century images of the frontier, from the movie Western to the "tall in the saddle" style of American diplomacy.

Buffalo Bill, however, saw the "Wild West" not as entertainment but as education for a public eager to know "how the West was won." In 1886, the "Wild West" began reenacting Custer's Last Stand by situating it within a historical context of preordained triumph. Year after year, as it toured throughout Europe and the United States, the "Wild West" dramatized, in the words of the cultural historian Richard Slotkin, "the principle that violence and savage war were the necessary instruments of American progress."[11]

Blurring the line between history and myth even further, Indian warriors at the forefront of the Plains wars such as Sitting Bull were later recruited to be part of the "Wild West." While it is tempting to view this as an example of Native peoples being manipulated for economic gain, each Native participant made something different out of the experience. Some returned to reservation life with substantial amounts of cash for their families. Sitting Bull, shocked at the sight of homeless children begging in the heart of New York City, distributed most of his earnings to these children, as any honorable Lakota would do. The famous Lakota holy man Black Elk, who as a young man went to Europe in the 1880s as part of Buffalo Bill's entourage, revealed his hope of learning some secrets of the white man that would help his people.

9.42 Buffalo Bill's Wild West, c. 1898. Lithographic 12-sheet poster. Circus World Museum of Baraboo, Wisconsin.

a buffalo robe and cradling a gun in his arm, encounters a voiceless technology. Leaning against a telegraph pole, he strains to hear the mysterious codes transmitted along the lines—an image of two cultures unable to communicate. Pictured against a bleak wintry landscape, the old man gazes toward the viewer with a pained expression. To the left of the telegraph poles is a buffalo skull, a *memento mori* marking the demise of the animal on which Plains cultures depended for survival. Like the earlier expressions of the "vanishing American" theme, these later works mingle regret over the plight of Native people in an era of technological progress with a sense of fatalism regarding their inability to adapt to the direction of history.

### THE NORTH AMERICAN INDIAN BY EDWARD CURTIS.
Beginning in the Centennial years, the new technology of the camera was put to the service of documenting Indian culture. Over a quarter-century after the Centennial, the photographer Edward Curtis began a project that would eventually become his twenty-volume *The North American Indian*. Begun in 1907 and completed in 1930, nearly a century after Catlin, *The North American Indian* resembled the earlier artist's project in many respects. Compelled by a desire to preserve in photographs the threatened traditions, knowledge, and sacred rites of Native people throughout the West, Curtis devoted his life to completing this vast project, comprised of some twenty-two hundred photo-engravings (photogravures) taken from eighty Indian nations (**fig. 9.43**). Earning the trust of sympathetic elders and medicine men through "weeks of patient endeavor," in his words, he also won the support of some of the wealthiest men in America, including J. P. Morgan.

*The North American Indian* surveyed Native peoples at a time when they were living on reservations and struggling to maintain their ceremonial life and art forms. In many cases—as for instance in his images of Plains war parties—Curtis asked his subjects to reenact traditional cultural practices. Like Catlin one hundred years earlier, Curtis wished to preserve the image of Native culture in a pristine condition, as he imagined it, prior to clocks, blue jeans, generators, and sewing machines. The velvety **chiaroscuro** of his portraits suggests a world already transformed into art. Curtis's work shared in the **pictorialist aesthetics** of his generation, aesthetics that distanced his subjects from the present. He saw his project as a form of what is called today "salvage anthropology"—involving the collection and cataloguing of detailed observations about everything from music, dance, and dress, to food preparation, language, religion, and burial customs—an archive of knowledge that framed the individual Indian subject.

From the beginning, Native people had viewed photography warily. Was the photographer robbing Native subjects of their inner lives by pinioning them to a photographic archive, or did the camera capture the fleeting spirit on film? The photographic image, associated with death and memorialization from the mid-nineteenth century on, helped entrench the idea that Native societies were threatened with extinction. On the other hand, photography also served Native cultures' desires for images of their traditions. Native Americans themselves used the camera for purposes of self-documentation. Each party to the photographic encounter played an active role.

In meticulously documenting reenactments of vanishing ways, Curtis furnished what proved to be a vital record, enriching cultural memory for later generations of Indians. George P. Horse Capture, for example, first came across his great-grandfather, a Gros Ventre tribal leader from Montana, in 1969, through a Curtis photograph he was shown in a historical archive. Seeing Curtis's photograph of

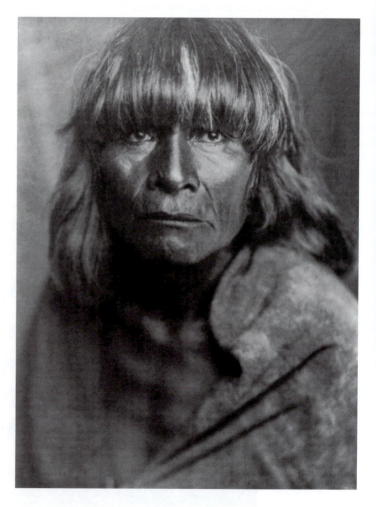

9.43 EDWARD CURTIS, Hopi Man from *The North American Indian*, vol 12, plate 420, 1907–30. Photo-engraving. Library of Congress, Washington, D.C.

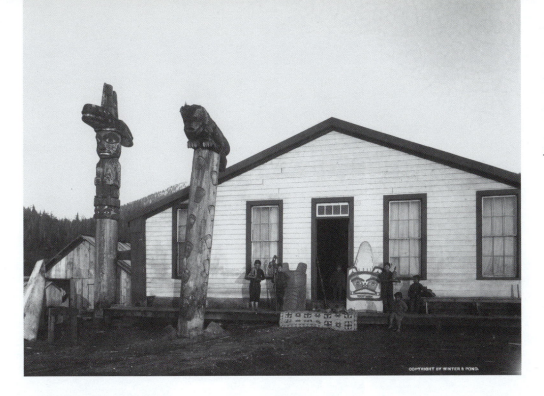

9.44 **LLOYD WINTER & E. PERCY POND**, Totem poles, Chief Shake's House, Fort Wrangell, Alaska, c. 1900. Alaska Historical Society, Juneau.

the tribal elder launched his great-grandson on a journey into tribal history and identity.

**"ALASKA VIEWS."** Unlike Curtis, who staged idealized portrayals of the "vanishing" American Indian, some photographers matter-of-factly recorded the changing realities of life in turn-of-the-century Native America. Lloyd Winter and E. Percy Pond were commercial photographers who operated a studio in Juneau, Alaska, from 1893 to 1943. Both were from San Francisco, where Winter had studied art at the California School of Design. In Alaska they provided the burgeoning tourist trade with images of "Alaska Views. Choicest and largest collection of Views of Alaska Scenery, comprising illustrations of Indian Life, Totems, Glaciers, Seal Islands, Mines, Yukon, Sitka, Juneau, Wrangel, and other Points of Interest in Alaska," as they advertised in an Alaskan newspaper in 1894.

Winter and Pond used dry **glass-plate** negatives, a technological improvement over the previous generation's wet-plate negatives, which had to be developed immediately after exposure. This made working in remote areas an easier proposition. In bracing contrast to Curtis's romanticism, Winter and Pond documented the bustling commercialism and the hybrid nature of turn-of-the-century Alaskan villages. In their work, ceremonial regalia exists comfortably alongside tailored shirts and suspenders (see fig. 7.22, Interior of Whale House of Raven Clan), and Tlingit mortuary poles stand proudly in front of a chief's modern frame house with glass windows (**fig. 9.44**).

# Conclusion

The occasion of the Centennial inspired retrospection and commemoration, even as the new infrastructure of an expanding and consolidating nation was being put into place. While much of the art of this period was both stylistically and temperamentally conservative, artists also took steps toward new modes of representation, as can be seen in Homer's and Saint-Gaudens's combinations of realism infused with symbol; in Wohaw's condensation of historical complexities into memorably terse images; or in Tanner's transformation of race stereotypes into a poignant essay on African American tradition.

The 1870s, however, was a period not only of national introspection, but also a time of growing cosmopolitanism, as the inward-turning and nation-bound attitudes of antebellum culture gave way to increasing international travel and study. After this time, artists, designers, and architects would look to a vastly enlarged global arena of forms and motifs, opened up by travel and by a series of World's Fairs that fueled curiosity and encouraged international exchange. Gradually the nation's artists would come to think of themselves as citizens of a wider world.

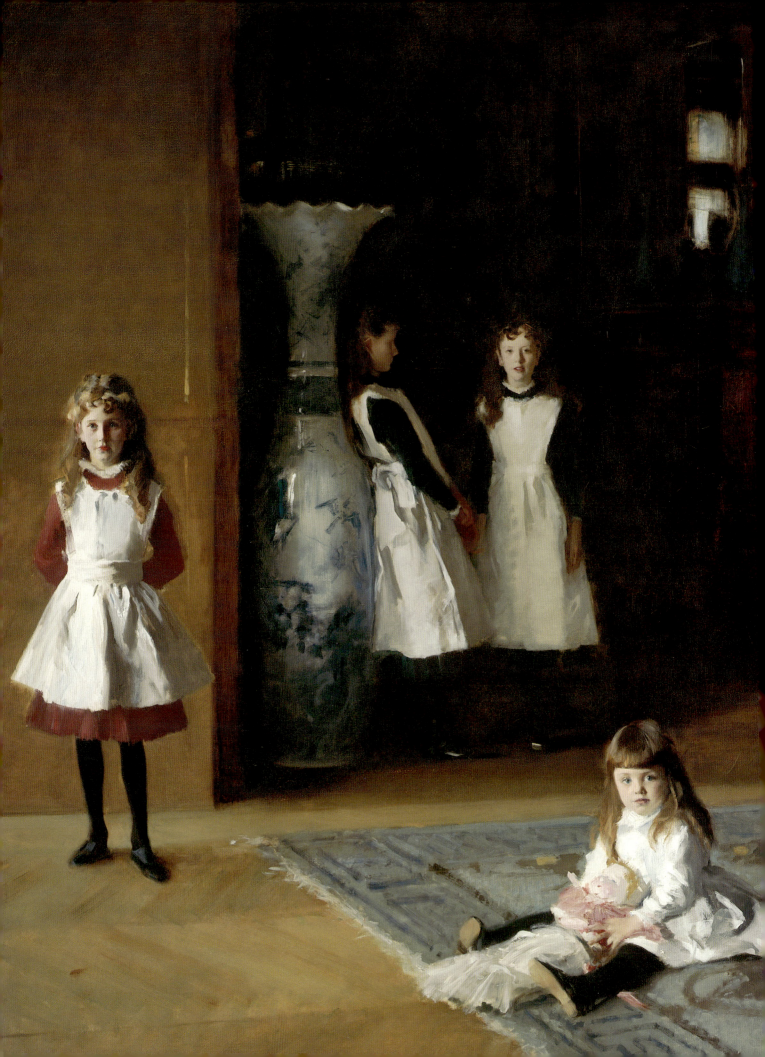

# 10 | A New Internationalism: The Arts in an Expanding World, 1876–1900

I N   T H E   L A T E nineteenth century, encounters with the art worlds of Paris and London influenced many American artists, who found in this internationalism a liberating departure from the nationalistic styles that preoccupied American art before the Civil War. Several new developments interrupted the nation's absorption with itself. In 1866, after twelve years of effort, the first transatlantic cable was laid. The cable—two thousand miles long and three miles deep—replaced a months-long ocean voyage with instantaneous telegraphic communication. In addition, the increased industrial capacity sparked by the Civil War yielded "peace dividends," such as a new generation of larger, faster ocean liners. Suddenly, the Atlantic Ocean—once the barrier symbolizing America's exceptionalism and historical remove from Europe—became a means of connection.

Beyond such technological bridges, the war experience also encouraged a new, more pragmatic and flexible outlook, coaxing the nation beyond its provincial certainties and strong local attachments. In similar fashion, exposure to European society tempered individualistic attitudes: Americans became more willing to see that the individual is also shaped by circumstances of family, and by habits of mind and social background. The socially constructed self acquired new significance.

Improved transportation and telecommunication fostered travel, international exchanges among artists, exposure to European art publications, participation in international exhibitions, and increased commercial relations, linking the United States with the Mediterranean world and Japan, and introducing new directions into American art. The first of these was a turning away from the urge to create self-consciously national art. Instead, artists saw themselves as members of a community of like-minded artists and patrons. Innovative styles, techniques, and materials introduced greater opulence and variety (**fig. 10.1**). Paralleling growing class distinctions,

10.1 **LOUIS COMFORT TIFFANY**, Vase, 1893–1896. Favrile glass, 9⅛ in (22.9 cm) high. Metropolitan Museum of Art, New York. Gift of H.O. Havemeyer, 1896.

(opposite) **JOHN SINGER SARGENT**, *Daughters of Edward Darley Boit* (detail), 1882. Oil on canvas, 87⅜ × 87⅜ in (221.9 × 222.6 cm). Museum of Fine Arts, Boston, Massachusetts. (See also fig. 10.9)

the nation's visual culture became more separated along lines of the fine arts and popular media. In addition to a new generation of talent, the new national and international infrastructure of trade and commerce introduced innovative methods of marketing and distribution.

In 1851, and again in 1876 and 1893, a series of World's Fairs—exhibitions featuring the arts and industries of countries around the globe—made arts and design from all regions of the world available for designers and consumers alike (**fig. 10.2**). From Asia to the Middle East, the world became a single marketplace, while historical discoveries—from Egypt to ancient Rome, Renaissance Italy, and Japan—likewise opened a storehouse of styles. As the American novelist and quintessential **cosmopolitan** Henry James put it, "We [Americans] can deal freely with forms of civilization not our own, can pick and choose and assimilate and in short ... claim our property wherever we find it."[1]

The new internationalism introduced sensuous experience and visual delight to the nation's artistic output, in contrast to the moralistic and nationalistic impulse of much American art up to that time. In the fine arts, architecture, and the decorative arts this period was distinguished by a spirit of experimentation, an openness to new, revitalizing influences and new solutions for old problems, and a readiness to look well beyond national traditions for inspiration.

# The Cosmopolitan Spirit in American Art

Throughout the history of the United States, Americans have defined their culture in terms of its relationship to Europe. Europe was the "old home." From its beginnings, the nation's ambitious artists sought out European training, and self-consciously positioned themselves in relation to European art and history. From London in the late eighteenth century, to Rome in the early nineteenth, to Düsseldorf in the mid-nineteenth, to Munich, Paris, and Venice in the post-Civil War period, European cities had long offered prominent art academies, private collections and museums, exhibition possibilities, patronage, and international communities of artists. European study was widely regarded as a necessary apprenticeship on the way to becoming an artist.

But, while recognizing this debt, American artists found the burden of European tradition stifling. The cultural nationalism that dominated the decades before the Civil War had established "American" priorities. Advocates of nationalism imagined America—with its unsettled frontier and dawning democracy—at the vanguard of history, representing the future, while Europe represented the past.

10.2 World's Fair, Machinery Hall, Chicago, 1893, from *The Magic City*, J. W. Buel, St. Louis, Missouri, 1894.

In those years, most American artists who studied abroad returned home, although some remained, especially in Rome. Yet staying on in Europe always involved a difficult decision to turn away from the pursuit of a national art.

The Civil War initiated massive changes in American culture and society; the nationalistic sentiments of the pre-war years gave way to the feeling that American history was after all an extension of European history rather than separate from it. The notion that American art and literature needed an identity in opposition to Europe gave way to a growing sense of America's involvement in a trans-atlantic world. No longer culturally and geographically isolated, America was becoming more cosmopolitan (the word derives from the Greek words for "world" and "citizen"—thus "citizen of the world," lacking in national attachments).

What changed as well was the sheer volume and success of young American artists in Europe. Formerly considered barbarians from the wilds of North America—or worse, provincials—they now routinely won prizes at the Paris Salon, the most prestigious venue for artists on either side of the Atlantic, and gold medals at the many **international expositions**. "When to-day we look for 'American art,'" wrote Henry James, "we find it mainly in Paris. When we find it out of Paris, we at least find a great deal of Paris in it."[2] Often staying abroad for years, Americans frequented the same art colonies as French artists, traveling to the **Barbizon**, Brittany, and Giverny. Many never returned; not since the late eighteenth century had the nation exported so many leading artists to Europe. Others, however, eventually did return, pursuing successful careers.

In addition to this more open embrace of European culture, artists and writers had come to recognize that America's materialistic and utilitarian civilization did not support the arts. From John Singleton Copley forward, American artists had carried on a long quarrel with their own country. Copley lamented that in the colonies, the skill of the artist was considered "like that of a Carpenter tailor or shoemaker."[3] Nathaniel Hawthorne contrasted the sensitive "artist of the beautiful"[4] with the men of iron and brawn who cared only for the things of this world and had little time for imagination or beauty. Such feelings multiplied in the later nineteenth century. Writers and critics pointed to the crass newness of American cities, and bemoaned the utilitarian and business values of the United States, which gave no quarter to aesthetic cultivation. They lamented the absence of public patronage on the scale available to French, German, and British artists. As the pace of modernization quickened, creative people increasingly envied Europe's ties to history, and the

institutions and traditions that sheltered art, aspects of European culture they had previously rejected.

## Generational Divisions

In the 1870s a split emerged among artists, as well as between factions of the artgoing public. These differences were generational in part. Artists who had made their careers in the mid-century remained devoted to older traditions of storytelling, or narrative, and to what were termed "home subjects." These artists painted in a highly detailed, smoothly finished style prevalent in American art during the 1840s to 1860s. They remained loyal to the idea that art should place the individual imagination of the artist at the service of collective uplift and moral education.

A younger generation of artists rejected the requirement that art remain loyal to American themes. Increased travel and study abroad—particularly to Munich, Paris, and Venice—brought artists into conversation with a wider world and longer history. American art increasingly addressed themes shared in common across national boundaries. The younger generation favored newer "painterly" methods that highlighted the paint surface rather than disguising the artist's hand in order better to mirror nature itself. William Merritt Chase (1849–1916)—one of the leading "new men," as critics termed them to distinguish them from the older artists of the Hudson River School—summed up his philosophy as artist and teacher in 1899: "It is never the subject of a picture which makes it great; it is the brush treatment, the color, the line. There is no great art without a great technique back of it."[5] How one saw rather than what one painted became the focus of a new cosmopolitan art. The shift from the mid-century aesthetic to a more painterly and fluid brushwork is evident in comparing the meticulous enamel-like finish of Chase's early work (**fig. 10.3**) with the work he did after his return from Munich. In figure 10.3, forms are clearly bounded, and color seems to reside in the objects themselves. A mere decade later, the boundaries between object and environment give way to an overall pattern of light and shadow, and local colors are muted and tonally harmonized.

**THE ARTIST AND HIS STUDIO.** Nowhere are these differences between the pre- and post-war generations of artists more apparent than in the appearance of the artist's studio as a new subject in post-war art. For the older Hudson River School painters, the "studio" of the landscape painter was nature itself. Artists such as Thomas Cole and Asher B. Durand had claimed their artistic authority directly from nature—and nature's divine source—rather than from

10.3 WILLIAM MERRITT CHASE, *Still Life with Fruit*, 1871. Oil on canvas, 30½ × 25 in (77.4 × 63.5 cm). The Parrish Art Museum, Southampton, New York. Littlejohn Collection.

cultural institutions. By contrast, William Merritt Chase's famous studio embodied his belief that art drew inspiration not from nature but from other art. Located on the top floor of the Tenth Street Studio Building in New York City (built 1858; demolished 1956), where many of the leading painters (including Winslow Homer, Frederic Church, and Albert Bierstadt) had their studios, Chase arranged his as an artwork in its own right, an aesthetic sanctuary of exquisitely coordinated colors and textures.

His 1882 *In the Studio* (**fig. 10.4**) is one of a series of paintings in which the studio itself becomes the subject.

In an asymmetrical composition, a young woman studies prints in a large bound volume. She is surrounded by the works of art from which Chase drew his inspiration: a print after his beloved Frans Hals, landscapes, Japanese woodblock prints, and portraits. Chase's studio also contained Persian, Chinese, and Japanese ceramics, Renaissance bronzes and carved chests, Mexican *retablos*, and a range of other artifacts he had collected during his years in Europe for the express purpose of creating his aesthetic sanctuary. His studio paintings announce an artist comfortable with the cultures of East and West, ready to put all of history to

the service of his cosmopolitan art, linked by a kindred spirit to the great artists of the past. At home in the world, Chase considered himself a member of an elite international brotherhood of artists whose ties reached across the Atlantic. For him, being an American now offered the freedom to explore all of history; to choose, to select, and to create new identities from its rich storehouse.

The only figure in Chase's studio, the elegantly attired female friend or patron, is both an object of beauty in her own right—a part of the aesthetic ensemble of the studio—and one who has the leisure and the financial means necessary for the cultivated appreciation of art. Repeatedly in the "new art" beginning in the 1870s, the artist who creates is male, the audience who consumes is female, a pattern that registers a significant shift from the older traditions of elite male patronage and art appreciation. The reasons for this "feminization" of artistic consumption touch on both gender and class definition in the late

10.4 WILLIAM MERRITT CHASE, *In the Studio*, 1882. Oil on canvas, 28⅛ × 40⅟₁₆ in (71.3 × 101.8 cm). The Brooklyn Museum, New York.

nineteenth century, reflecting structural shifts in American society. The art world of these decades increasingly withdrew from the public and national realm, and into rarefied environments populated by likeminded people. A mark of difference separating upper-class Americans from all the rest was the privileged condition of elite women, now assigned the role of cultural refinement and uplift. Cultural endowments—the ability to appreciate fine art and music in particular—came to be a mark of superiority among the nation's upper classes, and the symbol of such superiority was the aesthetic woman, meditatively engaged with works of art. Nevertheless, however exalted her symbolic place, such a position did nothing to encourage women's movement into art*making*, where males continued to dominate.

Though advanced art in these decades defined itself in contrast to the vulgar world of business and money-getting, the "new men" nonetheless learned a variety of ways to promote themselves and market their art. They threw their studios open to the public, showcasing their talents. Exhibition spaces, both private and public, came to resemble the material delights of a well-stocked department

store in their lavish display of beautiful objects. Artistic studios resembled the bazaar of exotic objects readily seen at the great international expositions of the later nineteenth century. The fashion for the "artistic studio" drew on the collectible goods acquired during travel, and united artists with their wealthy patrons who were also furnishing domestic interiors arrayed with objects from around the world.

**BREAKING HOME TIES.** Despite the growing international stature of American art, much of the public continued to prefer paintings with storytelling power. Though trained in Paris, Thomas Hovenden (1840–95) adopted a style and subject matter easily accessible to a broad middle-class public. Following his return from Paris he directed his art toward the broadest public appeal. The enormous popular success of his *Breaking Home Ties* (**fig. 10.5**), shown at the World's Fair or Columbian Exposition of 1893 in Chicago, retells the well-worn story of the country boy leaving his family to seek fame and fortune in the great city. Despite his European training, Hovenden maintained his ties with an older narrative and democratic art, speaking to the popular preference for art that was accessible in meaning and meticulously detailed.

Many other artists returning from Europe, however, resisted the notion that they should appeal to the aesthetically untutored masses. Preferring the company of those already initiated into the mysteries of art, they took refuge in a self-created social world inhabited by other artists and punctuated by studio visits and summers at artistic colonies throughout Long Island and New England. The painter Arthur Hoeber wrote of one such gathering, "There were glorious nights … when they painted tiles, made monotypes and etchings and discussed art…. It was true Bohemia when all the world was young and the possibilities were unlimited."[6]

## *Japonisme*: The Meeting of East and West

Even though racial theories relegated non-Western cultures to the historical margins, artists throughout America and Europe studied and assimilated the aesthetic products of these very cultures, especially Japan, which held a place of honor. Following centuries of self-imposed isolation, Japan was forced to reopen relations with the West by the American fleet under Admiral Perry in 1854. Japanese prints, **lacquerware**, ceramics, and textiles quickly found wide appreciation, first through collectors and galleries, and later through Japanese participation at universal expositions. The vogue for things Japanese was dubbed *Japonisme* by a French critic, Philippe Burty, in 1872. American audiences and designers first encountered Japanese arts at the 1876 Centennial Exposition. The Japanese Pavilion, one of the most popular, exhibited a range of ceramics and textiles the aesthetic refinement of which forced the reassessment of

10.5 **THOMAS HOVENDEN**, *Breaking Home Ties*, 1890. Oil on canvas, 52⅛ × 72¼ in (132.3 × 183.5 cm). Philadelphia Museum of Art, Pennsylvania.

# Race and Class: "Highbrow" and "Lowbrow"

THE DIVISIONS in artists and publics that emerged in the late nineteenth century persisted well into the twentieth. "High brow" came to be associated with the intellectually challenging and difficult, resisting easy comprehension or clear narrative. Where did the term come from? "High brow" originated in the discourse of late-nineteenth-century pseudo-scientific race theory, which ranked the cultures of the world according to an ascending scale linked to intelligence and aesthetic achievement. This theory postulated that the lighter-skinned races had high foreheads, and were correspondingly more evolved and higher on the scale of culture. By extension, the more "primitive" (i.e., less evolved) races of Asia, indigenous America, and Africa (in descending order) were associated with progressively more sloping or low-browed crania, and were therefore less prepared by nature to advance alongside the progressive march of Western culture. The term "**highbrow**" thus derived from upper-class preferences for the physical characteristics associated with northern European ancestry. Around 1900, the term "**lowbrow**" would be added to this cultural map, associated with the preferences of the "vulgar" classes, and increasingly, in the twentieth century, with those who consumed the products of mass culture.

entrenched attitudes about European cultural superiority: "How can [one] longer think of a nation as semi-civilized that makes the finest porcelain, while we in America have not advanced beyond the common kinds of pottery ... that sends us silks that vie with the products of the looms of Lyons ...?"[7]

Exposure especially to Japanese woodblock prints opened up an alternative way of thinking about pictorial composition that departed from the Renaissance-derived idea of the **picture plane** as a window into fictional space. Instead, the prints of Hokusai (1760–1849), Hiroshige (1797–1858) (see fig. 10.13), and others organized forms according to their **two-dimensional** relationships on the plane of the image. Artists who came under the Japanese influence showed a pronounced interest in abstract pattern, simplified forms, and silhouettes. While these images could still be read dimensionally and narratively, they

exchanged a sense of deep space for an interest in the play of shapes, line, textures, and flat color harmonies. Pushing the arts beyond naturalism, Japanese influence fed formal experimentation that emphasized the autonomy of the image as distinct from nature.

In New England in particular, the interest in Asian culture and philosophy had a long history, prompted in part by the long-established trade with the Far East among New England merchants centered in Boston. Ernest Fenellosa (1853–1908), who traveled to Japan in 1878, stayed for many years, converting to Buddhism, assuming a Japanese name, and becoming a passionate collector and student of Japanese culture who broadened appreciation of its artistic traditions in both Japan and the United States. Ironically, he played a key role in the revival of traditional Japanese painting in Japan at a time when artists there were coming under Western influences. Returning to Boston, he became curator of Asian art at the Museum of Fine Arts. The industrialist Charles Lang Freer collected Asian arts along with the work of such artists as James Abbott McNeill Whistler (1834–1903) and Thomas Wilmer Dewing (1851–1938), two painters influenced by Asian visual principles. He combined this passion for collecting with a belief in the role of Asian aesthetics as an agent of cultural refinement in the United States. Fenellosa, Freer, and others made careers out of educating American audiences to the philosophical and spiritual refinements of Japan.

Despite this admiration for Japanese aesthetics and culture, subtle forms of condescension placed Japan in a subordinate position vis-à-vis the "progressive" West. Japan, along with the rest of Asian culture, was associated with the feminine realm of aesthetic refinement. This viewpoint saw Asia as ineffectual—offering beauty and exotic pleasures but lacking the masculine muscularity of modern nations. Artworks frequently draw an iconographic link between women, Japanese objects, and aesthetic interiors, instances of the feminized Orient and the orientalized feminine (see fig. 10.9).

## American Impressionism

Among the challenges of the new cosmopolitanism was the encounter with the more artistically radical styles of the French avant-garde. Beginning in the late 1860s, French artists such as Claude Monet (1840–1926) and Edgar Degas (1834–1917) embraced subjects of urban modernity, centered in Paris, and explored in views of urban work and leisure, boulevards, outdoor concerts, and train stations. Their paintings registered the flux of sensation as the individual was bombarded by the fleeting impressions of the

modern city. French Impressionism grounded vision in the optical experience of the individual, viewing reality through a subjective lens. The authority of the "real" gave way to the primacy of sensory experience.

The influence of French Impressionism came slowly to the United States. Unlike French Impressionists, American artists kept modern life at arm's length. In the decades after the Centennial of 1876, American Impressionists favored rural landscapes and New England themes, cast in a perpetual autumn glow. In formal terms they were conservative as well. Retaining a sense of stable form and conventional composition, American Impressionists resisted the breakup of the visual field before the flow of optical sensation.

**CHILDE HASSAM: AESTHETICIZING THE CITY.** Following a sojourn to Paris from 1886 to 1889, Childe Hassam (1859–1935) pursued his career in New York. His paintings, such as *The El, New York*, locate the more disruptive features of the new city—the **elevated rail**, for instance—within a stable perspectival space, often from a slightly raised point of view and shrouded in fog or snow (**fig. 10.6**). Hassam used the loose brushwork and the urban themes associated with French Impressionism in tandem with softening veils of twilight, fog, or muted color. Like his fellow Impressionists John Henry Twachtman (1853–1902) and Julian Alden Weir (1852–1919), Hassam generally renounced the **chromatic** purity of the French Impressionists in favor of muted color harmonies. The effect was to aestheticize

10.6 CHILDE HASSAM, *The El, New York*, 1894. Oil on canvas, 18¼ × 14¼ in (46.3 × 36.1 cm). Private Collection.

the city, redeeming its raw appearance during a time of rapid construction and demographic change. In the next few years, Hassam retreated to the uncomplicated rural environments of coastal New England, where artists gathered in colonies as they did in Europe during these same years in a turn away from modern urban subjects.

**JOHN HENRY TWACHTMAN: BEYOND IMPRESSIONISM.**
Like Monet's "Grainstack" series or Hassam's *Church at Old Lyme, Connecticut* (1905), Twachtman's *Winter Harmony* exudes a timeless mood (**fig. 10.7**). His mature art distilled the international influences of his training in Munich, Paris, and New York; born in Cincinnati, he frequented the American artists' colonies in Florence, Venice, Normandy, and Holland before settling in Greenwich, Connecticut, where his work drew from the pastoral and domesticated nature near his home. Throughout the 1890s, Twachtman pursued what the scholar Kathleen Pyne has noted as a sense of duration, in which the isolated moment of perception gives way to a more complex, layered time, infused with memory.[8] Unlike earlier French Impressionism, his surfaces are textured and dense; only touches of green enliven a scene of nature, stilled and muted by winter. Low light, delicate color harmonies, and restricted hues contribute to an effect of intimacy and mental calm far removed from the heroics of the mid-century panoramic landscape. In psychological retreat from the intensities of the city, Twachtman's painting mingles introspection and retrospection, drawing sustained attention not through detail or optical interest, but through meditative absorption.

## American Expatriates: At Home Abroad

These years saw greater numbers of American artists choosing to spend their careers in Europe. The decision to live abroad was nothing new for American artists: Benjamin West and John Singleton Copley had established this pattern in the late eighteenth century, and, trading on their novelty as Americans (New World primitives who could paint!), they became leading lights of the London art world. The late nineteenth century once again witnessed the phenomenon of the American artist as international art star, in the figures of James Abbott McNeill Whistler and John Singer Sargent. For Copley and West, born during the colonial period, England was the mother country, and the colonies a distant outpost where they found themselves by accident of birth. In the late nineteenth century, Paris was the heart of the international art world. For Whistler and Sargent, the decision to remain in Europe was prompted by a sense that Europe was their true artistic home, which they sought by fleeing the United States, a culture alien to their ambitions and creative needs.

10.7 JOHN TWACHTMAN, *Winter Harmony*, c. 1890–1900. Oil on canvas, 25¾ × 32 in (65.3 × 81.2 cm). National Gallery of Art, Washington, D.C. Gift of the Avalon Foundation.

**JOHN SINGER SARGENT.** Sargent ranged freely through the artistic cultures of the world, unencumbered by the restrictions of nationality or nationalism. Born in Florence, Sargent (1856–1925) was the son of parents who had left the United States to wander restlessly through Europe with their three children. A precocious talent, Sargent painted with miraculous fluency, honing his technique first through travel and self-study with his parents, and then through academic study in Florence and at the Parisian **atelier** of the academician Carolus-Duran (1837–1917). From the start, Sargent drew omnivorously on the history of art, ranging from Egypt to Greek vase painting, from Renaissance and Baroque art—Piero della Francesca and Velázquez most notably—to Japanese woodblock prints and the art of his own contemporaries. From such eclectic sources, Sargent developed into the leading portraitist of his generation. His social and artistic career was as fluid as his paint handling, his style suiting both the nervous intensity of the bohemian art world and the modern temperament of the Paris and London upper classes. But his success was due as well to his keen ability to tailor his artistic approach to his subject and his audience. Style was something to be worn lightly, taken on and off depending on the occasion, like a suit of clothing. Sargent embodies the way that art in an increasingly commercialized setting comes to rely on effects calculated to appeal to specific audiences.

A much acclaimed work Sargent did following a trip to North Africa, *Fumée d'Ambregris* (**fig. 10.8**), depicts an exotic young woman perfuming her clothes and opening her senses to the stimulating properties of the fumes issuing from a small lamp. Ambergris, excreted from the sperm whale, was highly valued on an international market controlled by American whalers, and Arab traders paid considerable sums for it, as an ingredient in perfume and as an aphrodisiac. Ambergris thus represented an Atlantic circuit of exchange linking Europe, America, and North Africa—a symbol of the cosmopolitan world within which Sargent himself operated.

*Fumée d'Ambregris* demonstrates Sargent's mastery of the most advanced forms of international art. The subject suggested the sensuous delights and sensual pleasures associated with Mediterranean Africa and other regions on the periphery of Europe. Such themes, loosely linked under the term "Orientalism," had their origins in early-nineteenth-century French art. American Orientalism—coming decades later—represents another episode in the internationalization of American art, as painters such as Sargent traveled beyond Europe in pursuit of exotic subjects. *Fumée d'Ambregris*, with its elegant modulations of white and its harmonious integration of figure and setting,

10.8 JOHN SINGER SARGENT, *Fumée d'Ambregris*, 1880. Oil on canvas, 54¾ × 35⅝ in (139 × 90.4 cm). Sterling and Francine Clark Art Institute, Williamstown, Massachusetts.

demonstrates Sargent's stylish approach, in which storytelling matters less than the sheer beauty of light and color, and the pleasures of the eye.

Sargent's advanced aesthetic suited his flamboyant European patrons. As a portraitist he studied the dress, gesture, attitude, and social space through which cosmopolitan men and women came to know one another. Madame Merle, a worldly expatriate in Henry James's 1881 novel *Portrait of a Lady*, expressed the essence of this cosmopolitan view: "What shall we call our 'self'? Where does it begin? where does it end? … One's self—for other people—is one's expression of one's self; … one's house, one's furniture, one's garments, the books one reads, the company one keeps—these things are all expressive." Sargent shared with James a piercing eye for the socially constructed self that came from a more European understanding of how society defined—and often limited—individual choice and the formation of personality.

encounters increasingly restricted possibilities. And here, the growing conviction that individuals cannot control their own destinies becomes even more pronounced when those individuals are female.

Sargent cultivated celebrity, gambling on winning public attention through displays of virtuosic skill. In one notorious instance, he hitched his ambitions to a celebrated Parisian beauty (**fig. 10.10**). In Parisian high society, Virginie Gautreau had traded on her exotic looks and New World origins (she was from New Orleans) to win a wealthy French husband. Virginie, who was—like Sargent—

**10.9** JOHN SINGER SARGENT, *Daughters of Edward Darley Boit*, 1882. Oil on canvas, 87⅝ × 87⅝ in (221.9 × 222.6 cm). Museum of Fine Arts, Boston, Massachusetts. (See also p. 320)

At the same time, Sargent had a brilliant ability to use interior space to suggest the psychology of his sitters. Reflecting how selfhood is shaped by social circumstance, his *Daughters of Edward Darley Boit* (**fig. 10.9** and **p. 320**) sensitively portrays the development of femininity from childhood to adolescence. In his portrait of the four daughters of an American artist living in Paris, Sargent tells his tale by moving from the clear light and gracefully awkward pose of the small girl in the center, wearing a white pinafore and clutching her doll, to the dawning reticence of the girl on the left, who still engages us directly. Furthest from the viewer, the two oldest girls hover on the edge of a shadowed room defined by two enormous Chinese vases, symbols of their future as maternal "vessels," increasingly withdrawing into a private world no longer engaged with ours. The older Boit daughters stand on the threshold of a world in which their selfhood will be defined by their gender and limited by their status as exquisite possessions—like the vases whose shapes they resemble—of a husband. Sargent presents the passage into womanhood as a gradual tightening of boundaries. From foreground to background, and from childlike receptivity to growing reserve, the painting charts the age-old theme of innocence and experience, in which the originally unencumbered self

**10.10** JOHN SINGER SARGENT, *Portrait of Madame Virginie Gautreau (Madame X)*, 1883–4. Oil on canvas, 82⅛ × 43¼ in (208.6 × 109.9 cm). Metropolitan Museum of Art, New York. Arthur Hoppock Hearn Fund.

twenty-six at the time, proved a perfect collaborator. Sargent showed her (the portrait is now known as *Madame X*) dressed in a revealing but stark black dress, in which she strikes a highly unnatural pose, her torso twisted and held in place by her splayed hand. Defying the gaze of her admirers, she presents a profile view showing expanses of violet-tinted skin with vermilion highlights. Sargent originally painted the strap of her dress slipping off her shoulder, increasing its provocative appeal. Challenging propriety and the ideals of feminine grace, the portrait offended the public, and sent the artist packing to London to escape the shadow of scandal. Despite this lapse in judgment, Sargent went on to a brilliant career furthered by his uncanny ability to match style to audience.

**JAMES ABBOTT MCNEILL WHISTLER.** Like Sargent, Whistler (1834–1903) was American by parentage and education. And like Sargent, he chose to spend his life abroad. Educated first in St. Petersburg, Russia (where his father worked as a civil engineer), and then in the United States, he was thrown out of West Point Military Academy for failing chemistry. Eventually he made his way to Paris in 1855, where he learned to be an artist by visiting the Louvre, and by studying contemporary French art. In 1859 he moved to London, his primary base for the remainder of his career. Whistler invented an artistic persona, practice, and aesthetic philosophy that synthesized the most progressive ideas about art in these years. He melded influences from Japanese woodblock prints, aestheticism—in which subject matter carried less importance than aesthetic effects—and European **Symbolism**, in which mood and suggestion took the place of realist detail, allowing room for imaginative engagement. Famous for his unconventional personal behavior, flamboyant dress, and bold pronouncements, as well as his highly recognizable style (so distinctive that it gained its own adjective—"Whistlerian"), Whistler enlivened his international career with a flair for self-invention. He excelled in several media, leading the late-nineteenth-century revival of etching (see The Fine Art Print, page 334).

In the 1870s Whistler moved away from more densely painted and observed pictures to thinly washed landscapes and portraits—images that worked not through description but through evocation and suggestion, like music. Reacting against the idea of art as a mirror of nature, he diluted his paints and restricted his palette to a narrow range of chromatically muted tones. **Tonalism**, as this style came to be known, would have an international influence. Whistler also began calling his works by musical names: symphonies, harmonies, arrangements, variations. At times, his paintings bordered on **abstraction**. The way in which music echoes the effects of color, and color the effects of music, is known as **synaesthesia** (a union of different sensations). Whistler's exploration of synaesthesia, with its emphasis

10.11 JAMES ABBOTT MCNEILL WHISTLER, *Arrangement in Grey and Black: Portrait of the Painter's Mother*, 1871. Oil on canvas, 56¼ × 64 in (144.3 × 162.5 cm). Musée d'Orsay, Paris.

devotion, pity, love, patriotism, and the like. All these have no kind of concern with it, and that is why I insist on calling my works "arrangements" and "harmonies."[9] Whistler's portrait of his mother (**fig. 10.11**) is a good example of his emphasis on form over content. The cultural image of the mother carried a long and charged history, burdened with sentiment of the kind Whistler denounced as irrelevant to art. Here he reduces the subject of his mother to a severe arrangement of shapes against a stark background, forming an elegant silhouette. Even so, Whistler's minimal means fully realize his subject: a New England woman of puritanical austerity, given new life through aesthetic language, freed from the crutch of narrative and symbolism.

Japanese art greatly contributed to Whistler's development. His *Nocturne: Blue and Gold—Old Battersea Bridge* (**fig. 10.12**), indebted to the Japanese artist Hiroshige (**fig. 10.13**: *Ohashi, Sudden Shower at Atake*), transforms a gritty industrial section of the Thames River in West London into a fairyland of shadowy shapes and magical

10.12 JAMES ABBOTT MCNEILL WHISTLER, *Nocturne: Blue and Gold— Old Battersea Bridge*, 1872–7. Oil on canvas, 26⅞ × 20⅛ in (68.3 × 51.2 cm). Tate Gallery, London.

on the evocative qualities of color, anticipated the concerns of modernism.

In 1877, Whistler's loose style provoked the wrath of the leading Anglo-American writer on art and aesthetics during the second half of the nineteenth century, the Englishman John Ruskin. A deeply reverent man who felt that art should serve nature through humble observation, Ruskin publicly accused Whistler of "flinging a pot of paint in the public's face." Whistler took Ruskin to court for libel, arguing that his art, though executed quickly, drew upon a lifetime of aesthetic expertise. The Ten O'Clock Lecture (1885, published in 1892) was Whistler's aesthetic manifesto, written in the wake of the court trial. Dispensing with the moralism that had underpinned art in both England and America—most fully expressed by Ruskin—Whistler emphasized instead that nature was no more than raw material for the artist, whose authority now came from his heightened aesthetic sense. "Art should be independent of all clap-trap—should stand alone, and appeal to the artistic sense of eye or ear, without confounding this, with emotions entirely foreign to it, as

10.13 ANDO HIROSHIGE, *Ohashi, Sudden Shower at Atake* from the series *One Hundred Views of Edo*, 1857. Woodblock print, 13³⁄₁₆ × 8¹¹⁄₁₆ in (33.5 × 22.3 cm). Private Collection.

# The Fine Art Print

THE SAME YEARS that saw the popularity of the "chromo" as a form of middle-class decoration also witnessed the emergence of the "fine art print" centered around the revived interest in etching. Inspired by Whistler, who learned to etch in the 1850s at the beginning of his career, artists in Europe and the United States produced prints that—unlike the chromo—were intended for a select audience of those who could appreciate the fine handling of the medium and the subtle line value and tonal effects of a well-executed print (**fig. 10.14**). Further reinforcing its differences from the "vulgar" chromo, Whistler devised the strategy of **striking plates**—crossing them out—so that they could never be printed again, thus controlling the market for a print edition by limiting the supply. The production of a "**limited edition**" increased the value of individual prints by artificially maintaining their scarcity.

10.14 JAMES MCNEILL WHISTLER, *The Rialto*, 1879–80. Etching and drypoint, 11⁷⁄₁₆ × 7⅞ in (29 × 20 cm). National Gallery of Art, Washington, D.C. Rosenwald Collection.

pinpricks of light. The darkness compresses the sense of deep space, inducing us to focus on the patterns created by the bridge against the muted background of bank and river. The subdued palette of blue-grays also pares away distracting visual details in favor of abstract forms. Whistler distilled not simply the motifs, but the underlying principles of Japanese art. The scholar of Japanese art and culture Ernest Fenellosa paid tribute to him at the end of his career: Whistler, he wrote, "stands forever at the meeting point" of Asia and Europe, "the interpreter of East to West, and of West to East."

**MARY CASSATT AND HENRY OSSAWA TANNER.** While some artists left America to pursue European opportunities, others left to escape social conditions at home. For Mary Cassatt (1844–1926) and Henry Ossawa Tanner (1859–1937), gender and race imposed limits as long as they remained in the United States. The Parisian metropolis allowed Cassatt to be herself. Very early in her training, she determined that France was, as she wrote to a friend, a country where "[W]omen do not have to fight for recognition ... if they do serious work."[10] For Tanner, Paris afforded an opportunity to escape the "race prejudice" of the United States in a more cosmopolitan environment. For both Tanner and Cassatt, expatriation allowed them the freedom to become artists first and foremost, unqualified by the circumstances of gender and ethnicity.

Freed by family money to pursue her career as a single woman, Cassatt first moved to Paris in 1865 and was exhibiting in the Paris Salon by 1868. Encountering the work of Edgar Degas shaped her emerging talent; beginning in 1879 she was the lone American to exhibit with the Impressionists, testing her talent within male-centered modernist art circles. Like her male colleagues, she claimed all of art history as hers. Best known for her paintings of mothers and children, Cassatt enriched this subject by looking back to the Madonna and child theme central to Christian art throughout the Renaissance. She coupled an interest in the Old Masters—studied during trips to Spain and Italy—with the newest currents in French art, including *Japonisme*, through stylistic experimentation in line and pattern. More than a mere follower of the French avant-garde, her artistic personality emerged through the combination of Impressionist brushstrokes with stable, solid structure, undercutting clichéd conceptions about the woman artist as predisposed to the decorative and the ephemeral. Cassatt's 1889 *Mother and Child* (**fig. 10.15**) brings together strikingly abstract brushwork—especially evident in the water pitcher, which seems to be on the same plane as the mother's head—with the two fully realized

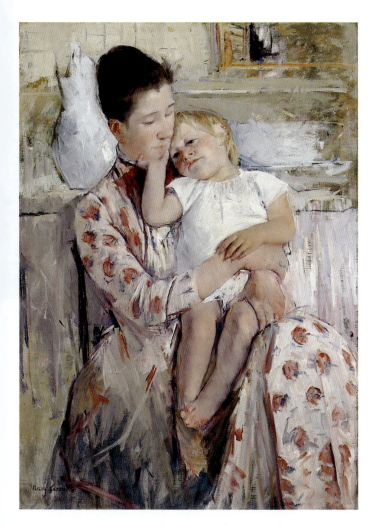

10.15 MARY CASSATT, *Mother and Child*, 1889. Oil on canvas, 35⅜ × 25⅜ in (90 × 64.5 cm). Wichita Art Museum, Kansas.

successes. Celebrated at the highest levels, Tanner was considered by the French establishment to be among the greatest artists produced by the United States. Such recognition early on spurred Tanner's ambition to develop a style that was his own while building on the achievements of the Old Masters. After 1894, he turned his energies to New Testament subjects, one of a small number of contemporary European or American artists painting such themes. This choice drew upon the different strands of Tanner's identity as an artist: his turn to scriptural subjects was linked to the church he had known as a child through his father (see Chapter 9), but it also connected his work with subject matter venerated throughout European art history. *The Annunciation* of 1898 (**fig. 10.16**) was a strikingly original treatment of the theme. In 1897 Tanner had traveled to the Middle East; the impact of the trip is apparent in the new attention to the textiles, the dress, architecture, and ethnic appearance of the young Mary. In the spirit of nineteenth-century historical scholarship that transformed biblical studies, Tanner situated the Christ cycle in the historical environment of Palestine. Breaking with centuries of tradition, he painted the Angel of the Annunciation as a blindingly intense pillar of white light. Tanner's conception gave to the biblical story a new psychological immediacy and historical realism, while preserving its miraculous and sacred nature.

While Tanner acknowledged his black cultural heritage both directly and indirectly, he resisted the role in which

figures in a still moment of intimacy. As if fending off sleep, the child rests his hand on his mother's chin, completing a circuit of linked arms and hands that expresses the bond between the two.

Following study at the Académie Julian, Tanner established his career in Paris. There were many reasons for him to remain in Paris, not least of which was his feeling that there he would be taken first as an artist, and only secondly as a man of African American ancestry. Throughout his life, Tanner rejected the notion that his development as an artist had anything to do with his ethnic make-up. "I suppose," he wrote in 1914, "according to the distorted way things are seen in the States my blond curly-headed little boy would be 'Negro.'"[11] The artificiality of racial labels in the United States struck him as absurd, even as he acknowledged their power to condition the reception of his art.

In 1894, Tanner's painting *The Banjo Lesson* (see fig. 9.12) was accepted into the Paris Salon, the first of a string of

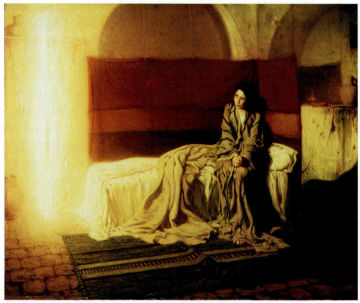

10.16 HENRY OSSAWA TANNER, *The Annunciation*, Oil on canvas, 57 × 71½ in (144.7 × 181.6 cm), 1898. Philadelphia Museum of Art, Pennsylvania.

white American patrons and critics placed him, as representing the "race" potential of black artists. His expatriation and early success in France had given him, in the words of the black historian James A. Porter in 1943, "a sense of expanded manhood and a consciousness of self-responsibility,"[12] words that convey the difference that expatriation made for him in his quest to transcend what W. E. B. Dubois would call in 1903 "the problem of the color line."[13]

## The Marketplace of Styles

World's Fairs were crucial incubators of the influences that transformed European and American art and design in the final decades of the nineteenth century. The opening up of new markets in Asia and the Middle East enriched the range of styles available to artists, stimulating consumer taste in exotic objects and leading to a vogue for incorporating Japanese and Islamic influences into domestic interiors (**fig. 10.17**). World's Fairs began as international trade fairs with London's Crystal Palace Exhibition in 1851, showcasing industrial and artisanal goods from around the world as a way of promoting domestic crafts and industries to international audiences. The display of the most characteristic products of a culture helped to establish categories in which the diversity of market goods from around the world could be organized. World's Fairs fueled consumer fantasies of exotic locales and peoples. Yet while providing entertainment, the international exhibitions of goods at the World's Fairs also connected the industrialized, developed nations to the less "advanced" cultures of North Africa, the Middle East, and Asia. These non-Western participants occupied a subordinate position as colonies supplying the growing consumer appetites of a prosperous middle class in Europe and the United States. World's Fairs promoted the idea that the more advanced nations were entitled to assimilate goods and materials from around the world, and claim all of history and geography as their own. This imperial attitude was linked to racial ideas that—as we have seen—also shaped social and class difference on the national level.

The scholar Anne McClintock identifies the World's Fairs of the late nineteenth century as primary sites of what she terms "commodity racism."[14] World's Fairs displays and advertisements visualized the racial hierarchies around which the national cultures of these years were organized. Western commodities such as soap were advertised as missionaries of enlightenment, extending influence around the globe from the metropolitan centers of London, Chicago, and Paris to the benighted colonial hinterlands of Africa,

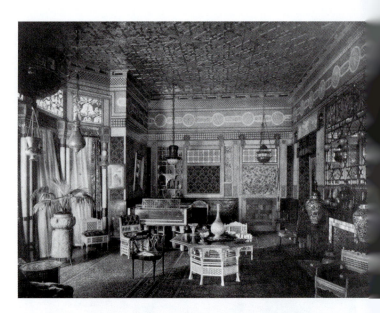

10.17 LOUIS COMFORT TIFFANY & CANDACE WHEELER, *Mr. George Kemp's Salon*, c. 1883, from *Artistic Houses: Being a Series of Interior Views of a Number of the Most Beautiful and Celebrated Homes in the United States* (1883–1884), vol. 1, pt. 1, reprinted in Amelia Peck and Carol Irish, *Candace Wheeler: The Art and Enterprise of American Design, 1875–1900.* Photograph. Metropolitan Museum of Art, New York. Thomas J. Watson Library.

Asia, and the Middle East. The geographical reach of Western goods and markets subsumed the world's cultures into a single ascending scale of development, measured by Western standards of progress.

**THE CRAZY QUILT MANIA AND THE PHILADELPHIA EXPOSITION.** The international influences of the World's Fairs expanded the vocabulary not only of fine artists but also of designers and quilt makers, who were endlessly resourceful in incorporating new approaches to pattern making. From 1876 on, motifs derived from Japanese decorative arts enriched the domestic arts of women. The flat, two-dimensional design sense of the Japanese woodblock print became part of the everyday visual landscape of the urban home.

By the 1870s, classic patchwork quilts were out of fashion among the urban middle class, though they continued to be popular in rural areas. A new fad seized America's middle-class women, inspired by the Japanese art displays at the 1876 Centennial Exhibition, which were visited by more than nine million spectators. American quilt makers devised a new quilt form: the Crazy Quilt, a name thought to derive from its lunatic visual extravagance. While this interpretation is not wrong, the term is actually derived from "crazed," as applied to the all-over crazing in some Japanese ceramics where the surface glaze is cracked

or broken up into an irregular pattern. Indeed, some contemporary accounts even referred to this type of textile as "Japanese patchwork."

Seldom bedcovers, these were smaller, ornamental throws, draped over the back of a sofa or screen in the parlor, or laid atop a plain bed coverlet as a decorative accent. Crazy quilts were usually made of fine silks, sometimes dressmaker's scraps, but more often fabric bought specifically for the purpose. The extravagant use of silk was a result of developments in international trade and manufacturing that made this formerly costly material affordable to middle-class women. American trade with

China, the world's great silk producer, increased in the second half of the nineteenth century, and imported silks became widely available. By the 1880s, Chinese silk thread was being woven into cloth within the United States, and this reduced the cost even further.

When M. M. Hernandred Ricard (1838–1915) began the work she entitled *My Crazy Dream* in Boston in 1877 (**fig. 10.18**), she surely never imagined it would take thirty-five

10.18 **M.M HERNANDRED RICARD**, *My Crazy Dream*, 1877–1912. Silk, velvet cloth, embroidery thread, 74¼ × 68¾ in (188.5 × 174 cm). International Quilt Study Center. University of Nebraska, Lincoln.

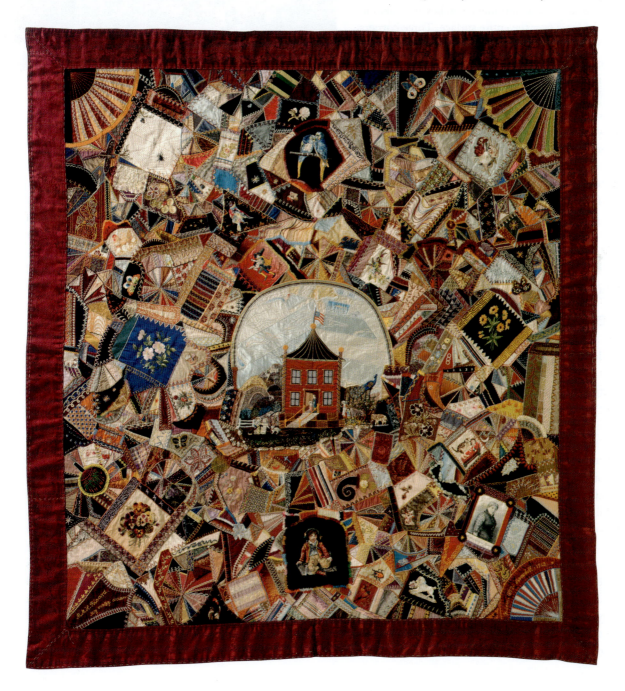

years to complete. In the center, she embroidered an odd scene in which a giant peacock and a small elephant share the landscape with a house, six human figures, and a dog. The sky is composed of various light blue silks with embroidered clouds. An embroidered rainbow arcs over the scene, separating it from the wild patchwork of the rest of the coverlet.

Sometimes individual squares of crazed patchwork overlaid with embroidery were organized into a grid pattern, like other classic American quilts. But in this case, the artist took pains to conceal the fact that her masterpiece is composed of individual blocks fitted together: she overlapped the silks and the embroidery stitches to make an asymmetrical mosaic over the entire surface. Three corners are filled with Japanese fan designs; in the lower left corner the artist has embroidered her name and the title of her work. Amid the profusion of embroidered flowers, animals, and insects, Ricard included a signed photolithograph of herself (lower right).

In 1912, when she finally finished the handsewing on her *Crazy Dream*, silk had become more costly and difficult to obtain, because of civil war in China, and it came to be used less often in quilts. Though the Crazy Quilt fad was over, many families handed these valued coverlets down through the generations.

# The New American Architecture

In the decades after the Civil War, the nation still lacked architectural traditions in which to develop building forms for an emerging urban industrial society. Mirroring the robustly free enterprise of the times, American architects competed fiercely with one another, producing an eclectic and chaotic mix of buildings (**fig. 10.19**). The following generation attacked such "mongrel" inventions, which lacked proportion and combined elements with little sense of overall massing.

This earlier architecture had been shaped by historicism—the use of styles and forms, dominated by the Greek and Gothic Revivals, associated with specific historical periods and qualities. Within this practice, attributes of style mattered more than the program requirements of a specific building. Architects were trained through apprenticeship; only after the Civil War did architecture emerge as a professional practice with a methodical approach shaped by an academic curriculum.

10.19 Wall Street, New York, c. 1882. New-York Historical Society.

## The Influence of the École des Beaux Arts in Paris

The catalyst for an energetic, original, and functionally integrated architecture in the post-war years was study in Paris, at the École des Beaux Arts, where the major American architects of the period all received training. (At this time, the only American institution to offer professional architectural training was the Massachusetts Institute of Technology, opened in 1865 and directly based on the philosophy of the École.)

At the École, aspiring architects learned to think of design as a rigorously rational "science" in which the plan (the *parti*, or building program dictating functional requirements) unfolded logically and bore a close relationship to the style—the building's dress. No more were the architectural sins committed of applying the Greek Revival arbitrarily to houses, churches, and banks. Style would now be logically related to building type and function as well as symbolic association—plan, interior volumes, and elevation now integrated into a unity. French training provided young American architects with a design approach that could be flexibly adapted to a range of styles and functional needs, as is evident from the wide range of architecture produced by this generation. Although criticized for its emphasis on historical styles, Beaux Arts training furnished architects with thorough principles and a complete toolbox to resolve the complex programmatic requirements of new building types such as concert halls, tall office buildings, railroad stations, and department stores.

**RICHARD MORRIS HUNT.** Hunt (1827–95) was the first American architect to attend the École. He went on to become the most successful architect of his generation, in a career that paralleled the painter William Merritt Chase—cosmopolitan, celebrated, and influential in shaping the next generation. Hunt mastered a range of classical styles, from French Renaissance to Second Empire (classically derived and widely used in contemporary France). Along with other New York architects—most notably the firm of McKim, Mead, and White—Hunt combined historical forms with steel frame construction, which allowed for the creation of dramatic new spaces: enormous exhibition halls, tall office buildings. The real modernity of these structures was not in their sheathing of historical forms, but rather in the way they skillfully managed problems of human circulation, multi-use, and broad-span spaces using new construction materials and methods.

**ORIGINS OF THE SKYSCRAPER.** As land in American cities became more expensive, buildings expanded skyward to maximize income relative to the cost of property. Soon to become an international building type, the skyscraper originated in the United States at the end of the nineteenth century, primarily in two places: Chicago and New York, assuming a distinctive form in each city. Daniel Burnham (1846–1912) and Louis Sullivan (1856–1924), members of what has come to be called the Chicago School, used the steel frame to generate new forms shaped both by the structural potential of steel and by the economics of urban real estate. Burnham began his career in Chicago and went on to an international practice that included large-scale urban design. His flexible and inventive approach is evident in his Fuller Building, also known as the "Flatiron Building" (see fig. 12.23), in New York City, whose attenuated shape reflects its narrow triangular footprint at the diagonal juncture of Broadway and Fifth Avenue in Manhattan. While Burnham did work in New York, his approach to design was shaped by the Chicago School, with its bold expression of structure and its unified building mass. New York architects, though they also used steel frame construction for tall buildings, favored picturesque outlines and an emphasis on historical styles. It was the Chicago School's more direct expression of a building's structural frame in its outline and fenestration that furnished the inspiration for twentieth-century modernist architecture. Yet far from merely expressing the logic of commercial profit, tall buildings in Chicago and elsewhere incorporated a range of entryway ornament, roof gardens, luxurious restaurants, and skylit lobbies that graced urban life and expressed the civic pride of the urban business class.

## History and the Individual Talent: H. H. Richardson

The international emergence of American architecture in the later nineteenth century was propelled by the career of Henry Hobson Richardson (1838–86), cut short by his untimely death but which, in a brief span of twenty-one years or so, produced an approach to building that was monumental, forceful, and unified. Richardson's lessons contributed to the younger Louis Sullivan's own prophetic vision of a new, more vigorous American architecture. Richardson went well beyond the imitative **eclecticism** of the post-war period into an idiom that, while still drawing on the past, could also claim to be something new. His massive load-bearing walls, his squat arches and use of boulders, the tautly stretched skin of his shingled houses, and his broad, unified, and gravity-bound monumentality, gave architectural practice in the United States a new authority. Richardson gave his name to an architectural style—the "Richardsonian Romanesque"—that was assertively individual and yet flexible enough for a range of building types.

Richardson was a southerner but moved north to study at Harvard, the nation's leading university, where he found his architectural calling. After graduating there in 1859 he spent six years in Paris at the École (thus avoiding as well the problems of being a southerner in the North during the Civil War). In Paris, he saw large-scale building projects engaging the collaboration of architects, sculptors, painters, and designers. He also encountered a range of historical styles—including the French Romanesque, with its massive volumes and simple outlines—that offered alternatives to the Classical and Gothic Revival styles that had dominated American architecture up to then. At the same time, his sense of massing bore the impress of the warehouses along Boston's wharf.

**TRINITY CHURCH, BOSTON.** This was the building that made Richardson's international reputation (**fig. 10.20**). After six years of practice in New York City, Richardson won the competition for this prestigious commission, and shortly thereafter assembled an extraordinary team of transatlantic collaborators—including John La Farge (1835–1910), Augustus Saint-Gaudens (1848–1907), and the English designer William Morris (1834–96)—who helped him to realize the most aesthetically harmonized interior in American architecture up to that time (**fig. 10.21**). Reflecting the growing sophistication of the arts, the collaborative model assumed a common aesthetic vision to which individual personalities and disciplines were subordinated.

10.20 | HENRY HOBSON RICHARDSON, Trinity Church, Copley Square, Boston, Massachusetts, 1872–7.

10.21 (opposite) HENRY HOBSON RICHARDSON, Trinity Church, interior, Copley Square, Boston, Massachusetts, 1872–7.

The idea of architecture as a unified work of art orchestrating interior volumes with colored and filtered light, wall treatment, interior appointments, and painted decoration would be realized by a range of architects and designers working collaboratively, from the late nineteenth century into the twentieth. Collaboration went hand in hand with the concept of a total environment, in which each individual artistic element was submerged within a larger whole, and in which the individual creative personalities likewise submitted to a single governing conception.

For the plan of Trinity, Richardson used a Greek rather than a Latin cross; all four arms are of equal length, unified around a central volume culminating on the exterior in a squat Romanesque tower. The subdued polychrome interior of wooden barrel vaults and exposed beams, stenciled inscriptions and geometric designs, and stained glass, served as an expansive expression of the renowned preacher and rector of Trinity, Phillips Brooks, whose sonorous voice and unifying message of hope and redemption packed hundreds into the church each Sunday. (He is best known today as the author of the Christmas carol "Oh Little Town of Bethlehem.") With no nave columns but only four corner piers supporting the central tower, the interior is a single unobstructed acoustical chamber. The great arches of the barrel vaults are repeated on a smaller scale on the exterior entrance porch and throughout the façade. With its stately organization of exterior forms, building up to the tower, Trinity Church is a commanding presence in Copley Square. Facing the site of what would soon become the Boston Public Library, Trinity comprises part of a symbolic urban space, joining sacred and secular in an expression of authority and civic pride. With its load-bearing walls, its structural accents of contrasting stone, and its play of solids and voids, Trinity—like most of Richardson's architecture—left behind the language of applied ornament in favor of "a bold, rich, living architecture" that satisfies viscerally through sheer weight and visual power.[15]

Through his time at Harvard, Richardson established the social ties that would propel future commissions. Thereafter, his architecture, continually enriched through travel and study, would develop toward more elemental forms, expressing a building's purpose with clarity while never departing from his distinctive earth-bound and load-bearing style, which would spread throughout the United States in myriad imitations. Such an architecture of massive and elemental forms answered a widely felt need among local and national governments requiring courthouses, government and educational buildings, train stations, and armories. The Richardsonian Romanesque offered a reassuring image of stability, history, and authority.

## Architecture and the New Metropolis: Louis Sullivan

In Theodore Dreiser's novel *Sister Carrie* (1900), Carrie Meeber, a young girl from a Midwestern town, arrives in Chicago to start a new life. Among the new allures of urban life for Carrie are the ready-to-wear fashions of well-dressed urban women. Carrie finds these in abundance at the Schlesinger and Mayer Department Store, where she is seduced by displays of consumer goods

eliciting unfamiliar desires at every turn. By the end of the novel, city life has shaped Carrie into someone new, someone modern.

The architect of the Schlesinger and Mayer Department Store was Louis Sullivan. Like Carrie, he grew up in the countryside of an older America, shaped, according to his *Autobiography*, by intimacy with nature. During a career that took him first to Boston and then to Chicago, Sullivan created compelling new forms for the tall office building and other new urban building types.

**THE DEPARTMENT STORE.** Twelve stories high, Schlesinger and Mayer—now Carson, Pirie, Scott—is a steel frame structure encased in fireproof ceramic tiles (**fig. 10.22**). Sullivan refused to disguise the underlying structural grid of the department store, which is evident in the clean and continuous horizontal lines of its extended façade along the street. In the hands of other architects, this new building technology—used throughout the Chicago business district known as the Loop—was obscured with massive stone facing, heavy cornices, columns, and other classical elements. Sullivan's approach was more matter-of-fact. At the corner, where two major thoroughfares meet, the building splits apart, like a limb exposing ligature and muscle, breaking into a curved bay in which a vertical element becomes more assertive. At the time, this curved corner echoed the curve of the streetcars as they swung around State onto Madison. At the base of the bay is the entrance to the building, contained in a wrought bronze screen of exuberantly stylized foliation (**fig. 10.23** and **p. 278**). Situated at the intersection of two soberly functional

10.23 **LOUIS SULLIVAN**, Schlesinger and Mayer Department Store (Carson Pirie Scott), detail, 1899. (See also p. 278)

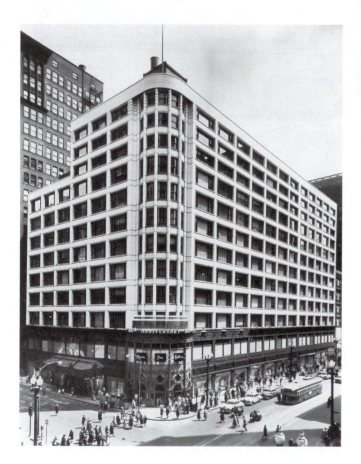

10.22 **LOUIS SULLIVAN**, Schlesinger and Mayer Department Store (Carson Pirie Scott), 1899. Chicago Historical Society, Illinois.

façades dominated by plate glass windows, this entry must have seemed a prodigal offering to the shoppers who stepped within—tired shopgirls, middle-class matrons, rural visitors like Carrie—all ready to be dazzled by this new democratic emporium.

The department store, one of the new urban building types, incorporated a number of new materials, chief among them plate glass, first industrially produced in the 1870s. In tandem with steel frame construction, plate glass brought expansive displays of consumer items into the public spaces of the city street. Sullivan's Schlesinger and Mayer store redefined the street-level experience of the pedestrian with an uninterrupted use of plate glass, lightly framed by decorative panels.

The building's interior was an open expanse supported by a grid of columns. Sightlines were unobstructed by partitions or walls, leaving the eye free to roam from one

display to the next. Departments were separated into stories; functional requirements were met at the perimeters of the open floors. On the third floor a spacious lounge offered comforts previously available only in men's clubs; here women shoppers could rest, read or write, and talk quietly. Further appealing to urban professionals and women of leisure was an eighth-floor restaurant. Sullivan's program for the department store dignified consumption and made even the most modest urban shopper feel welcome.

Sullivan arrived at his design philosophy through a combination of American and European influences. From his early mentor, Philadelphia architect Frank Furness, he learned to think about how to express the building's structure and function through dramatic exterior form. Yet Sullivan believed as well that function should be expressed not merely through engineering but also through poetic metaphor. Decoration played an important role in this poetic expression—articulating, in a non-structural way, the symbolic energies of the building on its surface.

Integrating all these influences, however, was the approach to design he learned at the École—a rational and rigorously analytic form of problem-solving. Without this disciplined approach, Sullivan might never have found solutions to the range of new urban and social functions developing in the American city of these years. Each new project demanded its own specific solution, and precedent had little to contribute in determining the shape of the present. Structural logic, not inherited forms, drove his rational approach to design, shaped by his French training. As he wrote much later, the École had planted the seed of his later design philosophy, summed up as "Form follows function."[16]

**THE OFFICE BUILDING.** The Wainwright Building in St. Louis (**fig. 10.24**) lucidly expressed Sullivan's commitment to structural logic, poetically expressed. Conceived in a three-minute "volcanic" burst of inspiration, as he described it later, the Wainwright is not tall by present-day standards. Yet to Sullivan and future observers, it expressed the soaring verticality of the modern office building. Unlike earlier steel frame multistory structures, the Wainwright understated the horizontal dimension—the expression of stories one on top of another—in favor of uninterrupted vertical piers running from the third floor to the tenth floor where they reach the cornice. Only alternate piers are structural—that is, load-bearing: they alternate with non-structural mullions which look exactly the same. Here Sullivan departed from strict expression of function in order to emphasize the appearance of height. His humane attitude toward new urban forms is evident as well in the

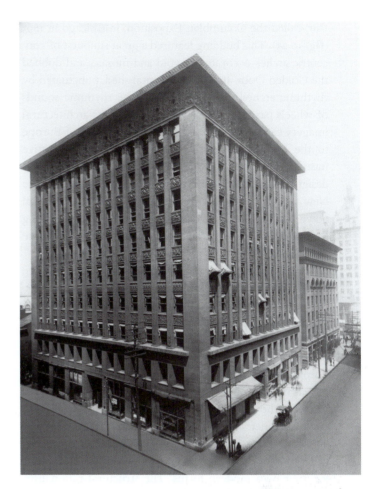

10.24 LOUIS SULLIVAN, Wainwright Building, St. Louis, Missouri, 1890–1. St. Louis Historical Society.

overall form of the Wainwright. The building sits on a strong three-story base; plate glass windows allow visual access into street-level shops. Capped by a bold cornice, at its corners the Wainwright is firmly bounded by broad piers. This lucid, unified façade is enlivened by molded ceramic tiles sheathing the steel cage. The warm color of the ceramic, along with the building's reference to the classical language of base, shaft, and capital, grounds Sullivan's tall office building in a familiar language.

**THE TRANSPORTATION BUILDING.** Sullivan ultimately believed that the role of the architect was to realize in built forms the visionary potential of modern life and institutions, in which ideas circulated freely between nations, through new means of communication and trade. As A. W. Barker wrote in 1901 with respect to Sullivan's work, "… all art of the future must tend toward the expression of the modern cosmopolitan spirit, rather than a distinctively national idea."[17] Sullivan's cosmopolitan spirit was realized in his design for a Transportation Building at the World's

Fair, called the Columbian Exposition, in Chicago in 1893 (**fig. 10.25**). This building featured a great sunburst of concentric arches decorated in gold and mosaic, and dubbed the Golden Door. Its long horizontal shed, punctuated by rhythmic arches, expressed visually the rhythmic sounds of wheels passing over railroad crossbars. Its architectural imagery extended beyond the classical language of Europe to the Middle East and Syria, its splendidly decorative motifs evoking the exoticism of the Orient. Sullivan's design also implied that the modern technology of the New World would accomplish the same thing as imperial power had in the Old World, spanning distances, bridging Europe and Asia, and transcending the boundaries of the nation-state.

Hoping passionately for a new democratic culture, free to develop unencumbered by the authority of past forms, Sullivan was a lone voice of dissent condemning the great spectacle of classicizing architecture displayed at the 1893 Fair, which he saw as the defeat of his organic principles of design, and the triumph of aristocratic forms indebted to Europe. Yet, in the words of a contemporary critic in 1905, he was first to "boldly cast off the thralldom of precedent" to treat "the new condition of structure in a frank and artistic manner."[18] Following his death in 1924, Sullivan was heralded as a prophetic figure, an inspiration to a later generation of European modernists looking for precedents for their own modern forms. The structural rationalism they developed would in turn be exported back to the United States, becoming the so-called International Style.

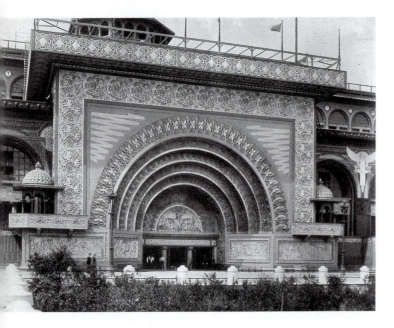

10.25 LOUIS SULLIVAN, Transportation Building, World's Columbian Exposition (World's Fair), Illinois, 1893.

# Reform and Innovation: Handcraft and Mechanization in the Decorative Arts, 1860–1900

Since the fifteenth and sixteenth centuries, the fine arts have been defined as separate from the medieval craft tradition. Within Renaissance art theory, the artist was motivated by humanist ideals of creative freedom, while the artisan was preoccupied by the problems of craft, or *techne*, defined by everyday utilitarian requirements. Creative choice was opposed to necessity, art to craft, and intellectual, religious, or symbolic meaning to use-value. In the later nineteenth century, artists began questioning such polarities. As industrial manufacturing transformed every aspect of life in the later nineteenth century, artists and theorists in England—and slightly later in the United States—turned to older craft methods of workmanship as an arena in which to reconnect hand and brain, a link severed by machine manufacture. They found in beautifully designed and crafted objects a way of counteracting the spiritually numbing effects of machine-made goods. By bridging art and life, artist-craftsmen also rejected the isolation of art in museums and private collections, instead applying aesthetic concerns to utilitarian objects and everyday environments. Advocates of what would come to be known as the **Arts and Crafts movement** (English, originating in the mid-century, reaching its height in the 1880s) and those of the associated "**Aesthetic movement**" promoted the idea that in choosing household furnishings, consumers also shaped the moral and social environment. As one contemporary, a Chicago sociologist (C. R. Henderson), put it in 1897, "Our works and our surroundings corrupt or refine our souls."[19]

## Origins in Social Theory

The idea that the physical environment in which people live could be "designed" to fit social values had its origins in the later nineteenth century, as part of a broad critical reaction to the historical effects of industrialization. This reaction occurred most profoundly in England, where it focused on the nature of industrial labor and its products. English social critics such as Thomas Carlyle in the mid-nineteenth century, and later John Ruskin and William Morris (all three widely read in the United States), analyzed the manner in which factory production fragmented the work process, replaced hand labor with machines, and

subjected the worker to a mindless repetitive process that drained labor and its products of meaning and wholeness. Mechanization had made possible a culture of replication, in which factories could now turn out versions of historical furniture and decorative arts originally produced by hand: Rococo-inspired curvilinear chairs and sofas; garlands of fruit and flowers mounted onto massive Renaissance Revival sideboards; pressed wood urns and classical heads; heavy upholstery; and chromolithographs that reproduced oil paintings (see fig. 9.20). Fueled by a growing urban middle class clamoring for affordable goods with a luxury look, machine manufacture forever changed the look of everyday life.

Beginning with the English Arts and Crafts movement, designers in Europe and the United States wished to restore labor to a central place in community life, by returning control of the labor process to the worker. They advocated a revival of the workmanship they associated with the medieval era, and urged laborers to seek creative fulfillment in work and in an "organic" integration of life and work to replace the separation of work and home, designer and fabricator. These design reforms were not tied to any one historical style; rather than imitating forms from the past, the reformers sought their underlying principles of design. These reform movements drew freely from medieval, Japanese, and Islamic art, and from a range of national vernaculars, stylizing historical motifs but also, in the case of the most original designers—such as Frank Lloyd Wright—inventing new design vocabularies. Design reform embraced not only handcraft but also machine production, subordinated to the will of the designer. The movement for design reform spread throughout Europe and the United States as designers actively exchanged ideas across national borders. Here again, World's Fairs played an important role.

Motivating design reform was the quest for aesthetic simplification. In response to the clutter, visual overload, and over-upholstered excesses of the High Victorian era, design reforms strove to harmonize furnishings, **frieze** decorations, tile work, rugs, and fabrics to form a complete, visually integrated whole. Advocates of "art in industry" and those who hoped to revive handcrafts both found inspiration in the ideal of an aesthetically integrated environment as a total work of art bringing painters, sculptors, designers, and architects together in collaboration.

A number of institutions for training designers appeared in these years in response to the call for improved design in industry: the Pratt Institute and Cooper Union in New York; the School of Art at Washington University; and the California College of Arts and Crafts, among others. All of them traced their roots to the Victoria and Albert Museum in London, established after the 1851 Crystal Palace Exhibition to address the perceived inadequacies of Victorian design.

**HERTER BROTHERS.** The Herter Brothers—leading producers of fine furniture in New York during the 1870s and 1880s—combined exquisite design with costly materials and highly skilled handcraft. They provided furnishings for America's wealthy—the Vanderbilts, J. Pierpont Morgan, and others—and collaborated with some of the leading architects of these years. Their studied eclecticism drew upon a range of historical styles—classical, Louis XVI, Japanese, Gothic, Moorish; the currency of a transatlantic community of designers who exchanged influences and friendships. The Herters' Desk of 1882 (**fig. 10.26**), made for the financier Jay Gould, is in a style known as "Anglo-Japanese." Its ebonized finish resembles Japanese lacquerwork, while its stylized bisymmetric floral **inlay**, restrained rectilinearity, and flat patterned approach to decoration recall the leading principles of international design reform.

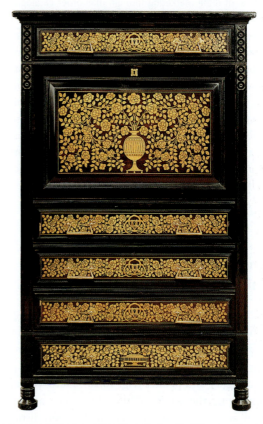

10.26 THE HERTER BROTHERS, Desk (for Jay Gould), 1882. Ebonized cherry, cherry, mahogany, Easter red cedar, butternut; marquetry of various woods; maple, hard maple, cherry, white oak (secondary woods); brass, printed suede, 54 × 34⅛ × 19 in (137.2 × 86.7 × 48.3 cm). Metropolitan Museum of Art, New York. Gift of Paul Martini.

# Inventions, Patents, and the (Non)Collapsible Chair

UNENCUMBERED BY a centuries-old European guild tradition that limited innovation or experimentation, and fueled by a growing national market, American designers such as George Hunzinger (1835–1898) devised ingenious solutions to such perennial problems as chairs collapsing as men tilted back in them (**fig. 10.27**). From this American breach of manners, Hunzinger saw his marketing opportunity. Armed with another very American institution—the patent—Hunzinger created a diagonal brace used on a variety of chairs he marketed, guaranteed to withstand the rigors of the American parlor or dinner table. Patented furniture flourished in the post-Civil War decades. Folding and stacking chairs (to which Hunzinger made his own contribution), sofa beds, and extension tables all spoke to the needs of a new, more active, practical-minded public drawn to multifunctional designs for everyday living. Hunzinger's skillful use of sales agents throughout the United States, of retail marketing through mail order catalogues, and of minor design modifications targeted to different market niches, all served growing levels of consumption while maintaining high standards of workmanship. Combining the technique of interchangeable parts—chair seats or crests—with a diverse range of styles, Hunzinger accommodated the desire for individuality and product novelty while exploiting the economies of mass production. The growing design sophistication of everyday furnishings such as Hunzinger's was fueled by a happy combination of ingenious and skilled immigrants (Hunzinger was from Germany), entrepreneurial talent and marketing flexibility, and growing consumer demand.

10.27 GEORGE HUNZINGER, Armchair, patented in 1869, 1876. Walnut, steel mesh. Brooklyn Museum of Art, New York.

## Women Designers and Artistic Collaboration

In 1883, two years after painting his own studio (see fig. 10.4), William Merritt Chase completed a striking full-length portrait of Dora Wheeler, a former student of his, commemorating a significant moment in her life as a professional designer and painter (**fig. 10.28**). Here, rather than contemplating the works of the older male artist, Dora Wheeler appears as a woman of intellect and distinction. Her head thoughtfully cradled in her left hand, feet planted solidly on the ground, she stares soberly at the viewer. The portrait is a study in what were then considered daring color values—a lush, fur-trimmed at-home gown of teal

blue, against a wall covering of variegated gold. The color scheme is reprised in the gorgeous teal vase with daffodils placed next to her. But while Dora is here part of an aesthetic ensemble, it is an ensemble that she herself has shaped. The portrait was painted in her studio. The daughter and partner of Candace Wheeler, a leading figure in the design world of New York City, Dora had recently been appointed chief designer in her mother's company, which produced textiles and wallpapers for the city's taste-setters. Chase used this audacious portrait to parade his sophisticated tastes and his emerging talents as a painter, but he did so with the active collaboration of his admired former student. Chase made good his tribute to the professional woman artist by opening a summer landscape school on

Long Island, dedicated to training women art students, and patronized by Candace and Dora.

These two women embodied in their own successful careers the skill with which ambitious women transformed older types of feminine expression—in this case needle arts—into dynamic new forms of aesthetic entrepreneurship. In 1879, Candace joined with Louis Comfort Tiffany and two others in forming The Associated Artists (1879–83), committed to a new integrated approach to interior design in which all the elements of a room were collaboratively designed to achieve aesthetic unity. Wheeler's own company, formed in 1883 and also called Associated Artists, designed some of the most notable interiors in New York

City (see fig. 10.17), with a mix of international styles, exotic materials, and sumptuous effects. Self-taught, Candace projected herself into the forefront of American design in the late nineteenth century. The domestic realm of middle-class women and their traditional needle arts proved for Candace and her daughter Dora to be a springboard to professional achievement and public recognition.

## The Arts and Crafts Movement

Though deeply influenced by English Arts and Crafts, the American Arts and Crafts movement incorporated national and regional influences specific to U.S. culture. Key to the Arts and Crafts philosophy was the insistence that design be tied to place, through the use of local and regional materials and forms as well as through the integration of

10.28 WILLIAM MERRITT CHASE, *Miss Dora Wheeler*, 1883. Oil on canvas, 62 × 65 in (159 × 165 cm). Cleveland Museum of Art, Ohio.

# Hawai'ian Quilts and Cross-Cultural Collaborations

WOMEN'S NEEDLE ARTS, even in the professional design world of New York, were often grounded in collaborative methods. Around the same time that the Wheelers were launching their successful business, white and Native Hawai'ian women collaborated in taking American quilt making in a new direction (**fig. 10.29**). Before contact with outsiders, indigenous women of Hawai'i made cloth from tree bark, which they dyed and stamped with geometric designs. Missionary women from New England began to teach quilting in Hawai'i as early as 1820, choosing women of high rank as their apprentices, an appropriate action in this status-conscious society. Although the New Englanders may not have grasped the implications of their actions, by introducing needlework to the highest-ranking women first, they ensured acceptance of quilting among all Hawai'ian women.

One distinctive Hawai'ian type is the flag quilt, demonstrating yet another use for quilts: as commemorative patriotic banners. Hawai'i's flag, adopted in 1845, is made up of eight red, white, and blue stripes, standing for the eight major islands. Where the stars in a U.S. flag would be, there is the Union Jack—the British flag—recalling the eighteenth- and nineteenth-century colonial power that preceded the U.S. government. In this quilt, four flags encircle the central appliqué design of the Hawaiian coat of arms. Just as Hawai'ian quilting itself was an encounter between the art forms of two cultures, so too this quilt reflects artistic collaboration between a white woman and a Native Hawai'ian woman.

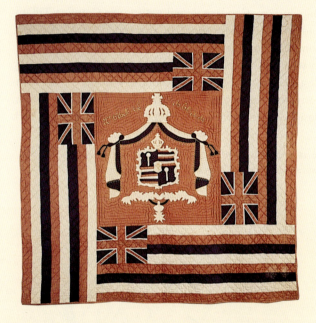

10.29 WILHELMINA EICHINGER & MRS. AMOS, *Ku'u Hae Aloha (My Beloved Flag)*, Hawai'ian quilt, c. 1900. Cotton, 81⅛ × 84 in (205.9 × 213.3 cm). Bishop Museum, Honolulu, Hawai'i.

built forms with their natural environments. In Californian architecture, for instance, the Spanish mission style furnished a regional version of rough, honest vernacular building that expressed ties to the culture of the original colonizers. In the work of the Pasadena architectural firm Greene and Greene, Japanese and Chinese elements are added as well—an influence appropriate to their location on the Pacific Rim. Greene and Greene also used the woods and stylized forms of trees native to California (**figs. 10.30 and 10.31**). The Greene brothers (Henry M., 1870–1954, and Charles S., 1868–1857) served a cultured clientele—many of whom had migrated from the east—who helped nurture a local variant of Arts and Crafts, known as the "Arroyo" style for its location alongside a steep-sided dry creek bed near the San Gabriel mountains. Here landscape, local

history and influences, and patronage fused in a regional variant of the international language of Arts and Crafts.

The American Arts and Crafts movement drew inspiration from Native American as well as Asian cultures, where beautifully crafted objects played central roles in everyday life. Finding affinities with the simplified geometric designs and handmade forms of Southwest Indian design, *The Craftsman* and other Arts and Crafts publications of these years advocated the use of Native weavings, baskets, and pottery in domestic interiors. Pueblo pottery forms also influenced Arts and Crafts potters themselves.

Yet the Arts and Crafts return to a preindustrial form of workmanship often went hand-in-hand with a stratified commercial organization, combining master designers with skilled craftsworkers, marketing and distribution

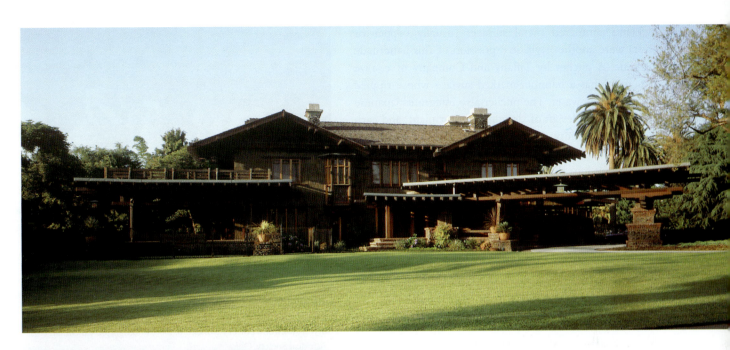

10.30 (above) **CHARLES AND HENRY GREENE**, Blacker House, Pasadena, 1907–09.

10.31 **CHARLES AND HENRY GREENE**, Blacker House, interior detail, 1907–09.

(1858–1942), among others, advocated the judicious use of machine production, in tandem with handwork. The problem for them was not in machinery as such, but in the tendency to use machines merely to replicate a dead past. Instead they promoted the use of machines to spare drudgery, to act as vital servants of human creative will. Stickley, a tireless supporter of Arts and Crafts philosophy and an influential manufacturer, started out life as a stonemason, and was thus familiar with labor carried out without the assistance of machinery. Around the turn of the century, he began mass-marketing the "simple life" look of the preindustrial historical forms borrowed from the Colonial Revival and related styles. Influenced by British socialist ideals, he began publishing a magazine, *The Craftsman*, in 1901 to promote his ideology of simplified and honest domestic living and a restoration of the workman's control over the product of his labor. Stickley's guild organization the United Crafts was directed at bringing the designer and the fabricator—separated by industrial production—back together in one person. Yet alongside this medieval ideal, Stickley employed the most up-to-date mail order marketing, and used *The Craftsman* to create a national audience for his furniture. Affordable, well-made "Craftsman" furniture appealed to progressive American families who embraced the link between honest design and good citizenship.

departments. Though frequently associated with a single individual—Louis Comfort Tiffany (1848–1933), for instance—the products of such companies represented the work of multitudes.

Machine production put Arts and Crafts furniture within reach of the middle class by bringing down costs. Frank Lloyd Wright (1867–1959) and Gustav Stickley

Hand-hammered metal surfaces (usually copper or silver) were another stylistic expression of this handmade aesthetic. A pitcher by Tiffany and Company of c. 1878 (**fig. 10.32**) has a hammer-marked surface whose rippled effect suggests water. The pitcher also integrates Japanese influences: the design of dragonfly, water plant, and carp shows an economy of line and composition for which Japanese woodblock prints had been admired since their introduction into the West in the mid-century. The shape of the pitcher, on the other hand, derives from traditional Anglo-American sources, thus exhibiting the stylistic eclecticism characteristic of the Arts and Crafts fusion of East and West. The Tiffany Company's technical and stylistic innovations—the use of copper- and brass-colored mounts in tandem with the silver body of the piece, for instance—were widely copied within an increasingly international marketplace for handmade crafts. The aesthetic of the handmade also favored matt finishes and aged patinas over the highly glossy or shiny surfaces associated with machine production. The deliberately rough, weathered qualities of Japanese crafts carried the same appeal. Ironically, these very qualities could now be replicated through the ingenuities of American machines.

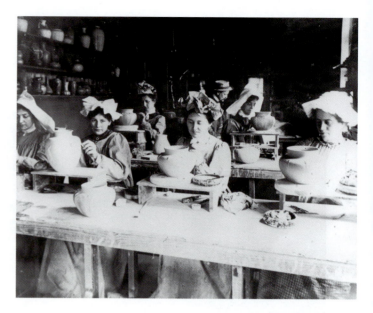

10.33 Rookwood pottery workshop, 1900. Photograph. Cincinnati Historical Society, Ohio.

Popularized through *Ladies' Home Journal* and elsewhere, the Arts and Crafts style emerged as a lucrative industry that reproduced the handmade "look" through machine-based or standardized forms of production. Though proclaiming the "freedom of expression" of the individual artist, Arts and Crafts products often incorporated the widespread division of labor prevalent in industry (**fig. 10.33**), especially as successful firms began catering to a broader market, and producing multiples from someone else's design.

The Arts and Crafts concepts of meaningful work, wholesome life, and community had a wide appeal among the American middle class. But in the context of wage labor and the growing industrial-era gap between work and home, maker and user, the movement fell well short of the significant social reforms required to realize these ideals. The high cost of handmade goods often placed them beyond the reach of ordinary families, but mass marketing through catalogues and retail brought the "look" of the preindustrial into homes throughout the nation. If Arts and Crafts itself became another style successfully marketed to sell consumer goods, it nonetheless produced a new aesthetically integrated approach to the American home and its furnishings that has remained a high point in the history of American design (**fig. 10.34**).

**CALIFORNIA BASKETS AND THE ARTS AND CRAFTS MOVEMENT.** Native American women across the continent had made baskets for several thousand years. But with the growing value placed on the handmade within the Arts and Crafts movement, Native women's basketry became

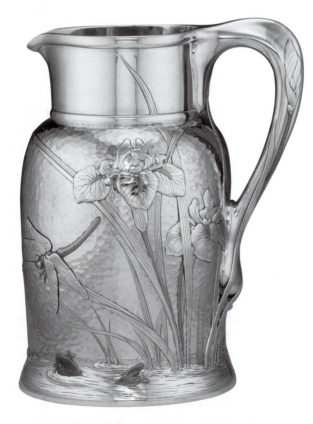

10.32 **TIFFANY & CO.**, Pitcher, c. 1878. Silver, with alloys of copper, silver, and gold, 8⅞ in (22.6 cm) high, 6¾ in (17.1 cm) wide. Art Institute of Chicago.

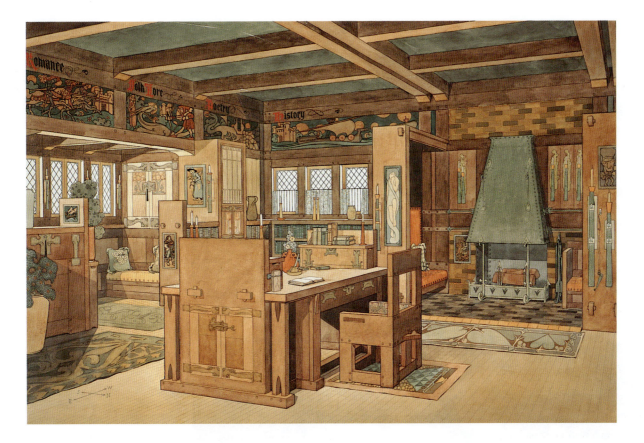

10.34 WILL H. BRADLEY, Drawing for a library, c. 1902. Graphite, ink and watercolor on paper, 25½ × 37½ in (64.8 × 95.3 cm). Published in *Ladies' Home Journal*, 1905. Huntington Library, Art Collections and Botanical Gardens. Gift of the artist.

weighted with new cultural meanings for American collectors. Nostalgic for a lost past, the white middle-class purchasers of such objects held romantic notions about Indians while remaining ignorant of their real lives. Discussions of basketry during the era 1890 to 1920 focused on the authenticity and anti-modernity of these objects and their makers. Yet the women who wove for what came to be called "the basketry craze" were very practical about their audience, providing wares for different price ranges, sizes, and tastes. While the California basketry trade provides one example of such interactions, similar processes occurred in the northwest and southwest regions as well.

During the second half of the nineteenth century, Pomo Indian women in the mountainous area of northern California were unsurpassed as basketmakers, this art form having been handed down from mother to daughter for at least three hundred years. When Sir Francis Drake sailed into Point Reyes, California, in 1579, a member of his expedition noted that the local baskets were "so well wrought as to hold Water. They hang pieces of Pearl shells and sometimes Links of these Chains on the Brims ... They are wrought with matted down of red Feathers in various Forms." He was referring to the renowned Pomo ceremonial basket into which were woven red woodpecker feathers. But Pomo basketry was far more varied, and characterized by fine design (**fig. 10.35**). Made of willow, sedge roots, and bulrushes, the design patterns were built

up horizontally and diagonally around the vessel, often in complex rotational schemes. In addition to coiled and twined color patterning, surface decoration was sometimes supplemented by feathers or beads, creating a three-dimensional design effect.

The market that developed in the early twentieth century for these extraordinary baskets illustrates that two parties with different cultural concerns can nonetheless carry on profitable exchange to the benefit of both. In the market for handcrafted goods, Anglo and Native met on grounds that were more nearly equal than in any other arena. Throughout much of Native California, basketry held an important place: men caught fish in basketry traps, and women harvested wild seeds using a woven seed beater and basket. Baskets were prominent in ceremonies marking rites of passage ranging from birth, to marriage, to death. As Pomo people came into more direct contact with outsiders during the second half of the nineteenth century, the daily use of baskets declined and they were made principally for sale to outsiders; they were much in demand by collectors by about 1900. While the Pomo had

10.35 SALLY BURRIS, Pomo Basket, c. 1905. University of Pennsylvania Museum, Philadelphia.

10.36 (below) ELIZABETH HICKOX, Basket, Lower Klamath Region, California, c. 1913. Redwood root, maidenhair fern, 9 in (23 cm) high. Southwest Museum, Los Angeles, California. Caroline Boeing Poole Collection.

always made both large and small baskets, the external market encouraged extremes. Collectors vied for the enormous and the diminutive. In fact, the tiniest Pomo baskets were so small that several could fit on a penny. In both the miniature and the gigantic, the artist pushed her technical capabilities to the maximum. Because of its large scale and elaborate design, the basket in figure 10.35 was almost certainly made on commission to a dealer or collector. Yet its maker, Sally Burris (1840–1912), was a traditional Pomo woman who had little contact with outsiders until late in her life.

In contrast, the life and work of Elizabeth Hickox (1872–1947) was more representative of intercultural complexities. She was a mixed-race woman of the lower Klamath River area of northern California, where Yurok, Karuk, and Hupa weavers lived, worked, and intermarried with each other and with non-Natives. As a result, their baskets often assimilated the styles of different groups. Hickox married a mixed-race businessman; the couple owned cars and radios, and traveled. Regarded as the finest weaver in her region, she specialized in globular baskets

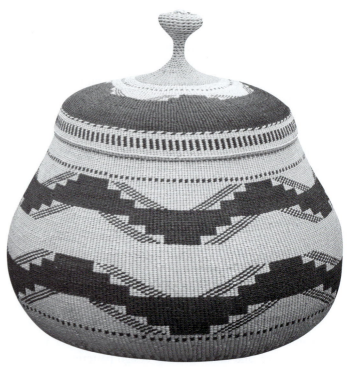

10.37 Grace Nicholson's Indian Art Gallery in her Pasadena home, c. 1925. Photograph. Huntington Library, Pasadena, California. Grace Nicholson Photo Collection.

with lids (**fig. 10.36**). For many years she was under exclusive contract to Grace Nicholson, a wealthy California dealer who guaranteed her an annual income of $500 so that she could devote herself to her craft. Nicholson lived in Pasadena, the epicenter of the Arts and Crafts movement in the West. She transformed the first floor of her spacious home into a gallery (**fig. 10.37**) stuffed with textiles, baskets, and other Native objects. For most of the first quarter of the twentieth century, she sold such items to wealthy collectors, including women who eagerly sought Native women's artwork to adorn their own domestic interiors. In this instance, Nicholson promoted Elizabeth Hickox as a marketable commodity during an era when Americans were increasingly focused on name recognition and brand recognition in many aspects of their daily lives.

Hickox won individual recognition for her work, living comfortably between cultures. Paradoxically, her patrons believed they were investing in an authentic "premodern" work of Native craft that they alone valued as art. Each side in this exchange had its own objectives, each reconfirming identities through exchange. Hickox, far from being "contaminated" by contact with the market, used Nicholson's patronage to advance her most original designs. At a time when other forces were fragmenting Native lives and craft practices, the basketry trade promoted cultural survival. Having a patron who bought everything she made allowed Hickox to continue to create unique baskets—some woven with more than 800 stitches per square inch—at a time

when nothing in her local culture rewarded such painstaking artistry. Elizabeth Hickox is an example of a Native artist who negotiated the opportunities of the market to nurture her own craft and to move fluidly between Native and European societies. In the marketplace of style, Native Californians recovered some of the agency and independence they had lost with the imposition of the mission system in the eighteenth century.

**TIFFANY, AMERICAN INDIAN BASKETRY DESIGN, AND THE 1900 PARIS EXPOSITION.** 1900 was a year of unparalleled prosperity for American elites. Nowhere was America's wealth demonstrated with greater opulence than at Tiffany and Company's exhibit at the Exposition Universelle in Paris. The head of Tiffany's Art Department, Paulding Farnham (1859–1927), chose to display items that, in materials and imagery, represented all North America. From jewelry set with Mexican opals and Montana sapphires, to silver bowls based on Native American basketry and pottery and set with Arizona turquoise (**fig. 10.38**), the splendor and originality of American design was on display. Farnham had created jewelry and bowls based on Native designs for Tiffany's exhibits at the Paris Exposition of 1890 and the 1893 Chicago World's Fair, but the designs for 1900 were particularly bold, and won numerous medals.

This vessel, formed of silver, beaten copper, and turquoise, demonstrates how indigenous design became

10.38 TIFFANY & CO., Bowl, American Indian style, 1900. Silver, copper, turquoise, 7½ in (19 cm) high. High Museum of Art, Atlanta, Georgia.

part of the universal vocabulary of design reform at the turn of the century. It is based on a late-nineteenth-century Hupa basket from northern California. To the ordinary viewer at the exposition, much of the delight in this object may have been in the apparent contradiction seen in the transformation of a vernacular object made of humble materials (the basket) into an opulent object of semi-precious materials. Yet the basket, transformed into a luxury object by the creativity of Tiffany's designers, itself represented the highest standards of Native craftsmanship. The form adopted by Tiffany was already an object of intercultural commerce, made expressly for a high-end market and conferring status on its maker, as we have seen in the example of Elizabeth Hickox's basket, above.

## Awakening the Senses: The Glasswork of Tiffany and Company and John La Farge

The decorative arts were an area not only of technical and design innovation but also of exploration into the purely sensuous properties of materials. The most advanced expression of this interest concerned stained and blown glass. It is fitting that the two most innovative designers in this area were men who had distinguished themselves in numerous other media as well. Louis Comfort Tiffany crossed the boundaries separating art from craft and painting from decoration. He produced easel paintings, but also worked in metal, mosaics, and glass, introducing rich textures, pattern, and color into unified aesthetic environments. John La Farge was a painter and watercolorist, precociously interested in the optical effects of light and color on the perception of form, before becoming interested in stained glass. Both men embraced "eye appeal" and the affective power of rich, deep color as a foundational element of design. As Tiffany explained years later, "The sovereign importance of Color is only beginning to be realized in modern times…. These light vibrations have a subjective power and affect the mind and soul, producing feelings and ideas of their own."[20] Tiffany credited a trip to Egypt and North Africa with awakening his passion for color: "I returned to New York," he later wrote, "wondering why we made so little use of our eyes."[21]

Both an artist and a businessman who ran one of the most successful companies in the history of American decorative arts, Tiffany made technical innovations that, in tandem with his marketing genius, were widely adopted. An avid traveler, he used his curiosity about other cultures and traditions—from Japan and China to Egypt, the Middle East, India, classical Greece, and Native America; and from Byzantine mosaics to Venetian glass—to fuel his

10.39 JOHN LA FARGE, *Fish and Flowering Branch*, c. 1896. Stained glass, 26½ × 26½ in (67.3 × 67.3 cm). Museum of Fine Arts, Boston, Massachusetts.

visual imagination. Driving his creativity was a passion for color and light. These two concerns—grounded in the sensory apparatus of the body itself—increasingly characterized many aspects of late-nineteenth-century art. Tiffany's importance extends far beyond the leaded glass lamps, endlessly imitated, for which he is best known. He mastered a number of media (painting and watercolor, ceramic, glass and stained glass, mosaic, and metal) in an era that saw its share of "multimedia" artists. His company won international fame not simply for the extraordinary quality and beauty of its work but for combining handcraft methods with an industrial scale of production and marketing.

In 1893 Tiffany developed a technique known as **favrile** (see fig. 10.1) in which pigments were swirled into molten glass, making color integral with the glass body, and fusing form and surface in a spectacular harmony. Glass was the very embodiment of colored light, and Tiffany exploited its translucency and its fluid nature to the fullest, with swelling forms gracefully contracting to narrow openings, flaring out and pulled tautly slender. Tiffany handled these materials with a new freedom, technical innovation, and appreciation for the abstract qualities of light and color that suggest the first stirrings of a modernist sensibility.

Along with his cosmopolitan influences, Tiffany drew from the imagery of a fecund and vital organic world, fitting comfortably within an American context while making its own unique contribution to the international language of **Art Nouveau**: the "new art" whose swirling, attenuated, and asymmetrical forms found their way into the visual and decorative arts of America and Europe around the turn of the century. The fluid shapes of favrile glass, along with its surface designs, suggest sea forms and flowers, while its iridescent colors recall exotic birds.

Stained glass was an important area of innovation in American design of the late nineteenth century, for both Tiffany and La Farge. John La Farge described stained glass window decoration as "the art of painting in air with a material carrying colored light."[22] Competing for new effects that would express the beauty of colored glass, both artists embarked on a restless search for new techniques that brought them leading commissions and international fame (La Farge received a Legion of Honor decoration from the French government). Their list of patrons was a Who's Who of American business and industry, from J. P. Morgan to the Vanderbilts. The art of stained glass had changed little since its height in the twelfth and thirteenth centuries. Extending the possibilities of colored light into this medium, both artists developed parallel methods for achieving layered depths of modulated color, and new effects of shading and variegated hue that approximated the complex colors of nature. Both men used a vastly expanded array of colored glass, newly available through industrial methods, blended together to suggest depth and subtlety. Their techniques included incorporating opalescent glass, floating small bits of colored glass between layers (known as confetti), swirling molten glass to achieve rippled textures, and using the leading between the glass as a decorative element in the composition (**fig. 10.39**). They eliminated techniques that detracted from translucency—such as the medieval technique of painting in details—and they exploited random variations in color density and range to achieve painterly effects. La Farge's sources ranged from Japanese woodblock prints to Chinese Ming Dynasty painting and the monumental figural art of the Italian Renaissance. Flooded with sunlight, the stained glass of La Farge and Tiffany achieved—in the words of one European admirer—an "astonishing brilliance," unrivaled by any other art form.[23]

# Conclusion

The new cosmopolitanism of trade exchange, tourism, and World's Fairs—and a new fluency in an international range of design vocabularies—offered vastly expanded resources for American artists, architects, and designers. Rarely before or since have the American arts been as unified by a common impulse to refine and reform the material and visual environment. The global market and circulation of styles, the appropriation of other cultural forms, and the eclectic range of taste that we see today are not new: fueled by global consumerism and a shrinking world, today's transnational flow of goods had its origins in the later nineteenth century. At that time, many American artists found their identity in a new freedom to range throughout history, in the company of the great artists of the past, while opening up their curiosity to non-Western influences. These influences catalyzed the careers of all the distinctive personalities of the age: Louis Comfort Tiffany, James McNeill Whistler, Louis Sullivan, H. H. Richardson, and many others. Although American culture would alternate between nationalism and internationalism over the next century—and at times be accused of "provincialism"—America's artistic and cultural innovators never again broke their ties to the rest of the world.

American culture's expansion beyond its national boundaries entailed both gain and loss. If the gains are obvious, the losses are perhaps less so. The dizzying array of consumer choices now permitted the invention of a social self, determined merely by the particular impression one wished to make. A person's identity derived less and less from experience, background, and moral character, and more from superficialities such as style and appearance; the connections between things and their meanings came to seem increasingly arbitrary and less reliable. The novelist Edith Wharton, writing about wealthy New Yorkers at the end of the nineteenth century, identified a new "hieroglyphic world," in which things stood not for themselves but for social pretensions. While people, objects, styles, and motifs have always been mobile—even across continents—what changed in the late nineteenth century was the speed of this movement. Such rapid social mobility challenged the older ways of knowing the world, ways based on local custom, social tradition, moralistic values, and historical association. These values countered the challenges of mobility by attempting to reassert stable boundaries, as we shall see in the next chapter.

# 11 | Exploration and Retrenchment: The Arts in Unsettling Times, 1890–1900

By THE FINAL DECADE of the nineteenth century, America was enjoying a vast expansion of material comfort, along with unprecedented concentrations of wealth, both personal and corporate. Commerce, industry, and culture were advancing westward, colonizing previously alien regions of the nation. In 1893 American historian Frederic Jackson Turner delivered his essay "The Significance of the Frontier in American History," in which he pronounced the frontier officially closed. With the conclusion of the Plains Indian Wars and the confinement of the Indians to reservations, the federal government and the military were free to redirect their energies to extending the U.S. sphere of influence in the Pacific and the Caribbean. The nation was assuming a new identity. In commemoration of the four-hundredth anniversary of Columbus's "discovery" of the New World, it put its growing imperial confidence on extravagant display at the 1893 Chicago World's Fair, as the world was about to enter "the American Century."

Yet beneath such celebrations of "progress" were depths of experience beyond the reach of both science and older forms of faith. Darwin's *Origin of Species*, first published in 1859, had proposed the theory that the biological world is governed by a process of natural selection in which plants and animals evolve by random genetic variations. Evolutionary theory contradicted religious dogma and unsettled religious faith. Instead, it inspired a new philosophical skepticism and doubt concerning older forms of intellectual and scientific authority. The process of empirical observation that drove scientific advance was

also turned inward, toward the human mind, inspiring a new interest in psychology and perception. Artists and writers in both Europe and the United States began to focus their work upon their own subjective experience, explorations that would prepare the way for modernism.

The 1890s witnessed many new and unsettling challenges to customary hierarchies: of male over female, tradition over individuality, fact over imagination. While middle-class women were pressing for legal rights and fuller representation in public life, middle-class men were experiencing a loss of power over their work and identities. Traditions of masculine independence gave way to corporate business life dominated by impersonal bureaucracy. Masculinity—associated with self-discipline—came under further threat from society's growing preoccupation with feminized leisure and consumption. Both older restrictive ideals and more open possibilities were played out in art concerned with masculine and feminine identities.

Photography began to touch all aspects of life. The documentary power of the camera exposed the poverty and the social inequality previously only dimly recognized. The camera also democratized the power of image-making by giving ordinary Americans a tool with which to record the world around them. Its ability to seize a moment in time revealed an underlying structure of motion that the naked eye was unable to grasp. With its unprecedented ability to reproduce the world, photography prompted artists to shift their concerns away from the imitation of nature and toward new ideas grounded in subjectivity.

Artists grappled with the problems of finding meaning in this "open" universe beyond religious faith, secure social identities, and belief in a benign nature. Drawn toward the intricate recesses of the mind, some artists explored the

(opposite) AUGUSTUS SAINT GAUDENS, *Memorial to Clover Adams*, 1891. Bronze. Rock Creek Cemetery, Washington, D.C.

complexities of human psychology, charting distances between public and private worlds, and between official and personal versions of truth. Emphasizing individual experience and the open-endedness of meaning, this exploratory impulse ran contrary to the conventional sectors of society that still emphasized history and precedent as a means of shoring up their cultural authority. Exploration and retrenchment mutually defined a culture internally divided. Emerging languages of visual art expressed both the unsettling ambiguities and the ruthless certainties of life at the end of the century.

## Victorian into Modern: Exploring the Boundaries between Mind and World

In 1870 American historian and author Henry Adams, at the time a young diplomat, was summoned to Tuscany where he witnessed the death of his "gay and brilliant" sister "after ten days of fiendish torture" from lockjaw following a cab accident that had bruised her foot. Art, literature, and religion, he wrote nearly forty years later (1907), merely veiled the horror of death; confronted with the reality, "the human mind felt itself stripped naked, vibrating in a void of shapeless energies." The entire edifice of culture, with its progressive pieties and quest for meaning, seemed to Adams, for a time at least, to mask a chaos at the heart of things.

Later, Adams faced another personal loss. In 1885 his beloved wife, with whom he had shared his life's work, committed suicide by drinking developing fluid used in her photography. Childless and prone to depression, Marian Hooper Adams, known as Clover, had turned to photography as a creative outlet in which her considerable talents might not be confined by her gender. The shock of Clover's death was such that, even decades later, Adams excised from his autobiography the twenty years covering their marriage and her suicide, never mentioning his wife. In 1888, he sought out his friend Augustus Saint-Gaudens (1848–1907) to sculpt a memorial to Clover, to express his longings for meaning in the face of loss.

The memorial to Clover Adams in Rock Creek Cemetery, Washington, D.C. (**p. 356**), presides over an intimate space, originally landscaped to obscure it from the common view of passersby. Seated on a rock bench, back upright against a **classical** plinth, is a bronze figure. Right arm raised, its spread fingers barely graze the chin in a gesture of contemplation. The fine-boned face, with its classical features and full lips, is shadowed by the drape that shrouds the head and cascades down in gracefully severe folds, revealing little of the body beneath. The eyes are lowered, or perhaps closed, and seem internally focused rather than turned outward to engage the world beyond the self. This interiority is virtually unknown in the sculpture of the later nineteenth century. Saint-Gaudens's figure models meditation: its downcast eyes shun exchange with others.

Adams had asked Saint-Gaudens to reach beyond traditional sculptural motifs. In response, Saint-Gaudens spurned the allegorical mode that characterized most **neoclassical** sculpture (in which identifiable attributes carry specific meanings—scales for justice, laurel branch for fame) in favor of imagery in which meaning is indeterminate. Each viewer is thus free to arrive at the significance of the work through his or her own experience. Though today the figure appears feminine, its original intention was to transcend sexual division. Clover herself suffered from the limitations imposed upon her by her gender. Adams later wrote to his friend Theodore Roosevelt that Saint-Gaudens had wanted "to exclude sex, and sink it in the idea of humanity. The figure is sexless."[1]

The work's symbolic program thus united the opposing realms of male and female, an impulse that extended to another organizing opposition of Adams's generation: that of East and West. While evoking Michelangelo's monumental sibyls on the Sistine Ceiling, Saint-Gaudens's enigmatic figure goes beyond the classical language of the Renaissance and embraces Asian forms. Adams had visited Japan with his friend John La Farge (1835–1910), their itinerary including some sacred sites of Buddhism. Adams

11.1 JOHN LA FARGE, *The Great Statue of Amida Buddha at Kamakura* (known as the Daibutsu), from the Priest's Garden, c. 1887. Watercolor and gouache on off-white wove paper, 19¼ × 12½ in (49 × 31.8 cm). Metropolitan Museum of Art, New York. Gift of the family of Maria L. Hoyt, 1966.

reported that as Saint-Gaudens puzzled out his memorial, his studio was filled with images of the Buddha and of Kwannon, the all-merciful maternal figure whose love offers refuge from the isolation of the self (**fig. 11.1**).

Bridging male and female, East and West, Saint-Gaudens's memorial to Clover Adams expresses deep yearnings for unity. "Beyond pain, and beyond joy," in Saint-Gaudens's words,[2] the Adams Memorial resists the fixed meanings and absolute truths that had guided artistic

**allegory** in previous generations. Even while looking backward across history, it anticipates the ethical and spiritual explorations of the century that lay ahead.

## The Antimaterialist Impulse: Symbolism and Tonalism

American novelist Henry James (1843–1916) observed that "In the mansion of art there are many rooms." In the final years of the nineteenth century, such pluralism acquired new relevance. In place of settled notions, American art was undergoing a "crisis of faith" in the evidence of the senses, and fundamental shifts in attitudes about the role of imagination in the artistic process.

In the same years when American Impressionists pursued their untroubled sunlit vision, another, very different art emerged that explored the shadowy, twilight experience of nature, resonating with interior moods and states of emotion. These Tonalists and Symbolists used paint to explore a world in retreat from hard fact and empirical measures of meaning. They emphasized internal states in a philosophic retreat from naturalism. They believed in art as a refuge from science, technology, and an increasingly regulated social existence. In the sciences, the compulsion to order, measure, dissect, and catalogue the natural world was leading to the growing conviction that the human mind itself—the instrument of knowing—resisted full understanding. This crisis of faith in the rationality and orderliness of both mind and world turned artists in new directions; many questioned sensory evidence, investigating the extrasensory or spiritual dimensions of experience. In the Symbolist approach, art was the zone of encounter between the material—paint and canvas—and the immaterial—the realm of suggestion, imagination, and escape from the constraints of the body and of nature.

The terms Symbolism and Tonalism describe tendencies shared by a wide range of artists rather than distinct movements. "Tonalism" was used by the art historian Wanda Corn in 1972 to describe the soft focus and muted light and color effects of artists drawing away from the intense heightened palette of **Impressionism**. Tonalists accordingly preferred weather conditions—fog and winter—and times of day—dawn and dusk—when both nature and the city were veiled by atmosphere or muted light. Precise description—associated with an empirical approach to the world—was repudiated in favor of "visionary" states, reverie, and introspective awareness. Avoiding detail, Tonalism aspired to unity of effect. Using a restricted range of hue, Tonalism's subtle tonal harmonies and veils of color offered a refuge from the sensory overload of urban

life. It encouraged aesthetic withdrawal rather than confrontation. In its withdrawal from modern life it was "antimodern"; but in its turn toward subjective experience over objective authority it anticipated **modernism**.

Tonalism traced its inspiration to James Abbott McNeill Whistler, whose influence was assimilated by many American artists in the last two decades of the century, and whose insistence on the imagination's superiority to nature also contributed to the Symbolist movement. Whistler diluted his paints to the consistency of india ink. Washed onto unprimed canvas, they sank into it, creating veils of color that dematerialized the paint surface and encouraged subjective engagement with the image. Tonalism had roots as well in the French mid-century landscapes of the Barbizon—an artistic colony near Paris that anticipated the later-nineteenth-century taste for a domesticated, homely nature of wistful moods and emotional suggestion.

II.2 GEORGE INNESS, *Scene at Durham, an Idyl*, 1882–5. Oil on canvas, 40 × 30 in (101.6 × 76.2 cm). Collection of Frank and Katherine Martucci.

**GEORGE INNESS.** George Inness (1825–94), the leading landscape artist of the 1880s and 1890s (**fig. 11.2**), realized this shift toward a more subjective mode of landscape painting in which the experience of nature was filtered through mood, memory, and association. Inness's loose handling and tonally unified palette blurred the specific details of the landscape. He wrote that "The greatness of art is not in the display of knowledge, or in material accuracy, but in the distinctness with which it conveys the impressions of a personal vital force."[3] Inness's soft, modulated colors and restful imagery appealed to audiences whose nerves were stretched taut by the experience of modern life. In place of discrete particulars was a unity of effect that seemed to still the frenetic succession of impressions in the late-nineteenth-century city. From the late 1870s on, Inness looked toward a more domesticated form of landscape imagery that ran through such European movements as the Barbizon School. Drawn to the low light of sunset and dusk, and the transitory effects of cloud-streaked skies, Inness painted the flat marshy and forested scenery of his New Jersey home. His landscapes show a long-domesticated nature, where the human response is muted and elegiac. Drawing back from overt symbolism, they also allowed more room for private associations. His paintings carry the consolations of a civilized nature—remote from the more charged moments of natural fullness and energy that characterized the mid-century, yet deeply infused with a sense of human presence and spiritual reverence.

**WILLARD METCALF.** Tonalism comes together with Symbolist themes of private experience in a painting by Willard Metcalf (1858–1925), *May Night* (**fig. 11.3**). The diaphanous figure of a woman appears mesmerized by the ghostly apparition of an imposing classical façade, whose luminous white columns radiate an unearthly light. While the intensity of dark shadows cast by the trees on the lawn suggests a full moon, and therefore offers a commonsense explanation for the scene, the painting suggests mystery and implies a narrative. The woman is drawn trancelike toward the seated figure of a man beneath the columned porch, her movements dictated by some inner mind-driven compulsion. Moonlight here serves as visual metaphor for the transforming powers of imagination upon the hard facts of the real. In the Symbolist mode, the world outside the self is mysteriously aligned with the world of imagination. Symbolism—the last gasp of nineteenth-century romanticism—was a prelude to those aspects of modernism that emphasized the mind's way of knowing, over and against naturalistic vision. Symbolist works

11.3 WILLARD METCALF, *May Night*, 1906. Oil on canvas, 39½ × 36⅛ in (100.3 × 92 cm). Corcoran Gallery of Art, Washington, D.C.

11.4 ALBERT PINKHAM RYDER, *Toilers of the Sea*, 1883–4. Oil on wood panel, 11½ × 12 in (29.2 × 30.4 cm). Metropolitan Museum of Art, New York.

retreated altogether from the world of objects into a "temple of the mind," to borrow the title of a work by Albert Pinkham Ryder.

**ALBERT PINKHAM RYDER.** The mystic, unworldly art of Ryder (1847–1917) proved especially resonant for later artists searching for a visionary tradition to anchor their own turn from modernity. Ryder was famous in his own lifetime for his eccentric and reclusive habits, haunting Manhattan in the small hours of the morning, hanging on for years to paintings he had promised to patrons as he obsessively repainted them. By all counts, Ryder's best works were little masterpieces of jewel-like color perfectly coupled with melancholy themes of loss and spiritual yearning. His work was the very antithesis of the daytime world of business and money; he drew his subjects from the operatic legends of Siegfried and the Rhinemaidens in Wagner's *Ring* Cycle (Wagner was widely performed in New York at the end of the century), from the Bible, and from his own mind.

*Toilers of the Sea* (**fig. 11.4**) combines the marine subjects Ryder loved with the theme of the voyaging self, alone in a universe filled with spirit. Ryder struggled to coax the materiality of paint into an expression of the transcendental,

using whatever he had at hand—including shoe blacking—to achieve the luminous and enchanted effects he saw with such intensity in his imagination. Today his paintings, encrusted with darkened and cracked pigment, have lost their luminosity—ghosts of their former selves. With their bold forms and open-ended narratives, however, they appealed to modernists from Marsden Hartley to Jackson Pollock.

## Trompe l'Oeil: "The Real Thing"?

Skepticism about all philosophical systems offering closed truths was part of a broader mood of questioning and doubt that seeped its way into many areas of cultural life in the United States at the end of the century. Among the more fanciful expressions of this skepticism was the vogue for **trompe l'oeil** (in French, "fool the eye") paintings. Despite their intense visual **realism**, these paintings engage by deceptiveness.

The tradition of *trompe l'oeil* goes back practically to the origin of art, in playful forms of heightened illusionism that tricked the viewer into confusing the two-dimensional image with the three-dimensional reality. *Trompe l'oeil* painting often works by simulating a doorway, cupboard,

# American Art and the New Perceptual Psychology

THE PRIVATE WORLDS of imagination, memory, and subjective experience presented a compelling alternative to older forms of public and institutional authority. Bolstering this shift toward the subjective basis of artmaking was a new awareness of the role of the body in producing vision. Experimental artists on both sides of the Atlantic began to emphasize the medium of perception—the eye—over the thing perceived. The shifting and unstable conditions of light and other contingent factors themselves became the subject of art. In contrast to primary attributes which exist in the object—hardness, shape, volume—color and light are secondary perceptual attributes that exist as a result of the human sensory apparatus of vision itself. What shaped visual (and other forms of) experience, in short, was the perceiving subject.

A number of cultural influences paralleled—and perhaps contributed to—this aesthetic "paradigm shift." Among these was the "new psychology" pioneered by the American philosopher William James (1842–1910). In work published in the 1890s, James redefined the nature of human thought in a manner that blurred the boundaries between the perceiving subject and the object of perception, between mind and world. James understood perception to be a product of environment—mental and physical—rather than a matter of grasping an unchanging reality. Both world and mind were in a constant state of flux, in endless interaction with one another.

James's new psychology articulated ideas already being explored in the visual arts in the final decades of the century. In the early 1860s, several decades in advance of other artists, John La Farge painted a series of floral landscapes in which the flowers themselves are seen

less as discrete objects than as elements in a visual field defined by subtly modulated color (*Flowers on a Window Ledge*, **fig. 11.5**). Here, the measured spaces of earlier American painters give way to a blurred field of vision, in which foreground and background blend into one another optically. There are no firm contours anywhere in the image; as with Impressionism, which he in some ways anticipated, La Farge eliminated black chiaroscuro in favor of opalescent colored shadows. The entire image shimmers as if to capture the subtle quality of vision energized by light. The contemporary scholar Henry Adams has argued that James's new perceptual psychology was itself influenced by his youthful encounter with the art of his friend La Farge.

11.5 JOHN LA FARGE, *Flowers on a Window Ledge*, c. 1867. Oil on canvas, 24 × 20 in (61 × 50.8 cm). Corcoran Gallery of Art, Washington, D.C. Anna E. Clark Fund.

or wall surface, as in Charles Willson Peale's *Staircase Group* (see fig. 5.32). Heightening awareness of the fictitious nature of painting, it also prompts delight in the devices by which the illusion of life is achieved.

**JOHN HABERLE.** John Haberle's (1856–1933) *Changes of Time* (1888) (**fig. 11.6**) is a wondrous feat of illusionism, in which a range of currency bills appears to be pinned to a wood cabinet door, complete with a key that dangles from a keyhole, teasing the viewer to "unlock" the mysteries that lie hidden beneath the surface of appearances. (Three nails, however, secure the door from our prying natures.) Yet the painting betrays its own promises at every turn, like the currency whose value, though boldly asserted, is notoriously unreliable. (The printing on the freshly minted bill at the center of the painting reads "This certifies that there have been deposited in the Treasury of the United States FIVE SILVER DOLLARS.") Bearing the images of various presidents, from Washington to Grant to Lincoln, Haberle's frayed and yellowed currency implies that the

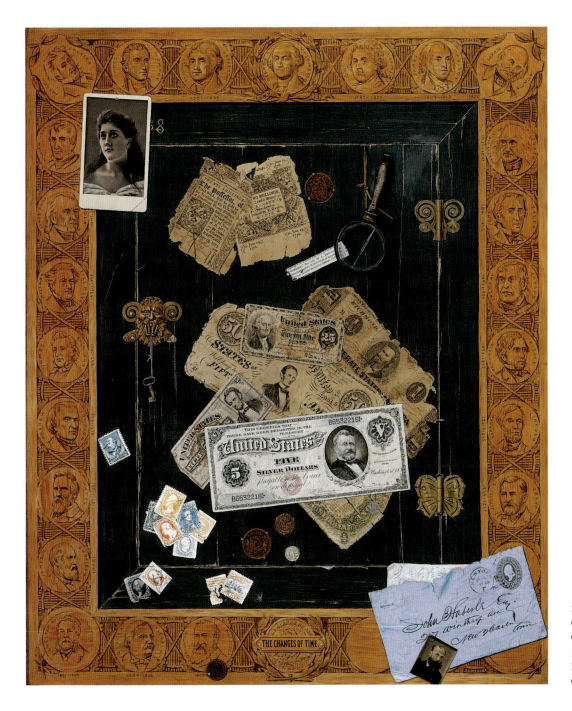

11.6 JOHN HABERLE, *Changes of Time*, 1888. Oil on canvas, 23 ¾ × 15 ¾ in (60.3 × 40 cm). Manoogian Collection, New York.

nation's public figures—like the values they represent—are susceptible to the ravages of time; their images toy with the idea of graven idols, bearing feet of clay. A snapshot of a Victorian beauty is pinned to the edge of the cupboard, a suggestion of lost love and transitory hopes. A magnifying glass is nailed amidst the scraps of old money, tantalizingly set upon a legible piece of newspaper clipping whose snatches of phrase—"J. Haberle ... remarkable piece of imitation of nature ... and a most deceptive *trompe l'oil*"— refer the viewer back to the artifice of the painting itself— Haberle puns here as well on oil (as in painting) and *oeil* (the French word for "eye"), implicating oil painting in the deceptions of vision. As if to "nail" the point down, Haberle's magnifying glass is cracked. We the viewers see the crack, rather than the surface behind the transparent glass. Haberle comments here on the collapse of **painterly** illusionism—the window-into-space model of painting since the Renaissance. His *trompe l'oeil*—the art of illusion— reveals the essential nature of painting itself, as a lie or fiction of truth. Yet barred from any further access to something beyond, the viewer is left with this fiction as the only available truth. The quest for ultimate or absolute meanings here is playfully subverted.

Paper currency formed one of the recurring elements of *trompe l'oeil* painting. A flat object on a flat surface, currency challenged illusionism. As a medium of wealth and exchange, its value fluctuated. As national currency, paper money also blurred the boundaries of public and private: although engraved with presidents and other symbols of the nation, money was an object that excited personal ambition. By referring value back to the self, the desire for money called into question shared public values. By revealing the deceptions of art, *trompe l'oeil* paintings also subverted the idea that art had a special hold on truth. Like paper money, these paintings suggested that art has value only when people believe it does. And once that confidence is gone, art—like money—is no more valuable than "the paper it's printed on." *Trompe l'oeil* playfully taught its viewers to distrust appearances, a valuable lesson for city dwellers surrounded by swindlers who presented themselves as something other than what they were. Much popular entertainment, from Phineas T. Barnum on, turned on the thrill of discovering the mechanics of deception, of having revealed to one's eyes the tricks by which one was fooled. Audiences were genuinely delighted by the success of the illusion. Finally, many *trompe l'oeil* painters trumped claims about the truthfulness of photography by painting photographs into their work and deceiving the viewer into thinking they were "real." In doubtful times, notions of the real appeared increasingly fictitious.

## Late Homer, Early Modernism

The great challenge facing American artists at the turn of the century was, as art historian Bruce Robertson has phrased it, "how to assimilate modern European art without losing their own voice." Winslow Homer (1836–1910) was perceived in his lifetime as an American "authentic," a native painter who turned his back not only on the fashions of European painting, but on the distractions of modern urban life in favor of the "essential" American experience. By mid-life Homer was already a myth; his private life blurred indistinguishably with his paintings. In 1883 he retired to Prout's Neck, Maine, where, according to legend, he "scared off visitors with a gun" and spent his isolated hours painting the mystical power of the ocean and the shore in collision.[4]

In fact, Prout's Neck was an active tourist resort during the summer, and Homer spent most of his time with his family, who lived nearby. He was also a frequent visitor to Boston and New York. But the ruggedness of his paintings in his late phase—the solitary lives of the fishermen and women he portrayed, the elemental power of the Maine coast—worked to convince his audience (and perhaps Homer himself) that his subject was nothing less than the American soul itself.

To contemporary eyes, this vision of Homer as an isolated genius seems naïve. What we recognize today is how profoundly Homer assimilated a range of influences. Homer responded to Japanese prints with the same passion that had once characterized his response to photography. *Japonisme* helped Homer liberate his art from its own narrative tendencies and allowed him instead to concentrate ever more intently on surfaces, pattern, and decoration.

***RIGHT AND LEFT.*** For Homer, as for so many other turn-of-the-century artists, "flatness was the stylistic mechanism that released his art from the obligation to descriptiveness and illusionism and equipped it to register feeling and assert meaning."[5] For Homer, that meaning concerned the ability of the imagination to match nature's power. One year before his death, Homer painted *Right and Left* (**fig. 11.7**), an image of two ducks hovering above a green sea. Their splayed symmetry, derived from Japanese prints, exemplifies the simplification of form, planar composition, flattening of space, and arrested motion that characterize Homer's later work. Such formal concerns hold our attention until we notice the diminutive forms of two hunters in a boat beneath the wing and leg of the ascending duck. The serenity of the painting—its quality as a modern **still-life**—is shattered by the pessimism that suddenly emerges. The ducks do not hover abstractly before the viewer.

11.7  WINSLOW HOMER, *Right and Left*, 1909. Oil on canvas, 28¼ × 48 in (71.7 × 121.9 cm). National Gallery of Art, Washington, D.C.

They have been shot in flight; the bird to the right has already begun its plunge to the ocean. *Right and Left* sets the formal beauty of the birds against the sudden violent cessation of life.

That contrast is the key to the painting. Homer establishes a dialectic between beauty and death that hinges on the question of point-of-view. We observe the plight of the birds from a disembodied stance. We are in the air, with the ducks, empathetically witnessing their terrible beauty precisely because we do not share the hunter's perspective. We might read *Right and Left* as a meditation on Homer's own relation to the world. His withdrawal from the New York art scene allowed him a perspective and distance that cast the world in a new light. Homer imagines the beauty of the ducks only after ascending metaphorically to their height, viewing them outside time and nature.

But, as Homer suggests in *Right and Left*, there is a price for such perspective. To see the world's symmetries, the viewer must first give up his place in the world (on the boat). Art is born from worldly withdrawal. The powerful formal beauty of *Right and Left*—among Homer's most aesthetically satisfying works—is hard-won, achieved through renunciation, the act of giving up the world for the permanence of form.

Homer was an extraordinary social critic who viewed society with a clear head and a sense of compassion that his contemporaries often lacked. Nevertheless—influenced in the final decades of the century by the Aesthetic Movement of writers and painters who espoused the cause of art for art's sake—Homer shared with them a sense of the canvas as a world of its own, defined by its flatness, its decorative possibilities, and its painterly nature. The act of painting, rooted in the condition of nature and of the cycles of life and death, ultimately finds meaning through the power of the artist to endow nature with a formal order, despite the profound limits mortality imposes on artistic ambition. While sharing much with the outlook of this generation, Homer's belief in the power of the artist, informed by the resources of culture and history, represented yet another inquiry into the nature of pictorial truth—as ultimately removed from nature—that was such a defining feature of these decades.

# Feminine/Masculine: Gender and Late-Nineteenth-Century Arts

The 1890s was a time of rigid gender definition. Saint-Gaudens's refusal to make the shrouded figure in his Memorial to Clover Adams (see p. 356) identifiably male or female was a rarity. Since the early nineteenth century, the ideology of separate but complementary spheres for men and women had been an organizing principle of American social and cultural life. As industry displaced artisanal production, and work moved out of the home, the distinction between public (male) and private (female) worlds widened over the course of the century. According to this ideology, men's talents lay in the public realm of business and politics, industry and technology; men were the agents of social progress, of artistic, scientific, and intellectual advance. Women, by contrast, were destined by their natures for the private realm of home and family (see fig. 6.1); they were the element that stabilized society through their selfless devotion to aesthetic and spiritual ideals, cultivation of beauty and emotion, and moral elevation—in short, "the higher life." The ideology of separate spheres, complementary and unequal, while elevating women as the "angels" of the household, and as morally refining "procreative" influences, also denied them the power of original creation. Women's role was to *reproduce* the cultural order. Throughout the repeated shocks of modernization, clearly defined gender roles offered reassurance that the basic arrangements of social life were stable.

Yet the cultural organization of gender difference was increasingly out of step with women's demands for greater self-determination. Middle-class women began to enter the public sphere through the social reform movements of the antebellum era—such as suffrage and abolition. Intensified female participation in the civic sphere during the Civil War demonstrated the power that alliances of women could exert on the moral and social fabric of the nation decades before the Nineteenth Amendment (1920), which gave the vote to women. After the war, growing numbers of women wanted an active part in the cultural, social, and professional worlds of the nation, flocking to universities and newly opened colleges for women, such as Vassar (est. 1865) and Bryn Mawr (est. 1885), as well as art academies and professional schools.

However, female assertiveness provoked a multilayered reaction directed at containing women's claims for public recognition on the same terms as men. While women by the 1890s had gained some recognition of their rights to education, and to professional and creative lives outside their roles as wives and mothers, they faced a range of obstacles beyond institutional barriers.

In late-nineteenth-century society, the nonproductive realms of consumption, aesthetics, and refined perception were considered feminine. Despite a growing presence in the public sphere, women were still symbolically linked to the domestic realm and to private life, and were thought to have a kind of interiority, or subjective life, suited to the appreciation of art. But this did not mean women were to be accepted *as artists*; on the contrary, the attributes of an original artist—a pronounced individuality, a "bold" or daring execution, and focused mental power—were thought to belong uniquely to men. According to this thinking, the qualities that made women good consumers, mothers, and wives—susceptibility and intuition—made them unsuited to creative endeavors—to anything but minor, imitative art. To paint like a man was damning praise, implying that a woman had desexed herself. Narrowly defined by their reproductive function and by their biological rhythms, women who aspired to be taken seriously as artists were accused of betraying their own natures. And their natures denied them artistic genius, which was exclusively associated with male individuality.

Women's attempts at creativity automatically gave rise to assessments that subtly demeaned their efforts while reinforcing men's status as the producers of culture. This gendering of aesthetic worth, as scholar Sarah Burns has pointed out, linked artistic skill to expertise, dispassionate scientific vision, and analytic force. In these decades, style carried deeply gendered meanings for both female and male artists. Men as much as women were defined by these aesthetic discourses, even as they produced them. A more bureaucratic and technologically driven work world compromised men's sense of autonomy in the workplace and control over their professional lives, producing new forms of gender anxiety. Themes of athleticism, intellectuality, and confrontation with nature in the artworks of Thomas Eakins and Winslow Homer reflect these masculine preoccupations. Such works bear witness both to the defining role of gender in late-nineteenth-century culture, and to the efforts of art to give dimensionality and breadth to gendered selfhood.

## Women Artists and Professionalization

From the late eighteenth century on, artistic women had been consigned to amateur status by their lack of academic training, and their links with such "minor" media as watercolor. Women were also valued as copyists of the Old

Masters; lacking in creative ego—so this thinking went—they transmitted the spirit of the male artist in all its unsullied purity. Women's marginalization within the art world resulted in part from lack of access to the institutions of training and the time to devote themselves to art. Nevertheless, between 1870 and 1890 the number of professional women artists increased from 414 to 11,000, according to the U.S. Census. Academic training now allowed them to master the technical requirements for making art; European study and travel put the great inheritance of past art within reach; force of numbers created supportive communities of women artists as alternatives to the social networks, clubs, and student/teacher bonding that helped male artists along the path of success. Women students in Paris submitted works to the French **Salon** in growing numbers, testing themselves in the most challenging arenas of male artistic professionalism.

**A WOMAN ARTIST'S SELF-PORTRAIT.** One such aspiring artist in Paris was Ellen Day Hale (1855–1940), who submitted a self-portrait entitled *Lady with a Fan (Self-Portrait)* (**fig. 11.8**) to the Paris Salon in 1885. Turned sideways in her chair, she confronts the viewer directly, a slight challenge

suggested by her upturned chin. While she holds a black feather fan—an emblem of coquetry—she has painted herself with the look and attitude of a young boy, although she was thirty-five at the time. Refusing to veil her individuality or artistic ambition, Hale uses her self-portrait to demonstrate her familiarity with the latest and most sophisticated languages of art. Her confident self-presentation is set against an aesthetic organization of abstract colors and shapes. In the very act of painting a self-portrait, she lays claim to her right to be an artist.

Hale's self-portrait reveals a sense of energy and professional self-regard in which the woman appears as an actor in the art world rather than as a passive consumer, decoratively posed in the studio of a male artist, as in figure 10.4 by William Merritt Chase. Her androgynous self-presentation resists the gender typing that confined women within prescribed boundaries, even as it subtly reconfirms the association between the feminine and the decorative.

11.8 ELLEN DAY HALE, *Lady with a Fan (Self-Portrait)*, 1885. Oil on canvas, 28½ × 38¾ in (72.3 × 98.4 cm). Museum of Fine Arts, Boston, Massachusetts.

## Men Painting Women; Women Painting Themselves

At the same time that women were exerting their presence as active creators of art, they entered American art in another manner: as the object of aesthetic interest among male painters. Indeed women, as scholar Griselda Pollock points out, were *"the* continual subject of much of what we consider modern painting."[6] The growing difference between male and female spheres of action led, in turn, to increasing differences in the ways that men and women were represented. Women had appeared frequently in antebellum art; with rare exceptions, however, they were depicted as marginal figures in a social landscape of mixed company, often spanning generations and including servants. While a crucial element in the domestic economy of antebellum America, women in **genre** painting nonetheless remain onlookers in a world that belonged largely to men.

11.9 WILLIAM PAXTON, *Tea Leaves*, 1909. Oil on canvas, 36⅛ × 28¾ in (91.5 × 73 cm). Metropolitan Museum of Art, New York. Gift of George A. Hearn, 1910.

In the post-war years, however, the figure of the middle-class woman, often minding children, gave way to a new subject: the elegantly dressed woman of leisure, usually alone, and situated in a beautifully arranged interior where she does nothing in particular. Why the sudden prevalence of this highly staged and artificial subject?

As American society became increasingly defined along class lines, clear demarcations of social status acquired greater importance. This new subject matter served to assert the superiority of the upper classes, who considered themselves to be the custodians of beauty and refinement, while simultaneously idealizing restrictive roles for women. Leisure and self-cultivation were luxuries afforded only by the privileged; the upper-class home was to serve as a showcase of luxury and refined taste.

**GETTING TOGETHER FOR TEA.** In William Paxton's *Tea Leaves* (**fig. 11.9**), two well-dressed women have tea in an elegant interior. A Chinese table, Japanese screen, embroidered shawls, blue Delftware, and Colonial silver suggest the accoutrements of an upper-class Boston milieu with its taste for antiques and its aestheticism. One woman leans back in her chair to contemplate the contents of her tea cup, with the suggestion that they hold the answer to life's most difficult problems. Yet her desultory attitude suggests too much time on her hands; she appears slightly bored. Much painting of the so-called "Boston School," flourishing from the 1870s until well into the twentieth century, drew inspiration from the Dutch interiors of Jan Vermeer, where women pause in a charged atmosphere of radiant quiet. Ignoring the social issues of the day, such as ethnic immigration, labor militancy, and the movement for women's rights, the paintings of the Boston School escape instead into a world of exquisite confinement. Stylistically conservative, the Boston School painters situated the privileges of culture and wealth at a safe remove from social realities. The male who enables such privileges is absent. Instead, feminine leisure, aesthetic taste, and careful orchestration of décor symbolize the prestige of the unseen male head of household who makes it all possible.

**THE LIFE OF LEISURE.** Musical themes, in which women in aesthetic dress strum long-necked antique instruments or pluck keys on a harpsichord, suggest both the rarefied environments of wealth and leisure and the interweaving tonal harmonies of color and sound. In Thomas Wilmer Dewing's (1851–1938) *Brocart de Venise* (Venetian Brocade) (**fig. 11.10**), the woman closest to the viewer seems transported to another world by the music of a harpsichord, an eighteenth-century instrument whose rarity was symbolically

11.10 THOMAS WILMER DEWING, *Brocart de Venise (Venetian Brocade)*, 1904–05. Oil on panel, 19⅜ × 25½ in (49.2 × 64.7 cm). Mildred Lane Kemper Art Museum, Washington University in St. Louis, Missouri. University Purchase, Bixby Fund, 1906.

linked to the attenuated beauty of the woman herself. In these works, women appear not as social subjects but as aesthetic objects in an artistic composition, paradoxically protected from the public sphere yet on view as symbols of refinement and culture. This strict separation of public and private, cultural refinement and social realities, was termed the Genteel Tradition by philosopher George Santayana in 1911.

**THE FEMALE EXPERIENCE.** Women artists confirmed, but also expanded, and occasionally subverted received ideas about their proper sphere. Mary Cassatt's family wealth afforded her the privilege of setting up a household in Paris where she could enjoy great personal independence (her parents and sister soon joined her). At the same time, Cassatt (1844–1926) was unable to paint the café-concerts, the bars, the brothels, races, and the backstage theatrical scenes that distinguished the work of Manet and Degas—such places were off-limits to a respectable single woman. Instead, Cassatt chose to paint the public, and, later, the domestic, lives of women—as mothers, sisters, and members of privileged social networks with which she had intimate familiarity. In a series of works set in public spaces, Cassatt painted young upper-class women shyly presenting themselves to the gaze of the public as they emerge into consciousness of their femininity. These works transmute the familiar theme of the female on display for the male gaze by portraying the female experience instead; rather than mere objects of desire and aesthetic control, Cassatt's women seem fully alive, responsive, and psychologically complex. And in one instance, *In The Loge* (**fig. 11.11**), the woman is the one who looks, training her opera glasses on the stage. Dressed in the black proper for older bourgeois (or prosperous upper-middle-class) women in public, she is intent on observing the world around her. In the background, from the other side of the *loge*, an older man in evening dress directs his opera glass at the woman in a knowing commentary on the frequency of the theme of men looking at women. Here, however, the woman assumes an active stance, leaning forward with confidence as she claims the privilege of looking openly, a curious, fully present subject rather than an object of another's gaze.

Although Cassatt actively supported the emerging feminist movement that transformed opportunities for women in the twentieth century, she did not wish to be considered first and foremost as a "woman artist." Cassatt transformed the restrictions on the lives of bourgeois women into the enabling conditions of her art. She developed her own formal language—admired by her Impressionist contemporaries—out of the spaces of urban bourgeois

11.11 MARY CASSATT, *In The Loge*, 1877–8. Oil on canvas, 31⅞ × 26 in (81 × 66 cm). Museum of Fine Arts, Boston, Massachusetts.

femininity: the theater, the domestic parlor, the public garden, and the nursery. She used these settings to forward her aims and gave to her female subjects a sense of interior life that drew them beyond the realm of spectacle and fashion to which conventional art so often consigned them. She made women the subject rather than the object of art.

**THE ARTIFICE OF FEMININE BEHAVIOR.** Cassatt's much-admired Philadelphia contemporary, Cecilia Beaux (1855–1942), also transformed the subject of women from objects of enigma, beauty, and mystery to female subjects with intelligence and assertiveness. Beaux's *Dorothea and Francesca* (**fig. 11.12**) combines portrait and genre elements

in an understated image of the two young daughters of close friends. Beaux's painting begins and ends with a specific moment in which femininity is *performed*. Their heads bowed and hands clasped, the two girls are intensely absorbed in the act of learning. The smaller girl points her foot tentatively forward, as if feeling the ground, while her older, more confident sister instructs her through example. Everything, from the angle of their heads to the subtle cues of posture, suggests the artifice of feminine behavior. Yet here we also sense that, in the intense concentration and inward focus of the two girls, there remains—within these learned roles—room for personal growth and self-expression.

Beaux's painting reflects on her own life. Remaining single, she achieved an international reputation, exhibiting in Paris, New York, and Philadelphia, and was hailed toward the end of her life by First Lady Eleanor Roosevelt as "the American woman who had made the greatest contribution to the culture of the world."[7] She learned and practiced the codes of feminine behavior well enough to defuse the threat of a style that male critics identified as "masculine" in its assurance and vigor. Unlike Cassatt, Beaux was opposed to women's suffrage, and convinced that most women were happiest in domestic roles. She compared her own creative urge to the maternal act of birthing. Yet like

11.12 CECILIA BEAUX, *Dorothea and Francesca*, 1898. Oil on canvas, 80⅛ × 46 in (203.5 × 116.8 cm). Art Institute of Chicago, Illinois. A.A. Munger Collection, 1921.

Cassatt, she refused identification as a "woman" artist, even as she honored conventional notions of femininity in her personal life. Freedom to live in a wider world, Beaux's career suggests, was earned, for this generation, through the successful performance of femininity.

## Thomas Eakins: Restoring the (Male) Self

Gender is a social rather than a biological category. It is a way of thinking about the effects of culture on the body. No American painter of the late nineteenth century pursued issues of gender more relentlessly than Thomas Eakins (1844–1916). As a young man, Eakins had combined drawing classes at the Pennsylvania Academy of Fine Arts with anatomy instruction at the local medical school. While a student in Paris, he had boycotted the classes of his teacher Jean-Léon Gérôme on days when the class drew from antique casts. Later, as a teacher, Eakins insisted instead on drawing from live figures, producing animated charcoal sketches on those occasions when a model posed for the class.

**MECHANIZATION SETS THE TERMS.** Eakins viewed the male body through the lens of industrial production, as an efficiently calibrated machine. When painting women, on the other hand, he highlighted their inner worlds of thought, consciousness, and feeling. In Eakins's early works, men are often portrayed in the midst of athletic activities outdoors. Women appear almost exclusively in interior settings. The two worlds meet only when Eakins brings his men indoors, portraying them as professionals surrounded by the tools of their trade.

Eakins's treatment of men coincides with what literary critic Mark Seltzer has termed the "machine culture" of the late nineteenth century. Over time, human labor would come to be measured by the standards of productivity and efficiency that were associated with machines. While some of Eakins's contemporaries would celebrate the body-as-machine, Eakins came to feel entrapped by it. In the early 1870s, Eakins painted images of scullers boating on Philadelphia's Schuylkill River. Sculling was regarded as a "scientific" sport. One of many leisure activities that developed as a form of middle-class relaxation—an antidote to the rigors of industrialization—sculling nonetheless required machine-like technique, self-discipline, and mental concentration. For men in particular, athletic events like sculling offered an opportunity to reassert their control over their environment, after toiling all week within what was often a depersonalized work space. The bright skies, crystalline air, and stilled spaces of Eakins's *The Champion*

11.13 **THOMAS EAKINS**, *The Champion Single Sculls (Max Schmitt in a Single Scull)*, 1871. Oil on canvas, 31 ¼ × 46 ¼ in (81.9 × 117.4 cm). Metropolitan Museum of Art, New York.

*Single Sculls*, 1871 (formerly known as *Max Schmitt in a Single Scull*) (**fig. 11.13**), evokes a world of calmness and repose. But the scene also contains an undercurrent of anxiety, as if, in the words of Henry David Thoreau, men have become the "tools of their tools."

The painting contrasts the leisure activities of its two scullers, gliding across the Schuylkill River on a crisp October day, with the signs of industrial work, signaled by the smallish puffs of white smoke in the background. The figure in the foreground, Max Schmitt, turns to look at the viewer as his scull drifts into the left foreground. In the background is Thomas Eakins, who has signed his name across the hull of his boat. Behind the scullers we see Philadelphia's

Railroad Connection Bridge and the Girard Avenue Bridge, over which a train enters on the right. Together these signify the forces of industrial production. They contrast not only with the natural world of clouds and sky, but with the more human world of the painting's two scullers, whose success depends on discipline and bodily strength rather than steam and technology. Eakins's scullers are thoroughgoing professionals, men who dominate their worlds through intellectual and bodily exertion. By inserting himself into the picture, Eakins identifies his activities with those of Schmitt. As art historian Martin Berger has argued, Eakins links his skills as a painter with Schmitt's prowess as an athlete. In the process, Eakins converts painting from a socially marginalized—and potentially feminized—occupation into a masculine and professional endeavor.

Yet *The Champion Single Sculls* converts leisurely activity into another form of industrial discipline. Though the

scullers take command of their watery world, they do so only by *internalizing* the efficiency, concentration, and mental control that govern their behavior in the work world. We see this tension between work and leisure in the striking way that Eakins portrays both Schmitt and himself, each figure rising perpendicularly against the lateral sweep of the Schuylkill River. That uprightness stands as a sign of their mastery over their environment. It is the most human element in the painting. And yet each figure is also enclosed by a visual parallelogram formed by the two oars and their reflection in the water. This compositional diamond claps the scullers in a grid that arrests their motion and diminishes each man when measured against the Schuylkill's broad expanse. Are the men masters of their environment or trapped within it? Are they in control of the body-machine, or extensions of it? Although *The Champion Single Sculls* offers no clear answer to these questions, it tells us, by its juxtaposition of scullers with trains and steamboats, that we cannot understand the former except in the language provided by the latter. The world of steam, iron, and mechanization, though confined to the background, nonetheless sets the terms for the figures in the foreground.

**LIFE OF THE MIND, LIFE OF THE BODY.** If Eakins's men inhabit a realm that is hard, disciplined, and machine-like, then Eakins's women dwell in a domain of thought, feeling, and self-reflexiveness: a rich inner life unfazed by technology. The split between the two reflects a larger division in Eakins's life between mind and body, grounded in the conditions of labor in the late nineteenth century. *Portrait of Mrs. Edith Mahon* (**fig. 11.14**) appears to brood on feelings or memories that the viewer can only imagine. The mood of the painting is somber. The brown background, dark dress, and black ribbon extend spatially the sad and intense emotions that define Mahon's face. Her eyes are moist, and her chin and cheeks are ruddy. Her mouth slants downward in a slight frown, sealed as tightly as the emotions she seems to hold in. Eakins has aged Mahon, who was an accomplished pianist in Philadelphia. He often portrayed his women sitters as older than they were, burdening them with an awareness of time and loss. Mahon later confided to a friend that she was unhappy with the portrait but accepted it as a favor to Eakins, whose paintings were often uncommissioned. Eakins wrote on the back of the canvas: "To My Friend Edith Mahon/ Thomas Eakins 1904."

Art historian David Lubin has suggested that Eakins's portrait offers a pointed contrast to the tradition of male figures shown in public positions. The painting highlights

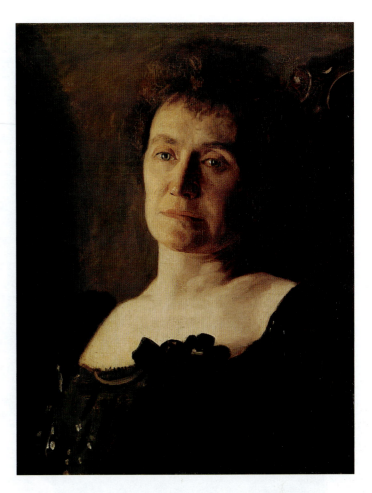

11.14  THOMAS EAKINS, *Portrait of Mrs. Edith Mahon*, 1904. Oil on canvas, 20 ⅝ × 16 ⁵⁄₁₆ in (52.3 × 41.4 cm). Smith College Museum of Art, Northhampton, Massachusetts.

emotion rather than civic action, and captures feelings that are fleeting and fragile rather than the timeless and classical expressions associated with men's public roles. *Edith Mahon* also anticipates early cinema's experiments with close-up shots as a way of visualizing a character's inner states. The portrait embodies precisely what is missing from the world of Eakins's athlete heroes.

In 1875, Eakins turned a canvas of rowing studies over on its back and started sketching a portrait of Dr. Samuel Gross, a well-known Philadelphia surgeon. *The Clinic of Doctor Samuel Gross* (*The Gross Clinic*) (1875) portrays Gross in a surgical amphitheater operating on a patient for osteomyelitis, in which the femur bone becomes infected, and for which the treatment had been amputation of the limb (**fig. 11.15**). Gross stands to the left of the operating table. He is assisted by five physicians, one of whom sits behind Gross and is visible only by his hands. To Gross's side, at the canvas's bottom left, the patient's mother turns her head away from the procedure. She shields her eyes

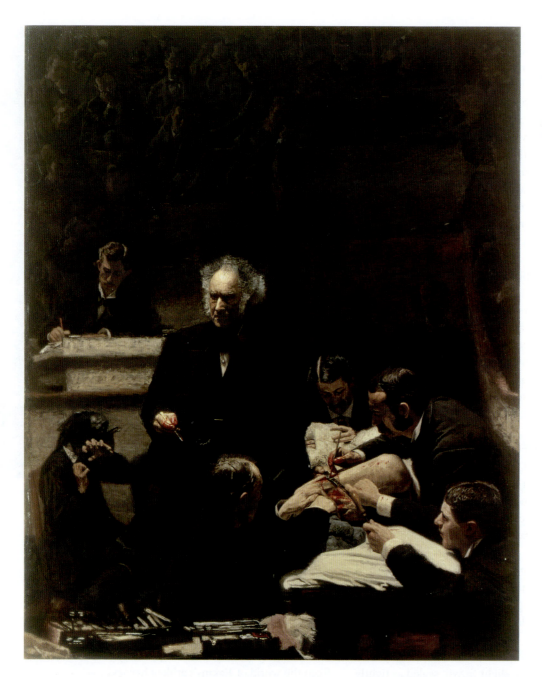

11.15 THOMAS EAKINS,
*The Clinic of Dr. Samuel Gross
(The Gross Clinic),* 1875.
Oil on canvas, 96 × 78½ in
(243.8 × 199.4 cm). Jefferson
Medical College, Thomas
Jefferson University,
Philadelphia, Pennsylvania.

with her fisted left hand. Seated next to the amphitheater entrance at the far right of the canvas, barely visible in the shadows, Eakins includes himself, observing the operation with a pencil and pad.

The painting was originally designed to hang in the art exhibition section of the 1876 Philadelphia Centennial Exposition. But the Centennial art jury found *The Gross Clinic* too distasteful. The prominent exposure of the patient's thigh and buttock, together with the bright red blood covering Gross's fingers and scalpel, left the jury feeling that *The Gross Clinic* was unfit for a mixed audience of men and women. Its realism seemed all too real. For Victorian viewers, the painting lacked elevating moral content. *The Gross Clinic* was displayed instead in the medical section of the Centennial Exposition, the first in a series of controversial decisions that would dog Eakins's life. One decade later, Eakins would be expelled from his teaching position at the Pennsylvania Academy of Fine Arts for removing the loincloth from a male model in a drawing class attended by both men and women.

Eakins's commitment to realism was more than a question of style or aesthetics. Realism represented a commitment to scientific investigation and to a worldview grounded in natural laws. It stood opposed to sentimentalism or any

other approach that valued emotion and feelings above dispassionate rational inquiry. When Eakins insisted that his students at the Pennsylvania Academy study anatomy from cadavers, he did so because he believed that every painter needed to understand the human body as precisely as possible. Artists, for Eakins, were professionals, and like all professionals, they needed to view the world with full knowledge and intellectual objectivity.

Realism was also tied to questions of gender. We see this in the relation of the distraught mother in *The Gross Clinic* to the surgeons—all male—engaged in the operation. By making the mother the bearer of emotion in the painting, Eakins contrasts her smallish figure with the upright and commanding presence of Dr. Gross. Her hysteria contrasts with his rationality. Her presence also alludes to the professionalization of medicine after the Civil War, when physicians and surgeons began to form their own associations. They established professional codes of behavior to distinguish their activities from those of the female world of amateur healers. As with architects, doctors now possessed the power to accredit new members, prescribe standards of conduct, and oversee the education of those entering the profession (the role occupied by Dr. Gross as he instructs an amphitheater full of medical students).

The blood on Gross's hand and scalpel signals Eakins's refusal to allow his art to be compromised by Victorian notions of propriety. Eakins just as deliberately affronted the sensibilities of his nineteenth-century viewers by portraying the buttocks and anus of the patient. Scholar Michael Fried has interpreted the blood-red scalpel as an allusion to the artist's brush and palette knife, the dripping vermilion of the blood echoing the pigment on the painter's brush. Eakins, in effect, transforms Gross into an artist-figure, a stand-in for Eakins himself. In so doing, he links painting to surgery as he had earlier linked painting and sculling. In each case, the common bond is the display of discipline and mastery that distinguishes scullers, surgeons, and painters as modern professionals.

Dr. Gross's bloodied hand also calls attention to the essential unity of intellectual and manual labor. Eakins highlights Gross's forehead with an intense white that counterpoints the red of the scalpel. Gross is defined visually by the relation of these two compositional foci: head and hand. Like John Singleton Copley's *Portrait of Paul Revere* a century earlier (see fig. 4.32), Eakins's portrayal of Dr. Gross emphasizes the intellectual mastery that guides the surgeon's—or silversmith's—hand. The figure of the professional embodies a unity of mind and body that predates the modern division of labor. In *The Gross Clinic*

Eakins counters the effects of modernization not by retreating from them, but by transforming the newly modern professional into a figure who restores precisely what has been lost with the advent of corporate society. *The Gross Clinic* uses modernity against itself by rendering the professional an heroic figure.

### PORTRAIT OF FRANK HAMILTON CUSHING: CROSSING CULTURES.

By the late nineteenth century, the battle between Native and white for control of the frontier was largely over. With the surrender of Geronimo to the U. S. Army in 1886 and the Wounded Knee Massacre (1890), the Plains Indian Wars came to an end. European Americans had reshaped the West in their own image. The terms of encounter now included a new figure: the anthropologist. Anthropology developed in the nineteenth century as a profession devoted to the study of so-called "primitive" societies, those occupying the lowest rung on the ladder leading from savagery to civilization. But with proper tutelage, they could rise to a higher state. Anthropology in these years employed an absolute (Western) standard of measure by which non-Western cultures were judged and found wanting.

In 1895, Thomas Eakins painted a portrait of an anthropologist who worked against the grain of his profession (**fig. 11.16**). Frank Hamilton Cushing, employed by the Smithsonian Institution, was the first person to use the word "culture" in the plural: "cultures." Cushing refused to believe that Western society represented the highest form of evolution, employing instead a relative measure of value. For Cushing, non-Western traditions, rituals, customs, languages, and complex forms of social organization, though different from those of the West, were not inferior. To the contrary, Cushing found that Native societies of the Southwest, in particular the Zuni, provided forms of spiritual and cultural wholeness lacking in European and American life.

Cushing earned both fame and derision for his decision to become a member of the Zuni. Originally sent in 1879 by the Smithsonian Institution on a two-month fact-finding and collecting tour, Cushing decided to become a full-fledged member of the tribe instead. He stayed for four and a half years, mastering Zuni language and customs, joining the Bow Priesthood, and rising to the position of First Chief Warrior. He was finally recalled to Washington after participating in a Zuni raid on a Navajo encampment, arguing for Zuni ownership of a disputed land claim, and signing his official correspondence with the Smithsonian "1st War Chief of Zuni, U.S. Asst. Ethnologist." Cushing had become a man of two worlds.

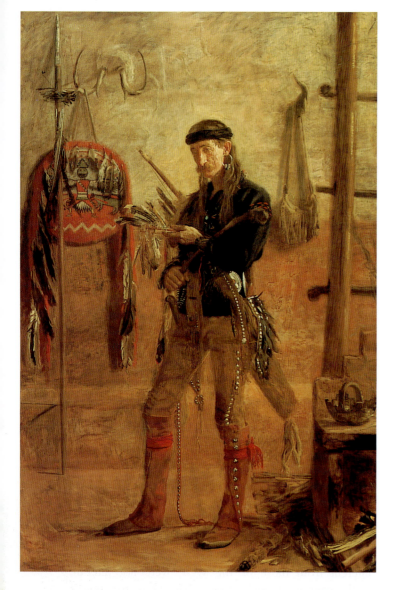

11.16 **THOMAS EAKINS**, *Portrait of Frank Hamilton Cushing*, 1895. Oil on canvas, 90 × 60 in (228.6 × 152.4 cm). Gilcrease Museum, Tulsa, Oklahoma.

In order to paint Cushing's portrait, Eakins first converted a corner of his studio into a space resembling a Zuni kiva. The full-length portrait frames Cushing between a ladder on the right (for entering the kiva) and a large spear with dangling feathers on the left. In the lower right of the portrait, a small altar holds a Zuni bowl. A fire burns below it. According to a student of Eakins, the fire was lit in the studio in order to reproduce the smoky atmosphere of an actual kiva. A war shield with an image of the Zuni war god hangs from the wall on the left, below a pair of antlers.

Cushing posed for the portrait in the costume that he routinely wore while at Zuni. It is anything but authentic. Rather than dress in the white cotton blouse and baggy trousers that members of the Bow Priesthood wore during sacred ceremonies, Cushing invented his own, highly picturesque version of Indian dress. He wears a dark blue shirt embroidered in bright colors at the shoulders. His buckskin belt threads through large silver circles hammered from silver dollars. The buckskin trousers feature a line of silver buttons running down the side. Two red sashes on the leggings complement the red scarves around his neck. Cushing wraps a dark blue sash around his head and wears silver and turquoise earrings.

Cushing's lean and ravaged face contrasts with his clothing and paraphernalia. He holds a Zuni war club in his right hand and a prayer plume in his left. The strap dangling behind his right leg was used to whip mules and horses. Yet the face suggests a man of introspection. The heavy lines and pockmarks age Cushing far beyond his thirty-eight years. His portrait, painted exactly two decades after *The Gross Clinic*, taps into Eakins's lifelong desire to capture on canvas the professional world of scientists, scholars, and teachers whom he admired. But whereas Gross and others painted by Eakins embraced modern life, Cushing took the opposite tack. He attempted to enter a different, premodern world, maintaining an identity grounded in two worlds simultaneously.

Eakins's portrait presents a man who imagined himself as the "soul of an Indian of olden times." At the same time, Eakins frames Cushing with objects larger than he is (the ladder and spear), and contrasts the full roundness of the war shield in the background with the sharp angles and emaciated face of someone whose thoughts seem to be reaching back to a world that survives only through its relics.

The portrait is a meditation on the Western relation to the cultural other. Cushing's act of cross-dressing is more than "playing Indian." By recreating his kiva world in Eakins's studio, Cushing attempts to reclaim a former identity; his costume is an effort at rejuvenation that his downcast gaze suggests can never really happen. What Eakins's portrait captures is Cushing's *need* to feel Indian. At the same time as the West dominated Native peoples economically and militarily, it also turned to those it conquered for spiritual solace and renewal. Eakins's painting captures both the power of that nostalgia and the profundity of introspective loss when faced with its futility.

Eakins's portrait of Cushing contrasts strongly with the self-portrait of Kiowa artist Wohaw, "Wohaw Between Two Worlds," painted at almost the same time as Cushing's residence among the Zuni (see fig. 9.37). Cushing voluntarily reached out to Zuni culture for a sense of wholeness and masculinity that he found lacking in Western society.

Wohaw, on the other hand, came to understand Western culture through his experience as a prisoner of the United States. What both men share is the awareness that their lives have changed through contact with another culture: Wohaw can look calmly toward Western culture because he is grounded in Kiowa customs. Cushing's world is a personal creation, surviving only in his mind and his artifacts. There is no make-believe for Wohaw. There is instead the reality of conquest, and the need to navigate two worlds in order to survive.

# Reasserting Cultural Authority

Augustus Saint-Gaudens' Adams Memorial commemorated a deeply private loss (see p. 356). But Saint-Gaudens also made numerous public monuments that would be widely emulated in memorial sculpture in the next generation. Among his most visible is that to William Tecumseh Sherman (**fig. 11.17**), the general who turned the tide of the Civil War in a destructive southern campaign most remembered for the burning of Atlanta. Though originally intended by Saint-Gaudens for a site within Central Park, the monument is now situated across from the Plaza Hotel at the corner of Central Park South and Fifth Avenue where, regilded, it has become a familiar landmark. Saint-Gaudens combined a powerful naturalism—in the figure of Sherman himself, with his weathered face and billowing cape—with the Renaissance language of allegory, as he had in his memorial to Robert Gould Shaw (see fig. 9.6). Leading the general on horseback is a winged angel of victory, wearing a Greek *peplos* that flutters out behind her. She wears a laurel wreath signifying fame and clutches a palm branch of peace. The massive stone Renaissance plinth of the memorial, designed once again by his friend the architect Stanford White, provides a fitting support for the figural group, which combines lifelike animation with a sense of Renaissance *terribilità*, the avenging moral and physical force of the conqueror. The equestrian monument advances south, in the same direction as traffic on Fifth Avenue, a triumphal allusion to resolute leadership. The Sherman Monument carries viewers well beyond New York: recalling the grand equestrian portraits of Europe, it summons the nation to honor valor. General Sherman offered an example of the ruthless courage required of the empire that America was becoming, in the decade that saw the bloody Spanish American War (1898) culminating in the transfer of the Philippines from Spain to the United States, the forced annexation of the autonomous islands of Hawai'i (1893–1900), and the internal conquest and confinement of Plains Indian cultures. In keeping with such imperial ambitions, the Sherman memorial exemplifies a reassertion in the 1890s of older forms of cultural authority.

Together Saint-Gaudens and Stanford White epitomize the "American Renaissance" (a phrase first used in 1880), a bold and confident movement spanning the arts of sculpture, painting, architecture, and decorative arts that was grounded in the authoritative use of monumental forms drawn from the past.

Financed by public funds and the huge industrial fortunes made during the post-war period, the great public edifices of this period—libraries, men's clubs, government buildings, railroad stations, museums, opera houses, monuments, and exposition halls—turned to classical art and architecture. Classical allegory and architectural forms were heralded as a shared cultural language safely above the fluctuating sphere of the personal and the subjective. Artists of the American Renaissance saw themselves as carriers of tradition, drawing upon the finest models of the past to open a new era of cultural polish for a young nation long derided as provincial and crassly materialistic. In addition, the American Renaissance signaled a shift away

11.17 AUGUSTUS SAINT GAUDENS, *Memorial to William Tecumseh Sherman*, Grand Army Plaza, New York, 1903. Gilded bronze.

from predominantly rural, agrarian, and individualistic values to the urban and cosmopolitan identity that characterized much of post-war American culture. "Now," wrote the art critic William Brownell in 1881, "we are beginning to paint as other people paint."[8] What distinguished the American Renaissance was the authoritative role held by the classical tradition. Those who spoke on its behalf denounced the qualities that Symbolist artists in these same years embraced—personal expressiveness and the cultivation of a private vision—in favor of historical precedent. Classical forms carried the message of cultural hierarchy and control (both architectural and social), and the magnificence of the classical tradition lent weight and authority to the numerous new public institutions that were taking form.

## The Universal Language of Art

A leading exponent of the American Renaissance was Kenyon Cox (1856–1919), a painter, muralist, and outspoken defender of artistic precedent as a guide to the present. *The Classic Point of View* (1911) was his declaration of the enduring significance of craftsmanship and technique, the reliance on artistic models, and the continuity between past and present. Turning away from the struggle to define a peculiar American identity in the arts, Cox embraced the nation's European heritage. Unlike the next generation of modernists, against whom he loudly declaimed, the academicians believed that cultural authority rested in history: the classical language "asks of a work, not that it shall be novel or effective, but that it shall be fine and noble. It seeks not merely to express individuality or emotion.... It strives

for the essential rather than the accidental, the eternal rather than the momentary—loves impersonality more than personality."[9] The academic viewpoint submerged the personality and idiosyncrasy of the artist in public symbols. Accordingly, academic public art couched its appeal to universal values in allegorical figures, invested with symbolic meaning—Truth, Justice, Art, History, and so forth—as in Elihu Vedder's *Rome* or *The Art Idea* (1894), painted for Bowdoin College in Maine (**fig. 11.18**).

Claims to universality, however, made sense only among those who assumed that the classical tradition was the measure against which all other cultural achievements were to be judged. In fact, as a visual language, allegory was remote from everyday experience, referring to a Greek and Roman heritage far removed from the working people and immigrants who were the intended audience for its message of cultural uplift and timeless truth.

## Monumental Architecture in the Age of American Empire

From Boston to New York to Cleveland and San Francisco, the ideals of the American Renaissance are still visible in a legacy of monumental civic architecture and urban design. The leading architectural firm associated with the American Renaissance was the New York-based McKim, Mead, and White. The firm completed over 300 commissions in New York between 1879 and 1910. Pennsylvania Station (**fig. 11.19**) served as an imposing gateway into New York City for travelers arriving by train. Combining the grand stone-**vaulted** spaces of imperial Rome (**fig. 11.20**) with the modern construction methods of **cast iron** in the train

11.19 MCKIM, MEAD, AND WHITE, Pennsylvania Station, 1902–10.
New-York Historical Society, New York.

11.20 MCKIM, MEAD, AND WHITE, Pennsylvania Station, interior,
1902–10. New-York Historical Society, New York.

sheds, Penn Station gave the new era of train travel a grandiose aspect. The General Waiting Room rivaled St. Peter's in scale, and was touted as the largest single room in the world. With its integrated program of waiting rooms, commercial arcades, concourses, and dining areas, Penn Station achieved a new combination of practicality and architectural sophistication. Its destruction in 1963 following a long fight to save it was a tremendous loss to the nation's architectural heritage.

An "American" renaissance implied a comparison with the princely and civic patronage that fostered the Italian "rebirth" of classical culture in the fifteenth and sixteenth centuries. In parallel fashion, the new American civic landscape, with its message of cultural order and historical authority directed at the urban masses, was supported by the fortunes of those fueling industrial expansion: Andrew Carnegie (who endowed libraries), Henry Clay Frick, J. Pierpont Morgan (who bought manuscripts), John D. Rockefeller, the Astor and Whitney families, and Henry Villard. The buildings recalled Renaissance palazzi and other familiar historical forms: hemispheric domes and majestically vaulted spaces, classical façades, painted and sculpted female figures, and **axial** planning of both architectural interiors and of the city as a whole.

In architectural terms, the American Renaissance sought to do away with the chaotic styles of previous decades. As with other Paris-trained architects of the postwar years, the architects of the American Renaissance sought a new visual unity and design discipline, attuned to modern requirements and functions. But unlike Richardson and Sullivan, they practiced an archaeologically precise emulation of the past.

The American Renaissance gave a cultural and artistic shape to America's emerging imperial identity—its rise to a new military, industrial, and commercial dominance in both the Atlantic and Pacific arenas. Stanford White's (1853–1906) triumphal *Arch of the Rising Sun from the Court of the Universe* (**fig. 11.21**), done for the Panama-Pacific International Exposition in 1915, employs the form of the triumphal arch associated with the Roman Empire. Such arches appeared frequently in these imperial decades: commemorating America's past wars, celebrating its imperial present, and celebrating military victories such as that of Admiral Dewey over Spain. White's arch includes a double **colonnade** inspired by Bernini's design for the piazza in front of St. Peter's in Rome. In place of the *quadriga* of the

11.21 **STANDFORD WHITE** (architect), **JULES GUERIN** (renderer), *Arch of the Rising Sun from the Court of the Universe*, Panama-Pacific Exposition, San Francisco, 1915. Watercolor on paper, 40 × 38 in (101.6 × 96.5 cm). San Francisco Public Library, California.

victor (a charioteer driving four horses) that traditionally adorns the top of triumphal arches, White has, somewhat whimsically, placed an oriental retinue, complete with bejeweled Indian elephant. Here, White's arch announces the hopes of extending America's trade empire to Asia, at the edge of the Pacific Rim in San Francisco, the culmination of the westward course of empire, the fabled "passage to India" that realized the dream of unity between East and West. In the 1890s and early 1900s that dream carried both democratic possibilities and imperial ambitions. America, heir of the ages, was a new Rome, borrowing older forms to project an image of a rising empire.

The American Renaissance was full of impulses that seem contradictory to us today: objectifying women through the repeated use of the female nude as allegory, the movement also supported artistic training for women; taking a stand against artistic individualism, it nonetheless fostered a range of impressively creative talents; exercising elite control over culture, it also contributed to the establishment of numerous new art institutions—from the Society of American Artists to the American Academy in Rome—that would collectively revitalize American art training. Despite its hierarchical and elitist orientation, the American Renaissance promoted public monuments such

as the Statue of Liberty and later the Lincoln Memorial that have come to symbolize the dream of an inclusive, yet ethnically and socially diverse democracy.

**THE LIBRARY OF CONGRESS.** The Library of Congress exemplifies the American Renaissance's impulse toward incorporation and unity. The Reading Room expresses this quest for centralized control of knowledge. Circular in form, it is loosely based—like Jefferson's Library at the University of Virginia (see fig. 5.16)—on the Roman Pantheon, symbol of the known world. The Library of Congress aspired to be a democratic version of the great libraries of the Old World, such as the ancient library at Alexandria, or the vast imperial and papal collections that contained Europe's cultural heritage. A hemicycle **mural** on the ceiling allegorized the four continents; the cultures of East and West—Asia, Europe, and the New World; and the Greco-Roman and Christian cultural inheritances from the past (**fig. 11.22**). The accumulated knowledge of the ages is the subject matter of **mosaics**, murals, sculpture, and stained glass throughout the Library. Assisting in the management of this world of knowledge was the Dewey decimal system, invented by an American librarian (Melvil Dewey) in 1876—a new method for classifying, cataloguing, and archiving knowledge. Such cataloguing systems were just one aspect of the managerial efficiency that increasingly characterized the administration of learning, scientific expertise, and governmental control in these years. But while centralizing knowledge, the Library of Congress also democratized it by allowing the public access to the vast archive of history and information it contained, in a manner that anticipated the internet today.

11.22 JOHN SMITHMEYER & PAUL PELZ Reading Room, Library of Congress, Washington, D.C., 1897.

**THE COLUMBIAN EXPOSITION IN CHICAGO, 1893.** The fullest realization of the American Renaissance quest for unity and centralized control was the Chicago World's Fair, or Columbian Exposition, of 1893. Ironically, this vision of cultural stability and permanence was itself a mirage, a plaster and lathe concoction of historical forms, supported by an iron armature. The centerpiece was the Court of Honor (**fig. 11.23**), a dazzling stage set evoking the grand empires of the Old World. Dubbed "the White City," it rose in a few short months along the shores of Lake Michigan. Daniel Burnham (1846–1912), based in Chicago, led a team of designers—"the greatest meeting of artists since the fifteenth century!" as Augustus Saint-Gaudens proclaimed.[10] They established a uniform **cornice line** and imposed a strict axial arrangement of space throughout the central zone. At the center of the Court of Honor was a huge reflecting pool presided over by Daniel Chester French's (1850–1931) monumental allegory of the Republic. Rigidly frontal, its archaic form projected the discipline and strength befitting a muscular young empire, while recalling the ancient Greek origins of the American nation-state. This monumental tribute to the classical world differed vastly from the modest virtues of the Greek Revival in the early part of the century.

Around the court were arranged the exhibition buildings: Machinery, Electricity, Mines and Mining, Liberal Arts, and Agriculture, the nodes of America's emerging industrial infrastructure. The figure of Christopher Columbus

presided over the fair; his role in "discovering" the New World gained symbolic importance in the context of the "world-making" discoveries in science and industry displayed there.

With its lagoon, classical buildings, and public statuary, the Court of Honor bore more than a passing resemblance to the central canvas of Thomas Cole's *The Course of Empire* (see fig. 8.19). Yet the architects of the fair—unlike Cole half a century earlier—now embraced the analogy with imperial Rome rather than taking it as a stern warning. This shift in identity from republic to empire was in keeping with the imperial ambitions of the times. Revealing the distance between image and reality, however, was the real city of Chicago, just beyond the boundaries of the fair, reeking of industry and stockyards, its commercial landscape blackened by urban grime, its architecture a chaos of different styles.

As the historian Henry Adams—a visitor at the fair—wrote years later, the Chicago Exposition "was the first expression of American thought as a unity." This "unity," however, was not merely formal and architectural, but ideological. It organized the history and cultures of the world around a single measure that ranked social and cultural development according to race. The ideology of the fair misapplied the theory of evolution to a descending scale of "civilization," with the white European at the top, followed by the cultures of Asia, Africa, and the New World Indian.

One of many posters celebrating the fair as both education and entertainment (**fig. 11.24**) exposes its object lessons as well as its contradictions. At the top of the image is Richard Morris Hunt's Administration Building, at the head of the Court of Honor, its beam of light illuminating a parade of nations. This parade ends in a troupe of African Bushmen located furthest from the white Administration Building (but closest to us) and equipped with spears and shields. The poster presents the world's cultures as both objectified and available for the entertainment of fairgoers. While reaffirming the "object lesson" of imperial order, the visual economy of the fair was propelled by the market-based relations between Americans and the world in which all things appear as consumable commodities.

Virtually every exhibit in the fair projected the lesson of cultural superiority and imperial condescension. **Ethnological** exhibits equated the non-Western societies on the peripheries of empire with the "primitive" origins of the human race as well as with the developmental phase of childhood. Barring the participation of African Americans as anything other than measures of cultural inferiority, the fair gave a scientific gloss to segregationist

11.23 DANIEL BURNHAM et al, Court of Honor, World's Columbian Exposition, Chicago, Illinois, 1891–3. Chicago Historical Society, Illinois.

swallowers, and belly dancers appeared alongside naked Bushmen and Southwest Pueblo Indians in mock authentic settings. In the Midway, the pleasures of the body took over; visitors could relax while maintaining a safe distance from the "lower orders" of humanity. The thrilling sensations of the Ferris Wheel, which was making its first appearance, and the gyrations of the infamous belly dancer "Little Egypt," who made strong men go weak at the knees, offered an escape from bourgeois constraints. The formal discipline of the Court of Honor gave way to serpentine footpaths and uncensored experience. Visitors gawked and roamed freely in search of new sensations, participating in a new consumer culture of pleasure and impulse. The Midway anticipated the popular entertainments that took center stage in the twentieth century and undermined from within the racial and cultural hierarchies that were still so crucial to the thinking of American elites at the end of the nineteenth.

11.24 Programme, "World's Columbian Exposition Programme", 1893. Colored lithograph, 48 × 28 in (121.9 × 71.1 cm). National Museum of American History, Smithsonian Institution, Washington, D.C.

ideology. The dream of cultural perfection—of light, order, and global harmony—was grounded in a hierarchy embodied in the layout of the fair itself, moving from the glistening white and rigidly formal Court of Honor to the more park-like "Wooded Isle," containing the Women's Building and the Japanese exhibits—both proximate to the white European male. Beyond these "wooded isles" was the Midway Plaisance (**fig. 11.25**), a "living museum of humanity," opening with German and Irish villages and "descending" to Asian, North American Indian, and African.[11] In a carnival zone, bearded ladies, sword-

11.25 Midway Plaisance (*A Carnival in the Street of Cairo*), Columbian Exposition, c. 1894, from J.W. Buel, *The Magic City* (St Louis, Missouri: Historical Publishing Company, 1894).

# Photography and Modernity

Over the course of the nineteenth century, photography established a new standard of objective visual truth grounded in the possibility of a direct, unmediated transcription of the real world. Uniquely capable of documenting nature and events with optical accuracy, photography was one of the factors that pushed the arts toward establishing a different basis of artistic truth—one that need not compete with photography's ability to represent the world. Meanwhile, photography introduced its own kind of visual modernity: the modernity of the documentary archive—a compendium of images used to organize new empirical data from the natural and social worlds. The archive served contrary functions: both organizing knowledge and abstracting from human variety for the purposes of social regulation and control. As an instrument of scientific surveys of the West, photography had proved to be a useful tool for promoting colonization and industrial development. But it was also used to document the urban poor, the insane, and the criminal, as well as the ethnic variety of the non-European world, in the process objectifying these people by implicitly denying their human dignity and singularity. Photography was not only a new visual technology, but it was also put at the disposal of an emerging bureaucracy as a new way by which "lower" sectors of society might be classified, analyzed, and managed as information.

Photography enabled a new form of seeing, of freezing motion, of making the invisible visible and the unknown known. New split-second exposure times made it possible to capture the moment, and photographic studies of animals in motion by Eadweard Muybridge anticipated the motion picture. Photography also democratized the act of image-making through the new portable and inexpensive Kodak camera, giving ordinary consumers a convenient tool for recording private life and shaping personal identity. The rise of snapshot photography put the camera in the hands of millions of Americans, fostering personal whimsy and a "backstage," less formal view of culture. On the verge of the twentieth century, photography stood at the intersection of scientific and social documentation on the one hand, and the dream factories of mass media on the other.

## Jacob Riis: "Capturing" the Slum

Beginning in the late nineteenth century, the camera was enlisted in the enterprise of documenting, typing, and locating those who did not already fit the prescribed image of middle-class Anglo-Americans. This middle-class image was itself in part a creation of photography; photographic portraits of middle-class Americans conformed to conventions that dictated pose, attitude, and dress. Through *cartes de visite*—small, wallet-size posed photographs used as calling cards—middle-class men and women presented themselves to a public of social equals and intimates. For those falling below the middle class—the immigrant poor, the urban underclass of criminals and paupers—other rules applied. Unable to control the terms of their photographic representation, the poor became instead objects of the camera.

Arriving from Denmark in 1870, Jacob Riis (1849–1914) struggled his way out of poverty to become a police reporter and eventually a crusading reformer for slum clearance and housing reform in lower Manhattan. Riis's photographic expeditions into the slums there resembled police raids; bursting into unlit rooms, he would light a magnesium flare whose explosion furnished the illumination required to photograph in the dark. His subjects were often startled and disheveled in appearance, deprived of any opportunity to compose themselves, and thus of their dignity (**fig. 11.26**). His preference for night-time and for subterranean haunts reveals a debt to an older genre—known as *Lights and Shadows*—of sensationalistic urban reportage geared toward middle-class audiences. Published engravings and lurid accounts of life in the "city beneath the city" fed fears of the potential for violence lurking in its heart, and produced periodic calls to improve slum conditions.

11.26 JACOB RIIS, *Five Cents a Spot*, from *How the Other Half Lives*, c. 1888. Gelatin silver print. Private Collection.

**HOW THE OTHER HALF LIVES.** Riis never thought of himself as a photographer; the camera was merely a convenient instrument for recording the conditions he hoped to reform: trash-filled alleys where children lived stunted lives; coal cellars containing human beings; sweatshops and dens where sleepers were packed floor-to-ceiling. A record of human misery at the heart of Manhattan, Riis's *How the Other Half Lives: Studies Among the Tenements of New York* (1890) remains disturbing even today. Its title confirmed the social divide separating his subjects from his audience. The book was among the first to use the half-tone process, which allowed photographs to be reproduced with text, and comprised one of the first published uses of photography in the service of social reform. Previously,

photographs had been translated into line engravings; the half-tone process eliminated this human interpreter, adding "truth value" to Riis's book—an indisputable witness to the "real." Yet while Riis's photographs stand at the beginning of the documentary tradition, they are also infused with longstanding assumptions about poverty that conditioned what, how, when, and where he photographed. *Bandit's Roost, 59½ Mulberry Street* (**fig. 11.27**) is among his most memorable photographs, revealing—in its choice of subject, framing, and point of view—a range of attitudes about his subject. As with many of Riis's photographs, the perspective is constricted, in pointed contrast to the genre of urban panoramas that celebrated the expansive space (and opportunity) represented by

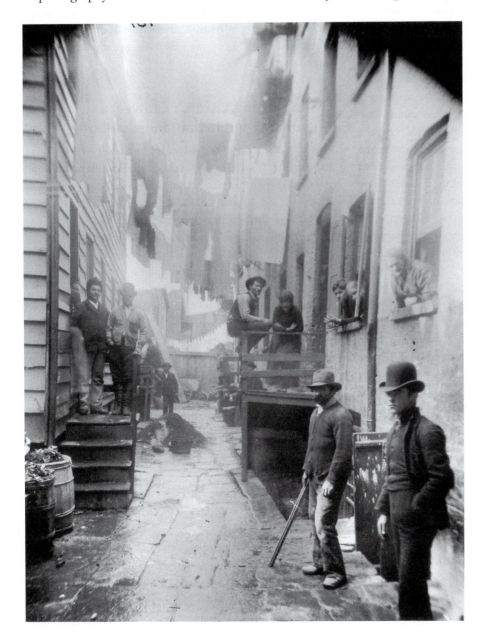

11.27 JACOB RIIS, *Bandit's Roost, 59½ Mulberry Street*, c. 1888. Gelatin silver print, 19⁹⁄₁₆ × 15½ in (48.6 × 39.4 cm). Museum of the City of New York.

America's burgeoning cities. Its narrow crooked alley and feeling of entrapment contrast strikingly with the broad imposing spread of the Court of Honor, the model for civic centers and slum clearance for decades to come.

Two roughly dressed young men stare threateningly toward the camera; others lean out of windows, ignoring the boundaries between public and private worlds that structured middle-class life. The mix of men and women also raised suspicions about the immoral behavior associated with the slum environment. Barrels of trash and heaps of refuse punctuate our journey through the slums, a counterpart to the human detritus that is Riis's subject. Some of his photographs reveal the struggles of the poor to retain some shred of dignity, drawing a connection across ethnic and social lines. More commonly, however, Riis emphasized the gulf separating viewer from subject; his photographs transformed the slum into a spectacle, joining the lantern slide exhibitions, wood engravings, and moralizing accounts that shaped public perceptions.

*Bandit's Roost* leads the eye to a fence running along the horizon line, and revealing only further ramshackle housing. For American audiences, who associated the open horizon with mobility and possibility, nothing expressed the sense of the slum as a physical, moral, and social dead end more powerfully than this. The photographer—Riis himself—occupies an authoritative point of view, inside the scene yet apart from it. This position encouraged viewers to identify with Riis, drawing a safe boundary between themselves and the ethnic and social others who occupy the scene.

Riis's considerable professional ambitions as a self-made immigrant were tied to an attitude toward the poor that made them actors in someone else's play. Yet his career also demonstrates the ability of photography to expose areas of social life that had remained hidden. Although objectifying the poor, such exposure opened immigrant neighborhoods to improved living conditions, education, and early forms of social welfare, while submitting them to middle-class norms of behavior and measures of value.

## The People Take the Pictures: Democratizing Photography with the Kodak

While photography might be a means of enforcing social norms, it also served other, more personal uses. The advent of the **dry-plate process** in 1879 freed the photographer to prepare the plate in advance and develop it any time after exposure. The appearance of the small, portable Kodak camera in 1888 further put photography within the reach of ordinary Americans. No more heavy box cameras,

no more challenging preparation of wet plates requiring precise exposure and volatile and toxic chemicals. Now all that was required was to point the camera at the desired subject and press the shutter. "You press the button, we do the rest," as an early Kodak advertisement put it. Such ease of use, along with faster film speeds that could capture spontaneous action, helped realize a democratic revolution in image-making. Amateur photography grew exponentially; anyone who could afford a camera could now create images that recorded personal histories and desires. Amateurs produced offbeat, sometimes humorous responses to public life, at times knowingly ironic in their "behind the scenes" glimpses of official events, such as World's Fairs. Lacking artistic intention, blurry and spontaneous in appearance, and randomly composed, snapshots possess their own aesthetic, reminding us of the unscripted passages of everyday life, in contrast to more staged presentations.

## "Modernizing Vision": Eadweard Muybridge and Instantaneous Photography

Between 1872 and 1878, Eadweard Muybridge (1830–1904), an English photographer based in San Francisco and already known for his mammoth landscape views of Yosemite, did a series of photographs that transformed the view of the world as seen by the naked eye. Under the patronage of Leland Stanford—railroad magnate, industrialist, and founder of Stanford University—Muybridge devised a method for photographing a horse in motion using a series of cameras spaced at 21-inch intervals and attached to wires that were tripped as the horse galloped down the racecourse (**fig. 11.28**). Coupled with electrically powered shutter speeds of up to 1/1000th of a second, Muybridge's stop-action photographs revealed a new reality that broke time and motion into discrete, measurable, and visible units. Later, in the mid-1880s, Muybridge worked at the University of Pennsylvania with painter Thomas Eakins, producing over 20,000 studies of men jumping, boxing, wrestling, fencing, and batting, and of women dancing and making beds, as well as numerous animal species, from birds to lions, trotting, galloping, and flying. Winnowed down to 781 plates, each with multiple exposures, these were published as *Animal Locomotion* in 1887.

Unlike the optical effects explored by Impressionists in these decades, stop-action photography employed the objectivity of the camera rather than the subjectivity of the human eye. Which form of knowledge carried greater authority: the scientific or the artistic? The mechanical or the mental? Writing in 1881, one critic pronounced that

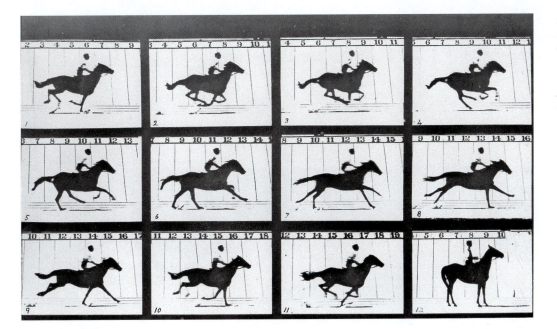

11.28 EADWARD MUYBRIDGE, "Sallie Gardner" running at a 1:40 gait, June 1878, from *The Horse in Motion*. Albumen print, 4 × 8⅛ in (10.3 × 20.7 cm). Kingston-upon-Thames Museum, England.

"[T]he artist must fail when he attempts to depict what *is*, instead of what *seems to be*."[12] Instantaneous photography contributed to a growing skepticism about the evidence of the senses and this served to redirect artistic investigations of the world toward the expressive and the conceptual.

Muybridge's stop-action photographs contributed in one further way to the foundations of twentieth-century visual culture by furnishing a basis for motion picture technology. As early as 1879, Muybridge's "zoopraxiscope" sequenced glass slides around a 12-inch spinning disc, illuminated by light from a magic lantern. The resulting flickering projection created a primitive form of movie predating the experiments of Thomas Edison. Running a closely timed sequence of still photographs through a projector, at approximately twenty-four frames per second, created the illusion of real-life action and motion. Through a principle known as the "persistence of vision," the retinal after-image filled the gap between frames, resulting in an illusion of seamless continuity. Such photographic effects became the basis for film: the most perfect illusion of life, a stream of never-ending sensation and experience that cinema, more than any medium before it, was now capable of grasping.

# Conclusion

While World's Fairs expressed imperialist certainties about cultural and racial superiority, in the next century these certainties would be profoundly displaced. Their unsettling was already evident in artistic tendencies during the last years of the nineteenth century. Older histories of American modernism have told a story of a dramatic break between the nineteenth and the twentieth centuries; however, well before 1900, artists, writers, and philosophers explored new theories of perception and of mental experience that furnished the groundwork for a culture of modernity. Internal tensions evident in the 1890s would surface more directly in the following decades. Contrary to the racial hierarchies of America's "age of empire," a new longing to identify with non-Western cultures and ways of being was emerging, as is evident for instance in Saint-Gaudens's memorial to Clover Adams. Modern industrial production was providing new mechanical means, such as the camera, that could remarkably increase the power and autonomy of the individual. Historian Jackson Lears has identified a range of tendencies that signal the unsettled nature of the 1890s, from the search for spiritual awakening and transcendence to a fascination with extreme forms of physical and emotional experience, all of which would converge to form twentieth-century modernity. Bridging the nineteenth and twentieth centuries was the belief that art could heal the fractured modern personality, progressively more adrift in a world without moral certainty. The growing autonomy of private experience in the late nineteenth century pointed toward modernism's faith that the embrace of art would make life whole.

# PART 4

# The New Century, 1900–1960

CHARLES DEMUTH'S *I Saw the Figure 5 in Gold* heralds the arrival of a new urban vernacular of storefront advertising, graphic design, and neon billboards that increasingly characterized the visual environment of the twentieth century. While abstracting elements from the city night, this pulsating visual collage acknowledges the dynamism of modern commerce while asserting the power of the modernist artist to combine the random events of city living into a meaningful aesthetic unity.

*I Saw the Figure 5 in Gold* represents one among many negotiations between "high" and "low" culture in the first four decades of the new century. The genteel establishment of the later nineteenth century had put into place a strict segregation of elite and popular culture, along with other boundaries between culture and nature, male and female, and mind and body. The opening of the 20th twentieth century brought with it a new urban modernity, overturning older social and gender roles, and directing artistic expression at everyday energies and toward a new mobility of perception evident in the fractured field of vision that Demuth evoked with such elegance. These years also saw the emergence of the first American avant garde—artists who critically engaged the very category of art itself, as well as the art world institutions that supported it. Such playful questioning was sparked by the presence of French exiles from World War I, who turned a humorously ironic eye on the conservative modernism that had taken shape in New York City between 1900 and 1920. In short, the geography of culture in the first half of the twentieth century became increasingly complex, as audiences, taste, and institutions fractured along new faultlines.

Measured by sheer volume, the visual culture of these years expanded exponentially with the growth of film, advertising, photojournalism, and commercial photography. These mass media, however, had contradictory effects. They colonized the imagination with manufactured images of wealth, glamour, and prestige remote from everyday lives; but they also brought poverty, social injustice, and international events to public awareness. By challenging traditional representational languages and cultural hierarchies, mass media transformed the nation.

In an archaeological cross-section, the visual detritus of these years would give us evidence of the period's complexity. It would trace different worlds, from the streamlined gadgets of modern conveniences in millions of middle-class homes, to the handmade fetish-like forms of modernist direct carvers in wood and stone; from the formalized photographs of the skyscraper city, with its severe geometries, to the evocative abstract depths of nature lovingly wrought by modernist painters. Such a cross-section would yield as well the ruins of factories whose form follows function, alongside of houses built in styles nostalgically recreating the past; it would yield historical romances such as *Gone with the Wind*, alongside of searingly realistic films about urban life such as King Vidor's *The Crowd*.

The pace of historical crisis, in these four decades, would test and stretch new aesthetic languages to their breaking point. Two great wars wrought vast changes in basic assumptions about progress and human nature but sent a revitalizing stream of émigrés to America; in between these two wars, a global economic depression accompanied by the rise of fascism in Europe and Asia gave to the arts an unprecedented sense of political and social urgency that propelled ever closer ties to life and history.

(opposite) CHARLES DEMUTH, *I Saw the Figure Five in Gold* (detail), 1928. Oil on composition board, 36 × 29¼ in (91.4 × 75.5 cm). Metropolitan Museum of Art, New York. (See also fig. 14.23)

# 12 | The Arts Confront the New Century: Renewal and Continuity,

## 1900–1920

In 1905, when Henry James returned to New York City after twenty-five years in Europe, he confronted a city that no longer seemed to have any relation to the town of his youth. While the strange languages and new faces of the city's immigrant hordes both fascinated and appalled him, James was even more amazed by the transformation of the city's scale. New York had become a "pin-cushion" of skyscrapers, a city of "bigness and bravery and insolence, … of everything that rushed and shrieked…." For James, the new city assaulted the sensibilities, leaving no room for "detachment, dignity, meaning."[1] New York City had become the epicenter of **modernization**.

Yet even though the United States was at the forefront of modernization, nevertheless American arts remained tethered to Europe, and lacked a modernism of their own. The next two decades, however, saw the emergence of an American-born art that responded to the modern city, and to life energies liberated from middle-class convention. This art embraced the creative potential unleashed by modernization in the belief that the vision of the individual had the power to shape modern social reality. Artists and photographers felt challenged to develop new modes of expression, new theories of creativity, and new aesthetic forms that would guide the nation's cultural life amidst tumultuous change. While this new art combined both Native and European influences, its intentions remained focused on the peculiar conditions and needs of American

culture in the new century. This process of self-discovery was encouraged by a new generation of critics who shaped an influential discourse of **cultural nationalism**.

During the years from 1900 to 1920, artists reacted to urban and social change by both engagement and withdrawal—using various means to produce an American art that was strikingly different from the art of preceding decades. Two leading figures—Robert Henri, who led a group of **urban realist** artists, and Alfred Stieglitz, who supported artists associated with the first phase of American abstraction—emphasized the role of personal expression in the emergence of a new art. Breaking with the genteel tradition, they insisted that art should engage life, although they each defined "life" in different ways. For both men, the organizing power of art resided in the masculine personality, driven by a desire to assert creative control over the restless energies of the new century.

Despite an insistence on personal vision, this phase of modern American art—both figurative and abstract—was the result of multiple encounters. Of primary importance was the renewal of indigenous democratic traditions of thought. Inspired by the example of the American poet Walt Whitman (1819–92) in particular, urban realist painters of the early twentieth century sought an art that embodied democracy, and they found new energy and inspiration in the everyday landscapes of the street and the immigrant districts of lower Manhattan. Meanwhile, early modernist abstraction in the United States learned from native voices such as Arthur Dow, who introduced Japanese principles of composition into American art pedagogy. Abstract artists also looked to theories of organic growth extending

(opposite) **GEORGIA O'KEEFFE**, *Red and Orange Streak*, 1919. Oil on canvas, 27 × 23 in (68.5 × 58.4 cm). Philadelphia Museum of Art.

from nineteenth-century American and European nature philosophies, such as **vitalism**, which posited that life energies give structure to the random flux of reality, and underlie all forms of creativity. This vitalist outlook found meaning in the biological rhythms, abstracted forms, and temporal unfolding of nature, and it could also be used to understand the very urban energies that Henry James had found so disturbing. Such intellectual tendencies, linked to the past yet responsive to new philosophical influences from beyond the American tradition, restored a measure of "dignity and meaning" to the new century. All these native currents shared a vision of art as a form of personal expression and liberation that opened the way for political and social transformation.

## Early-Twentieth-Century Urban Realism

In the first decade of the twentieth century a group of urban realists in painting, prints, and sculpture took on new immigrant and working-class subjects that the previous generation had considered inappropriate to the fine arts. These realists humanized the titanic new forms of the city by engaging street-level views of people interacting with one another, in everyday encounters, displaying a range of behaviors that set them distinctly apart from the middle class. Urban realists found their art in the spectacle of the immigrant slum, as well as in the new urban entertainments, young working-class women, domestic arrangements, and new forms of sociability that animated the ethnically diverse metropolis. Painters and sculptors both, they were not stylistically radical; indeed, they drew upon long-established traditions of European realism, from the seventeenth-century Dutch artist Frans Hals, to the Spanish artist Diego Velázquez—an important influence on the previous generation as well—to the nineteenth-century French satirist Honoré Daumier, whose lithographs scourged the pretensions of wealth and power. Their modernity came not from the form of their work but from their subject matter, from their rapid style of execution, which embodied the pace of urban experience, and from the incorporation of new urban viewpoints into their work.

What united the urban realists with their modernist contemporaries was an attitude of rebellion against the polite world of late-nineteenth-century art and its preoccupation with aesthetic refinement and exclusive focus on the world of privileged urban elites. Central to the move-

## Modernism/Modernity/ Modernization

THESE THREE TERMS—modernism, modernity, and modernization—have specific applications not interchangeable with those of the others. The root of all three is the word "modern," derived from *modo*, a form of the Latin word *modus* meaning "just now" or "very recently." In art, *modernism* refers to a style encompassing a wide range of formal practices that began in explorations outside of the art establishment in the later nineteenth century, but which eventually became institutionalized in art. While modernism emerged out of European culture in the late nineteenth century, it fed off forms of cultural modernity that were taking shape on both sides of the Atlantic. *Modernity* refers to an epoch in cultural history that some historians date back as far as the sixteenth century, and which is marked by movement toward scientific rationalism, the growth of large-scale social institutions, and the transformation of production by mechanization. *Modernization* refers to the active process of social change caused by the technological transformation of production, usually producing a sense of shock and dislocation among those caught up in it. **Postmodernism** demarcates the end of the modern era and a dismantling of the Enlightenment belief in a centered subjectivity that organizes the world through rational structures.

ments of renewal within American art of the new century was the value of authenticity—a quality associated with direct expression, immediacy of execution, and a new emphasis on the truth of the first impression, seized and translated into paint with all the force of an intuitive emotional connection. These new urban realists renounced skillful drawing, finish, and the ability to reproduce the outward appearance of things—all tenets of the accepted art of the National Academy of Design in New York, the nation's premier institution for promoting and exhibiting American art. Robert Henri's emphasis on direct expression was reinforced by the experience many of these artists gained by working for urban newspapers before taking up art full-time. In the years before the rise of photography, squadrons of mobile illustrators captured the sensational events of the daily urban scene. Their quick on-the-spot sketches were translated into line engravings. This kind of

visual journalism schooled them in the art of visual drama and immediacy.

## The Ashcan Artists

In the art of the urban realists, authenticity came to be associated with the subject matter of the foreign immigrants who had been changing the character of lower Manhattan from the late nineteenth century onward. Along with an older population of poor Irish—present in New York since the 1840s—were newer arrivals: Jews from Eastern Europe, Italians, Poles, Bohemians, and other rural Europeans uprooted from agrarian lives by hard times. Living in crowded quarters with far less privacy than other Americans were used to, these new immigrants—Catholic and Jewish rather than Protestant—spilled into the streets of New York with their strange languages, their odd dress and peddlers' carts, their different forms of worship and family life. Their otherness was both threatening and exhilarating to mainstream Americans, who reacted squeamishly to the dirtiness, poverty, and lack of privacy in the immigrant neighborhoods, a response earning those who painted them the label of "**Ashcan**" artists. Hailing from the Midwest or the urban centers of the East, the Ashcan artists were of English and French ancestry. They were drawn to the immediacy of life that distinguished these neighborhoods from the stifling conventionality of middle-class existence, and they embraced the urban immigrant lifestyle that seemed free from the oppressive codes of middle-class behavior. Exposure to the extremes of wealth and poverty in the new metropolis also aroused their political sentiments, driving some Ashcan artists toward social satire through the print medium, as well as toward direct political action.

**ROBERT HENRI: "THE ART SPIRIT."** The guiding spirit of these new artists was embodied in the figure of Robert Henri (1865–1929), an older artist whose teaching at the Ferrer School and the Art Students' League in New York influenced their art-making and helped shape the broader practices of twentieth-century realism. In 1908, reacting against the jury system of the National Academy, of which he was a member, Henri organized an exhibition of "Independents" at the Macbeth Gallery, comprising eight American artists ranging from the realists to urban impressionists and symbolists. As well as Henri, John Sloan, William Glackens, and George Luks, the group included Everett Shinn (1876–1953), Arthur Davies (1862–1928), Maurice Prendergast (1859–1924), and Ernest Lawson (1873–1939). Following the practices of French and German modernists in seceding from the official art establishments, Henri also astutely managed the publicity for the event, garnering much attention for his artistic cause.

Henri's teachings, assembled by his students and published in 1923 under the title *The Art Spirit*, are summed up by the paradoxical notion of cultivated spontaneity. "The original mood" inspired by the quality of life, he told his students, "must be held to."[2] The trick was to capture the intensity of the original experience—a kind of raw data that was valuable in its own right. His catchwords, as the scholar Rebecca Zurier notes, were "energy, vitality, and unity," a unity achieved by a direct, visceral expression unfettered by traditional notions of beauty or technique. The quality of seeming uncomposed conveyed the impression of life experienced at firsthand rather than through the filter of artistic conventions. Rough, loose brushwork came to carry the rhetorical force of life itself. Through the vigor of his teaching Henri won a passionate following. One student, the art editor Forbes Watson, recalled how young manual laborers, having worked long hours, painted all evening under the eye of the master, and then slept on park benches because they could not afford a room. Henri shifted the focus of art from the aesthetic expertise of an elite to the idea that it was an ability possessed by all, needing only to be nurtured.

**GEORGE BELLOWS.** In his boxing paintings, George Bellows (1882–1925) graphically realized his teacher Henri's insistence on experience as the source of all great art. Bellows's *Stag at Sharkey's* (**fig. 12.1**) centers on two lanky male boxers engaged in an illegal prizefight. Tendons stretched to snapping point, they pummel one another, their faces buried in locked arms. The boxer on the right prepares to deliver a right jab while simultaneously thrusting a knee toward the groin of his adversary in a two-pronged attack. The second boxer lunges at his opponent, his body forming an extreme diagonal. Bellows heightens our visceral response to the scene with touches of red paint that evoke raw meat. Red also appears on the faces leering around the ring. The slashing, crude brushwork omits detail in favor of broad outline; faces border on caricature. The space of the ring is quite shallow; indeed, we become part of the audience, positioned in the third or fourth row from the ring, at eye level with others in the crowd. Rather than situating us at a genteel distance from the action, Bellows thrusts us into the fray.

While Thomas Eakins's (1844–1916) paintings of sportsmen affirmed the power, beauty, and willed discipline of the male body (see fig. 11.13), Bellows's boxing paintings suggest a different appeal: from being a proving ground of physical and mental discipline, sport had become, by the

12.1 GEORGE BELLOWS, *Stag at Sharkeys*, 1909. Oil on canvas, 36¼ × 48¼ in (92.1 × 122.6 cm). Cleveland Museum of Art, Ohio. Hinman B. Hurlbut Collection.

early twentieth century, an arena in which to slough off the constraints of civilized life. The faceless anonymity of the boxers, the leering of the crowd, and the brutish nature of the match, all indicate masculine behavior far removed from the sunny precision of Eakins's rowers. Bellows's boxers act out a masculine contest of primitive strength and animality. The explosive energy of their bodies displaces them into an urban underworld of violent sport. Illegal prizefighting leveled the class and ethnic distinctions that prevailed in most other areas of American life by bringing together wealthy top-hatted men "slumming" for the night with rough workingmen, and by crossing racial and ethnic lines. The action draws the viewer in irresistibly, implicating us in the lusty animality of the scene.

Bellows's painting collapses the distinction between nature and culture—a distinction around which much late Victorian society was organized—in other ways as well. In the early 1900s, Bellows and his fellow Ashcan artists painted the city as a raw, disordered realm, from the animalistic behavior of his boxers to the literal bedrock on which the city stood. In his *Pennsylvania Station Excavation* (**fig. 12.2**), Bellows took as his motif the gaping hole in the fabric of the city where a great monument to civilized urban life would soon arise: Pennsylvania Station, a splendid Beaux Arts structure styled after imperial Roman

architecture (see fig. 11.19). Unlike the American Impressionists, who focused on the glistening monuments and fog-shrouded elegance of the modern city, Bellows chose an ugly stretch of snow-covered earth. The surface of the painting is impastoed and scumbled; the city itself is pushed to the distant skyline, where it is dwarfed by the size of the hole extending back toward the horizon. The city is no longer defined in terms of opposition to nature, but as a new kind of nature; and urban progress as a process of violence and rupture.

**JOHN SLOAN AND THE ACT OF LOOKING.** The art of the Ashcan painters reveals another aspect of emergent urban culture: the act of looking. The crowded quarters of the new city offered rich new opportunities for voyeurism, intimate glimpses into curtained, lamp-lit interiors that transgressed the boundary between public and private. In John Sloan's (1871–1951) etching *Night Windows* (**fig. 12.3**), a peeping Tom looks down upon a young woman preparing to go to bed, illuminated against the surrounding night. Another woman leans out the window directly below him. Sloan's city is a place of permeable boundaries between private and public. The urban environment of entertainment and consumption blurred differences between people—between "older Americans" and newer immigrants, proper

12.2 GEORGE BELLOWS, *Pennsylvania Station Excavation*, 1909. Oil on canvas, 31¼ × 38¼ in (79.3 × 97.1 cm). Brooklyn Museum of Art, New York. A. Augustus Healy Fund.

ladies and "new women," leisure class and working class. Looking became a way to gauge one's distance, to reaffirm one's social existence in the anonymous environment of the city. Looks are everywhere in the Ashcan School—in the desiring gaze of shoppers, fueled by the lavish plate glass display of goods; in the eager spectatorship of moviegoers; and in the appraising glances of men at women loose in the city.

Sloan's *Sunday Afternoon in Union Square* (**fig. 12.4**) implicates his audience in the act of looking that is also the subject of his painting. Like the young men seated in the park, the gaze lingers, perhaps a moment too long, on a woman's back or well-turned ankle. Gazes cross and recross here, as young girls, who admire two strolling women, are themselves the object of the gaze of an older man on the park bench next to them. The subject of the working-class woman was new in American art, though it appeared earlier in the graphic media of mass-circulation journals. Often the child of immigrants, the working girl proved fascinating and unnerving for middle-class audiences. Sexually and, to an extent, financially independent, she embodied the transformation of urban culture and urban space in these post-Victorian years. With newly disposable income, she could move freely through the city with or without male escorts, put herself together with

a range of stylish readymade clothing, and take in the new popular and mass culture of vaudeville and movies. Her flamboyant dress and behavior challenged **bourgeois** notions of respectability, while at the same time representing the tempting new freedoms of the city, where an expanding economy of consumable goods available to everyone was eroding older social boundaries.

12.3 JOHN SLOAN, *Night Windows*, 1910. Etching, 5¼ × 7 in (13.6 × 17.9 cm). National Gallery of Art, Washington, D.C. Rosenwald Collection.

12.4 JOHN SLOAN, *Sunday Afternoon in Union Square*, 1912. Oil on canvas, 26⅛ × 32⅛ in (66.3 × 81.6 cm). Bowdoin College Museum of Art, Brunswick, Maine. Bequest of George Otis Hamlin.

Framing all these acts of urban looking was the gaze of the art-going public, those critics, collectors, and audiences who consumed these paintings of modern life and, in doing so, made art into an activity only one step removed from voyeurism. Linking the aesthetic gaze to commerce, motivated by consumption and desire, the Ashcan painters joined a long line of later artists who worked on the borderline between art and the everyday.

*Hairdresser's Window* (**fig. 12.5**), also by Sloan, shows a young woman, probably one such working girl, her face turned tantalizingly away as her long red hair (a familiar marker of Irish ethnicity) is parted and colored by a buxom woman of coarse features and conspicuously dyed blonde hair. We can only guess what her new color will be; the freedom to choose, however, is also the freedom to disguise

her social and ethnic identity. Such disguise provoked growing anxiety from the mid-nineteenth century forward, playing on older fears about the social fluidity of life in the nation's cities. Sloan's painting, however, goes one step further by revealing—indeed putting on display—the mechanics of such deception by which one thing disguised itself as another: Irish working-girl as fashionable woman. The use of hair dye and cosmetics was frowned upon, especially by those struggling to preserve older standards of feminine behavior from the taint of the "new woman." Sloan flaunts the ways in which the ethnic and working-class cultures of lower Manhattan joyously intermingled public and private spaces. The painting is full of his humorous asides to his audience (the hairdresser, in a French pun, is "Malcomb"). At street level are passersby, ranging from the heavily made-up woman on the far left— a streetwalker, perhaps—to the animated shop girls who respond to the spectacle with giddy laughter, and the workingman, pipe in mouth, and bowler-hatted gawkers

12.5 JOHN SLOAN, *Hairdresser's Window*, 1907. Oil on canvas, 31⅞ × 26 in (81 × 66 cm). Wadsworth Atheneum, Hartford, Connecticut. Ella Gallup Sumner and Mary Catlin Sumner Collection.

**ETHNIC CARICATURE.** Visual markers of ethnic difference helped preserve the social boundaries between middle-class audiences and the immigrant and ethnic subjects of the Ashcan painters. Motivated by a democratic vision explored in the poetry of Walt Whitman beginning in the 1850s, the paintings and graphic images of the Ashcan group took in all classes and ethnic types in the new city. Despite this inclusiveness, however, Ashcan artists still shared a strong impulse to organize the social variety of the urban environment through ethnic typing.

Their graphic training as visual journalists encouraged forms of shorthand that bordered on caricature, as visual and social typing blurred into stereotype. George Luks (1866–1933) began his career as a sketch-reporter and a cartoonist; his *New Year's Celebration* in *Hogan's Alley* Sunday comic (**fig. 12.6**) featured a motley array of urban ethnic and social types. These ranged from young Irish street toughs to banjo-strumming "darkies," to Englishmen, Cossacks, and middle-class female settlement house workers, in a joyously boisterous parade through the tenements. Contained within the borders of the immigrant ghetto, such subjects were unthreatening, offering easy humor

hoping to catch a glimpse of the mysterious beauty. From the window scene of hair-dyeing to the manikin heads in the storefront below, and the signs advertising gowns, the scene proceeds seamlessly toward the crowded streets, connecting the socially mixed urban population to new habits of dress and appearance. Privacy was a privilege of middle-class life not afforded by the crowded streets of lower Manhattan. Yet, Sloan implies, there is a certain enjoyment to be taken from the spectacle of the city, framed as a window within a window. The framed image of the hairdresser becomes yet another commercial sign advertising goods and services for sale.

Like others in the Ashcan group, Sloan embraced the democratic, leveling effects of the twentieth-century urban environment, even as he allowed middle-class audiences to view the scene through window-like openings and stage-like spaces that maintained a safe social distance. Differences in codes of dress and behavior also helped middle-class viewers maintain their moral and social grounding as they savored the heady and liberating environment of the new city.

12.6 GEORGE LUKS, *New Year's Celebration in Hogan's Alley*, 1896, from *New York World*, Sunday December 27, 1896, "Comic Weekly" page. Clyde Singer Collection.

12.7 (above) GEORGE LUKS, *Hester Street*, 1905, Oil on canvas, 26⅛ × 36⅛ in (66.4 × 91.8 cm). Brooklyn Museum of Art, New York. Dick S. Ramsay Fund.

of the sort that was mostly excluded from the high art medium of painting. Luks's *Hester Street* (**fig. 12.7**) is a more sober view of this dense immigrant neighborhood in lower Manhattan, marked by subtly observed class and social distinctions among individuals within the mass.

In other images, however, boundaries disappear in a vision of the city as a melting pot. In William Glackens's (1870–1938) *Washington Square* (**fig. 12.8**), the viewer encounters children tormenting one another, old women dozing, respectable matrons with their children, nannies, top-hatted gentlemen, and street toughs, in an apparently untroubled if chaotic setting. Glackens grabs the eye with cartoon-like vignettes; with its high horizon line, *Washington Square* offers an exuberant panorama of a democratic culture where everyone has a place. In paintings, prints, and comics, the urban realists spanned a range of responses to the

12.8 WILLIAM GLACKENS, *Washington Square*, 1913, published as *A White Christmas in Collier's*, no. 52, December 13, 1913, p. 8. Charcoal, pencil, colored pencil, gouache, and watercolor, 29 × 22 in (73.9 × 56.2 cm). Museum of Modern Art, New York. Gift of Abby Aldrich Rockefeller.

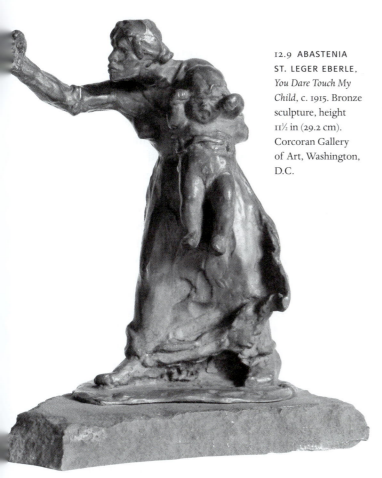

12.9 ABASTENIA ST. LEGER EBERLE, *You Dare Touch My Child*, c. 1915. Bronze sculpture, height 11½ in (29.2 cm). Corcoran Gallery of Art, Washington, D.C.

In its militant subject matter and implied struggle against anonymous forces threatening the mother–child bond, the work closely resembles the political lithographs of *The Masses* (see below). By choosing to depict maternal rage in the face of an unseen threat, Eberle also revealed a feminist understanding of how women's experience as mothers could be mobilized for political action.

## Graphic Satire in *The Masses*

Much of the work by the Ashcan artists bordered on the satirical. This impulse, however, was restrained by the fine art medium in which they worked. Graphic arts traditions and print media—unlike fine art—allowed greater room for narrative condensation, caricature, and caustic satire. Radical politics and satire came together in the graphic art of *The Masses*, a periodical magazine whose contributors included John Sloan and George Bellows. Beginning publication in 1911, *The Masses* expressed social and political critique with a new graphic language: abbreviated, rough, bitingly humorous, keenly responsive to the contradictions of society and to the daily violations of hallowed ideals. As writer, activist, and editor Max Eastman put it, "We would give anything for a good laugh except our principles."[3] Devoted to a form of home-grown socialism, *The Masses* remained in circulation until 1917, when it was shut down by the U.S. Postal Service for its opposition to America's entry into World War I. The targets of its satire extended from the idle rich to militarism, corporate greed, the hypocrisy of organized religion, and the corruption

emerging pluralism of the new American city—from parading ethnic difference to celebrating a common civic culture of shared public spaces, as first envisioned in Frederick Law Olmsted's Central Park (see fig. 8.7).

**GENDER AND THE ASHCAN ARTISTS.** Despite the democratic inclusiveness of Ashcan rhetoric, their insistence on the virile individualism of the male artist implicitly excluded women. Abastenia St. Leger Eberle (1878–1942) shared subject matter with the Ashcan artists, but a different attitude is evident in her sculptural work. The male artists of the Ashcan group kept their distance from their ethnic subjects. They also rarely allowed overt political topics to intrude into their paintings, retaining the traditional distinction between fine art and graphic media. Influenced by the settlement movement of Jane Addams, in which reformers took up residence among the immigrant poor, Eberle made her studio in New York's Lower East Side. In her bronze sculpture *You Dare Touch My Child* (**fig. 12.9**) she pushes the urban realist encounter with the audience one step further. Eberle's subject is a scrawny woman of haggard features holding a screaming child, and raising her fist in anger toward an unseen antagonist. Her stance transforms the viewer from voyeur into engaged participant.

12.10 BOARDMAN ROBINSON, *Europe 1916*, published in *The Masses*, no. 8, October 1916, pp. 18–19. Crayon, india ink, and opaque white on paper, 19 × 26¾ in (48.2 × 67.9 cm). Library of Congress, Washington, D.C.

of the mass media by big business. Rebecca Zurier has identified the significance of the graphic style developed at *The Masses*, where a rough crayon line came to convey "a graphic tradition of social protest," breaking with the suave manner of such mainstream illustrators as Charles Dana Gibson (1867–1944).[4] Visually condensed, and accompanied by captions or titles steeped in irony, the best of this work expressed complex ideas in simple terms. In Boardman Robinson's (1876–1952) haunting image, *Europe 1916* (**fig. 12.10**), a shrouded figure rides an emaciated donkey in pursuit of a carrot on a stick labeled "Victory," and held over a precipice. In the tersest possible terms, the image conveys the futility of World War I. The graphic work of *The Masses* also heralded a new internationalism; alongside everyday images of New York working girls and laboring men were works critical of the nationalistic fervor that fueled World War I.

As its statement of purpose proclaimed, *The Masses* was owned by those who made and produced it; with admirable consistency, it remained accountable only to its principles. "Printing what is too Naked or True for a Moneymaking Press," its policy was "to do as it Pleases and Conciliate Nobody."[5] The editorial independence of *The Masses* proved crucial to its freedom of expression, especially in an era that witnessed growing media consolidation and corporate control.

## The Social Documentary Vision: Lewis Hine

Along with Jacob Riis (1849–1914; see Chapter 11), though a generation later, Lewis Hine (1874–1940) stands at the beginning of the photographic **documentary** tradition that takes as its subject the working poor and the socially marginalized. Their documentary work overlaps with that of urban realist painters in the opening years of the twentieth century. Riis's subjects display the physical marks of the "slum"; they reach us through the language of difference, conveyed by their squalid surroundings. The Ashcan artists, by contrast, were drawn to the animated spectacle of street life, and rarely focused on the individual in favor of social types increasingly familiar to audiences through their portrayals in films, cartoons, and prints. Hine's objective, however, differed fundamentally from both Riis and the Ashcan School. Sponsored by the National Child Labor Committee, part of a broader Progressive reform movement during the first two decades of the century, Hine documented children working in order to call attention to their difficult work conditions. He often smuggled his camera into factories to avoid detection. Progressive reform attempted to work within the existing two-party system of government to address a wide range of issues facing American cities as they struggled to accommodate the massive influx of new arrivals. The reform movement's policy issues included child welfare, regulation of industry, workers' compensation, and the overhaul of corrupt urban machine politics.

At its best, documentary endowed images with the power to motivate social change. Supported by social statistics—a new practice derived from the emerging field of social science—Hine's photographs brought to light the poverty and exploitation of those living beyond the confines of middle-class experience. His close framing and direct approach brought his viewers into an intimate encounter with the subjects of his photographs. His pioneering work led directly to federal legislation prohibiting child labor, passed in 1916. With its power to bring previously hidden social conditions to light, documentary photography became the first step toward social action to improve lives. Riis's photographs produced the effect of a sudden and shocking revelation; Hine's were thoughtfully framed and drew on a familiar cultural imagery of mothers and children, childhood innocence, and stoic dignity in the face of hardship.

In recent years, the tradition of social documentary has been criticized by historians for exploiting its human subjects and denying their individuality and power to make constructive change in their own lives; it has been accused of rendering its subjects passive in the face of overwhelming problems. Hine's contribution to the documentary tradition contradicts this view. The human subjects of his photographs retain their individual identities; their worlds remain continuous with ours. Whether poor tenement dwellers in the Lower East Side, steelworkers in Pittsburgh, or immigrants from Russia and Eastern Europe facing an uncertain future in Ellis Island, Hine's subjects reveal a range of response to life usually effaced by the abstractions of social science. Early on, Hine's mentor at the Ethical Culture School urged him to photograph the immigrants at Ellis Island with the same regard as he would give "the pilgrims who landed at Plymouth Rock."[6] Here were the faces of the "huddled masses yearning to breathe free," in the words of the American poet Emma Lazarus (1849–87) in her sonnet "The New Colossus" (1883), inscribed on the pedestal of the Statue of Liberty.

Hine's respect for his subjects produced images of individuals struggling to maintain human connection and domestic order amidst impossible conditions. His camera surveyed a range of moods, from childish delight to curiosity, boredom, watchfulness, mischievous fun, moral and physical exhaustion, and despair. There is, in his collective

## The Road to Abstraction

12.11 LEWIS HINE, *Little Mother in the Steel District, Pittsburgh,* 1909. Gelatin silver print, 6⅞ × 4⅞ in (17.3 × 12.5 cm).

work, no single "image of the slum," or of the immigrant working classes, only a range of individuals facing the difficult challenge of starting over in a strange new land. Hine emphasized not the markers of difference (poverty, sordid surroundings, physical brutalization) but the bonds of common humanity uniting Americans across class and ethnic lines. *Little Mother in the Steel District, Pittsburgh* (**fig. 12.11**) is remarkable for its intent focus on the physical bond between the young girl, still a child, and her brother. This girl-woman, whose long hair cascades down her back, holds a real baby instead of a doll; both seem unconscious of the presence of the camera, caught in a moment of mutual affection, touch, and budding curiosity about the world beyond the self. Self-sufficiency supplants desperation: we are engaged, not through pity but through empathetic connection.

Another current of artistic innovation, grounded in abstraction, emerged alongside of twentieth-century urban realism. Abstraction was perhaps the fundamental feature of aesthetic modernism. Several developments opened the way. In the aftermath of urbanization and colonial expansion into the nonindustrialized world, modernist movements found inspiration in the arts of supposedly rural "folk" and preindustrial "primitive" cultures. Writing in 1901, the photographer Alvin Langdon Coburn (1882–1966) expressed a disaffection felt by many: "now that we have reached the acme of civilization with our fire-proof skyscrapers and our millions of spindles, it still remains to climb to the height of artistic achievement reached by the Zuni and the South Sea Islander."[7] Coburn's comment inverted customary hierarchies; the "primitive" was now the most aesthetically advanced. This attitude was symptomatic of the realignment of values in early modernism. Encountering these cultures, metropolitan artists set aside their own representational conventions and traditions, rooted in naturalism and realism, and found fresh inspiration in the abstraction and ritual functions of non-Western art. The Arts and Crafts movement (see Chapter 10) had anticipated trends in the early twentieth century when it repudiated the products of industry and mechanization, turning instead to Native American textiles, baskets, pottery, and other handmade objects. The geometric abstraction of Native American arts in pottery and weaving furnished an American parallel to the "primitive" arts of Africa that catalyzed European modernism.

The first phase of this turn away from Western sources was the fascination with Japanese arts (known as *Japonisme*—see Chapter 10) dating from the late nineteenth century. The career of Arthur Wesley Dow (1857–1922) connects the late nineteenth with the early twentieth century in several respects. One of the primary tenets of artistic modernism was the assertion of formal values over and above the claims of truth to nature, or **illusionism**.[8] Through his teaching, his practice, and his published work, Dow influenced numerous young painters and photographers who would later emerge as leading modernists, including Georgia O'Keeffe (who wrote of Dow, "This man had one dominating idea: to fill a space in a beautiful way"), and Clarence White (1871–1925), who taught some of the leading young photographers of the 1920s and 1930s.[9] At Columbia Teachers' College in New York City, Dow's teaching was grounded in the lessons he had learned from his study of Japanese art. A disciple and student of the Harvard scholar of Japanese art Ernest Fenellosa (see

12.12 ARTHUR WESLEY DOW, Plate from *Composition: A Series of Exercises in Art Structure for the Use of Students and Teachers*, 1919.

examined in the museums of Paris during his studies there from 1905 to 1908 (see fig. 14.12).

Dow was among the first to use music to assist his students in abstract visualization—a method that would become standard in many art schools. *Synaesthesia* was the principle that the properties of sound and color—aural and visual—produce parallel aesthetic effects, an idea familiar to nineteenth-century Romantic and Symbolist artists, and one that would provide an important road to abstraction for early modernists such as Georgia O'Keeffe and the **Synchromists** (for more on synaesthesia, see Chapter 10). Along with the shared notion of harmony that united music and color, musical qualities of rhythmic repetition and **counterpoint** came to be recognized as elements of form in all the arts, from dance to sculpture to poetry. The idea that music was the most purely abstract art form helped free the visual arts from their referential basis in nature, and stimulated the growth of abstraction in painting.

## Cultural Nationalism/Aesthetic Modernism: Alfred Stieglitz

Guided by such critical voices from the nineteenth century as Walt Whitman and Louis Sullivan (see Chapter 11), many among those exploring new art and literary forms felt that American culture had failed to produce a national expression worthy of the young democracy. By 1913, the summons to a revived cultural nationalism following the cosmopolitanism of the late nineteenth century had spread across a range of publications and personalities. Cultural nationalism was the belief in cultural forms as uniquely expressive of the nation—its democratic heritage, and its freedom to forge a new language attuned to contemporary realities, without the restrictions of traditions and conventions. And within the tenets of cultural nationalism, a central figure in this process was the creative artist—form-giver to the new.

A key figure in this early-twentieth-century "cultural renaissance"—as artist/intellectual, gallery owner, and tireless promoter of the new American modernism—was Alfred Stieglitz (1864–1946). Born in Hoboken, New Jersey, of a German Jewish family, Stieglitz had discovered photography as an engineering student in Germany. By the 1890s, he was exhibiting internationally, and established himself as a chief exponent of photography as an expressive art. With the zeal of a missionary and a charismatic power that won many followers, Stieglitz expanded his interests well beyond photography to include the latest developments in European and American modernism.

Chapter 10), Dow helped to shape American modernism through his book *Composition* (1905), which transformed admiration for Asian art into principles that could be taught. "I hold that art should be approached through composition rather than through imitative drawing," he wrote.[10] Beginning with the fundamentals of Japanese woodblock, his teaching emphasized formal simplification, attention to the harmonious organization of lights and darks (which he referred to through the Japanese concept of *notan*), absence of illusionistic perspective and chiaroscuro, and emphasis on surface design (**fig. 12.12**). But his sources reached beyond the art of Japan to include Native American design. Dow and others of his generation found in Native art not only a new use of line and color abstracted from the need for describing the world, but one that had a specifically American stamp appropriate for a generation seeking to define a distinctly American brand of modernism. Dow's student Max Weber (1881–1961) exemplified the range of influences on this first generation of modernists, from Asian and Native American to the arts of Africa, which he

# Disney's *Fantasia*: Middlebrow Modernism

MODERNISTS CLAIMED a privileged status for music because it was a fully abstract medium. That status came under siege with Walt Disney's *Fantasia* (1940–1). Considered today to be Disney's masterpiece, *Fantasia* took excerpts from the canonical works of the classical music tradition—from Bach's Toccata and Fugue in D Minor to Beethoven's "Pastoral" Symphony, Tchaikovsky's *Nutcracker*, and the works of many other mostly nineteenth-century composers—and set them to animation, giving them a storyline and a narrative structure. The intention of *Fantasia* was to broaden the audience for classical music (already a mission of Leopold Stokowski, the conductor featured in the film) by attaching stories to the music. However, highbrow critics attacked the film, arguing that it diminished the music and that animated narrative restricted music's suggestive richness. *Fantasia* also brought synaesthesia—an idea key to the emergence of abstraction—to a mass audience, with music evoking abstract visuals in one sequence at the beginning of the film (**fig. 12.13**). *Fantasia* even took the avant-garde music of Stravinsky's *Rite of Spring*, which had so provoked Parisian audiences at its première in 1913, and used it to drive a compelling visual narrative of the natural history of the earth, bringing Stravinsky's musical primitivism and percussive power to an audience largely uninitiated into musical modernism.

Besides disrupting the autonomy of the music with images, *Fantasia* also extracted parts from a larger whole, a kind of *Reader's Digest* or "Greatest Hits" approach to classical music. In place of introspection and absorption was distraction—an ever-changing stream of images and musical excerpts. Such pabulum, so the critics argued, spoon-fed audiences who resisted the rigors of refined taste. *Fantasia* thus found itself at the center of a debate about just how far cultural producers could go in making high art accessible to mass audiences before the very character of the art was itself in peril.

12.13 WALT DISNEY, *Fantasia*, 1940–1. © Disney Enterprises.

**STIEGLITZ AS GALLERY OWNER.** Stieglitz's role as self-appointed spokesman for the new American art took shape most fully through his activities as a gallery owner at 291 Fifth Avenue, dedicated first to photography (the Little Galleries of the Photo-Secession) in 1905, and then, as Gallery 291, to modern art, from 1907 until its closing in 1917. It was at Gallery 291 that young American modernists were exposed to the new art in a series of one-person exhibitions—the first of their kind in the United States—of artworks by Auguste Rodin (1840–1917), Henri Matisse (1869–1954), Paul Cézanne (1839–1906), Constantin Brancusi (1876–1957), and Henri Rousseau (1844–1910), among others. In 1911 Gallery 291 presented what it claimed was the first one-man exhibition of Pablo Picasso (1881–1973): eighty-three drawings and watercolors, later offered to the Metropolitan Museum for two thousand dollars (and refused). Pursuing other sources of European modernism, Stieglitz presented a series of exhibitions featuring children's art, which embodied a sense of naïve wonder and intuitive form that he cherished, as well as African sculpture. For Stieglitz, European modernism was a critical resource for an evolving native expression; eager to keep abreast of European developments, he sent the young photographer Edward Steichen (1879–1973) to Paris, where he made direct

contact with artists and secured exhibitions for 291. It may seem odd that a man dedicated to fostering an American art would devote so much energy to presenting and promoting European modernism. Yet Stieglitz saw Gallery 291 as a laboratory—a place vitalized by the most recent transnational artistic and intellectual currents, a space for animated talk and debate, within which artists of all persuasions would come to learn from others, and to experiment with new expressive forms. Encouraged by him to work independently, the artists Stieglitz nurtured quickly developed their own language. His greatest success lay in his openness to new ideas, and his resistance to all art doctrine and dogma. Believing above all in the creative spirit unfettered by received ideas or traditions, Stieglitz felt the best way to foster an authentic national art was to carve out a space where his artists could develop their own creative instincts, free from the pressures of the market. Here they would wed modernist form to American subjects.

**STIEGLITZ AS MAGAZINE PUBLISHER.** Stieglitz expanded his mission to educate those interested in modern art through the magazine *Camera Work*, which he published quarterly. From 1905 to 1917, *Camera Work* shaped a generation of younger artists by presenting excerpts from the leading critics, artists, and philosophers of the modern movement, including the French vitalist philosopher Henri Bergson (1859–1941) and the Russian Expressionist painter Wassily Kandinsky (1866–1944), whose essay *On the Spiritual in Art* offered a language for conveying the visionary properties of form and color. *Camera Work* published some of the leading essayists and critics in American photography, and staged debates between the Pictorialists, who developed a range of painterly effects, and the practitioners of the straight, or unmanipulated, print. Through its reproductions of paintings, drawings, photographs, sculpture, and prints, the magazine publicized new developments and spurred discussions about the relationships between various media.

**STIEGLITZ'S *EQUIVALENTS*.** Grounded in the Romantic tradition of artistic self-expression, Stieglitz struggled to understand the new art coming out of Europe. In matters of philosophy, he himself had few new ideas. Many of his theories about art—along with the work of the writers and artists he mentored and promoted—represented a late expression of nineteenth-century Symbolism with ties to the **Romantic movement**. For Symbolists, meaning expanded **metaphorically** through the artist's imagination, drawing connections from the thing itself to a wider world of significance. "Art, for me, is nothing more than an

12.14 ALFRED STIEGLITZ, *Equivalent*, 1930. Gelatin silver print, 4½ × 3⁹⁄₁₆ in (11.4 × 9.9 cm). Metropolitan Museum of Art, New York. Alfred Stieglitz Collection, 1949.

expression of life," Stieglitz wrote. "That expression must come from within and not from without." This late Symbolist attitude is evident in Stieglitz's series of photographs known as *Equivalents* (**fig. 12.14**)—a sequence of cloud portraits, in which endlessly shifting patterns, densities, luminosities, and variations of light and shadow suggest a chronicle of moods or transitory mental states. This correlation between nature and inner states of being was the essence of Symbolist expression, and it proved a supple language for an emergent cultural nationalism that sought analogies in nature to express creative inspiration.

## Stieglitz and His Circle

Throughout his life Stieglitz remained strikingly consistent in his preference for a modernism rooted in expressive abstraction. He remained loyal to a small group of artists with whom he was closely associated throughout their careers: Marsden Hartley (1877–1943), Arthur Dove (1880–1946), John Marin (1870–1953), and Georgia O'Keeffe

(1887–1986). There were others who came into his orbit at various times, including Edward Steichen, Paul Strand (1890–1976), and Charles Demuth (1883–1935). But Stieglitz's domineering personality, and intolerance for any form of artistic activity involving commerce or the business of buying and selling, made for many broken alliances in the course of his career.

The circle of artists and critics that formed around Stieglitz was marked by its focus on a "native" or home-grown art summed up by the phrase "**soil spirit**." Coined in 1922 by a critic who disdained their personal and highly subjective language, the term "soil spirit" nonetheless captures the nature-based **organic abstractions** of Dove and O'Keeffe.[11] Reaching its fullest articulation after 1917, this alliance of artists was formed by the varied strands of native and international artistic discourse, placed in the service of a self-proclaimed new American art. Stieglitz's high-minded attacks on "Philistines"—profit-minded businessmen insensitive to aesthetic values—echoed his efforts to remove art from the corrupting influences of modern life. The artist as visionary was a stance that preserved creative autonomy apart from any identification with commerce, mass media, and industry.

Stieglitz's version of American modernism differed from those of the artists and writers who embraced the pounding intensities and fractured sensations of urban life. These artists—the subject of the next chapter—felt that **technology** was the primary condition of their time, and they sought ways to express modernization through their art. These two factions of artists represent the extremes between which modernist practice in the United States took shape.

## The Lyrical Left

THE "LYRICAL LEFT" is a term coined by the historian Edward Abrahams for those artists, writers, thinkers, and social activists who believed that the task of transforming society began with transforming the self. Creative expression was one avenue to self-liberation. The lyrical expression of the soulful self—through dance, prose, poetry, and image-making—went hand in hand with efforts to rethink conventional social and gender attitudes. These included relations between men and women, newly restructured to embrace sexual and social equality. Campaigns for birth control and women's rights found their place in the lyrical left, alongside activism on behalf of workers' rights to organize against the paralyzing drudgery of industrial work. Ultimately the lyrical left encompassed a broader, native-born, socialist critique of a business culture that generated militarism, imperial conquest, and war. The lyrical left reached across widely differing artistic camps, taking in both the Ashcan artists and the Stieglitz circle. It involved artists in social causes, and it cut across class lines, bringing together Fifth Avenue matrons with Wobblies (members of the International Workers of the World, led by "Big Bill" Heywood), and the sons and daughters of old eastern elites with immigrant workers. For a brief few years, before World War I shut down the galleries, coffeehouses, and salons of the lyrical left, these men and women brought together the personal and the political, exploring new ways of living and loving, of working and creating, that furnished a model and an inspiration for later generations committed to transforming self and society.

**ORGANIC ABSTRACTION: ARTHUR DOVE.** "I look at nature, I see myself. Paintings are mirrors, so is nature."[12] Since the Romantic Movement of the early nineteenth century, nature had offered spiritual refuge for those unsettled by the rapid pace of historical change. The first generation of American modernist abstraction faced in two directions. For the artists around Stieglitz, organic abstraction responded to modernity by returning to the slow, sustained rhythms of the natural world. Even when they painted the city, they imbued its tall buildings and clangorous environment with the vital energies of natural, living things. Collectively they searched for an American art grounded in nature, intimately known and part of the nation's living past.

Organic abstraction, as practiced by Arthur Dove, expressed a growing reaction to mechanization and the analytic thrust of modern science. Drawing on a fascination with biology, it took its inspiration from plant forms, the ebb and flow of water, the dilating light of a sunrise, the universal force of growth and creation charging the world of matter, expressing in turn the rhythms and sensations of the body. Though indebted to such contemporary European thinkers as the French philosopher Henri Bergson—whose work was widely read—Dove's thinking was also shaped by older organicist philosophies traceable to the nineteenth-century American writers Ralph Waldo Emerson (1803–82) and Henry David Thoreau (1817–62). Like them, Dove looked to nature, informed by imagination, for a renewal of vision, finding there a bridge between self and world, matter and spirit. Very much in the American grain, organic abstraction offered an avenue

12.15 ARTHUR DOVE, *Alfie's Delight*, 1929. Oil on canvas, 22¾ × 31 in (57.7 × 78.7 cm). Herbert F. Johnson Museum, Cornell University, Ithaca, New York. Dr. and Mrs. Milton Lurie Kramer Collection.

into nonrepresentational art that was grounded in earlier American arts and letters. In Dove's *Alfie's Delight* (**fig. 12.15**), overlapping orbs of variegated earthy colors form petal-like ridges suggesting floating protoplasmic forms. These pulsate in a vaguely defined space of nature, simultaneously expanding and contracting as they recede toward a horizon and then funnel energies back toward the donut-like shape at the right center. A serpentine blue suggesting a river flows across and behind the concentric horizons of receding disks. In the lower left-hand corner a sulfurous yellow wash bleeds into the canvas, running and ridging to create different densities. At other points the viewer can discern Dove's graphic underdrawing as well as the track of the paintbrushes he used. Despite the appearance of accident, he skillfully orchestrates different densities of color, from the veil-like yellows to the intervals

of impenetrable black, balancing the decorative shapes on the surface against the suggestion of a natural space.

Dove began his artistic career as an illustrator, taking up oils at the instigation of John Sloan and William Glackens. He quickly moved from clear debts to Post-Impressionism, in his first paintings of 1907–8, to a type of abstraction in which natural and vegetal forms are disciplined into rhythmic curves and volumes, suggesting the biological principles of ordered growth that fascinated him throughout his life. Through most of his career he avoided New York City, living instead in physically difficult circumstances in which the landscape of sea, shore, and woods was an immediate and real presence. Dove wished, in his words, "to enjoy life out loud," and wanted to convey a sense of nature unmediated, as if experienced through his pores.[13]

Dove's early abstractions at times suggest the exuberant energies of Art Nouveau, bursting into convolutions and spirals, as in *Nature Symbolized,* no. 2 (**fig. 12.16**). They appear larger than the small dimensions of the paper itself; the same invisible energies animate both self and universe.

12.16 ARTHUR DOVE, *Nature Symbolized,* no. 2, c. 1911. Pastel on paper, 18 × 21⅛ in (45.7 × 54.8 cm). Art Institute of Chicago, Illinois. Alfred Stieglitz Collection, 1949.

These early abstractions (from 1910 on) coincided with the Russian Wassily Kandinsky's movement into pure abstraction, suggesting the simultaneous but independent "invention" of abstraction on both sides of the Atlantic. The question of priority—who did what first—is perhaps less important than the fact that many artists in these years were thinking about abstraction from nature.

In his assemblages of the 1920s, Dove incorporated nature very directly—in the form of dried flowers, wood, sand, and twigs—into his abstract compositions. *Ralph Dusenberry* (**fig. 12.17**) is a portrait of his Long Island neighbor, a high-spirited handyman, carpenter, and roustabout. Juxtaposing found objects—wood shingles, a folding ruler (alluding to Dusenberry's carpentering), and sheet music—against a painted canvas background, Dove evokes the man with humorous affection. Dusenberry was a legendary swimmer who could dive into the Sound like a kingfisher (suggested by the vector-shaped shingle). When "liquored up" he was known to sing a traditional hymn ("Shall We Gather By the River"), a fragment of which is pasted on the lower edge of the work. Dove pays tribute to his neighbor's homegrown "all-American" qualities and patriotism with a fragment of the flag. His collage resembles the manner in which the American modernist composer Charles Ives (1874–1954) used musical fragments of hymns and popular band music, woven into an orchestral tapestry that nonetheless preserved their identity. Found objects in Dove's assemblages of the 1920s act in a similar fashion, retaining their "thingness" (Dove's own label for these works was his "thing paintings") while creating new meanings through juxtaposition with other objects.

**GEORGIA O'KEEFFE.** Georgia O'Keeffe's career-long meditation on landscape and nature resembled Dove's in its turn away from the city as the focus of a native modernism. O'Keeffe was born in Wisconsin in 1887; her early

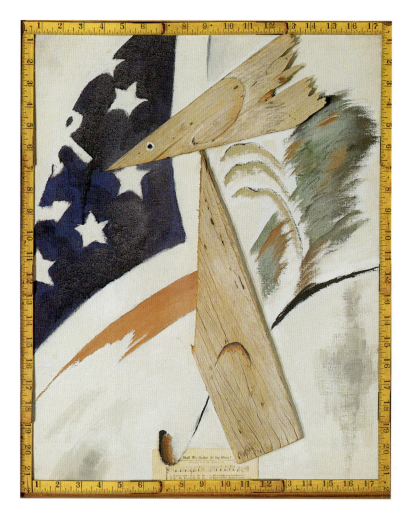

12.17 ARTHUR DOVE, *Ralph Dusenberry*, 1924. Oil, folding wooden ruler, wood, and printed paper pasted onto canvas, 22 × 18 in (55.8 × 45.7 cm). Metropolitan Museum of Art, New York. Alfred Stieglitz Collection, 1949.

training as an artist coincided with the waning years of the genteel tradition in the arts. In the artistic output of 1900 to 1910, a tonalist sensibility of vague contours, blurred by twilight and mist, of muted pigments and indefinite forms, gave way to a cleansing new intensity of vision. O'Keeffe's work, breaking into abstraction in 1915, embodied this new attitude fully. She was, as Marsden Hartley put it, "modern by instinct."[14]

Modern by instinct perhaps, she nonetheless required a long period of tutelage before arriving at her own visual language. She was conventionally trained, first at the Chicago Art Institute and then at the Art Students' League in New York City under William Merritt Chase (1849–1916). While she later expressed her admiration for Chase, his painterly style, which she initially emulated, was still based on transient **optical** effects of light and shadow, which she would later renounce. In the dauntingly vast and uncluttered landscape of the western Plains, where she traveled to teach in 1915, she distilled various influences into a new language of abstract forms. In a series of watercolors done in 1917, she cultivated the willful accidents of the medium

(uneven transparency, bleeding, and ridges of pigment), as well as the appearance of naïve drawing (**fig. 12.18**). In Arthur Wesley Dow's classes at the Columbia Teachers' College, O'Keeffe drew from music and learned to visualize abstract form. Into the late 1910s, O'Keeffe continued to find visual inspiration in sounds; cattle lowing on the Texas plains at sunset became a piercing arc of intense color breaking the horizon in *Red and Orange Streak* (**p. 390**). Although she always denied outside influences on her work and insisted that it expressed a personal experience of the world, O'Keeffe read widely, in literature, contemporary philosophy and drama, and art criticism. Through *Camera Work* she became informed about the most recent intellectual and artistic developments in modern art. Breaking free from older ways of painting was also her personal declaration of independence; she later explained that as a woman, having few freedoms in other areas of her life, she determined to paint in her own way, following no one else's rules.

Returning to New York in 1917, O'Keeffe began a professional and personal involvement with Alfred Stieglitz that lasted until his death in 1946. Her relationship with the

foremost promoter of modernism brought other new influences on her art as well, through the male painters surrounding Gallery 291. From the photographer Paul Strand, O'Keeffe learned a modernist strategy of focusing on the detail isolated from the larger whole, prompting a fresh new vision of the already known. She advised a young artist in 1933 to paint as though, Adam-like, he were the first to see the world.

O'Keeffe refused the organizing distinctions between abstraction and representation; as her companion, Juan Hamilton, put it after her death in 1986, for O'Keeffe they were one and the same.[15] The genres that had organized nineteenth-century painting—landscape, still-life, and portraiture—ceased to have meaning for her, as she painted land-forms with the intimacy of still-life, and fruit and flowers on a scale that resembled the forms of the earth.

12.18 GEORGIA O'KEEFFE, *Evening Star,* no. IV, 1917. Oil on canvas, 27 × 23 in (68.5 × 58.4 cm). Private Collection.

In the 1920s, O'Keeffe began painting flowers, a subject that brought together a number of her artistic concerns. Flowers were traditionally associated with amateur female painters, but O'Keeffe painted flowers as never before, with petals pressing at the boundaries of the frame, their sexual parts looming out of shadowy interiors. She chose colors of garish intensity—"magnificently vulgar," in her own words.[16] *Jack-in-the-Pulpit* is a series of six paintings of various dimensions, which begin with an exterior view of the flower, gradually focusing in on the interior configuration of stamen and pistils. The fourth of this series (**fig. 12.19**) explores ambiguities of scale and reference; the interior is magnified to fill the entire canvas. Interior and exterior, space and mass, float in and out of one another; concave becomes convex. At the four corners of the painting, a deep blue suggests the void of space surrounding the central motif. The profound black of the central petal reads as an interior void, penetrated by the slender flame-like form. The dark form of the pistil retains this ambiguity,

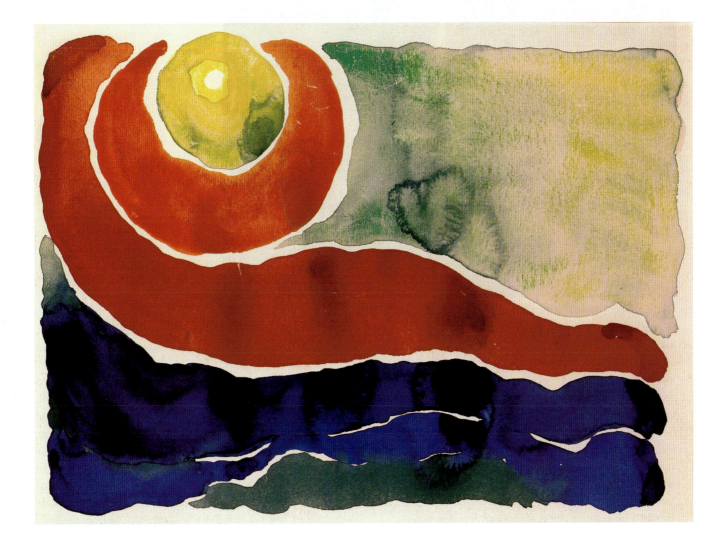

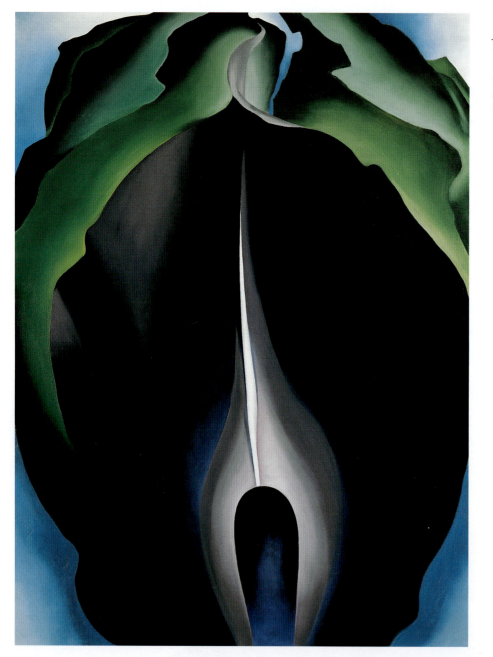

12.19 GEORGIA O'KEEFFE, *Jack-in-the-Pulpit,* no. IV, 1930. Oil on canvas, 40 × 30 in (101.6 × 76.2 cm). National Gallery of Art, Washington, DC. Alfred Stieglitz Collection. Bequest of Georgia O'Keeffe.

becoming now a phallic projection into a pale void, now a cavernous space. Such formal ambiguities parallel sexual ambiguities—simultaneously male and female, O'Keeffe's imagery carries an androgynous quality that resists efforts to read it solely in terms of feminine experience, readings that O'Keeffe herself vehemently rejected. Such sexualization of her paintings, she felt, denied their full metaphorical range, from body to nature and landscape. Metaphor—understanding one thing through the experience of another—was central to her art. Like much of O'Keeffe's best work, *Jack-in-the-Pulpit* preserves this ambiguity, bringing us to view the already known and familiar in a new way.

O'Keeffe's career and marriage to Stieglitz confined her to New York City through the 1920s. In 1925, she and Stieglitz moved into the upper stories of the Shelton Hotel, where she commenced a series of New York cityscapes and skyscrapers (see Chapter 14). In 1929 she traveled to New Mexico at the invitation of Mabel Dodge, former hostess of the New York avant-garde turned Taos earth mother. The move was the beginning of O'Keeffe's deep love affair with the region, and it gave birth to the second phase of the O'Keeffe myth, the one that has fused artist and place into one powerful cultural image. Integrating the various threads of her art through the 1920s, O'Keeffe discovered

new subjects: pelvic bones opening into blue voids; rams' skulls floating above the wind-carved earth of northern New Mexico. Starkly beautiful records of self-imposed desert exile, O'Keeffe's forms cut through our cluttered visual environment and engage us in the meditative act of seeing, as if for the first time.

**STIEGLITZ AND O'KEEFFE: "LOVE IN THE MACHINE AGE."**[17] The artists of the Stieglitz circle were deeply influenced by changing attitudes about sex and the body. In the 1910s and 1920s Americans discovered Freud's theories of sexual repression, which fueled the desire among modernists to free current cultural mores from lingering puritanism and to pursue a new candor in matters of sex. Indeed, sex became a kind of sacrament for the modernists, drawing an overly rationalized culture back to fundamental forms of experience (what Benjamin de Casseres, an associate of Stieglitz's, termed "The great American sexquake").[18]

This infatuation with the liberating potential of sex helped shape a new brand of American art criticism, best exemplified in the writings of Stieglitz's acolyte Paul Rosenfeld (1890–1946). Rosenfeld found in the works of both Dove and O'Keeffe a forthright expression of unfettered physical and sexual sensation. About Dove he wrote: "A tremendous muscular tension is revealed in the fullest of the man's pastels.... A male vitality is being released.... And in everything he does, there is the nether trunk, the gross and vital organs, the human being as the indelicate processes of nature have shaped him."[19] O'Keeffe, by contrast, "gives the world as it is known to woman."[20] Rosenfeld saw her art in terms of feeling: O'Keeffe exposed women's sexual feelings to men. His heated rhetoric was fueled by Stieglitz's nude studies of O'Keeffe in post-coital relaxation (one phase of a series of photographic portraits that spanned the years 1917 to 1935), which caused a minor sensation when they were exhibited in 1921, flooding the gallery with curiosity-seekers drawn to images of the young artist "Naked on Broadway." Helped along by the criticism that flowed forth from the excited pens of critics, O'Keeffe's modern vision and inner selfhood—linked to her sexuality—proved to be a highly marketable commodity. Yet the discourse of modernism worked differently for

## Vision as Meditation

IN THE MINDS of some critics, the accessibility of O'Keeffe's images and her popularity with the public pushed her accomplishments to the margins of "serious" art. For example, Clement Greenberg (1909–94)—a leading American art theorist beginning in the late 1930s—believed that "true" modernist painting developed toward the purest expression of the medium itself: paint on a flat surface, working against illusion and banishing all references to anything beyond the canvas. For Greenberg, modernist painting should exist as an object, to be perceived instantaneously in its entirety, without recourse to the dimensions of narrative, time, or space. "[T]he whole of a picture should be taken in at a glance; its unity should be immediately evident."[21] Greenberg's modernist ideal represented a flight from temporal duration, and from the embodied condition of the viewer, qualities that he associated with O'Keeffe.

However, in contrast to Greenberg's insistence on reductionism, O'Keeffe stands at the head of a long line of modern American artists, filmmakers, writers, and poets whose work is concerned with the actual unfolding of perception within the body and across the surfaces of nature. Critical of an increasingly managed and programmed world, these artists celebrate the sensuous reality of nature and resist the separation of vision from the other senses. Since the beginning of the twentieth century, such concerns have taken various forms. In the post-World War II years, the Beats and the post-Beat generation looked to eastern philosophies—Zen Buddhism in particular—to restore the moment to its place within a continuum of perception. Beginning in the 1960s, experimental film used the motion picture camera to turn the tradition of **montage** and fast-paced editing on its head. In long, unedited, meditative takes, the camera pursued its own singular monotony of vision, transcribing rhythms and sensations of the body. This exploration of perception—unfolding through time and as a result of the body's movement through space—formed an element in artistic developments as diverse as Minimalism (see fig. 18.10) and performance art (see fig. 18.11), with its redirection of attention beyond the purely ocular to the senses of smell, touch, taste, and hearing. By activating all the senses, these artists reconnected sight to the impulses, desires, and memories of the body.

men than for women artists. Dove was never narrowly defined by his gender. O'Keeffe's male critics, by contrast, conflated her sex with her identity as an artist. In their terms, being a woman was an experience that shaped and conditioned all that she did and thought. Her sex was—in their eyes—the primary determinant of her art. Modernism's embrace of the sexualized body, grounded in nature, broke dramatically with the genteel tradition and its insistence on drawing a firm boundary between the human and the natural worlds. In a form of what the writer Malcolm Cowley called "carnal mysticism," sexuality and physical life became the avenue to transcendence.[22] Nevertheless, while announcing a greater sexual freedom for women, these new attitudes still resisted the idea of women as self-formed creators and producers of culture.

Although Stieglitz renounced the commercialization of art in the strongest terms, the income from the sales of O'Keeffe's paintings—assisted by the sensationalism of his nude photographs of her—kept his galleries afloat in the 1920s and 1930s. Despite his insistence that he was above crass commercialism, Stieglitz was quick to use the tactics of modern marketing. Knowing that "sex sells," he actively endorsed the view of O'Keeffe's art as an expression of her carnal knowledge. The seductions of fame were hard to resist. Fame, however, came at a cost for O'Keeffe, as she found herself and her art confined by a critical discourse that linked creativity to gender. If her expressive power came directly from her womb, as critics claimed, then the artist herself was denied the very powers of original invention that defined the heroic male modernists around her.

**AN ORGANIC EXPRESSIONIST: JOHN MARIN.** Organic abstraction lent itself not only to subjects from nature but also to those from the city, a central preoccupation in the long career of John Marin. His watercolors and paintings of the city captured the roiling, vital energies of both natural and man-made landscapes. From his emergence as a mature modernist in the 1920s, Marin was widely considered among the leading American artists of the first half of the twentieth century. His work and the responses to it teach us a great deal about the emergence of a peculiarly American language of image-making.

Returning from several years in Europe (1905–11), where he practiced a delicate Whistler-influenced Tonalism, Marin responded to a rapidly modernizing New York with a new graphic style of slashing diagonals—"explosions of line and color," as his patron Duncan Phillips put it—and rapid brushstrokes suggesting the accelerating tempo of the city. Marin insisted that American subject matter had to be married to a new visual language capable of expressing a

new culture. In his etching of the Woolworth Building, subtitled *The Dance* (**fig. 12.20**), the forms of the city sway and pulsate: "… the whole city is alive; buildings, people, all are alive; and the more they move me the more I feel them to be alive."[23] The skyscraper is shown "pushing, pulling, sideways, downwards, upwards," as he explained in a statement of 1916. He imagined the city animated by the organic energies of nature. In *Lower Manhattan (Derived from Top of Woolworth Building)* (**fig. 12.21**), a yellow paper cutout sun, sewn onto the bottom of the watercolor, establishes the radiating spokes of the composition within a black charcoal nimbus. The sun stands in for the artist, organizing urban chaos into dynamic equilibrium. Marin disintegrated solid masses and charged space with new drama. For critics and audiences, he substituted natural for mechanical dynamism, rescuing the modern city from its associations with the brute force of the machine. The result was a form of personal expressionism linked to the visionary optimism of Walt Whitman and others who embraced the vital energies of modern life.

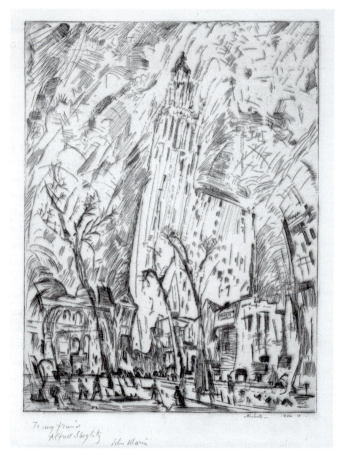

12.20 JOHN MARIN, *Woolworth Building: The Dance*, 1913. Etching, 13 × 10½ in (33 × 26.6 cm). Art Institute of Chicago, Illinois. Alfred Stieglitz Collection, 1949.

12.21 JOHN MARIN, *Lower Manhattan (Derived from Top of the Woolworth Building)*, 1922. Watercolor and collage on paper, 21⅛ × 26⅞ in (54.8 × 68.3 cm). Museum of Modern Art, New York.

# Photography: From Pictorialism to "Straight"

Marin presented himself as a naïf, writing in broken sentences, painting ambidextrously with the fingers of both hands, and drawing directly with the brush. Watercolor appealed to him for its immediacy of communication. His patron Duncan Phillips called him "a bold adventurer of the moment's intuition," reaffirming a deep-seated image of American individualism.[24] Dividing his time between the environs of New York and the shoreline of Maine, Marin alternated between depicting urban subjects and landscapes of nature. In this and many other ways, he spanned a generation's divided consciousness, resolving contradictions between the mechanical and the human, the future and the past, the city and nature.

Photography, like other media, went through its own defining encounter with the new century. Some of the challenges it faced were unique to the medium itself. As a very young development, photography had scant history on which to draw. Seen initially as an instrument of scientific and social documentation, it was a "recording angel," but lacked a clear claim to aesthetic status, and eminent commentators still weighed into the debate as to whether photography was an art.

Did the camera have its own aesthetic? What were the properties that made photography unique as a medium, and different from painting? Photography—at the threshold of modernism—shared with painting a new, self-conscious exploration of its own internal means. Could the camera,

itself a product of modernization, rise above its condition as a tool, a machine for investigating the world? Could it be turned back on itself, to consider how photographic vision altered our way of knowing reality? These issues were central to the emergence of a photographic modernism in the first decades of the twentieth century.

## Establishing Photography as a Fine Art

By the 1890s, photography had inspired a widespread international movement among amateurs whose interests were primarily aesthetic. Forming their own societies, clubs, and juried exhibitions, and including a significant number of women, these amateur practitioners of photography inspired a movement that came to be known as **Pictorialism**. To distinguish their practice from commercial photography, Pictorialists carefully controlled the environment in which their photographs were seen. They repudiated the utilitarian, documentary, or commercial uses of the camera, reclaiming photography for poetry, imagination, and art. Pictorialist photographs were meant to look like paintings ("paintographs" or "photopaints," as one critic sarcastically called them).[25] Pictorialists used a variety of techniques for reintroducing manual skill and aesthetic manipulation into the production of the photograph: staging it, wiping and brushing the photographic emulsion (gum bichromate, introduced in 1894) and painting the plate with pigment, and printing on platinum paper, which produced soft velvety tones. **Photoengraved** for reproduction in limited edition "little magazines" such as Stieglitz's *Camera Work*, these photographs disguised their origins in a mechanical apparatus with subtle gradations of tone, and deliberate blurring of optical clarity—techniques intended to mimic painting.

**THE PHOTO-SECESSION.** A central figure in this history was Alfred Stieglitz. In one of the many phases of this extraordinary man's career, Stieglitz seceded from the New York Camera Club, which he felt had become overly professionalized and commercial, and formed the Photo-Secession in 1902, opening the Little Galleries of the Photo-Secession in 1905, as we have seen (page 403). Stieglitz's Little Galleries offered an aesthetic refuge from the chaotic barrage of images that increasingly characterized the public environment of the city. Like the Tonalist painters, whose aesthetic they paralleled (see Chapter 11), the Pictorialists found their subject matter most often in nature, and in the frequent subject of the woman communing with another world. Anne Brigman's (1869–1950) *The Spirit of Photography* (**fig. 12.22**) transmutes the machine vision of the camera

12.22 ANNE W. BRIGMAN, *The Spirit of Photography*, 1907. Platinum print, 7⅝ (19.4 cm) diameter. Royal Photographic Society, Bath, England.

into a lens that reveals an immaterial world hovering at the brink of perception. Gazing into glass spheres, or at watery reflections, such figures symbolized mystical communion, and the power of art to transport us beyond the everyday. Artists were thought to resemble women in their power as spirit conductors. As the twentieth century opened, Pictorialists turned increasingly to the subject of the modern city, aligned with the hard matter of the real world and with the male energies of city-building. Here they faced the ultimate test of art's ability to transmute: its power to transform the urban, industrial reality into the stuff of poetry—to change matter into spirit. In the case of photography, the challenge was doubled, as the photograph itself was a technological product of modernity.

**"PICTORIALIST" PHOTOGRAPHY.** The Flatiron Building, designed by Daniel Burnham (1846–1912) and completed in 1902, was photographed numerous times in the first decade of the twentieth century. Rising twenty stories to 300 feet, it was not the tallest building in lower Manhattan, but it was among the most striking. Situated at the triangular juncture of Broadway and Fifth Avenue, the building echoes its site by being similarly three-sided. From the north, its mass appeared to Alfred Stieglitz like the prow of a great ocean liner slicing through the urban fabric of New York—a symbol of the titanic power of American business,

which the Pictorialists set out to rival. Writing in 1902, the critic Charles Caffin projected the modern artist as a man of business "who puts into a picture as much ... force of mind as another man puts into the building of a great business."[26] Edward Steichen's multiple views of the Flatiron (**fig. 12.23**) approach it across rain-soaked streets; through the delicate tracery of tree branches; or juxtaposed against the silhouetted forms of carriage drivers at twilight or in dim winter light, its looming mass pushed back into the middle distance. The globe lights of the newly electrified city appear like Chinese lanterns, festive pinpricks in the mood-filled urban night. As the Thames Embankment had earlier served Whistler, and as Brooklyn Bridge would later serve modernist poets and artists in the 1920s, the Flatiron embodied the promise of a crude commercial civilization redeemed through visual and poetic metaphor, its massive bulk etherialized through blurring of outline and tonal nuance.

In its struggle to establish itself as an art, Pictorialist photography renounced the very qualities that would come to distinguish photography as a medium: precise detail, sharp tonal distinctions, visual clarity. In place of delineation was suggestion, a retreat from the analytical vision associated with science. Many of the first generation of modernist photographers—Stieglitz, Edward Steichen, Paul Strand, Alvin Langdon Coburn—began as Pictorialists. Stieglitz, unlike his colleagues, preferred not to manipulate his negatives or to stage his photographs. But he cultivated a grainy imprecision by making exposures in low light, on foggy, snowy, or rainy days. In 1932, a critic of photography,

12.23 EDWARD STEICHEN, *The Flatiron—Evening*, 1909 (from a 1905 negative). Gelatin silver photograph, 18¾₆ × 15⅛ in (46.7 × 38.1 cm). Metropolitan Museum of Art, New York. Alfred Stieglitz Collection.

12.24 ALFRED STIEGLITZ, *The Hand of Man*, 1902. Gelatin silver print, 3¼ × 4⁷⁄₁₆ in (8.3 × 11.2 cm). J. Paul Getty Museum, Los Angeles, California.

looking back on Stieglitz's early work, wrote about his 1902 photograph of an industrial railroad, *The Hand of Man* (**fig. 12.24**): "a study of glinting rails and a plume of smoke under the pall of an approaching storm, that contains, in its black and gray gamut, the terror and tragedy of an entire era." A good part of Stieglitz's greatness, for his contemporaries, was his critical vision of modernization, and his desire to bear witness, both aesthetic and moral, to the world it had wrought. The aesthetic beauty of his photography remains in tension with its subject matter—an urban environment robbed of poetry and life, oppressing the human spirit. Stieglitz's early Pictorialism faced decisively toward the new century in grappling with the industrial and urban subjects that were to become one mark of the new American art.

## The Beginnings of Photographic Modernism

Photographic modernism in the United States rejected Pictorialist staging and manipulation in favor of a "straight" approach. The term "straight" meant that a photographic print was not manipulated: with the rise of modernist photography, it referred to a style of sharp focus, strong contrast, and direct engagement. As a black and white medium, photography conformed with the modernist tendency to see the world as abstract form. It endowed shadows with substance, telescoped and flattened space, and juxtaposed planes of vision. Photography thus helped artists see abstractly.

***THE STEERAGE.*** Years after he made his most famous photograph, *The Steerage* (**fig. 12.25**), Stieglitz explained its genesis during a trip to Europe in 1907 on board a "fashionable ship." Eager to escape the pall of privilege and money in his first-class quarters, Stieglitz wandered to the end of the deck, where he looked down on the "steerage," the lower deck of the ship reserved for the poorest travelers. He reported that "The scene fascinated me: A round straw hat; the funnel leaning left, the stairway leaning right; the white drawbridge, its railings made of chain; white suspenders crossed on the back of a man below … a mast that cut into the sky, completing a triangle. I stood spellbound," the photographer wrote, possessed by "a new vision that held me: simple people; the feeling of ship, ocean, sky; a sense of release that I was away from the mob called rich." The relationship of shapes to other shapes at that moment taught Stieglitz to see photographically. This aesthetic impulse—"a new vision"—vied with the social content of the experience: an encounter with class difference.[27] For Stieglitz, the internal act of vision took precedence over the act of social documentation that drove the photography of Lewis Hine (see above). The encounter with social realities was merely the point of departure for a subjective experience of aesthetic ordering, seized from the flux of modern life.

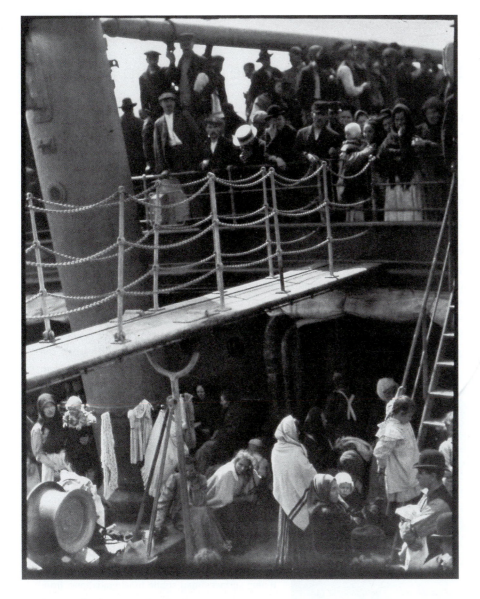

12.25 ALFRED STIEGLITZ, *The Steerage*, 1907. Photogravure, 12⅛ × 10⅛ in (32 × 25.7 cm). Library of Congress, Washington, D.C.

**PAUL STRAND.** A father figure for American photographers, Stieglitz with his overbearing presence inspired intense reaction. Paul Strand, though initially supported and mentored by Stieglitz (who first showed his work at Gallery 291 in 1916), established a different direction over the course of his long career. For Strand, departing from the inward orientation of his mentor, the aesthetic and the social would remain intimately intertwined. Strand's *Wall Street, 1915* (**fig. 12.27**) shows his genius for combining an abstracting vision with social commentary. A view of J. P. Morgan's Guaranty Trust building, Strand's photograph condensed a feeling, widely held by artists around Stieglitz, that America's growing and massively scaled corporate culture was incompatible with a humane social order. Years later, in 1951, Strand wrote about *Wall Street*, "I was … fascinated by all these little people walking by these great

big sinister, almost threatening shapes…." He was, he explained, "trying to photograph the 'rushing to work'"; the black shapes reminded him of "a great maw"[28] ready to crush the lilliputian humans who walk by. *Wall Street* gave material form to the unease inspired by the financial giants who were shaping the early twentieth century. For Strand, like Stieglitz, the creative autonomy of the artist developed in resistance to the dehumanizing effects of modernity. To see photographically was to bring an aesthetic organization back into a world in which a sense of underlying order had been disrupted by the forces of historical change. Photographers as artists bridged machine civilization with culture, synthesizing mechanical means and humanist ends. Originating in a similar vision, Strand and Stieglitz would put their practice of **straight photography** to fundamentally different uses in the next decades.

# Modernist Photography in the 1930s and the f.64 Group

"TO SEE THE THING itself is essential; the quintessence revealed direct, without the fog of impressionism."[29]

The practice of "straight" photography has arced over the twentieth century, and across a range of genres from documentary to art photography. If documentary tended to disguise these choices beneath a veneer of "objectivity" or transparency—the rhetoric of the real—art photography in the 1930s made them quite apparent, highlighting aesthetic choices from lens and camera type to decisions about framing, lighting, and printing. "Art" photography thus refers to the self-conscious practice of the medium as an aesthetic form, having its origins in the modernist photographers around Stieglitz.

The first generation of American modernist photographers, following Stieglitz's lead, had demonstrated the power of photography to reframe and transform reality. This impulse to renew vision—jolting it out of the rut of custom and returning it to a condition of first encounter—also jettisoned conventional notions of beauty, disregarding older aesthetic hierarchies. Such power of vision has held an abiding appeal for photographers throughout the twentieth century, but perhaps nowhere more so than in northern California in the 1930s. In 1932 a group of photographers, men and women based in the San Francisco Bay area, banded together to form a group they called f.64, dubbed "California Sharp." Members included Ansel Adams (1902–84), Imogen Cunningham (1883–1976), and Edward Weston (1886–1958), all of whom helped reshape the look of American photography; Adams in particular enjoyed considerable popular success in photographs of Californian nature that extended the grandiose vision of such nineteenth-century predecessors as Carleton Watkins (see fig. 9.22). The name "f.64" referred to the camera's focal length of 1:64. The group preferred large-format cameras, small apertures (assuring deep focus), and contact printing. Such preferences unified the group's varied personalities. Like the artists around Stieglitz, in particular O'Keeffe and Strand, f.64 frequently worked in close-up, isolating objects from their context in order to allow a sustained confrontation with the thing itself—its abstract formal properties, its textures, its patterning of light and shade, the ambiguous play of two and three dimensions on its surface. Edward Weston's *Pepper, no. 30* (**fig. 12.26**) tightly frames the object, whose glistening surfaces map subtle tonal gradations, from velvety blacks to reflective highlights. In its sinuous folds and muscular arcing forms, the pepper conjures associations with the human body, suggesting sleek animal shapes, and charging the vegetable with animate, erotic energies. Here, the camera serves imagination through a rigorous process of selection and focus, specificity of form expanding into metaphorical meaning. In the words of Ansel Adams, describing a practice he traced to Stieglitz, the f.64 group taught those who cared "to venture forth from the safe ritualistic shelter of the commonplace and look for themselves."[30]

12.26 EDWARD WESTON, *Pepper, no. 30*, 1930. Gelatin silver print, 9⅜ × 7½ in (23.8 × 19 cm). George Eastman House, Rochester, New York.

Unlike Stieglitz, who worked in thematic series that investigated aesthetic problems of form and used nature to explore shifting interior moods, Strand's energies moved outward, toward new regions of the world, from rural New England and Nova Scotia to Europe and Mexico; from landscapes to close-up studies of objects, elements of nature, machinery, portraits, city views, and photographic essays of village and regional cultures. As early as 1917 he had written that photography's greatest strength was its absolute objectivity. Deeply concerned with modernist formal language, he placed it in the service of social encounter: "I think that what exists outside the artist is much more important than his imagination. The world outside is inexhaustible ... I've always wanted to be aware of what's going on in the world around me, and I've wanted to use photography as an instrument of research into and reporting on the life of my own time.... I'm not trying to describe an inner state of being."[31]

12.27 PAUL STRAND, *Wall Street, 1915*, originally published as *New York* in *Camera Work*, no. 48, October 1916, pl. 25. Photogravure, 11¼ × 7¾ in (28.5 × 19.6 cm). Canadian Centre for Architecture, Montreal.

# Conclusion

The art of the urban realists, and the first phase of American modernism in painting and photography, found their most vibrant expression in the years around World War I. They emerged in tandem with the call for a self-consciously American art that resounded as well in poetry, dance, theater, and movements of social and cultural renewal. Dove, O'Keeffe, and Marin continued their associations with Stieglitz for several more decades, still bound to expressive abstraction while moving into new subjects and new landscapes. Yet their most original contribution to the arts of the new century was made by 1920, as was that of the urban realists around Robert Henri.

In these same years, a separate current of modernism was catalyzed by more direct contact with Europe and with European artists. The Armory Show of 1913, in tandem with the arrival of artists fleeing wartime Europe after 1914, took this current of modern American art beyond its native roots, by introducing an unfamiliar language of irony, by reconceptualizing the practices of art making, and by acknowledging, as no American artist had up to this time, the radical implications of technology on the aesthetic realm.

# 13 Transnational Exchanges: Modernism and Modernity Beyond Borders,

## 1913–1940

A<small>T THE BEGINNING</small> of the twentieth century, developments in European modernism began to have a profound effect on the direction of American art. Between 1913 and 1940 the artistic encounter between America and Europe underwent three distinct phases. In the first, American artists and audiences encountered European modernism through exposure to European art in publications and through travel to Europe. This phase culminated in a watershed event: the Armory Show of 1913, a large-scale international exhibition of art in New York City that opened the floodgates of European modernism to the broader American public. The experience of industrial heir, poet, and collector Walter Arensberg was emblematic: his initiation into modernism began at the Armory Show, which so captured his interest that he forgot to go home for three days.[1] Thereafter, he and his wife Louise went on to assemble the exceptional modernist collection that can now be seen at the Philadelphia Museum of Art.

In the second phase, European artists in New York encountered American modernity and made it the subject of their art. Propelled out of Europe by social turmoil and war, European artists became fascinated, not by American art, but by modern America, which they saw as unfettered by tradition, and brimming with the energies of popular expression, from jazz, film, and advertising to the infatuation with machines. European artists in New York delighted in America's expanding consumer culture as a source for their own playful inventions. They assumed new identities that flouted the cultural, social, and sexual norms of conventional society. In America's modernity they discovered the subject matter for a new twentieth-century art.

In the third phase, American artists integrated these two perspectives, by internalizing both the Europeans' modernist formalism and their enthusiasm for the dynamism of American culture in a startlingly fresh language of abstraction. The European enthusiasm for America helped American artists to overcome their own reluctance to engage technological modernity. Likewise, the ironic humor Europeans found in the machine-based, comfort-obsessed consumer culture of the United States was taken up by American artists living and traveling in Europe after World War I. Like European expatriates in America, American expatriates in Europe also played with social, gender, and racial identities in the relative freedom afforded by a foreign land.

The crosscurrents of international influence were especially distinctive in sculpture and architecture. In the medium of sculpture, European émigrés found a new freedom exploring American **vernacular**, popular, and folk materials, while American sculptors turned to **direct carving**, a technique associated with non-Western cultures. Paradoxically, these primitivizing approaches turned away from the modernist engagement with technology, finding inspiration instead directly from natural materials such as wood and stone.

In architecture the role of cultural exchange was even more pronounced. While reform-minded American designers looked abroad for inspiration, European designers—finding their way toward an architecture of pure

(opposite) **MARSDEN HARTLEY**, *Portrait of a German Officer*, 1914. Oil on canvas, 68¼ × 41⅜ in (173.3 × 105.1 cm). Metropolitan Museum of Art, New York. The Alfred Stieglitz Collection, 1949.

volumes and structural integrity—looked to American grain silos, exhibition buildings, and factories. Ultimately, European modernist ideas—derived from construction in the United States—shaped the emergence of American architectural modernism in the years around World War II when architects and designers from Germany and France emigrated to New York, Boston, Chicago, and Los Angeles.

The encounters of this era illustrate the co-evolution of American modernism and international developments. These exchanges were driven by the push and pull of opposing forces: the cataclysmic end of the old order in Europe, and the emergence in America of a youthful society of unprecedented abundance and dynamic energy.

# American Apprenticeship to European Modernism

American artists have always taken what they needed from the European tradition, recombining various sources, and choosing those elements of European art that best suit their own purposes. Until Alfred Stieglitz began a series of exhibitions at his 291 Gallery in 1908, works by the leading French modernists were unavailable to the art-going public. Private collectors began to acquire late-nineteenth- and early-twentieth-century European art only after World War

I, as Old Master works exceeded their budgets. The opening of the Museum of Modern Art in 1929 and the Whitney Museum of American Art in 1931 signaled the beginning of a large-scale institutional commitment to collecting modern art, although the ground had been laid by more informal exhibition spaces (see page 426).

## Before the Armory Show

The first generation of American modernist artists underwent their earliest exposure to modern art movements by going to Paris, where they had direct contact with European ideas and experimentation. They also learned of developments in French modernism through foreign journals carrying reproductions. At the home of expatriate Americans such as the brother and sister Leo and Gertrude Stein, many Americans first confronted the work of the masters among foundational modernists. At the Paris Salon d'Automne they could see the work of the Fauves, above all Matisse, whose non-naturalistic use of color proved liberating. American artists eager to try new approaches to pictorial space learned by imitation, studying the Cubist fracturing and faceting of the picture plane, as well as the uses of abstraction among the international avant-garde who gathered in Paris. Whether their masters were Cézanne, Matisse, Picasso, or Kandinsky, the results were often awkward and plainly derivative. For the strongest artists, however, such transitional work was a necessary stage on the path to a more personal style.

**AN AMERICAN IN PARIS.** European modernism proved a flexible language that could accommodate a range of materials and idiomatic expressions. Among the young

13.1 MARGUERITE ZORACH & WILLIAM ZORACH, *Maine Islands*, 1919. Needlepoint and pencil on canvas, 17¾ × 49¾ in (45.2 × 126.4 cm). National Museum of American Art, Smithsonian Institution, Washington, D.C.

13.2 HENRI MATISSE, *Le Bonheur de Vivre*, 1905–6. Oil on canvas, 69 ⅛ × 94 ⅞ in (175 × 241 cm). The Barnes Foundation, Lincoln University, Merion, Pennsylvania.

artists who traveled to Paris in search of new artistic worlds was Marguerite Thompson (1887–1968), from northern California. Studying briefly at Stanford University, she spent the years from 1908 to 1911 in Paris. Like so many other young American artists there, she visited the Salon d'Automne, where she saw the work of the Fauves. She visited Gertrude Stein (1874–1946), a friend of her aunt, and there gained further exposure to Matisse, whose work helped form her as an artist. She met her husband, the sculptor William Zorach (1887–1966), among the Parisian community of American artists. Returning to New York in 1912, Marguerite and William Zorach joined the bohemian culture of Provincetown, where they shared a life of art that accommodated their growing family and limited income. Marguerite, trained as a painter, took up embroidered tapestries in the 1910s; in tapestry wools she found colors more vibrant than she could find in paint, satisfying her Fauvist-influenced sense of color and her growing modernist taste for abstract pattern. Into the traditional needle arts mastered by generations of American women, she incorporated the joyous themes of earthly bliss and voluptuous pleasures in

nature first explored by Matisse. *Maine Islands* (**fig. 13.1**) was done in collaboration with her husband, an American version of Matisse's *Le Bonheur de Vivre* (**fig. 13.2**). As William wrote of the paintings they both did on related themes, "There were no problems in them … only a joyous awareness of the world about us. Flowers bloomed, wildlife carried on, clouds floated … Nude figures lay around pools, played with children, made love, dreamed."[2] *Maine Islands* also reflected the growing vogue for American folk art in its naïve style and in the patterned qualities of the tapestry yarn. Marguerite Zorach would continue to work in embroidery for several more decades; in a medium long associated with the feminine (therefore minor) domestic arts, she found the same formal challenges as those posed by modernist painting. Years later she wrote that "All the constructions and relations you find in painting are in the tapestries—just the technique and the materials are different."[3]

## The Armory Show

In 1913, the level of public exposure to European modernism—already prepared by a decade of cultural exchange—increased exponentially. The International Exhibition of Modern Art, known as the Armory Show for its location at the 69th Street Armory in New York City, brought together some 1600 paintings and sculptures by artists on both sides of the Atlantic (**fig. 13.3**). The previous generation of American artists had stood as equals in the art worlds of France and Germany. Now in 1913 they found themselves once again in a position of tutelage to developments occurring elsewhere. For some, the Armory Show was an infuriating spectacle of lapsed values, of artistic individualism run amok, an assault on the universal and timeless traditions of form serving moral decency and cultural enlightenment. Others protested that it made the American art world once again a colony of Europe. But for many younger artists, the experience of the Armory Show was liberating, transforming their fundamental understanding of as an autonomous language no longer tied to nature. For example, Stuart Davis (1894–1964) was particularly impressed by the paintings of Paul Gauguin (1848–1903), Vincent van Gogh (1853–90), and Matisse,

whose broad generalizations of form and non-imitative use of color resembled approaches he had begun to explore in his own practice. Across a wide spectrum of responses, the cultural impact of the Armory Show was unprecedented. After 1913, no one could afford to ignore its lessons.

Among these was a new way of understanding the history of art. The organizers of the Armory Show—Walt Kuhn, Arthur B. Davies, and Walter Pach, all of them members of the Association of American Painters and Sculptors—spent months in Europe surveying the latest developments and securing loans for the show. They took their lead from a series of large-scale exhibitions held in London (1911 and 1912) and Cologne, Germany (1912), whose purpose was to ground modernism in a longer perspective reaching back to the early nineteenth century. Artists such as Goya, Ingres, and Delacroix now appeared as grandfather figures; their interest in "plastic values"— the internal composition of line and volume which, wedded to content, offered the artist a new form of communication—gained them a place in the modernist pantheon. They were followed by Corot, Manet, and the Impressionists, opening into a now familiar canon of artists linked to a heroic history of modernism.

Framing the history of modernism in this way validated a tradition of artistic experimentation. Modernism found a place not only in the longer history of European culture

13.3 Armory Show, International Exhibition of Modern Art, 1913. Photograph. Museum of Modern Art, New York.

but in an American history of revolutionary change from old to new orders. The organizers of the Armory Show took as their symbol the uprooted pine used on the flag that the rebelling colonists from Massachusetts carried into battle. Mabel Dodge, already immersed in modernism through her friendships with Gertrude Stein and others, compared the Armory Show to the signing of the Declaration of Independence. Dodge's euphoria exposed a wider faith in the transatlantic nature of modernism, transcending national identities. For her, the Armory Show signaled a triumph of the new over the stultified cultures of both Europe and the United States. Echoing this vision, the collector John Quinn insisted that Americans need not react defensively to the lessons of the Armory Show: "Tonight will be a red-letter night in the history not only of American but of all modern art."[4] On the closing night, fueled by bottles of champagne, and accompanied by a fife and drum corps, artists, guards, and onlookers snakedanced their way through the exhibition, cheering the paintings.

Modernism was more than the latest import from Europe, however. It fundamentally transformed the way people saw. As Quinn wrote afterwards, "When one leaves this exhibition one goes outside and sees the lights streaking up and down the tall buildings and watches their shadows, and feels that the pictures that one has seen inside after all have some relations to the life and color and rhythm and movement that one sees outside."[5] Yet not everyone was prepared to accept the overthrow of the naturalistic language of representation evident at the Armory Show. Conservative members of the National Academy such as Kenyon Cox saw the new art as "the total destruction of the art of painting,"[6] a form of individualism that challenged received cultural authority. Humorists ridiculed the strange new styles, calling Cubism "an explosion in a shingle factory." Some, respecting the authority the new art carried with critics, were prepared to accept it on trust as the prelude to serious and original work by American artists, to paraphrase ex-president Theodore Roosevelt's skeptical reaction to the exhibition. No doubt, a feeling of cultural inferiority propelled a desire to understand, along with frustrated outbursts.

## DUCHAMP'S *NUDE DESCENDING A STAIRCASE NO. 2.*

One of the great sensations of the Armory exhibition was Marcel Duchamp's (1887–1968) *Nude Descending a Staircase no. 2* (**fig. 13.4**). As the high-end gossip magazine *Vanity Fair* reported, "it was discussed at dinner parties, at dances, … in editorials. … It caused more disputes than politics."[7] What was so troubling about the painting? *Nude Descending* was inspired not only by Duchamp's interest in Cubism but also by his fascination with stop-action photography as

13.4 MARCEL DUCHAMP, *Nude Descending a Staircase*, no. 2, 1912. Oil on canvas, 58 × 35 in (71.1 × 88.9 cm). Philadelphia Museum of Art, Pennsylvania.

it developed simultaneously on both sides of the Atlantic. His painting was a shocking departure from the venerable tradition of the nude in European culture, in which the body is shown as a sensuous unity. In place of "the human form divine" is a series of overlapping planes, reduced to underlying geometries. The movement of the body is rendered into component parts that resemble the rhythms of a machine. And—most disturbing—Duchamp's nude is neither identifiably male nor female, suggesting, once again, the genderless character of a machine. Behind

Duchamp's concept were the photographs of Jules Etienne Marey in France, and Eadweard Muybridge in the United States (see fig. 11.28), which broke continuous movement down into discrete photographic moments. Working on opposite sides of the Atlantic, these photographers brought two modes of seeing into dramatic confrontation: analytic vision—furnished by the camera—and the organic language of the body. But it was a European artist—Duchamp—who explored the implications of this shift in perspective on traditional notions of the body. Muybridge demonstrated the capabilities of photography to seize an image of life from the stream of perception, allowing study, analysis, understanding, and a renewal of vision. By the mid-1920s, stop-action could capture bullets passing through soap bubbles, at exposure times of 1/3,000,000 of a second.[8] Yet many among those who celebrated Muybridge's achievement in the realm of technology repudiated its applications to art, demonstrating once again the considerable gap between artistic/aesthetic culture in the United States and the scientific and social energies that would shape the nation in the twentieth century. Duchamp's *Nude* reunited the divided spheres of art and machine, and offered an alternative version of a new modern American art untethered from earlier histories.

# American Modernity, From Both Sides

There was not one but several American modernisms. Artists of the period were captivated by the spectacle of American modernity, both its technological and its urban forms. Captivation, however, implies a range of attitudes, from celebration to ambivalence and distrust. All of these attitudes are evident in artwork that engaged themes of modern American life—machines and bodies, industry, jazz and consumerism, sex, and the city, and—framing it all—the contentious love affair between America and Europe itself. From both sides of the Atlantic, motivated by both admiration and recoil, artists grappled with the central role of American modernity in the new century.

## New York Dada: A Transatlantic Collaboration

"The machine has become more than a mere adjunct of life. It is really part of human life ... perhaps the very soul"—*Francis Picabia.*

## Winning the Public Over to Modernism

THE ARMORY SHOW resulted in a new effort to educate the public in the mysteries of modern art. This effort took shape first through a steady stream of books that attempted to explain it to a wide public, beginning with Arthur Jerome Eddy's *Cubism and Post-Impressionism* (1914). In 1924, Seldon Cheney's *Primer of Modern Art* predicted that modern art would soon appear as inevitable as "death or taxes" (page 5). In the 1920s, a number of organizations and exhibitions exposed the public to ongoing developments in European art—Constructivism, Bauhaus, and other movements—including Katherine Dreier's Société Anonyme, Albert Gallatin's Gallery of Living Art in lower Manhattan, and the Harvard Society of Contemporary Art.

Despite these efforts at "mainstreaming" modernism, denunciations of the new art remained a persistent feature of the public reception of aesthetic forms that challenged conventional notions. Conservatives saw modernist art as a symptom of insanity, idiocy, Communist conspiracy, criminality, or bad eyesight (one prominent Chicago patron formed an organization called "Sanity in Art," which promoted the idea that abstract artists were astigmatic). Conservative critics in the 1910s and later linked abstraction, Expressionism, and other forms of modernism to dangerous foreign influences undermining the traditional values of the nation. Calling it "Ellis Island art," they associated it with immigrants—many of them Russian Jews fleeing persecution—whose presence they felt was diluting the values of an older America. Reactions against modernism coincided with currents of cultural isolationism. During such times, many Americans who felt threatened by changes in the economy and by the emergence of an increasingly multicultural society took refuge in an older version of American life that they felt was under siege by modernity. Modern art embodied their anxieties about a changing America.

"The machine is the religious expression of today"—
*The Little Review* II, No. I (Spring 1925).

By the early twentieth century, the United States was the most fully mechanized and industrially advanced country in the world. As the American-born Frenchman Eugène Jolas wrote in *transition* (June, 1930), here was a nation where "the social and human structure is ineluctably permeated with the ideology of the machine."[9] Machines had fundamentally transformed the ways in which urban Americans (by 1900 the greater part of the population) experienced time and space. Throughout much of the nineteenth century, art and the machine had been what Henry Adams would call "two realms of force," that of culture (mind, imagination, and creative expression, freed from utilitarian needs, as well as ethical ideals and spiritual aspiration) and that of society (industry, finance, and the governing institutions that created the infrastructure of the social world). Art, a product of human imagination and freedom, was defined in a manner that excluded the machine. But this older habit of mind overlooked the fact that the machine was itself a product of human imagination.

"Industrial civilization," wrote one philosopher, "must either find a means of ending the divorce between its industry and its 'culture' or perish."[10] A new modernist culture would have to embrace the machine as a major element. Machines were no longer things to be avoided in the search for a higher life that had dominated the genteel culture of the late nineteenth century. Now they claimed the interests of artists as the subjects of art; as new instruments with which to make art (the still camera, the motion picture camera, and the airbrush were all machines); as furnishing new principles of aesthetic organization; and as aesthetic objects in their own right. In short, a machine age called for a machine art. At the same time, however, World War I offered a horrifying display of machine-driven mass destruction, casting a dark shadow over this love affair with technology.

**EMIGRÉ INFLUENCE.** What is most remarkable about this aesthetic embrace of America's technological modernity was that it happened first among European artists. Only in the wake of this European encounter would American artists come to appreciate the artistic potential of their own society. World War I brought an influx of new creative personalities. The cultural bonuses provided by their arrival in New York were many: they made fun of the pieties that ruled American art, introducing irony, attacking entrenched notions of "high art," and adding a welcome measure of sheer silliness to the proceedings.

In 1915 Marcel Duchamp and other émigrés in flight from the war in Europe inspired a new kind of artistic activity which came to be known as New York **dada**. Preceding the official birth of international Dada in 1916 in the European capitals of Berlin, Zurich, and Paris, it was the product of a particular transatlantic exchange between French and American artists. In contrast to European Dada, which was fed by a deep sense of cultural exhaustion and disgust with the prevailing political and social order that had produced the war, New York dada sprang from a fascination with the exciting new forms of urban modernity taking shape on this side of the Atlantic. Leading the new art were Duchamp and Francis Picabia (1879–1953). Both had already been introduced to U.S. audiences through their works at the Armory Show. Bored by a New York art world earnestly pursuing its own brand of native modernism, these Frenchmen were far more engaged by American modernity—fast cars, fast women, machines, skyscrapers, and popular entertainment. New York dada assumed newly mobile gender identities, used found objects, and rejected aesthetic modernism—those forms of artmaking that centered around easel painting, pursuing a separate aesthetic language distinct from everyday forms. New York dada was the first genuinely transatlantic movement, bringing European and American artists together in a mutual exploration of machine-made modern America. Their example revitalized American art at a critical moment. But at the same time, their encounter with American modernity would produce radically anti-art gestures that left their mark on the subsequent history of the international avant-garde.

Duchamp had begun as a painter, part of a circle of avant-garde artists and writers who gathered in a suburb of Paris. Even before his presence at the Armory Show, he was showing signs of boredom with easel painting. He turned to chance procedures and **mechanomorphic** narratives involving witty commentaries on human sexual drives; he repudiated any willed aesthetic program. By 1913 Duchamp had given up painting and had created his first "**readymade**," a snow shovel which he hung from the ceiling and titled *In Advance of the Broken Arm*. Picabia in turn contributed the mechanomorph. Resembling anonymous mechanical drawings, these works portrayed human subjects as machines. Picabia's **mechanomorphs** mocked the quest for authentic selfhood and creative originality that obsessed his American counterparts. They revealed his combined sense of delight and anxiety over the prospect of a world where mechanical functions had displaced the human.

Picabia's *Ici, C'est Ici Stieglitz: Foi et Amour* (**fig. 13.5**) is an affectionately satirical mechanical portrait of his friend

Alfred Stieglitz as a box camera. Set on its face, bellows extended but sagging, Stieglitz-as-camera aspires heavenward but falls short of reaching the ideal (IDEAL, printed in Gothic script). Stieglitz's creativity is here linked to his masculine potency. Both, Picabia suggests, were less than fully functioning (this was two years before Stieglitz began his passionate relationship with O'Keeffe). The lens pointed upward suggests native modernism's (failed) pursuit of a form of visionary seeing based on nature. Picabia and Duchamp would both repudiate such forms of nature based on **retinal art**. Along with other forms of New York dada, Picabia's mechanomorphs wittily dispensed with modernist notions of self-expression in order to comment on the category of art itself. Pursuing an anemic idealism,

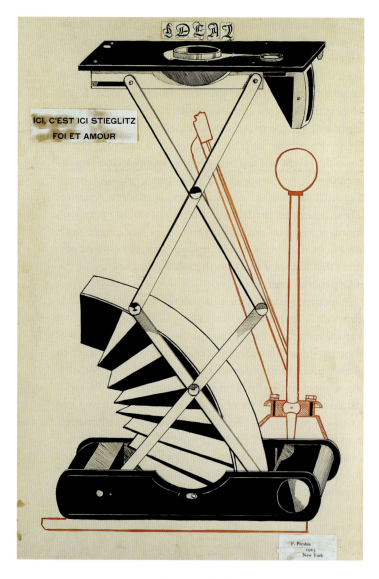

13.5 FRANCIS PICABIA, *Ici, C'est Ici Stieglitz Foi et Amour*, 1915. Pen, red and black ink on paper, 29¾ × 20 in (75.9 × 50.8 cm). Metropolitan Museum of Art, New York. The Alfred Stieglitz Collection, 1949.

Stieglitz's brand of modernism—or so Picabia's portrait suggests—lacked the creative spark that would ignite the engine of a new American art: his stickshift is in neutral and his car is going nowhere.

**GENDER PLAY.** Picabia and his colleagues delighted in giving the machine—traditionally associated with masculinity—feminine attributes. Technology and "manliness" had come to be closely allied in the late nineteenth century. The giant Corliss engine (see fig. 9.15) at the heart of the 1876 Centennial exhibition was characterized as "an athlete of steel and iron."[11] The French artists, however, humorously subverted such associations by linking the machine to the feminine. In so doing, they exposed the extent to which machines—far from being allies of masculine identity—threatened it in fundamental ways, much as women themselves were threatening male authority by their claims to greater sexual and social independence in the early twentieth century. Women also held increasing power in the marketplace as consumers, posing a further threat to male autonomy through the feminization of public space. The French émigrés in New York were keen analysts of American dreams and anxieties, scrambling older divisions between masculine technology and feminine culture. A decade later, the heroic figure of the masculine engineer, central to much American modernism, emerged to reassert the power of men over machines, and, by extension, over women.

For American genteel culture, male and female had been unquestioned absolutes, rooted in biological difference. Critical to New York dada's unsettling of bourgeois conventions grounded in nature was a new playfulness toward gender identity, as something socially performed rather than dictated by biology. Marcel Duchamp adopted a feminine persona (**fig. 13.6**, *Marcel Duchamp Dressed as Rrose Sélavy*), for which he cross-dressed as a woman. Duchamp's gender play drew upon a vibrant new popular culture centered in **vaudeville**, **burlesque**, and film. One inspiration for his coy persona (a pun on the French phrase "Eros C'est la Vie," translated as "Sex, that's Life") may have come from the popular theater of New York City in the opening years of the century. Julian Eltinge (**fig. 13.7**) was a transvestite performer whose fame crossed social lines to appeal to a wide audience. His spoofs on the manners and dress of upper-class ladies made cross-dressing a branch of legitimate entertainment, and continued with the inspired antics of Charlie Chaplin and Buster Keaton.

The patron saint of New York dada was the outrageous Baroness Elsa von Freytag-Loringhoven, who had emigrated to New York from Germany. The baroness paraded

13.6 **MAN RAY**, *Marcel Duchamp Dressed as Rrose Sélavy*, 1924. Gelatin silver print, 8½ × 6³⁄₁₆ in (21.5 × 15.7 cm). Philadelphia Museum of Art, Pennsylvania. Samuel S. White, 3rd, and Vera White Collection.

School" in New York, Man Ray (1890–1976)—like his close associate Duchamp, with whom he collaborated throughout the late 1910s and early 1920s—moved away from painting toward photography and found objects; in 1921 he left New York for Paris, where he established a twenty-year-long association with international Surrealist circles, and where he spent the bulk of his career.

The subversive humor of much New York dada lies in the sly manner in which the body—sexuality and desire, physical quirks and needs—reasserts its claims in spite of the American obsession with using technology to transcend the demands of physical life. Whether as machines for flying, eliminating waste, or winning eternal youth, such manifestations of technophilia—or worship of technology—bore the brunt of their humor. As Baroness Elsa—the diva of dada—put it in her broken English, "America's comfort:—sanitation—outside machinery—has made American forget own machinery—body!"[12]

13.7 **JULIAN ELTINGE**, *Julian Eltinge with and without the Julian Eltinge Cold Cream on His Face*, 1904. Photograph. Princeton University Theatre Collection, New Jersey.

through the haunts of the avant-garde, her head shaved and painted, wearing spoons, curtain rings, and headdresses of bird cages, and carrying a plaster cast of a penis with which she enjoyed shocking old ladies. The inspired madness of her performed life, her gender play, and her assemblages made out of found objects point toward new models of artmaking.

**THE PRIMITIVE AND THE MODERN.** Dada scrambled other distinctions that had organized bourgeois society on the eve of modernism. For instance, it blurred the boundaries between the **primitive** and the modern. Man Ray's photograph *Rebus* (**fig. 13.8**) exploits the accidental resemblances between very different things: here, the cross-section of a rifle, an industrial found object that, removed from its original context and positioned vertically, bore a striking similarity to "primitive" African sculpture. *Rebus* also combined male and female attributes, suggesting a seated man as well as the protruding belly and breasts of a woman. Having studied briefly at the Ferrer "Modern

13.8 (above) **MAN RAY**, *Rebus*, 1925. Bronze, 8¾ × 11 in (22.2 × 27.9 cm). Private Collection.

13.9 **BARONESS ELSA VON FREYTAG-LORINGHOVEN & MORTON SCHAMBERG**, *God*, c. 1918. Miter box and cast-iron plumbing trap, 10½ in (26.6 cm) high. Gelatin silver print. Metropolitan Museum of Art, New York. Elisha Whittelsey Collection, Elisha Whittelsey Fund, 1973.

13.10 (below) **RUBE GOLDBERG**, *Killer Stock Market Share Price Indicator*. Cartoon. Rube Goldberg, Inc.

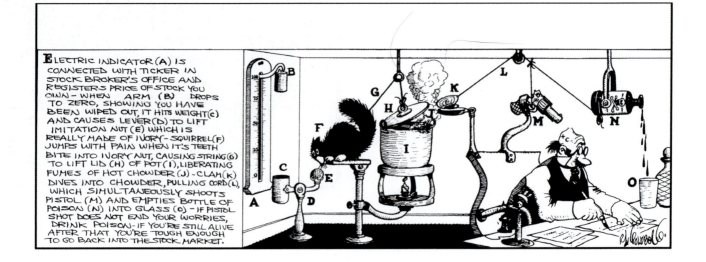

The Baroness titled her dada tribute to American plumbing *God* (**fig. 13.9**).

The Frenchmen were not alone in skewering America's obsession with machinery. The cartoonist Rube Goldberg, whose work was reproduced in Duchamp's little magazine *New York Dada* in 1921, found humor in America's substitution of machines for basic bodily functions and in its elaborate gadgetry for performing the most simple human tasks (**fig. 13.10**), be it making a pair of blue jeans or putting a bullet in one's head. As a popular medium, cartoons were freer than high art to engage the absurdities of everyday life, and they did so with considerable skill and inventiveness.

New York dada's most enduring contribution to twentieth-century art was the "found object," those anonymous products of American industry—bicycle wheels, urinals, egg beaters, and spark-plugs—which the dadaists displayed as "readymade" art.

## Duchamp and the "Readymade"

In 1917, Duchamp submitted a porcelain urinal to the show held by the New York Society of Independent Artists, an organization devoted to breaking the hold of the jury system over fine arts exhibitions. Duchamp offered the work under the pseudonym "R. Mutt" (**fig. 13.11**), a name that to most viewers evoked the cartoon character from *Mutt and Jeff* but which was also inspired by the J. L. Mott Ironworks, manufacturers of bathroom fixtures. Various collaborators—both men and women, fellow artists and patrons—have been suggested in Duchamp's act of aesthetic sabotage, which was directed at seeing just how far his American colleagues were willing to go in suspending aesthetic judgment on works declaring themselves to be art. His aesthetic provocation worked. The piece, entitled *Fountain*, was rejected by the exhibition organizers, all fellow artists, provoking a split within the organization and culminating in Duchamp's resignation from the Society's board. Alfred Stieglitz, the untiring defender of artistic freedom, intervened on his behalf, as did his patron Walter Arensberg, but to no avail. *Fountain* pulled the rug from under a number of stable notions about art: first, that art was different from the everyday; second, that it was the product of a creative act of making; and third, that it was the authentic expression of an individual sensibility. Finally, *Fountain* placed audiences in uncomfortable proximity with bodily processes, one of the very aspects of life that art was meant to transcend.

Critics writing about *Fountain* noted its ambiguous gender references. Everyone recognized it as a urinal, a receptacle for male fluids, yet turned upside down, the urinal now recalled in shape both a Madonna figure and an impassive, pear-shaped male Buddha, an association noted by several observers at the time. Such associations seemed obscene to many viewers. As with his cross-dressing, Duchamp used his found objects to unsettle received wisdom (a urinal is not a work of art), and to scramble distinctions between male and female. His work reflected critically on the historical assumptions behind much of art's history, by implying that art was a conceptual category rather than an essence. Art was what bore the label "art."

When Alfred Stieglitz photographed *Fountain*, he characteristically emphasized its aesthetic qualities by softening the light and setting the work against the background of a Marsden Hartley painting. The alternation of light and shadows on the porcelain object formed enigmatic shapes, transforming the object through association. These aesthetic qualities were noted at the time. Duchamp was quoted as saying that "beauty is around you wherever you choose to discover it."[13] His European colleagues expressed their admiration for this and several other of the artist's readymades: mass-produced objects such as snow shovels or bottle racks, divested of their use value to be

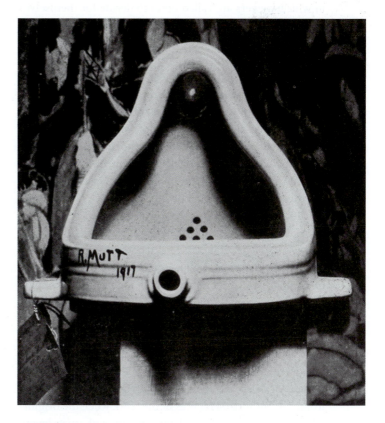

13.11 **MARCEL DUCHAMP**, *Fountain*, 1917. Original lost. Gelatin silver print photograph by Alfred Stieglitz, 9¼ × 7 in (23.4 × 17.7 cm). Philadelphia Museum of Art, Pennsylvania. Arensberg Archive.

made available as "art." Neatly reversing the objection of the Society jury that the urinal (an ordinary object) desecrated the sanctity of art, the French poet Guillaume Apollinaire (1880–1918) argued that calling an ordinary object art ennobled it. And, however outrageous, Duchamp's statement that America's plumbing and bridges were its greatest achievements conferred artistic value on the urinal as found object. His irreverent remark paid tribute to America's modernity by way of a backhanded compliment that simultaneously revealed the inability of American artists to make works to rival the nation's industrial products. The pursuit of cultural authenticity, Duchamp's act suggested, had produced nothing that could stand alongside the anonymous mass-produced industrial commodity.

"Whether Mr. Mutt with his own hands made the fountain or not has no importance. He CHOSE it. He took an ordinary article of life, placed it so that its useful significance disappeared under the new title and point of view—created a new thought for that object."[14] These words, most likely written in part by Duchamp himself, suggest that the aesthetic act consists of selecting rather than making; and of framing a familiar object in a new context in which viewers are called upon to decide for themselves what it means through a conceptual act. This was perhaps Duchamp's most radical move, because in doing so he challenged older forms of cultural authority that sought to dictate both the value and meaning of the work of art. Such "de-authorizing" of the authority vested in art-world voices proved most unsettling for the ostensibly non-juried Society of Independents, several of whom expressed outrage. *Fountain*'s pointed ambiguity opened up the range of possible responses audiences brought to his work; its refusal to be understood as one thing rather than another left the meaning to each individual.

Duchamp's insistence that anything could be denominated art subverted the venerated principle of artistic authorship. He redefined the realm of the aesthetic, opening it to the everyday, and relocating it not in the object but in acts of selection and naming. Duchamp uncoupled aesthetics from notions of beauty, and situated them in the recontextualizing act of seeing in an ordinary object something other than itself. His subversively democratic act was, however, largely overlooked at the time. *Fountain*, presumed to have been bought by Arensberg, was lost, broken, or destroyed soon thereafter. Duchamp, somewhat ironically, authorized replicas of the work when the original episode was uncovered by a later generation of artists beginning in the 1950s. Reframed in the context of Conceptual, Pop, and other movements in the 1960s, *Fountain* gained a new iconic importance as a foundational gesture. But locked into these different histories, the work and the gesture lose their original fluidity of meaning and become, once again, works of art like others in the museum.

Four years before Duchamp's provocative gesture of 1917, John Cotton Dana (1856–1929), pioneering director of the Newark Museum in New Jersey, actively collected and exhibited bathroom fixtures and other mass-produced objects previously off-limits to the museum. Unlike Duchamp, he frankly acknowledged them for what they were—products of American industry. Dana rejected the segregation of the museum from everyday associations. And he was prophetic in recognizing that modernism was not a movement limited to the high arts of painting and sculpture but one directed at redesigning everyday objects. Early on Dana recognized the contribution of German design, dedicated to integrating art and industry, with an exhibition of the Deutsche Werkbund in 1912. Inspired by their example, he put industrial objects—bathtubs and other plumbing fixtures—on display at the Newark. Banished from the realm of fine art exhibitions, Duchamp's urinal might have found a place in Dana's museum.

## Alexander Calder: Reinventing the Gadget

Driven by the encounter with French émigré artists, American art first engaged technology and machines in the 1910s. In the years between the wars, American artists (along with industrialists such as Henry Ford) began to think of the machine as having a history rooted in America's past. The parents of today's machines were yesterday's farm threshers, or the many-geared hand-turned devices of impossible ingenuity for peeling and coring apples. Seen from a European perspective, this American fascination with gadgetry was material for satire. For more than one émigré artist to the United States in the 1910s, the American obsession with means often obscured ends, as the manner of solving the problem became far more complicated than the problem itself. This perspective on American gadgetry helped form the sculptural imagination of Alexander Calder (1898–1976). As a young American in Paris, Calder cultivated a childlike whimsy that appealed to the French (Fernand Léger described his art as "100 percent American").[15] Calder brought good old American know-how to sculpture, along with a fascination with putting things together, an inventiveness toward new materials, and a background in mechanical engineering. He playfully engaged French stereotypes of the pragmatic American in love with plumbing, mocking this American obsession by

having an American flag wave every time the water closet (toilet) in his studio was flushed.[16] Calder's art made people laugh when they saw it, a response that violated the piety of high art, and put art on a different footing—whimsical, improvised, a sophisticated version of child's play.

Calder first made his name among the Parisian vanguard by performing with a toy circus he created out of wire sculpture and an elaborate series of strings, levers, and pulleys that set his tiny figures in motion (**fig. 13.12**). The circus, a subject long beloved of Europe's avant-garde, also had a distinctly American heritage. Cosmopolitan and American, it was the perfect subject for Calder's transatlantic vision.

To his delight in making things, Calder brought an appreciation for abstraction, heightened by his visit to the Paris studio of the Dutch modernist Piet Mondrian (1872–1944). From the recognizable subjects of his wire sculptures, Calder turned to mobiles—in which space is animated by small spheres, suggesting on a minute scale the immense distances of the universe itself (**fig. 13.13**). His sculptures wedded mechanical motions to nature in his use of **biomorphic** forms influenced by Surrealists like Joán Miró (1893–1983) and Hans Arp (1887–1966). In Calder's stabiles (set upon a stable base and immovable) and mobiles (suspended or supported from above and allowing movement), two-dimensional forms, cut out of sheet metal, are assembled into dynamic compositions. Calder's mobiles eliminated the traditional structural supports of sculpture, freeing it from the limitations of gravity by suspending forms from wires rather than placing them on a pedestal or base, viewed against a background. He transformed wire, sheet metal, and other industrial materials into objects of wonder, freeing them from associations with their utilitarian origins.

13.12 (left) **ALEXANDER CALDER**, *Circus*, 1926–31. Mixed media: wire, wood, metal, cloth, yarn, paper, cardboard, leather, string rubber tubing, corks, buttons, rhinestones, pipe cleaners, bottle caps, 54 × 94¼ × 94¼ in (137.2 × 239.4 × 239.4 cm). Whitney Museum of American Art, New York.

13.13 **ALEXANDER CALDER**, *Mobile (Universe)*, 1934. Motor-driven mobile. Museum of Modern Art, New York.

## Expatriation and Internal Exile Between the Wars

*"America is now early Victorian, very early Victorian, she is a rich and well nourished home but not a place to work. Your parents' home is never a place to work"*—*Gertrude Stein*.[17]

The 1920s was a decade of growing cultural self-consciousness as artists and writers struggled with divided feelings about their native home. Many American modernists were critical of America's business values and cultural shallowness, yet they nonetheless remained committed to a national art responsive to the present. They adopted a number of different approaches that allowed them to be "in the culture but not of it"—to engage American modernity in their work without becoming too closely identified with the cultural mainstream whose values they rejected. These included irony (a lesson learned from the émigré French artists of the 1910s) and temporary expatriation to Europe. Artists and writers of this generation spent long periods in Europe, eventually returning to make an uneasy peace with their native culture through the distancing strategy of irony.

The post-war devaluation of the French franc made living abroad affordable. Things that annoyed at close quarters charmed at a distance. The decision of many American artists and writers to remain abroad coincided with a vogue for things American—known in France as *Américanisme*. If European modernists turned their noses up at the art of America's academies and elite galleries, they openly embraced its popular culture: jazz, vaudeville, "negro songs," and the brash appeal of billboards, electric lights, and commercial messages emblazoned against the sky. In the 1920s the phenomenally successful African American cabaret and revue dancer Josephine Baker came to Paris from the Midwest (St. Louis); Louis Armstrong and Duke Ellington were all the rage. American artists, in short, went to Europe to discover America.

**IRONIC DISTANCE: GERALD MURPHY AND JOSEPHINE BAKER.** The European admiration for American modernity encouraged American artists to try new forms of artistic expression and to engage sources previously frowned upon by America's cultural elites because they derived from the "low" culture of advertising, commercial display, and found objects. From a safe remove, America's commercial forms of art became ripe for appropriation by this post-war

13.14 GERALD MURPHY, *Safety Razor*, 1924. Oil on canvas, 32⅛ × 36½ in (83 × 92.7 cm). Dallas Museum of Art, North Harwood, Dallas, Texas. Foundation for the Arts Collection.

generation. Transferred out of their business and advertising contexts, they became available for other kinds of cultural meanings. The artist and bon vivant Gerald Murphy (1888–1964) and his wife Sarah embraced American culture from the safe distance of the Left Bank of Paris or the Riviera. Murphy, a wealthy Yale-educated American, developed a visual idiom during a brief painting career (1922–9) that anticipated the Pop art movement of four decades later. Murphy took up painting not long after moving to Europe with Sarah. His friend the French modernist painter Fernand Léger (1881–1955), whose preference for monumentalized objects from everyday life resembled Murphy's own, pronounced him "the only *American* painter in Paris."[18] Like the French émigrés to New York before him, Murphy's paintings of overscaled fountain pens, safety matches, and safety razors (which the Mark Cross Company marketed) (**fig. 13.14**) commented wittily on Americans' naïve obsession with material comfort and consumer products that removed the element of risk and danger from life. Unburdened by the anxieties of the professional artist to prove himself within the arena of European modernism, Murphy unabashedly employed a commercial style. He made fun of the egomania of the self-made American millionaire ("Unknown Banker Buys Atlantic," screamed the front page of an American tabloid paper used as a backdrop for a comic ballet coproduced by Murphy and his friend Cole Porter). Murphy used the flat planes and unmodulated colors of advertising. To this he added the clean-edged precision of commercial illustration, a field in which he had training.

The Murphys' "Villa America" on the French Riviera was a gathering point for an international set of writers and artists, including Pablo Picasso and the Russian composer Igor Stravinsky (1882–1971). Among these visitors were Americans who traveled freely between Europe and the United States—including the writers Ernest Hemingway (1899–1961) and F. Scott Fitzgerald (1896–1940)—forming what Gertrude Stein had contemptuously dubbed the "lost generation" in a conversation reported years later by Hemingway himself. Like Murphy, they were in flight from a philistine culture mindless of the arts. "Living well was the best revenge"—to paraphrase Murphy—for their disappointment with the hollowness of a world the previous generation had created, and then destroyed in the Great War. In rebellion against the bourgeois values of their elders, the "lost generation" was well tuned to the French fascination with American popular culture after World War I. The Murphys and their guests danced the Charleston to the latest American recordings, drank American booze, and served their guests corn fritters. Performed for a

13.15 Josephine Baker with her banana skirt, c. 1927.

European audience, such activities lost their association with a crude materialist civilization and acquired the gloss of an uninhibited and exotic New World. By going abroad, expatriates like Murphy and Josephine Baker (1906–75) gained a measure of distance from those aspects of U.S. culture by which they felt trapped: an oppressive business environment on the one hand, and an entrenched racism on the other. Yet both skillfully exploited the very realities they wished to escape. Murphy transformed commercial graphics and advertising into art. Baker's stage persona—bare-breasted, and wearing a hip-hugging skirt of bananas—knowingly played on primitivist fantasies of the sexualized African (**fig. 13.15**). Each in their different ways turned confining cultural conditions on their heads, submitting them to irony, play, and satire. In the process, they achieved a creative triumph over the very circumstances that had driven them from America in the first place.

**HOMOSEXUAL EXILES: ROMAINE BROOKS, CHARLES DEMUTH, AND MARSDEN HARTLEY.** Europe offered other forms of liberation for those who wished to invent new identities for themselves. Romaine Brooks (1874–1970) was one of an international community of lesbian artists and writers who performed a range of new social, sexual, and gender roles for one another in the relative freedom of such oases as Paris and Capri. France, unusually tolerant toward same-sex love, became Brooks's primary home from 1905 on. The life she fashioned for herself there was made possible by family wealth. For Brooks's lesbian circle, androgyny—a cultivated sexual ambiguity—was linked to a sophisticated modern attitude of self-invention. Brooks's portrait of her friend Una, Lady Troubridge (**fig. 13.16**) employs a limited color range, enlivened only by Una's red lipstick, and an elegantly stark line linking the lady to her two dogs, to suggest the very stylized personality of the sitter. With her enormous monocle, arched eyebrows, and the severe cut of both her hair and her clothing, Lady Troubridge is the very type of the female dandy. It is somewhat ironic that Brooks and her lover—the wealthy heiress Natalie Barney—turned admiringly to fascism in the late

13.16 **ROMAINE BROOKS**, *Lady Una Troubridge*, 1924. Oil on canvas. Smithsonian American Art Museum, Washington, D.C.

1930s, a movement that declared all such forms of gender fluidity to be "degenerate."

For Charles Demuth (1883–1935) and Marsden Hartley, ambivalence toward American culture was further complicated by their homosexuality. Both artists were exhibited by Stieglitz, who supported Hartley financially throughout his life, while Demuth never felt entirely at ease with a nationalistic and heterosexual stance. Initially trained in Philadelphia, Demuth was shaped by his encounters with the various phases of European modernism: beginning in 1912, he produced sensuous watercolors of flowers and fruit, exploring metaphorical associations with the body and with sexuality. In the 1910s Demuth found a home in the avantgarde culture of New York dada. A friend of Duchamp's, he left his provincial origins in Lancaster, Pennsylvania, to reinvent himself as a European dandy in the metropolis of New York. There he painted the fast life of the city, from vaudeville to circuses and Harlem nightclubs. Watercolor washes bleed through his wavering pencil underdrawing. Within Demuth's deceptively casual linework flows a carefully cultivated energy, disbursed evenly throughout the surface, in modernist fashion eliminating the hierarchy of background/foreground. Until his death in 1935, Demuth alternated between these personally expressive, diaphanous watercolors and a crisp, hard-edged **Precisionist** style that brought his American roots to the fore.

In a body of private watercolors, Demuth also explored a new form of urban modernity—the culture of homosexuality that emerged in the public spaces of New York City in the early twentieth century. His watercolors of encounters between men in bathhouses and on beaches reveal an alternative network of urban social and sexual relations. In this world, male desire is communicated through the gaze, now however directed at other men, as in *Distinguished Air* (**fig. 13.17**). Demuth's watercolor humorously observes the circuit of sexualized glances taking place around the public exhibition of the modernist sculptor Constantin Brancusi's (1876–1957) *Mademoiselle Pogany*, whose phallic shape seems the public projection of private fantasies. Urban anonymity paradoxically permitted new forms of intimacy. Demuth's watercolors, like their subjects, circulated among particular audiences, their sinuous contours and delicately vibrating washes expressing a new sensuality. In the 1910s, when Demuth painted his sailors and sexually aroused male bathers, homosexuality was beginning to find its own expressive culture, based on recognizable codes of dress, social performance, and speech. As such it was part of a new urban environment shaped by pleasure and its pursuits: the colorful performers of vaudeville, burlesque, circus, cabaret, and jazz suggested an

13.17 CHARLES DEMUTH, *Distinguished Air*, 1930. Watercolor, 16³⁄₁₆ × 12⅛ in (42.6 × 30.5 cm). Whitney Museum of American Art, New York.

13.18 CHARLES DEMUTH, *My Egypt*, 1927. Oil on composition board, 35¾ × 30 in (90.8 × 76.2 cm). Whitney Museum of American Art, New York.

urban culture more physically and socially liberated than before. In the fluid social environment of the city, one could occupy many different social and personal roles simultaneously: professional, familial, and sexual. Even though he enjoyed Stieglitz's support in the 1920s, Demuth—like other members of the American avant-garde in these years—drew inspiration for his artistic and social experimentation from the popular culture of the metropolis. He occupied a different world from the virile heterosexual rhetoric and nature-based art of others in the Stieglitz circle.

Demuth's 1927 Precisionist painting *My Egypt* (**fig. 13.18**) directs our gaze upward toward the massive volumes of a concrete silo that fills the canvas. Beyond its study of intersecting planes and volumes—a self-consciously American riff on Cubism—*My Egypt* poignantly embodies Demuth's search for meaning in the unforgiving realities of America's industrial landscape. But *My Egypt* is also a symbolic exploration of exile within one's own country. Diagnosed with diabetes in 1921, he was forced by illness to abandon his international travels in order to return to his family in Lancaster, Pennsylvania. Making a virtue of necessity, Demuth turned his art to the silos, factories, warehouses,

and flimsy wood buildings that made up the aging fabric of many mid-sized industrial cities like Lancaster.

Demuth's understated irony paralleled that of his expatriate contemporaries, allowing him to use native subjects without becoming identified with the "America first" trumpeting and shallow patriotism that so often supported such themes. His reluctant decision to return home followed an exhilarating life in Europe. Reentry was a bitter pill.

The title *My Egypt* imagines Demuth's return to America in terms of the biblical exile of the Jews in Egypt. The connection comes in part through a familiar modernist association of the concrete silo with the enormous and powerful forms of the Egyptian pyramids. Demuth's use of the imagery of exile in the context of his return home suggests his ambivalence about his native land. *My Egypt* also records his sense of being overwhelmed by the sheer insistence of America's commercial/industrial presence, which blocks the horizon—long denoting the open space of the future. Yet *My Egypt* combines alienation from his native land with aesthetic admiration for its uncompromising forms. Demuth's towering icon of American vernacular ingenuity is flooded with light from

above; it confronts us with the massive monumentality of an ancient idol. And in its crisp and elegant arrangement of shaded planes and precise volumes, his style pays tribute to the meticulous design traditions of anonymous artisans.

Demuth's varied body of work expressed the divisions in his own life, vacillating between extremes of sensuality and austerity, tradition and innovation, past and present, private and public, Europe and the United States. Demuth transformed the crude materials of American life into a body of work striking for its visual refinement. His was a paradoxical modernism that took refuge in old industrial landscapes haunted by a persistent sense of loss. Asked in an interview in 1929 what he looked forward to, he answered "The past."[19]

Like Demuth, Marsden Hartley (1877–1943) felt alienated from the culture into which he was born. His career-long search for a spiritual and emotional home sent him wandering between Europe, New Mexico, Mexico, Maine, and Nova Scotia. Stylistically he was equally restless, moving from post-Impressionist landscape to iconic abstraction, and the expressionistic figurative and regional landscape subjects of his later career. Demuth, his friend and colleague, had moved back and forth between cosmopolitan elegance and works that explored his provincial American origins. Hartley likewise vacillated between European-inspired subjects and native visual traditions.

Europe offered Hartley—like others of his generation—a refuge from the commercial civilization of his native land. Following an initial stay in Paris, where he absorbed the lessons of Picasso and Cézanne, Hartley found his way to Berlin in the period just preceding the outbreak of World War I. There he found a social and artistic community

13.19 MARSDEN HARTLEY, *Christ Held by Half-Naked Men*, 1940–1. Oil on fiberboard, 40 × 30 in (101.6 × 76.2 cm). Hirshhorn Museum and Sculpture Garden, Smithsonian Institution, Washington, D.C. Gift of Joseph J. Hirshhorn, 1966.

in the pre-war avant-garde around Kandinsky and the painters of the *Blaue Reiter* (Blue Rider) group. In a series of Berlin works of 1914–15 (**p. 420**), Hartley created richly patterned heraldic designs into which he wove symbols—the abstract equivalents—of a young German officer killed in World War I, to whom he had become romantically attached. Iron crosses (German military emblems), and numbers and initials alluding to the regiment and name of the dead officer appear within a dense field of symbols including solar disks, eight-pointed stars, mandorlas, waving lines, and concentric circles. Coupling the immediate moment with symbols of universal meaning, Hartley struggled to redeem his personal loss.

Throughout his career Hartley remained drawn to **mysticism**, developing a visual language of occult symbols drawn from sources ranging from Native American cultures to medieval Christianity in an effort to find a personally expressive language. At these times he turned away from the transatlantic influences of international modernism and looked instead to native sources, seeking as well to capitalize on a growing critical and commercial taste for the American scene. Toward the end of his career, from 1939 to 1943, he found inspiration in the visionary intensity of Albert Pinkham Ryder. In these years he also painted monumental iconic figures of Canadian fishermen in the North Atlantic, such as *Christ Held by Half-Naked Men* (**fig. 13.19**). Calling these his "archaic portraits," Hartley used a

severely frontal composition, in which forms are simplified and flattened out. His move toward anti-naturalism drew him to sources as varied as the French painter Georges Rouault (1871–1958), ancient Egyptian *fayum* portraits, and folk painting. Such primitivizing techniques recall how earlier European artists responded to exotic non-Western subjects, from South Pacific to African. They also suggest Hartley's own yearning for a wholeness of experience that might remedy his persistent sense of homelessness.

**COMFORTABLY AT HOME IN THE NOT-AT-HOME: STUART DAVIS.** Stuart Davis—who began his career as an urban realist drawing scenes from New York life—first encountered European modernism at the Armory Show while still a very young artist. In 1928 he finally traveled to Paris for a year. When he returned he combined his apprenticeship to European modernism with his own cultural resources—among them jazz with its new syncopated rhythms, advertising, and billboards. Davis's *New York/Paris, no. 1* (**fig. 13.20**) imagines a world that is neither one city nor the other, but a product of both; a world where movement itself between the United States and Europe becomes the theme of his art. *New York/Paris No. 1* is a visual montage of images and objects associated with movement: a woman's stockinged leg caught in full stride; a station for the New York El, the elevated railroad; a dinghy and a fishing boat, associated with Gloucester,

13.20 **STUART DAVIS**, *New York/Paris*, no. 1, 1931. Oil on canvas, 39 × 54¾ in (99 × 139 cm). University of Iowa, Museum of Art, Iowa City, Iowa.

Massachusetts, where Davis had spent summers beginning in 1915. On the right is a streetside French café, and above it, turned on its side, the Chrysler Building, an instant icon of a glamorous new urban modernity. The narrative connecting these various elements is missing. This disjunctive approach suggests a life lived in many places simultaneously, and a mobile new identity comfortable with the dislocations of moving from place to place. Movement—and shifting cultural identities—were factors central to the new transatlantic artistic worlds of early modernism.

## Sculpture: The Primitive and the Modern

In painting, the lines between the old guard and the younger artists committed to modernism were clearly drawn. Such was not always the case for sculpture. Among the Americans representing sculpture at the Armory Show were academic sculptors like James Earle Fraser (see Chapter 9). They found themselves alongside sculptors such as Elie Nadelman (1882–1946), Alexander Archipenko (1887–1964), William Zorach (1887–1966), and Gaston Lachaise (1882–1935), who went on to establish a modernist idiom in sculpture in the following generation.

Bringing together tradition with modernism, sculpture in the years up to World War II represented other kinds of encounter. American sculptors joined an international interest in direct carving that had begun before World War I, literally grounding the figure in the massive forms of the pre-classical ancient world. In direct carving, the sculptor drew inspiration from the material itself, eliminating all conventional intermediary stages from sculptural mock-up to finished work—most commonly from clay or plaster into metal or stone. European émigrés and transatlantic sculptors from Elie Nadelman to Alexander Calder explored sculptural issues of buoyancy, freeing forms from gravity to float with the lightest of supports, or suspended in air. The modernist dream of escape from physical limits developed side by side with the direct carvers' heavy, earthbound forms recalling ancient prototypes.

### Direct Carving: Modernist Primitivism in Sculpture

It may seem odd that one significant current of modernist sculpture took shape using a technique as old as human representation itself: that of direct carving. Although already

practiced by a few American sculptors, direct carving was introduced to the public at the Armory Show as well as through Americans abroad and some European émigrés. It followed from the interest in folk art, where direct carving was widely used. The movement is best understood as an aspect of modernist primitivism inspired by the forms of pre-classical and non-Western expression rooted in an archaic past. Far from sloughing off the past in the manner of the modernists who pursued an abstract language of form, direct carvers redefined history for their own purposes, by inventing a past where primal impulses were unfiltered by conscious inhibitions or social repressions. Whether using stone or wood, modernist direct carvers renounced academic methods grounded in the Beaux Arts training that had dominated sculptural production on both sides of the Atlantic up to the turn of the century.

13.21 DANIEL CHESTER FRENCH, Large model in plaster, with the sculptor correcting a drapery fold, Chesterwood, 1914. Plaster. Chesterwood Archives, Chesterwood, Stockbridge, Massachusetts.

At the heart of this older academic tradition was the concept or governing idea behind the work. The idealized female figure, for example, served as the carrier for a multitude of allegorical or symbolic ideas—continents, virtues, personifications of various symbolic deities. Realistic portraiture was often combined with symbolic attributes—figures of Victory or Fame—as in the work of Augustus Saint-Gaudens (see fig. 11.17), in a manner that was calculated to elevate the specific to the universal.

According to established academic procedure, the sculptor first executed his idea in clay. This became the basis of a plaster cast, which in turn was used as the model for casting the final work in bronze (**fig. 13.21**). Alternatively, a sculptor could create a **maquette**, or small-scale study, which was then handed over to skilled technicians, who might then enlarge it or duplicate it in any number of materials. In stone, for instance, the use of a pointing machine allowed carvers to locate a point in space precisely, thereby furnishing a series of transfer marks from model to marble copy that made possible a precise scale reproduction of the original. As practiced by academicians, the hand of the artist was replaced in the final work by that of a studio workman who was intent, above all, on duplicating the original model, a process that tended to dull the expressiveness of the artwork's execution.

**WILLIAM ZORACH.** Direct carving, by contrast, engages the maker in the immediate properties of the material, while drawing inspiration from the shape, grain, texture, and hardness of a particular piece of wood or stone. The natural characteristics of the material, as discovered through the actual process of carving, inspire and determine the final form. William Zorach, one of the originators

of the direct carving tradition in America, recounted his turn from painting to sculpture as being inspired by a piece of butternut wood in his studio.

Along with a new attention to medium, sculptors and painters in the early years of American modernism emphasized the expressive possibilities of abstract form: of rhythm, repetition, balance, and opposition. Yet direct carvers also maintained ties to figuration. In their focus on the human form they continued the sculptural heritage of the late nineteenth century; but in every other way, their work was a departure from older sculptural traditions. Simplifying lines and volumes, they monumentalized the figure; rather than exploiting its tradition as a carrier of cultural values and meanings, they emphasized its archaic/elemental associations with nature. In his *Floating Figure* (**fig. 13.22**) Zorach shared this primitivist influence with European modernists such as Picasso; he and others acknowledged their new debts to the arts of Africa, and the pre-classical monumental traditions of Mesopotamia and Egypt. American sculptors also looked to American Indian forms. By the 1920s, direct carving techniques had been introduced into academic training at the Art Students' League in New York—part of the institutionalization of modernism in the years between the wars.

Direct carving methods were also part of a larger modernist reaction against machine production. Pointing—by which the artist's idea is realized through a mechanical system of reproduction—came to be associated with the alienated division of labor within industrial society. The return to artisanal modes of making carried the artist back to the origins of sculpture itself, and, many argued, restored the creative act to wholeness.

**JOHN FLANNAGAN.** John B. Flannagan (1895?–1942) distilled an aesthetic that combined the methods of direct carving with a belief in prerational modes of composition. He first began carving in stone around 1928. His approach

13.22 WILLIAM ZORACH, *Floating Figure*, 1922. Borneo mahogany, 9 × 33½ × 7 in (23 × 85.1 × 17.9 cm). Albright-Knox Art Gallery, Buffalo, New York.

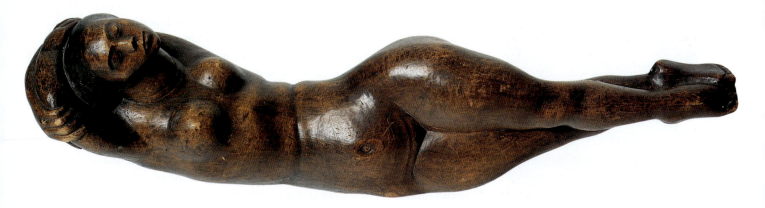

to sculpture was part of a wider cultural interest in the unconscious that took hold between the wars. Flannagan wrote of "the hand of the sculptor" as an "instrument of the unconscious." The creative act—responding to a "remote memory or a stirring impulse from the depth of the unconscious"—merely freed the abstract form imprisoned within it—"the image in the rock."[20] Direct carving was a means of thinking with one's hands. In a way similar to the **automatist** techniques of American artists influenced by **Surrealism**, Flannagan sought by his own account to relinquish creative will, desiring for his work the appearance of something as inevitable and impersonal as nature itself.

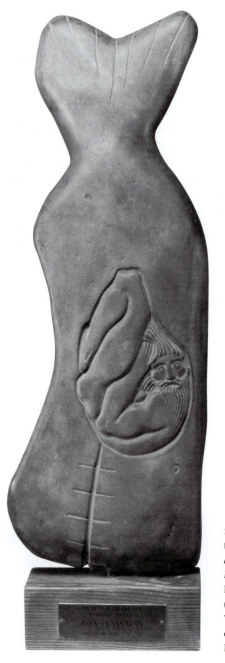

13.23 JOHN FLANNAGAN, *Jonah and the Whale: Rebirth Motif*, 1937. Bluestone, 30½ in (77.4 cm) high. Virginia Museum of Fine Arts, Richmond, Virginia.

Flannagan's *Jonah and the Whale: Rebirth Motif* (**fig. 13.23**) is a flat relief carved into the center of a long and narrow stone whose shape first suggested the subject of the biblical Jonah swallowed by the whale. Jonah's bearded face resembles Assyrian carvings of the second and first millennia B.C.E. His muscular body is folded in upon itself, forced to occupy the womblike space of the whale from which he will shortly be released in a symbolic narrative of death and resurrection. The stone is placed upright upon its simple wood pedestal; only a few lines inscribed into its top suggest the flukes of the whale. Flannagan tapped the Old Testament story of Jonah for its mythic associations with spiritual rebirth. Noting that the fish was an ancient female symbol, he here fuses dichotomous principles: life and death, male and female, containment and growth. The archaizing techniques of direct carving serve the elemental mythic themes through which Flannagan anticipated the universal concerns of abstract artists in the 1940s.

## A Stylized Modernism: European Emigrés and American Sources

The arrival of three leading émigré artists, each familiar with French modernism, helped nudge American sculptural practice beyond its academic forms: Gaston Lachaise from France in 1906; Elie Nadelman from Poland via Paris in 1914; and Alexander Archipenko (originally from Ukraine) in 1923. Once in the United States these three found enthusiastic support for their work, although at the time American sculpture remained largely indebted to the allegorical or naturalistic tradition of portraiture. All three readily embraced popular, folk, and commercial expression as the sources for a new American art. Their appreciation of such native forms was part of a recurrent phenomenon noted elsewhere, of European artists embracing the "low" and the vernacular in a manner that opened the way for American artists to follow suit.

**ELIE NADELMAN.** Nadelman, a prominent member of the Parisian avant-garde, by 1905 had developed his own theory of abstraction based on the dynamic balance of opposing curves and masses. Once in the United States, Nadelman was given a one-person show at Stieglitz's 291 Gallery in 1916. His gracefully stylized figures appealed to audiences not yet prepared for the ardors of more demanding abstraction. In *Dancer* (**fig. 13.24**), bodily volumes are reduced to their utmost purity and rendered as lines, voids, and solids. The rhythm of curve and countercurve is most evident in the dancer's legs and in the opposing balance of the right arm and the left profile of the attenuated head.

His sources for the *Dancer* ranged from the work of the French Post-Impressionist painter Georges Seurat (1859–91) to the formal simplifications of American folk art, which he began collecting in the early 1920s.

Nadelman's stylish geometries contributed to the formation of the Art Deco style (see Chapter 14); he was glamorized by *Vanity Fair* in the 1920s, while his work, straddling the breach between the difficult art of high modernism and the pleasures of stylized figuration embraced by a wider public, decorated the salons of the cosmetics entrepreneur Helena Rubinstein (a fellow émigrée who first bought his work in 1911, and helped him to move to the States). During his most productive years in the United States, from 1914 to 1929, Nadelman engaged in a lively dialogue with American culture. Drawing inspiration from the popular entertainments of burlesque and the circus, and also from folk art through his collecting of ship's figureheads and naïve painting, Nadelman bridged the worlds of modernism and an anonymous American vernacular, which he interpreted with whimsical humor.

**GASTON LACHAISE.** Gaston Lachaise was born and trained in Paris but followed his future wife and muse, the American Isabel Dutaud Nagle, to Boston in 1906, where he became apprenticed to the sculptor Paul Manship in 1913 (see Chapter 16). His lifelong obsession was the female nude, as in *Floating Woman* (**fig. 13.25**), her voluptuous volumes swelling to gigantic proportions, miraculously buoyed to weightlessness. Like Edward Weston's photographic nudes of the same years, the floating women of Lachaise erase the social to make the female body available for formal and aesthetic, but undeniably sexual, exploration and projection, freeing it into a frictionless environment of total possibility. Such openness to the subject of the body was still relatively new in American art; the body was arguably the central metaphor behind much American modernism in the **organicist** tradition, yet rarely its explicit theme. The studio nude was still the focus of much academic art, but never with the childlike infatuation of Lachaise.

13.24 ELIE NADELMAN, *Dancer (High Kicker)*, c. 1920–4. Stained, gessoed, and painted mahogany, 28 ¼ in (71 ¾ cm) high. Wadsworth Atheneum Museum of Art, Hartford, Connecticut. Philip L. Goodwin Collection.

13.25 GASTON LACHAISE, *Floating Woman*, 1924. Bronze, 12¾ in (32.4 cm) high, 17¾ in (45.1 cm) long. Fogg Art Museum, Cambridge, Massachusetts.

**ALEXANDER ARCHIPENKO.** Like Lachaise and Nadelman, Alexander Archipenko (1887–1964) was interested in freeing sculptural form from gravity by doing away with traditional supports. *Torso in Space* (**fig. 13.26**), an abstracted nude, is a variation on an older modernist fascination with the fragmented human form. The lower edge of the attenuated torso forms an elegant bow, while only the most generalized modeling suggests legs, breasts, waist, and shoulders. By 1935, when he completed *Torso in Space*, Archipenko had been in the United States for twelve years (he moved to New York City in 1923), time enough to absorb the streamlined aesthetic that dominated product design as a metaphor of the modern. The suave contours and soaring profile of his *Torso in Space* also suggest associations with flight and modern aviation, giving to the figure an American inflection. Archipenko cast several versions of the *Torso* in the traditional bronze as well as in aluminum and chrome-plate (seen here). He would later turn to other industrial materials, including plastics, whose reflective or transparent properties differed dramatically from the earthy massiveness of the stone and wood used by direct carvers in these same years. His use of such modern materials in tandem with the human form—among the oldest of all sculptural subjects—combines the industrial and the organic. While remaining true to the European traditions of the studio nude, these three émigré artists each devised an American sculptural practice responsive to the vernacular idioms and industrial materials of their adopted country.

# Architectural Encounters: Transnational Circuits

As with other areas of American arts and culture, architecture benefitted enormously from transnational exchanges in the opening decades of the twentieth century. But in this instance, these stimulations came not just from Europe but from Japan. World's Fairs (those of 1876 and 1893 in particular) had played a central role in exposing American designers to non-Western influences. This engagement with Asian arts continued into the twentieth century, as designers such as Frank Lloyd Wright and the Greene brothers of Pasadena—reacting against the eclectic clutter of late Victorian taste—turned to Japanese aesthetic principles of visual harmony and motifs stylized from natural forms. What they learned would play a central role in the emergence of a new modern American architecture integrated with nature. The modern movement, in both the United States and Europe, would come to associate visual clutter and spatial congestion with disease; the open plan, allowing free spatial flow and open sightlines, was linked to the space and light associated with good hygiene. Meshing with native concerns, such ideas were also introduced into the United States by such émigré architects as Richard Neutra (1892–1970), who was apprenticed to Wright. The emergence of a modern American architecture is a pronounced example of how contact with international influences not only challenged older canons but also reinforced

13.26 ALEXANDER ARCHIPENKO, *Torso in Space*, 1935. Chrome-plate bronze, 7 in (17.7 cm) high, 22¼ in (56.5 cm) long. Addison Gallery of American Art, Phillips Academy, Andover, Massachusetts.

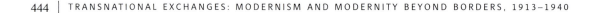

longstanding ideas about the role of architecture in shaping and reflecting national culture.

## The Early Career of Frank Lloyd Wright

Born in 1867, Frank Lloyd Wright came, over a very long career (from 1896 to his death in 1959), to be considered a uniquely American architect, steeped in the traditions of Jeffersonian thought, individualism, organic design, and nature. No one contributed more to the myth of Wright than Wright himself. Possessed of an extraordinary sense of mission, he promoted his ideas about architecture, individualism, and democracy through books, lectures, and his own foundation, Taliesin, in Wisconsin. Through the ups and downs of his career—including years in the 1920s when he built very little—Wright emerged as a visionary figure, adapting a core language of elemental forms to the evolving needs of the twentieth century, from domestic suburban design to large-scale corporate office buildings, planned communities, skyscrapers, and museums.

Coming out of Wisconsin, Wright identified himself with the landscape of the rural Midwest. In 1887 he went to Chicago, where he began his career in the office of Louis Sullivan. By 1892 he was in practice for himself in Oak Park, Illinois, a suburb of Chicago, where he built a studio and home. Here, from 1892 until his sudden departure for Europe in 1909, he developed his "**Prairie Style**," a regional school of reform design that would have an international influence.

Wright's "Prairie Style" was heralded by later historians as a turning point in the design of the American house, and—more than that—in the emergence of an independent American architecture. And yet in his search for a new architecture expressive of American democracy, Wright, like Sullivan, turned to non-Western sources. He learned a great deal about abstraction and simplification of natural forms from his extensive collection of Japanese prints: in

his *Autobiography* he wrote that "The gospel of elimination preached by the print came home to me in architecture … it lies at the bottom of all this so-called 'modernisme.'"[21] Wright's stylized ornament developed—in tandem with his incorporation of machine production—into his own organic design philosophy. From Owen Jones's *Grammar of Ornament* (1856)—an English compendium of decorative motifs from around the world, Indian, Chinese, Egyptian, Assyrian, Celtic, and more—both Wright and his teacher Sullivan encountered geometricized abstract patterns that would influence their own approach to form. Wright was proud to acknowledge these non-Western sources in his design philosophy, while playing down European influences.

Wright's most important innovation of the Prairie years was the so-called "open plan," which dramatically changed the character of domestic space by removing interior walls, "dynamiting" the boxlike forms of the past,

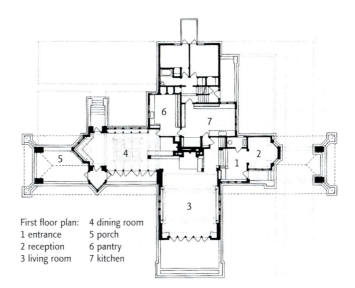

First floor plan:
1 entrance
2 reception
3 living room
4 dining room
5 porch
6 pantry
7 kitchen

13.27 A, B (above, below) FRANK LLOYD WRIGHT, *Ward Willits House*, façade and plan, 1902–03. Crayon, gouache, ink, and ink wash on paper, 8½ × 32 in (21.5 × 81.2 cm). Frank Lloyd Wright Foundation.

substituting partitions, and allowing for a more fluid circulation from room to room. Wood trim, flush with the wall surface, furnished ornamental accents. Wright's Prairie Style homes are characterized by long horizontal expanses with deep overhangs. Japanese architecture, as well as prints, played its part. The genesis for this new conception of space may well have been Wright's first encounter with Japanese buildings at the Chicago World's Fair of 1893, followed by a trip to Japan in 1905. In Chicago he saw for the first time the deep roof overhangs, interpenetrating interior spaces, and exposure of the wooden structural system as part of an overall aesthetic. The street façade of the Ward Willits house in the Chicago suburb of Highland Park (**fig. 13.27**) presents a long horizontal massing punctuated by a two-story central core. Here as elsewhere there is no attic; instead the hipped roof allows for an expansive second floor. Horizontal wood banding accenting the smooth surfaces of the house emphasizes its abstract geometries.

From Japanese domestic dwellings he may have also learned the lesson of a central focus. In many of Wright's houses, the fireplace not only anchors the cross-axes of the plan, but also serves as a symbolic focus of family life, a vertical accent that breaks the horizontal emphasis of the Prairie Style and suggests the presence of the father and household head. Prairie Style homes, with their central hearths and sheltering overhangs, created a strong feeling of refuge from the world without, linked to older Victorian notions of the separation between public and private spheres. Unlike later International Style architects, Wright rejected expansive use of glass to bring in light; his early houses (such as Willits) incorporate the landscape through porches but they also embody ancient notions of shelter with long, lowslung rooflines. Leaded casement windows filter light, allowing residents to see out without being seen. Such conservative features earned for Wright the dubious distinction of being "America's greatest nineteenth-century architect,"[22] in the words of modernist architect Philip Johnson.

Yet Wright's Prairie Style also paralleled the broader reforms in architecture linking America and Europe—in particular the Arts and Crafts movement—in such features as the use of structural elements in place of applied ornament and in the creation of aesthetically integrated environments. When possible, as at the Dana House in Springfield, Illinois (**fig. 13.28**), Wright and his office designed everything, from the stained glass to decorative murals, furniture, textiles, lighting, fountains, and sculpture. Visual unity and harmony reinforced efficient housekeeping practices. Wright, influenced by feminism, believed

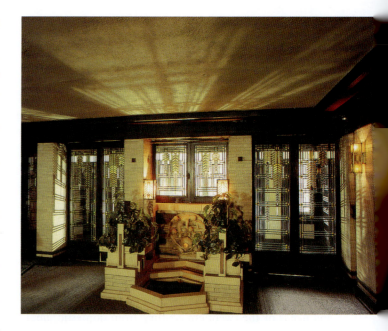

13.28 FRANK LLOYD WRIGHT, *Dana House*, Springfield, Illinois.

in simplifying the work of women by abolishing clutter, simplifying and flattening surfaces for easier cleaning.

Despite the concern with developing a national building style, architecture in the United States during these years was an international practice, and Wright's style was no exception. In addition to the influence of Japanese design, he kept abreast of European developments through architectural journals carrying the latest ideas, along with half-tone illustrations that conveyed a more direct understanding of the new building. In 1910 a trip to Europe reinforced these influences in Wright's own evolving practice.

The occasion for this trip was the publication of a deluxe edition of his work by a Berlin publisher. The so-called Wasmuth edition brought Wright's innovative Prairie Style to the attention of advanced designers in Germany, Britain, and Holland, who recognized affinities with their own reforms. On both sides of the Atlantic, leading architects were turning to non-classical sources, and to the basic geometry of squares and circles. Wright had already encountered advanced European architecture at the 1904 World's Fair in St. Louis, where he was much impressed by the style of the German and Viennese Secession. Breaking away from the dominant historicism of academic practice, these architectural reform movements offered Wright the example of simplified, bold massing and an elegant geometry of cubes and squares. Following such leads, Wright in turn explored Mayan, Egyptian, and Near Eastern design traditions, where he found the monumental forms

and the symbolic power of simple shapes that underlay much of his later practice. This work will be examined in Chapters 16 and 17.

## American Architecture Abroad

It is a commonplace that American art began to have an international presence only with the appearance of Abstract Expressionism, the "triumph" of American painting. Yet well before the New York School gained international prominence, American architects and their buildings were winning the admiration of critics, designers, and theorists throughout Europe. And they were transforming ideas about urbanism, construction methods, and expressive forms in ways that had an enduring impact on the development of European modernism.

Europeans recognized the skyscraper as an American type, and traced it to the architecture of the Chicago business section known as the Loop. Architects of the early modern movement visited Chicago to learn from the Loop; they avidly studied Sullivan's Schlesinger and Mayer department store (see Chapter 10). By the 1920s, the Schlesinger and Mayer building had become something of a landmark in European histories of modernism; the German modernist Walter Gropius (1883–1969) pronounced in 1938 that had the European avant-garde known about Sullivan's accomplishments earlier, it would have accelerated their exploration of modernism by some fifteen years. The Chicago school of skyscraper design inspired Gropius's own 1922 entry for the *Chicago Tribune* competition. Gropius—who would later become head of the Graduate School of Design at Harvard—admired Frank Lloyd Wright's modular geometries; he later identified the European edition of Wright's work as the "office bible."

### "SILO DREAMS": AMERICAN INDUSTRIAL ARCHITECTURE AND EUROPEAN MODERNISM. European architects learned from the large-scale industrial infrastructure and the movement through space that characterized American modernity. Beneath the classical forms of the buildings at the Chicago World's Fair they discovered an exciting new use of structural iron that, stripped of its fussy historical dress, conveyed to them the lessons of modern industrial materials and functional design. From American architecture, they learned how a coordinated approach to urban space such as that on view at the World's Fair could integrate systems of lighting, transportation, circulation, and landscaping. The functionality of utilitarian structures such as grain elevators, highways, and bridges, inspired a European romance with massive built forms, engineered

design, and the infrastructure of speed. The American engineer became an international hero.

The phrase "silo dreams" was the German architect Erich Mendelsohn's. Mendelsohn (1887–1953) was one of many European modernists who found in American concrete construction the realization of their own quest for a monumental, functional architecture of pure geometries uncompromised by references to historical forms. Unfettered by centuries of European tradition, American builders had been able to approach the needs of modern industry directly. Grain elevators, invented by the engineer Charles Turner in 1905, were the most visible and dramatic expression of the possibilities of concrete construction. Reinforced concrete, unlike steel frame, was fireproof, and required no added facing to resist a melting point. By 1910 cement was used some 1500 times more than in 1880. For Europeans this new aesthetic signified a liberation from history. Photographs of American elevators and factories were first published in Germany in 1913, and again in 1925, when they appeared in a book that announced the new structural logic by the Swiss-born modernist Le Corbusier (1887–1965) (**fig. 13.29**). Widely circulated among Europe's architectural vanguard, these photographs unleashed an ardent admiration for the unselfconsciously straightforward approach taken by American builders. European architects appropriated these utilitarian forms as antecedents that gave weight to their program of architectural reform.

At the forefront of design education internationally between the wars was the Bauhaus, first established in Weimar, Germany, in 1919. The Bauhaus offered an integrated design curriculum that aimed to eliminate the distinctions between art and craft, and to encourage a rigorous approach to design solutions grounded in the new principles of functionalism, rationalism, and efficiency. Its director Walter Gropius closed the school in 1933 in an atmosphere of deepening repression with the Nazi rise to power.

The belief that society could be aesthetically redeemed through improved design was at the heart of the Bauhaus's influential design philosophy and its curriculum of study. Partially shaping that design philosophy was the European reaction to U.S. industrial and engineering structures. Here, as in other areas of the European encounter with American culture, European modernists repudiated America's official high culture and academic architecture, while admiring and emulating its pragmatic solutions to the challenges of modern industry, mechanization, and media. "Our engineers are healthy and virile, active and useful, balanced and happy in their work. Our architects are disillusioned and unemployed, boastful or peevish," wrote Le Corbusier.[23] Certainly, surveying the motley variety of American

architectural styles—from Romanesque to Aztec, Mayan, Gothic, and "modernistic" or streamlined—a rational approach to design, based in simple geometries, seemed the most promising.

"Virile" European modernists thus took what they needed from the American grain elevator and factory, which they romanticized as the "primitive" expression of anonymous builders while renouncing the effete and outmoded productions of architectural historicists. In truth the factories and grain elevators that first utilized the construction possibilities of concrete *were* the product of trained architects, working outside the large urban centers for clients who needed cost-effective buildings solving specific problems of space and industrial process.

The structural and design innovations of European modernists, inspired by their encounter with American concrete and steel engineering in the pre-World War I years, in turn were critical to the rise of post-war architectural modernism in America. German émigré architects fleeing the rise of fascism and the outbreak of World War II carried this new functionalist approach across the Atlantic, where it came to be known as the "International Style," and its design philosophy became the basis for architectural education at such institutions as Harvard and the Illinois Institute of Technology (see Chapter 17).

In one more turn of the wheel, American modernists rediscovered their own native industrial buildings through the eyes of European modernists. Without the example of Gropius, Le Corbusier, and others, one wonders whether American artists and architects would have recognized their power and beauty as symbols of this proud American building vernacular.

**THE MODERN AMERICAN INDUSTRIAL FACTORY.** Along with new construction techniques, materials, and structural rationalism, a related innovation in American industrial architecture had far-reaching effects on industry internationally: the reorganization of factory space to create a horizontal continuity between the various phases of industrial production (**fig. 13.30**). Flow—through space and in time—became the aim of state-of-the-art factory space. Facilitating flow was the removal of spatial barriers and the minimization of columnar supports—both made possible by advances in the technical abilities of steel and concrete to span large spaces with minimal support. In the pioneering architecture of Albert Kahn (1869–1942), factories went from multiple to single-story, horizontally extended structures containing the various phases of the production process. The new face of industry was quickly exported to Europe and Russia, where it played a role in the massive industrialization of Soviet agriculture. A related innovation was the assembly line (first put into place at Henry Ford's Model-T automobile plant in 1913), in which parts moved past the workers, rather than workers being brought to

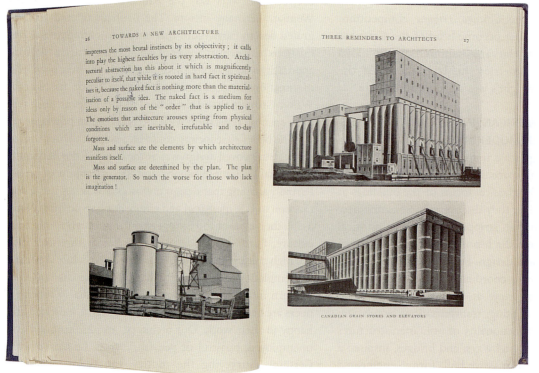

13.29 LE CORBUSIER, Plate from *Towards a New Architecture*, 1928, pp. 28–9. Private Collection.

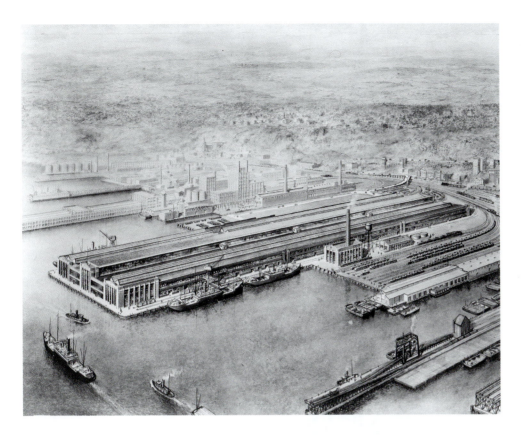

13.30 **ALBERT KAHN**, Ford Motor Company, Assembly Plant, Edgewater, New Jersey, 1929. Albert Kahn Associates, Detroit, Michigan.

the parts. In its most fully developed form, at Ford's River Rouge Plant in Dearborn, Michigan (built between 1917 and 1925), an internal system of canals and railroads brought raw materials to the building complex and then distributed them to their respective work areas, each representing a phase in a continuous cycle of production that included the manufacture of iron, cement, steel, glass, and rubber (see fig. 14.17). The reorganization of space and time in the twentieth-century system of American manufacturing would be exported to countries throughout the world in succeeding decades, narrowing the gap between the United States and the rest of the world.

## Conclusion

The European love affair with American modernity took many forms: from the ironic humor that European émigrés found in Americans' obsession with a clean, safe, and ordered life, to the admiration among European architects for the rational expression of function in American industrial buildings. Following the 1913 Armory Show, the encounter between European and American artists and architects continued through several fruitful cycles of exchange. Europeans awakened American artists to the vitality of their own popular culture and to the richness of their folk and vernacular traditions. Absorbing the lessons of European modernism, Americans created a transatlantic art that synthesized the perspectives of both Europe and the United States. American artists adopted the irony of their French colleagues as a way of utilizing American subjects while distancing themselves from any direct identification with a culture from which they felt estranged.

In the decades between the wars, the nation's growing economic and social power fed technological and urban optimism, along with a new pride in America's contributions to the world of the future. But shadowing this expansive spirit were reminders of the human costs of mechanization. The Italian theorist Antonio Gramsci warned of the "subjugation of natural instincts ... to ever more complex ... habits of order, exactness and precision."[24] American artists between the wars registered a range of reactions to the increasing industrial and urban regimentation of the human body, from celebration to ambivalence to condemnation, as the history of early-twentieth-century artistic responses to the city makes evident.

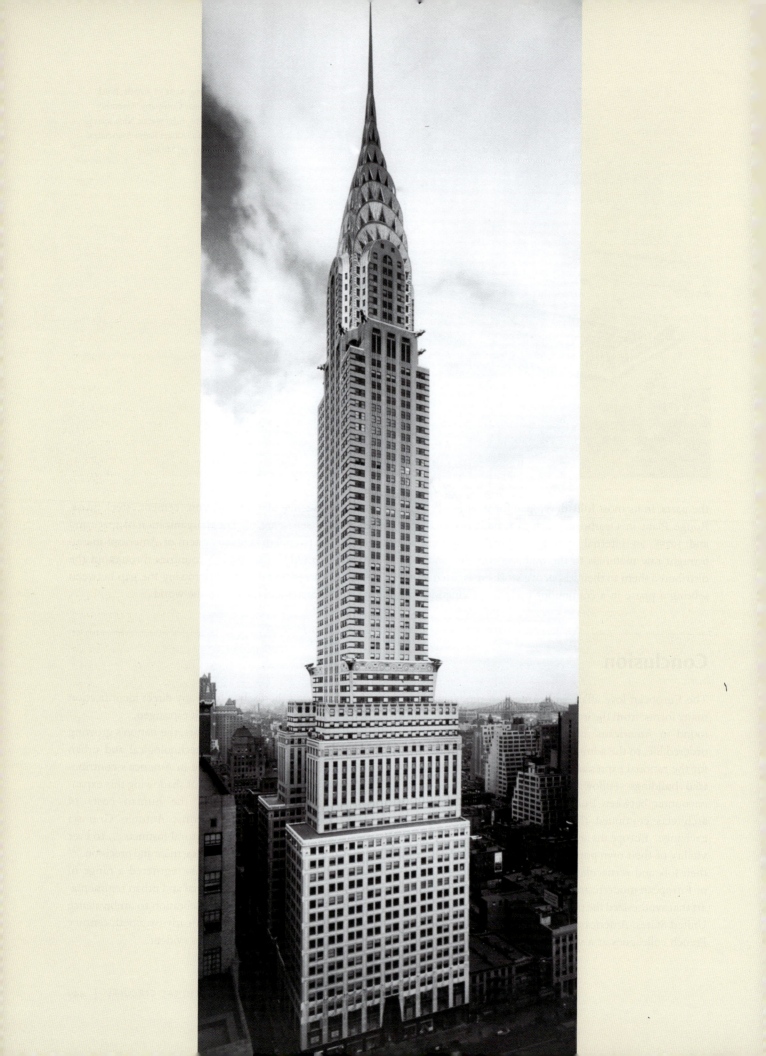

# 14 | The Arts and the City, 1913–1940

IN THE EARLY TWENTIETH CENTURY, new technologies radically reshaped space and time for urban Americans. Steel frame construction—along with the invention of the elevator—allowed buildings to soar to unprecedented heights. Since a grid of steel did the work of holding up the building, the exterior was left free for any decorative program. At first tall buildings were sheathed in stone, replicating familiar classical or Gothic forms from the past. Eventually, however, architectural modernism transformed the look of the tall office building, sheathing it in curtain walls of glass that imparted weightlessness and the crystaline luminosity of incandescence and reflection. The skyscraper imposed new perspectives that blasted apart older ways of understanding the city. From painting and sculpture to film, **animation**, and the decorative arts, the skyscraper came to symbolize modernity in all its anxious promise.

A new consumer culture arose, enshrined in department stores and store window displays, and tantalized by new leisure industries such as amusement parks and cinema that accelerated the pursuit of pleasure and private fantasy. Fueling consumer fantasies was a landscape of visual signage—billboards, electric lighting, and neon—that enlarged the scale and the intensity of commercial messages, injecting private needs and desires into the public landscape of the city.

In Chicago and New York, the elevated railroad, or El, sped urban dwellers across the city. The effect was to compress time and space. Not only did distances appear shorter, but the sustained experience of walking was now displaced by a discontinuous montage of rapid-fire impressions. As travelers saw the urban landscape flash by, they glimpsed into apartment interiors, further collapsing the distinction between public and private. The condensation

of time and space was intensified by the use of telephones. Instantaneous communication with people on the other side of the city, or the country, created a new experience of simultaneity. This effect was enhanced by the motion picture, which carried "live" images of people and places removed in time and space. An awareness of simultaneity was distinctly modern, liberating the imagination to radically recompose the spatial and temporal continuities of older experience. Reality itself appeared to be newly malleable, as the natural laws of the past were reconfigured by new technologies.

All these features of urban modernity made a profound mark on the arts. Modernism—itself a response to city life—furnished an awareness with which to apprehend the fractured perceptual and physical environment of the modern city. While artists had embraced these new urban energies in the 1910s, by the 1920s they were more cautious. Some tried to stabilize these energies by locking them into place with hard-edged forms that eliminated the human dimension. Other artists, still attached to the figure and to the public and private search for human meaning, turned to the streets and sidewalks, the tawdry and the worn underbelly of the city, for inspiration. They also explored the excitements of a new urban identity. There, at the margins of the modern, they reimagined a city of layered memories and an expanded sense of time.

## The Skyscraper in Architecture and the Arts

"Squares after squares of flame, set and cut into the ether. Here is our poetry, for we have pulled down the stars to our will"—*Ezra Pound*, "Patria Mia" (1913); from *Ezra Pound: Selected Prose, 1909–1965*, p. 107.

(opposite) WILLIAM VAN ALEN, Chrysler Building, New York City, 1928–32.

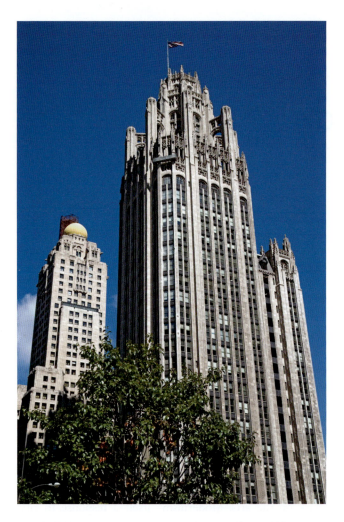

14.1 RAYMOND HOOD & JOHN MEAD HOWELLS, *Chicago Tribune Building*, 1925.

It is impossible today to write about the upward thrust of America's urban skyline with the same innocence, idealism, and romance that inspired Ezra Pound's 1913 tribute to the New York night. Pound's words recall the impossible reach and godlike energies symbolized by the nation's first skyscrapers. Such romantic dreams faded long before the horrific spectacle of September 11, 2001, when the twin towers of the World Trade Center—like pillars at the entrance to Manhattan's financial district, symbols of the nation's commercial power and financial reach—were toppled into rubble and carnage beyond our wildest nightmares. In the aftermath of that event, it is easy to forget the complex cultural meanings originally embodied in the skyscraper.

By the early twentieth century, the skyscraper had already become the preeminent symbol of America's ascendancy. As the most conspicuous feature of the new American city, the skyscraper was distinctively American, a form mostly absent from European cities, where the urban fabric dated back centuries. European admiration for these new forms relieved the longstanding sense of inadequacy

Americans had felt in the eyes of Europe. Although skyscrapers embodied the modernist romance with aviation, soaring height, and freedom from limits, nevertheless, with few exceptions, American skyscrapers were sheathed in historical forms. The best-known architectural competition of the 1920s—for the Chicago Tribune Building (**fig. 14.1**)—passed over numerous modernist designs submitted by Walter Gropius, Bruno Taut, and other Europeans in favor of a neo-gothic solution by American architects Raymond Hood (1881–1934) and John Mead Howells (1868–1959), complete with a crown-like top, flying buttresses, and piers running the shaft of the building. In the eyes of its proprietors, these decorative details suffused the Chicago Tribune Building with the poetry of history. The moguls of modern media were not quite ready to adopt architectural modernism.

Cultural critics debated both the necessity for the skyscraper and the form it should take. For urban visionaries like Ayn Rand (1905–82, author of *The Fountainhead*, published in 1943), the skyscraper was an emblem of heroic will and the ultimate demonstration of modernity's utopian promise. For skeptics like the writer and critic Lewis Mumford (1895–1990), the skyscraper represented a colossal waste of resources and an expression of hubris that would bring countless environmental problems in its wake. In addition, while conforming to the street grid, skyscrapers generally ignored their context, thereby neglecting the social life of public spaces and disrupting older, more use-oriented patterns of movement. Turning their back on the street, skyscrapers instead created fantasy worlds within.

The skyscraper came to symbolize the triumph of American capitalism, as expressive of the era of big money as temples were of the ancient world, or cathedrals of the Middle Ages. The collapse of the stock market in 1929 inevitably brought a dramatic shift in perspective; the New York designer Paul Frankl (1886–1958) proclaimed the Empire State building "the tombstone on the grave of the era that built it."[1] Yet the skyscrapers that redefined the look of the American city were far more than monuments to business and the spirit of commerce. On one level their form was generated by the logic of profit (building up rather than out in the high-rent urban core). Yet in their decorative schemes they represented culture by evoking ancient symbols, distant times and places. Their ornamental details and decorative interiors offered magic carpet rides across time and space. To enter the lobby of a skyscraper from the 1920s or 1930s is to find oneself in a dimly lit fantasy world, surrounded by stylized metalwork and extended friezes in which the forces of nature are displayed in a playful storyline of unfolding life. The imagery of the

nation's skyscrapers in the 1920s and 1930s takes in everything, from the underwater world to the heavens, freely associating East and West, past and future, labor and capital, the Greek gods and the gods of commerce. The imagination is transported beyond the flatfooted realities of present-day business and into sensuous realms where chiseled bodies display their gifts, linking business to humanity's oldest urges. Ambition and arrogance are redeemed; the empire-builders of the present day are linked to Prometheus, who defied the gods to bring fire to humanity. The business conducted within is blessed by fleetfooted Mercury, the god of commerce.

Perhaps no other skyscraper has acted as such a springboard to fantasy as the Chrysler Building (**p. 450**) in midtown Manhattan. Instantly recognizable, it makes an appearance in Joseph Cornell's portrait of Lauren Bacall (see fig. 14.34); the artist Matthew Barney (b. 1967) staged an entire episode of his film *Cremaster Cycle* (1994–2002) in its interior spaces. Like other buildings of these years, it is tripartite in form: a base of twenty stories with one setback, a shaft that sets back twice before a rise of twenty-seven more stories, at which point the tower begins its inward taper with a cascade of arches in sunburst formation, sheathed in stainless steel punctuated with **chevron** windows. For a brief period the tallest building in Manhattan, it was soon surpassed by the Empire State Building; together the two buildings still define the midtown skyline. With its stylized eagle gargoyles sixty-one stories up, and its four winged Mercury helmets (the hood ornament on the Chrysler car) at the thirty-first floor, along with a frieze of automotive hubcaps, the Chrysler Building offers a compelling display of urban theatricality, eclectic borrowing, and decorative fantasy from the corporate age. Its ground floor lobby (**fig. 14.2**) enfolds the urban voyager in a sensuous realm of exotic woods and Moroccan marble, Mexican onyx, and German travertine, elaborately inlaid in chevrons, zigzags, and other **Art Deco** motifs deriving from American Indian cultures, while suggesting the global reach of American commerce. On the ceiling is a mural of the building's construction, full of muscled men. The Chrysler Building is a monument to one man—Walter P. Chrysler—a self-made titan of the automotive industry whose first set of tools was enshrined like a holy relic in a glass case beneath the building's spire. Chrysler (1875–1940) was legendary for having demanded—and received—$1,000,000 a year as president of one of the large automotive companies in 1920. The Chrysler Corporation weathered the Great Depression when many other companies failed. Perhaps the Chrysler Building's greatest appeal is that it celebrated individual achievement in the era of big money.

14.2 WILLIAM VAN ALEN, Chrysler Building, New York City, interior, 1928–32.

## Designing for Modernity: The "Moderne" Style

Standardization and the mass production of everyday goods lay at the heart of America's rise to industrial preeminence in the twentieth century. Yet it was some time before an aesthetic expression of the new industrial modernity emerged to give American design a distinctive voice. Despite calls for reform during the Arts and Crafts movement of the later nineteenth century (see Chapter 10), American manufacturers continued to use mass-production techniques to replicate historic styles. Therefore, while America's emerging modernist artists might celebrate the industrial modernity of American skyscrapers and mass production, nevertheless most Americans lived out their lives in late Victorian domestic environments. As late as 1925, Paul Frankl wrote that "we have no decorative art." So poor was the level of American design that the nation was not even represented at the International Exposition of Modern Decorative and Industrial Arts, held in Paris in 1925 (the event that originated the term "Art Deco"[2]).

**LUXURY INTERIORS.** Following this embarrassment, Secretary of Commerce Herbert Hoover created a federal commission to encourage design innovation. The situation turned around so quickly that by 1928 Richard Bach of the Metropolitan Museum of Art could write, "The modern style ... has come to stay."[3] American Moderne, or Art Deco, as it came to be known, was associated with the disjunctive rhythms of machinery and the stylized contours of the urban skyline. Art Deco extended across the decorative arts, architecture, furnishings, and luxury items from cigarette cases to evening wear. Its clean lines, industrial metals, and stylized silhouettes, though often handcrafted, evoked machine fabrication. Considered a masterpiece of Art Deco, the Chanin gates from the Chanin Building in midtown New York City (**fig. 14.3**) use the stylized forms of Art Deco—spirals, vectors, jagged bolts, zigzags, and concentric circles linked by ray lines that give the design a futuristic look. Organic swirls jostle gear-like machine parts, while the entire gate is supported by spindly stacks of coins, a sly allusion to the money that underwrote the glamorous new modern city and provided the patronage for such buildings as the Chanin and the Chrysler.

**GLAMOROUS GARMENTS.** The Art Deco style was also associated with custom-made luxury goods such as this evening wrap of c. 1928 (**fig. 14.4**). The patterns on this formal coat—its chevrons and vectors suggesting rocket-like propulsion—capture the dynamic forces of the physical world, both human and natural. Three-dimensional **extruded** forms resemble crystals, which—steely hard, untouched by time—serve as prototypes for the skyscraper. Geometric shapes—hexagons, circles, and spirals—evoke inorganic nature. American Art Deco controlled and structured the surging energies of modernity, embracing nature and science. But it also incorporated the anti-naturalistic geometries of Egyptian and Native American arts, drawing upon formal similarities between Pueblo pottery and Navajo weaving, on the one hand, and the angular precision-cut qualities of new technology on the other. It reconciled desires for a footing in the past with

14.3 RENÉ CHAMBELLAN, Chanin Building (Executive suite entrance gates, 52nd floor), 1928. Wrought iron and bronze.

14.4 UNKNOWN ARTIST, *Evening Wrap*, c. 1928. Compound weave of gold, yellow, and black silk trimmed with brown-dyed skunk. Metropolitan Museum of Art, New York. Gift of the Fashion Group, Inc., 1975.

a longing for the glamor of the future, fed by modern materials such as plastics, chrome, and stainless steel. In this combined appeal to both modern and "primitive" elements, Art Deco resembled jazz—a musical language many critics of the time associated with both the pounding rhythms of modern machines and the "tribal" rhythms of Africa.

## Cubism in the American Grain

American artists were quick to exploit the aesthetic possibilities of the skyscraper and the new urban environment that resulted from the "skyward thrust" of American building. However, the necessities of photographing or painting a tall building require a radical readjustment of perspective. Standing on the ground looking up at twenty or thirty stories, one's orientation to a vanishing point located on a horizon line disappears and the ground plane now becomes flat in relation to the **recessional** spaces of the city. Avenues shoot diagonally across the plane of representation rather than receding into an illusionistic distance. This ambiguity between two and three dimensions was an essential feature of European **Cubism**. Modernist artists and photographers embraced this disruption of perspectival

space, unlike late-nineteenth-century artists, who retained a traditional sense of perspective by painting the skyscraper from a distance (see fig. 10.6). With time, modernist forms of urban representation—faceting to suggest passage between two and three dimensions, sharp diagonals, and radically tilted ground planes—entered advertising and **graphic design**, popular filmmaking, photojournalism, and even vernacular art.

**THE VIEW FROM THE TOP.** Some critics, concerned that American art would forever remain tethered to Europe, found hope for an original American modernism in the American skyscraper city. American artists no longer needed to copy Europeans. As they were quick to point out, the urban environment itself promoted radically new ways of seeing. The camera proved especially responsive to these fresh pictorial possibilities. Alvin Langdon Coburn's (1882–1966) *The Octopus, New York* (**fig. 14.5**) is a view of Madison Square, taken from the Metropolitan Life Building, whose shadow cuts diagonally across the frame. Leafless winter trees on a field of white snow appear like

14.5 ALVIN LANGDON COBURN, *The Octopus, New York*, 1912. George Eastman House, Rochester, New York.

spidery veins around the oculus of a great eye. The city is splayed out before the viewer perched high above. The perspective here resembles that of John Marin, whose *Lower Manhattan (Derived from Top of the Woolworth Building)* also reorganizes the visual prospect from a point high above the street (see fig. 12.21). From this high perspective, the horizon disappears completely and the ground appears as a flat plane. Coburn's movement beyond photographic illusion into abstract design was encouraged by his study with Arthur Wesley Dow, whose emphasis on Japanese design and pattern informed Coburn's tilted-up ground plane and flattened perspective. Coburn's image further anticipates the photography of such European artists as André Kertész (1894–1985) and László Moholy-Nagy (1895–1946) in the 1920s, who commonly shot the ground plane from above. The effect of this new photographic perspective was to isolate fragments of the city from their urban context. Displaced from the ground plane, recognizable elements are resituated in abstract compositions of shape and form.

**CUBISTIC CAMERAWORK.** Proponents of American art in the 1920s—intent on throwing off European influences—found in the disorienting perspectives of the American city a way to be both American and modern. American Cubism, they pointed out, saw things straight, unlike its French version, which manipulated and reordered the components of nature in the studio. By the 1920s, this **Cubist** perspective on American cities was fully domesticated in the work of Charles Sheeler and others; Sheeler demonstrated that Cubism existed in nature, merely awaiting the selective eye of the photographer or the artist. Sheeler and Paul Strand (1890–1976) collaborated on one of the earliest film portraits of the modern city, *Manhatta* (**fig. 14.6**). The seven-minute silent film is composed of long static shots of the dynamic metropolis. These are edited to create a visual montage of the city, with a narrative held together by superimposed quotes from the nineteenth-century New York poet Walt Whitman, whose embrace of modern life and visionary voice inspired many modernists. Throughout the film, the camera becomes an instrument of visual exploration and experimentation, sharply angled up or down, creating a montage out of discontinuous visual fragments, and playing with the ambiguity between the flat ground plane and the recession into depth. The film's beginning and its ending, however, offer a broader frame that unifies the modernist montage of the city: the opening shot is a heroic prospect of the urban skyline from the Staten Island ferry, while the closing shot surveys the Hudson River, looking toward the Atlantic world beyond the island. This encompassing gaze returns to older visual traditions of the

14.6 PAUL STRAND & CHARLES SHEELER, Film stills from *Manhatta*, 1921. *Vanity Fair*, April 1922.

framed view and functions as well to integrate city and nature. Stills from the film later served Sheeler as sources for his *Church Street EL* (**fig. 14.7**). Here the ground seems to be on the same plane as the elevated rail, seen "in plan" as a diagonal shape on the right side of the canvas. Sheeler translated the tonalities of the black and white film into unmodulated planes of color that enhanced the sense of abstract pattern.

## The Skyscraper City in Film

From the era of silent film through the end of the Depression, the dreams and challenges of the modern city were the subject of countless films in which the skyscraper served as a symbol of cultural ambivalence. From Fritz Lang's (1890–1976) *Metropolis*—a German film of 1926 inspired by the skyscraper city of New York—to the

14.7 CHARLES SHEELER, *Church Street EL*, 1920. Oil on canvas, 16⅛ × 19⅛ in (40.7 × 48.3 cm). Cleveland Museum of Art, Ohio.

14.8 HAROLD LLOYD, *Safety Last*, 1923. Film still. Hal Roach, Inc.

Emerald City of *The Wizard of Oz* (1939), the modern city suggested a new world free from the wreckage of history. It was a vision, however, that frequently dissolved into troubling tales of oppression (as revealed in the city of workers beneath the glittering metropolis of Lang's film) and disappointed dreams. For many Americans in the interwar years, the city promised wealth, opportunity, and a vast array of consumer goods. For others, it symbolized moral corruption and the hubris of America's business culture, as well as the dissolution of regional differences in a standardized landscape—the creation of an economic order at odds with everyday lives and sentiments.

A series of films suggests the range of meanings the skyscraper embodied in the 1920s and 1930s. In Harold Lloyd's (1893–1971) *Safety Last* of 1923 (**fig. 14.8**), a young man from small-town America scales a ten-story building in downtown L.A. in an effort to win the stunt money he needs to marry his sweetheart. His act takes the skyscraper's association with social and financial ambition literally, while Lloyd's everyman figure reassuringly links the nation's small-town past to its big-city future. *The Crowd* by King Vidor (1894–1982) (**fig. 14.9**), though only a few years later, is a far more caustic film that dwells not on the continuity between past and future but on their rupture. The young man from the small town confronts the visionary prospect of the city at the film's opening. Its cloud-aspiring towers recall the opening shots of Strand's and Sheeler's *Manhatta*. Yet after this heroic beginning he experiences a series of tragic disappointments in his struggle

to realize his dreams. The skyscraper in Vidor's film is an emblem of gridded conformity and ruthless oppression—memorably captured in a crane shot that moves up the full height of the building (in reality a model) and then dissolves into an office interior of row upon row of men at desks. The work grid finds its echo in the film's final image of endless gridded rows of filmgoers anesthetized by mass entertainment, linking the parallel worlds of work and leisure. In *Baby Face* (1933), Barbara Stanwyck (1907–90)—the tough-as-nails, self-made woman at the film's center—literally sleeps her way to the top, occupying successively higher floors of the skyscraper that houses her corporate

14.9 KING VIDOR, *The Crowd*, 1928. Film still. M.G.M.

lovers. The innocent American ambition of Harold Lloyd's boy from the country has become a craven quest for social power, epitomized by the "view from the top."

The cynicism of filmmakers in the 1920s and 1930s was transformed once again into idealism in the ultimate skyscraper film: King Vidor's *The Fountainhead*, based on a novel by Ayn Rand. A celebration of titanic male will inspired by the figure of Frank Lloyd Wright (who, ironically, built only one skyscraper, in Bartlesville, Oklahoma), the film saves the skyscraper from its damaging associations with corporate power and restores it to the creative control of the architect as modernist visionary.

## Imaginary Skyscrapers and Visionary Artists

Modernist visionaries come in different guises. The work of two artists outside the mainstream art and culture system reveals the ways in which the modernist idea of the skyscraper percolated into the imaginations of everyone in the first half of the twentieth century, and sometimes was expressed in offbeat and grandiose ways.

**Y.T.T.E.** Achilles Rizzoli (1896–1981) was born in Marin County, California, to a Swiss dairy-farming couple. In making the fantastical architectural drawings for which he is famous he drew upon his training in the Beaux Arts style of architectural rendering at the California Polytechnic College of Engineering. Rizzoli worked as an architectural draftsman for most of his adult life, and his art reflects his skill at hand-lettering and at precisely rendering buildings with a compass, straight-edge, and triangle. The buildings that he drew with fanatical precision at home (many of the drawings are up to 5 feet tall) were far from standard Beaux Arts temples and towers. They were symbolic portraits of the people to whom this painfully introverted man wished to reach out. *Shirley's Temple* (**fig. 14.10**), done in 1939, was a play on the name of the famous child movie star of the 1930s and 1940s. It was intended as a homage to a neighbor's child, Shirley Jean Bersie, who was interested in his art. In other drawings, the artist rendered his mother—to whom he was slavishly devoted for his entire life—as a Gothic cathedral.

Rizzoli saw visions and heard voices. He called himself "the architectural transcriber of the divine." He worked for many years on plans for his own private world's fair, recalling the splendors of the 1915 Panama Pacific Exposition in the San Francisco of his youth. A private abbreviation, "Y.T.T.E.," lettered on many of his drawings, gives insight into the role obsessive art making had for this troubled

14.10 ACHILLES RIZZOLI, *Shirley's Temple*, 1939. Colored inks on paper, 37¼ × 23⅞ in (95.8 × 60.7 cm). Ames Gallery, Berkeley, California.

recluse: "Yield To Total Elation." And so he did, in the fantastical creations of his pen and his brain.

**SIMON RODIA'S *WATTS TOWERS*.** Unlike Rizzoli, Simon Rodia (c. 1879–1965) designed and executed his architectural fantasy in three dimensions, and in a public, urban space (**fig. 14.11**). Born in Rome, Rodia emigrated to the United States as a child, and earned his living as a tile-setter. Like Rizzoli, his visionary art drew upon the skills of his trade. Starting in 1921, in the Watts neighborhood of Los Angeles, Rodia began to build a series of towers out of steel reinforcing rods covered with wire mesh and daubed with

cement into which he embedded sea-shells and broken tiles, dishes, and bottles, as well as other cast-offs. The tallest tower is nearly 100 feet high, built without benefit of scaffolding. A series of fountains, archways, and paths enclosed by a wall completes his architectural fantasy. After laboring upon his creation for thirty years, in 1954 when he was in his late seventies, Rodia gave his property to a neighbor and moved away, his work complete.

Simon Rodia's Watts Towers, which was slated for demolition in 1959, became the first such environment to be listed on the National Register of Historic Places, and to be declared a National Monument. In the center of what is today an African American neighborhood of low-rise houses and apartments, it remains one man's fantasy of a skyscraper city, assembled lovingly with the detritus of both culture and nature.

14.11 SIMON RODIA, *Watts Tower*, Los Angeles, 1921–54.

# The Urban/Industrial Image, 1910–30

"One cannot live on a visual diet of skyscrapers and produce the same sort of art as one who is fed visually on the Acropolis"—*Jacques Lipchitz (1891–1973)*.[4]

The first generation of American modernists had sought ways of expressing the internal sensations inspired by their experiences of the modern. However, their **Expressionism** failed to serve the needs of the following generation of modernists, who were drawn instead to a new classicism. As if wishing to lock into place the unstable energies of the city, many among the next generation of the 1920s turned to a range of styles associated with an aesthetic of restraint, balance, and immobility. They purged art of emotion. This range of response charts a mix of social meanings inspired by the freedoms, but also by the increasing rationalization and structure, of social life in the city. Blending dynamism, efficiency, and impersonal power, the skyscraper image in the 1920s and 1930s also masked the human element that propelled the new city.

## From Fragmentation to Unity

The United States, where technology was reengineering culture, seemed well suited to Italian **Futurism**. A movement in art that glorified the machine age, Futurism attempted to capture the sensory impact of a newly mechanized environment of speed that blurred the lines between self and external world, placing "the spectator in the center of the picture," in the words of the Futurists themselves.[5] Max Weber (1881–1961) and Joseph Stella (1877–1946) responded to the new urban environment by adapting certain formal features of Futurism. They did so by repeating forms dynamized by color and light, and by abolishing conventional perspective.

**MAX WEBER.** In Max Weber's *Rush Hour, New York* (**fig. 14.12**), a sense of dynamic motion is conveyed through overlapping planes and exploded forms; shapes seem mechanically repeated, as if punched out by a machine. Circles, triangles, and vectors clash with one another, while strips of windowed façades suggest the plunging perspectives of the city seen from twenty stories up. Weber's prismatic imagery recreates in two dimensions the staccato impressions and random movements of the metropolis. Rather than organizing the painting from the perspective of a privileged observer, Weber draws the viewer into it.

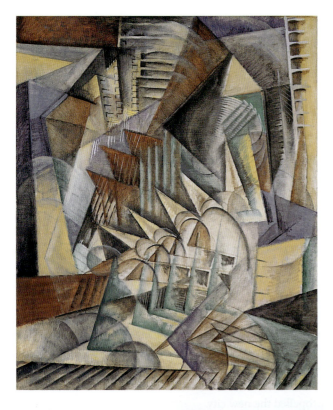

**JOSEPH STELLA.** The Futurists' ecstatic embrace of modern technology—planes, cars, subway trains, as well as machine guns and other engines of mass destruction for smashing the old order—also informed Joseph Stella's *Battle of Lights, Coney Island* (**fig. 14.13**). The painting is among the most interesting efforts to express the new urban experiences of speed, machine-driven motion, and kaleidoscopic sensations collapsing time and space. Stella was an Italian immigrant who brought to his encounter with American modernity the fervor of a convert to a new creed. His paintings of modern New York contain a range of religious symbols, from stained-glass mosaic to soaring Gothic arches. Having read Walt Whitman while still in Italy, Stella was steeped in the mythology of a new land rife with possibilities for a democratic embrace of modern life. Traveling from his home in southern Italy as a young man to join his brother in New York City, Stella was headed for a career as a doctor. Soon, however, he turned to art. Following a long period of apprenticeship, first to the Old Masters, and then to Post-Impressionism, he followed the herd of American artists to Paris. There in 1912 he met the Italian Futurists, who provided him with a language for capturing his giddy

14.12 (above) MAX WEBER, *Rush Hour, New York*, 1915. Oil on canvas, 36¼ × 30¼ in (92 × 76.8 cm). National Gallery of Art, Washington, D.C. Gift of the Avalon Foundation.

14.13 JOSEPH STELLA, *Battle of Lights, Coney Island*, 1913. Oil on canvas, 6 ft 4 in × 7 ft (1.93 × 2.13 m). Yale University Art Gallery, New Haven, Connecticut.

impressions of the new. These various influences came together during a trip to Coney Island, a place that combined technology, ecstatic pleasure, danger, and crowds of people—for Stella the essential elements of an art grounded in his religion of modernity. The amusement park at Coney Island transformed industrial machinery—the tracks and cars used to mine coal and transport urban crowds from place to place—into roller-coasters, the agents of a dizzying new exhilaration. In celebrating the new sensations created by the intimate dance of the machine with the human body, Stella turned to the experience of crowds, whipped up by mechanized motion and lights into a state of "carnal frenzy."[6] This blend of crowds and machines is expressed in Stella's painting as a swirling motion suggesting the centrifugal force of a rollercoaster ride. Spinning out from the center, it also sucks us back in like a vortex. Anchoring the composition is the only recognizable motif in the painting—the electric tower of Luna Park in the upper center, resembling the spire of an Eastern Orthodox church. The painting is an intricate mosaic of splintered geometric patterns intermixed with organic swirls and spirals, a "dynamic arabesque," in Stella's words. In the lower register tiny human shapes pulsate in a sea of fractured forms. Abolishing all references to the humanistic perspective of his Italian heritage, Stella erases the boundaries separating the individual from his or her surroundings. Body and world become one in an experience that leaves

behind both history and a sense of grounded selfhood. A carnival for men and women exhausted by industrial labor, *Battle of Lights* heralds an emerging culture of mass entertainment and mechanized leisure. In the experience of the modern and the loss of self, Stella found a new means of transcendence, but also the unsettling potential for alienation and a descent into frenzied unreason.

The frenetic and unsettling pace of urban life called forth a search for symbols that would connect the old century with the new. Brooklyn Bridge was one such cultural icon (**fig. 14.14**). The first bridge between Brooklyn and Manhattan, it helped realize the dream of a "greater" New York, incorporating the boroughs into a unified metropolis. Its design and construction, which cost many lives, became a legendary example of technical innovation and human heroism. Its massive load-bearing piers, with their gothic profiles, signified stability and strength, while its etherial steel cables, from which the roadbed was suspended, suggested modernist aspiration. For Joseph Stella as well as others, the pier and cable together epitomized an American culture that had wedded matter and spirit. The bridge, spanning old and new, past and present, pastoral Brooklyn and urban New York, became a potent symbol of the power of the modernist artist to bridge—or integrate—the divided realities of the new century.

The image of the bridge appeared frequently in the arts and poetry of the 1920s, a decade when the initial

14.14 CHARLES GRAHAM, *Brooklyn Bridge: General View*, from *Harper's Weekly*, May 26, 1883. Print. Private Collection.

exuberance of the first phase of modernism gave way to a desire for historical and cultural anchors. The bridge holds a key place in Stella's 1920–2 five-paneled *Voice of the City of New York Interpreted* (**fig. 14.15**). Here he has tamed the wild impulses of his *Coney Island*, transforming his splintered shards of colored light into a grand hymn of exaltation to the new America. *Voice of the City* used the **polyptych**, a form associated with the religious altarpiece, complete with smaller panels below the main canvases. In contrast to *Battle of Lights*, *Voice of the City* is a work of integration in which the fragmented, disorienting metropolis achieves a monumental new stability, anchored symbolically by the stone piers of the bridge itself. Four panels are symmetrically disposed on either side of a larger central panel, rising in a kind of crescendo from the outer reaches of the metropolis—the New York port and the Brooklyn Bridge approach to Manhattan—to two decorative panels of the Great White Way, culminating in the central New York skyline. The title *Voice of the City* recalls the origins of the term "vaudeville" in the French *voix de ville*, or voice of the city. And like vaudeville, Stella's polyptych is a performance in several acts. Each panel steps forward to present a different face, while forming one part in a larger unity. Speaking in many accents, vaudeville—like Stella's painting—condensed the variety, excitement, and polyphonal richness of the new city into manageable forms.

Perhaps more than any other artist of early American modernism, Stella expressed, with an immigrant's deep conviction, the sense of spiritual and social liberation offered by the new American city—a liberation from history as well as from inherited forms. Movement away from his European past allowed Stella, in his own words, to find "the green freedom of my own self."[7]

14.15 (above) JOSEPH STELLA, *Voice of the City of New York Interpreted*, 1920–2. Oil and tempera on canvas, 7 ft 4 in × 22 ft 6 in (2.2 × 6.85 m). Newark Museum, Newark, New Jersey.

14.16 JOHN STORRS, *New York*, c. 1925. Brass and steel on black marble base, 25⅞ × 5½ × 3½ in (65.7 × 13.9 × 8.8 cm). Indianapolis Museum of Art, Indiana. Discretionary Fund.

## Precisionism: Modernist Classicism and the Aesthetics of Immobility

*"It was clearly the problem of the modern painter to purge himself of all individualistic tendencies.... He should devote himself to the cause of purity and precision"—Peter Blume.*[8]

Precisionism, which stabilized and ordered the anarchic energies seen in Stella's *Battle of Lights*, was a form of modernist classicism. Applied to machinery, to industrial architecture, and to tall buildings and urban skylines, Precisionism evacuated the human presence to emphasize the remote, impersonal appeal of pristine geometries. Yet these very qualities—remoteness, cool impersonality—suggest an undercurrent of ambivalence; erasing the human presence also erased the liveliness of variety and mobility.

Precisionism in the United States was part of an international reaction against Expressionism in art. In Germany it took the form of the **Neue Sachlichkeit** or New Objectivity,

in France, of "Purism." These various movements shared a desire for clarity, stripping away fuzzy emotionalism and expressive brushwork. Impersonality and austere handling were now desired qualities. Characteristics associated with the machine—functionality, impassiveness, formal precision —were extended to image-making. The search for classical poise reinforced a related impulse toward objective form, which was coupled with a tight, airless rendering in which all accidents of vision were purged. In sculpture, the Precisionist impulse found expression in the elegant monoliths of John Storrs (1885–1956), whose staggered profiles refer to the setback skyscrapers from the 1910s forward (**fig. 14.16**).

**CHARLES SHEELER.** The classicizing impulse was also linked to older art. Precisionists Charles Sheeler (1883–1965), Morton Schamberg (1881–1918), and Elsie Driggs (1898–1992) were among those artists deeply impressed with such early

14.17 CHARLES SHEELER, *Classic Landscape*, 1931. Oil on canvas, 25 × 32¼ in (63.5 × 81.9 cm). Mr. and Mrs. Barney A. Ebsworth Foundation.

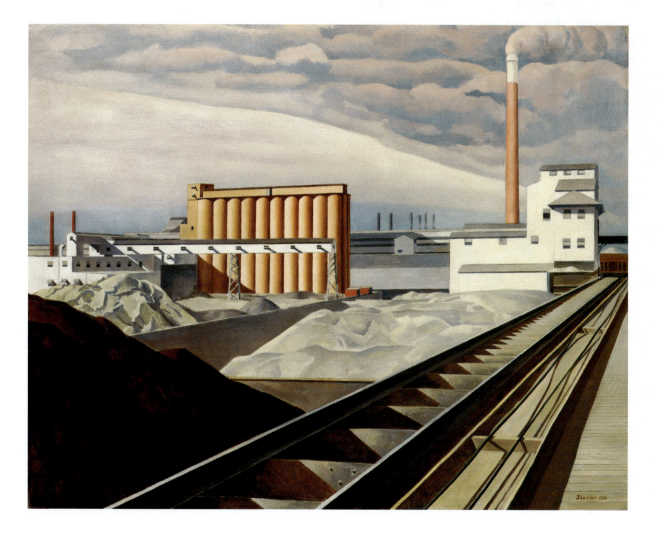

Italian Renaissance masters as Giotto, Masaccio, and Piero della Francesca. Such inspiration offered a way of redeeming modern subject matter through historical associations with the monumental art of the past. Sheeler's *Classic Landscape* (**fig. 14.17**) associates the industrial present with the stability and harmony of classical aesthetics. Sheeler much admired the art of the Greeks, who represented for him an ideal balance between the human and the natural. Applied to the complex interlocking industrial landscape of the Ford plant, Sheeler's title and ordered composition suggest an effort to find heroic order and balance in the operations of a factory. At River Rouge, all facets of the industrial process were controlled by Ford, from the supply of raw materials (the Ford empire included rubber plants in Brazil, ore mines in Michigan, and coal mines in Appalachia) to their transportation and processing. In the background are the mountains of iron ore, limestone, and coke used to make iron, the main ingredient in steel manufacturing. In his representational strategy Sheeler differs

from other painters of machine-age America in showing the manufacturing process as a sequence from raw materials (extraction) to processing to parts production, to assembly, rather than isolating machines from their industrial context. In doing so, he restores a narrative to the subject of industry. However, by banishing the human element, he avoids the social conflicts that attended Ford's industrial monopoly in Detroit. In place of the fractured plans and exploded perspectives of works from the 1910s, with their spatial discontinuities, Sheeler's *Classic Landscape* restores industry to temporal continuity, physical integrity, and harmonious balance.

Commissioned by the founder to create a series of views of his factory, Sheeler was sarcastically dubbed the "Raphael of the Fords." While he did occasionally betray some ambivalence toward American industry, in *Crisscrossed Conveyors, River Rouge Plant, Ford Motor Company* (**fig. 14.18**) Sheeler nevertheless created his most reverential image. Slightly off-center, crossed diagonal conveyor belts are anchored by the staccato verticals of the smokestacks; the viewer's gaze is upward, as if in religious contemplation. "It may be true," Sheeler wrote, "that our factories are our substitute for religious expression."[9] Judging from the number of times *Crisscrossed Conveyors* was reproduced, it clearly struck a chord with business leaders looking to exalt the image of industry.

**"TOMBSTONES OF CAPITALISM."** Certain artists such as Stefan Hirsch (1899–1964), Francis Criss (1901–73), George Ault (1891–1948), and Peter Blume (1906–92) employed the visual rhetoric of Precisionism in a more direct indictment of the very structures of industry and capital that their clean-edged and rationalized style appeared to emulate. Ault's *From Brooklyn Heights* (**fig. 14.19**) transforms the soaring skyscrapers of lower Manhattan into brooding, oppressive gray monoliths, "tombstones of capitalism," in the words of the artist, inverting their celebratory description as "cathedrals of commerce."[10] Seen from across the East River, they are reduced to stark volumes softened only by plumes of smoke. Hirsch—in a similar vein—wrote that his 1921 painting of Manhattan "expressed my recoil from the monstrosity that industrial life had become in 'megapolitania.'" In this instance, Precisionism was turned against itself, its pristine geometries and airless clarity expressing the dehumanizing scale and inhuman might of capitalism allied to industry.

Georgia O'Keeffe (1887–1986) also complicated Precisionism with her own nature-based language. Between 1925 and 1930 O'Keeffe completed over twenty paintings featuring the skyscraper city. These represented a

14.18 CHARLES SHEELER, *Crisscrossed Conveyors, River Rouge Plant, Ford Motor Company*, 1927. Gelatin silver print, 9 ⁷⁄₁₆ × 7 ⁷⁄₁₆ in (23.5 × 18.8 cm). Henry Ford Museum & Greenfield Village.

14.19 GEORGE AULT, *From Brooklyn Heights*, 1925. Oil on canvas, 20 × 20 in (50.8 × 50.8 cm). Newark Museum, New Jersey.

major shift in subject matter for the artist. By this time the leading American female modernist, O'Keeffe was associated with the feminine subjects of still-life and landscape. Her turn to the skyscraper—associated with the masculine spheres of business and technology—troubled her critics, who were willing to acknowledge her modernism as long as it safely pertained to a traditional subject matter linked to her "feminine nature." From O'Keeffe's perspective, however, urban subjects offered new challenges. Always interested in the form-defining properties of space, O'Keeffe used the urban landscape to invert the emphasis of male Precisionist painters on hard-edged mass and volume. Paintings in the series give equal visual weight to the spaces *between* the massive towers of the city. For O'Keeffe,

painting the city in terms of canyons, spatial voids, sky, sun, and moon gave to this modern subject an American twist by associating it with the grand scale of the American landscape. She redefined the urban theme by bringing nature back into the city. Mass is dematerialized in the light of the sun, in her *The Shelton with Sunspots, New York* (**fig. 14.20**). She noted later that as she started to work, "there was the optical illusion of a bite out of one side of the tower made by the sun. …"[11] Ridged clouds cascade down, animating the spaces between the buildings. Nature vies for power with the city.

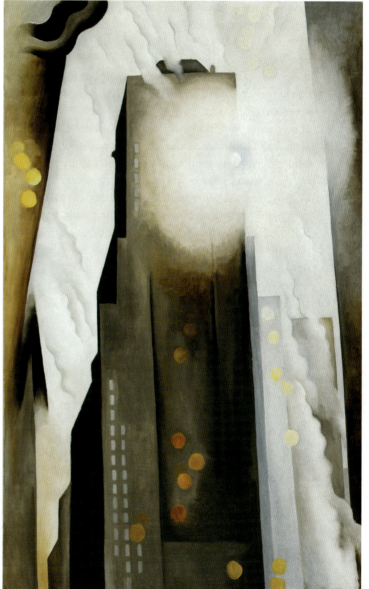

14.20 GEORGIA O'KEEFFE, *The Shelton with Sunspots, New York*, 1926. Oil on canvas, 48½ × 30¼ in (123.2 × 76.8 cm). Art Institute of Chicago, Illinois. Gift of Leigh H. Block.

# The Commercial Landscape
of the Everyday

The new American city of the twentieth century inspired a raucous endorsement among a group of writers and artists dubbed the "new vulgarians," those who wanted American art to draw its content and its forms directly from the commercial, machine-based culture of modern America.[12] They were critical of the "soil-spirit" artists celebrated by Alfred Stieglitz, who repudiated the messy commercial landscape of the urban present in favor of art forms that looked to the spiritual heritage of the nation, rooted in the natural landscape—the "soil"—of the country. The writer Edmund Wilson (1895–1972) summed up the credo of the new vulgarians, "[t]he hawking taxis, the screaming sirens, the joyous yell of the mechanical life, all this we hear every day; it is the music to which we dance, to which the power-drunk city exults."[13] For the "soil-spirit" camp, such efforts to capture the shock and confusion of modernity threatened to prostrate the artist before the "monster" of commercial civilization, a new machine culture that made machine men. Between these two extremes were a range of positions, as American artists struggled to create a compelling new visual language of their time and place. Advertising, packaging, and graphic design—the signage of a new commercial culture—played a key role in this new American art.

## "Modern Vernacular"

The bold, attention-grabbing graphics of billboards and advertising plastered on urban walls, product packaging, and consumer objects formed a growing part of the every-day—or vernacular—visual landscape of American cities by the early twentieth century. American artists took a number of approaches to this new landscape. Though undeniably modern and American, it was also dominated by the commercial values that many artists loved to hate. While quite a few became involved in commercial design at various points in their careers, others cordoned themselves off from any such involvement with business. Yet these same artists occasionally appropriated aspects of the new visual environment in their own work, as a sign of their modernity, their desire to address a wider audience, or their ability to transform the raw materials of a mass consumer culture into the stuff of art.

**STUART DAVIS.** The paintings of Stuart Davis (1894–1964), in the words of a mid-century critic, were "as American as a New England patchquilt, though having the pattern of late cubism."[14] Davis domesticated Cubism with graphic forms and bold colors inspired by America's new commercial landscape. A prolific writer, he wrote that he "enjoyed the dynamic American scene ... all my pictures ... have their originating impulse in the impact of the contemporary American environment."[15] He identified some of his inspirations as "American wood and iron work of the past; Civil War and skyscraper architecture; the brilliant colors on gasoline stations; chain-store fronts and taxi-cabs; the music of Bach; ... fast travel by train, auto, and aeroplane which brought new and multiple perspectives; electric signs; the landscape and boats of Gloucester, Mass.; 5 & 10 cent store kitchen utensils; movies and radio; Earl Hines hot piano and negro jazz music in general, etc." These things, he concluded, all shared a similar sense of formal, spatial, and sound dynamics that he wished to incorporate into his art, dynamics expressing "the new lights, speeds and spaces of our epoch."[16]

Davis's *Odol* (**fig. 14.21**) features a well-known German mouthwash marketed in the United States. His painting reproduces the distinctive angled neck of the bottle. In a fashion that anticipated the Pop art Campbell's soup cans of Andy Warhol (see fig. 18.6), Davis reproduced the precise labeling and packaging of the commercial product. Yet the painting is also Davis's "riff"—the term is appropriate, given his taste for jazz—on the European Cubist studio still-life. The advertising phrase "It purifies" refers both to the product and to the artist's relationship to European modernism. Davis had tried his hand in 1922 at a Cubist-style still-life that referred directly to the table-top compositions of Braque and Picasso. However, he realized a more successful synthesis of Cubist space and American subject matter in a series of works drawing directly on American products—*Lucky Strike* (1921) and *Cigarette Papers* (1921)—which translated the Cubist ambiguity between two and three dimensions, flatness and illusion, into boldly simplified terms. In *Odol*, a checkerboard bathroom tile floor is upended in a bold gesture that banishes all reference to illusionistic space. The only exception is the three-dimensional lettering on the Odol bottle itself. Davis also plays with spatial illusion in the illogical frame he superimposes upon the composition. In place of Cubist "passage"—the shaded transitional zones between areas of the composition, which suggest a lingering debt to chiaroscuro—he gives us a "purified" American expression, moving American art away from European modernism and into an unapologetic embrace of the bold flat quality of modern advertising.

Though he possessed a sophisticated knowledge of European modernism, Davis wrote that he wanted to paint

14.21 STUART DAVIS, *Odol*, 1924. Oil on canvas board, 24 × 18 in (61 × 45.7 cm). Museum of Modern Art, New York.

"direct simple pictures of classic beauty—expressing the immediate life of the day … They should be sold in stores like newspapers and magazines." "I do not belong to the human race but am a product made by the American Can Company and the New York *Evening Journal*."[17] His notion of a "vernacular" language of art did not extend to creating real advertisements, however, and he refused any direct commercial involvement with advertising, unlike his contemporaries, Maxfield Parrish and Rockwell Kent. Though these latter two artists were stylistically conservative, they were professionally tied to the realms of business and advertising that were reshaping the visual landscape of the everyday. Davis's high modernist prejudices kept him from direct involvement with commercial media; claiming the subject matter of advertising for his art, he nonetheless clung fast to the privileged voice of the artist. (See fig. 16.13 for more on Davis.)

## Photography and Advertising: Modernism Allied to Commerce

If modernist artists often felt they debased their art by associating it with commodities, commodities—and the whole business of buying and selling—could benefit considerably from an association with modern art. Artistic modernism exerted a wide influence, evident in the proliferation of modernist styles such as Cubism and **Constructivism** in such upscale publications as *Vanity Fair*, *Vogue*, *Harper's Bazaar*, and *Fortune*. "[T]he principles of Cézanne," as one advertiser put it in 1927, "have been put to use admirably in the advertising of Snowdrift and Wesson Oil."[18]

Not everyone agreed that modernism was suited to commercial uses. Advertisers were increasingly concerned with the ability of the image to communicate to a mass public. Some argued that abstraction, grounded in pattern and shape apart from subject, obscured the message. In this context, "transparency"—seeing through the image to the thing it represented—was an important consideration. Advertising adjusted its approaches to "niche" markets: vanguard styles for sophisticated consumers, graphic readability and an interesting narrative for "middlebrow" audiences. Techniques of persuasion thus varied along class and consumer lines.

The invention of the half-tone photographic process in the 1890s made photomechanical reproduction possible. Despite this, photography was not widely used in advertising until the 1920s, when photographers would master a range of new techniques that glamorized consumer products. After that date, photography dominated the magazines, constituting over 60 percent of all ads by the mid-1930s. In addition to its claims to truth, the camera had a second appeal for advertisers: it was distinctively American: "… leadership with the camera belongs to America. … A new art is reflecting a new scene. Skyscraper, grain elevator, dynamo, smoking factory chimneys—these become as appropriately themes for the camera as was the French landscape for the brush of Corot, or the mists of an English harbor for the art of Turner."[19]

Photographic advertising, as Lincoln Kirstein put it in the 1930s, "learned how to make spools of thread look like grain elevators and buttons like galaxies of moons."[20] Using seductive lighting and dramatic framing, photography could make the small seem big and the everyday seem fantastical. To mass audiences, photography was less intimidating than the fine arts, but it did popularize modernism with its skewed perspectives (such as the popular "angle shot"), flattened spaces, and attention to abstract pattern. Such devices associated consumer products with an up-to-date, adventurous modern outlook and helped sell a way of life.

**STEICHEN AS AD ARTIST.** Instrumental in creating this new language was Edward Steichen, whose involvement reveals just how permeable were the boundaries between art and commerce. Steichen's career, which extended from Pictorialism to fashion, and advertising to journalism and documentary, embodies the varieties of twentieth-century photographic practice. By 1923, when he was hired by *Vanity Fair*, Steichen had come to think of photography as serving a wider audience. Steichen's status as a "fine art" photographer increased his appeal for advertisers. Like other media such as animation—going through a similar process of industrialization—advertising and fashion photography were produced by teams of technicians. While Steichen acknowledged his lack of control over the final product, nevertheless he still directed the entire process and put his stamp on the end result. In his advertising work he used modernist formal strategies—isolating the object from any context, repeating it to create abstract pattern, and framing it at odd angles, as well as using antinaturalistic lighting, tonality, and perspective—to sell an image of modern life as seductive, glamorous, and excitingly new (**fig. 14.22**). Steichen popularized a style that combined the geometries of Art Deco with extreme camera angles. At a time when Americans relied more and more on consumption to establish a self-image, Steichen created photographs in which commodities were springboards for private fantasies, evoking materialistic desires and longings for status.

Steichen supported aesthetic collaboration with modern business. Emphasizing the message over the maker, he located the "truth value" of the photograph not in its unique artistic vision but in the power of the image itself—regardless of its source in advertising, propaganda, or photojournalism—to shape public desires, memories, and future hopes. In 1929 he proclaimed that "there never has been a period when the best thing we had was not commercial art."[21]

## The Painter, the Poet, and the City: Charles Demuth's Poster Portrait of William Carlos Williams

*"The Great Figure"—William Carlos Williams*

Among the rain
and lights
I saw the figure 5
in gold
on a red
firetruck
moving
tense
unheeded
to gong clangs
siren howls
and wheels rumbling
through the dark city.

In the 1920s, Charles Demuth did a series of "poster portraits" of his friends and fellow artists. In their abstract and coded character (devoid of direct physical references), these resemble the emblematic portraits Demuth's friend Marsden Hartley had done a decade before (see Chapter 13). Visually stunning, these works nonetheless elude understanding but suggest a strategy by which artists both participated in the commercial culture of their time, and remained aloof, preserving separate identities. Demuth's 1928 painting *I Saw the Figure Five in Gold* (**fig. 14.23**) pays tribute to the modernist poet William Carlos Williams (1883–1963), whose poem "The Great Figure" inspired Demuth's painting. Williams's poem describes a vision of a fire truck speeding through the streets of New York. *I Saw the Figure Five* takes this vision as its central motif. In the lower third of the painting is the horizontal axle of the

14.22 EDWARD STEICHEN, *Douglass Lighters*, 1928. Photograph. George Eastman House, Rochester, New York.

14.23 CHARLES DEMUTH, *I Saw the Figure Five in Gold*, 1928. Oil on composition board, 36 × 29¾ in (91.4 × 75.5 cm). Metropolitan Museum of Art, New York. Alfred Stieglitz Collection, 1949. (See also p. 388)

truck, while the globes of light in the upper right and left corners may be read both as headlights and as street lights. The painting offers other glimpses of an urban landscape at night—tall buildings, illuminated storefronts, electric billboards, and theater marquees take their place in an abstract composition. Demuth's painting suggests the way in which the gold five—painted on the side of the truck—activates the poet's perceptual field, a moment of revelation that unites the poem and the painting.

Demuth's dynamic composition of crisply painted letters and numerals is intersected by prismatic rays. These raylines, influenced by Futurism, bring to mind another familiar aspect of urban life in the 1920s: they resemble the light cones of cinematic projection. Like a moving picture, the city absorbs the viewer in a whirl of light and sound, superimposing a sequence of moments as layers of space. The series of fives creates a recession carrying the viewer into the depth of the canvas, only to be ping-ponged back toward the surface; the effect is of energies that expand and contract simultaneously. Background and foreground are brought together in a design of overlapping diagonals, suggesting the **syncopations** of jazz, or the sound of a siren as it passes, **Doppler**-like, through space. The visual effect

of the painting echoes Williams's own call for a new poetry that would capture the "jumps, swiftnesses, colors, movements" of the modern city.[22]

Both Demuth and Williams directed their separate art forms toward the qualities, textures, and sensory environment of the new city—the accelerated speed of perceptions, the fractured visual field, and the impact of new media such as film in transforming life into spectacle. *I Saw the Figure Five* is a painter's tribute to a poet, implying a creative bond between two members of the American avant-garde engaged in a common effort to forge a new American art based in the commercial landscape.

While using imagery drawn from this familiar landscape might allow art to fulfill its democratic promise, nevertheless only those who shared Demuth's knowledge of Williams and his vanguard associates in the 1920s would understand his painting entirely. Demuth's portrait places this commercial vernacular in the service of coded meanings, difficult to grasp. Appealing to a machine-age public familiar with billboard graphics, it resisted the accessibility of commercial messages by employing a language of private allusion. In doing so, Demuth's coded images lifted his art above the "vulgar" commercial culture that supplied his raw material.

The uses Davis and Demuth made of urban graphics, packaging, and advertising were new to American art. Although *trompe l'oeil* paintings of the late nineteenth century depicted paper money, along with bits of popular ephemera such as theater tickets, newspaper ads, and early pin-ups (see fig. 11.6), these objects in no way suggested a new visual *style*, serving instead a purely iconographic function. By contrast, early modernists went beyond the mere appropriation of objects from popular culture to exploit not only the visual properties of new materials, but also the sensations associated with new urban experiences.

## The City and Popular Media: Comics and Animation

American modernist painters struggled to represent urban modernity's condensation of time and space in the static medium of easel painting. They used the limited means available to them—abstraction, montage, Cubist fragmentation, and Futurist repetition of forms—to suggest the ways in which trains, planes, telephones, telegraphs, tall buildings, and photography transform the experience of reality. Early cartoons and animation—with their inherent capacity to free time and space from its everyday laws—proved far more effective than the fine arts in capturing the fluid nature of urban reality in the modern

era, or so at least one commentator thought in the 1920s. Journalist Creighton Peet celebrated his favorite animated character—Felix the Cat—as "one of the few sparks of vitality in a world of insistent proprieties."[23]

**LITTLE NEMO.** In the strip cartoon *Little Nemo's Adventures in Slumberland*, drawn by Winsor McCay (1867–1934) from 1905 until 1911 for the *New York Herald*, a young boy travels across time and space in a series of extraordinary dream/nightmare adventures induced by having eaten rich foods before bed (**fig. 14.24**). Each strip begins with Nemo being spirited away by one of a cast of characters who take him on mock epic journeys, and each ends with Little Nemo tumbling out of bed and waking up. McCay's strip brought together the storybook characters of polite children's literature with an assortment of raucous ethnic stereotypes: spear-wielding Africans, ferocious redskins, vulgar cigar-smoking Irishmen. In the highly condensed space of the strip, Nemo's dreams reproduce the time

14.24 WINSOR MCCAY, *Little Nemo's Adventure in Slumberland*, Sept 29, 1907. Ink drawing, 9 × 8 in (28 × 23 cm).

travel and random illogical juxtapositions that had come to seem commonplace in everyday urban life. McCay leavened his narrative with a grasp of the unconscious, where desires have an uncanny tendency to take real form. From the polar icecaps to the tropics, from the heart of darkest Africa to the heart of the American skyscraper city, Nemo's adventures reflect the mobility of imagination liberated by new technologies of travel, and empowered by dream. McCay's *Little Nemo* animated the inanimate, warping an everyday sense of scale and proportion through dreamscapes that collapsed time and space and acted out the repressed anxieties and fears of modern urban Americans. It did so with wit, humor, and consummate artistry. McCay was among the first to try his hand at animation, characteristically hand-drawing each frame himself for his *Gertie the Dinosaur*, insisting on individual control over each aspect of a medium that, by the 1920s, had come increasingly to resemble industrial modes of production.

*Little Nemo's* ethnic stereotyping, along with its sudden leaps between times and places, drew upon McCay's own experience in vaudeville, a fertile source for a variety of popular forms, from film to stand-up comedy. While such stereotypes occasionally made their way into the work of the Ashcan artists of these same years (see Chapter 12), they remained generally off limits to art deemed to be serious.

**GEORGE HERRIMAN'S *KRAZY KAT*.** Despite their graphic and narrative power, comic strips have been widely decried by those interested in policing public taste and morality as the lowest of the "low art" forms. Having fought long and hard to establish fine arts institutions, public respect for the arts, and a serious audience, American elites were rigid in enforcing boundaries between fine arts and popular media. Persistent insecurity about the status of high culture in the United States also contributed to reluctance to recognize the inventiveness of low art media. Such had not been the case in Europe, where artists from Juan Gris (1887–1927) to George Grosz (1893–1959) moved fluidly between the worlds of painting and popular media, including cartoons, both making and consuming them. Picasso, Ernest Hemingway, and T. S. Eliot were among the avid readers of George Herriman's (1880–1944) *Krazy Kat* (begun 1913; **fig. 14.25**). Such adulation contributed to growing recognition for cartoons in this country.

Like Winsor McCay's *Little Nemo*, the premise of the *Krazy Kat* strip was deceptively simple: a lovesick cat romantically attached to a sadistic mouse named Ignatz, whose violence toward his admirer is policed by Officer Pupp, a canine law enforcer who is himself in love with the

14.25 GEORGE HERRIMAN, *Krazy Kat*, from *New York Evening Journal*, March 15, 1925.

cat. The strip invariably ends with Ignatz throwing a brick at Krazy Kat, who remains deluded enough to believe that such actions are motivated by love. Their antics are played out in the lunar landscape of the American Southwest, with its rocky outcroppings and otherworldly desolation. Herriman's strip brought the surreal Southwest, with its Spanish place names (Cococino, Desierto Pintado), together with a character who muses in the vaguely Yiddish accents of an immigrant to the New World, in flights of poetry that delighted his readers. Combining slapstick comedy with snatches of Spanish, broken English, and a lovable character impervious to the hard knocks of reality, *Krazy Kat* celebrated the comic collision of New and Old Worlds. Herriman, who was of African American parentage although he passed as white, used the freedom of the new medium to transform a delusional obsession into compelling visual and verbal poetry and inspired comedy. Drawn with a scratchy shorthand, the strip changed landscape from frame to frame, a whimsical commentary on the pace of change in the new America.

**A COMIC STRIP BY A MODERNIST ARTIST.** The extraordinary history of American comics and their international influence was the product of native talent, unburdened by fine art requirements and wedded to the mass-circulation daily newspaper. Under the guidance of William Randolph Hearst, Joseph Pulitzer, and others, these newspapers established an unprecedented sway over the lives of urban Americans. In one instance, a brilliant if short-lived comic strip published in the *Chicago Tribune* was the product of a German-American artist better known for his modernist canvases. Lyonel Feininger (1871–1956), American-born but living in Germany since his teens, trained as an artist there and brought his interest in Art Nouveau and *Japonisme* to his comic art. Feininger began as a cartoonist for European journals but eventually developed his own set of characters, traceable back to the earliest cartoon in Europe, *Max and Moritz* (1865) by the German cartoonist Wilhelm Busch (1843–1908). Busch's naughty boys influenced the shape of later American comics such as R. F. Outcault's *Yellow Kid* (1896) and the *Katzenjammer Kids* (1896), a popular strip published in the *New York Journal*. These "demon children" engaged in pranks that satirize adult behavior and poke fun at adult pretensions. Hired by the *Tribune* to woo German immigrants and others to the paper, Feininger created *Kin-der-Kids* (1906; **fig. 14.26**), which featured a motley crew of characters with such American-sounding names as Aunty Jim-Jam and Cousin Gussy. In figure 14.26,

14.26 LYONEL FEININGER, *Kin-der-Kids Abroad*, from *The Chicago Sunday Tribune*, May 6 1906. Letterpress and line block. Gift of the artist. Museum of Modern Art, New York.

the Kin-der-kids sail back to Europe in a bathtub, reversing the usual direction and turning their back on a comically distorted Statue of Liberty, who waves farewell with a huge white handkerchief.

### THE BEGINNINGS OF ANIMATION: "FELIX THE CAT."

The animation medium was the same as film: **celluloid** run through a projector, in a sequence of individual frames that created the appearance of continuous motion. Yet unlike film, animation freed itself from the real world by substituting hand-drawn for photographic frames. These frames were then photographed by a motion picture camera designed to stop after each exposure. With the invention of the "cel"—short for celluloid—in 1914, animation became less labor-intensive, as multiple layers of celluloid separated the static landscape backdrops from the moving figures in the foreground. These alone were redrawn to produce the illusion of motion. As the commercial possibilities of animation became apparent, studios emerged to produce

shorts shown before feature-length live action films. Resembling the division of labor within industry, animation studios were hierarchically organized by skill level, from master animators to tracers and inkers. Critics of animation charged that because animation was the result of a "production line of specialists," it lacked "a single brain and sensibility," and could not achieve aesthetic unity.

Despite the criticism that animation allowed little individual creativity, the history of the medium has been marked by strong creative personalities whose vision guided the production process. One such personality was Otto Messmer (1894–1985), creator of Felix the Cat (**fig. 14.27**). Widely known and loved following his first appearance in 1919, Felix was an "everyman" figure with whom audiences of all social backgrounds could identify. Felix, endowed with extraordinary powers of self-transformation, faced the constant challenges of everyday life—hunger, fear, the need for love and acknowledgment, the quest for pleasure, the battle between men and machines, the battle

between the sexes, and the age-old desire to transcend the limits of bodily existence—with endless ingenuity, and occasional help from his animator. *Felix Dines and Pines* (1926) is played out in an urban setting characterized by syncopated jazz rhythms, swaying skyscrapers, and carousing companions. The experience of following Felix through trial, challenge, and happy (or humorous) resolution carried a cathartic force for audiences whose own experiences with modern life often presented intractable difficulties.

Watching Felix was cathartic in another sense as well; animation was a mechanized medium, yet one that balanced machine production with the individual talents and creative imagination of the animator. With minimal means—the reductive and simplified black and white of Felix and the things he is transformed into, against a stark background of abstracted props—the Felix cartoons acted out the tension between personal fantasy and mechanical form, a struggle that allowed audiences to work through their own anxieties about mechanization. Embodying the everyday travails of ordinary Americans coping with a sometimes frightening urban environment, Felix won the day through his power to improvise a quick response to new situations by shifting shapes. The ability of one thing to transform itself into something else—shape-shifting—was unique to animation; no other medium had such fluid capabilities. Animation "gave man the power finally to create something new in the world," as one admiring critic put it in the 1920s,[24] and Messmer used this power to the fullest. Felix's tail might become an umbrella, which in turn could become the propeller of a plane, allowing him a con-venient escape from the ubiquitous predators that haunt his many lives. For viewers increasingly locked into the regimen of the production line, the time clock, the scheduled arrival and departure of trains, and the routinized nature of daily life, Felix represented freedom and possibility.

Animation shared with modernism the power to transform one thing into another. Modernism did this through metaphor: abstract forms conjure associations with the body, or with nature. Animation did this through more direct means: a lamppost becomes a sinuous monster, or a line of linked sausages becomes a corps of fighting soldiers. Modernism engaged the powers of unconscious association; animation likewise played upon such psychic mechanisms as displacement, free association, and projection, as when Felix, haunted by hunger, hallucinates edibles at every turn. In one final respect, animation paralleled modernism by calling attention to the medium and revealing its own mode of production. In *Comicalamities* of 1928, the hand of the animator appears, drawing Felix with pen and ink. Felix thenceforth repeatedly summons his animator to do his bidding, as when he asks him to repaint the face of an ugly female cat. After being rejected by the newly desirable cat, Felix tears a hole in the paper on which she is drawn and tosses her out, once again asserting control over the narrative. In its powers of transformation, its grasp of the unconscious, and its self-referentiality, animation also resembled Surrealism, as European commentators noted. The advent of sound technology in 1927 dramatically transformed animation by introducing narrative structures that relied far less on the visual logic of shape-shifting to drive the story.

14.27 OTTO MESSMER, *Felix the Cat*, 1923.

# The Human City: Spectacle, Memory, Desire

The "Felix" animated films exposed the complex human dimensions of urban modernity. His adventures also revealed the shifting nature of urban public space in the early twentieth century under the growing pressures of private, consumer-based forms of experience and leisure pursuits. The cinema offered a good example of this; occurring in the public space of the theater, its peculiar mode of address—in the dark, with the flickering lights and shadows of the moving image absorbing the watcher's full attention—lent itself to personal fantasy and the projection of purely private desires. Artists engaged with the human side of the city in a range of ways that embodied the intertwined nature of public and private worlds in the era of **mass media**.

## The City as Spectacle: Reginald Marsh

From the late nineteenth century on, American artists had been fascinated by urban spectacle: the drama of the boxing ring, the circus, the popular theater, movie houses, vaudeville, and amusement parks that immersed the spectator in a world of light, color, sound, and movement. In the 1920s and 1930s, artists were particularly drawn to the parade of humanity across the stage of the city itself. Artists painting around Union Square in lower Manhattan focused repeatedly on the figure of the female shopper, and on the young working women who formed a growing percentage of the urban work force. For these so-called 14th Street School painters the new public presence of women in the city inspired ambivalent responses to the role of consumerism, advertising, and media culture more generally in shaping urban life.

Educated at Yale, Reginald Marsh (1898–1954) started out as an illustrator and cartoonist. His drawing skills served him well in capturing the energetic, pleasure-seeking urban crowds he sought out on beaches, in Coney Island, in burlesque theaters and on the streets. Like others among the 14th Street School, Marsh extended the figurative concerns of early-twentieth-century Ashcan artists, bringing in addition a devotion to the Old Masters, inspired during a trip to Europe in 1925 by the multifigural compositions of Rubens and Michelangelo. His interest in urban crowds frequently focused upon the figure of the voluptuous and sexualized female pursuing urban pleasures. What, asks scholar Ellen Todd, are we to make of this "hyper-glamorized working-class femininity," apparently removed from the realities of low wages and the dreary routines of the workaday world that preoccupied the Social Realists in these same years?[25] Separated by class and social privilege from his subject matter, Marsh extended a tradition of urban voyeurism that began with such artists as John Sloan (see Chapter 12). His female figures—flamboyantly dressed and flaunting themselves to the viewer—betray the artist's critical view, shared with others of his generation, regarding the impact of mass media on behavior. Women, the primary targets of advertising campaigns for everything from clothing to perfume, embodied fears about a loss of individuality under the homogenizing force of commercial media, driven by a desire to sell.

In Marsh's *Twenty Cent Movie* (**fig. 14.28**), the action occurs on a shallow, stagelike space that mimics the screen spectacles advertised throughout the painting on marquees and posters. In Marsh's world, "mass media" creates life in its own image. The movie theater is contained within the broader stage scenery of 42nd Street, like a set of Chinese boxes. Marsh's subject is a form of live street theater. His characters represent the motley mix of race, ethnicity, gender, and social group that increasingly occupied the public spaces of midtown Manhattan, from the confident, brazenly single working girl, to the short, dapper, red-headed fellow, hands in pockets, forever waiting for his next opportunity, to the lanky, good-natured black man who looks us rakishly in the eye. Provocative phrases—"Joys of the Flesh," "Sin," "Blood," "Stripped Bare"—and vampish women on movie posters grab our attention while flirting with our curiosity, mimicking the titillations of tabloid journalism, film, and advertising. Marsh's subject here is the urban spectacle of men and women looking at one another, their interests driven by a mix of sexual, social, and consuming appetites, fed by mass media. The three central actors return our gaze, implicating us in the street play. Two men intently study a bill in the theater lobby, while the two young women on the left peer expectantly out toward the street. In *Twenty Cent Movie*, Marsh explores how the consumption of urban commercial messages flowing from newspapers, films, advertising, billboards, and marquees was reshaping personal behavior. The term "attraction" (as in "coming attraction") links mass entertainment to the body and the senses, distancing modern urban existence even further from the ideal of self-discipline so important to maintaining social order in the older republic. By linking urban women so closely to advertising and consumption, Marsh promotes their objectification. Passive before the onslaught of commercial messages, his women embody deep-seated fears about the erosion of free will and the selfish feminine pursuit of gratification.

14.28 REGINALD MARSH, *Twenty Cent Movie*, 1936. Egg tempera on board, 30 × 40 in (76.2 × 101.6 cm). Whitney Museum of American Art, New York.

## Quiet Absorption: Isabel Bishop's Women

Marsh's sirens differ pointedly from the young, delicately drawn female office workers of Isabel Bishop (1902–88). In their slightly rumpled ready-to-wear fashions and ordinary looks, these women turn toward one another, sharing a book or a meal, or speaking to one another across the interval of a male friend. This female world of affectionate companionship draws the viewer into an intimate exchange with them, which contrasts with the theatricality of other artists in the 14th Street School. In Bishop's *Two Girls* (**fig. 14.29**) gazes are focused inward, in response to the content of a letter that draws the two figures together. The shallow spaces mostly eliminate the urban environment in which they live out their workday lives. *Two Girls*

was purchased by the Metropolitan Museum of Art in 1936, signaling the arrival of Bishop as an artist of note. Despite the charged emotion of the scene, it exudes a poised stillness far removed from the agitated energy of Marsh's street scenes. Bishop, like Marsh, was a careful student of the Old Masters, although her approach suggests Rembrandt rather than Rubens. A narrow color range, tight framing, and centered compositions pull us back from the spectacle of the urban commercial landscape into a more private sphere. For many years, Bishop kept a studio in Union Square, asking the working women of the neighborhood to model for her, and studying them at close range. Like Marsh, she was distanced from her working-class subjects by a privileged background, but her method of painting worked against the objectifying gaze of Marsh. Bishop's women comfortably occupy their environment while suggesting a subtle vitality, conveyed through her brushwork, which weaves together figure and ground. Bishop expresses her own need to paint people who seemed

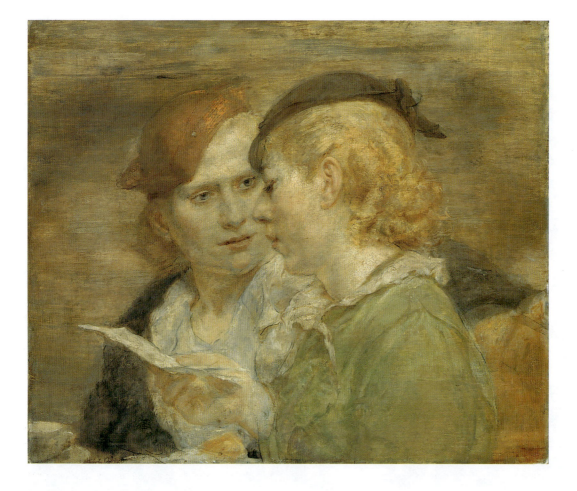

14.29  ISABEL BISHOP, *Two Girls,* 1935. Oil and tempera on masonite, 20 × 24 in (50.8 × 60.9 cm). Metropolitan Museum of Art, New York.

real to her, fully realized as subjects rather than as performers on a stage. Her women, passing between work and marriage, signal the promise of social mobility in the twentieth-century city. Individualized and anchored in their shallow spaces, their self-containment countervenes associations of women with mass culture, as well as with political mobilization.

## The Emergence of Urban Black Culture

Historically a largely rural and southern population, black Americans relocated to northern cities beginning in the 1910s in one of the greatest demographic shifts in American history, known as the "Great Migration." The children of former slaves, they moved north in search of industrial jobs. With this shift a new urban identity began to take shape, fostering, in the era of Jim Crow, a new measure of social, cultural, and economic independence for a community shaped by a history of slavery, **peonage**, and poverty.

**ARCHIBALD MOTLEY, JR.** As the nation's largest black community, Harlem was the very type of the new black metropolis. Elsewhere in the great industrial cities of the North—Chicago in particular—vibrant black communities also took shape, characterized by black-owned businesses, churches, and nightclubs. Archibald Motley's *Black Belt* (**fig. 14.30**) is a panorama of the social habits and behavior of modern blacks in his home city of Chicago. After graduating from the Art Institute of Chicago in 1918, where he received solid if conservative academic training, Motley (1891–1981) embarked on a successful painting career which included sensitive portraits of mixed-race women and scenes of urban black entertainment. Motley was quite explicit about his desire to create an image of black culture for black audiences: he made them "part of my own work so they could see themselves as they are … I've always wanted to paint my people just the way they are."[26] Though deeply committed to black subjects, he married a white woman and lived in a white neighborhood. Intent on creating a visual language that served his own sense of modern black life, he asked, "Why should the Negro painter, the Negro sculptor mimic that which the white

man is doing, when he has such an enormous colossal field practically all his own?"[27] In the 1920s he moved away from the naturalism that he felt characterized much black art of the time, and toward more volumetric, simplified, and stylized forms and rhythmically organized compositions. These qualities served what Motley called "the jazz aspects of the Negro" at a time when jazz music was entering its golden days of the 1920s.[28] It helped shape a black urban identity. Originating as a slang word for sex, jazz continued to be a liberating force for middle-class Americans still struggling to free themselves from older conservative attitudes toward the body. Jazz was a hybrid, fusing European, African, and American musical elements, and traditional forms with modern urban innovations. It was itself the product of cultural migration.

Motley was granted a Guggenheim Fellowship to study in Paris in 1929, where he extended his fascination with the black metropolis to the expatriate Africans and West Indians congregating there, along with Americans of color, as part of an international black culture that developed in Paris in the decades between the wars. Black performers such as Josephine Baker and the jazz saxophonist Sidney Bechet had been drawn to Paris by a growing international enthusiasm for jazz, and by greater openness toward American black culture among sophisticated Parisians. Upon returning from Paris, Motley explored a cast of characters—from sleek light-skinned women and jazz babies to the street preachers, urban tricksters and card sharps, and romantic young couples—who came together to form a vibrantly varied social life. Drinking cocktails, preening their way through garden parties and barbecues, or dancing in jazz cabarets, they confidently laid claim—like Motley himself—to the privileges and possibilities of urban modernity, while remaining within the black community.

## The Margins of the Modern: Edward Hopper and Charles Burchfield

"… This place / Is full, so full, of vacancy"—*John Hollander.*[29]

The sleek profile of the skyscraper city was ubiquitous in America between the wars—in advertising, and in promotional symbols of progress. The immobility of Precisionism, with its iconography of heaven-surging towers, expressed a longing to lift the city above the haphazard and the randomly human, moving it from shadow to light. As a cultural icon, the skyscraper symbolized modernity's triumph over human limits, as well as transcendence of the body and of history itself. This "utopian" modernism banished waste areas from view, but these areas remained nonetheless— zones of derelict buildings and derelict people, of discarded machinery, of pawnshops and vacant laundromats. Existing on the margins of a dynamic new order, these waste spaces held (and still hold) an important place in the imaginations of writers and artists questioning the costs of an economy and a culture relentlessly focused on money and glamor. They embody the blighting effects that a collective obsession

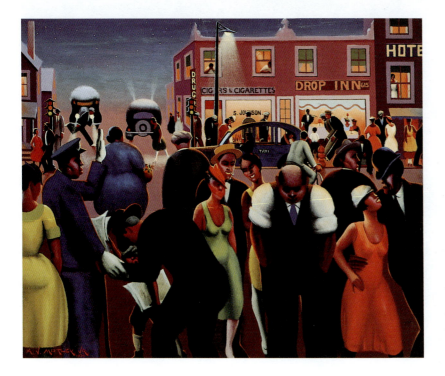

14.30 ARCHIBALD MOTLEY, *Black Belt*, 1934. Oil on canvas, 31¼ × 39⅜ in (79.3 × 11 cm). Hampton University Museum, Virginia.

with "success" produces. The discarded and the derelict possess a perennial appeal among those who have been scorched by too much exposure to modernity. The deserted streets of Edward Hopper and the lyrically melancholy images of Charles Burchfield cast their long shadow on the corporate rhetoric of engineered perfection and eternal youth holding sway over the nation's self-image.

**EDWARD HOPPER.** Edward Hopper (1882–1967)—an artist of monumental silence and stillness—is an odd figure in an urban culture of unremitting noisy movement. His images of urban desolation and solitude have shaped several generations of artists, writers, and filmmakers. His enigmatic art was the product of many influences. Along with training in Paris, and deep study of European art, he steeped himself throughout his lifetime in literature, theater, and Hollywood film—all narrative forms that influenced his approach to painting.

He has been called a realist. Yet Hopper's eerily empty rooms and streets, his mask-like faces, and charged intervals of space between people, suggest stories, and imply actions, occurring both before and after the scene represented. Their enigmatic narratives link them to the Magic

Realism of the 1940s (see Chapter 17). Hopper's figures frequently seem to be listening to or looking at people or things beyond the frame of the painting in a way that recalls cinematic editing (**shot** and **counter-shot**). There is as well a sense of *déjà vu*—things once seen and experienced but forgotten, returning to haunt the present.

In the history of encounters between the fine arts and popular media, Hopper's art holds a place of honor, influenced by, and in turn influencing, the film culture from which he drew inspiration. The affinities between Hopper's art and *film noir*—a style of Hollywood film influenced by the migration of German expressionists such as Fritz Lang to Hollywood between the wars, and characterized by dark, psychologically charged settings—are especially close. In *Nighthawks* (**fig. 14.31**), with its sultry atmosphere, eerie copper-green shadows, and suggestion of narrative, the composition of the painting, and the placement of objects within it, tell us more than the expressionless figures themselves; the two stainless steel streamlined coffee urns seem to act out the suppressed physical tension between the man and woman sitting at the counter. Behind the scene, like a theatrical backdrop, is the anonymous urban architecture of storefronts and apartments, all dark, and apparently vacant.

Mass media was not only the inspiration but also the direct subject of Hopper's art. In his 1939 *New York Movie* (**fig. 14.32**), a statuesque usherette leans pensively against

14.31 EDWARD HOPPER, *Nighthawks*, 1942. Oil on canvas, 33 × 56¹¹⁄₁₆ in (76.2 × 144 cm). Art Institute of Chicago, Illinois. Friends of the American Art Collection.

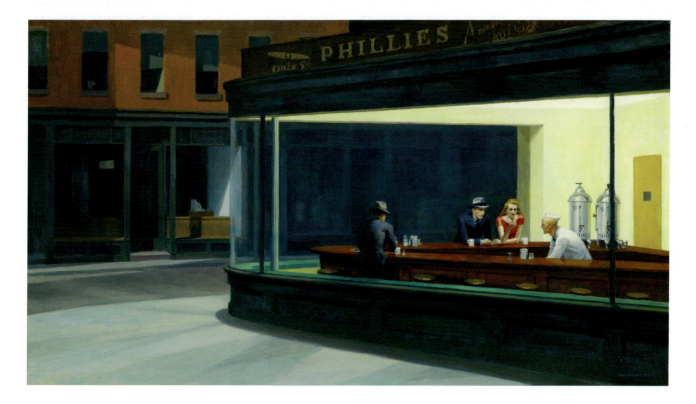

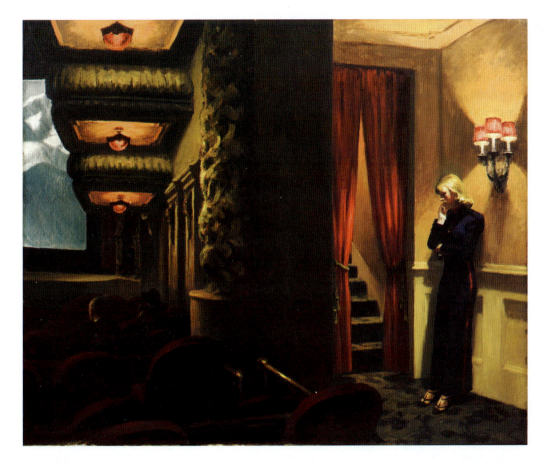

14.32 EDWARD HOPPER, *New York Movie*, 1939. Oil on canvas, 32¼ × 40⅛ in (81.9 × 101.9 cm). Museum of Modern Art, New York.

the wall, lost in her own world, while to the left an audience sits absorbed in the flickering images passing before them on the screen. Yet we do not see what they see; as is often the case, looking at a Hopper, one watches figures who are watching, without sharing their view. In *New York Movie*, the world of commercial media and the production of mass-consumed fantasies remain both irrelevant and inaccessible to the young woman and to us. Here Hopper explores the breach between the fantasy world of cinema, and the burden of boredom, isolation, and unrealized selfhood that remains for each dweller in the city to negotiate, mostly alone.

Hopper's paintings are populated by closed doors, tunnels, and blank windows that suggest an iconography of absence and failed efforts to find meaning. His interiors and city views are landscapes of urban exile from the plenitude of nature. In American art, nature was long the source of national identity and difference from Europe. In Hopper's art, it is blocked by houses and buildings, or forced to the margins of the composition, glimpsed out of a window, or in the form of dark, mysterious woods that hover beyond the well of light within which his figures act out their frozen sociability. Elsewhere nature appears as barren dunes, prairies, or treeless plains, drained of symbolic meaning.

Hopper's urban views are haunted by a sense of history. Corporate modernism produced a human subject who had no ties, who was unbound by the past, ready to experiment, to go forward into a future freed from the corrosions of time (for example, see fig. 17.33). Hopper's work returns us to a world that has been lost in the forward rush of technological modernization. His buildings have faces and histories; as novelist John Updike put it, "The architecture in Hopper *acts*, even when … it is unpopulated and calm."[30] Unlike the unpopulated landscapes of Precisionism, the urban and the human mirror one another, and carry the marks of time.

Despite his reputation as the visual poet of loneliness, Hopper was also drawn to the ways people set down roots against the odds, creating an awkward, sometimes homely sense of place out of placelessness. An old house sits beside railroad tracks—the symbol of mobility; the sculptural volumes of a lighthouse appear glistening white against a deep blue sky. His buildings carry the traces of the character and history that have been erased from the blank faces of his people. The built environment in Hopper becomes the living embodiment of culture, the material projection of a way of life. Yet Hopper—unlike other artists and writers searching for roots between the two world wars—

remained suspicious of an easily recovered "premodern" past. In its resistance to roots, his United States had always been modern. For anyone who has felt the poetry of emptiness, and the resistance of the American landscape to human habitation, Hopper's paintings evoke a paradoxical sense of place in the absence of roots.

**CHARLES BURCHFIELD.** Like Hopper, Charles Burchfield (1893–1967) was drawn to the poetry of dereliction, of a youthful culture gone prematurely aged. Burchfield's paintings in the years between the wars are a catalogue of tattered dreams: abandoned towns with their false-fronted ramshackle façades, sitting on the edge of vast prairies (**fig. 14.33**); decrepit Victorian rowhouses, resembling toothless old women; the barren wastes left by industries once robust, but which have moved on. Burchfield's ravaged countryside and shabby towns find their larger logic in the regionalist attack on the culture of the American pioneer. The years between the two world wars saw a broad reaction in the arts and letters against a commercial civilization that many traced back to the "slash and burn" mentality of westward expansion. For these critics, in place of community building and stewardship over nature, pioneers took what they needed and moved on, living only for the present, with no concern to create deeper ties to nature or history. In the unkempt and brittle quality of small towns Burchfield's vision echoes that of his friend the writer Sherwood Anderson, whose *Winesburg, Ohio* (1919) is a series of fictional sketches of small-town folk, rescued from insignificance through richly human stories otherwise untold. Burchfield's characters are buildings rather than people. These buildings resemble faces; his houses and streets are physiognomies of the lives lived within, expressing the passage of time and the imprint of history on the landscape. His cobwebbed, memory-haunted interiors reveal the dusky underside of the brash promotional rhetoric resounding through chambers of commerce around the country.

In Burchfield's gothic imagination, the past haunts the present. Yet he also found in the world of nature a source of reenchantment. Throughout his career, in brilliant watercolors, he evoked the hidden life of nature's forms with visionary intensity—the inverse of a cultural landscape drained of energy.

## The Dream-life of Popular Culture

Writing about Joseph Cornell, the biographer Deborah Solomon observed that "Nothing is more modern … than a yearning for the past."[31] Modernity sparked a reaction, which—in Cornell's case—took the form of objects recovered from intimate histories and salvaged from the ephemeral world of consumer culture by his act of collecting and preserving. Cornell holds a key place in a tradition of assemblage art that extends forward to the Beats in the 1950s and beyond. His work makes an instructive comparison with that of his contemporary Henry Darger, a visionary existing outside the art world. Cornell eventually achieved renown in the New York art scene, despite his odd and reclusive ways, whereas Darger lived a hermit-like life in a cramped studio apartment in Chicago, and only after his death was his work discovered.

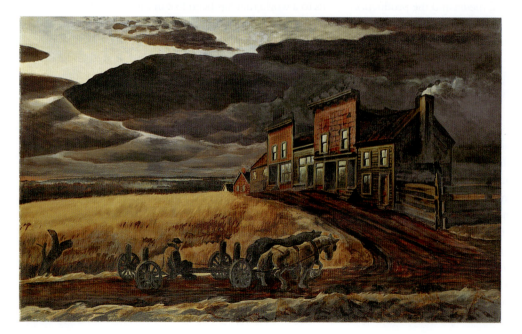

14.33 CHARLES BURCHFIELD, *November Evening*, 1931–4. Oil on canvas, 32⅛ × 52 in (81.7 × 132 cm). Metropolitan Museum of Art, New York. George A. Hearn Fund, 1934.

**JOSEPH CORNELL.** Like Hopper, whose work he admired, Joseph Cornell (1903–72) was an urban fantasist. He sought to memorialize the fleeting life of the past, to give permanence to the transitory beauty he found in the city. Cornell's work was assembled from the already made; he transformed a modernist tradition of found objects through a highly personal landscape of associations and memories. He first started inserting these found objects into boxed constructions in the 1930s—years dominated by painters of the American scene working in a realist mode. Yet that decade also witnessed the introduction of Surrealism to the art culture of the United States through the Julien Levy Gallery and a related exhibition at the Wadsworth Atheneum in Hartford, Connecticut, in 1931. Exposure to Surrealism freed Cornell's imagination. Working in the basement studio of a small house on Utopia Parkway in Flushing, Long Island, where he lived all his adult life, he meticulously constructed **collages** and wooden boxes

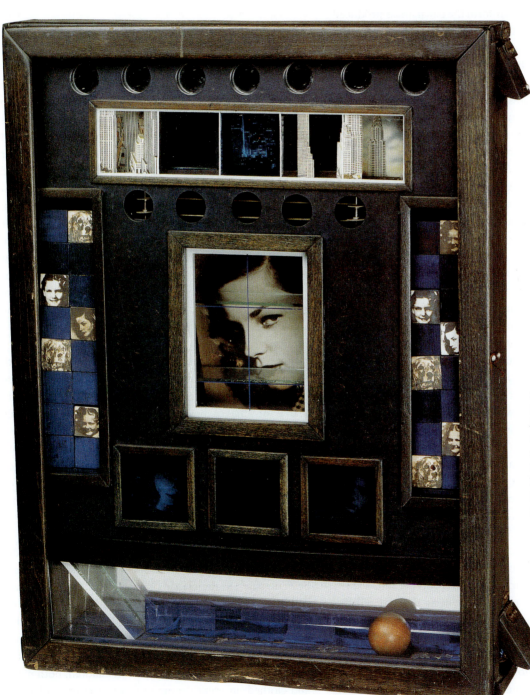

14.34 JOSEPH CORNELL, *Untitled (Penny Arcade Portrait of Lauren Bacall)*, 1945–6. Mixed media, 20½ × 16½ in (52 × 41.9 cm). Private collection. On long-term loan to Art Institute of Chicago, Illinois.

containing worlds—sometimes galaxies—in miniature, collections of apparently unrelated objects poetically transformed by being placed alongside other objects to create new meanings. Rambling through New York City thrift shops, Cornell collected nineteenth-century engravings, biographies of people mostly forgotten, photographs, shells, bells, feathers, dolls, and cheap mass-produced and easily discarded objects from the dime store, such as the glass goblet that appears in many of his boxed constructions. Suggesting vast worlds of time and space, Cornell's intimately scaled boxes transform the banal, mass-produced products of commercial life into objects of wonder and poignant reminders of change and loss.

Cornell's relationship with American mass media was highly conflicted. What he referred to as "this age of endless dull pictures and endlessly dull movie personalities, of an incredible mediocrity and banality"[32] could also become the raw material of new art forms. Cornell's gentle obsessions transformed his source material. In *Untitled (Penny Arcade Portrait of Lauren Bacall)* (**fig. 14.34**), a celebrity icon is transported into Cornell's dreamworld—a box 3½ inches deep and fitted with a series of interior ramps of glass, glimpsed through five "portholes." A wooden ball, released through a trapdoor at the top, would travel down the ramps in a continuous motion. At the center of the box is a large photograph of Lauren Bacall, regarding us with a sultry gaze. A Hollywood sensation in the 1940s, Bacall (b. 1924) appears as a young girl in two smaller photographs, alternating with snapshots of her cocker spaniel Droopy and with later publicity stills. The sequence of images of the screen idol shuttles us between past and present, and redeems the worldly young actress through association with childhood innocence. Bacall's image in turn is juxtaposed with gleaming white skyscrapers soaring above street-level chaos and impurity, including the Chrysler Building, another "icon," like Bacall herself. Juxtaposing private family photographs, publicity shots, and iconic urban images, Cornell collapses the boundaries between public and private, past and present. Ultimately *Penny Arcade* realizes the power of private imagination to fuse the separate "compartments" of our lives.

*Penny Arcade* recalls the origins of cinema in early-twentieth-century American cities. The window-like box frame around Bacall's face both transforms her into a work of art and recalls the peep-show effects that excited the voyeurism of early cinema audiences. Only here, the subject of our desire looks back at us. The staccato arrangement of photographs of the star recalls the flickering rhythms of early film projection. The blue tonality of the work also resembles early cinema. The immobility of the still image vies with the motion of the pinball as it travels down the internal ramps. Stopping and starting time, *Penny Arcade* explores the curious double life of mass media, the ephemerality of which—linked to mortality—paradoxically produces timeless icons. *Penny Arcade* inspires a shrine-like meditative engagement with the image of a mysterious and beautiful woman. Popular cinema—in the hands of Cornell—becomes an imaginary journey, saved from the banality of its mechanical means and its manufactured illusions.

**HENRY DARGER.** While Cornell stood at the edge of the New York art scene, and made nervous forays into it, Henry Darger's (1892–1973) art world was resolutely private—revealed only after his death. He shared with Cornell a love of popular culture, though for the most part it was the pop culture of his youth, rather than his adulthood. And, as with Cornell, change and loss were the underpinnings of his work. Three years after Darger was born, his mother died in childbirth, and he spent much of his childhood in an orphanage, later being sent to a state-run asylum for "feebleminded" children. At the age of about eighteen, shortly after his return to city life in Chicago, Darger began the epic fantasy that would absorb him for more than sixty years: *The Realms of the Unreal*, consisting of over 15,000 manuscript pages and several hundred illustrations centering on "The Vivian Girls," an imaginary corps of seven brave little girls who battle against their foes, the Glandelinians, who have enslaved them.

Darger held a job as a janitor and dishwasher at a hospital, went to church daily, but rarely socialized with others, preferring his fantasy world. He obsessively collected coloring books, advertising circulars, and magazines, in search of images he could adapt for his work. While Cornell's collecting mania extended to all sorts of three-dimensional ephemera, toys, and games, Darger's work was resolutely two-dimensional. He sometimes collaged these found images into his paintings. More often he traced or copied photos and drawings of little girls. He sometimes glued pieces of paper together to make panels as large as nine feet long for his epic panoramas.

Rather than focusing on contemporary popular culture such as movie stars and skyscrapers, Darger seems to have become stuck in the classic popular literature of his early childhood, including L. Frank Baum's *The Wizard of Oz* books, Charles Dickens's novels, and Harriet Beecher Stowe's *Uncle Tom's Cabin*. He adapted themes from these books into his own illustrated novel with its distinctive iconography. His imagery focuses on children, both naked and clothed, in scenes ranging from carefree garden and

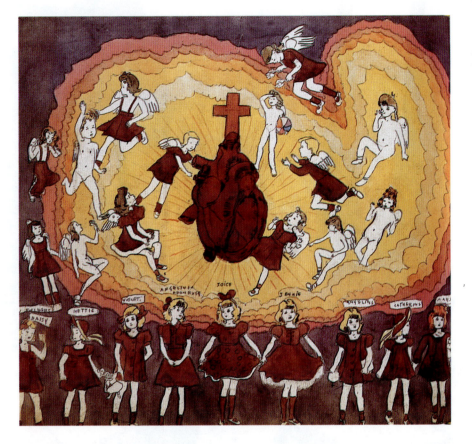

14.35 HENRY DARGER, *Untitled (The Vivian Girls and the Sacred Heart)*, undated. Collage, pencil, and watercolor, 19 × 24 in (48.2 × 60.9 cm). Estate of Henry Darger, Andrew Edlin Gallery, New York.

domestic settings to warfare, horseback riding, and sword fighting. Some of the nude children are sexually ambiguous, or have male genitals. In some illustrations, the children are being hung, crucified, or mutilated. In the work illustrated here (**fig. 14.35**), the Vivian Girls and their cohorts are at peace in a scene of Christian redemption. Darger was a devout Catholic; here, the Sacred Heart of Jesus (rendered with almost clinical precision) is the focal point of the scene.

While some viewers find his obsession with little girls pathological and sinister, it seems clear that he identified with the tribulations of these brave pre-pubescent children. He himself had been a powerless (and possibly abused) child, held in the clutches of an early-twentieth-century mental health system that did little more than warehouse disturbed children. Darger writes in his narrative about the horrors of child slavery, and celebrates the bravery of his beloved Vivian Girls: "In these countries I write about, girls and boys fear nothing, not even dangerous snakes, vicious rats or mice, deadly insects, nor anything because they do not have wickedness in their characters."[33]

When Darger died, his landlord found his tiny Chicago apartment crammed with huge notebooks of typed narrative, collages, pictures of little girls, and a wealth of unused collage materials. The landlord, Nathan Lerner—a designer and photographer—recognized the artistic significance of this motley collection. Only after his death was Darger's secret fantasy world recognized as one of the great imaginative works of twentieth-century art.

## Conclusion

The physical environment of the new American city, with its plunging perspectives, its speed, its clattering machine rhythms, and its commercial landscape, helped give birth to American modernism. But it also contained the seeds of an antimodern reaction that drew artists, writers, and intellectuals back to the nation's regional cultures and land-scapes. It propelled them in search of older craft traditions, a premodern built environment, and forms of community life remote from the competitive individualism of the present. As life in the nation's cities eroded a sense of connection with history, a desire to reground identity in inheritance grew stronger. That impulse is the focus of the following chapter.

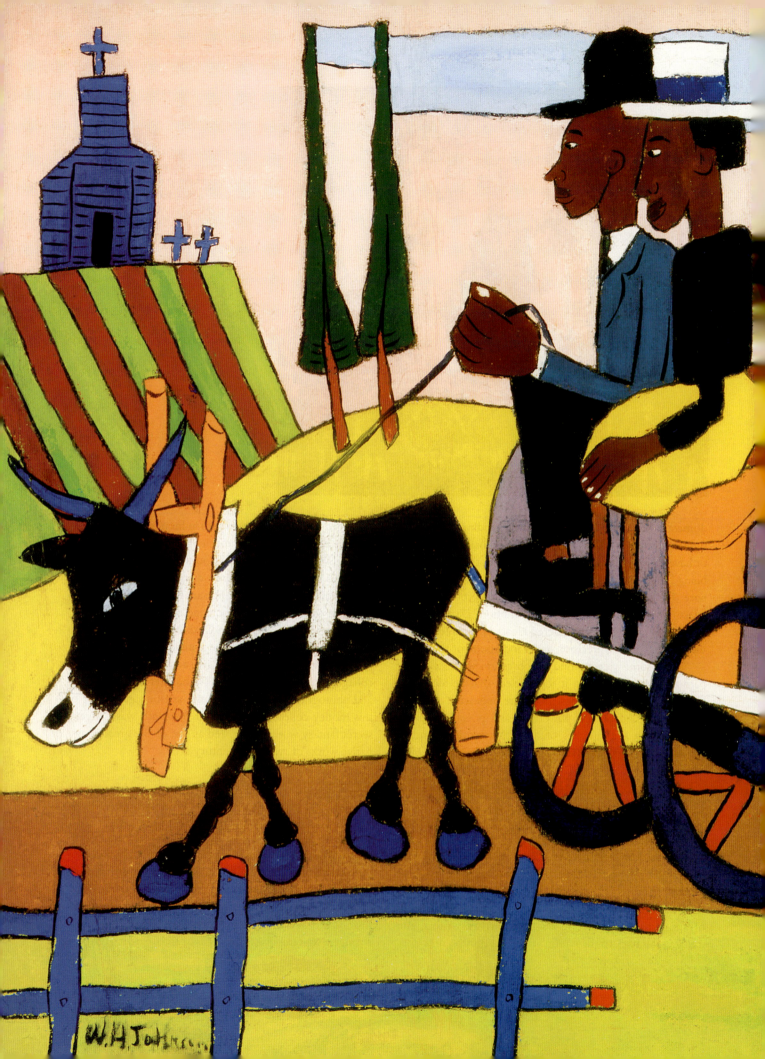

# 15 | Searching for Roots, 1918–1940

"I wanted ... to belong ... [t]o an America alive, an America that was no longer a despised cultural foster child of Europe ... to an America that had begun to be conscious of itself as a living home-making folk ...."
*Sherwood Anderson, "A Story Teller's Story."*

During the rapid modernization of the 1920s and 1930s, Americans experienced a powerful desire to renew ties to a past they felt to be slipping away. The Great Depression of the 1930s—the focus of the next chapter—further propelled such desires for imaginary homelands far from the difficulties of the moment. Unlike the "American Scene" artists considered in the last chapter, other artists turned away from the nation's cities and the culture of mass consumption and entertainment, toward older ways of life. This impulse pointed both modernists and traditionalists toward **folk**, Native, and colonial arts, and it impelled various artists to take up their **ethnic** heritages as part of a "usable past" (see box, page 486). A range of artists and writers turned to regions such as New England, Appalachia, and the Southwest—where rural ways of life, preindustrial crafts, and older patterns of community were still intact—as well as toward periods in the nation's history when aesthetics were still part of the fabric of the everyday.

This "usable past" was put to a variety of different uses. The search for roots ranged from the modernist recontextualization of earlier forms to the revival of older traditions, the "invention" of new traditions, and the romance with "folk." The search for roots also compelled Native, Hispanic, Appalachian, and "outsider" artists. These regional and ethnic **subcultures**, themselves experiencing the pressures of modernization, renewed and reinvented older craft traditions through their encounters with new patrons and

new markets. Commercial interests as well appropriated aspects of the "usable past," contributing to the commodification of history. The roots industry—now a mainstay of contemporary culture—had its origins in these decades and in the craving for more "authentic" modes of existence.

Creative expansion and renewal were only one side of the coin, however. Internationally as well as at home, rapid modernization produced reactionary social movements that defined identity along racially and ethnically exclusionary lines. The displacements of modernization engendered **xenophobic** impulses to rid the community of "outsiders." For those uneasy with modernization, the concept of the folk offered a comforting point of reference. But different "folks" traced their ancestry to different origins. Laying claim to roots necessarily excluded other groups who arrived later, or were not part of the same ethnic culture. Material and visual culture played a role in embodying ethnically exclusive identities. Shadowing the search for roots was an anxious craving for self-affirmation that fueled disastrous hatred and bigotry on both the national and the international stages.

## The Rediscovery of America

Malcolm Cowley's classic memoir *Exile's Return* (1933/1951) outlines the stages in American artists' and writers' changing relationship to European modernism and to their own native culture. First came a full-blown romance with European culture and a disenchantment with American life that naturally led to **expatriation** or "exile" to Europe, to a turning away from one's own national culture as the source of one's art. Yet expatriation produced a new perspective on American culture, which expatriates came to "admire ... from a distance."[1] The next stage was repatriation, a return of the exile induced by the realization that, as Charles

Demuth put it after returning from Paris in 1921, "It [life in Europe] was all very wonderful,—but, I must work here."[2] America looked different after one had been abroad. Its traditions and history helped ground the returning exiles, who felt a new commitment to their native land, and to those aspects of America's cultural inheritance that marked its difference from Europe. That final stage was a "rediscovery of America."

This rediscovery took a range of different forms, drawing on modernist formal concerns coupled with home-grown subject matter, but also employing older narrative, figural, and iconographic elements. Vernacular culture offered forms and subject matter that spoke to the widely felt hunger for premodern life. Answering this hunger were regional promoters who seized on the picturesque elements of the past of various regions to forge an appealing alternative to the commercial present.

## Forging Continuities with the Nineteenth-century Craft Tradition

The first years of Americans' encounters with European modernism were characterized by a studied apprenticeship to newer styles, occasionally bordering on slavish imitation.

## The Usable Past

THE TERM "usable past" originated in a 1918 essay by Van Wyck Brooks[3] championing the importance of a living tradition of literature to which modern writers could connect. To Brooks, the absence of historical links to the past seemed to impoverish American letters. Key to the notion of the usable past was the creative reinterpretation of historical sources, whereby each generation might create its own relationship to history, in a manner that would serve its particular needs. Every new generation defines what is most useful and admirable about the past for the present moment. The usable past made history a source of renewal rather than a burden. "The past," wrote the cultural critic Lewis Mumford in 1925, "is a state to conserve, ... a reservoir from which we can replenish our own emptiness ... the abiding heritage in a community's life." It was, Mumford continued, the repository of enduring values and qualities that assisted each generation to navigate its challenging encounter with modernity.[4]

Such a situation brought feelings of cultural inadequacy. Many critics and artists argued that what made American culture distinct was its vernacular, folk, and commercial productions (see Chapter 6). Robert Coady (1876–1921), New York gallery owner and artist, complained in 1917: "Our art is, as yet, outside of our art world." He then enumerated the subject matter available to American artists, once they put aside their high art prejudices: "The Panama Canal, the Sky-Scraper and Colonial Architecture ... Indian Beadwork, ... Decorations, Music and Dances ... The Crazy Quilt and the Rag-mat ... The Cigar-Store Indians ... The Factories and Mills ... Grain Elevators, Trench Excavators, Blast Furnaces—This is American Art."[5] Coady's list anticipated the subject matter that American artists would seize upon in the ensuing decades, as they struggled to reconcile the formal innovations of modernism with native materials. For American modernists such as Coady and the poet William Carlos Williams, the artist made contact with the soil of place—the physical and historical environment unique to America—and in doing so created a "homegrown" modernism. In the years after World War I, artists on both sides of the Atlantic sought out rural havens where they could live and work cheaply while communing with what they believed to be the authentic character of preindustrial regional cultures—more authentic than the urban, at any rate. For many, the retreat to the great continent that lay beyond the nation's cities was also a revolt against a standardized, spiritually impoverished modernity. Paul Strand, in a letter to Stieglitz, complained of the "deadness and cheapness, standardized mediocrity" that he feared would flow outward from New York to corrupt the hinterlands. "I am sure the Americans have already introduced Coney island into heaven...." Marsden Hartley—one of Cowley's cosmopolitans caught between Europe and the United States—announced "the return of the native" to his origins in the rugged landscape of Maine in the late 1920s (see fig. 13.19). Charles Sheeler (1883–1965) felt a similar impulse: "It seems to be a persistent necessity for me to feel a sense of derivation from the country in which I live and work."[6] Numbed by the tawdriness of mass-produced objects, these and other artists in the decades between the wars turned back to place, producing a striking body of work in which modernist formal strategies are coupled with American content: vernacular building traditions and preindustrial crafts.

**SHEELER'S BARNS.** By the late 1910s, Sheeler was deeply drawn to the historic buildings and artifacts of Bucks County, Pennsylvania, where he began spending his weekends.

15.1 CHARLES SHEELER, *Side of a White Barn*, c. 1916–17. Gelatin silver print, 7⁷⁄₁₆ × 9⁹⁄₁₆ in (18.7 × 23.8 cm). Museum of Fine Arts, Boston, Massachusetts.

15.2 (below) CHARLES SHEELER, *Interior*, 1926. Oil on canvas, 33 × 22 in (84 × 56 cm). Whitney Museum of American Art, New York. Gift of Gertrude Vanderbilt Whitney.

Living in an eighteenth-century farmhouse, he used photography to explore the play of abstract forms, light and shadow, and textures in the interior of the house. **Vernacular** structures such as barns (which he painted more than eighty times during his career) also offered the artist a readymade subject for exploring a familiar modernist concern: the ambiguous relationship of two to three dimensions. In *Side of a White Barn* (**fig. 15.1**), the arbitrary boundaries of the image, as well as the close focus on the plane of the wall, removed from any larger spatial context, frame our attention on the weathered surface and textures of knotted whitewashed pine board, lime plaster, and wood shingle. The effect, as the art historian Karen Lucic has pointed out, is to short-circuit the narrative associations brought by viewers to this familiar icon of rural culture, startling us into seeing the known and familiar with fresh eyes. The cubist geometries and varied surfaces of barns satisfied a desire to reconcile modernist form with historically meaningful subject matter. Critics saw in Sheeler's images an austere and plain-spoken style that was recognizably "American."[7] Throughout the 1920s Sheeler collected and painted early Americana, collaging the flat patterned surfaces of quilts, braided rugs, and Shaker artifacts into Cubist compositions without departing from his sharp-edged realism (**fig. 15.2**).

**FOLK ART REVIVAL.** The collector Hamilton Easter Field played a crucial role in this expanding interest in **folk art**. Field's Ogunquit School of Painting and Sculpture in Maine (established 1913) was a vital gathering point for modernists (including Marsden Hartley and William Zorach) looking to weathervanes, textiles, and other vernacular objects as models for their own formal experiments. By 1921, when Field compared an eighteenth-century colonial Dutch portrait to a late Picasso, his thinking had become symptomatic of a generation looking to root modernist formal values in the past. In the 1920s Gertrude Vanderbilt Whitney exhibited folk art at the Whitney Studio Club (precursor to the Whitney Museum), and Edith Halpert opened her American Folk Art Gallery in New York City (1929), with works chosen "because of their definite relationship to vital elements in contemporary American art." Anonymous works such as *Mrs. Elizabeth Freake and Baby Mary* (see fig. 3.13) gained new aesthetic appreciation from this generation. Electra Havemeyer Webb began a collection of quilts and folk sculptures that would become the Shelburne Museum in Vermont in 1947. The Polish émigré artist Elie Nadelman and his wealthy American wife Viola accumulated over 15,000 pieces of folk art beginning in the late 1910s. The impact of the expressive direct-carving tradition of folk sculpture on Nadelman's own work was profound (see Chapter 13).

If modernists found usable formal qualities in the folk arts of the past, others found in the same traditions a different "usable past" that validated their version of American history. Sheeler's patron, the industrialist Henry Ford, anchored the innovations of industrialism in Anglo-colonial America. Ford opened Greenfield Village in Dearborn, Michigan, in 1929, an open-air museum of agricultural and manufacturing history that traced the nineteenth-century roots of the modern industry on view at Ford's state-of-the-art River Rouge plant nearby. Emphasizing the tradition of "Yankee" ingenuity that connected colonial and nineteenth-century inventors with twentieth-century industrialists, Ford's version of the past excluded the contributions of the immigrants who formed such a significant part of the work force at River Rouge. His anti-Semitic and xenophobic politics—he was a supporter of Hitler in the 1930s—underscore this version of an American past cleansed of all "foreign" influences. The oil magnate John D. Rockefeller was also deeply involved in both collecting and preservation. Rockefeller was the moving power behind the recreation of historic Williamsburg in the 1930s, where his wife Abby Aldrich Rockefeller's important collection of folk art would be housed. Banishing any reference to the slaves who formed fifty percent of the population of eighteenth-century Williamsburg, Rockefeller's reconstruction was history from the top down, focusing on colonial elites.

**THE DARK SIDE OF THE "FOLK."** In both America and Europe, governments in the 1930s appealed to the "folk"—ordinary people whose virtues and traditions acquired new political authority on both the right and the left. In America, **populism**—the political appeal to everyday people—offered a platform of progressive change in the 1930s, but it shaded into dangerous forms of mass mobilization and mob violence in Germany, where Hitler's National Socialist (Nazi) Party propaganda manipulated faith in the *Volk* to create popular acceptance of institutionalized anti-Semitism. The United States had its own homegrown forms of collective madness; foremost among these was the practice of **lynching**.

In 2000 the New-York Historical Society opened an exhibition of lynching photographs entitled *Without Sanctuary*. The exhibition described the widespread circulation of postcards through the U.S. Postal Service, carrying horrific images, mostly of black men who had been lynched and often burned and mutilated as well. Not merely the work of a small band of hooded fanatics, lynching was a form of violence involving entire communities—men, women, and children. While these postcards were originally circulated to celebrate the intimidation of Negroes and mobilize a sense of community among white racists, today they are grotesque reminders of the reign of terror against black Americans in the era before Civil Rights.

The construction of the folk thus points in opposing directions. On the one hand, it was a way of supporting belief in the simple goodness of ordinary people, far from the corruptions of modern urban life. Yet on the other, it was also a concept that fomented mob violence directed at "outsiders" who were seen as spoiling the purity of the community.

## The Regionalist Philosophy

"Folk" along with Native arts offered a vital example for another influential group of writers and thinkers in the interwar years: the self-described Regionalists, who emphasized cultural rejuvenation through the rediscovery of traditions grounded in the life, history, and landscape of a region. Regionalist philosophy addressed the concern that the repetitive labor required by mass production alienated people from meaningful work. **Regionalism** in the 1930s opposed the growing standardization of a national consumer culture that it perceived as homogeneous, placeless, and lacking roots. Instead, it sought cultural identity

in the history, landscape, legends, and music of rural and small-town America. Shaped by a powerful reaction against uniformity, and an equally powerful longing for place, it discerned distinct regional identities in the South, the Southwest, the Northeast, and the Midwest. The Southwest, for instance, acquired its regional identity when influence from the East was strongest; the South's regional identity was formed in the decades after the Civil War, when it defended its distinctive culture against the incursions of the industrial North. The Regionalist movement in the Midwest reacted against the concentration of wealth and cultural resources in the East, insisting on the rural and small-town origins of national culture. Overall, Regionalists protested at the emergence of a mass public dulled by a national media, and seduced away from the core values of community by the lure of consumer goods and private pleasures. The recovery and promotion of regional identity in the 1920s and 1930s involved writers, artists, and social scientists. More than a style or subject matter, Regionalism was a philosophy.

**COMMODIFICATION OF FOLK AND NATIVE ART.** Native American cultures provided an example of a living folk tradition admired by Regionalists, in which basketry, pottery, weaving, and dance were practices that integrated the aesthetic, the spiritual, and the social. Such noncompetitive

and communitarian practices linked the individual to the larger group in a network of shared meanings. Increasingly in the interwar decades, the folk came to represent for many American artists and writers a culture connected to place, and opposed to the slash-and-burn mentality of the pioneer. Americans disenchanted with the migratory habits of the current generation and the standardized products of consumer culture longed for objects that carried the patina of age and use; being tradition-bound came to represent a virtue.

The reinvigoration of democratic and populist ideologies in the 1930s further promoted interest in the art of the folk. Most influential was Holger Cahill's tellingly titled "American Folk Art: the Art of the Common Man in America, 1750–1900," at the Museum of Modern Art in 1932, which opened its doors in the depths of the Depression. Cahill became a pivotal figure in Roosevelt's New Deal, which offered federal patronage for grassroots community-based arts such as Appalachian music and New Mexican village arts.

Also part of the federal relief programs of the 1930s was the Index of American Design (from 1935 to 1941 a unit of the **Federal Art Project**, or FAP), which put some one thousand artists to work doing meticulous watercolors of about 18,000 folk and vernacular objects (**fig. 15.3**). The Index not only documented the regional diversity of American

15.3 MAGNUS FOSSUM, a WPA artist, copying the 1770 coverlet "Boston Town Pattern" for the Index of American Design, Coral Gables, Florida, February 1940. National Archives, Smithsonian Institution, Washington, D.C. Records of the Works Project Administration.

material culture from the colonial period to 1900, but it created a vital resource for American artists themselves engaged in the ongoing effort to create an American design tradition. Choosing watercolor over photography as a method of documentation enhanced the colors, shapes, silhouettes, and volumes of these objects and allowed artists to interpret them creatively. Documentation was the first phase of imaginative assimilation. The artist had to grasp the technical procedures and structural components of the object in order to reproduce them convincingly. The Index, now housed at the National Gallery of Art in Washington, D.C., remains the fullest survey in existence of America's material culture.

Patronized by collectors and museums, and nurtured by the federal government, folk and Native arts quickly became commodified. The folk aesthetic was used to sell a range of household goods. Ownership of such objects offered a quick ticket to the preindustrial past. The market extended into such areas as Appalachia, where baskets were turned out in mass quantities. Regional promoters meanwhile played down the hardships of life in Appalachia—terrible poverty, the lack of electricity, running water, and schooling. In the Southwest, a romanticized Hispanic and Native history coexisted with the economic marginalization of Pueblo and Hispanic citizens.

## The Politics of Artistic Regionalism

In the years between the wars, Regionalism in the visual arts came to be most directly identified with a widely celebrated triumvirate of painters: Grant Wood, John Steuart Curry, and Thomas Hart Benton. Benton's self-portrait was on the cover of *Time* magazine in 1934. Dramatically varied in style, these artists shared a belief that art is most vital when it expresses the particularities of a locality. The Regionalism of Wood, Curry, and Benton also shared with other art forms in these decades between the wars a sense of art's obligation to shape popular histories, beliefs, and legends. Regionalism was about public memory and collective identity; artists were mythmakers, not only reflecting but also creating a sense of place.

Yet from the 1930s up to the present, the regional themes of Wood, Curry, and Benton have raised suspicions about their conservative social values and rejection of modernism. These suspicions first took shape in the charged international climate of emerging **fascism**. To some, Regionalism represented a dangerously isolationist, regressive, and anti-modern impulse in art that paralleled the Nazi art of the Third Reich. Regionalism and its foremost apologist, the art critic Thomas Craven, had set its course

against European modernism, with its formal distortions and anti-naturalistic interests. Its anti-modern stance linked it to the Nazi propagandizing against the **"degenerate art"** of the German Expressionists and other modernists.

Was there any validity to these claims that the Regionalists were first cousins to the blindly xenophobic artists who served Hitler's Reich? The questions are still debated, but the evidence suggests otherwise. All three artists called for an indigenous expression as far removed as possible from the abstractions of blind patriotism. Rejecting provincialism (a narrow attachment to one's place of birth), all three artists shared a belief that art stemmed from experience, and was most powerful when tied to what the artist himself knew directly. Despite their dismissal of modernism, Wood, Benton, and Curry were all urban-trained artists who had traveled widely, studied the artistic traditions of Europe, and had an understanding of how painting had evolved since Impressionism. Wood's art is grounded in modernist design as influenced by Japanese woodblock prints and the period's streamlined stylization of form. Benton began his career doing abstract exercises in color and studies of Constructivist form. Critics missed the manner in which all three Regionalists commented—often with biting humor—on the very social myths they were attacked for celebrating.

**JOHN STEUART CURRY.** An early Regionalist work, John Steuart Curry's (1897–1946) *Baptism in Kansas* (**fig. 15.4**) complicates the picture of rural piety so frequently offered as a bedrock value of the American "folk." Indeed, Edward Alden Jewell, a well-known art critic for the *New York Times*, read the painting as "a gorgeous piece of satire" on religious fanaticism.[8] It is difficult to see how anyone missed the satire, here or in other Regionalist works. The young woman, her hands clasped in prayer, is preparing to be immersed in a wooden trough—normally reserved for watering livestock—by a mustachioed preacher. Two doves plunge down from the light-streaked clouds above the scene, as in a baroque altarpiece. High religious drama is played off against the homely elements of the Midwestern farm scene. Curry's satire, however, is leavened by a touch of nostalgia for the communal piety signified by the closed circle of worshipers with their downcast eyes.

Modernization revived a taste for "old-time religion"; **evangelical** movements were widespread throughout the early twentieth century. Within the scene, the agents of the new urban order—automobiles, circled round the scene like prairie schooners, rural electrification (electric wires in the background), and city fashions—all signal the forces of change at work in the American countryside. Is "old-time

15.4 JOHN STEUART CURRY, *Baptism in Kansas*, 1928. Oil on canvas, 40 × 50 in (101.6 × 127 cm). Whitney Museum of American Art, New York. Gift of Gertrude Vanderbilt Whitney.

religion" the adversary of modernization, or its symptom? *Baptism in Kansas* gives evidence of both.

**GRANT WOOD.** *American Gothic* (**fig. 15.5**) is Grant Wood's (1891–1942) humorous commentary on the puritanical streak in the American character. The prematurely wizened woman (based on Wood's sister) wears a cameo brooch whose image of a wood nymph—hair streaming out, full of natural fecundity, beauty, and grace—contrasts in every way with the wearer's spinsterish appearance. The **board and batten** farmhouse has the gothic tracery found in American rural wood structures as a distant echo of its European sources. Its American version, however, is altogether different. The farmer holds a pitchfork, repeated in the lines of his overalls, which he grips like a weapon. Everything associated with the two—except the worried glance of the spinster toward the left—is frontal, unflinchingly rectilinear; everywhere is a nature disciplined and straightened, forced to conform to the iron will of the American farmer, who brooks no whimsy. The same unflinching determination, in Wood's good-natured satire, drives the sallow-faced humorless pair who walk the straight and narrow way, closer to God but far removed from their own natures.

But *American Gothic* is also a tribute to the rural Midwestern heritage that produced Wood's own Iowa family. Wood's sources for the painting, as Wanda Corn has shown, ranged from blue willow-pattern chinaware to nineteenth-century daguerreotypes, Victorian prints, and premodern agricultural implements. The figures in *American Gothic* are the product of the same culture that produced the artifacts Wood admired and collected. Threatened by modernization, these older regional folkways and character types were ripe for literary and artistic treatment. The humor of the painting, as with much Regionalist humor, comes from a self-styled insider, not from the critical condescension of the outsider.

In 1939 Hitler invaded Poland, the opening act of World War II. In that year Wood painted *Parson Weems' Fable* (**fig. 15.6**). A child's storybook fable of exemplary honesty (George Washington as a child admits his naughty deed to his father), it was popularized by Washington's most famous biographer, Parson Weems, who stands outside the scene pulling aside a theatrical curtain. The head of the young Washington is that of Gilbert Stuart's famous painting of the first president as a bewigged old man—an iconic image universally known by its use on the dollar bill (see fig. 5.6). So wide was its circulation that Stuart's

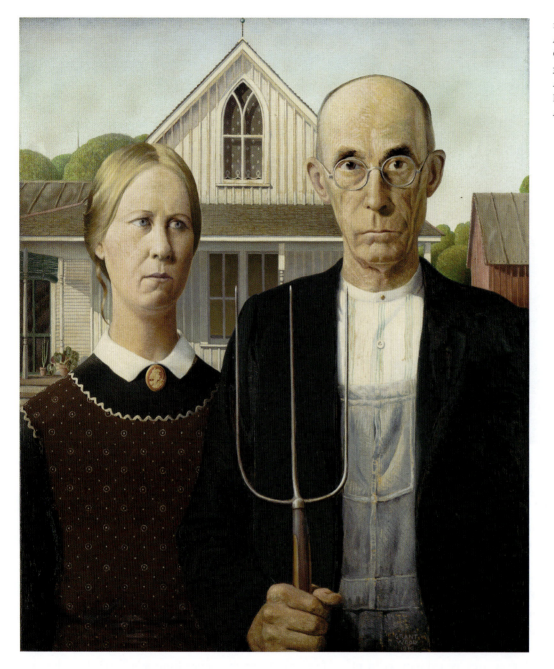

15.5 GRANT WOOD,
*American Gothic*, 1930.
Oil on composition board,
30 × 25 in (76.2 × 63.5 cm).
Art Institute of Chicago,
Illinois. Friends of the
American Art Collection.

portrait has itself displaced in national memory the historical figure of George Washington as a young boy (or so Wood suggests). In the background of the scene, two slaves are shown picking fruit from a cherry tree, an allusion to the gap between myth and social reality in our national imagination.

*Parson Weems' Fable* calls attention to the ways in which our understanding of the past is mediated—literally framed—by representations, by stories within stories, like a series of Chinese boxes. With its toy-like landscape, deliberately naïve presentation, and tale-within-a-tale structure, *Parson Weems' Fable* reveals how we construct our national myths, and witnesses the framing power of stories and legends in shaping our collective identity. Unlike the painters of the German Reich, Wood recognized the "folk" as an invented concept, the product not of some essential race identity grounded in the soil, but of stories told and retold, tales whose **"authenticity"** was itself a product of a nation-state that required unifying myths. *Parson Weems' Fable* pointedly exposes the mechanisms of cultural myth rather than presenting them as transparent truths. Among those who collected Wood's work were a number of Hollywood actors and directors, who, like him, engaged myths with humor and irony.

15.6 GRANT WOOD, *Parson Weems' Fable*, 1939. Oil on canvas, 30⅛ × 50⅛ in (77.2 × 127.4 cm). Amon Carter Museum, Forth Worth, Texas.

**THOMAS HART BENTON.** The best known of the trio of Regionalist painters, Thomas Hart Benton (1889–1975) was also the most widely attacked. His style—like himself—was full of swagger. Robust in its swelling volumes and baroque curves, it bordered on caricature, which brought angry denunciations when it came to ethnic depictions. Benton, who was highly articulate, scrapped with his critics and was unapologetic about his murals painted for a broad public, among them *America Today* (1930); *The Arts of Life*

(1932); and *A Social History of Missouri* (1936), done for the House lounge of the State Capitol in Jefferson City.

Benton considered *A Social History of the State of Missouri* his best work. Here as elsewhere he created a fluid montage of figures and episodes, condensing past and present, history and fiction, into a seamless unity. Yet his dynamic composition results in an open-ended narrative that engages each viewer's own version of the past: history as storymaking, in short. On either end of the room Benton featured Huck and Jim from Mark Twain's great novel of the Mississippi, *Adventures of Huckleberry Finn* (**fig. 15.7**), and a scene from the ballad of "Frankie and Johnnie," showing a crime of passion in a saloon. Here, as in other public murals Benton painted in the 1930s, he gives to literature and legend the status of folk epic, recognizing their role in shaping regional identity. History is revealed as part myth, while regional lore is **historicized**. Benton's montage technique resembled the new form of visual modernity evident in tabloid journalism and in film editing. Indeed, the artist had considerable interest in the film industry; he visited Hollywood in 1937, where he produced some eight hundred drawings. Benton's *History of Missouri* is mostly devoid of great men, favoring instead the everyday—farming, family life, political campaigning, industry. Scenes in the mural bluntly acknowledge racism (a slave auction and a lynching), criminality (the James brothers), and exploitation (in a scene where an early trader trades whisky for Indian blankets).

15.7 THOMAS HART BENTON, *A Social History of Missouri: Pioneer Days and Early Settlers*, 1936. Egg tempera on canvas, 25 ft × 14 ft 2 in (7.62 × 4.31 m). Missouri State Museum, Jefferson City.

Speaking to the 1930s' need to reengage history and everyday experience, the Regionalist art of Curry, Wood, and Benton was ultimately discarded by the turn toward abstraction and a language of universal forms in the following decade. In 1949, *Life* magazine posed the question as to whether Jackson Pollock (1912–56)—Benton's former student, who had long since repudiated his teacher's art—was "The Greatest Living Painter in the United States." Pollock's own career reveals the transformation of mythic content from the social to the psychological (see Chapter 17).

## Art Colonies and the Anti-modern Impulse

Many readers today carry an image of New Mexico seen through the lens of Georgia O'Keeffe's now famous paintings. First introduced to New Mexico by her friend Mabel Dodge Luhan in 1929, O'Keeffe spent the rest of her career focusing on the wind-carved stark landscapes of northern New Mexico near her home in Abiquiu. But O'Keeffe is only the best-known of an extensive colony of artists drawn to New Mexico by its particular blend of austere beauty, premodern village life, and Pueblo and Hispanic spirituality. Beginning in the 1890s, artists from the East flocked to

Taos and Santa Fe in northern New Mexico. Culturally remote from the Euro-dominated eastern half of the nation, New Mexico was, as Charles Lummis put it, "the United States which is *not* the United States." Spanning the spectrum from academic to modernist, these artists struggled to anchor the lessons of their European training in native themes. The peasant cultures of Brittany had furnished subject matter for American artists working in France. Returning to the United States, they responded eagerly to the possibilities presented by the Pueblo Indians and Hispanic villagers of the Rio Grande Valley, whose lives seemed to embody a timeless round of earthbound ritual and communal piety.

From the Renaissance to the "new age" movements of the late twentieth century, Europeans have romanticized Native cultures as embodying virtues their own societies were lacking. We have seen instances of this identification, from Benjamin West's admiration for the Mohawk of Pennsylvania (see fig. 4.35) to Catlin's career-long devotion to documenting embattled Plains cultures in the mid-nineteenth century, to Frank Hamilton Cushing in the 1880s (see fig. 11.16). White identification with the indigenous, however, acquired new intensity between the wars, furnishing a way of exploring alternatives to the cultures of

15.8 ERNEST BLUMENSCHEIN, *Sangre de Cristo Mountains*, 1925. Oil on canvas, 50¼ × 60 in (127.6 × 152.4 cm). Anschutz Collection, Denver, Colorado.

modernity. "I have done everything ... except lash myself and carry a cross," wrote Mabel Dodge Luhan, former New York hostess of the avant-garde, in a letter about the Penitente practices of the villagers in northern New Mexico where she moved in the 1910s. International interest in the culture of the Pueblo Indians prompted Carl Jung, the influential Swiss psychologist and student of cross-cultural myth, to travel to New Mexico in the 1920s, a trip that helped inspire his later ideas about the need to balance Western rationality with intuitive, non-rational approaches to knowledge. The English novelist D. H. Lawrence, who spent his later life in New Mexico, lamented that Americans "have buried so much of the delicate magic of life."

In Ernest Blumenschein's (1874–1960) *Sangre de Cristo Mountains* (**fig. 15.8**), a procession of Christian penitents winds its way up the path of the Cross, reenacting the passion of Christ in a yearly drama. Blumenschein's northern New Mexico villagers act out their communal ritual of penance in stylized gestures of grief. The figures recall centuries of Christian imagery. Three bare-chested men lead the way, the third bowed beneath a massive wooden cross which he drags toward the site of the crucifixion. Earth-colored adobe buildings occupy the middle distance. Filling the upper half of the canvas are the Sangre de Cristo ("blood of Christ") Mountains of the title, deeply creased by snowy ravines. The rounded, weathered natural forms of the mountains offer a grandiose symbolic frame for the local human action in the foreground. Blumenschein has simplified and reduced a complex landscape in order to emphasize the congruence of human and natural, the timeless rhythms of village ritual and the cycles of the seasons. His formal simplifications, the anonymity of his faceless penitents, and the suggestion of universal meanings in the drama of village life, all link the artist to earlier European interest in peasant and preindustrial cultures. The offspring of such paintings are found everywhere today in the galleries of Santa Fe.

## Romantic Regionalism in California and New Mexico

Interest in the Spanish legacy of the Southwest was one of a series of romantic revivals beginning in the nineteenth century. In the early twentieth century, the Pueblo and Mission revivals found their place within a broader national (indeed international) movement to recover the artisanal and communal building traditions identified with the origins of national cultures. Nationalistic pride played a role in these historical revivals, which were celebrated as "straight from our own soil" and "a true product of America."

Romantic Regionalism brought together businessmen, architects, and regional promoters around a picturesque vision of a premodern past before the arrival of the Yankees. It may seem paradoxical that these very Yankees were responsible for shaping a regional image so indebted to a time before they arrived. The fascination with the premodern era—here as elsewhere in American arts and culture—often accompanied and even facilitated the process of modernization by offering an imaginative retreat from the pressures of the present.

**"MISSION REVIVAL" STYLE.** California led the way in exploiting its Hispanic heritage. At the Chicago World's Fair or Columbian Exposition of 1893, state pavilions were designed in a range of regional styles: plantations for the South, for example, and Spanish Mission styles for the California Building (identified by red-tiled roofs, arcades, **stuccoed** walls, and asymmetrical massing). By 1915, at international expositions held in San Francisco and San Diego, the Mission style had become the official expression of California's regional identity. In the years after statehood in 1912, New Mexicans developed their own versions of the "Mission revival," inspired by the ancient cliff dwellings and historic Pueblo villages of this region.

The "Mission myth" of an exotic Hispanic and Indian heritage had several major components, as outlined by the historian Mike Davis: a peaceful population of Mission Indians living in harmony with their European conquerors, and a colorful Mexican population who passed along their music, carefree ways, and picturesque buildings to the more dynamic Euro-American cultures that took their place. The Mission myth transformed the region's troubled history of forced Native labor on the Missions into a fantasy of *caballeros* and dark-eyed *señoritas*. For generations of Californians, the curved gables, red-tiled roofs, bell towers, and arcaded plazas of Catholic Missions became for the West Coast what the Colonial Revival was to New England and plantation-style homes were to the South: a means of instant access to a romantic past, remote from the present.

One of the primary figures behind the creation and promotion of the regional myth in California was actually from Ohio. Charles Lummis (1859–1928), a young journalist, had walked to Los Angeles in 1884 in search of a better climate and improved health. In his writings and activities as an editor, amateur archaeologist, founder of the Southwest Museum in Los Angeles, and preservationist, Lummis helped spawn a new regional consciousness among wealthy exiles from the East. Lummis was at the heart of the region's first literary and artistic vanguard, centered along the Arroyo, a wooded gulch set against

15.9 CHARLES LUMMIS, *El Alisal, Los Angeles*, 1897–1910. Southwest Museum, Los Angeles, California.

the dramatic backdrop of the San Gabriel Mountains in Pasadena. Drawn by the healthful Mediterranean climate of the region, Lummis constructed a baronial home for himself with the invented Spanish name of El Alisal (1897–1910), built of boulders hauled up from the dry creek bed by the labor of Pueblo Indians imported from New Mexico (**fig. 15.9**). Combining such picturesque features as a defensive tower, a Mission-style gabled wing with hanging bell (inspired by the newly restored Mission San Gabriel nearby), and **hacienda**-like main house, and surrounded by indigenous plantings, El Alisal expressed a widespread fascination with California's Hispanic past, filtered through an image of Spain's aristocratic Old World culture. In his home, life, and writings, Lummis helped foster the regional myth that would shape the restoration of California's Franciscan Missions in the early twentieth century.

**"PUEBLO REVIVAL" OR "SANTA FE" STYLE.** In the 1850s Jean-Baptiste Lamy, archbishop of Santa Fe, newly arrived from the East, campaigned to obliterate the art of the *santeros*. For him this was a shameful reminder of the barbaric conditions of a frontier society that his enlightened leadership would soon leave behind. Half a century later, attitudes toward the Hispanic heritage of the Southwest had radically changed. As in California, architects, preservationists, and civic promoters now turned to the Spanish and Native history of the region for a romanticized regional image: "One must go to New Mexico to find an

15.10 ISAAC HAMILTON RAPP, *New Mexico Building, Panama-California Exposition, San Diego, California*, 1915. Watercolor. Museum of New Mexico, Santa Fe.

15.11 MARY COLTER (designer), Fred Harvey Indian Building Room, c. 1908. University of Arizona Library, Tucson. Special Collections.

American architecture and an American art."[9] Promoters celebrated the Southwest for its archaic and spiritual intensity. In the decades between the wars, tourists from the East flocked to New Mexico and Arizona in unprecedented numbers, in search of ancient mysteries and legendary histories. Indigenous ruins dating back ten centuries offered parallels to the great ruins of Old World civilizations, and captured Americans' romantic longing for a deep history that would counter claims of their nation's cultural shallowness.

In New Mexico, the "Pueblo" style—drawing on the massive simplified adobe contours, wooden beam construction, and battered and buttressed walls of such buildings as the church of San Esteban at Acoma Pueblo (see fig. 2.31)—fused Native and Hispanic adobe building traditions in a distinct architectural image. San Esteban served as the source for the architect Isaac Hamilton Rapp's (1854–1933) New Mexico state building at the San Diego exposition of 1915, and later for the Museum of New Mexico building in Santa Fe (**fig. 15.10**). The architects Charles Whittlesey and Mary Colter (1869–1958)—whose 1904 Hopi House perched on the rim of the Grand Canyon—drew inspiration from the multistoried buildings of the Hopi and other Pueblo peoples. In America's first restaurant chain, the Fred Harvey Company furnished travelers on the Santa Fe Railroad with not only good food but a romanticized regional image drawing on Hispanic and Indian elements (**fig. 15.11**). Building on its Hispanic past, Santa Fe changed street names from English to Spanish in these years.

**THE BIOGRAPHY OF A BUILDING.** Buildings, like the people who make and use them, have biographies. They carry their histories with them, though it takes some digging to recover these histories. The Palace of the Governors on the central plaza in Santa Fe (**fig. 15.12**) is a much beloved icon of New Mexico's regional Hispanic heritage. But the building tourists encounter today dates largely from 1913, and represents what has come to be known as the

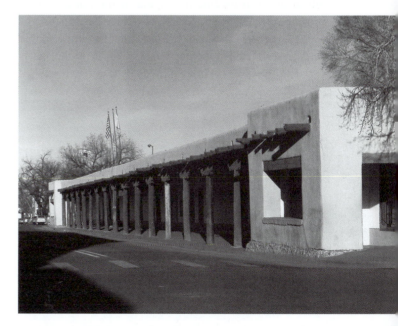

15.12 Palace of the Governors, Santa Fe, New Mexico, 1610–14. Museum of New Mexico, Albuquerque.

"Santa Fe style." In the early twentieth century, regional promoters, architects, and city fathers devised a style of softly modeled adobe construction, complete with covered walkways, or *portals*, and projecting ceiling beams, or *vigas*, that combined indigenous Pueblo forms in use for nearly a millennium with Hispanic adobe building originating in the seventeenth century. The 1913 building was intended to give a recognizable and picturesque look to Santa Fe, increasing tourism to the city. Indeed, it has become the legislated style for use in the historic city center.

The 1913 building itself replaced a structure from the late nineteenth century that had a very different architectural heritage (**fig. 15.13**). Known as the **"Territorial style,"** it reflected the influence of the newly arrived railroad linking the remote Southwest to eastern markets and architectural styles. The Territorial style included prefabricated pedimented window surrounds, as well as brick coping at the roofline, giving a sharper, more classical profile to adobe construction, and carrying with it the message of eastern civilizing influences domesticating the rough wood and clay vernacular forms associated with Hispanic and Pueblo New Mexico. This building embodied the tastes of a generation of non-Spanish European-American businessmen for whom the associations with Indian and Hispanic traditions were liabilities and not—as they would become in the early twentieth century—the source of a romanticized regional identity.

Beneath these historical accretions of style and taste lie parts of the original 1610 building that occupied the site when the town became the capital of the northernmost province of New Spain. This was a somewhat nondescript adobe structure flush with the street, containing a simple *portal* and situated at the north end of the central plaza as

15.13 *El Palacio de Adobe*, c. 1880. Engraving. Palace of the Governors, Santa Fe, New Mexico.

dictated by the administrative laws of the Spanish empire in the New World. The building combined a garrison with a residence for the governor, and had itself incorporated the **puddled** walls of a Pueblo structure predating Spanish occupation. Which of these various versions of the Palace of the Governors is the "real" one? To which should we accord pride of place in recounting the history of Santa Fe as regional capital? Focusing on only one version of the building has the effect of overriding the previous histories it has embodied.

## Norman Rockwell: Illustrator for the American People?

Belief in the continuity between past and present is a critical ingredient of a "search for roots." A sense of continuity with the past helps maintain stability in the midst of change. Beginning in the 1910s, the illustrator Norman Rockwell (1894–1978) gave this to mass audiences in abundance. In Rockwell's America, cars, television antennae, and other complications of modern life are framed and defined by the persistence of the past, which lies reassuringly just beneath the thin veneer of modernity. In *Walking to Church* (**fig. 15.14**), the decay of American cities resulting from the 1950s flight to the suburbs offers a picturesque backdrop to the white nuclear family who proceed, Pilgrim's Progress-style, through a vale of urban woe on their way to church, oblivious to their surroundings. Rockwell visually puns on their "righteous course" with a series of parallel planes that connect them to the roof and steeple of the background church. Commercialism, consumerism, standardization—decried by cultural critics throughout the twentieth century—are background influences woven into Rockwell's easily recognizable dramas of everyday life.

Rockwell is one of a handful of household names among America's image-makers who are broadly familiar to the general public. Yet, until recently, those who were serious about fine art—critics, museum curators, men and women of "taste"—would have nothing to do with him. He was maligned for giving audiences what they wanted—a vision of a national life that never existed—rather than confronting them with difficult dilemmas (although he did take on race prejudice and the Civil Rights movement in a series of late works). In addition, he was *merely* an illustrator; most of his work was done for the *Saturday Evening Post*, a mass circulation middlebrow journal for which he produced 322 covers between 1916 and 1963. Rockwell photographed "on location" and then obsessively recreated scenes in the studio by working from photographs and live models. His critics believed that illustration required

15.14 NORMAN ROCKWELL, *Walking to Church*, 1953. Oil on canvas, 18¾ × 17¾ in (47.6 × 45 cm). Private collection.

less skill than art: modern artists transform reality rather than merely mirror it. Yet the notion that illustration—and artistic naturalism more generally—is less "artful" than other forms of image-making is belied by Rockwell's compositions. He shows us not the way things were, but the ways in which many Americans wanted to believe they were. Whatever the value of his art, his illustrations, with their wealth of meaningful detail (clothing, posture and gesture, facial type, domestic and urban backdrop), reveal the elements of Rockwell's America and why it proved so compelling to his public.[10]

Rockwell's images embodied "The American Way of Life," a populist notion of shared national character and core values. His magazine covers (often reprinted as posters) speak in a voice of social inclusiveness and shared humor. They imply a confidence that, confronted with the situations shown, we will respond the same way as Rockwell's subjects themselves. In *Saying Grace* (**fig. 15.15**), differences between generations, between rural and urban, and between traditional and modern America are bridged in an image intended to tap universal emotions inspired by everyday acts.

Rockwell's exacting realism gave his depictions a feel of authenticity. From the 1930s on, his work enjoyed such wide circulation that at times it seemed to take the place of

lived memories, reshaping the recollection of national life. Like the family snapshot that stands in for, and ultimately replaces, the actual event, his illustrations have, for many Americans then and now, become "our America." Yet those who do not recognize Rockwell's America as theirs feel a sense of alienation: "Where am I in this picture?"

Paradoxically, Rockwell's rise to fame between the world wars coincided with a time of unprecedented movement away from the ideals his images represent: small-town, face-to-face, rooted in stable social identity. In his upbringing, Rockwell himself had little direct experience of the small-town life he depicted on the covers of the *Saturday Evening Post*. His nostalgic vision was avidly consumed by millions of *Post* readers, yet the *Post* was a part of the national media, the newspapers and broadcasting, that were displacing regional and local identity. The consumer culture advertised by mass circulation magazines was taking the place of the older way of life commemorated in Rockwell's images. His appeal to the purportedly universal elements connecting people across class, regional, and ethnic lines was something that linked him to other purveyors of mass culture, such as his friend Walt Disney.

Was Rockwell merely pandering to his audience's desire for an America out of which all unpleasantness had

15.15 NORMAN ROCKWELL, *Saying Grace*, 1951. Oil on canvas, 42 × 40 in (106 × 101 cm). Private collection, loan to Norman Rockwell Museum, Stockbridge, Massachusetts.

been imagined away? Or did he, as his defenders suggest, build on pride in the inheritance of democratic values: self-reliance, belief in community, and determined pursuit of one's dreams? And why were these values so often linked to an old-fashioned version of America rather than to its contentious present?

# Preservation, Tradition, and Reinvention in the Twentieth Century

Heritage and tradition are in a constant process of change and renewal, rendering the quest for authenticity, as the critic Lucy Lippard puts it, "a false grail."[11] Yet Euro-American artists, patrons, and architects throughout the first half of the twentieth century approached preindustrial, Native, and Hispanic cultures with preconceptions about a timeless, unchanging world remote from the pressures of modernization. The "false grail" of authenticity, however, fueled financial support and patronage for regional crafts in crisis. In what follows, we consider the efforts of regional craftspeople themselves to respond creatively to new forms of patronage, both private and federal, preserving existing patterns of use while producing for a market.

## Potters, Painters, and Patrons: The Market for Pueblo Arts

Art historians have long recognized the important role of patrons in shaping art traditions around the world, from Chinese emperors to Catholic popes. Yet in the study of Native American art, the issue of patronage can be seen to be more problematic. Because of the economic imbalances between a dominant culture and an indigenous community, the patrons have the power to define authenticity and determine value according to their own criteria, rather than those of the indigenous community. Yet, as we shall see, Native artists have always negotiated between the worlds of commerce and of their own cultural values. Nowhere is this more evident than in the Pueblo arts of painting and pottery-making at the beginning of the twentieth century, when new markets opened up and Pueblo artwork was celebrated far from the small villages where it was created. Two examples, of a male painter and a female potter, illustrate the complexity of the artistic and cultural encounter in the Southwest in the first half of the twentieth century.

**PUEBLO WATERCOLORS AND AWA TSIREH.** Many Native peoples in the early twentieth century believed that their unique cultural features were destined to die out. It seemed to them that young people, having been educated in white schools, were not interested in the old ways and no longer spoke the language. Some Native people collaborated with anthropologists, to make sure that their cultural artifacts and knowledge were preserved in museums and books. Others looked to art as a form of cultural preservation. In this endeavor, they were encouraged and supported by a small group of white patrons. These patrons (artists themselves, as well as anthropologists and other intellectuals) promoted Pueblo art because they believed that it was through fine arts, as opposed to cheap tourist trinkets, that the culture would survive.

After 1900, Pueblo painters, particularly at Hopi and San Ildefonso, began to experiment with a style of **pictorial narrative** that had no precedent in their artistic traditions. In many cases the painters were motivated by the same impulse that Plains ledger artists had worked under in the 1880s: to explain their culture through pictorial means, both to themselves and to outsiders. We might use the term **"auto-ethnography"** for this, for they were narrating their own cultural ways during the same period that anthropologists were writing ethnographic accounts of their cultures. In their art they depicted the unique features of their culture, such as ritual dances and methods of pottery-making. They made small watercolor paintings for sale, sometimes under the sponsorship of local museums, anthropologists, and artists. The Hopi artist Fred Kabotie (1900–80), for example, repeatedly painted the Snake Dance, a performance that fascinated outsiders and attracted many tourists. Kabotie and Awa Tsireh (1898–1955) were the most celebrated Native painters of the early twentieth century. Both were prolific and innovative artists.

Awa Tsireh adeptly melded diverse pictorial influences into a coherent style. Born in San Ildefonso in 1898, and given a Spanish name, he later signed his work with his Indian name, which means "Cattail Bird." This was surely a deliberate choice, for many Indian artists recognized that their white audience found Indian names more "authentic." Awa Tsireh came to the attention of the Santa Fe art world in 1917, when Alice Corbin Henderson, a figure in the local literary community, and her husband William Henderson, a painter, befriended the Pueblo painter and began to buy his works. In their home he examined books on modern art, Japanese woodblock prints, Persian miniature painting, and Egyptian art. In 1920, Edgar Lee Hewett, an anthropologist and director of the School of American Research in Santa Fe, commissioned the artist to paint pictures at the

15.16 AWA TSIREH (ALFONSO ROYBAL), *Koshare on Rainbow*, c. 1925–30. Ink on linen textured paper, 11½ × 8 in (29.2 × 20.3 cm). Indian Arts Research Collection, School of American Research, Santa Fe, New Mexico.

school. There, Awa Tsireh worked alongside Kabotie and other Native-born artists.

More than any of his peers, Awa Tsireh successfully merged the symbolic vocabulary of indigenous Pueblo pottery decoration and the eclectic international style of Art Deco and Egyptian Revival. Sometimes he used Egyptian-style outlining of eyes and Art Deco-like abstraction of forms and use of color. In *Koshare on Rainbow*, done in the late 1920s (**fig. 15.16**), he depicts the distinctive Pueblo striped clowns who climb poles and engage in buffoonery (see also fig. 2.30). Here they straddle a rainbow that emerges from stepped Pueblo cloud forms. Below, two horned serpents create a groundline; out of their tails grows a complex abstract design derived from Pueblo pottery-painting imagery. The colors are the black, white, and rust-red of pottery and ancient mural painting. Native decorative motifs had themselves contributed to the emergence of Art Deco, which in turn became one of several sources that shaped an eclectic style of "Indian" painting. Embedded within a two-way cultural exchange, from colonized to colonizer and back, this art perfectly expressed the situation of Indian peoples in the early twentieth century.

Those who wrote about Native art in the 1920s saw it primarily in romantic terms, as a "pure" expression of indigenous identity, despite the fact that Pueblo people had had four hundred years of continuous contact with non-Indian peoples. The artist and critic Walter Pach, writing in 1920 about contemporary Pueblo watercolors, praised the "amazing pattern … pure and intense expression" that characterized "the great Primitives"—an art that was "instinctive," and "American."[12] Pueblo watercolor paintings were exhibited for the first time in fine arts contexts (rather than anthropological ones) in Santa Fe in 1919 and in New York City and Chicago in 1920. The first Indian art gallery opened on Madison Avenue in New York City in 1922.

In 1932, the Studio School was established at the Santa Fe Indian School. There, Dorothy Dunn (1903–91) promulgated an "authentically Indian" way to paint, derived from decorative designs in indigenous arts such as pottery and basketry. But it was actually the generation of Awa Tsireh and his peers that set the standard for Indian painting, which subsequent generations of Indian artists rebelled against when they wished to pursue new forms of experimentation and self-expression.

**MARIA MARTINEZ AND THE MARKETING OF PUEBLO POTTERY.** New to Indian art in the early twentieth century were concerns about audience and creative individuality. The most famous Native artist of the first half of the cen-

tury, Maria Martinez (c. 1880–1980) of San Ildefonso Pueblo, was one of the first potters to sign her work. Biographies and films were devoted to her artistic career, and literally thousands of photographs captured her at work. At a time when the question of how to incorporate Native people into the cultural fabric of America was a vexing issue, she became, in the American imagination, the ideal Indian success story: a woman who integrated the traditional and the modern, the domestic and the cosmopolitan, negotiating the worlds of white patrons and Indian artists, and bringing wealth to her community while embodying the virtues of modesty and industry.

Recognized as an exemplary craftswoman even in her youth, Maria first came to public attention when she and her husband Julian Martinez (1885–1943) spent their honeymoon demonstrating pottery-making at the St. Louis World's Fair in 1904. They worked on archaeological excavations in Frijoles Canyon in 1908 and 1909. Asked by Edgar Lee Hewett, director of the excavations, to make pots in the style of the unusual black pottery shards that they were finding at the site, she and Julian experimented with firing, and eventually painting, blackware. While black pottery had been made up to the present at the nearby pueblo of Santa Clara, Maria Martinez refined the form with thinner walls, patiently **burnishing** the surface for hours with polishing stones. When the pottery was fired, this resulted in a lustrous black finish. Julian (who, like Awa Tsireh, was a painter) devised a **matte** paint technique that resulted, after firing, in an elegantly understated black matt design against a shiny black field. The end product appealed to sophisticated metropolitan tastes (**fig. 15.17**). By 1920, the pots of Maria Martinez, which she now signed, brought top dollar on an international market. However, by calling attention to her individuality, her signature and her financial success led to strife within the small community of San Ildefonso.

Maria came up with an ingenious solution to squelch potential resentments: signing other people's pots, as well as burnishing pots made by other women and then distributing them to other artists (mostly family members) to paint. The fine, large jar illustrated here is a good example. Signed "Maria and Julian Martinez," the vessel itself was apparently shaped by Serafina Tafoya of Santa Clara Pueblo, polished by Maria's sister Clara Montoya, and painted by Julian Martinez. In these transactions, Maria's role appears to have been entrepreneurial. Was this a form of misrepresentation? In many ways, it constituted an ideal model of Pueblo cooperation, in which each person in the transaction is satisfied. The white patron has the pot with its authenticating signatures. The Pueblo participants, on the other hand, successfully adapted the demands of the market to the needs of the community, devising a way of sharing both work and profits.

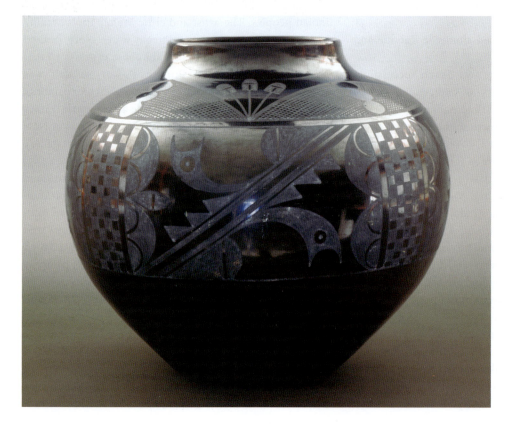

15.17 MARIA MARTINEZ, JULIAN MARTINEZ, SERAFINA TAFOYA & CLARA MONTOYA, *San Ildefonso Black-on-Black Storage Jar*, c. 1942. Museum of Indian Arts & Culture/Laboratory of Anthropology, Santa Fe, New Mexico.

Both painting and pottery-making brought wealth into small Native communities such as San Ildefonso. In the 1920s, painters could earn about $900 a year; the best potters made more than twice that—an excellent salary then. The wealth Maria and Julian accrued from the marketing of pottery allowed them to live in a way enjoyed by few Indian people at the time. They hired others to do their farming and household chores, and they owned the first car at San Ildefonso Pueblo. Julian painted this black Ford with his characteristic matte designs, which must have been an impressive sight. Unfortunately photographs were not circulated of these two successful artistic entrepreneurs and their innovative vehicle; instead, the public saw only an image of Maria locked in a timeless world of tradition and authenticity.

## The Reinvention of Tradition: Twentieth-century *Santero* Art

"Tradition liberates creativity, it doesn't stifle it."[13]

By the 1920s, in the face of poverty and cheap standardized goods, Hispanic village art production had fallen off drastically. Efforts to document, preserve, and develop new markets for traditional artistic and religious expression eventually came from the very culture whose dominance had done so much to undermine these arts. White artists, writers, and collectors embraced the Native and Hispanic arts of the Southwest as refreshingly naïve and untainted by modernity, prompting collecting and preservation efforts on behalf of endangered arts. The Spanish Colonial Arts Society (SCAS, established 1925) linked Hispanic artists to wealthy patrons, and initiated the production of folk arts for a new audience. Such initiatives paralleled related private efforts to preserve and nurture Native American arts through the New Mexico Association on Indian Affairs (established 1923; later the Southwestern Association on Indian Affairs), which sponsored an annual Indian Market and administered an Indian Arts Fund.

The *santero* work preserved by the Spanish Colonial Arts Society furnished a vital source of inspiration and support for later generations of *santeros*. Working in the 1930s, the woodcarver José Dolores López (1868–1937), whose powerful hieratic style recalled ancient Mexican stone sculpture, influenced local carving down to the present (**fig. 15.18**). López's inventive use of indigenous Mexican sources indicates the increasingly international influence on "folk" traditions in the twentieth century, as well as the permeability of the boundary between Mexico and the United States.

15.18 **T. HARMON PARKHURST**, *José Dolores López, Córdova, New Mexico,* c. 1935. Photograph. Museum of New Mexico, Santa Fe.

Extending the private patronage of the SCAS were the federal programs of the New Deal, discussed in the next chapter. Patrocinio Barela (1900–64), another Hispanic carver who helped reinvent older *santero* traditions, was supported and exhibited by the Federal Art Project, and was hailed by *Time* magazine as the "discovery of the year." Barela, like other nonacademic artists in these years, was called a "true primitive" and "a naïve genius"; his work was shown at the Museum of Modern Art in 1936, in an exhibition entitled "New Horizons in American Art."

Choosing to keep alive the devotional power of their images within a rapidly changing world, *santeros*, from the early-twentieth-century revival of the art into the present, have created works for family and village use, but also for sale to museums and private buyers. Spiritual and communal functions of the saint figures go hand in hand with aesthetic and commercial interests. Working for a wider market, however, gives them the economic independence with which to master a demanding craft.

## Festivals: Invented Traditions and Ancestral Memories

During the period from the 1880s to the 1950s Americans in small towns and larger cities originated a rich variety of civic, religious, and historical festivals and pageants. These served many functions, from commemorating significant events in local or regional history to promoting pride of place, with major benefits to commerce and tourism. The "San Jacinto Day Festival" held in San Antonio, for instance, marks Texan independence from Mexico in 1836. German populations in Texas and Missouri originated a variety of "Maifests" and "Oktoberfests" in the later nineteenth century that reinvented seasonal harvest and winemaking celebrations. Suspended during the two world wars because of anti-German feeling, they were resumed and still draw tourists at a time when ethnic ties to Germany are several generations removed.

Such festivals continue into the twenty-first century. Given the deep effect of mass media in shaping our personal and collective identities, along with the spread of a consumer culture that transcends regional and ethnic identities, the role these occasions play in shaping these identities remains an open question. Do they still help renew ties across space and between generations? Or have they become events staged under increasingly artificial conditions, primarily directed at tourism? Both effects are seen, in different degrees.

The proliferation of communal festivals from the 1880s on may be linked to what the historian Eric Hobsbawm has called "the invention of tradition." In a society undergoing transformation from a rural to an urban economic order, with the growing movement of small-town residents to

## The Late-Twentieth-century *Santero* Revival

THE MOST RECENT REVIVAL of the *santero* tradition dates from the 1980s; according to one account, it has produced more artists than the entire period from 1790 to 1890.[14] The current revival, which draws energy from the ethnic identity movements of the 1960s, now includes women, among them Marie Romero Cash, whose *La Santisima Trinidad* of 1994 (**fig. 15.19**) revives a nineteenth-century tradition of showing the Trinity (Father, Son, and Holy Ghost) as three identical figures (see fig. 3.17). Artists such as Romero Cash forge deliberate links with the past, reviving the old ways of making images of the saints. They also embrace innovation, appraising their cultures with the eyes of men and women who have gone away and returned. The disruption of village life resulting from modernization, national markets, new patterns of work, and the growing "Anglo" (or non-Hispanic) presence in New Mexico have brought a new self-awareness among *santeros*. Studiously exploring a two-hundred-year history has given them an enlarged perspective on their art, as well as a new measure of interpretive freedom. As with Native arts, standards of authenticity, often imposed by outsiders, have conflicted with the artists' desire for innovation. And, as with the Pueblo potters discussed above, the market often insists on a timeless image of their culture. By embracing change and hybridity, however, ethnic artists honor the creative adaptations and cultural mixing that have always characterized encounter in the Southwest.

15.19 MARIA ROMERO CASH, *La Santisima Trinidad*, 1994. Cottonwood, gesso, gessoed fabric, watercolor, varnish, 14¾ × 15 × 9⅝ in (37.4 × 38.1 × 24.3 cm). Maxwell Museum of Anthropology, University of New Mexico, Albuquerque.

the city, and with the trauma of two world wars, invented traditions were able to provide a connection to a "suitable historic past."[15] The invented festivals of the last century reaffirmed the continuities between the generations and assured participants of the persistence of old ways in times of rapid change. They helped Americans make the transition from rural to urban life in a time of geographical and familial uprooting. But the reinvention of tradition also involves reinterpreting the past. To serve the needs of the present, such reinterpretations can result in pronounced topicality, as in the case of the 1947 "Democracy vs. Communism" festival of Aransas Pass, Texas, later renamed the grand "Shrimp-O-Ree," in honor of the community's primary industry. Festivals serve the search for roots in a time of change; they likewise introduce new themes into older forms, balancing tradition with innovation. While noting the continual incorporation of contemporary themes, the historian Beverly Stoeltje nevertheless insists that "if the traditional substance becomes lost, the festival dies."[16]

## "Fiestas Patrias"

Throughout the Southwest, a long history of Hispanic presence and cultural influence is marked by *fiestas patrias*—ethnic nationalist festivals—which celebrate Hispanic cultural traditions and art forms. Such ethnic festivals rally shared loyalties and maintain historical bonds in the face of pressures to assimilate. Increasingly, with the commodification of ethnic identity, such festivals have played a role in the tourist industry, and are promoted by chambers of commerce. Many of these *fiestas patrias* are supported by Hispanic business people working "to promote our way of life to the younger generation," in the words of one fiesta organizer.[17]

**HISPANIC ETHNIC FESTIVALS.** These festivals take numerous forms. *Las Posadas*, celebrated in both Arizona and New Mexico, traces its origins to Mexico in 1587, when the Catholic Church used its reenactment of Joseph's and Mary's pilgrimage to Bethlehem, and their search for an inn ("posada"), as a way of attracting Indian converts. The drama was revived in Arizona in 1937 by an Anglo schoolteacher as a means of instilling cultural pride in her Mexican students. It is still performed in Santa Fe during the Christmas season. Also drawing upon the Christ story for popular theater is the *Teatro Campesino* in San Juan Bautista, California, which produced for television a modern version of the Annunciation to the Shepherds, complete with low riders, migrant farmworkers, and other elements of modern life.

*Tejano* festivals celebrate the unique Hispanic culture of Texas. Yet like all such invented traditions, they draw on a range of cultural sources and rituals combining Spanish, Aztec, Arab, Jewish, African, German, and Scottish influences, all of which have fed into the modern day cultures of the Southwest.

*El Día de la Raza* is celebrated by Hispanic communities on Columbus Day, reinventing Columbus as the father of *mestizaje*, the mestizo fusion of Hispanic and Native American cultures unique to the New World. An expression both of Hispanic cultural pride and of the new cultural identity emerging from the encounter of European and Native societies, such festivals contributed to the Chicano identity movements of the 1970s.

**"DAYS OF THE DEAD."** Festival traditions follow the movement of people and cultures across national borders, as communities maintain the traditions of their homelands under new conditions. Mexican festivals such as *Cinco de Mayo* (the "Fifth of May," honoring a decisive Mexican victory against the French in the 1862 Battle of Puebla) and *Los Días de los Muertos* (the Days of the Dead) have acquired new life in *El Norte*—the country north of the border.

Like other aspects of New World Catholicism, the Days of the Dead festival incorporates elements of pre-Conquest indigenous traditions. The Christian holy days—"Feast of All Saints" (November 1) and "Feast of All Souls" (November 2)—were established in medieval Europe to celebrate the dead who had been observant. The Aztecs of Mexico had two summer festivals that separately honored dead children and dead adults. During the sixteenth and seventeenth centuries, under Spanish Catholic rule, these shifted to late autumn, in order to continue under cover of the Christian holy days. In Mexico it is believed that, on the Days of the Dead, the spirits of the deceased return to this realm. So families hold all-night parties in cemeteries where they offer the pleasures of life, including food, drink, music, flowers, and cigars, to the spirits of their loved ones.

As the festival has migrated across the border, however, the rituals and meanings associated with it have changed subtly. In the Southwest, the Days of the Dead celebrations strengthen kinship ties across generations and national borders, as well as between the living and the dead. Like other more local or regional festivals these celebrations—now seen as a Mexican version of Halloween—bind generations to one another. Related to the Days of the Dead is the *"calavera,"* the laughing or dancing skeleton popularized by the Mexican artist José Guadalupe Posada (1852–1913). Crossing the boundary between the living and the dead, the animated skeleton, whose barbed wit is aimed at those still

15.20 *Days of the Dead, Ofrenda*, 2002. National Museum of the American Indian, Smithsonian Institution, Washington, D.C.

on earth, has become a familiar figure in the cultural landscape of the Hispanic Southwest. Other practices associated with the Days of the Dead range from the decoration of the gravesites to the creation of *ofrendas*, domestic altars piled with flowers, candles, and food offerings for the dead (**fig. 15.20**). More recently, the *ofrenda* has become a vehicle for exploring issues of Mexican American identity and shared traditions binding those who have crossed the border to those left behind.

## Carnival

Many hybrid cultural performances throughout American history have featured a strong African American component. Mostly forgotten today is Pinkster, derived from a Dutch Christian celebration in New Amsterdam, but which in the eighteenth and early nineteenth centuries was an occasion for both slaves and free blacks to come together for revelry, and to crown an "African king." An eighteenth-century poet wrote of Pinkster, "Every colour revels there, from ebon black to lily fair." More familiar is the Mardi Gras Carnival celebrated in New Orleans, which has become an ever-changing fusion of centuries-old European and sub-Saharan African performance traditions and beliefs.

Celebrated throughout the Catholic world, from Europe to the Caribbean and South America, as well as in New York City, Toronto, and New Orleans, Carnival's origin is in medieval European Christianity, marking the last opportunity for revelry before the devout austerities of Lent. Carnival varies in form from place to place. In the New World, it has especially come to exemplify the transnational links of the African diaspora, an event occasioning vibrant displays of black solidarity and creative outpouring. (Also see Winslow Homer's 1877 painting *Dressing for the Carnival*, fig. 9.8, showing "Pitchy-patchy," an African American performer in patchwork costume who appeared at various occasions, including Carnival.) New Orleans' carnival hybrid of medieval European and African modes of performance fused in the melting pot of the Caribbean from the seventeenth through the nineteenth century. In the United States, New Orleans was a crucible for the merging of cultures. Around 1800, the city was nearly 50 percent black (both slave and free). Its population included Native Americans, as well as French, Hispanic, and British settlers. In the eighteenth and early nineteenth centuries, blacks congregated in "Congo Square" in the French Quarter to dance on Sundays, and it was here that African American contributions to Carnival coalesced.

**MARDI GRAS "TRIBES."** In addition to festival performance mimicking European-style high society (with kings and queens, lords and ladies, and jesters), African American performers added something new in the 1890s: they dressed as American Indian warriors (**fig. 15.21**). In this lavish fantasy of a Plains Indian costume, the eagle feather headdress is replaced by dyed ostrich feathers, while heavily encrusted panels of sequined beadwork replace the buckskin garments of the Indian warrior. Long hair extensions (again, feathered and sequined) mimic the warrior's braids.

The black Mardi Gras Indian performance troops of New Orleans refer to themselves as "tribes." The making of their sumptuous costumes is a year-long endeavor, requiring a cash outlay of several thousand dollars' worth of ostrich plumes, beads, sequins, and velvet. The "tribe" members are predominantly working-class black men for whom this represents a substantial investment, though some recoup a portion of their expenses by selling the beaded panels of their shirts and dance aprons. Proceeds then go toward inventive new costumes made afresh for the next Mardi Gras season.

Such performers thrive not just in New Orleans, but throughout the Caribbean, in Bermuda, the Dominican Republic, Trinidad, Jamaica, and Cuba.[18] The derivation of the black Indians is complex, involving multiple strands of popular culture, religious practice, American and Caribbean history, and a grassroots understanding of the potency of visual symbols for cultural survival. Buffalo Bill's Wild West Show (see fig. 9.42) toured New Orleans in early 1885, just before the Mardi Gras season. The beaded and feathered costumes of the Plains Indian performers in that spectacle surely impressed the African American viewers. Concurrently, in the syncretic Afro-Christian religion of Puerto Rico and Cuba called *Espiritismo*, some of the "spirit guides" are Native American warrior spirits, whose power derives from their status as aboriginals who resisted European encroachment. Africans in the New World (religious practitioners and festival dancers alike) must have seen in the figure of the American Indian strong parallels to their own oppression. So the American Indian warrior became a symbol of resistance.

Whites were wary of blacks assembling for dancing and performing in ways that might assert their autonomy, so African-style masked performances were sometimes outlawed. The art historian Judith Bettelheim has suggested that while an African American could not masquerade as a powerful African warrior, he could get away with doing so as an American Indian warrior.[19] Since white Americans, too, were fascinated with Plains Indians, this was not seen as threatening. In this fashion, a subversive message was carried in an altered medium. To battle with finery rather than weapons, and to adopt the identity of proud warriors of another ethnicity, was one way for African Americans covertly to assert cultural autonomy and resistance in an ostensibly harmless performance.

15.21 **LARRY BANNOCK**, *"Black Indian" Performance, New Orleans Mardi Gras*, 1986.

# The "New Negro" Movement and Versions of a Black Art

"A people that has produced great art and literature has never been looked upon as distinctly inferior."
*Charles Johnson* [20]

The 1920s and 1930s saw a renaissance of artistic and literary expression within the black community, known in these

years as the "New Negro" movement, and mostly centered in the new black neighborhoods of America's cities. A lively debate emerged over what form the new black art should take. Long defined by distorted stereotypes and racist caricature, black artists sought to gain control over their own representations, and assume authority over their own cultural identity. Yet what was to be the shape of this cultural identity? Should it look to American urban modernity, where most black artists and writers were located? Or should it look to Africa? But were black Americans not also heirs, along with Americans of European descent, to the great visual traditions of Western art and European modernism? These questions percolated through discussions among artists and intellectuals about the nature of a black visual aesthetic.

Modern black identity is a product of momentous and often violent encounters between Europe, Africa, and the New World, originating with the transatlantic slave trade of the sixteenth century. In the wake of the emancipation movements of the nineteenth century, black artists, writers, and performers sought to give voice to their experience as members of American society. Given this complex and painful history of displacement, enslavement, exploitation, and disenfranchisement, the search for roots necessarily pointed in several directions.

The failure of Reconstruction following the Civil War initiated a system of racial apartheid which came to be known as "Jim Crow," in which black citizens were physically and socially segregated and denied basic civil rights in housing, employment, and education. From 1896 on, "separate but equal" (as declared by the Supreme Court decision Plessy vs. Ferguson) was the law of the land. The depth of black oppression was brought home dramatically when black soldiers, having fought for their country in World War I, were victimized in 1919 by a campaign of lynchings and race riots costing so many lives that it came to be known as Red Summer.

Recognizing the unique contribution the arts could make to the process of black self-definition, a broad alliance of writers and artists explored new forms of black self-expression. While much of this investigation occurred in Harlem, in New York City, it was by no means the only center of black intellectual and artistic activity. The nation's largest black community, Harlem promised economic, social, and cultural autonomy for a people who had lived on the fringes of white society throughout their history.

In a 1931 essay, "The American Negro as Artist," Alain Locke (1886–1954), a noted black intellectual of the "Harlem Renaissance"—a subdivision of the New Negro movement—distinguished three categories of artistic prac-

tice: the Africanists or neo-primitives, the traditionalists, and the modernists. Casting about for myths of their cultural and historical origins, some American black artists (Locke's Africanists or neo-primitives) turned to the ancestral continent for inspiration. Since the breakthrough years of Parisian modernism, African art had enjoyed new stature in the West. Picasso and many others had learned a great deal about abstraction by looking at African carvings in the museums of Paris. American black artists laid special claim to this heritage; their modernism did not have to derive from Europe but could now turn to Africa as the source of a "usable past." Identification with Africa engendered racial pride and a new cultural self-assertiveness. Recent decades have witnessed a greater embrace of the hybrid nature of black modern identity—the product of a European and American black diaspora—and a movement toward what the scholar Richard Powell identifies as "an international art language."[21]

Other black intellectuals and artists (Locke's traditionalists), struggling to articulate the distinctive features of the black American experience, looked to the African American folk culture of the South forged in the period of slavery and its aftermath. Here the wrenching separation from the culture of Africa became the justification for a cultural expression born of the American experience, including slavery and the "folk" characteristics of the black cultural heritage. Vernacular speech and musical forms migrated north between 1910 and 1930, as the black folk culture of southern slavery shaded into the culture of the black urban working class.

However, for a segment of newly urbanized African Americans (Locke's modernists), ties with a rural, oppressed past rooted in slavery appeared to be a liability, not an asset. Instead, this current of thinking identified black Americans as linked by their experience of forced displacement to the essentially rootless quality of modern life itself. Following the loss of their homelands, and their migration from country to city, the cultural essence of the modernist New Negro was to be found in a new black urban identity.

Underlying these varied prescriptions for a black cultural expression was the issue of the role of black history in the creation of a new modern black identity. Segregation and oppression produced deep social, economic, and political suffering, but also gave urgency to the emergence of an assertively black cultural voice. Were the painful historical roots of black identity a burden to be thrown off or were they a necessary condition for self-fulfillment?

Africanist, traditionalist, and modernist approaches most often intermixed in the practice of black artists

between the wars. Much of the work of those artists associated with the "New Negro" movement explored, with varying degrees of self-consciousness, the mixed or hybrid nature of black historical experience, as both urban *and* rural, African *and* American, modern *and* "folk." A vibrant expression of this hybrid black identity was jazz, a musical form that fused these varied elements. In Chapter 14, we explored one example of a black modern yet vernacular expression in the work of Archibald Motley. Here, we consider how black artists used traditional materials associated with the rural experience of life in the South.

## The Black Artist and the Folk

By the late 1930s, African American artists and performers, from Paul Robeson, in theater, to Jean Toomer and Zora Neal Hurston, in literature, to Duke Ellington and Cab Calloway, in jazz, had all drawn upon southern black dialect and experience in shaping their expressive languages. Adding legitimacy to the artistic uses of such folk elements were oral histories taken from still living ex-slaves; recordings of the music of black chain gangs by Alan Lomax; and the "discovery" of Huddie Ledbetter, a.k.a. "Leadbelly," an ex-convict, performer, and songwriter whose music linked the "blues"—an urban idiom—to southern rural musical forms. Southern black religion also was seen as a premodern "folk" form that transmuted physical and material hardships into moving spiritual and communal expression.

**SARGENT JOHNSON.** Black artists between the wars combined a sophisticated modernism with these varied vernacular cultural sources. Sargent Johnson, a California artist, epitomized this hybridity, marked by the multiple currents of twentieth-century history and culture. Based in San Francisco and Berkeley, he drew upon a rich mosaic of West Coast regional cultures: European immigrant, Mexican, Asian-Pacific. From his mentor, the Italian American Benjamin Bufano, Johnson absorbed the compact, monumental, and simplified forms that fused the modernism of Constantin Brancusi (1876–1957) with the influences of Mexican sculpture. From Diego Rivera (see Chapter 16), the Mexican muralist who had executed several Bay Area commissions in 1930, he found support for his own interest in the sober dignity of those who worked the earth—Mexican peasants for Rivera, the descendants of slaves for Johnson.

Johnson's *Forever Free* (**fig. 15.22**) grounds black identity in emancipation and the ongoing struggle for freedom that connected the past and future of black Americans. Past and future are apparent as well in the forms he uses.

15.22 SARGENT JOHNSON, *Forever Free*, 1933. Wood with lacquer on cloth, 36 × 11½ × 9½ in (91.44 × 29.21 × 24.13 cm). San Francisco Museum of Modern Art, California. Gift of Mrs. E.D. Lederman.

The simplified style of "folk" art had gained new validity in the 1930s, among both black and white intellectuals. *Forever Free* reveals the growing modernist interest in the work of anonymous regional carvers. Johnson's admiration for West African sculpture, further evident in a series entitled *Mask* from the late 1920s to the early 1930s, finds expression here in the stylized treatment of facial features and the use

of polychrome. The superimposition of the children's figures onto the monumental form of the mother recalls both Brancusi and Mexican sources, while the features of the black mother (modeled on a woman who worked as a maid in Johnson's Berkeley neighborhood) reclaim from racist caricature what Johnson called "the natural beauty and dignity" of his people.[22]

**WILLIAM JOHNSON.** Another academically trained cosmopolitan artist, William Johnson (1901–70) spent a decade in Denmark, returning in 1938 to invent his own folk idiom. He developed a simplified and monumentalized figural language drawing on such European artists as Picasso and Georges Rouault. But he also mined a range of other sources, from children's art (he taught children at the WPA-funded Harlem Community Arts Center in 1939) to African art, to medieval tapestry (encountered through his Danish wife, the textile artist Holche Krake). In place, however, of the earlier emphasis of such artists as Elie Nadelman (see fig. 13.24) on the whimsical and decorative aspects of American folk art, Johnson devised a powerful and original style for painting the southern folk of his South Carolina childhood, their image intensified by

his own transatlantic pilgrimage and subsequent homecoming. Like Marsden Hartley, Johnson honed himself as a painter in a variety of different styles, from academic naturalism to a vibrant expressionism. And, like Hartley, he eventually arrived at a self-described "modern primitive" style informed by a sophisticated sense of abstraction.[23]

*Going to Church* (**fig. 15.23** and **p. 484**) is a tapestry of saturated color, flat forms, and repeating shapes and stripes. resembling both the collaged cutouts of European modernists and the pieced quilts of southern African American women. Everything seems paired, from the front-seat couple to their two sons in the rear of the wagon, the slender trees and crosses on the hill, and the church and cabin that echo one another on opposite sides of the painting. In graphically simplified narrative, the family unit connects the home to its spiritual counterpart, the church on the hill. As Richard Powell has pointed out, Johnson's primitivism was more than a mirror of European sources. It was a fully internalized expression of his desire to integrate the divisions within black experience—as an artist educated in European traditions yet intent on creating a visual language embodying the memories of his rural African American origins.

15.23 WILLIAM H. JOHNSON, *Going to Church*, c. 1940–1. Oil on burlap, 38⅛ × 45½ in (96.8 × 115.6 cm). National Museum of American Art, Smithsonian Institution, Washington, D.C. (See also p. 484)

## Vernacular Black Artists of the Twentieth Century

Members of all ethnic groups make works of art that have life and vitality outside the institutional, studio, and gallery systems. Such works are sometimes lumped together under the rubric of "folk art." Yet it seems prejudicial to call these "folk arts," as if the art of any culture other than mainstream America were operating as nothing more than a tangent to one high culture system. It makes more sense to speak of diverse vernacular traditions, all of which operate independently, yet in an interrelated fashion, and often incorporate aspects of consumer culture into their work, frequently in inventive and humorous ways. Numerous twentieth-century African American vernacular artists have produced works of striking vitality and originality.

**HORACE PIPPIN.** This self-taught painter (1888–1946) presents a particular challenge to art world standards and stereotypes. His work, along with that of Edmondson and Traylor (discussed below), was among the first to be celebrated by the New York art world. His paintings were included in an exhibit, "Masters of Popular Painting," held at the Museum of Modern Art in 1938. Pippin's show marked a shift; in the catalogue, the Museum's director, Alfred Barr, wrote that "the purpose of this exhibition is to show, without apology or condescension, the paintings of some of these individuals, not as folk art but as the work of painters of marked talent and consistently distinct personality."[24] Lifted out of the category of folk art, Pippin joined the ranks of other major international artists, past and present, celebrated by the Museum of Modern Art for their contributions to aesthetic form.

15.24 HORACE PIPPIN, *Mr. Prejudice*, 1943. Oil on canvas, 18 × 14 in (45.7 × 35.5 cm). Philadelphia Museum of Art, Pennsylvania.

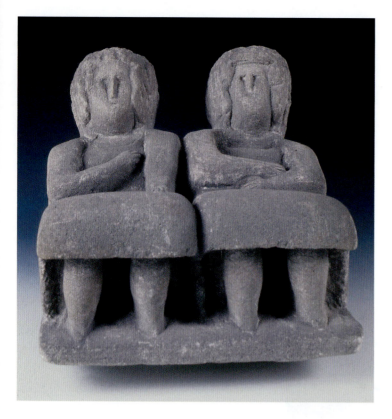

15.25 WILLIAM EDMONDSON, *Po'ch Ladies*, ca. 1941. Montclair Art Museum, New Jersey.

Like some of the early-twentieth-century Native American artists we have examined (see fig. 15.16), Pippin was interested in producing a kind of "insider ethnography"—teaching people about the African American community through his pictures. He once said of himself, "You know why I am great? Because I paint things exactly the way they are. I don't go around making up a whole lot of stuff. I paint it exactly the way it is and exactly the way I see it."[25] Pippin was keenly interested in the events of daily life in the African American community around him. He painted scenes of families playing dominoes, saying prayers, eating breakfast. But he also painted portraits of his Amish neighbors, and recreated scenes in the Bible stories that he heard as he grew up. Big themes concerned him as well: events in American history, World Wars I and II, and racism. Pippin had fought in World War I, where he was disabled and shipped home after a year in France; he painted many scenes from his experiences there. In *Mr. Prejudice* (**fig. 15.24**), painted during World War II, Pippin provided a trenchant social commentary on racism in America, reminding the viewer that while "V" stood for Victory, and black machinists and steel workers were of vital importance to the war effort at home, the Ku Klux Klan (on the right) and the Statue of Liberty (on the left)

still vied for control of America. The African American soldiers and sailors, fighting abroad for international freedom even as he painted this work, were still serving in a segregated military.

**WILLIAM EDMONDSON.** The sculptor William Edmondson (1874–1951) achieved national recognition in 1937 when he became the first African American to have an exhibition at New York's Museum of Modern Art. This occurred during an era of widespread interest in folk, Native American, and African American art on the part of mainstream art institutions, when academically trained artists were, as we have seen, keenly interested in learning from the expressive works of the self-taught. Edmondson was the son of freed slaves who emigrated from rural Tennessee to Nashville at the end of the nineteenth century. He worked as a laborer in Nashville, doing a stint as a stonemason's helper. When physical ailments caused him to give up a regular job, he turned full-time to carving gravestones and garden ornaments for the local working-class African American community of which he was a part. He carved relatively soft limestone, using a hammer and an old railroad spike as a chisel.

Edmondson's work extended to biblical themes such as Adam and Eve and Noah's Ark, political and social figures including the First Lady, Eleanor Roosevelt, and the popular black boxer Jack Johnson. Humorous vignettes of daily life, such as *Po'ch Ladies* (**fig. 15.25**), were important to him, too. In this simple, direct carving of two prim women, side by side, with similar poses, Edmondson captured the essence of a southern neighborhood scene.

Edmondson was "discovered" for the larger art world when an artist who taught at a local college brought the famous fashion photographer Louise Dahl-Wolfe (1895–1989) to photograph the imposing-looking sculptor and his works. Dahl-Wolfe's elegant pictures of Edmondson's extraordinary carvings prompted the Museum of Modern Art to organize an exhibition. Though his individual works are now housed in museums and private collections across the country, he intended them for a local audience. Displayed as a haphazard and exuberant group on his own property, under a hand-lettered sign reading "Tombstones for sale. Garden Ornaments. Stone Work. Wm. Edmondson," they became a sculpture gallery of sorts, part of the southern African American tradition of "yard shows" in which diverse media provide a whimsical commentary on all aspects of life, from the spiritual to the political to the aesthetic. Such yard shows continue to be an important feature of the vernacular landscape in the South today, and are not necessarily limited to the black community.

**BILL TRAYLOR.** Another important vernacular artist, Bill Traylor (1856–1949), was born a slave on the Traylor plantation in Alabama, where he lived and worked most of his life as a field hand and blacksmith, moving to Montgomery in his old age, during the Great Depression. There he made a new life for himself, creating and selling drawings. He slept on the floor of a shoe repair shop, and had a small "workshop" sheltered in an unused doorway on the sidewalk.

More than a thousand drawings are known from the intensive period from 1939 to 1942 when Traylor worked every day, using pencils, poster paint, and cardboard to make scenes of daily life. Even when given clean artists' **posterboard**, he would set it aside to "ripen up." He preferred the scuffed and battered surfaces of the cast-off cardboard boxes he was accustomed to. Traylor fashioned his own public art gallery, attaching his work with string to a nearby fence. He sold many of these drawings for a dime or a quarter. In *Kitchen Scene* (**fig. 15.26**), he combines dark outline and profile images, above, with a bold yellow house, below. He keenly observed the urban life that passed in front of his little worktable on Monroe Street in Montgomery. But he also drew upon his eight decades of rural life, composing scenes of dogs, farmyard animals, snakes, and birds, with great mastery and a strong sense of line and form. Traylor was known to be a great storyteller, and some of his animals recall the wise beasts of Bre'r Rabbit and other African American folktales.

Charles Shannon (1915–96), a young modernist artist who was fascinated with black culture and music, befriended the elderly artist in 1939, organizing exhibitions for him, and buying many of his works.[26] Some thirty years after Traylor died, three dozen of his works were part of an important exhibition, "Black Folk Art in America 1930–1980," at the Corcoran Gallery in Washington, D.C. The unknown Bill Traylor was deemed "the star of the show" and his works are now among the most sought-after vernacular art.

**JAMES HAMPTON.** Many self-taught artists draw, carve, or make constructions because they have a religious message to convey. In some cases, the intensity of their devotion to art-making is the result of a vision or a revelation from God, and they are called **"Visionary Artists."** In 1950, James Hampton (1909–64), a soft-spoken African American in his forties, rented a garage in a run-down Washington neighborhood to house a project he had toiled at for some time. Over the next fourteen years, until his death, he worked at night, in solitude, after spending all day as a janitor in a government building. Hampton's reclusive life was shaped by three religious experiences he underwent

15.26 BILL TRAYLOR, *Kitchen Scene*, c. 1940. Pencil on cardboard, 22 × 14 in (55.8 × 35.5 cm). Metropolitan Museum of Art, New York.

in early adulthood: visions of Moses, the Virgin Mary, and Adam. These apparently were the impetus for his life's work. *The Throne of the Third Heaven of the Nation's Millennium General Assembly* is a **multimedia installation** (**fig. 15.28**) comprising more than two hundred individual pieces, including thrones, altars, tables, pulpits, and winged figures. The work is made of cast-off furniture, cardboard tubes, bottles, burned-out light bulbs, and other detritus, all meticulously covered in gold and silver foil scrounged from liquor bottles, cigarette packs, and food wrappings. *The Throne of the Third Heaven* is rigorously symmetrical, with one side referring to the Old and the other to the New Testament. Hampton's unusual avocation issued from a religious and artistic vision rooted in a strong Baptist faith and a rural African American belief in the power of personal revelation.

# Lonnie Holley: A Contemporary Vernacular Artist

THE VERNACULAR TRADITION still flourishes in African American neighborhoods across America. In *Him and Her Hold the Root* (**fig. 15.27**), the Georgia artist Lonnie Holley (b. 1950) combines two rocking chairs and a gigantic, gnarled tree root. For each viewer, something different comes to mind. To those knowledgeable about African American cultural practices, the composition suggests the potency of roots in medicine and magic, and the power of folk healers and conjurors who have access to a legacy of ancient herbal knowledge. The paired rocking chairs of different sizes (male and female?) suggest the wisdom of the elderly, who may sit and rock quietly on the porch but who carry profound knowledge inside them. Or perhaps Holley is playfully referring to a search for the "roots" of culture—the subject of this chapter. Holley often takes discarded consumer goods (a tabletop copy machine, an electric guitar, a television), conjoins them, and offers them up as trenchant social commentary. The detritus of

consumer culture finds new, poetic uses in his humorous and sophisticated work. For more than twenty years, Holley lived near the airport at Birmingham, Alabama, on a property that had long served as an informal dumping ground. He took many of the items discarded there and made his own ingenious built environment, which the city of Birmingham bulldozed in 1995 (after he had achieved international acclaim for his work). Holley commented, "I saw that in the city of Birmingham, where art could be tore down so easy, and trampled upon, it was my responsibility to fight for the rights of the art. I have been to many places. I have understood that our kind of art, the art of black people, have been the first to come and is always the first to go. When our art is too strong, it gets tore down."

15.27 LONNIE HOLLEY, *Him and Her Hold the Root*, 1994. Rocking chairs, pillow, root, 45½ × 73 × 30½ in (115.5 × 185 × 77.4 cm). Private collection.

15.28 **JAMES HAMPTON**, *The Throne of the Third Heaven of the Nations' Millennium General Assembly*, c. 1950–64. Wood, cardboard, aluminum foil and found materials. National Museum of American Art, Smithsonian Institution, Washington, D.C.

Among the many inscriptions on his work, the exhortation "Where there is No Vision The People Perish" may best express Hampton's own feelings about his project. In other inscriptions, he referred to himself as "St. James, Director of Special Projects for the Archives of the State of Eternity." Though his work was not secret—Hampton occasionally showed it to people, and he spoke of wanting to start a ministry in his retirement—it is a reflection of a solitary and eloquent vision.

Some scholars have argued that African American artists such as Hampton, sometimes classified as outsiders or visionaries, fully participate in an African American aesthetic tradition grounded in an African past, and in southern black rural Christian spirituality. Many twentieth-century metropolitan artists of color (see Betye Saar, in fig. 18.24) claim these "outsider" works as their aesthetic legacy, alongside the work of modern European masters, a vital heritage to which contemporary artists lay claim in their search for roots. Recent, keen interest in vernacular arts suggests the appeal of something elemental and unspoiled, a vitality not found in work made by people with degrees in studio art and a sophisticated understanding of the art world.

# Conclusion

The impulse to ground modernism in an older American vernacular, beginning in the 1910s, reached full flower a decade later with the growing aesthetic appreciation for homegrown culture. In the 1930s, the WPA, a branch of President Franklin Roosevelt's New Deal, further facilitated the artistic and cultural recovery of regional, ethnic, and "folk" arts and crafts. The search for roots had occasionally encouraged clannishness, driven by the polarizing language of identity and difference. In the next chapter we consider visual forms associated with the Depression era, and directed at identifying not differences but broad democratic commonalities during a decade of national crisis.

# 16 | Social Visions: The Arts in the Depression Years, 1929–1941

"There is a crisis in art as deep, if not as obvious, as the economic crisis. The shock of the crash has tumbled the ivory towers. Artists are beginning to realize that they are a group possessing interests in common with other groups, and not the isolated individualists they once pictured themselves. The present period demands a new art, not necessarily new in form, but new in expression."[1]

The stock market crash of 1929 brought on a profound crisis in America. The hopes after World War I for a prosperous way of life based on industrial mechanization suffered a major setback when the massive overproduction of consumer goods resulted in falling wages and widespread unemployment. The free fall of financial markets dislodged faith in capitalism, and the ensuing economic collapse, known as the Great Depression, was interpreted by some as the death throes of an ailing system. Many citizens sought collective solutions at both the community and the national level. During the presidency of Franklin D. Roosevelt, an emergency policy of governmental intervention known as the New Deal was instituted to create jobs and restart the economy. Throughout these years of crisis, a range of government agencies employed artists in public works projects. As a result, mural projects and **documentary** photography achieved new prominence among the arts. The conviction that art drew its vitality not from aesthetic concerns but from links with popular beliefs, traditions, and ideals was a catalytic force in the 1930s.

(opposite) BEN SHAHN, *The Passion of Sacco and Vanzetti*, 1931–2. Tempera on canvas, 84½ × 48 in (214.6 × 121.9 cm). Whitney Museum of American Art, New York.

Also motivating the movement toward collective solutions was the admiration among the political left for the utopian ideals of Communism in the Soviet Union. From 1937 on, the culture of the "Democratic Front"—a broad alliance of Communists and others on the political left and center united to stem the rising tide of fascism in Europe and the United States—sought to revive principles of social justice and democracy associated with the foundation of the republic, but seemingly lost with the growth of private wealth and power. They sought to reignite faith in the future by valuing communal over individual forms of experience.

Social crisis propelled protest and activism, pitting wage-earning working people against the monopolistic powers of business allied to elected officials. Protests took the form of labor strikes and demonstrations. Artists mobilized as well, forming unions and clubs, and debating the role of art in social transformation. Driven by their anger as well as by their ideals, artists sought to communicate to the broad masses of ordinary Americans.

New sources of influence continued to enter American art in these years, most prominently from Mexico. In the 1920s, following a decade of revolution, a reform government in Mexico launched a public mural program to instill pride in the nation's indigenous heritage. The example of Mexico stimulated American artists as well in their search for an epic, politically engaged public art. Throughout the 1930s, the politics of style were widely debated, as artists considered the implications of **Social Realism** versus abstraction, of "traditionalist" versus modernist forms. Such choices carried broader implications for the role of the arts in society.

While some in the 1930s saw the solution to the nation's crisis in a reenergized social conscience and mass mobilization,

others envisioned technocratic solutions devised and administered by experts invested with governing authority. Commercial interests sought to use the "arts of persuasion" to encourage consumer fantasies of the good life through world's fairs, consumer advertising, marketing and display, and industrial design. Streamlining—a style of product design associated with the new figure of the industrial designer—joined other strategies in promoting the consumption required to keep pace with industrial production. The various actors of the 1930s had different purposes and goals in mind, ranging from a "people's culture" of collective expression to new corporate and media forms of "manufactured consent." Despite these differences—collectivist or technocratic, communitarian or corporate—all located in the realm of the visual a power to persuade the public and compel social change.

# The Depression and the Narrative Impulse

People tell stories to remind themselves of where they came from, and to secure their identities against the pressures of everyday survival. The narratives of the 1930s, whether texts or images, persistently situated the period in a broader historical landscape. Narrative, however, can act in a variety of ways, creating reassuring fables or fully engaging the complexities of experience. Common to all forms of narrative art in the 1930s—from history to legend to contemporary social conflict, and from mural painting to photography—is a focus on the human figure as the carrier of political, social, and mythic meanings.

The belief that the arts played a major part in shaping communal life supported the narrative impulse. Whether in the post office murals done under the aegis of the federal Treasury Section of Painting and Sculpture (1938–43), or in the fostering of community art centers, the 1930s turned away from the elitist basis of earlier art. The idea of aesthetics as remote from the concerns of everyday life—"art for art's sake"—gave way to a different model of "art as experience," in the words of John Dewey (1859–1952), the influential American philosopher and author of a book by that title, published in 1934. Dewey argued that the "aesthetic" was "part of the significant life of an organized community," rather than something separate from it. Art was, in his terms, an intensification of life. He opposed "the museum conception of art" which failed to satisfy the aesthetic impulses of ordinary people.[2] The modernist conception of art as "self-expression," the particular badge of an individual creator, gave way to a reassertion of art's role in the symbolic life of people tied to a particular place. Dewey's ideal of "art as experience" dispensed with the hierarchies between fine and practical arts, and between the high arts and popular media. A Pueblo pot, a mural in a public building, a quilt, a harvest dance—each gave aesthetic form to the social relations that linked members of a community to one another and to a place.

One of the great artistic accomplishments in the 1930s was the development of large-scale public mural art. Before the 1930s, murals and sculpture in public places were supposed to depict values outside politics, as well as above the growing social, class, and ethnic divisions within urban populations. In truth, however, such "public" art always served specific political interests. At the turn of the century, murals usually spoke from a position of greater economic and social power to those with less power.

The relationship between the artist and the public shifted between the turn-of-the-century years and the 1930s. Artists began to give voice to the experiences of ordinary men and women, as workers, as family members, as citizens. Artists increasingly thought of themselves as workers, sharing concerns about wages and working conditions with other laborers. The effect was to politicize artmaking, moving art out of the museum and the gallery and into the lives of ordinary people, as they visited hospitals, post offices, libraries, or other public buildings. With its democratic premise of "art for all," 1930s public art aspired to visual readability and clarity of meaning, in the process enlarging the limited story-telling capabilities of easel art.

## Mexican Muralists and Their Influence on Public Art

Of critical importance to the scale and ambition of American mural art during the 1930s was the precedent of mural painting in Mexico, inspired by the revolution (1910–17). After overthrowing the corrupt regime of Porfirio Díaz, reformers sought to redistribute the wealth of the financiers and landowners, who had ruled during decades of modernization, to the broad base of newly empowered peasants and urban workers. Beginning in the 1920s, the newly installed reform government decorated public buildings in Mexico City and elsewhere, in an effort to create new national narratives that would glorify the goals of the revolution. Mexico's mural movement looked to the country's indigenous history to ground an emergent national identity independent of European culture. The Mexican mural program was an important example for

# Taylorization and the Assembly Line "Speed-up"

IN THE EARLY TWENTIETH CENTURY, Frederick Winslow Taylor's time-and-motion studies of workers, together with Henry Ford's assembly-line methods, revolutionized mass production. Taylorization and Fordism, the bywords of this new system, restructured the workplace, and transformed the nature of human labor. Taylorization aimed to reengineer the human body itself by forcing it to conform to the "laws" of efficiency, eliminating all wasted motion. Ford's assembly-line production in turn required the worker to repeat the same task over and over, on the same set of parts, through the innovation of the conveyor belt and the craneway, which brought the parts to the worker. The resulting regimentation of labor forced the body of the worker to conform to the demands of the production process.

The "speed-up," which forced workers to increase production by speeding up the conveyor belt that set the pace of their labor, contributed not only to the growing volume of goods available to American consumers, but also prompted increased labor militancy between the wars. In the 1936 film *Modern Times*, the Tramp, played by Charlie Chaplin, first submits to, and then resists, the discipline of the assembly line. The famous opening factory sequence reveals the ironclad necessities of production and profit that threaten quite literally to consume the worker. The Tramp reclaims his quirky irregularity of movement only following a physical breakdown, which begins when he throws himself into the guts of the machine (**fig. 16.1**). Chaplin brilliantly dramatizes the fear that mechanization would crush the subtle inner rhythms of the human body and spirit.

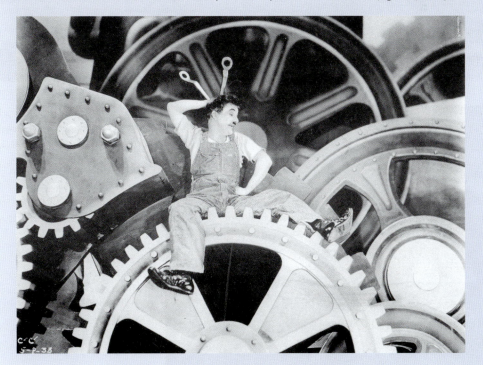

16.1 CHARLIE CHAPLIN, *Modern Times*, 1936. Film still.

George Biddle, an American artist who first proposed it as a model of patronage to President Roosevelt as a means of promoting his New Deal program of national recovery. A national art had the power to mobilize collective energies toward a more just society, and its emotional reach would compel public consent for a reengineered social order, while at the same time revitalizing American art by linking it to national life and ideals.

Hundreds of American artists traveled to Mexico to view these works firsthand. They also learned from Mexican muralists who came to execute works in the United States. José Clemente Orozco (1893–1949), David Siqueiros (1896–1974), and Diego Rivera (1886–1957), known collectively as "Los Tres Grandes" (The Three Great Ones), won major commissions in the United States beginning in the late 1920s. Ironically, while inspiring a socially engaged

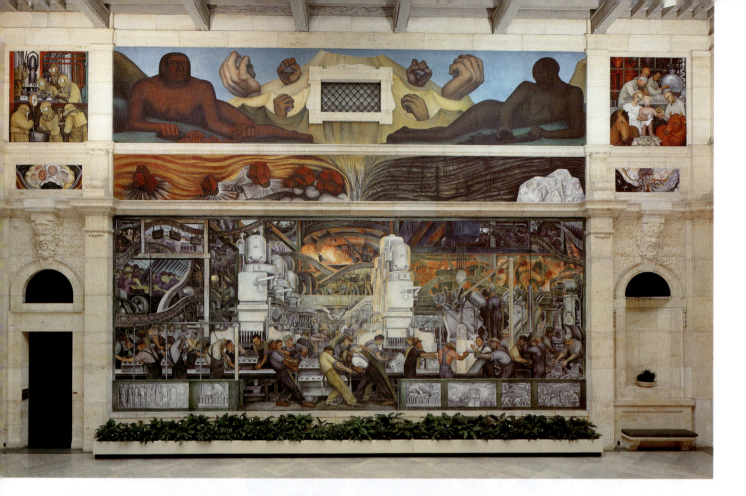

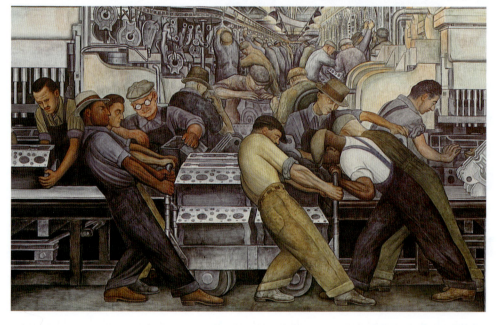

16.2 (above) **DIEGO RIVERA**, *Detroit Industry, North Wall*, 1932. Fresco: *The Red and Black Races*, 8ft 8 in × 45 ft (2.69 × 13.72 m); *Geological Strata*, 4 ft 4 in × 45 ft (1.33 × 13.72 m); *Manufacture of Poisonous Gas Bombs*, 8 ft 5 in × 7 ft (2.58 × 2.13 m); *Vaccination*, 8 ft 5 in × 7 ft (2.58 × 2.13 m); *Cells Suffocated by Poisonous Gases*, 2 ft 3 in × 6 ft (.68 × 1.85 m); *Healthy Human Embryo*, 2 ft 3 in × 6 ft (.68 × 1.85 m); *Production and Manufacture of Engine and Transmission (Ford V-8)*, 17 ft 8 in × 45 ft (5.4 × 13.72 m).

16.3 (left) **DIEGO RIVERA**, *Detroit Industry, North Wall*, detail, 1932. Fresco.

art of the people, much of the Mexican muralists' work in the United States was commissioned by wealthy capitalists.

America's infatuation with things Mexican reached across the political spectrum. Rivera and his colleagues were emulated by American artists on the left who embraced their vision of a revolutionary society. Artists and writers of all political stripes longed for intact folk and Indian cultures such as they saw in Mexico. A wealthy capitalist such as John D. Rockefeller, who held major investments in oil, had other reasons for pursuing Rivera and his colleagues. Responding to the threat of Mexican nationalization of industry, the Rockefellers courted favor with the new government by patronizing its favorite artists. They sponsored exhibitions of Mexican art at the Museum of Modern

Art and elsewhere. Nelson Rockefeller (son of John D. and an heir to the Standard Oil fortune) commissioned Rivera to paint a mural in the lobby of the RCA Building in Rockefeller Center. However, when the Communist Rivera included a prominent portrait of the Russian revolutionary Lenin in his mural, his patrons had the entire work destroyed.

**DIEGO RIVERA IN DETROIT.** The most fully realized of Rivera's murals in America was his epic cycle of American industry painted in Detroit under the patronage of Edsel Ford (son of Henry). Rivera arrived in the United States with his wife, the painter Frida Kahlo (1907–54), in 1930, in response to growing enthusiasm for his work. Following several commissions from patrons in the San Francisco area, including a mural in the San Francisco Stock Exchange, Rivera accepted an invitation from the director of the Detroit Institute of Arts (DIA) to paint two large murals in the Garden Court at the heart of the Renaissance-inspired museum building. Detroit was then dominated by the automobile industry, centered at River Rouge, heart of the Ford empire. The entire project of twenty-seven panels was completed in less than eight months, from July 1932 to March 1933. Rivera, backed by a team of assistants, worked in the true fresco technique he had first studied in Italy in 1920–1: a labor-intensive medium that required three coats of plaster, on-the-spot preparation of pigments, transfer of the design onto the wall, and a carefully plotted, day-by-day application of pigment onto wet plaster.

Rivera was absorbed by the spectacle of American industry. Two large narrative panels on the north and south walls of the court show in exacting detail the stages in the production of a V-8 Ford automobile, based on his on-site observations at the Ford plant. These panels highlight the two main principles behind the Ford manufacturing revolution: assembly-line production and the integration of all stages of the manufacturing process in one vast factory complex, from the production of steel in a blast furnace (north wall)—shown just below the volcano, its natural counterpart—to the milling, rolling, and stamping of steel, glass manufacture, and motor assembly (south wall). Rivera skillfully montaged the separate stages of the manufacturing process, which occupied ten buildings in the multiacre Rouge plant, into a narrative unity.

The north wall features scenes in the "Production and Manufacture of Engine and Transmission (Ford V-8)" (**figs. 16.2** and **16.3**). On the lower level Rivera painted a frieze of workers, each representing a different ethnic component of the Detroit workforce, from Bulgarian to Mexican, Japanese, and African American. During a period when Detroit's work force was struggling to bond ethnic divisions together in unions, this vision of multiethnic harmony was a powerful recruiting tool for the city's labor organizers, who rallied in front of Rivera's mural. The south wall shows "The Production of Automobile Exterior and Final Assembly," witnessed by crowds of visitors who gawk at Ford's industrial miracle.

Above the scenes of Detroit labor, Rivera represented the geological sources of industry in the giant hands that hold the limestone, iron ore, and coal used to produce steel. Moving from the scenes of industry up the wall, the viewer proceeds from narrative to allegory, from the historically specific to the universal, and from culture to nature.

In its epic sweep, *The Birth of Industry* draws parallels between biological processes and technology, and between ancient and modern cultures. The huge stamping press dominating the right side of the south wall was inspired by a sculpture of an Aztec goddess (Coatlicue), who combines the forces of life and death, creation and sacrifice. An organizing theme throughout the mural is the dual potential of technology to deliver both life and death. On the west wall, wartime and peacetime aviation confront each other. Beneath gas-masked fighters Rivera has placed a bird of prey; beneath the domestic aviation industry, a dove. And in the center of the lower panel is a symbolic head, split between life and death.

Animating Rivera's work in the United States was a vision of **Pan-Americanism**: the rebirth of hemispheric culture through the economic and social integration of North and South America. Pan-Americanism had attracted American industrialists from the turn of the century on, as they looked longingly toward the raw materials of Mexico and South America. Rivera gives the idea a new twist, however, emphasizing the union of indigenous and industrial cultures in a non-exploitative future. His utopian cycle redeems the fragmented industrial present through an image of cosmic wholeness and peace.

Unlike Charles Sheeler's *Classic Landscape* (see fig. 14.17), which focuses on the exterior vista of railroad, raw materials, and distant smokestacks at the Rouge plant, Rivera's mural foregrounds the laboring body of the worker, nowhere apparent in Sheeler's work. Months before Rivera arrived in Detroit, workers at the Rouge walked out to protest at a "speed-up" on the assembly line, resulting in a violent clash with police and the deaths of four men (see Box, p. 519). Human labor was the sticking point of Henry Ford's revolution in production; by placing the industrial worker at the center of his mural, Rivera asserts the importance of the social dimension missing from Sheeler's vision.

**JOSÉ CLEMENTE OROZCO AT DARTMOUTH.** At the height of American interest in the Mexican muralists, Dartmouth College in New Hampshire invited José Clemente Orozco—who went there to teach in 1932—to do an ambitious cycle of murals in the library. Enjoying the enthusiastic support of the faculty and the president of Dartmouth, Orozco embarked on the most extensive fresco cycle completed in the United States to date. It took Michelangelo three years to paint the Book of Genesis on the Sistine Ceiling; it took Orozco about a year and a half to paint his *Epic of American Civilization*—a topic only slightly less grand than Michelangelo's—onto the 3000 square feet of Baker Library at Dartmouth. The feat was nothing short of heroic; furthermore Orozco, unlike Michelangelo (or Rivera), worked without assistants. The challenge Orozco set for himself at Dartmouth was the creation of a modern myth of the artist-revolutionary as redeemer of a morally and spiritually corrupt social order. He did so in twenty-four separate murals, whose historical reach extended from the ancient Toltec civilization of Mexico's "golden age," through the murderous and war-driven culture of the Aztecs, to the arrival of Cortéz and the brutal imposition of a new colonial order. Exemplifying the parallel historical structure within the cycle, Orozco placed the violent autocratic rule of the Aztecs, whose gods demanded human sacrifice, alongside the modern militarized nation state, sending its youth to slaughter while suffocated by patriotic symbols. "Gods of the Modern World, or Stillborn Education" (**fig. 16.4**) is a savage caricature of modern institutions of higher learning, personified as death's-heads in academic dress who oversee the birth agonies of a skeletal "alma mater" upon a bed of books. The stillbirth of knowledge is represented as a shriveled fetus held by a hunched doctor of death. Orozco's macabre allegory inverts life-giving knowledge into mummified and sterile traditions whose function is to perpetuate entrenched power at the cost of society's dynamic growth.

16.4 JOSÉ CLEMENTE OROZCO, *Epic of American Civilization: Gods of the Modern World*, 1932–4. Fresco. Hood Museum of Art. Baker Library, Dartmouth College, Hanover, Vermont.

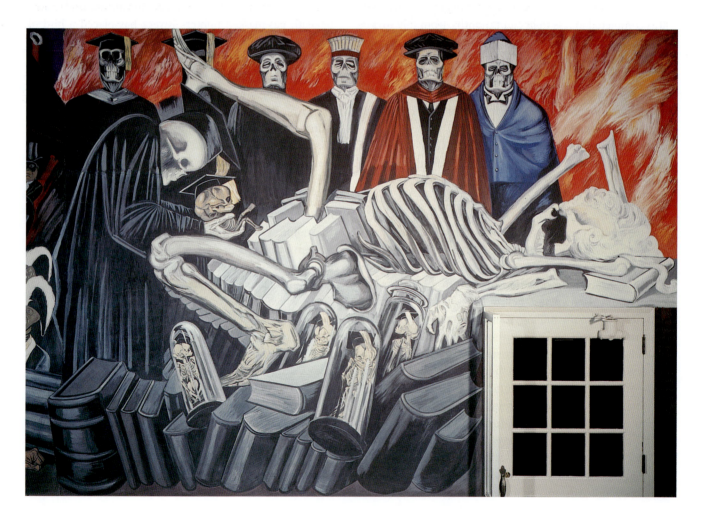

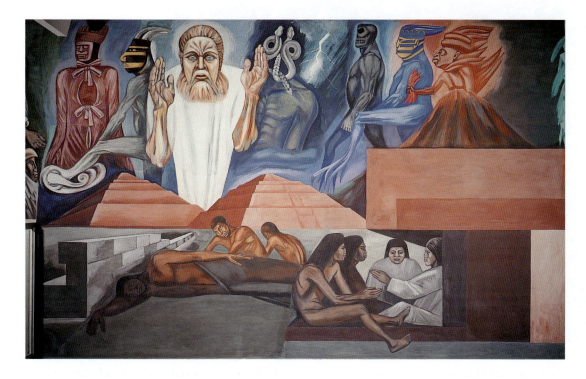

16.5 JOSÉ CLEMENTE OROZCO, *The Coming of Quetzalcoatl*, 1932–4. Fresco. Hood Museum of Art. Baker Library, Dartmouth College, Hanover, Vermont.

The hero at the center of Orozco's epic is Quetzalcoatl, an ancient Mexican god and savior figure who brought a message of enlightenment that fostered moral and cultural growth among New World societies. Quetzalcoatl fuses Old Testament prophets with New World symbols of power—snakes (**fig. 16.5**). His departure heralds the end of the golden age of indigenous societies, and sets the stage for his reappearance in another epoch during which technology—identified throughout the cycle with false gods—is transformed into a liberator of human creativity. Orozco's mural, painted in the heart of New England, offered a historical epic centered around the indigenous societies of Mexico, and on the Spanish Conquest in place of Plymouth Rock and other Anglo-centered founding national myths.

Orozco's epic themes echo Rivera's Detroit cycle: the dialectic of good and evil, playing itself out over history, awaits a synthesis fusing North and South, indigenous and European, Old and New Worlds, the mechanical and the organic. Both murals united North and South America in a single trajectory, a hemispheric perspective that countered narrow forms of U.S. nationalism. Orozco's visual imagination, steeped in satire and cartoon-like exaggeration, inspired several generations of political muralists for whom realism was inadequate to portray the grotesque injustices of modern life.

The impact of the Mexican muralists was profound. A trip to Mexico was a virtual requirement for U.S. artists aspiring to a politically and culturally mobilized public art. Mexico offered a different version of America's cultural and artistic origins, looking not to European modernism but to the great civilizations of the New World—the "American Sources of Modern Art," as the title of a 1933 exhibition at the Museum of Modern Art put it.[3] Featuring art of the Maya, Aztec, Zapotec, Inca, and other New World cultures, the exhibition celebrated the formal power and aesthetic value of an art "not derived from the Old World, but originating and growing up here, without models or masters," as Holger Cahill's essay for the catalogue put it. The arts of ancient Mexico also joined Old World and African influences on modernist formal abstraction in both Mexico and the United States.

**CHARLES WHITE.** The artistic exchange between the United States and Mexico in the decades between the wars left a legacy of public murals, paintings, photographs, and prints. Charles White's *The Contribution of the Negro to Democracy in America*, a mural completed in 1943 for Hampton University (**fig. 16.6**), draws upon the spatial and temporal condensation and the synoptic reach of the Mexican muralists, to travel across centuries of black history. From a poor neighborhood in Chicago, White (1918–79) pieced together his artistic and political education from exchanges with prominent black and white artists, intellectuals, and writers in Chicago, who pointed the way toward a structural understanding of racism. Like the printmaker Elizabeth Catlett (b. 1915), to whom he was briefly married (see Box, p. 525), White traveled to Mexico after painting murals for the WPA and joining the Negro

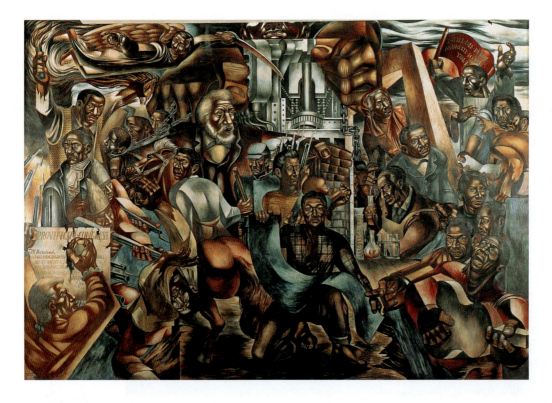

16.6 CHARLES WHITE, *The Contribution of the Negro to Democracy in America*, completed 1943. Egg tempera (fresco secco), 11 ft 9 in × 17 ft 3 in (3.58 × 5.25 m). Hampton University Museum, Virginia.

People's Theater. White structured his epic history around racial and class oppression. At its center is a black architect unrolling a blueprint symbolic of the constructive energies of a liberated race. On the left side are scenes of armed Klansmen and chained black men; and on the other side, leading figures in the black struggle for justice (Frederick Douglass and Harriet Tubman), along with scientists (George Washington Carver) and anonymous musicians. At the center is a huge dynamo gripped by a bronze colossus recalling the Aztec creator/destroyer beings of Rivera and Orozco—part of a broader symbolism weaving together the forces of life and death, creation and repression. White, like other black artists in these years, saw his people's history as part of a wider struggle of oppressed groups throughout the hemisphere. Race and class oppression—exceeding the boundaries of the nation—informed the strong political affinities between American black painters and Mexican muralists.

## Social Realism

While public art expressed unifying ideals, artists' organizations engaged with politics more directly. As historical conditions drove artists out of their studios and into activism, they formed alliances with workers to protest the displacement caused by industrial capitalism. Growing disparities of wealth and widespread misery caused intellectuals, artists, and writers in the 1930s to look beyond the *status quo* toward political philosophies—Marxism most directly—that were critical of capitalism.

Social Realism was rooted in the belief that art was a means with which to change the world order. As the singer/songwriter Woody Guthrie expressed it in a sticker he put on his guitar, "This machine kills fascists." By enhancing people's awareness of their place within an exploitative social order, artists, musicians, and writers could also radicalize them.

**BEN SHAHN.** The execution in 1927 of Nicola Sacco and Bartolomeo Vanzetti, two Italian immigrant workingmen from Braintree, Massachusetts, provoked outrage around the world. Many observers were convinced that the two avowed anarchists were executed for their political beliefs rather than for any complicity in the 1920 murder of a paymaster and his guard during a robbery at the shoe factory where Sacco was employed. The closely watched trial crystallized the growing sense that the United States was betraying its democratic legacy of civil rights, its embrace of immigrants, and its vaunted system of justice for all.

For Ben Shahn (1898–1969), a young artist struggling to find his voice, the event helped to turn him away from his pursuit of French art, to which many American artists still felt they must apprentice themselves. "Here," he wrote years later, "was something to paint,"[4] a subject both monumental and timely. The story of the two Italian immigrants, their families and communities, and their trial, developed into a series of images in many different media. Of these, the best known is Shahn's *The Passion of Sacco and Vanzetti* (**p. 516**). Shahn's theme here is the hypocrisy of the powerful in the presence of martyrdom. In the foreground,

# The Continuing Relevance of Mexican Art

MEXICAN ART between the wars has continued to influence community art forms, including murals and prints, attacking U.S. imperialism. Elizabeth Catlett's *Latin America Says "No!"* of 1963 (**fig. 16.7**) summarizes the history of U.S. military interventions throughout Latin America, from Guatemala to Cuba, Chile, and El Salvador, on behalf of American corporations threatened by nationalization of industries. A rifle-wielding U.S. soldier resembling a death's-head, his standard issue army helmet bearing a dollar sign, confronts two peasants—a man and a woman—barring access to the land, people, and wealth of Latin America. The graphic simplification and allegorical reduction of Catlett's print reveal the impact of the political print styles she had absorbed as an artist in Mexico from 1946 on. Catlett had worked briefly for the Public Works of Art Project, one of the initial projects of the New Deal; she studied painting, ceramics, and printmaking at the Art Students' League and elsewhere in the United States before traveling south. Catlett soon joined the "Taller de Gráfica Popular." Founded in 1937, the Taller was a collective of politically active printmakers in Mexico City who produced posters,

prints, and broadsides for popular distribution on such subjects as literacy, land expropriation, and popular resistance. Like other African American artists, Catlett identified black struggles for equality with the goals of the Mexican revolution. Catlett has remained in Mexico up to the present, her interests encompassing hemispheric popular movements against entrenched power.

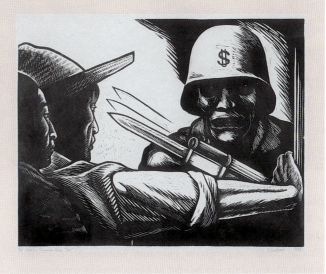

16.7 ELIZABETH CATLETT, *Latin America Says No!*, 1963. Linocut. Studio Museum, Harlem, New York.

three men—the so-called Lowell Committee appointed to review the case for the State of Massachusetts—pay their respects at the coffins of the executed men, gazing vacantly past the bodies. They are Harvard President A. Lawrence Lowell (center), MIT President Samuel W. Stratton (left), and Judge Robert Grant (right). Judge Webster Thayer is pictured, like a wooden idol in the background, taking the oath to support justice. Dispensing with consistent scale, perspective, and illusionistic shading, Shahn developed a style that combined the naive drawing of children's and "folk" art with the monumental humanist art of the early Renaissance. While Shahn clearly learned a great deal from European modernism, he rejected its arcane concerns.

**PHILIP EVERGOOD.** For Philip Evergood (1901–73), politics and art were intimately linked. As he wrote regarding his 1937 painting *American Tragedy* (**fig. 16.8**), "I don't think anybody who hasn't been really beaten up by the police badly, as I have, could have painted" such a work.[5] *American*

*Tragedy* shows—in the starkest possible terms—a confrontation between steelworkers, their families, and armed police in front of the South Chicago plant of Republic Steel. As part of an effort to organize the smaller steel companies following the unionization of workers at U.S. Steel, the Steel Workers' Union held a rally and parade on Memorial Day 1937. As recounted in Paul Strand's film *Native Land*, made by the film collective Nykino in 1942, the festive atmosphere of the demonstration ended violently when the unarmed marchers were attacked and fired upon by the Chicago police, leaving eleven men dead, and over a hundred injured. The effort to derail the union through violence succeeded only in the short term. Union members were laid off, or returned to work under a cloud. Eventually, the right to unionize was upheld by the Congressional committee that investigated the episode.

Evergood's figurative style is deliberately crude and caricatural; workers and their wives, dressed in Sunday best, flee, stagger, and collapse before the bullets and batons of

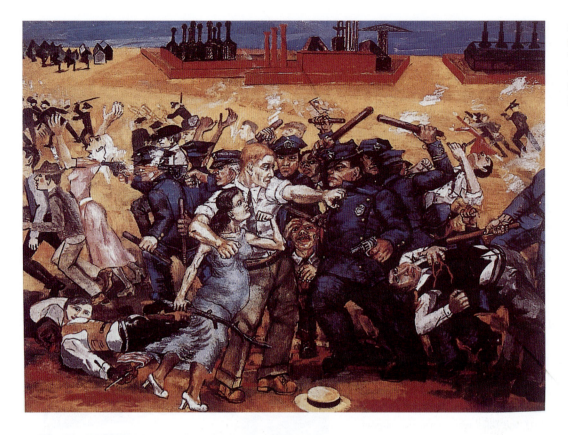

16.8 PHILIP EVERGOOD, *American Tragedy*, 1937. Oil on canvas, 29½ × 39½ in (74.9 × 100.3 cm). Private collection.

police. On the left, a black worker has fallen, still clutching a small American flag in his hand—Evergood's tribute to the patriotism sustaining the movement for workers' rights. At the center, a pregnant Hispanic woman arms herself with a stick and shakes her fist at a gun-wielding policeman who points his gun at her belly while her husband grabs him by the coat. This act of defiance in the face of violence and intimidation holds the key to Evergood's drama. Its title universalizes the action, removing it from immediate events to occupy a bigger historical stage, as one episode in a broader struggle. Through cartoon-like exaggeration, a deliberately harsh color scheme, and distortions of scale and perspective, Evergood turns away from the idealized figural tradition of the Old Masters toward what the writer and philosopher Kenneth Burke called "the proletarian grotesque"—a vision of embattled humanity inspired by the Spanish artist Franciso Goya (1746–1828) and others who had grappled with the contorted features of human extremity.

## Epics of Migration

A defining impulse of the 1930s was to set down roots, to search out a usable past that would anchor the nation in a time of crisis. Yet it found expression in the face of widespread human displacement—a massive *uprooting* of Americans in search of employment, new homes, more fer-

tile lands. Migration between worlds had been the defining experience for Americans from Africa, Asia, and Europe over four centuries of history. Men and women of different regional, ethnic, social, and educational backgrounds found themselves poised between old and new worlds, tradition and modernity, historical limitations and future possibilities. From pioneers to the American West, to European and Asian immigrants in search of new opportunities, they carried, in the memorable image of the black poet Langston Hughes (1902–67), the seeds of new cultures "from far-off places/ Growing in soil/That's strange and thin,/Hybrid plants/ In another's garden" ("Black Seed," 1930). Hughes was writing about the great southern migration to the North, but his images apply to any people on the move between cultures.

The epic of human migration took a number of visual forms in the 1930s, the reverse of the frontier myth of America as land of opportunity for new immigrants. Two of the greatest internal migrations in the twentieth century occurred during the years between the wars: the Dust Bowl migration, primarily of white grain farmers to California in the 1930s; and the movement of black sharecroppers out of the South toward the industrial cities of the North. In image after image of people displaced from their homes, migration in the 1930s emerged not as a search for new horizons but as a desperate flight from unsupportable lives and devastated lands.

**JACOB LAWRENCE.** Jacob Lawrence's *The Migration Series* (1941), done when the artist was only twenty-three, offers a black perspective on the national drama of peoples in transition. Consisting of sixty small panels, it was one of several focusing on black history that Lawrence (1917–2000) did over his long career (**fig. 16.9**). Lawrence worked in series because, as he put it, the artist cannot "tell a story in a single painting."[6] In doing so, he also gave visual expression to the African American tradition of oral narrative. *The Migration Series* fused this ethnic inheritance with the broader 1930s narrative impulse. He was communal storyteller, historian, poet, and mythmaker all at once, telling a tale of the shift "from medieval America to modern," in the words of Alain Locke.[7]

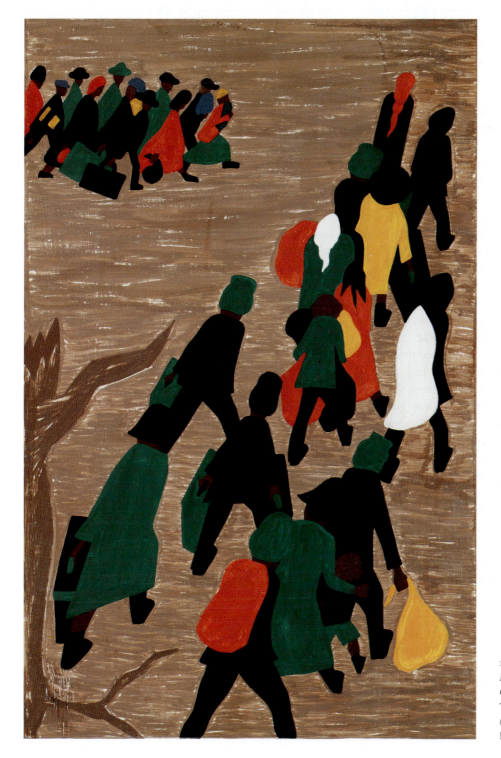

16.9 JACOB LAWRENCE, *The Migration Series: The Migration Gained in Momentum*, 1940–1. Tempera on masonite, 12 × 18 in (30.4 × 45.7 cm). Museum of Modern Art, New York.

Following the Civil War, a feudal system of rural sharecropping had betrayed the promise of emancipation, reducing black families to peonage. Responding to labor shortages following World War I, and the lure of better wages that promised a way out of chronic indebtedness and poverty, black sharecroppers migrated north to fill industrial jobs. By the conclusion of World War II, nearly half the black population in the United States lived in cities. Lawrence's series represented the labor camps, poor and crowded housing, discrimination, riots and violence, disease, and class prejudice that accompanied the pursuit of economic and social betterment—voting rights and education—in the North.

Lawrence presented his migration story in the stark imagery of colluding forces pushing black families out of the South and pulling them northward toward new opportunities. He devised a recurring symbolism of thresholds, crossroads, bus and train stations, ladders, stairs, barriers, bars, and boundaries to suggest the passage from South to North and rural to modern. Stylistically as well, Lawrence's series represented a movement between worlds. His simplified, silhouetted human forms painted in broad, uninflected fields of vivid ochers, yellows, blues, rust reds, and forest greens, bring together the tilted and flattened spaces of Post-Impressionism with the intense colors of Lawrence's youth in Harlem. There his eye was first educated in the rich and colorful streetscapes shaped by rural black migrants who brought with them the memory of rural patchwork quilts. He drew as well upon the black oral traditions that connected rural past with urban present, even as the easel format in which he chose to tell his story was inherited from the Christian and classical narratives of the Italian Renaissance. Terse captions accompanied each panel, advancing the story through a few expressive elements.

In its subsequent history, *The Migration Series* also migrated between the two worlds of black art and white patronage, interrupting a practice of cultural segregation that had long kept black artists out of white galleries. Lawrence was the first African American to benefit from the initiatives of Edith Halpert, a prominent *galleriste* and patron of both modern and folk art in Manhattan, and, like Lawrence, an émigrée from another land. Born into a Jewish family from Odessa, Russia, she had arrived in Harlem as a young child to begin a new life. By 1926 she had opened an art gallery, motivated by a desire to democratize American art by promoting its affordability, and by drawing attention to the exclusion of black artists by white dealers and galleries. Exhibited at her Downtown Gallery in 1941, the series drew the support of Alfred Barr, director of the Museum of Modern Art, and Duncan Phillips, founder of the Phillips Collection of modern American and European art in Washington, D.C. Each man purchased half the series, or thirty canvases each.

Lawrence's narrative was grounded in his historical research at the Schomburg Library in Harlem as well as his family's own experience migrating from the South to the North. The theme of cultural migration between worlds had been taken up by the poet Langston Hughes, the musicians Duke Ellington and Muddy Waters, and the novelists Richard Wright and Ralph Ellison. To his rich mix of influences, Lawrence's 1930s schooling in the American left added an understanding of the role played by an oppressed racial group in the larger national story, through its labor, its quest for full humanity, and its investment in the American dream of self betterment.

Lawrence's emphasis on black identity as a product of culture and history was part of a broader reaction against the idea of race as a biological given, and a new emphasis on environment in shaping human experience and identity. The new field of cultural anthropology played an important role in bringing about a revaluation of non-European cultures, especially African and Native American. Critical in this rethinking was the work of the Columbia University anthropologist Franz Boas, who helped pioneer the field of cultural anthropology. Boas pointed the way for a cultural relativism that by the 1930s was widely accepted by progressive thinkers in the United States and that worked against forms of racial essentialism, the belief that identity is fixed at birth. The study of cultural anthropology helped undermine the cultural hierarchies that had long consigned non-white societies to inferiority as measured against a standard derived from the European mainstream.

**AARON DOUGLAS.** The will to transform a history of oppression into a new collective identity guided a second important painting cycle between the wars: Aaron Douglas's (1899–1979) four-part *Aspects of Negro Life* (1934), painted for Countee Cullen Branch of the New York Public Library, in Harlem, under the patronage of the PWAP (Public Works of Art Project), a predecessor of the WPA. In *Song of the Towers* (**fig. 16.10**), a musician, standing on a giant cogwheel symbolizing industry, suggests the fate of the southern migrant—from slavery to industrial enslavement in the crushing discipline of the factory. Douglas's saxophonist stands triumphant above the grasping hands that draw others down into a feudal past, but his liberation is temporary, for the cog will carry him back down into the bowels of the city. Located at the center of the composition, his raised right arm beckons the distant figure of the Statue of Liberty, a mirage of unrealized freedom that floats

16.10 AARON DOUGLAS, *Aspects of Negro Life: Song of the Towers*, 1934. Oil on canvas, 9 ft × 9 ft (2.74 × 2.74 m). Schomburg Center for Research in Black Culture, New York Public Library. Astor, Lenox, and Tilden Foundations.

between the faceted skyscrapers looming over the foreground. *Aspects of Negro Life* unfolds the voyage of African Americans from Africa, shown in the opening canvas of silhouetted dancers who embody a primitivist fantasy of tribal rhythm, to plantation life under slavery, to the Civil War, Emancipation, and Jim Crow, concluding the journey with apparent pessimism in the modern city.

Douglas, like other artists in these years, was a member of the Communist Party USA, an organization that supported African Americans' struggle for racial equality and economic justice. In *Song of the Towers*, musical expression becomes a cry for freedom. Douglas's saxophonist remains precariously balanced atop the great cogwheel, recalling the enormous industrial gears that draw in the Tramp in Chaplin's *Modern Times* (see box, page 519). But the black musician also draws upon his prophetic powers to "wake the living nations," in the words of the black poet James Weldon Johnson (*God's Trombones*), who used religious oratory, ragtime, and spirituals to lay claim to the great forms of Western culture and epic poetry. Douglas translated jazz rhythm and improvisation into visual terms: concentric circles suggest sound emanating from raised instruments, syncopated by the intercepting silhouetted figures. In his speech at the First American Artists' Congress in 1936, Douglas made his case for why black artists should look to vernacular traditions such as jazz and dance rather than to visual traditions rooted in Europe. The task of the black artist was to give "creative expression to a traditionless people … [he] is essentially a product of the masses and can never take a position above or beyond their level." Jazz was a New World art form, its potential to liberate expressed in the face of an oppressive history.[8]

**DIS-ARTICULATING IDENTITY: ISAMU NOGUCHI.**
Conservative forms of nationalism in the decades between the wars grounded identity in place and in an exclusionary racial inheritance. In these same years, artists such as Lawrence, Douglas, and, slightly later, Isamu Noguchi (1904–88), were exploring identity through experiences of mobility, dislocation, and hybridity. Noguchi was an American sculptor of mixed parentage (Japanese, Scottish, and Native American). Criticized in the 1930s for his graphic portrayal of a lynching victim, Noguchi turned to abstraction in the war years. The scholar Amy Lyford has argued

16.11 ISAMU NOGUCHI, *Kouros*, 1945. Metropolitan Museum of Art, New York.

that Noguchi's work in these years carries the traces of his own struggle against racial typing.[9] In 1945, the final year of World War II, Noguchi took on a theme with roots in Western culture, that of the *kouros*, the standing young man of ancient Greece, the archaic expression of male wholeness and strength. Noguchi's *Kouros* (**fig. 16.11**) consists of thin polished marble forms slotted and notched together in a tense balance. Readily disassembled and transported, *Kouros* challenges the Western tradition by reconstituting the figure as a precarious arrangement of solids and voids in place of the gravity and weight of the older tradition.

Noguchi had reasons to challenge these older traditions based in the stable human form. Though an American citizen, he was interned briefly during World War II with other Americans of Japanese descent who were relocated to concentration camps throughout the American West. In the fever of war, the loyalty of Japanese Americans was cast into doubt, along with their claims to citizenship, purely because of their ancestry. The race-based internment of U.S. citizens resembled policies in fascist Germany and Italy, where the classical tradition had been propagandistically associated with a particular racial type. Noguchi's deliberate dis-articulation of the body in *Kouros* symbolically associates identity with something that is literally constructed, and easily disassembled for portability. "To be hybrid," he wrote in 1942, "anticipates the future." Noguchi understood and affirmed the challenge mixed-race individuals posed to constructions of identity grounded in racial purity and "essence" and linked to an exclusionary definition of the nation.

## Anti-Fascism and the Democratic Front: Abstraction and Social Surrealism

Surrealism and abstraction, two art forms associated with modernism, also found a place within wider debates about the social and political relevance of artistic style and content.

For many artists in the 1930s, Social Realism was inadequate to express the irrationalities of mass hunger amidst wealth, or the grotesque spectacle of fascism abroad and political reaction at home. Stuart Davis (1894–1964) was unusual in giving his commitment to abstraction a more direct political rationale. In these years Davis decried what he termed "domestic naturalism" as an evasion of present realities. In his thinking, realism and naturalism, by presenting an illusion of the real, condoned the way things were, and gave legitimacy to the structures of power that needed to be exposed. For Davis, abstraction uncoupled the appearance of things from their underlying reality, and freed people to rethink the social order. Davis was one

16.12 STUART DAVIS, *Swing Landscape*, 1937–8. Oil on canvas, 22 × 28¾ in (55.8 × 73 cm). Indiana University Art Museum.

of twelve artists, including Willem de Kooning—most of whom painted abstractly—who were commissioned to paint murals for the newly completed Williamsburg Housing Project in Brooklyn in 1937. This public project of twenty four-story buildings was designed by a modernist architect; the murals within were unusual in choosing abstraction for a public commission. Up to that time, such commissions had favored figural and narrative art over abstract or "avant-garde" styles. Davis's *Study for Swing Landscape* (**fig. 16.12**) weaves together motifs from the waterfront / wharf area—buoys, ladders, rope and rigging, and lobster traps—in an eye-dazzling array of saturated colors intended both to stimulate and to relax his working-class audience. Committed to abstraction as a progressive new democratic art accessible to ordinary Americans, Davis referred to his work as a new form of realism—anti-naturalistic, yet tied to the realities of an interracial society, and embodying the spatial and temporal disjunctions of modernity. The title refers to jazz, a musical language that crossed color lines and represented for Davis something both modern and American. *Swing Landscape* synaesthetically recreates the syncopated rhythms and instrumental colorism of the swing bands of the late 1930s.

Davis's mural was not in the end installed at Williamsburg, though it is today among his best-known works. Although an abstraction, *Swing Landscape* went out of its way to engage its intended audience. Through its

scale, bright colors, and references to everyday objects and to swing music, it was intended to appeal across a wide social spectrum from black to Jewish and white ethnic groups. *Swing Landscape* both expressed and helped to create a pluralistic, ethnically and socially inclusive "people's culture," using everyday subjects that communicated to the masses in familiar terms: jazz, sports, popular film, cartoons, radio, and theater. *Swing Landscape* embodied the cultural politics of the Popular Front, the American version of the international Communist Party's turn toward a more accessible language and movement beyond narrowly proletarian themes. The Democratic Front aspired to forms of artistic expression that grew out of, and in turn supported, the organizing efforts of American unions and other popular movements. Davis himself was active in radical politics; his own brand of modernism—recognizable objects montaged into dynamic compositions—integrated aesthetically radical form with a progressive social vision.

In 1937, the town of Guernica in Spain was bombed by German planes allied to the reactionary Loyalist forces of General Francisco Franco during the Spanish Civil War. The event provoked international outrage and inspired Picasso's *Guernica*, a mural-sized, monochrome painting that became a rallying point for artists on the left.

Like *Guernica*, Louis Guglielmi's *Mental Geography* (**fig. 16.13**) responded to the Spanish Civil War in an image intended to mobilize its audiences through symbols that pushed beyond immediate events. Years later Guglielmi wrote that he had pictured the imagined destruction of the Brooklyn Bridge "after an air raid: the towers bomb-pocked, the cables a mass of twisted debris. I meant to say that an era had ended and that the rivers of Spain flowed to the Atlantic and mixed with our waters as well."[10]

Guglielmi was one of a group of artists in the 1930s who found Social Realism inadequate to the political and social realities of the present. Called **Social Surrealists**, they used techniques associated with European Surrealism: condensing time and space, montaging elements together, juxtaposing objects in an apparently illogical manner, and creating scenes which, while improbable, conveyed a poetic or imaginative truth at a time when social values were often inverted in practice. Social Surrealists drew

on fantasy and subjective experience in order to expand the reach of Social Realism, but retained that movement's concern for an art that communicated broad social themes. Combining two languages not normally linked—the language of the unconscious and the language of social concern—they focused on themes of racial and social injustice, poverty in a land of plenty, and institutional abuses of power. They aimed, like European Surrealists, to reorder society through the unmasking power of imagination. However, Social Surrealists dispensed with the psychological landscapes that dominated Surrealism. They preferred instead to explore the injustices of the social order while sharing with other movements a desire to expand beyond the narrative limitations of older art forms.

In the 1930s, the mass dissemination of political ideologies through radio and film offered a troubling new form of mass "enlightenment," the machinery of propaganda through which Adolf Hitler, elected in Germany in 1933, established his sway. American filmmakers such as Orson Welles (1915–85; *Citizen Kane* in 1939) and Frank Capra (1897–1991; **fig. 16.14**) took on the power of mass media to shape public attitudes as well as its misuses by the forces of political reaction. In Capra's film a homeless man ("John Doe"), played by Gary Cooper, becomes an unwitting player in a well-intentioned newspaper ploy to increase circulation. The gambit, however, spins out of control; in the penultimate scene, which deliberately evokes Hitler's Nuremberg rallies, John Doe repudiates the role of charismatic leader of the people to which he has, against his will, been raised by the combined force of popular gullibility and media manipulation.

16.13 **LOUIS GUGLIELMI**, *Mental Geography*, 1938. Oil on masonite, 35¼ × 24 in (90.8 × 61 cm). Barney A. Ebsworth Collection.

16.14 **FRANK CAPRA**, *Meet John Doe*, 1941. Film still.

# Federal Patronage: Roosevelt's Works Progress Administration (WPA)

*"How can a finished citizen be made in an artless town?" Postmaster Basil V. Jones*[11]

The turn to a more public, democratic art was energized by the most massive public works initiative in American history. Franklin D. Roosevelt's New Deal (1934–41) was put into place at the height of the Depression, when one out of four working Americans was unemployed. The New Deal's Works Progress Administration was a cluster of federal agencies, each with its own acronym, administering a range of publicly funded programs intended to put Americans back to work. The New Deal was directed at not only economic but moral recovery—an effort to rally public support for the government by invoking familiar images and shared values. Much public art of the New Deal was directed at conserving a cultural heritage that was itself being defined throughout the 1930s. Its appeal was broadly populist. Artists male and female, black, white, and Native, were recruited to work on New Deal programs, not only in the visual arts but in theater and other programs as well. Far from undermining capitalism, as some of its opponents claimed, Roosevelt's New Deal reinforced its foundations by restoring economic health and cultural viability.

## Art Programs of the New Deal

The art programs of the New Deal consisted of the Public Works of Art Project (1933–4); the Treasury Section of Fine Arts (1934–43); the Treasury Relief Art Project (1935–8); and the Federal Art Project (1935–43). The Treasury Section awarded commissions competitively; 1116 murals were completed in 1083 cities throughout the country. The Federal Art Project, by contrast, was need-based, putting thousands of artists to work at the height of the Depression years. Its objective was to broaden the role of the arts in public life, bringing the artist "into closer touch with American life," and furnishing alternative support for artists who had become dependent on an elitist and narrow art market. The years between the wars saw a similar expansion in Germany, Russia, and Mexico of government involvement in the arts as vehicles of propaganda and public education. In the United States, controversy about government patronage arose from the tension between the democratic philosophy of public representation and the exercise of control over decisions by hand-picked professional boards. As the scholar Andrew Hemingway has pointed out, the public art of the WPA suffered from a fundamental conflict at the heart of its consensus model of U.S. culture: a model that assumed that everyone shared basic beliefs and agreed on the direction of American society. Yet the government's pursuit of such a consensus and its expression in unifying national myths was troubled by the gap between myth and the realities of ethnic, class, and gender inequality. New Deal public art represented both possibilities, underwriting a pluralistic vision of national inclusiveness, as well as engineering consensus in the face of a divisive and contentious history.[12]

**A FRESCO FOR A GARMENT WORKERS' COMMUNITY.** Ben Shahn's fresco for the Jersey (now Roosevelt) Homesteads in New Jersey (**fig. 16.15**) was done with the assistance of Shahn's partner, the artist Bernarda Bryson (1903–2004). The Jersey Homesteads, created under the New Deal's Resettlement Administration (1935–7), was a cooperative community for New York Jewish garment workers. Combining farming with factory work, the Homesteads gave workers a new start in life through land ownership and farming, while providing them with additional sources of income. They could, as one supporter put it, "sew and sow at the same time."[13] The mural begins on the upper left with the persecution of Jews in the pogroms of Eastern Europe, and then in Hitler's Germany, signaled by a Nazi soldier (unique in New Deal murals, according to the scholar Diana Linden). At the center left, a group of immigrants, including Shahn's friend the artist Raphael Soyer, Shahn's mother, and Albert Einstein, cross a bridge. Here, the Old Testament story of the Exodus across the Red Sea merges with New World myths of migration. To the lower left is Ellis Island, with its gridded spaces, American flag, and Statue of Liberty. The central sections of the mural show New York's low-wage garment factories; the background scene alludes to the devastating Triangle Shirt Waist Factory fire, which took the lives of 146 women in 1911. The union movement—so critical to securing the rights of immigrant workers—is represented in portraits of labor leaders including CIO (Congress of Industrial Organizations) founder John L. Lewis. Creating a continuous narrative linking Jewish and American history, Shahn's mural served the multiple identities of those living in the Homesteads, as exiles from the Old World and as pioneering Americans, struggling to rebuild.

Montaging scenes and locations, combining a horizontal narrative arrangement with spatial depth, Shahn's mural revealed its debt to Diego Rivera, whom Shahn had assisted at Rockefeller Center. Montage allowed Shahn to compress into one wall a series of places and events spanning two continents and decades of time. Such montaging leaves the

16.15 BEN SHAHN, *Jersey Homesteads Mural* (detail), 1937–8. Fresco. Stephen Lee Taller Ben Shahn Archive, Berkeley, California.

precise narrative construction up to the viewer. This unsettling of an established narrative sequence has the effect of activating public art as a space of historical memory tied to the present. In its cinematic sweep from past to present and future, its history of sacrifice and redemption, Shahn's mural also paid tribute to the idealism of the New Deal, integrated within a broader narrative of Jewish pilgrimage toward a better life.

**A NATIVE AMERICAN MURALIST AT THE DEPARTMENT OF THE INTERIOR.** Among the best-known New Deal art projects were the large-scale public murals painted in post offices and other public buildings across the country. Embodying the democratic ideals of the New Deal, the range of artists chosen to participate included Native and African Americans. Native artists such as the Kiowa painter Stephen Mopope (1898–1974) painted murals at the University of Oklahoma in Norman, and at the State Historical Society Building in Oklahoma City, in the 1930s. In 1939, he and five other Native artists from the Plains and Southwest were among those chosen to decorate the walls of the gigantic new Department of the Interior Building, which opened in Washington, D.C. in 1937. Secretary of the Interior Harold Ickes, long an advocate of Indian causes,

was adamant that the building would include work by Indian artists, overseeing the choice of artists himself.

While most workers in New Deal projects were paid a modest hourly or monthly wage (the Civilian Conservation Corps workers, for example, earned $30 per month), the professional artists who worked for the Section of Fine Arts were chosen by recommendation or competition, and their pay was based on the square footage allotted to them. The Department of the Interior muralists were paid the same amount regardless of race or gender (an unusual practice in the 1930s, when white workers routinely earned more than black or Native workers, and men were paid more than women).

Mopope's mural on the 50-foot-long arching lunette on the east wall of the basement cafeteria is a frieze of single processional life-sized figures (**fig. 16.16**). They rise from seated positions on either end to varied standing dance poses. They move in profile from each end toward the central seated figure, seen from the rear. In addition to being an accomplished painter in both large- and small-scale work, Mopope was himself a dancer in pow-wows and other competitions. The repeating silhouetted forms of his mural suggest the rhythms of the dance.

Like other artists of this era, the Indian painters who worked on these commissions remembered this work fondly in their later years. Despite the exacting specifications and bureaucratic nature of the commission and design

process, they were grateful for work in their chosen professions at a time when many Americans had no work. Though such murals present a romantic view of American Indians frozen in the traditional past, they were painted by cosmopolitan Native artists whose work by this time had been exhibited all over the United States and in Europe.

**A TYPICAL POST OFFICE MURAL.** A common theme of the Treasury Section's post office murals was the founding of communities. Allan Thomas's (1902–74) mural for Crystal Falls, Michigan (**fig. 16.17**) connects the local history of the town to frontier settlement: in stylized forms, an upright male farmer prepares to seed the soil, working alongside a woman whose horizontal bend associates her with the earth. The figures dominate the view, animating the landscape in a tableau that was echoed in the federal theater programs of the same years as well as in the earth-bound choreography of the dancer Martha Graham (1894–1991). Here the present is linked to a reassuringly familiar set of ostensibly shared communal myths relating to pioneer origins, a world of complementary and non-competing gender divisions, and traditional forms of agriculture. Seeking consensus in a mythologized past, much public art of the New Deal avoided provocative subjects engaging the problems of uneven power that motivated the social activism of the 1930s.

## A New Deal for Indians

Part of Roosevelt's New Deal was directed at the documentation and preservation of the nation's cultural heritage, including the arts of Native peoples—another example of the "Searching for Roots" examined in the previous chapter. The Indian Arts and Crafts Board, created in 1935, fostered economic development on reservations through the promotion and sale of Indian crafts. It developed standards of excellence for Indian silverwork and Navajo weaving, and sought to ensure that Natives themselves made the products sold at trading posts and in tourist shops. The Indian Arts and Crafts Board also played an important role in redirecting attention from ethnographic to aesthetic interest in ancient, historic, and contemporary Native arts, through exhibitions at the Museum of Modern Art in 1941 and elsewhere. In New Mexico, Bandelier National Monument (an ancient Pueblo archaeological site) was excavated and restored under the auspices of the Civilian Conservation Corps. Other CCC projects included the restoration of major totem poles in Alaska. Some poles were removed from isolated and abandoned sites and relocated in Native towns such as Sitka. Other poles, too decayed for restoration, were carved anew. In this project, Native carvers and elders were called upon for their expertise, and some young Native men, paid by the federal government, learned to carve in the old ways.

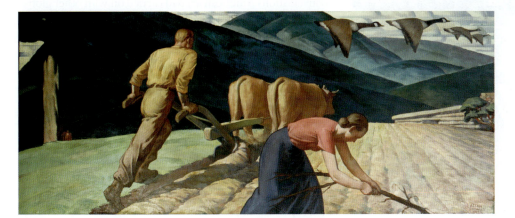

**THE RENOVATION OF CHIEF SHAKES' HOUSE.** One of the most notable projects of the CCC in Alaska was the renewal of Chief Shakes' Community House in Wrangell (**fig. 16.18**). As a model for the exterior painting on this house, the artists used a famous nineteenth-century Grizzly Bear screen (see fig. 7.28) for the bear emblem belonging exclusively to Chief Shakes. In Northwest Coast cultures, only the owner of a design has the right to display and use it. By the late nineteenth century, Chief Shakes' House was clapboarded and outfitted with glass windows and a door. The restored house, built by a CCC team that included local Tlingit men, was an idealized replica of a century-old house form. The crew painstakingly reproduced traditional **mortise and tenon** joinery characteristic of ancestral Tlingit architecture. Using commercial paints, they matched the old colors made with natural pigments. The dedication of the restored house in 1940 was the occasion for Charley Jones, who had worked on the crew, to assume his hereditary title as the seventh Chief Shakes.[14] Thus both Tlingit and federal aims were served in this project. Chief Shakes' House was meant both to serve as a magnet for tourists and to encourage Native pride. It continues to do both.

## Archaism in Public Sculpture

The term **"archaism"** denotes a return to the beginning (*arche* in Greek), signaled by the use of styles associated with ancient forms. Unlike modernist primitivism, which looked to tribal arts, archaism looked to the courtly sculptural traditions of both the East (taking in India, Assyria, and Egypt) and the West (Greece). It was a tendency well suited to the monumental forms preferred for public sculptural commissions.

16.18 CIVILIAN CONSERVATION CORPS, Restoration of Chief Shakes's House, Wrangell, Alaska, 1930s.

16.19 PAUL MANSHIP, *Centaur and Dryad*, 1912–13. Bronze, 29 in (73.6 cm) high. Metropolitan Museum of Art.

Paul Manship (1885–1966), perhaps the best-known American sculptor in the years between the wars, helped to popularize archaism in the United States. Like modernism, archaism renounced naturalism in favor of stylized form, drawing upon archaic Greek, Assyrian, and classical Indian sources, all of which shared an emphasis on silhouette. This stylization of form appealed to a "middlebrow" modernism that signaled sophistication without the challenges of "high" modernism. Archaism extended the cosmopolitan conversations American art had carried on with other global traditions since the later nineteenth century. Manship's *Centaur and Dryad* established the language of archaism by the early 1910s (**fig. 16.19**), revealing his taut design sense, his articulation of draperies through rhythmically incised lines, and his attention to the relationship of voids to solids. These qualities won him popularity with critics and public alike for their accessibility and their grounding in ancient myth.

By the 1930s, monumental public sculpture throughout Europe and the United States had adopted the conventions of archaism—stylization, incisive silhouette, planar forms, and solid compact shapes—that came to prevail in the state-sponsored and institutional sculpture not only of

Roosevelt's America, but of Nazi Germany and the Soviet Union under Stalin. With its stylized forms, archaism was well suited to placement within the classicizing architecture of power—both private and public—that left its mark on institutional and government centers between the wars. Archaism was also the style of choice for the sculptures of the Federal Triangle along the mall in Washington, D.C., and at state capitols and public monuments built during the 1930s throughout the nation. Located next to the Federal Trade Commission building, Michael Lantz's (1908–88) 1942 sculpture *Man Controlling Trade* (**fig. 16.20**) employed a familiar language of heroic masculinity that spoke to the national crisis of confidence. Drawing on an iconography going back to ancient Rome (the *Dioscuri*, or Horse Tamers), Lantz allegorized the market as an unruly animal requiring domestication. Reassuringly grounded in older forms and symbols, archaism proved an effective language for public sculpture. However, it was later condemned by modernist critics as "middlebrow" **kitsch** because of its emphasis on the decorative quality of line and its reluctance to challenge the public. Though it was banished from the Museum of Modern Art, it still sits comfortably in our public landscape, simultaneously part of a familiar national idiom and an international mainstream.

16.20 **MICHAEL LANTZ**, *Man Controlling Trade*, 1942. Limestone. Federal Triangle Commission Building.

# The Varieties of Photographic Documentary

The economic crisis of the 1930s brought a new national mood and set of social concerns into photography, as it did into other art forms. Many photographers turned away from the emphasis on formal values that had dominated the first generation of modernists around Stieglitz, embracing instead politically and socially engaged forms and subjects. Photographic form and meaning became as actively debated as other areas of visual practice in the politicized climate of the Depression era.

## The "File": The Farm Security Administration and "the Camera with a Purpose"

In the 1930s, the documentary mode extended from journalism to newsreels to mass circulation magazines, and from still photography to film, as well as spanning a wide range of photographers and practices. Part of the New Deal, the Farm Security Administration, or **FSA**, as it was known, sponsored much of the documentary work in these years. Known as the Resettlement Administration from 1935 to 1937, the FSA addressed the problems of drought, soil exhaustion, and flooding that had devastated the nation's farming communities. The photographic section of the FSA was part of its publicity department, and was dedicated to creating a visual archive (the "File") numbering some 77,000 prints (from a larger archive of 145,000 negatives) and documenting the nation in these years—its coal miners, small towns, cities, family farms, breadlines and destitution, popular culture, and everyday landscapes. Directed from Washington by Roy Stryker, the File employed a corps of sixteen photographers between its founding, in 1935, and 1943, when it was incorporated into the Office of War Information to serve pressing wartime needs.

One purpose of the File was to win public approval for federal intervention on behalf of the nation's farmers. With its images of lives ravaged by natural conditions produced by decades of human and social mismanagement, the FSA documentary work argued the need for public assistance to an audience raised to believe that responsibility rested with the individual. As head of the photographic project, Stryker gave his staff photographers "shooting scripts" that encouraged full coverage—work, home, and community—of their complex subjects. In the field, the FSA photographers employed a variety of techniques—composition, framing, lighting, camera angle, point of view—to shape the messages viewers took away from their images.

The "transparency" of photography, the appearance that it captures the world directly, without the intervention of subjective intentions, seems to suggest a distinctive "truth value" of the photograph as documentary. However, documentary is a genre with its own conventions of representation—a style mediated by certain visual cues or codes that paradoxically signify that the image is unmediated, a transcription of the real world. In truth, creative decisions, and the desire to convey specific content, begin the moment a photographer picks up a camera. Images from the File were available to the public, the press, and the publishing world, and still are today: for a nominal fee of $10.00 anyone can order a print from any negative in the File, which is now digitized and available through the Library of Congress, which houses it. When captioned, positioned within a larger sequence of images, or located within a broader narrative, the documentary image could be made to support widely varying points of view, thus belying its claims to objective "truth." Documentary was, in the words of one practitioner, "a camera with a purpose."

**DOROTHEA LANGE.** Lange's photograph *Migrant Mother* (**fig. 16.21**) drew on the fine arts and on a familiar language of motherhood to document the plight of migrant farmworkers in California's Central Valley. Lange took a series of shots of the thirty-two-year-old Florence Thompson and her children at a makeshift roadside camp, varying the distance between the camera and her subjects, and showing mother and children in a range of attitudes. Although this image was not the only shot of this series to be published, it has come to sum up how many Americans imagine the Depression. Lange herself (1895–1965) was initially unsure which exposure communicated most effectively. The title was also added later. In short, the cultural impact of this photograph developed over time, and was realized only in competition with the other exposures. Why did this one win out over the others, in public memory?

Drawing upon a long tradition of Christian Madonnas and nurturing women who bear the woes of humanity, *Migrant Mother* frames the realities of the farm Depression selectively. The shot eliminates the surroundings in a tightly framed close-up, removing any specific context in favor of a generalized image of stoic endurance. The children are obscured as they bend into their mother's sheltering body. Her lined and weathered face suggests the condition of the land itself, eroded by wind and drought. Her worried gaze solicits our sympathies without addressing us personally. The absence of a male figure increases the sense of women and children bereft and vulnerable, without a breadwinner. The universal appeal of *Migrant Mother* is thus a product

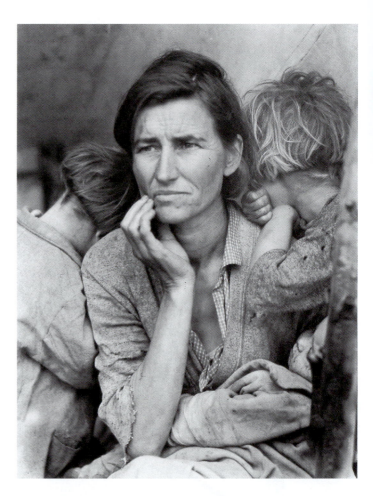

16.21 DOROTHEA LANGE, *Migrant Mother*, 1936. Photograph. Library of Congress, Washington, D.C.

of the selective framing of the circumstances in which it was made.

Ironically, later generations have brought other meanings to light. Florence Thompson, we now know, was of Cherokee Indian ancestry, a fact that transforms the image in ways unintended by Lange herself. A century earlier the Cherokees migrated west on the "Trail of Tears," the forced exodus of Native farmers out of Georgia to the unoccupied lands of Oklahoma. In the Depression, "Okies"—some of them, like Thompson, descendants of the Cherokee—migrated to California. In Lange's iconic image, this historical sediment remains buried, only recently brought to light by researchers interested in the woman behind the myth.

## Margaret Bourke-White and Walker Evans: Documentary Extremes

A significant subgenre of documentary was the photo book, a series of photographs captioned and accompanied by a text. Pairing photographers with writers or sociologists,

these books directed the meaning of the image through words and through narrative sequencing. The photo book raised issues about documentary truth and objectivity more pointedly than the individual image: intended to "demonstrate a thesis," the book form provoked concerns that the photographer's subjects could be manipulated, and the image itself selected and framed, to prove a point. The photo essay became a staple of the postwar photographic journalism of *Life* magazine, though it was maligned by some as a form of mass persuasion that played on popular emotions. The two early examples here exemplify the spectrum of approaches inherent in the genre.

**YOU HAVE SEEN THEIR FACES.** Among the more controversial photo books was Margaret Bourke-White and Erskine Caldwell's 1937 *You Have Seen Their Faces* (**fig. 16.22**), a relentless vision of rural poverty that presented its southern sharecroppers as the wretched victims of a corrupt

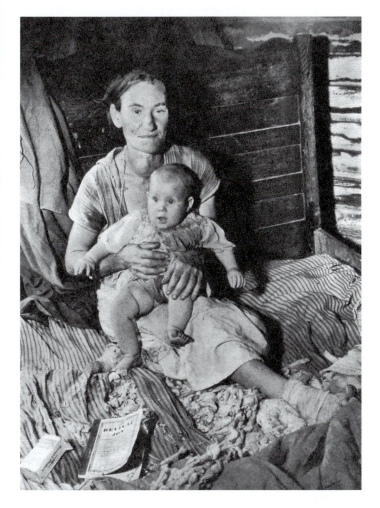

16.22 MARGARET BOURKE-WHITE & ERSKINE CALDWELL, *Happy Hollow, Georgia*, plate from *You Have Seen Their Faces*, 1937. Photograph.

southern society, deprived of dignity and incapable of managing their lives. White and Caldwell saw themselves as social activists exposing particular truths in order to promote programs that would improve the lives of those they depicted. To do so they resorted to putting words into the mouths of their subjects and selecting the most extreme examples of hopelessness. The images used dramatic angles and lighting to provoke a particular response. Their approach to documentary disturbed others who recognized the unequal nature of the encounter between documentary photographer (educated, urban, and often backed by government authority) and his or her subjects, whose lives were frequently made to illustrate particular lessons. Bourke-White (1906–71) and Caldwell (1903–87) were not alone in facing charges of staged or manipulated subject matter in order to promote certain "truth effects." In one notorious episode, an FSA photographer, Arthur Rothstein, was exposed for using a cow skull as a movable prop in various photographs—a convenient symbol for capturing the desolation of the water-starved region he was sent to photograph. Today, in the wake of Photoshop and other programs that digitally manipulate the photographic image, such minor alterations of the documentary subject might seem innocent enough. But they violated public trust in the unaltered truth of the photograph.

***LET US NOW PRAISE FAMOUS MEN.*** Walker Evans's collaboration with the writer James Agee (1909–55) in *Let Us Now Praise Famous Men* (**fig. 16.23**) took a very different approach to 1930s documentary. Evans's (1903–75) photographs of three southern sharecropper families offered a less manipulative kind of documentary: a respectful and sustained visual record of the lives, homes, and personal possessions of the poor. Endowing them with specific identities and painstakingly engaging the intimate realities of their lives, Evans's photographs and Agee's text insisted on the everyday dignity of those whose identities had been erased by the generalities of social science and federal programs intended to address the problems of rural poverty. Floyd Burroughs and his daughter Lucille meet our gaze, sitting on their immaculate but worn front porch. This is their space, into which Evans was invited as a guest. The frontality of Evans's photographs refuses to impose a point of view beyond the realities of the moment. Occasionally however, Evans did move furnishings around in order to impart a sense of order in the most humble interiors.

Evans departed from much 1930s documentary practice by refusing to use captions in his work, which was often presented in book form, as in his *American Photographs*. He resisted any form of scripting, insisting instead on the mute

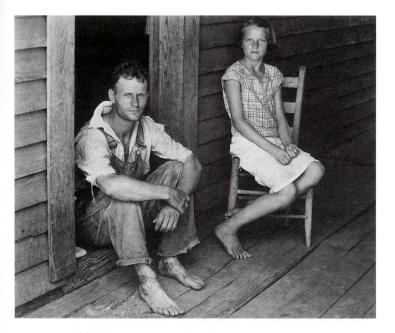

16.23 WALKER EVANS, *Floyd and Lucille Burroughs*, from James Agee and Walker Evans *Let Us Now Praise Famous Men*, 1936. Gelatin silver print, 6½ × 9⅛ in (16.5 × 23.1 cm). Library of Congress, Washington, D.C.

witness of the visual record itself. Yet Evans had an understated irony, conveyed through sequencing of images in the book or juxtaposition of details within the frame.

Despite his success, Evans remained a controversial figure throughout the 1930s; he worked briefly for the FSA, resisting the ways in which photographs were often made to serve a preordained set of meanings. Ansel Adams, a member of f.64, found Evans's frequently barren, marginal, or dejected subjects sordid and insulting to an American sense of pride; others were offended by his preference for the homely, the marginal, and the cast-off, reading his images as critical of national culture. *Houses and Billboards in Atlanta* (**fig. 16.24**) documented the strange meeting of dingy house façades with images of a glamorous mass-produced urban culture. The gulf separating Hollywood from real lives was a recurrent theme of both painting and photography in these years.

Evans expanded documentary means, bringing the formalist approach of modernist photographers to an engagement with the ways in which places and things reveal history and culture. By emphasizing the act of "seeing," Evans and those he influenced reconciled a commitment to straight photography with efforts to broaden photography as an expressive medium. As another documentary photographer from the 1930s, Berenice Abbott (1898–1991), put it succinctly, "Photography . . . teaches you to see."[15]

# Design and Architecture in the 1930s: Corporate Patronage and Individual Genius

"Style is a manifestation of an attitude toward life. It serves to chronicle a period as effectively as written history."[16]

As with other subjects examined in this chapter, American design in the interwar years reached out to a mass public. Along with the Democratic Front and other populist movements, the design industry rendered modernism into accessible form. But unlike the politicized public art of the 1930s, design was firmly entrenched within a consumer market that addressed well-being from an entirely different direction. Design shared with Social Realism and documentary the arts of persuasion, but it did so through everyday objects that appealed to consumer fantasies and anxieties.

Design involves a self-conscious approach to the creation of objects that form the environments in which we live: furniture, appliances, lighting fixtures, rugs, and textiles, as well as a range of new consumer and industrial products, such as cars and trains. In expanding to reach a mass public, design developed from the realm of customized luxury items—labor-intensive and made from costly materials—into broadly marketed, affordable consumer goods. Sharing in the democratizing impulse of other forms of cultural

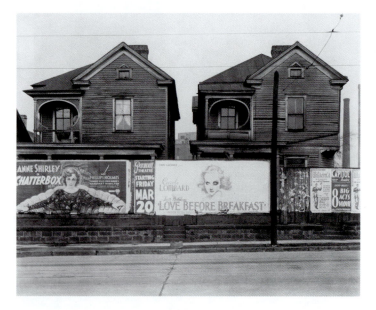

16.24 WALKER EVANS, *Houses and Billboards in Atlanta*, from *American Photographs*, 1931. Gelatin silver print, 6½ × 9⅛ in (16.5 × 23.1 cm). Library of Congress, Washington, D.C.

expression, design history nonetheless offers a different perspective on the years of crisis. Designers responded to the public's desires for psychological and historical reassurance. However, rather than looking to the past—to narratives that located the present within a perspective of history—designers pursued several strategies to promote consumer confidence about the future: by appealing to a reassuring professional expertise, by streamlining forms to create comforting environments, and by making an engineered future appear exciting, desirable, and inevitable.

Design was distinct from manufacturing, and engaged an unprecedented range of social institutions, from corporate business and industry to museums, retailers, advertisers, and consumers. All of these played their part in the look, promotion, and circulation of designed objects which reshaped the everyday world of millions of Americans.

## Mass-Marketing the Modern: Industrial Design

By the early 1930s, American designers were actively pursuing new models of how to marry mass production and industrial materials to good design. "The machine is a communist!" proclaimed the cultural critic Lewis Mumford (1895–1990) in 1930, recognizing its potential to level class and social distinctions by making good industrial design available to all. In pursuit of better models, design between the wars drew lessons from a variety of European modernist sources, from the German **Bauhaus** (established in Weimar Germany in 1919 with precisely those aims) to Scandinavian modern. Supported by an odd alliance of artists, manufacturers, museums, and department stores—Lord and Taylor, Macy's, and Saks among them—the "design in industry" movement promoted affordable domestic consumer goods. Many of the main contributors to American design in the years between the wars were emigrés: Paul Frankl (1886–1958) and Joseph Urban (1872–1933) from Vienna; Kem Weber (1889–1963) from Germany; Eliel Saarinen (1873–1950) from Finland, along with his son Eero (1910–61), who would go on to become a leading postwar designer and architect; Raymond Loewy (1893–1987) from France, and many others. These men were eventually joined by a number of talented Americans, many of whom studied or traveled in Europe during these seminal years. Exploiting new materials such as plastics, Bakelite, Formica, aluminum, stainless steel, and chrome, these designers combined the lessons of purity, simplicity, and elimination of ornament learned from European modernism, with manufacturers' and marketers' concepts of practicality and desirability.

Industrial design, along with advertising, commercial photography, and graphics, took modernism and domesticated and popularized it. Modernist concerns with pure form were now routinely applied, not only to the fine arts, but to everything from refrigerators to bridges. Designers such as Norman Bel Geddes (1893–1958) won celebrity status, while artists such as Charles Sheeler, Charles Burchfield (1893–1967), and John Storrs (1885–1956) designed textiles, rugs, and wallpaper. The painter and printmaker Louis Lozowick (1892–1973)—who did much to promote Russian Constructivism in the United States—and the sculptor Alexander Archipenko (1887–1964) (see fig. 13.26) both designed store window displays, linking avant-garde styles to high fashion.

**THE STREAMLINED STYLE.** The "design in industry" movement had its origins in the late nineteenth century, taking root in England, and thereafter in Germany. Brought over to the United States by émigré designers between the wars, it encountered a receptive environment. American businesses, advertisers, and retailers seized on modern styling as a highly effective marketing tool. Responding to the consumer's desire to be "up-to-date," designers and their corporate sponsors devised a style in the 1930s known as "Streamlined" that would supplant Art Deco. The crisis of the Depression brought a longing for psychological reassurance and a reaction against the edgy, nervous dynamism of Art Deco. Art Deco corresponded to what Richard Wilson has termed the "machine-as-parts" aesthetic in which individual design elements are incorporated in a composition featuring abrupt transitions and sudden changes of scale. In Streamlined design, visual continuity replaces fractured planes, and sleek smooth contours replace jagged silhouettes. Horizontal extension, suggesting continuity across space and time, replaces vertical aspiration as the new axis of the modern. The **Streamlined style** extended its reach from teapots, lamps, automobiles, and trains to sculpture and buildings in an integrated interior design.

First articulated as a design principle by the European modernist Le Corbusier, the Streamlined style came to be widely applied by American industry. Streamlining began through the principles of aerodynamic flight (the elimination of "drag"). Speed had become the primary metaphor driving the search for a modern form. Ultimately it drove the redesign of everyday life, consistent with the modern ideals of efficiency, hygiene, rationality, and the elimination of waste. In practice, streamlining had rather little to do with functional efficiency, but it had a great deal to do with cushioning the consumer's encounter with technology.

Perhaps the most intimate of these encounters occurred in the home, where objects, mass-produced and standardized, brought a tactile and sensory immediacy to the vague promises of a better life. In the home, objects generally stayed in place rather than flying through the air, so the principle of minimizing aerodynamic drag made no sense. Yet industrial designers such as Raymond Loewy routinely encased stationary objects like pencil sharpeners (**fig. 16.25**) and meat slicers in sleek streamlined forms. Any claims to functional necessity dissolve before the sheer absurdity of a streamlined tricycle. The "function" of streamlining, in short, was emotional reassurance; the complicated, unwieldy interiors of gadgets and appliances were shrouded in smooth surfaces that insulated the user from the shock and rough edges of modern technology. From science fiction to urban visionary planning, a "brave new world" promised to free audiences from the discomforts of the past. Streamlining symbolized a speedy, smooth voyage into the future. As Lewis Mumford aptly put it in 1934, "simplification of the externals of the mechanical world is almost a prerequisite for dealing with its internal complications."[17]

The genius behind this new modern vernacular was the industrial designer, who made his first appearance in the 1930s (**fig. 16.26**). Like the technological wizards of science (the man behind the curtain, in *The Wizard of Oz*) and the dream factories of the Hollywood studio system, product

16.26 **RAYMOND LOEWY & LEE SIMONSON,** Industrial designer's office from *Contemporary American Industrial Art* exhibition, Metropolitan Museum of Art, New York, 1934. Installation photograph. Metropolitan Museum of Art, New York.

designers disguised their methods, appealing to the psychological needs of consumers. Streamlining was applied not only to cars, trains, and appliances, but to bodies and labor processes as well (see Box, p. 519). Yet ironically, the corporate obsession with efficiency created tremendous waste: garbage dumps of fully functional appliances, rendered stylistically obsolete; thousands of deaths each year on streamlined highways and parkways. The cult of efficiency, applied to urban spaces, produced a network of superhighways that sliced through neighborhoods, dislocating urban populations, leaving inner cities isolated from residential areas, and creating an environmentally devastating dependence on the automobile.

## The Machine Art Show at the Modern

The Museum of Modern Art in New York City took a different approach in defining an industrial aesthetic. In 1934, the Modern, since its establishment in 1929 the leading

16.25 **RAYMOND LOEWY,** *Pencil Sharpener,* 1933. Metal and wood, 4¼ × 5½ × 2¼ in (12 × 13.9 × 5.7 cm). Private Collection.

institution promoting modernism in the arts, sponsored an exhibition of machine parts—including a variety of industrially produced springs, coils, boat and airplane propellers, and ball bearings—followed by household appliances, hospital supplies, and scientific instruments (**fig. 16.27**). These springs, coils, and propellers were not found objects in the sense of Duchamp's porcelain urinal, with its frontal assault on the notion of art as a privileged realm. The intention of Alfred Barr, director of the Modern, was not, as with Duchamp, to challenge the aesthetic gaze but to widen it to include machines, machine parts, and machine-made products. For Barr, these represented the purity of platonic forms, of "straight lines and circles," machines created by machines in an unintended play on the self-generating power of technology that was the subject of New York dada's "machine born without a mother." But unlike dada, the exhibition at the Modern was full of high-minded devotion to the formal properties of machines. Audiences were asked to see these industrial objects as art.[18]

Barr and his curator, the young architect Philip Johnson, repudiated the historicism of "revival" styles, along with the contemporary Art Deco and the Streamlined style

16.27 Installation view of *Machine Art* exhibition, Museum of Modern Art, New York, 1934. Courtesy Wurtz Brothers.

which the Museum of Modern Art felt appealed to irrational desires and lacked the rigor of **"machine art."** But in the trough of the Depression, the machine aesthetic was contested by industrial workers who wished to assert their role in the process of production. Machines were not born of other machines but of the men who made them; this was the insistent message of Lewis Hine's *Men at Work* and *Empire State* series, a rebuke directed at the aestheticized machine.

**LEWIS HINE'S *MEN AT WORK*.** "Cities do not build themselves, machines cannot make machines, unless [at the] back of them all are the brains and toil of men. We call this the Machine Age. But the more machines we use the more do we need real men to make and direct them." So said Lewis Hine (1874–1940).[19] Throughout much of American history, "manliness" and "independence" were closely related terms. The godlike power of the muscular male body was a crucial element of Depression-era iconography, from poster art to public murals. Such images reinstated faith in human agency at a time when technology offered an uncertain promise of economic and social recovery. Lewis Hine's photographs of men at work, done toward the end of a long career that began in the early 1900s, leave no doubt about who is in command. The body of the

worker in his later photography comes to symbolize the integrity of the republic itself. Hine's men at work, making the machines, building the skyscrapers, balancing gracefully if precariously at the edge of the horizon, represented productive labor at a time of massive unemployment. *Icarus Atop Empire State Building* (**fig. 16.28**) was part of a series Hine did on the construction of what was then the tallest building in the world. This collective portrait of the men behind the building required the aging photographer to be hoisted to the top of the construction site, a hundred floors above the city, where his own work replicated the heroism of his subjects. *Icarus*—referring to the Greek myth of the heedless youth who flies too close to the sun—suggests both the aspiration and the risk associated with the ambition of the modern skyscraper city. In Hine's photographs, these are expressed by the reckless grace of the worker. No longer identifying himself as a documentary photographer, Hine described his work as "interpretive."[20] Drawing upon traditional American values, he projected

a heroic image of labor—a utopian vision of the body opposed to the disembodied aesthetics of the Machine Art show.

## Corporate Utopias: The World's Fairs of the 1930s

Utopian projections of a streamlined future were accompanied by vivid anxieties about machines. Mechanization furnished the key to the future, but it also fueled fears of a soulless world of robotic men driven by motorized impulses. In the 1930s such contradictory attitudes reached new levels, as Americans invested in a corporate-sponsored vision of the future, while simultaneously seeking refuge in nostalgic visions of an older agrarian republic.

The world's fairs of 1933 (Chicago) and 1939 (New York) were awesome, Oz-like spectacles—glistening stage sets, complete with colored floodlights that furnished magical night-time illumination, and elaborate displays of consumer goods and services promising a new version of "the American way of life" grounded in mass production. Visitors could temporarily ignore the threat of fascism abroad and the painful and halting recovery from the Depression at home. Yet the corporate sponsors of 1939 grounded their spectacle of the future in the reassuring imagery of the past. Presiding over the fair was a monumental statue of George Washington, the nation's father figure, reminding visitors of their history in the midst of accelerating change. Fairgoers were urged to embrace innovation in the context of tradition. The glittering new appliances featured in corporate pavilions allowed Americans to cash in on the benefits of science allied to industry. Such modernistic appliances could be found in Colonial Revival homes like that of George F. Babbitt, the frumpy leading man of *Babbitt*, Sinclair Lewis's novel of 1922. Lewis put his finger on the split personality of middle-class Americans, their days regulated by sleek gadgets like Babbitt's alarm clock, "the best of nationally advertised and quantitatively produced ... with all modern attachments," their nights haunted by dreams of escape.

Consistent with its largely corporate sponsorship, the 1939 World's Fair sported a logo that was used on everything from sheet music to advertisements: the Trylon and Perisphere at the heart of the fair (**fig. 16.29**). Resembling forms celebrated at the Machine Age exhibition, they modified the revolutionary aesthetics of Russian Constructivism, which had migrated to the United States from Europe in the 1920s, into an American vernacular. The Trylon suggested rocket-like energies that could carry the nation from the depths of the Depression to a soaring

16.28 LEWIS HINE, *Icarus Atop Empire State Building*, New York, 1931. Gelatin Silver Print.

16.29 *Trylon and Perisphere, New York World's Fair, 1939.* Courtesy A. F. Sozio.

new space age. The Perisphere enclosed them in a womb-like space where they experienced a miniaturized and controlled encounter with the future. In "Democracity" superhighways directed frictionless flow through space, and high-rise buildings preserved the countryside by eliminating sprawl. Dynamic and protective, the complementary forms of Trylon and Perisphere reproduced the cultural spheres of male and female, public and private. They implied an ideal world where the energies of thrust and progress were balanced by stasis and containment.

## Frank Lloyd Wright in the 1930s

Product design was closely adjusted to the demands of consumption. Minor stylistic changes—or redesign—signaled that a product differed from last year's model, and was therefore more "up-to-date." **Stylistic obsolescence**, first identified as a marketing strategy in the 1930s, assured that no form was permanent or absolute, but was destined to change according to the imperatives of consumer "taste."

This fluctuating realm of taste—an unstable amalgam of advertising, consumer insecurity, and consumer desire—was antithetical to the ambitions of modernist architects such as Frank Lloyd Wright (1867–1959), whose quest for elemental form went hand-in-hand with an uncompromising personal vision. Wright's career bridged progressive forces in American architecture and organicist, nature-based design philosophies deeply tied to the previous century. His buildings balanced structural innovation with powerfully expressive forms in a manner that spoke to his clients' desire for a modernity with roots.

Over his later career, Wright designed for virtually every building type, including skyscrapers and government centers. He devised inventive new solutions for each client and commission, working through a set of principles to which he was firmly committed until his death in 1959, grounded in an endlessly varied geometry of forms which carried specific symbolic meanings: circles (infinity), triangles (stability), squares (integrity), spirals (organic process).[21] His preference for elemental forms guided his encounter with a number of new architectural influences in the years between the wars. It also shaped a practice distinct from the main idioms of the time: Bauhaus-inspired functionalism, Art Deco and Streamlined, and historicist. Each of these styles spoke to specific audiences; Wright, by contrast, aspired to a "democratic" architecture freed from earlier models, and universal in its appeal. His version of democracy, however, turned from shared collective symbols toward the leadership of visionary individuals, whose power to point the way toward the future would be taken on faith by those wise enough to listen.

What Anthony Alofsin has termed the "primitivist" phase of Wright's career led him to a range of non-Western influences. Wright's philosophy of design drew on ancient forms found in what were then considered "primitive" or folk cultures—a return to first principles that motivated other phases of modernism between the wars. This contact with non-Western societies had contributed to the renewal of nineteenth-century architecture. Wright's assimilation of global traditions reinforced a belief that to be an American was to have the resources of the world's cultures at one's disposal. Like his mentor Louis Sullivan, Wright assumed the position of a prophet whose role would be to educate his people in the virtues of a living architecture. Toward this end, he carried on far-ranging dialogues with a variety of building traditions from around the world, expressing admiration for Maya and African, as well as Chinese and Japanese building traditions. These fueled his endlessly fertile imagination.

Already by the late 1910s, Wright was exploring the heavy massing, inward-turning quality, and **battered** walls of Central American and Southwest adobe architecture. In his design for an heiress and arts patron, Aline Barnsdall, in Los Angeles (1916–21), known as the "Hollyhock House" (**fig. 16.30**), he drew upon Maya architectural forms for the terraced walkways that circulate on the roofs of the house itself. The interior courtyards of European villas and Southwest haciendas were another inspiration. The house took its name from the mold-cast ornamentation of stylized flowers that forms a unifying motif throughout. Suggesting monumental permanence in a city known for its mobility, the Hollyhock House is constructed of **stucco-on-lathe**, though resembling the concrete that Wright would use in other Los Angeles houses designed in the 1920s. As William Curtis has pointed out,[22] the theatrical siting, massive forms, and decorative wall textures were well suited for a house originally conceived as the center of an extended arts complex, echoing as well the extravagant stage sets of Hollywood in the 1920s.

16.30 FRANK LLOYD WRIGHT, *Hollyhock House* for Aline Barnsdall, Hollywood, California, c. 1916–21.

Despite his claims to being unique and American, Wright was fully international, a fact evident in the people who worked for him. His office included apprentice architects from Japan, Puerto Rico, Czechoslovakia, Austria, and Switzerland; he pursued important exchanges and friendships with German architects including Erich Mendelsohn (1887–1953), a modernist architect and writer who promoted Wright's reputation in that country, as well as with Dutch and English practitioners. Wright's home and office, Taliesin, in Spring Green, Wisconsin, became a site of pilgrimage for many young European architects. Wright more than gave back what he learned from other traditions: his buildings and proselytizing writings would help architects from Japan, Mexico, and elsewhere rediscover their own architectural heritage.

Natural architecture was among the ideas Wright most tirelessly advocated. By "natural architecture," however, he did not mean that his buildings should blend into nature. The concept of an organic architecture meant, above all, a form of design responsive to the specific needs of the client and the conditions of the site itself. His Imperial Hotel in Tokyo, for instance, was set on floating foundations placed on movable concrete sections that would not break up

16.31 FRANK LLOYD WRIGHT, *Fallingwater*, 1934–8.

under severe stress. As a result, the Imperial was one of the few buildings to withstand a devastating earthquake shortly after its completion in 1922. Yet his notion of organic architecture could also be at variance with natural facts such as gravity and rainfall; his beloved **cantilevers** sag; his long low roofs leak.

**FALLINGWATER.** Along with Monticello and Mount Vernon, Fallingwater (1934–7: Bear Run, Pennsylvania) is one of the most famous houses in America, and it catapulted Wright, by this time almost seventy years old, back into the limelight after a long period of public indifference toward his work. The most widely circulated view of the house is from below, looking up at a powerful composition of intersecting planes, formed by the cantilevers for which the house is famous (**fig. 16.31**). Vertical and horizontal planes are further distinguished by differences in material, from the smooth warm colored concrete with its softened edges, to the stratified limestone chimney and central core, which anchor the dynamic reach of the cantilevers. At the heart of this complex interplay is a rectangular living/dining room around which the various subsidiary spaces are arranged. This central space (**fig. 16.32**) is low-ceilinged,

directing one's sight outward through the strip of windows toward the woods beyond. Unlike the inward-turning Prairie homes of Wright's early career, with their suburban locations, Fallingwater lets light and nature in. The cantilevers, projecting unsupported into space, create a series of outdoor extensions of the living room and the master bedroom on the second floor. The four elements of nature enliven the living room: fire (in the central hearth), water (in the perpetual sound of the stream and falls over which the house is built), air (in the play of light), and earth (in the great boulder that rises up from the sublevels of the house to break through the surface of the floor). Nature is not merely seen, but heard and touched, evoked and experienced.

According to later accounts, Fallingwater was conceived in one day. Commissioned as a weekend retreat by Edgar Kaufmann Sr., the owner of a successful department store business in nearby Pittsburgh, Fallingwater married technology to nature in a classic solution both brilliantly inventive and grounded in the familiar. With its assertive

geometries and modern materials and construction methods, Fallingwater shared in the machine-age aesthetics of the decades between the wars. Anchored to the bedrock, its cantilevers project over Bear Creek to a waterfall directly beneath the house. Engineered controversially at the time, these cantilevers would eventually require complete restructuring and restabilization. Throughout his career, Wright had embraced methods and materials still new to architecture, sometimes pushing them past their performance limits.

Wright's particular concerns as an architect working within an American tradition become clearer in relation to the work of his famous contemporary, the Swiss architect Le Corbusier, whose Villa Savoye of 1928–30 (**fig. 16.33**) parallels Fallingwater as a landmark of modernist domestic design. In these years between the two world wars, both Le Corbusier and Wright were preoccupied with "type-forms," the purified expression of basic forms found in nature. Both architects drew on deep study of the past.

Le Corbusier's conception of the past was framed by the classical tradition, while Wright drew upon older American ideals concerning the role of nature in shaping culture and generating the abstract principles of design. Edgar Kaufmann Jr., who lived in the house for many years, observed that Wright proceeded "from principle, not from precedent."[23] If mobility, circulation, and flow are central features of Villa Savoye, Fallingwater offers instead a primordial quality of shelter, permanence, and stability.

Wright framed his organic architecture in opposition to the European "International Style," as embodied in the Villa Savoye. He denounced its boxlike forms and flat cut-out quality, in favor of designs that were "elemental … complementary to [their] natural environment."[24] Wright insisted upon the tactile and the sensuous, in contrast to what he felt was the sterility of the International Style.

16.32 FRANK LLOYD WRIGHT, *Fallingwater* living room with fireplace, 1943–8.

16.33 LE CORBUSIER, *Villa Savoye*, Poissy, France, 1928–31.

## Conclusion

The culture of the 1930s was, in Terry Cooney's words, a "balancing act," a complex negotiation between past and future, premodern loyalties and modern aspirations.[25] The Great Depression of the 1930s shaped the federal government's commitment to social welfare for the next half-century. The nation survived years of mass unemployment, poverty, and homelessness through the massive publicly funded morale-building experiments of the New Deal. In the face of rising fascism throughout the world, Americans reaffirmed a fundamental commitment to democracy built upon pluralism. The range of possible solutions to the challenges of mass society was spread across a wide spectrum, from the heirs of the Democratic Front in the labor movement, the arts, and public life to corporate engineers and their allies in design, advertising, and mass media. The dream of reengineering the world through manufacturing and industry persisted. After the World's Fair of 1939, the ardor for technological utopia would periodically revive, from the harnessing of atomic energy in the 1950s to the computer age. However, this utopian impulse to sidestep history and let technology solve all mankind's problems was persistently impeded by the psychic costs of modern life that technology itself generated. Much art of the subsequent decade turned away from epic fantasies of a perfect future, toward explorations of selfhood increasingly at odds with collective solutions.

# 17 | Cold War and the Age of the Atom: Consensus and Anxiety 1945–1960

For all the efforts of the New Deal, ultimately it was World War II that jumpstarted the nation's economy. The war effort required major reinvestment in American industries, from shipbuilding to steel, and laid the foundations for America's global dominance after the war. Out of a total population of 133 million people, 16 million Americans went to war while 60 million mobilized at home to supply the war effort. 295,000 American soldiers died in action. Worldwide, total war fatalities numbered 61 million people (soldiers and civilians). By the end of the war, the cities and factories of Europe and Asia were in shambles, while America's homeland was unscathed.

Victory produced a wellspring of optimism. In peacetime, Americans became "a people of plenty." Men returning from World War II entered institutions of higher education in unprecedented numbers, supported by the federal G.I. Bill. Newly married vets also spawned a "baby boom" that sent new families to post-war suburbs where they enjoyed an unprecedented level of consumer spending on cars and home appliances, assuring continued economic growth. Post-war prosperity produced a confident new national self-image of America as the world leader of modern technological progress.

Yet uneasiness grew over technology's impact. Increasingly, Americans questioned the nation's ability to preserve its values in the face of an emerging technocracy, by which fundamental decisions about governance would be made to serve the interests of what President Dwight Eisenhower (1890–1969) would warily term "the military–industrial complex." Especially overshadowing the confidence of the post-war years were anxieties about nuclear annihilation. In August 1945, America dropped nuclear bombs on Hiroshima and Nagasaki, leveling both Japanese cities and killing 234,000 persons in two strokes. After the destructive might of America's bombs became clear, the Soviet Union—formerly allied with the United States in World War II—felt compelled to develop its own arsenal of nuclear weaponry to counterbalance American power. The ensuing arms race between the United States and the Soviet Union was felt at every level of society, and fears of "creeping" Soviet-style Communism led to a climate of suspicion and social conformism.

In the face of such pressures, new artistic energies were brewing in American society, fueled by increasing international contact and influence. These years witnessed new forms of abstraction, drawing on a range of philosophical, pictorial, and psychological currents, including Native American art and religion, Zen Buddhism, and Asian calligraphic traditions. The political and social engagement of the 1930s, along with its strong narrative impulse, gave way to a longing for spiritual integration and a synthesis of mind and body. In resistance to the growing atmosphere of conformism, artists turned away from collective to personal sources of meaning, producing new content. In the words of philosopher Paul Goodman (1911–72), "The root is man." The social image of the artist shifted: no longer representing the 1930s quest for political solutions through united action, the artist now embodied the individual's anguished struggle with meaning. The 1950s spawned the image of the artist associated with **Abstract Expressionism**: emotive, defiantly masculine, and at odds with the culture of consensus and consumerism. Only a few years later, younger artists in turn rejected this heroic pose in favor of deadpan delivery and opaque meanings, preparing the way for the developments of the 1960s.

(opposite) JASPER JOHNS, *Gray Numbers*, 1958. Encaustic and collage on canvas, 67 × 49½ in (170.2 × 125.7 cm). Private collection.

Distinguishing the 1950s from earlier decades are the connections that were drawn between formal, expressive, and design elements and discourses of freedom. But freedom carried different meanings for different sectors of society. For those dissenting from the manufactured consensus of Cold War conformism, freedom involved resistance and risk. For those who took part in the consumer society of corporate culture, freedom was sought in well-being, comfort, and security. Taken together, a new range of artistic strategies emerged to express the realities of the nuclear age for an anxious generation.

## The Crisis of the Subject: From Narrative to Myth and Symbol in the 1940s

*"It seems to me that the modern painter cannot express this age, the airplane, the atom bomb, the radio, in the old forms of the Renaissance or of any other past culture. Each age finds its own technique." Jackson Pollock*[1]

The revelations of the Nazi death camps, the madness of Hitler's Germany, the betrayal of the Russian Revolution by Joseph Stalin, and the vision of European cities bombed into rubble and Japanese cities annihilated by the world's first

atomic weapons all combined to undermine confidence in mankind's rationality and morality. Representational forms linked to figuration and naturalism—Social Realism, Regionalism, and **American Scene painting**—no longer seemed adequate to communicate the temper of the times. The war and its aftermath demanded a new artistic language. While Social Surrealism had offered one alternative in the late 1930s, by the 1940s its historically specific subject matter gave way to a preference for universal themes that spanned disparate cultures. Both figuration and abstraction were transformed by the horrors of recent history and the resultant shift in how artists understood their human subject.

## "Magic Realism"

In the 1940s many figurative artists painted psychologically charged landscapes lacking identifiable historical referents. Director of the Museum of Modern Art Alfred Barr (1902–81) used the term **"Magic Realism"** in 1942, to refer to painters who combined "realistic technique" with "improbable, dreamlike or fantastic visions." Magic Realists were bound less by an identifiable movement than by a loose preference for poetic structures of meaning— metaphor, symbol, suggestion, and condensed time and space.[2] Magic Realism used an allusive language of private symbols and personal sources of meaning frequently difficult to access. It shared with other post-war tendencies a

17.1 **ANDREW WYETH**, *Christina's World*, 1948. Tempera on gessoed panel, 32¼ × 47¼ in (81.9 × 121.2 cm). Museum of Modern Art, New York.

17.2 HENRY KOERNER,
*Lebenspiegel (Mirror of Life)*, also
called *Vanity Fair*, 1946. Oil on
composition board, 36 × 42 in
(81.4 × 106.6 cm). Whitney
Museum of American Art,
New York.

retreat from public forms of meaning, which came to be associated with a broader failure of politics. Private symbols replaced collective forms of belief and value, forms that had proven to be too susceptible to fascistic manipulation.

**ANDREW WYETH.** Vacant spaces and incidents that interrupt ordinary narrative logic characterized a range of artists, including Andrew Wyeth (b. 1917), who created dreamlike scenarios using small brushes and precise draftsmanship in the demanding medium of tempera. Like other works of the 1940s, Wyeth's *Christina's World* (**fig. 17.1**) of 1948 depicts a landscape where the human presence has been marginalized. The middle ground and distance, where narrative traditionally unfolds, reveal a stretch of empty field. Only a house on the horizon offers any refuge for the yearning figure of the crippled woman. Yet the house seems to mirror the vacancy in the landscape rather than promise sanctuary or fulfillment.

**HENRY KOERNER.** Another among the most celebrated of these post-war artists was Henry Koerner (1915–91), an émigré from Austria who had lost his parents in the Holocaust. Koerner came to the attention of a larger public with such images as *Lebenspiegel, Mirror of Life*, painted in 1946 (**fig. 17.2**). Here, Koerner compresses an extraordinary range of times and places: from the man surveying the scene from the bedroom window of an old urban row house to the streetscapes of Europe, including an urban park from his own Vienna, department stores, and Coney Island resorts of leisure and fun, complete with a Ferris "wheel of life" in the distance. Throughout, scale distortions and strange juxtapositions add to the fantastic quality. In the background, two nude men appear on a hillside—Cain and Abel, by the artist's account. The story, from the Book of Genesis, was a common reference in art of the 1940s to the fratricidal world war just concluded. *Vanity Fair* condenses the time and space of the artist's own life, spanning Europe and America, to link the present to a much wider history.

## "Modern Man" and "Primitive" Ritual

Themes of ritualized violence and primitive impulses linked Magic Realism and other forms of figurative art in the 1940s with the emerging abstract painters of the **New York School**. Despite other differences, both groups traced the source of such violence to the psyche—the unconscious mind that connected the individual to an archaic past. Many among this generation found confirmation of a link between modern and primitive in the psychology of Carl Jung (1875–1961), whose writings, translated from German, were widely read in the 1940s. Jung's version of the psyche contained an entire archaeology of history, promising

access to the deepest human motives shaping culture. Jung proposed the existence of persistent features—or archetypes—common to human psychology throughout time and finding expression in all cultures, in dreams, and in myths. According to Jung's theory, archetypes shaped transcultural ritual; to deny them expression would result in imbalance.

Art historian Michael Leja has linked such ideas, in which cultural forms expressed universal psychic forces, to the dilemma of "modern man." Psychological theory suggested that ancient ritual and religion, increasingly familiar through anthropology and through studies of comparative mythology, helped integrate the individual into a larger symbolic world. However, modernity, lacking such a healing ritual, left the individual internally divided, and left society prey to the horrific consequences of this divided psyche. Trapped in the labyrinth of the private mind, "modern man" had lost touch with the healing communal forms of premodern societies. Drawing upon this paradigm, many looked to art as the vehicle of psychic integration, whose function paralleled ancient forms of ritual.

The interest in "modern man" and Jungian archetypes together signal a shift away from the political engagements of the 1930s toward a more psychological, universalizing approach that emphasized underlying transhistorical causes as the motive force of individual behavior. In this mindset, culture was effect, not cause.

**ARSHILE GORKY: ABSTRACTION AND MEMORY.** Other artists and writers in these years, however, explored a different psychological language, which grounded the haunted modern imagination in recent history rather than in universal or archaic impulses.

Arshile Gorky (1904–48) fled with his sister to the United States in 1919, following the Turkish government's ethnic cleansing of the minority Christian Armenians in 1915, the first genocide of the twentieth century. Having lost everything, Gorky turned with passionate determination to the language of artistic modernism as a young artist in New York. About Picasso he wrote "when he drips, I drip," while meticulously working his way through the central developments of European modernism toward a strikingly lyrical and original language of abstraction in the early 1940s (**fig. 17.3**). Gorky's work helped define a shift from the geometric and Constructivist abstractions of the 1930s toward organic shapes rooted in bodily and cultural memories: "Our beautiful Armenia which we lost and which I will repossess in my art." Through a palette resembling the rich tapestry of rug-weaving traditions in the Caucasus, as well as through evocative visceral and natural references and sensuous line, Gorky resurrected his lost homeland. For Gorky, the international language of modernist abstraction was a school that both educated and liberated him to express a historically and personally resonant language. Gorky referred to these paintings as "hybrids," their

17.3 ARSHILE GORKY, *The Liver Is the Cock's Comb*, 1944. Oil on canvas, 73¼ × 98 in (186 × 248.9 cm). Albright-Knox Gallery, Buffalo, New York. Gift of Seymour H. Knox, 1956.

17.4 JACKSON POLLOCK,
*Guardians of the Secret*, 1943.
Oil on canvas, 4 ft ⅜ in ×
6 ft 3 ⅝ in (122.9 × 191.5 cm).
San Francisco Museum of
Modern Art, California.
Albert M. Bender Collection.

abstract forms and colors encoded with the history of his culture in what writer Peter Balakian has called "representations of grief and loss."[3] Demoralized by multiple tragedies, Gorky committed suicide in 1948, leaving an enormous impact on the emerging Abstract Expressionists.

## The Origins of Abstract Expressionism

In the early 1940s Jackson Pollock (1912–56), Mark Rothko (1903–70), Adolph Gottlieb (1903–74), and other artists who had come of age painting figurative art during the 1930s turned to new sources and procedures of artmaking in an effort to express the recent realities of the post-war world. They found inspiration and sources in Native cultures. Work by the Pueblo and Navajo Indians of the Southwest, as well as by the Northwest Coast culture of the Kwakiutl, was widely available in New York from 1900 on, at such collections as the American Museum of Natural History, and such comprehensive exhibitions as the "Exposition of Indian Tribal Arts" (1931) and the "Indian Art of the United States" at the Museum of Modern Art in 1941. The 1941 exhibition in particular offered a crucial catalyst for those artists who emerged into international prominence in the next generation. American artists collected and studied Native masks, rock art, pottery, weavings, and carvings, drawn both by their expressive abstraction and by their placement in a complex world of ritual and communal enactment. In Native forms they found an expression of unconscious energies that occurred in cultures across time and space, yet that was specifically American in its origins.

**EARLY JACKSON POLLOCK.** Pollock's *Guardians of the Secret* (**fig. 17.4**) features a horizontal tablet inscribed with indecipherable markings that suggest hieroglyphs or other ancient forms of writing. This tablet evokes the layers of language, myth, memory, and experience that comprise the archaeology of both culture and psyche. Inside and around the tablet are passages that recall Indian pictographs: a fish-like form at the top of the tablet, and at the upper center of the canvas, a black form curling in on itself. Scholar Jackson Rushing has identified the source of this fetal shape in a Mimbres pottery bowl (see figs. 1.19 and 1.20) that appeared in the 1941 exhibition at the Museum of Modern Art, which Pollock saw and studied. Pollock derived the masklike form at the top left of the canvas, outlined in white, from a Northwest Coast mask of a cannibal spirit. Lying prone below the central white tablet is a wolf-like creature. The guardian figures on either side of the central tablet are indebted to Pollock's knowledge of the male-centered secret societies of the Southwest Pueblo Indians, responsible for the ceremonial lives of their people. Throughout, Pollock's brushwork conjures violent energies that are, nonetheless, contained by the tablet, frame, and figure, emblems of the power of ritual and ceremony to structure the unconscious psyche.

Beyond his borrowings from Native art, Pollock was struggling toward a more direct identification with non-Western forms of creation, in particular the shaman figure endowed with the power to heal and shape the course of events. Shamanic power derived from identification with an animal spirit, in the form of a mask of that animal.

17.5 JACKSON POLLOCK, *Number 1, 1950 (Lavender Mist)*. Oil, enamel, and aluminum paint on canvas, 7 ft 3 in × 9 ft 10 in (221 × 299.7 cm). National Gallery of Art, Washington, D.C.

By using Native American forms, Pollock assumed the mask of another culture, metaphorically expanding his powers as an artist. He had long suffered from alcoholism and bouts of depression. Deeply affected by his growing knowledge of Indian art, Pollock would come to endow his painting with the instrumental power of ritual, to heal and to make whole the psyche divided against itself.

Several other influences shaped Pollock's work. From his mentor at the Art Students' League, Thomas Hart Benton (1889–1975), Pollock absorbed—and transformed— the concept of myth from a collective social to a personal resource. He also learned from the Mexican muralist David Siqueiros (1896–1974) at Siqueiros's New York-based Experimental Workshop (1936), where he used newly developed synthetic paints easily poured, dripped, and splattered onto surfaces placed on the floor. Siqueiros incorporated handprints and found objects, including sand, into the picture surface. At the workshop, Pollock encountered ways of working that would become central to his breakthrough painting methods a decade later, providing him with a liberating if demanding mode of expression that bypassed academic Cubism and grounded his art in the radical and transforming ambitions of the Mexican muralists. Siqueiros's commitment to new artmaking techniques appropriate to a new era was prophetic indeed. The example of José Clemente Orozco (1883–1949) was equally crucial; Pollock had visited Orozco's titanic *Prometheus* mural in progress at Pomona College (1930) in his home in Los Angeles, which Pollock later declared "the greatest painting done in modern times."[4] Orozco's sweeping epic forms and spiraling energies, conveying struggle and violent birth, are especially apparent in Pollock's early work.

In their unprecedented scale (as big as 9 by 17 feet), Pollock's works extended the concerns of the Mexican muralists, while turning them to very different ends. Tying the two generations together was a shared repudiation of the small, portable easel painting, an aesthetic object that remained discrete from the viewer. The sheer size of Pollock's work and that of fellow Abstract Expressionists was intended to envelop the viewer's sensory field. At close range, these works projected a psychological intensity that narrowed the distance separating art from life.

In the late 1930s Pollock underwent Jungian psychotherapy. Binding artmaking to psychic process and to a deep

transcultural history of symbols, Pollock's work of the early 1940s transformed the alliance of art and life that had motivated the public art culture of the 1930s in which he first began his career.

**POLLOCK'S DRIP PAINTINGS.** *Guardians* remains a representation, rather than an enactment, of ritual. In the years ahead Pollock would devise a new technique in which the act of making art itself approximated the power of the Native shaman. By 1947, Pollock had left behind all direct references to Indian art in favor of a technique in which fluid housepaint was dripped by a stiffened brush or kitchen baster, or poured directly from the can, onto unstretched canvas (**fig. 17.5**). Despite popular misconceptions about Pollock's drip paintings, they demanded a high degree of skill, comparable in terms of motor control to the Navajo sand painters he had seen in 1941 at the Museum of Modern Art (**fig. 17.6**). Indeed he would later compare his own method of laying the canvas on the floor and painting onto it from above to that of the Navajo. Such paintings were done on the ground, in a freehand but exacting manner. Ground pigments, minerals, and pollens were scattered from the hand to create complex designs of ritual figures meant to be used in a healing ceremony. Pollock adapted this method, using a basting syringe or a brush to drip his paint in a loose gesture onto a canvas laid out on the floor. About this process, Pollock wrote, "On the floor I feel nearer, more a part of the painting, since this way I can walk around it, work from the four sides and literally be in the painting. This is akin to the Indian sand painters of the West."[5]

17.6 Navajo sand painters at work, from *Indian Art of the United States* exhibition, 1941. Photograph. Museum of Modern Art, New York.

# Jackson Pollock and Navajo Sand Painting

THE ENCOUNTER BETWEEN Native arts and Abstract Expressionism was one more episode in a longer history of **primitivism**. Pollock, however, was distinct in emulating both the manner of artmaking and the powers of the shaman artist. For both the Navajo healer and for Pollock, the process was as important as the finished product.

But like many other American and European artists of the twentieth century, Pollock held overly romantic notions about tribal artists. He believed that their work was a direct emanation from the unconscious, unmediated by the over-intellectualization and rigorous training of the Western professional artist. Navajo sand painters, however, studied in an apprenticeship system as long-lasting and exacting as the most academic form of art training in the Western tradition. As with many other cultural encounters discussed in this book, this one was characterized by a certain amount of productive misunderstanding; that is, Pollock interpreted the cultural tradition of the Navajo in ways that served his own particular creative needs.

As Hans Namuth's (1915–90) famous film of the artist painting at his Long Island studio reveals, Pollock assumed a dance-like rhythm as he moved his body down the length of the canvas. A related gestural rhythm is apparent in many of his works. Such direct physical involvement in the act of painting seemed unprecedented; the bodily rhythms of Pollock painting link his methods to the dance, in which art and act, work and creator, become one. Pollock was, in effect, inventing his own way of bringing together mind and body, form and content, in a manner that was inspired by the example of the Native artist, while achieving something new in Western art. These methods expressed a longing for a loss of self in ritualized acts.

## The Abstract Expressionist Movement

Pollock's transfiguration was repeated by others in what came to be known as the Abstract Expressionist movement. The term was coined in 1946 by critic Robert Coates in *The New Yorker*, and was taken up more broadly in the early 1950s to describe a spectrum of approaches bound together by a shared reaction against the geometric

abstraction of the 1930s and by a desire to combine an art of content with non-referential forms.

Abstract Expressionism took shape out of the encounter not only with Native arts and with Mexican muralism, but also with European Surrealist émigrés, in flight once again from war. As with Native arts, Surrealism provided a path into the energies of the unconscious mind, offering its own version of psychic integration as the path into a poetically enriched life. Pollock, Willem de Kooning (1904–97), and others transformed the technique of "**psychic automatism**," learned from their encounter with Surrealism, into something far more fluid and open-ended. In the Freudian model of the psyche, the conscious mind censored the unruly and presocial energies of the unconscious. Believing this uncensored part of the mind to hold the key to purer forms of creativity, the Surrealists felt that it was possible to access these energies through automatic drawing, allowing direct expression of the unconscious mind through the apparently random doodlings and scribblings of the hand. Automatism generated raw material that would enrich older methods of artmaking.

In the wake of their encounter with Surrealism, Abstract Expressionists reconceived automatism in terms of the paint medium itself; each mark produced a condition to which the artist responded, in an unfolding and open-ended manner that generated new forms. Plastic automatism, as it was called by the artist Robert Motherwell, by emphasizing the materiality of the medium itself over psychic content, recast Surrealism in important ways.

A generation of artists committed themselves to painting as a method of exploration—of self, of medium, of existence. In an essay on Abstract Expressionism written in 1952 ("The American Action Painters"), the critic Harold Rosenberg probed the significance of the new gestural art, seeing the canvas as an **existential** arena in which the artist acted out the dilemmas of choice that confronted the individual in a world lacking clear moral coordinates. French Existentialism had an influential presence among post-war New York intellectuals; it offered one way of reading the significance of Abstract Expressionism, and shared with these artists the conviction that inherited ideas about the world—whether social, artistic, or philosophical—blocked

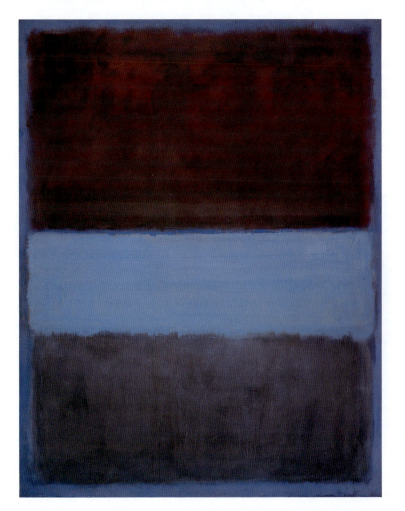

17.7 MARK ROTHKO, *No. 61 (Rust and Blue) (Brown, Blue, Brown on Blue)*, 1953. Oil on canvas, 9 ft 6 in × 7 ft 7 in (2.94 × 2.32 m). Museum of Contemporary Art, Los Angeles, California. Panza Collection.

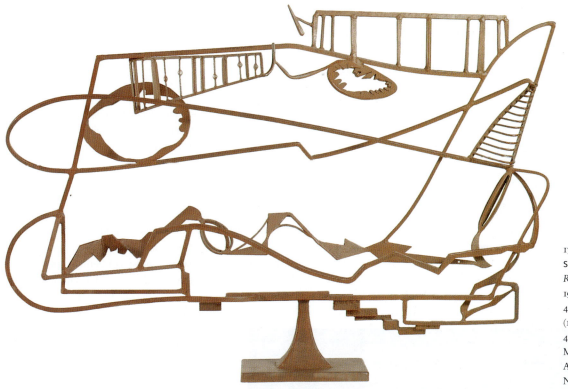

17.8 DAVID SMITH, *Hudson River Landscape*, 1951. Welded steel, 49⅜ × 75 × 18½ in (125.5 × 190.5 × 47 cm). Whitney Museum of American Art, New York.

or distorted the direct confrontation with experience itself. Emphasizing process over a preconceived image, their way of making art embodied a belief that painting should be difficult, with each stroke measured for its honesty as an expression of authentic individuality.

**COLOR FIELD PAINTING.** In the practice of the "color field" artists within Abstract Expressionism—Mark Rothko (**fig. 17.7**), Barnett Newman (1905–70), and Ad Reinhardt (1913–67)—gestural concerns gave way to broad expanses of unmodulated color, or to floating and vaguely bounded shapes that expanded perceptually to absorb the viewer's field of vision. Rothko wished his works to be hung alongside one another, low on the wall, and in lowered light, resulting in a visually resonant field of color that would draw the viewer in. Rothko's paintings have no impasto; his technique of brushing diluted paint directly onto unprimed canvas contributes a sense of weightlessness. Through their resonating color fields and the vagueness of their boundaries, these images involve the viewer by inducing a form of contemplative engagement. Purged of subject matter or emotional display, they nonetheless remain grounded in a search for meaning. But in canvases that banish iconography, symbol, or clear referent, the search is in the hands of the viewer. Rothko's subtly palpitant screens also recall the television set, a new medium in the home that brought with it a range of commercial messages

and forms of cultural "chatter." Insisting on silence and contemplation, Rothko's floating rectangles negate the impact of the very medium whose forms they recall.

**THE ABSTRACT EXPRESSIONIST SCULPTOR: DAVID SMITH.** The move toward media responsive to presocial energies and presymbolic expression also drove the work of the leading post-war sculptor, David Smith (1906–65), who had welded tanks during the war. Allied to the procedures and rhetoric of Abstract Expressionism, Smith chose to work in welded metal in preference to the older techniques of direct carving. Trained as a painter, Smith often conceived his sculptures in two dimensions, which also suited layouts of heavy steel on the factory floor. Breaking entirely with the forms of earlier American sculpture, Smith made works in which the focus is dispersed, the space animated by edges and shapes. Following preliminary works during the war years that graphically depicted wartime violence in an imagery of sexualized aggression, Smith, like Gorky, turned to agricultural themes and mythic narratives of procreation. Incorporating ploughshares, along with other agricultural implements and industrial artifacts, into his work, Smith renounced any reliance on nature as a reference in his art. Yet working in the countryside of upstate New York, he felt challenged by the scale and shapes of nature to create his own "poetic transposition" of nature's forms (**fig. 17.8**).[6] For him, as for his Abstract Expressionist colleagues, art

# Abstract Art and American Quilts

FOR ALL ITS CLAIMS to aesthetic purity, color field painting resembled other visual forms. One such documented connection is with American quilts. Not until Jonathan Holstein and Gail van der Hoof curated a groundbreaking exhibition, "Abstract Design in American Quilts," at the Whitney Museum in New York in 1971, did the public appreciate that quilt makers too were sometimes concerned with abstraction in a painterly sense. In a manner analogous to the abstract color fields in work by artists such as Barnett Newman (1905–70), Mark Rothko (see fig. 17.7), Josef Albers (1888–1976) (see fig. 17.18), and Kenneth Noland (b. 1924), some nineteenth-century quilt makers clearly were experimenting with the optical properties of color and simplified geometric form. Correspondingly, several Abstract Expressionist painters owned quilts, and Barnett Newman himself advised Holstein on his groundbreaking exhibition of quilts.

Most nineteenth-century quilts were made to be draped over beds, but when hung on the walls of an art museum, it became obvious that late-nineteenth-century and early-twentieth-century Amish women, working in the medium of cloth, had conceived of their quilts as bold graphic design fields (**fig. 17.9**). Today these descendants of German-speaking immigrants (who came to the United States in the seventeenth and eighteenth centuries seeking religious freedom) reject the secular world and wear plain, old-fashioned clothing. Yet their quilts reveal a measure of exuberance, using wool fabrics in saturated colors sold by itinerant traders in the Amish regions of Pennsylvania and Ohio. These fine wools absorb and reflect light in a different way from the cotton fabric more commonly used in quilts.

Art critic Robert Hughes has called Amish quilts "aesthetically radiant objects." Simple and bold in their design and color choices, they are extravagantly worked in fine hand-quilting stitches (often not apparent in photographs). Amish textile artists delight in startling color combinations: turquoise and brown; magenta and red; pink and lavender against red and blue-green; vivid blue against black.

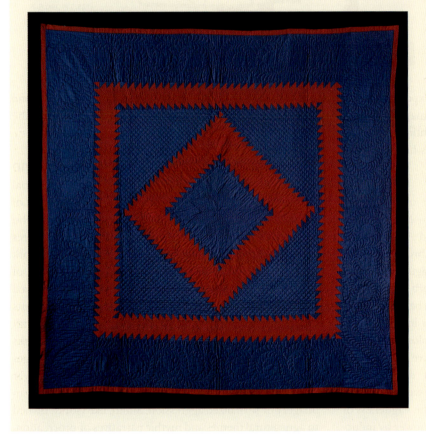

17.9 UNKNOWN ARTIST (AMISH), *Center Diamond in a Square Quilt*, Lancaster County, Pennsylvania. Cotton, 83 × 82 in (210.8 × 208.2 cm). Shelburne Museum, Vermont.

was a form of the "real" rather than its representation. And, like them, he allowed his materials and his process to shape the direction of the work. His *Hudson River Landscape* of 1951, like other works of these years, resembles a drawing in space; its fluid shapes recall the automatic drawing of the Surrealists who influenced this generation. Smith's work resembled the lyricism of Pollock as well, and like Pollock he rewrote the rules of the game by fundamentally transforming sculpture's traditional concerns with centered mass, three-dimensionality, and human focus.

# Abstract Expressionism and the Rhetoric of Nature

WHEN THE PAINTER Hans Hofmann (1880–1966) criticized Pollock for not painting from nature, the artist famously responded, "I am nature." In the post-war period when Pollock made this comment, "nature" signified an America remote from Europe, defined against history and culture. For Pollock to identify himself with nature was to claim an artmaking process that was freed from European influence. Critics obliged by associating Pollock's explosive energies with natural forces: "Pollock's talent is volcanic. It has fire. It is unpredictable. It is undisciplined. It spills itself out in a mineral prodigality not yet crystallized."[7] Such comments drew upon the old rhetoric that associated American art with the raw, sublime power of American nature. Pollock and his critics did what others had done since the nineteenth century; they turned a cultural liability—the lack of history—into a defiant boast.

Yet Pollock's boast masked a more complex situation. His art, like that of others in the New York School, was deeply influenced by European modernism. Far from being a primal outpouring of an untutored "new American Adam," it was acutely aware of its place in history. From Cubism, the Abstract Expressionists took an understanding of the canvas as a flat surface on which to construct an arbitrary pictorial order; from Surrealism they acquired the technique of automatism. They also learned from more distant masters—from Monet to Rembrandt, Goya, and El Greco. The "new American painting" spoke to a generation who valued innovation and change while claiming a place in a history of art that expanded across time and space to attain a "universal" scope.

# The "Triumph" of Abstract Expressionism and Beyond

Distancing itself from a public sphere in turmoil following World War II, the discourse of Abstract Expressionism rejected political involvement. Yet politics entered on another level, in the public reception and international circulation of Abstract Expressionism during the 1950s. In 1949, the Soviet Union detonated its first atomic weapon, triggering an arms race with America. The success of the Chinese Communists in 1949 further fed American paranoia, which feared a conspiracy to establish Communism throughout the world. In the politically charged environment of the "**Cold War**" in 1950s America, Abstract Expressionism, with its bold, slashing forms and open-ended meanings, was played off against the Socialist Realism of the Soviet Union, a style dictated by the state and disallowing any form of experimentation. Promoted as a heroic expression of American freedom, Abstract Expressionism moved from embattled marginality to growing official celebration. Using art as a form of cultural diplomacy, government-sponsored exhibitions of Abstract Expressionism toured internationally as representatives of cultural democracy, liberal individualism, and a free society.

Despite such emerging recognition, the early 1950s also saw a reactionary attack against modern art, waged by allies of Senator Joseph McCarthy's (1908–57) crusade to root out Communists in the government. Such reactionaries aligned modern art not with freedom but with "Bolshevism"—the dangerous revolutionary philosophy propelling the Russian Revolution—and suspected that it was part of a conspiracy to subvert American values. Abstract Expressionism, despite its ambition to achieve universality, became a kind of **Rorschach test** in which different social groups saw diametrically opposed meanings.

## The Contradictions of Success

In 1956, after drinking heavily, Pollock smashed his car into a tree, killing himself and a passenger. Pollock's dramatic death not only fueled the myth surrounding him, but sent the value of his work soaring. While the artist might be idolized as a rugged individualist, tormented by his own demanding quest for authenticity, his art was simply a commodity whose value was determined by the law of supply and demand.

Several Abstract Expressionists had to contend with the "dilemmas" of financial success and popular recognition, making their artistic program appear increasingly problematic with time. After struggling to create a social and artistic "space of resistance" for themselves in the 1940s, their work was widely collected, exhibited, and cataloged by the mid-1950s. Their institutional patrons ranged from

the Museum of Modern Art—which they had protested against in 1950 for ignoring their work—to the U.S. State Department. Powerful art dealers and critics such as Clement Greenberg (1909–94) promoted them. All this threatened a group identity based on their embattled position in American society, waging war against a mainstream culture and corporate accommodation. Their gestural brushstroke—the mark of authenticity—itself became a style to be imitated, as art schools institutionalized their way of making art. However, as their marks became conventionalized through repetition, spontaneity proved an impossible model to follow.

Even at the height of the "New York School," as the Abstract Expressionists came to be called, other painting practices emerged both inside and outside New York. Younger artists, including several notable women painters, were freeing the language of gestural abstraction from its associations with the embattled masculine quest for authenticity. The assertive, crisis-driven language of the male New York artists differed as well from the quietist Asian-inspired calligraphy of West Coast abstraction. Even figuration returned, bearing with it a new social content. Still other younger male artists adapted a range of tactics that carried them beyond the long shadow of their elders, through satire, subversion, and irony.

## Helen Frankenthaler and the "Soak-Stain" Method

In 1952, shortly after seeing an exhibition of Pollock's work, Helen Frankenthaler (b. 1928), a twenty-three-year-old New York painter, made *Mountains and Sea* (**fig. 17.10**), a lyrical abstract landscape recalling a trip to Nova Scotia with her companion Clement Greenberg. Though very young and female, Frankenthaler had been welcomed into the Abstract Expressionist "club" after struggling to master the languages of Cubism and automatism that had fed their "American-style" painting. For Frankenthaler, the spontaneous methods of her male colleagues opened not into self-revelation but into a freedom from earlier models. *Mountains and Sea* initiated a remarkable history in postwar American art; reinterpreting Pollock's legacy, it also transformed his working methods in important ways. Instead of pouring paint onto canvas in emulation of Pollock's "drip" method, Frankenthaler diluted her paints into soft pastels and applied them directly to unprimed canvas, "staining" and soaking her canvases with color so that pigment and support became one. Resembling dyed cloth, her work further blurred the relationship of figure and ground with a lightened palette that reduced value (light/dark) contrasts and exploited the canvas itself as an

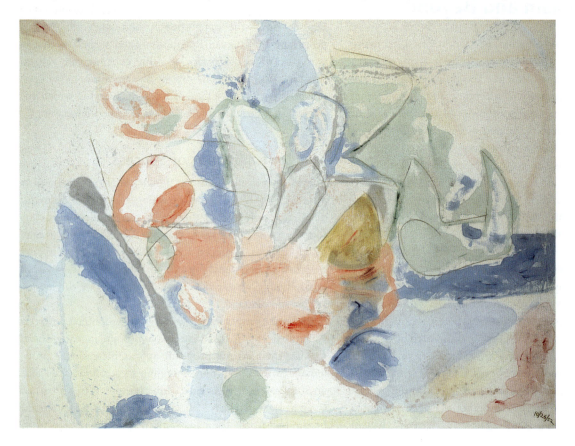

17.10 HELEN FRANKENTHALER, *Mountains and Sea*, 1952. Oil on canvas, 7 ft 2⅝ in × 9 ft 9¼ in (2.2 × 2.97 m). Collection of the artist, on extended loan to the National Gallery of Art, Washington, D.C.

equal element in the design. Though this technique induced a tendency to see the canvas in terms of surface effect, *Mountains and Sea* also suggests spatial illusion through the landscape element within the work; the painting turns upon a central episode evoking mountain or rock forms and vegetation, anchored on the right side by the suggestion of a blue horizon. Frankenthaler's nature was different from Pollock's; it was, in her words, "the totally abstract memory of the landscape."

Frankenthaler's work combined tradition and technical innovation. In terms of scale, Frankenthaler matched her male colleagues: *Mountains and Sea* was roughly 7 by 9 feet. Yet she paradoxically used scale to produce intimacy of vision, serving private sources of meaning and symbolism. *Mountains and Sea* also introduced a new lyricism of pooled color in place of the fierce gestures of older Abstract Expressionist painters. Shortly after she completed her breakthrough work, its dematerialized and floating fields of color furnished inspiration for the artists Kenneth Noland and Morris Louis in their version of **color field painting**.

Resourceful and independent, Frankenthaler took what she needed from the largely male traditions of artmaking that had defined modernism, and incorporated these lessons into her own contribution. Her innovations are all the more striking in a decade characterized by pressures on women to marry, and to renounce personal objectives in service to the family. Frankenthaler's breakthrough required willful absorption in her own creative development, made possible by the financial support of her family. An elite education at Bennington, an all-women's college committed to professional training—especially in the arts—had furthermore given her confidence in her own intellect that allowed her to hold her own alongside male critics and artists.[8] Like O'Keeffe before her, she resisted being labeled as a woman artist by critics who interpreted her art exclusively in terms of gender and "essential" feminine experience. Yet, like other female artists in the 1950s, she struggled with the universalizing and often explicitly male discourses and practices of her older colleagues in Abstract Expressionism. To step outside the subordinate roles assigned to women in the 1950s, and to assert the authority of one's own experience and sexuality, was a course taken by other women artists who collectively represented alternative forms of Abstract Expressionism.

## Pacific Rim Influences

Although frequently synonymous with the New York School, Abstract Expressionism was a nationwide movement that appeared simultaneously in several urban centers.

Most observers assume that the influence flowed from New York to the rest of the country, and thus give priority to art made in that city. But in San Francisco and Seattle communities of artists produced their own distinctive forms of abstraction. These West Coast movements were shaped by the presence of strongly defined personalities, but also by specific physical landscapes, intellectual and social environments. A shared artistic and historical inheritance was filtered through local conditions, resulting in regional schools of abstraction. West Coast artists such as Mark Tobey were included in surveys of modern American art from the late 1940s. But since then, such national coverage has given way to a history of American art largely centered on New York.

One regional influence came from the West Coast's location on the Pacific Rim, in proximity to intellectual and aesthetic influences from Asia. Artists and intellectuals across America were introduced to Zen Buddhism, which finds enlightenment (or *satori* in Japanese) through the meditative discipline of mindfulness—a paradoxical disengagement of the mind and judgment through experience of the moment. The lectures and writings of the Japanese scholar Daisetz Suzuki (1870–1966) played a central role in the dissemination of Zen Buddhism; his ideas particularly took root on the West Coast, especially in San Francisco and Seattle. Suzuki first visited the United States from 1897 to 1908 and returned in 1950, at the age of eighty, for a decade of teaching at leading institutions such as Columbia University, during which period he published in English influential books such as *Zen and Japanese Culture*.

**MARK TOBEY.** Mark Tobey (1890–1976), working in the Pacific Northwest, took the universal preoccupations of Abstract Expressionism in another direction. Tobey renounced any claim to an American painting, which he associated with nationalistic rivalries leading to war, in favor of "universal citizenship,"[9] reviving and extending the older concept of the cosmopolitan as a citizen of the world to include not only European and Native American but Asian culture, which he identified as his greatest influence. Introduced in the 1920s to Chinese brush painting by a Chinese friend in Seattle, Tobey also spent time in a Zen monastery near Kyoto, Japan, in 1934, and retained a life-long interest in Asian art and culture. He shared with other West Coast artists an interest in Japanese calligraphy and ink painting, a vital tradition made available to a wider audience at the Museum of Modern Art's 1954 exhibition *Abstract Japanese Calligraphy*. Tobey's markmaking was intimate and meditative, far removed from the psychic automatism that was a point of departure for New York abstraction.

17.11 **MARK TOBEY**, *Golden Mountains*, 1953. Opaque watercolor on composition board, 39¼ × 18¼ in (99.7 × 46.4 cm). Seattle Art Museum, Washington. Gift of the Eugene Fuller Memorial Collection.

Tobey's "white writing" dated from as early as the 1930s—"all-over" compositions that preceded Pollock's. Unlike Pollock, Tobey meticulously applied tempera paint (rather than fluid housepaints) in layers. Like other abstract artists in these years, however, he began with no preconceived idea, combining discipline and improvisation. Tobey

worked on a small scale, his works delicately patterned at a time when large bold painting had become the norm. His controlled tracery of paint suggested fields of energy, differing however from the full-body drip gestures of Pollock. *Golden Mountains* of 1953 (**fig. 17.11**) suggests an ethereal response to nature that inverts the relationship of mass and void through a dynamic stitchery of line over a luminous yellow/white field.

**ALL-OVER COMPOSITION AND THE BREAK FROM HIERARCHY.** At both ends of the continent, in New York and the Pacific Northwest, the practice of abstraction turned away from centered composition, perspectival vision, and geometric structure. Such hierarchical ways of seeing—which organized space according to foreground and background, figure and ground, object and environment—privileged artistic will in giving order to a disordered universe. Developments in theoretical physics disrupted such hierarchies, as did Asian Buddhist concepts of selfhood as an illusion. Both of these envisioned a universe in which space was activated by unseen energies, in which "emptiness" and silence represented a paradoxical fullness. Particle physics and a Zen openness to the undifferentiated flow of everyday perception freed from judgment or control inspired the chance operations of the radically experimental composer John Cage (1912–92), as well as Abstract Expressionism's complication of the figure/ground dualism. Cage had considerable influence on post-war art through his teaching at Black Mountain College in North Carolina. In the 1950s, Black Mountain gathered together the avant-garde in dance, music, studio arts, ceramics, and performance. Its collaborative, experimental environment played an important role in shaping the next generation of artists, many of whom absorbed its lessons of open-ended engagement with experience and the materials of art.

## Image Culture, Gender Crisis, and Identity in the 1950s

In 1925, the outspoken critic Thomas Craven wrote that "[The artist] is an effeminate creature who paints still-life, tepid landscapes, and incomprehensible abstractions purporting to express the aesthetic states of his wounded soul. No doubt the increasing effeminacy of the American environment has much to do with the shaping of his conceptions, but if he possesses no masculine virtues to begin with, let him bob his hair and design Futurist lingerie or sets for movies.

"Painting is essentially a man's art, and all great painters have been coarse, earthy and intolerable. In the entire

range of art there is not a single picture entitled to a moment's consideration that has been done by a woman."[10]

With admirable concision, Craven (an ardent supporter of Pollock's first teacher Thomas Hart Benton) summed up well-worn attitudes about artists. In the nineteenth century art for art's sake acquired effete connotations. Craven extended the taint of effeminacy to the formal obsessions of the modernist artist, and linked them once again to a prissy, self-absorbed concern for fashion. A virulent nationalist, Craven repudiated most forms of modernism; his image of the effeminate artist was widely shared, and helped fuel the defiant masculinity of Jackson Pollock as he revitalized abstraction from the 1940s. The image of the feminized aesthete dabbling in formal problems was one Pollock clearly had to exorcise. His brooding style and rough self-assertiveness in the face of earlier art contributed to Pollock's emerging celebrity. In magazine articles on the painter and his wife Lee Krasner (1908–84), an important artist in her own right, she appears as "Mrs Jackson Pollock," making jam or observing her husband as he enacts his heroic gestures.

17.12 ALBERTO VARGAS, *Varga Girl*, from *Esquire* Magazine, April, 1945. Courtesy Hearst Licensing, New York.

**"THE GIRL BACK HOME."** From bad boys of film Marlon Brando and James Dean to John Wayne, popular idols asserted an image of beleaguered but surly American masculinity. American men confronting a generation of women recently empowered by wartime employment anxiously demanded a return to domestic norms or, conversely, a feminine sexuality that was playful, available, and non-threatening—more kitten than panther. The Varga pin-up girl (**fig. 17.12**), a favorite feature in the men's magazine *Esquire* from 1940 to 1946, was the work of Alberto Vargas, a Peruvian émigré whose skills with the airbrush and intuitive grasp of a male wartime fantasy world made him synonymous with a particular version of the "girl back home." Impossibly long-limbed and poreless, she accompanied American GIs overseas, her sexual allure conveniently reinforcing patriotic duty as a reminder of a nation worth defending. There was another, darker side to feminine sexuality, however; in the seductresses of Hollywood *film noir* (a genre of psychological thriller that often involved some form of female betrayal, shot in high contrast black and white) male viewers found reason to distrust women who coveted male potency. The studies in sexual behavior of Alfred Kinsey (1948 / 1953), based on interviews of more than 11,000 men and women, revealed a decline in men's sexual energies relative to women's after their early twenties, and contributed to a growing sense of male inadequacy. Linking sex and death, the "blond bombshell," like her dark-haired *noir* counterpart, was a type that conveyed considerable ambivalence toward women. The classic 1950s icons of female beauty—tightly packaged yet bursting at the seams—summed up these conflicting desires: for control and for loss of control, for constructing and exceeding boundaries.

**WILLEM DE KOONING'S *WOMAN*.** Among the most notorious icons of male ambivalence toward women was Willem de Kooning's *Woman* series, painted between 1950 and 1953 (**fig. 17.13**). These canvases are characterized by leering masklike faces, predatory toothy mouths and buglike eyes, and enormous breasts that alternately offer "pneumatic bliss" and threaten suffocation.[11] Grotesquely humorous, they seem parodies of male anxieties about women. For de Kooning, their ferocious aspect carried a certain hilarity. No doubt they record de Kooning's own sense of awe about the female, whose archaic power was registered in the shocking frontality of these figures. There were multiple inspirations behind these works, spanning the history of art from Cycladic figurines to modern billboards and media images of women. De Kooning actually collaged cutout mouths from cigarette advertisements

17.13 WILLEM DE KOONING, *Woman I*, 1950–2. Oil on canvas, 75⅞ × 55 in (192.7 × 147.3 cm). Museum of Modern Art, New York.

directly onto one of these canvases. If their parodic quality links them to the Pop artists of the 1960s, their painterly strokes and layered, scratched, scraped, and smudged surfaces puts these works squarely in the milieu of Abstract Expressionism. At the same time, they also look back at the Old Masters so admired by de Kooning—in particular, to the Flemish master of female flesh, Peter Paul Rubens—as well as to Picasso's *Demoiselles d'Avignon*. At the height of Abstract Expressionism, de Kooning's series signaled a return to the figure with a vengeance, causing consternation among the supporters of 1950s abstraction.

**GEORGE TOOKER'S *WAITING ROOM*.** Masculinity was under fire from another direction, however. In the increasingly hostile and paranoid political climate of the government-based McCarthy investigations of Communist ties, identity—public, personal, political, and sexual—had to be closely guarded. George Tooker's (b. 1920) *Waiting Room* of

1959 (**fig. 17.14**) reveals an airless underground world of gridded spaces and social anonymity. Here is no human contact; faces and eyes are cut in half, blocked, or hidden behind opaque glasses. Deadened by life, his sleepwalkers find no meaningful exchange, occupying an existential room with no exit. Waiting implies an outcome; here is no outcome, but only moments as undifferentiated as the repeating cubicles each figure occupies. The only suggestion of life is the forced smile of a cover girl who appears on a mass-marketed journal, blocking out the face of the female reader.

Tooker's vision of urban alienation, in which personal identity literally disappears behind the manufactured images of the mass media, was colored by his own homosexuality. In the 1950s sexual and political repression were often linked, as fear of Communism was associated with fear of sexual difference. To be "straight" implied allegiance to both a sexual and a political norm; to step beyond the bounds of accepted behavior was to risk social persecution. Tooker's art revealed the deep cynicism many intellectuals felt in the face of the increasingly bureaucratic and impersonal social landscape of the 1950s.

Like others of his generation, Tooker revived the use of tempera, a quick-drying medium in which pigment is suspended in egg yolk, widely used in the Renaissance. Using figuration and a meticulous perspectival space, Tooker and other nonabstract artists represented a response dramatically different from Abstract Expressionism to the same cultural conditions: an extreme disenchantment with the spiritual hollowness of modern life. Abstract Expressionism exploded the traditional space of easel painting in an aesthetic detonation comparable to the revolution in the physical sciences that produced the atomic age itself. By contrast, Tooker reaffirmed traditional means but placed them in the service of a devastating critique of mass society.

## Beyond Abstract Expressionism

Young artists in the early years of the 1950s were surrounded—indeed, trapped—by the important work of their elders. From Picasso to de Kooning and Pollock, several generations of modernist experimentation had left little room for them to maneuver. Outsiders to the art worlds of New York and Europe, Jasper Johns (from South Carolina) and Robert Rauschenberg (from Texas) felt few commitments to the past. In the very years that Abstract Expressionism "triumphed" as a critically and officially accepted style, these younger artists pushed American art beyond subject matter, beyond expression, and beyond the subjectivity of the artist as creative force. The art of Johns

17.14 GEORGE TOOKER, *The Waiting Room,* 1959. Egg tempera on gessoed panel, 24 × 30 in (60.9 × 76.2 cm). National Museum of American Art, Smithsonian Institution, Washington, D.C.

and Rauschenberg remained indifferent to received notions of artist as hero, as well as of beauty. Offering no clear paths to meaning, their works questioned the fictions that supported art—that a painting is a true image of reality; or that it offers access to a world beyond itself.

**JASPER JOHNS.** Issues of identity were especially significant for Jasper Johns (b. 1930), a reticent young artist whose first exhibition in 1955 in New York City broke radically with the reigning style of the older Abstract Expressionists. Johns's avoidance of anything approaching self-exposure takes on

17.15 JASPER JOHNS, *Flag,* 1954–5. Encaustic, oil and collage on fabric mounted on plywood (three panels), 42¼ × 60⅛ in (107.3 × 154 cm). Museum of Modern Art, New York. Gift of Phillip Johnson.

new meaning in light of his homosexuality. In the climate of Cold War surveillance, Johns's art refused to be identified, named, or targeted. In its strategic silences, it opted out of accusation, finger pointing, and society's impulse to pin down and compartmentalize identities, both social and sexual. Identity remains elusive in Johns's work, impossible to decode from the numbers and symbols of the information age, which he painted with such loving anonymity.

Johns's 1958 *Gray Numbers* (**p. 550**), like Pollock's gestural abstraction, is an all-over painting. But there the resemblance ends. Johns grids his picture plane to contain numbers from one to nine, read down as well as across in repeated sequences. Figure / ground distinctions are also leveled, since the painting is all in shades of blue–gray monochrome. In the gridded impersonality of numbers Johns evokes a world organized around information broken down into component parts uninflected by meaning. Here is an abstract order that operates apart from hierarchies of importance or judgment—a veiled comment on post-war bureaucratic culture. Yet the painting nonetheless subverts such sameness through a surface whose tactility and color variations imply the complexity of nature. *Gray Numbers* occupies a different world from the slashing, heroic gestures of Abstract Expressionism. With very different artistic means, Johns, Pollock, and Tooker were all responding to a world that tracked and gridded individual identities. Despite their extreme differences, Pollock and Johns would be among the most influential artists for the next generation of American art.

Johns's early *Target with Four Faces* of 1955 (**fig. 17.16**) makes the idea of visual focus the subject of a deadpan joke; the target so insistently focusing our sight has no significance. Meaning remains neutral, as does hue: the corners of the canvas are as saturated as the heart of the painting. The result is to undermine the hierarchies of vision that had shaped painting as a practice, in which greatest attention goes toward the center. Abstract Expressionism had already undermined these hierarchies. Johns does so while painting concrete objects. The bull's eye corresponds to the vanishing point of a perspectival space. While referring to the Renaissance conception of space, Johns's artwork delivers not the illusion of space but a blankness onto which we project our own meanings. The human face, around which so much of the humanist tradition of European art was centered, is offered but thwarted: the eyes, seat of the soul, are cut off; and the hinged lid that stands above, once dropped into place, will hide these faces in their four compartments. That contraption suggests a play on identity as well, both revealed and obscured. Newspaper print is visible beneath the paint surface but not legible. The faces convey

17.16 JASPER JOHNS, *Target with Four Faces*, 1955. Encaustic on newspaper and cloth over canvas surmounted by four tinted-plaster faces in wooden box with hinged front, overall with box open: 33⅝ × 26 × 3 in (85.3 × 66 × 7.6 cm); canvas: 26 × 26 in (66 × 66 cm); box closed 3¾ × 26 × 3½ in (9.5 × 66 × 8.9 cm). Museum of Modern Art, New York. Gift of Mr. and Mrs. Robert C. Scull.

no expression or emotion. Everywhere, Johns thwarts communication. In its place he offers only mute witness.

Johns's surfaces are beautifully textured and layered. His medium was encaustic, in which pigment is dissolved into hot wax. Lacking fluidity, it is the very opposite of Pollock's poured enamel housepaints. In its imperfection and its varying densities, its rough surface, and its laborious application, it represented a rebellion against the exhausted language of spontaneity associated with Abstract Expressionism. Johns's aesthetic refinement is worlds away from Pollock's tumultuous energies. And, in another departure from Abstract Expressionism, idea precedes execution, rather than evolving in tandem with the act of painting itself. A friend reported that Johns would sit for hours in his studio, thinking.

He would not begin painting until the work was fully formed in his mind. Unlike the older New York School painters, process was unimportant. The idea that painting could be a primarily intellectual act was a revelation for artists younger than Johns. For painter Ed Ruscha, seeing *Target with Four Faces* "was the atomic bomb of my education."[12]

Johns's early work also engaged in questioning the picture plane, around which so much experimentation had been focused ever since Cubism. He repeatedly chose subjects in which the image and the thing were one and the same. Two-dimensional flags (**fig. 17.15**), targets, and letters, painted onto canvas, were precisely what they resembled: the thing itself. Johns's flags place a familiar object in a new context, emptied of emotional associations. Choosing to paint flat objects, Johns also obliterated the hierarchy of background and foreground in one further assault on illusionism. Representation and reality, form and content, collapsed into one. Johns's work replaces realism with the thing itself.

**ROBERT RAUSCHENBERG.** Beginning in 1949, and with calculated naïveté, another young artist, Robert Rauschenberg (b. 1925), experimented with what went into making a painting. Why not attach a man's tie to the canvas, or a can of paint? Why wasn't dirt as beautiful as gilt paint? From 1954, in a series of works he called "Combines" (which combined painting and sculpture), Rauschenberg amplified the collage tradition in twentieth-century art by literally incorporating life into his work, in the form of ladders, quilts, clock faces, and a menagerie of animals—from stuffed hens and birds of prey to an Angora goat, belted by a rubber tire. His use of these found objects, and various other kinds of junk, anticipated the "Assemblage" art of the 1960s.

*Bed* of 1955 (**fig. 17.17**) was made, according to Rauschenberg, with a bed quilt given to him by a friend while at Black Mountain because he had no other materials to paint on, and he was broke.[13] Onto the quilt Rauschenberg dripped and slathered paint, an act associated by critics with the violence of everything from an ax murder to a rape. Rauschenberg's interest here, however, is in paint, which flows and drips and spatters, conveying the messiness of life as the realm of the artist. As art historian Leo Steinberg has pointed out, *Bed* takes as its subject an object most insistently associated with life. Here—the place of dreams, of love, of conception—is unpredictability, randomness, disorder. By simply inflecting a horizontal surface (the bed we lie upon) into a vertical surface situated against a wall, Rauschenberg recasts it as art in an act of naming and recontextualization.

17.17 ROBERT RAUSCHENBERG, *Bed*, 1955. Combine painting, oil and pencil on pillow, quilt, and sheet, mounted on wood, 6 ft 3¼ in × 2 ft 7¼ in × 6 ft ⅛ in (191.1 × 80 × 16.5 cm). Museum of Modern Art, New York. Gift of Leo Castelli, 1989.

*Bed* may also be a playful jibe at the modernist concerns of his teacher at Black Mountain College in North Carolina, Josef Albers (1888–1976). Albers had devoted years to a series of paintings known as the *Homage to the Square* (**fig. 17.18**), begun in 1950, five years prior to Rauschenberg's work. Squares of the same color are surrounded by concentric squares of other hues in a meticulous study of color interaction. Albers had emigrated to the United States from the German Bauhaus, a bastion of uncompromising modernism. Albers's experimentation with color screened out all extraneous elements.

In its own vernacular, the quilt in *Bed* is also an homage to the square, a variant on a traditional pattern known as "log cabin." Each square is surrounded by a border altering—in the manner of Albers—our perception of its scale and tone. In using a quilt as its point of departure, *Bed* wittily reasserts the priority of everyday life over the modernism of Albers, which drew precise boundaries between life and art. As Rauschenberg said later, "Albers's rule was to make order, but I only consider myself successful when I do something that resembles the lack of order I sense."[14]

Rauschenberg's aesthetic ran parallel to that of John Cage (who called their friendship a matter of "understanding

17.19 ROBERT RAUSCHENBERG, *White Paintings* installation shot from *Robert Rauschenberg Paintings and Sculpture* exhibition, Stable Gallery, New York, 1953.

at first sight").[15] Rauschenberg had met the composer, who was older, in 1951. Cage's Zen-influenced aesthetic of emptiness was directed at tossing out the clutter of associations, memory, emotionalism, and received ideas about beauty in order to clear a mental and creative space where things could occur without the directing will of the artist. The principles of chance and random variation now took the place of aesthetic influence and creative will. Beginning in 1951, Rauschenberg did a series of monochromatic white paintings (**fig. 17.19**), radically purging his art of subject matter, gestural action, or emotional content, all of which were so central to the Expressionist avant-garde when Rauschenberg arrived in New York in 1949 as a young man. Looking at these white paintings one saw only shadows, drifting like random thoughts. Letting go of any control over the meaning of the work, Rauschenberg allowed for an unstructured experience open to events. Lacking was the sense of art as a projection of personality. Once the artwork is no longer an expression of the artist himself, what becomes important is the viewer's presence, which animates the work and becomes its content.

Rauschenberg's early work also explored new ways of making images that removed the hand of the artist. In 1953 he did this quite literally, by erasing a drawing by his friend and colleague Willem de Kooning. He then presented it as

17.18 JOSEF ALBERS, *Apparition*, from *Homage to the Square* series, 1959. Oil on masonite, 47½ × 47½ in (120.7 × 120.7 cm). Solomon R. Guggenheim Museum, New York.

a work of art in its own right. Ironically, it would become the most famous of de Kooning's drawings. Predictably, it does not reproduce well. *Erased de Kooning Drawing* symbolically acts out Rauschenberg's neutralization of art grounded in technique, style, and the aesthetic object. He chose de Kooning because, as he put it later, "his work was definitely art."[16] Rauschenberg's *Automobile Tire Print*, a collaboration with John Cage in 1953, was a scroll-like strip of paper 264 inches long, across which an inked auto tire has been driven. Like Johns, Rauschenberg understood that any form or meaning imposed by the artist was a foreclosure of experience itself. The two artists, only years removed from World War II and working on the cusp of a radically new understanding of artmaking, shared a principled indifference to art forms which insist upon specific content. In their apolitical stance, they introduced a new kind of political content.

# Photography: From Photojournalism to the Eccentric Eye

Photohistorian Peter Galassi notes a shift in the "standard of realism" from the static poised images of documentary photography of the 1930s to the blurred, grainy images "caught on the run" with hand-held cameras that would come to characterize post-war photographic practice.[17] Exchanging their unwieldy box cameras for nimble 35 mm cameras—Leicas were special favorites—photographers turned the documentary urge of the 1930s to an expanded field: the horrors of the Nazi death camps when first revealed by the camera of Margaret Bourke-White; the mushroom cloud of atomic detonation; the image of an American GI holding a naked baby found in the jungles of Saipan, an island in the Pacific. In the process they disseminated to a mass readership an image of cultural and national unity, grounding collective experience in the stories of individual Americans. **Photojournalism** crossed lines of region and class, and, occasionally, of color; most often, however, it assumed the sympathies of white middle-class America. Unlike photojournalists, who used photography as a means to an end, the New York School of photographers experimented with the medium itself. Their often idiosyncratic vision was best served in book-length collections that examined a darker vision of America beneath the bland appearances of prosperity, security, and comfort.

## Photojournalism

The term photojournalism refers to an institutional context—mass circulation newspapers and magazines—rather than a particular style; it rose to pre-eminence in the 1940s and 1950s in several different forms. The term even encompasses the sensationalistic tabloid style best exemplified by Arthur Fellig, known as Weegee (1899–1968) (**fig. 17.20**), whose photography explored the bizarre extremes of human behavior, exploiting the voyeur in all of us. An ace New York City crime scene photographer, Weegee reveled in such scenes as mobsters shot dead in the streets and the leering faces of onlookers, shot at point-blank range.

Following a narrative model, American photojournalism told stories through images, expanding beyond the possibility of the single frame to two-page spreads featuring unposed shots of people and current events, accompanied by a text that firmly grounded the meanings of the images in a narrative structure. Already well established in German illustrated newspapers since the 1920s, photojournalism got its start in the United States in 1934 with the appearance of *Life Magazine*, fueled by the prewar emigration of European photographers such as Albert Eisenstadt (1898–1995) and Henri Cartier-Bresson (1908–2004). *Life Magazine* opened its first issue with a promise to readers: "to see the world, to eyewitness great events ... to see strange things—machines, armies, multitudes, shadows in the jungle and the moon."[18] During the war years, as one American recalled, "*Life* came every week to deliver

17.20 WEEGEE (ARTHUR FELLIG), *Brooklyn School Children See Gambler Murdered in Street (Their First Murder, 9 October 1941)*, 1941. Gelatin silver print, 10⁵⁄₁₆ × 13³⁄₁₆ (26.2 × 33.5 cm). Museum of Modern Art, New York.

the war to our doorstep and replenish our fear."[19] In the post-war years, the photojournalism of *Life Magazine* disseminated an image of cultural and national unity, grounding collective experience in the stories of individual Americans.

It is hard for us today to appreciate the impact of weekly magazines. Their advertisements, glamor shots, and fashion photography served up images of youth, beauty, and affluence, enticing consumers to pursue manufactured visions of the good life. They commandeered the way Americans imagined distant lands, bringing images from the far corners of the world into the living room. Photojournalism vastly expanded the power of the photograph. Though many have ceased to believe that photography "holds a mirror to the world," its "truth value" as witness to history is still uniquely compelling.

**ROBERT CAPA.** The force of photojournalism to shape our memory of history was expressed with extraordinary immediacy in the war photography of Robert Capa (1913–54) (**fig. 17.21**). Shot at the precise meeting point of life and death, Capa's war photographs established a new level of heroic veracity for photojournalism. At their best, his images erase the presence of the photographer in the face of the event itself; a fiction, but one that furnished an unparalleled testimonial to the power of photography as a witness to life. Capa became one of four founding members of the Magnum Photo Agency, a collective of photojournalists including Henri Cartier-Bresson, who worked independently and beyond the control of syndicated news. Keeping control of their negatives, they were free to distribute them as they wished, retaining rights of ownership to their photography.

**EUGENE SMITH.** Smith (1918–78), photographer for *Life*, used the emerging genre of photojournalism with an intense sense of moral mission (**fig. 17.22**). His caption for "Nurse Midwife: North Carolina, 1951" reads: "This essay on the nurse midwife, Maude Callen, is, in many ways, the most rewarding experience photography has allowed me … she is probably the greatest person I have been privileged to know. … She is, to me, near the pure ideal of what a life of affirmative contribution can be." The photojournalism of *Life* presumed a close identification between viewer and subject through informality, subjective immediacy, and transparency—the quality that encouraged audiences to connect directly with the reality represented in the image.

***THE FAMILY OF MAN.*** In 1947 Edward Steichen (1879–1973) became director of the Photography Department at the Museum of Modern Art. There, in 1955, he curated one of the most popular exhibitions in the history of photography.

17.21 ROBERT CAPA, *The Death of a Loyalist Militiaman, near Cerro Muriano (Cordoba front)*, c. September 5, 1936. Photograph.

Drawing away from what he felt were the self-involved aesthetic concerns of art photography, Steichen came to see photography as a democratic form capable of molding public attitudes. His *The Family of Man* exhibition (**fig. 17.23**) was a fitting conclusion to a distinguished career that spanned fine art, commercial, and public forms of photography. *The Family of Man*, an extended photo essay on the commonalties that draw the human family together across lines of race, geography, poverty, development and under-development, toured over thirty countries and was seen by some nine million visitors. The 503 images in the exhibition were chosen from thousands submitted. The individual personalities of the photographers—273 in all from around the world, including the leading figures of these decades, from Ansel Adams (1902–84) to Henri Cartier-Bresson—were lost in the insistent theme of universality, which downplayed cultural differences and structural inequalities between rich and poor nations in favor of a humanist message of harmony and cooperation. The culminating image of the exhibition was that of a mushroom cloud, clearly identifying the common threat facing the nations of the world.

Favoring the message over the maker, *The Family of Man* put photography firmly in the service of a mass public audience. Its accessible meanings and insistence on photographic transparency—reading through the image to the reality it represents—took shape against the practice of photography as a fine art with its own arcane formalist concerns. And like Abstract Expressionism in the service of international diplomacy, *The Family of Man* assembled

17.22 (above) W. EUGENE SMITH, *Nurse Midwife*, from *Life* Magazine, no. 31, pp. 134–45, December 3, 1951. Gelatin silver print, 10 ⁵⁄₁₆ × 13 ⁵⁄₁₆ in (26.2 × 33.5 cm).

17.23 EZRA STOLLER, Family portraits from *The Family of Man* exhibition, 1955. Photograph.

the nations and peoples of the world under the umbrella of the United States Information Agency, the public relations branch of the government responsible for encouraging international goodwill toward the United States.

## The "New York School" of Photographers

Another area of post-war photography, however, departed dramatically from the style and assumptions that informed photojournalism. A group of photographers working in New York explored the medium itself in a way that paralleled developments in painting. These photographers, who included William Klein (b. 1928), Diane Arbus (1923–71), Weegee, Richard Avedon (1923–2004), Ted Croner (1922–2005), Lisette Model (1901–83), Bruce Davidson (b. 1933), and Robert Frank (b. 1924), were linked by a shared aesthetic and subject matter. They exploited a number of new effects previously avoided by fine art and documentary photographers: blurring, light flares, halation (the halo resulting from shooting toward light sources), and graininess. Photographers such as William Klein and Bruce Davidson produced pictures in which context was often lacking, focus blurred, and figures isolated or oblivious to one another. Giving up tight control over lighting, capturing motion, and incorporating the limitations of the camera into their aesthetic, these photographers favored an improvisational, uncrafted look for capturing the private urban worlds and underworlds of New York in the 1950s. Disregarding photographic finish, they emphasized process and threw off the fiction of objectivity by inserting their presence through hand-held cameras: reality can only be known through an individual sensibility. The influential curator of photography, John Szarkowski, at the Museum of Modern Art wrote that the aim of the younger photographers "has not been to reform life, but to know it. Their work betrays a sympathy—almost an affection—for the imperfections and the frailties of society."[20] This new breed of 1950s photographers was in revolt against the readability and coherence of mainstream photojournalism. In place of the human bonds uniting Steichen's *Family of Man*, their work conveys a sense of social fragmentation and urban alienation. The focus was often on the grotesque or absurd, the strange deformities of mass society. And yet their images speak to basic human promptings—the search for companionship and beauty, the desire for love, the craving for recognition, and voyeurism—expressed in uncanny moments that jolt us and disturb our notions of propriety.

**DIANE ARBUS.** Arbus (**fig. 17.24**), the youngest of the New York school, continued a tradition of what historian

17.24 STEPHEN FRANK, Diane Arbus with *Child with a Toy Hand Grenade in Central Park, New York City*, 1970.

Christopher Phillips has called the "social fantastic"—drawn to human eccentricity, to urban subcultures such as female impersonators, and exhibiting an immense range of human behavior, a tradition traceable to such European photographers as André Kertész (1894–1985) and Brassaï (1899–1984). Yet, coming of age in the repressive conformism of 1950s society, Arbus's nonjudgmental approach established an influential new vocabulary. Arbus took the singular and the odd as a measure of the human, approaching photography as—in her words—a form of "contemporary anthropology."[21] Unlike her colleagues, Arbus's mature work (beginning in 1962) was carefully posed, often shot at close range, and involved an intimate exchange with the subject. Her work, like others of this generation, embraced the intersubjective nature of photography—that is, how the presence of the photographer transformed the subject itself. *Child with a Toy Hand Grenade in Central Park, New York City*, posed but uncropped, captures a moment of sudden revelatory encounter between the boy and Arbus. Here, self-absorbed play stops and communication takes over, a communication expressed in the odd details of crabbed left hand, cocked head and grimace, and dropped suspender strap. The image, while funny, compels us to acknowledge this small inconsequential actor.

**ROBERT FRANK.** The New York School included several European émigrés; among the best-known of the group was a young Swiss photographer named Robert Frank (b. 1924) who had arrived in 1947, one of a long line of

European travelers to cast a curious, probing eye on the United States. Like others before him he studied the nation for a glimpse—often disturbing—of Europe's future. On a road trip across the country, funded by the Guggenheim Foundation, Frank shot 687 rolls of film, training his Leica camera at the nation's bars, diners, parks, roadside motels, dreary small towns, big city scenes, Hollywood glamor and media culture, black funerals and segregated buses; Americans driving, eating, loving, gathering, dying in a regional and social cross-section of the country. The result was *The Americans* (American edition 1959), the best-known of a series of photographic books from this decade.

It is hard today to grasp just how shocking a book it was. Like Walker Evans (1903–75), a big influence on the young photographer, Frank found his subject in the emptiness of the American landscape. Frank, like Evans, wanted his photographs shown without text; both artists thought hard about the sequence of images. Frank's Leica camera meant smaller-format shots; he gave up control over lighting as well. Frank's photography was sometimes blurry and unevenly exposed, retaining what earlier photographers would have considered technical flaws. He embraced the uncontrolled and accidental. His framing is frequently tilted or arbitrary. His human subjects, pushed to the margins, look away from the camera, or are otherwise obscured. The jukebox, which appears in several shots, seems a symbol of elusive community, occupying an empty space while promising companionship. Compiled in book form, Frank's images produce their meaning cumulatively. His photographic style declared, rather than seeking

to disguise, his own presence in the photograph, and with it his subjective vision of the world.

Frank's anti-aesthetic style would be linked with the anti-establishment stance of the Beat artists and poets among whom he found sympathetic collaborators. He stripped his chronicle of the bland reassurances often projected by photojournalism, and his road trip exposed a rootless society of spiritual nomads. Like the Beats, he looked for authenticity within the minority fringes of American life—African Americans worshiping at the river's edge, or confronting the photographer with expressions of pain that contrast sharply with the masklike stares of those better off. Like other European travelers before him, Frank had a sharp eye for the hypocrisies of American claims to equality in a time of segregation.

## Post-war Design and the Domestication of Modernism

In another sector of American culture, far removed from the edginess of the 1950s avant-garde, were designers and architects who combined a new sophistication and confidence with international influences, using new manufacturing techniques and materials. In the decades after World War II, the redesign of the everyday living environment emerged as a central undertaking for this generation of designers. Good design was no longer merely for the elite.

17.25 Installation view of furniture by Charles Eames and Eero Saarinen from *Organic Design in Home Furnishings* exhibition, Museum of Modern Art, New York, 1941. Museum of Modern Art, New York.

Beauty, convenience, and comfort were now to be within the reach of ordinary Americans, including returning veterans and their young families. As with streamlining—the style of the years between the wars—the movement for good design profited from the presence of European talent. Two furniture companies in particular—Herman Miller and Knoll Associates—worked closely with modernist designers such as the Americans Charles Eames (1907–78) and George Nelson (1908–86), Finnish architect Alvar Aalto (1898–1976), and émigré German architect Mies van der Rohe (1886–1969), to produce and distribute innovative furniture. In collaboration with museums and department stores, post-war designers marketed modernism to the masses. The good design movement of the post-war years turned away from streamlined forms suggesting speed-driven frictionless modernity, preferring instead organic shapes emphasizing comfort and functionality. Biomorphic design, evoking nature and the body, helped consumers feel at ease in the increasingly artificial environments of air travel, and corporate and suburban spaces. In architecture and product design, organic forms, soft contours, and molded spaces vied with the impersonal appeal of stark "International Style" modernism in giving a new image to post-war America.

## Museums and the Marketing of "Good Design"

Continuing a marketing trend established in the 1920s, American museums took the lead in educating consumers about good design. In such exhibits as the Museum of Modern Art's "Useful Objects," which offered products ranging in price from 25 cents to 25 dollars in 1946, and its "Good Design" program between 1950 and 1954 (**fig. 17.25**), or the Walker Art Center's Everyday Art Gallery, in Minneapolis, featuring bowls, ceramics, radios, and household appliances, fine arts institutions around the nation encouraged high-quality industrial and product design.

17.26 NORMAN ROCKWELL, *Easter Morning*, 1959. Oil on canvas, 53 × 49 in (134.6 × 124.4 cm). Private collection.

# Communities of Taste

LIKE OTHER CONSUMER PRODUCTS, one's choice of everyday design came to denote a great deal about one's educational level, living preferences, and social networks. In the 1950s post-war tract developments of single-family homes with lawns and small children, the furniture of choice was stuffed, padded, and upholstered. More sophisticated consumers (those who may have also listened to jazz and traveled to Europe) chose Scandinavian modern. Scandinavian proved to be an acceptable middle-of-the-road form of modernist design for many: well made, with accommodatingly soft contours and the comforting familiarity of wood, Scandinavian furniture introduced a new level of unornamented simplicity and harmonious lines that combined machine manufacture with handcrafted forms. Textiles, ceramics, and glassware expanded on the Scandinavian aesthetic.

Taste in the mid-century United States was precisely calibrated to one's social class, as this staged photograph suggests (**fig. 17.27**). The social stratification of "high brows," "middle brows," and "low brows" was given material expression through product design. The ostensibly classless nature of American society paradoxically produced class anxieties: the more one insisted on the absence of social distinctions based on equal access to opportunity, the more they came in through the back door of design and material life. Apart from the big divide between modern and traditional, the modern itself was a rather complicated affair. One observer identified ten different types of modern design in American everyday living, among them "Unrelenting Modern" (Bauhaus); "Nostalgic Modern" (streamlined); Floradora Modern (glitzy glamorous Hollywood, identified with the work of the well-known designer Elsie de Wolfe, 1865?–1950); and Jukebox Modern (self-explanatory).[22] Bridging these stylistic distinctions was a common concern with style as an indicator of one's particular social identity, self-image, and placement within American life.

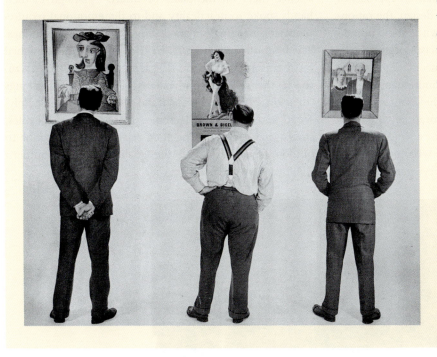

17.27 **HERBERT GEHR**, *High-brow, Low-brow, Middle-brow* from *Life* Magazine, April 11, 1949.

The museum expanded its educational mission to the middle class, and from the fine arts to domestic living. As American industry shifted from wartime to peacetime production, museums teamed up with industries, designers, and retailers to "domesticate" modernism: Norman Rockwell's young husband escapes church by reading the paper in Eero Saarinen's Womb Chair, as the newest in mid-century modern is comfortably accommodated in suburban domesticity (**fig. 17.26**). As the corporate "hidden persuaders" gained a hold over consumers through the allure of advertising, advocates of good design saw their mission as instructing middle-class families about how to live. Often they adopted the same strategies as corporate business. The Museum of Modern Art used the techniques associated with mass marketing—consumer surveys, TV and magazine advertising, and public education through panel discussions—to make good design widely accessible. As with so many other aspects of Cold War culture, design was recruited in the cause of a morally fortified nation, unified around core principles: good taste made good citizens.

## Charles and Ray Eames

From airport waiting areas, to university classrooms, to family dens, the designs of Charles and Ray (1912–88) Eames have enjoyed a deep presence in our everyday visual environment throughout the second half of the twentieth century. As a husband and wife team their careers wove together the best aspects of European modernist design—a commitment to affordable, functional, and aesthetically sensitive objects for everyday living—with an enthusiasm for new materials (plastic, fiberglass, molded plywood, and polyester resin), and an inventive approach to mass production that characterized post-war America (**fig. 17.28**). Buoyed by confidence in the applications of science and industry to solving quality-of-life issues for middle-class Americans, the Eameses offered a vital example of how to humanize environments shaped by mass production and standardization.

Their melding of European and American approaches also integrated two streams of modern design: the rationalist machine aesthetic associated with standardized production, and the biomorphic organicism of soft yielding shapes. Driven by the emerging science of ergonomics, these designs considered how to accommodate human bodies to machined objects. One of the Eameses' most ubiquitous chair designs, done in collaboration with architect Eero Saarinen (1910–61), consisted of a single molded plastic seat that could be combined with other parts in a wide variety of permutations. Varying a few basic elements—materials (molded plastic, wire mesh, and padded upholstery), color (orange, green, blue, black, and yellow), and base (pedestal, rocker, swivel, and wire strut)—the Eameses furnished a reliable standardized form with customized features, in a manner similar to earlier inventive American designers like Hunzinger (see fig. 10.27). Their exuberant personal style, friendly designs, and marketing sophistication made modernism accessible to millions of middle-class Americans. During wartime, they developed leg splints and litters for the Navy out of molded laminated bentwood, in which industrial methods were combined with a technique for bending thin layers of wood that had its counterpart in bentwood containers made in Native Alaskan and Northwest Coast cultures (see fig. 7.30). After the war, they perfected their methods to mass-produce the distinctive plywood "Eames Chair." As one admirer wrote, they produced "organic abstractions in which esthetics and science meet on the plane of utility."[23] Design in their hands spoke to practicality and to the emotional requirements for meaningful connection with the world of things. The interior of the home Charles and Ray Eames designed for themselves in Pacific Palisades, California (**fig. 17.29**) shows the relaxed combination of modern furnishings (their own 1956 lounge chair and ottoman of molded plywood and leather) and ethnic artifacts—masks, textiles, stools, and carvings. The fluid relationship of indoor to outdoor space exploited the qualities of the southern California environment.

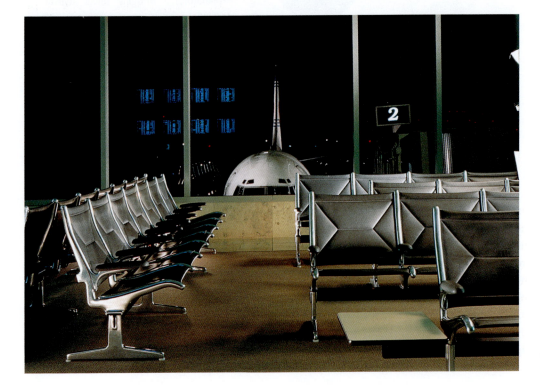

17.28 CHARLES & RAY EAMES, *Tandem Sling Seating*, 1962, John Wayne Airport, Orange County, California, 1993.

## Machines to Bodies: Biomorphic Design

Machine Age design between the two world wars took its inspiration from the precise, interchangeable, repetitive forms of machine production; design in the years following World War II increasingly emphasized wholeness, integrity, and organic unity. This turn to the "biomorphic" crossed the design arts to take in architecture, offering an alternative to the sleek glass and steel modernism that increasingly defined corporate culture.[24] Artists such as the sculptor Isamu Noguchi (1904–88) (**fig. 17.30**) and architects such as Noguchi also turned to furniture design. Saarinen's Womb Chair (see fig. 17.26), manufactured by Knoll, employed a fiberglass shell over bent steel rods with other biomorphic shapes in Saarinen's furniture, compound curves (curves, that is, in multiple planes). laplike welcome of the Womb Chair carried a ready appeal for consumers who admired the combination of up to date industrial materials with yielding forms and reassuring references to the human body

Like streamlining in the 1930s, post-war biomorphic design developed into a style independent of function. It was applied to everything from kitchenware to casinos, from textiles to ceramics, glassware, and furniture, and from architectural interiors to the kidney-shaped pool in the backyard. It reached across media and across the economic and taste spectrum. It brought the night-time fantasies and whimsical psychic landscapes of the Surrealists—in particular the biomorphic shapes of Jean Arp (1886–1966), Paul Klee (1879–1940), and Max Ernst (1891–1976)—into the light of an American suburban morning. Designer Eva Zeisel compared the melting forms of 1940s tables, containers, and other household objects to the

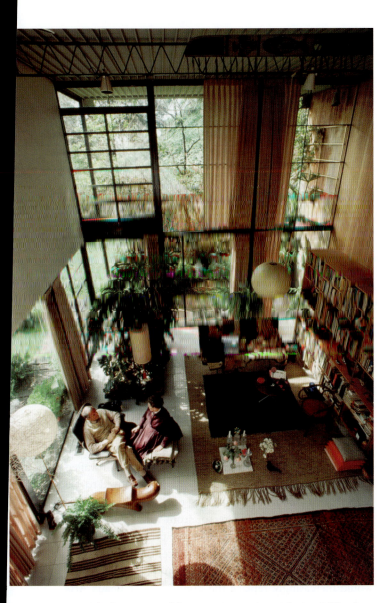

17.29  The living room of the Eames House, Santa Monica, California, 1992. Lucia Eames Demetrios and Shelley Mills.

Women were among the major figures of post-war American design. Ray Eames, though overshadowed by her husband Charles, has recently been restored to her proper place as an innovator. Florence Knoll (b. 1917) established one of the leading design firms of these years, Knoll International, with her husband, and went on to transform the look of the American corporate office with sleek upholstered chairs and sofas that combined European modernist influences with American comfort. Annie Albers (1899–1994) and Eva Zeisel (b. 1906) made important contributions to textile and ceramic design. Yet hierarchies remained. Architecture was a difficult profession for women to enter in the 1950s; they instead directed their talents into textiles, ceramics, and other "minor" arts.

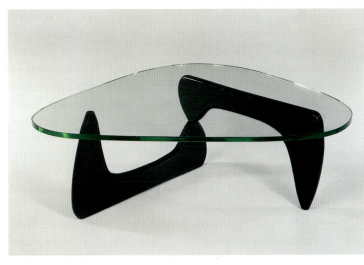

17.30  **ISAMU NOGUCHI**, *Lounge Table*, 1944. Glass and oiled walnut cabinet, 15¾ × 50 × 36 in (40 × 127 × 91.4 cm).

disturbingly fluid shapes of Surrealist painter Salvador Dalí, suggesting metamorphosis, mutation, and transformation.[25] Like the organic abstraction of the early twentieth century, biomorphism represented a return to nature as a realm distinct from the technological, a flight from the hard-edged, the machined, and the geometric. It returned the post-war consumer back to the curving, welcoming shapes of the maternal body.

Unlike that earlier organic abstraction, however, the "vital forms" of these decades were shaped by a knowledge of nuclear science and atomic radiation. Embedded in these fluid shapes were echoes of another kind of transformation: genetic mutation. Fantasies of mutating life forms found expression in popular film, venting widely felt anxieties about the impact of radiation. Invoking a life energy running through matter, biomorphic objects threatened to exceed boundaries and defy containment— to seep, like the amoeboid body snatchers and monsters of B-grade horror films, into the cells of wholesome Americans. Like the atom, the life force expressed in biomorphic design served widely varied cultural fantasies and anxieties.

## The International Style: Architecture as Icon

In 1932 the Museum of Modern Art opened an influential exhibition of modernist architecture curated by Henry Russell Hitchcock (1903–87), a historian, and a young Harvard-trained architectural enthusiast, Philip Johnson (1906–2005). Called "The International Style: Architecture since 1922," the survey included some fifteen different Western nations, and some forty architects. Hitchcock and Johnson's selection revealed a unifying style: "a modern style as original, as consistent, and as logical, … as any in the past."[26] The 1932 exhibition codified a series of developments in architecture of the 1920s. These included an emphasis on volume over mass: the walls, freed from their load-bearing function by the steel skeleton or cage, could become membranes containing space. Asymmetry and modularity, the expression of standardized parts or building units, now replaced classical and static symmetry. Applied decoration was banished; natural colors were preferred to applied colors. Any form of whimsy or personal idiosyncrasy was decried.

In the decades between the wars, **International Style modernism** developed away from the tight prescriptions of the style as it was put on view at the Museum of Modern Art. Ironically, the principles codified by the 1932 exhibition at the Modern would become a "style" self-consciously emulated rather than emerging out of experimentation and innovation. The **Modern Movement** would come to include independents such as Frank Lloyd Wright, who did not conform to the tenets of the International Style but who, nonetheless, influenced such key figures as Mies van der Rohe and Walter Gropius. Other tendencies emerged in modern American architecture in the years following 1932, including regional influences, local non-industrial materials, and a more sculptural treatment of space. The term "International Style," however, would remain in circulation, though primarily in reference to the steel and transparent glass curtain-wall monoliths of corporations. During the 1950s, the "International Style" acquired the aura of prestige associated with wealth and sophisticated taste.

### MIES VAN DER ROHE AND THE CORPORATE BUILDING.

The highly rationalized glass and steel language of the transparent skyscraper, originating in unbuilt visionary schemes by Mies, Le Corbusier, and others in Europe in the 1920s, found a particularly hospitable home in the corporate America of the 1950s. The architect most responsible for the transatlantic migration of the glass skyscraper in the 1940s and 1950s was the émigré German Ludwig Mies van der Rohe. After working in Berlin in the 1910s, Mies had designed a handful of steel-framed, glass curtain-walled buildings in the 1920s and 1930s. In 1937 Mies moved to the United States following the closing of the Bauhaus, where he taught and served as director from 1930 to 1933. After World War II, and benefiting from the presence of former Bauhaus designers such as Mies, Marcel Breuer (1902–81), and Walter Gropius (1883–1969), modernist design principles would increasingly replace the dominance of Beaux Arts pedagogy in schools of architecture around the country, most notably in Chicago, when Mies became director of the Illinois Institute of Technology in 1938; and at the Graduate School of Design at Harvard, where Gropius became Chair of Architecture in 1937. The corporate patronage of the leading prewar figures of European architectural Modernism was perceived by many as a sign of American cultural ascendancy after World War II.

The classic expression of the glass and steel office building of the 1950s was Mies's Seagram Building (**fig. 17.31**). Towering over Park Avenue, a dark weighty monolith, the Seagram became the very image of corporate culture: sternly disciplined, self-contained, aloof yet powerful. A skin of bronze I-beam mullions and tinted bronze glass surrounds a steel cage; within, the column grid opens space for multiple and flexible uses. Yet a closer engagement with the building reveals a different side.

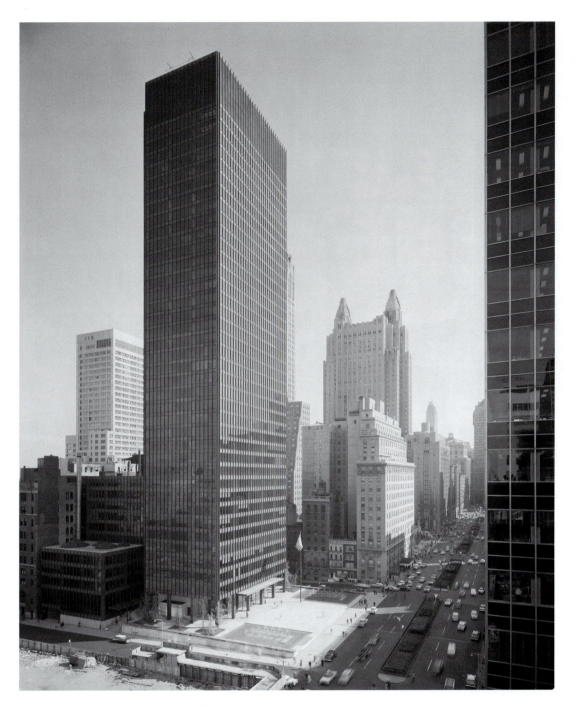

Architectural historian William Jordy has analyzed the humanism of the Seagram. Its 3:5 ratio of depth to width gives it a reassuring bulk; its colored glass and bronze façade works against a sense of weightless transparency often associated with the style. Thirty-eight stories high, the Seagram is set back 90 feet from the street, giving the pedestrian an opportunity to take its measure before entering. Within, the meticulous detailing of every aspect of the interior, from lighting to plumbing fixtures and door knobs, elevator cabs, and graphic design elements,

embodies the architect's rigorous attention to every part of the building. Classically proportioned, thoughtfully sited, and sensitively detailed, the Seagram belies charges that the International Style was impersonal and bureaucratic. However, its rationalism, no longer serving the utopian ideals of architectural modernism in the 1920s, now appeared to many as the architectural arm of corporate business.

Paul Cadmus's *The Architect* (**fig. 17.32**) is a disturbing tribute to this latter vision of the International Style.

17.32 PAUL CADMUS, *Architect*, 1950. Egg tempera on Masonite panel, 16 × 16 in (40.6 × 40.6 cm). Wadsworth Atheneum Museum of Art, Hartford, Connecticut. Gift of an anonymous donor.

Holding the T-square, the square-jawed young architect sits before a transparent cube, his head located at the vanishing point in a perspectival space formed by a series of gridded planes and buildings. A phantom-like muse hovers behind him, the only exception to the rigidly right-angled world of the painting. Cadmus captures the static Platonic perfection of the glass monolith. But he also captures the critique launched against it by those who felt it served an arid and inhuman vision of urban modernity. Architectural historian William Curtis sums up this current of thought: "The 'Modern Project' achieved something of a popular victory on American soil, but in the process lost something of its soul."[27]

## Organic Design: Architecture as Sculpture

For architects converted to the rigors of European modernism, the seductive curves and swelling ovoids of biomorphic design were highly suspect. They were associated with the feminine realm brought to excess in the 1950s infatuation with the breast, and associated with male dependence on the mother. Biomorphic design also carried the unwanted allure of advertising and commerce—like

the streamlined, it addressed consumer desire rather than abstract reason. Appropriate for the realms of post-war pleasure—resort hotels, lounges and bars, department stores, and suburban backyards—the biomorphic was considered a concession to popular taste, and banished from the corporate boardroom or from such spaces of elite culture as the Museum of Modern Art. Nevertheless, two exceptional projects by two exceptional architects realized the sculptural possibilities inherent in cast-in-place concrete on a monumental scale.

### FRANK LLOYD WRIGHT'S GUGGENHEIM MUSEUM.

In the tradition of organic design descending from Louis Sullivan, Frank Lloyd Wright (1867–1959) remained true to his organic principles until his death; indeed, his commitment to archetypal form found extraordinary expression in the final building of his career, the Solomon R. Guggenheim Museum (**figs. 17.33** and **17.34**). It took sixteen years to complete, years filled with doubts about the museum's viability as an exhibition space, as well as with outright ridicule. In 1956, the editors of the *New York Times* described the effect of the new building as that of "an oversized and indigestible hot cross bun."

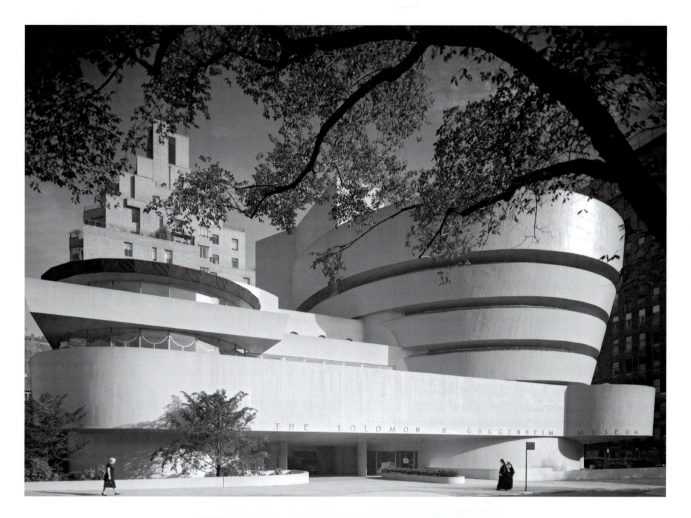

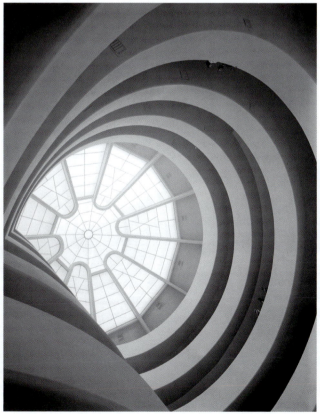

17.33 (above) **FRANK LLOYD WRIGHT**, Solomon R. Guggenheim Museum, New York, 1943–59. Photograph by Ezra Stoller.

17.34 **FRANK LLOYD WRIGHT**, Solomon R. Guggenheim Museum, view of oculus, New York, 1943–59. Photograph by Ezra Stoller.

Wright violated a number of received ideas in his design. The core of the building was an inverted spiral, a form he had used for earlier designs never built. The Guggenheim combined modern poured concrete with ancient forms like the ziggurat (stepped pyramid) of the ancient Near East. Like so many other aspects of the 1950s which brought together Western physics and Eastern philosophies, the Guggenheim expressed the new reality of energized space, as Wright put it himself, *"space* instead of matter," drawing an idea from the Chinese philosopher Lao Tze.[28] But this ziggurat with its ancient associations seemed ill-suited to the grid of Manhattan avenues and streets. Inside, it is expressed as an inclined ramp that circles upward, around and around toward the light-filled oculus. Primary exhibition space is located along the exterior curving walls, a design that provoked protests from artists and critics alike. Most agreed that however bold and effective Wright's building was as form, it did not serve its function particularly well. Despite the controversy, in 1959, the year it opened (and the year of Wright's death), five hundred leading architects ranked it in a survey as the eighteenth most important building in the United States.

Even if Wright's design did not serve the exhibition needs of the Guggenheim, it served the museum in other ways. By the 1950s, Wright was a figure of international renown, acknowledged as the nation's greatest living architect. And the Guggenheim, having begun as an elite private collection, was established as a powerful and memorable presence in Manhattan, drawing crowds into its dramatic spiraling interior. The instant notoriety of the new Guggenheim accounted, according to a survey undertaken soon after its opening, for 40 percent of the visitors who walked through its doors. Despite the conservative nature of Wright's ideas—individualistic in a time of expanding corporate presence in American life; inward-turning during a period when urban life was ever more shaped by mass media and consumerism—he nonetheless anticipated with uncanny accuracy what the public wanted in a museum of modern art. Modern art would come to be associated as much with the spectacle of movement, light, and space animated by people, as it would with the contemplation of the art on its walls. Through his signature building, Wright succeeded in creating an audience for modernism never dreamed of even by its most ardent proselytizers.

**EERO SAARINEN'S TWA TERMINAL.** For his design for a new TWA terminal at New York City's Idlewild (now JFK) Airport (**figs. 17.35** and **17.36**), Eero Saarinen (1910–61) chose an elegantly stylized organic form of cast concrete lobes

17.35 EERO SAARINEN, Trans World Airlines Terminal, JFK Airport, Queens, New York, 1956–62.

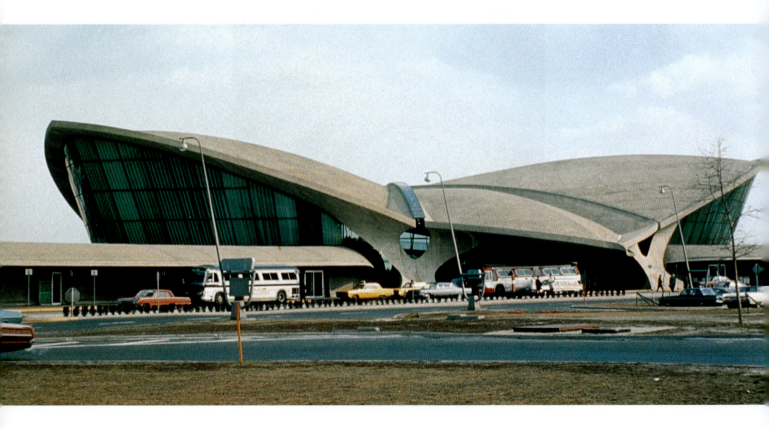

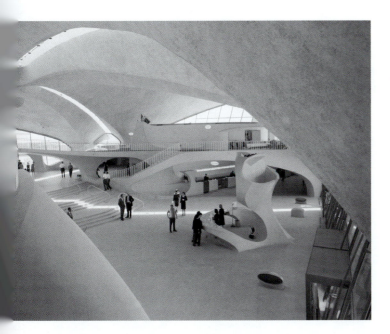

17.36 EERO SAARINEN, Trans World Airlines Terminal, interior view, JFK Airport, Queens, New York, 1956–62. Photograph by Ezro Stoller.

that billowed out in bold cantilevers, resembling a great bird in flight. Saarinen had begun his career studying sculpture, a sensibility dramatically apparent in his manner of designing the TWA Terminal. In these years the reigning traditions of architectural design derived from either the Paris Beaux Arts or from the German Bauhaus. In both traditions, space was conceived in two-dimensional representations: drawings on paper relaying the site plan of the building, the elevations of its façades, cross-sections of its inner workings, and details of its constituent elements. Orthogonal plans readily worked for right-angled buildings, or for forms that curved in only two dimensions (a curved wall for instance). Saarinen, on the other hand, developed his sculptural forms through models that realized the three-dimensional curving forms of his design. Only after this model phase did his office produce drawings—nearly six hundred—that translated the three-dimensional model back into two dimensions. Saarinen's working method and sculptural conception were altogether new.

The TWA Terminal was a resounding popular success, giving to the new industry of commercial flight—just entering its jet phase—a glamorous and dynamic stage through which passengers flowed in arcing movements that mirrored its sinuous spaces. The TWA Terminal served both those who used the building and its corporate patrons, offering to the first visual drama with subliminal appeal, and to the second a "signature" building markedly different from the glass cubicles of other airlines. Saarinen's design pushed the structural limits of cast concrete, implying technical mastery and aspiration, while creating a serene space where travelers could pause amidst the dynamic energies of modern travel.

# Conclusion

Stimulated since the 1930s by the steady flow of leading European modernist artists, designers, and photographers in flight from political repression and war, American art-making expanded in new directions from the 1940s. The "new American abstraction" brought international attention to an artistic culture many considered provincial up to that time. Contact with the mural art of Mexico, as well as the infusion of philosophic currents from Asia, and a deepening fascination with Native arts, also contributed. Not only did American culture assimilate and transform global influences, but Americans vigorously promoted themselves as the democracy that had stemmed the tide of European fascism, assisted materially in the post-war rebuilding of Europe, and now stood steadfast in the face of Communism. America's geopolitical ascendancy was accompanied by an art considered, for the first time, worthy of comparison to the art of Europe.

The period covered by the final two chapters of our book, 1960 to the present, witnessed an unraveling of the "official story" held tensely in place throughout the 1950s. The cultural dissent, ironic detachment, and claims to representation by groups marginalized by mainstream values, all present to a degree in the 1950s, emerged after 1960 to transform American arts once again. Official consensus culture appeared increasingly hollow as the moral authority of political elites was compromised by the Vietnam War, and by a spiritually arid technocratic culture. In the arts, this broadly skeptical atmosphere contributed to the development of new, self-reflexive artistic practices that questioned social myths, and that challenged the normative constructions of race, gender, and sexuality supposedly holding the nation together in the face of widening fractures.

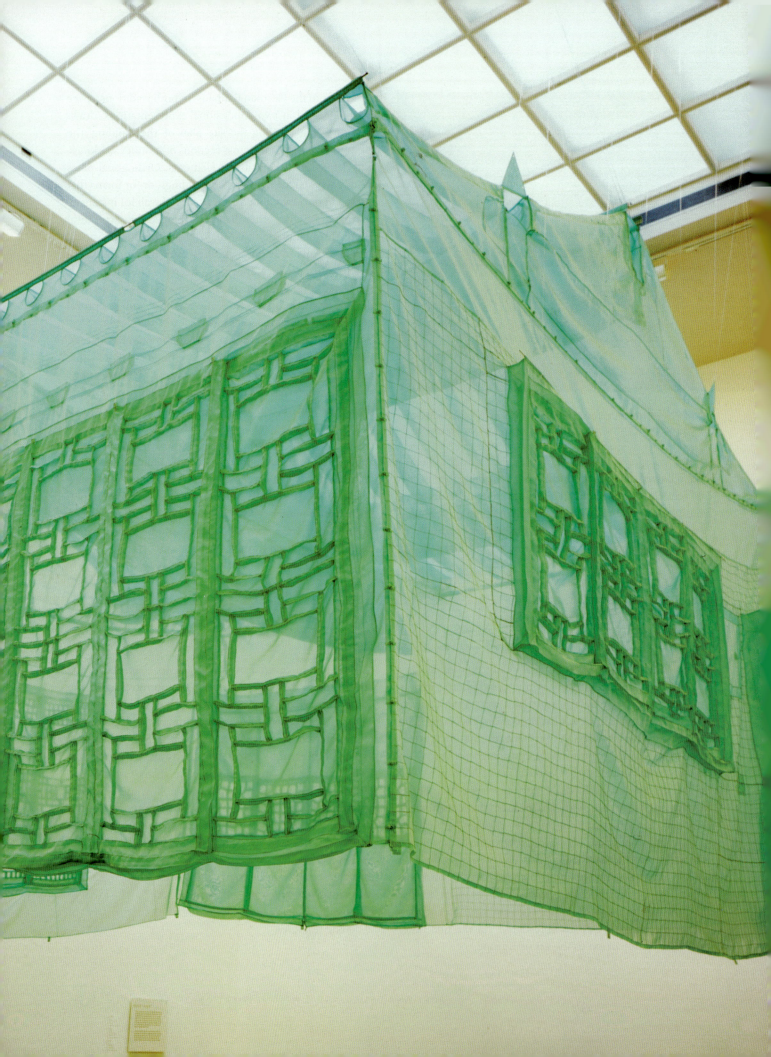

# The Sixties to the Present

AFTER 1960, as the Cold War wore on and the United States negotiated its new role as a global superpower, American society entered a period of cultural destabilization and divisive internal conflict. The antiwar movement, the Civil Rights movement, the feminist movement, and the environmental movement unraveled the consensus culture of the 1950s. The transition from an industrial to a post-industrial economy undermined economic hierarchies while displacing entire categories of labor. The pervasive reach of television and other mass media overturned traditional divisions between public and private space. With the fall of the Berlin Wall and the end of the Cold War in 1989, America entered a complex new era of multilateral geopolitics characterized by economic globalization and rapidly shifting foreign policy strategies. The scope and impact of these upheavals were not unprecedented in American history. But the active role of the arts in addressing them was indeed something new.

In the late twentieth century, art no longer simply represented the world but attempted instead to intervene in it. While Asher B. Durand had painted images of the American landscape, (see fig. 8.21), Robert Smithson confronted the landscape directly with bulldozers and dump trucks (see fig. 18.30). While Lilly Martin Spencer's paintings had commented on the position of women in the home (see fig. 6.1), a group of students in a Feminist Art Program in 1970 "commented" with hammers and wrenches, physically altering an existing building (see fig. 18.34). While Reginald Marsh pictured the city of New York as dazzled by spectacle and bombarded by advertising signage (see fig. 14.28), Jenny Holzer entered that urban space directly, flashing her own powerful messages from the largest advertising lightboard in Times Square (see fig. 19.5).

Projects like these signaled a historic collapse in the traditional distinctions between the "fine" and "applied" arts, the arts of contemplation and the arts of instrumental production. In the years after 1960, "fine art" became nearly inseparable from architecture, fashion, furniture, landscaping, advertising, genetic engineering, or product design. Collapsed as well were distinctions between the various traditional media—painting, sculpture, theater, etcetera—that up until this time had remained largely segregated in independent academic bastions.

The New York artist Do-Ho-Suh's *Seoul Home/ L.A. Home/New York Home/Baltimore Home/London Home/ Seattle Home* (1999–2002) on the opposite page exemplifies this new model of active, multimedia arts. A meticulously sewn, translucent silk replica of Suh's childhood home in Korea, the work is part sculpture, part architecture, part textile, part installation, and part performance. It is also part "American" and part international; as it travels throughout the world, it creates transnational encounters by triggering complex intersections of space and memory in every city visited. The title records the itinerary of its exhibition in each of the cities mentioned, marking its leaps across oceans and national boundaries. In doing so, Suh's *Home* explicitly engages the increasingly global context in which the arts in America are now produced and perceived. And it reminds us of the global networks that have always shaped American art. As we have seen throughout this book, the American "homeland" is a shifting and overlapping terrain.

(opposite) DO-HO SUH, *Seoul Home/L.A. Home/New York Home/ Baltimore Home/London Home/Seattle Home* (detail), 1999–2002. Silk, 12 ft 5 in x 20 ft x 20 ft (3.78 × 6 × 6 m). (See also fig. 19.24)

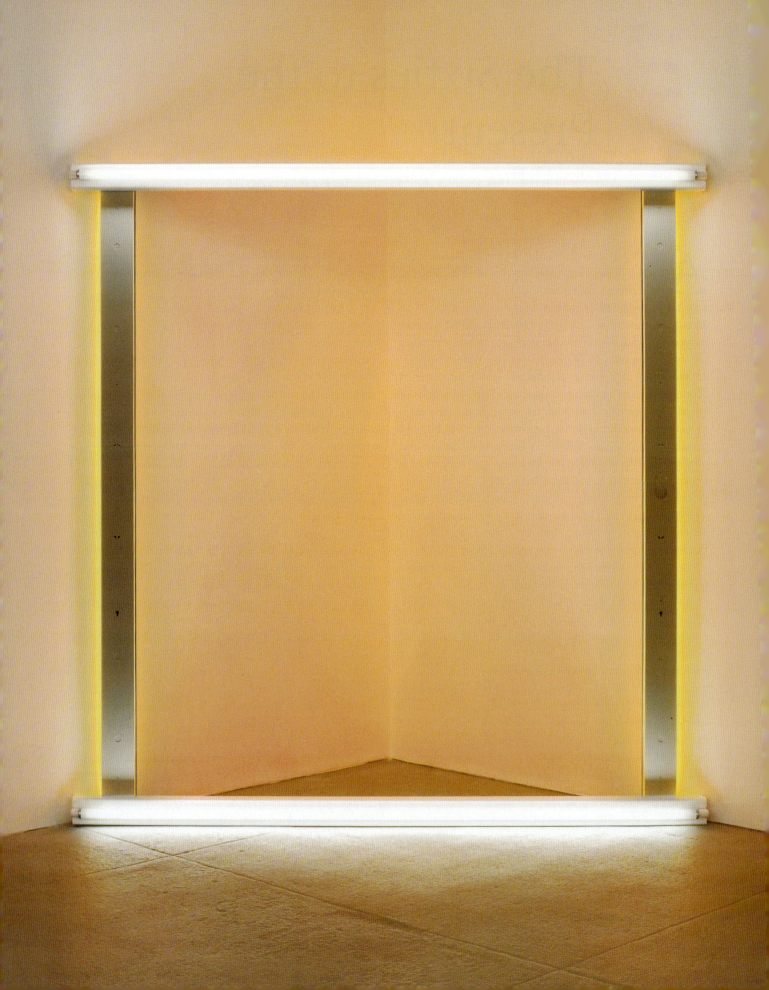

# 18 | Art into Life, 1960–1980

DURING THE 1960s and 1970s, new practices of artmaking emerged that overturned nearly every imaginable piety of art in Western modernity. Conventional conceptions of the artwork as a portable object for purchase, of the artist as creative, dexterous, and unique, of the museum as a timeless bastion of refinement, and of the viewer as a passive recipient of the artist's message, all came under scrutiny. This upheaval in the arts paralleled wide-ranging transformations in American society as a whole. Mass protests against racial prejudice, gender discrimination, environmental degradation, and military aggression brought these issues to the forefront of political debate, exposing deep divides in American society. The illusion of consensus that had held sway during the immediate postwar years was shattered.

American art of this period did more than merely reflect the atmosphere of dissent in the country; it played an active part in it. By collapsing distinctions between the aesthetic and the political spheres, and by adopting "real world" processes, materials, and sites, the new art practices under development imagined new opportunities for intervening in that real world. **Performance**-based practices blurred the distinction between life and theater by turning spectators into participants. **Pop art** experimented with notions of the studio as factory and the art exhibition as retail environment, thereby dissolving distinctions between art culture and consumer culture. **Minimalism** diverted attention away from the art object as such to the spatial and temporal conditions surrounding it. **Conceptual art** proposed equivalences between "art work" and the systematic tasks of workaday life in an increasingly bureaucratic society. **Land Art** and architectural installation escaped the confines of the museum entirely, occupying real land and real buildings and reconfiguring longstanding national traditions of landscape and domesticity in the process. Even the seemingly well-behaved practice of figurative representation became disruptive when familiar historical stereotypes were transformed into uncanny images intended to haunt the present. All of these new practices attacked conventional barriers that had preserved the aesthetic sphere as a realm of refinement, transcendence, and good taste.

Yet uncertainties about the efficacy and purpose of these oppositional arts always lingered. Was it truly possible—or desirable—to obliterate all barriers between art and life? Was there a danger that the critical powers of art might thereby be diluted, rather than intensified? Was there a danger that, instead of enlivening art, this process might instead tame and aestheticize life? The remarkably varied work of artists of this period reflects the care and complexity with which they responded to these challenges.

## The Space and Objects of Everyday Life: Performance, Pop, and Minimalism

In 1958, the young artist and art historian Allan Kaprow (1927–2006) published an article titled "The Legacy of Jackson Pollock":

Pollock, as I see him, left us at the point where we must become preoccupied with and even dazzled by the space and objects of our everyday life. ... Not satisfied with the suggestion through paint of our other senses, we shall utilize the specific substances of sight, sound, movements, people, odors, touch. ... Not only will

(opposite) **DAN FLAVIN**, *Untitled (To the "Innovator" of Wheeling Peachblow)*, 1966–8. Daylight, yellow, and pink fluorescent light, 8 ft (2.4 m) square across a corner.

[future artists] show us, as if for the first time, the world we have always had about us, but ignored, but they will disclose entirely unheard of happenings and events, found in garbage cans, police files, hotel lobbies, seen in store windows and on the streets, and sensed in dreams and horrible accidents. An odor of crushed strawberries, a letter from a friend or a billboard selling Drano; three taps on the front door, a scratch, a sigh or a voice lecturing endlessly, a blinding staccato flash, a bowler hat—all will become materials for this new concrete art.[1]

Reading Jackson Pollock's work through the intervening influence of John Cage, Jasper Johns, and Robert Rauschenberg (see Chapter 17), Kaprow argued that Pollock had broken painting open to a direct encounter with reality, rescuing art from its traditionally secondhand relationship to the world. For Kaprow, the performative quality of Pollock's painting motions, the physicality of his environmentally-sized canvases, and the materiality of his paint hinted at "new concrete art" to come.

Kaprow's analysis turned out to be prophetic, predicting much that would follow in late twentieth-century American art. Kaprow suggested that after Pollock the realm of aesthetics need no longer be populated by discrete "art" objects (paintings, sculptures) or confined to designated "art" spaces (museums, galleries), but might rather extend to "the space and objects of our everyday life." Aesthetic apprehension need no longer be funneled solely through vision (the proper "art" sense) but might also function through smell, touch, hearing, and taste. Art need no longer pretend to exist in a timeless realm, but might flow seamlessly through ordinary time and ordinary events.

## Performance

Kaprow was part of a community of artists, dramatists, dancers, choreographers, and musicians in New York in the 1960s who were working to develop new forms of multimedia art and performance. Along with Kaprow and artists closely associated with him, other groups like the **Judson Dance Theater** and **Fluxus** (from the Latin for "flow") shared a common focus on chance techniques, ephemeral materials, sensory complexity, and audience participation.

**HAPPENINGS.** In his own work, Kaprow attempted to bring to fruition the all-enveloping, interactive, multisensory art that Pollock had begun to introduce. He did this at first by developing **"environments."** In 1958, at the Hansa Gallery in New York, he filled a room with tangles of scotch tape, sheets of plastic, Christmas lights, and skeins of shredded fabric hanging from the ceiling (all accompanied by a pine-scented deodorizer mist). In *The Apple Shrine* of 1960 (**fig. 18.1**), he used chicken wire, crumpled newspaper, and dangling straw. Visitors moved through these installations as if they were feeling their way through three-dimensional paintings.

18.1 ALLAN KAPROW, *The Apple Shrine*, Judson Gallery, New York, November–December 1960. Mixed media environment. Photograph © Robert R. McElroy.

Kaprow went on to expand these quasi-painterly environments into what were eventually called **Happenings**. Happenings included all of the unpredictable textures and smells of the environments, but added unpredictable events that unfolded in the temporal dimension. These events were initiated by small groups of performers who, working from loose instructions, carried out mundane tasks, made noises or improvised speeches, moved objects around the space, and interacted in various ways with the audience. For audiences, these events evoked surprise, delight, confusion, and even fear. Kaprow described the typical experience of a Happening this way:

> Tin cans rattle and you stand up to see or change your seat or answer questions shouted at you by shoeshine boys and old ladies. Long silences when nothing happens, and you're sore because you paid $1.50 contribution, when bang! there you are facing yourself in a mirror jammed at you. Listen. A cough from the alley. You giggle because you're afraid, suffer claustrophobia, talk to someone nonchalantly, but all the time you're *there*, getting into the act ...[2]

Happenings invariably provoked associations with theater. But traditional stage-and-curtain dramatic theater depends upon framing devices that divide the "real" space and time of the audience from the representational space and time of the performance. The stage is separated from the audience by a curtain, proscenium, lighting, and platform, and the beginning and end of the performance are clearly demarcated. These framing devices were abolished in the Happenings along with the separation of art and life that they signified. Happenings were not staged in theaters, but rather (as Kaprow put it), "in old lofts, basements, vacant stores, natural surroundings, and the street, where very small audiences ... are commingled in some way with the event, flowing in and among its parts."[3] Loosely scripted, Happenings were not repeatable or predictable, and it was often difficult to tell when they began or ended.

Happenings, Kaprow wrote in 1961, "are events that, put simply, happen."[4] This seems obvious enough. But in uttering this statement Kaprow was alluding to an urgent problem; namely, that authentic everyday experience, the experience of something "simply happening," seemed more and more rare in a culture where every conceivable sensation could be prepackaged by corporate interests, advertising, and the media. In 1961, the historian Daniel Boorstin (1914–2004) wrote his influential book *The Image*, in which he argued that events in America were being rapidly replaced by "pseudo-events": planned activities like photo ops that might appear spontaneous but are, in fact, staged for public

relations purposes. Against this background, Happenings were intended to provide the kind of "spontaneous experience" that was being leached out of American life.

In Happenings this goal of authentic experience, however utopian, more often than not required discomfort. For the duration of Kaprow's *A Spring Happening* of 1961, for example, spectators were crowded inside a wooden box with only a few peepholes. The Happening was over when the walls of the box collapsed and the people were driven out of the room with a power lawnmower. The sadism here was intentional; in fact, Kaprow had been deeply influenced by the French avant-garde dramatist Antonin Artaud's (1896–1948) notion of the "theater of cruelty," which argued that drastic measures must be taken to break audiences out of their habitually detached and passive absorption of theatrical spectacle. Forced to participate physically in the action, and denied the comforts of impervious spectatorship, the audience had no choice but to embody the encounter of art and life.

**FLUXUS.** Yet it was not only the audience whose complacency was shattered by this interactive ethic. Yoko Ono's *Cut Piece*, performed at Carnegie Hall, New York, in 1965, demonstrates how the artist, too, was now vulnerable (**fig. 18.2**). Ono (b. 1933) was associated with Fluxus, an international group of artists centered in New York in the mid-1960s. Fluxus "events" shared many qualities with

18.2 YOKO ONO, *Cut Piece*, 1965, Carnegie Hall, New York.

Happenings but tended to be more spare and elegant in their execution. *Cut Piece*, in fact, consisted of a single directive. Ono knelt on a stage, wearing her best clothing, and set out a large pair of scissors. In a short verbal statement, she invited the audience members to come up one by one and cut away a piece of her clothing. She then remained silent as her audience progressively denuded her.

The artists associated with Kaprow's Happenings were mostly men (sometimes called "The Happenings Boys"), but women, like Ono, Carolee Schneeman (b. 1939), Charlotte Moorman (1933–1991), Trisha Brown (b. 1936) (see fig. 18.18), and Yvonne Rainer (b. 1934) (see fig. 18.15) were pivotal figures in performance-based art of the 1960s also. The impact of *Cut Piece* depends largely upon Ono's gender. As she was progressively stripped of her clothing with a sharp instrument, it was impossible to ignore the connotations of sexual violence. Moreover, as the performance progressed, Ono began to look less like a woman kneeling on stage and more like a "nude"—more like a work of art. *Cut Piece* thus made the disturbing suggestion that the aestheticization of the female nude in art had some root connection with violence.

As an artist of Japanese ancestry working in post-war America, Ono also brought historical resonances into play with *Cut Piece*. She had been twelve years old, starving in the Japanese countryside, when the atomic bombs were dropped on Hiroshima and Nagasaki in 1945. All her later work was informed by these events. As the art historian Julia Bryan-Wilson has shown, *Cut Piece* recalled photographs, widely circulated at the time, of bomb victims limping through ruins in tattered garments. In the mid-1960s, American society was only beginning to come to terms with the horrors of Hiroshima and Nagasaki. The participatory aspect of *Cut Piece* compelled the audience to revisit the nuclear destruction of World War II, but even as it served as a grim reminder, its ritual symbolism also suggested hope through collective gathering and shared witness. Audience members, dispersing, returned home with the scraps of fabric that they had cut, souvenir fragments imbued with a memory of their communal presence at the event. In performance, *Cut Piece* cut two ways: it activated both the memory of destruction and the imagination of peace.

## Pop Art, Consumerism, and Media Culture

The liberatory blurring of art and life that artists like Kaprow and Ono hoped to achieve was not without its complications. Many post-war artists turned to the "every-

18.3 CLAES OLDENBURG, *The Store*, 1961. Mixed media environment. Oldenburg van Bruggen Foundation, Inc. © Robert R. McElroy.

day" as an antidote to capitalist conformism—as a field of spontaneity, serendipity, and freedom. But others wondered whether the American everyday had not, in fact, already been thoroughly saturated by corporate media. By the early 1960s, the post-war economic boom had progressed to the point where its commercial effects had permeated the everyday landscape with standardized objects, architectures, and media—dizzying arrangements of billboards, subway advertisements, tabloids, comic books, movie posters, and supermarket signs—and the din of televisions and radios. What would happen to the critical function of art if it were to expand so far as to include not only (to quote Kaprow) "the odor of crushed strawberries" but also "a billboard selling Drano"? Would art simply collapse into advertising? Would commodities be reclassified as art?

**THE STORE AND THE FACTORY.** One of the artists to confront these questions in the early 1960s was Claes Oldenburg (b. 1942), already well known for his Happenings and environments. In December 1961, Oldenburg opened an environment called *The Store* in an actual storefront on the lower east side of Manhattan (**fig. 18.3**). Surrounded by blue-collar clothing outlets and humble grocery stores, Oldenburg set up shop. He sold actual-scale versions, made of painted, plaster-soaked muslin, of the banal commodities for sale all around him in the neighborhood: ice cream sandwiches, cigarettes, cheeseburgers with everything. *The Store* asked uncomfortable questions about the distinctions (if any) between art and commerce. Was *The Store* a gallery or a retail space? The "goods" for sale alluded to ordinary manufactures and were sold in a storefront among storefronts, but they were also handmade, unique objects. Their price tags evoked both the art auction and the discount store (a man's sock at *The Store*, for example, cost $199.95).

Oldenburg's productive confusions between high and commercial culture helped stimulate the development of what we now call Pop art, which explored the unstable boundaries between aesthetics and commerce in America. Although *The Store* itself retained the slapdash look of environments and Happenings, many later Pop artists mixed traditional painting methods with the slick styles and production schemes of commercial imagery. Roy Lichtenstein (1923–97) painstakingly arranged and rebalanced his compositions according to academic dictates, but derived his images from lowbrow advertisements and comic books (**fig. 18.4**). His paintings featured the small **"Benday" dots** used in the mechanical reproduction of color in comic books and newspapers, but he painted these dots carefully by hand. Andy Warhol (1928–87) went even further: he appropriated his subject matter directly from product design and mass-media photojournalism, manufactured many of his paintings using commercial silkscreen technology, and worked in a studio he called "The Factory." Many Pop artists, like Oldenburg, also experimented with categorical overlaps between retail and gallery spaces. Galleries sometimes played along: the Bianchini Gallery in New York held a "supermarket" exhibition in 1964, where Pop art was displayed along with real products in an installation complete with aisles and refrigerated display cases.

Pop art like this filled the gallery space, which had long claimed to serve as a refuge from the vulgar commercial world, with the air of the marketplace. The acute cultural discomfort caused by this particular brand of art/life encounter quickly became evident in Pop's critical reception. Max Kozloff asserted that "the truth is, the art galleries are being invaded by the pin-headed and contemptible style of gum chewers, bobbysoxers, and worse, delinquents."[5] Alan Solomon lamented in 1963 that "Instead of rejecting the deplorable and grotesque products of the modern commercial industrial world … these new artists have turned with relish and excitement to what those of us who know better regard as the wasteland of television commercials, comic strips, hot dog stands, billboards, junk

18.4 ROY LICHTENSTEIN, *Whaam!*, 1963. Acrylic and oil on canvas, total dimensions 68 × 166 in (172.7 × 421.6 cm). Tate Gallery, London.

yards, hamburger joints, used car lots, juke boxes, slot machines and supermarkets."[6]

### THE COMMERCIAL UNCONSCIOUS.

The siege mentality that pervaded early criticism of Pop art mirrored widespread concerns—surfacing at precisely this time—about the possibility that the "wasteland of television commercials" had already infiltrated not only the autonomous gallery space but also the last refuge of individual authenticity in America: the psyches of Americans themselves. As the art historian Cécile Whiting has demonstrated, the growth of supermarket-style shopping in the 1950s and 1960s was accompanied by increasingly sophisticated "motivation research" on the part of advertisers. Through motivation research, advertisers hoped to pinpoint, and then exploit, the unconscious desires, fears, and fantasies that drove consumers (imagined almost universally as women) to purchase products. This, in turn, provoked intense concern about the psychological power of advertising. Vance Packard, in his well-known exposé *The Hidden Persuaders*, went so far as to suggest that women floated through supermarkets in a trancelike state, dangerously vulnerable to the seductions of the packaging surrounding them.

The specter of the commercial colonization of the psyche was directly provoked by Pop art. Pop often presented itself as a parodic offshoot of Abstract Expressionism (see Chapter 17), suggesting that the collective unconscious once invoked by action painting had now been replaced by commercial culture. An image like Lichtenstein's *Whaam!* evokes all of the impact, immediacy, and heroic drama of an Abstract Expressionist painting, but it locates the source of that power in the lowbrow hyperboles of the popular comic book rather than in the roiling, primitive depths of the painter's subconscious. It suggests that the flood of authentic primal force coded in Abstract Expressionism might ultimately be inseparable from the equally formidable power of mass hucksterism: what one critic called the "Mississippi-like flood of information, cajolery, overstatement, and plain bamboozledom from which few Americans are ever free for long."[7]

Warhol's early painting *Dick Tracy*, of 1960, is painted in a deliberately fake Abstract Expressionist manner: the drips and gestural paint handling function as coy signs of spontaneity (**fig. 18.5**). The text in the speech bubble—granted a certain mystic ineffability through selective erasure of letters—resembles the half-formed archetypal symbols in Pollock's early paintings. But if we are to read this scumbled form as having been dredged up from the deepest registers of Warhol's subconscious, what he seems to have found there is not an appealingly preindustrial, Jungian archetype, but rather a vulgar, hackneyed commercial archetype; not Zeus or the She-Wolf but Dick Tracy (compare Pollock's 1943 *Guardians of the Secret*, fig. 17.4). Warhol proposes here a transfer of the universal archetype from the primordial depths of the collective unconscious to the droll superficiality of the Sunday funnies.

Warhol's painting begs an important question: Is this our true subconscious? Can the common denominator of American life really be found deep in the archetypal collective, or is it in the standardized products and media that all Americans consume? Although Warhol's true feelings on this and other matters were notoriously hard to determine, his work certainly suggested the latter: it is American mass consumption that provides the universal symbols knitting American life together, transcending all distinctions of class or celebrity. As he put it: "what's great about this country is that America started the tradition

18.5 **ANDY WARHOL**, *Dick Tracy*, 1960. Synthetic polymer paint on canvas, 79 × 44⅞ in (201 × 114 cm). Collection of Mr. and Mrs. S. I. Newhouse, Jr.

18.6 ANDY WARHOL, *Two Hundred Campbell's Soup Cans*, 1962. Synthetic polymer paint on canvas, 5 ft 11 in × 8 ft 4 in (1.82 × 2.54 m). Collection of John and Kimiko Powers.

where the richest consumers buy essentially the same things as the poorest ... the President drinks Coke, Liz Taylor drinks Coke, and just think, you can drink Coke, too. A Coke is a Coke and no amount of money can get you a better Coke than the one the bum on the corner is drinking. All the Cokes are the same and all the Cokes are good."[8] Unity and community emerge not through shared struggle or dialogue, but rather simply through mass production and consumption. In paintings like *Two Hundred Campbell's Soup Cans* of 1962 (**fig. 18.6**), Warhol's repetitive grid and "all-over" composition conveys abundance—an abundance subtly nationalized by its compositional resemblance to the stripes of the American flag. America, the supermarket: an array of commercial sameness in which distinctions and variations are minor and relatively meaningless.

**WARHOL'S *DISASTER* SERIES.** Warhol's experiments in a kind of commercial unconscious forced art to recognize its shared territory with marketing and advertising. In some ways, then, Warhol's paintings can be seen to have produced a bracing and transformative encounter with the consumerist reality of post-war American life. But Warhol's work also suggests that the new reality might not be "reality" at all; his paintings explore the possibility that commercial filters have blocked all access to authentic experience. Nowhere is this uncertainty more pronounced than in his *Disaster* series, produced beginning in 1963 by silkscreening multiple copies of horrific accident photographs onto painted canvases. The image in *White Disaster* (**fig. 18.7**) is almost inconceivably terrible: a man, thrown from a mangled, burning car, has been impaled on a nearby telephone pole. In an interview, Warhol evoked the numbing power of mass reproduction, explaining that the repetition of images in the media made them easier to take: "When you see a gruesome picture over and over again, it doesn't really have any effect."[9] Yet the *Disaster* paintings

18.7 ANDY WARHOL,
*White Disaster*, 1963. Silkscreen
and acrylic paint on canvas,
100 × 78 in (255.3 × 200 cm).
Staatsgalerie, Stuttgart.

seem determined to test rather than simply to prove this collapse of empathy. Are these images appalling enough to break the modern viewer out of the anesthesia of a packaged and mediated world?

Critics continue to disagree about the ultimate effect of these paintings. For Thomas Crow, the painful reality captured in the images does break through the surface: "the brutal fact of death and suffering cancels the possibility of passive and complacent consumption."[10] For Hal Foster, on the other hand, the paintings can only point to an immediacy that has been irrevocably lost. He compares Warhol's repeated disaster images to the pathology of traumatic repetition, in which a person cannot fully absorb the impact of a traumatic event but can only meaninglessly repeat superficial recollections of its occurrence. According

to Foster, Warhol's *Disaster* series, like all of contemporary life, consists only of "missed encounters with the real."[11] Whatever one's position on the ultimate meaning of these images, it is clear that Warhol has chosen the most nauseating possible content and subjected it to a test of the limits of empathy in a mediated culture.

In Warhol's use of repetition as a distancing device, we can begin to ascertain a central irony of Pop art: although it helped return avant-garde painting to realism after many years of Abstract Expressionism, it tended to hold its subject matter out of reach, at an immeasurable and impassable distance. Pop art returned painting to the observation of the material world, but the material world had itself become dematerialized—it had become a shallow world of signs, information, and images rather than real things.

If Pop art was a form of realism, it was a realism that represented the ways American consumer culture had altered the perception of reality itself.

**WAR AND CONSUMPTION: _F-111_.** Pop artists imagined themselves confronting a world in which the scale and compass of consumer capitalism, with its near-total saturation of society, exceeded traditional perceptual structures. The artist James Rosenquist (b. 1933) first felt this while working as a billboard painter in New York in the late 1950s. High above Manhattan, pressed up against a gigantic Hebrew Salami or Man Tan ad, he found himself intrigued by the simultaneously intimate and fragmented vision created by his close proximity to the oversized image. While painting one advertisement, "the face became a strange geography, the nose like a map of Yugoslavia."[12] He realized that these intense yet disconnected glimpses of an ungraspable whole were analogous to the consumer's perception of the growing post-war economy, and he took to analyzing this insight in his own paintings.

In April 1965, Rosenquist exhibited _F-111_ (**fig. 18.8**) at the Leo Castelli Gallery. Scattered across the surface of the painting are images of various quotidian commodities: lightbulbs, broken eggs, a tire, canned spaghetti. An innocent-looking blond girl under a hair dryer presides over the assortment. But behind her, across the entire horizontal expanse of the painting, lurks an F-111, the new fighter-bomber that had just been successfully tested by the Air Force. At 10 by 86 feet, Rosenquist's painting was so large that it wrapped four walls of the small gallery, crowding viewers with the same experience of fragmented proximity that he had experienced as a billboard painter. (This

constriction has been relieved in the work's current installation.) _F-111_ also drew upon the work of the Mexican muralists (see Chapter 16), not only in its scale but also in its intermingling of bodies and machines, its compositional techniques, and its political intent.

For Rosenquist, what was menacing about the F-111 fighter was not only its destructive power, but also the nearly imperceptible way in which the mission of its production had insinuated itself throughout the entire consumer economy. 6703 suppliers located in forty-four states contributed to the design and production of the F-111. Moreover, because huge American corporations like General Electric were also major defense contractors for the project, consumers found themselves indirectly supporting the production of the F-111 simply by purchasing items as seemingly innocuous as GE lightbulbs. As Rosenquist's interlocking images implied, the F-111 was inextricable from the general cornucopia of American consumer culture.

Echoing President Eisenhower's recent warnings about the growth of the American "military–industrial complex," Rosenquist claimed in an interview that the American consumer "has already bought these airplanes by paying income taxes or being part of the community and the economy. The present men participate in the world whether it's good or not and they may physically have bought parts of what this image represents many times."[13] When _F-111_ was exhibited, American combat troops had already entered Vietnam, and the question of whether the war was "good or not" was beginning to be controversial. Of course,

18.8 JAMES ROSENQUIST, _F-III_, 1964–5. Oil on canvas with aluminum, 10 × 86 ft (3.04 × 26.2 m). Museum of Modern Art, New York.

Americans had been asked to contribute to many previous war efforts, but they generally did so knowingly. Rosenquist was criticizing a world in which Americans might be unwittingly contributing to a war that they did not support simply by switching on lightbulbs.

*F-111* is assembled from fifty-one painted panels, each of which Rosenquist intended to sell separately. Each collector was supposed to take home a single panel, which would then appear as an unintelligible splinter of a larger image. Thus, built into the very structure of Rosenquist's painting was the reminder that every individual act of consumption is part of a bigger picture—a picture that may not be a pretty one. Like Yoko Ono's *Cut Piece* (see fig. 18.2), which was performed in New York in the same year that *F-111* was exhibited, Rosenquist deployed the strategy of dispersion to help individuals recognize their connections to one another in an increasingly intangible social whole. Ironically, the leading Pop collectors Robert and Ethel Scull purchased the entire *F-111* ensemble, which now resides intact at the Museum of Modern Art in New York. Still, the cracks between the panels remain, hinting at the elusive and illusory nature of the consumer society with which Rosenquist grappled.

## Minimalism

The regression of reality that Pop art explored would haunt American art and culture for the rest of the century. Is authentic experience possible in an age of mass consumption? Can reality be directly encountered? In the mid-1960s, a group of artists loosely termed **Minimalists** (for the spare, laconic objects they produced) took up this question in hopes of answering it in the affirmative. They did so by pursuing the seemingly remedial project of making objects that might be experienced as fully concrete, real entities. In order to create such literal "things," however, they needed to purge sculpture of all its remaining vestiges of representation and illusionism. This was a more difficult prospect than it might seem.

**PRECURSORS OF MINIMALISM IN PAINTING.** In their attempts to circumvent illusion, Minimalists followed upon painters who had already faced the same challenge. Any mark, however abstract, on a two-dimensional canvas tends to "bend" the flat surface of the canvas into a suggestion of three-dimensional space, an illusionistic space that does not really exist. Coming upon such a painting, the viewer does not truly confront the painting as a thing in itself, a thing sharing her or his own space, but rather as a "window" into an imaginary representational space. As we have seen

in paintings like *Flag* of 1954–5 (see fig. 17.15), Jasper Johns tried to solve this problem by flattening the flag's pattern and eliminating its background, creating an object (a flag placed bluntly in the viewer's immediate space), rather than a representation (of a flag framed within some other illusionary space). Frank Stella (b. 1936), working largely in response to Johns, was also trying to break free of the illusionism and spatial slippage endemic to painting. Speaking of painters, he said, "If you pin them down, they always end up asserting that there is something there besides the paint on the canvas. My painting is based on the fact that only what can be seen there *is* there. It really is an object. ... What you see is what you see."[14]

In his "stripe paintings," like *Ophir* of 1960–1 (**fig. 18.9**), Stella attempted to develop a form of visual patterning that would resist slipping into illusionistic depth. The stripes guided the viewer's eye along the surface of the painting, like tracks. Stella painted the stripes in regular, parallel configurations to avoid producing the kind of overlapping planes that the Cubists had used to construct their shallow spatial oscillations. He also used a relatively hard edge, avoiding the misty, spatial atmospherics of color field paintings like those of Mark Rothko (see fig. 17.7). The stripes also followed a "deductive structure," meaning that their arrangement derived from, and drew attention to, the shape and dimension of the actual, physical canvas. Often using industrial metallic paints whose reflective qualities would repel the eye from the surface, Stella applied the paint in a flat, impersonal manner so as to avoid the psychological depth implied by gestural touches. The paint would not represent anything; it would just be itself: "I wanted to get the paint out of the can and onto the canvas. ... I tried to keep the paint as good as it was in the can."[15]

**DONALD JUDD AND CARL ANDRE.** Inspired by Stella's example, the artist Donald Judd (1928–94) felt that this kind of literalness would be even more powerful if it could be achieved in sculpture, because it would allow the artist to deploy "the specificity and power of actual materials, actual color and actual space."[16] His drastic measures to destroy what he called "fictive space"—so drastic that for many his work ceased to function as art at all—can be seen in his *Untitled* of 1966 (**fig. 18.10**). Note, first of all, that Judd's piece sits directly on the floor, without a base. Traditionally, the sculptural base or pedestal is analogous to a frame around a painting; it separates the sculpture from its everyday surroundings. Taken off its pedestal, Judd's artwork shares the floor with its viewer, who must in turn share the floor with the work, and encounter it as an object in his or her own world.

18.9 FRANK STELLA, *Ophir*, 1961–1. Copper oil paint on canvas, 98½ × 82¾ in (250 × 210.1 cm). Private collection. Gagosian Gallery, New York.

One form of lingering illusionism that Judd and others hoped to eradicate from sculpture was anthropomorphism (the attribution of human form to nonhuman objects). Yet, inherent in our instinct to think symbolically, anthropomorphism is difficult to shake: even a simple standing column triggers an anthropomorphic response. We tend to confer personality upon it, sensing that, like a human being, it harbors an inner life of its own. During the mid-1960s, artists in many different media worked to forestall anthropomorphism and the illusionary "interpersonal" relationships it creates. There was a strong moral component to these efforts: Alain Robbe-Grillet (b. 1922), a French novelist whose work influenced many American artists of this time, felt that things in the world had become "clogged

with an anthropomorphic vocabulary," and that it was only by returning objects to their mute, inanimate purview that humans would be able to define the sphere of their own control accurately, confront the world directly, and address social problems responsibly.[17]

Judd worked to evade anthropomorphism in several ways. First, by using synthetic materials, regularized compositions, and industrial fabrication, he purged his pieces of any traces of organic form. Second, he took measures to deny all interiority to his sculpture. In *Untitled*, he used shiny industrial materials on some faces of the box in order to emphasize the quality of a hard, repellent surface that cannot be imaginatively penetrated, and used transparent materials like colored Plexiglas on other sides, so that the

18.10 DONALD JUDD, *Untitled*, 1966. Amber plexiglas and stainless steel, 20 × 48 × 34 in (50.8 × 121.9 × 86.3 cm). Froehlich Collection, Stuttgart.

interior opens as if to prove to viewers that it's only space— just ordinary everyday space—between the structural walls. Inspired by the principle of transparency that had been developed by Soviet **Constructivist** artists earlier in the century, Judd's piece allows no mystery about its method of construction and hides nothing from its viewer. Its avoidance of compositional complexity imparts a wholeness and reductive simplicity that prevent the viewer from projecting a narrative or personality onto it.

The low profile of Judd's *Untitled* was a common strategy among Minimalists. Carl Andre's (b. 1935) floor pieces—checkerboard arrangements of metal plates placed directly on the floor (**fig 18.11**)—were the most extreme examples of this. Not only did they represent the ultimate in horizontality, but their two-dimensional form removed all possibility of interiority. As the critic Rosalind Krauss described it, in Andre's work "internal space is literally being squeezed out of the sculptural object."[18] There is a certain brutality about this evisceration of anthropomorphic internal space. Actual space destroys and displaces fictive space.

18.11 CARL ANDRE, *Magnesium-Zinc Plain*, 1969. Magnesium and zinc, ⅜ × 72 × 72 in (1 × 182.8 × 182.8 cm). Museum of Contemporary Art, San Diego, California.

**CRITICAL DEBATES ABOUT MINIMALISM.** This rhetoric of aggression, along with the obduracy, blankness, and extreme reductiveness of Minimalist forms, led many critics to interpret Minimal sculpture as nihilistic. To some, the objects' indifference to the viewer seemed smug and sadistic, while to others the artists' denial of transcendent aesthetic experience seemed objectionable. Critics pointed out that Minimalism did not truly evade referentiality as its champions claimed. The industrial idiom and repetitive serial arrangements of the work "referred" to many aspects of contemporary American culture: the repetition of factory production, the technophilia of the military–industrial complex, the banalization of the built environment through urban "superblocks" and suburban "little boxes," and the anonymity of post-industrial finance capital. Indeed, corporations and conglomerates did sense a shared sensibility in Minimalism, and it quickly became part of the decorative lexicon of corporate boardrooms and plazas.

But for others, Minimalism empowered rather than disempowered the viewer by promoting an active, attentive,

FRAMING THE DISCOURSE

# The Politics of Assemblage

THE MATERIALS OF Minimalism were new: fresh sheets of metal, cleanly cut lumber, and gleaming industrial plastics. But a parallel strand of sculptural production in the 1960s, broadly called **Assemblage**, favored the use of found objects, scrap metal, and other used materials. Assemblage drew upon a cluster of precedents: Duchamp's readymades, Cubist collages, and Surrealist techniques of juxtaposition. It was also related to current works like Rauschenberg's mixed-media pieces (see fig. 17.17) and the obsolescent props used in Happenings and environments. Assemblage was practiced throughout the United States by such artists as John Chamberlain (b. 1927), Joseph Cornell (1903–1972; see fig. 14.34), H. C. Westermann (1922–1981), Bruce Conner (b. 1933), and Betye Saar (b. 1926; see fig. 18.24).

Assemblage thrived in a wide range of forms because its diverse materials activated historical and cultural associations that were not so readily conducted in the deadpan syntax of Minimalism. In 1963, for example, the Los Angeles artist Melvin Edwards (b. 1937) began a lifelong series of *Lynch Fragments* that address the long struggle for African American rights (**fig. 18.12**). He welded each elegant relief from battered and twisted scrap steel that carries connotations of violence, harm, or force: nails, spikes, chains, hammers, scissors, wrenches, etc. But the delicacy of his assemblies allows these same objects to suggest fortitude and transformation. The chain in *Afro Phoenix, no. 1* implies both bondage and bonding; the horseshoe, both restriction and flight (and, with its blatantly vaginal form, fertility and rebirth). Although the *Lynch Fragments* are abstract, their source materials invite a complex play of cultural associations.

Edwards made *Afro Phoenix No. 1* in 1963, the year of the March on Washington and the bombing of the 16th Street church in Birmingham. But given its title's reference to the phoenix (the mythical bird reborn from ashes), the work took on heightened significance two years later, in 1965, when the burning and rioting in the Watts neighborhood of Los Angeles left thirty-four people dead. This only reinforced Edwards's determination to provide hope and rebirth through his activity as an artist: "My effort in sculpture had to be as intense as injustice, in reverse."[19]

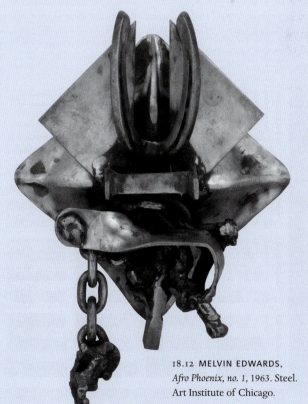

18.12 MELVIN EDWARDS, *Afro Phoenix, no. 1*, 1963. Steel. Art Institute of Chicago.

and expanded model of sculptural spectatorship. Denied the escape of illusionism, viewers were encouraged to appreciate their own existence as real presences in the real space of the gallery. The sculptor Robert Morris (b. 1931) was among the most eloquent proponents of this view. He argued that the underlying logic of Minimal sculpture was not so much reduction as deflection: Minimal sculpture constantly shunted the viewer's attention from the object to its broader context. "The better new work takes relationships out of the work and makes them a function of space, light, and the viewer's field of vision." This, in turn, produces a new awareness of the entire site, including all possible variables of light, positioning, and perspective. For Morris, whose matte gray plywood sculptures were among the most meticulously "minimal" of all, the simplicity of these objects produced a profound environmental and kinesthetic awareness in the viewer. The intimacy, incident, and complexity denied to the objects themselves were returned tenfold to the viewer in the form of an expansive awareness of participatory space. As Morris put it, "it is the viewer who changes the shape constantly by his change in position relative to the work."[20]

## SOL LEWITT AND DAN FLAVIN: THE ROLE OF THE VIEWER.

Sol LeWitt's (b. 1928) *Open Modular Cube* (**fig. 18.13**) demonstrates the active role of the viewer in the Minimalist installation. Although the sculpture seems so basic as to be simply a diagram of itself—it's just a multi-part cubic lattice—its form becomes endlessly complicated by the viewer's presence. From the shifting perspective of the perambulating viewer, the "arms" of the structure move in and out of alignment, gathering and sustaining the viewer's shifting sightlines as if plotting his or her trajectory in space. The sculpture's simplicity seems to promise the viewer a kind of mathematical purity, but it is impossible to see it from a disembodied position; the form does not

18.13 SOL LEWITT, *Open Modular Cube*, 1966. Painted aluminum, 4 ft ¹⁵⁄₁₆ × 4 ft ¹⁵⁄₁₆ in (1.52 × 1.52 m). Art Gallery of Ontario, Toronto. Purchase, 1969.

remain still because it responds to the viewer's eye. This is true of all sculpture, of course, but the simplicity of Minimal sculpture made such effects of kinesthesia more obvious. As Morris put it, "One is more aware than before that he himself is establishing relationships as he apprehends the object from various positions and under varying conditions of light and spatial context."[21]

Some Minimalist artists chose to embrace light and space not just as "conditions" but also as artistic media. Beginning in 1963, Dan Flavin (1933–96) used standard fluorescent light fixtures as the primary building blocks of his work. Flavin's *Untitled (To the "Innovator" of Wheeling Peachblow)* of 1968 (**p. 588**) straddles the corner of the gallery space. Light from the yellow and pink lamps facing away from the viewer mingles in the corner to create a lovely peach-coral hue. As Flavin's title suggests, a similar color can be found in Wheeling peachblow, a form of late-nineteenth-century glassware that was manufactured in Wheeling, West Virginia. Flavin was an avid collector of peachblow pieces. The difference between his work and its glassware inspiration, however, is that the peachblow color cannot be located anywhere within the physical boundaries of Flavin's fluorescent tubes. Instead it emerges atmospherically and perceptually, by virtue of the mixing and reflection of colored light in the corner (and in the viewer's eye). The "sculpture" is that perceptual space itself.

This activated space was perhaps Minimalism's greatest legacy. Minimalism called for a new level of active participation in the production of meaning; it defined the work of art not as an object but as an encounter between an object, a space, and a viewer or viewers. The "meaning" of a Minimal work was not inherent to the object, but was defined in terms of a field of temporal, spatial, and bodily interaction. The Minimal work did not exist all at once, but rather changed and developed over the entire span of the viewer's attention. This suggested that meaning is constructed in a public space rather than a private one, and helped open art to the social and political field.

# The Figure in Crisis

Although Minimalists ostensibly created objects, what they really created were fields—activated zones of kinesthetic space. And within these fields, objects were no longer objects in the traditional sense. They were understood not as inert, constant, securely bounded packages of matter, but rather as shifting perceptual phenomena that changed constantly in relation to their surroundings and their

viewers. Viewers in this expanded field were similarly redefined—from stable Cartesian selves coolly assessing objects in neutral spaces to beings whose self-awareness emerged in a continuous, variable relationship to the spatial and material environment. Expressed in artistic terms, Minimalism helped blur the distinction between "figure" and "ground"—bodies and their environments became entangled in a mutual interplay. The implications of this shift were felt throughout American art in the late 1960s and early 1970s.

## Bodily Dispersions: Postminimalism, Dance, and Video

One of the primary manifestations of this destabilization of the figure was the rise of a new interest in contingent forms and open-ended processes. This new approach developed simultaneously across many different media—not only sculpture but also performance and the new medium of video. Some artists broke down the sculptural object (or sculptural figure) through the dispersion of materials; others the human object (or human figure) by exploring the dispersion in time and space of the viewer's consciousness.

**EVA HESSE AND POSTMINIMALISM.** Eva Hesse (1936–70) was among the first to explore the changed condition of objects in the newly charged environmental field of Minimalism. As is evident in *Contingent* of 1969 (**fig. 18.14**), Hesse's work had strong ties to Minimalism: like Minimal works, her sculptures derived from serial repetition, simple geometries, and synthetic materials (polyester resin, latex, fiberglass, and plastic tubing in her case). But while Minimal sculpture triggered the *viewer's* awareness of bodily contingency, Hesse's works carry signs of bodily contingency themselves. Her forms seem marked by time, gravity, and atmosphere: they crack, wrinkle, slump, congeal, yellow, and harden. They seem vaguely human in their organic vulnerability. But their random massing, scattered arrangement, indeterminate contours, and decaying materials suggest not intact, independent figures but rather a kind of invertebrate, primitive, or incontinent corporeality. It is as if the new field of change and contingency opened by Minimalism had begun to act upon the very forms that had triggered it.

Hesse's work is widely understood to have served as the bridge between Minimalism and an entire subgenre called **Postminimalism**. Searching for a new kind of sculptural form that would be defined by its environment rather than vice versa, Richard Serra (b. 1939) splashed molten lead

18.14 EVA HESSE, *Contingent*, 1969. Sculpture, cheesecloth, latex, fiberglass, 11 ft 6 in × 20 ft 6 in × 3 ft 6 in (3.5 × 6.3 × 1. 09 m). National Gallery of Australia, Canberra.

along the bases of gallery walls; Lynda Benglis (b. 1941) made floor works of pooled and puddled acrylic foam; Robert Morris filled galleries with drooping felt and thread-waste. Many artists saw in work like this the true fulfillment of Minimalism's anti-figural aims. These "sculptures" have no independent formal integrity; they borrow their contours from the spaces they occupy.

At age thirty-four, just as her career was beginning to flourish, Hesse died of brain cancer. While it is tempting to see her scattered, slumping forms as premonitions of her own bodily deterioration, the decay implied in Hesse's work need not be understood as wholly tragic. If in her work we witness the body becoming the field—moving away from its status as "figure" and becoming closer to what we might call "ground"—this is not necessarily a negative process. For the French philosopher Maurice Merleau-Ponty, whose writings on bodily perception were to be found on many artists' bookshelves during these years, this field condition approximated our true relationship to the world: we do not move through our environment as self-contained figures in front of neutral backgrounds, but are rather constantly engaged in a perceptual, physical, reciprocal "intertwining" with our surroundings. In Merleau-Ponty's thought, figure and ground, object and context, merge. Robert Morris echoed this sentiment when he suggested that the new sculpture approximated "heterogeneous, ran-domized distributions that characterize figureless sectors of the world."[22]

**YVONNE RAINER AND A NEW CHOREOGRAPHY.** Perhaps the last place that one would expect to find a "figureless sector of the world" would be the world of dance. After all, dance involves bodies (figures) moving in space. But here, too, the 1960s saw an increasing emphasis on the choreographic equivalent of the field condition. In many of Yvonne Rainer's performances, the bombastic tendencies of traditional dance were deemphasized; spins and leaps were replaced by everyday "task-oriented" or "deskilled" movements like walking, eating, or sitting down and standing up. In her work *Trio A* of 1966 (**fig. 18.15**), moreover, Rainer destroyed the choreographic equivalent of the figure: the "dance phrase." Dance phrases are a key tool in the traditional choreographic vocabulary, because they allow the dancer to mark the passage of time

18.15 YVONNE RAINER, *Trio A*, 1966. Photograph by Peter Moore, © Estate of Peter Moore.

into a series of coherent, discrete stages, each building to a high point of physical exertion that serves as the main image or "figure" of the dance. Rainer removed such stops and starts and flattened out the hierarchy of movement, so that the dance would appear as a fluid continuum. As art historian Carrie Lambert-Beatty puts it, "the dance becomes difficult to parse visually, like a sentencewith-outspacingbetweenwords."[23] The dancer's body is spread out evenly over time in a process akin to the spread of forms over the gallery space in Eva Hesse's work.

**VIDEO AND THE NEW-MEDIA BODY.** This dispersion of the body in time and space was especially marked in the new medium of video. Video first became widely available to artists at the time of Minimalism's ascendancy, when Sony introduced its relatively affordable "Portapak" camera and recording system in 1965. It was quickly adopted by artists like Nam June Paik (1932–2006), Joan Jonas (b. 1936), Dan Graham (b. 1942), and Bruce Nauman (b. 1941), who, through their associations with Minimalism and performance, were already working with expanded space and durational time. In his installation *Live/Taped Video Corridor* of 1970 (**fig. 18.16**), Nauman took advantage of features peculiar to the video medium, such as its ability to transmit a live image from one place to another, in order to complicate the viewer's existence in time and space. The installation consists of a closed-circuit video system deployed within a long, narrow hallway just 20 inches wide. At the near end of the corridor, above the entrance, is a video camera, and at the far end are two television monitors. One of the monitors shows a live image of the corridor as surveilled

by the camera at the entrance; the other shows a taped image of the corridor while empty.

The simplicity of this arrangement belies the mind-boggling quality of the experience once the viewer sets it into motion. Upon entering the corridor, the viewer sees herself moving on the live monitor in the distance. The first and natural impulse upon seeing oneself in a television monitor with a live video feed is to treat the monitor like a mirror (which, indeed, it closely resembles in its real-time relay of movement). One tends to move narcissistically toward the monitor, expecting the image to come forward as well. In his installation, Nauman encourages this behavior by placing the monitors far enough away that one needs to proceed down the corridor in hope of seeing one's image clearly. But a viewer entering the corridor finds that

18.16 BRUCE NAUMAN, *Live/Taped Video Corridor*, 1970. Wallboard, video camera, two video monitors, videotape, 12 ft × 32 ft × 1 ft 8 in (3.65 × 9.75 × 0.5 m). Guggenheim Museum, New York.

as she moves toward the monitor in order to "meet" her image, the image on the screen recedes rather than approaches. Because the camera is behind her, the closer she comes to the monitor, the further she is from the camera, which means that as she approaches the monitor at the end of the hall she sees her own back walking away. Narcissistic satisfaction is thus always tantalizingly out of reach: with each step taken to attain it, it only becomes more elusive. The image on the live monitor forces the viewer to identify with two viewpoints operating at cross-purposes. The other monitor, which shows only a taped image of the empty corridor, proves equally disorienting. Its persistent blankness puts the viewer in the position of a vampire whose reflection in the mirror is always empty. Nauman's corridor makes it difficult for the viewer to hold herself together in the here and now. In doing so, however, it demonstrates the kinesthetic relationship between perception and bodily consciousness in a way that no traditional sculpture could.

While Nauman's corridor borrowed its drama of bodily awareness (as well as its monitor "boxes") from the vocabulary of Minimalism, by using video it connected Minimalist space to media space. Thus, along with other video work done at the time, it brought contemporary debates about television and surveillance technology into the purview of the art world. During the 1960s and 1970s, as television attained a definitive hold on American cultural life, well-known media theorists like Marshall McLuhan explored the collapse of distance and the new forms of connectivity that the televisual world would bring. Would this connectivity bring humankind a new and ecstatic form of global awareness? Would the human body transcend its physical limits through media technology (the "extensions of Man," as McLuhan put it) and attain a new, utopian potential? Or would new media usher in a dystopian surveillance state and the destruction of privacy and individuality? Nauman's installation explores these questions without offering an easy solution. The media space in Nauman's corridor—with its delayed, displaced, and self-estranged body—partakes of both the funhouse and the haunted house.

## The Subject and the System: Conceptual Art

In the work of Hesse, Rainer, and Nauman, figures lose their integrity and melt into their spatial and perceptual environments. But there are other kinds of environments that also affect the bodies within them: consider the networks of language, information, and economics that structure social and material life. Conceptual art explored the impact of these symbolic systems.

**DEFINING CONCEPTUAL ART.** Although the meaning of the term "Conceptual Art" is still actively contested among art historians, it generally refers to concept-driven art that flourished on a global scale in the late 1960s and early 1970s. It is sometimes defined as art in which ideas take precedence over physical execution. In the late 1960s, for example, Lawrence Weiner wrote a series of terse statements describing the production of hypothetical works, such as *Gloss White Lacquer Sprayed for 2 Minutes at Forty Pound Pressure Directly Upon the Floor.* As far as Weiner was concerned, a statement like this *was* the work. The work could either remain in this propositional state indefinitely, or it could be physically performed as instructed. Weiner claimed that this decision was up to the owner.

Because art like Weiner's invested so conspicuously in language, with a physical existence limited to a few dry leaves of documentation, some early commentators claimed that his work, like much Conceptual art, promised a new "dematerialization" of art. But even works that were never physically realized remained stubbornly material as written inscriptions on a surface medium. As writing, these propositions always had some kind of body, and the absence of the described work made the physicality of the inscription all the more precious and conspicuous. Indeed, many Conceptual artists made a point of exploring the visual, physical, and even aesthetic dimensions of seemingly immaterial language. In the late 1960s, John Baldessari (b. 1931) produced a series of paintings featuring snippets of prescriptive prose that he borrowed from art history books. After selecting the passages, he hired a commercial artist to paint the texts onto stretched canvases in standard lettering styles (**fig. 18.17**). The results, as in *What is Painting?* of 1968, are humorously paradoxical. The words claim that "Art is a creation for the eye and can only be hinted at with words," but the painted words proclaiming this *are* the art, and themselves appeal to the eye as a pleasing arrangement of lines and shapes.

Given works like these, it is difficult to define Conceptual art simply as "dematerialization." It is ultimately more accurate to say that it exposed the interdependence of ideality and materiality. We will define it here as art that explores the tension between an idea or conceptual system and its embodiment in the real, material world.

**CONTRACTUAL PROCEDURES.** Like Weiner's statements, works of Conceptual art often consisted of two clearly defined stages: proposition and execution. The artist would first set forth a formula, define a parameter, or simply devise a set of instructions for making a work of art. The plan or idea might then be systematically realized in material form

WHAT IS PAINTING

DO YOU SENSE HOW ALL THE PARTS OF A GOOD
PICTURE ARE INVOLVED WITH EACH OTHER, NOT
JUST PLACED SIDE BY SIDE ?  ART IS A CREATION
FOR THE EYE AND CAN ONLY BE HINTED AT WITH
WORDS.

18.17 JOHN BALDESSARI, *What Is Painting?*, 1968. Synthetic polymer
on canvas, 5 ft 6 in × 4 ft 7 in (1.72 × 1.44 cm). Museum of Modern Art,
New York.

(not necessarily by the artist him- or herself). Sol LeWitt
(see fig. 18.13) was influential in articulating this formulaic,
contractual procedure. LeWitt, whose work had both min-
imal and conceptual qualities, insisted that once the param-
eters of a work had been set, the artist must assiduously
obey them. There was no room for improvisation once
the process of realization had begun: "The idea becomes
a machine that makes the art. If the artist changes his mind
midway through the execution of the piece he compro-
mises the result." "The process is mechanical and should
not be tampered with. It should run its course."[24]

The contractual basis of Conceptual art was closely
related to the rise of the post-industrial service economy
in the 1960s and 1970s. As the American economy began
to focus more and more upon the management of
information and capital (leaving the actual production of
goods to unskilled workers and foreign subcontracts), the
relationship between the proposition and the execution
of ideas became explicitly political. As art historian
Helen Molesworth has argued, Conceptual art production
"mimick[ed] the logic of labor's division into manual and
mental realms."[25] Conceptual artists were aware of these
associations; as LeWitt wrote, the artist "functions merely

as a clerk cataloguing the results of his premise."[26] Thus,
while the Minimalists had borrowed their formal vocabu-
lary from industrial fabrication, the artists associated with
Conceptual art tapped into what Benjamin Buchloh has
called the "aesthetic of administration." This aesthetic was
evident in the appearance of much Conceptual art: type-
written texts, mimeographed diagrams, charts, graphs,
reports, and black-and-white documentary photographs
presented in gridded formats. And much like a scientific
experiment, corporate business plan, or military training
exercise, the actual production of the work was a strictly
controlled procedure.

**INFORMATION AND ITS FAILURES.** Conceptual artists
used these methodical procedures in order to analyze
and critique the administrative powers from which they
had been appropriated. In translating directions into
action, they highlighted the failures and uncertainties of
the process, thus promoting skepticism about the wonders
of efficient administration. In Trisha Brown's *Roof Piece* of
1973 (**fig 18.18**), for example, fourteen dancers in bright
orange uniforms were spread out across a mile-long line of
rooftops in lower Manhattan. Brown initiated a sequence
of movements, which the next dancer observed and then
attempted to replicate, onward through the line of dancers
and ultimately returning to Brown herself. But the distance
separating the dancers assured that atmospheric "noise"
interfered with the accuracy of the "signal," and made this
piece a visual equivalent of the game of telephone. By the
time the gesture had returned to Brown, it had decayed
noticeably from the original. In a decade defined by the
rise of information technology (this was the era of the

18.18 TRISHA BROWN, *Roof Piece*, 1973. Photo © 1973 Babette Mangolte.
All rights of reproduction reserved.

18.19A,B
(left, far left)
DOUGLAS
HUEBLER,
*Variable Piece,
# 101*, 1973.
Photographs and
letter. Private
collection.

**18.19**), Douglas Huebler (1924–97) sat down with a friend (the German photographer Bernd Becher) and read to him the following words: "priest," "criminal," "lover," "old man," "policeman," "artist," "Bernd Becher," "philosopher," "spy," and "nice guy." Becher's job was to adopt a facial expression that would embody each social type while Huebler documented the expressions in photographs. After this initial stage of the project, Huebler waited for two months and then mailed the photographs to Becher, asking him to match the faces he had made with the labels that had originally inspired them. Becher could not put them in the proper order.

*Variable Piece* is, of course, funny—and not just because Becher's face has such droll elasticity. Conceptual art frequently reveals, with comic sobriety, the mistranslations, fumbles, and failures of logical and linguistic systems. But this is a critical brand of humor, for Huebler's piece is quite serious about the problem of stereotypes. Huebler demonstrates the inaccuracy—even the cruelty—of the semiotic systems that make society comprehensible. At root, Huebler's work opposes the despotic power of language to promote stereotypical thinking. "I'm speaking," said Huebler, "against the irresponsibility of language."[28]

**THE ARTIST'S BODY: ELEANOR ANTIN AND CHRIS BURDEN.** In Huebler's work, the failure of language to map itself accurately onto the human body exemplified broader concerns with the unstable intersection of subjects and systems in the 1970s. In many Conceptual works, artists used their own bodies to reveal the uncomfortable collision of abstract systems and living, breathing individuals. In these cases, the distinctions between Conceptual art and what is sometimes called **Body art** become increasingly

efflorescence of digital computing), Brown's work questioned the accuracy of the transmission and transcription of information. As critic Jack Burnham put it in a 1970 essay about Conceptual art's range of concerns, "Questions of information's *predictability, improbability, complexity, message structure, dissemination, delay,* and *distortion* are factors … for consideration."[27]

Other artists explored the inadequacy of systems of social classification. For his *Variable Piece no. 101* of 1973 (**fig.**

difficult to draw, and the social criticism becomes more evident. Eleanor Antin's (b. 1935) *Carving: A Traditional Sculpture* of 1973 (**fig. 18.20**), for example, used a Conceptual vocabulary to deliver a lashing critique of the impact of cultural ideals of feminine beauty. During the summer of 1973, Antin put herself on a strict diet. She documented the diet with one hundred and forty-four 5 × 7 black and white photographs arranged in a grid, showing her progressively thinning body as seen each morning from the front, back, left, and right sides. *Carving* was based on the tradition of "ideal form" in the history of sculpture. Antin had found a paragraph in a book on carving technique instructing the artist to turn the piece intermittently on its four axes, carving off a bit at a time until the ideal form had been achieved. By following these instructions to document her own weight reduction program, Antin suggests that dieting is an ongoing Conceptual sculpture in which women suffer to achieve artificial idealizations of beauty.

The monkish discipline of Antin's performance was a common aspect of Body art and Conceptual practice, in which artists passively followed their own injunctions, even at the expense of comfort or safety. In its extreme forms this practice shaded into outright masochism, the notorious apex of which was reached on the evening of November 19, 1971, at 7:45 p.m., when the Los Angeles artist Chris Burden (b. 1946), in front of a small invited audience, had a friend shoot him in the arm with a 22 caliber rifle from a distance of 15 feet (**fig. 18.21**). The intended result was that the bullet would merely graze Burden's flesh, but some flinch either of Burden's or the marksman's caused the bullet to stray off course. Burden's arm was shot all the way through and he had to be rushed to the hospital.

Burden already had a reputation for placing himself in dangerous or excruciating situations. For his first performance, while still in graduate school, he confined himself in a locker for five consecutive days—a locker just two feet high, two feet long, and three feet deep (*Five Day Locker*

18.20 ELEANOR ANTIN, *Carving: A Traditional Sculpture*, 1973. Black-and-white photographs (144), 7 × 5 in (17.7 × 12.7 cm) each, text. Art Institute of Chicago, Illinois.

*Piece*, 1971). He would go on to crucify himself on the hood of a Volkswagen (*Trans-fixed*, 1974) and to bring himself, several times, to the verge of electrocution (*Doorway to Heaven*, 1973, 220, *F-Space*, 1971). Did these performances stem from some deranged sensationalism? Or were they more meaningful than that?

For Burden, *Shoot* was the epitome of American art, with deep roots in American folklore and culture. As he put it, "Being shot, at least in America, is as American as apple pie, it's sort of an American tradition almost." "Everybody watches shooting on TV every day. America is the big shoot-out country. About fifty per cent of American folklore is about people getting shot."[29] Burden

Shoot
F Space: November 19, 1971

At 7:45 p.m. I was shot in the left arm by a friend. The bullet was a copper jacket 22 long rifle. My friend was standing about fifteen feet from me.

18.21 CHRIS BURDEN, *Shoot*, 1971. Gagosian Gallery, California.

performed *Shoot* against the backdrop of the Vietnam War, which was by then being presented in horrific detail on the nightly news. Like Warhol's *Disaster* paintings, Burden's work raised questions about the representation of violence and the possibility of an empathetic response to it.

By staring down the barrel of the gun himself, Burden brought the American culture of violence into the purview of what we might call the conceptual contract. This contract, common to both Body and Conceptual art, places the artist on both sides of the disciplinary divide: the artist functions as the litigator, administrator, executioner—the designer or enforcer of the system—as well as the subject who is subject to its physical and psychological effects. This double role caused considerable anxiety for Burden: "Dealing with it psychologically, I have fear—but once I have set it up, as far as I am concerned, it is inevitable. … Sometimes I can feel myself getting really knotted up about it, and I just have to relax, because I know it is inevitable. The hardest time is when I am deciding whether to do a piece or not, because once I make a decision to do it, then I have decided—that's the real turning point. It's a commitment. That's the crux of it right then."[30]

In *Shoot*, because Burden had initiated the procedure that he now found himself enduring, the option of simply aborting the experiment was always available. Thus the absurdity, danger, and arbitrariness of the procedure were highlighted, and the "inevitability" Burden invokes above brought into question. The art historian Frazer Ward draws attention to the role of the audience in *Shoot*, showing that the work also begged the question of public complicity. By including a small but formal audience in the performance, Burden shifted part of the dilemma of responsibility onto them. Why did no one in the audience stop the shooting? By inviting this question, Burden's work aligns the conceptual contract with the social contract. For if Burden's shooting was not really inevitable, how inevitable are the similarly contractual rules and abstractions (military strategies, the death penalty, etc.) that lead to violent deaths around the world? Burden's meticulous passivity in the face of "inevitable" procedures functioned as a call to action, and forged a concrete connection between the ethics of art and the ethics of obligation.

## Figures of Resistance

The crisis of the figure in the 1960s and 1970s was carried out primarily through real bodies—we have traced it, for example, in video works that disperse the viewer's bodily consciousness and in conceptual works that subject the artist's body to mechanistic procedures. But despite the flourish

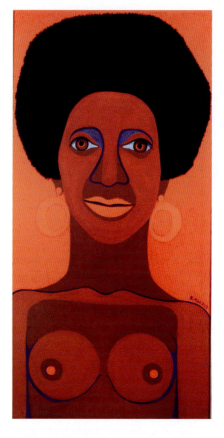

18.22 FAITH RINGGOLD, *Soul Sister*, 1967. Oil on canvas, 36 × 18 in (91.4 × 45.7 cm).

of these direct bodily practices in this period, figurative representation—the depiction of the human form—did not simply disappear. In addition to its persistence in Pop painting, figuration developed in vibrant new directions in the work of artists like Chuck Close (b. 1940), Alice Neel (1900–84), and Philip Pearlstein (b. 1924). And it played a critical role in the work of artists of color, who used it to contend with political problems related to the perception—the representation—of bodies. This activist figuration operated on many levels. Faith Ringgold (b. 1930), in her *Black Light* series of 1967 (**fig. 18.22**), developed an entirely new theory of color in painting, in which she rejected the traditional use of white paint to create the effects of light in an image, substituting instead subtle variations of color. In her paintings, the beauty of the black body does not depend upon a color scale in which white signifies light or purity.

**T. C. CANNON AND BETYE SAAR: REANIMATED STEREOTYPES.** More commonly, artists of color used figurative imagery as "found imagery," which they repurposed in order to dismantle derogatory stereotypes that misrepresented their historical experiences. Native American artists, long laboring under the rubric of the "Vanishing Race," had much to gain by critiquing such stereotypes. But instead of attempting to circumvent or deny the feather-bonneted warriors that had been this country's

visual legacy since George Catlin and Edward Curtis, many Indian artists in the 1970s seized these stereotypes and turned them to their own purposes. T. C. Cannon's (1946–78) painting *Collector no. 5* or *Osage with Van Gogh* of 1975 (**fig. 18.23**) updates *Wohaw Between Two Worlds* (see fig. 9.37) of a century earlier. Unlike Wohaw, the Indian subject no longer seeks rapprochement between two worlds—he has achieved it. Although he strikes the stereotypical pose of the stoic Indian, Cannon's collector embraces the globe with his eclectic possessions: a Navajo rug, an Indonesian wicker chair, historic Oklahoma Native finery, and Van Gogh's iconic *Wheatfields* on the wall. Inverting the expected ethnicities of collector and collected, he crosses his leg jauntily, confident in his understanding that Native peoples have long mediated diverse worlds in a cosmopolitan manner (see portrait of Hendrick, fig. 2.22).

In the 1970s, African American artists also confronted a pervasive culture of stereotype that they were determined to overturn. As in the New Negro movement earlier in the century (see Chapter 15), their overall intent was to replace negative images with positive images, but their approach refrained from the assimilationist tone of New Negro rhetoric. The California artist Betye Saar applied militant

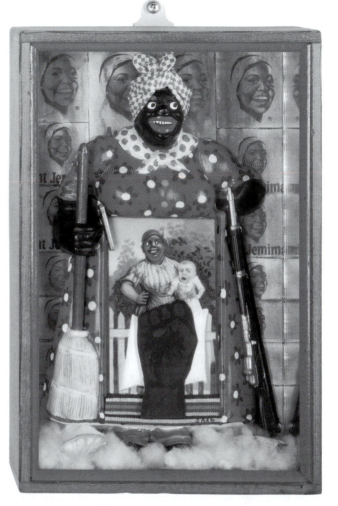

18.24 BETYE SAAR, *The Liberation of Aunt Jemima*, 1972. Mixed media. Berkeley Art Museum, University of California.

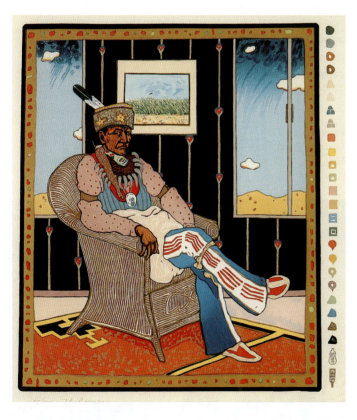

18.23 T.C. CANNON, *Collector no. 5* or *Osage with Van Gogh*, 1975. Color woodcut, after a painting by the artist, 25¼ × 21⅞ in (64.1 × 55.1 cm). Heard Museum, Phoenix, Arizona.

humor to her reworking of the "black mammy" stereotype, used for decades in advertising as a symbol of cheerful and reliable subservience. In her 1972 assemblage *The Liberation of Aunt Jemima* (**fig. 18.24**), inspired in part by Joseph Cornell's box assemblages (see fig. 14.34), Saar used a found figurine, a "black mammy" memo-and-pen holder, and recontextualized it in order to reverse its original meanings. She augmented the figure's emblem of servitude, the broom, with a pistol and a shotgun, converting docile servility to angry volatility. In the place of the memo pad, Saar inserted an image of a black nursemaid holding a white baby together with the symbol of the Black Power movement—a clenched fist. The "memo" to be taken here, Saar implies, is that black slaves and servants have taken care of whites long enough. The shallow wooden box is lined with a grid of faces from the Aunt Jemima pancake mix logo and bracketed with mirrors so that the smiling stereotypical faces seem to extend forever. Repeated *ad infinitum*, the smile becomes sinister, perhaps masking

other, more aggressive intentions. Saar's repetition and recontextualization of the "black mammy" stereotype transform it from a racist device into a new symbol of the black woman as knowing, powerful, and ready to act in her own interests.

**MURALS, ON AND OFF THE WALL.** A strong community of **Chicano** figurative artists developed in Los Angeles in the 1970s. Perhaps the most conspicuous—and certainly the largest—example of their work is *The Great Wall of Los Angeles*. Painted under the direction of Judith Baca along a concrete wall in the San Fernando Valley, the mural stretches over a half mile. The longest mural in the world, it reinterprets the history of Los Angeles from a multiracial perspective, using figurative representation to recover and preserve narratives that might otherwise have been lost (**fig. 18.25**). The project was part of a nationwide revival during the 1960s and 1970s of the mural form, which had been made popular by Mexican artists in the 1930s (see Chapter 16). Unlike the murals of the 1930s, however, Chicano murals flourished without institutional endorsement. Like graffiti, these murals tended to be produced "a la brava," which means that they were improvised in the field without elaborate preparatory sketches.

In the early 1970s, the Chicano artists' group Asco (meaning "nausea" in Spanish) devised a form of active figuration that combined Conceptual art and performance with the mural painting tradition. The members of Asco felt that murals had become too comfortably established as the "Chicano" medium, and had succumbed to the inertia of tradition. Moreover, the members (including Harry Gamboa, Jr. (b. 1951), Gronk (b. 1957), Willie Herrón (b. 1951), and Patssi Valdez (b. 1951)) felt that in recovering

lost histories, murals tended to immobilize them within predictable formats. Asco preferred the uncertainty of a constantly rewritten present. As Gronk put it, "A lot of Latino artists went back in history for imagery because they needed an identity, a starting place. ... We didn't want to go back, we wanted to stay in the present ... and produce a body of work out of our sense of displacement."[31]

That sense of displacement became evident in Asco's displacement of the mural tradition itself. Asco was (to quote Gamboa) "intent on transforming muralism from a static to a performance medium."[32] In 1972, having been rebuffed by a curator at the Los Angeles County Museum of Art for suggesting that Chicano art be included in museum exhibitions, group members spray-painted their names, graffiti style, onto all of the museum entrances. This "mural," according to Gamboa, became "the first Conceptual work of Chicano art to be exhibited at LACMA." In *Instant Mural* (1974), two members of the group were strapped to the exterior wall of an East Los Angeles liquor store with masking tape. In *Walking Mural* (**fig. 18.26**), the group dressed up as characters from typical mural scenes and wandered along a busy street in East Los Angeles. One character's headdress included part of a portable masonite wall-structure, making it clear that this was a mural that had come down from the wall and walked away. For Asco, history was not to be encapsulated in representational form but was to be perpetually reanimated, capable of making direct and unpredictable interventions in contemporary politics.

18.25 JUDITH F. BACA, *The Great Wall of Los Angeles*, Tujunga Flood Drainage Canal, Van Nuys, California, 1968–73. Mural, 13 ft (3.96 m) high, 2,500 ft (762 m) long.

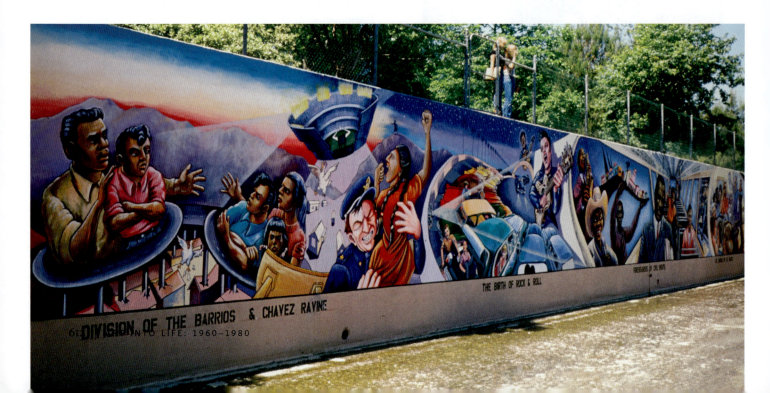

18.26 ASCO, *Walking Mural*, 1972. Performance. Photograph © 1990 Harry Gamboa, Jr.

# American Spaces Revisited

By the mid-1970s, American art had fulfilled many of Kaprow's 1958 predictions about a "new concrete art." It had shifted decisively toward a direct and multifarious engagement with everyday life, and had become an instrument of social activism and political confrontation. In the process, many layers of aesthetic distance that traditionally separated art from its objects of commentary had been stripped away. As art moved to occupy the spaces of everyday life, it altered those spaces irrevocably; this was particularly true of three spheres that have long traditional histories in American culture: the museum, the landscape, and the home.

# Challenging the Museum

The most immediate space to be transformed by these newly active arts was the museum itself. Whereas in 1822 Charles Willson Peale had pictured the museum in a natural and seamless relationship to the artist (see *The Artist in His Museum*, fig. 5.33), artists now had more complex, antagonistic attitudes toward the institutions that controlled the presentation of their work. Minimalism, Pop, Conceptual art, and Performance were the origins of what is now known as **institutional critique,** a cluster of art practices that aim to reveal the social and political conditions of the art museum (its funding structures, its class, race, and gender biases, etc.) that are neutralized or rendered invisible by traditional practices of display.

**HANS HAACKE AND VITO ACCONCI.** An early and influential work of institutional critique was Hans Haacke's (b. 1936) *Condensation Cube* of 1963–5 (**fig. 18.27**). Produced at the height of Minimalism's popularity, it elegantly demonstrated that Minimalism's hypersensitivity to its surroundings could lead to a broader awareness of the conditions governing museum display. The piece is disarmingly simple: a quantity of water is sealed inside a plastic cube and set on a pedestal. Gallery spotlights, along with the presence of warm bodies in the room, cause the temperature inside the unventilated cube to rise. The water inside evaporates and condenses along the inner surface of the plastic, changing the appearance of the work. Thus, while *Condensation Cube* resembles Minimal sculpture, it is closer in spirit to the small instruments in museums (called hygrometers) that measure humidity. Museums install these instruments to help ensure that atmospheric conditions remain constant in the galleries and do not affect the art. Haacke's cube, on the other hand, is not there to protect art from such "conditions," but rather to internalize and display them. Art, it suggests, is inseparable from the conditions under which it is observed.

Vito Acconci's (b. 1940) 1970 work *Proximity Piece* used the strategies of Performance and Conceptual art to demonstrate that the "neutral" conditions of the art museum required careful social maintenance (**fig. 18.28**). His work, too, was inspired by Minimalism; speaking of Minimal artists, Acconci said that "their work made me think of a room as an art space, rather than just a space

18.28 **VITO ACCONCI**, *Proximity Piece*, performed at the "Software" exhibition, Jewish Museum, New York, 1970.

that happens to hold art. The notion of being forced to confront that space and the people around the sculpture was exciting to me."[33] This confrontation was coded into Acconci's proposition for *Proximity Piece*: "I wander through the museum and pick out, at random, a visitor to one of the exhibits: I'm standing beside that person, or behind, closer than the accustomed distance—I crowd the person until he/she moves away, or until he/she moves me out of the way."[34] The stereotypical museum experience is one of quiet, solitary contemplation in which the individual viewer communes intimately with art and factors out everyday social life. Acconci's *Proximity Piece* attacked this truism, forcing other museumgoers into the uncomfortable realization that the contemplation of art is not natural or neutral, but is sustained by an elaborate series of social conventions that only become visible when they are breached.

18.27 **HANS HAACKE**, *Condensation Cube*, 1963–5. Acrylic, water, light, air, currents, and temperature, 12 × 12 × 12 in (30.4 × 30.4 × 30.4 cm). Collection of the artist.

**MIERLE LADERMAN UKELES.** Conceptual art, by incorporating everyday forms of labor and activity into the work of art, made it possible to imagine a collapse in the traditional distinctions between artistic work and regular work. This contributed to institutional critique because it allowed the museum itself to be seen as a space of everyday labor rather than privileged creation. After having her first child in 1969, sculptor Mierle Laderman Ukeles (b. 1939) found herself torn (like so many women before her) between her work as a mother and her work as an artist. Instead of spending her time doing creative work in the studio, she found herself overwhelmed with the repetitive, seemingly endless tasks of nurturing that an infant requires. She eventually came to realize that it was not so much the activities of feeding, bathing, and changing diapers that bothered her as it was that "there were no words in the culture that gave value for the work I was doing." She realized that her art training had only prepared her for a very particular model of work: creative work that led to breakthroughs, advances, and innovations. "*Nothing* educated me for how to bring a wholeness to taking care, not only creating life, but maintaining life. The creating, the originating, that's the easy part." But the "implementation … follow-through, hanging in there" had been lacking. "I had no models, none, in my entire education to deal with repetitiveness, continuity."[35]

In 1969 she published a "Maintenance Art Manifesto" and began using the tactics of Conceptual and Performance art to promote visibility and appreciation for housework, sanitation, and maintenance tasks that are usually regarded as "outside culture, thus formless and unspeakable."[36] She illuminated these activities "outside culture" by bringing them into the space most fully inside culture (the art museum) and demonstrating how they were normally excluded from view in this context. For Ukeles, art museums maintained their cultural status by functioning as temples of creativity, genius, and originality, which were thereby obligated to stigmatize and marginalize maintenance activities (with their close association with "women's work"). In 1973 she performed a series of planned actions at Hartford's Wadsworth Atheneum that dramatized these priorities. In *Hartford Wash*, she spent eight hours scrubbing the entry steps and floor of the museum, confronting visitors with the normally invisible labor that was necessary to keep gleaming galleries clean and "neutral" (**fig. 18.29**).

By revealing the social valencies of exhibition space, artists like Haacke, Acconci, and Ukeles opened the way for subsequent critiques of art-world demographics and representation. For if the apparently neutral gallery space

18.29 MIERLE LADERMAN UKELES, *Hartford Wash: Washing Tracks, Maintenance Outside,* performed at Wadsworth Atheneum, Hartford, Connecticut, 1973.

("The White Cube," as artist and art critic Brian O'Doherty labeled it in 1976) could be revealed as socially charged, so might the objects and artists chosen to fill that field. We will return to these critiques in Chapter 19.

## The Mediated Landscape

Like the landscape painters of earlier centuries, late-twentieth-century American landscape artists worked to interpret the interface between nature and culture. Yet by the 1970s this interface was changing rapidly. Although some new landscape art expressed nostalgia for a sublime natural space safe from an increasingly polluted realm of culture, the most influential landscape art in this period sprung from the recognition that nature and culture were inextricable. The global extent of tourism, mapping, mining, and man-made technology suggested that there was no longer any such thing as virgin wilderness. Working directly in the landscape, often at a monumental scale, the new landscape artists encountered nature as an already-mediated sphere rather than a symbol of unsullied purity.

**ROBERT SMITHSON.** Robert Smithson's *Spiral Jetty*, built in 1970, springs into the Great Salt Lake from a remote point on its northern shoreline (**fig. 18.30**). The work is monumental in size as well as ambition: built from 6650 tons of rock and mud by a crew of skilled engineers and heavy equipment operators, the spiral is a quarter-mile long. *Spiral Jetty* was designed to meld with the geology and ecology of its site. Smithson (1938–73), who was interested in crystallography, knew that the lake would eventually deposit a layer of ghostly salt crystals along the margins of the black rock. He knew that the sheltering arms of the spiral would increase the concentration of brine and microorganisms in the salt water, turning the water a deep blood red at the center of the earthwork. He recognized that the *Jetty* would be subject to the same forces of erosion, alluviation, and disintegration as the rest of the landscape, and would thus function less as outdoor sculpture than as natural formation. All this, along with the profound isolation and stark beauty of the site, makes it tempting to interpret *Spiral Jetty* as a fully "natural" work of art.

But culture and industry also inform the *Jetty*. The earthwork lies just a few miles from Promontory Summit, the site of the driving of the Golden Spike that completed the transcontinental railroad in 1869. Smithson was aware of this when he planned *Spiral Jetty*, and the two monuments (Golden Spike and *Spiral Jetty*) remain bound in a cross-historical dialogue today. The *Jetty*'s own structure—a roadbed embankment with a path atop it—makes explicit reference to railroad trackbeds. And the *Jetty* was built with the same heavy machinery and engineering techniques—indeed, by some of the same men—as the railroad causeways that were built across the Great Salt Lake in the twentieth century. The earthwork synthesizes industrial processes with natural processes.

By integrating the idea of the railroad in this way, Smithson enters a perennial artistic discourse about the relationship between nature and civilization, landscape and technology. Nineteenth-century imagery tended to place the railroad and the natural world either into a limited state of balance within a narrow "middle landscape" (see Chapter 8), or into strictly oppositional positions. In Asher B. Durand's *Progress* (see fig. 7.12), for instance, Native Americans, emblems of vanishing nature, resignedly observe the railroad as it conveys the force of "civilization" across the frontier. *Spiral Jetty*, by contrast, rejects any opposition between nature and industry. In doing so, it also rejects any model of progress measured by the advance of technology over nature; indeed, *Spiral Jetty*, as it swerves counterclockwise into the lake, suggests a derailment of the linear progress that the transcontinental railroad once embodied. Smithson linked nature and culture in a dialectical synthesis; for him, all landscape was "middle landscape."

**CHRISTO AND JEANNE-CLAUDE.** Another important landscape work of the 1970s was *Running Fence*, designed by the husband–wife team of Christo (b. 1935) and Jeanne-Claude (b. 1935). Over the span of two weeks in the autumn of 1976, this 18-foot-high, 24 and a half mile-long white

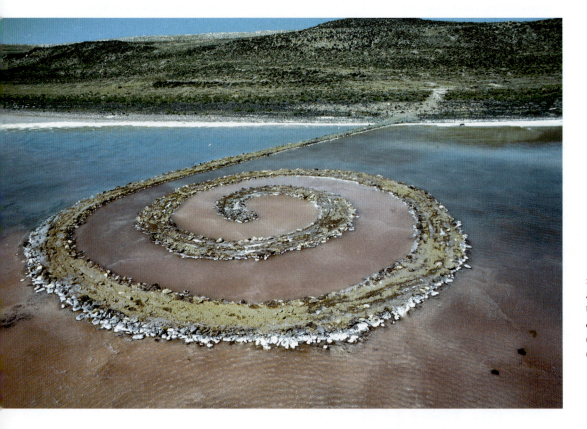

18.30 ROBERT SMITHSON, *Spiral Jetty*, Great Salt Lake, Utah, 1970. Black rock, salt crystals, earth, and red water (algae), 4 × 15 × 1500 ft (1.21 × 4.57 × 457.2 m).

# Mark Dion

SMITHSON'S MEDIATED STATE of nature remains compelling for artists today. Mark Dion (b. 1961), one of many contemporary artists influenced by Smithson, explores the systems of knowledge that humans devise to comprehend the natural world. Dion has studied both art and biology, traveled in the Central American rainforests, and worked in a conservation laboratory specializing in Hudson River School landscape painting. His installations typically involve the sorting, arrangement, and display of specimens that are ambiguously located between nature and culture. In his *Upper West Side Plant Project* of 1993, for example, a collection of fruits, vegetables, and plants purchased on Broadway between 110th and 111th Streets were dried, preserved, and displayed as if they were strange exotica gathered on a far-flung expedition.

Dion's 2005 installation, *Library for the Birds of Massachusetts* **(fig. 18.31)**, in a nod to John James Audubon (see p. 170), features a large aviary. Within the aviary is a dead maple tree whose branches, functioning like library shelves, are filled with ornithology books. Flitting around the tree are twelve live zebra finches. Viewers are invited to enter the aviary and observe the beautiful birds up close. Dion thus creates for his viewers an intimate encounter with real nature (live birds), but everything about the installation calls the directness of that encounter into question. The books are not really "for the birds"; instead they represent the human "tree of knowledge" that structures and determines our understanding of the actual creatures flying around our heads. Dion's point is that just as the birds are trapped in the aviary, we, too, are trapped within a cage of knowledge. We cannot escape it and see these birds in their true unmediated state of reality.

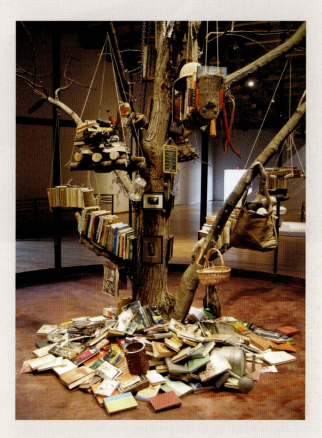

18.31 MARK DION, *Library for the Birds of Massachusetts*, 2005. Massachusetts Museum of Contemporary Art, North Adams.

nylon "fence" meandered through the hilly grasslands north of San Francisco (**fig. 18.32**). Christo and Jeanne-Claude spent years preparing this transitory work, which, despite its massive scale and complexity, was financed entirely through the sale of preliminary drawings, collages, and early work of the 1950s and 1960s. Catching and conducting the shifting natural light and color, billowing, stiffening, and slackening in the breezes, and following the gentle roll of the hills, this "ribbon of light" was breathtakingly beautiful. But Christo and Jeanne-Claude did not intend *Running Fence* simply to accentuate the natural sublimity of the area; they also hoped that it would "grab [the] American

social structure."[37] In other words, they hoped the *Fence* would register cultural as well as natural conditions.

In order to realize the project, Christo and Jeanne-Claude required the cooperation of engineers, surveyors, fabricators, politicians, and ordinary citizens. The *Fence* ran through fifty-nine privately owned ranches and other properties, crossed fourteen roads, and bisected a town. Thus the challenges facing the artists included not only design and construction, but also the securing of building permits, easement agreements, removal bonds, and environmental impact reports—in short, the permission of society. The project was constantly exposed to the possibility of

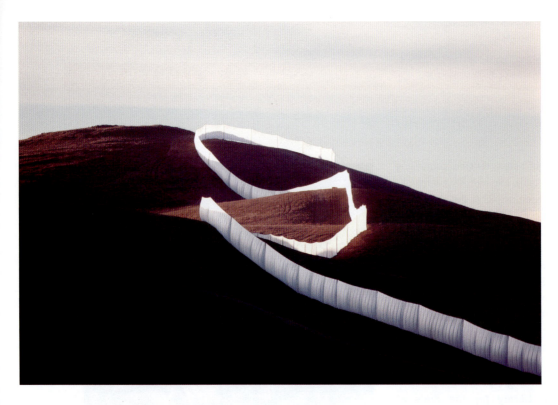

18.32 CHRISTO & JEANNE-CLAUDE, *Running Fence*, Sonoma and Marin Counties, California, 1972–6. Woven white nylon fabric, steel cable, steel poles, earth anchors, 18 ft (5.48 m) high, 24½ miles long.

failure. Through seventeen contentious public hearings, the artists had to persuade people unfamiliar with the virtues of contemporary art to support their efforts. A group of local citizens skeptical of the artists' intentions formed "The Committee to Stop the Running Fence" (at hearings, one man repeatedly compared the work to a giant roll of toilet paper). But Christo and Jeanne-Claude considered even their most implacable opponents to be full participants in the project. Every gap and switchback added to avoid the land of an uncooperative rancher, every design compromise made to mollify traffic officers, helped the *Fence* to reveal the political contours of this particular landscape. And, four years and 3,000,000 dollars after it was conceived, *Running Fence* was finally built.

The achievement of *Running Fence* was to manifest a social reality that was not openly acknowledged in earlier American art: namely, that the American landscape is always a ground of passionate opinions, public debate, dissent, conciliation, improvisation, and legal process. In the end the shape of the work follows a political trajectory as much as it does the natural topography, and demonstrates that the western landscape it occupies has as much to do with fences as it does with wide open spaces.

**ANA MENDIETA.** Fences; administration; territory: these were inevitable catchwords for an art that occupied the real land rather than picturing it from afar. But these words also capture the experiences of many of the immigrants and refugees who encountered the American landscape as part of an unstable new Cold War geography. Ana Mendieta

18.33 ANA MENDIETA, *Untitled*, from the *Silueta* series, 1978. Gelatin silver print, 19¹⁵⁄₁₆ × 15¹³⁄₁₆ in (50.6 × 40.1 cm). San Francisco Museum of Modern Art, California.

(1948–85) came to the United States in 1961, at the age of twelve. Her parents in Cuba sent her as part of Operation Peter Pan, a controversial effort organized by the CIA and the Roman Catholic Church to evacuate Cuban children who were perceived as vulnerable to Castro's revolutionary government. Although the operation was touted as a rescue, Mendieta remembered it as a wrenching, lonely exile; it was five years before her mother was able to enter the United States to join her. She moved through a series of foster homes and orphanages in Iowa, where she was a frequent target of ethnic slurs.

Mendieta studied Performance art, Land Art, and Body art in graduate school, and in 1973 began her series of earth/body performances called the *Silueta* series. In these landscape interventions, many of them in Iowa, she used dirt, grass, flowers, etc., to make silhouettes in the scale and shape of her own body (often pressing her body to the ground to do so), then documented the imprint in photographs and films (**fig. 18.33**). Mendieta's series embodies the double logic of the silhouette as a form that suggests both presence and absence (see Chapter 6). Mendieta felt acutely that she was in the American landscape but not of it, present in Iowa but always only because she was absent from Cuba. As rendered by Mendieta, the Iowa earth—the heartland of American Regionalism (see fig. 15.5)—becomes a place of alienation.

The forms of the Siluetas recall the ancient fertility "Earth-Mother" that many feminist artists of the period used as a symbol of feminine strength. But Mendieta presents these Venus-like contours as traces rather than presences. She thus celebrates the female figure but protects it from the problematic and dangerous state of objecthood. Throughout the 1970s, Mendieta protested vigorously against the objectification of women's bodies—she was one of many feminist artists in America at the time who staged performances that challenged societal indifference to violence against women. Mendieta's dissolution of bodily presence further illustrates the Postminimalist strategy of "figurelessness" as also seen in the work of Hesse, Rainer, and Nauman. Indeed, what better example of the body-becoming-field than a ghostly form merging into an Iowa prairie?

## Broken Homes

The expanded field of American art after the 1960s embraced not only the vast American landscape but also smaller, more intimate spaces. Myths and traditions surrounding "The American Home" became an especially important field of artistic interrogation. Many of the most influential domestic interventions in the early 1970s were associated with the feminist movement and its reconsideration of traditional assumptions about the home as the realm of women.

The model of American domesticity in the years following World War II was the suburban home, constructed by the tens of thousands and featured as the natural habitat of the nuclear family in countless TV shows and magazines.

## Art and Feminism in the 1970s

AS A STRATEGY designed to overcome the isolation of women, one of the most important feminist tactics of the 1970s was known as "consciousness-raising." It involved bringing groups of women together to share their personal experiences. As they talked, women often realized that the difficulties that they had assumed were personal and particular to them were actually shared by other women. They also learned to consider the ways in which their problems might stem from restrictive cultural norms and social policy rather than personal or biological failings.

An important catchphrase for feminists at this time was "the personal is political." This equation had a galvanizing effect on many women artists of the 1970s, and led them to produce art based on personal experience that would also expose broader political realities. It also laid the groundwork for women artists to explore the causes of gender discrimination in the art world. Linda Nochlin's provocatively titled 1971 essay "Why Have There Been No Great Women Artists?" did just this. Nochlin rejected the argument that women were inherently inferior as artists, and went on to demonstrate in detail the institutional and cultural barriers that prevented women from succeeding. Feminist art programs slowly began to develop in universities, where newly energized artists and scholars began to rescue women artists of the past from historical oblivion and to fight for recognition for contemporary women artists.

This wholesale suburbanization of middle-class life combined with the gendered division of labor that characterized the post-war economy: men had careers and mobility; women had children and stayed home.

By the late 1960s, a newly energized feminist movement began to develop the tools to analyze this situation, its causes, and its effects upon American women. Betty Friedan's 1963 bestseller *The Feminine Mystique* punctured the romanticized myth of the happy, hyperfeminine homemaker, exposing the frustration and despair of women trapped in a "separate sphere" that differed little from the domestic ideal of nineteenth-century American sentimental culture (see Chapter 6).

**WOMANHOUSE.** The *Womanhouse* project of 1972 was a collaborative performance/installation work that intervened in domestic ideology by physically altering a house. A group of twenty-one students in the pioneering Feminist Art Program, run by Judy Chicago (1939–) and Miriam Schapiro (1923–) at the California Institute of the Arts, transformed a derelict seventeen-room Hollywood mansion into a scathing attack on the "feminine mystique." The house, lent to the group by the City of Los Angeles, had been condemned and scheduled for demolition. In order to prepare it for exhibition, the women had to replace broken windows, install heating and plumbing, rehang doors, replaster walls, and refinish floors (inverting the usual gendering of "domestic labor" as they did so). Once the house was stabilized, each member of the group was responsible for transforming a single room or area.

As they developed their installations, the artists held consciousness-raising meetings in order to tap their memories of childhood homes and their current perceptions of domestic space. Many of the resulting installations used irony and exaggeration to portray the entrapment and loneliness of home life. The kitchen and bathrooms, as highly gendered spaces, were transformed in particularly memorable ways. In *Lipstick Bathroom* (**fig. 18.34**), Camille Grey coated the space in a bright lipstick red, as if the room had preserved on its surfaces all of the lipstick applied in front of the mirror over the years. Inevitably recalling blood as well as lipstick, the bathroom equated beauty with horror and highlighted the obsessive quality of make-up rituals and the social insecurities that encourage them. Vicki Hodgetts's *Nurturant Kitchen* (another monochromatic space—this time in pink) made the biological determinism of the kitchen disturbingly explicit, as multiple fried-egg forms glued to the ceiling morphed into breasts that lined the pink kitchen walls, eventually transforming into plates of prepared food along the counters.

18.34 CAMILLE GREY *Lipstick Bathroom* from *Womanhouse*, 1972. Photograph by Lloyd Hamrol.

*Womanhouse* fused art world trends with feminist tactics. The Minimalist use of serial repetition was here deployed to emphasize the numbing repetition of domestic life and labor. Conceptual art's deconstruction of "pure ideas" became a tool for demonstrating the inadequacy of sentimental idealizations of ethereal womanhood. The participatory audience, as awakened by Happenings, was granted a communal space for support and discussion. *Womanhouse* was open to visitors for the entire month of February 1972, attracting widespread media coverage and some 10,000 people to see the environment and performances.

**GORDON MATTA-CLARK.** Gordon Matta-Clark (1943–78), like the *Womanhouse* artists, treated architecture as a medium for sculptural alteration. Using everything from chisels to acetylene torches, he made "building cuts" that altered the perception of architectural space. Following upon the Minimalists' shift from fictive space to real space, Matta-Clark wondered: "Why hang things on the wall when the wall itself is so much more a challenging medium?"[38]

Matta-Clark's cuts perforated domestic structures, opening new connections between public and private space. The site for his 1974 project *Splitting* was a condemned suburban house in a blighted area of Englewood, New Jersey (**fig. 18.35**). With the help of Manfred Hecht, Matta-Clark sliced the house clean down the middle. The idea was simple, but the procedure was extremely difficult. After making the cut (no small task in itself), half of the house had to be held in place with jacks while the foundation below it was cut away. Then the jacks were carefully released and the entire house-half lowered so that the cut would blossom into an open wedge above. This was an exhausting and hazardous endeavor; as Hecht put it, "It was always exciting working with Gordon—there was always a good chance of getting killed."[39]

Matta-Clark had been trained as an architect at Cornell but soon disavowed the profession; he felt that modern buildings imposed ideology and that architecture was too easily accepted as a limit. In *Splitting*, he breached that limit. The cut produced a delicate tracery of light that transected the building with "long slivers of liberated space."[40] Unexpected spatial relationships between rooms became apprehensible. Thus, even though it literally severed the house, the cut had a connective effect, joining previously separated areas of the house to each other and to the outside world. Matta-Clark wanted to replace the viewer's architectural conditioning with a sense of ambiguity.

For all its beauty, *Splitting* did not directly address certain of its own preconditions: namely, the planned demolition of the building and the eviction of the African American family that had lived there. In an interview about the project, Matta-Clark noted that "the shadows of the persons who had lived there were still pretty warm,"[41] but their fate remains ambiguous. A contradiction embedded in both *Womanhouse* and *Splitting* is that their revolutionary reorganization of domestic space depended upon economic upheavals, the condemnation of the host buildings, and the displacement of the former residents. By the 1980s, as artists became more sensitive to such displacements, they began to address domesticity by systematically examining its negation—homelessness—as we shall see in Chapter 19.

18.35 GORDON MATTA-CLARK, *Splitting*, performed in Englewood, New Jersey, 1974. Chromogenic prints mounted on board, 41 × 31 in (104.1 × 78.7 cm). Metropolitan Museum of Art, New York.

## Conclusion

In the 1960s and 1970s, the critical function of art was increasingly seen to derive from its engagement with everyday life. The power of art was more likely to be generated from art's contact with the randomness, contingency, and complexity of the world than it was to emerge from a hermetic realm of its own. This imperative produced arts that were characterized by the renunciation of controlling artistic will, the tendency to grant the viewer an active role in the process of art, and the willingness to allow chance processes and extrinsic factors to affect the meaning and appearance of works of art. But questions remained: what was to guarantee that the extrinsic factors in question were truly authentic wellsprings of raw experience? How was one to know that everyday American life had not already been "framed" by the advertising industry, the mass media, or the government? As the 1980s began, these questions became increasingly difficult to ignore.

# 19 | American Art in Flux, 1980–PRESENT

TODAY AMERICAN ART is in flux. Although the history of American art has often been marked by efforts to stabilize the nation's cultural identity and produce permanent monuments of a shared historical tradition, this has not been true of the recent past. In order to understand American art of the past three decades, we must think in terms of dynamism, dialectics, and difference.

During the 1980s, **Postmodernism** became the dominant mode of thought in American intellectual circles, and artists and critics cast doubt on the validity of Modernist ideas about progress, objectivity, originality, and agency. The notion of the unique, self-determining person or "self" was challenged by a model of the individual as an entity constructed dynamically by social forces. Qualities as seemingly natural and inarguable as gender, race, and nationality were imagined to be contingent effects of continual social negotiation. Even the possibility of originality came under question, as "original" ideas were seen as having been patched together from borrowed thoughts circulating through culture at large. Along with this general rejection of the tenets of Modernism came a redefinition of the meaning of history. The concept of memory, the role of the monument, and progressive narratives of American history were all radically challenged. In the place of monolithic, enduring forms, the memorial arts substituted emptiness, change, and ambiguity.

Postmodernism's de-centering of American traditions has been amplified, from the 1990s onward, by an accelerated process of **globalization**. While international connections have defined American culture from the outset, the scale and speed of the globalization process have increased drastically since the end of the Cold War. The globalization of finance, production, marketing, and consumption; the development and entrenchment of worldwide digital communication networks; the rapid spread of AIDS and other diseases; and the increasing awareness of the transnational implications of climate change have made it increasingly difficult to separate American interests from those of the wider world. The process of globalization has also made it impossible to isolate some unchanging kernel of a specifically "American" art. At the beginning of this textbook, we identified a web of global relationships that defined the arts in what would someday become America. Now, at the end, we will look to a globalized art to imagine what America will someday become.

## Decenterings: the 1980s

American art of the 1980s drew upon developments of the previous two decades. In Minimalism and Postminimalism, for example, the center or anchor of the work had been impossible to locate; it emerged dynamically at the interstices between object, viewer, and space. This decentered model of meaning applied not only to art but also, increasingly, to artists. In works like Andy Warhol's silkscreen paintings or Mierle Laderman Ukeles's floor-scrubbing performances (see figs. 18.8 and 18.30), the artist's own inner source of creativity was similarly unlocatable. By adopting readymade content and rote, mechanical, or otherwise automatic production techniques, much of Pop and Conceptual art threatened to reposition the artist as a kind of borrower rather than a sovereign creator drawing upon an interior wellspring of genius.

(opposite) IÑIGO MANGLANO-OVALLE, *Carter, Anna, and Darryl* (from the *Garden of Delights*), 1998. C-prints of DNA analyses to Plexiglas, edition of 3, 60 × 74 in (152.4 × 187.9 cm). Courtesy of Max Protetch Gallery, New York.

## "The Death of the Artist" in Postmodernism

The meaning of artistic creativity was under intense investigation across the humanities and across the globe during the late twentieth century. The transatlantic, inter-disciplinary nature of this discussion was evident in the close ties between American art criticism and French literary criticism during this period. The French critic Roland Barthes (1915–80), to suggest just one example, became an influential figure in American art at this time. His 1967 essay "The Death of the Author" challenged the standard mythology of the artist, and became a hallmark of debates over the nature of creativity and the possibility—or not—of true originality.

Barthes argued against the usual tendency to explain works of literature by recourse to the author's biography or internal development. Not only was this simply too easy, he argued, but it also ignored the vast "intertextual" web of sources from which every author must draw while writing. Narrative structures, turns of phrase, even the very words that any writer uses are preexisting elements created by collective cultural systems—they come, in other words, from without rather than within. A piece of literature should be understood as "a multi-dimensional space in which a variety of writings, none of them original, blend and clash. The text is a tissue of quotations drawn from the innumerable centers of culture."[1]

Barthes's essay became required reading in the 1980s art world because it helped focus and articulate an array of tendencies that were beginning to coalesce under the term Postmodernism. These included a new interest in the formative activity of reception (as Barthes argued, the work would find its true "origin" not in the mind of the author but rather in the shifting perspectives of its multiple readers), a suspicion of **intentionality** (the idea that the meaning of a work lies entirely in the artist's intentions), and a new interest in **appropriation art** (that which unabashedly copies or borrows prefabricated content).

**FILM STILLS BY CINDY SHERMAN.** Cindy Sherman's photographs exemplified the doubts about selfhood, creativity, and identity that Barthes and others had introduced to the American art world (**fig. 19.1**). In 1977, Sherman (b. 1954) began to take black-and-white photographs that she called *Film Stills*. For each of the dozens of images that came to constitute the series, Sherman dressed up and posed herself in settings that recall stereotypical scenes

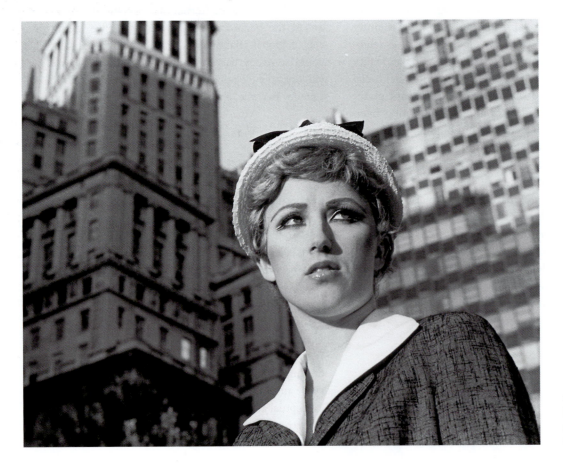

19.1 CINDY SHERMAN, *Untitled Film Still, no. 21*, 1978. Courtesy the artist and Metro Pictures.

and characters from European and American films. In one she posed as the classic 1950s pin-up beauty, in another the runaway teenager, in others the lush, the office girl, the librarian, etc. Sherman was particularly interested in evoking the look of B-movies—low-budget films that tend to deploy stock characters and predictable stereotypes rather than investing in complicated character development.

Although each of Sherman's photographs is technically a self-portrait, no single self is being portrayed—only a parade of familiar caricatures. There are as many Shermans as there are photographs; she, like the series, is unfinished, fragmented, and arbitrary. In each image Sherman aimed for an expressionless look, as if she were a doll or a robot without internal motivation. This uncanny blankness, as well as the evacuation of identity that it suggests, contributes to the general sense of listlessness that haunts the series. In each image, the protagonist seems immobilized, as if waiting for direction. Indeed, as fictional film *stills*, Sherman's images adopt a format in which activity is drained out of the image by definition. "The shots I would choose were always the ones in-between the action."[2] Something seems always about to happen *to* the protagonist, who waits for—what? Perhaps for the external "reading" that will bring her the meaning that she cannot carry alone.

It was not only their radical deconstruction of identity that made Sherman's *Film Stills* so influential; it was also their basic status as photographs. During the 1980s, the displacement of individual creativity became increasingly associated with the medium of photography. The rhetoric of mastery and genius that had surrounded *auteur* photographers of earlier decades gave way to an emphasis on the mechanical production and infinite reproducibility of the photographic image. As a medium whose basic operation does not require extensive training, photography could be seen as part of the "deskilling" of technique that attended so much contemporary art production. For the same reason, it became an ideal medium through which to explore the collapsing distinctions between high art practice and mass media production. Its inherent reproducibility also made it a perfect tool for interrogating the status of originality in art.

Another text that became important for photographers and art critics at this time was the German philosopher Walter Benjamin's 1936 essay "The Work of Art in the Age of Mechanical Reproduction," which argued that photography tended to confuse the distinction between the original and the copy. Compared to traditional media like painting, Benjamin (1892–1940) argued, there is no meaningful concept of the "original" in photography. However fanatically collectors might chase after vintage prints, it

makes little sense to seek a single authentic print from a negative that can always yield new ones. All prints are equally secondary. All photographs, in other words, are already copies.

**SHERRIE LEVINE'S REPHOTOGRAPHS.** In the early 1980s Sherrie Levine (b. 1947) took a series of photographs that brazenly asserted the status of photography as reproduction. A typical example from the series is *Untitled, After Walker Evans* (**fig. 19.2**) of 1981. At first, nothing about the picture seems amiss; it is a searching, beautifully composed portrait. But Levine's photograph is, in fact, a photograph *of* an existing photograph—a 1930s documentary image taken by Walker Evans (1903–1975) of the sharecropper's wife Allie Mae Burroughs (see fig. 16.23). In this act of appropriation, Levine reproduced Evans's image without altering it, and exhibited it in such a way that only the title

19.2 **SHERRIE LEVINE,** *Untitled, After Walker Evans #4 (Allie Mae Burroughs),* 1981. Gelatin silver print. Metropolitan Museum of Art. Gift of the artist.

# 1970s Feminism vs 1980s Feminism

IT IS NO ACCIDENT that women like Sherman and Levine played prominent roles in deconstructing the art world pieties of genius and originality. Most of the "original geniuses" and "masters" in Western art had been, after all, defined categorically as men. Feminist artists had an outsized role in defining the Postmodern emphasis on the external construction of identity and the impossibility of the centered self. But these new understandings of the self also altered the development of feminism and led to a rift within the community of feminist artists.

The most prominent and influential feminist art of the 1970s had insisted upon creating positive images and practices out of the traditionally devalued terms of womanhood. It seized upon aspects of femininity that have historically been understood as weak, passive, or empty (the intimate, infolded biology of the female reproductive organs, the mythical history of women's close relationship to nature and to the earth, and the ancient practices of domesticity, craft, and "women's work"), and inverted them into images of strength. This frequently involved reimagining the history of civilization from a "gynocentric" perspective. Judy Chicago's (b. 1939) famous installation *The Dinner Party* of 1974–9 did just this. At a large triangular dinner table, she and her team of collaborators made place settings for women whose talents had been marginalized throughout history. Each "plate" evokes the woman in question with a blatantly vaginal/floral ceramic object (**fig. 19.3**). Chicago, in an obvious allusion to the Last Supper, "sets a place" for women at the world-historical table. The plates celebrate, rather than disavow, the feared and despised elements of feminine anatomy and creative production.

Chicago's work accepts the unique cultural and biological status of women, and seizes upon femininity as a platform for collective action. By the 1980s, however, this strategy was coming into conflict with the new critiques of stable selfhood. The new brand of feminism that was emerging in the work of artists like Cindy Sherman positioned femininity—indeed, gender itself—as socially constructed rather than biologically essential. Although the distinctions between essentialist and constructionist feminism were hardly absolute, 1980s feminists often felt that their 1970s precursors had slipped into a restrictive biological determinism. Another critique was that 1970s

19.3 JUDY CHICAGO, *The Dinner Party*, 1974–9. Mixed media, 48 × 42 × 3 ft (14.6 × 12.8 × 9 m). Courtesy Through the Flower.

feminists had proposed a false unity among all women, ignoring social, cultural, and economic differences (the differences between the experiences of white and black, or upper- and working-class women, for example) that cannot be explained biologically but can be analyzed politically.

1980s feminists refused to posit any essentially feminine qualities. They argued that the very concept of "the feminine" had emerged from patriarchal social systems in order to provide an opposite and subordinate term to all that was masculine. Hoping to disrupt this social binary, they defined femininity not as a real quality but rather as a masquerade or a performance, a detachable costume that anyone, male or female, could shed and change at will. They worked on both the visual and theoretical level to analyze and expose the codes and stereotypes of gender polarity. This new model had an activist dimension—if femininity was merely a construction, after all, then it was certainly available for deconstruction. But many 1970s-era feminists felt that the new model was damaging. Many even argued that it was insidious, for it questioned the very possibility of identity at precisely the moment that women and other disenfranchised groups had begun to assert their power and autonomy.

acknowledged anything about its "original" authorship. As the critic Douglas Crimp wrote, Levine "merely, and literally, *takes* photographs."[3]

Levine's act of rephotography, however simple it may have been as a technical operation, raised all sorts of complicated questions about the general possibility of originality and about Evans's originality in particular. For if we agree that Levine's photograph is merely a copy, what, we must next ask, is it a copy *of*? It isn't exactly a copy of Evans's photograph, because Levine aimed her camera not at an original photographic print, but rather at a photomechanical reproduction printed in a book. So her photo is really a copy of a copy; and since even the "original" print was itself a copy (as Benjamin would have it), Levine's is then a copy of a copy of a copy. Once this reverberation of copying has been set into play, it becomes possible to see that even Evans's original vision for his photograph—for example, the flat background that creates a direct connection between sitter and viewer, the cropping and composition that focus attention on the face—is itself derived from the long tradition of religious icon painting that has provided the ultimate model of portraiture in the West for millennia. Evans's "original" photograph, in other words, is itself a collection of copies, a "tissue of quotations drawn from the innumerable centers of culture." Levine's objective in copying Evans was not simply to announce that *she* was a copyist (that much was obvious), but also that *Evans*, despite all of the rhetoric of documentary immediacy surrounding his work, was also a copyist. As a favorite catchphrase of the day put it, "underneath each picture there is always another picture."[4]

Levine's work was not a personal attack on Evans; it was a critical statement concerning visual culture in general. Her rephotographs dramatized the process of appropriation, reproduction, and re-use that distinguishes the entire history of art. Photography, for Levine, is merely a more conspicuous model of the borrowing and reproduction that haunt all representation and all "expression"; all artists share the same heritage of appropriation and inauthenticity. Levine's critique of the originality of the work of art, moreover, was analogous to the critique of the centered and original self that Sherman explored in her "self" portraits. Just as Barthes had argued that there is no original point of authorship lurking at the core of a text, but only echoes of language itself, so is all identity understood as constructed from borrowed self-images. As Crimp put it in reference to appropriation artists like Levine, "In their work, the original cannot be located; it is always deferred; even the self which might have generated an original is shown to be itself a copy."[5]

**POSTMODERN THEORIES OF REFERENCE.** According to the logic of Levine's photographs, the viewer has no access to the plenitude and truth of the thing shown (in this case, Allie Mae Burroughs). One looks instead at a picture that sits, in a sense, atop an infinite stack of other pictures, references, and copies. "Allie Mae Burroughs" can simply never be reached (in period parlance this was known as "the flight of the referent"). This model of representation denies the possibility of any access to reality—indeed, it denies the possibility that any knowable reality exists outside the act of representation. Many theorists and philosophers who came to prominence during the late 1970s and 1980s—Jean Baudrillard (b. 1929), Fredric Jameson (b. 1934), Jacques Lacan (1901–81), Jacques Derrida (1930–2004), Michel Foucault (1926–84), and others—offered versions of this argument. This belief that there is no "deeper" meaning "behind" representations (representations and signs being all that there are) was one of the guiding rubrics of Postmodernism.

While some understood Postmodernism as a philosophical truth (i.e., humans have *never* had access to reality) it was equally common to view the Postmodern as a historical condition. In this version, as articulated by the critic Fredric Jameson, the late twentieth century was an era of "late capitalism," in which the global proliferation of mass media and the commodification of experience left no authentic, original, or individual space uncolonized. As the painter and theorist Thomas Lawson (b. 1951) wrote: "the insistent penetration of the mass media into every facet of our daily lives has made the possibility of authentic experience difficult, if not impossible…. Every cigarette, every drink, every love affair echoes down a never-ending passageway of references—to advertisements, to television shows, to movies—to the point where we no longer know if we mimic or are mimicked."[6]

**POSTMODERN PASTICHE IN ARCHITECTURE.** Many theorists of Postmodernism had been inspired by Warhol's silkscreen paintings (see fig. 18.7), where replicated images, seeming to float atop a shallow surface, refuse access to an "interior" meaning or content. Indeed, although Postmodern theories of pictorial representation came to critical fruition in the 1980s, their continuity with the image recycling of Robert Rauschenberg, Jasper Johns, and the Pop artists twenty years earlier was clear. The advent of Postmodernism in the realm of American architecture, however, was more jarring, for it rudely interrupted the preeminence that the International Style had enjoyed throughout the mid-century period (see Chapter 17). The AT&T Building (now the Sony Building), completed

19.4 PHILIP JOHNSON, AT&T (Sony) Building, 1984.

## Art and Language

If Postmodern models of the image rejected the notion that pictures provided clear, unfettered access to the referents "behind" them, Postmodern models of text did the same. Many artists of the 1980s, producing works that were based primarily in text and typography, explored the opacity of language. By fostering doubt about the objectivity of text, they demonstrated that language is not a neutral carrier of information, but rather a supple tool for the creation and perpetuation of power relationships. They aimed to expose the hidden politics lurking beneath ostensibly neutral language.

**JENNY HOLZER.** In a career spanning from the 1970s to the present, Jenny Holzer (b. 1950) has aimed to disrupt the apparent objectivity of "common language." For her *Truisms* project, produced between 1979 and 1982, she wrote short statements that resembled commonsensical aphorisms but carried disturbingly sinister, violent, or cynical messages: "Absolute submission can be a form of freedom"; "Abuse of power comes as no surprise"; "Enjoy yourself because you can't change anything anyway." She then disseminated the statements throughout Lower Manhattan on cheap offset posters; soon she had them appearing on T-shirts, hats, pencils, electronic signs, and even condom wrappers. In 1982, they were flashed at 40-second intervals to a mass urban audience on the enormous Spectacolor board in Times Square (**fig. 19.5**).

Holzer crafted the *Truisms* so that they would seem to have been issued by an anonymous common voice rather than a particular individual. She wanted them to appear to emanate from the genderless, ubiquitous "they" in the phrase "you know what they say." As Holzer said, "I find it better to have no particular associations attached to the 'voice' in order for it to be perceived as true."[7] The illusion of anonymity, in other words, begets the illusion of unanimity. Yet even as she established this illusion, she immediately undermined the *Truisms'* truth value by riddling them with contradictions (one *Truism* will often contradict another). And by pushing each of them just beyond the edge of generally acceptable sentiments (for example, "Bad intentions can yield good results"), Holzer jarred her viewers out of their customary passivity in the face of public pronouncements. She hoped that this would set up a resistance, however small, to the suggestions of mass communication that were normally accepted unreflectingly. As described by the critic

in Manhattan in 1984 (**fig. 19.4**), was a bellwether of the new architectural paradigm. Its departure from formula was surprising because it was designed by Philip Johnson, who had been one of the curators of the groundbreaking 1932 Museum of Modern Art exhibition *The International Style* and one of the most prominent American advocates of the purist Modernism of Mies van der Rohe (see fig. 17.31) during the middle of the century.

The AT&T building evokes multiple design styles and historical periods at once: gigantic arches along the base of the building recall a Renaissance chapel by Brunelleschi, the broken pediment at the top evokes eighteenth-century Chippendale highboys, and the fenestration pattern along the sides resembles a Rolls Royce radiator grille. Whereas the International Style had shunned historical reference in favor of an elegant, universal functionalism, here were historicism and referentiality with a vengeance. True to the new models of referential superficiality espoused by Postmodernists, these historical signals function ornamentally. They are not pure, nor are they rigorous revivals of

19.5 JENNY HOLZER, *Selections from Truisms*, installation, Times Square, 1982. Spectacolor board, 20 × 40 ft (6 × 12.1 m). Courtesy the artist.

Hal Foster, "coercive languages are usually hidden, at work everywhere and nowhere: when they are exposed, they look ridiculous."[8] Ideally, this exposure causes viewers to question all the other messages (especially advertisements) surrounding them in common space. In her momentary disruption of a cultural operation that normally functions imperceptibly, Holzer builds upon the strategies of Conceptual artists of the 1970s (see figs. 18.17, 18.19), who were also revealing the distortions within systems of language.

**GUERRILLA GIRLS.** Other artists hijacked the seeming objectivity of institutional language in order to smuggle disruptive messages into the public sphere. In 1985, a series of mysterious "Public Service Messages" began appearing in art magazines and on Manhattan streets, buses, and subways. In stark, affectless black type, using lists and statistics, the posters exposed the biases of prominent art institutions. *The Advantages of Being a Woman Artist* (**fig. 19.6**) dispassionately enumerated the absurd discrimination still

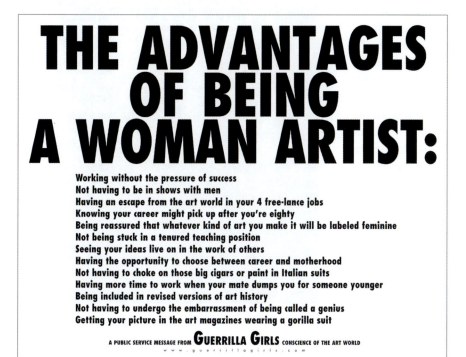

# THE ADVANTAGES OF BEING A WOMAN ARTIST:

Working without the pressure of success
Not having to be in shows with men
Having an escape from the art world in your 4 free-lance jobs
Knowing your career might pick up after you're eighty
Being reassured that whatever kind of art you make it will be labeled feminine
Not being stuck in a tenured teaching position
Seeing your ideas live on in the work of others
Having the opportunity to choose between career and motherhood
Not having to choke on those big cigars or paint in Italian suits
Having more time to work when your mate dumps you for someone younger
Being included in revised versions of art history
Not having to undergo the embarrassment of being called a genius
Getting your picture in the art magazines wearing a gorilla suit

A PUBLIC SERVICE MESSAGE FROM **GUERRILLA GIRLS** CONSCIENCE OF THE ART WORLD
www.guerrillagirls.com

19.6 GUERRILLA GIRLS, *The Advantages of Being a Woman Artist*, 1989. Offset lithograph poster.

facing women artists in 1989. In *Do women have to be naked to get into the Met. Museum?*, the text noted that women made up less than five percent of the artists shown, but eighty-five percent of the nudes. Who had created these posters? They bore only the enigmatic attribution "Guerrilla Girls: Conscience of the Art World."

When groups of people answering to that description began to appear in public at lectures and press events, they kept their identities concealed behind gorilla masks. The pun on guerrilla/gorilla was typical of the group's wordplay. But despite the humor of their subversions, the group's need to resort to guerrilla tactics served as testimony to the strength of the forces arrayed against them. During this period of conservative retrenchment (see pp. 635–6), feminism had been defanged. Feminism was often perceived as embarrassing; the dissatisfactions of women were interpreted as if they were symptoms of personal hysteria rather than rational responses to real conditions. The businesslike rationality and statistical acumen of the Guerrilla Girls' text works helped disarm this critique. So, too, did their anonymity. Like Holzer's *Truisms*, their voiceless texts projected an air of commonsensical validity.

**GLENN LIGON.** Glenn Ligon's textual paintings explore the power of language to obscure, rather than enable, communication. In his 1992 *Untitled (I'm Turning into a Specter Before Your Very Eyes and I'm Going to Haunt You)* (**fig. 19.7**), Ligon (b. 1960) used a black oilstick and hand stencil to repeat, line after line, a phrase adapted from Jean Genet's 1958 play *The Blacks*. As the words spill down the canvas, the stenciling becomes less and less precise, until the phrase becomes so blotched, smirched, and smudged as to be virtually illegible. Like Jasper Johns's *Gray Numbers* (see p. 550), the painting emphasizes the material weight and heft of writing. One looks *at* Ligon's text, not *through* it. The painting refuses the notion of language as a transparent tool for the conveyance of meaning, producing instead an effect of blockage and opacity. This is further emphasized by the size of the canvas, 80 × 32 inches, which is precisely the dimension of a standard doorway. Thus the painting sets itself up as a threshold, a space for passage and communication, but becomes instead a barricade of language.

As a black artist who grew up in the Bronx at the height of the Civil Rights struggle in the 1960s, Ligon was particularly interested in the language barricades that the haunting legacy of racial discrimination imposes upon African Americans. Even if outright slavery has ended, its effects still resound in the English language. How are black Americans to communicate when using a language that defines them negatively and oppositionally, as the non-white, the not-quite-human? How are they to communicate when they do not yet have full status as free speakers? Ligon's work exposes these difficulties; the reader's struggle to make sense of the clotted letters parallels the speaker's struggle to be understood.

19.7 GLENN LIGON, *Untitled (I'm Turning into a Specter Before Your Very Eyes and I'm Going to Haunt You)*, 1992. Oil and gesso on canvas, 80⅛ × 32⅛ × 2 in (203.4 × 81.5 × 5 cm). Philadelphia Museum of Art, Pennsylvania.

## Consumption, Critique, and Complicity

Postmodernism suggested that "original" expression is wholly derived from existing cultural systems. When added to the growing suspicion that, in the era of late capitalism, the existing cultural system was wholly determined by market values and consumer behavior, an unprecedented debate arose about the collapsing distinction between art and commerce. While avant-garde art had, throughout the century, attempted to oppose commercialism from the outside, it now seemed that there was no longer *any* expression—much less any art expression—free from the taint of market values. Given this situation, many artists felt that rather than attempt to find a space outside capitalism from which to attack it, they might do better to explore a complex and subversive complicity, penetrating the system in order to expose and thereby destabilize its otherwise invisible functions. As the artist Barbara Kruger

(b. 1945) put it, "I wanted [my work] to enter the market-place because I began to understand that outside the market there is nothing—not a piece of lint, a cardigan, a coffee table, a human being."[9]

**HAIM STEINBACH.** Haim Steinbach (b. 1944) made "commodity sculptures" in which he arranged shiny store-bought objects on clean, minimal, laminated shelving (**fig. 19.8**). Featuring everything from Yoda masks to toilet brushes, the installations combine the strategies of Pop, Minimalism, and the Duchampian readymade. Steinbach's work equates artistic production with the practice of appraising, choosing, purchasing, and displaying—the

19.8 **HAIM STEINBACH**, *Ultra Red, no. 2*, 1986. Wood, plastic laminates, lava lamps, enamel pots, digital clocks, 67 × 76 × 19 in (170.1 × 193 × 48.2 cm). Solomon R. Guggenheim Museum, New York. Gift of Barbara and Eugene Schwartz.

major activities of consumer society: "What I do with objects is what anyone does … with objects, which is talk and communicate through a socially shared ritual of moving, placing, and arranging them."[10] Contemporary identity, for Steinbach, is a product of consumption rather than production. It is not developed from within but rather patched together out of brand affiliations and consumption choices made in the marketplace.

**JEFF KOONS.** Jeff Koons (b. 1955) produced vexing sculptures that expose the strangeness of a world in which art has become a commodity and commodities have become art. His sculpture has qualities associated with cheap products that are designed to attract consumers—gleaming, shiny surfaces, seductive bright colors, and kitschy, popular, or sentimental subject matter. But his pieces are typically rendered in heavy, permanent materials, expanded to a looming scale, or otherwise presented as if they are monuments to the achievements of Western civilization. His most iconic work of the 1980s was *Rabbit* of 1986 (**fig. 19.9**), a solid stainless steel cast of a child's popular blow-up Easter toy. The toy's transformation into steel grants permanence to a fleeting, obsolescent consumer object, but also changes the character of that object in unsettling ways. In the process of casting, the air in the toy was heated, so the final sculpture has an especially taut and distorted shape, its seams straining as if it were about to explode. Koons produced several other sculptures that used a paradoxical blend of gravity and buoyancy to explore the contradictions of late capitalism's merger of art and the commodity; these featured inflatable rescue devices like rafts and life vests cast in heavy bronze. Each of these works lent art world gravitas to the effervescent, inflationary quality of the American economy, but hinted that both worlds might thereby sink.

Although these sculptures had a critical element, Koons was frequently accused of exploiting, rather than resisting, the logic of consumer capitalism and its speculative bubbles. He certainly knew that logic well as he spent six years as a commodities trader on Wall Street before turning full-time to his art. He was a savvy self-promoter, introducing each new series of sculptures with glamorous advertisements. He produced eminently saleable luxury objects—and they sold briskly—just as a boom in the 1980s art market sent prices skyrocketing. The perfect ambivalence of Koons's work—was it cynical or oppositional?—made him a test case for art criticism of the 1980s, much of which devoted itself to making increasingly fine-grained and difficult distinctions between critique and complicity among artists whose work engaged the theme of consumption.

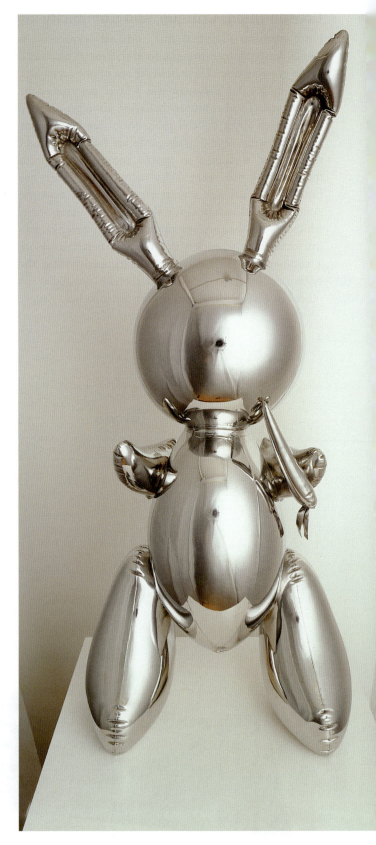

19.9 JEFF KOONS, *Rabbit*, 1986. Stainless steel, 41 × 19 × 12 in (104.1 × 48.2 × 30.4 cm). Museum of Contemporary Art, Chicago, Illinois.

**DAVID HAMMONS.** More unambiguously critical was art that approached the culture of consumption from the standpoint of the dispossessed. David Hammons (b. 1943) held his *Bliz-aard Ball Sale* in 1983 on a cold Manhattan street corner (**fig. 19.10**). Working and living in Harlem, Hammons was known in the 1980s for work that reflected both the deprivation and the ingenuity of African American material culture in economically stagnant urban areas. He had previously lived in Los Angeles, where he was inspired by Melvin Edwards's *Lynch Fragments* made of scavenged steel (see fig. 18.13); his own work made use of even baser materials such as hair, grease, and paper bags. For the *Ball Sale* he formed street snow into near-perfect spheres of variable sizes and arranged them for sale to passersby. Like Steinbach and Koons, Hammons is explicit about the commodity context of his art—he is, after all, hawking his work on the street. But his model of salesmanship is

hardly Koons's white-collar enterprise of finance and slick advertising. It is closer, instead, to the face-to-face haggling that characterizes bootstrap, street-level commercial exchange in the inner city. Like Koons and Steinbach (not to mention Warhol), Hammons offers an array of consumer choices: his snowballs come in several different sizes, carefully arranged in "product lines." He thus mimics the way the American economy stimulates consumption by offering an abundant selection of slightly different products, but he also signals the patent superficiality of all such illusions of choice. When it comes right down to it, it is all just snow. Like Koons and Steinbach, Hammons makes saleable objects, but his will serve rather poorly as durable private property. In fact, the point of sale is also the point of destruction, since in handling and carrying the snowballs, any "collectors" would either throw them or cause them to melt.

19.10 DAVID HAMMONS, *Bliz-aard Ball Sale*, 1983. Installation view, Cooper Square, New York. Courtesy Jack Tilton Gallery, New York.

It is this very delicacy that matters most in Hammons's sale. Everything about it is liminal and tenuous: only the finest of material and conceptual distinctions separate these artworks from worthless urban detritus. A small folded rug is all that separates Hammons's handiworks from the slush on the sidewalk from which, one presumes, they originated. This is definitely "commodity sculpture," but it speaks of a world in which the exchange of commodities represent not the promise of accumulation but rather the thin line between survival and desperation. Note that there are other "sales" going on around Hammons's; people have set out makeshift tables to sell products that are nearly as heartbreakingly worthless as snowballs.

Despite its "low" materials and locale, Hammons's sale reflects upon the most refined art trends of the twentieth century. Its liminality suggests not only the poverty line but also the conceptual line—first limned by Duchamp with his readymades—between art and everyday objects (see fig. 13.11). Its pure geometric forms mimic abstract sculpture generally, and Minimalism specifically, especially in their meticulous layout, serial repetition, and ground-based presentation. The elements of absurdism, performance, obsolescence, and audience participation recall Happenings and Fluxus events. As "sale art," it evokes Pop and particularly Oldenburg's *The Store* (see fig. 18.3). For Hammons, both art and economic life are tenuous. He explores the economies of desperation that spring up around the edges of affluence—scavenging, recycling, and repurposing—and adopts them as art practices.

**KRZYSZTOF WODICZKO.** These liminal economies were also addressed by Krzysztof Wodiczko (b. 1943), a Polish artist who had recently immigrated to the United States. In 1988–9 he developed and tested a series of prototype *Homeless Vehicles* in Manhattan (**fig. 19.11**). In New York, severe cutbacks in funding for public housing, new development policies favoring the destruction of low-income neighborhoods for corporate development, and the wholesale deinstitutionalization of mental hospitals had led to a drastic increase in homelessness. And yet the homeless seemed to remain invisible. They were frequently evicted from public spaces or simply ignored through workaday acts of neglect, as other citizens sidestepped them on the streets.

Wodiczko's *Homeless Vehicles* were designed to ameliorate the most pressing problems of the homeless and, simultaneously, to force those problems back into public visibility. Designed in active consultation with homeless people, the vehicles were part sleeping pod, part security capsule, part recycling cart, and part aerodynamic symbol of the perpetual movement that defines the state of

19.11 KRZYSZTOF WODICZKO, *Homeless Vehicles*, 1988–9.

homelessness. They gave concrete shape to the struggle for survival in the city. In doing so, they interrupted the existing consumer order. From a classical economic perspective, it is absurd to design and manufacture specialized equipment to meet the needs of the destitute. After all, in a consumer society, products are designed only for those who have the resources to buy them. Wodiczko, who had worked for many years as an industrial designer in Warsaw, considered his project to be an example not of traditional product design but instead of "interrogative design," which draws attention to problems and serves as "a point of convergence that concentrates a plethora of embarrassing questions."[11] Therefore, while the vehicles served as temporary palliatives for their homeless users, they were also intended as an irritant to the city at large, which was forced to notice these gleaming symbols of the scandal of homelessness.

**JAUNE QUICK-TO-SEE SMITH.** Native American artists were in a position to make particularly nuanced contributions to the period's debates about American consumerism. Jaune Quick-To-See Smith (b. 1940), of French Cree, Flathead, and Shoshone descent, came from a family of nomadic horse traders. Her 1992 work *Trade (Gifts for Trading Land with White People)* (**fig. 19.12**) drew its visual vocabulary from the Indian rock art of Montana, the prehistoric paintings of Lascaux, the abstracted figuration of Plains ledger drawings, and the amalgamation of painting and collage in Robert Rauschenberg's work (see fig. 17.17). The heavy red paint that layers the surface drips down like blood, an indictment of the so-called "exchange" between Native and non-Native.

Smith's painting features a huge canoe of the type used for trading expeditions; strung above it are the "gifts" of the title. These are not Native-made items, but the kitsch to which Indian identity has been reduced: fake headdresses and arrow quivers, a plastic Indian princess doll, a Red Man tobacco tin, Washington Redskins and Atlanta Braves baseball caps, and cheap beaded belts made in China or the Philippines. This work was made in 1992 as a commentary on Columbus's journey to the Americas in 1492—the year that the Native American "market" was first opened to Europe and a year that Smith has sardonically called "the year that tourism began." Whereas the stereotypical "beads-for-Manhattan" fable envisions white men snickering as they trade trinkets for huge tracts of land,

Smith here imagines the inversion of that situation. Now it is white people who are entranced by cheap plastic gimcracks. Smith's work also followed closely upon the passage in 1990 of an important Federal law—NAGPRA, or the Native American Graves Protection and Repatriation Act—which compelled American museums to return (or "repatriate") Native remains and sacred objects to Native groups if requested. Smith's work suggests a kind of reverse repatriation. The commodities attached to the painting serve certain sacred anthropological purposes for whites but do not belong in Native value systems. So Smith offers to give them back to the American museum world.

## The Culture Wars

In 1980 the United States entered a phase of political and cultural conservatism signaled by the election (and, in 1984, the reelection) of Ronald Reagan as president. Reagan's administration corresponded with a widespread backlash against feminism, civil rights, gay rights, and many other socially progressive trends of the 1960s and 1970s. Reagan's financial policies (popularly called "Reaganomics") emphasized tax cuts and a general reduction in governmental economic regulation, encouraging the expansion of large

19.12 JAUNE QUICK-TO-SEE SMITH, *Trade (Gifts for Trading Land with White People)*, 1992. Oil and mixed media on canvas, 5 ft × 14 ft 1 in (1.52 × 4.31 m). Chrysler Museum of Art, Norfolk, Virginia.

corporations and the consolidation of individual wealth. Both the cultural and the fiscal conservatism of the Reagan years had a direct impact on the American art world. On the one hand, the Reagan economy stimulated a boom in the art market, while on the other hand, its tone of social conservatism antagonized artists who did not hold to its definitions of art and propriety. By the early 1990s, the hostility between the conservative establishment and the art world had erupted into a full-blown "culture war."

At the same time, the highly theoretical basis of much advanced art in the 1980s contributed to a broader disconnection between the art world and mainstream culture. For many Americans, art had begun to seem overly rarefied and "difficult," out of touch with commonsense aesthetics. In the polarized cultural climate of the time, there were few incentives to bridge the gap between the intellectual vanguard and an increasingly alienated mainstream audience. Throughout the 1980s and 1990s, this misfit became evident on many levels. Most troubling was a series of highly publicized clashes between artists and conservative religious organizations in the late 1980s.

**ANDRES SERRANO'S *PISS CHRIST*.** In 1987, Andres Serrano (b. 1950), a Brooklyn artist of Honduran-Afro-Cuban ancestry who had spent a troubled childhood taking refuge among Renaissance religious paintings at the Metropolitan Museum, exhibited an altarpiece-sized photograph showing a crucifix surrounded by a luminous, ethereal glow (**fig. 19.13**). The controversy lay in the fact that the photograph was titled *Piss Christ*, and that Serrano had produced it by immersing a small plastic crucifix in a Plexiglas tank of his own urine. When Donald E. Wildmon, leader of the Christian decency group the American Family Association, found out about the photograph, and learned that Serrano had previously received a grant from the National Endowment for the Arts, he sent a protest letter to every member of Congress and encouraged his followers to do the same. This resulted, eventually, in the conservative legislator Jesse Helms calling Serrano a "jerk" on the Senate floor, and begging his supporters "to stop the liberals from spending taxpayers' money on perverted, deviant art."[12]

Serrano had been photographing bodily fluids such as blood, milk, and urine in tanks for some time, interested in their abstract formal beauty as well as their complicated relationship to the Catholicism with which he grew up. He was interested in Catholicism's deep ambivalence about the body. As he put it: "The Church is obsessed with the body and blood of Christ. At the same time, there is the impulse to repress and deny the physical nature of the Church's membership. There is a real ambivalence there....

19.13 ANDRES SERRANO, *Piss Christ*, 1987, edition of 4. Cibrachrome, silicone, Plexiglas, wood frame, 60 × 40 in (152.4 × 101.6 cm). Paula Cooper Gallery, New York.

In my work, I attempt to personalize this tension in institutional religion by revising the way in which body fluids are idealized."[13] Such ambivalence, however, was drowned out by the fervor of religious outrage that followed. Serrano had intended his photograph to be provocative, but he did not count on such a broad audience among Americans outside the art world. This audience approached the photograph (or, rather, reproductions of it) without any knowledge of Serrano's larger body of work, nor, generally, with any understanding of the traditions of Body art, Assemblage, and Postmodernism that might have permitted a more nuanced understanding of the image. Whereas Postmodernism modeled the photographic image as a juxtaposition of mere signs without any real connection to the things represented (Serrano's obviously cheap plastic crucifix emphasizes the superficial status of the picture as a whole), many politicians reacted to the image literally, as if Serrano were actually pissing on Christ.

Added to the problem was the fact that bodily fluids in general had taken on a highly political charge by the late 1980s. The AIDS crisis had erupted, and it had become evident that HIV could be spread through the blood and other bodily fluids. Bodily fluids thus conveyed connotations of confusion and fear, and became associated with the conflation of homosexuality and toxicity. Urine was also politically charged, since, in Reagan's "War on Drugs," debates were raging about the constitutionality of routine drug testing. The battles over Serrano's photograph thus came to be about much more than art or even religion—at stake for both sides was the freedom or restriction of bodies in a context of fear, uncertainty, and misunderstanding.

**CONTROVERSIES OVER PUBLIC FUNDING.** Throughout the late 1980s and early 1990s, several similar controversies erupted over federally funded art. Works deemed obscene or offensive, notably Robert Mapplethorpe's photographs of gay men engaged in sadomasochistic activities, were loudly and frequently denounced in Congress. Even abstract sculpture became controversial, as in the case of Richard Serra's federal art commission *Tilted Arc*, a 12-foot-high steel slab installed across the courtyard plaza of the Jacob Javits Federal Building in New York. The work was removed and destroyed in 1989 after protracted public hearings. Serra (b. 1939), working with the language of Postminimalism,

had placed the sculpture in the open plaza in such a way as to force pedestrians to walk long detours to enter the building, thus drawing attention to the impact of physical objects on the bodily experience of public space. He wanted pedestrians to attend to the subtle perceptual changes that the sculpture created. But the language of Postminimalism did not translate clearly to the everyday lives of federal workers, many of whom resented being lectured to about phenomenology and felt that the piece was ugly and aggressive.

**THE AIDS CRISIS.** Although the culture wars were fueled by political differences and mistranslations between traditional ideas of art and the theoretical notions current in the art world, some art did manage to straddle this barrier. Ross Bleckner's (b. 1949) paintings (**fig. 19.14**) were made according to the logic of the Postmodern "flight of the referent." They lie somewhere between abstraction and representation—they look like dim and fuzzy representations of faraway abstract paintings, and have the melancholy air of the Postmodernist's inability to reach through the surface of pictures to something true and concrete below. They are beautiful, unthreatening, and

19.14 ROSS BLECKNER, *The Arrangement of Things*, 1982–5. Oil on canvas, 8 ft × 13 ft (2.43 × 4 m). Museum of Fine Arts, Boston, Massachusetts.

unapologetically romantic, and they sold well in the gallery boom of the 1980s. But at the same time they are deeply political: they function as mourning pictures for Bleckner's many friends who had died of AIDS. In Bleckner's paintings, the postmodern "retreat of the real" paralleled other, more immediate losses.

The NAMES Project AIDS quilt (**fig. 19.15**) was a collective protest project born of grief and anger. But because it took the form of a quilt—perhaps the most comforting form of American art possible—it did not have the immediately polarizing effect that some other AIDS-related art did in the 1980s. In 1985, when AIDS was still thought to be a disease limited to the male homosexual community, many either ignored AIDS deaths or claimed that they were justified punishments for the practice of homosexuality. Cleve Jones (b. 1954), a San Francisco gay

19.15 NAMES, AIDS Memorial quilt, the Mall, Washington DC, October 1996.

activist who had recently been viciously stabbed by a homophobic gang and was facing his own death from AIDS, wanted to produce a memorial for the thousands of people who had already died. But in order to do so, he knew that he needed to find a way to break through the hostility and fear surrounding the disease so that the dead might be treated with empathy and respect: "I was just overwhelmed by the need to find a way to grieve together for our loved ones who had died so horribly, and also to try to find the weapon that would break through the stupidity and the bigotry and all of the cruel indifference that even today hampers our response."[14] He remembered the cherished quilts that his grandmother and great-grandmother had made in his hometown of Bee Ridge, Indiana, and immediately he hit upon the idea of the AIDS quilt. As he relates in a recent interview (the development of triple-cocktail AIDS drugs in the late 1980s saved his life): "I thought, what a perfect symbol; what a warm, comforting, middle-class, middle-American, traditional-family-values symbol to attach to this disease that's killing homosexuals and IV drug users and Haitian immigrants, and maybe, just maybe, we could apply those traditional family values to my family."[15] He realized that a work of public art about AIDS in the format of a familiar domestic icon might jar Americans into acknowledging the humanity of the dead.

He invited others to contribute to the quilt and, within two years, some 1900 panels commemorating the lives of people who had died of AIDS were exhibited on the Mall in Washington, D.C. By 2003, over 45,000 panels memorializing some 82,000 individuals had been added; more are submitted each month. Each quilt block is made up of eight 3 × 6 foot panels, each of which, in turn, mimics the size of a coffin—a fitting format for a funerary monument.

The AIDS quilt makes the collective loss immediate by recording the individual names of the dead. Just as the nineteenth-century quilter Elizabeth Roseberry Mitchell recorded the names of her dead sons on tiny coffins in her graveyard quilt which honored her whole family (see fig. 8.5), the AIDS quilt honors both the dead and the bereaved who made the panels. The NAMES Project Archive has kept meticulous records of these individuals, including photos, letters, and personal statements. The work was last seen in its entirety in 1996, when nearly 40,000 panels covered the full eleven-block expanse of the Mall in Washington—the largest urban public space in the entire United States. Having now outgrown the Mall, the quilt is exhibited in portions. At every installation site, the ritual of remembrance is enacted by unfolding and laying down the quilt blocks and reciting the names of the dead.

# The New Arts of Memory

The AIDS quilt's success as a memorial has been due largely to its divergence from conventional models of monumentality. Mobile rather than static, flexible rather than rigid, personal rather than absolute, it suggests a form of active memory based in ritual, participation, and change, rather than a didactic history invested in oversized stone monuments. In this sense, the AIDS quilt has shared in recent redefinitions of the arts of memory.

## Monuments and Memorials Redefined

Monuments have changed radically over the past quarter century. In the United States, where a polarized national politics has complicated the meaning of national identity, a new skepticism has arisen about the capacity of triumphal arches, equestrian statues, and grand obelisks to embody public memory. Many theorists now argue that such monuments stifle lived history beneath layers of didactic nationalist myth and prevent the internalization of memory by fixing history in external, material form. One of the inspirations for these critiques was the Vietnam Veterans Memorial.

**VIETNAM VETERANS MEMORIAL.** World War II memorials in the United States, designed for a relatively unified public with a sense of clear moral certitude about the conflict, had tended to adopt traditional modes of heroic figuration. But when a national design competition was announced in 1980 for a Vietnam Veterans Memorial, Americans were still bitterly divided about the purpose and meaning of the war. Because it had lacked a clear motivation or resolution, because American soldiers had been associated with atrocities during the campaign, and because the soldiers that were killed disproportionately represented minority groups and lower income levels, the memory of the war continued to be unsettling for Americans. Acknowledging the complexity of the issue, the criteria for the design competition stipulated only that the memorial encourage contemplation—and explicitly forbade the designs from making overt political statements about the war.

Out of more than 1,400 entries to the open, anonymous competition for the memorial, the panel selected a stark and simple design that turned out to have been created by a twenty-one-year-old architecture student named Maya Lin (b. 1959). In contrast to the towering white monuments populating the rest of the National Mall, Lin's memorial would consist entirely of polished black granite and would

be sited below ground level along a shallow embankment. The memorial would not be figurative but would instead take the form of a 500-foot-long, V-shaped wall, tapered at each end. Like a work of Land Art or Minimalism, the wall would establish an environmental situation rather than define a discrete artistic form. The names of each of the soldiers killed during the conflict (some 58,000 of them) would be incised into the stone according to the chronological order of their deaths, without regard for military rank.

Before the memorial was built, its design became the subject of intense public controversy. Members of the public who had expected a traditional design were quick to react against the emasculation suggested by what many took to calling the "black gash of shame." Some expressed doubts about Lin's qualifications (as a very young woman) to represent the experiences of middle-aged American male war veterans. Some veterans were concerned that the memorial's equivocation about the meaning of the war would permanently enshrine the hostility and disavowal

they had faced upon their return to the United States. Class concerns also intruded, since the abstraction of the design was prone to be interpreted as an elite pretension overwriting the populist preference for representational art.

But, as Lin relates, "The minute the piece was opened to the public, the controversy ceased, and I started getting the most amazing letters from veterans."[16] Viewers responded to the memorial's reticence, its intimacy, and the interpretive freedom it granted to them. Unlike the billboard-scale pronouncements carved into the other mall memorials, the thousands of names of the Vietnam dead are inscribed at an intimate scale—they require the viewer to come within a few feet of the wall in order to read them (**fig. 19.16**). Once at close range, viewers discover their own images reflected among the names in the polished façade. Rubbings of individual names can be taken from the surface of the monument; it invites both tactile and

19.16 MAYA LIN, *Vietnam Veterans Memorial*, Constitution Gardens, Washington, D.C, 1982. Black granite.

19.17 JAMES LUNA, *Artifact Piece*, performed at the San Diego Museum of Man, 1987. Courtesy the artist.

emotional intimacy. The memorial engages each viewer individually, even as its cumulative registration of names acknowledges a broader collective context (in this sense, Lin's design shares in the participatory spatial aesthetic of Minimalism).

The Vietnam Veterans Memorial, by presenting itself as an absence rather than a presence, radically inverted standard monumental strategy. It did not provide a form for memory so much as it provided a space for memory, and its impact on future memorial design in the United States and abroad was immense.

## Memory and the Museum

Like monuments, museums and galleries are repositories of cultural memory. And they, too, have been engaged in a redefinition of memorial practice. In projects that synthesize institutional critique (introduced in Chapter 18) and memorial discourse, many contemporary artists have worked to change the shape of American history by intervening in the display and curation of museum collections.

**JAMES LUNA.** James Luna (b. 1950) lives on the La Jolla Indian Reservation in northern San Diego County, California. He uses performance to challenge longstanding practices of placing Native American art in natural history museums rather than art museums, showing that this practice perpetuates damaging assumptions about Native Americans in both the past and the present. In *Artifact Piece* of 1987 (**fig. 19.17**), Luna resuscitated the tradition of live ethnographic display (see Box, "The Indian as Spectacle," in Chapter 7, p. 221) by lying in a glass case, wearing only a loincloth, in San Diego's Museum of Man. Typed labels on the display case described Luna's body—including its most intense physical and emotional scars—in the language of detached anthropological description: "Having been married less than two years, the sharing of emotional scars from alcoholic family backgrounds was cause for fears of giving, communicating, and mistrust. Skin callus on ring finger remains ...."[17] Nearby, also encased behind glass, was a collection of his "artifacts," which included such

"ritual objects" as a Rolling Stones album. Luna's perform-ance embodied the conventional construction of Native Americans as a mummified, vanished race, whose produc-tions are to be grouped with animals and minerals, but the signs of contemporaneity in the piece (whether the Rolling Stones album or Luna's own living, breathing presence) disrupted these conventions from within. For unsuspecting viewers, the installation shattered the customary detach-ment of this cross-cultural encounter. Shocked into recognizing Luna's shared humanity, they were forced to reconsider the assumptions underlying all the other ethnographic displays in the museum. Sophisticated Native American art, implies Luna, is still here and still breathing; it is not an extinct form of natural production.

**FRED WILSON.** While Luna worked to expose the racism underlying natural history museum conventions, the New York artist Fred Wilson (b. 1954) was performing sim-ilar interventions. Having become interested in museum practices while working at the Metropolitan Museum of Art, Wilson developed his own brand of "curatorial action" that he used at several museums to intervene in the normal course of object interpretation. He was invited in 1991 to spend a year as artist-in-residence at the Maryland Historical Society in Baltimore, whose director was look-ing for ways to transform the fusty traditionalism of its displays. Wilson was surprised to discover that the displays at the historical society, located in a city where eighty percent of residents were black, made scant reference to African American history. The museum had never before mounted an exhibition about slavery, racism, or the Civil Rights struggle.

After a year of archival research, Wilson's *Mining the Museum* installation opened, becoming the most popular exhibition in the museum's entire 150-year history. Wilson's work for the project did not involve creating new objects, but rather creatively curating the existing objects. He simply reinstalled the museum's collections, redistributing objects from storage to display contexts, rewriting didactic wall texts and manipulating lighting, color, and display architecture. In doing so, he rewrote the museum's history of minority life in Maryland. Wilson's tactics included a straightforward recovery of disregarded historical figures (as in his installation devoted to the Marylander Benjamin Banneker, a freeborn black astronomer of the eighteenth century), but also more complex acts of juxtaposition, as in the "Metalwork, 1723–1880" display, which featured a pair of iron slave shackles nestled among a collection of exquis-itely crafted Baltimore silver (**fig. 19.18**). Arrangements like this transgress the hygienic segregation of artifacts that

have structured conventional versions of American history: Wilson's "Metalwork" display reveals a real continuity between the fine arts and the blunter arts of slavery and repression. Other installations reflected upon absences, draw-ing attention to gaps in the collection. The first room of the exhibition featured a series of six low columns. Three white columns were topped with portrait busts of Henry Clay, Napoleon Bonaparte, and Andrew Jackson (white states-men with no significant links to Maryland). Three empty black columns were labeled with the names of three emi-nent African American Marylanders whose absence from the bust collection thereby became conspicuous: Harriet Tubman, Frederick Douglass, and Benjamin Banneker. By deftly highlighting gaps in the historical society's collection, Wilson illustrated the imperfect construction of history itself. For Wilson, history is an interrogative process that is always open to reinterpretation.

## Craft Anachronism

Lin, Luna, and Wilson all refuse to let the past be past. By breaking history out of its petrified memorial forms, each of these artists practices a form of anachronistic critique. By inviting the past to inhabit—even to haunt—the present, they argue against the idea of a linear historical progress in which the past is left safely behind. Similar motivations explain the tendency of a surprising number of contemporary artists to use "old-fashioned" media. Despite the proliferating array of sophisticated new digital media available, many artists today have chosen to revive relatively moribund historical media such as silhouettes and embroi-dery. Drawing upon widespread reconsiderations of craft practice by feminist artists in the 1970s, as well as the impor-tant precedent of the AIDS quilt, contemporary artists have rejected the stabilization of these media as docile "heritage arts," bringing them into an active and critical relationship with contemporary culture and politics.

**SAMPLERS BY ELAINE REICHEK.** Elaine Reichek (b. 1943) was trained as a painter. In the early 1970s, while studying the geometric structure of abstract painting and the textual practices of Conceptual art, she had begun to wonder whether those avant-garde exercises were fundamentally different from the samplers and embroideries that had been produced by women for centuries (see fig. 5.28). When she realized the richness of this question, she decided to devote her entire career to needlework. Reichek produces erudite, witty, and skillful samplers that collapse the gendered hier-archy of art and craft. In one series, she replaced traditional maxims and epigrams with passages from canonical texts

19.18 FRED WILSON, *Metalwork, 1723–1880* from *Mining the Museum*, temporary installation at the Maryland Historical Society, 1992–3. Courtesy the artist and Pace Wildenstein, New York.

(Ovid, Melville, Darwin, Freud, Tennyson, Kierkegaard) that reveal cultural fears about the power of women and needlework. Her 1996 *Sampler (Dispositional Hypnoid States)* includes quotes from Freud and Colette that worry over the subversive potential of women as they enter the state of deep concentration required by knitting or embroidering (**fig. 19.19**). Reichek based this sampler on an eighteenth-century American design that already seemed to her to embody the darker side of feminine iconography: "the motifs around the border, which are actually florals, have little antennae and seem to metamorphose into insects—a creepy effect out of Kafka …."[18]

In her work and writings, Reichek has demonstrated the inescapable structural connection between needlepoint and the grid-based paintings of artists such as Jasper Johns (see p. 550). She has pointed out that modern computational systems originated in the nineteenth-century textile industry, and that the origin of writing itself is rooted in the history of textiles (the word "text" itself derives from

the Latin word *texere*, to weave). In showing women's work to be at the center of high culture, Reichek does more than simply revive a historical medium. Rather, she uses that medium as the vehicle for a new kind of historical thought. Reichek proposes that history can be rewritten—or rather rewoven—by drawing threads between high and low, women's work and art work, so tightly that they cannot be unraveled.

**CLAY FIGURES BY ROXANNE SWENTZELL.** While many Native American artists work in media like installation and video, others have deliberately chosen materials such as clay, beads, quills, or buffalo hides that have been used in their communities for hundreds, if not thousands, of years. In New Mexico, at the beginning of the twenty-first century, Pueblo potters continue to dig local clay, coil it by hand, and fire it outdoors, much as their ancestors have done since before 1000 C.E. Roxanne Swentzell (b. 1962), a sculptor from Santa Clara Pueblo, sees herself as part of this continuum that stretches back for generations through her maternal lineage. Swentzell operates within the standards of her community's pottery traditions, but also pushes their boundaries. Like her female ancestors,

ABCDEF GHIJKL MNOP
STUVWXYZ &

Dispositional hypnoid states...grow
out of the day-dreams to which
needlework and similar occupations
render women especially prone ....
[and] intrude into waking life in the
form of hysterical symptoms.

— Sigmund Freud

I don't much like my daughter sew-
ing...She is silent, and she—why not
write down the word that fright-
ens me—she is thinking.

— Colette

she rolls her clay into long sausage-like forms, and hand-coils them to create her work. Yet, instead of building jars or bowls, she creates human forms (**fig. 19.20**). Some are self-portraits; others, like the one illustrated here, depict the striped Pueblo clown familiar in the art of the Southwest for a thousand years.

Certain male members of Pueblo secret societies paint themselves with the black and white stripes of the clown in order to perform in ceremony. Clowns teach through parody, buffoonery, and bad example (see discussion in Chapter 2). Swentzell's *Despairing Clown* misbehaves by peeling off his stripes, as if peeling off his very skin. In doing so, the figure (like the artist) interrogates the notion of a fixed Indian identity. Although born from a medium that embodies the deep origins of Pueblo society,

19.19 ELAINE REICHEK, *Sampler (Dispositional Hypnoid States),* 1996. Embroidery on linen, 18¾ × 20¼ in (47.6 × 51.4 cm). Nicole Klagsbrun Gallery, New York. Collection of Melva Bucksbaum.

Swentzell's figures occupy a Postmodern universe where identity is a matter of detachable surfaces. The irreconcilable tension between the old medium and the new message helps account for the note of melancholy in Swentzell's ostensibly humorous artifacts.

**SILHOUETTES BY KARA WALKER.** Kara Walker's 1997 installation *Slavery! Slavery!* (**fig. 19.21**) revives one of the most popular media of nineteenth-century America: the silhouette (see fig. 6.17). But instead of using the silhouette in its traditional, intimate portrait format, Walker (b. 1969)

composes large-scale figures into complex scenes. Upon first viewing, the delicate, winsome outlines of her silhouettes evoke nostalgic associations of a bygone, simpler time. Moss-covered trees recall the moonlight-and-magnolia romance of the Old South, and Walker's composition and design suggest decorative refinement.

Upon closer examination, however, these genteel impressions are quickly dashed. Many of the decorative arabesques in the scene represent abject bodily liquids and gases. The "fountain" at the center flows with spit, urine, and breast milk; kneeling in front of it is a man farting. Other scenes (here and throughout Walker's work) include dismemberment, scatological spectacles, pedophilia, and various other improper sexual acts. Perhaps most disturbingly, in the figures that are meant to be interpreted as African Americans, Walker revives the derogatory stereotypical fea-

tures of "blackness"—low brows, large lips, "pickaninny" hair, etc—that have marked the most insidious images in the history of American visual culture. Walker has argued that the silhouette and the stereotype are structurally equivalent: both convey a lot of information with very little means.

Walker's nightmarish antebellum carnivals have been denounced by members of the previous generation of African American artists. In 1997, after Walker became the youngest person ever to win a MacArthur "genius" grant, Betye Saar launched a campaign to protest against Walker's work. Saar and many other artists were appalled by Walker's recirculation of harmful stereotypes; accusing Walker of complicity with the white art establishment that had eagerly embraced her work, Saar claimed that "Kara is selling us down the river."[19] Saar, of course, had famously worked with stereotypes herself (see *The Liberation of Aunt*

19.20 ROXANNE SWENTZELL, *Despairing Clown*, 1991. Clay, 26 in (66 cm) high. Wheelwright Museum of the American Indian, Santa Fe, New Mexico.

*Jemima*, fig. 18.24). But Saar had turned negative images against their creators, reinventing stereotypes as armed allies in the Civil Rights struggle. For Saar and some other artists of her generation, Walker's regressive stereotypes threaten to undo all of the progress they have made.

Walker, however, feels that the long and complex history of stereotyping in America, like that of slavery, has not yet been resolved, and that all Americans are implicated, consciously or not, in the perpetuation of racism. To her mind, the only way to obliterate these stereotypes is to confront us with their lingering presence in our own minds and fantasies. The silhouette art form allows Walker to implicate her viewers in the scenes before them in a way that would not be possible in other media. Most of the figures in her tableaux are life-sized, as if they were shadows thrown by the people standing in the room. This has the imaginative effect of collapsing historical distance and encouraging viewers to think about the persistence of slavery's impact today. Each viewer standing before the work is

**19.21 KARA WALKER**, *Slavery! Slavery!*, 1997. Cut paper and adhesive on wall. Installation view, Walker Art Center, Minneapolis, Minnesota. Private Collection. Courtesy the artist and Sikkema Jenkins & Co., New York.

symbolically implicated in the shadow-play transpiring on the wall. Walker has compared her silhouettes to the Rorschach (ink blot) tests in which psychiatric patients are asked to describe what they see in a series of abstract black blobs against white backgrounds, thereby projecting their own mental states onto the forms. As art historian Gwendolyn DuBois Shaw has shown, the shadow also has a long cultural history as a symbol of repressed evil; the Swiss psychologist Carl Jung (whom we encountered in Chapter 17, pp. 553–4) gave the name of "shadow" to the repressed, socially unacceptable urges that inhabit the individual unconscious. Looming like shadows of America's past, Walker's silhouettes insist that the horrors and degradations of slavery have not been resolved and should not be forgotten.

# Contemporary American Art and Globalization

Globalization is a complex phenomenon that often seems to exist only as the sum total of a handful of contemporary catchwords—"de-territorialization," "nomadism," "transnationalism," "diaspora," "consolidation," "connectivity," "liquidity." Behind each of these terms, however, lies a common connotation of movement, exchange, and communication. Globalization can be considered, most broadly, as a worldwide process of translation—translation achieved by establishing common codes and languages between previously isolated entities. Given this broad emphasis on translation, we need not think of globalization as belonging only to the economic sphere; it is also a technological, biological, and, of course, a geopolitical force.

It is standard practice to view globalization in economic terms: separate national economies are linked through standard systems of trade and monetary variables so that transnational exchange can take place easily. The Euro, for example, provides a common unit of exchange that allows relatively unfettered trade between different nations of Europe. The globalization of the economy is producing the rapid consolidation of trade networks, speeding the flow of information and resources across national boundaries, producing a steep rise in outsourcing and other transnational business practices, and exposing local cultures and value systems to the homogenizing pressure of a single global economy. The ultimate implications of this process are now a subject of intense debate, but one possible outcome is the retreat of the nation-state and the rise of the corporation or conglomerate as the basic unit of geopolitical identity and power.

Globalization can also be understood technologically. Economic consolidation is closely linked with the development of digital technologies, which function by reducing all information, whatever its form, into a binary code. This permits the mobility and interchangeability of all information, regardless of its original medium of inscription; thus college students can now listen to wax-cylinder sound recordings by Thomas Edison and the soundtracks of recent Hollywood films in rapid succession on a single media player. Differences in form and medium are obliterated for the sake of easy transfer and broad dissemination. Also sharing in this process of transcoding is the current revolution in genetic engineering, for it allows the migration of genetic information between previously separated groups and species. In essence, by opening up new means of communication, grounds of similarity, and avenues of

equivalence and exchange, the process of globalization transposes the location of "encounter" into new spaces—mobile, monetary, and microcosmic. American art today reflects both optimism and anxiety about these changes.

## Nomads

Few works have focused debate about the art world implications of globalization as intensely as the Guggenheim Museum in Bilbao (**fig. 19.22**). Bilbao, a center of the once-prosperous steel industry in the Basque region of Spain, was attempting in the 1990s to reinvent itself for the tourist and information economy. It thus welcomed the advances of the Guggenheim Foundation, which was pursuing a global expansion of the Guggenheim Museum and searching for a site for a new building. Thomas Krens, the director of the Foundation, felt that globalization offered unprecedented opportunities for museums. The Guggenheim, like any other corporation, would benefit (according to Krens) from developing a "global brand" and opening "branches" throughout the world. This would allow it to acquire sorely needed new exhibition space (like most museums, the Guggenheim can exhibit only a fraction of its collection at any one time), to increase the cultural influence of its collection, and to create new opportunities for revenue, all while efficiently streamlining its administrative operations.

Because the Guggenheim "brand" was already synonymous with a futuristic architectural landmark (see figs. 17.35, 17.36), Krens sought a similarly bold statement for the Bilbao location. The architect Frank Gehry (b. 1929) was chosen to design the building; it was completed in 1997. It has already become an unofficial icon of the era's utopian dreams—of fluidity, connectivity, and technological sophistication—as well as of some of its nightmares.

Despite its gigantic size, the Guggenheim Bilbao, like the information world itself, seems constantly to be in motion. Its complex curves suggest ships' hulls, sails, and the shimmer of darting fish (Gehry's signature forms derive from childhood memories of watching carp swimming). The building also suggests weightlessness and flight—appropriately so, since its contours were designed with the aid of a computer program originally developed for the aerospace industry. The titanium "scales" that clad the structure provide an infinitely variable response to the site, echoing the gleam of the adjacent river and reflecting color from the sky and surrounding buildings. Titanium, which provides far more resistance to urban pollution than does stone, is so tough that the scales need be only a third of a millimeter thick. The panels are so thin that the surface pillows slightly, even fluttering a little in a strong wind.

19.22 **FRANK GEHRY**, Guggenheim Museum, Bilbao, 1997. Titanium, Spanish limestone, glass.

Unlike a traditional museum space, Gehry's building does not pretend to be a neutral space architecturally, nor is it designed for small, obedient objects. It features soaring galleries that can easily accommodate even the most immense, ambitious, and difficult sculptural installation. Yet some critics have charged that the breathtaking spaces of Gehry's building function as mere spectacle, overwhelming the viewer's critical faculties with a kind of empty wonderment. They also argue that these spaces overwhelm the art within them. This, they feel, has destroyed any opportunity for productive tension between art and its architectural frame and has neutralized the critical function of the art that the museum absorbs. Many of the works displayed at the Guggenheim were originally developed as part of the institutional critique movement (see Chapter 18), and were intended to strain at the limits of the spaces they inhabited. Institutional critique has, in this sense, been swallowed whole at the new Guggenheim. As the art critic Hal Foster recently described the diminished critical presence of art in spectacular museums like Gehry's: "It used to be Ahab against the whale, now it is Jonah in the Whale."[20] Debates about the ultimate implications of the Guggenheim are ongoing. Critics argue that the museum has alighted like an alien spaceship in the city of Bilbao, ready to colonize the local culture with the aesthetic standards of New York and other major art world capitals (the museum does not provide exhibition opportunities for Basque artists). This, they feel, suggests that its formal gestures toward integration with its surroundings are ultimately meaningless. And yet there is no question that the Guggenheim has brought prosperity to Bilbao, as it has become an important site of art world pilgrimage. It has brought a major cultural resource to an area of Spain that might not otherwise have been able to develop one, and it has become a point of pride for the local Basque population.

Whatever the final verdict on Gehry's structure at Bilbao from the museological perspective, it is clear that its elastic forms respond to one of the key challenges driving current architectural design; namely, how to adapt an art of monumentality and permanence to a cultural milieu of mobility, portability, and liquidity. Gehry addresses this problem by adopting aeronautical engineering techniques and glistening, quasi-mobile surfaces.

But not all contemporary architecture attempts to adopt the Guggenheim's monumental scale. Indeed, in a globalizing climate with an increasing emphasis on itinerancy, there has also been a resurgence of interest in mobile, transient, and compact architectural forms. Oddly enough, projects like Krzysztof Wodiczko's *Homeless*

*Vehicles* (see fig. 19.11) of the late 1980s can be understood as important precedents for contemporary architecture. The conditions of homelessness that Wodiczko explored (the confusion of distinctions between public and private space, the imperative of constant relocation, and the need for protection) are becoming increasingly common attributes of domesticity itself. Indeed, artists and architects are exploring portability of all sorts as they search for the limit conditions of domesticity under the pressure of mobility. Andrea Zittel (b. 1965), for example, creates luxurious "Living Units" that unfold from portable crates. Lot-Ek Architects of New York (Ada Tolla, b. 1964, and Giuseppe Lignano, b. 1963) design homes made from tanker trucks, cement mixers, and other mobile containers. The standard shipping container—both symbol and agent of today's global economic network—serves as the basic module of many of their architectural designs. Their *MDU Mobile Dwelling Unit* (**fig. 19.23**) can be transported as a single container but unfolds into a fully functioning modern home.

Many of the most celebrated contemporary artists working in the United States emigrated from elsewhere, and their work often addresses their experiences of dislocation. Do-Ho Suh was born in Seoul, Korea, in 1962, and moved to New York City in 1997. For him, one of the strangest aspects of the move was the shift in the scale and texture, between Korea and the United States, of the architectural and spatial environment. He found himself grappling with an acute sense of disorientation: "I felt that I was granted a new body when I came to America. I was dropped into a strange, foreign space. I felt like I didn't know how long my arms were or how tall I was. I tried to find ways to relate to myself in this new environment …."[21] The memory of this dislocation colors much of his work, which deals with issues of migration, memory, and longing.

In 1999 Suh returned to the Korean home of his own childhood to produce the work *Seoul Home*, which is a full-scale, meticulously detailed reproduction in diaphanous green silk of the architectural space of the building. Working in collaboration with master Korean seamstresses, Suh produced a custom-fitted dressing of silk that perfectly reproduced in its sewn seams all of the many architectural details of the original house. Suh's cross of architecture and dressmaking here is not unusual, for as the culture of nomadism develops and architecture searches for more dynamic models of shelter, fashion—which is, in its own way, a portable shell or home for the body—has become a productive metaphor.

When finished, this "dressing" was folded, packed, and taken to the Korean Cultural Center in Los Angeles, where

19.23 LOT-EK, *MDU Mobile Dwelling Unit*, c. 1999.

we see it installed (**fig. 19.24**). The work subsequently traveled throughout the United States and Britain and, as it did, Suh expanded its title to include the names of all the cities in which it had been hosted. As of 2002, its title was no longer *Seoul Home*, but rather *Seoul Home/L.A. Home/New York Home/Baltimore Home/London Home/ Seattle Home*. The title of the work functions as a record of its public exhibition history. This means that the work internalizes the globalization of the art world itself (major installation pieces like this are now routinely carted around the world to be featured in an ever-expanding network of international biennials). In addition, and perhaps more importantly, the growing list of cities modifies the noun "home" in such a way that it loses its firm association with a single emotional origin and slips paradoxically into an itinerary of displacement. Accordingly, Suh conceives of this "home" as a kind of vehicle for safe passage—"my

transportable Korean house has been my parachute," he has written.[22] "As we all move around from one country to another, from one city to another, and from one space to another, we are always crossing boundaries of all sorts. In this constant passage through spaces, I wonder how much of one's own space one carries along with oneself."[23]

## Cyborgs

In the contemporary mythology of globalization, the elite "new nomads" and the unfolding architectures designed for them move through a series of "nonplaces." As Carol Becker describes them, "Nomads traditionally are preurban or unurban, but this new breed of nomads is actually posturban, dwelling for a large part in airports—shelters of transport—all over the world, living within a series of temporary nonengagements, … yet connected to those not present through nomadic objects—cell phones, laptops."[24] These posturban nonplaces are often associated with

cyberspace, and indeed they share many qualities—featurelessness, timelessness, and homogeneity. This "nonplace" global space has the potential to be liberating, as it allows for unrestricted movement and constant reinvention. But there are other nomads today, far more numerous: the dispossessed, traumatized, or poverty-stricken who must move in order to survive or find a tolerable life. This is the globalization of the migrant laborer, the political refugee, the exile, and the literally homeless. For these, the act of crossing is not as seamless as it is for the nomadic elite, and the global space they inhabit, policed by border patrols and distorted by ancient prejudices, is not as exhilarating.

19.24 **DO-HO SUH**, *Seoul Home / L.A. Home / New York Home / Baltimore Home / London Home / Seattle Home*, 1999. Silk, 12 ft 5 in × 20 ft × 20 ft (3.78 × 6 × 6 m). Museum of Contemporary Art, Los Angeles. Purchased with funds from an anonymous donor and a gift of the artist. Courtesy Lehmann Maupin Gallery, New York. (See also p. 586)

This "other" global space has been explored by the performance artists Roberto Sifuentes (b. 1955) and Guillermo Gómez-Peña (b. 1955), whose work traces the persistence of brick-and-mortar politics in global cyberspace. As Gómez-Peña writes in his essay "The Virtual Barrio @ The Other Frontier," he was "perplexed by the fact that when referring to 'cyberspace' or 'the net,' [some American artists] spoke of a politically neutral, raceless, genderless, classless, and allegedly egalitarian 'territory' that would provide everyone with unlimited opportunities for participation, interaction and belonging .... The utopian rhetoric around digital technologies reminded me of a sanitized version of the pioneer and frontier mentalities of the Old West ....."[25]

Sifuentes and Gómez-Peña set out to show that the new frontiers retained many of the qualities of the old, especially regarding the stereotypes surrounding Chicano and Mexican culture. In 1995 they began working on an internet-based performance project (**fig. 19.25**). At the height of 1990s anxieties over NAFTA and border policy, they opened a website that invited visitors to confess their most deeply held views of Mexican American culture. Finding that the majority of the responses were variations on the theme of an unstoppable invasion from south of the border, the artists decided to call the project the *Mexterminator* project. They used the stereotypes collected on the site in order to build hybrid cyborg performative personas ("El CyberVato," etc) that would embody the fears and desires of their internet audience. "The composite personae we created were stylized representations of a non-existent, phantasmatic Mexican/Chicano identity, projections of people's own psychological and cultural monsters—an army of Mexican Frankensteins ready to rebel against their Anglo creators."[26]

Humor is an important aspect of the *Mexterminator* project. Hoping "to infect virtual space with Chicano humor," Sifuentes and Gómez-Peña use the absurdity of their hybrids to ask why they seem funny in the first place.[27] Why do people smile at terms the artists invent like "cyber-immigrants," "web-backs," "lowrider laptop," and "Naftaztecs"? The laughter these composite terms and objects elicit is, for the artists, direct proof of the persistence of stereotypes of Latinos as technologically inept. Gómez-Peña has noted that even the language of techno culture reveals its lingering attachment to Anglo-American hierarchies. Any phoneme from the Spanish language sounds jarringly foreign in technospeak, and by inserting it there, Sifuentes and Gómez-Peña hope to make cyberspace a truly global space—not an anglocentric zone masquerading as an abstract nonplace but a real contact zone, filled with what the artists call "Linguas Polutas" like

19.25 ROBERTO SIFUENTES & GUILLERMO GÓMEZ-PEÑA, *Cybervato Prototype, no. 227* from the *Mexterminator Project*, c. 1995. Performance.

Spanglish, Franglais, and cyberñol. Eventually, the hope is, Mexicans crossing into cyberspace will not seem funny—or threatening—anymore.

## Hybrids

As bioengineering becomes a more and more conspicuous feature of the current cultural landscape, artists are becoming interested in examining another aspect of global "crossing"—namely the crossing of genes. Iñigo Manglano-Ovalle is one of many contemporary artists exploring the politics of identity and hybridity in genetic terms. His genetic portraits (**p. 622**) are large, luminous photographic prints showing side-by-side colored DNA analyses of three individuals. They are presented as group

portraits, loosely based on a form of eighteenth-century Spanish colonial group portraiture known as **casta painting**. Each casta painting featured a three-figure family: two parents of different ethnicities (carefully labeled), and their child (also labeled). The paintings were usually presented in gridded sets so that all possible combinations of racial mixing could be pictured and seen at once. The casta paintings may themselves be understood as concerned with "bioengineering," inasmuch as they respond to the genetic hybridization that slavery and colonialism brought to New Spain in the eighteenth century. The paintings attempted to codify the uncontrollable process of racial mixing.

Manglano-Ovalle's work updates casta painting by translating it into the conventions of scientific imaging and by emphasizing the destabilization of identity that the previous paintings had already hinted at. The DNA analyses reveal vestiges of individuality—after all, none of the three portraits is the same—but by acknowledging that these individualities are simply effects of differing patterns of the same basic units, the portraits seem to predict the future transcoding, intermingling, and perhaps even homogenization of these separate identities. More disturbingly, they demonstrate that at the deepest levels of the self, supposedly immured and protected from the reaches of globalization and information culture, there are only more codes; codes that can be exchanged and manipulated

like any other part of the global economy. Here we see globalization penetrating the most intimate recesses of the body itself, a place that we might otherwise like to imagine to be "off the grid." By drawing our attention to the penetrability of our bodies by the informational matrix, work like Manglano-Ovalle's also entails a radical collapse of the distinctions between interior and exterior space. To quote Mona Hatoum (b. 1952), another contemporary artist working with themes of globalization and exile, "we are closest to our body, and yet it is a foreign territory."[28]

Eduardo Kac (b. 1962) is a Brazilian-born artist who has been living and teaching in Chicago since 1989. Kac is interested in exploring a new kind of "encounter" and "translation" that is being made possible through bioengineering: the crossing of traditional species barriers. He hopes to introduce subtlety and ambiguity into the highly polarized debates over genetically modified organisms, stem cell research, cloning, and the Human Genome Project. For his *GFP Bunny* project, Kac collaborated with a French laboratory to produce Alba, a transgenic rabbit (**fig. 19.26**). Alba's genes have been spliced with a gene from a fluorescent jellyfish, so that when she is illuminated with a certain wavelength of blue light, her entire body glows green. The gene for GFP (Green Fluorescent Protein) is routinely used in bioengineering as a marker. But by "commissioning" Alba as an art project, Kac has raised

19.26 EDUARDO KAC, *GFP Bunny*, 2000–present. Genetically modified albino rabbit. Courtesy the artist.

19.27 JOLENE RICKARD, *Corn Blue Room*, 1998–9. Installation, photographs, corn, photographic CD projections. Canadian Museum of Civilization, Ottawa.

ethical debates about the propriety of bioengineering as an art medium and ultimately about the distinction—if any remains—between the ethics of art and science. By commissioning the rabbit as an artwork, he insists that biotechnological development be examined through an interdisciplinary dialogue.

Kac describes the *GFP Bunny* project as "a complex social event that starts with the creation of a chimerical animal"[29] and follows the ethical controversies that arise from that creation. But his idea is not simply to set off a cascade of ethical debates; he is also determined to remain forever responsible for the socialization of the rabbit, "above all, with a commitment to respect, nurture, and love the life thus created."[30] He insists that Alba is a sovereign life form, not a laboratory object, and that the interspecies communication that genetic modification sets in motion must move beyond mere manipulation to become an ongoing conversation.

The same eerie blue light that triggers Alba's transgenic green glow bathes large swags of ancestral corn in the Tuscarora artist Jolene Rickard's *Corn Blue Room* of 1998–9 (**fig. 19.27**). Rickard (b. 1956), who was trained in photography and worked in advertising in Manhattan before becoming a full-time artist and scholar, descends from a family of prominent activists who lived (as she continues to) on the Tuscarora Reservation near Buffalo, New York. Her grandfather founded the Indian Defense League in 1926, and was a tireless advocate for Native rights. This

activism fuels her work, which explores issues of Native American cultural sovereignty. *Corn Blue Room* is comprised of ancestral Iroquois corn which hangs in the center of a space formed by photo stands arranged in the shape of a traditional Iroquois longhouse. The photos there, and in the accompanying CD-Rom projected on the wall, may seem incongruent: corn, a sunflower, a power line, generating stations, and photos of Iroquois political marches. The kaleidoscope of images sets up juxtapositions between manifold forms of power, particularly the industrial power and energy generated by the Niagara Mohawk Power Authority, which in 1957 flooded one-third of Tuscarora land (and which is today one of New York State's biggest polluters), and the caloric energy and cultural power generated by the strains of corn kept and nurtured by generations of Tuscarora women.

The blue light in the installation (which is now widely associated with genetic engineering) confers an aura of technological know-how on the corn, suggesting that the protection of these strains by Tuscarora women is not to be regarded as a merely "natural" or instinctual behavior, but has amounted to a sophisticated form of genetic knowledge and management all along. Indeed, Tuscarora white corn has been carefully bred for size and flavor; its kernels have as much as 50 percent more protein than ordinary corn. At the same time, the blue light seems alien and hostile, and reminds us that these native strains of corn are constantly threatened by the genetic pollution introduced by the genetically modified corn hybrids used widely in American agribusiness. In order to avoid the migration of commercially modified genes into their stock, Native horticulturalists now must time their plantings so that their corn pollinates at a different time from the commercial corn planted nearby. The installation suggests that transgenic encounter is not always beneficial, and that the right to refuse genetic "communication" requires as much knowledge, power, and vigilance as does the impulse to impose it.

# Conclusion

Throughout this book, we have used the principle of "encounter" to structure our account of the arts in America. American art, we have argued, has developed from a series of contacts, confrontations, and compromises between cultural traditions and across cultural boundaries. As the twenty-first century gets under way, the encounter-driven development of American art and culture continues apace. But these encounters are being accelerated—and perhaps fundamentally altered—under the pressure of changes associated with contemporary globalization. American art has always emerged from the negotiation of cultural faultlines, but the locations of those faultlines, as well as the pace, scale, and character of encounter itself, are shifting. In *Corn Blue Room*, we find ourselves revisiting, at a newly microbiological scale, the first encounters of European and Native American cultures that we featured at the beginning of this volume. Rickard's work attests to the fact that this early encounter was not to be a single, isolated event, but rather the inauguration of an ongoing series of complex cultural negotiations.

# Glossary

**Abstract Expressionism** a mid-20th-century school of American painting characterized by abstracted forms—both gestural and "color field" (*see* **Color Field painting**) that are intended as the unfettered expression of the artist. Major artists are Jackson Pollock, Willem de Kooning, and Mark Rothko.

**Abstract, abstraction** a modern aesthetic, originating in the early 20th century and in all media. Characterized by a focus on properties of pure form, pattern, and shape, rather than on recording every observable detail. Abstract art can be subject-based (portraits or studio still-lifes), or non-representational constructions of forms, lines, colors.

**Adobe** the primary building material used in the American Southwest and elsewhere by both the native Pueblo people and the Spanish colonizers; sub-hardened sand, clay, and straw, either puddled (built up in layers) or formed into brick.

**Aesthetic movement** a late 19th-century European and American artistic movement that emphasized the pursuit of beauty, "art for art's sake," by turning away from literary, narrative, or symbolic content. Produced interior designs integrating painting and decorative arts.

**Aesthetics** a set of principles or a philosophy concerned with the nature of beauty, originating in Europe in the 18th century; now more broadly used to encompass the physical form or appearance of a work of art.

**Airbrush** an artist's tool for spraying paint propelled by compressed air; associated with commercial artists.

**Allegory** a story, poem, or picture in which abstract or symbolic qualities, moral or political meanings—virtue or freedom, for instance—are embodied in figures—often female.

**American Moderne** another term for Art Deco (*see* **Art Deco**).

**American Scene painting** a term loosely designating both Social Realist and Regionalist works between World Wars I and II, depicting various aspects of urban and rural life in a range of styles. Subject-driven, painters of the American Scene rejected European Modernist abstraction in favor of readable narrative and broad audience appeal.

**Anasazi** a Navajo word meaning "enemy ancestors" formerly used to refer to the Ancestral Pueblo peoples of the Southwest.

**Ancestral Pueblo (or Puebloan)** the ancestors of contemporary Hopi, Zuni, and other Pueblo people. They are best known for the "great houses" at Chaco Canyon, NM, most notably "Pueblo Bonito."

**Angle shot** in which ordinary perspectives on an object are altered by extreme tilting or framing.

**Animation** the film technique of photographing a series of drawings such that when they are shown in rapid succession they create the visual effect of a moving image.

**Antebellum** from the Latin: *ante* (before); *bellum* (war). The period before the American Civil War (1861–5) typically encompassing the decades from 1820 to 1860.

**Anthropologist** a scholar who studies the characteristics and development of different human societies and cultural phenomena. The term usually implies the study of non-Western, generally colonized or formerly colonized societies.

**Appliqué** a sewing technique in which one pattern of cloth is cut and then sewn onto another cloth, resulting in a design.

**Appropriation art** art that unabashedly copies or borrows preexisting images or content, often in order to make a critical statement about the role of creativity and originality in modern art. Associated with Postmodernism (*see* **Postmodernism**).

**Apse** in church architecture, the semi-circular space immediately behind the altar, usually at the end of a processional aisle or axis opposite the church entrance.

**Arabesque** ornate or decorative patterning, usually comprised of a mix of geometric and natural forms, and often derived from Muslim art.

**Archaism** a style popular between the wars, designating forms associated with the origins of the high sculptural traditions of Mediterranean and Middle Eastern antiquity.

**Art Deco** a term originating with the Paris Exposition des Arts Décoratifs (1925), referring to geometric, stylized anti-naturalistic forms widely applied to architecture, decorative arts, textiles, etc.

**Art Nouveau** a French term literally meaning "new art"; an international style of art, architecture, and design characterized by flowing, curvilinear swelling lines often inspired by nature, such as plants or flowers.

**Articulated** architectural elements that are given clear expression and set off from—or in well-defined relation to—each other.

**Arts and Crafts movement** a British and American artistic and design movement that sought authentic and meaningful design, returning creative control to the individual artisan (in theory). A reaction to the industrialized aesthetic of mass-produced Victorian consumer goods, it influenced architecture, interior design, and decorative arts c. 1880–1910.

**Ashcan** a pejorative term given to artists surrounding Robert Henri in New York, c. 1900–20, who painted common or "low" urban and immigrant subjects; term now widely used without negative connotation.

**Assemblage** a form of three-dimensional sculpture assembled from found objects and non-art materials.

**Assembly line** a factory configuration in which productivity is maximized by arranging workers and machines to progressively assemble a succession of identical items.

**Atelier** a French term for artist's studio or workshop.

**Authenticity** the notion that a thing is more genuine, or "pure"—closer to its origins and therefore a more legitimate expression—than works employing new materials and methods. Once applied to objects believed to express older, more "traditional" ways of making art, most often from pre-industrial cultures such as Native American.

**Auto-ethnography** writing or filmmaking which documents the creator's own ethnic and social history. Often produced by colonized people who represent themselves and their societies to the colonial power. Auto-ethnography is typically subtly critical of the colonizer, emphasizing the superior harmony or efficiency of those who have been colonized.

**Automatist** a term for techniques directed at circumventing the censoring powers of the conscious mind. Used most often in relation to Surrealism and its American followers, as well as early phases of Abstract Expressionism.

**Axial** related to an axis, a strong central line around which a building is designed or a painting is organized.

**Barbizon** the c. 1830s school of French landscape painters working around the forest of Fontainebleau, including Theodore Rousseau and Camille Corot. Characterized by undramatic topography and moody, subdued light.

**Bargeboard** a decorative board that hangs from a projecting gable roof, often lavishly carved and ornamented in imitation of medieval styles.

**Baroque** an artistic style associated with the 17th century and characterized by elaborate ornamentation, dynamic visual oppositions, high contrasts, and dramatic uses of space.

**Bas-relief** a sculptural technique characterized by very shallow depth ("*bas*," as in the French for "low") as in representations on a medallion or set into an interior / exterior wall.

**Battered** characterized by a gradual slope backward in a wall or similar structure, as wall thickness tapers in from ground plane to create a buttressing effect.

**Bauhaus** the German school of design established by Walter Gropius in Weimar in 1919, and closed by the Nazis in 1933. Best known for integrating industrial mass production with good design based on function and simplicity.

**Benday dots** fields of small colored dots, arrayed in various densities and layers, used to reproduce color and shading in mechanically printed images.

**Biomorphic** *bio* (life) *morphic* (forms): composed of shapes or forms that resemble life organisms.

**Board and batten** a form of exterior house siding composed of wide wood planks set vertically with a thin strip of wood covering the joints or gaps between the planks.

**Body art** a form of art in which the artist's body is the primary medium of performance, inscription, or transformation.

**Bourgeois** the cultural forms, modes, and manners of the property-owning middle class or bourgeoisie, associated with conventional morals, material comfort, and capitalist forms of production.

**Broadside** a sheet of paper printed on one side only, often as a form of political or social commentary. Broadsides were often posted publicly or widely distributed.

**Bultos** figures of the saints, carved in wood and produced throughout the Catholic cultures of Hispanic settlement in the Southwest, for use in churches and private chapels.

**Bureaucratization** from the French word for desk (*bureau*); the process of arranging and subdividing the structure of an organization, such as a business or government, so that management is highly segmented by specialty.

**Burlesque** originating after the Civil War, a theatrical variety show, typically comedic or parodic, often with scantily clad women.

**Burnishing** rubbing or polishing to a high gloss.

**Buttress** an architectural structure that projects out from a building while supporting the walls and roof.

**Cabriole** the rounded shape of the leg of a piece of furniture, where the upper curve is convex and the lower curve is concave. The overall shape derives from certain animal legs.

**Cant** a slanting or oblique surface or form.

**Cantilever** a long projecting beam, girder, or other architectural form, which is supported at only one end.

**Casement** a window sash that opens on hinges on the sides.

**Cast iron** a form of metalwork made by pouring molten iron into shaped molds, as opposed to wrought or hammered metal.

**Catslide** a long, sloping roof at the rear of a building that continues over an extension of the building, rendering the back roof longer and lower than the front roof.

**Celluloid** the common term for nitrocellulose, an early plastic produced by combining gun cotton and plant fibre; used for numerous small consumer goods like combs and piano keys, and for early film stock; commonly used to refer to the material basis of film even though celluloid is no longer used for this purpose.

**Chattel** a form of property or possession. "Chattel slavery" designates a system where human beings are legally defined by their status as property.

**Chevron** a decorative element in the shape of a V or inverted V.

**Chiaroscuro** the treatment of light and shade in a drawing, painting, or other image in order to create the life-like illusion of three-dimensionality.

**Chicano** (fem. **Chicana**) a term used to denote an American of Mexican descent. Although it originally emerged as a derogatory term, its connotations shifted in the 1960s and 1970s, when it was embraced by Mexican-American activists as a designation of pride and heritage.

**Chromatic** related to or produced by color (*chroma*).

**Chromolithograph** a color picture printed by lithography (using multiple stone plates).

**Classical** referring to architectural or representational styles originally derived from ancient Greece and Rome; associated with proportional systems and with idealization in the treatment of the human figure.

**Cold War** an ideological battle between the United States and the Soviet Union, and their allies in Western and Eastern Europe, respectively; c. 1945–89.

**Collage** the technique of producing a picture by pasting together pieces of paper or other materials; from the French verb *coller*: to paste.

**Colonnade** an even row of columns along a hall or arcade, typically supporting a roof or arches.

**Color Field painting** an abstract style of painting that emerged in the 1950s within Abstract Expressionism, but was taken up by a subsequent generation of painters, characterized by large areas of color stained onto unprimed canvas in abstract patterns.

**Conceptual art** a form of art in which a detailed prescription or idea for the work precedes and often supersedes the work's physical execution. Conceptual art explores the tension between ideas and their embodiments in the real, material world.

**Conestoga wagon** named after a town in Pennsylvania, a large wagon covered with canvas and used to transport people and goods long distances. Typically associated with the westward migration of pioneers.

**Constructivism** an artistic and architectural movement in Russia after 1919 that prized art as an instrument for social purposes, especially the establishment of a Socialist system. Defined by pure geometries and non-representational forms signifying the utopian possibilities of a new society. Currently applied to an international style of abstract art that uses industrial materials, geometric formal elements, and precise methods of construction that are fully evident in the final work.

**Contrapposto** an Italian term used to describe a relaxed standing posture in which a figure's hips and shoulders are off-center but balanced, as when standing with the weight on one leg.

**Cornice** a horizontal element spanning the top of a building, typically above an ornamental frieze.

**Cosmopolitan** *cosmo* (world) *polis* (city/citizen of): familiar with or at ease with many places, cultures, or countries; worldly.

**Counterpoint** an element designed to create a contrast with the main element in a composition, musical or otherwise.

**Counting coup** the ultimate act of male bravery in Native American cultures of the Plains. Involves getting within reach of the enemy and touching him with a special coup stick rather than injuring him.

**Crane shot** in motion pictures, a scene shot by a camera mounted on a crane allowing the capture of a broad panorama, long uninterrupted takes, or the dramatic withdrawal of the camera up and away from the actors.

**Cross gable** a triangular section (gable) of a roof at right angles to the main roof.

**Cruciform** cross-shaped.

**Cubism, Cubist** an artistic style inaugurated in France c. 1907 by painters Pablo Picasso and Georges Braque, characterized by faceted forms designed to represent simultaneous views of a subject from multiple angles. Americans were first exposed to Cubism at the 1913 Armory Show (New York City).

**Cultural nationalism** the use of forms of cultural expression (art, architecture, and literature) to produce, cohere, and perpetuate a sense of national identity.

**Cultural patrimony** historical objects or places of extreme cultural importance to a nation or ethnic group. The Native American Graves Protection and Repatriation Act of 1990 is a federal law that concerns the legal rights to objects of cultural patrimony (*see* **Repatriation**).

**Dada** an artistic and literary movement which began in Zurich, Switzerland and peaked between 1916 and 1920; protested World War I and oppressive intellectual rigidity of bourgeois culture which they believed inspired the war; characterized by irony, caustic humor, and challenges to bourgeois convention. New York dada—launched by French artists fleeing World War I—preceded European dada; employed irony to subvert high-minded aesthetic attitudes and mocked Americans' obsessions with technology.

**Daguerreotype** an early photographic image made with mercury vapors and an iodine-sensitized silvered plate. Unlike most photographic images and prints, a daguerrotype is a single image that cannot be mechanically reproduced as multiples.

**"Degenerate art"** (*Entartete Kunst*) the derogatory characterization of modern European art by the Nazi Party for the famous "Degenerate Art Show" in Munich, in 1937.

**Dentil** a small rectangular or tooth-like block that forms part of an architectural series or molding.

**Direct carving** a movement initiated among European modernist sculptors such as Constantin Brancusi, involving direct engagement with the materials of sculpture, most often wood and stone. Relinquishing the use of intermediate models or maquettes, the sculptural idea responds to the process of carving, in theory, and to the unique visual or tactile qualities of the material.

**Disjunctive** serving to divide or having the effect of dividing; revealing the seams.

**Documentary** a filmic, photographic, or televisual genre involving specific devices or narrative styles that convey the aura of "truth"; aiming to record and convey as accurately as possible the nature of its chosen subject, often political, social, or historical, through the appearance of transparency (or the absence of a subjective point of view).

**Doppler** (**effect**) a perceived change in a sound as the distance between the source and the listener changes, as in the shift one detects in a police siren as it approaches the listener. Caused by the distorting effects of distance on sound waves.

**Dry-plate process** a photographic technique developed in the 1870s that recorded an image on a silver-gelatin coated surface; more durable and light-sensitive than the wet-plate process.

**Eclecticism** ideas, styles, or taste derived from a broad range of historical and formal sources.

**Effigy mound** an earthwork, generally very large in size, in the shape of an animal or other figure. These earthworks were inspired both by the natural world and by the religion and astronomical observation of Native Americans in the Eastern Woodlands.

**Elevated rail** (the 'El') elevated mass-transit railway built in American cities such as Chicago and New York, starting in the early 20th century.

**Elevation** an architectural drawing that shows a side view (the vertical elements) of a building, interior or exterior.

**Engraving** a process for making prints by incising lines into a hard, flat surface.

**Entablature** in classical architecture, the decorative beam carried by the columns and composed of architrave (below), frieze, and cornice (above).

**environments** three-dimensional, multimedia artworks that occupy an entire room or space. Viewers are surrounded by the work rather than approaching it as a discrete visual or sculptural object.

**Etching** a process for making prints by exposing a metal plate to acid. The plate is first coated with a protective substance and then drawn upon by a needle-like instrument, which cuts through the coated surface. The acid eats only the unprotected areas, which are then inked for printing.

**Ethnic** pertaining to the cultural heritage of a group of people understood as sharing a common history and a set of cultural practices.

**Ethnological** pertaining to the study of non-Western, typically colonized, cultures. In the late 19th century, ethnological exhibits of cultural artifacts equated non-Western societies with the "primitive" prehistoric origins of humanity. Also, cultural anthropology.

**Evangelical** pertaining to any Protestant Christian Church whose members believe in the authority of the Bible and salvation through personal acceptance of Jesus Christ.

**Existential** concerned with the nature of human existence; existentialist: a philosophy originating in post-war France but having a broad international influence, involving the idea that human meaning is immanent; rejecting transcendental sources of meaning beyond nature and human existence.

**Expatriation** to leave one's place or country of birth (*patria*) to live or work in another for an extended period of time, even permanently.

**Expressionism** a literary and artistic movement originating in pre-World War I Germany, seeking to represent internal subjective realities, often through lurid color and distortions in form (in Germany), or through abstraction from nature (U.S.).

**Extruded** in an architectural drawing or model, to extend upward from the floor plane or plan, at a consistent angle, to give the appearance of three-dimensional architectural form.

**FAP (Federal Art Project)** a division of the Works Progress Administration; one of the New Deal projects that provided federal sponsorship of the arts through non-competitive, needs-based funding; led to creation of hundreds of thousands of prints, murals, paintings, and posters for public exhibition.

**FSA (Farm Security Administration)** a division of the federal government (1935–43) inaugurated under the New Deal intended to mitigate rural poverty; under the Historical Section of the FSA, a team of photographers, directed by Roy Stryker, captured some of the most moving and memorable images of the effects of the Great Depression on rural America.

**Fascism** a political movement or tendency that favors dictatorial government, centralized control of business, industry, media, and culture; repression of political opposition; and extreme nationalism; as in National Socialism (Nazism) in Germany.

**Favrile** a type of iridescent glass patented in 1894 by Louis Comfort Tiffany, obtained by mixing together different colors of glass when hot.

**Fern-pocket** a niche or corner within a piece of furniture for holding ferns and other vegetation.

*Film noir* French for "black film," dark both in outlook and style; popular in the 1940s and 1950s, it was characterized by shadowy, high contrast lighting, cynicism toward human nature and ideals, and an antiheroic stance.

**Flat relief** a carving, embossing, or casting that protrudes moderately from the background plane.

**Fluxus** an international group of artists, flourish-ing in the 1960s and 1970s, devoted to the democrati-zation of the production and reception of art. They focused on the broad distribution of inex-pensive works ("multiples") and the staging of experimental performance events that emphasized the play of chance within repetition.

**Folk, "folk" art** a term applied to the culture of groups of people understood by outsiders as less modern and more in touch with tradition than most "modern" people. In the United States, the term "folk" is commonly used in reference to the cultures of Appalachia, New England, and the Southwest.

**Footprint** the shape or outline of the ground level of a building.

**Formal** pertaining to the relationship of formal ele-ments in an artistic composition, as opposed to the narrative or iconographic elements, or historical context of its production or reception.

**Frieze** in architecture, a horizontal band of decora-tion or sculpture forming part of the entablature of a building, above the wall but below the roof; also, a band of decoration on an interior wall.

**Futurism** an artistic and literary movement origi-nating in Italy c. 1909–18 that violently rejected traditional forms in favor of styles that celebrated the energy and dynamism of modern technology.

**Gable** a triangular wall section that either forms the vertical end of a building, or that sits at right angles to the roof. The latter is called a "cross gable."

**Garret** a room that sits just under the roof.

**Genre** a hierarchical categorization of artistic works, set into place by academic theory, according to subject matter as in the division of painting into history painting, portraiture, landscape, and still life; also scenes of domestic and everyday life.

**Gilded Age** a term employed by Mark Twain (1873) for the historical period between the end of the Civil War (1865) and the presidential election of 1896 characterized by the flowering of American arts and architecture, mass industrialization and urbanization, social and labor unrest, and the influx of European immigrants; refers to the idea of "gilding the lily," indicating wasteful opulence and ostentation.

**Glass-plate** a photographic technique in which images are recorded on a glass plate negative coated with light- sensitive solution that is then used to produce an unlimited number of photo-graphic positives (photographs).

**Globalization** the increasing interconnection and interdependence of economic, technological, and biological world systems.

**Graphic design** the art or skill of combining text and pictures in advertisements, magazines, or books in order to convey a message, often commercial but also political or social in nature.

**Groundline** a drawn or painted line that illustrates the break between earth and sky, or the place where figures stand in a landscape in drawings or paintings, especially in the European tradition.

**Hacienda** a large estate or landholding across the Spanish-speaking areas of the Americas; the main residence on such an estate.

**Half-tone** a printing technique which transforms a color or black-and-white image into tiny dots of various sizes which allows the image to be printed with a limited number of colors; enabling the printing of shaded or continuous tone images.

**Happenings** performance events first developed and theorized by Allan Kaprow in the late 1950s. Happenings were staged in non-theatrical loca-tions like lofts and basements and were character-ized by immediacy, unpredictability, and the direct involvement of the audience.

**Hasp** a device for fastening, for example, a lid or door.

**Highbrow** a 20th-century term originating in the 19th-century pseudoscientific belief that the shape of the skull was linked to intelligence and moral elevation; used in contrast to "lowbrow" culture, to distinguish cultural content associated with "high" moral or intellectual concerns, according to governing assumptions at the time.

**Hispanic** of or relating to Spanish-speaking people or people descended from ancestors of settlers from Spain, but frequently intermingled with other cultural groups.

**Historicize** to place in original historical context.

**Horsecar suburb** in the 1830s, horse-drawn cars pro-vided the first mass transit systems, allowing indi-viduals to live in suburbs outside of urban centers.

**Hypostyle** a roof directly supported by columns, typically arranged in several rows.

**Iconography** symbols and images which carry con-ventional meanings in art; also the study of such symbols by later historians, once their original meanings have been lost or displaced.

**Illusionism** the use of pictorial techniques to create the illusion of the real.

**Impasto** in painting, the thick application of pigment to the canvas.

**Impressionism** a late 19th-century French art move-ment whose paintings were characterized by loose application of unmixed colors, outdoor execution, and landscapes and bourgeois social subjects; style taken up by American artists in the Northeast in the mid-1880s through the 1910s.

**Inlay** an artisanal technique that sets one material, such as wood or stone, into another to form a decorative pattern.

**Institutional critique** a cluster of art practices, unfolding in the late 1960s and beyond, that aim to reveal and critique the social and political dimen-sions of art institutions (their funding structures, class biases, etc.).

**Intaglio** a form of printing in which the image is engraved or bitten into the plate, and only the lines thus formed are printed, as opposed to "relief" printing.

**International exposition** a series of large exhibitions or world's fairs held throughout Europe and the United States beginning in 1851, designed to encourage trade between nations and to showcase the technological, artistic, and agricultural progress of the participating nations.

**International Modernism** a major architectural style of the 1920s and 1930s, practiced by mod-ernist architects throughout Europe and by their American associates. First introduced to American audiences in 1932 by the Museum of Modern Art's International Style exhibition. A movement beyond historical styles and applied ornament, and toward abstract properties of balance and volume.

**Japanning** a European technique of imitating Asian lacquerwork that developed in 18th-century England.

*Japonisme* a late 19th-century European and American style in fine and decorative arts that imitated or was influenced by Japanese prints, painting, and furniture.

**Jim Crow** the legal segregation of black people in the U.S., put into place by the 1896 Supreme Court decision Plessy v. Ferguson, and only reversed during the movement for Civil Rights that began in the 1950s. Originally the name of a black character in a 19th-century plantation song.

**Judson Dance Theater** based at the Judson Memorial Church in Greenwich Village in the early 1960s, the Judson Dance Theater served as a venue for the experimentations of dancers and choreographers such as Yvonne Rainer, Steve Paxton, and Trisha Brown. Performances at the Theater helped intro-duce everyday movement, non-hierarchical pacing, and improvisational techniques into choreographic practice.

**Jut** or **Jutt** a projection, protruding point, or architec-tural overhang.

**Kachina, Katsina** an important Pueblo spirit and ancestral being thought to influence the affairs of living people. Public performances by the various male Pueblo Kachina societies are believed to bring these spirits and ancestors to the village.

**Kill hole** a hole punctured in the bottom of a Mimbres funerary bowl. The hole renders the bowl unusable in this world and turns it into a symbolic object. It is believed that Mimbres people meant this hole to symbolize a passage of the dead between worlds.

**Kitsch** a derogatory term famously deployed by critic Clement Greenberg to describe art forms that—in his view—catered to the tastes of a mass public preferring sentimental, realist, or other easily consumed forms of culture.

*Kiva* the private ceremonial building at the heart of a Pueblo village. It is the modern descendent of the Ancestral Pueblo pit house (see **Pit house**). Both are partly underground with an entrance in the roof and a symbolic hole in the floor (see **Sipapu**).

*Koshare* ritual clowns in Pueblo performances that act out improper behavior. Their absurd antics encourage community members to value the moral and social order.

**Lacquer, lacquerware** a clear or colored coating used primarily in the decorative arts, which dries to a hard, shiny, durable finish; originally from China.

**Lancet window** a narrow window with a sharp pointed arch typical of English Gothic architecture and gothic revival styles.

**Land Art** a term sometimes used to denote large-scale sculpture that takes the earth and natural substances as its medium. Land Art is usually, but not always, sited and created outdoors.

**Lapidary industry** stone, or other hard natural material, finishing, working, or forming industry.

**Limited edition** a production of prints, books, or photographs issued in a limited, typically small, number with the effect of increasing their collectibility and value.

**Lithograph** a print made from an image drawn on a large flat stone with water resistant crayon. A planographic technique (image on same plane as the surface being printed), lithographs were drawn directly by the artist rather than copied after an original drawing.

**Lowbrow** a derogatory term that originated in the 20th century, used to characterize forms of cul-tural expression by "common," "low," or working-class people; unsophisticated, tasteless, etc. (see **Highbrow**).

**Luminism** a style of American landscape painting of the 1850s–1870s stemming from the national school based in New York, and characterized by effects of light in landscapes through the use of aerial perspectives and the suppression of visible brushstrokes.

**Lynching** a form of extrajudicial punishment meted out against African Americans between 1877 and c. 1940, mostly in the South, characterized by mob violence, gruesome torture, and hanging until death. The first federal prosecution for lynching was in 1946; no federal law against the practice exists, despite repeated campaigns.

**Magic Realism** a style of figurative painting, drawing, and photography c. 1940–60 that depicted enigmatic narratives and dreamlike scenarios using traditional techniques and materials.

**Mannerism** a style in architecture and other arts between 1530 and 1600 that was particularly prevalent in Italy and was characterized by an unconventional or exaggerated use of traditional elements.

**Maquette** a small-scale model of a sculpture or building made to visualize forms and shapes before incurring the cost of making the full-scale work.

**Mass media** modern forms of standardized communication, such as newspapers, magazines, radio, or television, which reach very large audiences due to the capabilities of new telecommunications and print technologies, and national distribution networks.

**Maulstick** a light stick, often with leather padding at one end, used by a painter to steady his or her hand while working.

**Mechanomorph, mechanomorphic** having the form (*morph*) of a mechanical object; a term used to describe New York dada drawings endowing humans with machine-like qualities.

**Metaphor** a figure of speech in which an object or word is used to evoke broader associations through layers of meaning that expand beyond the literal, or denotative significance.

**Minimalism** a style of abstract painting and sculpture developed in the 1960s. Characterized by pared-down forms, the use of industrial, often prefabricated, materials, serial compositions, the removal of the artist's personal gesture, and a close attention to the viewer's bodily experience with the object and the space surrounding it.

**Modernism, Modernist** in painting and sculpture, refers to a wide range of art practices, including abstraction, distortion, and anti-naturalism, departing from the naturalism and illusionism that defined academic art of the later 19th century. Modernism's origins are usually traced to France, among artists trained in but working outside of the academic establishment. Modernism eventually became institutionalized in art academies, patronage, and museums.

**Modernity** refers to an epoch in cultural history that some historians date back as far as the 16th century, and which is marked by movement toward scientific rationalism, the growth of large-scale social institutions, and the transformation of production by mechanization.

**Montage** the process of selecting, editing, and piecing together discrete images—in film or photography—to create new meanings greater than the individual elements.

**Morada** a long, low adobe building, dedicated to the devotional practices of the Catholic lay religious confraternities known as the Penitente, in New Mexico.

**Mortise and tenon** a wood joining technique in which a projection of wood (tenon) is inserted into a corresponding hole (mortise) in another piece of wood to join the two together, often seen in wood furniture and older forms of house construction.

**Mosaic** a decorative technique in which a design or picture is created on a flat surface such as a floor or wall through the arrangement of small pieces of colored stone, tile, or glass.

**Motion picture camera** a photographic camera that captures a moving subject through a series of still images which, when later projected in rapid succession, creates the visual impression of a moving image.

**Multimedia installation** an artistic exhibition, typically by a single artist, composed of a wide variety of materials.

**Mural** a large flat painting covering a wall or similar surface.

**Mysticism** a term loosely denoting philosophies or tendencies that look to supernatural agency and union with a force beyond the self, through meditation, prayer, or other spiritual practices.

**Naturalism** a strategy of art making that focuses on reproducing the appearance of the external, observable world. Typically the human body, animals, and other forms of life are carefully rendered. Also, a literary and artistic movement originating in the late 19th century, rooted in the direct engagement with the subject, whether social, religious, or historical, unfiltered by obvious moralistic or literary content, and rooted in close observation of life, dress, and environment.

**Neoclassical/Neoclassicism** an international movement beginning in the late 18th century and associated with the revival of classical architecture and design, inspired by archaeological excavations of sites from antiquity.

*Neue Sachlichkeit* "new objectivity": a movement in German art of the post-World War I period, representing a reaction to the highly fraught subjective Expressionism of the pre-war period, and a turn to surgically precise draftsmanship deliberately drained of emotive qualities.

**New Deal** a colloquial term to describe the series of social, governmental, and fiscal reforms and relief programs enacted under President F. D. Roosevelt to remedy the effects of the economic recession of 1929–39.

**New York School** informal group of modernist painters and poets active in New York City c. 1950s–1960s; most closely linked to the rise of Abstract Expressionism.

*Notan* a Japanese design concept involving the placement of light and dark next to each other to enhance abstract properties of form.

**Organic abstraction** referring to an approach to abstraction associated with the circle of artists around Alfred Stieglitz, involving abstraction of natural forms and organic rhythms.

**Organicist** a creative tradition in the arts stemming from the 19th century, drawing inspiration from the resonance between the human and the organic realm of nature.

**Orthogonal** in art, the diagonal lines that converge at the vanishing point and thereby create the traditional system of Renaissance perspective.

**Painterly** the use of color rather than line to represent shapes or structure a composition.

**Palladian window** a large window divided into three parts. The center section is bigger than the flanking two segments and is generally arched. Named for the great Renaissance architect Andrea Palladio.

**Pan-Americanism** in relation to the ideals of the Mexican muralists between the wars, a belief that the political and cultural destinies of North and South America were intertwined as a product of shared historical circumstances and patterns of migration from Africa, Europe, and indigenous America.

**Patina** a chemical compound forming on the surface of metals as a result of oxidation. Most often used in relation to bronze, where a lustrous darkening occurs.

**Patronage** the financial underwriting or sponsorship of an artist or work of art, either institutional or private in nature.

**Pediment** a gable-shaped (triangular) architectural form that sits either at the end of the roof above the horizontal cornice or above a façade, doorway, or window, and often contains sculpture.

*Penitente* **Brotherhood** Secret lay Catholic male societies in the Rio Grande Valley of northern New Mexico, whose penitential practices—involving flagellation (ritual whippings) and re-enactments of Christ's Passion—stemmed from medieval Spain.

**Peonage** a system used in Latin America and southern United States in which a debtor was forced to work for a creditor until a debt was paid.

**Performance** a form of art consisting of live performances given by artists that blur the boundaries of theater, music, and visual art. Allows the artist to engage with the audience and reject the centrality of the art object as commodity.

**Peristyle** a colonnade that encloses either the exterior of a building or the interior of a courtyard.

**Photoengraving** a method used mostly for reproducing illustrations, in which a printing plate is coated with photosensitive, acid resistant chemicals, then exposed to light through a negative. The resulting image is then etched with acid and printed.

**Photogravure** a process invented in 1850 and used into the 20th century to reproduce photographs, fine arts prints, and paintings, in which a photographic glass transparency is transferred and etched onto a copper plate.

**Photojournalism** a documentary style of photography typically connected to a journalistic enterprise such as a magazine or newspaper, and associated with mass media.

**Pictographic** pertaining to a system of symbolic images used to record and communicate personal accomplishments, historical events, and ideas.

**Pictorial narrative** the story told by a painting or print, constructed through an implied sequence of events.

**Pictorialist** a style of photography (c. 1885–1914) that subscribed to the idea that art photography needed to emulate current styles of painting and printmaking to achieve personal artistic expression; characterized by soft focus; black and white or sepia-toned images; and manipulation of the image in the darkroom.

**Picture plane** the material surface of a two-dimensional image such as a print, painting, or photograph; term typically used to contrast the material surface of the image with the illusion of depth that the image creates.

**Piecework** a sewing technique in which small pieces of cloth are sewn together, as in a quilt.

**Pit house** an Ancestral Pueblo architectural form that was built partly underground and included a round room, an entrance hole in the roof, and a symbolic hole in the floor (*see Sipapu*).

**Planar** flat, two-dimensional.

**Polychrome** literally, many-colored. The term is often used to distinguish pottery styles that use multiple colors (such as Hopi) from those that use only one color (monochrome) or black and white.

**Polyptych** a group of images, usually paintings, typically with a common theme or subject, meant to be displayed or exhibited as a single whole.

**Pop art** emerging in the late 1950s and associated primarily with painting and sculpture, Pop Art drew upon the styles, subject matter, and production techniques of commercial art, product design, and mass-media imagery.

**Populism** politics or forms of cultural expression based on the perceived interests of ordinary people as opposed to those of cultural or economic elites.

*Portal* in adobe architecture, a covered walkway.

**Posterboard** heavy paper or thick cardboard used as a ground or support for drawing or painting.

**Postminimalism** a mode of sculpture and sculptural installation developed in the late 1960s. Usually characterized by soft or pliable materials, scattered, slumping, or random arrangements, and an emphasis on process.

**Postmodernism** a movement in art, architecture, culture, and theory, flourishing in the 1970s and 1980s. Postmodernism challenged the cornerstones of originality, progress, essence, and rationality that had exemplified many forms of Modernism in the 19th and 20th centuries.

**Potlatch** feasts and give-away ceremonies in Northwest Coast Native American societies. These typically mark the passing of power through an elite family line, or a major social event, such as a marriage.

**Prairie Style** a term associated with the architecture of Frank Lloyd Wright, dating from his earliest work in Oak Park, Illinois; a style of low-slung roofs, horizontal expanse, and stylized decoration associated with the landscape and flora of the Midwest.

**Precisionist** a style of painting and photography from the 1920s associated with precisely rendered, static, or somewhat abstracted views of urban landscapes and technology (*see Neue Sachlichkeit*). Contrasting with the mobile dynamic forms of organic abstraction and other modernist styles of the 1910s and 1920s.

**Primitive** an outmoded term formerly applied to small-scale, usually colonized societies with limited social hierarchy. The "lack" of a state was used to suggest they were at a lower developmental stage of human history than Western Europe and other large, hierarchal societies. The term also came to be used in a "positive" sense by Western artists and intellectuals critical of their own societies. These disenchanted Westerners believed "primitive" people were less socially alienated, more in touch with unconscious impulses. Therefore, in the minds of Western artists, "primitive art" was more "natural," free, and creative.

*Psychic automatism see* **Automatist**.

**Puddling** a form of adobe construction, originally used by pre-contact Pueblo societies of the Southwest, involving successively layering mud, clumped by hand into balls, into courses to create walls. Contrasted with methods used by the Spanish, involving brick molds.

**Pueblo** the Spanish word for "people," referring both to the native inhabitants of New Mexico, so named by the colonizers and used up to the present, and to the settled villages where they lived (as in "pueblos").

**Quillwork** a type of embroidery using dyed porcupine and bird quills, practiced by Native American women of the Eastern Woodlands and Plains. Passed on through the generations by specialized quillworking guilds.

**Quoin** a masonry term referring to a hard brick or stone used to reinforce an external corner or edge.

**Readymade** a term originated by the French artist Marcel Duchamp referring to found, mass-produced objects resituated into new non-utilitarian contexts and designated as art.

**Realism** a general term for literature or art engaged with the social worlds of the artist's own time and place. Also referring to a set of conventions conveying a studied understanding of that world as opposed to fantastic, imaginary, or historical subjects.

**Recessional** that which appears to recede or become more distant from the observer.

**Regionalism** the identification of artists or artworks with a particular geographic region such as the Southwest or Midwest; specific movement of the 1930s including painters Thomas Hart Benton, Grant Wood, and John Steuart Curry.

**Register, registration mark** a mark made on printing blocks or stone with which the printing paper can be aligned for successive printings in different colors.

**Relief** a form of sculpture in which representations of figures and objects are raised from a flat surface as with a coin, medallion, or plaque; *see also* **bas-relief**.

**Repatriation** the return of objects of cultural significance to their original owners or makers. This is a major contemporary issue involving Native American objects in museum collections;

also to send a person or thing back to its original culture, society, or nation, as in the return of an immigrant to the birth country or the return of cultural artefacts to the people that produced them.

*Retablo* usually a religious image of a saint, typically painted on wood panel, either separate or part of a larger ensemble. Also, the frame, situated behind the altar in a church, which holds images of the saints.

**"Retinal" art** Marcel Duchamp's term for the emphasis, in high Modernist art of the early 20th century, on the flat painted surface, and on the visual structure of Modernism, as opposed to his conceptual approach which questioned received aesthetic categories and approached "art" as an operation of the mind.

**Rhyming forms** forms that echo each other visually through color, shape, size, or volume.

**Romantic movement** an artistic, literary, and philosophical movement that arose in Europe in the late 18th century and shaped American intellectual and artistic life in the first half of the 19th century. Romanticism tended to view the world as a living, organic force, where intuition is valued over reason, and the importance of the individual imagination in the discovery of truth is stressed.

**Rorschach test** a type of analytical test used in psychoanalysis in which a subject is shown a series of random ink blots on paper and asked to report what the blots resemble or suggest.

**Rotogravure** a print or printmaking process in which photographic images are etched onto copper cylinders to print using a rotary press.

**Salon (Paris)** the official art exhibition of the French Académie des Beaux-Arts, the national art school, held annually in Paris throughout the 19th century.

*Santero* an itinerant artist in Hispanic New Mexico, trained within a tradition of local production devoted to images of the saints painted for use in village churches and private chapels.

**Scaffolding** a temporary wooden structure or platform erected adjacent to a wall or building allowing workers to build, repair, clean, or decorate a building.

**Scrimshaw** a technique of incising lines on ivory or horn and then darkening them with ink, graphite, or some other medium.

*Shaman* an individual recognized in a great many societies as possessing an extraordinary receptivity to visionary experience and the power to receive spiritual protection. These important individuals could use their powers for constructive purposes, such as healing, or destructive purposes, such as injuring.

**Sharecropper** a tenant farmer who farms the land for a share of the crop yield.

**Shot, counter-shot** a form of cinematic editing in which a conversation between two people is conveyed by first showing a shot of a person speaking then a counter-shot of the second person speaking, etc.

*Sipapu* a hole in the floor of a pit house or kiva (*see* **Pit house, Kiva**). In Pueblo cosmology it symbolizes the hole in the earth from which Pueblo people entered the world.

**Social Realism** an artistic and literary movement that sought to depict working-class subjects; artists often had Socialist leanings and politically activist sensibilities.

**Social Surrealism** the name given to a set of tendencies among artists in the 1930s who felt that Social Realism was inadequate to convey the absurdities of an unjust capitalist society; artists adopted the illogical juxtapositions and enigmatic narratives of Surrealism to convey judgements on contemporary society.

**Soil spirit** a term, originally used with sarcasm in the 1920s, to identify the aesthetic nationalism of the artists around Alfred Stieglitz: the idea that the spiritual life of the nation's culture derives from its attachment to the landscape and the organic life of nature.

**Still camera** a conventional photographic camera used to take single images of a subject as opposed to a motion picture camera, which records a series of images to convey a moving subject.

**Still-life** a subject genre of painting typically composed of artfully arranged flowers or objects.

**"Straight" photography** the technique of taking photographs so that the resulting image mimics as closely as possible the way the world is seen with the naked eye; a movement out of "Pictorialist" photography, in which photographers emulated painterly effects.

**Streamlined style** a style of product design between World Wars I and II inspired by the principles of aerodynamic design deriving from the flight industry.

**Stringcourse** a horizontal band of masonry that extends decoratively across the façade of a structure, often marking off one story from another.

**Stucco, stuccoed** a fine plaster used for surfacing interior or exterior walls.

**Stucco-on-lathe** a wall covering consisting of stucco plaster applied over narrowly spaced thin strips of wood.

**Stylistic obsolescence** a strategy devised by marketers to promote continual new sales of consumer items by redesigning such products as refrigerators each new season through minor modifications in exterior appearance, rendering previous models obsolete in relation to up-to-date styling trends.

**Subculture** a minority or subversive cultural group or practice within a larger or dominant one.

**Sublime** in aesthetics, a quality of transcendent power that exceeds all measure, calculation, or comprehension and, as such, often induces a sense of awe or fear in the beholder.

**Supernatural** a realm beyond the observable world. Generally it is distinguished from the natural world by the breaking of laws of space and time, gravity, and other restrictions of natural movement. Understandings of the line between natural and supernatural vary greatly between cultures.

**Surrealism** an early 20th-century European and American artistic and literary movement that sought to express the energies of the unconscious by uncensoring the mind and releasing creativity. Characterized by fantastic imagery and illogical scenarios.

**Swallowtail joint** a joint used in carpentry to hold together wood parts by creating a tapered projection that resembles a swallow's tail or a pair of open scissors.

**Symbolism** a late 19th-century European literary and artistic movement that sought to evoke rather than describe ideas or feelings through the use of literary allusions and symbolic images.

**Synaesthesia** the production of an impression in one bodily sense by stimulating another, as in the perception of visual sensation through listening to music.

**Synchromist/Synchromism** an early 20th-century Modernist movement, centered on the work of Stanton MacDonald Wright and Morgan Russell, which produced among the first fully abstract works of painting. Paralleling the work of the French Orphists around Robert Delaunay, they developed a theory and practice centered on abstract color harmonies evoking musical effects.

**Syncopation** in music, a rhythmic technique in which the accent is shifted to a weak beat of the bar.

**Tambour** a circular or drum-shaped wall, door, or partition.

**Technology** from *techne*, Greek word for "craft"; loosely referring to devices, machines, or techniques by which humans alter or control their environment; in the 20th century, refers to large-scale industrial manufacturing and production processes which increasingly dominate over the handmade.

**Technophilia** the love or admiration of technology, especially machine technology.

**Territorial style** a 19th-century style of architecture in New Mexico, postdating the Mexican–American War (1846–8) and the opening of rail lines from the east, characterized by a marriage of adobe style and European classical motifs such as pedimented windows and brick coping at the roofline.

*Tihu* among Pueblo peoples of American Southwest, wooden replicas of Kachina spirits. Also known as "Kachina dolls."

**Tonalism** an art historical term which describes a late 19th-century style of painting that used harmoniously modulated color schemes to convey a "moody" or atmospheric image.

**Transept** the section of a church that crosses the nave, or main axis, at a right angle, producing a cruciform plan.

**Transverse clerestory** an invention of the colonial frontier of New Spain for introducing natural light into the sanctuary holding the altar in adobe mission churches. Created by an opening running the breadth of the church nave at the change of elevation between the nave and the altar.

*Trompe l'oeil* a French term, literally "fool the eye"; a form of realistic painting, typically artful arrangements of objects such as books, domestic objects, or musical instruments, which aims to mimic as closely as possible the illusion of real life.

**Truss** in architecture, a beam forming part of a network of rigid forms that support a roof or floor.

**Tudor** a late medieval style (1485–1603) that played a transitional role between Gothic and Renaissance forms. Tudor architecture is characterized by steeply pitched gables, elaborate chimneys, brickwork, and half-timbering on the exterior, and rich plaster relief ornament in interior spaces.

**Two-dimensional** generally referring to flat works of art such as paintings, photographs, drawings, prints, or architectural plans.

**Urban realists** artists creating work featuring everyday urban scenes, usually in reference to the early 20th century.

**Vanguard** the cutting edge or forefront of culture; the avant garde.

**Vaudeville** a popular urban entertainment form in the early 20th century consisting of live singers, dancers, and comedians on stage.

**Vault, vaulted** a roof in the form of an arch or series of arches, typical of churches or other large architectural structures.

**Vector** a line or shape indicating a trajectory of movement through space.

**Vernacular** everyday or common culture or forms of speech, as opposed to elite, special, or fine; also, a term commonly applied to art made by non-professional artists working outside of academic, gallery, and other art world institutions. These works are often understood to express the "tradition" of a particular locality or sometimes to express a more spontaneous or more original approach to art making. Sometimes used interchangeably with the terms "folk art" or "popular art." In architecture, a mode of building based on regional materials and forms and everyday usages.

**Victorian** in art history, styles associated with the reign of Queen Victoria (1837–1901), distinguished by eclecticism and historical references.

*Viga* in adobe architecture, a projecting ceiling beam.

**Vignette** a manner of composing a picture or landscape that circumscribes or miniaturizes it; forms of closed composition emphasizing the ornamental or decorative functions of a subject; or discrete episodes within a broader visual field.

**Visionary artist** an artist whose art making is inspired by a divine message or calling.

**Vitalism** a 19th-century European and American philosophy which posited that life energies underlie all forms of creativity and give structure to the random flux of reality.

**Wampum** strings or woven belts of white and purple shell beads that carry the force of law, like contracts or treaties. Patterns and images formed by the beads are symbolic, able to be read by specialized wampum keepers.

**Wattle-and-daub** a mode of construction that involves weaving twigs between vertical poles and then plastering the whole together with mud.

**Wet-plate process** an early photographic process involving a chemically treated (collodion) plate exposed in the camera while still wet. Considered one of the great developments in photographic technology, the wet-plate process dominated the medium from the early 1850s until the introduction of gelatine dry plates in the 1880s.

**Xenophobia** from *xeno*, the Greek word for guest, stranger, or foreigner; thus fear (phobia) or dislike of foreigners.

**Yeoman** historically, a man who owns and works his own plot of land and therefore embodies ideas of freedom and independence.

# Notes

## PREFACE

1 Stephen Greenblatt, *Marvelous Possessions: The Wonder of the New World* (Chicago, IL: University of Chicago Press, 1991).

## CHAPTER 1

1 Stephen K. Lekson, Thomas C. Windes, John R. Stein, and W. James Judge, "The Chaco Canyon Community," *Scientific American* 259/1 (July 1988), pp. 100–09.

2 Barbara L. Moulard, "Form, Function, and Interpretation of Mimbres Ceramic Hemispheric Vessels," in Janet Catherine Berlo & Lee Anne Wilson (eds.), *Arts of Africa, Oceania, and the Americas* (Englewood Cliffs, NJ: Prentice Hall, 1993), p. 266.

## CHAPTER 2

1 Patricia Seed, *Ceremonies of Possession in Europe's Conquest of the New World, 1492–1640* (Cambridge: Cambridge University Press, 1995).

2 Richard White, *The Middle Ground: Indians, Empires, and Republics in the Great Lakes Region, 1650–1815* (Cambridge: Cambridge University Press, 1991).

3 George Abrams, "The Case for Wampum," in *Museums and the Making of "Ourselves": The Role of Objects in National Identity*, ed. Flora Kaplan (London: Leicester University Press, 1994), p. 356.

4 Bernard Romans, *A Concise History of East and West Florida* [1775] as quoted in *Their Bearing Is Noble and Proud: A Collection of Narratives Regarding the Appearance of Native Americans from 1740–1815*, ed. James F. O'Neil, II (Dayton, OH: JTGS Publishing, 1995), p. 43.

5 Daniel H. Usner, Jr., *Indians, Settlers, and Slaves in a Frontier Exchange Economy* (Chapel Hill: University of North Carolina Press, 1992), p. 31.

## CHAPTER 3

1 Sally Promey, "The Return of Religion in the Scholarship of American Art," *Art Bulletin* 85 (2003), pp. 581–603.

## CHAPTER 4

1 George Washington, "Memorandum," November 5, 1797, Fitzpatrick 35:260, as cited in Allan Greenberg, *George Washington, Architect* (London: Andreas Papadakis Publisher, 1999), p. 10.

2 John Adams, Diary entry for Monday, September 25, 1775, in *The Works of John Adams*, vol. 2 of 10, ed. Charles Francis Adams (Boston: Little Brown, 1856), p. 428.

3 Kent Lightfoot, *Indians, Missionaries and Merchants: The Legacy of Colonial Encounters on the California Frontiers* (Berkeley: University of California Press, 2005), p. 3.

4 Benjamin Franklin, *Autobiography*, unfinished, written in 1771, first American edition 1818; first complete edition in English 1867, reprint pp. 100–101.

## CHAPTER 5

1 Quoted in Joseph Ellis, *After the Revolution: Profiles of Early American Culture* (New York: Norton, 1979), p. 5

2 Quoted in Frances K. Pohl, *Framing America: A Social History of American Art* (New York: Thames and Hudson, 2002), p. 80.

3 Robert and James Adam, *The Works in Architecture of Robert and James Adam, Esquires*, No. 1 (London: 1773), p. 3.

4 Edgar P. Richardson *et al.*, *Charles Willson Peale and His World* (New York: H.N. Abrams, 1983), p. 123.

## CHAPTER 6

1 Joy S. Kasson, "Narratives of the Female Body: *The Greek Slave*," in *Reading American Art*, ed. Marianne Doezema and Elizabeth Milroy (New Haven, CT: Yale University Press, 1998), p. 174.

2 Quoted in Elaine Hedges, Pat Ferrero, and Julie Silber, *Hearts and Hands: Women, Quilts, and American Society* (Nashville, TN: Rutledge Hills Press, 1996, first published 1987), p. 72.

3 Quoted in Elaine Hedges, Pat Ferrero, and Julie Silber, *Hearts and Hands: Women, Quilts, and American Society* (Nashville, TN: Rutledge Hills Press, 1996), p. 74.

4 Quoted in Brydon, Sherry, "Ingenuity in Art: The Early 19th-Century Works of David and Dennis Cusick," *American Indian Art* 20 (2), Spring 1995, pp. 60–69.

5 Ralph Waldo Emerson, "The American Scholar," in *Selections from Ralph Waldo Emerson*, ed. Stephen E. Whicher (Boston, MA: Houghton Mifflin, 1960), p. 64.

## CHAPTER 7

1 Arthur King Peters, *Seven Trails West* (New York: Abbeville Press, 1996), p. 35.

2 See Ron Tyler, et al., *Alfred Jacob Miller: Artist on the Oregon Trail* (Fort Worth: Amon Carter Museum, 1982), p. 85.

3 Dippie, *Catlin*, p. 59.

4 Rydell, Robert W., *All the World's a Fair: Visions of Empire at American International Expositions, 1876–1916* (Chicago, IL: University of Chicago Press, 1984).

## CHAPTER 8

1 Clifford Clark, Jr, "Domestic Architecture as an Index to Social History: The Romantic Revival and the Cult of Domesticity in America, 1840–70," in *Material Life in America*, ed. Robert Blair St. George (Boston: Northeastern University Press, 1987), p. 535.

2 Dell Upton, *Architecture in the United States* (Oxford, England: Oxford University Press, 1998), pp. 117–18.

3 Horatio Greenough, *Form and Function. Remarks on Art, Design and Architecture*, ed. Howard A. Small (Berkeley, CA: University of California Press, 1969), pp. 60–61, 57, 118, 71.

4 Kenneth John Myers, *The Catskills. Painters, Writers, and Tourists in the Mountains, 1825–1875* (Ithaca, NY: University Press of New England, 1993), pp. 51–2.

5 Kenneth John Myers, "On the Cultural Construction of Landscape Experience: Contact to 1830," in *American Iconology*, ed. David C. Miller (New Haven, CT: Yale University Press, 1993), p. 75.

6 Quoted in Franklin Kelly, "A Passion for Landscape: The Paintings of Frederic Edwin Church," in *Frederic Edwin Church* (Washington, National Gallery of Art, 1989), p. 34.

7 Rebecca Bedell, *The Anatomy of Nature. Geology and American Landscape Painting, 1825–1875* (Princeton, NJ: Princeton University Press, 2001), p. ix.

8 Alan Trachtenberg, *Reading American Photographs. Images as History from Mathew Brady to Walker Evans* (New York: Hill & Wang, 1989), p. 13.

9 Trachtenberg, *Reading American Photographs*, p. 42.

10 Kirsten P. Buick, "The Ideal Works of Edmonia Lewis: Invoking and Inverting Autobiography," in *Reading American Art*, ed. Marianne Doezema and Elizabeth Milroy (New Haven, CT: Yale University Press, 1998), pp. 193–4

## CHAPTER 9

1 Quoted in Keller, *The Art and Politics of Thomas Nast* (New York: Oxford University Press, 1968), p. 4.

2 Quoted in Stephen Whitfield, "'Sacred in History and in Art': The Shaw Memorial," *New England Quarterly*, 60, no. 1 (March 1987), p. 26.

3 Whitfield, "Sacred in History," p. 18.

4 Peter H. Wood and Karen C. C. Dalton, *Winslow Homer's Images of Blacks. The Civil War and Reconstruction Years* (The Menil Collection, University of Texas Press, 1988), pp. 101–3. See also David Park Curry, "Winslow Homer: Dressing for the Carnival,"

in *Winslow Homer. A Symposium*, ed. Nicolai Cikovsky, *Studies in the History of Art* 26 (National Gallery of Art, Washington, D.C., and University Press of New England, 1990), pp. 90–113.

5 Dewey Mosby, Introduction to Mosby and Darrel Sewell, *Henry Ossawa Tanner* (Philadelphia: Philadelphia Museum of Art, in tandem with Rizzoli, 1991), p. 11.

6 Judith Wilson, "Lifting the 'Veil': Henry O. Tanner's *The Banjo Lesson* and *The Thankful Poor*," in Mary Ann Calo, ed., *Critical Issues in American Art: A Book of Readings* (Boulder, CO: Westview Press/HarperCollins, 1998), p. 207.

7 See Peter Marzio, *The Democratic Art: Pictures for a Nineteenth-Century America: Chromolithography, 1840–1900* (Fort Worth, TX: Amon Carter Museum of Western Art, 1979), p. 2.

8 William Cronon, "Telling Tales on Canvas: *Landscapes of Frontier Change*," in Prown *et al.*, pp. 44–5.

9 James Gorman, "Yosemite and the Invention of Wilderness," *New York Times, Science Times*, Tuesday September 2, 2003, D 1–2.

10 Martha A. Sandweiss, "The Public Life of Western Art," in Prown *et al.*, pp. 118, 119–20.

11 Richard Slotkin, "Buffalo Bill's 'Wild West' and the Mythologization of American Empire," in Amy Kaplan and Donald E. Pease, eds., *Cultures of United States Imperialism* (Durham: Duke University Press, 1993), pp. 164–81.

## CHAPTER 10

1 Henry James to Thomas Sergeant Perry, September 20, 1867, in Leon Edel, ed., *Henry James, Letters*, 4 vols (Cambridge, MA: Harvard University Press, 1974–84), I, p. 77.

2 Henry James, "John Singer Sargent," *Harper's New Monthly Magazine*, 75 (October 1887), p. 684.

3 "Letters and Papers of John Singleton Copley and Peter Pelham," Collections of the Massachusetts Historical Society, no. 71 (1914), pp. 64–66; quoted in John McCoubrey, ed., *American Art, 1700–1960: Sources and Documents* (Englewood Cliffs, NJ: Prentice Hall, 1965), p. 18.

4 Nathaniel Hawthorne, "The Artist of the Beautiful" (1844).

5 Interview in *Saturday Evening Post*, quoted in Nicolai Cikovsky, Jr., "Interiors and Interiority," in D. Scott Atkinson and Nicolai Cikovsky, *William Merritt Chase: Summers at Shinnecock, 1891–1902* (Washington, D.C.: National Gallery of Art, 1987), p. 57.

6 "American Artists and Their Art," *Woman's Home Companion*, 37 (September 1910), p. 50; quoted in Hiesinger, p. 81.

7 E. V. Smalley, correspondent for the *New York Tribune*, label in "China and Japan at the 1876 Centennial," Philadelphia Museum of Art, February 2002.

8 Kathleen Pyne, "John Twachtman and the Therapeutic Landscape," in Deborah Chotner, Lisa N. Peters, Kathleen Pyne, *John Twachtman: Connecticut Landscapes* (Washington, D.C.: National Gallery of Art; New York: distributed by H. N. Abrams, 1989), pp. 49–69.

9 Quoted in Nigel Thorp, ed., *Whistler on Art: Selected Letters and Writings, 1849–1903* (Manchester: Fyfield Books in association with The Centre for Whistler Studies, 1994), p. 52.

10 Quoted in Linda Nochlin, *Representing Women* (London: Thames & Hudson, 1999), p. 214.

11 Quoted in Mosby, p. 13.

12 James A. Porter, *Modern Negro Art* (Washington, D.C.: Howard University Press, 1992), p. 58.

13 W. E. B. Dubois, *The Souls of Black Folk* (1903; New York: Penguin, 1989), p. 13.

14 *Imperial Leather: Race, Gender and Sexuality in the Colonial Contest* (New York: Routledge, 1995), p. 33 passim.

15 O'Gorman, *Living Architecture*, p. 78.

16 Quoted in Twombly, p. 75.

17 Quoted in Siry, p. 243.

18 Quoted in Siry, p. 4.

19 Quoted in Boris, p. 54.

20 "Color and its Kinship to Sound," *Art World*, 2 (May 1917), p. 143.

21 Quoted in Frelinghuysen, p. 6.

22 Quoted in Adams, p. 220.

23 Samuel Bing, quoted in Adams, p. 210.

## CHAPTER 11

1 Quoted in Kirstein, *Memorial*, p. 90.

2 As reported by his friend Mrs. Barnett Wendell; quoted in Kirstein, p. 90.

3 "Mr. Inness on Art Matters," *The Art Journal* London, n.s. 5 (1879), p. 377, quoted in Leo G. Mazow, *George Inness: the 1880s and 1890s* (Annville, PA: Suzanne H. Arnold Art Gallery, 1999), p. 12.

4 Robertson, *Reckoning with Winslow Homer*, pp. 3–5.

5 Nicolai Cikovsky, Jr., ed., *Winslow Homer: A Symposium* (Washington, D.C.: National Gallery of Art; Hanover, NH; distributed by the University Press of New England, 1990), p. 146.

6 *Mary Cassatt: Painter of Modern Women* (London: Thames and Hudson, 1998), p. 123.

7 Quoted in Tappert, p. 5.

8 Quoted in Rutkoff and Scott, p. 289.

9 Cox, pp. 3–4, quoted in Susan Rather, *Archaism, Modernism, and the Art of Paul Manship* (Austin: University of Texas Press, 1993), p. 85.

10 Wilson, p. 12.

11 Quoted in Rydell, p. 65.

12 Ott, p. 26.

## CHAPTER 12

1 Henry James, *The American Scene* (Bloomington, IN: Indiana University Press, 1968), pp. 75 and 83.

2 Henri, p. 27.

3 Quoted in Zurier, *Art for the Masses*, p. 126.

4 Zurier, *Art for The Masses*, p. 127.

5 Ibid., p. xvi.

6 Quoted in *Lewis W. Hine, The Empire State Building*, with an introduction by Freddy Langer (Munich, New York: Prestel, 1998), p. 16.

7 Quoted in Elizabeth West Hutchinson, "Progressive Primitivism: Race, Gender, and Turn-of-the-Century American Art." Ph.D, Stanford University, 1999, p. 162.

8 Arthur Wesley Dow, *Composition* (Doubleday, Page and Co., 1913).

9 Quoted in Beth Venn and Adam Weinberg, eds., *Frames of Reference: Looking at American Art, 1900–1950. Works from the Whitney Museum of American Art* (New York: Whitney Museum of American Art, 1999), p. 82.

10 Dow, *Composition*, p. 3.

11 See Corn, *Great American Thing*, p. 215.

12 Arthur Dove, quoted in Cohn, p. 2.

13 *Forum Exhibition*, n. p., quoted in Balken, p. 24.

14 Buhler Lynes, p. 171.

15 Jack Cowart, Juan Hamilton, and Sarah Greenough, *Georgia O'Keeffe: Art and Letters* (Washington, D.C.: National Gallery of Art, 1987), p. 10.

16 In 1927; quoted in Cowart *et al.*, p. 4.

17 The phrase is from Floyd Dell, as quoted in Joel Pfister and Nancy Schnog, eds., *Inventing the Psychological: Toward a Cultural History of Emotional Life in America* (New Haven: Yale University Press, 1997), p. 158.

18 Quoted in Balken, p. 35.

19 Rosenfeld, "American Painting" (1921), quoted in Balken, p. 23.

20 Quoted in Buhler Lynes, p. 207.

21 Greenberg, "The Case for Abstract Art," quoted in Jennifer Roberts, *Mirror-Travels: Robert Smithson and History* (New Haven, CT: Yale University Press, 2004), p. 33.

22 Malcolm Cowley, *After the Genteel Tradition: American Writers Since 1910* (Gloucester, MA: P. Smith, 1959), p. 215.

23 Quoted in Dickran Tashjian, *Skyscraper Primitives: Data and the American Avant-Garde, 1910–1925* (Middletown, CT: Wesleyan University Press, 1975), pp. 18–19.

24  Quoted in *John Marin: Tributes by William Carlos Williams, Duncan Phillips [and] Dorothy Norman* (Berkeley, CA: University of California Press, 1956).

25  Sadakichi Hartmann, quoted in Joel Smith, *Edward Steichen: The Early Years* (Princeton, NJ: Princeton University Press, 1999), p. 20.

26  Quoted in John Loughery, "Charles Caffin and Willard Huntington Wright, Advocates of Modern Art," *Arts Magazine* 59, no. 5 (Jan. 1985), pp. 102–3.

27  Quoted by Dorothy Norman, in *Alfred Stieglitz, With an Essay by Dorothy Norman* (New York: Aperture, Masters of Photography series, 1989), p. 9.

28  Quoted in Maria Morris Hambourg, *Paul Strand: Circa 1916* (New York: The Metropolitan Museum of Art; distributed by Harry N. Abrams, Inc., 1998), pp. 28–9.

29  Edward Weston, "Daybooks," quoted in Vicki Goldberg, ed., *Photography in Print: Writings from 1816 to the Present* (Albuquerque: University of New Mexico Press, 1981), p. 311.

30  Quoted in Jean S. Tucker, *A 1978 Exhibition of Photography by Members and Associates of Group f. 64* (St. Louis: University of Missouri-St. Louis Publications Office, 1978), p. 12.

31  Quoted in Calvin Tomkins, "Profiles: Look to the Things Around You," *New Yorker*, September 16, 1974, p. 45.

## CHAPTER 13

1  Watson, p. 181.

2  *Marguerite Zorach: The Early Years, 1908–1920* (National Collection of Fine Arts, Washington, D.C., 1973), pp. 42–3.

3  Quoted in Laura R. Prieto, *At Home in the Studio: The Professionalization of Women Artists in America* (Cambridge, MA: Harvard, 2001), p. 183.

4  Watson, p. 175.

5  Ibid., p. 175.

6  "The Modern Spirit in Art," *Harper's Weekly*, March 15, 1913, quoted in Barbara Rose, *Readings in American Art, 1900–1975* (New York: Praeger, 1975), p. 82.

7  Balken, p. 37.

8  Keith Davis, *An American Century of Photography: From Dry-Plate to Digital/The Hallmark Photographic Collection* (New York: Hallmark Cards in association with H. N. Abrams, 1995), p. 115.

9  "The Machine and Mystic America," quoted in "The Image of Urban Optimism," in Joshua Taylor, *America as Art* (Washington, D.C.: The National Collection of Fine Arts, 1976), p. 187.

10  L. P. Jacks, *Responsibility and Culture*, quoted in Philip Johnson, *Machine Art* (New York: Museum of Modern Art, 1934), n.p.

11  Quoted in Oldenziel, p. 31.

12  Rudolf E. Kuenzli, "Baroness Elsa Von Freytag-Loringhoven and New York Dada," in Naomi Sawelson-Gorse, *Women in Dada: Essays on Sex, Gender, and Identity* (Cambridge, MA: MIT Press, 1998), p. 451.

13  Quoted in Camfield, "Marcel Duchamp's *Fountain*," p. 79.

14  Quoted in Camfield, "Marcel Duchamp's *Fountain*," p. 76.

15  Quoted in Ellis, "Paris: Capital of America," in Turner, p. 66.

16  Quoted in Turner, "The View from Paris," p. 44.

17  Quoted in Turner, p. 31.

18  Quoted in Turner, p. 25.

19  Charles Demuth, "Confessions," *The Little Review* 12 (May 1929), p. 30; quoted in David Gebhard, *Charles Demuth: The Mechanical Encrusted on the Living* (Santa Barbara: University of California, 1971), p. 11.

20  Quoted in Dorothy C. Miller, ed., *The Sculpture of John B. Flannagan* (New York: Museum of Modern Art, 1942), p. 7.

21  Quoted in Alofsin, *Frank Lloyd Wright: Europe and Beyond*, p. 221, n. 15.

22  Quoted in William Cronon, "Inconstant Unity: The Passion of Frank Lloyd Wright," in Terence Riley, ed., *Frank Lloyd Wright, Architect* (New York: Museum of Modern Art, 1994), p. 10.

23  Le Corbusier, *Towards a New Architecture* (New York: Dover Publications, 1986; first published in 1924).

24  Antonio Gramsci, "Fordism and Americanism," quoted in Bucci, p. 19.

## CHAPTER 14

1  Quoted in Davies, p. 107.

2  Quoted in Votolato, p. 32.

3  Davies, p. 86.

4  Quoted in George Roeder, "What Have Modernists Looked At? Experiential Roots of Twentieth-Century American Painting," *American Quarterly*, 39, no. 1 (Spring 1987), pp. 56–83.

5  Quoted in Joshua Taylor, *Futurism* (New York: Museum of Modern Art, 1961), p. 13.

6  Stella's words, quoted in Kasson, p. 3.

7  Stella, "The Brooklyn Bridge (A Page of My Life)" (1928), reproduced in Barbara Haskell, *Joseph Stella* (New York: Whitney Museum of American Art, in association with H. N. Abrams, 1994), pp. 20–27.

8  Quoted in Trapp, p. 2.

9  Quoted in Venn and Weinberg, p. 85.

10  Quoted in Stavitsky, p. 22.

11  Quoted in Barbara Buhler Lynes, *Georgia O'Keeffe: The Catalogue Raisonné: Volume I* (New Haven, CT: Yale University Press, 1999), p. 296.

12  Wanda Corn, *The Great American Thing: Modern Art and National Identity, 1915–1935* (Berkeley: University of California Press, 1999), p. 215.

13  Edmund Wilson, "An Imaginary Conversation: Mr. Paul Rosenfeld and Mr. Matthew Josephson," *New Republic* (April 9, 1924), p. 180.

14  Sidney Janis, *Abstract and Surrealist Art in America* (New York: Reynal & Hitchcock, 1944), p. 50.

15  Quoted in Matthew Baigell, "American Art and National Identity: The 1920s" in Mary Ann Calo, ed., *Critical Issues in American Art: A Book of Readings* (Boulder, CO: Westview Press, 1998), p. 277.

16  "The Cube Root," *Art News*, XLI, no. 1 (February 1943), cited in Diane Kelder, ed., *Stuart Davis* (New York: Praeger, 1971).

17  Journal, quoted in Baigell, "Art in the 1920s," note 15 above.

18  Bogart, p. 142.

19  N. W. Ayer and Son, *Advertising and Selling*, May 14, 1930, p. 94, quoted in Johnston, p. 32.

20  Quoted in Holger Cahill and Alfred Barr, eds., *Art in America in Modern Times* (New York: Reynal and Hitchcock), p. 88.

21  Quoted in Barbara Haskell, *Edward Steichen* (New York: Whitney Museum of American Art, 2000), p. 35.

22  Quoted in Robin Jaffee Frank, *Charles Demuth Poster Portraits, 1923–1929* (New Haven: Yale University Art Gallery, 1994), p. 82.

23  Peet, "The Cartoon Comedy," *The New Republic* (August 14, 1929), p. 341.

24  Donald Crafton, *Before Mickey: The Animated Film, 1898–1928* (Chicago: University of Chicago Press, 1993), p. 348.

25  Todd, p. 178.

26  Theresa Leininger-Miller, *New Negro Artists in Paris: African American Painters and Sculptors in the City of Light, 1922–1934* (New Brunswick, NJ: Rutgers University Press, 2001), p. 143.

27  Motley, "The Negro in Art," quoted in Robinson and Greenhouse, p. 15.

28  Powell, p. 25.

29  Quoted in Lyons, pp. 87–8.

30  Quoted in Venn and Weinberg, p. 178.

31  Deborah Solomon, *Utopia Parkway: The Life and Work of Joseph Cornell* (New York: The Noonday Press, Farrar, Straus and Giroux, 1997), p. 115.

32  Quoted in Jodi Hauptman, *Joseph Cornell: Stargazing in the Cinema* (New Haven, CT: Yale University Press, 1999), p. 55.

33  Quoted in Bonesteel, p. 49.

## CHAPTER 15

1  Malcolm Cowley, *Exile's Return: A Literary Odyssey of the 1920s* (New York: Viking Press, 1951), pp. 289–91.

2  Quoted in Dickran Tashjian, *William Carlos Williams and the American Scene, 1920–1940* (New York: The Whitney Museum of American Art, 1978), p. 212.

3  Van Wyck Brooks, "On Creating a Usable Past," *The Dial*, 64 (April 11, 1918), pp. 337–41. Reproduced in Gordon Hutner, ed., *American Literature, American Culture* (New York: Oxford University Press, 1999), pp. 213–16.

4  "The Emergence of a Past," *New Republic*, 45 (November 25, 1925), p. 19; quoted in Casey Nelson Blake, *Beloved Community: The Cultural Criticism of Randolph Bourne, Van Wyck Brooks, Waldo Frank, and Lewis Mumford* (Chapel Hill: University of North Carolina Press, 1990), pp. 296–7.

5  "American Art," *Soil*, 1 (1917), pp. 3–4, quoted in Lucic, p. 12.

6  Constance Rourke, *Charles Sheeler: Artist in the American Tradition* (New York: Harcourt, Brace and Company, 1938), p. 130.

7  Lucic, p. 31, n. 33.

8  Quoted in Hills, "Painting, 1900–1940," in Hills and Tarbell, *The Figurative Tradition and the Whitney Museum of American Art* (Newark: University of Delaware Press, 1980), pp. 78–9.

9  Anonymous author, *Official Program of the Santa Fe Fiesta* (1922), n.p.

10  Rockwell, quoted in Arthur Leighton Guptill, *Norman Rockwell, Illustrator* (New York: Watson-Guptill Publications, Inc., 1946), p. 33.

11  Lucy Lippard, in Enrique R. Lamadrid, *Nuevo Mexico Profundo: Rituals of an Indo-Hispano Homeland* (Santa Fe, NM: Museum of New Mexico Press; Albuquerque: National Hispanic Cultural Center of New Mexico, 2000), p. 151.

12  "Notes on Pueblo Water-Colours," *The Dial*, 68 (March 1920), pp. 343–5.

13  Salvador, *Cuando Hablan*, p. 104.

14  Maria Vergara Wilson, *santero*, quoted in installation label, Taylor Museum, Colorado Springs.

15  Eric Hobsbawm and Terence Ranger, *The Invention of Tradition* (Cambridge, England: Cambridge University Press, 1994), p. 1.

16  Beverly Stoeltje, "Festival in America," in Richard Dorson, ed., *Handbook of American Folklore* (1983), p. 240.

17  Ann Perry, "Tejano Festivals: Celebrations of History and Community," in Helen Simons and Cathryn Hoyt, eds., *Hispanic Texas: A Historical Guide* (Austin: University of Texas, 1992), pp. 121–9.

18  Bettelheim. See also Kinser.

19  Bettelheim. See p. 26.

20  Quoted in Barbara Haskell, *The American Century: Art and Culture, 1900–1950* (New York: Whitney Museum of American Art in association with W.W. Norton, 1999), p. 188.

21  Powell, *Black Art*, p. 19.

22  Quoted in Lizzetta LeFalle-Collins and Shifra Goldman, *In the Spirit of Resistance: African-American Modernists and the Mexican Muralist School* (New York: American Federation of Arts, 1996), p. 15.

23  Powell, *Homecoming*, p. 123.

24  Cahill, p. 9.

25  As quoted in Stein, p. 15.

26  Maresca and Rico, "Remembering Bill Traylor: an Interview with Charles Shannon," in *Bill Traylor*.

## CHAPTER 16

1  Gertrude Benson, "Art and Social Theories," *Creative Arts*, 12 (March 1933), p. 216.

2  Dewey, pp. 7, 6.

3  Museum of Modern Art, *American Sources of Modern Art* (New York: W. W. Norton and Co. Inc., 1933), p. 17.

4  John D. Morse, "Ben Shahn: An Interview," *Magazine of Art* 37 (April 1944), p. 137, quoted in Weinberg and Venn, p. 144.

5  Quoted in Shapiro, p. 31.

6  Quoted in Weinberg and Venn, p. 104.
7  Quoted in Jeffrey C. Stewart, "(Un)Locke(ing) Jacob Lawrence's Migration Series," in Turner *et al.*, p. 46.
8  Aaron Douglas, "The Negro in American Culture" (1936), in Baigell and Williams, pp. 81, 83.
9  Lyford, pp. 136–51.
10 Louis Guglielmi, "I Hope to Sing Again," *Magazine of Art* 37 (May 1944), p. 174, quoted in Bruce Robertson, ed., *Twentieth-Century American Art: The Ebsworth Collection* (Washington, DC: National Gallery of Art, distributed by Harry N. Abrams, 1999), p. 124.
11 Quoted in McKinzie, p. 72.
12 "Cultural Democracy by Default: The Politics of the New Deal Arts Programmes," *Oxford Art Journal* 30, no. 2 (2007).
13 David Dubinsky, as quoted by Diana Linden, talk February 2000; see also Linden, "Ben Shahn's New Deal Murals: Jewish Identity in the American Scene," in Susan Chevlowe, ed., *Common Man, Mythic Vision: The Paintings of Ben Shahn* (Princeton University Press and the Jewish Museum, New York, 1998), pp. 40–50, 48.
14 Judith Ostrowitz, "Expedience and Classicism at the Chief Shakes Community House," in *Privileging the Past: Reconstructing History in Northwest Coast Art* (Seattle: University of Washington Press, 1999).
15 Avis Berman, "The Unflinching Eye of Berenice Abbott," *Artnews* 80, 1 (January 1981), p. 88.
16 Helen Appleton Read, "Twentieth-Century Decoration," *Vogue* (April 1928), p. 134. Quoted in Davies, p. 14.
17 Quoted by Pilgrim, "Design for the Machine," in Wilson, p. 307.
18 Quoted in Philip Johnson, *Machine Art* (New York: Museum of Modern Art in conjunction with W. W. Norton and Co., Inc., 1934), n.p.
19 Hine, in his foreword to *Men at Work: Photographic Studies of Modern Men and Machines* (New York: MacMillan Co., 1932).
20 Freddy Langer, Introduction to *Lewis Hine, The Empire State Building* (Munich; New York: Prestel, 1998).
21 Alofsin, p. 37.
22 Curtis, p. 230.
23 As quoted in Kenneth Love, dir., "Fallingwater: A Conversation with Edgar Kaufmann, Jr." Video-recording. (Santa Monica, CA: distributed by Direct Cinema Ltd., 1995).
24 Quoted in Curtis, p. 313.
25 Terry A. Cooney, *Balancing Acts: American Thought and Culture in the 1930s* (New York: Twayne Publishers, 1995).

## CHAPTER 17

1  "An interview with Jackson Pollock," in Francis O'Connor, *Jackson Pollock* (New York: Museum of Modern Art, 1967), pp. 79–81.
2  In Alfred Barr, ed., *Painting and Sculpture in the Museum of Modern Art*, N.Y., 1942. See also Dorothy C. Miller and Alfred H. Barr, eds., *American Realists and Magic Realists* (Museum of Modern Art, 1943).
3  Quoted by Peter Balakian, "Arshile Gorky and the Armenian Genocide," *Art in America* (February 1996), pp. 59, 66.
4  In Robert Storr, "A Piece of the Action," in Varnedoe and Karmel, p. 43.
5  Jackson Pollock, "My Painting," *Possibilities*, Vol. 1, winter 1947–8, p. 78, as quoted in Rushing, p. 188.
6  Smith, "The Artist and Nature" (1955), reproduced in Jörn Merkert, ed., *David Smith: Sculpture and Drawings* (Munich, Germany: Prestel-Verlag, 1986), p. 153.
7  James Johnson Sweeney, cited in Guilbaut, pp. 85–6.
8  My thanks to Bett Schumacher for sharing her research on Frankenthaler.
9  Tobey, quoted in Ament, *Iridescent Light*, p. 17.
10 "Men of Art. American Style," quoted in Kenneth Ames, "Afterword: History Pictures Past, Present, and Future," in William S. Ayres, ed., *Picturing History: American Painting, 1770–1930* (New York: Rizzoli in association with Fraunces Tavern Museum, 1993), p. 197.

11 David Sylvester, "Flesh was the Reason," quoting T. S. Eliot, in Prather, p. 16.
12 Varnedoe, *Jasper Johns*, p. 95.
13 Tomkins, p. 52.
14 Quoted in Tomkins, p. 52.
15 Ibid., p. 9.
16 Ibid., p. 96.
17 Galassi, p. 23.
18 Prospectus, *Life Magazine* quoted in Enyeart, p. 65.
19 Quoted in Harris, Mitchell, and Schechter, p. 72.
20 Quoted in *Arbus*, p. 51.
21 Ibid., p. 171.
22 Alfred Auerbach, "What is Modern?' in Barbara Goldstein, *Arts and Architecture: The Entenza Years* (Cambridge, MA: MIT Press, 1990).
23 Sidney Janis, in *Abstract and Surrealist Art in America* (New York: Reynal & Hitchcock, 1944), p. 51.
24 Votolano, p. 75.
25 Quoted in Jackson, p. 109.
26 Henry-Russell Hitchcock and Philip Johnson, *The International Style* (New York and London: W. W. Norton and Co., 1932/1995), p. 27.
27 Curtis, p. 415.
28 Ibid., p. 415.

## CHAPTER 18

1  "The Legacy of Jackson Pollock" (1958), in Kaprow, pp. 7, 9.
2  "Happenings in the New York Scene" (1961), in Kaprow, p. 16.
3  Ibid., p. 17.
4  Ibid., p. 16
5  Max Kozloff, "'Pop' Culture, Metaphysical Disgust, and the New Vulgarians" (1962), in Madoff, p. 32.
6  Alan R. Solomon, "The New Art" (1963), in Madoff, p. 90.
7  John Russell, "Introduction," in *Pop Art Redefined*, ed. John Russell and Suzi Gablik (New York: Praeger, 1969), p. 35.
8  Warhol, pp. 100–1.
9  Andy Warhol, "What Is Pop Art?" (interview with Gene Swenson, 1963), in Madoff, p. 105.
10 Thomas Crow, "Saturday Disasters: Trace and Reference in Early Warhol" (1996), in Michelson, p. 58.
11 Hal Foster, "Death in America" (1996), in Michelson, p. 73.
12 Aline B. Saarinen, "Explosions of Pop Art," *Vogue*, 15 April 1963, p. 136.
13 "The F-111: An Interview with James Rosenquist by G. R. Swenson," *Partisan Review* 32:4 (Fall 1965), p. 597.
14 "Questions to Stella and Judd" (interview by Bruce Glaser, 1966), in Battcock, pp. 157–8.
15 Ibid., p. 157.
16 Donald Judd, "In the Galleries: Kenneth Noland," *Arts Magazine*, 37:10 (September 1963), pp. 53–4.
17 Alain Robbe-Grillet, "Nature, Humanism, Tragedy" (1958), in *For A New Novel: Essays on Fiction* (New York: Grove Press, 1965), p. 57.
18 Krauss, p. 271.
19 Quoted in *Melvin Edwards, Sculpture*, p. 26.
20 Both quotes: "Notes on Sculpture, Part 2" (1966), in Morris, pp. 15–16.
21 Morris, p. 15.
22 "Notes on Sculpture, Part 4: Beyond Objects" (1969), in Morris, p. 54.
23 Carrie Lambert-Beatty, "On Being Moved: Rainer and the Aesthetics of Empathy," in Sachs, p. 47.
24 Sol Lewitt, "Paragraphs on Conceptual Art" (1967) and "Sentences on Conceptual Art" (1969), in Alberro and Stimson, pp. 12, 106, 107.
25 Molesworth, p. 39.
26 Sol Lewitt, "Serial Project #1, 1966," *Aspen* 5/6 (Winter 1967), unpaginated.
27 Jack Burnham, "Alice's Head: Reflections on Conceptual Art" (1970), in Alberro and Stimson, p. 218.
28 Douglas Huebler, in Michael Auping, "Talking with Douglas Huebler," *LA/CA Journal* 15 (July–August 1977), p. 38.

29 Both quotes: Chris Burden, quoted in Ward, pp. 118–19.
30 Chris Burden, "Untitled Statement" (1975), in Stiles and Selz, p. 769.
31 Gronk, quoted in C. Ondine Chavoya, "Internal Exiles: The Interventionist Public and Performance Art of Asco," in Erika Suderburg, ed., *Space, Site, Intervention: Situating Installation Art* (Minneapolis, MN: University of Minnesota Press, 2000), p. 200.
32 Gamboa, p. 79.
33 Vito Acconci, quoted in Ellen Schwartz, "Vito Acconci: 'I Want to Put the Viewer on Shaky Ground,'" *Artnews* 80, 6 (Summer 1981), p. 95.
34 Frazer Ward *et al.*, *Vito Acconci* (New York: Phaidon Press, 2002), p. 92.
35 All four quotes: "Interview: Mierle Laderman Ukeles on Maintenance and Sanitation Art," in Finkelpearl, pp. 302–3.
36 Ibid., p. 313.
37 Ibid., p. 34.
38 Quoted in Thomas Crow, "Survey," in Diserens and Crow, p. 19.
39 Ibid., p. 76.
40 Ibid., p. 92.
41 Ibid., p. 167.

## CHAPTER 19

1  Barthes, p. 146.
2  Sherman, p. 9.
3  Crimp, p. 99.
4  Douglas Crimp, in Wallis, p. 186.
5  Crimp, p. 98.
6  Thomas Lawson, "A Fatal Attraction" (1982), in *Mining for Gold: Selected Writings (1979–1996)*, ed. Lionel Bovier and Fabrice Stroun (Zurich: Ringier Kunstverlag, 2004), p. 69.
7  Bruce Ferguson, "Wordsmith: an Interview with Jenny Holzer," *Art in America*, 74, no. 12 (December 1986), p. 114.
8  Hal Foster, "Subversive Signs," *Art in America*, 70, no. 1 (November 1982), p. 91.
9  Quoted in Helen Hills, "Commonplaces: The Woman in the Street: Text and Image in the Work of Jenny Holzer and Barbara Kruger," in Sara Mills, ed., *Language and Gender: Interdisciplinary Perspectives* (London: Longman, 1995), pp. 246–7.
10 Haim Steinbach, "McDonald's in Moscow and the Shadow of Batman's Cape," *Tema Celeste* (April–June 1990), p. 36.
11 Wodiczko, p. 178.
12 Quoted in Hobbs, p. 33.
13 Ibid., p. 25.
14 http://www.pbs.org/wgbh/pages/frontline/aids/interviews/jones.html
15 Ibid.
16 Maya Lin, quoted in Finkelpearl, p. 123.
17 James Luna, display label, quoted in Linda Weintraub, *Art on the Edge and Over* (Lichfield, CT: Art Insights, 1996), p. 100.
18 Elaine Reichek, *When This You See* (New York: Braziller, 2000), n.p.
19 Quoted in Juliette Bowles, "Extreme Times Call for Extreme Heroes," *International Review of African American Art* 14 (1997), p. 4.
20 Quoted in Hal Foster *et al.*, "The MoMA Expansion: A Conversation with Terence Riley," *October*, 98, p. 20.
21 Quoted in Corrin and Kwon, p. 33.
22 Ibid., p. 39.
23 http://www.ps1.org/cut/Gny/dsuh.html
24 Carol Becker, "The Romance of Nomadism: A Series of Reflections," *Art Journal*, 58 no. 2 (June 1999), p. 29.
25 Gómez-Peña, pp. 255–7.
26 Ibid., p. 49.
27 Ibid., p. 46.
28 Mona Hatoum, interviewed by Janine Antoni, in Laura Steward Heon, ed., *Mona Hatoum: Domestic Disturbance* (North Adams, MA: Mass MOCA, 2001), p. 29.
29 Eduardo Kac, "GFP Bunny," http://www.ekac.org/gfpbunny.html#gfpbunnyanchor
30 Kac, ibid.

# Bibliography

**CHAPTER 1**

Brown, James, "Spiro Art and its Mortuary Contexts," in Elizabeth Benson, ed., *Death and the Afterlife in Pre-Columbian America* (Washington, D.C.: Dumbarton Oaks, 1975).

Brody, J. J., *Anasazi* (New York: Rizzoli International, 1990).

Fagan, Brian, *Ancient North America: The Archaeology of a Continent* (London: Thames and Hudson, 2nd ed., 1995).

Fitzhugh, W.W., and A. Crowell, eds., *Crossroads of Continents: Cultures of Siberia and Alaska* (Washington, D.C.: Smithsonian Institution, 1988).

Gibson, Jon, *The Ancient Mounds of Poverty Point: Place of Rings* (Gainesville, FL: University Press of Florida, 2001).

Kennedy, Roger, *Hidden Cities: The Discovery and Loss of Ancient North American Civilization* (New York: Penguin Books, 1994).

Miller, Angela, "'The Soil of an Unknown America': New World Lost Empires, and the Debate Over Cultural Origins," in *American Art* (Summer/Fall 1994), pp. 9–27.

Moulard, Barbara L., "Form, Function, and Interpretation of Mimbres Ceramic Hemispheric Vessels," in Janet Catherine Berlo and Lee Anne Wilson (eds), *Arts of Africa, Oceania, and the Americas* (Englewood Cliffs, NJ: Prentice Hall, 1993), pp. 259–70.

Townsend, Richard, ed., *Hero, Hawk, and Open Hand: American Indian Art of the Ancient Midwest and South* (New Haven, CT: Yale University Press, 2004).

Williamson, Ray, *Living the Sky: The Cosmos of the American Indian* (Norman, OH: University of Oklahoma Press, 1984).

**CHAPTER 2**

Brandon, William, *New Worlds for Old: Reports from the New World and their Effect on the Development of Social Thought in Europe, 1500–1800* (Athens, OH: Ohio University Press, 1986).

Calloway, Colin, *New Worlds for All: Indians, Europeans, and the Remaking of Early America* (Baltimore, MD: Johns Hopkins University Press, 1997).

Chavez, Thomas, "The Segesser Hide Paintings: History, Discovery, Art," *Great Plains Quarterly* 10(2), 1990.

Chavez, Thomas, "Santa Fe's Own: A History of Fiesta," *El Palacio* 91, no. 1 (Spring 1985), pp. 6–17.

Cronon, William, *Changes in the Land: Indians, Colonists, and the Ecology of New England* (New York: Hill and Wang, 1983).

Doggett, Rachel, *et al.*, *New World of Wonders: European Images of the Americas, 1492–1700* (Seattle, WA: University of Washington Press, 1992).

Edgerton, Samuel Y., *Theaters of Conversion: Religious Architecture and Indian Artisans in Colonial Mexico* (Albuquerque, NM: University of New Mexico Press, 2001).

Garratt, John, and Bruce Robertson, *The Four Indian Kings* (Ottawa: Public Archives of Canada, 1985).

"Gathering Up Again: Fiesta in Santa Fe," Video; Dir. Jeannette DeBouzek, 1992.

Greenblatt, Stephen, *Marvelous Possessions: The Wonder of the New World* (Chicago, IL: University of Chicago Press, 1991).

Grimes, Ronald, *Symbol and Conquest: Public Ritual and Drama in Santa Fe, New Mexico* (Ithaca, NY: Cornell University Press, 1976).

Honour, Hugh, *The European Vision of America* (Cleveland, OH: Cleveland Museum of Art; Kent, OH, distributed by Kent State University Press, 1975).

Honour, Hugh, *The New Golden Land: European Images of America from the Discoveries to the Present Time* (New York: Pantheon Books, 1975).

Hotz, Gottfried, *The Segesser Hide Paintings: Masterpieces Depicting Spanish Colonial New Mexico* (Santa Fe, NM: Museum of New Mexico Press, 1991).

Hulton, Paul, and David Beers Quinn, *The American Drawings of John White, 1577–1590* (London: Trustees of the British Museum, 1964).

Jones, Howard Mumford, *'O Strange New World': American Culture: The Formative Years* (New York, Viking Press, 1964).

Kennedy, Roger, *Mission: The History and Architecture of the Missions of North America* (Boston, MA: Houghton Mifflin, 1993).

Kessell, John L., *Kiva, Cross, and Crown: The Pecos Indians and New Mexico, 1540–1840* (Washington, D.C.: National Park Service, 1979).

Minge, Ward Alan, *Acoma: Pueblo in the Sky*, MOBIUS book.

Nabokov, Peter, *Architecture at Acoma Pueblo: The 1934 Historic American Building Survey* (Santa Fe, NM: Ancient City Press, 1986).

Phillips, Ruth, *Trading Identities: The Souvenir in Native North American Art from the Northeast, 1700–1900* (Seattle, WA: University of Washington Press, 1998).

Rodriguez, Sylvia, *The Matachines Dance* (Albuquerque, NM: University of New Mexico Press, 1996).

Seed, Patricia. *Ceremonies of Possession in Europe's Conquest of the New World, 1492–1640* (Cambridge University Press, 1995).

Sloan, Kim, *A New World: England's First View of America* (London: British Museum Press, 2007).

Sturtevant, William C, "The Sources for European Imagery of Native Americans," in Rachel Doggett, ed., *New World of Wonders: European Images of the Americas, 1492–1700* (Seattle, WA: University of Washington Press, 1992), p. 31.

Todorov, Tzvetan, *The Conquest of America: The Question of the Other* (New York: Harper and Row, 1984).

Treib, Marc, *Sanctuaries of Spanish New Mexico* (Berkeley, CA: University of California Press, 1993).

Usner, Daniel H., Jr., *Indians, Settlers, and Slaves in a Frontier Exchange Economy* (Chapel Hill, NC: University of North Carolina Press, 1992).

White, Richard, *The Middle Ground: Indians, Empires, and Republics in the Great Lakes Region, 1650–1815* (Cambridge, England: Cambridge University Press, 1991).

**CHAPTER 3**

Arana, Luis Rafael, and Albert Manucy, *The Building of Castillo de San Marcos* (San Augustine, FL: Eastern National Park and Monument Association, 1977).

Bennett, Ralph, *Settlements in the Americas* (Newark, NJ: University of Delaware, 1993).

Calvert, Karin, *Children in the House: The Material Culture of Early Childhood, 1600–1900* (Boston, MA: Northeastern University Press, 1992).

Campanella, Thomas J., "Sanctuary in the Wilderness: Deborah Moody and the Town Plan for Colonial Gravesend," *Landscape Journal* vol. 12, no. 2 (Fall, 1993), pp. 107–30.

Cronon, William, *Changes in the Land: Indians, Colonists, and the Ecology of New England* (New York: Hill and Wang, 1983).

Cummings, Abbott Lowell, *The Framed Houses of Massachusetts Bay, 1625–1725* (Cambridge, MA: Harvard University Press, 1979).

Fairbanks, Jonathan L., *New England Begins: The Seventeenth Century*, 3 vols (Boston, MA: Museum of Fine Arts, 1982).

Fales, Martha Gandy, *Early American Silver* (New York: Dutton, 1973).

Goldfield, David et al., *The American Journey* Vol 1 (New York: Prentice Hall, 2007).

Luria, Sarah, *Capital Speculations. Writing and Building Washington, D.C.* (Hanover, NH: University of New England Press, 2006).

Milanich, Jerald T., and Susan Milbrath, *First Encounters: Spanish Explorations in the Caribbean and the United States, 1492–1570* (Gainesville, FL: University of Florida Press, 1989).

Patton, Sharon F., *African–American Art* (New York, Oxford University Press, 1998).

Powell, Richard, *Black Art and Culture in the Twentieth Century* (New York, Thames and Hudson, 1997).

Promey, Sally, "The Return of Religion in the Scholarship of American Art," *Art Bulletin* LXXXV (Sept 2003), pp. 581–603.

Reps, John W., *The Making of Urban America: A History of City Planning in the United States* (Princeton, NJ: Princeton University Press, 1965).

Richter, Paula, *Painted With Thread: The Art of American Embroidery* (Salem, MA: The Peabody Essex Museum, 2001).

Ulrich, Laurel Thatcher, *The Age of Homespun* (New York: Knopf, 2001).

Upton, Dell, *Holy Things and Profane: Anglican Parish Churches in Colonial Virginia* (Cambridge, MA: MIT Press, 1986).

**CHAPTER 4**

Beckerdite, Luke, ed., *American Furniture* (Hanover, NY: University Press of New England, 1999).

Boime, Albert, *The Art of Exclusion: Representing Blacks in the Nineteenth Century* (Washington, D.C. and London: Smithsonian Institution Press, 1990).

Breen, T. H., *The Marketplace of Revolution. How Consumer Politics Shaped American Independence* (Oxford and New York: Oxford University Press, 2004).

Breskin, Isabel, "On the Periphery of a Greater World in John Singleton Copley's Turquerie Portraits," *Winterthur Portfolio* vol. 36 no. 2/3 (Summer/Autumn 2001), pp. 97–123.

Bushman, Richard L., *The Refinement of America. Persons, Houses, Cities* (New York: Knopf, 1992).

Fales, Martha Gandy, *Early American Silver for the Cautious Collector* (New York: Funk and Wagnalls, 1970).

Greenberg, Allan, *George Washington, Architect* (London: Andreas Papadakis Publisher, 1999).

Jackson, Robert H., ed., *New Views of Borderlands History* (Albuquerque, NM: University of New Mexico Press, 1998).

Lovell, Margaretta M., *Art in a Season of Revolution. Painters, Artisans and Patrons in Early America* (Philadelphia, PA: University of Pennsylvania Press, 2005).

Meinig, D. W., ed., *The Interpretation of Ordinary Landscapes* (Oxford: Oxford University Press, 1979).

Nemerov, Alexander, "The Ashes of Germanicus and the Skin of Painting: Sublimation and Money in Benjamin West's Agrippina," *Yale Journal of Criticism* 11 (Spring, 1998), pp. 11–27.

Palumbo, Anne Cannon, "Averting 'Present Commotions': History as Politics in 'Penn's Treaty'," *American Art* 9 (Autumn, 1995), pp. 28–55.

Sellars, Charles Coleman, *Charles Willson Peale*, vol. I *Early Life (1741–1790)* (Philadelphia, PA: The American Philosophical Society, 1947), p. 113, as quoted in E. P. Richardson, *A Short History of Painting in America* (New York: Thomas Y. Crowell Co., 1963), p. 84.

Upton, Dell, "White and Black Landscapes in Eighteenth-Century Virginia," in Robert Blair St. George, ed., *Material Life in America 1600–1860* (Boston, MA: Northeastern University Press, 1988), pp. 357–69.

Ward, Barbara McLean, and Gerald W. R. Ward, *Silver in American Life: Selections from the Mabel Brady Garvan and Other Collections at Yale University* (New Haven, CT: Yale University Art Gallery, 1979).

Whitehill, Walter Muir, Jonathan L. Fairbanks, *et al.*, *Paul Revere's Boston: 1735–1818* exh. cat. (Boston, MA: Museum of Fine Arts, Boston, 1975).

## CHAPTER 5

Berlin, Ira, *Many Thousands Gone: The First Two Centuries of Slavery in North America* (Cambridge, MA, Harvard University Press, 1998).

Bjelajac, David, *Millennial Desire and the Apocalyptic Vision of Washington Allston* (Washington, D.C., Smithsonian Institution Press, 1988).

Buhler, Kathryn C., *American Silver 1655–1825 in the Museum of Fine Arts, Boston* (Greenwich, CT: New York Graphic Society, 1972).

Burns, Sarah, *Painting the Dark Side. Art and the Gothic Imagination in 19th-Century America* (Berkeley, CA: University of California Press, 2004).

Condit, Carl W., *American Building: Materials and Techniques from the First Colonial Settlements to the Present* (Chicago, IL: University of Chicago Press, 1968).

Day, Douglas, *The Academical Village: Thomas Jefferson's University* (Charlottesville, VA: Thomasson Grant, 1982).

Deloria, Philip, *Playing Indian* (New Haven, CT: Yale University Press, 1998).

Ellis, Joseph, *After the Revolution: Profiles of Early American Culture* (New York: Norton, 1979).

Evans, Dorinda, *The Genius of Gilbert Stuart* (Princeton, NJ: Princeton University Press, 1999).

Fliegelman, Jay, *Declaring Independence. Jefferson, Natural Language, and the Culture of Performance.* (Stanford, CA: Stanford University Press, 1993).

Fortune, Brandon Brame with Deborah J. Warner, *Franklin and His Friends. Portraying the Man of Science in Eighteenth-Century America* (Smithsonian National Portrait Gallery, University of Pennsylvania Press, 1999).

Giffen, Jane, "Susanna Rowson and Her Academy," *Antiques* XCVIII (3), Sept. 1970.

Jaffee, David, "One of the Primitive Sort. Portrait Makers of the Rural North, 1760–1860," in *The Countryside in the Age of Capitalist Transformation. Essays in the Social History of Rural America*, ed. Steven Hahn and Jonathan Prude (Chapel Hill, NC: University of North Carolina Press, 1985), pp. 103–38.

Lubin, David, *Picturing a Nation. Art and Social Change in Nineteenth-Century America* (New Haven, CT: Yale University Press, 1994).

Montgomery, Charles F., *American Furniture: The Federal Period in the Henry Francis du Pont Winterthur Museum* (New York: Viking, 1966).

Nemerov, Alexander, *The Body of Raphaelle Peale. Still Life and Selfhood, 1812–1824* (Berkeley, CA: University of California Press, 2001).

Prince, Sue Ann, ed., *Stuffing Birds, Pressing Plants, Shaping Knowledge: Natural History in North America, 1730–1860* (Philadelphia, PA: American Philosophical Society, 2003).

Richardson, Edgar P. et al., *Charles Willson Peale and His World* (New York: H. N. Abrams, 1983).

Ring, Betty, *Girlhood Embroidery* 2 vols (New York: Alfred A. Knopf, 1993).

Roth, Leland M., *A Concise History of American Architecture* (New York: Harper and Row, 1979).

Shaw, Gwendolyn DuBois, *Portraits of a People. Picturing African Americans in the Nineteenth Century* (Seattle, WA: Addison Gallery of Art in association with the University of Washington Press, 2006).

Staiti, Paul, *Samuel F. B. Morse* (New York: Cambridge University Press, 1989).

Stein, Roger, "Charles Willson Peale's Expressive Design," pp. 204–8.

Steinberg, David, "Educating for Distinction? Art, Hierarchy, and Charles Willson Peale's Staircase Group," in Patricia Johnston, ed., *Seeing High & Low: Representing Social Conflict in American Visual Culture* (Berkeley, CA: University of California Press, 2006), pp. 25–41.

Stuckey, Sterling, *Going Through the Storm: the Influence of African American Art in History* (Oxford: Oxford University Press, 1994).

Upton, Dell, *Architecture in the United States* (Oxford: Oxford University Press, 1998).

Waldstreicher, David, *In the Midst of Perpetual Fetes. The Making of American Nationalism, 1776–1820* (Chapel Hill, CA: University of North Carolina Press, 1997).

Wallace, Marcia, "Washington Allston's *Moonlit Landscape*," in *The Italian Presence in American Art 1760–1860*, ed. Irma B. Jaffe (New York: Fordham University Press, 1989), pp. 82–94.

Whiffen, Marcus, and Frederick Koeper, *American Architecture 1607–1976* (Cambridge, MA: The MIT Press, 1981), 2 vols.

## CHAPTER 6

Ames, Kenneth L., ed., *Death in the Dining Room and Other Tales of Victorian Culture* (Philadelphia, PA: Temple University Press, 1992).

Beecher, Catherine E., and Harriet Beecher Stowe, *The American Woman's Home* (1869; Library of Victorian Culture reprint 1979).

Bellion, Wendy. "Heads of State: Profiles and Politics in Jeffersonian America," in Lisa Gitelman and Geoffrey B. Pingree, eds., *New Media, 1740–1915* (Cambridge, MA: MIT Press, 2003), pp. 31–59.

Berlo, Janet C., and Patricia Cox Crews, *Wild By Design: Two Hundred Years of Innovation and Artistry in American Quilts* (Seattle, WA: University of Washington Press, 2003).

Brydon, Sherry, "Ingenuity in Art: the Early 19th Century Works of David and Dennis Cusick," *American Indian Art* 20 (2) (Spring 1995), pp. 60–69.

Deloria, Philip, *Playing Indian* (New Haven, CT: Yale University Press, 1998).

Garrett, Elizabeth Donaghy, *At Home: The American Family, 1750–1870* (New York: Harry N. Abrams, 1990).

Hedges, Elaine, Pat Ferrero, and Julie Silber, *Hearts and Hands: Women, Quilts and American Society* (Nashville, TN: Routledge Hills Press, 1996, first published 1987).

Fryd, Vivian Green, "Two Sculptures for the Capitol: Horatio Greenough's *Rescue* and Luigi Persico's *Discovery of America*," in Mary Ann Calo, ed., *Critical Issues in American Art. A Book of Readings* (Boulder, CO: Westview Press, 1998).

Glassie, Henry, *The Spirit of Folk Art*, New York: Harry Abrams, 1989.

Gerdts, William H. *American Neo-Classic Sculpture. The Marble Resurrection* (New York: Viking, 1973), p. 17.

Goldsborough, Jennifer, "An Album of Baltimore Album Quilt Studies," *Uncoverings* 14: 73–110. 1994.

Johns, Elizabeth, *American Genre Painting: The Politics of Everyday Life* (New Haven, CT: Yale University Press, 1991).

Kasson, Joy. *Marble Queens and Captives. Women in Nineteenth Century American Sculpture* (New Haven, CT: Yale University Press, 1990).

Lott, Eric. *Love and Theft: Blackface Minstrelsy and the American Working Class* (New York: Oxford University Press, 1993).

Mainardi, Patricia, "Quilts: the Great American Art," *Feminist Art Journal* 2, 1 (1973).

Mayhew, Edgar de N., and Minor Myers, Jr., *A Documentary History of American Interiors from the Colonial Era to 1915* (New York: Charles Scribner's & Sons, 1980).

Promey, Sally, *Spiritual Spectacles: Vision and Image in Mid-Nineteenth Century Shakerism* (Bloomington, IN: Indiana University Press, 1993).

Sessions, Ralph, *The Shipcarvers' Art: Figure Carving in Nineteenth Century America* (Princeton, NJ: Princeton University Press, 2005).

Shaw, Gwendolyn DuBois, "'Moses Williams, Cutter of Profiles': Silhouettes and African American Identity in the Early Republic," *Proceedings of the American Philosophical Society* 149, no. 1 (2005): 22–39.

Upton, Dell, *Architecture in the United States* (Oxford: Oxford University Press, 1998).

"What is American Folk Art? A Symposium," *Antiques*, May, 1950, pp. 14–21.

## CHAPTER 7

Catlin, George, *Letters and Notes on the Manners, Customs, and Condition of North American Indians*, vol. 2 (London, 1841).

Cawelti, John, "The Frontier and the Native American," in Joshua Taylor, *America as Art* (Washington, D.C.: Smithsonian Institution Press, 1976, for the National Collection of Fine Arts), pp. 133–183.

Dippie, Brian W., *Catlin and His Contemporaries: The Politics of Patronage* (Lincoln, NB: University of Nebraska Press, 1990).

Harris, Neil, *Building Lives: Constructing Rites and Passages* (New Haven, CT: Yale University Press, 1999).

Klein, Cecelia, ed., "Depictions of the Dispossessed," special issue of *Art Journal* 49, no. 2 (Summer 1990).

Kropp, Phoebe S., "'There is a little sermon in that': Constructing the Native Southwest at the San Diego Panama–California Exposition of 1915," in Marta Weigle and Barbara Babcock, eds., *The Great Southwest of the Fred Harvey Company and the Santa Fe Railway* (Phoenix, AZ: The Heard Museum, 1996).

Maurer, Evan, "Presenting the American Indian: From Europe to America," in Richard West, ed., *The Changing Presentation of the American Indian: Museums and Native Cultures* (Washington, D.C.: The National Museum of the American Indian in association with the University of Washington Press, 2000), p. 18.

Mitchell, Lee Clark, *Witnesses to a Vanishing America: The Nineteenth-Century Response* (Princeton, NJ: Princeton University Press, 1981).

Slotkin, Richard, *Regeneration Through Violence: The Mythology of the American Frontier, 1600–1860* (Middletown, CT: Wesleyan University Press, 1973).

Tyler, Ron, and Peter Hassrick, eds., *American Frontier Life: Early Western Painting and Prints* (Amon Carter Museum, New York: Abbeville Press, 1987).

Weddle, Robert S., "Cross and Crown: The Spanish Missions in Texas," in Helen Simons and Cathryn A. Hoyt, eds., *Hispanic Texas: A Historical Guide* (Austin, TX: University of Texas Press, 1992), pp. 25–35.

### Plains

Grinnell, George Bird, *The Cheyenne Indians* (Lincoln, NB: University of Nebraska Press, 1972), reprint of 1923.

McLaughlin, Castle, "Objects and Identities: Another Look at Lewis and Clark's Side—Fold Dresses," *American Indian Art* 29 (1), Winter 2003.

Stern, Theodore, "Columbia River Trade Network," *Handbook of North American Indians* (Washington, D.C.: Smithsonian Institution, 1998), Vol. 12, pp. 641–52.

### Alaska

Dauenhauer, Nora Marks, "Tlingit At.óow: Traditions and Concepts," in Steve Brown, ed., *The Spirit Within* (Seattle, WA: Seattle Art Museum, 1995), pp. 21–9.

Gibson, James, *Otter Skins, Boston Ships, and China Goods* (Montreal: McGill-Queens University Press, 1992).

Holm, Bill, *Northwest Coast Art: An Analysis of Form* (Seattle, WA: University of Washington Press, 1967).

Jonaitis, Aldona, *Art of the Northern Tlingit* (Seattle, WA: University of Washington Press, 1986).

Ostrowitz, Judith, "Expedience and Classicism at the Chief Shakes Community House," Chapter One of *Privileging the Past: Reconstructing History in Northwest Coast Art* (Seattle, WA: University of Washington Press, 1999).

Ray, Dorothy Jean, "Happy Jack and his Artistry," *American Indian Art* 15 (1), 1989.

## CHAPTER 8

Adamson, Jeremy, *Niagara. Two Centuries of Changing Attitudes, 1697–1901* (Washington, D.C.: Corcoran, 1985).

Bedell, Rebecca, *The Anatomy of Nature. Geology and American Landscape Painting, 1825–1875* (Princeton, NJ: Princeton University Press, 2001).

Buell, Lawrence, *New England Literary Culture from Revolution through Renaissance* (Cambridge, England: Cambridge University Press, 1986).

Buick, Kirsten P., "The Ideal Works of Edmonia Lewis: Invoking and Inverting Autobiography," in Marianne Doezema and Elizabeth Milroy, *Reading American Art* (New Haven, CT: Yale University Press, 1998), pp 190–207.

Condit, Carl W., *American Building: Materials and Techniques from the First Colonial Settlements to the Present* (Chicago, IL: University of Chicago Press, 1968).

Davis, John H., "Eastman Johnson's *Negro Life at the South* and Urban Slavery in Washington, D.C.," *Art Bulletin* 80 (Mar 1998): 67–92.

Downing, A. J., *The Architecture of Country Houses* (1850; London: Dover, 1969, reprint).

Foner, Eric, *Politics and Ideology in the Age of the Civil War* (New York: Oxford University Press, 1980).

Greenough, Horatio, *Form and Function: Remarks on Art, Design and Architecture*, ed. Harold A. Small (Berkeley, CA: University of California Press, 1969).

Halttunen, Karen, *Confidence Men and Painted Women. A Study of Middle-Class Culture in America, 1830–1870* (New Haven, CT: Yale University Press, 1982).

Kelly, Franklin, *et al.*, *Frederic Edwin Church* (Washington, D.C.: National Gallery of Art, 1989).

Linden-Ward, Blanche, *Silent City on a Hill: Landscapes of Memory and Boston's Mount Auburn Cemetery* (Columbus, OH: Ohio University Press, 1989).

Marx, Leo, *The Machine in the Garden. Technology and the Pastoral Ideal in America* (New York: Oxford University Press, 1964).

McKinsey, Elizabeth, *Niagara Falls. Icon of the American Sublime* (Cambridge, England: Cambridge University Press, 1985).

Miller, Angela, *Empire of the Eye. Landscape Representation and American Cultural Politics, 1825–1875* (Ithaca, NY: Cornell University Press, 1993).

Myers, Kenneth John, *The Catskills. Painters, Writers, and Tourists in the Mountains 1820–1895* (Hanover, NH: University Press of New England, 1987).

Myers, Kenneth John, "On the Cultural Construction of Landscape Experience: Contact to 1830," in *American Iconology*, ed. David C. Miller (New Haven, CT: Yale University Press, 1993), pp. 58–79.

Novak, Barbara, *Nature and Culture. American Landscape and Painting, 1825–1875*, rev. ed. with a new preface (New York: Oxford University Press, 1995).

Nygren, Edward J., *et al.*, *Views and Visions. American Landscape Before 1830* (Washington, D.C.: Corcoran Gallery of Art, 1986).

Otto, Linda, *Elizabeth Roseberry Mitchell's Graveyard Quilt* (Dayton, OH: Halstead and Meadows, 1995).

St. George, Robert Blair, *Material Life in America, 1600–1860* (Boston, MA: Northeastern University Press, 1987).

Trachtenberg, Alan, *Reading American Photographs. Images as History from Mathew Brady to Walker Evans* (New York: Hill and Wang, 1989).

Truettner, William H., and Alan Wallach, eds., *Thomas Cole. Landscape into History* (New Haven and Washington, D.C.: Yale University Press and Smithsonian Institution, 1994).

Upton, Dell, *Architecture in the United States* (Oxford, England: Oxford University Press, 1998).

Wilmerding, John, ed., *American Light: The Luminist Moment, 1850–1875, Paintings, Drawings, Photographs* (Washington, D.C.: National Gallery of Art, 1980).

Wilton, Andrew, and T. J. Barringer, *American Sublime. Landscape Painting in the United States, 1820–1880* (London: Tate Publishing, 2002).

## CHAPTER 9

Batkin, Jonathan, *Pottery of the Pueblos of New Mexico 1740–1940* (Colorado Springs, CO: the Taylor Museum, 1987).

Berlo, Janet C., *Plains Indian Drawings 1865–1935: Pages from a Visual History* (New York: Abrams and the American Federation of Arts, 1996).

Berlo, Janet C., *Spirit Beings and Sun Dancers: Black Hawk's Vision of the Lakota World* (New York: George Braziller Art Books, 2000).

Boime, Albert, "Henry Ossawa Tanner's Subversion of Genre," *Art Bulletin* 75, no. 3 (September 1993), pp. 415–42.

Fry, Gladys-Marie, *Stitched from the Soul* (New York: Dutton Studio Books, 1990).

Green, Jesse, ed., *Zuni: Selected Writings of Frank Hamilton Cushing* (Lincoln, NB: University of Nebraska Press, 1979).

Harris, Michael D., *Colored Pictures: Race and Visual Representation* (Chapel Hill, NC: University of North Carolina Press, 2003).

Jurgena, Melissa Stewart and Patricia Crews, "The Reconciliation Quilt: Lucinda Ward Honstain's Pictorial Diary of an American Era," in *Folk Art Magazine*, Vol. 28 (3), 2003, pp. 38–47.

Kasson, Joy S., *Buffalo Bill's Wild West: Celebrity, Memory, and Popular History* (New York: Hill and Wang, 2000).

Keller, Morton, *The Art and Politics of Thomas Nast* (New York: Oxford University Press, 1968).

Kent, Kate Peck, *Navajo Weaving: Three Centuries of Change* (Santa Fe, NM: School of American Research Press, 1985).

LeBeau, Bryan F., *Currier & Ives: America Imagined* (Washington, D.C., and London: Smithsonian Institution Press, 2001).

Mazow, Leo G., and Sarah Burns, John Davis, Michael D. Harris, Joyce Henri Robinson, *Picturing the Banjo* (University Park, PA: Pennsylvania State University Press, 2005).

McElroy, Guy C., *Facing History: The Black Image in American Art, 1710–1940* (San Francisco, CA: Bedford Arts; Washington, D.C.: Corcoran Gallery of Art, 1990).

Orvell, Miles, *The Real Thing: Imitation and Authenticity in American Culture, 1880–1940* (Chapel Hill, NC: University of North Carolina Press, 1989).

Pearlstone, Zena, *Katsina: Commodified and Appropriated Images of Hopi Supernaturals* (Los Angeles, CA: UCLA Fowler Museum of Cultural History, 2001).

Perry, Regenia, *Harriet Powers's Bible Quilts* (New York: Rizzoli Art Series, 1994).

Prown, Jules, *et al. Discovered Lands, Invented Pasts: Transforming Visions of the American West* (New Haven, CT: Yale University Press; Yale University Art Gallery, 1992).

Savage, Kirk, *Standing Soldiers, Kneeling Slaves: Race, War, and Monument in Nineteenth-Century America* (Princeton, NJ: Princeton University Press, 1997).

Snyder, Joel, *American Frontiers: The Photographs of Timothy H. O'Sullivan, 1867–1874* (Millerton, NY: Aperture, 1981).

Spence, Mark David, *Dispossessing the Wilderness: Indian Removal and the Making of the National Parks* (New York: Oxford University Press, 1999).

Trachtenberg, Alan, *The Incorporation of America: Culture and Society in the Gilded Age* (New York: Hill and Wang, 1982).

Truettner, William, ed., *The West as America: Reinterpreting Images of the Frontier, 1820–1920* (Washington, D.C.: Published for the National Museum of American Art by the Smithsonian Institution Press, 1991).

Upton, Dell, *Architecture in the United States* (Oxford; New York: Oxford University Press, 1998).

Wheat, Joe Ben, *Blanket Weaving in the Southwest*, ed. Ann Lane Hedlund (Tucson, AZ: University of Arizona Press, 2003).

Wroth, William, *Images of Penance, Images of Mercy: Southwestern Santos in the Late Nineteenth Century* (Colorado Springs, CO: Taylor Museum of the Colorado Springs Fine Arts Center, 1991).

Wroth, William, *Revivals! Diverse Traditions, 1920–1945* (New York: Harry N. Abrams, in association with the American Craft Museum, 1994).

Wyatt, Victoria, *Images from the Inside Passage: An Alaskan Portrait by Winter and Pond* (Seattle, WA: University of Washington Press, 1989).

## CHAPTER 10

Adams, Henry, *et al.*, *John La Farge: Essays* (New York : Abbeville Press, 1987).

Adler, Kathleen, *et al.*, *Americans in Paris, 1860–1900* (London: National Gallery, 2006).

Banta, Martha, *Imaging American Women: Idea and Ideals in Cultural History* (New York: Columbia University Press, 1987).

Bluestone, Daniel, "'A City Under One Roof': Chicago Skyscrapers, 1880–1895," in Keith L. Eggener, ed., *American Architectural History: A Contemporary Reader* (London and New York: Routledge, 2004).

Boris, Eileen, *Art and Labor: Ruskin, Morris, and the Craftsman Ideal in America* (Philadelphia, PA: Temple University Press, 1986).

Bowman, Leslie Greene, *American Arts and Crafts: Virtue in Design* (Los Angeles, CA: Los Angeles County Museum of Art, 1990).

Burke, Doreen Bolger, *et al.*, *In Pursuit of Beauty: Americans and the Aesthetic Movement* (New York: Metropolitan Museum of Art/Rizzoli, 1986).

Cohodas, Marvin, *Basket Weavers for the California Curio Trade* (Tucson, AZ: University of Arizona Press, 1997).

Edwards, Holly, *Noble Dreams, Wicked Pleasures: Orientalism in America, 1870–1930* (Princeton, NJ: Princeton University Press, 2000).

Fischer, Diane P., ed., *Paris 1900: The "American School" at the Universal Exposition* (Newark, NJ: Rutgers, 2001).

Frelinghuysen, Alice Cooney, *Louis Comfort Tiffany at the Metropolitan Museum of Art* (New York: The Metropolitan Museum of Art; distributed by Harry N. Abrams, 1999).

Hiesinger, Ulrich W., *Impressionism in America: The Ten American Painters* (Munich: Prestel; New York; distributed in the USA and Canada by Te Neues, 1991).

Hounshell, David A., *From the American System to Mass Production, 1800–1932: The Development of Manufacturing Technology in the United States* (Baltimore, MD: Johns Hopkins University Press, 1984).

Hults, Linda C., *The Print in the Western World: An Introductory History* (Madison, WI: University of Wisconsin Press, 1996).

Kaplan, Wendy, with contributions by Eileen Boris, "The Art that Is Life": The Arts & Crafts Movement in America, 1875–1920* (Boston, MA: Museum of Fine Arts, in conjunction with Little, Brown, 1987).

Kaplan, Wendy, *et al.*, *The Arts and Crafts Movement in Europe and America: Design for the Modern World* (London: Thames & Hudson, in association with the Los Angeles County Museum of Art, 2004).

Kostof, Spiro, ed., *The Architect: Chapters in the History of a Profession* (Berkeley, CA: University of California, 1977), pp. 209–37.

Levine, Lawrence, *Highbrow/Lowbrow: The Emergence of Cultural Hierarchy in America* (Cambridge, MA: Harvard University Press, 1988).

Loring, John, *Tiffany's Twentieth Century* (New York: Abrams, 1997).

McMorris, Penny, *Crazy Quilts* (New York: E. P. Dutton, Inc., 1984).

Menand, Louis, *The Metaphysical Club* (New York: Farrar, Straus, and Giroux, 2001).

Mitchell, Timothy, "The World as Exhibition," *Comparative Studies in Society and History*, 31 (1989); pp. 217–36.

Mosby, Dewey, *Henry Ossawa Tanner* (New York: Rizzoli, in association with the Philadelphia Museum of Art, 1991).

O'Gorman, James F., *Living Architecture: A Biography of H. H. Richardson* (New York: Simon and Schuster, 1997).

O'Gorman, James F., *Three American Architects: Richardson, Sullivan, and Wright, 1865–1915* (Chicago, IL: University of Chicago Press, 1991).

Pyne, Kathleen A., "John Twachtman and the Therapeutic Landscape," in Lisa N. Peters *et al.*, *John Twachtman: Connecticut Landscapes* (New York: Harry N. Abrams, in conjunction with the National Gallery of Art, Washington, D.C., 1989), pp. 49–65.

Rosenbaum, Julia, *Visions of Belonging: New England Art and the Making of American Identity* (Ithaca, NY: Cornell University Press, 2006).

Simpson, Marc, with Richard Ormond, H. Barbara Weinberg, *Uncanny Spectacle: The Public Career of the Young John Singer Sargent* (New Haven, CT: Yale University Press, 1997).

Siry, Joseph, *Carson Pirie Scott: Louis Sullivan and the Chicago Department Store* (Chicago, IL: University of Chicago Press, 1988).

Twombly, Robert, *Louis Sullivan: His Life and Work* (New York: Viking, 1986).

Van Zanten, David, *Sullivan's City: The Meaning of Ornament for Louis Sullivan* (New York: W. W. Norton, 2000).

Weinberg, H. Barbara, Doreen Bolger, and David Park Curry, *American Impressionism and Realism: The Painting of Modern Life, 1885–1915* (New York: Metropolitan Museum of Art, distributed by H.N. Abrams, 1994).

Woods, Mary, *From Craft to Profession: The Practice of Architecture in Nineteenth-Century America* (Berkeley, CA: University of California Press, 1999).

Zapata, Janet, "The Rediscovery of Paulding Farnham, Tiffany's Designer Extraordinaire," *The Magazine Antiques*, 139, no. 4 (April 1991).

## CHAPTER 11

Adams, Henry, "William James, Henry James, John La Farge, and the Foundations of Radical Empiricism," *American Art Journal* (Winter 1985).

Barter, Judith A., with Erica E. Hirshler *et al.*, *Mary Cassatt, Modern Woman* (New York: H.N. Abrams, 1998).

Burns, Sarah, *Inventing the Modern Artist: Art and Culture in Gilded Age America* (New Haven, CT, and London: Yale University Press, 1996).

Burns, Sarah, *Painting the Dark Side: Art and the Gothic Imagination in Nineteenth-Century America* (Berkeley, CA: University of California Press, 2004).

Cikovsky, Nicolai, and Franklin Kelly *et al.*, *Winslow Homer* (Washington, D.C.: National Gallery of Art; New Haven: Yale University Press, 1995).

Crary, Jonathan, *Techniques of the Observer: On Vision and Modernity in the Nineteenth Century* (Cambridge, MA: MIT Press, 1990).

Davis, Keith, *A Century of Photography: From Dry-Plate to Digital. The Hallmark Photographic Collection* (Hallmark Cards, Inc. in association with Harry N. Abrams, Inc., 1995).

Dryfout, John, and Henry J. Duffy, *Augustus Saint-Gaudens, American Sculptor of the Gilded Age* (Washington, D.C.: Trust for Museum Exhibitions in cooperation with the Saint-Gaudens National Historic Site, Cornish, New Hampshire, 2003).

Harris, Neil, *Cultural Excursions: Marketing Appetites and Cultural Tastes in Modern America* (Chicago, IL: University of Chicago Press, 1990).

Hinsley, Curtis, "The World as Marketplace: Commodification of the Exotic at the World's Columbian Exposition, Chicago, 1893," in Ivan Karp and Steven D. Lavine, *Exhibiting Cultures: The Poetics and Politics of Museum Display* (Washington, D.C.: Smithsonian Institution Press, 1991), pp. 344–65.

Kirstein, Lincoln, *Memorial to a Marriage: An Album on the Saint-Gaudens Memorial in Rock Creek Cemetery* (New York: Metropolitan Museum of Art; distributed by Harry N. Abrams, 1989).

Lears, T. J. Jackson, *No Place of Grace: Antimodernism and the Transformation of American Culture, 1880–1920* (New York: Pantheon, 1981).

Leja, Michael, *Looking Askance: Skepticism and American Art from Eakins to Duchamp* (Berkeley, CA: University of California Press, 2004).

Ott, John, "Iron Horses: Leland Stanford, Eadweard Muybridge, and the Industrialized Eye," *Oxford Art Journal* 28:3 (Fall 2005), pp. 407–28.

Prodger, Phillip, *Time Stands Still: Muybridge and the Instantaneous Photography Movement* (Cantor Center for the Visual Arts, Stanford University, in association with Oxford University Press, 2003).

Pyne, Kathleen A., *Art and the Higher Life: Painting and Evolutionary Thought in Late Nineteenth-Century America* (Austin, TX: University of Texas Press, 1996).

Robertson, Bruce, *Reckoning with Winslow Homer: His Late Paintings and Their Influence* (Bloomington, IN: Indiana University Press, 1990).

Rutkoff, Peter M., and William B. Scott, "Before the Modern: The New York Renaissance, 1876–95," *Prospects* 25 (2000).

Rydell, Robert, *All the World's a Fair: Visions of Empire at American International Expositions, 1876–1916* (Chicago, IL: University of Chicago Press, 1984).

Tappert, Tara Leigh, *Cecilia Beaux and the Art of Portraiture* (Washington, D.C.: published for the National Portrait Gallery by the Smithsonian Institution Press, 1995).

Wilson, Richard Guy, *et al.*, *The American Renaissance, 1876–1917* (Brooklyn, N.Y.: Brooklyn Museum, in association with Pantheon Books, 1979).

## CHAPTER 12

Abrahams, Edward: *The Lyrical Left: Randolph Bourne, Alfred Stieglitz, and the Origins of Cultural Radicalism in America* (Charlottesville, VA: University of Virginia Press, 1986).

Balken, Debrah Bricker, *Arthur Dove: A Retrospective* (Cambridge, MA: MIT Press, in association with the Phillips Collection, Washington, D.C., 1997).

Brennan, Marcia, *Painting Gender, Constructing Theory: The Alfred Stieglitz Circle and American Formalist Aesthetics* (Cambridge, MA, and London: MIT Press, 2001).

Coco, Janice, "Re-viewing John Sloan's Images of Women," *Oxford Art Journal*, 21, no. 2 (1998), pp. 79–98.

Cohn, Sherrye, *Arthur Dove: Nature as Symbol* (Ann Arbor, MI: University of Michigan Research Press, 1985).

Corn, Wanda M., *The Great American Thing: Modern Art and National Identity, 1915–1935* (Berkeley, CA, and London: University of California Press, 1999).

Cowart, Jack, *et al.*, *Georgia O'Keeffe, Art and Letters* (Washington, D.C.: National Gallery of Art; Boston: New York Graphic Society, 1987).

Enyeart, James, *et al.*, *Decade by Decade: Twentieth-Century American Photography from the Collection of the Center for Creative Photography* (Boston, MA: Little, Brown; Tucson, AZ: Center for Creative Photography, University of Arizona, 1989).

Frank, Robin Jaffee, *Charles Demuth: Poster Portraits, 1923–1929* (New Haven, CT: Yale University Art Gallery, 1994).

Greenough, Sarah, and Juan Hamilton, *Alfred Stieglitz: Photographs and Writings* (Washington, D.C.: National Gallery of Art, 1983).

Hambourg, Maria Morris, *Paul Strand: Circa 1916* (New York: The Metropolitan Museum of Art; distributed by Abrams, 1998).

Henri, Robert, *The Art Spirit: Notes, Articles, Fragments of Letters and Talks to Students* (New York: Harper & Row, 1984).

Homer, William Innes, *Alfred Stieglitz and the American Avant-Garde* (Boston, MA: New York Graphic Society, 1977/79).

Johnston, Patricia A., *Real Fantasies: Edward Steichen's Advertising Photography* (Berkeley, CA: University of California Press, 1997).

Lucic, Karen, *Charles Sheeler in Doylestown: American Modernism and the Pennsylvania Tradition* (Allentown, PA: Allentown Art Museum; distributed by the University of Washington Press, 1997).

Tomkins, Calvin, "Look to the Things Around You: Profile of Paul Strand," *New Yorker*, September 16, 1974.

Trachtenberg, Alan, *Reading American Photographs: Images as History, Mathew Brady to Walker Evans* (New York: Hill and Wang, 1989).

Zurier, Rebecca, *et al.*, *Art for the Masses: A Radical Magazine and Its Graphics, 1911–1917* (Philadelphia, PA: Temple University Press, 1988).

Zurier, Rebecca, *Picturing the City: Urban Vision and the Ashcan School* (Berkeley, CA: University of California Press, 2006).

Zurier, Rebecca, Robert Snyder, and Virginia Mecklenberg, *Metropolitan Lives: The Ashcan Artists and Their New York* (Washington, D.C.: National Museum of American Art; New York: Norton, 1995).

## CHAPTER 13

Alofsin, Anthony, *Frank Lloyd Wright: The Lost Years, 1910–1922* (Chicago, IL: University of Chicago Press, 1993).

Alofsin, Anthony, ed., *Frank Lloyd Wright: Europe and Beyond* (Berkeley, CA: University of California Press, 1999).

Bacon, Mardges, *Le Corbusier in America: Travels in the Land of the Timid* (Cambridge, MA: MIT Press, 2001).

Balken, Debra Bricker, *Debating American Modernism: Stieglitz, Duchamp, and the New York Avant-Garde*, with an essay by Jay Bochner (New York: American Federation of Arts in association with D.A.P./Distributed Art Publishers, Inc., 2003).

Banham, Reyner, *A Concrete Atlantis: U.S. Industrial Building and European Modern Architecture, 1900–1925* (Cambridge, MA: MIT Press, 1986).

Brown, Milton, *American Painting, from the Armory Show to the Depression* (Princeton, NJ: Princeton University Press, 1955).

Bucci, Federico, *Albert Kahn: Architect of Ford* (New York: Princeton Architectural Press, 1993).

Camfield, William, "Marcel Duchamp's *Fountain*: Its History and Aesthetics in the Context of 1917," in Rudolf Kuenzli and Francis Naumann, eds., *Marcel Duchamp: Artist of the Century* (Cambridge, MA: MIT Press, 1989), pp. 64–94.

Cassidy, Donna, *Marsden Hartley: Race, Region, and Nation* (Durham, NH: University of New Hampshire Press, 2005).

Chadwick, Whitney, with an essay by Joe Lucchesi, *Amazons in the Drawing Room: The Art of Romaine Brooks* (Chesterfield, MA: Chameleon Books; Berkeley, CA: University of California Press, 2000).

Cohen, Jean-Louis, *Scenes of the World to Come: European Architecture and the American Challenge, 1893–1960* (Montreal: Canadian Centre for Architecture, 1995).

Connor, Janis, and Joel Rosenkranz, *Rediscoveries in American Sculpture: Studio Works, 1893–1939* (Austin, TX: University of Texas Press, 1989).

Corn, Wanda, *The Great American Thing: Modern Art and National Identity, 1915–1935* (Berkeley, CA, and London: University of California Press, 1999).

Frampton, Kenneth, *Modern Architecture: A Critical History* (New York/ London: Thames & Hudson, 1992).

Giedion, Sigfried, *Space, Time, and Architecture: The Growth of a New Tradition* (Cambridge, MA: Harvard University Press, 1954).

Gross, Jennifer, *The Société Anonyme: Modernism for America* (New Haven, CT: Yale University Art Gallery, 2006).

Haskell, Barbara, *The American Century: Art & Culture, 1900–1950* (New York: Whitney Museum of American Art in association with W. W. Norton, 1999).

Haskell, Barbara, *Elie Nadelman: Sculptor of Modern Life* (New York: Whitney Museum of American Art, 2003).

Kostof, Spiro, *America by Design* (New York: Oxford University Press, 1987).

Naumann, Francis, *New York Dada, 1915–1923* (New York: Abrams, 1994).

Oldenziel, Ruth, *Making Technology Masculine: Men, Women and Modern Machines in America, 1870–1945* (Amsterdam: Amsterdam University Press, 1999).

Prather, Marla, *et al.*, *Alexander Calder 1898–1976* (Washington, D.C.: National Gallery of Art; New Haven, CT: Yale University Press, 1998).

Rather, Susan, *Archaism, Modernism, and the Art of Paul Manship* (Austin, TX: University of Texas Press, 1993).

Schapiro, Meyer, "Introduction of Modern Art in America," in *Modern Art: 19th & 20th Centuries* (London: Chatto & Windus, 1978).

Tarbell, Roberta *et al.*, *Vanguard American Sculpture, 1913–1939* (New Brunswick, NJ: Rutgers University, 1979).

Tomkins, Calvin, *Living Well Is the Best Revenge* (New York: Viking Press, 1971).

Turner, Elizabeth Hutton, *Americans in Paris (1921–1931): Man Ray, Gerald Murphy, Stuart Davis, Alexander Calder*, with essays by Elizabeth Garrity Ellis, Guy Davenport (Washington, D.C.: Counterpoint, 1996).

Watson, Steven, *Strange Bedfellows: The First American Avant-Garde* (New York: Abbeville Press, 1991).

Weinberg, Jonathan, *Speaking for Vice: Homosexuality in the Art of Charles Demuth, Marsden Hartley, and the First American Avante-Garde* (New Haven, CT: Yale University Press, 1993).

## CHAPTER 14

Bogart, Michele Helene, *Artists, Advertising, and the Borders of Art* (Chicago, IL: University of Chicago Press, 1995).

Bonesteel, Michael, *Henry Darger, Art and Selected Writings* (New York: Rizzoli Press, 2000).

Curtis, William, J. R., *Modern Architecture Since 1900* (London: Phaidon, 1997).

Davies, Karen, *At Home in Manhattan: Modern Decorative Arts, 1925 to the Depression* (New Haven, CT: Yale University Art Gallery, 1983).

Hambourg, Maria Morris, *The New Vision: Photography Between the World Wars: Ford Motor Company Collection at the Metropolitan Museum of Art* (New York: Metropolitan Museum of Art, distributed by Harry N. Abrams, 1989).

Hambourg, Maria Morris, *Paul Strand, Circa 1916* (New York: Metropolitan Museum of Art, distributed by Harry N. Abrams, 1998).

Haskell, Barbara, *Joseph Stella* (New York: Whitney Museum of American Art: distributed by H.N. Abrams, 1994).

Hauptman, Jodi, *Joseph Cornell: Stargazing in the Cinema* (New Haven, CT: Yale University Press, 1999).

Johnston, Patricia, *Real Fantasies: Edward Steichen's Advertising Photography* (Berkeley, CA: University of California Press, 1997).

Kasson, John F., *Amusing the Million: Coney Island at the Turn of the Century* (New York: Hill & Wang, 1978).

Lyons, Deborah, *et al.*, *Edward Hopper and the American Imagination* (New York: Whitney Museum of American Art, in association with W. W. Norton, 1995).

Marling, Karal Ann, *"My Egypt": The Irony of the American Dream,"* *Winterthur Portfolio* 15 (Spring 1980).

McDonnell, Patricia, *On the Edge of Your Seat: Popular Theater and Film in Early-Twentieth-Century American Art* (New Haven, CT, and Minneapolis, MI: Yale University Press, in association with Frederick R. Weisman Art Museum, University of Minnesota, 2002).

Moudry, Roberta, ed., *The American Skyscraper: Cultural Histories* (Cambridge and New York: Cambridge University Press, 2005).

Powell, Richard, *The Blues Aesthetic: Black Culture and Modernism* (Washington, D.C.: Washington Project for the Arts, 1989).

Robinson, Jontyle Theresa, and Wendy Greenhouse, *The Art of Archibald J. Motley, Jr.* (Chicago, IL: Chicago Historical Society, 1991).

Sims, Lowery Stokes, *Stuart Davis: American Painter* (New York: Metropolitan Museum of Art, 1991).

Solomon, Deborah, *Utopia Parkway: The Life and Work of Joseph Cornell* (New York: Farrar, Straus and Giroux, 1997).

Stavitsky, Gail, *Precisionism in America, 1915–1941: Reordering Reality* (New York: H.N. Abrams, in association with the Montclair Art Museum, 1994).

Stravitz, David, *The Chrysler Building: Creating a New York Icon, Day by Day* (New York: Princeton Architectural Press, 2002).

Todd, Ellen Wiley, *The "New Woman" Revised: Painting and Gender Politics on Fourteenth Street* (Berkeley, CA: University of California Press, 1993).

Trapp, Frank Anderson, *Peter Blume* (New York: Rizzoli, 1987).

Venn, Beth, and Adam D. Weinberg, eds., *Frames of Reference: Looking at American Art, 1900–1950: Works from the Whitney Museum of American Art* (New York and Berkeley, CA: Whitney Museum of American Art, in association with University of California Press, 1999).

Votolato, Gregory, *American Design in the Twentieth Century: Personality and Performance* (Manchester and New York: Manchester University Press, 1998).

## CHAPTER 15

Becker, Jane S., *Selling Tradition: Appalachia and the Construction of an American Folk* (Chapel Hill, NC, and London: University of North Carolina, 1994).

Bettelheim, Judith, "Costume Types and Festival Elements in Caribbean Celebrations," *ACIJ Research Review* 4 (Kingston, Jamaica: African Caribbean Institute of Jamaica. 1999).

Brody, J. J., *Pueblo Indian Painting: Tradition and Modernism in New Mexico 1900–1930* (Santa Fe, NM: School of American Research Press, 1997).

Brooks, Van Wyck, *America's Coming of Age* (New York: B. W. Huebsch, 1915).

Cahill, Holger, *et al.*, *Masters of Popular Painting: Modern Primitives of Europe and America* (New York: Museum of Modern Art, 1938).

Davis, Mike, *City of Quartz: Excavating the Future in Los Angeles* (London and New York: Verso, 1990).

Dorman, Robert L., *Revolt of the Provinces: The Regionalist Movement in America, 1920–1945* (Chapel Hill, NC: University of North Carolina, 1993).

Eldredge, Charles C., *et al.*, *Art in New Mexico, 1900–1945: Paths to Taos and Santa Fe* (New York: Abbeville Press, 1986).

Forrest, Suzanne, *The Preservation of the Village: Hispanics and the New Deal* (Albuquerque, NM: University of New Mexico Press, 1989).

Gehbard, David, "The Myth and Power of Place: Hispanic Revivalism in the American Southwest," in Markovich & Preiser, pp. 143–58.

Hennessey, Maureen Hart, ed., *Norman Rockwell: Pictures for the American People* (Atlanta, GA: High Museum of Art; Stockbridge, MA: Norman Rockwell Museum; New York: H.N. Abrams, 1999).

Kalb, Laurie Beth, *Crafting Devotions: Tradition in Contemporary New Mexico Santos* (Albuquerque, NM: University of New Mexico Press, 1994).

Kardon, Janet, ed., *Revivals! Diverse Traditions, 1920–1945. The History of Twentieth-Century American Craft* (New York: Harry N. Abrams, 1994).

Kinser, Samuel, *Carnival American Style: Mardi Gras at New Orleans and Mobile* (Chicago, IL: University of Chicago Press, 1990).

Lucic, Karen, *Charles Sheeler in Doylestown: American Modernism and the Pennsylvania Tradition* (Allentown, PA: Allentown Art Museum; distributed by the University of Washington Press, 1997).

Maresca, F. and R. Rico, *Bill Traylor: His Art and His Life* (New York: Knopf, 1991).

Markovich, Nicholas C., and Wolfgang F. E. Preiser, Fred G. Sturm, *Pueblo Style and Regional Architecture* (New York: Van Nostrand Reinhold, 1990).

Pierce, Dona, and Marta Weigle, eds., *Spanish New Mexico: The Spanish Colonial Arts Society Collection* (Santa Fe, NM: Museum of New Mexico Press, 1996).

Powell, Richard J., *Black Art: A Cultural History* (London: Thames & Hudson, 2003).

Powell, Richard J., *Homecoming: The Art and Life of William H. Johnson* (Washington, D.C.: National Museum of American Art, Smithsonian Institution; New York: Rizzoli, 1991).

Rydell, Robert, *All the World's A Fair: Visions of Empire at American International Expositions, 1876–1915* (Chicago, IL: University of Chicago Press, 1984).

Salvador, Mari Lyn, *Cuando Hablan Los Santos: Contemporary Santero Traditions from Northern New Mexico* (Albuquerque, NM: Maxwell Museum of Anthropology, 1995).

Starr, Kevin, *Inventing the Dream: California Through the Progressive Era* (New York: Oxford University Press, 1985).

Stein, Judith, ed., *I Tell My Heart: The Art of Horace Pippin* (Philadelphia, PA: Pennsylvania Academy of Fine Arts, 1993).

Upton, Dell, *Architecture in the United States* (Oxford, England: Oxford University Press, 1998).

Van Slyck, Abigail A., "Mañana, Mañana: Racial Stereotypes and the Anglo Rediscovery of the Southwest's Vernacular Architecture, 1890–1920," in Elizabeth Cromley and Carter L. Hudgins, eds., *Gender, Class, and Shelter* (Knoxville, TN: University of Tennessee Press, 1995).

Wallace, Mike, *Mickey Mouse History and Other Essays on American Memory* (Philadelphia, PA: Temple University Press, 1996).

Weigle, Marta, and Barbara A. Babcock, eds., *The Great Southwest of the Fred Harvey Company and the Santa Fe Railway* (Phoenix, AZ: Heard Museum; Tucson, AZ: distributed by the University of Arizona Press, 1996).

Wilson, Christopher, *The Myth of Santa Fe: Creating a Modern Regional Tradition* (Albuquerque, NM: University of New Mexico Press, 1997).

## CHAPTER 16

Adams, Henry, *Thomas Hart Benton: An American Original* (New York: Knopf, distributed by Random House, 1989).

Alofsin, Anthony, ed., *Frank Lloyd Wright: Europe and Beyond* (Berkeley, CA: University of California Press, 1999).

Baigell, Matthew, and Julia Williams, eds., *Artists Against War and Fascism: Papers of the First American Artists' Congress* (New Brunswick, NJ: Rutgers University Press, 1986).

Curtis, William J. R., *Modern Architecture Since 1900* (London: Phaidon Press, 1996).

Delpar, Helen, *The Enormous Vogue for Things Mexican: Cultural Relations Between the United States and Mexico, 1920–1935* (Tuscaloosa, AL: University of Alabama Press, 1992).

Denning, Michael, *The Cultural Front: The Laboring of American Culture in the Twentieth Century* (London and New York: Verso, 1996).

Dennis, James M., *Renegade Regionalists: The Modern Independence of Grant Wood, Thomas Hart Benton, and John Steuart Curry* (University of Wisconsin Press, 1998).

Dervaux, Isabelle, *Surrealism USA* (New York: National Academy Museum: Ostfildern-Ruit, Germany: Hatje Cantz, 2005).

Dewey, John, *Art as Experience* (New York: Minton, Balch & Company, 1934).

Downs, Linda Bank, *Diego Rivera: The Detroit Industry Murals* (New York: Detroit Institute of Arts in association with W. W. Norton, 1999).

Hemingway, Andrew, *Artists on the Left: American Artists and the Communist Movement, 1926–1956* (New Haven, CT, and London: Yale University Press, 2002).

Hurlburt, Laurance P., *The Mexican Muralists in the United States* (Albuquerque, NM: University of New Mexico Press, 1989).

Lefalle-Collins, Lizzetta, and Shifra Goldman, *In the Spirit of Resistance: African-American Modernists and the Mexican Muralist School* (New York: American Federation of Arts, 1996).

Love, Kenneth, dir., *Fallingwater* (videorecording): *A Conversation with Edgar Kaufmann, Jr.* A film by Kenneth Love, in association with the Western Pennsylvania Conservancy; additional assistance by the Frank Lloyd Wright Archives (Santa Monica, CA: distributed by Direct Cinema Limited, 1995).

Lyford, Amy, "Noguchi, Sculptural Abstraction, and the Politics of Japanese American Internment," *Art Bulletin* 85, no. 1 (March 2003), pp. 136–51.

McKinzie, Richard D., *The New Deal for Artists* (Princeton, NJ: Princeton University Press, 1973).

Meikle, Jeffrey, *Twentieth Century Limited: Industrial Design in America, 1925–1939* (Philadelphia, PA: Temple University Press, 1979).

Mello, Renato Gonzáles, and Diane Miliotes, eds., *José Clemente Orozco in the United States, 1927–1934* (Hanover, NH: Hood Museum of Art/Dartmouth College; New York: copublished and distributed by W. W. Norton, 2002).

Miller, Angela, "'With Eyes Wide Open': The American Reception of Surrealism," in Sabine Eckmann and Lutz Koepnick, eds., *Caught by Politics: Hitler Exiles and American Visual Culture* (New York: Palgrave Macmillan, 2007), pp. 61–94.

Oles, James, with an essay by Karen Cordero Reiman, *South of the Border: Mexico in the American Imagination, 1914–1947* (Washington, D.C.: Smithsonian Institution Press, 1993).

Powell, Richard, *Black Art and Culture in the 20th Century* (New York: Thames & Hudson, 1997).

Rather, Susan, *Archaism, Modernism, and the Art of Paul Manship* (Austin, TX: University of Texas, 1993).

Riley, Terence, ed., *Frank Lloyd Wright, Architect* (New York: The Museum of Modern Art and Harry Abrams, 1994).

Shapiro, David, ed., *Social Realism: Art as a Weapon* (New York, Ungar 1973).

Stott, W. *Documentary Expression and Thirties America* (Chicago, IL: University of Chicago, 1973).

Turner, Elizabeth Hutton, *et al.*, *Jacob Lawrence: The Migration Series* (Washington, D.C.: Rappahannock Press in association with The Phillips Collection, 1993).

Weinberg, Adam, and Beth Venn, eds., *Frames of Reference: Looking at American Art, 1900–1950: Works from the Whitney Museum of American Art* (New York: Whitney Museum of American Art; Berkeley, CA: University of California Press, 1999).

Whiting, Cécile, *Antifascism in American Art* (New Haven, CT: Yale University Press, 1989).

Wilson, Richard Guy, ed., *The Machine Age in America, 1918–1941* (New York: Brooklyn Museum in association with Abrams, 1986).

Wright, Frank Lloyd, *Modern Architecture; Being the Kahn Lectures for 1930* (Princeton, NJ: Princeton University Press, 1931).

## CHAPTER 17

Ament, Deloris Tarzan, *Iridescent Light: The Emergence of Northwest Art* (Seattle, WA; London: University of Washington Press; La Conner, WA: Museum of Northwest Art, 2002).

Auping, Michael, ed., *Abstract Expressionism: The Critical Developments* (New York: H. N. Abrams in association with Albright-Knox Art Gallery, 1987).

Belgrad, Daniel, *The Culture of Spontaneity: Improvisation and the Arts in Postwar America* (Chicago, IL: University of Chicago Press, 1998).

Buszek, Maria Elena, *Pin-up Grrrls: Feminism, Sexuality, Popular Culture* (Durham, NC: Duke University Press, 2006).

Clearwater, Bonnie, ed., *West Coast Duchamp* (Miami Beach, FL: Grassfield Press, 1991).

Collins, Bradford, "Life Magazine and the Abstract Expressionists, 1948–1951: A Historiographic Study of a Late Bohemian Enterprise," *Art Bulletin* (June 1991).

Curtis, William J. R., *Modern Architecture since 1900* (London: Phaidon Press, 1996).

*Diane Arbus: Revelations* (New York: Random House, 2003).

Doss, Erika, *Benton, Pollock, and the Politics of Modernism: From Regionalism to Abstract Expressionism* (Chicago, IL: University of Chicago Press, 1991).

Enyeart, James, ed., *Decade by Decade: Twentieth-Century American Photography from the Collection of the Center for Creative Photography* (Boston, MA: Little, Brown; Tucson, AZ: Center for Creative Photography, University of Arizona, 1989).

Galassi, Peter, *American Photography, 1890–1965, From the Museum of Modern Art, New York* (New York: Museum of Modern Art, distributed by H. N. Abrams, 1995).

Gibson, Ann Eden, *Abstract Expressionism: Other Politics* (New Haven, CT: Yale University Press, 1997).

Guilbaut, Serge, *How New York Stole the Idea of Modern Art: Abstract Expressionism, Freedom, and the Cold War* (Chicago, IL: University of Chicago Press, 1983).

Harris, Mark Jonathan, Franklin D. Mitchell, and Steven J. Schechter, eds., *The Homefront: America during World War II* (New York: G. P. Putnam's Sons, 1984).

Holstein, Jonathan, *The Pieced Quilt: An American Design Tradition* (New York: Galahad Books, 1973).

Hopps, Walter, *Robert Rauschenberg: The Early 1950s* (Houston, TX: The Menil Collection, Houston Fine Art Pressor, 1991).

Hughes, Robert and Julie Silber, *Amish: The Art of the Quilt* (New York: Alfred A. Knopf, 1990).

Jackson, Lesley, *The New Look: Design in the Fifties* (New York: Thames & Hudson, 1991).

Jordy, William, "The Aftermath of the Bauhaus in America," in Donald Fleming and Bernard Bailyn, eds., *The Intellectual Migration: Europe and America, 1930–1960* (Cambridge, MA: Belknap Press of Harvard University Press, 1969), pp. 485–544.

Karmel, Pepe, ed., *Jackson Pollock: Interviews, Articles, and Reviews* (New York: Museum of Modern Art, distributed by H. N. Abrams, 1999).

Kentgens-Craig, Margaret, "The Search for Modernity: America, The International Style, and the Bauhaus," in Keith Eggener, ed., *American Architectural History: A Contemporary Reader* (London and New York: Routledge, 2004).

Kirkham, Pat, *Charles and Ray Eames: Designers of the Twentieth Century* (Cambridge, MA: MIT Press, 1995).

Leja, Michael, *Reframing Abstract Expressionism: Subjectivity and Painting in the 1940s* (New Haven, CT: Yale University Press, 1993).

Livingston, Jane, *The New York School: Photographs, 1936–1963* (New York: Stewart, Tabori & Chang, 1992).

Marling, Karal Ann, *As Seen on TV: The Visual Culture of Everyday Life in the 1950s* (Cambridge, MA: Harvard University Press, 1994).

Phillips, Lisa, *Beat Culture and the New America, 1950–1965* (New York: Whitney Museum of American Art, 1995).

Prather, Marla, *et al.*, *Willem de Kooning: Paintings* (Washington, D.C.: National Gallery of Art, 1994).

Rapaport, Brooke Kamin, *et al.*, *Vital Forms: American Art in the Atomic Age, 1940–1960* (New York: Brooklyn Museum of Art in association with H. N. Abrams, 2001).

Roman, Antonio, *Eero Saarinen: An Architecture of Multiplicity* (Princeton, NJ: Princeton Architectural Press, 2003).

Rushing, W. Jackson, *Native American Art and the New York Avant-Garde* (Austin, TX: University of Texas Press, 1995).

Sawin, Martica, *Surrealism in Exile and the New York School* (Cambridge, MA: MIT Press, 1995).

Schrecker, Ellen, *The Age of McCarthyism: A Brief History with Documents* (Boston, MA: Bedford Books of St. Martin's Press, 1994).

Steinberg, Leo, *Other Criteria: Confrontations with Twentieth-Century Art* (New York: Oxford University Press, 1972).

*The TWA Terminal*, photographs by Ezra Stoller (New York: Princeton Architectural Press, 1999).

Tomkins, Calvin, *Off the Wall: Robert Rauschenberg and the Art World of our Time* (Garden City, NY: Doubleday, 1980).

Varnedoe, Kirk, *Jasper Johns: A Retrospective* (New York: Museum of Modern Art, distributed by Abrams, 1996).

Varnedoe, Kirk, and Pepe Karmel, eds., *Jackson Pollock: New Approaches* (New York: Museum of Modern Art, 1999).

Votolato, Gregory, *American Design in the Twentieth Century: Personality and Performance* (Manchester; New York: Manchester University Press, 1998).

Waldman, Diane, *Willem de Kooning* (New York: Harry N. Abrams, Inc., in association with the National Museum of American Art, Smithsonian Institution, 1988).

Winther-Tamaki, Bert, *Art in the Encounter of Nations: Japanese and American Artists in the Early Postwar Years* (Honolulu, HI: University of Hawaii Press, 2001).

Whitfield, Stephen J., *The Culture of the Cold War* (Baltimore, PA: Johns Hopkins University Press, 1996).

## CHAPTER 18

Alberro, Alexander, and Blake Stimson, eds., *Conceptual Art: A Critical Anthology* (Cambridge, MA: MIT Press, 1999).

Baca, Judy, "Murals/Public Art," in *Chicano Expressions: A New View in American Art*, INTAR Latin American Gallery 1986.

Battcock, Gregory, ed., *Minimal Art: A Critical Anthology* (Berkeley, CA: University of California Press, 1995).

Bourdon, David, and Calvin Tomkins, *Christo, Running Fence: Sonoma and Marin Counties, California, 1972–1976* (New York: Abrams, 1978).

Broude, Norma, *et al.*, *The Power of Feminist Art: The American Movement of the 1970s, History and Impact* (New York: Abrams, 1994).

Bryan-Wilson, Julia, "Remembering Yoko Ono's *Cut Piece*," *Oxford Art Journal*, 26.1 (2003), pp. 99–124.

Corrin, Lisa G., *et al.*, *Mark Dion* (London: Phaidon, 1997).

Diserens, Corinne, and Thomas E. Crow, *Gordon Matta-Clark* (London: Phaidon, 2003).

Finkelpearl, Tom, *Dialogues in Public Art* (Cambridge, MA: MIT Press, 2000).

Gamboa, Harry, Jr., *Urban Exile: Collected Writings of Harry Gamboa, Jr.* (Minneapolis, MN: University of Minnesota Press, 2000).

Goldstein, Ann, and Anne Rominer, *Reconsidering the Object of Art: 1965–1975* (Cambridge, MA: MIT Press, 1995).

Griswold del Castillo, Richard, Teresa McKenna, and Yvonne Yarbro-Bejarano, *Chicano Art: Resistance and Affirmation, 1965–1985* (Los Angeles, CA: Wight Art Gallery, University of California, Los Angeles, 1991).

Kaprow, Allan, *Essays on the Blurring of Art and Life* (Berkeley, CA: University of California Press, 1993).

Krauss, Rosalind E., *Passages in Modern Sculpture* (Cambridge, MA: MIT Press, 1977).

Lobel, Michael, *Image Duplicator: Roy Lichtenstein and the Emergence of Pop Art* (New Haven, CT: Yale University Press, 2002).

Madoff, Steven Henry, *Pop Art: A Critical History* (Berkeley, CA: University of California Press, 1997).

*Melvin Edwards, Sculpture: A Thirty-Year Retrospective, 1963–1993* (Purchase, NY: Neuberger Museum of Art, 1993).

Meyer, James Sampson, *Minimalism: Art and Polemics in the 1960s* (New Haven, CT: Yale University Press, 2001).

Michelson, Annette, ed., *Andy Warhol* (Cambridge, MA: MIT Press, 2001).

Molesworth, Helen, *et al.*, *Work Ethic* (University Park, PA: Pennsylvania State University Press, 2003).

Morris, Robert, *Continuous Project Altered Daily: The Writing of Robert Morris* (Cambridge, MA: MIT Press, 1993).

Nixon, Mignon, ed., *Eva Hesse* (Cambridge, MA: MIT Press, 2002).

O'Doherty, Brian, *Inside the White Cube: The Ideology of the Gallery Space* (Santa Monica, CA: Lapis Press, 1976).

Roberts, Jennifer, L., *Mirror-Travels: Robert Smithson and History* (New Haven, CT: Yale University Press, 2004).

Sachs, Steve, ed., *Yvonne Rainer: Radical Juxtapositions 1961–2002* (Philadelphia, PA: The University of the Arts, 2003).

Stiles, Kristine, and Peter Selz, *Theories and Documents of Contemporary Art: A Sourcebook of Artists' Writings* (Berkeley, CA: University of California Press).

Ward, Frazer, "Gray Zone: Watching *Shoot*," *October*, 95 (Winter 2001), pp. 115–30.

Warhol, Andy, *The Philosophy of Andy Warhol: From A to B and Back Again* (New York: Harcourt Brace, 1975).

Whiting, Cécile, *A Taste for Pop: Pop Art, Gender, and Consumer Culture* (Cambridge, England: Cambridge University Press, 1997).

## CHAPTER 19

*Artforum*, 41 nos. 7–8 (March–April 2003). Double issue on the 1980s.

Barthes, Roland, *Image, Music, Text*, trans. Stephen Heath (New York: Hill and Wang, 1977).

Corrin, Lisa G., ed., *Mining the Museum: An Installation by Fred Wilson* (Baltimore, MD: The Contemporary in cooperation with The New Press, New York, 1994).

Corrin, Lisa G., and Miwon Kwon, *Do-Ho Suh* (London: Serpentine Gallery, 2002).

Crimp, Douglas, "The Photographic Activity of Postmodernism," *October*, 15 (Winter 1980), pp. 91–101.

Finkelpearl, Tom, *Dialogues in Public Art: Interviews* (Cambridge, MA: MIT Press, 2000).

Gómez-Peña, Guillermo, *Dangerous Border Crossers: the Artist Talks Back* (London: Routledge, 2000).

Guerrilla Girls, *Confessions of the Guerrilla Girls* (New York: HarperPerennial, 1995).

Hobbs, Robert, *Andres Serrano: Works 1983–1993* (Philadelphia, PA: Institute of Contemporary Art, 1995).

Jameson, Frederic, *Postmodernism: Or, The Cultural Logic of Late Capitalism* (Durham, NC: Duke University Press, 1991).

Joselit, David, *et al.*, *Jenny Holzer* (London: Phaidon, 1998).

Krauss, Rosalind, *The Originality of the Avant-Garde and Other Modernist Myths* (Cambridge, MA: MIT Press, 1985).

Owens, Craig, *Beyond Recognition: Representation, Power and Culture* (Berkeley, CA: University of California Press, 1992).

Shaw, Gwendolyn DuBois, *Seeing the Unspeakable: the Art of Kara Walker* (Durham, NC: Duke University Press, 2004).

Sherman, Cindy, *Cindy Sherman: The Complete Untitled Film Stills* (New York: Museum of Modern Art, 2003).

Tannenbaum, Judith, *Glenn Ligon: Unbecoming* (Philadelphia, PA: Institute of Contemporary Art, 1997).

Wallis, Brian, ed., *Art after Modernism: Rethinking Representation* (New York: New Museum of Contemporary Art, 1984).

Wodiczko, Krzysztof, *Critical Vehicles: Writings, Projects, Interviews* (Cambridge, MA: MIT Press, 1999).

# Picture Credits

Grateful acknowledgment is extended for use of the following images. Every effort has been made to trace and contact all copyright holders. Laurence King Publishing apologizes for any unintentional omissions or errors, and will be pleased to insert the appropriate acknowledgment in any subsequent edition of this book.

p. xvi & 2.16 Photo John Bigelow Taylor; p. 2 Reproduction, Art Institute of Chicago; 1.1, 1.7, 1.9 Photo David Heald; 1.4 Hopewell Culture National Historic Park, Ohio; 1.5 Photo Doug Carr; 1.6 Eliza McMillan Trust, 34:1953; 1.11 © William Morgan, William Morgan Architects, Florida; 1.13 Acc. no. VA71-009-0001; 1.14 Acc. no. VA72-049-001; 1.15, 1.18 Photo Janet Berlo; 1.16 University of Pennsylvania (image #150615); 1.17 Photo Adriel Heisey Photography; 1.20 Acc. no. TM4589; 1.21 Acc. no. T0770/Photo John Bigelow Taylor; 2.03 © Corbis/Historical Picture Archive; 2.5, 2.6 © British Museum; 2.10 © Corbis/Archivo Iconografico, S.A.; 2.13 Acc. no. T0024; 2.14 Acc. no. T0794; 2.17 Acc. no. T0008; 2.18 © Field Museum, #A99655-21c; 2.19 © 2006 Musée du Quai Branly, Photo Patrick Gries/Scala, Florence; 2.20, 2.21 British Museum; 2.22 Acc. no. 1977/35/4; 2.23 National Museums Liverpool; 2.25 Photo Janet Berlo; 2.26 Library of Congress; 2.30 Museum purchase, 1947.37 © 2006 Philbrook Museum of Art, Tulsa, Oklahoma; 2.31 Photo © Lee H. Marmon; 2.32 Private Collection; 2.33, 2.35 Photo © Jorge Perez de Lara; 2.34 Photo © Jan Butchofsky-Houser/Corbis; 2.37 Courtesy Palace of the Governors (MNM/DCA) Neg. no 149804 & 158345; p. 56 Photo Helen Ronan; 3.1 Courtesy Henry Whitfield State Museum, Guilford, CT, USA, CT Commission on Culture & Tourism; 3. 3 © Dr. Rodney Pygoya Chang, USA; 3.4 © Dick Kent, USA; 3.13 Acc. no. (1963.135); 3.14 Acc. no. (1963.134); 3.15 Gift of Mr. and Mrs. John D. Rockefeller 3rd, 1979.7.3; 3.16 Museum purchase, Acc. no. (1948.19); 3.17 Acc. no. TM5623; 3.18 Photo © Jorge Perez de Lara; 3.19 Acc. no. TM852; 3.21 Acc. no. TM1676; 3.22 Acc. no. TM885; 3.24, 3.25, 3.26 Photo G E Kidder Smith, Courtesy of Kidder Smith Collection, Rotch Visual Collections, M.I.T.; 3.25 Historic American Buildings Survey, Library of Congress, Washington; 3.29 Peabody Essex Museum, Salem, Massachusetts; 3.30 Photo © Jefferey Howe; 3.32 Acc. no. 1841.1; 3.35 Acc. no. 118284; 3.36 Acc. no. 4134.39; 3.37 Museum Collection. 1842.2.1. Negative number RHi X3 7354; 3.39 © British Museum; 3.42 Acc. no. 1961.701.2; p. 94 Photo © Michael Freeman/Corbis; 4.1 Acc. no. 1935.301.3; 4.3, 4.7 Photo © Rough Guides/Alamy; 4.4 Photo Richard K Dozier, Historic American Buildings Survey, Library of Congress, Washington; 4.5 © Corbis/Bob Krist; 4.6 Courtesy of Mount Vernon Ladies' Association; 4.8, 4.9 Private Collection; 4.10, 4.11 Jack E Boucher 1971, Historic American Buildings Survey, Library of Congress, Washington; 4.13 Courtesy of Whitehall Museum House, Rhode Island; 4.14 D Syndacker 1996, Newport Historical Society, Rhode Island; 4.15, 4.20 G E Kidder Smith, Courtesy of Kidder Smith Collection, Rotch Visual Collections, M.I.T.; 4.16 Newport Historical Society, Rhode Island; 4.17 Charles N Bayless, Historic American Buildings Survey, Library of Congress, Washington; 4.18 © JTB Photo Communications, Inc/Alamy; 4.19 Jet Lowe, 1983, Historic American Buildings Survey, Library of Congress, Washington; 4.21 © A T Willett/Alamy; 4.22 Henry F Withey 1936, Historic American Buildings Survey, Library of Congress, Washington; 4.24 Museum purchase with funds donated by contribution, and Francis Bartlett Fund 49.45. Photograph © 2007 Museum of Fine Arts, Boston; 4.27 Mabel Brady Garvan Collection, Acc. no. 1940.320; 4.29 Gift of Isaac Lothrop, Acc. no. 1808.1; 4.30 Harvard University Art Museums, Fogg Art Museum, Bequest of Ward Nicholas Boylston to Harvard College, 1828, H90. Photo Imaging Department © President and Fellows of Harvard College; 4.32 Gift of Joseph W. Revere, William B. Revere, and Edward H.R. Revere 30.781. Photograph © 2007 Museum of Fine Arts, Boston; 4.33 Gift of Louis M. Rabinowitz, 1947.16; 4.35 Gift of Mrs. Sarah Harrison (Joseph Harrison, Jr. Collection) Acc. no. 1878.1.10; 4.37 Museum Purchase, 256:1948; 4.38 Image © 2007 Board of Trustees, National Gallery of Art, Washington; p. 132 & 5.32 George W. Elkins Collection, 1945. Acc. no. E1945-1-1. Photo Philadelphia Museum of Art/Art Resource/Scala, Florence; © 2004; p. 134 Acc. no. M18627; 5.2 Private Collection; 5.4 Acc. no. 1832.1 5.5 Atwater Kent Museum of Philadelphia; 5.6 © 2004. Photo National Portrait Gallery, Smithsonian/Art Resource/Scala, Florence; 5.7 Acc. no. 1986-100-1; 5.11 Gift of Edgar William and Bernice Chrysler Garbish. Image © 2007 Board of Trustees, National Gallery of Art, Washington; 5.13 Gift of Henry Davis Sleeper in memory of his mother, Maris Westcote Sleeper, by exchange 60.1419a-b Photograph © 2007 Museum of Fine Arts, Boston; 5.14, 5.15 Photo Courtesy of Library of Virginia; 5.16b Photo Robert Llewellyn; 5.20 Corcoran Gallery of Art, Washington, DC. Museum Purchase, Gallery Fund. 11.14; 5.21 Gore Place Society, Waltham, Massachusetts; 5.22 Gift of Mrs. Horatio Appleton Lamb in memory of Mr. and Mrs. Winthrop Sargent 19.13. Photograph © 2007 Museum of Fine Arts, Boston; 5.25 Collection of H Richard Dietrich Jr, Photograph by Will Brown, Philadelphia, PA, Dietrich American Foundation; 5.27 Acc. no. 1908.28; 5.28 Acc. no. 138077; 5.29 Gift of a Friend of the Department of American Decorative Arts and Sculpture, a Supporter of the Department of American Decorative Arts and Sculpture, Barbara L. and Theodore B. Alfond, and Samuel A. Otis; and William Francis Warden Fund, Harriet Otis Cruft Fund, Otis Norcross Fund, Susan Cornelia, Warren Fund, Arthur Tracy Cabot Fund, Seth K. Sweetser Fund, Edwin E. Jack Fund, Helen B. Sweeney Fund, William E. Nickerson Fund, Arthur Mason Knapp Fund, Samuel Putnam Avery Fund, Benjamin Pierce Chency Fund, and Mary L. Smith Fund 1996.26. Photograph © 2007 Museum of Fine Arts, Boston; 5.30 Gift of Newton C. Brainard; 5.31 Andrew W. Mellon Collection. Image © 2007 Board of Trustees, National Gallery of Art, Washington; 5.33 Gift of Mrs. Sarah Harrison (The Joseph Harrison, Jr. Collection). Acc. no. 1878.1.2; 5.34 Acc. no. 1878.1.11; 5.35 Gift of Mrs. Samuel and Miss Alice Cooper 70.1 Photograph © 2007 Museum of Fine Arts, Boston; 5.36 William Sturgis Bigelow Collection 21.1429 Photograph © 2007 Museum of Fine Arts, Boston; p. 170 Acc. no.1863.17.26; 6.1 Detroit Institute of Arts, Bequest of Dr. and Mrs. James Cleland, Jr. Photograph © 1993 Detroit Institute of Arts; 6.3 Photo Smithsonian American Art Museum © 2007 Art Resource/Scala, Florence; 6.4 Olive Louise Dann Fund, Acc. no. 1962.43; 6.5 Purchased with funds from Florence Scott Libbey Bequest in Memory of her father, A. Scott, 1949.162; 6.6 Harris Brisbane Dick Fund, 1924 (24.66.14) Image © Metropolitan Museum of Art; 6.7 City of Oakland Cultural Arts and Marketing Division, California; 6.8 Museum purchase with funds provided by Anaruth and Aron S. Gordon; 6.9 Private collection; 6.10 Sansbury-Mills Fund, 1959 (59.152.1) Image © Metropolitan Museum of Art; 6.11 © Shelburne Museum, Shelburne, Vermont. Acc. no. 10-283; 6.12 Museum purchase with funds donated anonymously 1999.531 Photograph © 2007 Museum of Fine Arts, Boston; 6.13 Object number 1997.007.0697; 6.17 Acc. no. N-0084.1995; 6.18 Acc. no. 1959.305.1; 6.19 Edmund Carpenter Collection, Photo Otto Nelson; 6.22 Sam Abell/National Geographic Image Collection; 6.23 Photo Michael Freeman; 6.25 27.220 Photograph © 2007 Museum of Fine Arts, Boston; 6.26 Terra Foundation for American Art, Daniel J Terra Collection, 1992.51. Photograph Courtesy of the Terra Foundation for American Art, Chicago; 6.27 Bequest of Henry

C. Carey (The Carey Collection) Acc. no. 1879.8.18; 6.28 Image © 2007 Board of Trustees, National Gallery of Art, Washington; 6.30 Maria DeWitt Jesup Fund, 1949 (49.126) Image © The Metropolitan Museum; 6.31 Gift of Mr. and Mrs. Scott L. Probasco, Jr.; 6.32 Acc. no. N-0222.1956; 6.33 Gift of Frederick Sturges, Jr., 1954; 6.34 Acc. no. N-395.55; 6.35 Purchase 42.9; 6.36 Acc. no. 63.110; 6.37 Brooklyn Museum, Gift of Mr. and Mrs. Alastair Bradley Martin, 43.25; p. 208 & 7.2 Walters Art Museum, Baltimore; 7.3 Buffalo Bill Historical Center, Cody, Wyoming; Chandler-Pohrt Collection, Gift of Mr. and Mrs. Edson W. Spencer; NA.108.105. Photograph © 1985 Detroit Institute of Arts; 7.5 © 2006. Photo Smithsonian American Art Museum/Art Resource/Scala, Florence; 7.7 Joslyn Art Museum, Omaha, Nebraska; 7.08 © 2006 Harvard University, Peabody Museum, 99-12-10/53047/T2926; 7.09 Acc. no. NPG.70.14; 7.10 © 2004. Photo Smithsonian American Art Museum/Art Resource/Scala, Florence; 7.13 Acc. no. 1875.4; 7.15 © Shelburne Museum, Shelburne, Vermont. Acc. no. 27.1.5-018; 7.16 Gift of Nathaniel Phillips, 1890; 7.17 Image © 2007 Board of Trustees, National Gallery of Art, Washington; 7.18 (33.61) Photograph © 1999 Metropolitan Museum of Art; 7.20 Crocker Art Museum, E.B. Crocker Collection; 7.23 Acc. no. T307; 7.24 Seattle Art Museum, Gift of John H. Hauberg. Photo Paul Macapia; 7.26 Acc. no. T0210; 7.28 Denver Art Museum Collection: Native Arts Acquisition Fund, 1951.315. Photo © Denver Art Museum 2006. All Rights Reserved; 7.29 Acc. no. VK284; 7.30 © 2006. Photo Jewish Museum/Art Resource/Scala, Florence; 7.31 Joslyn Art Museum, Omaha, Nebraska; p. 240 and 8.30 Acc. no. 1977.17; 8.01 Bequest of Daniel Wordsworth; 8.2 Acc. no. (1916.97); 8.3 Acc. no. 1903.14; 8.04 Courtesy of Mount Auburn Cemetery, Cambridge and Watertown, Mass; 8.7 Private collection; 8.8, 8.9 R. Higginson; 8.10 Gift of Lenore B. and Sidney A. Alpert supplemented with Museum Acquisitions Funds. Photo David Stansbury; 8.12 © Matt Richardson; 8.14 Mabel Brady Garvan Collection, Acc. no. 1946.36; 8.16 (62.256.3) Photograph ©1998 Metropolitan Museum of Art; 8.17 Gift of Martha C. Karolik for the M. and M. Karolik Collection of American Painting, 815-1865. 47.1188. Photograph © 2007 Museum of Fine Arts, Boston; 8.18 Acc. no. 1858.2; 8.19 Acc. no. 1858.3 Photo David Stansbury; 8.20 Acc. no. 1858.4; 8.22 Photo: David Stansbury; 8.23 Gift of Lenore B. and Sidney A. Alpert supplemented with Museum Acquisitions Funds. Photo David Stansbury; 8.24 (09.95) Photograph © 1979 Metropolitan Museum of Art; 8.25 Negative number 61264; 8.26 (74.29) Photograph © 1984 Metropolitan Museum of Art; 8.27 Bequest of Martha C. Karolik for the M. and M. Karolik Collection of American Paintings, 1815-1865. 48.448 Photograph © 2007 Museum of Fine Arts, Boston; 8.28 Gift of Mr. and Mrs. J. Douglas Pardee, Mr. and Mrs. John McGreevey, and Mr. and Mrs. Charles C. Shoemaker. Photograph © 2006 Museum Associates/LACMA; 8.29 Detroit Institute of Arts, Founders Society Purchase, Robert H. Tannahill Foundation Fund, Gibbs-Williams Fund, Dexter M. Ferry, Jr., Fund, Merrill Fund, Beatrice W. Rogers Fund, and Richard A. Manoogian Fund. Photograph © 1985 Detroit Institute of Arts; 8.31 Robert L. Stuart Collection on permanent loan from the New York Public Library Negative number #27225; 8.32 Gift of Edward Southworth Hawes in memory of his father Josiah Johnson Hawes 43.1494 Photograph © 2007 Museum of Fine Arts, Boston; 8.33 © 2006 Harvard University, Peabody Museum, 35-5-10/53043 T1873; 8.38 Private Collection; 8.40 (22.207) Photograph © 1998 Metropolitan Museum of Art; 8.41 Photo The Newark Museum/Art Resource/Scala, Florence, © 2006; p. 278 and 10.23 © Lee Snider/Photo Images/Corbis; p. 280 Roger McCormick Endowment, 1998.1. Reproduction, The Art Institute of Chicago; 9.1 The Morgan Wesson Memorial Collection. Photo David Stansbury; 9.2, 9.3 Private Collection; 9.5 Object number 2001.011.0001; 9.6 © Swerve/Alamy; 9.7 Corcoran Gallery of Art, Washington, DC. Museum Purchase, Gallery Fund. 81.8; 9.8 (22.220) Photograph © 1984 Metropolitan Museum of Art; 9.9 Catharine Lorillard Wolfe Collection, 1906 (06.1234) Photograph ©1995 Metropolitan Museum of Art; 9.10 Brooklyn Museum, Sustaining Membership Fund, Alfred T. White Memorial Fund, and the A. Augustus Healy Fund, 23.98; 9.11 Bequest of Maxim Karolik 64.619 Photograph © 2007 Museum of Fine Arts, Boston; 9.13 Brooklyn Museum, Gift of Carll and Franklin Chace, in memory of their mother Pastora Forest Smith Chace, daughter of Thomas Carll Smith, the founder of the Union Porcelain Works, 43.25; 9.14 Acc. no. 1961.18.26; 9.15 Private Collection; 9.16 Photo Katherine Wetzel. © Virginia Museum of Fine Arts; 9.17 General Collections, Library of Congress, Washington; 9.18 Photo David Stansbury; 9.19 Gift of Lenore B. and Sidney A. Alpert supplemented with Museum Acquisitions Funds. Photo David Stansbury; 9.22 From the American Geographical Society Library, University of Wisconsin-Milwaukee Libraries; 9.23 Acc. no. 1909.16; 9.24 Lent by the Department of the Interior Museum © 2006. Photo Smithsonian American Art Museum/Art Resource/Scala, Florence; 9.27 Acc. no. TM1987.7; 9.28 Inv.Nr.IVB5106; 9.30 Denver Art Museum Collection: Gift of Alfred I. Barton, 1954.414. Photo © Denver Art Museum 2006. All Rights Reserved; 9.31 Acc. no. TM1215; 9.32 © 1981 Center for Creative Photography, Arizona Board of Regents; 9.33 Acc. no. TM3594; 9.37 Acc. no. 1882.18.32; 9.38 Acc. no. 1882.18.4; 9.39 Acc. no. T0614; 9.41 Photo Tony Walsh, Cincinnati, Ohio; p. 320 & 10.9 Gift of Mary Louisa Boit, Julia Overing Boit, Jane Hubbard Boit, and Florence D. Boit in memory of their father, Edward Darley Boit 19.124 Photograph © 2007 Museum of Fine Arts, Boston; 10.1 (96.17.21) Photograph © 1991 Metropolitan Museum of Art; 10.2 Private collection; 10.3 Acc. no. 1961.5.31; 10.4 Brooklyn Museum, Gift of Mrs. Carll H. de Silver in memory of her husband, 13.50; 10.5 Gift of Ellen Harrison McMichael in memory of C. Emory McMichael, 1942. Acc. no. 1942-60-1; 10.6 © Private Collection/Photo © Christie's Images/The Bridgeman Art Library; 10.7 Image © 2007 Board of Trustees, National Gallery of Art, Washington; 10.10 1916 (16.53) Photograph © 1997 Metropolitan Museum of Art; 10.11 RMN-Reversement Orsay; 10.12 © Tate, London 2007; 10.13 R. Higginson; 10.14 Image © 2007 Board of Trustees, National Gallery of Art, Washington; 10.15 The Roland P. Murdock Collection (M109.53); 10.16 Photo The Philadelphia Museum of Art/Art Resource/Scala, Florence, © 2006; 10.17Rogers Fund. Image © Metropolitan Museum of Art; 10.18 Object number 1997.007.0541; 10.19 Negative number 33494; 10.20, 10.21 © Paul Rocheleau; 10.26 1969 (69.146.3) Photograph © 1994 Metropolitan Museum of Art; 10.27 Brooklyn Museum, H. Randolph Lever Fund, 83.27; 10.28 © The Cleveland Museum of Art, 2002. Gift of Mrs. Boudinot Keith in memory of Mr. and Mrs. J.H. Wade. 1921.1239; 10.30, 10.31 Thomas A. Heinz, AIA, photographer © Copyright 2007 Thomas A. Heinz and Randell L. Makinson; 10.32 Restricted gift of Mrs. Frank L. Sulzberger, 1984.240. Reproduction, The Art Institute of Chicago; 10.35 University of Pennsylvania Museum (image #140400); 10.36 Courtesy of the Autry National Center, Southwest Museum, Los Angeles. Photo# 811-G-1460A; 10.38 Virginia Carroll Crawford Collection, 1984.170; 10.39 Edwin E. Jack Fund and Anonymous gift 69.1224. Photograph © 2007 Museum of Fine Arts, Boston; p. 356 © Jerry L Thompson; 11.1 (66.143) Photograph © 1989 Metropolitan Museum of Art; 11.3 Corcoran Gallery of Art, Washington, DC. Museum Purchase, Gallery Fund. 07.7; 11.4 George A. Hearn Fund, 1915 (15.32) Image © Metropolitan Museum of Art; 11.5 Corcoran Gallery of Art, Washington. Museum Purchase, Anna E. Clark Fund. 49.1; 11.7 Gift of the Avalon Foundation.

# Index